HOUSE OF THE SURGEON, POMPEII: EXCAVATIONS IN THE CASA DEL CHIRURGO (VI 1, 9-10.23)

HOUSE OF THE SURGEON, POMPEII

EXCAVATIONS IN THE CASA DEL CHIRURGO (VI 1, 9-10.23)

Michael A. Anderson and Damian Robinson

With contributions by

H. E. M. Cool, Richard Hobbs,
Charlene Murphy, Jane Richardson, Robyn Veal,
Helen White, Will Wootton

Foreword by

Rick Jones

OXBOW | books
Oxford & Philadelphia

For our parents

Published in the United Kingdom in 2018 by
OXBOW BOOKS
The Old Music Hall, 106-108 Cowley Road, Oxford, OX4 1JE

and in the United States by
OXBOW BOOKS
1950 Lawrence Road, Havertown, PA 19083

© Oxbow Books and the authors 2018

Hardcover Edition: ISBN 978-1-78570-728-5
Digital Edition: ISBN 978-1-78570-729-2 (epub)

A CIP record for this book is available from the British Library

Library of Congress Cataloging-in-Publication Data

Names: Anderson, Michael A., author. | Robinson, Damian, author. | Cool, H.
 E. M., author. | Jones, Rick (Archaeologist), writer of foreword.
Title: House of the Surgeon, Pompeii : excavations in the Casa del Chirurgo
 (VI 1, 9-10.23) / Michael A. Anderson and Damian Robinson ; with
 contributions by H.E.M. Cool [and 6 others] ; foreword by Rick Jones.
Description: Oxford ; Havertown, PA : Oxbow Books, 2017. | Includes
 bibliographical references and index.
Identifiers: LCCN 2017047685 (print) | LCCN 2018026653 (ebook) | ISBN
 9781785707292 (epub) | ISBN 9781785707308 (mobi) | ISBN 9781785707315 (
 pdf) | ISBN 9781785707285 (hb)
Subjects: LCSH: House of the Surgeon (Pompeii) | Excavations
 (Archaeology)--Italy--Pompeii (Extinct city) | Pompeii (Extinct
 city)--Buildings, structures, etc.
Classification: LCC DG70.P7 (ebook) | LCC DG70.P7 A653 2017 (print) | DDC
 937/.72568--dc23
LC record available at https://lccn.loc.gov/2017047685

Typeset in the United Kingdom by Frabjous Books
Printed in Malta by Melita Press

For a complete list of Oxbow titles, please contact:

United Kingdom
Oxbow Books
Telephone (01865) 241249
Email: oxbow@oxbowbooks.com
www.oxbowbooks.com

United States of America
Oxbow Books
Telephone (800) 791-9354, Fax (610) 853-9146
Email: queries@casemateacademic.com
www.casemateacademic.com/oxbow

Oxbow Books is part of the Casemate Group

CONTENTS

ACKNOWLEDGEMENTS

This work could not have been undertaken without the encouragement and support of Soprintendente, Prof. Pier Giovanni Guzzo, Direttore, dott. Antonio D'Ambrosio, and the entire staff of the *Soprintendenza Archeologica di Pompeii,* to whom the deepest thanks are due. Gratitude is also due to individuals too numerous to list here from all over the world, from the US to the UK to Italy, who helped to make the Project successful in its operation, both throughout the year and in the field. To them, the most sincere thanks are also given.

The process of processing the data produced, digitising the records, analysing and interpreting the results, also required the time and efforts of a large number of volunteers and funding agencies supporting them.[1] To these people, and especially to Hilary Cool, who tirelessly coordinated and facilitated these efforts, words do not suffice to express our thanks.

Finally, we would like to thank the students of the AAPP, whose work and enthusiasm produced the data published herein.

Sarah Abraham	Emily Bates	Sarah Brophy	Polly Cockerham	Barry DeSain
Jeffrey Aitchinson	Natalia Bauer	Jordan Bross	Nicole Colosimo	Gary Devore
Nathan Allen	Peggy Baxter	Kimberly (Max) Brown	Shaun Connor	Sara DeYoung
Rebecca Allen	Matthew Beazley	Connie Brown	Kellam Conover	Azzurra Di Marcello
Stephanie Allen	Jennifer Beckmann	Lacosta Browning	Rachel Cooper	Elizabeth Diggles
Jessica Ambler	Chris Beemer	James Bucko	Els Coppens	Alicia Dissinger
Moriah Amit	John Bennett	Sarah Easton Buker	Elizabeth Corbett	Sam Luke Dluzewski
Philip Anastasi	Jamie Benoit	Eleanor Bull	Hugh Corley	Lindsay Dobrovolny
Rossana Anderson	Craig Benson	Jordan Bunger	Jody Cornfeld	Heather Doherty
Michael A. Anderson	Jared Benton	Asha Burchett	Nicola Jane Cowie	Jamieson Donati
Elvira Anderson	Daniel Bera	Richard L Burchfield	Ellis Cox	Grace Doughty
Laura Anderson	Bastiaan van der Berg	Sara Burgess	Philip Cox	Andrew Douglas
James Andrews	Laura Berger	Benjamin Burnham	Frances Cox	Allison Downey
Meg Andrews	Sarah Bergh	Maureen A. Burns	Dwanna Crain	Meredith Downs
Francesca Angelini	Lauren Berkley	Michael Burns	Jay Cravens	Alana Doyle
Boshko Angelovski	Tiffany Best	Andrew Burton	Dennis Crayon	Cindy Drakeman
Benjamin Arato	Anna Betts	Amand Bush	Christopher Crockett	Gemma Driver
Graham Arkley	Judith Bianciardi	Eleanor Buttery	Owen Cross	Adam Dubbin
Jonathan Armitt	Lena Blixt-Schmid	Michael Byrne	Carl Crozier	Mary Louise Duncan
Chris Arnold	Claire Blizzard	Virginia Campbell	Rebecca Crump	Carly Dunn
Hayley Arnold	Diana Blumberg	Danielle Campbell	Julia Cudworth	Jennifer Dutko
Kathryn Arrighetti	Anna Marie Bohmann	Steven Campion	Julia Cussans	Charles Edel
Jennifer Arrington	Julia Borek	Michelle Campos	Joanne Cutler	Matt Edling
Ian Atkins	Kathryn Bormann	Mary Carello	Kendra Dacey	Sibyl Edwards
Graeme Attwood	Tim Boswell	Holly Carlton	Bogdan Damian	Emily Egan
Pam Aubrecht	Raul Botello	Kelly Carnes	Christian Dangremond	Jane Ellam
Lyn Aubrect	Dominique Bouchard	Lydia Carrington-Porter	Amy Dapling	Edawrd Elliott
Maribel Isabel Ayala-Gragera	Ellen Boucher	Holly Carter-Chappell	Robert Darby	Steven Ellis
Karl Ayers	Heather Bouchey	Sarah Castleberry	Tanya Dare	Jennifer Emmett
Jim Bachor	Peyton Bowman	Robert Chavez	Orit Darwish	Jamie Beth Erenstoft
Nadia Bagwell	Simon Bradbury	Barbara F. Chin	Eric Daum	Marlene Estabrooks
Darren Bailey	Jennifer Bradshaw	Popi Chrysistomou	Iain A. Davis	Rhian Evans
Jessica Baken	Katherine Brandon	Timothy Chubb	Tim Dawson	Syd Evans
Kristen Baldwin	Molly Breckenridge	Catherine Clark	Stephanie Dawson	Karen Evans
Maria Banane	Laura Breen	Elizabeth Clark	Stewart Dearing	Laura Evans
Mari-Ann Bankier	Demetrios Brellas	Katherine Clarke	Megan Denis	David Fabricant
Jason Barry	Caroline Brennan	Stephanie Clayton	Michael Denning	Erin Farley
Ashly Basgall	John Brisette	Chris Cloke	Lori Denton	Jason Farr
Laura Bateman	Lauren Britton	Mary Cochran	Tim Denton	Trisha Faulhafer

Heather Fawcett
Kate Feather
Keffie Feldman
Sarah Ferstel
Miriam Fettman
Albert Fischer
George Harrison Fisher
Emily Fitzgerald
Shannon Rogers Flynt
Amy Flynt
Louise Ford
Margaret Foster
Rachel Freel
Hannah Friedman
Alexis Fae Gach
Frances Gallart-Marques
Katerina Garajova
Emily Gaukler
Kimberley Gawel
Natascha Gibson
Simon Gibson
Beatriz L. Gallego Girona
Joy Glaister
Emily Glass
Katie Gleason
Kristina Jelena Glicksman
Benjamin John Goetsch
Brian W. Gohacki
Emma Golden
Leslie Goldmann
Kelly Goodman
Megan Gorman
Blair Gormley
Giselle Gos
Jessica Grant
Shannon Grant
Jessica Grant
Walton (Tinker) A. Green
Krista Greksouk
Maureen Grier
Rachel Griffiths
Claire Griffiths
David Griffiths
Carrie Grimes
Lisa Guerre
Jodi Gurnsey
Nicole Hackman
Ann-Marie Hadley
Patrick Hadley
Nicole Hagenbuch
Danielle Haley
Neil Hall
Zachary Hallock
Kristel Halter
Tracy Hanna
John (Jack) Hanson
Melanie Hargreaves
Jennifer Harshman
Emma Harvey
David Harwood
Julia Hasek
Michael Heard
Rachel Heatherly
Dan Hedges
Catherine Heite

Angela Helmer
Melissa Hendricks
Kimberley Herr
Rachel Hesse
Emily Higginbotham
Alvin Ho
Barry Hobson
Andrew Holland
Brooke Hollenshead
Karen Hollings
Adam Holman
Amber Hood
Tim Horsley
Sarah Hough
Alex Howard
Ria Huber
Michaela Huffman
Ryan Hughes
Brant Hunter
Angela Hurd
Nick Hyde
Catherine Illingworth
Yvonne Inall
Gemma Jackson
Daniel Jackson
John Jacobs
Sarah Jacobson
Sam Jahanmir
Thomas Jakab
Dan Jamison
Karen Jane Johnson
Emily Johnson
Eric Johnson
Erica Johnston
Adriana Jones
Laura Jones
Gwen Jones
Carla Jones
Hannah Jones
Christopher Jones
Katie Jordan
Melissa Joseph
Sylvia Junk
Rachel Belle-Ann Kahn
Tarah Kane
Lara Miriam Kaplan
Victoria Keitel
Erin Kelley
Heather Kelly
Mark Kelly
Judy Kemp
Toby Kendall
Frances Kern
Tara Keyser
Jenny Kim
Victoria (Vickie) L. King
Melanie-Jeanne Kingsley
Lynette Leila Kleinsasser
Guy Knight
Rebecca Knight
Julie Knoeller
Kathryn Elizabeth Kohout
Deanne Komlo
Annika Korsgaard
Suzanne Kortlucke

Emily Kouzes
Kelly Krause
Anna Kreder
Vinci Kwok
Ols Lafe
Nikolas Lamb
Jenni Lane
Sarah Langensiepen
Ruth Larkin
Amelia Larsen
Rachael Lavine
Marie-Christine Lecompte
Mabel Lee
Samantha LeHecka
Julie Leighton
Jared Lelos
Hallie Levin
Charles Lewandowski
Hana Yve Lewis
Craig Leyland
Shane Alan Lieffers
Matthew Lilley
Megan Lillie
Erin Linn
Rowena Llyod
Jarrett Lobell
Andrea Long
Brenda Longfellow
Andrea Lord
Maxine Love
Andrea Lowe
Katie Lu
Robert MacDonald
Giles Machell
Alan Mackenzie
Alexander Graham
 Mackenzie
Melissa Madden
Lisa Mallen
Xanthé Mallet
Luke Malone
Michele Malter
Mellisa Mance
Adriana Mandich
Crista Mannino
Mark Manuel
Emma Manzi
Megan Maples
Leeanna Marchant
Martin Marks
Paul Daniel Marr
Amy Elizabeth Marriott
Katherine Elizabeth
 Martin
Benjamin Martorell
Shellie Masri
Jennifer Lynne Mass
Patricia Mattern
Lucy Maxian
Mackenzie McAdams
Lynley McAlpine
Amy McCabe
Eric Daniel McCan
Jayne McCann
Dori McCarter

Mary McCarthy
Matthew McCarty
Katherine McClain
William (Billy) McCluskey
Kate McCowage
Emily McDonald
Katie McEnaney
Katherine McGhee-Snow
Caroline McKenzie
Mark McKenzie
Pamela McKenzie
Kathryn Elizabeth-Anne
 McKenzie
Jenny McLaine
Lisa McNally
Jessica McNeil
Kelly McQuillan
Kevin Mears
Olympia Carla Mercuri
Maggi Merten
Rachel Meyers
Shayna Meyers
Dimitra Michalopoulou
Lisa Marie Mignone
Gerard Milani
Philip Miles
Christine Miller
Alex Miller
Jessica Miller
Thomas Milner
Joji Min
Leta Mino
Mark D. Mitchell
Larkin Mitchell
Louise Mitchell
Joseph Mitchell
Helen Molesworth
Jessica Moore
Alex Moore
Elaine Moran
Lauren Moreau
Erika Morey
Kathryn Morgan
Peter Morley
Terry Morris
Lucy Moyden
Aisling Mulcahy
Celia Muller
Lisa Mulschlegel
Andrea Munro
Phil Murgatroyd
Carrie Murray
Sarah Murray
Danai-Christina Naoum
Therese Nation
Jaclyn Neel
James Neely
Taylor Rose Neff
Jodi Nelan
Julian Newman
Garry Ng
Catherine Ngo
Cindy Nguyen
Ayesha Nibbe
Joe Nigro

Monica Nilsson
Mattew Nisinson
Steve Noordyke
Kirk Norman
Shaina Morgaine Norvell-
 Cold
Kristyn Novotny
Adam Noyce
Eric Noyes
Kristin Nyweide
Ros O'Maolduin
Mark O'Brien
Clare O'Bryen
Catherine O'Connor
Emily Ogle
Kendal Ogles
Leigh Oldershaw
Owen O'leary
D'arne O'Neill
Rachael Orgill
Kathryn Ormston
Amelia Osborne
Cine Ostrow
Michel Chad (Elvis) Oxley
Stacey Ann Pabis
Nevelina Pachova
Veronica Pagan
Julie Palmer
Elizabeth Papworth
Elizabeth Paris
Ian Parker
Alistair Parker
Crystal Parsons
Francine Pashley
Cate Paskoff
Josh Patterson
Nicolette Pavlides
Kate Pearson
Andrea Perraud
Eric Peters
Erika Petersen
Gabriel Petrescu
Adam Pettigrew
Kathryn Pickles
Hillary Pietricola
Helen Plant
Verity Platt
Cherida Plumb
Eric Poehler
Jaye Pont
Fabiana Portolano
Rachel Poser
Victor Posthuma
Nicole Potdevin
Tracey Potter
Joan Pottinger
Jessica Pountney
Eleanor Power
Elizabeth Prezioso
Andrea Proffitt
Evan Proudfoot
Stephanie Pryor
Julian Quiterio
Alexa Raad
Sally Radford

[1] For more details please see the footnotes of each chapter.

Lian Ramage
Genevieve Raseman
Janet Rauscher
Nick Ray
Lilian Read
Anthea Reagan
Meghan Reidy
Cedar Anne Reimer
Amanda Reiterman
Amanda Reynolds
Sarah Rice
Jaclyn Richmond
Elizabeth De Ridder
David Rider
Sarah Ritchie
Amanda Roberts
Katrina Louise Roberts
Michael Rocchio
Ramiro De La Rocha
Fernando Romero
Maria Romero
Fiona Rose
Paula Rosenberg
Abbey Lauren Rothstein
Adam Rowland
Samantha Rubinson
Jane Ruffino
Christoph Rummel
Jill Rushton
Rosemarie Russo
Heather Russo
Lydia Ryan
Elizabeth Ryland
Ameet Sachdev
Eydie Saleh
Alexander Sammut
Jennifer Sandusky
Elise Sargeant
Noah Sassaman
Callista Sasser

Blake Sawicky
Abby Scheel
Amber Schneider
Gemma Scholes
Marc Schuhl
Katie Schuhl
Emily Schurr
Amber Scoon
Aimee Scorziello
Ian Scott
Jessica Self
Tara LaVonne Sewell
Naomi Sewpaul
Nabeel Shah
Hope Shannon
Claire Sharpe
Jessup Shean
Deborah Sheppard
Ed Sheridan
Jonathan Shimmin
Elizabeth Shollenberger
Maria De Simone
Molly Simpson
Michelle Sinclair
Jennie Sizemore
Mali Skotheim
Jessica Slawski
Jessica Smeeks
Mike Smith
Rebeccah Smith
Judy Smith
Imogen Smythson
Louise Snow
Lyndsey Snow
Jessica Solari
Gina Sorrentino
Nisha De Souza
Andrew Spence
Erik Spindler
Catherine Sprague

Beau Spry
Rebecca Stanwick
Lindsay Steeper
Bob Stefanowski
Jillian Steffes
Fiona Stewart
David Stifler
Chad W. Strong
Erica Stupp
Camilla Sulak
Carrie Sulosky
Ian Sumpter
Carrie Swan
Janine Switzer
Donna Sy
Maryse Sylvain
Michael Tanner
Carlotta Tavormina
Debra Taylor
Kristy-Ann Taylor
Amy Taylor
Oliver Taylor
Michael Teed
Tory Tellefsen
James Terry
Michael Terry
Pamela Terry
Polly Tessler
Carlotta Testori
Richard Thackeray
Dellan Theye
Laura Thomas
Alys Thompson
Benjamin Quincey
 Thompson
Elisabeth Thurber
Gina Tibbott
Soren Tillisch
Pavel Titz
Kathleen Tomajan

Hannah Tonge
David Trader
Lisa Trentin
Hayley Trezel
Yvona Trnka-Amrhein
Kate Trusler
Assimina Tsolaki
Emma Tutton
Jason Urbanus
Sonia Valente
Nancy Valiquette
Eveline Van Halem
Luke Vaneekeren
Kristine Anne
 Van Hamersveld
Robyn Veal
Natalia Vlassova
Celeste Walker
Karen Wallace
Alia Wallace
Amy Walters
Courtney Ward
Roz Ward
Kyle Waters
Judy Watson
Christo Watson
Suzanne Waugh
Chris Weatherby
Timothy Webb
Ann De Weck
Jennifer Wehby
Rachael Joy Weight
Claire Weiss
Cara Weiss
Elizabeth Weissenborn
Heidi Wendt
Beth Wexelman
Sam White
Jody White
Kirsten White

Helen White
Victoria Whitehouse
Elizabeth Sarah (Liz)
 Wickham
Ann Wilkinson
Carrie Willbanks
Andrea Williams
Joey Williams
Daniel Williams
Hannah Kate Willmer
Emily Wilson
Cate Wiltse
Kristen Witte
Carrie Wood
Sam Wood
Rachel Wood
Matthew Wood
Hazel Woodhams
Helen Woodhouse
Shanon Woodruff
Benjamin Woody
Serianne Worden
John Wrathmell
Daniel Wray
Vicky Wright
Courtney Wright
Geoffrey Hunter Wylde
Jennifer Sun Yao
Amy Yarnell
Suzanne Yusunas
Claudia Zambon
Kathryn Zavitz
Stephen Zdan
Elizabeth Zegos
Dorothy-Marie Ziemba
Sonia Zilberman

Please note, every effort has been made to make this list as complete and correct as possible, please accept our apologies if your name has accidentally been omitted or there is some other error.

PREFACE

Michael A. Anderson and Damian Robinson

When Michael Anderson (MAA) volunteered to write up the excavated stratigraphy for a publication on the Casa del Chirurgo – work he had overseen as Field Director during it's final two years – he never expected that ultimately it would fall to him to weave the volume together, or indeed that it would take the next ten years of his life to complete. In a similar way, Damian Robinson (DJR) started working on the Surgeon while a graduate student at the University of Bradford under the supervision of Rick Jones and it has followed him ever since, though a British Academy Postdoctoral Fellowship and a change in career direction from Pompeii to maritime archaeology. For both of us it has been a long, at times frustrating, but ultimately rewarding journey and we have many debts of thanks to offer to those who have helped us along the way.

We did not expect that the process of post-excavation and publication would involve the efforts of so many additional volunteers who, in the general dearth of funding that characterised the end of excavation, would so generously donate their time and resources to move the process of study, analysis, and publication forward and to contribute elements that have, in the end, made this volume so much more than we could ever have hoped it would be.

Far outreaching the initially planned publication of the stratigraphy and walls analysis alone, the present publication now contains a number of specialist chapters with particular focus on the results from the Casa del Chirurgo, each written by those scholars who studied the material recovered. While it ultimately and regrettably proved impossible to include chapters on some classes of recovered material, such as the egg shell or the fish bone, the end result is a largely-comprehensive collection of material from the Casa del Chirurgo, that permits a complete understanding of the data recovered from the AAPP excavations and an assessment of the basis of our conclusions. It was also

initially intended that this volume be accompanied by a second on the pottery, but sadly this has been delayed due to the untimely death of our sadly missed colleague John Dore. John's ceramicist colleagues, David Griffiths and Gary Forster, are now bringing work on this volume to completion. The decision to publish this present volume without certain elements was made from the perspective that the extensive record produced by one of the largest and most intensive campaigns of sub-surface archaeological research undertaken in Pompeii was too valuable to continue to leave unpublished while chasing after the unrealistic and elusive ideal of a perfect complete publication. Some may find fault with these omissions, or may object to elements that have been included, but each decision has been made in order to make this material the most useful it can possibly be. We have always tried to do the right thing and it has not been an easy task. Throughout, the most important goal has been to make the raw data itself as accessible as was feasible. The future will undoubtedly see the publication of the remaining data from the AAPP's work in Insula VI 1. In expectation of this, MAA has made every effort in this volume to facilitate the integration of new results within the current interpretations and has left the 'archaeological interface' exposed, as it were, so that from stratigraphic unit numbers to feature references to Harris Matrices, precise reference to specific deposits may be accessed and the reader should always be able to connect any future additions directly to the material published here.

To San Francisco State University, MAA owes thanks for two sabbaticals and one course-release in aid of his work on this publication. They enabled respectively the analysis of the initial stratigraphic sequence and the production of the plans in the first instance and the providing of additional chapters on the site history, scholarship, and overall interpretation in the other. To his parents and Clare O'Bryen, who have provided

endless support and encouragement without which this volume would never have been completed, he owes a debt of gratitude that can never be sufficiently expressed.

The analysis and checking of the architecture of the Casa del Chirurgo continued after the end of the excavation and DJR would like to thank the members of the Craven Committee of the Faculty of Classics, University of Oxford for three grants from the Thomas Whitcombe Greene Bequest. Other funds from Brasenose College, Oxford and a generous donation from Terry Lucas also ensured that the architectural fieldwork could be brought to completion. Much of the initial writing up was done in the Oxford Centre for Maritime Archaeology at the Institute of Archaeology, University of Oxford, during a sabbatical. The maritime centre is funded by the Hilti Foundation and sincere thanks are offered to Georg Rosenbauer, Hans Saxer, and Christine Rhomberg of the Foundation and also to Franck Goddio of the Institut Européen d'Archéologie Sous-Marine for their support and encouragement during the completion of this work.

Finally, both in Pompeii and beyond, Jane Richardson and Alexander Robinson have both put up with and contributed so much that DJR can never truly thank them enough.

We would also like to thank the courageous reviewers who agreed to tackle this weighty text. Their numerous suggestions and queries have greatly improved our original drafts. Any errors remaining naturally, remain our own.

But most of all, we would like to thank Hilary Cool for her pivotal role as the driving-force behind all post-excavation work on the Project and for her support and encouragement in the completion of the present volume, without either of which, this volume would never have been completed.

The House of the Surgeon/Casa del Chirurgo has played a long and important role in Pompeian archaeology and the study of Roman domestic space. We are grateful for the opportunity to have played a role in adding further information to what we hope will be a vigorous and continuing scholarly debate into the foreseeable future.

FOREWORD

THE OLD CERTAINTIES ARE CRUMBLING

Rick Jones

It is an enormous pleasure to introduce this volume reporting on the work of so many people at the Anglo-American Project in Pompeii. The genesis and development of the project are outlined in Chapter 2, but this foreword provides a moment to reflect on the changes that have taken place in our understanding of Pompeii over the past quarter of a century. "The old certainties are crumbling" are the perceptive words of Stephen L. Dyson in his closing reflection to the volume *Sequence and Space in Pompeii.*[1] The papers collected there included not only an attempt to express the ideas behind the AAPP at its outset, but also reflected the common ground shared with numerous other colleagues. There was certainly a feeling that we were opening up a new chapter, and that central aspects to that were the concepts of sequence and space. In other words, there was an interest in variations across the city and across time. This concern to understand the changing patterns of the city over time had been pursued in the 1920s and 1930s by Amedeo Maiuri, but had fallen from favour.[2] It was clear that the various excavation programmes starting from the 1990s were going to change perceptions of the city, by creating a body of reliable evidence for the dating of buildings and development that had hitherto not been available. The dating of structures had relied on typologies of building styles and of decoration, to which presumed chronologies had been attached. If many of us knew that we wanted to remedy these deficiencies, it is fair to admit that in the mid-1990s we had no idea exactly where our journey would lead. Dyson was optimistic, and closed his paper by anticipating exciting times coming for the study of Pompeii, "a new Golden Age".[3]

The results of our excavation of the Casa del Chirurgo must therefore be seen in that context of developing Pompeian studies. Our new dating of the house and recognition of a quite different initial design have together transformed the orthodoxy of how this house has been regarded over more than two centuries. It is a measure of how much has been learned about the city through the collective effort of all of these projects that the results reported here now sit happily within an emerging new consensus, based on solid archaeological evidence from across the city. A linking thread to this work has been the application of stratigraphic excavation. It is hard to imagine looking back to the early 1990s how little reliable stratigraphic evidence for the city had then been published.[4] Although projects in the recent phase of research have adopted a variety of specific strategies, there have been common concerns with a wide spatial view and with changes over time, and rigorous evidence for dating.[5] There have been other examinations across a complete insula,[6] and detailed examinations of specific economic activities.[7] These research projects are part of a wider abundance of work that has been carried out across the city over recent years. Great credit must be given to Pietro Giovanni Guzzo, who encouraged all these programmes during his tenure as Soprintendente at Pompeii. The full range can be appreciated in two volumes of short papers summarising many of these studies,[8] as well as in the impressive volumes in the rest of the series *Studi della Soprintendenza archeologica di Pompei.*

As far as the study of domestic architecture is concerned, it must be noted that the corpus of new work has substantially undermined much of the extensive debate that had gone before. It is no longer acceptable to argue for developments on the basis of generalisations and assumptions. This publication on the Casa del Chirurgo will stand among the ranks of houses where detailed modern studies provide reliable evidence on which future syntheses can draw, such as

the twelve monumental volumes of the series *Häuser in Pompeji*,[9] the Casa di Sallustio[10] and the Casa del Fauno.[11] Indeed the open aspect of the primary plan of the Casa del Chirurgo can now be seen as paralleled for example in the early versions of the Casa di Sallustio and the Casa delle Nozze d'Argento.[12]

Roger Ling's research on the Insula of the Menander (I, 10) is of special interest because of its comprehensive approach to the whole city block.[13] We owe the suggestion of this policy to Fausto Zevi and John Ward-Perkins.[14] It has proved to be a far-sighted one. As Ling points out, it has allowed his study to make a thoughtful contribution to the developing social life of the city.[15] Overall it is now possible to see a pattern of development emerging across the city.[16] There will certainly prove to be more inconsistencies than we yet know, but the framework seems well-established. It is surely strong enough that we can be confident in the robustness of the archaeology when faced with assumptions based on non-specific written sources, such as the establishment of the Sullan colony at Pompeii in 80 BC. The archaeology shows that there is a continuous pattern of change and development within the city, with undoubted responses to the social and economic changes that were occurring across the Roman world. However there is very little convincing evidence so far found within the fabric of the city to suggest a major population settlement to correspond with the historical event of the foundation of the colony. It is therefore reasonable to ask how many colonists were actually settled in the town, rather than to resort to the speculative argument that they were there, but must have lived outside the town.[17] We can be confident enough to build our explanations on the well-defined evidence now available.

The AAPP's commitment to investigating the complete insula of which the Casa del Chirurgo was part has opened new perspectives on the changing community who lived there. It is allowing us to compare buildings and assemblages across time and space. We can therefore examine changes in the patterns of life of this community in such terms as differential access to high quality goods and decoration, the ability to enjoy space and shade within a house and the potential sources of wealth and income of the occupants of a property. It also obliges us to evaluate urban complexity through contrasts in the stories of neighbouring properties. This opens fresh perspectives on the city's life and the processes of urbanism. It has proved helpful to explore these complexities through a framework of interacting themes: *Intensification* – planning and dense use of space; *differentiation* – the growth of commerce

and varied activities within the city; *inequality* – the increasing luxury enjoyed by the rich, the reductions in space for the poor.[18] Some of the social and economic implications of the structural and artefactual sequences we have recovered from Insula VI,1 have already been discussed,[19] but will certainly be explored further in the future. It is also clear that the wide research net cast over the insula produced many unexpected benefits beyond our central research agenda, as members of the team developed related but independent strands of research. Some of this work was directly focused on aspects of the results from Insula VI, 1.[20] Other initiatives had their origins here but ranged much more widely, such as Barry Hobson's comprehensive studies on toilets in Pompeii and Jaye McKenzie-Clark's work on red-slip pottery.[21]

It is gratifying to see the wide range of important research that has developed from the AAPP's programme, but at its heart lay the idea of comprehensively studying a whole insula. At the outset we had no information on how much we would be able to excavate, because we did not know where ancient floors had been lost and where they survived in good condition. Therefore, the commitment was to the research idea of total investigation, however long it took. Conventional funding with finite resources seemed highly unlikely to support this. The AAPP Field School was our chosen solution that provided sustainable funding for our work programme. It was conceived as a virtuous circle, whereby Field School students were trained in the disciplines of modern archaeological practice while their fees supported the high staffing levels needed for training, supervision and specialist support. That the outcomes were successful is attested by the subsequent careers of many of the Field School graduates and the fact that the numbers of applicants kept growing over the years, despite only minimal advertising and promotion. Our strongest recruiter was word-of-mouth recommendation.

This produced a cohort over the twelve seasons of the Field School of more than 700 students, drawn from at least 25 countries. It is normal in an excavation report to thank the agencies that funded the fieldwork. Here we must thank more than 700 funders. If it is sadly impractical to name them all individually here, that does not lessen the sense of gratitude felt for their efforts. Added to that, the project depended on the generosity of the large staff in fieldwork and post-excavation who often gave up their earnings elsewhere to join us, in return for their basic travel and living costs. The organisation and logistics for each season demanded enormous efforts. Here we have been very

lucky to have two people who carried so much of those burdens for the project. First Jarrett Lobell and then Barry Hobson worked tirelessly to recruit Field School students, to answer all their questions and reassure their concerned parents, and to carry those pastoral duties into the field seasons, where they also dealt with most of the thankless day to day logistical tasks we all depended on.

We could never have worked effectively without our support network in the local community. By far the most important part of this was the home provided for the team throughout by Camping Spartacus at Pompeii, and particularly by Orlando and Gennaro Piedepalumbo and their family. Their whole team looked after us all with great warmth, fed us thousands of excellent pizzas – and made us feel members of their family.

The academic equivalent was the welcome and encouragement we enjoyed from Pietro Giovanni Guzzo and everyone in the Soprintendenza Archaeologica di Pompei, especially Antonio d'Ambrosio and the late Annamaria Ciarallo. Their patient and supportive responses to whatever odd requests we made enabled our work to run much more smoothly.

It is a real pleasure to record my thanks to all these friends who have supported our work in Pompeii. What should be clear from these comments is that this was a very large international collective effort, involving students and staff from North America, Australia and from most parts of Europe, but also dependent on the kindnesses of the staff of the Soprintendenza Archaeologica di Pompei and of our friends in the local community of modern Pompeii.

All these people have contributed to this attempt to hasten the crumbling of old archaeological certainties, and to replace them with new interpretations more securely based on explicit evidence. I hope they will also allow others in the future to create new understandings of our ancestors who lived in what is now the astonishing common heritage of Pompeii.

Notes

1 Bon and Jones 1997; Dyson 1997, 156.
2 Maiuri 1973.
3 Dyson 1997, 156.
4 Bonghi Jovino 1984; D'Ambrosio and De Caro 1989; Arthur 1986.
5 E.g. Coarelli and Pesando 2006; 2011; Oriolo and Verzar-Bass 2010; Carafa 2007; 2011; Fulford and Wallace-Hadrill 1999.
6 Leander Touati 2010.
7 Bakeries: Monteix 2009. Fullonicae: Flohr 2003; 2007; 2011; 2013.
8 Guzzo and Guidobaldi 2005; 2008.
9 Strocka 1984; 1991; Ehrhardt 1988; 1998; 2005; Michel 1990; Seiler 1992; Stemmer 1993; Staub Gerow 1994; 2000; Fröhlich 1997; Allison and Sear 2002.
10 Laidlaw and Stella 2014.
11 Faber and Hoffman 2009.
12 Ehrhardt 2005, Abb. 107.
13 Ling 1997; Ling and Ling 2005.
14 Ling 1997, vii.
15 Ling 1997, 2.
16 Cf. Guzzo 2011.
17 Cf. Descoeudres 2007, 26 n.90.
18 Jones 2008; Jones and Robinson 2007.
19 Jones 2008; Jones and Robinson 2004; 2005; 2007; Jones and Schoonhoven 2003; Robinson 2005.
20 E.g. Hobbs 2013; DeSena and Ikäheimo 2003; Ciaraldi and Richardson 2000; Ciaraldi 2007; Murphy 2015; Burns 2003/4; Veal 2012; 2014; Veal and Thompson 2008.
21 Hobson 2009a; 2009b; McKenzie-Clark 2009; 2012a; 2012b.

1

POMPEII'S INSULA VI 1
AND THE CASA DEL CHIRURGO

Michael A. Anderson and Damian Robinson

Introduction

This volume was planned as one of a series to present the results of the archaeological excavations and architectural surveys conducted at Pompeii (Fig. 1.1) in a city block known as Insula VI 1, which took place over a period of 13 years from 1994 to 2006. The triangular-shaped insula lies in the north-west sector of the city immediately inside the Porta Ercolano (Fig. 1.2). Its north-western edge is formed by the city wall and its eastern alignment coordinated with the roughly orthogonal layout of Regio VI. On the south-west it is bounded by a main road – the Via

Consolare – onto which most of the properties had their primary entrances in AD 79. On the east of the block, the narrower Vicolo di Narciso provided access to the rear of the properties, and in combination with the direction of the primary street, produced the insula's distinctive triangular shape (Fig. 1.3).

This is one of the highest points of elevation in Pompeii. The road from Herculaneum, here called the Via dei Sepolcri, climbs an incline from the Villa dei Misteri, past the tombs and villas that cluster on each side of the Porta Ercolano. It thereafter descends towards the centre of the town (Fig. 1.2) and past Insula VI 1 as the Via Consolare.

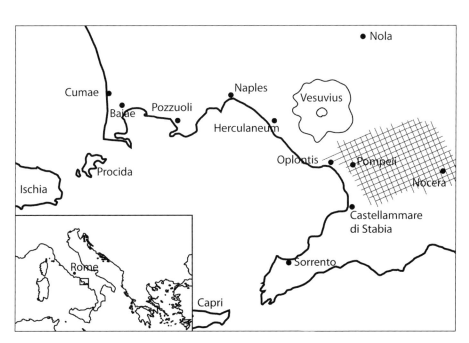

Figure 1.1. Location of Pompeii on the Bay of Naples, Italy, indicating approximate location of ancient roads and hypothetical centuriation, after Talbert 2000.

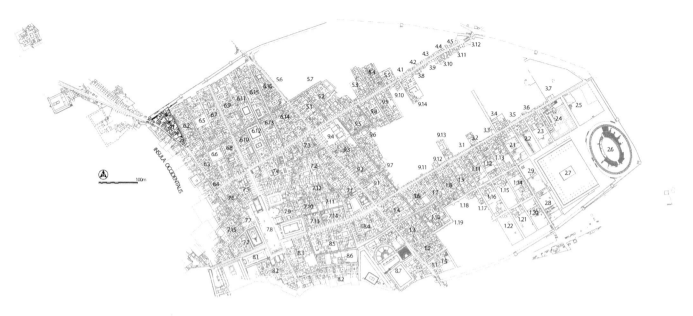

Figure 1.2. Overview of the town of Pompeii (© Soprintendenza Archeologica di Pompei). Insula VI 1 is indicated in dark grey.

Insula VI 1, like the Villa di Diomede, the Villa di Cicerone, and the Porta Ercolano itself, was one of the earliest areas of the city to be excavated. The suburban villas, tombs, and city gate formed one of the two major foci of early Bourbon investigations in Pompeii, which otherwise concentrated on the area of the Temple of Isis and the so-called Theatre district in the south-west of the city.[1] Unlike most previous explorations, during these excavations the areas cleared were generally left exposed rather than being backfilled after their finds had been removed. The insula has thus been exposed since the 1760–70s and has consequently experienced more than a quarter of a millennium of dilapidations caused by the early excavators, the weather, tourists, and bombs dropped by the Allies in 1943.[2] Though now it attracts little attention from visitors walking past it en route to see the tombs and the Villa dei Misteri, for early visitors it was an important destination, made all the more impressive since this was one of the first urban blocks to be encountered after entering the site from the old entrance at the base of the Via dei Sepolcri. The Marquis de Sade, for instance, visiting in the first half of 1776 noted approvingly of the area,

'Là, s'offrent jusqu'à la hauteur des premiers étages, plusiers maisons de particuliers, singulièrement bien conservées et dans lesquelles se voient des fresques dont la fraîcheur étonne.'[3]

At the time of the eruption of Vesuvius in AD 79, the properties that occupied the insula served a variety of purposes, including an inn, bars, shops, a shrine, and two houses. One of the largest houses in Pompeii,

the Casa delle Vestali, occupies much of the northern area. The smaller Casa del Chirurgo lies to the south. As the latter has played an important role in scholarly discussions of the chronology of the city and its urban development and a central role in the history of the so-called 'Roman atrium house,' it has been chosen as the subject of this first report to present the detailed results of the excavations in Insula VI 1.

Since this was intended to be the first volume in a series, the first part of the book contains introductory matter relevant to the whole insula. The rest of this chapter deals with general matters such as the divisions within the insula and the early work that has taken place in it. Chapter 2 provides a history of the excavations undertaken by the University of Bradford and the philosophy that underpinned them. The introductory matter about the Casa del Chirurgo itself and an overview of its long history of scholarship will be found in Chapter 3. This is followed by a synthetic narrative presenting the complete archaeological history of the property, from the earliest human activities through the eruption of Vesuvius in 79 AD and down to the present day in Chapter 4. Detailed room-by-room stratigraphic data for each excavated area are to be found in Chapter 5. Following this are a series of chapters presenting specialist studies of the excavated material, each written by the specialists responsible for the primary analysis of this material. Chapter 6 (Hilary Cool) considers glass vessels and small finds, which is an accompaniment to her full insula catalogue published elsewhere.[4] Chapter 7

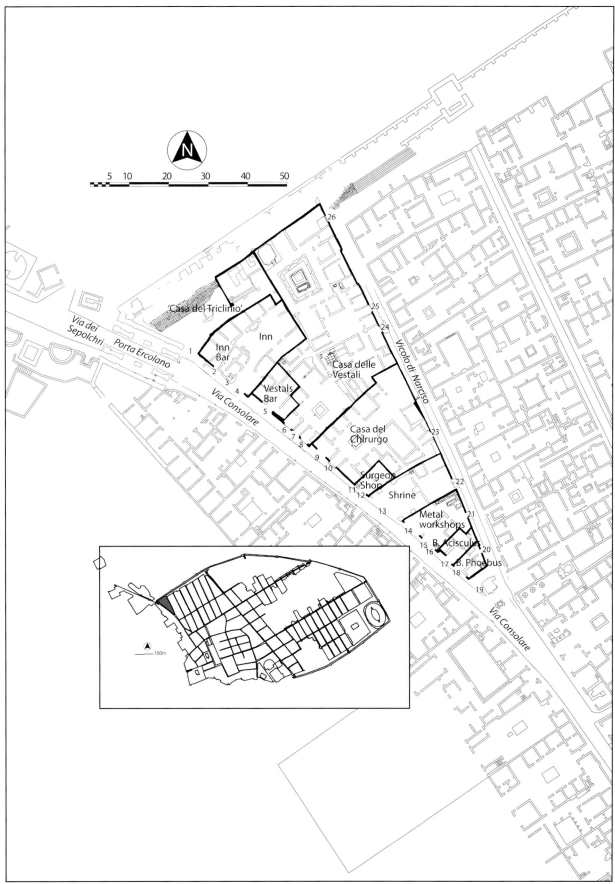

Figure 1.3. The area of Insula VI 1, with major properties and streets labelled.

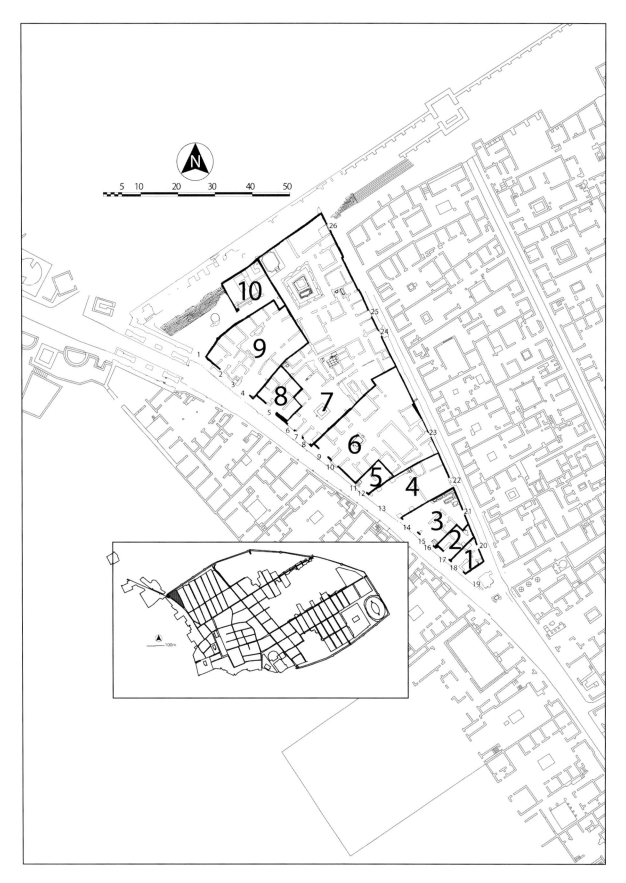

Figure 1.4. Plan of Insula VI 1 indicating Fiorelli's door numbers and AAPP Plot numbers referenced throughout the text.

(Richard Hobbs) examines the coins from the Casa del Chirurgo, in light of his published analysis of the complete coin assemblage from the insula.[5] Chapter 8 (Helen White) presents the results of the study of plaster fragments from the AD 79 decoration recovered in a collapsed cistern in the atrium of the house, and Chapter 9 (Will Wootton) presents the study and analysis of the house's preserved pavements. Following this are a series of short chapters dedicated to the analysis of the ecofactual remains recovered. Chapter 10 (Jane Richardson), examines the animal bone, and is followed by chapters on the macrobotanical remains (Chapter 11, Charlene Murphy), and the charcoal remains as indicators of ancient fuel use and economy (Chapter 12, Robyn Veal). These are followed by synthesis and general conclusions regarding the Campanian environment (Chapter 13, Robyn Veal and Charlene Murphy). Overall conclusions follow in Chapter 14 (Anderson).

Though it would normally be expected, unfortunately it has not been possible to include an analysis of the pottery from the Casa del Chirurgo in the present volume. The full report on this material, by David Griffiths and Gary Forster, is in progress and will follow. The chronological sequence presented here has been secured through dating from coins, the presence of datable glass finds, and with reference to the preliminary spot-dates and working dates assigned to some strata during fieldwork and during the early stages of the post-excavation publication, which will be cited in the footnotes where available.

The layout of the insula

Our excavations have demonstrated that the use of the space within the insula continually changed over time, but it will be appropriate at the outset to summarise the standing remains as they survived from AD 79 and in the terms with which they have traditionally been described. The interpretation and attribution of the various properties of the block has not changed substantially since Fiorelli's description of the area and many of their names have become conventionalised in Pompeian studies.[6]

During his tenure as superintendent of the excavations at Pompeii in the mid-19th century,[7] Guiseppe Fiorelli devised a numbering system for the *regiones*, *insulae*, and properties within the city, generally in an anti-clockwise fashion.[8] For Insula VI 1, the properties are first numbered according to the doorways that

open on to the Via Consolare. The order runs from the Porta Ercolano southward to the fountain at the tip of the insula where the numbering then runs back northward along the Vicolo di Narciso (Fig. 1.4). Modern conventions for the use of this address system involve the inclusion of all doorways associated with a given property. Hence, the address of the Casa del Chirurgo is (VI 1, 9.10.23). For simplicity sometimes only the primary address is given (i.e. VI 1, 10), particularly when the reference is only to that main building. During the 1995–2006 excavations the insula was also divided into ten "plots" numbered from south to north that divide the block into its respective properties (also indicated on Fig. 1.4). These plots formed the top level in any further numbering systems and are unique to the AAPP excavations. The Casa del Chirurgo and its dependencies included Plots 5 and 6. Within this system, individual rooms have been numbered according to the complete system employed in *Pitture e Pavimenti di Pompei*.[9]

As names will be more helpful to the reader for quickly identifying the part of the insula that is being referenced, this summary also provides those given to the various areas during the excavations. This is not straightforward, since while several of them have traditional names such as Casa delle Vestali, others do not. For many of the more generic properties of the block, Fiorelli assigned common Latin terms indicative of their presumed use. Others had traditional names that imply an earlier and often incorrect interpretation, e.g. the so-called '*fabbrica di sapone*.' In general, it has been the practice to retain established names of houses in Italian, but to employ English names in all instances that relate to function, for example Inn rather than the latin, *hospitium*. This choice has been made in order to avoid confusion between our results and pre-existing documentation, while also steering clear of the implications either of incorrect previous attributions or of the potential differences implied by Latin terms, e.g. *thermopolium*, *caupona*, and *popina*.[10] There are also several bars within the insula and in those cases in which they do not have a traditional name, the convention has been adopted of referring to them by the name of the adjacent property. In no case should the continued use of the traditional name be taken to imply support or credence in the validity of that name, the ownership, or function that it implies. They remain, for the purposes of this study, simply useful labels.

The information below is summarised further in Table 1.1.

VI 1, 1 Casa del Triclinio
This property is set back from the Via Consolare and backs onto the rampart of the city wall. Its main feature is a masonry triclinium and despite its name has traditionally been interpreted as some sort of lodging establishment with an outdoor dining room.[11] This was identified as Plot 10 during the excavations.

VI 1, 2 Inn Bar
This faces directly onto the Via Consolare and consists of the normal bar counter with two internal rooms and a latrine. This formed part of Plot 9. Traditionally it has been seen as a *thermopolium* and component of the Inn next door.[12]

VI 1, 3
Fiorelli gave this number to an independent stairway leading to an upper floor. It was part of Plot 9.[13]

VI 1, 4 Inn
This is the entrance to an 'L'-shaped property that expands around the back of the Inn Bar and which has a central courtyard with ranges of rooms on three sides. It was part of Plot 9. Fiorelli suggested that an inscription already missing in his time could provide some light on the use of the building. C. CVSPIVM PANSAM | AED. MVLIONES VNIVERSI | AGATHO VAIO.[14] Presumably this means he felt that it had some connection to the mule drivers mentioned in this inscription.

VI 1, 5 Vestals Bar
This is the second of the bars on the frontage, again with the typical counter and additional back rooms of uncertain use. Fiorelli suggested that the largest of these had been used for a bedroom but was a pantry in its final phase.[15] This was Plot 8.

VI 1, 6.7.8.24.25.26 Casa delle Vestali
This is the largest house in the insula. It is 'L'-shaped, extending across to the Vicolo di Narciso with doorways VI 1, 24–6 marking access points from that street. The long history of its development was noted by Fiorelli, who thought that it derived from two earlier houses.[16] The Via Consolare entrance opens into an atrium. Beyond that, and stretching back to the rampart of the city walls, the house includes one partial peristyle, a complete peristyle, a second atrium, and a bath suite. The traditional name of Casa delle Vestali (House of the Vestals) derives from a fanciful interpretation of some of the wall paintings.[17] The area was Plot 7.

VI 1, 9.10.23 Casa del Chirurgo
The subject of the current book, this property stretches across to the Vicolo di Narciso where the access point is numbered VI 1, 23. It is an atrium house, which is often claimed to provide an example of a very early form of the so-called Roman or Italic house (see Chapter 3), and was noted by Fiorelli as of the '*antichissima costruzione campana.*'[18] It takes its name (Casa del Chirurgo / House of the Surgeon) from the group of 40 possibly medical instruments found whilst it was first being excavated.[19] It was Plot 6 and includes the small shop at doorway 10.

VI 1, 11
Fiorelli gave this number to an independent stairway leading to an upper floor.[20] It was part of Plot 5.

VI 1, 12 Surgeon Shop
This is a small commercial property located within the south-western corner of the Casa del Chirurgo facing directly onto the Via Consolare. Its two rooms were also part of Plot 5.

VI 1, 13.22 Shrine
This area stretches back to the Vicolo di Narciso where the access point is numbered VI 1, 22. The area facing the Via Consolare is a platform, while the area facing the Vicolo di Narciso had two rooms, a latrine, and a large courtyard. Fiorelli noted that there could be no doubt that this area was a stable given the presence of the remains of a cart and the skeletons of two horses and their harness.[21] Eschebach identified it as a '*cura*' or '*statio saliniensium,*' perhaps a sort of *collegium* seat for mule drivers, while Fiorelli called it the '*Compitum.*'[22] It was suggested that the stable area serviced the shrine. This was Plot 4.

VI 1, 14.15.16.21 Metal workshops
This is the most northerly and largest of the three properties at the end of the insula known collectively during the excavation as the 'Commercial Triangle.' The access point onto the Vicolo di Narciso is VI 1, 21. The front part was originally interpreted as two shops and the rear area facing the Vicolo di Narciso as a manufacturing area. A quantity of lime was observed during the initial excavations leading to the suggestion it was a soap factory, but this suggestion had been discounted already before Fiorelli described the area.[23] Eschebach thought it might have be a *horreum* for salt and related to the shrine to the north.[24] During the excavations the remains of metal working were recovered and so the area became known as the metal workshops, though some of the records in the archive

Table 1.1. Addresses and Properties of Insula VI 1.

Fiorelli numbers		Name	Plot
Via Consolare addresses	Vicolo di Narciso addresses		
VI 1, 1	-	Casa del Triclinio	10
VI 1, 2	-	Inn Bar	9
VI 1, 3	-	Upstairs Apartment?	9
VI 1, 4	-	Inn	9
VI 1, 5	-	Vestals Bar	8
VI 1, 6 VI 1, 7 VI 1, 8	VI 1.24 VI 1.25 VI 1.26	Casa delle Vestali	7
VI 1, 9 VI 1, 10	VI 1.23	Casa del Chirurgo	6
VI 1, 11	-	Upstairs Apartment	5
VI 1, 12	-	Surgeon shop	5
VI 1, 13	VI 1.22	Shrine	4
VI 1, 14 VI 1, 15	VI 1.21	Metal workshop	3
VI 1, 16	-	Upstairs Apartment	2
VI 1, 17	-	Bar of Acisculus	2
VI 1, 18	VI 1.20	Bar of Pheobus	1
VI 1, 19		Well and fountain	

continue to refer to the area as the "Soap Factory" or "Fabbrica di Sapone," a name still present on the jamb of the entrance to the shop today. This was Plot 3.

VI 1, 16
Fiorelli gave this number to an independent stairway leading to an upper floor that he describes as entirely destroyed.[25] It was part of Plot 2.

VI 1, 17 Bar of Acisculus
This is the central property of the 'Commercial Triangle.' It stretches to the Vicolo di Narciso but has no access onto it in AD 79. It consists of three rooms with the bar facing onto the Via Consolare. This property forms Plot 2. The name appears to derive from an electoral *programma*, C. Lollio Fusco, *Aciscule (fac)*, mentioned by Della Corte.[26]

VI 1, 18 Bar of Pheobus
This is the southernmost property of the Commercial Triangle, forming Plot 1. It has three rooms with an access point to the Vicolo di Narciso at VI 1, 20. The bar counter faces onto the Via Consolare. It takes its

name from an inscription found on the southern wall of the block facing the fountain.

M· HOLCONIVM·PRISCVM
C·GAVIVM·RVFVM·II·VIR
PHOEBVS·CVM·EMPTORIBVS
SVIS·ROGAT[27]

VI 1, 19 Well and fountain
These occupy the tip of the insula at the junction of the Via Consolare and the Vicolo di Narciso. On the southern side of the well there was a painted shrine of the *magistri vici et compiti*.[28] No plot number was assigned to this feature.

The history of exploration and early sources of information

From Fiorelli's compilation of the earliest records of the excavations published in the *Pompeianarum Antiquitatum Historia*, it is possible to outline the original timetable for the uncovering of the insula.[29] The Porta Ercolano was excavated during three campaigns of exploration reported on the 14th September and 12th October 1763, 11th April to 28th July 1764, and 19th July to 11th November 1769.[30] It was during the second of these that attention was first directed immediately inside the walls to Insula VI 1, where excavations are recorded as taking place first just before the 14th April and 17th November 1764. After this first foray into Insula VI 1, the focus of excavation shifted to the area of the Large Theatre, the Temple of Isis, and the houses just to the north of it (VIII 4) and on the edges of the city (VIII 2). It would be some time before attention would return to Insula VI 1. As a result, the block was cleared of ash and lapilli in isolated campaigns separated by a few years. After the final push to clear the Porta Ercolano had been completed, the workmen began to clear the front rooms of the first properties on the north side of the street from the week of the 11th of November 1769. As work continued, the southern side of the street drew more attention so that by the 28th of April 1770, it had become the focus of activity. By the 29th of September 1770, the shop fronts and the still-decorated bar counter of VI 1, 2 had been uncovered as attention once again returned to the northern side of the street.

On the 27th of October, the heavy Sarno stone facade of the Casa del Chirurgo was discovered and from that point on this house remained the focus of excavators, so much so that it was referred to as '*la solita abitazione*' (the usual residence) in which excavations were undertaken

in the city.[31] Work alternated between the Casa del Chirurgo and the Villa di Diomede outside of the city until the 6th of July 1771. Only cursory excavation was undertaken in the front rooms of the Casa delle Vestali at this time, probably in order to clear access on the street level to the Casa di Chirurgo.

Attention then once again shifted to the Insula Occidentalis, while continuing in the Villa di Diomede, which resulted in a pause in the excavation of Insula VI 1 for over a decade. During this time, attention centred on the southern side of the street and the Villa, and ultimately, the street in front of Insula VI 2 and the Casa di Sallustio (then known as the Casa di Atteone) were uncovered,[32] which was reported on the 13th of July 1780. Clearance work returned to Insula VI 1 on the 13th of November 1783, when it was reported that excavation commenced at the city wall and continued over the top of the Casa delle Vestali, perhaps including the Vestals bar or the Inn. By the third of June 1784, the Vestals bar had been cleared and after the 22nd of July, excavation continued into the atrium of the Casa delle Vestali itself. From this point excavation would continue, at first deeper into the house and then northwards, finally exposing the peristyle. At this time the courtyard of the Inn to its west was also being cleared and, in the week of the 25th of January 1787, produced the skeleton of a horse and remains of a cart.

With the completion of the northern part of the block and the connection of these areas to the city wall, the southern part of the insula became the focus of excavation. This started first in the Shrine (VI 1, 13.22) by the 21st of May 1788,[33] with the rest of the block completed by the 30th December 1789. After this date, excavation work in Pompeii was moved exclusively to the Large Theatre, as per the King's dispatch of the 2nd of December 1789.[34] The *Pompeianarum Antiquitatum Historia* contains no records for the years 1790 and most of 1791, but when work resumed it continued in the area of the Large Theatre and no further records exist of excavations in Insula VI 1. The area was presumably included in the general cleaning of the excavated area mentioned in December of 1799, which appears to have been necessary after the French conquest of Naples had caused a period of nearly complete abandonment of the site.

Early visitors and early records

Although excavations in Pompeii had begun in earnest by 1754, visitors prior to about 1760 do not seem to have regularly been able to access the site.[35] After this date, those who were able to gain permission to enter will have visited the three major areas of excavation then available: the area of the Large Theatre and the Temple of Isis, the Villa di Diomede, and the stretch of the Via Consolare within the city, which comprised the front rooms of the northern part of Insula VI 1 and the Insula Occidentalis that had been cleared to the area opposite the Casa del Chirurgo. This property was thus one of the first well-preserved houses within the city to be cleared in its entirety and left exposed for a viewing public.

The earliest known plan of the city, drawn from memory by François-de-Paule Latapie in 1776, shows these areas clearly, if a little out of scale.[36] Visitors were strictly forbidden from taking notes, measurements, or drawings, but their descriptions permit some reconstruction of the original state of preservation of the block. One of the earliest to see Insula VI 1 and write about it was the poetess Lady Anna Riggs Miller, who visited the site in 1771. She mentions a house under excavation at that time, which from the date of her visit must be the Casa del Chirurgo, into which she tumbled after climbing up a ladder to gain a better view.[37] The description of the house also suits that of the Chirurgo, possibly *ala* 8.[38] She also reveals the lengths of deception necessary to complete the drawing of a stag away from the watchful eyes of the custodians, which she undertook in the area of the Theatre. When the Scottish physician and writer John Moore came to the site sometime between 1772–1776,[39] he clearly visited the same three areas of the city in the same order. He expressed an idea that would frequently be repeated by subsequent visitors: to rebuild roofing over one of the best houses as an example, leave its wall paintings intact, and repopulate it with its original finds. According to Ribau, La Vega had already made the same suggestion with specific reference to the oecus (Room 19) of the Casa del Chirurgo,[40] but to no avail, as the most famous and best preserved of the paintings from this room were duly cut out and sent to the museum at Portici, sharing the fate of so many other walls.[41] The late eighteenth century was also the period when some of the earliest representations of the city began to appear. They too focused upon imagining what would have been there, with the end result that these early images only impressionistically represent the city and are often without the accuracy that the modern researcher might desire.[42]

The earliest collection of plates of Pompeii were published in 1777 alongside the paper read in 1775 to the Society of Antiquaries of London for Sir William Hamilton, the British Ambassador to the Court of Naples and the Two Sicilies. This included etchings by James

I Barrie, based on the watercolours by Pietro Fabris[43] (Fig. 1.5). Several of these illustrated the then current excavations in Insula VI 1, and in particular, the Casa del Chirurgo. Though not of the highest quality, the original watercolours preserve a number of details of the properties facing out onto the Via Consolare. The drawing of the Casa del Chirurgo, though incorrect in several points of detail, does record the overall decorative scheme of the then excavated atrium[44] (Fig. 1.6).

Almost contemporary with Sir William Hamilton were those of the first architects and artists to visit the site, including especially Giovanni Battista Piranesi and his son Francesco Piranesi, along with Benedetto Mori between 1771–1772. The elder Piranesi carried out sketches and surveys of Pompeii and Herculaneum that were later engraved by his son, who possibly added some of his own original work to the collection before gradually publishing it between 1783 and 1807.[45] Along with other visitors of the time, they examined the open areas of Insula VI 1, and a number of the plates focus upon the Casa del Chirurgo and the shops on the northern end of the block, which were the only parts of the insula exposed at that time. In particular, these etchings contain several vistas up and down the Via Consolare, including a view of the facade of the Casa del Chirurgo and the Casa delle Vestali (Fig. 1.7),[46] plus a number of plans and sections through most of the properties of Insula VI 1.[47] Piranesi also undertook several reconstructions, including vistas through the

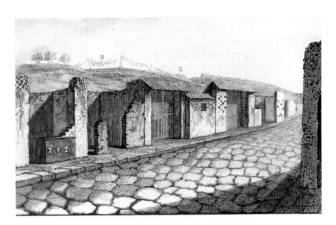

Figure 1.5. Etching by Barrie of Fabris of original watercolour of the Via Consolare looking south-east (image Hamilton 1777 Pl. IX. Courtesy of Heidelberg University Library: Digital Library).

atrium and kitchen of the Casa del Chirurgo,[48] which record wall painting details and a lararium painting that have long since disappeared (Fig. 1.8).[49]

His hypothetical restorations of a Vitruvian Tuscan atrium using the Casa del Chirurgo as a base are the earliest to use the house for this purpose,[50] while the site plan from this volume,[51] plus a later plan published in 1792, permit a clear understanding of the extent of excavations at this time.[52]

In 1776, the Marquis de Sade described the house as being at the entrance of a street that led to the gate,[53] which was the result of clearing the volcanic debris along the line of the street and thus creating a sort of channel that at this point led from the Porta Ercolano

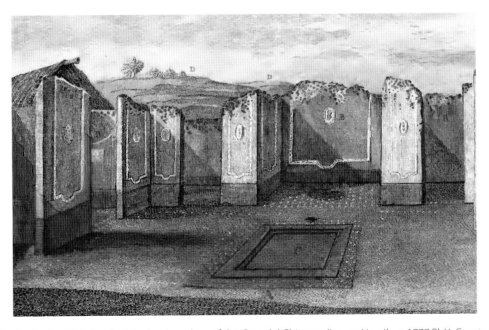

Figure 1.6. Etching by Barrie of Fabris of original watercolour of the Casa del Chirurgo (image Hamilton 1777 Pl. X. Courtesy of Heidelberg University Library: Digital Library).

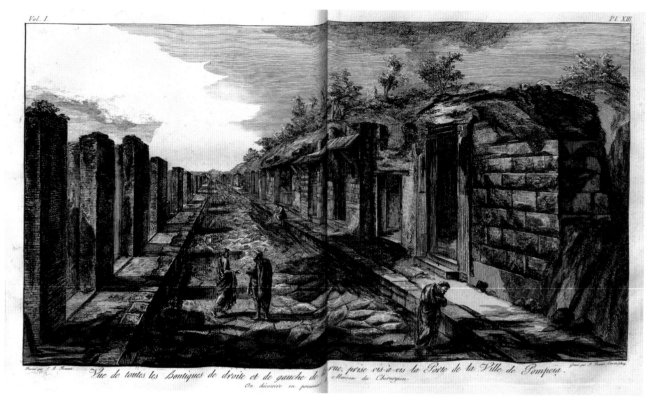

Figure 1.7. Piranesi's view of the frontage of the Casa del Chirurgo and the Via Consolare looking north (image Piranesi 1804 Vol. 1. Pl. XIII. Courtesy of Heidelberg University Library: Digital Library).

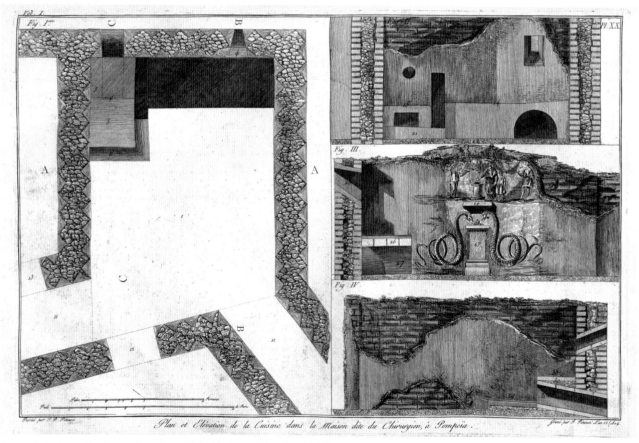

Figure 1.8. Piranesi's plan and sections of the kitchen of the Casa del Chirurgo (image Piranesi 1804 Vol. 1. Pl. XX. Courtesy of Heidelberg University Library: Digital Library).

to Casa del Chirurgo. It would appear that this area was not yet connected to the excavations elsewhere in the city and that the Casa delle Vestali, the Shrine, and the southern shops had yet to be excavated. Sade provides the following description, in which he clearly discusses the well-preserved painting of what is now known as the oecus (Room 19):

'La maison du chirurgien, dans laquelle furent retrouvés tous les instruments de son art, que l'on voit au Museum, est celle dans laquelle la distribution des appartements se distingue le mieux. On y voit à merveille l'emploi de toutes ces pièces, son laboratoire, sa salle, son jardin, sa cuisine, son cabinet: tout se reconnaît au mieux. On a couvert cette dernière pièce pour en conserver les peintures qui vraiment méritent de l'être, tant par leur mérite réel que par la singularité de leur conservation. On y voit de petits médaillons en paysage d'une délicatesse admirable; les arabesques y sont agréables, et la sculpture qui décore la corniche d'une légèreté surprenante. La mosaïque de ce cabinet est absolument dans son entier.'[54]

Indeed, the level of brightness and degree of preservation of Room 19 in particular, appear to have been the foremost attractions of the Casa del Chirurgo in its early years, an effect that due to its subsequent degradation is now largely lost. During the excavation in 2002, striking evidence of the brightness and freshness of the colours of the wall paintings that had so struck the early visitors was found in the atrium and tablinum of the Casa del Chirurgo.[55] In these rooms, collapsed cisterns had been filled with lapilli during the eruption, which the early excavators had partially excavated. The resulting void appears to have been used as a rubbish pit, either during the work to remove panels of decorated plaster from the walls,[56] following one of the severe frosts that hit the area in 1776 and 1786,[57] or possibly during one of the several general cleanings of the site that took place after 1799.[58] Whatever the cause, the fragments seem to have simply been disposed of in the pit. More than two centuries later, they retained the brilliance often commented on by the initial visitors (Fig. 1.9).

While these paintings are remarkable to us today, it is important to note that the original visitors seem primarily to have been impressed by a single room in the property – the so-called oecus (Room 19). This room contained a well-preserved painting of a woman surrounded by onlookers, engaged in painting a picture of a probably priapic herm. (Fig. 1.10).[59] From the moment of the first excavation, it was this particular painting, and the well-preserved room with all four walls intact that surrounded it, which seem to have excited the interest of early visitors. The oecus became, along with the required mention of the discovery of surgical equipments that gave the house its name, one

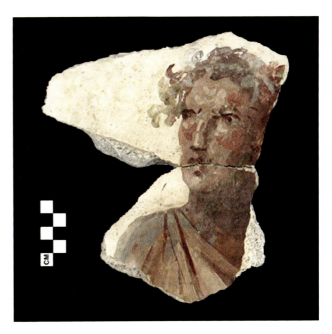

Figure 1.9. Fragments of the original plaster of the Casa del Chirurgo found in 2002 having been discarded in the atrium cistern collapse (image © 2004 Jennifer F. Stephens and Arthur E. Stephens).

of the major aspects of the property discussed in later guides and scholarship.[60] The equally highly-decorated but less well-preserved tablinum (Room 7), however, was described as 'di poca considerazione.'[61] Nevertheless, it appears that one of the primary reasons for the generally high value placed on the Casa del Chirurgo, noted by the Pompeianarum Antiquitatum Historia (PAH) as one of the best yet excavated – 'sì per la sua costruzione ed ornato, che per essere conservate le mura fino ad un'altezza, che può formarsi una giusta idea di come avea da restare nel suo essere'[62] – was the degree to which it preserved the full shape of an ancient house and could be easily imagined as a whole. This must have been the result of the solid opus quadratum and africanum walls, which were better able to withstand the violent, primitive methods of excavation then in use.

The early fame of the paintings of the Casa del Chirurgo was not to last. From the comparison of early reports, it appears that the usual visit to the city in the 1770s began in the area of the theatre and the Quadriporticus, progressed up to Insula VI 1, and finally ended at the Villa di Diomede outside of the walls. An example of this is to be found in the publication that was to result from the visit of Bergeret di Grancourt, with draughtsman Jean-Honoré Fragonard and architect Pierre-Adrien Pâris, to Pompeii in June 1774, which followed this route more or less precisely and seems to have summarised the remains of Insula

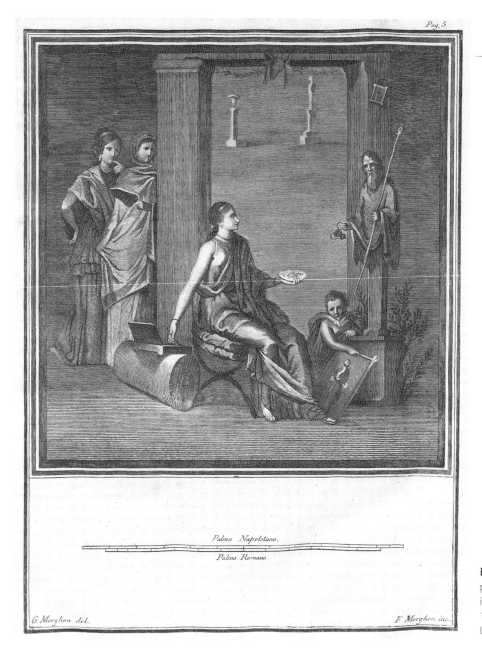

Figure 1.10. Image of a woman painting from Room 19 as it appears in *Pitture d'Ercolano* Vol. VII (V). Plate 1. 1779 (image courtesy of Heidelberg University Library: Digital Library).

VI 1 as those of "*maisons communes*."[63] Over time, the visit to VI 1 appears to have declined in importance on this itinerary. By the 1780's, when work had shifted to exhuming the Casa delle Vestali, the description by grand tourist Peter Beckford implies that contemporary visitors attention was ever more heavily focused on the Villa di Diomede,[64] and its collection of fugitives discovered in the cryptoporticus who left impressions in the ashes, including what was believed to be the negative of a woman's breast uncovered in 1772.[65] Presenting a grander and more luxurious impression, this villa overshadowed the finds in Insula VI 1 for centuries to come.

The publication by Abbot Richard de Saint-Non in 1782, under the name *Voyage pittoresque ou Description des royaumes de Naples et de Sicile*, followed a large expedition organised by Dominique Vivant Denon. This brought together the work of a number of draughtsmen and landscape artists including Pierre-Adrien Pâris, Louis Desprez, and Claude-Louis Châtelet, and focused heavily on the Villa di Diomede.[66] Among the images relevant to Insula VI 1 is an etching showing a vista down the Via Consolare, with the majority of Insula VI 1 still unexcavated.[67] A second, much more uncommon vista facing north from roughly in front of the as yet unexcavated Casa di Sallustio, indicates the degree of clearance that had taken place in the Insula Occidentalis, and shows a road that led to the

top of the unexcavated level running up and over the Vicolo di Narciso (Fig. 1.11).[68] The location of the Casa delle Vestali or the Inn is indicated by the presence of an awning built out over the northern sidewalk, a feature that also appears in Hamilton's images of the same area.[69] Strangely, despite detailing virtually every other aspect of the site exposed in 1777, the *Voyage pittoresque* does not mention the Casa del Chirurgo at all, instead focusing upon a phallus located between doorways 3 and 4 of the Insula Occidentalis along the Via Consolare in its description of the area of Insula VI 1.[70] Similarly, the view of the city produced by Jacob Philipp Hackert, dated between 1792 and 1794, and etched by Georg Abraham, focuses upon the 'standard set' of locations; the Large Theatre and the Temple of Isis, the Villa di Diomede, the Porta Ercolano, the Tombs (especially that of the priestess Mammia) and the 'Barracks' (the Quadriporticus), but does not seem to have included Insula VI 1.[71]

By the time Goethe visited the excavations on the 11th and 18th of March 1787,[72] it is clear that interest in the specifics of the city was losing some momentum. Instead of reporting individual finds, the approach to the site was now more generalising. Fino suggests that this may be the influence of the first hints of the Romantic age,[73] but other factors may also have been at work, including the ever-growing amount of information presented by the excavated area, in which specifics tended to be lost within the overall impression. Ironically, a number of visitors expressed some frustration at the perceived slow pace of excavation, wishing to see more of the city exposed. Visitors of the later part of the eighteenth century also tended to draw generalised conclusions about Pompeian housing in their descriptions rather than focusing on specific houses. David Sutherland, captain of the 25th English Regiment from Gibraltar, visited Pompeii in February of 1787. His account mentions that among the paintings he saw a Narcissus, which is probably the panel from *ala* 8 in the Casa del Chirurgo, but his descriptions of the houses themselves are relatively impressionistic.[74] Similarly, while Quatremère de Quincy's two visits to the site in 1779[75] and 1783–84 helped to convince him that the houses preserved could help explain the complicated text of Vitruvius (an aspect that would also be realised in concrete form by Piranesi and Mazois

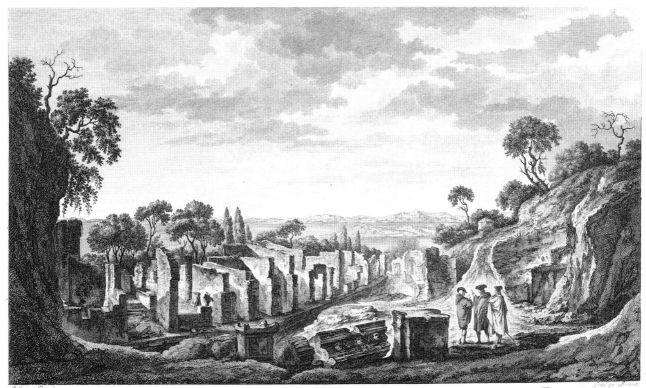

Vue de l'Entrée de Pompeï et de la Rue principale de cette ancienne Ville située près du Vésuve et détruite ainsi que Stabbia et Herculanum, dans la fameuse Eruption de ce Volcan en l'Année 79 la nuit du 24 au 25 Aout

Figure 1.11. View of Insula VI 1 from the south in Saint-Non. 1782, Vol. 2, 111 (image courtesy of Heidelberg University Library: Digital Library).

with respect to the Casa del Chirurgo itself),[76] this did not lead to recording specifics about the houses then exposed. The lack of details may also have had something to do with the necessity to bribe guards in order to produce drawings.[77] Indeed, many of drawings that were used in the *Voyage* had been copied from surveys of royal architects, and given that the Casa del Chirurgo was one of the most recently excavated properties, perhaps it was more difficult to find a way to record it surreptitiously.

Perhaps the general loss of interest in the discoveries of Insula VI 1 was the result of the excision of some of the central images from a number of the walls. Certainly the removal of paintings to the museum at Portici, especially the mythological panels, seems to have deprived Goethe of much enjoyment, who while not mentioning Insula VI 1 specifically, certainly visited the Schola tomb of Mammia and likely saw the nearby houses as well.[78] Ironically, this tomb, also removed at first, had been returned to its original location just two years earlier in January 1785.[79] While Hamilton's image of the atrium clearly shows that the central decorative images of each wall, which were apparently so pivotal to early visitors enjoyment of the site, were still in situ in roughly 1777, they appear to have been removed by the end of 1792, and the woman painter had already been taken from Room 19 in 1771.[80] A second factor may have been the continued excavation of the areas of the Insula Occidentalis that faced onto Insula VI 1, which may have interfered with a visit to these areas. Ultimately, this initial decline in interest in the insula would be accelerated not only because the French Revolution caused a sharp decline in the *Grand Tour d'Italie*, but also because subsequent unrest in Naples leading to the evacuation of the royal family in January of 1799 brought to a halt the excavations as a whole.[81] Though some work resumed under General Championnet and the short lived Parthenopaean Republic, continuing political turmoil meant that full excavation could only begin again somewhat later. During this time other visitors, in a time-honoured habit, decided to leave more tangible traces of their presence. In the oecus (Room 19) of the Casa del Chirurgo, a certain "Tullio" recorded his presence in 1799, and another anonymous visitor incised the date 1802.[82] Perhaps this is a relic of the traveller Lewis Engelbach, who visited the site in that year during the brief pause in French rule of Naples.[83] While discussing painting colours and patterns in house decorations in some detail, Engelbach appears to have overlooked the particulars of Insula VI 1 almost entirely.[84] He did, however, notice considerable damage to the once relatively well-preserved wall paintings, citing both exposure and their removal as the cause. An aquatint view of the Porta Ercolano by Thomas Rowlandson contained in Engelbach's letters,[85] shows what might be a protective roof over parts of Insula VI 1. This, however, must have been drawn after an earlier original, since it also portrays much of the block as unexcavated, even though it had certainly been cleared entirely by 1802.

A list of sites given by Viscount René de Chateaubriand, who visited the site in 1804, "*1° le temple, le quartier des soldats, les théâtres; 2° un maison nouvellement déblayée par les Français; 3° un quartier de la ville; 4° la maison hors de la ville*"[86] suggests that for the visitor in the early nineteenth century, the area of Insula VI 1 and the Insula Occidentalis was still the third stop on the itinerary. It is also clear, however, that for the casual visitor, the finds of Insula VI 1 had begun to transform into simply a row of houses on their way to the tombs and an extra-urban villa. The roughly contemporary guide of D'Ancora (1803) follows a similar pattern, focusing on the southern side of the Via Consolare and summarising the whole of this part of the city tour in just two brief pages.[87]

Large-scale excavation at Pompeii resumed in 1808 under the reign Joachim Murat, with the support of Queen Caroline Bonaparte.[88] This period witnessed the monumental publication of François Mazois, which represents the last major effort to document Insula VI 1 prior to the AAPP excavations. Although employed by Queen Carolina, Mazois managed to survive the political reversals caused by the fall of Murat and the subsequent return of Ferdinand IV to the throne of Naples. Mazois produced, with help from Franz Christian Gau in the final volume after his death, one of the first substantial publications of the city. His precise focus on the daily life and private dwellings of ancient Rome represents a new departure in the study of the city that was to have a profound impact on the understanding of Pompeii as a whole. His second volume included discussion, plans, and reconstruction sections of the Casa del Triclinio,[89] the Casa delle Vestali,[90] a reproduction of the decoration from the shrine in the Casa del Triclinio,[91] a plan of the Casa del Chirurgo,[92] and a general view of the fountain and Insula VI 1 from the south.[93] In addition to those images published in his second volume in 1824, there are the original colour images held in the *Bibliothèque nationale de France*, including a section through the peristyle of the Casa delle Vestali.[94] The explanations of these images are also extremely valuable for gaining an impression of the block in the early nineteenth century.

The fall of Murat and the end of French occupation after Waterloo meant that Naples and Pompeii would

once again be open to English visitors from 1815. Some of these added to the work of Mazois, who was also permitted to continue his work under the returned Bourbon ruler.[95] Despite this, the period of French rule appears to have served to divide the results of previous Bourbon excavations from those that would follow in such a way that help to push the remains of Insula VI 1 further into the background. Interest had shifted to the more recent excavations that had taken place during the period of French occupation, rather than on what had come before. The much larger area of the city that had now been cleared may have also contributed to a decline in the frequency of appearance of the remains of Insula VI 1 in the works of landscape artists, writers, and architects of the early nineteenth century onwards, except as a backdrop to the romantic landscapes of the tombs of the Via dei Sepolcri and the Porta Ercolano that began to proliferate at this time.[96] Landscape paintings during the following decade, including well-known examples from Neapolitan artists D'Anna and Saverio Della Gatta,[97] generally focused on a set of locales that matches Chateaubriand's list from 1804 and took a similar summary approach to the remains of Insula VI 1 and the Insula Occidentalis. The view up the Via del Sepolcri towards the Porta Ercolano, with a hint of the *'quartier de la ville'* inside, appears to have been a particularly popular way of capturing excavated remains in this area of the city at this time. Written accounts continued to follow the trend of the previous decade. Amaury Duval's narrative of the city in 1819–1821, though clearly highlighting a number of features from the block, such as the 'Salve' mosaic from the Casa delle Vestali,[98] the 'hot-water shop,' as the first bar (Inn bar) that had first been identified,[99] and the fountain at the intersection of the Via Consolare and the Vicolo di Narciso,[100] provided nothing more than a collection of random details and focused instead on the overall impact of the excavations and the city. A similar motivation underlies Castellan's description of his visit published in 1819, which simply gave a general impression of the city.[101] Perhaps the excavated area had become just too large to be considered in great detail by the average visitor.

By the time of the highly influential *Pompeiana* of Sir William Gell in 1817, emphasis in the study of the city had moved to the Forum, the Amphitheatre, and more recently excavated houses. His first edition included only two views of the Casa delle Vestali and none from the Casa del Chirurgo, which by this time had largely been surpassed by more recent discoveries. Later editions make this even more apparent with the majority of elements of Insula VI 1 being entirely

removed from the first expanded 1832 edition. When Lady Blessington (Margaret Power) visited the site with Gell in 1823, her visit began with the Via dei Sepolcri and then continued straight past Insula VI 1 to more important finds in the centre of the site.[102]

Indeed, of the 98 landscapes by Linton that were transformed into lithograph by Day, no view of Insula VI 1 was included.[103] Similarly, the numerous aquatints in Le Riche's 1822 *Vues des Monuments antiques de Naples*[104] focus on the Forum, the Theatre, the new discoveries, and the now venerable but ever-popular Villa di Diomede. By 1825, pride of place in the city began to fall increasingly to other parts, such as the Casa del Poeta Tragico, especially with the popularity of Edward George Bulwer-Lytton's *The Last Days of Pompeii*.[105] Even the identification of the Casa delle Vestali as the 'House of Ione'[106] from the same novel was insufficient to reverse this process, and after 1830, the Casa del Fauno, with its famous Alexander Mosaic would ensure that the decline of interest in Insula VI 1 was complete. This new focus of attention is made abundantly clear by the absence of the structures of Insula VI 1 from the Fourth Year 'restoration' projects of the winners of the *Grand Prix d'Architecture*, some of whom restored sections within the older excavated areas but ignored Insula VI 1.[107]

By the time of the earliest studies of decorations, the remains of Insula VI 1 had been so forgotten that they appear generally to have escaped attention. Goldicut only included the famous 'Salve' mosaic from the Casa del Vestali in his book of 1825 and none of the paintings (Fig. 1.12).[108] Similarly, Zahn's otherwise extensive illustrations published through the middle of the century include only one panel image each from the Casa delle Vestali and the Casa del Chirurgo,[109] focussing instead on the newest excavations and museum pieces. Similar collections of illustrations from the site by Rochette[110] and Ternite[111] seem not to have been interested at all in the remains of Insula VI 1. By the time the excavations in the Casa del Chirurgo were a century old in the 1870's, the descriptions of the houses of Insula VI 1 had followed the fate that virtually every

Figure 1.12. Salve mosaic from the Casa delle Vestali in Goldicutt 1825 (image courtesy of Heidelberg University Library: Digital Library).

house in Pompeii has experienced – being reduced to a conventionalised and repetitive set of tourist titbits – such that in Fiorelli's *Descrizione di Pompei*, the whole block could be summarised in just a few pages of text. Indeed, Casa del Chirurgo was passed by without reference to any paintings beyond the famous room with the woman painter, and with no mention of its finds aside from the supposed surgical instruments.[112] Similar information was repeated in Mau-Kelsey,[113] and practically every guidebook to the city until the present day. It was only due to the comprehensive approach to the city of scholars of the later nineteenth century such as Mau, Nissen, and Fiorelli, combined with the similarly thorough approach of the Niccolini[114] brothers that the Casa del Chirurgo, at least, did not disappear from modern scholarship entirely.

As will be seen in Chapter 3, the nineteenth century interest in the Casa del Chirurgo was for reasons entirely distinct from those that had originally made the house famous. Instead, the house began to play an exceptionally prominent role in a vigorous debate on the origins, form, and history of the so-called 'Roman atrium house,' a scholarly focus that carried on through the nineteenth and twentieth centuries. Central to this was the belief that the house was not only particularly early in date (estimated by the then-current building materials chronology to be as early as the fifth century BC),[115] and that it had fortuitously changed little in its layout since its original foundation. As a result, the house has played an on-going role in the debate about the development of Roman domestic architecture, but in the manner of a 'fossil' preserving earlier forms lost elsewhere. The house also played an important role in discussions of the early history of Pompeii and the chronology of its earliest foundations, particularly in relation to the city wall that runs just to the north of it. It was in order to resolve some of these debates that the Casa del Chirurgo was one of the first to receive subsurface excavations below the AD 79 level by Amedeo Maiuri in 1926,[116] which were designed to address some of these questions. Many of the sondages excavated by his workers in 1926 were re-excavated by the 1995–2006 team,[117] and his results are evaluated in Chapters 4 and 5.

The final major event in the history of Insula VI 1, prior to the commencement of the investigations by the University of Bradford in 1994, occurred in the late summer of 1943 when several of the bombs dropped by the Allies on Pompeii in preparation for the landing at Salerno, fell into the block. Two fell in the Casa delle Vestali, the first in the atrium on the Via Consolare, and the second between its peristyle and the Casa del Triclinio. Fortunately, the Casa del Chirurgo and the rest of the southern part of the insula survived this episode largely unscathed.[118]

The unassuming Insula VI 1 that today flanks the tourists on the Via Consolare as they journey to the Villa dei Misteri is quite unlike the famous set of buildings originally excavated in the eighteenth century. Its long history of exposure has removed much of the once remarkable wall painting, revealing the fabric of its walls. Once extensive floors have degraded leaving the underlying soils exposed, and the growth of vegetation and build-up of modern soils have combined to present the aspect of a ruin. There is evidence of several programmes of maintenance, including the rebuilding and pointing of walls and the repair of plaster, as well as the addition of roofs, from the early years of the site onwards. Indeed the insula has now been exposed as a ruin for longer than it was in use in antiquity and, like all of Pompeii, it requires frequent interventions and restoration which are still ongoing. The roofing in the peristyle of the Casa delle Vestali was replaced in 2008–9 and most recently metal ties were added to the Case delle Vestali and the Casa del Chirurgo to prevent the walls onto the Vicolo di Narciso falling into the street. This was carried out in 2015–16 by the Soprintendenza Archeologica di Napoli e Pompei as part of their ongoing battle to preserve the remains of the city. Poignantly, it is the very state of decay in this fallen 'superstar' that has made it possible to document not only its appearance in AD 79 but also to study the standing stratigraphy of its walls and to excavate through its damaged and ill-preserved floors, revealing the full development of the block before its destruction by Vesuvius. It transpires that this insula yet has many more interesting stories to tell. The work of the University of Bradford excavations (AAPP) was directed towards revealing these stories through the complete and comprehensive study of the evidence available in Insula VI 1.

This volume presents the results of this work for the Casa del Chirurgo, documenting the history of the structure (and indeed the area of the structure before its creation), from the earliest traces of human activity down until the completion of our research in 2006. Much more than just a famous early façade or a seemingly simple layout, the house and its stratigraphy preserve the full history of the site from the fourth or third century BC until the eruption. Filled with destructions, rebuilding, modifications, and repurposing, this house provides a window on the very forces of urban change in the ancient city.

Notes

1　Foss 2007, 31, fig. 3.1.
2　Garcia y Garcia 2006, 66.
3　Thomas 2008, 275.
4　Cool 2016a.
5　Hobbs 2013.
6　Fiorelli 1875, 76–82; cf. also Pappalardo 2001, 47–9.
7　Foss 2007, 34.
8　Replacing the 'shoe-string' method previously in use. Laidlaw 2007, 623; *CTP* V, 104; cf. also Tascone 1879. The numbering system corresponded to Fiorelli's ideas regarding the development of the city (cf. Fiorelli 1858).
9　Bragantini *et al.* 1981.
10　Ellis 2005 and especially Monteix 2007; cf. also Allison 2004a, 63–4 regarding similar problems with room nomenclature in domestic contexts.
11　Fiorelli 1875, 76.
12　*ibid.*
13　*ibid.*
14　*ibid.* 77; *CIL* IV 97.
15　*ibid.* 77.
16　Fiorelli *ibid.* 77.
17　Fiorelli 1873, 25. Certainly the name was in use by 1827 (Bonucci 1827, 88).
18　Fiorelli 1875, 80.
19　*PAH* I, 1, 253–4 (20th April 1771); Della Corte 1953, 34; Eschebach 1984, 6ff.
20　Fiorelli 1875, 80.
21　*PAH* I, 2, 42 (17th July 1788).
22　*PAH* I, 2, 43 (25th September 1788); Fiorelli 1875, 81; Eschebach 1993, 153.
23　Fiorelli 1875, 81.
24　Eschebach 1993, 153.
25　*PAH* I, 2, 43 (25th September 1788).
26　Della Corte 1954, 38; *CIL* IV 102.
27　Fiorelli 1875, 82; Pappalardo 2001, 49; *CIL* IV 103.
28　Fiorelli 1875, 82; Mazois, 1824, Part 2, Plate 2.1.
29　Fiorelli 1860–1864.
30　Cf. also Parslow 1995, 227 f.
31　*PAH* I, 1, 248 (26th January 1771)
32　Cf. Laidlaw and Stella 2014, 23–26 for more details.
33　Pappalardo 2001, 49; *PAH* I, 2, 41 (29th May 1788) mentions excavations in the "shrine."
34　*PAH* I, 2, 48.
35　Fino 2006, 49.
36　Cf. *CTP* V, 112.
37　Miller 1777, 99.
38　From the letter dated Feb. 9th 1771, "The walls are painted in fresco, divided into small compartments by borders a l'y grec; these compartments contain various representations of Chinese temples or mosques; others of the human figure, amongst which, an old man's head, and a Mercury, seem to be particularly well done." Miller 1776, 99.
39　Cf. Fino 2006, 52; Moore 1781, 170–187.
40　*PAH* I, 2, Addenda IV, 156 (22nd June 1771).
41　Seemingly shortly thereafter, so probably still in 1771.
42　Fino 2006, 69.
43　Fino 2006, 81.
44　Hamilton 1777, Plates VIII, IX, and X.
45　Piranesi 1804–7; Fino 2006, 74.
46　*ibid.* Vol. 1 Plate VIII, XIII, and XXII.
47　*ibid.* Vol. 1 Plate X, IX, XI; III, Fig. IV; XIV.
48　*ibid.* Vol. 1 Plate XVI, XX.
49　*ibid.* Vol. 1 Plate XIX.
50　*ibid.* Vol. 1 Plate XVII, Plate XV; Fino 2006 73.
51　*ibid.* Vol. 1 Plate II.
52　Piranesi 1785.
53　Thomas 2008, 276.
54　Thomas 2008, 275–6.
55　Cf. Chapters 5 and 8.
56　Such as documented in *PAH* I, 2, Addenda I, 172–173 (23rd November 1792). Cf. Chapter 8 for more about this process in the Casa del Chirurgo.
57　*PAH* I, 1, 288 (23–30th March 1776) and *PAH* I, 2, 34 (23rd November 1786).
58　*PAH* I, 2, 73.
59　*Ornati*, I 36; Helbig 1459 NAP Inv. No. 9018; Schefold 1957, 92.
60　Cf. for instance Mau 1899, 274–276; Fiorelli, 1875, 80. The other standard observation was the supposed very early date and form of the structure, an idea probably introduced by Fiorelli 1873, 81 and certainly repeated by Mau. It does not appear in Bonucci 1827, 94.
61　*PAH* I, 1, 248 (19th January 1771).
62　*PAH* I, 1, 249 (26th January 1771).
63　Tornézy 1894–95, 316.
64　Beckford 1786, Letter XV; Fino 2006, 53.
65　*PAH* I, 1, 268 (12th December 1772). Cf. the 1852 novella by Théophile Gautier *Arria Marcella*.
66　Fino 2006, 87.
67　Saint Non 1782, Vol. 2, 111.
68　Saint Non 1782, Vol. 2, 112.
69　Hamilton 1777, Plate IX.
70　Saint Non 1787, Vol. 2, 113.
71　Fino 2006, 98.
72　Fino 2006, 57.
73　Fino 2006, 58.
74　Sutherland 1790, 80.
75　With painter Jacques-Louis David, who declared that the visit had the same effect on him as 'cataract surgery.' Fino 2006, 62.
76　Fino 2006, 62–63.
77　Fino 2006, 89.
78　Goethe 1913, Vol. 1, 216 (13th March 1787); Fino 2006, 57.
79　*PAH* I, 2, 25 (13th January 1785).
80　*PAH* I, 2, Addenda II, 172–173; *PAH* I, 2, Addenda IV, 156.
81　Fino 2006, 106.
82　*PPP* 113.
83　Fino 2006, 113.
84　Engelbach 1815, 110–119.
85　Fino 2006, 113.
86　Chateaubriand 1804, 116.
87　D'Ancora 1803, 75–76.
88　Fino 2006, 112.
89　Mazois 1824, Vol. 2 Planche IX (fig. 3 and 5).
90　*ibid.* Vol. 2 XI (fig. 3 and 5).
91　*ibid.* Vol. 2 Planche X (fig 2).
92　*ibid.* Vol. 2 XIII (fig. 1).
93　*ibid.* Vol. 2 Planche II (fig. 1 and 2).
94　Mazois, Bibliothèque nationale de France, Département Estampes et Photographie, Gd 12E pl. 32 and 33; Cf. Dessales 2013, 258.
95　Fino 2006, 134.
96　Cf. Cooke 1827, whose volumes are filled with landscape images of the site, universally shows Insula VI 1 as simply a small speck through the Porta Ercolano.
97　Fino 2006, 128–9.

98 Duval 1821, 414.
99 *ibid.* 410.
100 *ibid.* 411.
101 Castellan 1819, Vol. 1. 346–367.
102 Blessington 1839.
103 Fino 2006, 162; 202 (fn 18).
104 Le Riche 1827.
105 Bulwer Lytton 1834.
106 Eschebach 1993, 151.
107 Cf. École nationale supérieure des beaux-arts; Institut français de Naples and Soprintendenza archeologica per le province di Napoli e Caserta, 1981; Cf. also Pinon and Amprimoz 1998, 409–410; Fino 2006, 172. These clearly centred on the buildings of the Forum, the Theatre District, the Villa di Diomede, the Casa di Championnet, the Casa di Pansa, Casa dei Dioscuri, and the Casa del Centenario, in lieu of any structures from Insula V 1.
108 Goldicut 1825.
109 Zahn 1828–1852, I 98.
110 Rochette 1844–1851.
111 Ternite 1839–1858.
112 Fiorelli 1875, 76–82.
113 Mau-Kelsey 1899, 280–282.
114 Niccolini 1862, 20–22.
115 Fiorelli 1873, 81.
116 Maiuri 1973 (1930), 2; cf. also Wallace-Hadrill 1997, 224.
117 Cf. Chapter 5.
118 García y García 2006, 66.

THE ANGLO-AMERICAN PROJECT IN POMPEII

*Damian Robinson, Michael A. Anderson, H. E. M. Cool, Robyn Veal,
and Charlene Murphy*

Introduction

The Anglo-American Project in Pompeii set out to study Insula VI 1 in Pompeii (Fig. 2.1) through the application of widespread sub-surface excavation in conjunction with close examination of standing remains, backed by a comprehensive policy of extensive artefact and ecofact recovery at all scales. This chapter explains the steps by which the project gained this particular research focus and agenda, the ways in which the research was conducted, how that process evolved from season to season, and the manner in which the post-excavation process has continued in the years following the completion of excavation itself. This will not only provide the necessary background for assessing the quality and meaning of the results presented in the following chapters of this volume, but will set the stage for subsequent publications of data deriving from this project, while also explaining the philosophy behind the entire campaign of excavations undertaken in Insula VI 1.

The beginning of the project, 1993–1994

A letter to The Guardian

The excavations and recording carried out by the AAPP in Insula VI 1 can trace their origins back to an article in the British newspaper, *The Guardian,* on the 13th of January 1993, entitled 'Up yours, Pompeii' by the former British Cabinet Minister, David Mellor.[1] Mellor had recently returned from a visit to the site

and was clearly less than impressed by what he had seen. In a typically robust, and deeply unpleasant way, he lambasted everything. From the 'unattractive cafés' and 'scruffy traders', to the entrance,[2] and especially inside the site where he catalogued a long litany of issues: stray dogs, graffiti, the behaviour of tourists and site custodians alike, closed buildings, a lack of explanatory material, signs, or an education centre, the cafeteria and its staff.[3] Mellor concluded pompously that Pompeii was a national shame on Italy, who were either unwilling or perhaps just unable to look after it properly.[4]

Understandably, Pompeii's then *Soprintendente,* Prof. Baldassare Conticello, sought a right of reply, which was published in the Letters to the Editor page of The Guardian a week later (20th of January 1993).[5] In it, he acknowledged that Pompeii had its problems and that the criticisms highlighted by Mellor also irritated the Italian visitor as much as the foreign tourist. In defence of Pompeii, and his own management of it, Conticello highlighted the major interdisciplinary project that he had inaugurated to 'restore the site in a responsible and structured manner.'[6] In reply to Mellor's antagonistic assertion that the site would be much better looked after by English Heritage, Conticello pointed out the sheer scale of Pompeii, along with all of Italy's other archaeological sites, when compared to British ones and the drain which caring for them had on Italian state finances.[7] Moreover, Conticello suggested that while there was an adequate budget to preserve the objects from the site, there was too little money to maintain Pompeii itself.[8] Citing the then recent earthquake in 1980, in which 600 out of the

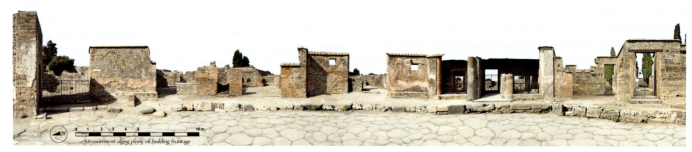

Figure 2.1. The western façade of Insula VI 1. Imagemosaic © Jennifer F. Stephens and Arthur E. Stephens.

800 ancient buildings in Pompeii had been damaged, Conticello accepted that Italy could not fund all works of restoration and 'everything that Mr Mellor sees desirable' and boldly suggested that other countries had a moral responsibility for helping to sustain this 'common heritage.' The letter concluded with a request for international support and a novel proposal that the restoration and maintenance of houses could be funded through a sort of 'adoption' scheme.[9]

At the University of Bradford, this exchange was read with interest by Rick Jones, then Senior Lecturer in Roman Archaeology in the Department of Archaeological Sciences. Jones, an enthusiastic fieldworker, had the previous summer completed a final season of excavation and survey at the Roman legionary fortress of Newstead, near Melrose in Scotland and was now interested in developing a new field project. Jones sensed an opportunity and wrote to Conticello offering the help and support of the Department of Archaeological Sciences in the adoption of a property or properties in the ancient city. Jones stressed that although the department had no large sources of funding with which to restore and maintain buildings, it could undertake research and fieldwork. In addition to this, other members of staff within the department in Bradford could also offer much additional support in terms of scientific archaeology, notably materials analysis, geophysics, environmental archaeology, and human osteology, which could complement and add value to any research project. Jones' offer of help was warmly received by the Pompeian authorities who invited him to put together a team to visit the city during the summer of 1994.

Prior to this preliminary field season, two important meetings were held that helped to determine the form and scale of the nascent project. The first of these was between Jones, Damian Robinson, currently Jones' Research Assistant in a project to create a digital map of Pompeii in AutoCAD funded by a learning and teaching research grant from the University of Bradford, and Roger Ling, Professor of Classical Art and Archaeology at the University of Manchester and the director of a British programme of research on the Insula of the Menander (Insula I 10) that was then coming to the end of its fieldwork phase.[10] Through discussions with Ling it became apparent that any Bradford project should equally use the insula as the basis for its fieldwork, but that it should also include a programme of stratigraphic excavation below the AD 79 ground surface. The advantages of such excavations would be to provide clarity and dating evidence for the sequencing of the standing archaeological remains. The opportunity to do this had been unavailable to Ling,[11] but had now become a possibility.

The second meeting took place shortly afterwards at the University of Bradford between Jones and Andrew Wallace-Hadrill, then Professor of Classics at the University of Reading. Wallace-Hadrill had been active in Pompeian scholarship for several years, previously undertaking analyses of the houses, their decoration, and social meaning.[12] Like Jones, in response to the new opportunities opening up at the site under Conticello, he was also planning on undertaking a fieldwork project. Wallace-Hadrill had already recruited his colleague Michael Fulford, Professor of Roman Archaeology in the Department of Archaeology at the University of Reading, to lead the excavation side of the project that would be centred upon Regio I 9.[13] Although there had been some suggestion from the *Soprintendenza* that the teams from the Universities of Bradford and Reading could combine to form a new large British project in Pompeii, it became clear that for both parties independent programmes of fieldwork was preferable. The result of this was that the *Soprintendenza* allocated Insula VI 1 to Jones and the University of Bradford as their primary research unit, while Wallace-Hadrill and Fulford focused their research on Insula I 9.

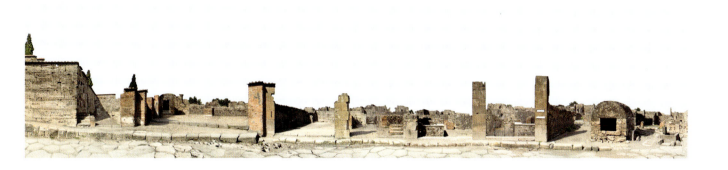

An exploratory season of fieldwork

A small, three-week exploratory season of fieldwork in Pompeii took place in August 1994, with a team largely drawn from the University of Bradford and other volunteers. The primary aims of the season were to assess the research potential of Insula VI 1, to investigate the prospects for using other scientific means for investigating the urban life of Pompeii, and to form partnerships with the Pompeian authorities in this research. The season was also of importance as it helped to shape the subsequent nature of the project in terms of its archaeological direction, the management team, and to emphasise the necessity for a long-term funding stream.

In Insula VI 1, a rapid photographic survey of the standing architecture was undertaken, which was complemented by experiments with rudimentary photogrammetric techniques using a medium format camera in an effort to devise ways in which to record the standing remains accurately and in a stratigraphic fashion.[14] This work was of key importance as it allowed the team to realise the complexity of the site, to devise ways of recording it, and to formulate some preliminary hypotheses pertaining to the structural development of the insula.[15] Subsequent detailed stratigraphic excavations and wall analyses, however, proved these initial hypotheses to be incorrect, which helps to vindicate the decision to investigate the insula intensively rather than in the extensive and relatively superficial way that it was analysed during the 1994 season.[16]

In addition to the team working in Insula VI 1, two other specialist teams were working in various locations around Pompeii.[17] In the store rooms of the Forum and Sarno baths (VII 8 and VIII 7), Jane Richardson and Margaret Judd assessed the potential of the animal and human bones for further study. As the human bones were already under analysis by Estelle Lazer, it rapidly

became apparent that little further work could be done in this area.[18] The animal bones, however, proved to be more fruitful and all the material that was in the stores was recorded. It was noted that the assemblage did not resemble that of a 'typical' archaeological site as it was dominated by partial or complete skeletons – clearly the result of the Pompeian 'death assemblage' – and included fourteen equids and between four and five dogs. The prevalence of these species may also suggest a deliberate collection and/or curatorial policy by the early excavators of the site.[19] This preliminary investigation resulted in subsequent work to document completely and publish this faunal material.[20]

A team also undertook a number of small-scale geophysical surveys around the city, using earth-resistance (resistivity) and magnetic gradiometery (magnetometery) techniques. The geophysical survey had two main aims. First, it sought to assess the potential of the techniques to reveal aspects of the layout of buildings that were destroyed in the AD 79 eruption, and which were still buried beneath the deposits of volcanic lapilli. It was envisaged that this would allow the team to 'fill-in' the blank, unexcavated, areas and enable a full reconstruction of Pompeii's ground plan.[21] Second, the techniques were used to investigate the extent to which earlier structures that were buried at the time of the AD 79 eruption could be detected. Here, the team were mindful of the limited excavations that had taken place in Room 18 of the House of the Menander and Room 51 of the House of the Faun,[22] in which excavation trenches had been deliberately left open to demonstrate the complexity of the subsurface archaeology. It was clear that Insula VI 1 would also likely contain similarly complex and deeply stratified subsurface deposits. As a way of initial investigation, it was thought that closely-spaced geophysical surveys had the potential to reveal some of this complexity and therefore, help allow excavation trenches to be located carefully. This

resulted in some initial work being undertaken inside Room 10 of the Casa del Chirurgo, where despite Maiuri's inconclusive initial excavations in the property in 1926, it was still thought that a large Sarno stone wall, forming an original southern boundary wall of the house, bisected the room.[23] The geophysical survey, like our later excavations, revealed no trace of this wall or of a foundation/robber trench[24] but did serve to highlight the practical and interpretative difficulties of working within such restricted space with then current technologies and suggested to the team that further geophysical surveys inside of AD 79 phase rooms would be unproductive. This reinforced the idea that subsurface excavation would be the only possible way in which to investigate any components of the archaeology of Insula VI 1 that were not readily apparent in the standing remains. Outside of Insula VI 1, geophysical survey proved relatively more successful in the investigation of extensive garden areas in the eastern areas of the city, in particular, the Casa della Nave Europa (I 15, 2.3.4.6), the Praedia di Giulia Felice (II 4, 2–12), the area long called the 'Foro Boario' (II 5, 1–4), the Palaestra Grande (II 7 1–10) and the Terme Centrale (IX 4, 5.10.15.16.18).[25] These investigations produced numerous interesting anomalies, particularly those to the west of the *natatio* in the Palaestra, which might have suggested the presence of earlier buildings. Other results, like the solid flooring under the Terme Centrale, have subsequently been confirmed by excavation.[26]

At the end of the three week field season, the overall results from the University of Bradford team in the different areas of activity were presented to Conticello, who was enthusiastic about many of them. In particular, he was forthright in his recommendation that the team should continue their work in documenting Insula VI 1, and was supportive of Jones' desire to excavate areas of it in order to supply dating information and to elucidate the sequential development of the city block. Furthermore, he promised that the *Soprintendenza* would undertake clearance work on the northern areas of Insula VI 1 that were then completely overgrown with weeds and brambles, so much so that the survey team had been unable to access the Inn and Casa del Triclinio and the areas around the city walls. Conticello was, however, largely dismissive of the geophysical research on top of the AD 79 lapilli, pointing out that although it was good to know that the techniques worked on the lapilli, it was no great surprise to find that there were buildings buried beneath it. He was, however, intrigued by results from the *Palaestra Grande*, and proposed that the Bradford team should work with the *Soprintendenza* and investigate the potential of the

buried archaeology in this area. Conticello suggested that this would be an excellent opportunity for a substantial open area excavation, though in fact this was never undertaken.[27]

The experience provided by the initial field season, coupled with the meeting with Conticello, helped to shape the future direction of the project. It was clear that a large-scale recording and excavation project to recover the full structural history of occupation of Insula VI 1 from its earliest period was feasible, and crucially, that this would have the full backing of the *Soprintendenza*. For certain specialists, however, the future was less clear. During the course of the season, it became apparent that there would be little that the Department of Archaeological Sciences could offer to the study of the human remains from the site. Similarly, for the geophysical survey team, the work in the Casa del Chirurgo during 1994 field season had demonstrated the difficulties in undertaking resistance and magnetic survey in small enclosed spaces, and the more extensive prospection work elsewhere in the city had already examined many of the larger open areas in the city with only limited degrees of success. Furthermore, there was no real desire from the Pompeian authorities for further geophysical work on the unexcavated portions of the city or beyond the city walls. Consequently, for Jones, the 'shape' of the new project was becoming clearer. The most direct contribution that the University of Bradford could make to Pompeian archaeology was indeed a more academic variation of Conticello's request for international support in the pages of the Guardian newspaper – the adoption of a city block and its systematic investigation. Fortunately for Jones, this was exactly the area where his research interests lay, and such a project began to take shape over the following autumn and winter.

The Anglo-American Project in Pompeii, 1995–2006

The management of the excavation

At the end of the preliminary field season, Jones appointed two co-directors to work alongside him in the academic management of the project: Sara E. Bon, a graduate student from the University of North Carolina at Chapel Hill, and Damian Robinson, a graduate student at the University of Bradford, whose doctoral research into the spatial structure of Pompeii was also being supervised by Jones. This division of responsibility was a development of Jones' policy from his previous

field project at Newstead Roman Fort (Trimontium) in the Scottish Borders. Here Jones had been the overall project director, with co-directors leading the work on excavations and the field survey.[28] In Pompeii, Jones and Bon would oversee the excavations as well as the administrative organisation of the project, a task that the two of them had performed together during the 1994 season. Robinson, having supervised the initial recording of the architecture in the insula and who had developed a methodology for the recording of stratigraphic information of different phases of construction, decoration, and restoration, took responsibility for the analysis of the standing architecture. This structure lasted for two seasons until Bon left the project, leaving Jones in charge of the excavations and Robinson the architecture, a situation that continued with only mild changes through to the end of the fieldwork phase of the project.

Excavation took place in discrete Archaeological Areas (abbreviation AA), often determined by the extent of a single room and its bounding walls, but sometimes extending beyond this to include nearby corridors. Each excavation team was led by its own supervisor, who was responsible for the recording and interpretation of the archaeology in his or her particular AA (or group of AA's), as well as the training and instruction of the team assigned to that area.[29] Though exceptional, it sometimes proved logistically necessary for the supervisor to shift roles throughout the season, such that a particular AA might have more than one supervisor in any given year.

As the scale of the excavation in Insula VI 1 increased, Jones began to require additional assistance in the day-to-day running of the Project. The result of this was a new tier in the project's management structure, that of Field Director, the role of which was to directly supervise a number of excavation teams, typically co-located in a discrete area of the insula, divided between the northern plots (Casa delle Vestali and north) and the southern plots (Casa del Chirurgo and south). The Field Director for the northern zones was Gary Devore (2001–2004). The Field Directors with responsibility for the Casa del Chirurgo were Steven Ellis (2003–2004) and Michael Anderson (2005–2006).[30] The Field Director for the southern areas was Briece Edwards (2001–2006), which included the Casa del Chirurgo for the first year of excavation there in 2002. At the same time, with increasing interest on the part of students to return for additional seasons of training, supervisors were assigned 'advanced' or 'returning' students to act as assistants in supervising and managing excavation in a particular area. This

formed a definite pathway to advancement within the project, and many later supervisors began their archaeological training as students, progressing to advanced students and assistant supervisors, until finally being promoted to full supervisor. Indeed, the same was true for the field directors, three of which (Gary Devore, Steven Ellis, and Michael Anderson) had all begun as students of the project.

Architectural analysis and survey

Initially, the walls and standing stratigraphy were analysed in isolation and with a different methodology from sub-surface excavations. This was partly as an outgrowth of the original administrative organisation of the Project with Damian Robinson in charge of architecture and Rick Jones heading excavation, and partly due to practicalities of the field school and its five-week field season. In theory, this made sense in terms of the distribution of resources, as it meant that the often time-consuming study of standing remains would not impede the progress of excavation, which was on a much more sensitive time schedule. In practice, however, it also introduced a degree of disconnection between the two processes that permeates many aspects of the record, and even the process of publication.[31] Beginning in 2002, and therefore for the full period of the excavation of the Casa del Chirurgo, an AA was defined in terms of both the buried *and* standing stratigraphy, covering both antiquity as well as modern interventions to the site, including episodes of reconstruction and/or repair. Consequently, the recording and interpretation of an archaeological area was undertaken by the same team with the intention of allowing a complete understanding of both the buried and built aspects. In teaching, recording, and interpretation, the area supervisor, who was first and foremost an excavator, was assisted by an architectural specialist who was specifically assigned to the Casa del Chirurgo and who worked with all of the teams operating within it.[32] Despite these changes, a degree of separation between the two processes of analysis persisted and will occasionally be evident in the current volume. From 2002 until 2006, the architecture team was also augmented with the addition of a Field Director, Astrid Schoonhoven, who worked closely with Robinson in order to bring the work of previous seasons into an integrated and complete state. Specific studies of the architectural environment, especially with regards to the standing remains, were undertaken by specialists Robert Chavez (1997–1998, 2000–2004) in plaster, Natalie

Messika (1997–1999) in CAD and data management, Will Wootton (2005–2006) in flooring, and Hélène Dessales (1999–2005) in archival research on the whole insula.

Total station based 3D topographic survey was also a prime goal of the architectural team. This was intended to provide an accurate plan of the standing remains, to coordinate architectural analysis, and to provide appropriate geo-location and elevation data to excavated trenches. Initially, this work was undertaken as a component of the field school (cf. infra) and supervised by Toby Kendal (1996–2000), followed by Eric Poehler (2000–2002). The requirement to rotate all students rapidly through this element of the curriculum, however, meant that at best a student would only have a single day working with the survey instrumentation, which was clearly insufficient from a learning and teaching perspective, and also resulted in a slow rate of progress and results of variable quality. The survey team was therefore made into an independent group of specialists, including Eric Poehler (2002–2006), Arthur Stephens (2002–2006), and Simon Barker (2005–2006), who resurveyed the entire insula and produced a completed geo-referenced wire-frame model of the block from scratch, abandoning earlier less-accurate results. All plans and sections of the Casa del Chirurgo presented in this volume involve some aspect of this end product.

Artefact processing and analysis

The study, analysis, illustration, and interpretation of all recovered artefacts was generally undertaken by a team of material specialists, ceramicists, and illustrators working for the most part independently of the field school and who were focused upon their particular material specialities. Between 1997 and 2004, Eric De Sena oversaw work on the pottery from the excavations, especially the Casa delle Vestali, with the aid of Louise Ford (2001–2002, 2005–2006), Jaye Mackenzie-Clarke (2002–2006), Søren Tillisch (2001–2004), Janne Ikäheimo (1999–2004), and Julie Hales (2001–2004) with a view to spot dating and establishing form/fabric typologies. After De Sena left the project and a brief interlude by Myles McCallum (2004), John Dore (2004–2006) was invited to co-ordinate the pottery work in 2004, when emphasis shifted to attempting to complete the job of analysis, at least initially in the Casa del Chirurgo. In this he was joined by Gary Forster (2005–2006) and David Griffiths (2005–2006). Following John Dore's untimely death in 2008, his team of Gary Foster, David Griffiths, and Jaye Mackenzie-Clarke continue to work on this through to the present day. Post-excavation

work on the pottery assemblage from the Casa del Chirurgo is now largely complete but has not yet been prepared for publication. Metals were first examined by Diana Blumberg (1995–2002; 2004–2005), before passing into the care of Hilary Cool who, in addition to providing expertise in glass, took on the responsibility for publishing all small finds (2001–present). Marble was examined by Will Clarke (2002–2006), and the study of coins was undertaken by Richard Hobbs (2002–present), while cleaning and conservation of these coins was carried out for two seasons (2005–2006) by Sas Hemmi. Plaster from the Casa del Chirurgo was studied by Helen White (2004) and Rick Jones. A team of illustrators, from 2002 headed by Jaye Mackenzie-Clarke (1999–2006), Mike Burns (2001–2006), and Jim Farrant (2005–2006), carried out illustration of pottery and key small finds, while photography was undertaken by Jennifer Stephens (2002–2006).

The primary sorting, inventory, cleaning, archiving, production of the database, and the organisation of the store of artefacts was undertaken under the leadership of several artefact supervisors, beginning first with Nick Harper (1996–1997) and Abigail Tebbs (1996–1997), followed by Diana Blumberg (1998–2002; 2004–2005) (who also operated as a metals specialist), Aisling Mulcahy (2003) and Norena Shopland (2005–2006), with the help of Ruth Young (1996), Cathy Douzil (1998), Erika Petersen (1998), Lindsey Smith (2005–6), Craig Walsh (2005–6), and Carolyn Swann (2006). Leadership finally passed to Hilary Cool (2006–present), who had joined as a specialist on glass and small finds in 2001, and David Griffiths (2006–present). Once a given deposit was closed in excavation, the actual work of sorting through finds trays, identifying errors in identification that had occurred at trench-side, preliminary cleaning, and creation of the primary inventory on record sheets, was undertaken by students currently on their half-week long rotation from excavation. These artefacts were eventually examined by specialists, forming the basis of their own reports and catalogues.

Ecofact analysis

Ecofact recovery, sorting, inventory, and archiving was similarly undertaken under the supervision of several environmental supervisors, who also provided the specialist expertise necessary for training the students who carried out many aspects of the work. Marina Ciaraldi (1996–1998; 2001–2004), Jill Thompson (1995–present) and Jane Richardson (1995–present), were the initial instigators responsible for environmental recovery at the AAPP, together with Andrew "Bone"

Jones (2000–2002; 2004–2006), assisted by Jessica Davies (1996, 1998) and Cherida Plumb (1997). When Ciaraldi was unable to return to the project regularly after 1998, and because many of the other specialists could not spare time to be present for the entire five week field season, the supervision of environmental recovery passed to additional supervisors, including Tom Tolley (1999–2001), Chris Weatherby (2002), and Hazel Woodhams (2003–2004), before becoming the responsibility of Charlene Murphy (2005–present), who saw the completion of the field campaign and continued to work upon this material in subsequent years, including a post-excavation season in 2007. Robyn Veal (2002–present) played an instrumental role in assisting in recovery and teaching for the full season, in addition to her specialisation in the study of carbonised wood. Emma Harvey (2001–2002) also provided expertise in archaeological soils.

The organisation and structure of the field school

The meeting in early 1994 with Wallace-Hadrill had confirmed to Jones that his proposed funding model for the project in Insula VI 1 – a field school – was undoubtedly the best way to fund a long-term excavation. The levels of academic funding available in the United Kingdom for the support of archaeological fieldwork were such that it would be difficult to envisage a situation where two relatively similar, and simultaneous, projects in Pompeii could both be adequately supported by UK funding agencies. In his former project at Newstead, Jones had piloted the idea of using an archaeological field school as a method of funding an excavation with some success, and had concluded that at an archaeologically-glamorous site such as Pompeii, student recruitment would not be an issue and that their fees could cover the cost of the fieldwork portion of the project. The fees were set at a rate whereby the money generated paid for the transport, accommodation, and meals of the staff members, including the area supervisors, who were mainly graduate students from the UK, North America, and Australia, finds specialists and directors, with a small surplus that paid for equipment and its transportation. In the later years of the project, the increasing size of the field school resulted in a larger surplus that initially funded Gary Devore's PhD at the University of Bradford,[33] and later allowed John Dore to be employed on short term contracts to lead the ceramic team, and Astrid Schoonhoven to work as Jones' Research Assistant in Bradford.

From its inception, Jones realised that the task of organising and running a field school, as well as recruiting students, would entail a substantial administrative load. Consequently, Bernice Kurchin (1995–1996) was added to the senior management group as Field School Director. Kurchin had previously worked on the Newstead project with Jones and was interested in developing the field school into a class at Hunter College, CUNY (City University of New York), where she worked as a member of the adjunct faculty. This had the added advantage that students enrolled on the field school course could take transfer credit back to their home university, and that it that could count towards their final degree. This collaborative partnership between Hunter College, CUNY and the University of Bradford resulted in the Insula VI 1 project coming to be known as the Anglo-American Project in Pompeii (AAPP). This link, however, was short-lived, as Kurchin left the project at the end of the 1996 field season. From this point onwards, the field school was run entirely through the University of Bradford, who also provided the academic credit. The name Anglo-American Project in Pompeii continued to be used as it more accurately described the organisational base of the project and the home of the majority of its students. Jarrett Lobell (1997–2001) succeeded Kurchin and remained in post until the end of the 2001 season, with Gary Devore (2002–2004), and then finally Michael Anderson (2005–2006), serving as head of Field School, both whom were assisted in this role as Field School Tutor by Barry Hobson (2002–2006), Assunta Trapanese (2005–2006), and Arthur Stephens (2002–2006). On site publicity was handled by Lisa Mignone from 2001–2002, and in 2005 Shellie McKinley undertook anthropological research on the Project itself.

As initially conceived, the five week long field school was divided into four units of experience: excavation and architecture, environmental analysis, artefact studies, and survey. The aim of the field school was to provide a basic level of competence in a number of archaeological field techniques (cf. Chapter 2 Appendix 1). The students were assigned to one core excavation team, but were moved out for periods of time to participate in the other three modules. By the time the excavations in the Casa del Chirurgo were undertaken, the survey module had been removed from the teaching component of the field school. Students were assessed weekly through the direct observation of their supervisor and the written description of this work in the student's individual field school journal. They were marked on the attainment of skills and the understanding of the principles behind the application

of these skills, as well as on the more intangible, and yet vital ingredient of attitude. The student assessment and its grading criteria were based upon those used in all of University of Bradford Department of Archaeological Sciences field courses. The structure of the field school, the organisation of the units of experience and grading criteria were all documented in the Field School Handbook, originally designed and written by Jones and Robinson during the winter of 1994/5, prior to the first field school season, and then continuously updated throughout the remainder of the life of the field school project.

Excavation and architecture: methodology and recording systems

From the start of the project, the built and buried archaeological remains were analysed and recorded stratigraphically using a paper-based, pro-forma documentation system, drawings (plans and sections), and photographs. The excavation records were developed during the winter of 1994 from those used in Jones' previous excavations in the Newstead Project. At this time, set of pro-forma sheets were also devised by Robinson for the stratigraphic recording of individual walls. The 'Archaeological Area' (AA) was the basic spatial unit of analysis and recording, with all excavation numbers cascading down from that unit (cf. Table 2.1 and Fig. 2.2). Commonly an AA was an individual room, or part thereof, but occasionally, especially during the last couple of seasons, an AA could also include other nearby spaces.

While at first architectural elements were treated independently and had a separate recording system, as mentioned above, by 2001, the AAPP had moved on conceptually from analysing and recording walls separately from excavation, to attempting to incorporate them into a single developmental narrative for each archaeological area. From this point onward, it was natural that architecture and excavation records should be combined, as walls or doorway thresholds, for example, could be present in both architectural and stratigraphic recording systems. In order to emphasise the singularity of the recording, and to reduce the potential for confusion now that the two systems were integrated, only one sequence of numbers was used for recording both archaeological and architectural features. Since study of the Casa del Chirurgo began in 2002, it was analysed entirely within this later systemic framework.

The basic unit of recording was the Stratigraphic Unit (abbreviated SU), ideologically an action preserved in the archaeological record that might include a deposit, a cut, or a construction event. Within the archaeological sequence, a SU number was assigned to individual cuts, fills, and layers. Within the architectural sequence, they were assigned to each separable feature or detail. Applying the strictest view of Harris' principles[34] to deposits that could not be investigated via excavation meant that on the whole, the decision was made to separate all stratigraphic units that did not share a physical relationship. This practice sometimes led to whole rows of features being separated into component parts, each of which was assigned a SU number.

The pro-forma for the SU was designed to standardise the record and encourage and facilitate the complete recording of each deposit (Chapter 2 Appendix 2), an activity that was normally carried out by area supervisors, but often also by field school students. These sheets were redesigned and redeveloped several times during the history of the AAPP in an effort to update and make them more appropriate to their purpose, which as a consequence, produced two major variants of stratigraphic unit sheets. The first was in use between 1995 and 2002, with the second variation appearing in 2003. This latter form was used, with some mild alterations, until the end of the excavation phase of the Project. From the beginning there was an effort during the field season to produce a digital version of this record. Sheets recorded in the field were entered at first into MS Excel spreadsheets, which also comprised a component of the final record of each area supervisor. From 2002, this data entry task was the responsibility of advanced students who would spend part of their field time entering Stratigraphic Unit sheets into a purpose designed MS Access database. Because the data entry was often undertaken prior to the finalisation of the sheets however, the final digital record is sometimes at odds with the paper database and frequently is less complete. Furthermore, since each version of the Stratigraphic Unit (SU) sheet had different fields and sometimes different possible values for those fields, it has proven difficult integrate these data smoothly into a single relational database,[35] and some problems of inter-compatibility across the three phases of data collection remain.

Beyond the Stratigraphic Unit sheet, recording of excavation and architecture involved the completion of a daily journal or supervisor notebook that was used by the supervisor for a variety of purposes, but mainly included daily observations about developing archaeological interpretations within the AA. The notebook was also commonly used to keep running list of drawings, photographs, stratigraphic units, and

Table 2.1 Complete list of AAs in Insula VI 1 with supervisor and year of excavation.

AA Number	Excavator	Area	Room	Year
1	Michelle Borowitz	Soap Factory	Room 4 - tanks	1995
2	Michelle Borowitz	Soap Factory	Room 4 - south	1995
3	Simon Clarke	Vestals	Room 11/ 4	1995
4	Simon Clarke	Vestals	Room 11/ 6	1995
5	Simon Clarke	Vestals	Room 6/ 5	1995
6	Briece Edwards	Vestals	Room 14	1995
7	Briece Edwards	Vestals	Room 15	1995
8	Briece Edwards	Vestals	Room 20	1995
9	Michelle Borowitz	Soap Factory	Room 1	1995
10	Briece Edwards	Vestals	Room 53/ 15	1995
11	Briece Edwards	Vestals	Room 15	1995
12	Simon Clarke	Vestals	Room 12	1995
13	Michelle Borowitz	Soap Factory	Room 4	1995
14	Michelle Borowitz	Soap Factory	Room 4	1995
15	Briece Edwards	Vestals	Room 20	1995
16	Briece Edwards	Vestals	Room 20	1995
17	Briece Edwards	Vestals	Room 20	1995
18	Michelle Borowitz	Soap Factory	Room 1	1995
19	Michelle Borowitz	Soap Factory	Room 1	1995
20	Michelle Borowitz	Soap Factory	Vicolo di Narciso	1995
21	Briece Edwards	Vestals	Room 15	1995
22	Briece Edwards	Vestals	Room 15	1995
23	Briece Edwards	Vestals	Room 20	1995
24	Briece Edwards	Vestals	Room 23	1995
25	Michelle Borowitz	Vicolo di Narciso	–	1995
26	Michelle Borowitz	Vicolo di Narciso	–	1995
27 (11B)	Briece Edwards	Vestals	Room 15	1995
30	Gary Devore	Vestals	Room 53	1996
31	Natalie Messika	Vestals	Room 5	1996
32	Amy Zoll	Vestals	Room 12	1996
33	Hugo Benavides	Vestals	Room 21	1996
34	Briece Edwards	Vestals	Room 14	1996
35	Amy Zoll	Vestals	Room 8	1996
36	Robert McNaught	Vestals	Room 2	1996
37	Natalie Messika	Vestals	Room 5	1996
38	Robert McNaught	Vestals	Room 6	1996
39	Gary Devore	Vestals	Room 5a	1996
40	Briece Edwards	Vestals	Room 14	1996
41	Briece Edwards	Vestals	Room 14	1996
42	Hugo Benavides	Vestals	Room 24	1996
43	Hugo Benavides	Vestals	Room 22	1996
44	Karen Johnson	Vestals Fountain North	Room 14	1996
45	Briece Edwards	Vestals	Room 26	1997

AA Number	Excavator	Area	Room	Year
46	Amy Zoll	Vestals	Room 31	1997
48	Karen Johnson	Vestals	Room 38	1997
49	Gary Devore	Vestals	Room 27	1997
50	Hugo Benavides	Vestals	Room 19	1997
51	Amy Zoll	Vestals	Room 29	1997
52	Briece Edwards	Vestals	Room 16	1997
53	Briece Edwards	Vestals	Room 20	1997
54	Amy Zoll	Vestals	Room 39	1997
65	Gary Devore	Vestals	Room 27	1998
66	Barry Hobson	Vicolo di Narciso	outside Door No. 25	1998
67	Michael Anderson/Megan Dennis	Vestals	Room 20	1998
68	Stuart Herkes	Vestals	Room 9	1998
69	Stuart Herkes	Vestals	Room 54/ 10	1998
70	Abigail Tebbs	Vestals	Room 39	1998
71	Briece Edwards	Vestals Bar	Room 4/ 2	1998
72	Briece Edwards	Vestals Bar	Room 3	1998
73	Briece Edwards	Vestals Bar	Room 1	1998
74	Michael Anderson	Vestals	Room 19	1998
75	Abigail Tebbs	Vestals	Room 33	1998
76	Abigail Tebbs	Vestals	Room 32	1998
77	Abigail Tebbs	Vestals	Room 34	1998
78	Robert McNaught	City Wall	top of defences	1998
79	Robert McNaught	City Wall	top of defences	1998
80	Toby Kendal	Vestals	Room 37	1998
81	Megan Dennis	Vestals	Room 27 and Room 20	1998
82	Megan Dennis	Vestals	Room 35	1999
83	Megan Dennis	Vestals	Room 36	1999
84	Michael Anderson	Vestals	Room 54/ 10	1999
85	Michael Anderson	Vestals	Room 9	1999
86	Michael Anderson	Vestals	Room 8	1999
87	Steven Ellis	Vestals Bar	Room 4	1999
88	Steven Ellis	Vestals Bar	Room 6	1999
89	Barry Hobson	Vicolo di Narciso	Outside of door 24	1999
90	Barry Hobson	Vicolo di Narciso	Vestals/ Surgeon plot division area	1999
91	Steven Ellis	Vestals Bar	Room 4/ 2	1999
92	Gary Devore	Vestals	Room 39	1999
93	Gary Devore	Vestals	Room 43	1999
94	Gary Devore	Vestals	Room 40	1999
95	Gary Devore	Vestals	Room 41	1999
96	Gary Devore	Vestals	Room 42	1999
97	Gary Devore	Vestals	Room 39	1999
98	Gary Devore	Vestals	Room 49	1999
99	Gary Devore	Vestals	Room 52	1999
100	Gary Devore	Vestals	Room 39	1999
101	Michael Anderson	Vestals	Room 7	1999

AA Number	Excavator	Area	Room	Year
102	Barry Hobson	Vicolo di Narciso	VI 2 pavement	1999
103	Toby Kendal	Via Consolare	in front of Vestals -north trench	1999
104	Toby Kendal	Via Consolare	in front of Vestals -south trench	1999
105	Gary Devore	Vestals	Room 46	1999
106	Gary Devore	Vestals	Room 39	1999
107	Gary Devore	Vestals	Room 47	1999
108	Michael Anderson	Vestals	Room 7	1999
109	Michael Anderson	Vestals	Room 28	1999
110	Barry Hobson	Vicolo di Narciso	northern end	1999
111	Gary Devore	Vestals	Room 39	1999
112	Gary Devore	Vestals	Room 48	1999
113	Gary Devore	Vestals	Room 44	1999
120	Gary Devore	Inn	Room 4	2000
121	Barry Hobson	Inn	Room 6	2000
122	Michael Anderson	Vestals	Room 10	2000
123	Megan Dennis	Inn	Room 1	2000
124	Megan Dennis	Via Consolare	in front of the Inn	2000
125	Amy Walters	Vestals Bar	Room 4	2000
126	Steven Ellis	Inn Bar	Room 6b	2000
127	Steven Ellis	Inn Bar	Room 1b	2000
128	Michael Anderson	Vestals	Room 7	2000
129	Jason Urbanus	Vestals	Room 44	2000
130	Jason Urbanus	Vestals	Room 42	2000
131	Barry Hobson	Inn	Room 9	2000
132	Barry Hobson	Inn	Room 9	2000
133	Jason Urbanus	Vicolo di Narciso	northern end of the Vicolo	2000
140	Pat Daniel	Soap Factory	Room 12	2001
141	Jason Urbanus	Bar of Acisculus	Room 3	2001
142	Jason Urbanus	Bar of Acisculus	Room 2	2001
143	Sam Wood	Well/ fountain	south of the well	2001
144	Sam Wood	Well/ fountain	north of the well	2001
145	Jason Urbanus	Bar of Acisculus	Room 1	2001
160	Megan Dennis	Inn	Room 1	2001
161	Megan Dennis	Inn	Room 3	2001
162	Amy Walters	Inn	Room 7	2001
163	Amy Walters	Inn	Room 8	2001
164	Amy Walters	Inn	Room 10	2001
165	Steven Ellis	Inn Bar	Room 1b and 3b	2001
166	Steven Ellis	Inn Bar	Room 5b	2001
167	Steven Ellis	Via Consolare	in front of Room 6b	2001
168	Barry Hobson	Triclinium	Rooms 1,2,3,4	2001
169	Nick Ray	Inn	Room 12	2001
170	Amy Walters	Inn	Room 9	2001
180	Nick Ray	Inn	Room 3	2002
181	Amy Walters	Inn	Room 9	2002

AA Number	Excavator	Area	Room	Year
182	Michael Anderson	Inn	Room 12	2002
183	Steven Ellis	Surgeon	Room 6a	2002
184	Steven Ellis	Surgeon	Room 6c	2002
185	Barry Hobson	Triclinium	ramp inside the House of the Triclinium	2002
186	Nick Ray	Inn	Room 3	2002
187	Amy Walters	Inn	Room 9	2002
200	Megan Dennis	Surgeon	Room 7	2002
201	Katerina Garajova	Surgeon	Room 5	2002
202	Katerina Garajova	Surgeon	Room 5	2002
203	Pat Daniel	Shrine	Room 1	2002
204	Diane Fortenberry	Shrine	Room 2	2002
205	Sam Wood	Vicolo di Narciso	-	2002
206	Sam Wood	Vicolo di Narciso	-	2002
207	Sam Wood	Vicolo di Narciso	-	2002
208	Diane Fortenberry	Shrine	Room 2	2002
209	Katerina Garajova	Surgeon	Room 5	2002
211	Katerina Garajova	Surgeon	Room 5	2002
212	Sam Wood	Vicolo di Narciso	-	2002
213	Katerina Garajova	Surgeon	Room 5	2002
221	Claire Weiss	Triclinium	Rooms 2 and 4	2003
222	Michael Anderson	Inn	Room 9	2003
223	Michael Anderson	Inn	Room 9	2003
224	Barry Hobson	Vestals	Room 10	2003
225	Claire Weiss	Inn Bar	Room 4b	2003
226	Claire Weiss	Via Consolare	-	2003
260	Katerina Garajova	Surgeon	Room 5	2003
261	Darren Bailey	Surgeon	Room 10	2003
262	Karen Derham	Surgeon	Room 23	2003
263	Karen Derham	Surgeon	Room 22	2003
264	Karen Derham	Surgeon	Room 15	2003
265	Phil Murgatroyd	Surgeon	Room 11	2003
270	Lisa Guerre	Triclinium	Ramp	2004
271	Michael Anderson	Inn	Room 9	2004
272	Lisa Guerre	Triclinium	Room 4	2004
273	Lisa Guerre	Triclinium	Ramp	2004
274	Lisa Guerre	Triclinium	Well and Stairs	2004
275	Katerina Garajova	Surgeon	Room 5	2004
276	Darren Bailey	Surgeon	Room 23	2004
277	Claire Weiss	Surgeon South Shop	Rooms 3 and 4	2004
310	Pat Daniel	Shrine	Room 1	2003
311	Pavel Titz	Soap Factory	Room 4	2003
312	Diane Fortenberry	Shrine	Room 2	2003
313	Diane Fortenberry	Shrine	Room 3	2003
314	Diane Fortenberry	Shrine	Room 4	2003

AA Number	Excavator	Area	Room	Year
315	Diane Fortenberry	Shrine	Room 2	2003
316	Pavel Titz	Vicolo di Narciso	-	2003
317	Barry Hobson	Bar of Phoebus	Room 2	2003
318	Barry Hobson	Surgeon South Shop	Room 4	2003
320	Pat Daniel	Shrine	Room 1	2004
321	Pavel Titz/Jennifer Wehby	Soap Factory	Room 4	2004
322	Pavel Titz/Jennifer Wehby	Soap Factory	Room 2	2004
323	Tim Webb	Bar of Acisculus	Room 1	2004
324	Tim Webb	Bar of Phoebus	Room 1	2004
401	Barry Hobson	Bar of Phoebus	Room 3	2004
402	Barry Hobson	Vicolo di Narciso	-	2004
500	Tim Webb	Bar of Phoebus	Room 1	2005
501	Tim Webb	Bar of Phoebus	Room 1	2005
502	Tim Webb	Bar of Acisculus	Room 1	2005
503	Jennifer Wehby	Soap Factory	Room 2	2005
504	Jennifer Wehby	Soap Factory	Room 5	2005
505	Katerina Garajova	Surgeon	Room 5	2005
507	Phil Murgatroyd	Surgeon	Room 2	2005
508	Keffie Feldman	Surgeon	Rooms 16 and 20	2005
509	Hannah Gajos	Herculaneum Gate	in front of the House of the Triclinium	2005
510	Claire Weiss	Shrine Front	Room 1	2005
511	Kelly Krause	Vestals	Room 15	2005
512	Els Coppens	Vicolo di Narciso	Back of Surgeon	2005
513	Hannah Gajos	Inn Frontage	in front of Inn	2005
515	Claire Weiss	Shrine Back	Room 3	2005
600	Jennifer Wehby	Soap Factory	Room 2	2006
601	Jennifer Wehby	Soap Factory	Rooms 3 and 5	2006
602	Els Coppens	Bar of Phoebus	Room 4	2006
603	Els Coppens	Bar of Phoebus	Room 3	2006
604	Tim Webb	Shrine Back	Room 3	2006
605	Tim Webb/Courtney Ward	City Wall	Back Wall	2006
606	Els Coppens	Surgeon South Shop	Room 3	2006
607	Phil Murgatroyd/Els Coppens	Surgeon	Room 2	2006
608	Katerina Garajova	Surgeon	Room 5	2006
609	Katerina Garajova	Surgeon	Room 6C	2006
610	Katerina Garajova/Dan Jackson	Surgeon	Room 12	2006
612	Keffie Feldman	Surgeon	Rooms 17 and 18	2006
613	Keffie Feldman	Surgeon	Room 13	2006
614	Keffie Feldman	Surgeon	Room 11	2006
615	Claire Weiss	VI 2, g	-	2006
616	Claire Weiss	VI 2, g	-	2006
617	Hannah Gajos	Inn Frontage	in front of Inn	2006
618	Hannah Gajos	Herculaneum Gate	in front of Herculaneum Gate	2006

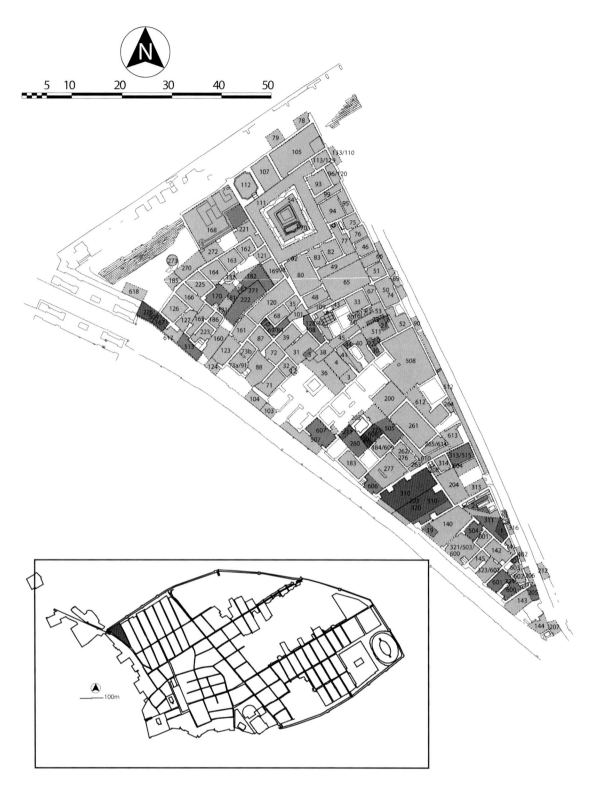

Figure 2.2. Archaeological areas excavated within Insula VI 1.

sometimes to maintain a running Harris Matrix of the excavated remains (though this was inconsistent). Initially, photographs were taken of each soil SU, employing 35mm colour slide and 35mm black and white prints. From 2002 onwards, the black and white film was replaced with film for colour prints, which were developed during the field season for the use of excavators in writing their final reports. An individual photographic record sheet per film accompanied each camera, since the limited number of cameras meant

that they were shared between area supervisors. Consequently, a running list of photographs per AA was sometimes kept in the supervisor's notebook. A placard in each photograph served to identify north and the deposit in question, though frequently the need for cameras pressured the process and photographs carrying the description 'multi-context', or a long list of SUs, were common. Also, the conditions of lighting within the block, which due to the height of preservation of Pompeian walls were rarely in either complete shade or sun, made photography relatively challenging, especially for the non-specialist excavators often responsible for this work. Depending upon their particular level of photographic expertise, some supervisors attempted to bracket their shots by one F-stop in order to help with these conditions, but some did not, and these inconsistencies could also cause difficulties. Frequently, the area would be shaded with a tarpaulin in order to remove high contrasts. Occasionally this led to discolouration or washing out of the resulting image. Overall however, the level of photographic recording, especially in the pre-digital camera age, is considerable. There were 3686 unique photos (i.e. not including duplication caused by taking each shot with slides and print film) produced for the excavations in the Casa del Chirurgo alone.

Where possible, a single-context plan of every SU was completed at 1:20 on permatrace (mylar) drawing film. During the later weeks of the excavation, however, multi-context planning was a more commonly practiced and, as a result, some SUs went unrecorded. In one exceptional case in the Casa del Chirurgo, some drawings were lost during the course of excavation and have had to be estimated in the resulting combined digital plan published here. In all such cases, in this volume, SUs that have suffered from these problems have been incorporated into the drawing record using the sketch plans present in the supervisor notebook or on SU sheets and are noted with a special pattern of dots and dashes in the plan (Fig. 2.3). Sections, particularly towards the end of excavation, or within pits and cuts when executed, were completed at a scale of 1:10. An AA-based pro-forma drawing record sheet was used to register the drawings. As the project progressed, it became normal for area supervisors to provide a close-out report describing the uncovered sequence, and a Harris Matrix, to contribute to the final process of publication. By the time of the excavations in the Casa del Chirurgo, this process was universal, though the quality and usefulness of these final reports, particularly of the Harris Matrices produced, was often highly variable.

edge of trench	
edge of context	
context detail	
edge of context later cut	
cut away detail	
approximate lines	
extent under unexcavated feature	

Figure 2.3 Planning conventions employed in this text (illustration M. A. Anderson).

Originally, the architectural analysis of the insula followed a separate system of recording. However, in 2001, new record sheets were developed so to incorporate them into the wider gambit of excavation. From this point, the architectural record consisted of a Wall Summary sheet (Chapter 2 Appendix 3), which was designed to help organise the information on a specific wall into a concise document to assist in interpretation. Each construction and destruction event visible in the wall was recorded by means of a Stratigraphic Unit sheet designed specifically for walls (Chapter 2 Appendix 4). The surface of each wall's major faces was photographed, using the same print and slide film cameras that were used for recording excavation. Details were entered on the photographic record sheet and also in the running photograph list in the supervisor's notebook. In addition, a multi-context drawing of each wall was completed at a scale of 1:20 by taking offset measurements at right angles from a horizontal line stretched across the wall surface.

Artefact analysis: methodology and recording systems

Artefacts were coarsely sorted at trench side and bagged by material categories within individual finds trays. The taphonomic processes at Pompeii meant that generally these categories fell into a predictable set of materials (cf. Table 2.2). Checking and resorting, initial accessioning, some cleaning and occasional recording and discarding of this material was undertaken by the field school students under the supervision of the artefacts supervisor. Pro-forma sheets for the accessioning of materials by AA were filled out, ultimately to be digitised in an MS Excel spreadsheet. The processing of pottery was a three-stage process. It

Table 2.2 Material types generally recovered during excavation in Insula VI 1 and their database codes.

Code	Artefact Type
?	Unknown
AG	Silver
AU	Gold
BT	Brick/Tile
CBM	Ceramic Building Material
CN	Coin
CP	Cocciopesto/Opus Signinum
CR	Other Ceramics
CU	Copper
DP	Decorated Plaster
EC	Ecofact
FE	Iron
GL	Glass
IW	Industrial Waste
MC	Mortar and Cocciopesto
MD	Modern
MR	Mortar
MS	Misc
PB	Lead
PL	Plaster
PT	Pottery/Ceramics
SP	Solid Colour Plaster
ST	Stucco
TS	Tesserae
UP	Unfinished Plaster
VOID	Voided Entry
WB	Worked Bone
WS	Worked Stone

was initially washed and bagged by the students. Then it was sorted into broad fabric and ware groups by a pot sorting team that could include students of the field school. The end product of this stage was a broad quantification by weight and the separation out of the diagnostic material for analysis by the specialist team. When possible, coins were conserved and cleaned prior to study. Most other material, including brick and tile, plaster, and flooring, was often brushed and examined for makers' marks or other interesting details prior to accessioning.

Finds that either did not fit into these course categories, or which required special preservation or attention, were given special finds numbers and processed somewhat differently. This sometimes led to inconsistencies in the record or abnormalities in the process. The occasional change of guard in supervision of this system also tended to generate mild shifts in practice, such that the numbering systems applied upon acquisition have generally become fraught and inconsistent. Specialists dedicated to the study of particular material types, each maintained their own databases with their own internal system of organisation, such that the one consistent key field uniting all of these data has become a six digit number (###.###), consisting of the archaeological area (AA) and the stratigraphic unit (SU) combined, with leading zeros. This format is employed in this volume in order to identify each deposit uniquely.

The policy of retention of finds, which at first included all finds including coarse building materials, was revised during the course of the project as the storeroom quickly became overfilled. Eventually most building materials were quantified at trench side, including monochrome plaster, undecorated plaster, mortar, *opus signinum* or other flooring, and ceramic building materials (brick and tile). Illustration of key artefacts, study of particular classes of finds and photography of important artefacts was undertaken after primary processing by specialists in these activities. In practice, this work normally lagged behind the current excavation by a year or more, as the sheer volume of materials produced by near 100% recovery practices meant that simply keeping pace with the rate of finds was a significant challenge. The processing of ceramics, both for the ultimate publication of the finds and dating of the site, also lagged behind excavation, and for some years the provision of spot dates for deposits to assist excavators in their interpretation was impossible. Even when providing spot dates was feasible, it presented a significant impediment to the normal processing, analysis, and recording of such material.

Environmental recovery and analysis: methodology and recording systems

As befitted a field school being run by the Department of Archaeological Sciences at Bradford University, a full programme of environmental sampling was implemented in the project. Near-total retrieval of environmental remains for the entire insula was employed. A strategy of sampling 20 litres of soil from every context was agreed in the early pilot year of excavation (1994) for the entirety of Insula VI 1. Machine flotation was chosen as the primary environmental recovery technique as large quantities

of matrix can be processed fairly easily, and one of the excavation goals was to provide training for field school students. All stratified deposits were dry-screened through 5 mm mesh, in addition to the flotation of at least one 20 litre soil sample per context (the soil volume of the individual context permitting) using a modified Ankara-style flotation tank.[36] A two-horsepower pump was used to force water through the underlying perforated metal pipes inside the tank, assisting the agitation of the matrix. This was augmented by manual disaggregation. A 0.5 mm mesh bag attached to the overflow spout captured the light fraction (LF). Due to water shortages in southern Italy during the summer months, a program piloted by Veal was established using a series of settling tanks to recycle water. The water in the processing tank was changed completely after two to three samples were floated, however, some small-scale contamination resulting from this practice between samples cannot be discounted entirely. In particular, fish bones and the carbonised and mineralised plant remains were recovered through this process. All excavation students spent just two to three days on average, learning flotation, documentation, and heavy fraction sorting.

Heavy fraction (HF) residues collected over a 1 mm mesh inside the flotation machine were also separately dried. Normally, roughly 25% of the HF was sorted in the field using geological sieves of 2 mm and 1 mm, although occasional samples of interest were 50–100% sorted, and only 10% of low yielding samples (i.e. those predominantly consisting of building rubble) were sorted. Field school students assisted in this step. In a laboratory at the Institute of Archaeology, University College London, weights and volumes of all LF samples were recorded before screening through 2 mm and 1 mm sieves for ease of sorting. Using a low-powered binocular microscope, 4.8[x] to 56[x] magnification, all biological material was sorted, measured, counted, and entered into an MS Excel database by Murphy. Excavation priorities were set in such a way that a large backlog of un-floated samples accumulated in the latter years of excavation, however, these were all processed in a final year devoted to post-excavation in 2007.

A blanket sampling strategy was employed, where all contexts from early phases, up to and including the Roman horizon, were sampled. Hence, this dataset may provide raw material for research for some time to come. Using a standard sample size throughout the research project reduced potential sampling bias.[37] This contrasts with much of the early environmental research at Pompeii that has largely concentrated on first century AD deposits, e.g. gardens, vineyards, and open spaces, sealed by the falling ash and lapilli of the eruption,[38] and in which sampling has been largely small-scale and from discrete areas of the city.[39] The task to float, sort, and curate this large amount of material, however, was Herculean, and in hindsight, it is debatable whether such a comprehensive collection strategy was the optimal choice.

Early work in other parts of the insula (primarily the Casa delle Vestali), revealed only a few charred seeds per litre in the initial analysis by Ciaraldi.[40] Fish bones were similarly sparse, while charcoal and animal bones were ubiquitous. For the charcoal, however, the floated remains were very fragmented and only the dry-sieved remains were examined, and even these were sub-sampled for identification from the material available. The majority of contexts consisted of secondary fill deposits, which Ciaraldi regarded as too disturbed to yield meaningful archaeobotanical information.

Post-excavation

When the field school and excavations finished at the end of 2006, there was a vast body of data that had been accumulated over more than a decade. Though post-excavation work had been ongoing throughout the project in tandem with the excavation, a great deal of the recovered material still remained to be examined, analysed, and interpreted at the end of the digging. Furthermore, even among the ostensibly 'completed' work there existed a mountain of not just excavation and architectural records, artefact and ecofact records and analysis, but also of specialist studies of particular categories of find and partial work-in-progress syntheses, much of which was not yet at the appropriate stage of organisation or completeness to proceed into immediate publication.

This section outlines the approach that has been taken to the post-excavation work. At the outset it is appropriate to say that progress has only been possible because many people have generously donated their time and expertise *pro bono*. The field school model of funding the excavations meant that with the end of the field school there was very little money available to fund post-excavation. The remaining excess from previous years supported some specialist work on site up until 2008. We are extremely grateful to the organisations thanked in the acknowledgments for the grants they have given us, which have allowed some of the costs of continuing specialist work on site to be defrayed. Some individuals were fortunate enough to work in institutions that allowed some work on the VI 1

records to be carried out as part of their normal duties, but for them and the rest of the team progress has only been made through the donation of large quantities of 'spare' time. This has naturally slowed down progress and ultimately delayed this publication.

The quality of the resulting record

Any post-excavation project needs to evaluate the quality of the stratigraphic records with which it is dealing. Even in the best-conducted, fully professional project, some errors and omissions will undoubtedly be uncovered. An excavation conducted as a field school over more than a decade with changing staff will inevitably pose many problems. As a primary mission of the field-school was first-hand education, work had been undertaken by students of classics, classical archaeology, archaeological sciences, history, anthropology, and related disciplines, mainly in the undergraduate phase of their academic careers and often with no or limited previous archaeological experience. These students were taught the basics of archaeological excavation and architectural sequence analysis by members of project staff, who themselves sometimes had comparatively little field experience, and many of whom had risen from the ranks of the students of previous years. In order to attempt to mitigate for the shortcomings of using a largely inexperienced workforce, the AAPP followed numerous practices that were intended to help to standardise and maintain the quality of the data produced, including the consistent systematic screening of all archaeologically significant soils through 5 mm sieves, the total recovery of finds, the regular environmental sampling of all archaeological deposits, and the use of pro-forma record sheets for the recording of built and buried context information. After the role of Field Directors had been created, these helped to lead the stratigraphic interpretation and also checked the site records in an attempt to ensure their completeness and consistency. Nevertheless, while many of these students and supervisors were extremely skilled and managed to produce outstanding, detailed, and well-documented excavation and archaeological study, others were less diligent in this task, and the end product of their work often required considerable and time-consuming reanalysis. Compiling a database of these records immediately reveals that the form, quantity, and quality of the data recovered varied considerably from year to year, and from trench to trench.

The number of years over which the Project was undertaken also tended to add to the complexity of the excavation data. The ideal situation was that an excavation in a particular area would be finished the same year it was begun. Often however, areas needed to be revisited in a subsequent field season, which often resulted in a different supervisor and occasionally a different Field Director overseeing the second phase of excavation. Normally excavation in the subsequent year was treated as *ex novo*, and little attempt at the time was made to link the two periods of excavation. In these cases a new AA number was issued with its own sequence of SU numbers, normally starting with 1, but in the final years sometimes starting at the next round number after the highest SU number reached in the previous excavation in that area. Though this practice was intended to maintain consistency in the record, this actually resulted in added complexity in that many archaeological deposits and features have multiple AA and SU numbers assigned to them, as will be apparent in the stratigraphic discussions in Chapter 5. This is particularly acute in locations such as the atrium and *alae* of the Casa del Chirurgo, which was excavated over five field seasons. Furthermore, the lack of consistency of supervisors in specific areas[41] and the practice of 'starting again' also meant that the written report of a supervisor for a particular AA would often be frustratingly independent from previous season's reports of the archaeology of the same area. The end result of these difficulties has been a massive, often inconsistent, and extremely complex record of excavation and architectural study.

In presenting the results of these excavations our aim has been to be as transparent as possible, both acknowledging the problems and explaining our full work process. Those involved in the post-excavation work of publication must acknowledge that they have been engaging in a form of 'rescue archaeology' not dissimilar from other efforts to restore and repair legacy data from earlier, unpublished excavations. Nothing that has been said above is intended to denigrate the students and staff, who gave their time, effort, and money to be part of the AAPP and to learn about field archaeology in such an extraordinary setting and from such a large and skilled group of experts. Without their commitment and enthusiasm, this project would not have happened and we would know far less about the development of this part of Pompeii than we do now. A great deal is owed to the 750 students and 108 staff who worked on site between 1995 and 2006. Furthermore, the scope of the data and the detail of excavation, the level of artefact and ecofact recovery, and the sheer enormity of conducting detailed and stratigraphic excavation across a whole city

block, means that whatever its shortcomings, the end product represents one of the single most important contributions to the study of the early history and development of Pompeii. A project of this enormity may never be repeated, and its results will continue to be valuable for many years to come.

Post-processing

The first stage of the post-excavation project was to establish a unique series of SU numbers for the whole insula. This was done by combining the AA and SU number into a six digit (maximum) decimal number. Thus SU 6 of AA 45 became 045.006; SU 10 of AA160 became 160.010 etc. While six figure context numbers such as these can lead to rather ungainly number strings in the detailed stratigraphic discussions, they do have the advantage that they can be easily manipulated within databases. The need for unique context numbers was also vital for the specialist studies that are insula wide.

The second stage was to create a digital archive. During the course of excavations, there had been previous attempts to create a digital version of the excavation record in the field. These were largely unsuccessful due to the limitations of the technology, particularly the project's inability to use computers to record the data directly on site. The paper record prevailed due to its simplicity, its robust nature in that it worked in the heat and the dust of Pompeii (unlike many of the project's computers), and because it was a relatively inexpensive option. This did, however, create a large post-excavation digitisation problem. The conversion of these to a digital format was initiated by Michael Anderson who simply began to photograph the SU sheets with a digital camera, and the majority of the work was carried out by Hilary Cool and David Griffiths between 2008 and 2010 using scanners. All of the written paper record (SU sheets, notebooks etc) was scanned and converted to PDF format, and the plans and sections scanned as TIFF files for archival purposes. The files were held on a secure website to which the team members, based by that time in three continents, had access. This had the advantage that all of the raw records were available to the whole team, whether they were working on the stratigraphy, the artefacts, or the ecofacts.

The process of preparing these materials for publication has entailed a complete reworking and overhaul of the data that were recovered. Each deposit needed to have its sequence checked against all available data so that a complete Harris Matrix could

be produced. Throughout, dating and stratigraphic inconsistencies have been checked, rechecked, and thoroughly examined. In cases where data were not well-recorded by the excavators or supervisors, every effort was made to work around these problems and to provide as accurate a sequence as possible. This obviously entailed a number of choices, such as which SU sheet record to believe when they were in disagreement and which sketch plan was likely to be the most indicative of the archaeological reality. A particularly difficult problem derived from the occasional tendency of SU sheet relationships of overlying and underlying, or before and after, to record the experience of excavation itself and therefore actually to indicate the reverse of the stratigraphic situation. The final data as presented here aims at being as transparent and useful for future archaeological research in Pompeii as possible. When particular SU sheets or records in the online archive contradict the narrative or Harris Matrices that are presented here, it is because the overall impression of the record dictated that there must have been an error. When a database entry field is missing, this is because it was not present in the materials available or was simply not recorded by the excavators.

Similar problems were also encountered during the writing up phase of the architecture, when it rapidly became apparent that teams of students working on the analysis of individual walls, while adequately identifying and recording the main sequence of construction, decoration, and restoration, would often miss crucial smaller points of detail or would greatly over, or under, record elements like plaster layers. The same layer of plaster can look very different at different places on a wall depending upon the degree of preservation and weathering of the plaster. On the same wall, for example, the same plaster layer can be represented by all stages from a smoothed 'finished' face to a small, highly-weathered patch. In such a case, the white lime component of the plaster is often preferentially weathered away, which tends to leave only the darker inclusions. Differentiating between plasters, therefore, takes a practiced eye and a level of time and experience that was simply beyond a student who would work for at best a day or two on a single wall. Consequently, the writing-up of the architecture took place on site in the Casa del Chirurgo following the end of the field school, where the written and drawn record could be compared against the standing remains, so that a consistent final publication could be achieved. With hindsight, it would be easy to suggest that it would have been far more efficient for Robinson

or Schoonhoven to simply have personally documented the architecture photographically, analysed it, and written it up. This would be, however, to overlook the fact that the overall Project was a field school and that training in architectural analysis was an integral component of its goals, while the examination of many eyes sometimes produced observations that would have been missed by a single researcher working alone.

The artefactual and ecofactual material

The initial processing of the material recovered from the excavations was an integral part of the field school and was carried out by the students. From an early stage, specialists were present on site with a view to eventual publication. Their presence was necessary because all of the material recovered remained on site in the official stores of the Soprintendenza Archeologica di Pompei. The problems over the variable quality of the records that beset the excavation and survey data are not such an issue here, but the sheer volume of material recovered is. This problem is most acute where the pottery is concerned. Given that the students spent much more time excavating than processing the finds, an imbalance was set up from the beginning, so that the project always had a backlog of unwashed pottery. Shortage of resources also meant that the volume of pottery regularly overwhelmed the pot sorting and specialist teams. Initial efforts were directed towards spot dating and establishing form/fabric typologies. From 2004, it was decided to focus work on the Casa del Chirurgo, which was already planned to be the focus of the first major publication. Following the end of the project and the untimely death of John Dore, the work of finishing this monumental task has been carried forward by Gary Forster, David Griffiths, and Jaye Mackenzie-Clarke, under the leadership of Hilary Cool, and the report on the pottery from the Casa del Chirurgo, and several other areas of Insula VI 1, is now well advanced. Jaye MacKenzie Clarke had developed an interest in the red-slipped wares while working on the Casa delle Vestali pottery which lead her on to a PhD on the material.[42] She was able to extract these fabrics from the ongoing pottery sorting, and so her work also covers material from the southern bars, parts of the Shrine, and the Inn and Casa del Triclinio in the north. David Griffiths, who recently completed a PhD on lamps from the southern bars, the Casa del Triclinio and the Inn, also has information about this specialist ware. Other than this it has not been possible to progress specialist work on the pottery from other areas. A planned project directed by David Griffiths and Katherine Huntley to complete the post-excavation of the AAPP materials has unfortunately not continued. The work on the other finds is, however, reaching completion. Richard Hobbs completed the cataloguing of the coins in 2008, and his volume is now published.[43] Hilary Cool oversaw the work on the small finds and vessel glass, and has also now published this material.[44]

For most excavations, spot dating for contexts is normally provided by the ceramic evidence, but it will be appreciated from the forgoing description that work on the pottery is generally not sufficiently advanced for it to provide this. All such pottery information that was available at the time of publication has been integrated into the footnotes of the detailed discussion of excavation in Chapter 5. Attempts were made during the excavations to have spot dating sessions with the pottery as it was excavated, but these were found to occupy too much specialist time at the expense of advancing the basic recording. Instead, much of the spot dating is currently under-pinned by the evidence of the coins, the small finds, and the vessel glass. Coins are always useful for dating, but the latter two categories are not normally expected to play a key role in this process. The special circumstances within the VI 1 excavations and its post-processing has meant that in this volume they have done so. In the north of the insula, numerous lead slingshots were recovered and have been the focus of a study by Mike Burns. They are vivid evidence of the siege of the town in the spring of 89 BC by the Roman forces under Sulla.[45] Their presence in any context naturally provides a secure *terminus post quem* of that date, though admittedly this context tends to be less useful in the Casa del Chirurgo itself, which is too far from the Porta Ercolano to have experienced this horizon. The sieving regime practised on site produced numerous very small fragments of glass, metalwork, and other pieces of material culture. In many cases it was only possible to identify if the glass vessels had been blown or cast, but this has an important dating implication. The technique of glass blowing was discovered in the mid first century BC,[46] but it was not until the Augustan period that blown vessels become widespread. The systematic recovery of blown fragments thus became a useful dating tool to indicate that contexts had to belong to the final century of Pompeii's history.

The extensive and comprehensive methodology applied to the recovery of ecofactual remains had also produced an enormous mountain of data by 2006. Recording and analysis of the mammal bone for the entire insula has been completed by Jane Richardson, and the botanical remains have been

the subject of three doctoral theses. Marina Ciarldi used aspects of the botanical remains from the initial years of the project in her thesis. This was followed by comprehensive investigation by Charlene Murphy of the macrofaunal remains and seeds. Robyn Veal, examined the carbonised wood. The theses of Murphy and Veal studied the material from the insula as a whole. Two of these has recently appeared in revised book form.[47] Analysis of the other materials, such as the fish bone and shell, have lagged in the post-excavation period with only a preliminary report available on the shells from the Casa delle Vestali.[48] The results from these materials unfortunately cannot be presented in this volume.

Availability of the excavation archive

Although tentative plans were made during the course of the project to release the full archive of the excavations in a digital form, these have not materialised, both because of the challenge of digitising and hosting such an extensive amount of material, and because of fears that the undigested data would be of such variable quality as to be of little use to scholarship. The relative fragmentation of the post-excavation team and the *pro-bono* nature of the work has meant that much of the archive also remains relatively dispersed. The physical archive, including drawings, notebooks, and context sheets, remains with Rick Jones, now at the University of Leeds, who will be responsible for its eventual disposition and availability. Much of this record, including copies of specialist analysis and databases, was digitised and collected by Hilary Cool and David Griffiths, while scanning of the majority of the analogue photographic record by Michael Anderson is still underway. While it has not yet been possible to supply the Soprintendenza Archeologica di Pompei with a copy of all digital materials, it is the intent of the authors to ensure that at least a digital copy of this material is deposited at Pompeii for the use of scholarship. It is hoped that some form of this processed and finalised record will be made available more widely online in the future.

Publication plans

Publication always represents a compromise between the ideal of 'the perfect publication' and the realities posed by the nature and volume of the data, any obstacles presented by incomplete records and post-processing, the challenges of funding, and the balance between perfection and the time taken to

achieve it. Ideally we would have wished to present fully integrated volumes where the stratigraphic and survey data was presented alongside the artefactual and ecofactual evidence. As will be appreciated from the description of the progress given above, work on the different strands is at different stages of completion. It has therefore been felt best to publish the different strands as and when they become available. We feel that this will serve the wider academic community better. We hope that the transparent approach we have taken to the stratigraphic records will enable all of the data to be eventually recombined, reused, and reanalysed by future scholarship.

Notes

1 Mellor, 13th of January 1993, A2–A3.
2 *ibid.* A2.
3 *ibid.* A3.
4 It should be noted that Mellor's criticisms of Pompeii and its management are somewhat perennial. A spate of recent wall collapses, beginning in the Winter of 2010 and continuing through 2014, have prompted repeated outcry in the media and generated no small degree of political action. Such critique has yet to provide (or suggest) a solution to the problems of funding and maintenance of the site.
5 Conticello, 20th of January 1993.
6 *ibid.* 18.
7 *ibid.* Also cf. *Rediscovering Pompeii* (1990) the catalogue of the exhibition of the same name, which provides insight into the work being undertaken in Pompeii during Conticello's period in office. In his letter to *The Guardian*, Conticello noted that Mellor had been invited to this exhibition (*ibid.*).
8 Conticello noted that 'we have only 70 billion lira and need 1500 billion lira to ensure that the Pompeian site is adequately maintained' (*ibid.*). This is equivalent to roughly €36–80,000,000, calculated at the Euro to Italian Lira fixed rate.
9 *ibid.*
10 Now published in Ling, 1997; Painter 2001; Ling and Ling, 2005; Allison, 2006; the final volume by Varone is still forthcoming.
11 Cf. Ling 1997, 17.
12 Cf. especially Wallace-Hadrill 1994.
13 Much of the initial work on this insula, and in particular upon its small finds assemblage had already been undertaken by Joanne Berry, a research student of Andrew Wallace-Hadrill, for her Masters thesis (Berry, 1993; 1997). Cf. also Fulford, Wallace-Hadrill *et al.*, 1999.
14 Cf. Bon *et al.* 1996a, 1996b; for preliminary thoughts on the use of digital photography to rapidly record the architecture.
15 Bon *et al.* 1995, 18–19; 1997; 1998.
16 Cf. Jones and Robinson 1998; 2004.
17 In addition to the teams working on the preliminary recording of Insula VI 1, the osteology and geophysics, Rob Janaway, of the University of Bradford, also undertook a preliminary survey of the textile properties in the city (Janaway 1995, 22–23). This investigation mainly came to fruition through the work of Janaway and Robinson's student Heather Hopkins who used the information

gathered in this preliminary season in her undergraduate and doctoral dissertations from the University of Bradford that investigated textile production through experimental archaeology in her reconstruction of Pompeian dye vats (cf. Hopkins 2005, 2007, 2008, 2010 and *forthcoming*).

18 Judd 1995, 22. The analyses of the human bones from Pompeii have now been published by Lazer 2007, 2009.
19 Richardson 1995, 21–22.
20 Richardson 1997.
21 This was perhaps a somewhat naïve aspiration given the taphonomic processes of the destruction where the rubble spreads created by the collapse of roofs and walls during the eruption hindered the detection of coherent building plans. Nevertheless, a number of different survey approaches were investigated, which while unable to demonstrate the complete layout of buildings, did show that walls could be located in the lapilli. This lead the geophysicists to believe that 'it is likely that further development of the techniques would allow at least an outline of the building plans in these areas [the unexcavated areas] to be produced' (Frankel and Cheetham 1995, 20). More recent efforts towards the same goal under the auspices of Progetto Regio VI of the Università di Perugia, Venezia, Trieste and the Università degli Studi di Napoli "L'Orientale" have produced relatively similar results. Cf. Anniboletti, Befani and Boila 2009.
22 Maiuri 1933, 182–186; Hoffman 2009.
23 Maiuri 1973, 10–1; figures 1 and 4.
24 The wall, in fact, never existed, see Maiuri 1973 (1930), 10–11 and the present volume, Chapter 5.
25 Results of this work is presented in Frankel and Cheetham 1995, 19–21.
26 De Haan and Wallat 2008, 15–24.
27 The proposed collaborative excavation of the intriguing anomalies detected by the geophysical survey of the Palaestra Grande was abandoned due to the change in *Soprintendente* during the winter of 1994/5 that saw the appointment of Pierre Giovani Guzzo. Prior to this Jones had also become increasingly concerned about the logistical and management issues raised by potentially needing to operate two distinct excavation teams at opposite ends of the city. This had been tried on Jones' previous field project in Newstead, with excavations taking place simultaneously on the Roman fort and native sites in the wider study region (cf. Jones, R. Newstead Final Reports in preparation). In Pompeii, however, he was keen to concentrate the work in a single location. Consequently, plans for excavations in the Palaestra Grande were put aside and work focused entirely on Insula VI 1.
28 Cf. Jones, R. Newstead Final Reports in preparation.
29 This group included Trench Supervisors and Senior Trench Supervisors, in chronological order: Michelle Borowitz (1995–1996), Simon Clarke (1995), Briece Edwards (1995–1998), Hugo Benavides (1996–1997), Robert McNaught (1996–1998), Natalie Messika (1996), Toby Kendal (1996–2000), Gary Devore (1997–1999), Karen Johnson (1997), Amy Zoll (1997), Michael Anderson (1998–2000; 2002–2004), Stuart Herkes (1998), Abigail Tebbs (1998), Steven Ellis (1998–2002), Barry Hobson (1998–2001), Megan Dennis (1999–2002), Jason Urbanus (2000–2001), Pat Daniel (2001–2004), Amy Walters (2000–2002), Sam Wood (2001–2002), Nick Ray (2001–2002), Diane Fortenberry (2002–2003), Katerina

Garajova (2003–2006), Pavel Titz (2003–2004), Karen Derham (2003), Claire Weiss (2003–2006), Lisa Guerre (2004), Jennifer Wehby (2004–2006), Tim Webb (2004–2006), Darren Bailey (2005–2006), Keffie Feldman (2005–2006), Hannah Gajos (2005–2006), Phil Murgatroyd (2005–2006), Els Coppens (2006), and Assistant Supervisors: Jennifer Beckmann (2002), Cindy Drakeman (2002–2003), Katerina Garajova (2002), Pavel Titz (2002), Lisa Guerre (2003), Phil Murgatroyd (2003–2004), Darren Bailey (2004), Keffie Feldman (2004), Kelly Krause (2005), Clare O'Bryen (2006), and Courtney Ward (2006).
30 It was also envisaged by Jones that in order for the Field Directors to be fully engaged the project and have a stake in its future, they would lead on the writing up the stratigraphic narratives from the areas under their supervision. In reality, all of the Field Directors and indeed one of the Directors were at relatively early stages in their archaeological careers and were engaged in full-time doctoral research and understandably found it difficult to reconcile the conflicting demands upon their time, slowing considerably the speed with which this work could be undertaken. It was only with Anderson's appointment to the Classics Department at San Francisco State University and Robinson's to the Institute of Archaeology at the University of Oxford, that they were able to have the space and time for the writing of this volume to proceed with any velocity.
31 Subsurface stratigraphy was prepared largely by Anderson, while standing architecture has been prepared by Robinson.
32 Casa del Chirurgo Architecture supervisors: Alys Thompson (1998–2002), Blair Gormley (1998–1999), Amy Flint (2000–2002), Alvin Ho (2004–2006), Michael Rocchio (2004–2006), and Saskia Stevens (2005–6).
33 During this time Devore also worked for the AAPP on aspects of the organisation and management of the field school.
34 Harris 1989.
35 At the time of writing, this work is only partially complete for the entire insula. Each SU assigned during the entire course of the excavation is represented, but these data are only partially complete. For the Casa del Chirurgo, the database is entirely complete.
36 Ciaraldi and Richardson 2000, 75–6.
37 Adams and Gasser 1980.
38 See for example Ciarallo 2000; Ciarallo and Lippi 1993; Jashemski's considerable number of studies summarised in Jashemski 1979, 1993; Meyer 1980. More recent studies, such as in the House of Amarantus, the via Consolare Project, and the Porta Stabia Project have, or will also report significant environmental recovery, although not to the extent of that practised by the AAPP.
39 Richardson *et al.* 1997.
40 Ciaraldi 2001.
41 With the exception of the atrium, which was consistently excavated/supervised by Katerina Garajova.
42 McKenzie-Clark 2006, leading to further formal publications and analysis (2009, 2012a and 2012b).
43 Hobbs 2013.
44 Cool 2016a.
45 Russo and Russo 2005.
46 Israeli 1991
47 Ciaraldi 2007, Murphy 2011; Veal 2009; Veal 2014.
48 Dapling and Thompson 2005.

Chapter Appendix 1: AAPP Field School Units Skills to be mastered

Excavation and architecture

The following skills are necessary and are to be mastered:

- Recognition of stratigraphic detail and removal of soil
- Use of trowel, shovel and pick, and understanding when each is appropriate
- Recognition of changes in soil colour and/or texture
- Ability to excavate defined stratigraphic deposits
- Definition of stratigraphic units, through description of soil matrix and inclusions, and stratigraphic relationships
- Screening for artefacts and visible ecofacts
- Preliminary sorting and recording of finds
- Completion of written records
- Drawing plans and sections
- Completion of photographic record
- Understanding detailed stratigraphic interpretation within overall site synthesis
- Recognition of Roman and modern building materials
- Recognition of Roman and modern construction and decoration techniques and conservation
- Stratigraphic analysis of standing walls
- Recording of wall construction & stratigraphy, using photography & drawings
- Comprehension of the relationship of architecture analysis to other site data, especially adjacent excavation
- Understanding of the role of architecture analysis in archaeological interpretation
- Completion of the written and drawn wall records

Artefacts

The following skills are necessary and are to be mastered:

- Artefact sorting
- Pottery washing
- Recognition of pottery types
- Labelling and recording finds
- Packaging and storing fragile finds
- Understanding the relationship of artefacts to other site data
- Understanding the role of artefacts in archaeological interpretation

Ecofacts

The following skills are necessary and are to be mastered:

- Operation of flotation equipment
- Recovery, recognition, and sorting of floral and faunal materials
- Recording and packing of ecofacts
- Washing of animal bones (*occurred in the latter years*)
- Understanding the relationship of ecofacts to other site data

Total station survey

The following skills are necessary and are to be mastered:

- Comprehension of the surveying software
- Set up and operation of the EDM machine
- Understanding the relative importance of standing structures such that meaningful results emerge

Chapter Appendix 2: AAPP Stratigraphic Unit pro-forma sheet

ANGLO-AMERICAN PROJECT IN POMPEII 2006
THE UNIVERSITY OF BRADFORD

STRATIGRAPHIC UNIT SHEET

Location	**AA #**	**SU VOLUME**	buckets	**SU #**
	STRAT UNIT BRIEF DESCRIPTION AND LOCATION			

Description

☐ **CUT**

Filled with SUs: _____

Shape: +sub linear curvilinear
circular square oval irregular
other: _____

Sides: vertical steep moderate
gentle undercut irregular

Base: flat sloping concave
convex irregular

Clarity:
excellent good moderate poor

Profile: (include sketch)

☐ **DEPOSIT**

Fill of cut SU: _____

Soil Type: sand clay
silty sand clayish silt sandy silt
gravel lapilli rubble loamy sand
other: _____

Compaction: solid firm friable
loose sticky

Munsell #:

Munsell Description:

Clarity:
excellent good moderate poor

Inclusions:

Stones _____% Pebbles _____%

Cobbles _____% Gravel _____%

Sand _____% Charcoal _____%

Lapilli _____% Mortar _____%

Plaster _____%

Other: _____

Notes:

Excavation

METHOD OF EXCAVATION:
☐ trowel ☐ heavy tools ☐ not excavated

RISK OF CONTAMINATION:
☐ low ☐ medium ☐ high

SCREENED:
☐ yes ☐ no

Archive

☐ photographed ☐ flot sampled ☐ soil sampled

☐ plan number ☐ section number ☐ notebook ref

Finished Revised		Entered Reentered		Revised Revised		Reentered Reentered	

ANGLO-AMERICAN PROJECT IN POMPEII 2006
THE UNIVERSITY OF BRADFORD

STRATIGRAPHIC UNIT SHEET

Stratigraphic Relations

This SU is before SU _____

This SU is equal to SU _____

This SU is after SU _____

Later

=

Earlier

Physical

This SU underlies SU _____

This SU abuts SU _____

This SU overlies SU _____

Sketch and Extended Description

North Arrow

Completed by _____

Checked by _____ Date _____

Chapter Appendix 3: AAPP pro-forma wall cover sheet

W-1

ANGLO-AMERICAN PROJECT IN POMPEII 2006
THE UNIVERSITY OF BRADFORD

WALL COVER SHEET

	AA #	WALL #	PLOT #	DRAWING #
Location				
	WALL BRIEF DESCRIPTION AND LOCATION			

	SU #	Description	SU #	Description
List of Wall SU's				
				⇐ Check if continued on Another sheet

Harris Matrix	**Show the Stratigraphic Relationship of the Wall's SU's**

W-1

ANGLO-AMERICAN PROJECT IN POMPEII 2006
THE UNIVERSITY OF BRADFORD

WALL COVER SHEET

Plan	**Sketch the Stratigraphic Relationship of this Wall to other Wall's and SU's**

Sketch of the Wall Face	**Show the Wall Face with its Stratigraphic Units**

Archive	**Completed by:**	
	Checked by Area Supervisor	**Date:**
	Checked by Architecture Specialist	**Date:**

Chapter Appendix 4: AAPP pro-forma stratigraphic unit sheet for walls

W-2

ANGLO-AMERICAN PROJECT IN POMPEII 2006
THE UNIVERSITY OF BRADFORD

STRATIGRAPHIC UNIT SHEET FOR WALLS

Location	AA #		WALL #		SU #	
	PLOT #		ROOM #		DRAWING #	
	SU- BRIEF DESCRIPTION AND LOCATION:					

Wall Construction

COMPOSITION: (Give rough percentages for materials visible)

Lava with White Flecks		Sarno Stone		White Limestone	
Lava with Black Particles		Opus Signinum		Brick/Tile	
Nocera Tufa		Cruma		Pottery Fragments	
Marble Fragments		Other (describe)			

CONSTRUCTION TECHNIQUES: (check)

Opus quadratum		Opus Incertum		Opus mixtum	
Checker Work		Opus vittatum		Opus spicatum	
Opus Africanum		Opus reticulatum		Opus testaceum	
Opus craticium		Opus quasi-reticulatum			

WALL BONDING:

AGENT	√	DESCRIPTION
Dry Bonded		
Clay		
Mortar		If mortar, complete the section below

Mortar surface is	very hard		firm		soft		disintegrating	
Mortar interior is	very hard		firm		soft		disintegrating	
Inclusion size is	large		small					
Inclusion density	high		low					
Particles	grain		sand		clay			

Mortar surface

color	light	medium	dark
grey			
brown			
yellow			
pink			
other			

Mortar interior

color	light	medium	dark
grey			
brown			
yellow			
pink			
other			

Wall Covering

Plaster Patching		Plaster Consolidation		Pointing	
Veneer		Stucco		Cocciopesto	
Final Plaster Layer		Plaster Layer			
Other					

Description:

W-2

ANGLO-AMERICAN PROJECT IN POMPEII 2006
THE UNIVERSITY OF BRADFORD

STRATIGRAPHIC UNIT SHEET FOR WALLS

Stratigraphic Relations

This SU is before SU _____

This SU is equal to SU _____

This SU is after SU _____

=

Physical

This SU underlies SU _____

This SU butts SU _____

This SU overlies SU _____

Additional Notes

Archive

Completed by:

Checked by Area Supervisor: | Date:

Checked by Architecture Specialist: | Date:

3

DIGGING THE CASA DEL CHIRURGO

Michael A. Anderson and Damian Robinson

'27 Ottobre [1770] 'Si è levata quantità di terreno da sopra le abitazioni contigue alla descritta nel passato rapporto, e specialmente in un edificio che promette essere di qualche conseguenza, essendo fabbricato di grosse pietre di taglio.' – PAH I, 1, 245.

Introduction

From the first moments of its discovery the Casa del Chirurgo seems destined to have been characterised by its most distinctive feature, the large Sarno stone blocks (*grosse pietre di taglio*) and ashlar masonry technique with which the façade and atrium walls were constructed. A relatively small property with several rooms with wall paintings that were initially considered outstanding, but already by the time of Mazois[1] were thought to be in poor condition, this house among all of those in Insula VI 1 has enjoyed a prominence in scholarly discussion rivalled by only a few of the largest and most impressive properties in the city. Its fame has been due primarily to the presumed antiquity of the house's construction and the supposed simplicity of its hypothetical original layout, factors that have led to its central role in discussions of Roman housing and the chronology of Pompeian urbanisation. As such, the Casa del Chirurgo has been seen as a physical manifestation of the archetypal early 'Roman atrium house,' its floor plan representative of one of the earliest steps in an evolutionary trajectory from its Italic ancestors and a pure reflection of the form described in the Augustan period by Vitruvius in his *de Architectura*.[2] At the same time, as an outgrowth from this role and as one of the earliest surviving examples of domestic stone architecture in Pompeii, the date of its construction has played an important role in discussions of the

urban development of the city. The Casa del Chirurgo is often invoked in debates about the chronology of the earliest urban layout and the growth of Pompeii in the so-called archaic period. Authors from Fiorelli, Nissen, Mau, and Carrington to Wallace-Hadrill, Carocci, De Albentiis, Gargiulo, and Pesando[3] have all commented upon both the antiquity of the house and the 'classical' or 'iconic' arrangement of its rooms. In a classic summary of its traditional role, De Albentiis writes that the Casa del Chrirugo, '*è unanimemente considerata la domus di maggiore antichà conservatasi nella città vesuviana.*'[4] For better or for worse, the house has long had an important place in scholarship. This chapter will attempt to provide an overview of this scholarship in order to situate the results of the AAPP's excavations in this well-known property.

Previous scholarship and the Casa del Chirurgo

Much of the fame of the Casa del Chirurgo is the result of its involvement in scholarly debates of the later nineteenth century, which themselves were efforts to explain and categorise the diverse archaeological data of Pompeii and to identify the major phases in the construction of the city through comprehensive study of its remains. After the considerable early interest in

the Casa del Chirurgo during and immediately after its excavation (cf. Chapter 1) had waned, the house passed through a period of relative obscurity, as attention was drawn to structures in the city currently under excavation. Though Piranesi[5] and Mazois[6] had both spent considerable time in the house, by the time of Gell the Casa del Chirurgo was clearly an afterthought that did not merit inclusion in the first edition of his classic *Pomepeiana*.[7] Subsequent publications throughout the early nineteenth century tended to ignore the monuments of Insula VI 1, and even the Niccolini brothers included only a brief description of the Casa del Chirurgo in their publication.[8]

The period of the second half of the nineteenth century, however, was a time when the study of Pompeii underwent a considerable transformation and systematisation. As a result of a new, comprehensive, and topological approach to the city, which saw its greatest expression in Fiorelli's revised address system and the creation of new and better maps of the site,[9] even long-excavated houses, such as the Casa del Chirurgo, were brought back into consideration. In 1855, Overbeck had attempted to come to terms with the range of evidence presented by close topographic examination of a number of different structures, including a range of houses of various types.[10] Applying the approach that had generally been followed up to this point, but with a new topographical comprehensiveness, Overbeck explained the rooms within these houses by applying ancient terms to each, ultimately producing an early form of the standard plan for 'the Roman atrium house.'[11] The reconstructions of Piranesi and Mazois (cf. Chapter 1) had already established such a connection between a type of house with a large central hall and the atrium house described by Vitruvius in his *de Architectura*.[12] Accordingly, the central hall of such houses, which in the previous excavation reports had normally been called a 'cortile,' was now identified as what Varro and Vitriuvius called the 'cavum aedium'[13] or 'atrium.'[14] Ancient literature[15] could then provide a set of associated activities for the atrium, ranging from weaving to social reception.[16] With the repetition of a similar approach for many of the other rooms of the house, from cubicula and alae to tablinum and triclinium, an ideological package was created that was so fully wedded with contemporary ideas of what ancient Roman elite daily life had been like, that the spaces, names, and the activities they contained became practically inseparable. While attempts to create a hypothetical plan of the 'Roman house' from literary descriptions independent of the discoveries at Pompeii and Herculaneum clearly reveal that the two distinct

sources of information do not actually align as neatly as is often imagined,[17] even recent criticism of this approach has had little effect on its pervasiveness.[18] The authoritative presentation of Overbeck may itself have had something to do with the wide acceptance of these ideas, but it is also true that the text-based narrative of the Roman house presents a deceptively plausible explanation that is sufficiently malleable that it can normally be made to fit and occlude even contradictory information from the archaeological record.

By 1873, focus had moved from description and categorisation of the remains to the explanation of change. Accordingly, Fiorelli suggested a step-by-step chronology of building within the city, based upon a rough sequence of construction materials – Sarno stone in the pre-Samnite phase, *tufo grigio di Nocera* in the period after the Samnite conquest, and volcanic stone in the Roman period.[19] Focusing upon construction in *opus quadratum*, he drew a direct connection between the Casa del Chirurgo, the Casa di Naviglio, and the Porta Stabiana, giving exhaustive measurements of the blocks present in each and suggesting a date in the pre-Samnite period, hence before about 424 BC.[20] At the same time, Fiorelli noted that the atria of the earliest houses in his chronology, those constructed in Sarno stone, all had impluvia of *tufo di Nocera*. He suggested that these must be secondary features, attributable to a subsequent phase of construction – in other words, during the following Samnite period. Building upon Fiorelli's arguments, in 1877, Nissen assigned the Casa del Chirurgo to the so-called period of the '*kalksteinatrien*' limestone atria, an attribution made largely on the basis that its street façade was composed of Sarno ashlar work and its inner walls were constructed in limestone framework (*opus Africanum*). He dated the house to prior to the end of the fifth century (i.e. the Samnite period or about 424 BC).[21] In refining Fiorelli's relative chronology, however, Nissen critiqued the idea that impluvia of *tufo di Nocera* were secondary features, arguing instead that they were original and had been created in this stone because the porous nature of Sarno stone made it inappropriate for channelling water.[22]

With the further adjustments of Mau in 1879, the stone-type and construction-method relative chronologies, together with a similar relative chronology of wall painting styles, came virtually into their present form.[23] These would form the basis of much of the chronological discussion of the city from that time to the present day, notably hanging heavily upon the date of the Casa del Chirurgo with its *opus quadratum* façade and *tufo di Nocera* impluvium.

Displaying his typical and seemingly prescient insight, the date assigned by Mau to the foundation of the house, however, was rather different from those of earlier scholars. He suggested that while the beginnings of Sarno stone construction could not be determined even approximately, the end was fixed by the beginning of widespread use of *tufo di Nocera* – the so-called Tufa Period – which he connected with the end of the Second Punic War (218–201 BC). Consequently, Mau assigned the '*kalksteinatrien*' properties to a period just preceding this war, in other words, a date in the late third century BC.[24] Despite this, he maintained the position that the *Casa del Chirurgo* was still the oldest of the Pompeian houses to have retained its original layout down to the final phase of the city.[25] This would serve to cement the particular role that the house has played in Pompeian studies and Roman architecture ever since: the perfect example of an early 'Roman atrium house.'

The traditional narrative of the development of the Roman atrium house

Though far from universal, the frequency of occurrence of the atrium house form in the Vesuvian cities,[26] combined with their perceived elite socio-cultural significance, naturally fuelled a desire to explain this common layout and to identify its origins. The work undertaken by Fiorelli, Nissen, and Mau helped to situate the *Casa del Chirurgo* as an early index within an evolutionary-diffusionist model explaining the advent, maturity, and gradual decline of the 'atrium house' that has become the standard explanation of the 'Roman house', and despite some criticism and concern (cf. infra) still dominates the scholarship of Pompeii and Roman domestic space.[27] The traditional narrative seeks the origins of the Roman atrium house within Italic antecedents, best reflected by evidence from early Etruria and Rome.[28] These are traced, if not directly to the open fire-pit roofing of the earliest huts suggested by Servius' connection of the term atrium with the term *ater*,[29] (black, dark), then from early structures such as the Regia[30] in the Forum Romanum, or from reflections of domestic space in seventh century BC southern Etruscan tomb decoration at Cerveteri and Tarquinia. More recently, the sixth century BC houses of Acquarossa and Roselle and those of the sixth to mid-fourth century BC at Marzabotto[31] have also been seen to support the Etruscan origins of the atrium house form. This appears to be confirmed by Vitruvius himself who, in discussing several types of atria, names one form Tuscan, seemingly due to its supposed ethnic origins.[32] Indeed, Varro was also content to derive the term atrium etymologically from Etruscan *Atria* (Adria).[33]

By the time of the middle Republic, the traditional narrative suggests that the atrium house had become associated, at least ideologically, with the daily life of the Roman elite.[34] Central to this argument is Vitruvius' explicit connection between the atrium house and Italian (i.e. not Greek) cultural needs,[35] in which he also noted that the lower classes had no need of atria.[36] Evidence of elite dwellings recovered from the Esquiline (under San Pietro in Vincoli)[37] and the northern Palatine Hill,[38] or the so-called house of Scipio under the Basilica Julia in the Forum Romanum,[39] could be seen to support this association. From this perspective, the spread of the atrium form, both throughout Italy and overseas, can be seen to have resulted from the process of Roman conquest and Romanisation. The appearance of atrium houses in Roman colonies, as close as Cosa or as far away as the Iberian peninsula, as an indication of *romanitas*, at least for elite members of society during the years after the Punic Wars.[40] Indeed, so strong has the connection in scholarship been between the atrium house and the social rituals of elite daily life, notably the *salutatio matutina* and *cena*, that the remains themselves have often been interpreted as though encoded with the traditional values of Roman 'daily life'.

From this apex, the further evolution of the 'atrium house,' is generally understood to involve the gradual disintegration of the pure atrium-core through the acquisition of neighbours' properties, the sale of portions of the original plot, the removal or conversion of rooms, the insertion of front shops,[41] and especially the addition of the ever-more luxurious spaces. Explanation for these changes are sought in the rising wealth of peninsular Italy in the wake of successful overseas conquest, the related rise in the practice of slavery on a large scale, and the foreign cultural contact that these wars encouraged.[42] The primary representative of such changes is the addition of one or more peristyles to the atrium core, which is generally seen to begun to occur in the late second century BC.[43] These extravagant features evoked the Hellenistic luxury of the palace or gymnasium,[44] and reflected the incorporation of civic forms within domestic architecture,[45] serving to modify the overall focus of the house. Continuing alterations from the middle of the first century BC onward, can be interpreted as a reflection of the loss of political independence under the Principate, a reality that created an even greater desire for domestic luxury at the expense

of architectural forms originally dedicated to social rituals of political importance in the Republican period. Accordingly, "austere" Republican forms such as the atrium and tablinum are seen to have declined in favour of the more luxurious domestic spaces. These are represented not only by the peristyle and triclinium, but also by a host of specialised rooms dedicated to *otium,* such as the *diaeta*, or the appropriately exotic, Greek-sounding, tetrastyle, Corinthian, Cyzicene or Egyptian oeci. Maiuri equated such dilution of the pure atrium house with a form of social or moral decline caused specifically by the rise of the lower social classes at the expense of the elites.[46] These forces, combined with population pressure and a need for multiple occupancy dwellings, a type of addition for which the atrium house was particularly ill-suited, are seen to bring about the demise of the form.[47] Indeed, Pompeian houses, such as the Casa degli Amorini dorati (VI 16, (6).7.38), which emphasise the peristyle over a diminutive and cursory atrium, and others, such as the Casa dei Vettii (VI 15, 1.27), or the Casa di Loreius Tibertinus/Octavius Quartio (II 2, 1.2.3.5.6), which lack the tablinum entirely in their final arrangements, are cited as examples of the degree to which older atrium house forms had become irrelevant. By the time that the houses of the second century AD preserved at Ostia and in North Africa were built, such a process would have been all but complete, with the replacement of atrium houses by other forms, notably those centred upon a peristyle.[48]

In the context of this narrative, the floor plans of the houses in the area of Vesuvius are generally invoked to explain and illustrate the early and middle stages of development. The earliest Pompeian examples illustrate the beginning of the formalisation of the ideal of the atrium house, while the remaining are seen to represent various stages in the transition between the early ideal and its eventual disintegration and disappearance. Within these, the Casa del Chirurgo, with its 'canonical' broad, longitudinal atrium and surrounding rooms, flanking alae, wide tablinum, axial vista through to a small hortus, and its supposed early date of construction, has naturally played a pivotal role as the classic early atrium house and a keystone upon which the whole developmental framework rests.[49]

First sub-surface excavation in the House of the Surgeon

Throughout all of the debates of the nineteenth century in which the Casa del Chirurgo had featured, both its

supposed early date and its imagined early form had been derived entirely deductively. Among the first to attempt to provide evidence for these ideas was the influential and energetic *Soprintendente* Amadeo Maiuri, who undertook stratigraphic archaeological excavation below the AD 79 levels, at which the initial clearance of the house had ceased, in order to resolve the central questions of the age of the Casa del Chirurgo and the nature of its original layout. In 1929, Maiuri excavated twelve relatively restricted trenches inside the house and outside on its pavement down to the level of the natural soil in an attempt to uncover the various phases of construction and preserved floor levels (Fig. 3.1). Ten of these trenches were published in a brief, but relatively detailed, report in the *Notizie degli Scavi di antichità* of 1930 that was ultimately republished in 1973.[50] Although this technique ought to have provided a solid date for the foundation of the property, Mauiri's still-developing archaeological methodology involved the excavation of small *sondages* that impeded his full appreciation of the stratigraphy. Similarly, the then underdeveloped understanding of the necessary ceramic chronology[51] allowed him only to suggest a likely date between the early fourth to third centuries for the construction of the property. The lower limit for the dating of the house was derived from Maiuri's excavation of a well whose fill was dated by pottery to not before the third century.[52] Although it was clear to Maiuri that the well had been dug prior to the construction of the house, he was unsure about when it had been abandoned. While it was possible that the well had been filled at the time of the construction of the Casa del Chirurgo, it could also, he suggested, have been closed after the house had been standing for some time.[53] Maiuri's upper limit for the construction of the property also used evidence provided by his other excavations. He noted that many of the Sarno stone blocks used in the foundations of the house had clearly been re-used since they were covered with a plaster that did not align with their present orientation. Associating this plaster with that of an earlier phase of the city wall, he suggested that the defences had been dismantled and used as a building material for nearby houses after the invading Samnites had constructed a second and larger fortification. Thus, he felt that the Casa del Chirurgo could not belong to a period prior to the Samnite invasion at the end of the fifth century, but likely dated to just after this, with the *tufo di Nocera* impluvium having been added afterwards.[54]

Maiuri's excavations in the fauces had also convinced him that the original level of the house corresponded more closely to the street level of the Via Consolare,

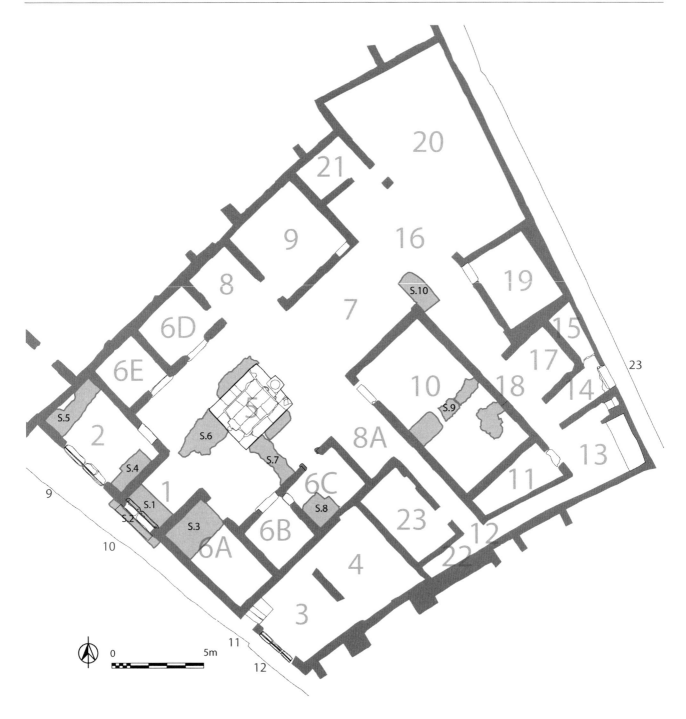

Figure 3.1. Plan of the Casa del Chirurgo indicating Maiuri's sondages 1–10 (illustration M. A. Anderson).

and that a smooth earth surface that he thought must be the original floor of the house underlying the discharge drain from the impluvium meant that this drain could not be primary. It is possible that in this observation, Maiuri was influenced by the desire to discover evidence against the then current position of Patroni, who maintained the Etruscan origins of the impluviate atrium form as had been suggested by Fiorelli, Nissen, and Mau. An impluvium-less original

phase for the house could have asserted the presence of a local tradition of house building independent of influence from Etruria.[55] Perhaps he was also supported in this conclusion by his idea that the well in Room 2 could have continued in use during the first phase of the Casa del Chirurgo, removing the need for an impluvium in which to collect water. Maiuri therefore concluded that Fiorelli had been correct: the first phase of the house had been built without an impluvium

and the feature present today had been added in the imperial period.

Maiuri also tackled questions concerning the original layout of the house, putting trenches against the outside wall of the tablinum and within Room 10, where, in order for the original plan to have its famous canonical symmetry, a wall ought to have continued across the middle of this room. He was relatively taciturn about these two trenches, noting only the high level of natural volcanic soils and the disappointing absence of evidence for the wall that he thought he would find there.

In the end, while Maiuri's excavations in the Casa del Chirurgo helped to lower the date of its original construction (albeit with a date that was still too early), the result of this change on the narrative of the development of the Roman house itself was relatively minimal. The house has continued to represent an early form of the 'Roman atrium house' in subsequent scholarship, with a slightly revised date.[56] The fact that Maiuri found no evidence of the hypothesized original wall through Room 10 also had little impact on the imagined and often reconstructed original layout of the structure, nor did it call into question any of the previous developmental assumptions. In fact, this aspect of his excavation appears to have been generally ignored by subsequent scholarship. As noted by Wallace-Hadrill, Maiuri's ideas concerning a different origin for the atrium house itself received little notice.[57] In fact, many scholars chose to retain Nissen's argument for an original impluvium, while employing Maiuri's (or even Fiorelli's) dates for its creation. The most influential aspect of his work has therefore been his conclusion that the original layout of the house lacked an impluvium, and even this did little other than to suggest that the first stage of the house had been *testudinate* (fully roofed) in its original form. The chronology implied by Maiuri's now apparently archaeologically secure date was incorporated into Carrington's work on refining and restating the relative material and construction method chronology developed by Nissen, Fiorelli, and Mau,[58] and the date also influenced Pernice in his discussion of the Hellenistic pavements of the Casa del Chirurgo.[59]

The history of the 'Roman atrium house' in recent years

The resilience of the traditional narrative of the 'Roman atrium house' to change has been considerable. Just as in the case of the nineteenth century relative chronologies based on wall painting styles, construction types,

and materials, most modern work has been directed towards refining and adjusting the chronology of the development of the 'Roman atrium house' rather than establishing a new narrative. Despite serious doubts regarding their use for specific dating purposes, most scholars would still accept that general temporally sensitive trends do exist within the changing use of building materials, construction types, decoration, and even house forms.[60] While Maiuri's new date for the Casa del Chirurgo meant that the traditional narrative of the 'Roman atrium house' had to be shifted to encompass a later date range, its overall trajectory remained largely unchanged.[61] Similarly, the development of the 'Roman atrium house' generally continues to be rehearsed in modern scholarship and the illusion of a well-understood and logical course of development has long been well accepted.[62]

The problems with the traditional narrative, however, are as varied and numerous as the approach is out-dated, and some modern scholarship has sought to challenge it. That such an evolutionary-diffusionist analysis smacks strongly of the archaeological approaches of the nineteenth century should hardly be surprising, since it is precisely during this time that the ideas first developed. Quite aside from concerns whether changes in house form may actually be understood through the lens of biological evolution,[63] whether the tripartite division of its history into periods of growth, maturity, and decline is appropriate for cultural phenomena, or whether the transfer of house form and ideology should be explained by cultural-diffusionist models, there is the even more worrying idea that such a thing as 'the archetypal Roman house' would ever have existed, either in the minds of the ancients or in the reality of their urban environment. Even if it did, one might question to what extent such an ideal can unproblematically be considered to be 'Roman.' Others have questioned the validity of using terms taken from ancient sources, such as atrium, cubiculum, or tablinum to describe archaeological remains, challenging the association of socio-cultural values or daily activities with them.[64] Also of concern is the emphasis placed in scholarship upon the atrium house and, in particular, the impluviate atrium house as the standard form of Roman domestic architecture.[65] Vitruvius himself indicates that a much more varied and diverse set of housing options existed, and while the Campanian remains do preserve a large number of houses with atria, to focus upon them exclusively misses out the much wider variety actually preserved there, to say nothing of the diverse remains from the rest of the Roman world. To concentrate nearly exclusively on the putatively elite form of housing as

the only form is to exclude a large percentage of Roman society and their domestic spaces.

But was the atrium house actually an elite form of house? In truth, it must be admitted that much of the answer to this question hinges on precisely what Vitriuvus had in mind when he said that only elites needed atria. The form of structures recovered from Roman colonies, such as the houses from roughly 328– 125 BC of Fregellae[66] or the second century BC houses of Cosa,[67] are arranged, not around an impluviate atrium, but rather a completely covered hall, a type of structure that Vitruvius might well indicate by his term 'testudinate' atrium.[68] Similarly, many houses at Pompeii, generally dubbed 'case a schiera'[69] because they are arranged in rows and make use of nearly identical plans contain covered halls or open central spaces that might also have qualified as atria, even if they were missing some of the more elaborate aspects found within the larger houses. As it will be seen in Chapter 4, it is now clear that these houses date to roughly the same time as the Casa del Chirurgo itself, and they consequently provide the general domestic background against which that particular atrium house must be understood. Surely these houses cannot all have belonged to elites, but rather document a generalised cultural trend towards houses outfitted with central halls. Wallace-Hadrill's convincing arguments that the atrium house is simply the functional result of covering an open central courtyard might mean that such a broad cultural trend could be entirely practical.[70]

But does this mean that the idea of the 'Roman atrium house' is a concept entirely devoid of meaning? While the traditional approach to the 'Roman atrium house' is certainly vulnerable to critique, it is clear that forces must have been at work that produced at least the general idea of what a house, or perhaps an elite house, should look like. Otherwise elements of the form would not be found in so many structures in Pompeii and the architectural prescriptions of Vitruvius would have had little meaning.[71] Furthermore, while the interconnection between the features of the 'Roman atrium house' and social rituals of elite daily life such as the *salutatio matutina* and *cena* must be a heavily oversimplified presentation of reality, it must also be admitted that these are precisely the activities for which the formal atrium house seems to have been particularly well-suited.[72]

While it is impossible to imagine these particular social rituals occurring in every instance of an atrium house in Pompeii on a daily basis, and analysis of both the finds and the spatial characteristics of atrium houses has concluded,[73] that atria were used for a wide variety of different functions.[74] It is not necessary for every owner of an atrium to have actually used it for the ideal of a 'Roman atrium house' to have had cultural connotations. The widespread dispersal of the form, both in the sites around Vesuvius and in Italy, does suggest that it was culturally desirable. In the socially competitive environment that produced the houses at Pompeii, the ideal of an elite form may have functioned as an element of social capital, regardless of the expectations for its actual use. Indeed, such a disconnect between actual function and intended architectural design could help to explain difficulties with the end of the traditional narrative, when despite clear evidence for the continuation, if not growth, of the social rituals of patronage with which the atrium and tablinum have been most strongly associated, they nevertheless appear to have disappeared from later Roman houses.[75] Clearly then, it makes a great deal of difference precisely when the elements of elite atrium construction became widespread. As will be seen in the concluding chapter (Chapter 14), evidence from the Casa del Chirurgo suggests that this phenomenon may have occurred rather later than has generally been thought, implying alternative interpretations for just when the ideal of the elite 'Roman atrium house' actually came to be.

The excavations of 2002–2006

The five seasons of excavations undertaken by the Project in the Casa del Chirurgo between 2002 and 2006[76] were designed to re-examine the surface and subsurface archaeology of the house afresh and to allow it to contribute accurately to the modern study of Roman houses and the understanding of the chronological development of Pompeii itself. Following in the footsteps of the pioneering excavation undertaken in the house by Maiuri in 1926, our questions, like his, were simple: when was the house built; what did it look like when first constructed; and how and when did it change over time? Fieldwork involved a comprehensive programme of investigations, including the re-excavation of Maiuri's trenches and the re-examination of his sections, the complete stratigraphic excavation of the house in all areas where flooring of the AD 79 period was not present or well-preserved, and the thorough examination and sequencing of stratigraphic information presented by the standing remains of the walls of the house (Fig. 3.2).

Excavation within the Casa del Chirurgo was undertaken systematically over a number of years.

Due to the complexity of the deposits uncovered, in some cases it was necessary to return to the same excavated area several times, e.g. the atrium (Room 5) was excavated throughout the entire period, while Rooms 22 and 6C were excavated in two non-contiguous seasons. In most areas, a single summer's excavation was sufficient to reveal the complete stratigraphic sequence as preserved. The first phase centred upon the old trenches of Maiuri and the atrium of the house.

Preliminary work began in 2002, with excavation within the tablinum (Room 7), the two cubicula on the southern side of the atrium (Rooms 6A and 6C), and the identification and reopening of Maiuri's original excavations in the atrium. Excavation was supervised by Megan Dennis, Steven Ellis, and Katerina Garajova in these areas. In 2003, work continued in the atrium (Room 5) with the area-wide excavation of the southeastern corner of this room by Katerina Garajova, which

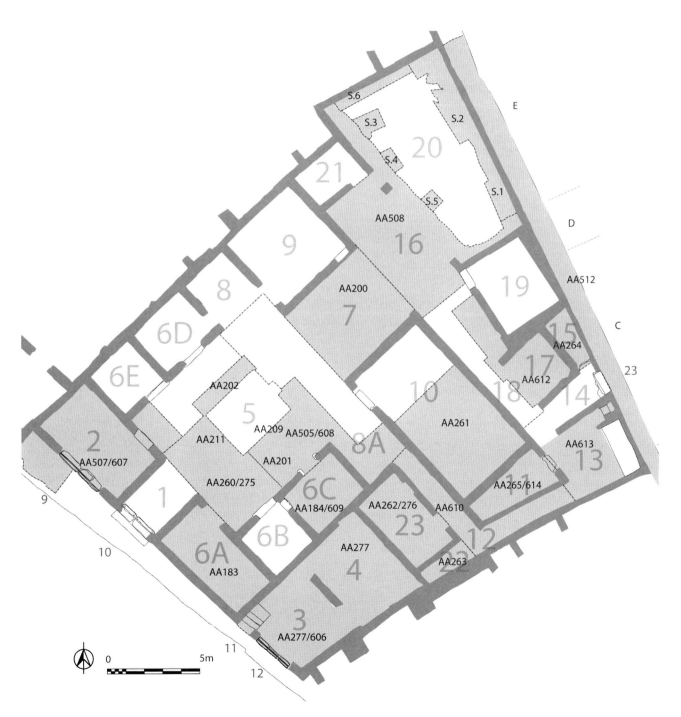

Figure 3.2. Areas excavated by the Anglo-American Project in the Casa del Chirurgo (illustration M. A. Anderson).

was investigated simultaneously with the triclinium (Room 10) by Darren Bailey and several areas of the service wing (Rooms 11, 15, 22, and 23) supervised by Karen Derham. Due to the unexpected discovery of the impluvium-like feature of Pre-Surgeon Structure in Room 23, 2004 saw a return to this area by Darren Bailey, along with the expansion of excavation within the atrium to include the entire southern half of the room, supervised by Katerina Garajova. At the same time, excavations within the southern shop (Rooms 3 and 4) were conducted by Claire Weiss. During the summer of 2005, excavations continued in the atrium (Katerina Garajova) and were augmented by new trenches in the northern shop (Room 2) by Phil Murgatroyd and in the hortus and portico (Rooms 16 and 20) by Keffie Feldman, with additional excavation in the sidewalk of the Vicolo di Narcisso along the back of the house by Els Coppens. With the recovery of the stratigraphic sequence in the atrium and surrounding rooms, focus in the house shifted towards the back of the property, including the garden and eastern service rooms. The final year of excavation in the Casa del Chirurgo saw a return to the atrium by Katerina Garajova and continued excavation in the northern shop (Room 2) because of the complicated stratigraphy that had been produced by the metalworking facility previously identified there. This was carried on by Phil Murgatroyd and completed by Els Coppens. Several areas from previous seasons were reopened in response to the preliminary overall sequencing work that had been undertaken by then Field Director, Michael Anderson. These involved excavations in the front of Room 3 and 4 undertaken by Els Coppens, which aimed at finding the full extent of the original front façade of the Casa del Chirurgo, Room 6C by Katerina Garajova, and Room 11 by Keffie Feldman, neither of which had been previously completed. Finally, work focused on completing excavation within the rest of the house in areas previously rendered inaccessible by earlier excavations. Thus, the L-shaped corridor (Room 12) was excavated by Daniel Jackson and Rooms 13, 17, and 18 by Keffie Feldman. Further cleaning in Room 10 was executed in 2007 by Ian Sumpter in order to complete an illustration of the *opus signinum* and traces of central emblema, but further excavation was not undertaken.

Analysis of the walls was completed in conjunction with excavation with the coordination of architectural specialists Alys Thompson, Amy Flint, Alvin Ho, Michael Rocchio, and Astrid Schoonhoven, while study of areas not within excavated zones were gradually incorporated during the same years. Recording of preserved mosaic flooring and *opus signinum* in Rooms

6B, 6D, 6E, and 8 was undertaken by Megan Dennis and Craig Leyland. Unfortunately, these drawings were not available for the production of this volume. Additional analysis of walls in unexcavated zones and throughout the property was undertaken by Damian Robinson and Astrid Schoonhoven in 2007. Topographic survey of the walls was undertaken independent of these methods by Arthur Stephens and Eric Poehler.

Post-excavation process

The end result of the 2002–2006 excavation seasons was 1682 context sheets, 533 drawings, 3686 photographs, a 3D DXF wire-frame model of the current state of the standing remains, and a store room full of finds. As detailed in Chapter 2, excavated deposits, cuts, and features were recorded with context sheets, plans, sections, and photography. All strata identified in either the section edges of the excavations themselves or in ancient cuts were similarly recorded. Construction events in walls were recorded with photographs, drawings, and context sheets that were different from those used for excavation. In some instances, particularly in the case of deposits that comprised an expected component of the natural underlying soils or the common series of levelling layers (Phase 2), contexts were recorded by name reference to similar soils recovered elsewhere, and therefore may lack full context sheets and/or descriptions. Context sheets provided areas for recording soil matrix, inclusions, colour, Munsell colour information, physical and stratigraphic information, descriptions, and volume excavated. In practice, these were not consistently filled out and the quality varied from sheet to sheet. Ultimately, the synthesis and data presented in this volume did not employ the context numbers for walls analysis, but utilised an abbreviated system employed during post-excavation by Damian Robinson in his completion of this work. This means that the sequences of these numbers in any one excavated area appear to have large gaps within them, representing numbers assigned to wall contexts omitted from post-excavation study. Any SU numbers assigned in error, or skipped inadvertently by excavators have been marked as 'dead' or 'killed,' a convention following in-field practice designed to remove the chance of replication. In all cases where deposits were only partially recorded, or received no SU number or context sheet, they have been identified within the following text as No SU Assigned, or by means of the conventional term applied to deposits of similar appearance in nearby excavations (e.g. natural, or

'black sand'). Where necessary, similar terminology has been applied on the plans.

Preparation of combined drawings

All plans drawn during the field season were initially returned to the University of Bradford. Complete scanning of these was undertaken by Hilary Cool and David Griffiths in tandem with the scanning of all surviving context sheets. Scans were completed at a resolution of 600 dpi and saved in TIFF file format. These individual files were coordinated within a scaled wall floor plan derived from the 3D Topographic Survey DXF file, making use of any and all records of excavation base lines surveyed during the course of the excavation. In any instances where records of the actual base lines for excavated areas had gone unrecorded, a 'best-fit' procedure was followed in manually aligning the scaled drawings within the scaled house outline on the basis of the walls present within the area drawings themselves. All drawings were coordinated within Adobe Illustrator by Michael Anderson, and digital tracing, labelling, and coordination was completed in tandem with the process of verifying and correcting the stratigraphic sequence for each deposit as recorded during the excavations. As a rule, for each phase discussed, the top-most deposits have been illustrated with underlying components of superimposed fill deposits omitted, unless components of these layered fills could be identified extending beyond the extent of the top most deposits. In all cases throughout the following text, deposits that actually appear in the illustrations are marked with **bold text**, while those not illustrated are left in normal text. Elevations taken from the drawings also record relevant elevations in metres above sea level (masl.), calculated from the geo-referenced points (ST 019, 020, and 060) placed by the *Soprintendenza Archaeologica di Pompei*.[77] In those cases where an important feature was not recorded in a surviving scaled illustration, sketch plans from excavator notebooks, or from context descriptions were used to rough-in the locations of these features or deposits, which have been denoted on plans with a special convention as noted on the key (Fig 2.3).

Context checking and Harris Matrix production

The process of verifying the stratigraphic sequence and the final excavated history of the development of the Casa del Chirurgo involved the creation of revised, coordinated, and annotated Harris Matrices for each excavated area.[78] In some cases it was possible to follow

the matrix produced by the excavators as a component of their final reports, but in each case, these were checked against photographs, SU sheets, and in some cases, site journals in order to ensure that the sequence is as accurate as possible. Often this involved diverging from the preliminary interpretations of the students or supervisors who undertook these operations and consequently, the field records have frequently required correction or augmentation. This was especially important given the variable quality of the record and the number of different students, supervisors, and field directors involved in its production. When it proved necessary to alter the interpretations of the excavators, all available data – plans, photographs, and supervisor notebooks – were used in order to provide support for such changes. When appropriate, such changes are also noted in the relevant chapters.

Due to multiple years of excavation in most areas, and the practice of assigning new AA numbers for each year, many features come from deposits whose excavation was not completed in the previous year and which received multiple numbers. The practice in the following pages has been to mark these with a series of equals signs. In any cases where the equation of two deposits is uncertain (but probable), these have been marked with an equals sign and a question mark. In the accompanying Harris Matrices, deposits have been sequenced according to their stratigraphic relationships. In all cases, where deposits are believed to belong to the same phase, they have been aligned horizontally. Where deposits are identical, equal signs have been used to equate them. Annotations have been added to the deposits to aid with correct identification.

Difficulties of the archaeology of the Casa del Chirurgo

The particular developmental history of the Casa del Chirurgo has produced a number of difficulties in producing a unified stratigraphic record. Repeated periods of truncation, especially in Rooms 2, 3, and 4, were caused by the creation of new shops lowered to the level of the Via Consolare. Similarly, the removal of a number of floors in antiquity, including several during the final phase, resulted in the removal of the tops of pits and cuts of earlier phases. The end result has been for the excavators to sometimes confuse the chronology of these deposits and sometimes to make it impossible to settle upon their precise chronological sequence. Throughout the process of post-excavation analysis, these deposits tended to drift between

several possible chronological alternatives. This will be obvious in the discussion of early pits and cuts that preceded the construction of the Casa del Chirurgo, which sometimes were found to contain various pottery sherds, materials, and even coins of occasionally later date after they had previously been sequenced into an earlier phase. The reason for this could be that some of the cuts and fills were cut from a higher, later level, only subsequently to have had their tops truncated by the removal of soils so as to appear concurrent with earlier cuts in the same area. Alternatively, earlier pit fills could contain various later sherds if soil removal in antiquity served to jumble and confuse the top layers. Due to the volume of material recovered on site, the AAPP followed a policy of combining all finds by context in a single bag without recording the absolute elevation. It is consequently possible that material from the top of pits, having been pressed down into the top surface through later exposure and trample could contaminate the full assemblage. This would indicate a later *terminus post quem* than should actually be the case. Fortunately, in most cases these cuts and pits have not been found to have a great impact upon the overall narrative of the property's development. In all instances, any uncertainties have been highlighted explicitly in the detailed discussion of Chapter 5.

Dating

For various reasons, the dating of deposits has also proven to be difficult. The dating presented in this volume derives from a number of sources. Spot dates were provided by the ceramics team during some years of excavation. Study of the red and black gloss by Jaye Mckenzie-Clark[79] has also produced some dates for deposits, though at the time of publication the full presentation of this work was not available. Dates are also derived from coins studied by Richard Hobbs and from glass dated by Hilary Cool. All of these dates have been applied to the Harris Matrix and phases have been grouped within these dates and the stratigraphic sequence with due considerations for possible outliers or the results of confused excavation and errors caused by truncation as discussed above. In general, it has been the practice to sequence any deposit into its latest feasible context, with the exception of the dating of the Casa del Chirurgo itself, which has been produced as a compromise between the earliest possible date permitted by finds and the likely date of subsequent changes to the property. On the whole, it must be admitted that despite the level of detail with which the excavations were undertaken, and the amount of data recovered, the dating has not been as secure as might have been desirable. Despite the frustration that this has caused on the part of those undertaking the post-excavation sequencing, the resolution presented in this volume is greater and more secure than anything that has previously been available for this property. Whilst it is unlikely that the dating of any general phase will be changed by publications of the artefact data or the full pottery catalogue, the possibility exists that some individual deposits may yet be slightly out of place.

Data accessibility

This volume is an effort to make available and accessible, as much of the information produced by the AAPP excavations as possible. The hierarchy presented here has been designed specifically in order to enable the reader to access the desired level of detail quickly and easily, and to minimise any need to re-synthesise or re-contextualise data from the bottom up, but also to facilitate future reinterpretation. The stratigraphic numbers make available all levels of data, so that the interested reader will be able to 'dig down' to the required level of resolution within this resource, without being hindered by the sheer quantity of individual facts, observations, and records. To this end, the following Chapter (Chapter 4) presents the combined, synthetic results of these excavations, while detailed discussion of the above and below surface stratigraphy of each room of the house follow in Chapter 5.

Notes

1 *"Il reste si peu de chose des peintures qui la décoroient, qu'on ne peut rien dire de leur exécution"* Mazois 1824, Vol. 2, 51.
2 Vitr. *De arch.* 6.3.1–11; Gros 2001, 39; De Albentiis 1990, 81–82. Cf. also Carrington 1933b and *contra* Boëthius 1934; Clarke 1991, 2–4.
3 Mau-Kelsey 1902, 274; Fiorelli 1873, 81; cf. discussion in Wallace-Hadrill 1997, 224–225; Carocci *et al.* 1990, 200.
4 De Albentiis 1990, 81.
5 Piranesi 1804–7; Fino 2006, 74.
6 Mazois 1824, Vol. 2.
7 Gell 1817. There also appears to have been a mistake made at that time that associated the name of the Casa del Chirurgo with another location in Insula VI 2 where surgical instruments had also been found. Thus, the illustration of the 'House of the Surgeon' in Gell 1852, 120, Plate 25 is actually of the nearby VI 2, 15.22.
8 Niccolini 1862, (Descrizione Generale) 20–22.
9 Cassanelli *et al.* 2002, 11; Tascone 1879, 2, 3–6; *CTP* Van der Poel 1981, 104–105.
10 Overbeck 1856.
11 *ibid.*, 183.

12 Vitr. *De arch.* 6.3.

13 Varro, *Ling.* 5.161 '*Cavum aedium dictum qui locus tectur intra parietes relinquebatur patulus, qui esset ad com<m>unem omnium usam. In hoc locus si nullus relictus erat, sub divo qui esset, dicebatur testudo ab testudinis similtudine, ut est in praetorio et castris. Si relictum erat in medio ut lucemcaperet, deorsum quo impluebat, dictum impluium, susum qua compluebat, compluium: utrumque a pluvia. Tuscanicum dictum a Tuscis, posteaquam illorum cavum aedium simulare coeperunt. Atrium appelatum ab Atriatibus Tuscis: illinc enim exemplum sumptum.*' Kent 1938.

14 Vitr. *De arch.* 6.3.1–4; Varro *Ling.* 5.161; Plin. *Ep.* 2.17.4; 5.6.15.

15 e.g. Gell. *NA* 16.5.3; Vitr. 6.7.1; Sen., *Ep.* 5.44.5; Polyb. 6.53; Plin. *HN* 35.6.

16 e.g. Mau-Kelsey 1899, 240–273; Clarke 1991, 2–12; McKay 1977, 32–59; Overbeck-Mau 1884, 248–249; Maiuri and Ragozzino 2000.

17 Cf. especially Allison 1994a, 82–89.

18 Though long standing, such associations are hardly unproblematic. Cf. criticism in Allison 2004, 63, supported by multi-functionality expressed by her analysis of the finds; cf. Allison 1993; 1994a; 2001; 2004b; Berry 1997. The widespread and potentially spurious use of ancient nomenclature for the purpose of labelling Pompeian rooms has long been called into question. Cf. Allison 1994, 82–89; 2004a, 63–64; Leach 1997, 50–72.

19 Fiorelli 1873, 78–86.

20 Fiorelli 1873, 81.

21 Mau-Kelsey 1902, 39–40 and 280.

22 Nissen 1877, 38. Cf. Wallace-Hadrill 1997, 224.

23 Mau 1879, 1; Overbeck and Mau 1884, 497–531.

24 Mau-Kelsey 1899, 39–40 and 274–276. 'This house was undoubtedly built before 200 B.C.' (p. 274).

25 *ibid.*

26 Dwyer 1991, 25, but note also Wallace-Hadrill 1994, 82–87 who found that only 41% of houses in his sample had identifiable *atria*. Even so, this is a very high percentage for a form that nominally was only needed by elites, as Vitruvius states '*Communia autem sunt, quibus etiam invocati suo iure de populo possunt venire, id est vestibula, cava aedium, peristylia, quaeque eundem habere possunt usum. igitur is, qui communi sunt fortuna, non necessaria magnifica vestibula nec tabulina neque atria, quod aliis officia praestant ambiundo neque ab aliis ambiuntur.*' Vitr. *De arch.* 6.5.1; Gros 2001, 38.

27 e.g. De Albentiis 1990; McKay 1977, 32–59; Ellis 2000; Clarke 1991; Thébert, 1993; Maiuri and Ragozzino 2000; Gros 2001. The most recent expression of this idea finds a strong expression in Jolivet's 2011 reconstruction of the cannon of the Etruscan and Roman *atrium* house.

28 The Italic nature of this form is well argued by Wallace-Hadrill 2007, 280 in which he highlights the use of *italico more*, not *romano more* in Vitruvius' discussion of the form (*De arch.* 6.7.7). De Albentiis 1990, 83 sees the Casa del Chirurgo itself as a representative of this form. Gros 2001, 22 reasonably suggests that connecting the atrium house to Etruscan antecedents is too narrow an explanation, implying a broader Italic derivation. Jolivet 2011 traces the ideological development of this cultural norm in direct opposition those who have questioned whether such a mental category could be said to have existed.

29 Serv., *ad Aen.* I 726. '*ibi et culina erat: unde et atrium dictum est; atrum enim erat ex fumo.*' Text Thilo and Hagen 1881–1902.

30 De Albentiis 1990, 25.

31 De Albentiis 1990, 41, 65; Gros 2001, 33, 35.

32 De Albentiis 1990, 85; cf. also Vitriuvius *De arch.* 6.7.1.

33 Varro *Ling.* 5.33.2; cf. Gros 2001, 22.

34 Gros 2001, 36–37.

35 Vitr. *De arch.* (6.7.1.) '*Atriis Graeci quia non utuntur, neque aedificant, sed ab ianua introeuntibus itinera faciunt latitudinibus non spatiosis, et ex una parte equilia, ex altera ostiariis cellas, statimque ianuae interiores finiuntur.*' Text Rose 1899.

36 *ibid.*

37 De Albentiis 1990, 78.

38 Excavated by Carandini, cf. Gros 2001, 37.

39 De Albentiis 1990, 78.

40 On Cosa, Bruno and Scott 1993; On Iberian examples of *atrium* houses Ellis 2000, 29; Gros 2001, 140–141.

41 Gros 2001, 41; Wallace-Hadrill 2007, 286–288. On the creation of shops especially post-earthquake cf. Maiuri 1942.

42 De Albentiis 1990, 108.

43 Dickmann 1997, 122.

44 De Albentiis 1990, 108; Ling 2005, 43–46; on Hellenistic luxuries especially Zanker 1998.

45 Wallace Hadrill 1994, 20–23.

46 Especially Maiuri 1942.

47 Wallace Hadrill 1994, 51.

48 Wallace-Hadrill 1994, 16, 51–52; Ellis 2000, 36.

49 e.g. Clarke 1991, 2; Gros 2001, 30, 40–41; Maiuri and Ragozzino 2000, 36; De Albentiis 1990, 83; McKay 1975, 36–37; Overbeck-Mau 1884, 279; Nissen 1877, 402ff; Mau-Kelsey 1899, 280–282; Carrington 1933, 128; Maiuri 1973, 12; Fiorelli 1873, 81; Sear 1982, 32.

50 Maiuri 1973, 1–13.

51 Indeed, Maiuri appears not to have looked at the coarse wares from his excavated contexts, which were all reburied in the backfill of one of his *sondages* in the atrium and were recovered during excavations by the AAPP in 2002.

52 Maiuri 1973, 6–8.

53 *ibid.* Our re-assessment of the local stratigraphy would seem to indicate that the well would have been sealed and indeed covered by the artificial terrace created by the destruction of the building with which the well was most probably associated. Consequently Maiuri's failure to interpret the stratigraphy correctly had serious repercussions for the continued misunderstanding of this property.

54 Maiuri 1973, 12.

55 Wallace-Hadrill 1997, 226 suggests that Maiuri was likely looking specifically for the Samnite origins of the impluvium/atrium form that stood in direct opposition to the ideas of Patroni.

56 e.g. De Haan *et al.* 2005, 248; Peterse 2007, 377; Peterse 1999, 56–57.

57 Wallace-Hadrill 1997.

58 Carrington 1933a, 125–138.

59 Pernice 1938, 84.

60 A number of publications serve to undermine the established chronology, most notably the work of Fulford and Wallace-Hadrill in Insula I 9. Cf. Berry 2008, 63–9; Wallace-Hadrill 2007, 281; Dobbins *pers. comm.*; Carafa 2011; 2005 in the Triangular Forum, although this work has sometimes has surprisingly little impact on the still widespread use of these systems, e.g. the on-going debates discussed in Carafa 2005, 25 regarding the dating of structures in '*tufo di Nocera.*'

61 Cf. De Albentiis 1990, 81–82 who dates the structure to the second half of fourth century BC. Cf. also Clarke 1991, 2; Overbeck and Mau 1884, 248; Carrington 1933a, 1933b; Boëthius 1934; McKay 1975, 55; Maiuri 1978, 14–15; De Vos and De Vos 1994, 56–57; Barton 1996, 33–43; Maiuri and

Ragozzino 2000, 36. The house does not appear in Pesando 1997, presumably because it was thought to be too early.

62 e.g. McKay 1977; Clarke 1991; De Albentiis 1990; Gros 2001; Barton 1996; Sear 1982; Ellis 2000; Boëthius and Ward-Perkins 1970, 66. As pointed out by Wallace-Hadrill 1997, 217, these derive from the now-enshrined ideas of Mau and others. Attempts to break the mould include Wallace-Hadrill 1997; Tamm 1973; Evans 1978.

63 The use of the evolutionary metaphor to describe change and innovation both in the Roman house and in material culture more generally, while seductively simple, is fraught with difficulty. Cf. Gamble 2007, 107. Small-scale incremental change at a biological level that is imperceptible to humans is not how changes in domestic architecture occur, but through individual social choices and action within the complexity of culture.

64 Especially Allison 1992, 12–13; 2004, 11–12.

65 Wallace-Hadrill 1997 suggests that this is due to the ease with which impliuviate atria are preserved in archaeological contexts.

66 De Albentiis 1990, 101; Cf. also Pesando 1997, 277–284.

67 Bruno and Scott 1993; Pesando 1997, 284–290.

68 De Albentiis 1990, 101; Vitr. *De arch.* 6.3.1.

69 Hoffman 1979; Nappo 1997.

70 Patroni 1902, 467–507 suggested a Bronze Age *megaron*; Wallace-Hadrill 1997, 223–228 examines the potential for the development of the space from an open courtyard.

71 Dwyer 1991, 25. Jolivet's 2011 work on the ideological origins of the cannonical plan of the Etruscan and Roman house is also relevant to this discussion.

72 Clarke 1991, 2–29; Gros 2001, 22–27; and in a different way Wallace-Hadrill 1994, 3–64. See also discussions of the axial alignment in atrium houses, e.g. Drerup 1959; Bek 1980, 164–203; Jung 1984; Hales 2003, 107–122.

73 On finds analysis cf. Allison 1993; 1994a; 2001; 2004b; Berry 1997; On spatial analysis; Grahame 1997, 2000; Anderson 2005.

74 For instance, cf. Allison's discussion of her category of front halls (atria) Allison 2004a, 65–70.

75 Wallace Hadrill 1994, 51; Saller 1982, 7ff.

76 We would like to thank all of the supervisors and students upon whose work this report is based. We would also like to thank the large team of specialists who are acknowledged alongside the data that they have generously allowed us to use in this report.

77 Morichi *et al.* 2008.

78 This work was undertaken by Michael Anderson.

79 Mckenzie-Clark 2006, 2009, 2012a, 2012b.

4

THE STRATIGRAPHIC AND STRUCTURAL SEQUENCE OF THE CASA DEL CHIRURGO

Michael A. Anderson and Damian Robinson

Excavation in nineteen of the twenty-eight internal spaces within the Casa del Chirurgo and its dependencies (Plots 5 and 6), combined with comprehensive architectural analysis of the whole structure, has produced a complete record of the built and buried stratigraphy for the site (cf. Fig. 3.1 supra).[1] This chapter documents the full history of development of the property from the pre-existing natural topography through the creation of the first structure in the area,[2] its replacement by the famous Sarno stone atrium house, its subsequent alteration and modification, and its final years prior to the eruption of AD 79. While in some cases, these results support earlier observations regarding the course of the development of this well known Pompeian property, a number of long-held hypotheses have also been invalidated, including the supposed great antiquity of the Sarno stone core of the structure, the reconstructed initial layout of the house, and the believed absence of its tuff impluvium in its earliest phase. Analysis of the stratigraphic record has also revealed the individual steps by which the house developed from its original form into its final appearance, an aspect that has never been considered in any detail. For most of the identified phases of the property, it has been possible to suggest a date range based on a greater quantity of scientific evidence than was previously available. This chapter presents an overview of the development of the Casa del Chirurgo, detailing each phase identified and explaining their major events. Further particulars, including precise discussion of stratigraphy from each excavated archaeological area and detailed analysis of the standing wall structure, is organised room by room and may be found in Chapter 5.

Phase 1. Natural soils

Natural soils were generally recovered as the lowest stratum in excavations throughout the Casa del Chirurgo and its dependencies (Figs. 4.1 and 4.2). These were found to consist of a series of related levels arranged in a regular and predictable gradient of colours and textures.[3] The top layer of natural soil was a thick (sometimes more than 20 cm) deposit of fine, silty soil, chocolate-brown in colour, representing a long period of accumulation and top-soil creation, capped by a thin, degraded, yellow-tan, silty layer that has been interpreted as a sign of organic growth

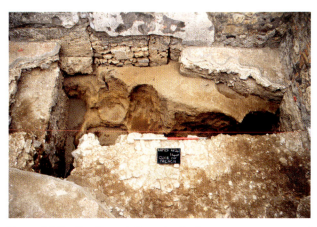

Figure 4.1. Section through the natural soils sequence as recovered in Room 10 (AA261) (image AAPP).

Figure 4.2. Plan of the deposits recovered from Phase 1 (illustration M. A. Anderson).

on top of the soil as it lay open prior to a subsequent burial.[4] Immediately underlying the chocolate-brown soil, the silty soil gradually and smoothly graded into different colours and textures, transitioning first to a sharp yellow and then to a bright orange silty soil.[5] Similar natural soils, particularly at the lower level of the gradient, appear to have been recovered in the earliest phases of the Casa di Sallustio.[6] At depth, the soils became increasingly gritty, with ever-higher percentages of coarse, black volcanic inclusions and

altering in colour from a yellow to a greenish hue. Finally, underlying all of these was a loose and variable course sandy-gravel of fragmented dark grey to black volcanic scoriae. These were similar to the inclusions found at higher levels, although in this stratum they comprise the majority of the soil matrix and probably represent the degraded top surface of the underlying solid lava stone.[7] This gradient of natural soils, the product of the geological process of soil production through weathering of ancient eruptive debris atop the

volcanic plateau upon which Pompeii is built, produced no signs of human activity or other datable residue.

The undisturbed top surface of this sequence of natural soils was only infrequently recovered within the area of the Casa del Chirurgo, as it was often truncated by later activities and because excavation regularly terminated at one of the several strata that immediately overlay it (cf. infra). The top surface of this sequence was exposed on the southern side of the tablinum (Room 7), the south-eastern side of the triclinium (Room 10) (Fig. 4.1) and was also observed in the section of later pits in the eastern portico (Room 16). Elsewhere, later pits, terracing, and construction had removed various parts of the natural sequence to different depths. Consequently, the earliest recovered anthropogenic deposits lay immediately above deeper levels of the natural soil gradient. Hence, on the eastern side of the atrium (Room 5), within the south ala (Room 8A), and on the north-eastern side of Room 2, chocolate-brown silty soil was recovered truncated by only a few centimetres, whereas in Room 23, Rooms 3 and 4, the western side of Room 10, and the northernmost part of Room 11, only the lower, yellowish part of the natural sequence was preserved, generally at an elevation about 80 cm lower than in the central areas of the house.

The soils that comprise this natural gradient may be compared directly to very similar strata recovered at depth in a number of excavations across the city.[8] These have been identified by a recent study as deriving from the Mercato eruption of Vesuvius.[9] The top surface of this gradient may therefore represent the topography present in the late Neolithic or early Bronze Age. Similar soils from V 3, 4 appear to have produced prehistoric remains.[10] There was no indication, however, of any form of human activity at this time in the area of Insula VI 1. It is nevertheless possible to provide a general impression of the natural lie of the land, even though its partial preservation means that this early topographic portrait of the area remains somewhat conjectural. It seems that the area later occupied by the Casa del Chirurgo and the Casa delle Vestali, was originally a mildly elevated hillock with respect to Insulae VI 2 and VI 3 on the east and the Insula Occidentalis on the west.[11] This is suggested by a comparison of elevations taken on this deposit throughout the Casa del Chirurgo, which indicate that while its overall surface undulated mildly, there was a slight inclination towards the area of the later tablinum (Room 7). The later truncation of these deposits on the southern side of the property, especially evident within Rooms 6A, 6C, and 11 and to the south, destroyed traces of the initial topography in these areas, but it is likely that the primary natural

surface continued to slope downward in a manner similar to the incline of the present Via Consolare. The course of this thoroughfare, though not the street itself, is likely to have already been present in the form of a gully or small ravine similar to what seems to have been the case for the early Via Vesuvio/Via Stabiana.[12] The only proof of this is that the earliest phases of occupation universally respected the edge of the Via Consolare, suggesting that it preserves a natural feature that had long been in place. Unfortunately, the Casa del Chirurgo's façade interfered with any further understanding of the relationship of the insula to this gully. Similarly, on the eastern side of the block, a later lowering of the pavement of the Vicolo di Narciso has removed any early evidence in this area.

Phase 2. Volcanic deposits and early constructions[13]

The first strata overlying the natural soils consist of two deposits of likely volcanic origin. They were deposited in a uniform pattern across the entire insula and were encountered in excavations within the Casa del Chirurgo and the northern part of the insula, especially the Casa delle Vestali, Inn, and northern bars.[14] Like the lower natural soils, it is clear that the later terracing of the topography removed evidence of a much more extensive original distribution of these deposits to the south. The yellow-tan silty top surface of the natural soils was sealed by a layer of light, fine, pea-sized gravel, roughly 5 mm in size. The layer varied in thickness, often being as thin as only a few centimetres, but measuring up to about 20 cm thick in areas to the north of the Casa del Chirurgo. Overlying this was a firm stratum of extremely fine silty soil that was partially laminate in texture and capped by a friable 'pocked' or 'pitted' surface, comprised of small holes, cracks, and striations that was generally less than 5 cm thick.[15] This upper 'pitted' earth surface was often so integrated with the underlying pea-sized gravel as to be practically inseparable from the upper surface of the lower deposit and it seems likely that the two were deposited as part of the same event.

Strongly similar deposits from excavations in the Casa degli Epigrammi Greci (V 1, 18.11–12), the shop at V 1, 13, and under the Via delle Nozze d'Argento have been attributed to two different eruptive phases from the Campi Flegri.[16] This suggests that the deposits from Insula VI 1 may also derive from the same, or similar eruptions, though due to the difficulty of synchronising excavated data with published descriptions and

photographs, this connection must remain tentative.[17] The deposition process suggested by this identification could potentially help to explain the underlying yellow-tan 'turf' surface of the natural soils as the result of anaerobic decay after a sudden volcanic burial. In Insula VI 1, the degree of later interference in these layers meant that they occasionally erroneously appeared to have produced artefacts, leading the excavators to conclude that these deposits were anthropogenic, a theory that must now be discarded.[18] The characteristic pock-marked surface of the upper strata, which was interpreted as evidence of use for agricultural production, remains a plausible identification, although in the absence of any actual artefacts from this layer it is perhaps less likely.[19] A similar surface in the excavations of the Casa dei Postumii (VIII 4, 4.49) was also interpreted as showing traces of agricultural activities.[20] Unlike the deposits recovered in the area of Insula V 1, however, no traces of Bronze Age pottery or use were recovered from the area of the Casa del Chirurgo. The eruptive deposits rest directly on the underlying palaeosols and were themselves buried directly by another layer of soil that is also of likely volcanic origin. In fact, any dated material recovered from these layers was of such a late date that it must be regarded as contamination. As a result, it would appear that this area of Insula VI 1 remained either entirely underutilised, or was engaged only in light agricultural pursuits well into the early first millennium BC. This supports the theory that the locus of Bronze Age

activity in Pompeii may have been situated further to the east.[21]

On the eastern sides of the tablinum (Room 7) and in rooms to the east of this (Rooms 17 and 18) the sequence of pea-sized gravel and grey-silt layers was found to repeat with a second, nearly identical, 5 cm thick layer of pea-sized gravel and silty capping that immediately overlay the first[22] (Fig. 4.3). In the tablinum, these layers sealed what was interpreted as a root cavity. Plausibly these are traces of a second, later eruptive phase, as identified in Insula V 1,[23] with an absence of evidence for human activity or build-up in between them. This leaves the question of why this repetition should be present on only one side of the insula. Perhaps it relates in some way to the underlying topography, which appears to have been sloping gradually downward towards the east.[24] It is also possible that in a situation analogous to later eruptive deposits described by Robinson, a more immediate burial occurred in these areas that protected it from rapid erosion and degradation.[25] Continued agricultural use of the area may itself have resulted in differential preservation or truncation of earlier soils in the rest of Insula VI 1. Alluvial action may also have produced a similar repetition.[26]

Dark-grey to black sand[27]

Directly overlying these strata was a layer of dark-grey to purple-grey volcanic sand that, just like the natural soils and overlying eruptive debris,[28] once

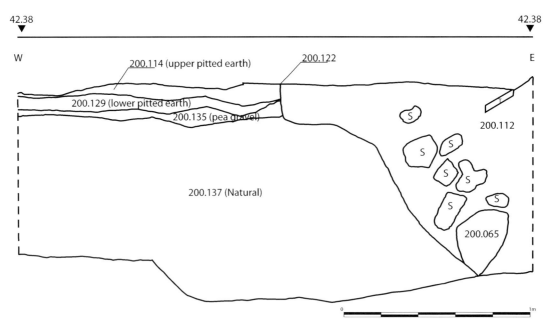

Figure 4.3. Section through a pit in Room 7 (AA200), showing the double layer of 'pitted earth' SUs 200.114 and 200.129 (illustration M. A. Anderson).

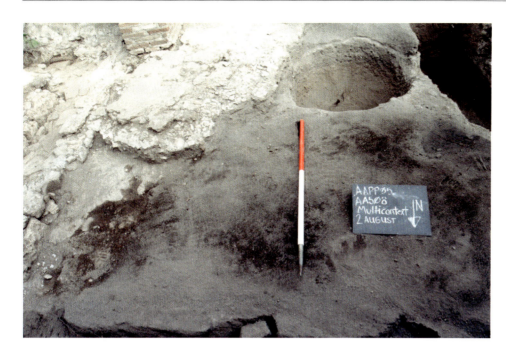

Figure 4.4. So-called 'black sand' deposits of likely volcanic origin recovered in the Casa del Chirurgo, here in Room 16 (AA508) (image AAPP).

extended across the entirety of Insula VI 1. Like all of the earlier layers, however, this had been truncated in the southern half of the block beginning roughly mid-way through the Casa del Chirurgo (Fig. 4.4). Within the Casa del Chirurgo, this layer was found generally to the north and east of Room 23, including the tablinum (Room 7), the portico and hortus (Rooms 16 and 20), Rooms 18 and 17, and on the northern side of Room 13, where it generally measured 15–25 cm thick. Elsewhere, such as the in triclinium (Room 10), it barely occurred at all or was entirely non-existent, such as in the atrium (Room 5). This layer was found much more uniformly within the excavations in the Casa delle Vestali, the Inn, and Casa del Triclinio, but was not present at all in excavations at the southern end of the block. Colloquially known by the excavators as 'the black sand,' this layer also posed some difficulty for interpretation and sequencing as later cuts through it were sometimes not clearly observed until 'the black sand' had itself been removed causing some confusion in the final record.[29] Additionally, ancient builders in Insula VI 1 had the habit of exposing the top surface of this deposit by removing concrete floors overlying 'the black sand' in preparation for construction, an activity that introduced considerable contamination by later materials and probably truncated earlier cuts and pits. At the same time, it is clear that this deposit was once present across most of Insula VI 1 before any large-scale construction or terracing, all of which was cut directly into this deposit. Precisely how early this 'black sand' should be sequenced in terms of the chronology of Pompeii and its exact origin are difficult questions

exacerbated by fact that no solid dating information was recovered from these sterile soils.

This matter may only be partially resolved through a comparison with similar deposits excavated elsewhere in the city, which are frequently described as an ashy layer of sterile '*cenere vulcaniche*' directly underlying the earliest anthropogenic remains.[30] The descriptions of these soils in reports of subsurface excavations pose the same difficulties for comparing with the results in Insula VI 1 as the underlying 'pitted earth.' Indeed, it is possible that elsewhere these two deposits have been equated. Recently, soils described as a sandy soil of 'volcanic origin with lapilli' have been attributed to one of the several ante-Plinian (AP) eruptions of Vesuvius, dated roughly to between 1700 and 700 BC.[31] Such an attribution would be supported by the recovery of seventh century pottery in association with the layers in those excavations.[32] Indeed, in VIII 4, 42, the top surface of the AP eruptions witnessed not only probable agricultural activities, but also another eruption from Ischia and the significant build up of Iron Age debris.[33] These were sealed by strata dated by ceramics and radiocarbon to roughly 1000–830 BC.[34] If they are the same this would also mean that when present, the grey volcanic deposits in the Casa del Chirurgo predate the earliest (mid-sixth century BC) remains of the city wall and contemporary 'archaic' foundations in 'pappamonte' stone, which are often noted as being cut into the underlying soil.[35] Certainly, predating the earliest stone construction, either of the archaic or subsequent periods, is the one thing that these similar strata appear universally to have in

common throughout the city, and this is shared with the 'black sand' of Insula VI 1. However, no remains from the archaic period were recovered from our excavations and the earliest attested feature nearby is the city wall to the north. Maiuri's excavations at the Porta Ercolano suggested that a city circuit, religious boundary, or terracing would have run across the northern end of the block by mid-sixth century BC.[36] Recent work by De Caro, Sakai, and Iorio has supported this chronology, and excavations at the Porta Capua suggest that the 'black sand' does underlie the earliest 'pappamonte' masonry in the city wall.[37] Excavations within the Casa del Triclinio in Insula VI 1 revealed that the same 'black sand' deposit certainly predated the roughly third century BC addition of an inner curtain wall and steps in Nocera tuff,[38] but did not reveal its relationship to any earlier phases of the city walls. In fact, as in many other excavations in the city, the most that can be said about this deposit is that in Insula VI 1 it directly underlies the earliest activities attested in the block, which date to the fourth to mid-third century BC. This might mean that the 'black sand' in Insula VI 1 was deposited during a long period in which the area was exposed to the open-air, before the archaic structures in 'pappamonte' that appear elsewhere in the city were constructed.

Its immediate presence under much later structures in Insula VI 1 may suggest that this part of Regio VI continued to be largely unoccupied or used for light agriculture until this time. This might appear to support a long standing belief that much of the northern part of the city was sparsely occupied, or even that it was in use as a sacred grove, as suggested by Bonghi-Jovino whose excavations also recovered a dark soil that was filled with carbonised wood from beech trees, as well as finds datable to the archaic period.[39] At the same time, the nearby discovery by Progetto Regio VI, not only of archaic 'pappamonte' and coarse lava stone foundations,[40] but also overlying alluvial soils indicative of abandonment in the mid-fifth century BC,[41] demonstrate that Regio VI was not entirely vacant in the archaic period, even if the urban density was nothing like that in the period after the end of the third century BC.[42] Indeed, it has become increasingly clear that much of the area within the circuit wall was just as densely occupied as the central core, traditionally, though perhaps erroneously, identified as an 'altstadt.'[43] This raises the question of why nothing comparable was found in Insula VI 1. The complete absence of such deposits in Insula VI 1, might suggest that intervening layers have been truncated. The widespread terracing that is the hallmark of the

subsequent phase (cf. infra), the effects of which have already been mentioned, may well have also included the areas to the north. Perhaps the area later occupied by the Casa del Triclinio, Inn, Casa delle Vestali, and Casa di Chirurgo, represent an upper terracing step, while the area to the south represents the next step down. Such work might have truncated the top layer of the 'black sand' removing any anthropogenic traces from its surface, presenting a 'clean slate' for the earliest attested activities in the fourth century BC.[44] The fact that the AP eruptive deposits recovered outside of the city and in Insula V 1, 18 are nearly a metre in depth, might lend support to such an interpretation. Within Insula VI 1, the maximum thickness of similar soils approaches roughly half a metre. The absence of data from Insula VI 1 until after the mid-fifth to mid-fourth century BC 'gap'[45] in the Pompeian sequence may well be a result of the initial activities of the 'early Samnite period' of reconstruction and urban planning between the late fourth and early third century BC.[46]

Activity prior to the construction of the Casa del Chirurgo

Terracing[47]

The first clear evidence of human activity in the area of Plots 5 and 6 was the excavation and removal of soil on the southern side of the property to the depth of roughly one metre (70–100 cm). This cut through the original natural to the depth of the yellow-orange silty soils and simultaneously removed any traces of the surface of the soil, 'pea-gravel,' 'pitted-earth,' and generally 'the black sand' from these areas to create a lower terrace. It is likely that this also involved a lowering or levelling of much of the area to the north. Though later interventions have obscured many aspects of the terrace's original appearance, sufficient elements of the terrace edge were recovered from Rooms 10, 11, and 23 to form a general impression of its shape and direction. These do not form a single linear feature stretching across the insula, possibly due to subsequent alteration. The clearest traces of the terracing cut were recovered from the northern end of Room 23, where a stepped bulk against the northern natural soils was found that clearly followed a different alignment to that of the Casa del Chirurgo. This bulk edge is mirrored in alignment with a roughly straight-sided cut in Room 11 and when both of these are taken together they produce a 2.2 m wide channel that runs eastward before turning roughly north through Room 10 (Fig. 4.5). Furthermore,

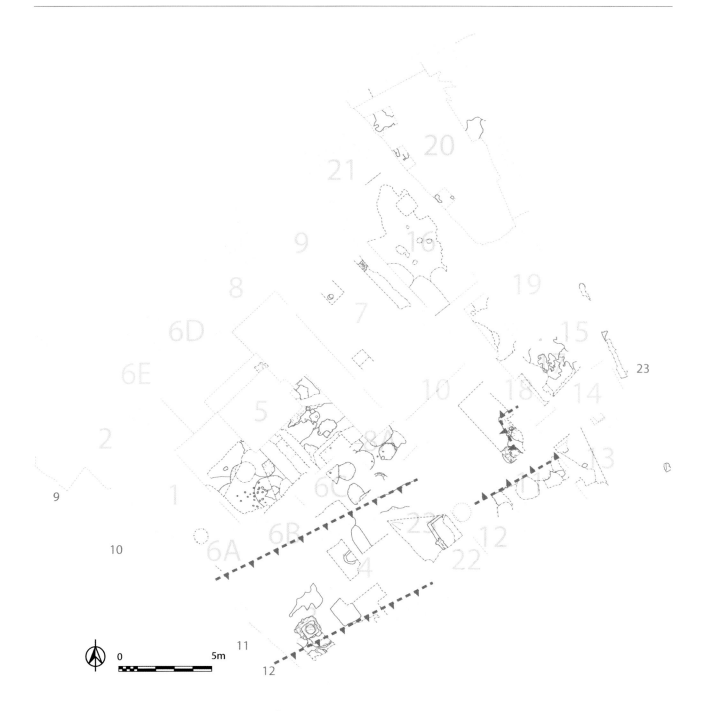

Figure 4.5. Terracing cuts recovered in the area of the Casa del Chirurgo marked in a thick dashed line (illustration M. A. Anderson).

a cut observed in the section of a pit within Room 6A suggests that the terrace cut may also have included the intentional broadening or formalisation of the natural or pre-existing channel on the west marking the course of the Via Consolare.

In the south-west corner of Room 3, there was another terrace step that penetrated deeper into the black-gritty soils at the bottom of the natural sequence. Excavations within the insula to the south of the Casa

del Chirurgo suggest that this second drop in level probably extended across much of the southern part of the block, which remained at a lower general elevation throughout its subsequent development. The end result was an upper terrace that preserved the level of the original high ground, a middle terrace to the south that began on the southern side of the Casa del Chirurgo, and at least one lower terrace to the south of this. The precise purpose of these terraced steps

is uncertain, but the removal of so much soil clearly required a considerable investment of labour. While the terracing might simply represent preparations for the construction activity that was to follow, there is no reason why the two activities should be directly connected and it is clear that the subsequent properties were not bound by the terraces, which were not treated as plot divisions. Significantly, neither the final northern boundary of the later Casa del Chirurgo, nor the Via Consolare itself seem to have been elements governing the alignment or arrangement of these terracing cuts, which for the most part are aligned either parallel to or at right angles with the Vicolo di Narciso and hence the Via Mercurio.[48] It is consequently possible that the initial removal of soils on the southern side of Insula VI 1 was a direct result of the planning of the city grid as a whole, rather than the construction of individual buildings. Certainly, the phenomenon of early terracing within the city has begun to be revealed in a number of excavations.[49] From the evidence recovered within Insula VI 1 and the Casa del Chirurgo, it is not possible to be certain of the chronology of this terracing. While 'pappamonte' tuff blocks of the archaic period have been interpreted as related to terracing elsewhere,[50] on the whole it seems more likely that the terracing activities documented within Insula VI 1 took place later, perhaps between the mid-fourth to mid-third century BC, after the beginning of the so-called 'Samnite phase' of the city when it has been hypothesised that the planning of the city grid may have taken place, if it had not already been accomplished before.[51] Certainly there is no layer of build-up present between the terrace cut into the natural soils and the subsequent primary constructions in Insula VI 1.

The Pre-Surgeon Structure

Following these cuts, most likely in the first half of the third century BC, a structure was built directly onto the exposed natural soils.[52] Although only fragmentary traces of it have survived amongst the interventions of later phases, sufficient evidence remains to be able to say something about the size, layout, and development of the early building. Its function remains relatively opaque and for this reason it has been given a neutral description as the 'Pre-Surgeon Structure,' though it is certainly possible, and perhaps even likely, that it was a house. Given that it is situated at the base of a terrace scarp, it is also conceivable that the structure formed some sort of basement for a now missing superstructure. The surviving elements of the structure, however, give no strong indications that this was the case. The structure appears to have occupied most of the middle terrace level, possibly in some cases cutting back into the terrace scarp to make space for its rooms. The walls of the building were entirely removed during its destruction, but were apparently built directly against the terrace scarps, probably employing beaten earth (pisé) over a single course of stone foundations.[53] The most extensive evidence for the structure was recovered from Room 23 of the Casa del Chirurgo, which also provides the only indication of any stages of development within the structure's occupation. These sub-phases may either document the process of construction followed by a period of use, or simply attest to a relatively long period of utilisation for the structure with some modifications over time.

Sub-phase A

The earliest indications of construction were several roughly square cuts into the lower terrace surface approximately one metre long and about half a metre wide, situated in the middle of the area that would later become Room 23. Tamping or packing in the base of these cuts suggested that they might once have held stone blocks arranged at 90 degrees to each other (Fig. 4.6). These were roughly aligned with the terrace cuts and the Vicolo di Narciso. It is difficult to assign any function to these features, but they may have played a role in support of the now-missing wall system, or simply have been temporary residue of the construction of the building itself.

Sub-phase B

After the removal these features, the robber-trenches were filled with a dark volcanic sandy soil that was very similar to the soil discussed above and likely originated from it. Afterwards, thin levelling layers and an earthen surface were deposited across the area. According to spot dates produced during the excavation, pottery from the fills of the robber-trenches and the levelling layers gives this activity a terminus post quem of 320–270 BC.[54] The area was also provided with a roughly square 'impluvium-like' feature consisting of an internal core of Sarno stone overlain by a hard, pale brown mortar (Figs. 4.7, 4.8). Overlying the mortar base was a thinner layer of opus signinum containing frequent limestone inclusions that created a decorative finish and rendered its surface waterproof.[55] Following the creation of the 'impluvium-like' feature, a silty-sand was deposited in a 4 cm thick layer that abutted the lower portion of the walls of the feature and created the first floor surface associated with it.[56] An orange-red stain in this

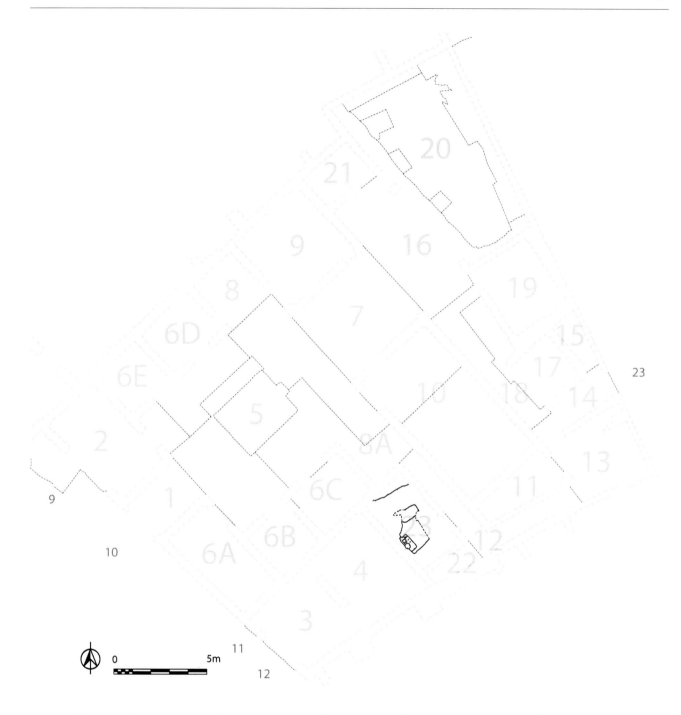

Figure 4.6. Elements of the Pre-Surgeon Structure during sub-phase A in Room 23 as recovered by excavation (illustration M. A. Anderson).

surface and its associated fragments of charcoal might suggest that a brazier or a small fire had been located here. The floor also showed signs of repair implying a certain longevity of use. A second layer of sandy silt was subsequently deposited across the space perhaps to refresh the surface.

The purpose of this 'impluvium-like' feature seems to have been to create a shallow basin into which water (probably rainwater) might fall to be collected.

The *opus signinum* surface sloped gently, dropping by approximately 10 mm from the north, south, and west towards the east. The position where a cistern for storage ought to have been is now occupied by a deep shaft lined with waterproof plaster that, at least in its present form, pertains not to this phase but to the subsequent Casa del Chirurgo (Phase 3 Room 12). It is suggested that despite its narrow well-like shape, this feature represents an original cistern of the Pre-

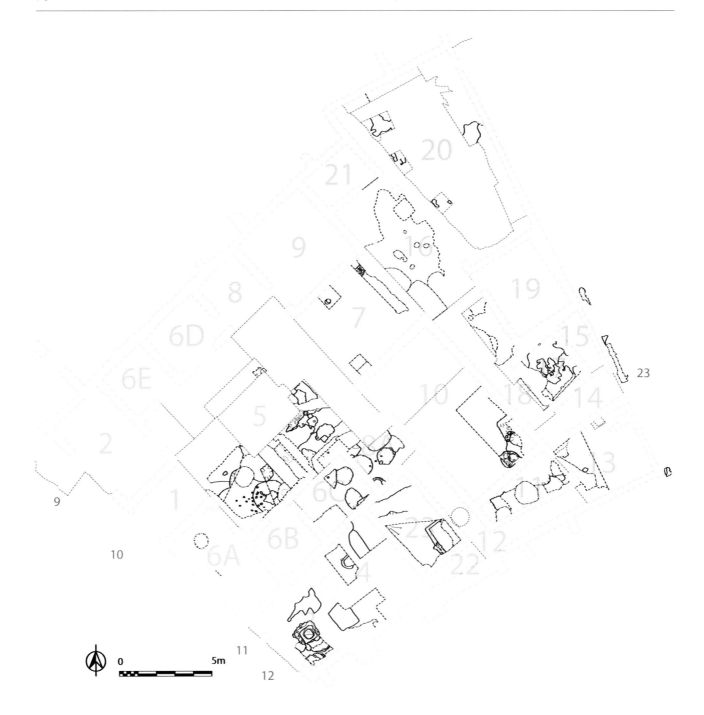

Figure 4.7. Elements of the Pre-Surgeon Structure during sub-phase B as recovered by excavation (illustration M. A. Anderson).

Surgeon Structure that was reused and modified in the next phase of construction.[57] A similar reused cistern was found in Room 22 that may also have originally been connected to this system, but its precise relationship has been obscured by the construction of later walls through these spaces. Since neither well nor cistern were excavated to depth, it is impossible to be certain of their earliest phases.

Additional water storage and procurement features of the Pre-Surgeon Structure include another possibly reused narrow cistern in Room 3 and the well excavated by Maiuri in Room 6A. If the cistern in Room 3 pertains to the Pre-Surgeon Structure, it will have experienced two phases of reuse and modification as its level will have been raised during Phase 3 and then lowered again in Phase 5. The final position of the stone collar that caps the cistern nevertheless matches the alignment of the Pre-Surgeon Structure and its position within the overall property is analogous to that of Maiuri's well in Room 6A, aspects that bolster

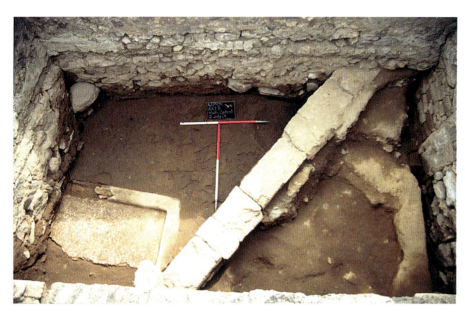

Figure 4.8. The Pre-Surgeon Structure impluvium-like feature and beaten earth upper floor surface (image AAPP).

the case for its history of repeated reuse.[58] Given the visual similarity of these features to Maiuri's well, it seems likely that they may be contemporary and it is possible that Maiuri's well was also a cistern. The pottery Maiuri found in its closure, which he dated to the third century BC,[59] is not incompatible with the chronology presented here, suggesting that it went out of use prior to the construction of the Casa del Chirurgo in Phase 3 and that it was perhaps filled with materials from the Pre-Surgeon Structure. Beyond these features, little additional evidence of the Pre-Surgeon Structure survived to the west of Room 23, due to the later removal of soils down to the level of the Via Consolare. Nevertheless, faint traces of squared cuts, postholes, and a possible hearth base in Room 4, were also roughly in alignment with the Pre-Surgeon Structure and plausibly represent truncated elements of features related to this phase.

The rest of the Pre-Surgeon Structure
On the north-east an adjoining area was attached to the space with the 'impluvium,' creating a rectangular space roughly double the size of the 'impluvium' itself. Connected to this, further elements of the Pre-Surgeon Structure ran throughout the area of Room 10 and contained more significant evidence of the use of space. In alignment with the terrace edge, a narrow, vertical-sided 2.25 m deep pit was found filled with a loose green deposit containing twelve almost complete Greco-Italic amphorae (Fig. 4.9) and intermixed throughout the whole of its depth with large black lava stones and other debris. The morphology of the pit is unusual and it is

significant that its contents were stained with a yellow-green mineral deposit. This form of mineralisation has most commonly been found elsewhere in the insula on the contents of drains and cesspits.[60] It is therefore suggested that the pit was used either as a latrine or a cesspit in the period prior to the construction of the

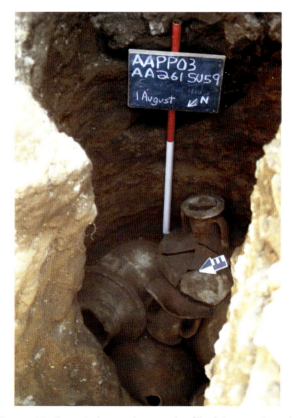

Figure 4.9. Greco-Italic amphora in the fill of the pre-Casa del Chirurgo latrine pit (image AAPP).

Casa del Chirurgo. The fill of the pit, and hence the termination of its use, can be given a *terminus post quem* between the fourth and second centuries BC.[61]

Northern terrace of the Pre-Surgeon Structure
To the north of this structure, in the area of higher ground untouched by the initial terracing cut and on top of the natural ground surface, traces of early activity demonstrate the extensive use of this area prior to the construction of the Casa del Chirurgo. Numerous small pits, postholes, and stake-holes were cut and re-cut into the lower surfaces, producing a very complicated sequence of inter-cutting pits.[62] This suggests that this space was in use, possibly for cultivation or some other repetitive activity. In the area of the portico (Room 16) six postholes were cut in two roughly parallel lines (Fig. 4.2) through the 'black sand' and into the underlying 'pitted earth' and natural. Similar cuts, often of isolated postholes but also broad, shallow and roughly circular cuts were found scattered throughout the southern side of the atrium (Room 5), the southern ala (Room 8A), and its adjacent Room 6C. Unfortunately, it is difficult to be certain whether all, some, or any of these postholes belong together and relate to any kind of structure, or whether, such as appears to be the case for the swarm of stake-holes located in the south-western corner of the later atrium (Fig. 4.2), they are simply representative of a single activity repeated through numerous iterations over a period of time. The intensity of cutting in these areas was unmatched by any other contemporaneous activity and the fills of these cuts, which largely consisted of building materials, did little to suggest any clear function or purpose for their creation. These areas, especially the western half of the atrium (Room 5), were subjected to considerable alterations during later phases and were punctuated by later cuts and fills that have complicated the sequence significantly.[63] For this reason, it is not possible to be more precise about the use of the space on the northern terrace during the period of the Pre-Surgeon Structure.

During this same period, the tablinum (Room 7) preserved traces of a shallow (13 cm deep) Sarno stone rubble wall set with earth-mortar, cut into the underlying 'black sand,' with a roughly east–west alignment (Fig. 4.2). If this fragmentary feature was part of an early structure in the area, it may support the idea that some elements of the Pre-Surgeon Structure continued to the north at the level of the northern terrace. This wall is, however, far too fragmentary to be able to reveal more about the activities in this area. It is nevertheless tentatively suggested that the northern terrace belonged to the Pre-Surgeon Structure at this time, perhaps functioning as a garden/horticultural space.

Pre-Surgeon Structure layout
While the presence of an impluvium-like feature in roughly the centre of the Pre-Surgeon Structure does not itself indicate that the building was an early 'atrium house,'[64] this remains a likely possibility. It is clear, however, that there is insufficient space for most of the 'classic' features of the atrium house and no specific evidence was recovered that makes a domestic attribution certain. Regardless of its actual function, it is nevertheless possible to speculate about the layout and probable property boundaries of the Pre-Surgeon Structure on the basis of the remaining evidence.

The distance between the 'impluvium-like' feature and the surviving line of the northern terraced scarp is roughly 9 Oscan feet. If the impluvium-like feature is reconstructed at roughly 4–5 Oscan feet square, which seems likely given the position of the cistern to the east and the surviving remains, then a similar distance of about 9 Oscan feet separated the eastern side of the feature from both another terrace edge on the east (in the western end of Room 11) and the southern side of the impluvium-like feature from the southern boundary terrace edge (preserved in Room 3). Taken together, this would produce an overall width of 22–23 Oscan feet. Similar modules of 9 Oscan feet separate further elements of terracing, such as the long terrace cut through Room 10 in coordination with a toilet which is 18 Oscan feet from the impluvium-like feature. On the whole, while these observations do not coordinate into a full or comprehensible plan of the Pre-Surgeon Structure, they reveal aspects of the architectural planning behind it. This implies a central core space roughly 22–23 Oscan feet wide, with associated spaces that were sometimes cut back into the terrace with a plan featuring common modules of 9 Oscan feet (Fig. 4.10).[65]

Taken together, the overall dimensions of the Pre-Surgeon Structure with a narrow width of roughly 22–23 Oscan feet are comparable, if a bit on the small side, to the plot dimensions described by Nappo in the *case a schiera* of Regiones I and II, which were 29–36 Oscan feet wide.[66] This smaller division may plausibly be explained by a consideration of the property boundaries of the later Casa del Chirurgo, which measures 69 (3 multiples of 23) Oscan feet along the Via Consolare and 92 (4 multiples of 23) Oscan feet along the Vicolo di Narciso. A method of plot division via multiples of consistent modules along street frontages and their logical intersections within

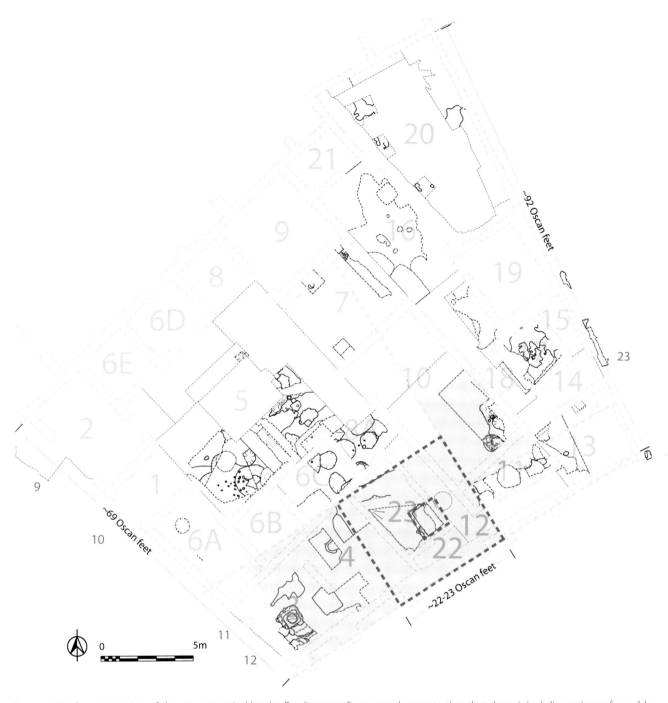

Figure 4.10. Reconstruction of the area occupied by the Pre-Surgeon Structure, demonstrating that the original dimensions of roughly 22–23 Oscan feet are also reflected in multiples of 3 and 4 on the Via Consolare and Vicolo di Narciso respectively (illustration M. A. Anderson).

the blocks has been suggested for Pompeii on the basis of metrical studies throughout the city.[67] In the case of the Pre-Surgeon Structure, it would seem that one factor in this process might have been the terracing of the soil, since it is the width between two steps in the terracing that forms the basic module (22–23 Oscan feet) in both the Pre-Surgeon layout and the later property boundary. Ultimately, this came to influence the form of

the Pre-Surgeon Structure since it occupied the lowest of the terrace steps within this area. However, while the Pre-Surgeon Structure was built to occupy the southern side of the plot, the full width of the later Casa del Chirurgo likely represents the actual property division. From this, it can be seen that the original property boundaries occupied by the Pre-Surgeon Structure were not dissimilar from those of the later Casa del Chirurgo

itself. This means that the same plot boundaries that would govern the division of the insula throughout its later history were already in place by the mid-third century BC if not earlier.[68] Modifications to the city wall in the form of the addition of another internal circuit in *tufo di Nocera* in the mid-third century BC have been suggested as an important impetus for the layout of the city,[69] a date that is compatible with the information from the Pre-Surgeon Structure.

It is impossible to be entirely certain of the full extent of the Pre-Surgeon Structure because later destructive events have truncated it in most directions. Nevertheless, it is likely that the broad picture of these events is largely correct. It is also significant that while the planning of the property itself made use of both street frontages for its measurements, the surviving evidence from the Pre-Surgeon Structure align not with the Via Consolare, but with Regio VI and the Via Mercurio. Unfortunately, insufficient elements of the Pre-Surgeon Structure survive to suggest where the main entrance might have been, but its overall orientation suggests that the Vicolo di Narciso, at least at first, was a more important consideration.[70] Perhaps a similar situation prevailed here to that observed in the earliest layouts of the properties of Insula VI 16, which similarly backed onto an early gully that became the Via del Vesuvio. It has been suggested for this block that the desire expressed in the initial plot development was at first to face away from a dirty, water-channelling thoroughfare in preference for the quieter Vico dei Vettii.[71] If similar concerns governed the layout of the Pre-Surgeon Structure in Insula VI 1, then it is clear that things had changed by the time the Casa del Chirurgo was created.

Phase 3. The construction of the Casa del Chirurgo (c. 200–130 BC)

At a point certainly no earlier than 216 BC and perhaps as late as 130 BC,[72] the Sarno stone atrium house known as the Casa del Chirurgo was constructed in a position on the local higher ground, taking over part of the northern and all of the middle terrace of the previous phase[73] (Fig. 4.11). As a precursor to this, all aspects of the Pre-Surgeon Structure were demolished and the terraces into which this structure had been built were filled in. On this newly levelled surface, an extensive campaign of construction was launched producing the Sarno stone core of one of the most famous and oft discussed houses in the ancient city.[74]

Preparations and filling

The cutting of terraces prior to the Pre-Surgeon Structure had resulted in the removal of about a metre's depth of natural soils from the southern side of the property. In order to produce a level surface equal to the elevation of the higher northern terrace, all this space had to be replaced as part of the preparations for the next phase of construction.[75] This resulted in the deposition of a thick levelling layer in Room 23 and the western side of Room 11, which in some places contained significant quantities of building debris and was characterised by the presence of large amounts of distinctive blue-grey plaster fragments in certain orangey deposits (Fig. 4.12).[76] The highly characteristic material appears to result from the demolition of the plaster covered earthen walls of Pre-Surgeon Structure. Certainly, the bright yellow/orange colour corresponds with the fabric of a similar a rammed-earth (*pisé*) feature recovered within the atrium of the Casa delle Vestali,[77] the potentially early wall fragment in the eastern side of the tablinum (Room 7), and indeed the colour of the earth-based mortars employed in the first construction of the Casa del Chirurgo itself. Otherwise, the destruction of the Pre-Surgeon Structure is traceable only by the cuts around its foundations that resulted from the demolition of the walls on the northern side of Room 23 and also the removal of the row of foundation stones that are presumed to have lain under the walls themselves. Debris from this destruction, possibly combined with material from elsewhere, was then used to create a level surface prior to the layout and construction of the Casa del Chirurgo.

Similar deposits were used to fill depressions and postholes on the south-western half of the later atrium that anticipated the demolition of the Pre-Surgeon Structure. Elements from the Pre-Surgeon Structure also appear to have been used to fill the foundation trenches of the walls of the tablinum (Room 7), implying that the processes of demolition, filling, and construction occurred roughly simultaneously. This is also suggested by the presence of some small quantities of apparently re-deposited black sands within the general fills of Room 23 (and especially over the impluvium-like feature), which may represent debris from initial preparations on the northern side which cut into the 'black sand' layers below. During or after the filling of the terraced areas, the area to the north also seems to have received some thinner levelling layers in order to provide a uniform initial surface for construction.

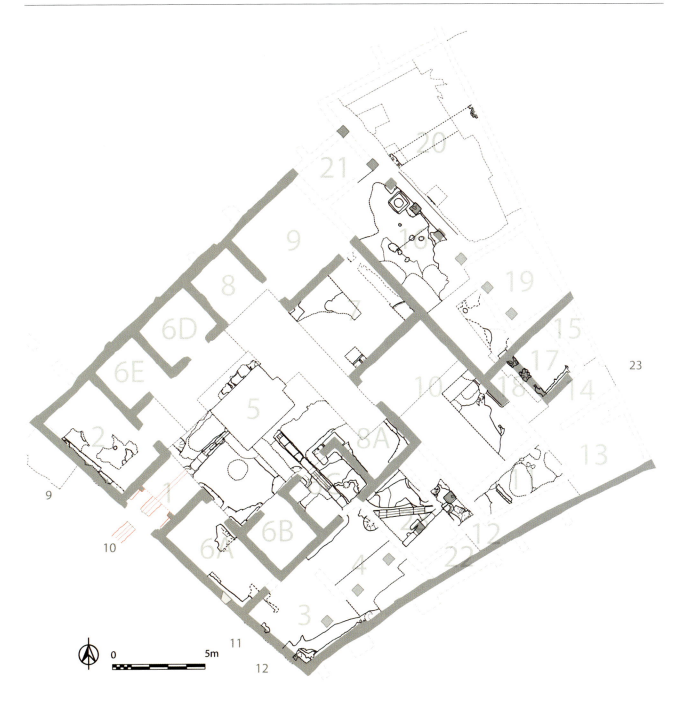

Figure 4.11. Plan of the deposits recovered from Phase 3 (illustration M. A. Anderson).

Foundations

After a level building surface had been produced, foundation trenches could be excavated for the creation of the walls of the Casa del Chirurgo. These were built with a mix of techniques, chosen specifically such that load-bearing or walls important for display were executed in the more impressive *opus quadratum* technique, while dividing walls employed *opus africanum*, both of which were bound in a yellow silty clay.

The process of *opus quadratum* construction was

most clearly documented on the southern side of the atrium, where deep foundation trenches (0.17–0.43 m or deeper) for the *opus quadratum* walls that surround this central space (Room 5) were cut directly into the newly levelled surface. Where no raising of the level had been necessary due to the absence of a terracing cut, these trenches were cut directly from the level of the underlying black sandy soil, 'pitted earth,' and natural deposits. This was especially true of the walls of the tablinum (Room 7), and probably also included

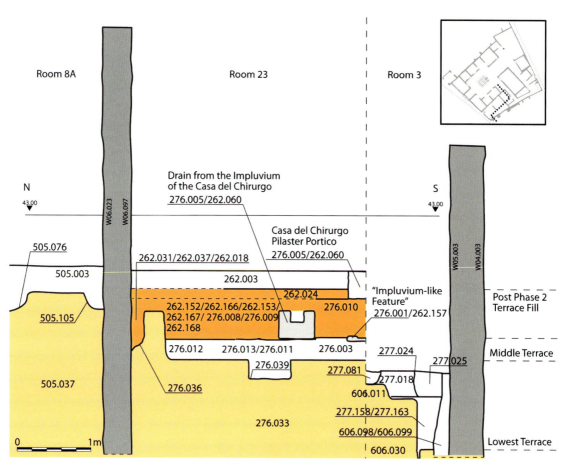

Figure 4.12. Section through Rooms 8A, 23, and 3, illustrating the terrace steps as preserved in levels to which the natural soils have been cut away and the filling layer necessary to fill in the middle terrace to be level with the northernmost terrace elevation (illustration M. A. Anderson).

the northern walls of the atrium, which were not excavated due to the well-preserved AD 79 flooring in this area. On the southern side of the property, where the terraced areas had recently been refilled, the foundation cuts penetrated the blue-grey plaster-rich levelling deposits. All of the foundation trenches seem to have been cut during a single action and according to a precisely planned layout. A space was left for each of the intended doorways, which were originally without either foundation trench or threshold stone. A single course of wide Sarno blocks were used to create the lowest course of foundation stones that jut out roughly 10 cm wider than the overlying courses, the purpose of which must have been to create a stable foundation pad upon which the narrower upper portion of the wall could be built.[78]

Similar methods were employed in the creation of the famous *opus quadratum* façade of the Casa del Chirurgo, long an important factor in the supposed early date of the house.[79] Although the later removal of soils in Room 6A meant that only the slightest traces

of the foundation trench was recovered, at the base, a similar 10 cm projecting wider course of foundation stones was observed. This façade originally continued both to the north and south of its preserved extent, encompassing and sealing off Room 2 within the structure, as well as the space later occupied by the shop unit in Rooms 3 and 4. This means that the original façade would have spanned the entire western side of the property, with only the main entrance to the fauces (Room 1) open to the Via Consolare, an opening that is notably not centrally situated within the façade itself.[80] The stones of the foundation course excavated within Room 2 (41.28 MASL) on the northern side of the façade are 34 cm higher in overall elevation than those found in Room 3 on the south (40.94 MASL), a fact that might have been caused by the pre-existing slope or the difference between excavating foundation trenches in natural soils and the refilled terrace.

The surviving east–west walls that flank Rooms 6A, 6B, 6C, and 8A on the southern side, as well as all of the dividing walls that created these rooms were built

using the *opus africanum* technique. Clearly intended to bear lighter loads, these *opus africanum* walls were constructed without the wide and deep foundation pad present in *opus quadratum* walls and instead with a narrow and relatively shallow foundation trench (Fig. 4.11). These were clearly recovered within Room 6C, especially on the eastern side, but were also visible on the western sides of Room 8A. The foundation trenches of the Casa del Chirurgo continued seamlessly between the walls constructed in *opus quadratum* and in *opus africanum*, the marriage of these two construction methods seemingly causing no difficulties for the builders. In these areas, it seems that the foundation cut was gradually broadened to the appropriately greater width necessary to accommodate the large foundation stones used in the *opus quadratum* walls. Heavily reworked traces of similar *opus africanum* walls are also preserved in Rooms 17 and 18 on the eastern side of the property, providing a window into the initial layout of this area of the house. Here, the walls were cut directly into the pre-existing black sand deposits and exhibited relatively shallow and narrow foundations appropriate for interior, non-load bearing walls. A notable joint between the two techniques was visible in the lower part of the northern wall of Room 6A, where the *opus quadratum* ran around the corner to mate with the *opus africanum* with a simple sabre-cut in the stonework in the centre of the wall after the corner (Fig. 4.13).[81] A turn of the corner is visible on the southern side of Room 6A, where the façade of the Casa del Chirurgo similarly mated with *opus africanum* construction using headers. That these two types of construction techniques were employed as part of a single and unified process of construction is most clearly observed in the southern ala (Room 8A), where the foundations of the *opus africanum* wall run over the lowest foundation stone of the *opus quadratum* wall in the atrium and is keyed together to such an extent that the two could only have been built contemporaneously (Fig. 4.14).

Elsewhere, the decision between the two methods appears to have been driven by concerns for the underlying stability of deposits. The northern wall of the triclinium (Room 10) was built in *opus quadratum*, as were the original parts of the eastern and western walls of this space.[82] This is due to these walls being built over the levelling deposits, whereas on the northern side of the tablinum (Room 7) all of the walls were created in the lighter *opus africanum* technique since their foundations were cut in to the natural soils.

If the Casa del Chirurgo was originally sealed with a wall on its eastern side, no clear traces were recovered

Figure 4.13. A juncture between *opus quadratum* and *opus africanum* constructions in the northern wall of Room 6A (W06.115) (image AAPP).

Figure 4.14. *Opus quadratum* construction overlain by *opus africanum* construction in Room 8A (image AAPP).

in the archaeological record, and the wall that presently seals the property does not date from the time of the original construction. The southern wall, on the other hand, has sufficient traces of headers and stringers surviving in its construction to suggest at least a retaining wall in *opus africanum*. While it might seem strange that the property should not initially have been sealed off from its surroundings, this may be explained by consideration of the overall layout of the structure, which, particularly in Rooms 9 and 10, seem designed to frame views out towards the east and south. Pompeii may have been less densely urbanised at this time and it seems possible that the initial concept was to create a vista much in the way that later suburban villas would be designed to view their surroundings.

Dating

The precise dating of the construction of the Casa del Chirurgo has been made difficult by the nature of the deposits recovered. Dates were obtained from coins, pottery, lamp, and glass fragments that were recovered from strata related to the filling in of the Pre-Surgeon Structure terrace, the creation of the floor of the house, and the refilling of foundation trenches for the Sarno stone walls. Unfortunately, they all derive from areas that also received considerable intervention in later phases. The wholesale removal of floors and the re-exposure of these earlier surfaces during modifications to the house especially during the late first century BC to early first century AD, which often truncated the tops of lower features such as pits and cuts, while also leaving the top surface of these features exposed during construction, introduced the lower deposits to a degree of contamination and has resulted in a relatively jumbled record.[83] Nevertheless, sufficient evidence survives in a few apparently undisturbed contexts, such as in the deep foundation trenches around the atrium and the first fills or destruction of the Pre-Surgeon Structure, to provide support for the earlier range of dates recovered in the more contaminated deposits. They suggest a rough date range for the construction of the Sarno stone atrium house of about 200–130 BC.[84]

The source of the Sarno stone blocks

Just as had been noted by Maiuri, many of the foundation blocks show signs of having been reused and often preserve fragments of plaster on various faces, at depths below the level of the first floor of the house, clearly attesting to at least one previous use of the stones.[85] In contrast to the interpretations of Maiuri, however, it should be noted that no elements of the primary plaster of the Casa del Chirurgo were recovered at depth and that the original flooring of the house was at an elevation not vastly dissimilar to that of the final floor surface.[86] The previous use of the blocks is uncertain, but as the construction of the Casa del Chirurgo no longer chronologically matches any known or hypothetical demolition of the city wall (the most recent interventions to which being the destruction of the double circuit wall '*ad orthostati*' at the end of the fourth century BC and its replacement with a double curtain with an *agger*[87]). Maiuri's suggestion that the blocks derived from it may therefore now be discarded, at least in the case of the Casa del Chirurgo.[88] Furthermore, given that the blocks generally preserved a relatively fine plaster, a prior domestic use perhaps seems more likely than a military or even a civic one, although the size of the blocks means that the possibility of such 'official' prior uses cannot be excluded. Indeed, at least some of these blocks may have once served as the foundation course for the Pre-Surgeon Structure's beaten earth walls or have come from another nearby property.

Impluvium and drain

The atrium of the Casa del Chirurgo seems to have been provided from the outset with an impluvium or similar water collection feature, possibly the same *tufo di Nocera* feature present today, albeit having been raised and modified.[89] Significantly, this is contrary to Maiuri's interpretations.[90] The presence of a water collection feature is attested by two drains that both run away from this central location. This also indicates that the original arrangement of the atrium would not have been *testudinate* and that it likely had a *compluviate* roof.[91] To the south-west, an overflow drain led out to the Via Consolare underneath the fauces, while a second drain led to the south-east through a wide doorway quoined with Sarno blocks in the southern wall of Room 6C and into the area of Room 23 beyond (Fig. 4.15). To the south of Room 6C this drain turned from its north-west south-east heading towards an east–west alignment (cf. Fig. 4.8). Traces of this segment of the drain are clearly preserved in the northern and eastern walls of Room 4 (cf. infra). The drain headed directly towards a cistern that had probably been a component of the Pre-Surgeon Structure's 'impluvium' (cf. supra). This early cistern appears to have been reused at this time as the primary storage for water from the impluvium of the Casa del Chirurgo. If so, its re-use must have been an important consideration in

the overall planning of the layout of the Sarno stone house. Indeed, the north-west to south-east (henceforth simplified to "north-south") drain runs from the impluvium directly through the centre of two of the original doorways in the walls to the south, which was clearly a primary element of the overall design.

Both drains were constructed with characteristic modular blocks of *tufo di Nocera* with a square channel cut into the top, which acted as the drainage conduit, and were capped with a series of thin, squared Sarno stone blocks.[92] In the atrium (Fig. 4.15) and Room 23, the foundation trench for the north-west to south-east drain was cut down through the same levelling layers into which the foundations of the house itself had been cut. The lower portions of the drain were then placed into this trench. Towards the southern end of this conduit, however, the manner of construction was different. In Room 6C, and especially within Room 23, the *tufo* base blocks seem to have been filled around with levelling debris, rather than having been placed into the cut made after the filling of the terrace.

Figure 4.15. The drain running southward from the central atrium (image AAPP).

Perhaps this indicates that these areas had not yet been filled up to ground level when the drain base was run from the future atrium to the north, or that the work was carried out by two different teams of workmen with different ideas on how to build a drain. Possibly the reuse of the cistern or well from the impluvium-like feature of the Pre-Surgeon Structure meant that this aspect of the drain had to be aligned prior to the complete filling of the terrace. The drain was designed with a gradual slope, dropping approximately 34 cm from the atrium to its cistern in Corridor 12 at a gradient of roughly 3.3 per cent.

Initial layout

The primary core of the Casa del Chirurgo is perhaps its most discussed element. It has played a major role in the discussion of the so-called 'Roman' or 'Italic atrium house,'[93] particularly as a representative of a 'limestone atrium house' of 'Samnite' or 'Oscan' Pompeii.[94] While its original layout can be seen to conform largely to the traditionally recognised pattern for the idealised 'atrium house,' with a central atrium and impluvium flanked by ranges of rooms, with two open rooms (alae) arranged transversally at the back of the atrium,[95] our excavations have also revealed a number of non-canonical elements. The axial arrangement of the fauces-atrium-tablinum, often seen as one of the essential features of the 'atrium house,'[96] was present from the start in the original layout of the house, emphasising the importance of the view from the Via Consolare. It is clear, however, that this was not the only, or even the most important, vista present within the house. Much of the structure was not primarily inwardly focused upon its central courtyard. Rather the house also seems to have been orientated towards its eastern and southern outside spaces with potential vistas in these directions.[97] This is emphasised by the excavations of Maiuri in the fauces, which uncovered evidence of a *vestibulum* that separated from the fauces by *antae* and probably another set of doors that would have narrowed and reduced this view even when (perhaps rarely) open.[98]

The neat, rectangular shape of the atrium and surrounding rooms has tended to encourage the hypothetical reconstruction of a continuation of the southern wall (flanking rooms 6A, 6B, 6C, and 8A) across the middle of Room 10,[99] in an effort to focus upon the central core of the atrium itself. This was made a particularly attractive choice since the walls of Room 10 themselves, fashioned in *opus quadratum*, originally stopped at the mid-point of both the

western and eastern walls. Indeed, in order to try and locate this 'missing' wall, Maiuri excavated a *sondage* that produced inconclusive, but negative results.[100] Strangely, this seems to have had little effect on subsequent interpretations of the house, most of which continued to reconstruct a wall that was never there.[101] Our more comprehensive excavations have confirmed his reluctant conclusion that no such lateral wall existed during any phase of the building. Thus it must be concluded that in its primary phase Room 10 was entirely open to the area to the south of the Casa del Chirurgo, in a situation perfectly analogous to Room 9, though rotated by 90 degrees. In fact, having dispensed with these earlier ideas, the internal logic of the house layout is even more apparent, with two similar wings on the east and south, each with a primarily outward-facing space (Rooms 9 and 10).[102] Intact floor surfaces in Rooms 9 and 21 prevented the subsurface investigation of the eastern wall of Room 9, but it is certain that the eastern *opus incertum* wall was constructed at a later date, probably as a part of a phase of redevelopment that saw the construction of Room 21 between 100 and 50 BC (cf. infra).

These two rooms both opened onto porticoes that initially ran down both the eastern and southern sides of the house. By the time of the property's destruction in AD 79, this garden area had been reduced in size such that only the area at the rear of the tablinum (Room 7) preserved elements of the original plan.[103] Excavations beneath the portico (Room 16) and in the hortus (Room 20) have nevertheless revealed the original layout of this structure. The foundation trench for the square Sarno bases of the portico, the rectangular Sarno stones of the gutter, as well as the cistern, were cut down through 'black sand' deposits, 'pitted earth' levels and natural soils like the walls of tablinum (Room 7) (Fig. 4.16). The continuity of the foundation cut for these features implies that they were all laid out at the same time. Some of these Sarno stone elements also show signs of reuse, just like the foundation stones used in the atrium. In order to store rainwater from the roof, a cistern was also cut into the natural soils, even though the opening collar in *tufo di Nocera* may be a later replacement. A hole in the eastern side of the cistern shaft appears to have been the outlet of an overflow drain that originally led through the garden space and out into the Vicolo di Narciso. Although the conduit was largely removed during a later phase of the garden, the outlet can be seen to emerge through a gap in the Sarno stones at the base of the gutter. Unlike the drain of the impluvium, the bottom of this drain was lined with tile and its walls were constructed from small pieces of Sarno stone.

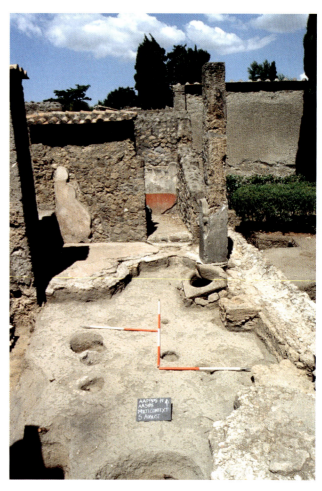

Figure 4.16. The northern portion of the eastern portico, drain and cistern head seen in Room 16 (image AAPP).

The portico was supported by a row of square Sarno stone pillars. Excavation revealed three of the bases for these pillars in the area of the hortus (Rooms 16 and 20), with a further two being incorporated into the north and south corners of Room 21, as well as the suggestion of a further one beneath the later *opus testacaeum* work at the northern end of the doorway into the oecus (Room 19). On the southern sides of the house, traces of a second, complementary portico were recovered beneath Corridor 12 and within Room 23, where two further pillar bases and three continuous sections of gutter base in Sarno stone were recovered.[104] In Room 23, these had been bedded into the upper levelling deposits (Fig. 4.17) that had finalised the construction of drain that ran from the impluvium in the atrium into the reused cistern in Corridor 12. Another square pillar base was uncovered beneath Corridor 12 (Fig. 4.18) and was attached to the same Sarno gutter base that was overlain by the later eastern wall of Room 23 (Fig. 4.19). The gutter of the portico would have drained water to the inlet from which it was led to the cistern.

Given that there were two lateral porticoes in the initial phase of the house, it would be natural to imagine them to have intersected at the south-eastern corner in order to wrap neatly around the outside of the house, but this does not seem to have been the case. The southern end of the eastern portico is marked by evidence of additional walls in *opus africanum* on the northern side of Room 17 continuing from Room 10 in alignment with the southern wall of the atrium. Evidence of another wall was recovered at depth suggesting that this was a small room. In the southern portico, a single Sarno stone found in Room 11, arranged perpendicular to the direction of the southern corridor, might indicate that it either ended at this point or turned to the south. The rest of the south-east corner of the property produced no evidence for structures during this phase, leaving an open question as to the original configuration of space. Comparison of the early plan of the Casa del Chirurgo to that of the earliest form of the Casa di Sallustio, a house that while not a Sarno stone atrium house does have deep similarities in layout, reveals traces

Figure 4.17. Sarno stone foundations for the portico in Room 23, showing materials into which they were cut (image AAPP).

Figure 4.18. Sarno stone foundations for the portico in Room 12, showing base and channel for drainage into the cistern below (image AAPP).

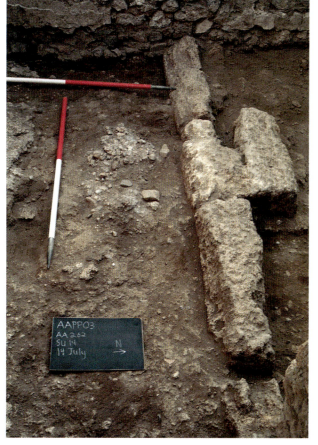

Figure 4.19. Sarno stone foundations for the portico in Room 23, with adjacent edging stones (image AAPP).

of narrow corridors where its southern and eastern porticos joined.[105] Perhaps a similar situation was to be found in the Casa del Chirurgo. Certainly it seems likely that this area was designed to provide some sort of secondary entrance on the eastern side of the insula. Possibly they coordinated with whatever wall or fence ran along the Vicolo di Narciso at this time in a manner that has been lost in later modifications to the house.

It was not only the two large rooms that flanked the tablinum that had openings onto the portico. The southern walls of Rooms 6C, and probably also 6A, originally had a wide doorways in their *opus africanum* walls (cf. Fig. 4.11) that would have permitted movement between the atrium and the southern portico. Perhaps this indicates that the southern portico and the presumed garden space beyond it was a particularly vital part of the property or its domestic functions. The southern portico and its outside space was initially shielded from the Via Consolare by the *opus quadratum* façade, which continued southward to meet the southern terrace boundary wall of the plot (cf. Fig. 4.11). Unfortunately, the later removal of most of the remains of this wall in the creation of Rooms 3 and 4, means that it is very difficult to say more about the primary southern boundary of the property. At the western end, the deposits of this phase are not preserved (having been removed for Rooms 3 and 4), and throughout most of Corridor 12 on the east, an intact *opus signinum* floor precluded excavation against the southern boundary wall. Nevertheless, sufficient traces of heavily reworked *opus africanum* exist in the present southern boundary wall to demonstrate that an earlier wall did occupy this space. It is possible that this was not built to the same height as the *opus quadratum* façade on the Via Consolare, but was only a retaining wall designed to hold back the higher ground upon which the house had been constructed and allowing views over it towards the south from the portico and outside space.

The only rooms on the southern side that do not appear to have opened onto either the eastern or southern portico are the tablinum (Room 7), Room 6B, the south ala (Room 8A), and all of the rooms on the northern side of the property, with the exception of Room 9. Excavation within Room 7 revealed a small fragment of what was most likely originally an *opus africanum* wall, heavily rebuilt in *opus incertum*, which sealed the eastern side of the tablinum. The *opus incertum* traces probably derive from alterations to this wall undertaken in the first century BC when the eastern side of Room 9 to the north was closed. It is, consequently, possible to suggest the presence of a wall across the rear of the tablinum that originally blocked access to the portico. It is impossible to know whether it was provided with a window to afford views through the portico and into the garden, but this seems likely.

Initial decoration and flooring

Scarcely any traces survive of the primary wall decorations within the core of the Casa del Chirurgo, since three subsequent and quite extensive periods of redecoration have generally removed them. It is equally impossible to know whether the earliest surviving traces of plaster derive from the original decoration or a subsequent one that simply predates later decorations that have left more extensive evidence. A band of stucco relief of the First Style on the north wall of Room 2 was recorded by Laidlaw as a yellow *fascia*, although today little remains of the colour today.[106] It is conceivable that this derives from the initial decoration. Other traces were evident to Mau, but are no longer preserved, including the left pilaster of the tablinum (an element dated to a much later phase by our analysis), the south-west corner of one of the rooms off the atrium (probably Room 6A), the northern side of the fauces, and the south-west corner of Room 9.[107] He also mentions remnants of First Style plaster used in the fill of the niche in Room 8A and the west and south walls of Room 21, which were also mentioned by Laidlaw,[108] but now appear to be lost. This may be sufficient evidence to suggest that a number, but probably not all of the rooms of the core of the Casa del Chirurgo, were initially decorated in the First Style.[109] All that remains of the decoration of the atrium at this time are slight traces of plaster backing. Excavations within the atrium and Room 23 suggest strongly that the first flooring of the structure was of beaten earth, just as Maiuri had hypothesised.[110] It seems likely that this flooring extended throughout the interior of the original core of the house and was only replaced with more elegant flooring in the following phase.

The Casa del Chirurgo in context

By the end of Phase 3, the core of the Casa del Chirurgo had been completed, consisting of a symmetrically arranged plan with a number of rooms clustered around a central impluviate atrium and two large rooms with vistas to the east and south through two flanking porticos. The date of its construction, which it now shares with numerous other excavated properties in Pompeii,[111] perhaps attests to an increasing density of population in the late-third century BC, an effect that

could have been a result of increased prosperity or displaced populations in the wake of the Second Punic War.[112] Alternatively, since some other houses have been found to date within the fourth century BC,[113] perhaps it is better to see this as the result of a phenomenon that commenced with Roman victories in the Samnite wars of the mid-fourth to early third century BC.[114] It is possible that the presence of an earlier structure in the space that was later occupied by the Casa del Chirurgo served to delay its construction, as might be suggested too for the Sarno stone phase of the Casa delle Nozze di Ercole (VII 9, 47).[115] Certainly, the Casa del Chirurgo used its allotted space more intensively than the Pre-Surgeon Structure, producing property with much larger internal dimensions. A bigger house appears to have been a priority, but it may also be that there was some degree of competition over space in the city at this time. Significantly, while the overall boundaries of the property remained unchanged, the centre of the house was also shifted to occupy the high ground of the upper terrace and was aligned with both the northern boundary wall and the Via Consolare, producing a degree of prominence that may suggest that this street had also grown in importance by this time.[116]

Phase 4. Initial changes to the property (c. 100 BC – 50 BC)

At roughly the end the first century BC, a number of changes began to be made to the Casa del Chirurgo that provided it with new rooms, outfitted the house with new wall decorations, and laid its first concrete decorative floors (Fig. 4.20). Since many of these changes occurred in areas where excavation was not possible or where deposits had later been heavily removed, they have generally produced little stratigraphic evidence that would permit the dates of these modifications to be identified with precision. They may, nevertheless, be sequenced relative to each other and also be dated by reference to the style and composition of each element, producing three distinct phases of construction. The earliest of these changes were spurred by the expansion of the Casa delle Vestali to the north, an action dated to roughly to the late second century BC by excavations in that area,[117] so the beginning of these alterations may be situated as shortly after that moment.[118] It seems convenient to locate the beginning of the second sub-phase in the years between roughly 100 BC – 50 BC, which would be approximately 2 to 3 generations after the first creation of the Casa del Chirurgo and

at least one generation prior to beginning of the next major phase of reconstruction and modification. Such a date moreover is supported by stylistic analysis of the surviving elements of the changes of this phase. The final sub-phase must have come after this, occurring between about the 50 BC and the late first century BC to early first century AD when Phase 5 began.

Sub-phase A

The first major structural alteration to the Casa del Chirurgo involved the completion of the northern boundary wall. In the Casa delle Vestali, the construction of this wall was undertaken during the addition of a rear range of rooms on the Vicolo di Narciso and is dated by pottery in the foundation trenches to circa 100 BC.[119] A characteristic pinkish coloured mortar, present throughout these constructions, permits them to be sequenced into a single phase of activity. The creation of a new range of rectangular rooms in the rear extension of the Casa delle Vestali enabled the Casa del Chirurgo to define the northern end of its garden space and preserved in masonry a peculiar 'kick' or 'jink' in the eastern end of the dividing wall, a feature that requires some explanation. The irregularity probably resulted from the initial planning of the insula, since the eastern end of this wall, along with the most of the eastern side of the property and even the Pre-Surgeon Structure, had all been aligned at right angles with the Vicolo di Narciso. The north-western side of the insula, on the other hand, seems at least from the time of the Casa del Chirurgo, to have been aligned to the Via Consolare. When the northern boundary of the property was used to plan the Casa del Chirurgo, however, the majority of the property was re-aligned with the Via Consolare, presumably causing a problem on the eastern end. While this would not explain why the northern property line was not simply extended directly across the top of the property, it should also be observed that the full extent of the southern portico in the house layout is precisely the same as the eastern portico only if it includes the extra length provided by this 'kick.' Unfortunately, insufficient data are currently available from the Casa delle Vestali to be certain of exactly how the Casa del Chirurgo originally related to the area to its north, but it does seem that the 'kick' was an original component of the plan in this phase. In fact, it seems possible that the expansion of the Casa delle Vestali took over a small space to the north of what was to become Room 21.

The presence of a small, high window in the small room in the Casa delle Vestali immediately to the

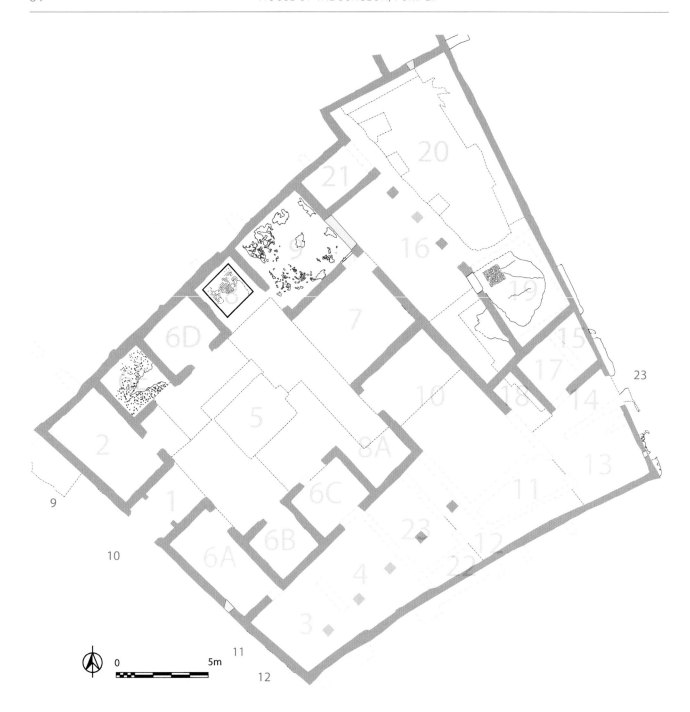

Figure 4.20. Plan of earlier changes in Phase 4 (illustration M. A. Anderson).

north of the boundary wall adjacent to the Vicolo di Narciso, opening directly from these rooms into the garden of the Casa del Chirurgo, has also suggested an alternative explanation.[120] Since Roman law (at least as we have it preserved) focussed particular attention on issues of access to light and space,[121] it is possible that an agreement may have been reached between the owners of these two properties as a component of this building activity.[122] Perhaps the owner of the Casa del Chirurgo gained the extra garden space in return

for providing the Casa delle Vestali with the light from the garden. Although little precedent exists for such an interpretation, the interconnected windows, which are by no means uncommon in the city of Pompeii, do have the feel of a servitude placed on the property. It is not currently possible to decide between these two alternative explanations, but it is clear that whatever the cause for the 'kick' in the design, it became fossilised in the wall structure at this time.

Room 21 was created as a component of the con-

4. THE STRATIGRAPHIC AND STRUCTURAL SEQUENCE OF THE CASA DEL CHIRURGO

struction of eastern segment of the wall that would ultimately separate these two properties. This was the first room to be added to the property and was built by filling in the space between the original house walls and two of the pillars in the northernmost extent of the eastern portico. The creation of this room also involved the blocking of the wide, eastern-facing doorway of Room 9, which subsequently had only a window at its southern end to provide a view into the garden space beyond (cf. Fig. 4.20). The walls of Room 21 were faced in *opus incertum* with a distinctive very pale brown mortar that was generously applied and smoothed around the edges of the stones to create a flat face for the application of wall plaster.

As a direct result of the closure of the eastern side of Room 9, further changes were undertaken in the back wall of the tablinum (Room 7), which was heavily modified. Unfortunately, the subsequent complete removal of the back wall means that the precise details of these alterations were not preserved, but they were likely intended to provide a doorway to give access to the garden, which the closure of Room 9 would have otherwise rendered inaccessible. The creation of a new doorway, combined with the sealing of the eastern side of Room 9, clearly required heavy reworking of the entire wall system, which the mortar-less original *opus africanum* might in any case have required by this stage in the house's history. As a component of these changes, the doorway between the tablinum (Room 7) and Room 9, was outfitted with a new limestone threshold in conjunction with a new floor (cf. infra).

Sub-phase B

The second component of the changes taking place around the end of the first century BC was the creation (or rebuilding) of the tall masonry wall, sealing off the eastern side of the Casa del Chirurgo from the Vicolo di Narciso. That this took place after the northern property division had already been completed is suggested by the intersection between the northern and eastern property boundary walls of the Casa del Chirurgo, where a thin layer of finished white plaster may be observed running all of the way up the junction, which is formed with a butting joint. This, along with a different source of building material and mortar for the two sections of wall, would suggest a pause between the construction of the northern wall and the completion of the eastern boundary wall. Nevertheless, it seems likely that both walls must have been constructed within a relatively short time of each other and the pause witnessed by their relative

sequence may simply indicate the order in which the work was carried out. This primary form of the eastern *opus incertum* boundary wall of the house contained a wide doorway on the southern end that provided access to the back rooms of the house and was framed in large Sarno stone blocks.[123] From there, the wall continued southwards until it contacted the southern boundary wall of the property, which, if it had been originally only a retaining wall, must have been raised in height at this time in order to match the wall on the east.

With the eastern and southern boundaries of the property now definitively sealed, the opportunity was taken to create another new room that faced northward onto the garden by the addition of a single wall in *opus incertum* on the western side of what was eventually to become a decorated oecus (Room 19). The method employed in the creation of the room – infilling in the portico – was identical to that used to create Room 21. The builders of the oecus made use of the original *opus africanum* wall to the south, with the eastern property boundary wall being substantially thickened at this point in order to produce walls meeting at right angles within the room. Unfortunately, subsequent modifications and well-preserved later plaster decoration have obscured the evidence that would reveal precisely when this thickening took place, but given the alignment chosen for the western wall, it seems probable that it would have occurred at the first creation of the room. The construction of these two rooms provided the eastern portico with two spaces with broad openings and vistas onto the garden, suggesting a growing emphasis on the hortus and perhaps reflecting a citywide growth of interest in the pseudo-peristyle that would gain further momentum in the coming centuries.[124]

Redecoration

Following these changes, the Casa del Chirurgo witnessed an extensive phase of decoration, including at least some wall plaster and a number of concrete and decorative floors, which appear to have been the first such elegant surfaces in the property. In fact, the overall character of the changes in this phase can be explained as an initial attempt to augment the property with new luxurious features. While many of these decorations did not survive later periods of renovation, those that are preserved appear to coordinate into a unified programme that clearly dates to the late second to early first century BC and should be seen as part of this phase of construction. While the direct impetus for this redecoration appears to have been the creation of Room

21, Room 19, and the associated alterations to Rooms 7 and 9, it is clear that a number of other areas in the property were also redecorated at this time. Throughout the house, there are signs of repair to the original *opus africanum* walls with *opus incertum*, as well as extensive re-pointing with mortar, much of which probably took place immediately prior to these redecorations. Such repair is evident throughout the property, especially within the zones of *caementa* between orthostats, which presumably would have been the areas most likely to degrade over time and require renovation.[125]

In Rooms 9 and 19, the newly constructed *opus incertum* walls would have required covering, which necessitated the redecoration of both rooms. The western side of the west wall of Room 19 received a new plaster decoration that has generally been identified as First Style, because it consists of rows of isodomic courses of now poorly preserved, imitation marble, with wide drafted purple borders.[126] The plaster surface, however, is not in relief, but is simply incised into a flat surface in a manner that appears to be more appropriate for a Second Style imitation of the First Style[127] (Fig. 4.21). This conclusion is strengthened by the fact that this decoration is not situated on one of the primary walls of the house and comes from a secondary phase of plastering. While either style would ultimately permit the general sequencing of this wall to around 100 BC, plus or minus 25 years or so, on the whole it seems more likely that the redecoration was undertaken near the beginning of the Second Style, so just after about 80 BC. Inside Room 19, an unusual floor of irregular grey-blue and white stones reminded Pernice of the floors of the so-called 'Tufa Period'

(200–80 BC),[128] but is not entirely uncharacteristic of Second Style floors and clearly cannot predate the room it occupies. Perhaps it represents a particularly early example. At the same time, the space outside of Room 19 was also provided with a floor in a simple *opus signinum*, which represents the earliest floor recovered through excavation within the property.

In Room 9, a highly distinctive style of yellow and grey sand-rich mortar was used to provide an initial backing layer on the eastern wall.[129] Identical mortars have also been recorded on the walls of the fauces, atrium (Fig. 4.22), and tablinum (Room 7) suggesting that these rooms also underwent a refurbishment of their decorative schemes in the period around 100 BC. It is probable that many of these rooms also received floors at this time, even though only one of them seems to have survived later alterations. The flooring of Room 9 was in chips of lime with purple, yellow, and green fragments that has been dated to the 'Second Style.'[130] Similarly, the floor of the north ala (Room 8) consisted of 'lithostroton', white mosaic with embedded regular rows of yellow, red, black, grey and green marble with a black border 5 tesserae wide. It was seen by Pernice as particularly characteristic of the Second Style with strong parallels in the Villa dei Misteri.[131] In the central portion of the room the white *tesserae* were set on a 45-degree angle to the borders, resulting in a diamond pattern effect.[132] It is possible that a central decorative feature existed, such as a star.[133] While other clearly Second Style floors are generally absent from the house, this is probably a result of widespread repaving at the end of the first century BC. Traces of these floors may possibly be indicated by the presence of limestone

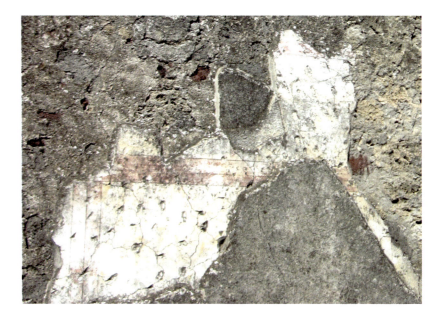

Figure 4.21. Second Style imitation of First Style decoration on the outside of Room 19 (image M. A. Anderson).

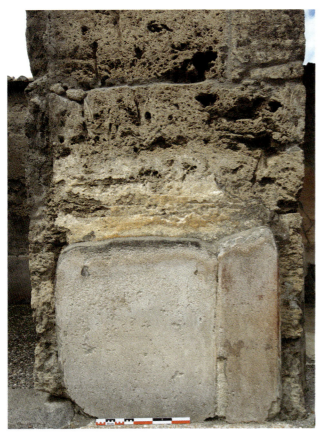

Figure 4.22. Detail of the northern walls of the atrium around the entrance into Room 6E displaying a yellow sand-rich mortar (image D. J. Robinson).

thresholds, which are in association with the floors in Room 19, the doorway between the tablinum (Room 7) and Room 9, and the doorway leading into Room 10.

Sub-phase C

At some point after the creation of the eastern boundary wall, and probably at a time distinct from the above decorations, changes were made to the eastern entrance to the house that opened onto the Vicolo di Narciso (Fig. 4.23). An 'L' shaped wall was constructed that served to narrow the doorway and to divide off a small area of space in the extreme south-east corner of the property in order to create a large room in the area later occupied by the kitchen (Room 13). While only the most ephemeral traces of this phase were recovered from Room 13, the extent of the northern wall was preserved at depth running across the later threshold into Room 18. Later interventions served to reconnect these spaces. The western extent of the 'L' shaped wall reached the north-eastern corner of Room 11, where it was later integrated into the eastern wall of Room 10.

The fact that the area saw later use as a kitchen and its proximity to the back entrance of the house may indicate that by this time it had already begun to function as such. The configuration of space during this phase consisted of two large rooms, a corridor to the back of the house, and a broad access way through to Room 10 and the southern portico. Storage and domestic activities such as cooking seem likely functional explanations of these otherwise undecorated spaces. If this is correct, then this moment represents the first addition of a set of spaces to the house that were to those service activities that would characterise the south-eastern corner of the property for the rest of its life.

The Casa del Chirurgo and its surroundings

By the time the three sub-phases of Phase 4 were complete, the Casa del Chirurgo had been outfitted with a distinct boundary wall that separated it from the surrounding urban environment, several new rooms focused on the hortus, a number of decorated floors, and at least some elements of Second Style wall painting. The inward-looking emphasis of these developments suggests that they may have been responses to the increasingly built-up nature of the local urban environment at this time, since they serve to seal off the Casa del Chirurgo from its immediate surroundings and transfer the visual focus of the house to the garden in Room 20.[134] The date of these changes suggests a possible connection either to the flurry of construction during the late second century BC, prior to the establishment of the Roman colony in 80 BC, or the seemingly extensive period of building in the city in the years immediately following.[135] Both actions could easily have generated such a response in the Casa del Chirurgo.

Phase 5. Redecoration and redevelopment in the late first century BC to early first century AD[136]

The second major campaign of redecoration in the Casa del Chirurgo occurred at a point between the late first century BC and the early first century AD (Fig. 4.24). So extensive where these changes that hardly any areas of the property remained unaffected and the result produced most of the major architectural features visible in the final version of the house. Considerable damage to, and contamination of, the underlying

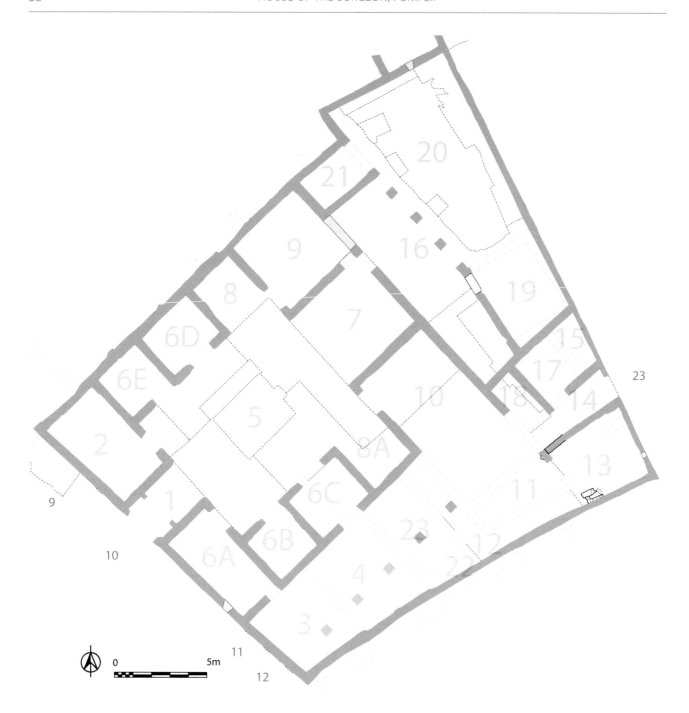

Figure 4.23. Plan of later changes within Phase 4 (mainly in the areas of Rooms 13 and 14) (illustration M. A. Anderson).

earlier deposits also occurred at this time when floor levels were lowered in several areas by as much as a metre. The renovations involved not only the addition of new, luxurious features to the house, but also the creation of two separate facilities for commercial and/or production activities and overall repairs and refurbishments related to these additions.

Thus, while on the one hand the house experienced the loss of some interior space to economic activities,

at the same time the impact of these changes was tempered through the provision of heightened luxury and the creation of additional areas dedicated to household service activities. Precisely what might have triggered such widespread construction and alteration is unknown, but since most of the luxurious additions seem to have been a response to the damage caused by the creation of the shops, it is possible that desire for profit derived from these economic undertakings

was one motivation. Perhaps these new ventures were intended to help to defray the costs of the new luxuries, or plausibly both represent provision of what was seen as the 'appropriate' features for a domestic structure in the late first century BC.[137] It is also important to point out that these changes appear to coincide with others to the Via Consolare and Vicolo di Narciso themselves, both of which seem to have received their earliest street pavements at this time.[138] It is likely that the increased traffic or economic prominence that such changes suggest is what caused the owners to consider the opportunities presented by shops situated on the Via Consolare. There also appears to be a relatively widespread phenomenon of reconstruction within Pompeii during this time, of which these changes were clearly just one part.[139] Whatever the actual motivation, the construction of these two shops produced a number of structural ramifications meaning that much of the rest of the house also needed to be redecorated. The owners of the Casa del Chirurgo took this as an opportunity to update their house and to bring it into line with current trends for luxury, including the

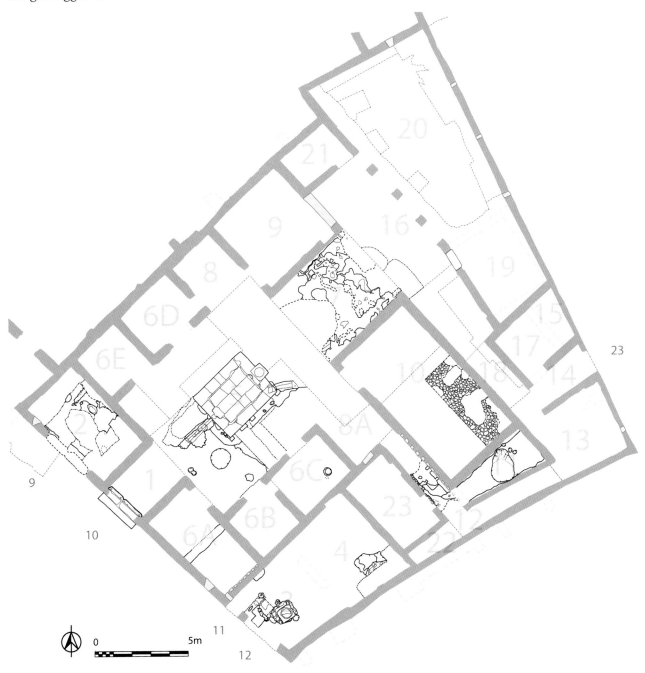

Figure 4.24. Changes and deposits uncovered from the early stages of Phase 5 (illustration M. A. Anderson).

reception of guests, and the emphasis of architectural vistas that seem to have been especially important at this time.[140] The expenditure of resources involved in these changes must have been considerable and close examination of the individual elements of the redecoration suggests that some were carried out selectively. Perhaps this indicates that the budget had been strained by the scope of the project and the owner decided to economise on less important rooms in the final decorative scheme.

Addition of commercial properties

South-west shop

In order to create the southernmost of the two economic properties, it was necessary not only to dismantle and remove the portico that had previously run along the southern side of the property, but also to lower the level of the soil in the area so that the shop could open out onto the level of the Via Consolare. To the east, the remaining area, still at the higher elevation, was converted into two ranges of rooms reached by openings created in the southern ala (Room 8A) and on the southern side of Room 16. These rooms were to the west and east of the triclinium (Room 10), which was enlarged and separated from the service rooms by a new southern wall. Immediately to the south of Room 10, a small closet-like Room 11 was created initially with a doorway on its western side. To the west of the triclinium, Rooms 22 and 23 were constructed, while to its east, Room 13 was simultaneously reworked by opening access to the north through the 'L' shaped wall that had been created during Phase 4. Together these changes created two suites of three rooms; one accessed from the southern ala (Room 8A), the other coordinated around the back door. Both of these areas were connected by a narrow corridor ran that between the two ranges of rooms to facilitate movement between them and the more prestigious areas of the house beyond.

The westernmost area of the southern portico was cleanly divided off from the main house and given over to new, commercial activities. A wall was created on what would become the western side of Room 23 and the doorways into Rooms 6A, 6B, and 6C, which had formerly led out into the portico, were sealed with *opus incertum* blockings. At the same time, the soil to the west of this was lowered by roughly a metre – lower than the foundations of the intended retaining wall – leaving some of the underlying stratigraphy of the Pre-Surgeon Structure terrace fill exposed. This action also removed nearly all traces of earlier periods and the Pre-Surgeon

Structure from within Rooms 3 and 4.[141] Thereafter, the southern end of the Via Consolare façade of the Casa del Chirurgo was demolished, probably leaving only the lowest course of stones intact. These may have initially served as a threshold for the shop. The shop was accessed by a broad doorway, separated from a smaller one by a brick/tile pillar. The new, lower elevation of the rooms was appropriate for the creation of an economic space (later divided into Rooms 3 and 4) that opened directly onto the Via Consolare. Above the shop, a second storey appears to have been fitted at this time, with joist holes present on the eastern wall of Corridor 12 within the Casa del Chirurgo, suggesting that the second storey ran across the space of Room 23. This transformed the access corridor and surrounding rooms into dark, narrow spaces, with low ceilings. Consequently, a small light well at the corner of the 'L'-shaped corridor (Room 22) was created, where captured rainwater drained into a cistern located at its western end.[142] It is possible that this cistern was created by reusing one that had been present in this location in during the Pre-Surgeon Structure, but too little evidence was recovered to be certain. The fact that the upper storey was separated from the activities going on downstairs implies strongly that it was used as a separate rental apartment. Nevertheless, it seems quite likely that both the shop and the upstairs apartment were part of the patrimony of the larger house. While specific ownership is notoriously difficult to prove through archaeological evidence alone, it has often been understood that that normal operation of Roman property law gave primacy to the owners of the ground floor property, meaning that above floors would also belong to the owner of that underneath.[143] If this was the case, then similar logic might apply in this case, as the rental apartment is located over the ground floor of the Casa del Chirurgo, suggesting that the owner of the house was also the owner of the apartment, and as the apartment was over the shop, this too would have been part of the overall patrimony of the house. While in our opinion this is the most likely scenario in a range of ownership possibilities, it has been demonstrated that the principle of *superficies solo cedit* did not always apply universally, perhaps particularly in cases of rental apartments (*cenacula*) and the separation of properties.[144] It therefore remains possible that a different solution was reached between the inhabitants of the shop, the rental apartment, and the house in this case.

Excavations produced little evidence of the precise functions of this shop unit in its first phase, aside from the suggestion of a beaten earth floor as its primary

working surface. The only signs of activity traceable to the period of its creation include a possible soak-away drain in north-west corner at the front of the shop (Room 3),[145] and a water storage feature or cesspit situated in the south-east corner of Room 4. Due to considerable modern intervention this could not be fully excavated and its function remains somewhat unclear. It is quite likely that during this phase it represented a secondary storage of water fed from the lightwell within the Casa del Chirurgo just to the east (Room 22). It is also clear that a cistern present in the centre of the western half of the shop was in use at this time, similarly potentially a feature reused from the Pre-Surgeon Structure.[146] Such an interpretation might explain why the cistern head is aligned with the Vicolo di Narciso and the Pre-Surgeon Structure and not the Via Consolare or the frontage of the shop.

North-west shop

At the same time, in the north-west corner of the Casa del Chirurgo, Room 2 was also converted into space for production and/or commercial activity.[147] As on the southern side of the property, the façade of the Casa del Chirurgo was removed down to the level of the course of wider blocks that had served as the foundation pad (Fig. 4.25). This was also accompanied by the removal of a little less than a metre of deposits so that the new shop unit could open out at the lower elevation of the pavement for the Via Consolare. A new, wide doorway for the shop unit (VI 1, 9) was built using *opus testaceum* with a small quantity of *opus quasi-reticulatum*. The doorway into the atrium was blocked, preventing direct access between the shop and the house, seemingly with *opus craticium* or similar ephemeral material. Unlike the southern shop however, there is a great deal more evidence for the initial and continuing activities of this space over the next 50 to 75 years.

The northern shop unit appears to have operated first as a metal-working establishment. This can be seen by the quantity of slag, hammerscale, charcoal, and other ashy deposits that covered the floors of the room (Fig. 4.26) and which testify to repeated burning at high temperatures. There is also possible evidence of small furnaces built with broken pottery, which were periodically destroyed with their remains also being incorporated in the gradual build-up of deposits in the room. This period of production may be divided into three main sub-phases, though the activity represented by these divisions seems likely to have been continuous rather than periodic. Occasionally, a new, thin mortar floor surface was applied to the top of these deposits, only to be followed by the deposition of more ash, charcoal, and the repeated cutting of shallow pits. The cuts through these floors could be result of small-scale smelting via tall, thin furnaces – a conclusion supported by the discovery of several large lumps of iron within the build-up, plausibly to be identified as iron blooms.[148] Dating from the lowest deposits of the first sub-phase indicated that these metal working activities began in the last quarter of the first century BC and continued until roughly the mid-first century AD when the nature of shop was altered dramatically.

The most convincing evidence for small-scale metal production and working involving high temperatures

Figure 4.25. The lowest activity surface in the northern shop unit revealing the foundations of the Casa del Chirurgo, plaster on re-used Sarno stone blocks, the stair base, and ashy deposits (image AAPP).

Figure 4.26. An amphora apparently put to industrial use in the shop during Room 2 (image AAPP).

is an amphora, set on its side in roughly the centre of the eastern side of Room 2, seemingly in conjunction with a wall and punctured by the removal of the neck of the vessel with a nozzle hole on its side. It had been carefully packed into place and was surrounded, particularly on the southern punctured end, with bright red to orange discoloured soils and considerable amounts of slag, flux, and fragments of iron and lead. The feature has been interpreted as a furnace, although precisely how it would have functioned is unclear. The second sub-phase saw the destruction of this amphora feature along with its adjoined wall, and the laying of a compact grey surface consisting of the packed debris derived from the use of the shop itself. This surface yielded a considerable amount of metal working residue and though it did not contain a feature similar to that of the previous sub-phase, depressions present across its surface may nevertheless have been the result of similar features that were subsequently removed. This second general phase of utilisation also witnessed the creation of a stairway leading from the shop floor

to an upper storey over the shop, as is indicated by two masonry steps in the south-eastern corner of the room.[149] Beyond the first two steps in Sarno stone *opus incertum*, the second of which was capped with a roofing tile *imbrex* (39 × 63 cm),[150] the stair continued in wood, which has left visible traces on the southern wall of Room 2. The final sub-phase of metal working in Room 2 witnessed the continuation of the build-up of ashy residue from these activities over a low-quality mortar floor. Since the practice of cutting small pits into the surface that had characterised the previous two sub-phases continued in this phase, the mortar surface was preserved only in isolated fragments.

An opportunity for Augustan luxuria

The insertion of the two shops caused considerable disruption in the Casa del Chirurgo. Most importantly, the north-south drain that had originally connected the impluvium to its cistern had been cut by the removal of soils in Rooms 3 and 4. It seems that the owners took this opportunity to undertake a widespread redecoration and updating of the property, which included not only the necessary refurbishment of the atrium and its water collection features but also the provision of the long-rectangular room identifiable unequivocally for the first time as a triclinium (Room 10). Coordinating these efforts seems to have been a combined interest in providing new reception rooms and in highlighting the vista from the fauces through the atrium and tablinum onto the garden space and its luxuries, while at the same time also extending the range of services spaces in the house (cf. supra).

Atrium and cubicula
The excavation of the shop unit cut down through the drain that had previously run southward from the atrium, breaking it into two parts and causing its associated cistern to be abandoned. Drainage from the impluvium was redirected towards two new cisterns that were constructed during this phase; a southern one located in front of the doorway into Room 10, and one slightly to the north, which also reached back into the tablinum (Room 7) (Fig. 4.27). The excavation necessary for the creation of these cisterns was clearly preceded by the removal of the flooring the atrium had been provided with in Phase 4, except in the area of the fauces. The cisterns were fed by water captured in an impluvium made from *tufo di Nocera*.[151] This was connected to the southernmost eastern cistern via a tile-lined and capped drain, which ran from the south-east corner of the impluvium. A similar

connection probably joined the northern cistern to the impluvium, but was not excavated due to the presence of preserved *opus signinum* flooring above it. Despite the fact that the *tufo di Nocera* impluvium was constructed in similar materials to the bases of the drains of the original house, it is quite clear that it was either was an entirely new replacement or was substantially modified at this time. There is no way for water collected in the present impluvium to reach the north-south drain of Phase 3, nor does the feature appear to have blocked holes which might originally have connected with the earlier drain. Presumably it was these features that led Maiuri to conclude that the impluvium was a secondary feature of the house,[152] even though the presence of the north-south drain means that some sort of water-collection basin must have already been present in this area prior to the current impluvium, even if it may have had a different form. A relatively wide foundation cut (Fig. 4.28) was made for the placement of this impluvium, which must also have allowed the removal of the previous water-collection feature along with the northern part of the grey tuff and Sarno drain from the previous phase. This new impluvium was raised and levelled slightly above the elevation of the original water-catchment feature by chocks of Sarno, possibly reused capping from the southward running drain or the original impluvium itself. Unlike the north-south drain, the western outflow drain that led out of the fauces to the Via Consolare was clearly reused in the new

configuration, albeit with some modifications to its eastern end. Indeed, the older flooring of the fauces appears also to have remained largely unmodified as is visible in a clear join on its eastern side.

Following the reworking of the water-collection conduits in the atrium, new lava-stone thresholds were fitted into many of the rooms surrounding the atrium. In some cases, this involved extensive chipping away at the original Sarno stone walls so that the threshold stones could be levered into place. It is unclear why the threshold of Room 6C, was completed with two separate stones, rather than a single block, but perhaps it related to narrowing of the doorway that also occurred at this time. After this had been accomplished, a levelling layer of rubble was deposited throughout the room upon which an *opus signinum* floor surface was laid.[153] This comprised a rough bedding layer for a relatively coarse upper *opus signinum* in which red, grey, black, green, and yellow marl chips were embedded to create a decorative finish to the final polished surface.[154] Elements of this floor were extended onto the southern side of north ala (Room 8), where the older Second Style mosaic flooring of the previous phase had been retained. The line of the threshold was reworked at this time with a decorative pattern of five squares each with a different central motif, which has been dated to the first century AD.[155] This decorative border, which today is nearly entirely lost, has been reconstructed in plan by rectifying photos from Pernice's 1938 publication

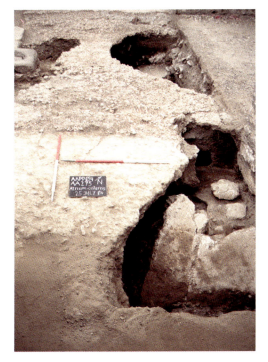

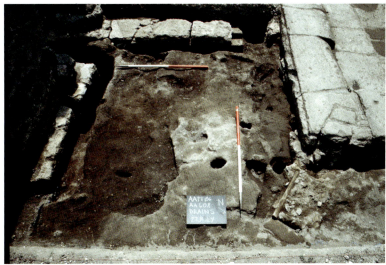

Figure 4.27. (*Left*) Collapse of cisterns at the time of excavation indicating their spatial relationship with the impluvium (image AAPP).

Figure 4.28. (*Above*) The foundations of the Nocera tuff impluvium in the atrium, and the drain to the new cistern on the south-east (image AAPP).

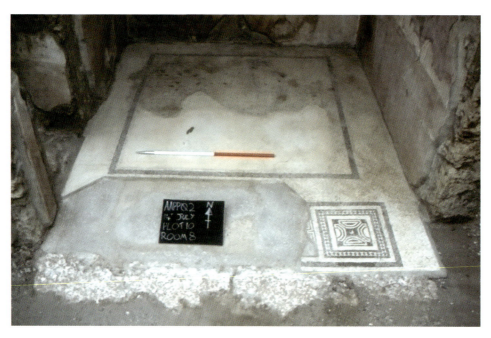

Figure 4.29. Current state of mosaic border of ala 8 (image AAPP).

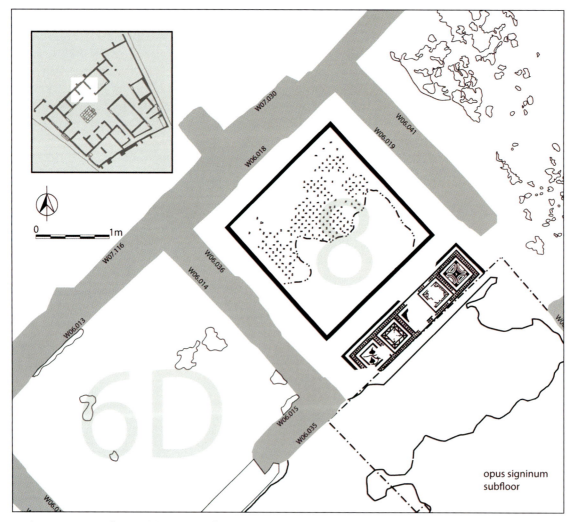

Figure 4.30. Reconstruction of original decoration after Pernice 1938 (produced by rectifying the original photo onto a 3D model of the floor surface). Remains from both Phases 4 and 5 are illustrated (illustration M. A. Anderson.)

(cf. Figs. 4.29 and 4.30). The effort taken to integrate the new flooring with the old is also reflected in the nature of the *opus signinum* with which the atrium and its surrounding rooms was finished. Pernice noted that were it not for the fact that this floor is certainly later, he would have thought it to date from the "Tufa Period" (i.e. 200–80 BC). The renovation of the Casa del Chirurgo therefore appears to have been intended to preserve the 'archaic' flavour of the structure and its earlier features as much as possible. The blocking of the original doorways in the south walls of the southern cubicula meant that these rooms also required some redecoration at this time, which included not only the walls, but also the floors. The process of sealing the openings had probably required the removal of any earlier flooring in order to provide access to the wall at depth. Each of these rooms appears to have been repaved in *opus signinum* similar to that used to repave the atrium. At the same time, the owner of the Casa del Chirurgo decided to repave and redecorate Room 6D in northern range of cubicula in a similar fashion.

Fauces
Beyond the general refurbishment of the atrium, an emphasis on the vista through the atrium and tablinum was one of the major alterations to the property in this phase. This vista was framed by engaged pilasters that reflected similar ones that now flanked the fauces.[156] At the same time the *antae*, which had originally divided the entranceway into a *vestibulum* and fauces, were removed and a new doorframe was added with work in brick/tile corners.[157] This was set on top of a new grey lava threshold that was added in this phase.[158] The reasons for narrowing of the main entrance to the house are not entirely clear. It is possible that the pillar was intended to strengthen the opening in order to bear the loads of the upper storey that would soon be added to Room 2.[159] As noted above, the floor of the fauces appears to be an older floor that was preserved during the interventions of this phase.[160] Perhaps it was this that encouraged the imitation of an older style in the flooring of the atrium and some of its surrounding rooms. While Maiuri thought that the surface of the fauces had been raised significantly,[161] his interpretations regarding the drain from the impluvium and the fauces ultimately have proven to be incorrect. The addition of a new grey lava threshold stone may be a response to a new raised pavement on the Via Consolare, which was recovered from this phase outside of Room 2. Similar additions were made to the Vicolo di Narciso in this phase.[162]

Tablinum
The vista from the fauces, into the atrium and tablinum was extended through to the hortus (Rooms 16 and 20) by the complete removal of the back wall of the tablinum. This is clearly documented by the robber-trench filled with building debris and pottery that helped to date this phase after the late Augustan period.[163] A large wooden shuttered doorway most likely replaced the wall, as is suggested by the grey lava stone threshold stones found adjacent to the north-east and south-east corners of the room, which could have supported a wooden jamb for doors. The small doorway at the eastern end of the northern wall of the tablinum, no longer being necessary for access to the garden, was blocked and became a niche in Room 9.

The removal of the rear wall of the tablinum and excavation of cisterns provided the opportunity for a new floor. First, a layer of building rubble was deposited, overlying which was placed a layer of dark red *opus signinum rudus*. Over this came a thin spread of pinkish white mortar *nucleus* into which the *tesserae* of a mosaic were set. Around the edges of the room ran a double black border, each band four *tesserae* wide, with the *tesserae* set parallel to the walls (Fig. 4.31). It is possible that this border had two further borders more central to the design, which may be preserved in the cork model of the house in the Museo Archeologico Nazionale di Napoli.[164] The original excavation reports mention an *emblema* of a star surrounded by various ornaments in a roughly 62–66 cm (3 *palme*, 7 *oncie*) square that does not survive today.[165]

Hortus
The new emphasis on the visual axis through the fauces, atrium, and tablinum was completed by emphasising its destination, the eastern hortus, which appears to have been transformed at this time into a formal planted garden.[166] The first changes witnessed by this space involved the general removal of most of the *opus signinum* in the portico and the excavation of several large pits that penetrated down to the natural soils. Possibly, these were intended to recover materials appropriate for building such as sand or some component of the natural soils.[167] Certainly, these are the only elements found missing from these pits, since they were filled again with building debris and other detritus. The garden was then created by dumping a significant quantity of topsoil into which ten *ollae perforatae* (planting pots) were placed, spaced roughly every 0.6–0.7 m along the eastern wall of the garden (Fig. 4.32).[168] A further seven planting pots were found along the northern wall of the garden. The regular spacing of

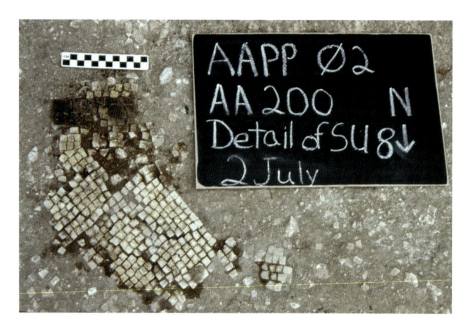

Figure 4.31. Preserved traces of original tesserae with black band of decoration in tablinum (Room 7) (image AAPP).

the *ollae perforatae* suggests that both lines were planted at the same time as part of a coherent scheme to create a carefully planned outdoor space, possibly involving vines trained against the northern and eastern walls of the garden. Charcoal remains suggest that the garden may also have included an ornamental beech tree as some part of this planting scheme.[169] While some of these deposits were spot-dated to the last quarter of the first century BC, many also contained glass of the first century AD. In fact, the garden soils were highly churned, presumably a result both to its ancient and modern use,[170] and for this reason these changes have been sequenced within this phase because they logically fit here, but they could equally have occurred somewhat later, even in the subsequent phase. Finally the portico was repaved with a second *opus signinum* floor that ran over the earlier flooring, covering the pits that had heralded construction in this area.

Triclinium

Beyond emphasising the visual axis through the house, the addition of Augustan *luxuria* to the Casa del Chirurgo took care to provide a locus of 'elite' dining and reception. Room 10 received lavish decoration, becoming for the first time clearly identifiable as an elongated triclinium, created by extending the

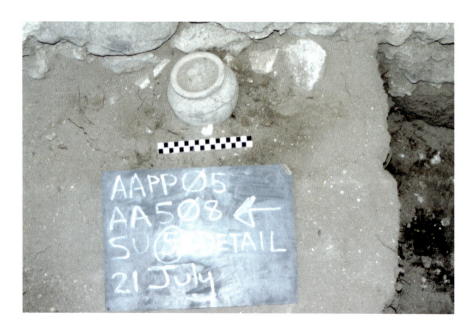

Figure 4.32. In situ *ollae perforatae* along the eastern wall of the garden (image AAPP).

walls of Room 10 to the south. The foundations of the new walls were dug and then completely filled with *opus incertum* that was continued above the level of the ground using shuttering techniques, in order to provide a wide foundation pad on which the narrower *opus incertum* upper portions of the walls were then constructed. Following this, a substantial sub-floor was laid throughout the room consisting of a closely packed preparation layer of angular black lava cobbles.[171] Overlying the cobble raft was a thick layer of rough *opus signinum* sub-floor topped by a fine *opus signinum* that was smoothed to create the final floor surface (Fig. 4.33), into which marble *opus sectile* diamonds and other more irregular pieces of marble were set[172] (Fig. 4.34). A thin band of marble *opus sectile* also bordered the room. In the centre of the southern end of Room 10 a rectangular section of pink mortar marks the location of a marble *opus sectile emblema* designed to decorate the area between the benches of the triclinium (Fig. 4.34). The pattern of marble in this feature is still identifiable by the indentations from missing marble fragments.

Decoration
Finally, a new scheme of wall painting was added to much of the house, including the fauces, atrium, cubicula, tablinum, and the triclinium. In the fauces, engaged pilasters were created in stucco in order to flank the visual axis through the house, but most other traces of the decorative scheme are not preserved. In the atrium, it would appear that much of the previous plaster and its backing was removed following the

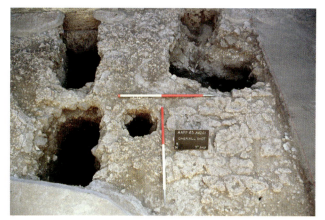

Figure 4.33. *Opus signinum* floor in Room 10 with remains of bedding for the central emblema (image AAPP).

laying of the floor. After this, a layer of backing plaster was applied to the walls, followed by a thin coat of fine white plaster bearing painted decoration. In the recess left by later alterations to the doorway into Room 2, traces of the original plaster provide a small window onto the decorative scheme. Here, the walls of the atrium were decorated with broad golden and narrow reddish brown vertical decorative bands, possibly on a white ground (cf. Fig 5.5.25). Presumably these would have formed elements of a Third Style decoration that is otherwise lost. In the triclinium, the original plaster decorative surface of the walls of the previous phase was removed prior to the laying of the *opus signinum* floor and the walls of the now enlarged triclinium were plastered and decorated.

Much of the rest of the property was also redecorated at this time. Certainly the walls of the southern cubicula

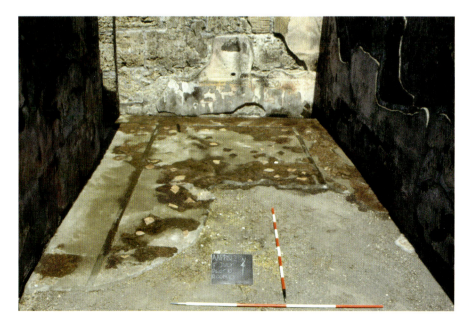

Figure 4.34. *Opus signinum* floor, sub-floor; sectile inlay and pink mortar base for the sectile (image AAPP).

required new plaster to cover their recently blocked doorways. Importantly, however, there appears to have been a spending hierarchy and different amounts of wealth were invested in various areas of the house. The tablinum, for example, was lavishly redecorated; the previous phase of wall painting was largely removed and a new white backing plaster was applied. This backing plaster was also used to create the five architectural flutes of the engaged plaster pillar at the western end of the northern wall that reflected those in the fauces. A final layer of fine white plaster was thereafter applied to the wall onto which the decorative pigments were presumably applied. On the other hand, while the walls of floor of Room 6E were redecorated, it would appear that cost savings were made with regards to the wall painting. Here, the previous backing plaster was reused and only a very thin new coat of plaster was applied to the wall prior to the application of a dark blue or black pigment. Consequently, it seems that although reception rooms received lavish attention during the phase of redevelopment during the Augustan era, elsewhere savings were made, perhaps in an attempt to keep a control on the costs of this significant phase of renovation.

The service wing
This phase of construction, which saw the creation of the southern shop (Rooms 3 and 4) and the enlargement of the triclinium (Room 10), also witnessed the extensive redevelopment of the southern and eastern sides of the house, including the removal of the southern portico and any related roofing. To the east, this work created a range of rooms clustered around the enlarged triclinium and back door. The space that had been divided off by the 'L' shaped wall (Room 13) in the previous phase, received an *opus signinum* flooring for the first time. It possibly also received a cooking platform, indicating its role as the kitchen of the house. While modern reconstruction of the current masonry platform and changes in the subsequent phase make it impossible be certain, this seems probable. It is possible that the *lararium* decoration that graced the south wall of this room was added at this time, though on the whole this seems more likely to have been completed in a later phase.[173] Most surrounding rooms do not seem to have received *opus signinum* floor surfaces and probably continued to be used for simple storage. Since the triclinium had sealed off the original points of access to this area, a new opening was created on the northern end of Room 18 in order to create a corridor connected to the hortus and remaining portico. The

opus signinum pavement of Room 13 appears to have been extended through this doorway to Room 18,[174] although it was strictly utilitarian and had none of the decorative features present in the atrium and cubicula. The lack of similar flooring from Room 17 highlights the fact that a wall separated these spaces at this time.

On the west, a pair of rooms (Rooms 23 and 22) was created on the western side of the triclinium (Room 10) that were connected to the kitchen and service rooms by a narrow L-shaped corridor (Room 12) and to Room 8A and the atrium through a narrow doorway at the northern end of this corridor. These rooms were built as part of the same sequence of activities that saw the creation of the southern shop in Rooms 3 and 4. Initially this necessitated the complete dismantling of the southern portico down to the level of its foundations. After this, the western wall of Rooms 23 and 22 was constructed as a retaining wall for the soils to the east, allowing the lowering of the ground level for the creation of the shop. All of the walls of these service rooms used the same construction technique, employing a wide *opus incertum* 'cut and fill' foundation pad with a narrower upper *opus incertum* wall. The opening to the cistern into which waters from the portico roof had formerly drained was sealed over and buried under a beaten earth floor. The intended function of Room 23 is unclear, but considering that it was not included in the luxurious decoration of the atrium, a service function seems probable.

The Casa del Chirurgo as an elite urban dwelling

By the late first century BC to early first century AD, the Casa del Chirurgo had been provided with most of the major features it presents today, largely the result of a single widespread period of transformation (Fig. 4.35). From its original form – essentially a portico-surrounded, outwardly focused central core appropriate for sparsely occupied surroundings – the house had been changed into a form more appropriate for the dense urban environment which had grown up around it; an atrium house with small pseudo-peristyle, with an independent service wing and several fine areas for the reception of guests, including an emphasised tablinum and decorated triclinium. The significant investment represented by this activity, as well as its association with two new commercial properties, is a telling moment in the development of the property and the urban evolution of the city, particularly in the early imperial period.

Phases 6–7. Mid-first century AD to AD 79

During the period between AD 42 and the eruption of Vesuvius, the Casa del Chirurgo witnessed two further phases: a final period of redecoration and modification and a period when the house seems to have experienced damage and subsequently began reconstruction that was not yet complete at the time of the eruption. Due to the coarseness of the dates produced by materials recovered from excavation, the poor preservation and uncertainty of final phase floors, and the presence of significant modern disturbance and degradation, the archaeological record for these periods is somewhat compressed and difficult to untangle with certainty. This time frame also witnessed the earthquake of AD 62/3, an event that according to the ancient sources caused widespread damage in the area and which perhaps too often features as the explanation of major damage or change to Pompeian structures.[175] Recent work has focused on evidence for ongoing seismic

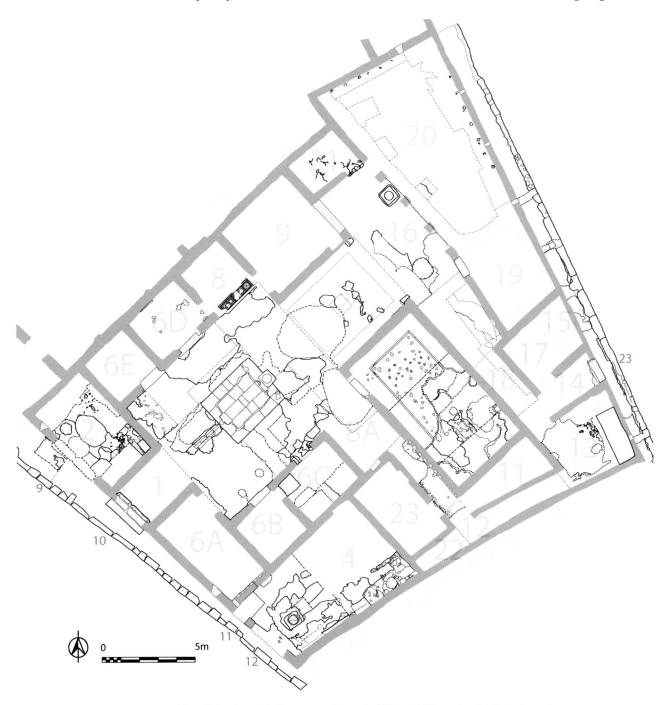

Figure 4.35. Plan of the Casa del Chirurgo at the end of Phase 5 (illustration M. A. Anderson).

disturbance in the city and the effects of continuing or worsening damage caused by minor tremors or aftershocks in the years leading up to the eruption itself.[176] While it is naturally possible that the two phases occurred entirely independent of any seismic activity, on the whole it seems likely that the Casa del Chirurgo will have experienced some damage during this period. For this reason, much significance hinges on whether the first of these two phases in the Casa del Chirurgo is seen having occurring prior to the earthquake(s) or whether indeed, it should be seen as a response to it. While either interpretation would be equally appropriate given the *terminus post quem* of AD 42, additional evidence is provided in the form of the wall decoration undertaken during Phase 6, which was in the Fourth Pompeian style, and in the case of the Casa del Chirurgo, has been at least tentatively identified as belonging to the period before the earthquake of AD 62/3.[177] It should be noted however, that while it is now widely – if not universally – accepted that the Forth Style had, in fact, reached Pompeii prior to the earthquake,[178] this matter is complicated further by the possibility for ongoing disturbance and aftershocks and it must be admitted that the remains surviving for analysis within this house are either in relatively poor condition, or survive in small fragments preserved under unusual circumstances (in the cisterns of the house cf. Chapter 8). It is therefore possible to reconstruct two different plausible scenarios. Given that the analysis of the wall painting suggests that the first phase of decoration had taken place before the earthquake(s) of AD 62/3, that sequence will be presented here first. The meaning of the alternative interpretation will be considered at the end of Phases 7 and 8.

Shops and upper storeys[179]

The most substantial changes in this phase took place within the shops, and just as had been the case during their creation in the late first century BC to early first century AD (Phase 5), modifications in these locations created the need for further alterations within the Casa del Chirurgo itself (Fig. 4.36). The result of this process was a period of upgrading and redecoration, presumably intended to neaten up after the more substantial alterations had been completed. In the northern shop (Room 2) the metal working activities that had taken place since its separation from the main property seem to have come to an end in about the middle of the first century AD. A coin from the final layer of these activities dated to AD 42 gives a *terminus post quem* for a change in the role of the northern

shop from production to some sort of retail activity. From the '*hydriai*' recovered from this room during the excavation of this property in the Bourbon period,[180] it may be suggested tentatively that it was converted to function as a commercial site for either the contents of the vessels or the vessels themselves.[181] When the northern shop ceased its production activities, the upper storey that had been installed during the course of the previous period was made accessible from the atrium and the blocked doorway that had once connected the two areas was reopened. The steps leading from Room 2 were sealed in a broad bank of masonry that aligned neatly with the doorway into the atrium of the house. It is not entirely clear whether this meant that the upper storey was no longer accessible from the shop, since traces of any wall to the north of the stairway that might have divided off Room 2 from the stair has not been preserved. In the absence of any explicit evidence for separation, it is probably best to see both Room 2 and that atrium (Room 5) as having had access to this stairway.

At roughly the same time, in the southern shop (Rooms 3 and 4), alterations were made to the stairway that led from the street to the upper storey that ran over the shop itself and above Room 23 and the northern part of Corridor 12 of the Casa del Chirurgo. A large number of substantial postholes cut into the general area of the western threshold, suggest that the process of modification was not straightforward and required considerable reworking of the surrounding wall structure and support for the lintel itself during the procedure. Thickening of the southern wall of the shop may also have been necessary at this time (or shortly afterwards) in order to bear the loads of whatever alterations were undertaken. The need for additional support for the upper storey is also suggested by the rebuilding of the wall between Room 23 and Corridor 12, through which the floor beams would have passed (but are not preserved). Perhaps this was because the changes involved the addition of yet another storey or because the modifications to the doorway itself undermined the stability of the lintel. Certainly a new, more substantial set of stairs was added, cutting through the brick/tile pillar of the earlier phase. These continued on in wood up to the second storey leaving distinctive marks in the face of the northern wall of Room 3. Notably, these stairs were accessed from outside of the shop, making it clear that this was now an independent unit, perhaps for rental. To the south of this a new grey lava shop threshold was inserted and the space was finished with a new floor surface of *opus signinum* in the back (Room 4) and a simpler

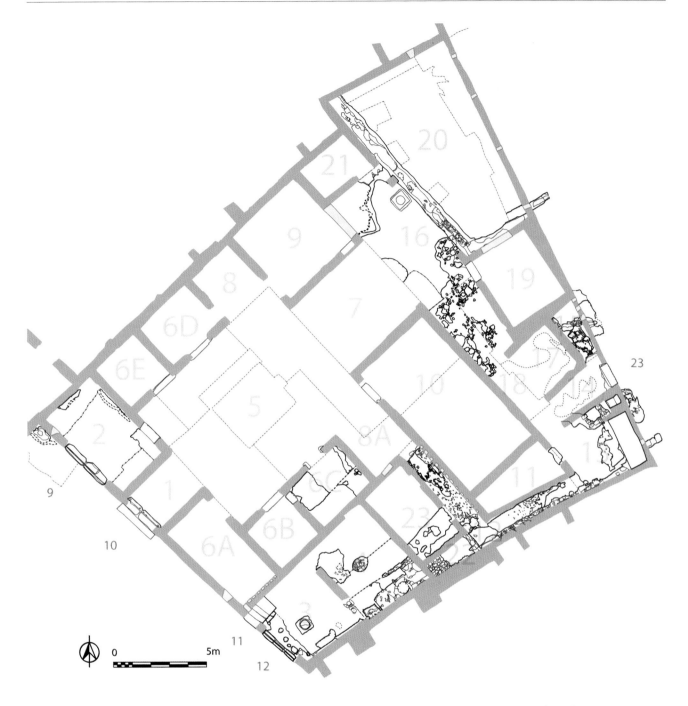

Figure 4.36. Plan of the changes in the Casa del Chirurgo in Phase 6 (illustration M. A. Anderson).

mortar floor in the front room (Room 3). Continued use of the water drainage and storage feature in the south-eastern corner of Room 4 is attested by additional constructions around it, including waterproofed tanks. The ongoing presence of water is also suggested by a soak-away feature built into the *opus signinum* floor of Room 4.[182] At some point after the completion of the floors, a short wall was created dividing off Room 4 from Room 3 for the first time, constructed directly over these floor surfaces and without foundations.

Plausibly, this relates to ongoing difficulties with the new upper storey, possibly caused by the earthquake(s) of 62/3, which may also be the actual reason for the thickening of the southern wall of the shop.

Alterations to the upper storey over the southern shop also necessitated further changes within the service rooms to the east of Rooms 3 and 4. The western wall was reworked substantially at this time, seemingly also with the intention to bolster its load bearing capacity. The wall was largely rebuilt from its original

foundation pad. At the same time, the doorway into Room 11 was sealed and a new opening was made on the eastern side of the room. Changes were also made to the light well arrangement. The southern arm of this corridor was fitted with a tile-lined drain adjacent to the southern boundary wall of the property (Fig. 4.37). The drain led from Room 22, where the cistern into which water had flowed in the previous phase was now sealed. Excavation revealed an area of subsidence and collapse in the kitchen (Room 13) that suggests the presence of a void once occupied by a cistern. The collected water was therefore diverted into the drain in Corridor 12 and towards the cistern in the kitchen. An overflow from this cistern drained through the pavement and onto the Vicolo di Narciso.

Changes within the Casa del Chirurgo

Additional upper storeys were installed inside the property. It seems probable that the addition of the upper storey over both the northern and southern shops in Phase 5 were produced by societal pressures that only increased with time encouraging the addition of further upper stories.

Upper storeys within the Casa del Chirurgo and the service wing

The interior of the house gained an upper storey over its service wing. A stairway, comprising a series of wooden planks for steps cut directly into the Second Style plaster, was inserted into the western wall of the oecus (Room 19). This would have led up to a new set of upper storey rooms over some, or perhaps all, of the eastern service area of the property.[183] Certainly second storeys must have existed over Rooms 17 and 18, and some traces of an upper storey latrine (with window) exist over Room 15. Elements of the downpipe from this latrine were visible from the cesspit on the Vicolo di Narciso. Two additional toilets on the ground floor of the service wing were added during this period of renovation. One toilet or chute ran from the area immediately to the north of the kitchen bench in Room 13[184] into a cesspit to the south of the back door, situated below the pavement of the Vicolo di Narciso. The second, in combination with the upstairs latrine, ran into a second cesspit under the same pavement to the north, and was decorated with a false vaulted ceiling in stucco.[185]

The installation of the stairway, upper storey rooms, and toilets resulted in considerable damage to the southern wall of Room 19 and those around it. It is also likely that the old portico would also have been removed during this phase of construction, which saw the near complete rebuilding of this structure. A large brick/tile pier was built over the base for the Sarno-stone pillar that had originally formed the north-east corner of Room 19 so as to support the southern end of the new portico and to bear the additional loads of the upper storey. At the same time, large segments of the eastern and southern walls of Room 19 were rebuilt and a hanging vaulted ceiling was either installed for the first time or rebuilt in the oecus. The rebuilding of these walls appears also to have damaged the flooring of the room, which was repaired in *opus signinum*.[186] The northern entrance to the oecus was sealed with a wall with a broad picture window that opened onto

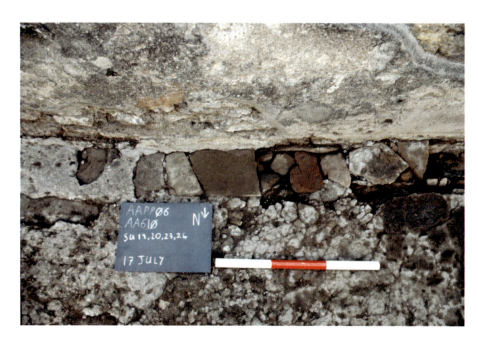

Figure 4.37. Tile-covered drain in the southern portion of L-shaped Corridor 12 (image AAPP).

the garden, while a doorway on the northern end of the western wall was retained at this location.

It seems likely that most of the Sarno stone pillars of the portico were removed at this time, creating an ambitiously wide span between the new brick/tile pillar and the sole remaining Sarno stone pillar on the northern side of the tablinum. This new roofing arrangement was reflected in the provision of a new channel for conducting excess water away from the cistern at the northern end of the portico. If the traces that have been interpreted as an earlier drain running across the garden are correct, then this was now removed. Excess water was thereafter evacuated from the garden via a new *opus signinum* topped gutter set upon a tile base that ran along the bottom of the northern wall of the oecus (Room 19) and butted directly against the eastern side of Room 21. The channel ultimately emptied out onto the Vicolo di Narciso through a new hole in the eastern wall of the garden and through a modified tuff kerbing stone onto the street itself.[187] The same *opus signinum* was also used to re-line the rest of the remaining guttering of the portico.

Underneath the portico a new *opus signinum* flooring was poured over a thick layer of coloured and decorated wall plaster fragments, seemingly designed to seal the footings of the new stairway and to secure the western end of the steps in a construction that must have been entirely of wood. Traces of the steps, clearly chipped directly into the eastern wall surface, are still visible (Fig. 4.38). However, the placement of this flooring was not limited to the area around the stairway, but was extended to include the whole service wing of the house, including Corridor 12 and plausibly also all connected rooms (though if so, it was removed from some of these in the following phase). In each case, this final phase of *opus signinum* was run over a bedding of fragmented, multi-colour plaster as a base, supporting the identification of this activity as a single, coordinated process.

Redecoration
This phase of building and re-organisation was brought to a close by a coherent programme of redecoration, which can be seen throughout the fauces-atrium-tablinum axis, in which the walls were brought up to date in frescoes associated with the early Fourth Style.[188] The floors from the previous period of renovation in the late first century BC to early first century AD were retained with only minor changes and repairs. The plaster employed in this redecoration involved a highly distinctive, final surface that contained large quantities of angular quartz fragments, that is found in all of the rooms of the core of the house, indicating a total redecoration of the property at this time.[189]

Tablinum
In preparation for the redecoration of the tablinum (Room 7), the previous final plaster surface was largely removed and the backing plaster repeatedly picked to roughen up the surface prior to the addition of a new final coat. A layer of white plaster with translucent to light-brown quartz grains was then applied to the wall and smoothed to create a surface suitable for the application of fresco (Fig. 4.39). If the cork model of the city in the Museo Archeologico Nazionale di Napoli[190] preserves the design correctly,[191] the north and the south walls of the tablinum were decorated with an intricate design of a central yellow socle, with a lower red band at the floor level that extends the full width of the wall, with a middle zone containing a yellow panel surrounded first with a thin white and then broad red border.[192] To either side of the border there appear to have been white ground *durchblicke* containing architectural vistas or columns and candelabra, probably in green resting upon yellow podia that appeared to project from the socle. To either side, a black socle completed the design with blue middle zones, separated by a horizontal division in white.

Figure 4.38. Evidence for steps and a brick/tile reinforcing column on the outer wall of Room 19 (W06.066) (image AAPP).

Figure 4.39. Pick marks to prepare the initial plaster layer to receive the final layer in the tablinum (image D. J. Robinson).

The blue panels were separated from the *durchblicke* by yellow bands, columns, or candelabra. Overall, the upper zone of the wall is not recorded, but hints at a white ground with architectural elements. Evidence from the wall plaster demonstrates that the fluted engaged faux pillar in the upper zone of the western edge of the wall from the previous decoration was retained and incorporated into the new decorative scheme, and was painted red.[193] It seems likely that the brick/tile elements repairing the rubblework of the north and south walls of the room also took place at this time. Possibly, this was in order to strengthen the wall structure in preparation for the loads of nearby upper storeys.

Atrium
In the atrium, the first step seems to have been to remove the previous fresco surface prior to the picking of the backing plaster and the application of a thin white plaster layer containing translucent to light-brown angular quartz crystals very similar to that employed in the tablinum. Application was restricted to the middle and upper zones of the walls and the engaged plaster pilasters that defined the eastern entrance to the fauces, which were incorporated into the new decoration. Following the coating of the pilasters, a final coat of plaster was applied to the lower register. This was a fine, white plaster containing a limited quantity of the angular quartz crystals, as well as large amounts of black inclusions and crushed ceramics giving the plaster an overall pink hue today.[194] There are fine traces of incised guide lines providing the layout of the decoration of the atrium walls.

On the basis of the cork model, the design of the atrium and the southern ala (Room 8A) involved a black socle, separated from a yellow middle zone by a thin white band. Within the space between each doorway, the central yellow/mustard panel was decorated with a thin white line or border design. The best preserved of these appear to have been on the western and northern sides of the atrium. The fluted pilasters that flanked the fauces appear to have been decorated in the same general design, certainly with yellow upper zones. An identical decoration carried through into the southern ala (Room 8A), where the cork model shows traces on the southern wall and in the niche. According to the *PPP*, it would appear that both the socle and the middle zone displayed central roundels,[195] one of which produced a feminine bust preserved in *Le Pitture Antiche d'Ercolano* that was one of the initial finds from the house.[196] There were also tapestry borders and turned ribbons, swags or garland decoration in the corners, some of which may have been red.[197] The wall between Rooms 6D and the northern ala (Room 8) appears to have been discoloured entirely red, possibly as a result of damage during the eruption as it does not appear to have been a part of the original design.

Rooms around the atrium
The redecoration program also extended into the fauces (Room 1).[198] Here, according to the cork model, the north wall was decorated with a refined and complicated design with a black socle running the whole width of the wall and a middle zone separated into two main panels in red, divided by a thinner yellow panel, possibly with bands, architecture, or candelabra in red.[199] While Schefold suggested that the element drawn in *Le Pitture Antiche di Ercolano*, Volume V, Tav IV, which produced the *tondo* of the woman's head with *amorino* touching her face came from here, it is virtually certain that this detail derives comes from the atrium.[200] In the centre of the red main zones are central black panels, with concave top and bottom edges. Above the main zone ran a blue praedella, itself surmounted by a white zone that appears to have contained thin architectural designs. The south wall appears to have been a reflection of the same layout while the pilasters of this area were also incorporated into the final decoration.

Unlike the southern ala (Room 8A), the northern (Room 8) was decorated in a layout that was more like the tablinum than the atrium. The walls appear to have had a black socle decorated with plants[201] (with a dolphin on the eastern wall) that ran across the whole width of the wall, surmounted by a central middle zone in yellow with a broad band of red dividing off a central yellow panel, possibly with purple borders and architectural vistas on either side. The *PPP*

notes female figures on either side (some removed) and green partitions, and suggests that the central panel of the northern wall was of Narcissus.[202] The decoration of Room 9 involved a red socle with white linear decorations and medallions that included the head of a panther on the north wall.[203] Above this was a black middle zone, separated by linear white or yellow bands, candelabra, or columns, that appear to have divided the wall into roughly three main and two intermediate zones. The same divisions appear to have divided the socle. Of the upper zone, little trace has survived.

The east wall of the triclinium (Room 10) also received decoration with a red socle, divided into three main segments by white linear designs and two intermediate segments with bands in green that appear to have contained architectural fantasies. The middle of the socle was characterised by a shift to yellow/mustard with a central lozenge in red, a white border, and some decoration, possibly grotesques.[204] The middle zone was similarly divided into three major and two minor parts with a yellow ground. Each major part had a white border or tapestry pattern within it and the minor parts were separated by vertical green bands. The central area was also flanked by two wide red bands with thin white bands on either side. A similar design appears to have been present on the remaining walls. The *PPP* mentions a red socle and discoloured middle zone on the north, dolphins in the central panel on the east, and further dolphins, aediculae with figures, and triangular tapestry borders on the south.[205] From the cork model, it seems likely that these were in the socle, which just like the east wall, had its central area marked off with a yellow band around a red central lozenge. Similar decoration occurred on the north wall, and each corner of the room bore a broad green vertical band. During the primary excavations in this room, the excavators noticed that some central panels, set in wood and hence intended to be removable, had fallen out.[206]

Of the remaining cubicula of the atrium, Room 6D was decorated with a black socle with plants and a white middle zone divided into panels and decorated with a rectangular tapestry pattern in yellow or gold. The excavators mention square divisions and seven female figures and geniuses, plausibly floating within the upper zone, since the socle would was clearly decorated in a different manner.[207] Between the socle and the upper zone ran a band possibly of red or purple. Room 6E had a purple socle with a white middle zone enlivened with central candelabra in red and yellow and lateral panels with triangular tapestry borders that appear to have been followed by an outer border of

yellow and a red inner border, divided by a white band. Scarcely any trace of the decorations in the southern cubicula (Rooms 6B and 6C) have survived and they also appear bare in the cork model. Room 6A shows traces of a black socle and yellow middle zone decor on its south wall.

Rooms off the Hortus
The oecus (Room 19), which had received considerable alteration due to the creation of the upper storey over the service rooms to the south, appears to have received some of the finest decoration (Fig. 4.40). Certainly it seems to have been in the best condition at the time of excavation since the majority of discussion centred upon this room.[208] An image of a woman painter recovered from the east wall of this room is the house's most famous wall painting.[209] This painting was the best preserved of three central painting panels, the southern of which portrayed three female figures (one seated and seen from the back, one from the side, and one on foot adorning a statue or herm) with arches in the back,[210] and the western a seated poet with diptych, a female figure with a shepard's hook (*pedum*) and another also adorning a herm.[211] The northern wall was dominated by a wide picture window to the garden with a marble sill with holes for turning shutters. The walls were executed largely in yellow, with a purple-reddish socle itself decorated with linear patterns and garlands.[212] Resting upon the socle were panthers and dramatic masks. The centre of each wall bore an aedicula in green that surrounded the central painting panel and were traced in thin columns that rest upon podia that extend from the socle and bear landscape decorations. On either side, the yellow panels were enlivened with fine details of garlands and linear patterns around a central gorgoneion, and the upper zone was decorated with fanciful architecture, enthroned figures, hippocamps and swans.[213] The room had a hanging vault, evidenced by beam holes above a lunette outlined in red on the north and south walls, which also had yellow ground and appears to have borne facing figures, perhaps of birds or animals. Between the vault and main walls ran a Lesbian cyma in stucco relief that was painted or flanked by bands in green, white, and red. Wide green vertical bands ran down each corner of the room.[214] The northern room facing the hortus (Room 21) was decorated much more simply, with a high red socle and a white upper zone that ran around all four sides.[215]

The hortus itself (Room 20) seems to have been decorated simply in a coarse white plaster without additional colour, while the area of the portico had

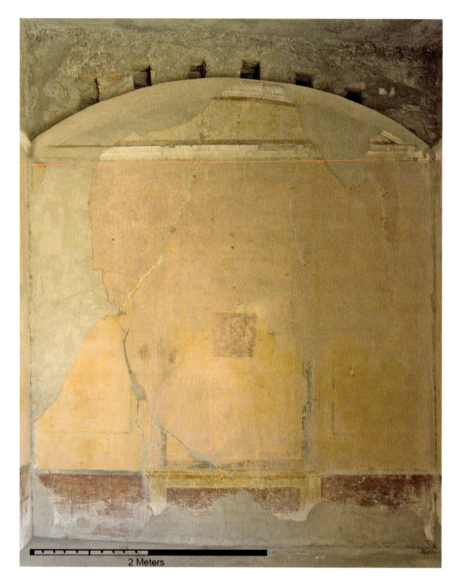

Figure 4.40. View of Room 19, wall (W06.064) (image © 2004 Jennifer F. Stephens and Arthur E. Stephens).

a high socle in *opus signinum* plaster, emphasising a possible utilitarian function or preparation for a high level of activity and use.[216]

Remaining service rooms
The high *opus signinum* socle, producing a bipartite division of the wall in red lower and white upper plaster, also characterised the continuation of the portico into the northern part of Room 18, where it covered over earlier Second Style plaster and was applied against the steps of the stairway that had been inserted against this wall. Similar plaster was used to decorate Room 17 where the red *opus signinum* plaster appears to have taken up most, if not all, of the wall surface. In the toilet (Room 15), a similar high, red *opus signinum* socle ended in white plaster that decorated two windows facing onto the Vicolo di Narciso. The hanging vault of this space is attested by joist holes on the northern wall. Traces of the same utilitarian plaster indicate that it

continued through the kitchen (Room 13) (except on the north wall where there was a *lararium* painting),[217] the *posticum* (Room 14), the small Room 11, and the corridor (Room 12). The evidence from Room 23 would suggest that it received a coating of white plaster, while the adjacent light well (Room 22) was redecorated in a ceramic rich plaster layer finished with a fine surface coat of *opus signinum*.

Shop units
Since the door into the northern shop unit from the atrium had been reopened, the shop was included in the process of redecoration. This might also have been necessary due to the change in function of the space from metal working to retail activities. A new floor surface of *opus signinum* was constructed directly on top of the metal working debris after new grey lava shop threshold had been inserted to accommodate the new floor.[218] The walls then received the same quartz-rich

wall plaster as the atrium and tablinum, although the decoration in the shop remained strictly utilitarian with a high, protruding *opus signinum* socle with white upper zone, which, from the cork model, appears to have been decorated with light-coloured linear borders. The plaster also preserved clear signs of the stairway ascending the southern wall.

The redevelopment of the southern economic unit to create an external entrance for the newly remodelled apartment over the shop and Corridor 12 of the Casa del Chirurgo provided the context for another phase of decoration. Although no final plaster layers were visible in either room of the shop, this does not mean that it would have been undecorated and the remnants of backing plaster sequenced to this phase indicate that any decorative layers have, most likely, simply not survived.

Diversifying the portfolio of the Casa del Chirurgo

In general, the changes undertaken in the Casa del Chirurgo in the mid-first century AD seem to have been directed towards the expansion of the commercial portfolio of its owners,[219] while displaying an overall desire to move away from the production activities of the previous phase. It is impossible to be certain of why such a change would have been deemed necessary at this time. On the basis of a similar end to metal working that took place in the Inn to the north of the Casa delle Vestali at roughly the same time, one might conjecture a change in city regulations as the cause. Of course, it is also possible that the house owner simply wanted to avoid the noise, heat, smoke, or other nuisances that might have been caused by such a facility. The phenomenon of adding a rental apartment in a second storey at this time is not restricted to the Casa del Chirurgo and is also witnessed in the Inn and Commercial Triangle in Insula VI 1 and elsewhere in the city.[220] Such a phenomenon is likely to be the result of a variety of factors including a general rise in prosperity enabling owners to invest in their economic portfolios, an increase in the urban population driving up the demand for accommodation, and perhaps also the influx of new workers involved in the rebuilding of Pompeii.[221] Within the house, there seems to have been a general desire to bring the 'public' and 'reception' areas of the house into line with the current decorative standard of the times.[222] The design of the new fresco has been assigned to the early Fourth Style, with Mau suggesting that the decoration was likely to have been complete before the earthquake of AD 62/63 at the latest.[223]

Phases 7 and 8. Post-earthquake and eruption changes in the Casa del Chirurgo

While the earthquake(s) of AD 62/3 appear perhaps too frequently as a means of explanation for architectural and decorative change and its influence on Pompeian daily life has perhaps been exaggerated, nevertheless the fact remains that a large number of houses in the city were similarly engaged some kind of renovation during the last years of the town's life, repairing damage that can be plausibly be interpreted as earthquake disruption.[224] The Casa del Chirurgo appears to be no exception. At some point after the changes of the mid-first century AD, but before the eruption of AD 79, the Casa del Chirurgo experienced one final period of redevelopment – one that is at least suggestive of a response to seismic trauma. By far the greatest concentration of this evidence comes from the southern side of the property (Fig. 4.41). This points to some damage having taken place to the southern half of the atrium roof or the plaster on its walls. Perhaps these had been weakened by the addition of upper storeys in the previous phase or were slightly less stable with their foundations in refilled terraces. Otherwise, drains seem to have been the major victims of seismic disturbances of this period. Efforts to begin to repair the damage had already begun. The storage and provision of materials for rebuilding implies that the house was not operating at full capacity at the time of the eruption, but equally indicates that it was probably far from abandoned. Indeed, little damage is evident in the structure of the walls of the property as a whole, indicating that this damage was more of an opportunity than a setback. If the damage was wrought by either the AD 62/3 earthquake alone, or was the result of continued seismic disturbances, it was also never completely repaired. Notably Mazois indicated in 1824 that not many of the final phase paintings survived in this house,[225] perhaps because a number had already been damaged during either the earthquake(s) or the eruption itself.

Atrium and surrounding rooms

The drains of the impluvium in the atrium appear to have been repaired or cleaned in this period. This can be observed in a series of cuts through the *opus signinum* floor that provided access to the tile capped drain leading to the southern and northern cisterns that were attached to the impluvium. Similarly, the western overflow drain to the Via Consolare was also

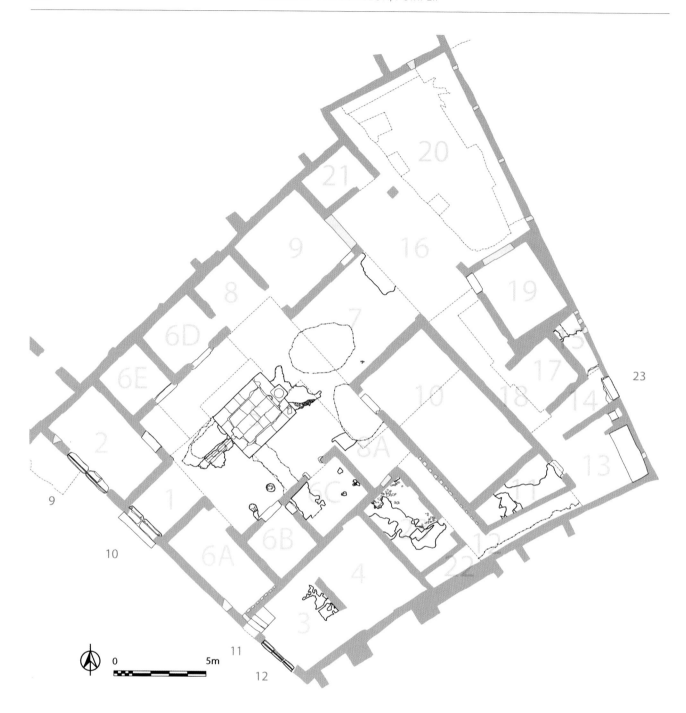

Figure 4.41. Plan of the changes to the property in Phase 7. Changes linked to the earthquake include holes in the south-west corner of the atrium (Room 5), the removal of the flooring in Room 8A, pick-marks in the south-west corner of the tablinum (Room 7) and piles of building debris in Rooms 11 and 23 (illustration M. A. Anderson).

worked on at this time. A cut exposed the drain which may have been when the earlier Sarno stone caps were replaced with roofing *imbrices* (Fig. 4.42).

These measures would have resulted in unsightly damage to the *opus signinum* floor, which never appears to have been repaired or repaved. Perhaps these were intended as temporary repairs to fix pressing problems in preparation for a future repaving of the atrium that

never occurred. Further damage to atrium's pavement was caused when at least two large postholes were cut through the *opus signinum* surface and down into the underlying levelling deposits on the eastern side of the room[226] (Fig. 4.41, cf. Fig. 5.5.28). These substantial holes imply that at least two sizable lengths of timber had been used to prop up parts of the *compluviate* roof or wall decoration of the atrium. Charcoal and ashy

residues inside the postholes might imply that these supports were still in place during the eruption and were carbonised at this time. Similar indications of extensive damage and repair were observed in the southern cubicula and ala. After the complete removal of *opus signinum* surface from the area of the southern ala (Room 8a) a row of small supporting posts seem to have been cut into the now exposed soils. Possibly related postholes for additional posts were also found in Room 6C. These posts may have formed an additional component of the system that was holding up the roof in the atrium and surrounding rooms while repairs could be undertaken. Indeed, the fact that the eastern side of the property as a whole tends to have been much less well preserved at the moment of excavation suggests considerable difficulty with the roofing and upper structures in this area. Certainly the different underlying 'geology' of the house on the southern side, the foundations of which were not in natural soils but in refilled terrace deposits might also have contributed to the susceptibility of this area to seismic damage.

That repairs were, in fact, underway in the house is suggested by evidence from the tablinum (Room 7) where the white and black mosaic from Phase 5 was damaged, seemingly from the dragging of heavy objects across its surface. This removed many of the tesserae and left behind linear scratches and some pick marks in the mosaic nucleus (Fig. 4.43). Fortunately, the poor state of preservation of this floor was noted by the original excavators, indicating that the damage was done during this phase rather than by the early excavators themselves.[227] Maiuri suggested that the brick/tile repairs in the northern and southern walls of the tablinum should be dated to the period of the earthquake, but it is possible that these changes had already been made in Phase 6.[228] When taken together, these facts suggest that the atrium of the Casa del Chirurgo had suffered from the earthquake(s) of AD 62/3 and subsequent aftershocks.[229] While there is no particular evidence of on-going damage from this house, it seems likely that the incompleteness of the works in progress, combined with the extremely temporary and almost emergency-like nature of some of these interventions, implies a period of on-going disturbance in the 17 years prior to the eruption.

Building materials

It is within the context of a house undergoing long-term or multiple phases of repair and damage that evidence from the service areas should be taken. A large, unconsolidated deposit of lime that was spread through

Figure 4.42. Evidence of repairs to the western drain of the impluvium (image AAPP).

Figure 4.43. Pick marks in the *opus signinum* below the mosaic surface in the tablinum (Room 7) (image AAPP).

much of Room 11 was perhaps all that remained of a larger pile stored in this room with the intention of being used for repairs or the restoration of the service wing or the rest of the house. Rubble and debris in the upper levels excavated in Room 23 might be remains of stored building materials. Room 6A also produced

evidence of a large (roughly 2.5 m square) pit excavated against the surviving walls that was filled with lime, however, a number of factors discussed below indicate that this feature is more likely to be modern.

On the pavement of the Vicolo di Narciso, every cesspit attached to the toilets of the house appears to have been open and largely empty at the time of the eruption. Lapilli fills within the pits themselves suggest that none of these features was actually in operation. While it is possible that such a situation could have been caused by the decomposition of wooden covers over voids that have decayed with time, the lapilli excavated from these features did not permit the proper assessment of this possibility. Given the number of drainage and cesspit features that appear to have been open in the moment just prior to the eruption, such as pavements outside of houses that were reported by Nappo,[230] the recent excavations of the Casa dei Casti Amanti,[231] and discoveries on the southern side of Insula VII 6,[232] it seems likely that the lack of evidence for closures indicates that these cesspits too were out of commission. Equally, the toilet in Room 15 was filled at least partially with rubble debris and could not have been used. It too, was filled with lapilli during the eruption.

This ongoing phase of redecoration and reconstruction was obviously never completed and parts of the Casa del Chirurgo remained in a poor state of repair at the time of the eruption. At this time the immense seismic turbulence, either prior to or during the eruption of Vesuvius in AD 79, led to the collapse of the northern and southern cisterns at the end of the atrium and the structural failure of their overlying floor surfaces, which crashed down into the voids (Fig. 4.44). These open holes in the atrium and tablinum, just like the open cesspits on the Vicolo di Narciso, were subsequently filled with stratified deposits of lapilli during the course of the eruption.

An alternative interpretation

As was stated at the beginning of this section, the sequence and interpretation presented here depends entirely on the belief that the reconstruction and decorations of Phase 6 belongs to the period prior to the earthquake(s) of AD 62/3. This interpretation would place the initial redecoration of the property with Fourth Style wall painting very shortly before AD 62/3 with subsequent damage in Phase 7 caused by the earthquake(s) and continued seismic disturbance sometime in the intervening 17 years before the eruption of Vesuvius. This would mean that the house

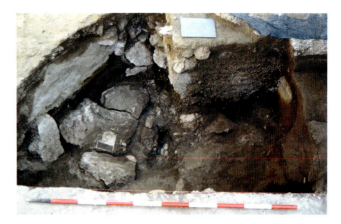

Figure 4.44. Mosaic floor at the base of the cistern collapse (image AAPP).

would have been in a state of some disturbance for many of the final years of life in the city, perhaps even a semi-derelict shadow of its former self undergoing a halting and possibly even abandoned programme of restoration incomplete at the time of the eruption. If, however, the Fourth Style wall paintings belong to the period *after* the earthquake of AD 62/3, a very different story presents itself. This interpretation would see at least some of the numerous second storeys currently sequenced in Phase 6, as the direct result of post-earthquake rebuilding, indicating that the house operated generally successfully for much of the intervening period prior to renewed seismic instability shortly before the eruption of AD 79, which called for another phase of repairs that were never completed. Given the surviving evidence it seems that the former explanation is more likely and that has been preferred in this narrative. However, given the degree of uncertainty involved and the different conclusions that might be reached from the alternative interpretation, it seems prudent to suggest that both are possible.

Phases 8 and 9. Changes in the eruption and modern period

There is insufficient evidence for us to be certain whether the period between the eruption of AD 79 and the initial excavations of the Casa del Chirurgo witnessed any looting or the recovery of possessions similar to that seen elsewhere in Pompeii.[233] While no obvious 'looter's holes' were found in the walls, they can not be completely ruled out, especially given the degree of restoration clearly undertaken on the northern side of the property at the time of excavation and the generally poor state of preservation across much of

the southern side, particularly in the service wing. Almost immediately upon excavation, the house was noted as one of the best preserved unearthed to date; a comment that relates as much to the height of the walls on the northern side of the property and the ease of understanding its layout as to the high quality of its surviving decoration.[234] It is clear that the southern side of the house was in a poor state, probably as a result of the collapse of the upper storeys documented above either during the earthquake(s) or the eruption itself.

Modern excavations began on the 27th of October 1770,[235] with the clearance of sufficient material to identify the large limestone blocks of the façade or atrium. About two weeks later, a tondo on a yellow ground of a woman's bust with green cap and an *amorino* touching her chin was recovered from the atrium indicating continued work in this area.[236] Concurrent excavations in the Villa di Diomede outside the Porta Ercolano, the Insula Occidentalis to the west, and the Casa delle Vestali to the north, tended to interrupt the excavations in the Casa del Chirurgo. By the 19th of January 1771, four rooms around the atrium had been cleared, including Room 2, where pottery *hydriai* were found, Room 8 with its white mosaic, plus two others, likely Rooms 6E and the fauces.[237] In these excavations a series of 38 weights, some of which bore the inscription 'EME' and 'HABEBIS', were discovered[238] (cf. Chapter 6). By the 26th of January 1771, the tablinum with its and its black mosaic bands had been uncovered, with a central emblema of a star.[239] By the 2nd of February 1771, another four rooms had been cleared, likely the southern range, whose lack of well-preserved decoration might explain their cursory annotation in the reports.[240] Continuing excavation in the house through the 9th of March 1771 may have included the shop (Rooms 3 and 4) to the south, Room 23, or general cleaning, but on the whole, Room 9 is probably the most likely candidate for this period of excavation. By the 20th of April 1771, the triclinium (Room 10) appears to have been cleared, where among a number of finds potentially appropriate for such a space were recovered, as well as the 'surgical implements' that gave the house its name.[241] By the 16th of May 1771, the excavation of the atrium and its rooms were completed with the clearance of Room 6D, which is clearly identifiable as the only room in the house with the black socle mentioned in the report. By the 22nd of June 1771, the garden had been cleared and Room 19 had been discovered, along with its famous decoration and the image of the woman painter.[242] Excavations continued until the 6th of July 1771 and saw the clearance of the corridor (Room 18) and service rooms, which

probably included Room 17 and possibly Room 14 or 13. Excavation of the remaining elements of the house did not receive specific mention, and it may not have been entirely cleared until the 21st of March 1788 when, after a considerable delay, work continued to the south of the Casa del Chirurgo.[243]

Throughout and following the primary excavation of the house, the walls seem to have been consolidated, while preserved plaster was re-affixed to the walls using the then current methods, including iron butterfly clips, some of which are still in place in the oecus (Room 19). In addition, as is clear, both from early illustrations of the house and from the cork model in the Museum of Naples, the tops of the walls were at first covered with rows of roofing tiles, intended to protect the walls and possibly their exposed wall paintings from damage from the weather. A considerable number of these remain in place today, especially in the atrium.

In Room 6A, our excavations uncovered a lime tank, a feature that given its size, depth, and the soft, damp condition of its lime fills, is probably a modern feature added to the Casa del Chirurgo plausibly during the widespread early restoration of the house[244] (Figs. 4.45 and 4.46). Although the tank was not mentioned by either Mau or Maiuri, the latter nevertheless decided to excavate just to the north of it in Room 6A in a spot that managed to survive the cutting out of the feature in a way that seems unlikely to have been accidental. Indeed there is evidence for the prolonged exposure of the surface of the lime to the elements, which include a row of drip marks noticed by the excavators that align neatly with the roof tiles used to line the top surface of the surrounding walls, as well as traces of water damage on the surface of the lime, including cracking of the surface, and dark rings. Clearly the tank lay exposed in the modern period for some period of time before it was filled with debris, which included Bourbon period remains (a clay pipe) from the upper levels of this pit.

The collapsed cisterns on the eastern side of the atrium and the western half of the tablinum (Room 7) (Fig. 4.45) also appear to have been left exposed for some period of time after their initial investigation, though interestingly they also receive no comment from early excavators or visitors. Nevertheless, disturbance and the churning of the lapilli within the cisterns attest to the early, but incomplete, investigations by the initial excavators, followed at some later point by their refilling. One component of these fills included fragments of decorated plaster, the provenance of which has plausibly been identified as the final-phase walls of the tablinum, and the rooms

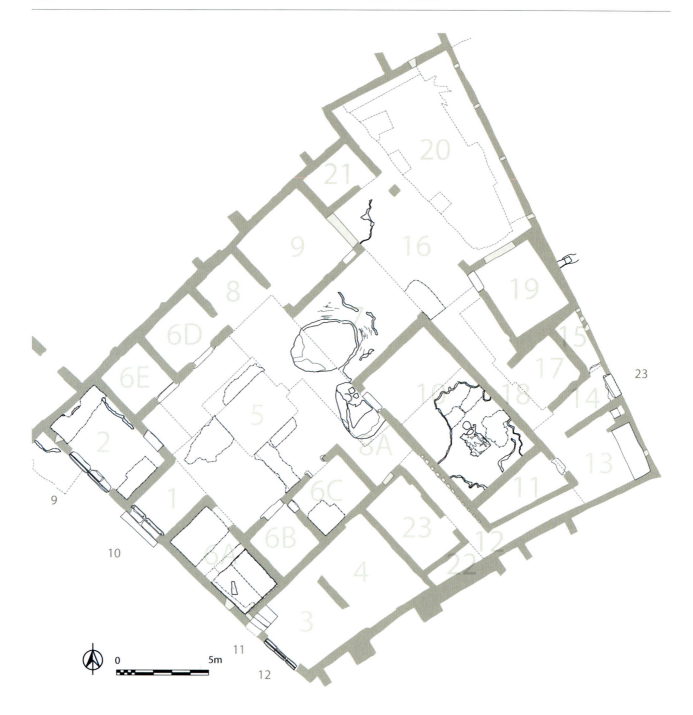

Figure 4.45. Plan of the changes to the property in Phases 8–9 (illustration M. A. Anderson).

to the north of the atrium, including Room 6D which still preserves scant traces of similar decoration on its walls. The origin of at least some of these fragments may be found in the cleaning up after paintings were cut from the walls. Possible moments are recorded in the *PAH* and include: following the night of 23rd of November 1792;[245] during the winter of 1789 when it is noted that much of the wall plaster from the then exposed parts of the city had fallen due to damage from frost;[246] or after the Napoleon's conquest of

Naples, during which time the excavations appear to have fallen into some disarray.[247]

The process of consolidation, repair, and replacement of the archaeological remains has continued throughout the post-clearance life history of the Casa del Chirurgo down to the present day, a Sisyphean task that is common to all buildings within the city. These interventions have included the placement of a lightning rod attached to the roof over the front rooms of the Casa delle Vestali, a roof over Rooms 8 and 19,

Figure 4.46. Lime-slaking tank recovered in Room 6A (image AAPP).

and efforts directed towards the stabilisation of the structural integrity of the walls and their preserved wall plaster. More recent interventions included the planting and maintenance of a garden in the area of the hortus (Room 20) and the deposition of a layer of blue-grey gravel across the majority of the rooms of the property in order both to keep down dust and to prevent continued degradation of the AD 79 surfaces due to foot-traffic.

Conclusions

The excavations of the Anglo-American Project in Pompeii (AAPP) have produced a wealth of new data on the chronology and development of the Casa del Chirurgo. Following this summary individual sections of Chapter 5 are dedicated to each trench area examined, organised by Room and including the particulars of excavation and wall analysis to the level of each stratigraphic unit.

Notes

1 As emphasised by Wallace-Hadrill (2005, 101) in reflecting on the excavation in the House of Amarantus, the complete history and not simply a chronology was similarly the most important goal of the excavations in Insula VI 1. The chronological approach has tended to dominate in Pompeian

studies, up to and including today (e.g. Coarelli and Pesando 2006).

2 Maiuri (1973, 7, 11) hypothesised the existence of such a structure but did not find definitive proof of its existence.

3 The same sequence of soils is described by Varone (2008, 356–357) and Berg (2008, 369) (Saggio B), as well as in the soil sequences discussed by Robinson (2008). Another similar gradient of textures and colours is described by Esposito (2008, 74) in the Casa dei Gladiatori (V 5 3.4.a) but it seems to have a different relationship to the subsequent deposits.

4 This interpretation was supported by phytolith analysis by Dennis (2001 unpublished) undertaken at the University of Bradford. Similar details appear to have been present in the excavations in V 3, 4 (Pucci *et al.* 2008, 233, Fig. 13). The same sequence appears in the section provided by excavations in the House of Amarantus (Fulford *et al.* 1999, 46) with probably their contexts 6, 5, and 4 with 4 being equal to chocolate brown layer in Insula VI 1. These are described as a palaeosol and Fulford *et al.* date the sequence to after the Pleistocene (their layers 7 and 8), which may possibly be equated with the gritty black soils of Insula VI 1 (cf. infra).

5 The upper yellow soil would appear to be comparable to the "giallo-marrone" soil 14, and the bright orange might be the same as stratum 15 "Loam siltoso giallo" as described by Robinson (2008, 125) from his analysis of excavations at the Porta Vesuvio, where he identifies these soils as degraded elements of the Mercato eruption of Vesuvius. Cf. also Varone 2008, 356. They also bear a strong resemblance to U.S. 33, 34, and 35 of the excavations in the street outside the Casa dei Casti Amanti (Berg 2005, 203). Notably, no turf line is mentioned but the same colour transition is highlighted.

6 Stella and Laidlaw 2008, 149, 155, Fig. 9; Laidlaw and Stella 2014, 170.

7 The 'greenish' to black soils recovered in Insula VI 1 are identifiable as being roughly equivalent to stratum 16 in the

Porta Vesuvio sequence examined by Robinson (2008, 125). This is described as "lava nera solida con inclusioni bianche" and forms the lowest of his examined soils, approximately 1.7 m below the upper level of these 'natural' soils.

8 The closest parallels in terms of proximity are the soils recovered in Insula VI 5, in Saggio 11, strato VIII, which was described as a very dark brown soil underlying grey volcanic ash, a relationship shared with the soils in Insula VI 1. In photographs, however, most of the overlying 'ash' deposits from this excavation might instead plausibly be identified with the chocolate brown topsoil itself. The excavators of Saggio 11 felt that this soil had been brought in from elsewhere (Bonghi Jovino 1984, 67), but this is not supported by the excavations in the Casa del Chirurgo.

9 Robinson 2008, 130

10 Pucci et al. 2008, 233; Varone (2008, 358) also mentions that within a similar layer recovered throughout the excavations in the streets of the Casa dei Casti Amanti, impasto sherds and worked stone tools were found dating the deposit to the Diana culture of the Neolithic. Perhaps the artefacts he mentions from higher strata derive from the top surface of the underlying soils.

11 Although their analysis is of the layers over the top of the earliest natural, a similar topography appears to have existed under the Casa di M. Lucrezio (IX 3, 5.24) (Castrén et al. 2008, 334).

12 Seiler et al. 2005, 217 for early Via Vesuvio; also Maiuri 1930, 184–187. Concerning the possible original course of the Via Consolare, Carocci et al. 1990, 196–197; also Haverfield 1913; von Gerkan 1940; Geertman 2007. For recent ideas concerning the primacy of the Via del Mercurio alignment see D'Ambrosio and De Caro 1989, 197; Guzzo 2011, 15. On old streets in irregular ravines, Eschebach 1970, 15, Abb. 4; Holappa and Viitanen 2011, 182; Ellis believes he has identified a process of canalisation on the Via Stabiana, Ellis pers. com. 08. 2013.

13 These soils are clearly the same as those Fulford et al. (1999, 43) attributed to the Avellino eruption (deposits 1 and 2). The palaeosol was generally truncated, such as context 064 in house 10, which matches the appearance of this soil in Insula VI 1.

14 Jones and Robinson 2005, 257.

15 The elevation of this deposit ranged between 42.03 and 42.05 MASL.

16 Robinson 2008, 128; Staub Gierow 2008, 93; Nilsson 2008, 84 identify it as a paleosol, whereas Esposito et al. 2011, 120 identify it as a Bronze Age palaeosol.

17 There have been considerable difficulties in drawing connections between the sequence in Insula VI 1 and other early excavated deposits, such that the connection being drawn here between the 'pocked earth' and 'pea gravel' layers could equally apply to later deposits identified by Robinson (2008) and in numerous other excavations that refer to 'ceneri vulcaniche' cf. infra.

18 Jones and Robinson 2007, 389–390; eidem 2004, 109.

19 The surface pictured in the excavations in Via delle Nozze d'Argento (Nilsson 2008, Figs. 4 and 8) clearly matches that recovered in Insula VI 1, both in surface and in section. Nilsson suggests that the surface derives from pre-existing vegetation or animal burrowing. Agricultural use has been suggested by Robinson (2005, 257) for the upper surface of a subsequent eruptive deposit recovered in VIII 4, 2 and V, 1 18, a layer that may have been truncated in Insula VI 1. Fulford et al. (1999, 46) note that its surface is gullied and

uneven suggesting water exposure prior to later palaeosol build-up.

20 Dickmann and Pirson (2005, 156) found a human cranium fragment on top of this layer.

21 Robinson 2008, 126; Robinson 2011, 21.

22 The elevation of this layer varied between 42.08 and 42.13 MASL.

23 Robinson 2008, 128; Nilsson 2008.

24 This is most notable in the area of the hortus where the pocked earth and pea gravel deposits slope downward from between 41.94 and 42.03 MASL on the west and the tablinum to between 41.79–41.27 MASL against the eastern property wall.

25 Robinson (2008, 130) suggests that the layers he identifies come from an Iron Age eruption of Ischia, which would have decomposed quickly had it not been for their immediate burial.

26 Fulford et al. 1999, 46.

27 Fulford et al. (1999, 46) see this black sand as a palaesol and part of the same sequence in House 10 (Context 064). "It was characterised by its very dark brown to almost black colour and its high silt content. This soil was not sufficiently calcareous for mollusc shells to survive." Their strata also appear to have undergone considerable truncation.

28 This relationship is precisely the same as soils described by Staub Gierow 2008, 94.

29 On the difficulties of this deposit see also Fulford et al. 1999, 41.

30 A few published photos of similar deposits recovered in other excavations permit the suggestion of interconnections to be made. Gallo (2008, 322) found a similar stratum in the Casa degli Epigrammi Greci (V 1, 18.11.12) as did Fulford et al. (1999, 41, 43–44) in the House of Amarantus. Staub Gierow (2008, 94) recovered similar layers under the first constructions dated to 200–120 BC. Similarly, in VI 13, 19, an early wall was built on this layer and butted against a 'tufaceous' layer that is probably equivalent to the underlying black sand in Insula VI 1 (Verzár Bass et al. 2008, 191). Seemingly, the sterile volcanic layer in trench Delta (US 8) cut by the foundation walls of the Casa di M. Epidio Sabino (IX 1, 29) would also qualify as a possible comparandum (Gallo 2008, 321). Archaic (end sixth-fifth century BC) walls found in street north of IX, 7 25 have beaten surfaces atop a similar volcanic layer (Giglio 2008, 342). The pappamonte walls found under the Casa di M. Lucrezio (IX 3, 5.24) were dug into volcanic ash that might be similar to this or the earlier pitted earth layers (Castrén et al. 2008, 332).

31 These deposits are probably equal to stratum 12 at the Porta Vesuvio, stratum 22 at V 1, 13, stratum 46 at VIII 4, 42, and stratum 32 at V, 1, 18 (Robinson 2008, 125). It should be noted, however, that in Fig 3 (Robinson 2008, 128), this stratum appears to include both an upper layer of sand and a lower firmer ashy deposit comparable to the 'pitted earth' recovered in Insula VI 1.

32 Overlying was a layer of cobbles with impasto pottery dated to the seventh century BC (Dickmann and Pirson 2005, 156). In the excavations of VI 5 of Bonghi Jovino in Saggio 14 strato VIII, the excavators recovered impasto and bucchero that they felt dated this deposit to the archaic period (Bonghi Jovino 1984, 65).

33 Robinson 2008, 133.

34 Strata 11 from Porta Vesuvio, 31 from V 1, 18, and 45 from VIII, 4, 42, Robinson 2008, 129.

35 Examples of the recovery of pappamonte stone foundations

are now numerous, not just within the so-called 'altstadt' but also outside of it. See Carafa 1997, 22; Fulford *et al.* 1999, 46–50; Wallace-Hadrill 2005, 103; Esposito 2008, 71. On being cut into the soil see Verzár Bass *et al.* 2008, 191; Esposito *et al.* 2011, 120.

36 Maiuri 1930. On the idea that the earliest wall was for terracing purposes see Sakai 2000–2001, 92; Esposito 2008, 74.

37 On the pappamonte wall itself cf. De Caro 1985; Chiaramonte 2007, 140. Excavations by the Japan Institute of Paleological Studies of Kyoto strongly suggests that this layer does in fact, underlie the 'pappamonte' phase of the city wall. Here it is described as the remains of the Avellino eruption and dated to probably between the end of the Bronze Age and the beginning of the Iron Age on the basis of ceramic finds (Sakai and Iorio 2005, 328). A clearly similar deposit is also shown in photographs of the excavations under the Via delle Nozze d'Argento sealing the Bronze Age levels (Nilsson 2008, 85, Fig. 8).

38 Chiaramonte 2007, 142.

39 Bonghi Jovino 1984, 363. These same carbonised wood laden deposits were recently found nearby in Insula VI 5, 16, Pucci *et al.* 2008, 230.

40 Coarelli and Pesando 2006, 23, 114.

41 Deposits interpreted as alluvial have been recovered over pappamonte structures by Progetto Regio VI (VI, 10 4) (Pesando 2005, 74). These pappamonte blocks appear to rest upon a pale grey compact level that may be equivalent to the 'pitted' earth recovered in Insula VI 1. Notably, no equivalent of the 'black sand' appears in a photo of these excavations (Pesando 2005, 77, Fig. 5). Excavations in the House of Amarantus also found post sixth century deposits indicative of abandonment – in this case ploughed soil (Wallace-Hadrill 2005, 103).

42 Esposito 2008, 75–76.

43 Haverfield 1913; Von Gerkan 1940; Eschebach 1970; De Caro 1992.

44 A rammed earth wall recovered in the atrium area of the Case delle Vestali, Jones and Robinson 2005, 257.

45 A period running from roughly 460–360 BC, Descourdres 2007, 15.

46 Dickmann and Pirson 2005, 156–157; Pesando 2008, 159; Coarelli 2008, 175.

47 The presence of such terracing throughout the city has increasingly been noticed, cf. Holappa and Viitanen 2011, 172.

48 For recent ideas concerning the primacy of the Via del Mercurio alignment see Guzzo 2011 15; D'Ambrosio and De Caro 1989, 197.

49 E.g. Ellis and Devore 2008, 311. Cf. also Guzzo 2011, 16; Holappa and Viitanen 2011.

50 Esposito 2008, 74.

51 A similar interpretation for the terracing is expressed in Guzzo 2011, 16; Holappa and Viitanen 2011, 169. On city planning as a result of the Samnite phase cf. Coarelli and Pesando 2006, 24; Geertman 2007, 87; Coarelli 2008; Pesando 2008, 159. Giglio (2008, 344) sees the planning of the Vico di Tesmo as taking place in the third century BC. Fulford *et al.* (1999, 105–110) alternatively see the planning of the urban grid in the archaic period. Berg (2008, 374) notes, however, that even if the streets were planned earlier there was no street *per se* outside of Insula XI 12 until about 200 BC.

52 This date would put the structure into direct comparison with the Phase 3 (c. 250–200 BC) house with limestone and

lava chip foundations under the Casa delle Nozze di Ercole, a structure that also had an impluvium, albeit a considerably more elaborate one (D'Alessio 2008, 279–280). It might also be comparable to an impluvium in lavapesta in the Casa di M. Epidio Sabino (IX 1, 29), which had a *terminus post quem* between the fourth and early third century BC (Gallo 2008, 323).

53 Pesando (2005, 87) uses the term *opus formaceum* for internal elements of the Casa del Centauro (VI 9, 3–5) (third century BC) that were created in the same way. Also see Coarelli and Pesando 2011, 52.

54 Preliminary spot dating is based on a fragment of bucchero within the fill of one of the square features, but without further identification of the vessel form or identification. General levelling layers also produced a rim of type Morel 1551b 1 dated to 300 BC. See the forthcoming pottery volume for full discussion and or any necessary correction.

55 While the presence of such an 'impluvium' is insufficient evidence to be certain that the Pre-Surgeon Structure was a house, nevertheless, it is probable. Pesando (2008, 162–163) and Pucci *et al.* (2008, 223) both highlight the importance of the presence of an impluvium in *opus signinum* in the earliest Samnite period foundations within the city. See also Pernice 1938, 119, note 3 who suggests that "'limestone period houses' should have *opus signinum impluvia*." Cf. also Joyce 1979.

56 A similar earthen surface was recovered in Saggio 10 of the excavations in Insula VI 5 (Bonghi Jovino 1984, 60–61). This was cut directly into archaic levels identified there and underlay a levelling layer of perhaps the late third or second century BC in a situation precisely analogous to that recovered in the Casa del Chirurgo.

57 Jansen 1991 suggests that many cisterns could have a narrow, well-like form.

58 For similar possible reuse of a well in the Casa di Popidius Priscus (VII, 2, 20) see Pedroni 2008, 239, though it is notable that in this case the well was retained at its original level in subterranean rooms.

59 Maiuri 1973, 6–8.

60 Ciaraldi and Richardson 2000.

61 This date derives from provisional spot dating. See the forthcoming pottery volume for full discussion and or any necessary correction.

62 The appearance is not dissimilar from those excavated at Poggiomarino, perhaps suggesting a similar type of construction albeit clearly at a considerably different date (Cicirelli and Albore Livadie 2008, 481, Fig. 8).

63 As discussed in Chapter 5. For similar problems cf. Fulford *et al.* 1999, 44.

64 Wallace-Hadrill 1997, 219–220 points out that too often this association is made uncritically.

65 The precise size of the Oscan Foot, calculated by Nissen (1877, 75) to be 27.5 cm, clearly ranges between about 27.5 and 27.7 cm. Peterse and De Waele (2005, 198) also suggest that the precise module varies for each structure. On the basis of Geertman and Schoonhoven's work, the value of 27.534 has been employed here (Schoonhoven 2006, 37) especially since few of the Pre-Surgeon Structure's full measurements are present to permit the derivation of a more precise value.

66 Nappo 2007, 349; 1997; They fit even better with the repeated module identified in the layout of Insula V, 3, 5.7 m or ~20–21 Oscan feet, Pucci *et al.* 2008, 232.

67 Such as Geertman 1998; 2007; Schoonhoven 2003.

68 Guzzo 2011, 16; Holappa and Viitanen 2011, 196; Geertman

1998; 2007, 87; Schoonhoven 2003, 33; Coarelli 2008; Pesando 2008, 159; Coarelli and Pesando 2006, 24. But cf. Berg 2008, 374.

69 Pesando 2008, 159; Coarelli 2008, 175.

70 *Contra* Jones and Robinson 2004, 112, which based only on the Casa delle Vestali indicated that the Via Consolare was the earliest important alignment.

71 Seiler *et al.* 2005, 217.

72 The dating evidence from the house provides the earliest possible *terminus post quem* from a coin of 216 BC, but the evidence is relatively difficult. Cf. infra footnotes 83 and 84 for details. This has been expressed by Jones and Robinson (2005, 257) as 'no later than 200 BC' and this position must be corrected here as on the whole the evidence implies a later date, perhaps as late as 130 BC. Tamm (1973) had already suggested that an early second century date this might be the case in and was followed by Gassner (1986, 50). In fact, it is appearing increasingly likely that no house standing in the city today originates from long before the end of the third century BC, as was recently summarised by Ling (2005, 36).

73 The Sarno stone phases of the Casa di M. Lucrezio (IX 3, 5.24), early third century BC, followed precisely the same pattern (Castrén *et al.* 2008, 334).

74 Literature that discusses or makes use of the Casa del Chirurgo is extensive, particularly in terms of the iconic early role of its layout. Cf. Nissen 1877, 402–412; Mau-Kelsey 1902, 290–293; Carrington 1913; Tamm 1973; Gros 2001, 40; De Albentiis 1990, 81–83; McKay 1975, 37–38; Evans 1978; Boëthius 1934; Little 1935; Graham 1966 etc.

75 That such filling was not unusual, is testified by a similar, although temporally distinct filling that appears to have taken place prior to the creation of the Casa di Popidius Priscus (VII, 2, 20) (Pedroni 2008, 239). On changes to the natural topography including filling and terracing see Holappa and Viitanen (2011).

76 The 'Protocasa del Centauro' (VI 9, 3) was similarly covered in a roughly one metre deep fill, Coarelli and Pesando 2011, 51.

77 Jones and Robinson 2005, 257.

78 Vitruvius *de arch.* 1.9; Cf. Adam 2005, 107. The same construction technique, albeit 15 cm wider than the wall, was employed in a quadratum construction in Insula V, 3 4 (Pucci *et al.* 2008, 233). In the Casa di M. Epidio Sabino (IX 1, 29) the offset width of the lower quadratum course was 20 cm (Gallo 2008, 322, fn. 8).

79 Though universally accepted as early, the precise date has tended to evolve over time. Fiorelli (1875, 80) thought it dated to the fifth century and was followed by Nissen (1877, 403), while Mau-Kelsey (1899, 274) limited his *terminus ante quem* to c. 200 BC. Maiuri, citing Pernice (1926, 16) mentioned the previous date from the middle of the fifth to the mid-fourth century BC, but refined this to the fourth-third century BC on the basis of the filling of the well in Room 2 and was followed in this by Carrington (1933, 128). Peterse's dates (1999, 56–57; 164; 2008, 377) on basis of the *opus africanum* (Type B), should be c. 420 – c. 275 BC, and De Albentiis (1990, 81) retains an early date of the second half of fourth century BC. Cf. also Wallace-Hadrill (2007, 280). Our excavations lower this date to roughly 150–130 BC.

80 An aspect commented on by Nissen 1877, 403.

81 On the technique of joining *opus quadratum* with *opus africanum* see Peterse 1999 *passim.* De Haan *et al.* 2005, 250.

82 Peterse and De Waele (2005, 217) note that the house employs

a much greater degree of *opus quadratum* than either the Casa degli Scienziati (VI 14, 43) or the Casa del Naviglio (VI 10, 11), implying a much costlier build.

83 Fills and strata that have experienced truncation or re-exposure in the late first century BC to first century AD unsurprisingly produce dates ranging from the late third or early second century BC to the first century BC or first century AD. Fills within the triclinium (Room 10) (SUs 261.043, 261.045 and 261.047) are the best example of this. SU 261.043 produced three coins (Coin Inventory No.'s 835, 901, 1445) dating from the third to the first centuries BC (Hobbs 2013, 223). SU 261.045 produced fragments of black gloss identified as Morel 5814c 1 (9941) provides a *terminus post quem* of the early third century BC. Other material from the three deposits in general indicate an equally broad time band indicative of disturbance. Lamps produced a range of dates including examples from the third/first BC+; 250–50 BC; 150–70 BC, (Cosa), 50 BC+ (Bailey Q713), and AD 1–79 (Bisi Ingrasia Tipo XI, A). Vessel glass dated to the end of the first century BC+, and red slip dated to the 25–20 BC+ (Accession No. 261-8026, Atlante 20 v 12; Accession No. 261-8141 Berenice B 419; Naples 1987a 3.15, and Accession No. 261-8142, Berenice B 425.2; Morel 1224, 1226). Additional black gloss (Accession No. 11686, Morel 2285b 1) dated to the first century BC. Elsewhere, similar terrace fills were also contaminated within the same range. From Rooms 2 and 3 dates are indicative of the removal of soils down to very early deposits in Phase 5. For instance, SU 607.311 contained red slip (Accession Nos. 607.32037/32014) dated to AD 41–68. SU 607.314, which produced a coin of c. 206–144 BC (Hobbs 2013, 161), also contained red slip (Accession No. 607.32063) dated to AD 1–40 (Berenice B 423). The removal of floor surfaces in the atrium (Room 5) also produced some contamination of the underlying fills. SU 275.038, produced a coin (Inventory No. 567) of the second to early first century BC (Hobbs 2013, 149) but a spot date based on study of the pottery during the field season suggested a *terminus post quem* of the third century BC.

84 Several of these came from foundation trenches, such as SU 260.081 which produced a knob of black gloss identified as similar to Morel 4713a 1 provides a *terminus post quem* of the end of the fourth century BC; 276.035 Black Gloss (Morel 2283d 1 dated to 140–130 BC). Other dates were from the filling in of the terrace (276.010) which produced Black Gloss (Morel 1314e 1–300 BC).

85 Maiuri 1973, 11–12.

86 It appears to be that Maiuri's (1973, 3) mistaken identification of a low surface under the overflow drain of the impluvium in the fauces is what led him to conclude that the floor level in the original house must have been much lower. In turn, this led to the conclusion that the impluvium and its features, which sat atop this surface, must be secondary. We now know that both of these conclusions are incorrect. The surface that Maiuri identified must have been the top of the filling of the terrace after the Pre-Surgeon Structure.

87 Chiaramonte 2007, 142; De Caro 1985 *passim.*

88 This connection, which certainly is attractive for its simplicity, continues to be employed elsewhere, cf. Brun 2008, 62 on the first phases of Insula I 5.

89 Excavations in the Casa degli Scienziati (VI 13, 43) have suggested not only that it had an original impluvium, but that it was probably of Nocera tuff (De Haan *et al.* 2005, 245). While it is also possible that it may have been of *opus signinum*, a feature common in Samnite foundations

(Pesando 2008, 162–163), excavations in the Casa di M. Epidio Sabino (IX, 1, 29) however, recovered a Nocera tuff impluvium dating to roughly the same phase and in combination with a beaten earth floor (Gallo 2008, 321–322) that might provide evidence in support of the originality of the impluvium, which is remarkably similar in form. Though the issue of whether atrium houses were originally equipped with impluvia is debated, the Protocase del Grandduca Michele (VI 5, 5) and Nettuno (VI 5, 1) were provided with such in their earliest phases (Pesando 2008, 166; Pucci *et al.* 2008, 223).

90 Maiuri 1973, 9–10 and 12.

91 Discussion of the nature of the atrium and its development cf. especially Wallace Hadrill 1997.

92 This use of tuff as the base of the conduit is interesting, since Nocera tuff is normally seen as an expensive, luxury material when used in combination with Sarno stone. Cf. Peterse 2007, 375, though it would support Nissen's 1877, 38 suggestion that it was employed because it was more waterproof than Sarno.

93 Cf. Nissen 1877, 402–412; Mau 1882, 66; Mau-Kelsey 1899, 280–283; Carrington 1913; Tamm 1973; Gros 2001, 38–40; De Albentiis 1990, 81–83; McKay 1975, 37–38; Evans 1978; Boëthius 1934; Little 1935; Graham 1966.

94 This has a long history of discussion, cf. Fiorelli 1873, summarised in Peterse 1999, 3.

95 Although already highly developed by Nissen (1877, 402–412) one of the most exhaustive recent studies of the metrics of the house is De Waele and Peterse (2005). Refreshingly, they question whether the oft applied precepts of Vitruvius can be applied in Samnite Pompeii and instead identify a number of rules of thumb for room sizes that appear to have resulted in a conceptual plan.

96 Drerup 1959; Bek 1980, 164–203; Jung 1984; Hales 2003, 107–122.

97 *Contra* Ling's 1997, 225 assumption of a 'rule' that rooms around the atrium initially faced inwards and only later were rearranged to face garden spaces.

98 Maiuri 1973, 5.

99 E.g. De Albentiis 1990, 82; Gros 2001, 40 following De Albentiis.

100 Maiuri 1973, 10–11. His trench No. 9. The absence of the expected wall clearly confused Mairui who wrote "*Dinanzi a questo risulto del tutto negativo, l'affermazione della esistenza del muro resta assai dubbia.*"

101 E.g. Peterse 1999, Plate 7; Gros 2001, 40; De Albentiis 1990, 142; De Waele and Peterse 2005, 212.

102 The deliberate square-ness of these rooms, in turn appears to derive from the particular spatial qualities of the plot itself, particularly the length of the north and south porticoes.

103 They did not escape the notice of Mau 1899, 275, although he did not speculate as to how far south the portico actually went and did not suggest the continuation on the southern side.

104 The presence of a portico in this area of the property was not suggested by Mau 1899, 275, nor any subsequent authors.

105 This is particularly clear in a hypothetical early reconstruction in Dickmann (1997, 131) but is less clear in the recent comprehensive study of the house by Laidlaw and Stella (2014, 124, 128). Notably this area is left as question marks on the earliest plan, but the similarity to layout in the final phase is unmistakable and potentially important.

106 Laidlaw 1985, 116.

107 Mau 1882, 66 suggests that the pilaster on the north side

of the tablinum dates from the First Style, but it has been sequenced by our investigations to the end of the first century BC.

108 Laidlaw 1985, 117.

109 Schefold 1957, 92.

110 Maiuri 1973, 9; Pesando (2008, 167) has found similar earthen floors in numerous houses investigated by Progetto Regio VI and suggests that this was the normal flooring arrangement for the earliest surviving structures. In some places, notably the Protocasa del Granduca Michele (VI 5, 5–6), and especially in corridors, these floors remained in use throughout the history of the structure (Pesando 2008, 168). For similar floors in the Casa dell'Ancora (VI 10, 7) (Pesando 2005, 78) and Casa del Centauro (VI 9, 3–5) (Pesando 2005, 82) and for similar in the first phases of houses in Insula VI 2 (Coarelli 2005, 97).

111 Other examples of masonry constructions dated between the end third century and the early second century BC now abound and the mid-third to early second century has been identified as the boom period of Samnite construction (Pesando 2008, 159). Examples include the so called Hellenistic houses A, B and C from Insula VI 5 (end of third century BC) (Bonghi Jovino 1984, 385); early structures in Insula VI 5, 1–3.22, VI 5, 17–18, VI 5, 16, VI 15, 9 and V 3, 4 (Pucci *et al.* 2008), the *opus africanum* constructions of VI 13, 13 and VI 13, 16 (Verzár Bass *et al.* 2008, 193), the Casa di Giuseppe II (VIII 2, 38–39) (Carafa 2005, 19) and the Casa dei Postumi (VIII 4, 4.49) (Dickmann and Pirson, 2005, 157). Although it can sometimes be difficult to tell whether Sarno stone *quadratum* and *africanum* has been dated by excavation or is being used to date the excavation, this probably includes the earliest structures of Insula VII 14 (De Simone *et al.* 2008) and Insula VIII 7 (Ellis and Devore 2008, 313). An important cautionary to this, however, are the results of the excavations in the House of Amarantus where limestone structures are dated to after the first century BC (Wallace-Hadrill 2005 103–108). There are also particularly early examples to remember, e.g. in the Casa degli Scienziati (VI 14, 43) (De Haan *et al.* 2005).

112 Notably suggested already by Mau-Kelsey (1902, 280) and reiterated by Nappo (1997, 120) and Guzzo (2011, 17). Cf. also Castrén 1975 on the influx of *gentes* into Pompeii. A similar explanation has been given for the timing of the creation of shops south of the Casa di Popidius Priscus (VII 2, 20) on the Via degli Augustali (Pedroni 2008, 239).

113 It is likely that some do date a bit earlier, such as the Casa degli Scienziati (VI 14, 43) (De Haan *et al.* 2005. 248), although Peterse's dating of 420–275 BC is probably still too early. Also in this group are the Sarno stone houses in *opus quadratum* of Insula VI, 7, dated by Zaccaria Riggiu and Maratini (2008, 177–178) to the late fourth to mid-third century BC. Pesando (2008, 159) places the Casa del Naviglio (VI 10, 8.9.11.14) in the mid-third century BC. This would mean that far from being the first, the Casa del Chirurgo is actually one of the final limestone atrium houses to be built!

114 Pesando 2008, 159, but see Carafa 2011, 95.

115 D'Alessio 2008, 275 dates this house to after the Casa del Chirurgo in the second half of the second century BC, but the site appears to have been occupied from the archaic period onwards.

116 Recent excavations in the streets outside of Insula IX 12 imply that these areas only became proper city street surfaces c. 200 BC. This could suggest a connection between the creation of the Casa del Chirurgo and the formalisation

of the Via Consolare, which may have received its earliest official surface at the same time.

117 Jones and Robinson 2005, 258. Progretto Regio VI found similar encroachment on the area of the rampart and city defences not earlier than the middle of the second century BC, Coarelli 2005, 99–100.

118 Jones and Robinson 2004, 121; 2007, 393. This phase of construction was characterised by a distinctive pinkish mortar employed in the creation of the walls.

119 Jones and Robinson 2005, 258.

120 This is unlike the case in the Insula of the Menander (I 10) where Ling (1997, 249) argued that the householders entirely avoided having windows opening into others property. Similar arguments for Phase 4 connection between properties 4 and 7 on basis of windows (Ling 1997, 231).

121 Cf. Saliou 1994, 217–228. The Justinianic Digest (Dig. 8.2.1–2 and 8.2.6) emphasises legal ramifications of blocking of sources of light through the construction of upper storeys, e.g. 8.2.2 Gaius libro septimo ad edictum provinciale. Urbanorum praediorum iura talia sunt: altius tollendi et officiendi luminibus vicini aut non extollendi: item stillicidium avertendi in tectum vel aream vicini aut non avertendi: item immittendi tigna in parietem vicini et denique proiciendi protegendive ceteraque istis similia. | GAIUS, Provincial Edict, Book 7: Urban praedial servitudes are as follows: the right to build higher and obstruct a neighbour's light or the right to prevent such building; the right to discharge eaves drip on to a neighbour's roof or vacant ground or the right to prevent such discharge; the right to insert beams into a neighbour's wall; and lastly the right to have a roof or other structure projecting, as well as other similar rights." (Text Krueger et al. 1893; Translation Watson 1998).

122 Saliou (1994, 225) imagines a similar situation.

123 It should be noted that contrary to Bon, Jones, Kurchin, and Robinson (1997, 47) this wide Sarno framed doorway did not lead into an earlier property at the rear of the house. This hypothesis was based on analysis of standing architecture alone and has been proven incorrect by excavation.

124 Cf. Dickmann 1997, although the dates of this phenomenon he suggests would obviously need to be lowered.

125 Similar interpretations have been expressed by Coarelli (2005, 97) for the façades of the houses in Insula VI 2.

126 Laidlaw 1985, 117; Mau 1882, 66 mentions First Style in the house having been preserved in his time in the NW and SE corners of Room 2, the left side of the tablinum (Room 7), the SW corner of Room 6A, the SW corner of Room 9, the niche in the south ala (Room 8A), and numerous fragments "beim Bau der W- und S-wand des Zimmers am N-ende des Ganges vor dem Garten verwandt worden" (in the construction of the S and W walls of the room at the north end of the corridor that goes before the garden). This could be the exterior of Room 16/18 or Room 21.

127 Pernice 1938, 84 indicates that his colleague Franz Winter, who had begun the series that was carried on by Pernice after Winter's death, thought that this wall was Second Style. Pernice did not indicate where this observation was made, but it might have been a personal communication or within volumes 1–3 but it has not been possible to find further information on these volumes.

128 Pernice 1938, 84. The PPP II 113 dates this to the First Style.

129 This same plaster appears to have been noticed by Mau 1879, 50 on the southern side of Room 6A.

130 Pernice 1938 84; PPP II 113.

131 Pernice 1938, 84.

132 PPP II 112.

133 PAH I, 1, 248–249, "nel mezzo vi è un quadrato di pal[me] 3 ed on[cie] 7[= 1,92 m] con quasi una stella circondata di alcuni ornamenti."

134 Such focus on the garden spaces and enclosed exteriors may also be reflected by similar changes in other houses in Pompeii at this time. The second peristyle of the Casa del Fauno (VI 12, 1.2.3.5.7.8) for instance, has been dated to between 100–75 BC (Faber and Hoffman 2008) and similarly in the Casa di Arianna (VII 4, 31–33.50.51) (Albiach et al. 2008, 252), contra the long held belief that peristyles were added in the second century BC (Dickmann 1997).

135 Significant changes to the city can be sequenced to the years immediately before the Social War and it is possible that these changes belong to this phenomenon. Ling 2005, 43–46; Zanker 1998, 32–60; cf. also the alterations to the Temple of Venus at this time Curti 2008, 49–49. Cf. especially the chart in Carafa 2011, 102.

136 It will be noted in this and the subsequent chapter that many of the structural changes to the walls of the Casa del Chirurgo in Phase 5 involve the use of brick or tile quoining, which has been challenged by some readers of this text. It should be emphasised that in each case, these have been sequenced on the basis of the close stratigraphic sequence of the phases of construction in the walls, and where possible in conjunction with excavated soil stratigraphy, and that in most cases, these uses of brick/tile do not constitute proper opus testaceum, but rather are supporting elements, quoining, or versions of opus mixtum that are more in concert with the date range of Phase 5.

137 Robinson has recently suggested that this sort of balancing between economic and luxurious was a key aspect of Roman economic thought (Robinson 2017).

138 The dating of the pavement kerbs in the area of Insula VI 1, which is only partially secure, gains support from the similar dating of kerbing on the streets outside Insula XI 12 (Berg 2008, 369). The eastern side of the Vicolo di Narciso has produced evidence of two pavements, one provisionally dated to the late Samnite period and probably redone in the Augustan period (Coarelli 2005, 98), perhaps at the same time as the kerbing and pavements in Insula VI 1. The lower of these two pavements has been dated to between the beginning of the third and second century BC, suggesting that Insula VI 1 may have been late in receiving its pavements, or that the earlier ones were removed prior to refurbishment.

139 Other examples of properties that underwent changes in roughly the 'Augustan period' include the Casa dei Gladiatori (Ins V 5) (Esposito 2008, 76); the Casa degli Epigrammi Greci (V, 1, 18.11.12) (Staub Gierow 2008, 97); the relatively small House VI 13, 16 (Verzár Bass et al. 2008, 194); the Casa dell' Amore Punito (VII 2, 23) and Casa delle Quadrighe (VII, 2, 25) (Pedroni 2008, 241–242). Cosmetic changes also occurred in House VI 10 4 (Pesando 2005, 74) and the Casa di Marcus Fabius Rufus (Grimaldi 2011, 153).

140 Drerup 1959; Bek 1980, 164–203; Jung 1984; Hales 2003, 107–122.

141 It should be noted that the ground surface of the new shop was just below the level of the Pre-Surgeon Structure, leaving only the faintest of suggestions of earlier activities.

142 The presence of this light well was first suggested by Mau 1902, 281.

143 E.g. Pirson 1997, 165–181; Varone, 2008, 355; Ulpian Dig. 43.17.3.7 Sed si supra aedes, quas possideo, cenaculum sit, in

quo alius quasi dominus moretur, interdicto uti possidetis me uti posse Labeo ait, non eum qui in cenaculo moretur: semper enim superficiem solo cedere. "But if above the house which I possess there is an upstairs apartment in which someone else is residing as if he were its owner, Labeo says that the interdict is available to me but not to the resident in the upstairs apartments; for the *superficies* always yields place to the land." Gaius in Dig. 43.18.2 *Superficiarias aedes appellamus, quae in conduto solo positae sunt: quarum proprietas et civili et naturali iure eius est, cuius et solum.* "We mean by superficiary buildings those that are sited on leased land. By both civil and natural law their ownership belongs to the owner of the land." Though it does seem possible that this situation might not to have existed in every case. Cf. Paul in Dig. 8.2.24 *Cuius aedificium iure superius est, ei ius est in infinito supra suum aedificum imponere, dum inferiora aedificia non graviore servitute onerei quam pati debent.* "The owner of a building lawfully built over another has the right to build on top of his own structure to an unlimited extent, provided the lower buildings are not subjected to a more onerous servitude than they ought to bear" (Text Krueger *et al.* 1893; Translation Watson 1998).

144 Cf. Dig. 39.2.47. Saliou 1994. 45–48

145 Soak-aways appear to have been extremely common under *opus signinum* floors. Comparanda are found in House IX 7, 21–22 (Giglio 2008, 346) and the second half of the second century BC phase of the Casa dell'Ancora (VI 10, 7) (Pesando 2005, 78), House VI, 7, 7 (saggio 3) and House VI, 7, 8–14 (saggio 6) (Zaccaria Riggiu and Maratini 2008, 178).

146 The cistern head itself would have to have been raised during Phase 3, and then lowered again during this phase, processes which have served to obscure any evidence of any earlier phases. It cannot be known with certainly whether this cistern was actually reused, but while such a story of reuse would be unusual, it is not entirely without parallels (Pedroni 2008, 239).

147 *Contra* Eschebach (1993, 152) who sequences the first phase of this shop in the third – second century BC. This is impossible given the now established chronology. Gassner (1986, 49–50) discusses the creation of this shop specifically as an example of her Type 1A, giving it as an 'early' example. She rightly argues however, that Maiuri's date must be lowered, and that a "tufa period" date for the shop is not correct. Our excavations lower this date further, suggesting an archaeologically secure date of the end of the first century BC for the creation of this shop.

148 This cannot be proven definitively, but seems likely given the evidence recovered. The furnaces in use would then have correspond roughly to Cleere's types A 1 and B 1.ii (Cleere 1976, 127–141), however, the use of amphora would be unusual as in these types the whole furnace is constructed from raw clay. The question of slag tapping is also important. Cleere's Group A does not have provision for slag and the hearth is below the level of the soil, which appears to be similar to the situation in Room 2.

149 Similar timing for upper storeys took place in the north-eastern shop added to Property 1 of Insula I 10, which came after third Style redecorations (Ling 1997, 231).

150 Adam 2003, 213.

151 A similar *tufo di Nocera* impluvium was apparently reused in subsequent phases of the Casa degli Scienziati (VI 14, 43) (De Haan *et al.* 2005, 245) and almost identical impluvium was also recently excavated in the Casa di M. Epidio Sabino (IX, 1, 29) (Gallo 2008, 321–322).

152 Maiuri 1973, 9–11.

153 This was also noted by Maiuri 1973, 9–10.

154 Pernice (1938, 84) thought these floors were "Second Style" (see also *PPP* 111–114). However, it now would seem that they must be excellent Augustan 'forgeries' or simply reused elements of earlier floors. Almost precisely the same sequence of beaten earth floors, followed by *opus signinum* in the Augustan period, has been suggested by preliminary publications of results from Insula VI 2, 16 (Coarelli 2005, 97).

155 Blake (1930, 107) and Pernice (1938, 84) are not inconsistent with this analysis. Most of the relevant data are missing due to heavy restoration of the relevant threshold border pattern.

156 Mau (1882, 66) felt that these pilasters were First Style Elements, but stratigraphically they appear to belong in this phase.

157 Maiuri 1973, 3–4. Eschebach (1993, 152) suggests that this action was in conjunction with the creation of the upper storey. Clear evidence suggests that these brick/tile faced frames belong to this phase, including similarity of the mortar in the *quasi-reticulatum* constructions of the facade of the shop in Room 2 and surviving plaster running across the frame that is earlier than that of Phase 6. These represent corner/quoins rather than full *opus testaceum* which would traditionally date the addition to the mid-first century AD.

158 Maiuri 1973, 3–4.

159 Maiuri (1942, 98) thought that this was post-earthquake repair, especially since they appear to never have been plastered over. Study of the mortars involved in the construction of this pillar however, suggest that it was a part of the activities of this phase, rather than a later addition (cf. Chapter 5 for more details).

160 Pernice 1938, 84; *PPP* 112–114.

161 Maiuri 1973, 8.

162 Similar dating of pavement works in the Augustan period, are found at Insula XI 12 (Berg 2008, 369) and Insula VI 2 (Coarelli 2005, 98). Maiuri (1973, 3–4) and Pernice (1938, 66) suggested that the final pavement of the house relates the alteration of the street related to changes in the Herculaneum Gate. Our excavations tend to support this conclusion.

163 As elsewhere, the dating evidence for this phase is also somewhat confused, though there is considerably more of it. Material recovered from under the floors of the atrium (Room 5), the tablinum (Room 7) and the south ala (Room 8A) consists of coins, glass and some pottery, only some of which corresponds to the late first century BC to early first century AD date of Phase 5. SU 200.057 produced vessel glass (Finds No. 45) providing a *terminus post quem* c. 25 BC to the first century AD, and red slip ware (Accession No. 200.9759) providing a *terminus post quem* of prior to AD 1–40 or 10–1 BC depending on comparanda (Berenice B 400; Sabratha 85.45; Sicily 1184). SU 260.012 produced vessel glass dating between the end of first century BC and AD 50, red slip (Accession No. 260.9951), with a date of between 150 to 50 BC, a coin (Inventory No. 918), possibly from c. 206–144 BC. SU 260.027 produced vessel glass providing a *terminus post quem* between c. 25 BC and the first century AD, while SU 260.094 produced Black gloss (Inventory No. 9776) comparable to Morel 2791b 1 (end of the third century BC), clearly indicating the reuse of residual materials. SU 505.010 on the other hand, produced glass dating after AD 50 and must indicate disruption from the final phase, which certainly occurred with the frequent removal of Phase 5 flooring.

164 Dust on the floor surfaces of the model at the time of the last observation makes this detail partially uncertain.

165 *PAH* I, 1, 248.

166 A similar focus on the garden areas occurred in the Casa degli Epigrammi Greci (V 1, 18.11.12) (Staub Gierow 2008, 97). The nature of the garden soil described in the excavations in this house match very closely to that recovered in the Casa del Chirurgo.

167 The interpretation of deep pits penetrating through to the natural soils as mines for clean soils, or even for *pozzolana*, in preparation for construction has now become common-place. Examples include House VI 13, 8 (Verzár Bass *et al.* 2008, 193; Gobbo and Loccardi, 2005 191–192); the central peristyle of the Casa di Arianna (VII 4, 31–33.50.51) (Albiach Ballester*et al.* 2008, 252); a pit in the atrium of House VI 2, 16 (Coarelli 2005, 97); Casa delle Nozze d'Ercole (VII 9, 47.48.51.65) (D'Alessio 2008, 281). The connection of these activities to planned building activities seems clear, but what exactly they are intended to procure remains to be clearly demonstrated.

168 For a discussion of similar pots found in the excavations in Pompeii (particularly the 28 examples recovered from the Casa della Nave Europa (I 15, 2.3.4.6) and the Roman world generally cf. Jashemski (1979, Vol. 1, 238–241). Contexts suggest a wide range of use for these vessels, from flowers to trees, with grafting being Jashemski's suggestion for their primary use. Those from the Casa del Chirurgo were found below the surface of the ground and were generally broken, often missing top rim, probably representing deliberate breakage. Those in the Casa della Nave Europa were found at just below the surface and at depth under root cavities (cf. also Paribeni 1902, Macaulay Lewis 2006).

169 We are particularly grateful to our colleague Robyn Veal who is studying of the charcoal and pollen from Insula VI 1 for this insight into the planting scheme of the Augustan garden. We await the results of her pollen analysis of the contents of the planting pots and surrounding soils with interest.

170 Dates from the soils derive from a mixture of materials. E.g. 508.028 – Vessel glass dating after the end of the first century BC and red slip (Accession Nos. 508.21210, 21211) from 30 BC+ (Atlante 6 v 9); 508.036 – pottery spot date (fourth quarter first century BC) (from Conspectus form 33 dated to the Augustan period) and vessel glass dating after the end first century BC; 508.044 – vessel glass dating after the end of the first century BC; 508.051 – vessel glass dating from the first century AD and red slip (Accession No. 508.23384) from AD 1–37 (Conspectus 35.1.1); 508.054 – vessel glass providing a *terminus post quem* of c. 25 BC to the first century AD and red slip (Accession No. 508.20609) providing a *terminus post quem* of 20 BC+ (Conspectus 22.2.1). 508.057 – red slip (Accession Nos. 508.21352 and 508.21349) dated to 20 BC+ (Atlante 31) and AD 1–50 (Conspectus 26.2.1) and vessel glass dated to after AD 50; 508.063 – vessel glass providing a *terminus post quem* of c. 25 BC to the first century AD and red slip (Accession No. 508.21316) dated to 10 BC+ (Atlante 10); 508.067 Glass (AD 50+); 508.07 – vessel glass (no Finds No.) from this deposit provides a *terminus post quem* of after AD 50 suggestive of considerable later churning.

171 Similar packed cobbles were used to prepare for the flooring of the light well (Room 22) and were also employed in the sub-floor of the *natatio* of the Central Baths (De Haan and Wallat 2008, 23), and in the now-occluded floors of the two incomplete shops in brick/tile added to the north side of the

"Granaio" in the final phase, facing onto Vico dei Soprastanti (VII 7, 24 and 25) (Anderson, personal observation during restoration of the rooms by the SAP in 2012.

172 Both Pernice 1938, 84 and *PPP* 113 date this to the first century AD.

173 Piranesi 1804 Pl. XX; Boyce (1937, 43, Nr. 135) notes in reference to the image left by Piranesi that there was a lower zone with two serpents, flanking an altar with offerings. The upper zone contained a *genius* pouring a libation from *patera* in his right hand, with a *camillus* to his right with jar in left hand, flanked by indistinct figures with two more above.

174 Traces of this surface were not recovered from within the corridor, but it was not possible to excavate much of this area and the possibility exists that it was present.

175 Seneca *QNat.* 6.1.1–3; Tacitus *Ann.* 15.22

176 Allison 1995; Jacobelli 1995; Varone 1995; Ling 2005, 169–170 (*Contra* Ling 1995) have all emphasised not only the likelihood that this period was characterised by multiple tremors and aftershocks, which have complicated significantly the understanding of the sequence of the final phases of the town.

177 Mau-Kelsey (1899, 275) specifically indicated a pre-earthquake *TAQ* for the painting in the house. We are grateful to both Eric Mormann and Wolfgang Ehrhardt who both confirmed the attribution of surviving pieces of wall plaster to the early Fourth Style.

178 On this problem cf. Archer 1990; Vos 1977; Allison 1995; Ling 1995; Ehrhardt 1995; Ling 2005 (Postscript).

179 In analyses of building structure across the city, the addition of upper storeys has often been seen as a post-earthquake phenomenon, e.g. the Casa dei Casti Amanti (IX 12, 6) (Varone 2008, 356–358). However, that upper storeys were already being added is not only suggested by the results from Insula VI 1, but also by Ling (1997, 227–231) who documents the addition of upper storeys already in the mid-second to early first century BC, as well as in the Augustan period.

180 *PAH* I, 1, 248 (19th January 1771) "*Si sono scavate sino al piano 4 stanze dell'abitazione espressa nel passato rapporto con parte del cortile, e le stanze sono quelle verso ponente della medesima abitazione. In una che ha l'ingresso dalla strada si sono trovate delle idrie di creta, ma rotte.*"

181 Eschebach (1993) suggests that this might have been a pharmacy, presumably on the basis of its connecting doorway to a house attributed to a surgeon, itself a dubious attribution, given that Della Corte thought they were "*dell'arte veterinaria*" (Della Corte 1954, 33).

182 Comparanda are found in House IX 7, 21–22 (Giglio 2008, 346) and the second half of the second century BC phase of the Casa dell'Ancora (VI 10, 7) (Pesando 2005, 78); House VI, 7, 7 (saggio 3) and House VI, 7, 8–14 (saggio 6) (Zaccaria Riggiu and Maratini 2008, 178).

183 Certainly there is evidence in the surviving architecture to suggest that the second storey extended over Rooms 15, 17 and 18 at the very least.

184 Discovery of this toilet means that Eschebach's (1993, 152) attribution of this room as a slave or porter's room must be incorrect.

185 Similar cesspits or septic tanks were likewise installed in the pavements outside of Insula IX 12, some also in conjunction with upper storeys, one of which seemingly dates after the Augustan period on the basis of its fill (Berg 2008, 366). Cf. also Jansen 1997; Hobson 2009a; 2009b.

186 Pernice 1938, 84.

187 On the drainage of gardens cf. Jansen 2005, 289.

188 *PPP* II 111–114; Schefold 1957, 92–93.

189 Mau-Kelsey 1899, 281.

190 Cf. Tascone 1879; also David 1997.

191 It certainly seems to do so, despite clear omissions and small errors. Cf. similar use of the cork model in Laidlaw and Stella 2014, 101. However, as has been pointed out, a lack of sufficient study of this resource and its potential changes over time as it has been restored means that inferences drawn from the evidence it presents must remain tentative. Many thanks to N. Monteix for this observation.

192 *PPP* II 112, notes that on the north wall, the middle zone central panel was red, but this is probably because the image described only preserves the outer border of the central panel. There are traces of incised guidelines in the final surface indicating the location of different panels of painting. Remains of red, white, blue, brown and orange fresco are observable, though the decorations are in a fairly poor state of preservation today.

193 *PPP* II, 112, notes that on the north wall, the middle zone central panel was red, but this is probably because the image described only preserves the outer border of the central panel.

194 *PPP* II, 112 notes a discoloured socle, red middle, and red tapestry borders.

195 *PPP* II, 112.

196 Another roundel from the same area is preserved in *Pd'E* 1779, Vol. V, Tav. IV, 23. This is described in the *PAH* (*PAH* I, 1, 245, 10th November 1770).

197 *PPP* II, 112.

198 The *PPP* II, 112 mentions a black socle, a discoloured yellow middle zone with architectural vistas flanking and tapestry borders. This may be reflected in the cork model in the Museo Archeologico Nazionale di Napoli.

199 The *PPP* II, 111 describes a yellow socle, a discoloured central zone, glimpses of architecture in the central panel, lateral tapestry borders, and pilasters with white decor.

200 Schefold 1957, 92; *Pd'E* 1779, Vol. V, Tav. 81, 361, with a detail of the tondo (*Pd'E* Vol. V, Tav. 4). Cf. also *PAH* I, 1, 245.

201 *PPP* II, 112. None of this plaster survives today.

202 *PPP* II, 112.

203 *PPP* II, 113 mentions medallions and panther, which are not present today.

204 The *PPP* II, 113 notes a red middle zone with architectural vistas described as angular with divisions but it seems likely that this is actually the socle.

205 *PPP* II, 113.

206 *PAH* I, 1, 253–254.

207 *PAH* I, 1, 255.

208 Ribau noted in his notes to 22nd June 1771, that La Vega even considered leaving all of the plaster in place since it could be roofed, and was the most intact room to be discovered to date (*PAH* I, 2, Addenda IV, 156).

209 Practically every book that discusses the Casa del Chirurgo in the years after its excavation references this painting, e.g. *PAH* I, 1, 256; *Pd'E* 1779, Vol. V, Tav. 1, 5; 82, 365; Mau-Kelsey 1899, 281–281; *Ornati* 1829, Tav. 6, Tav. 26; Helbig 1868, no. 1443, 341–342; Zahn 1828–1852, I, 98; Reinach 1922, 262; Schefold 1957, 92; Stutz 2005.

210 *Ornati* 1829 Tav. 6, Tav 26.

211 These details are from the *PPP* II, 114.

212 *PAH* I, 1, 256 (22nd June 1771)

213 Schefold 1957, 92.

214 *PPP* II, 113 mentions graffiti on the S wall E part S: 'Tullio,' '1799,' and '1802.'

215 *PPP* II, 115 incorrectly described by Schefold 1857, 92 as containing the female painter.

216 *PPP* II, 113.

217 Piranesi 1804, Pl. XX; Boyce 1937, 43 Nr. 135.

218 *PPP* II, 111.

219 Similar to conclusions reached by Robinson (2005; 2017).

220 E.g. Varone 2008, 355. Ling (1997 227–237) indicates a long phenomenon of building second storeys, but especially pronounced in from about AD 50 onwards. Andrews (unpublished PhD thesis, 180) indicates a distinct increase in the addition of upper storeys beginning in the late first century BC and continuing at Herculaneum, in a pattern that mirrors that found in the Casa del Chirurgo.

221 Robinson 2017; Dobbins 1994, 694.

222 Mau-Kelsey (1899, 275) specifically indicated a pre-earthquake *TAQ* for the painting in the house. We are grateful to both Eric Mormann and Wolfgang Ehrhardt who both confirmed the attribution of surviving pieces of wall plaster to the early Fourth Style.

223 Mau-Kelsey 1899, 275.

224 Recently excavated examples include the Casa di M. Lucrezio (IX 3, 5.24) (Castrén *et al.* 2008, 339), possibly the Casa degli Epigrammi Greci (V, 1, 18.11–12) (Staub Gierow 2008, 98–99), Insula VI 13 (Verzár Bass *et al.* 2008, 194), La Casa delle Nozze di Ercole (VII 9, 47) (D'Alessio 2008, 281). Cf. Ling (1997, 235–247; 2005, 169–170) for the extensive changes wrought by earthquake damage in the Insula of the Menander. While the comprehensive study by Maiuri (1942) is useful for appreciating the scope of damage his related socio-cultural conclusions may have been extreme. Cf. Dobbins 1994, 694 and Anderson 2011 on the effects of earthquake rebuilding on daily life.

225 Mazois 1824 Vol. 2, 51 *"Il reste si peu de chose des peintures qui la décoroient, qu'on ne peut rien dire de leur exécution."*

226 Extensive cleaning of the flooring on the northern side of the atrium did not produce evidence for any postholes on this side of the structure.

227 *PAH* I, 1, 248. *"è questo pavimento alquanto patito."*

228 Maiuri 1942, 98.

229 The idea of continued seismic activity, aftershocks or earthquakes heralding the eruption itself, as previously noted, is now generally accepted. Cf. Allison 1995; Jacobelli 1995; Varone 1995; *contra* Ling 1995.

230 Nappo 1996.

231 Berg 2008, 200.

232 Anderson *et al.* 2012.

233 Zevi 1981,14; Allison 1992, 17–18; 2004, 21–22; Berry 1997, 187.

234 *PAH* I, 1, 248–249 (26th January 1771) *"Il notato edificio è uno de'migliori che sino ad ora si sia scoperto, sì per la sua costruzione ed ornato, che per essere conservate le mura fino ad un'altezza, che può formarsi una giusta idea di come avea da restare nel suo essere."*

235 *PAH* I, 1, 245. This brief overview of the excavations serves to introduce a much more extensive discussion including a consideration of the finds recovered. See Chapter 6.

236 *PAH* I, 1, 245.

237 *PAH* I, 1, 248–249.

238 *PAH* I, 1, 248; Notably, by 1827 it was thought that these finds came from either Rooms 3 and 4 or the 'Shrine,' by which time the space had been identified as a 'Customs House' (Bonucci 1827, 94). On loom weights see also Monteix 2010, 180–185.

239 This is certainly the tablinum. Cf. Ribau in *PAH* I, 2, Addenda IV, 156.

240 *PAH* I, 1, 249.

241 *PAH* I, 1, 254; But Della Corte 1953, 33.

242 *PAH* I, 1, 256.

243 *PAH* I, 2, 41.

244 The stratigraphic position of this feature, situated at the top of the sequence, does leave the slight possibility that it could be an ancient feature and a component of the post-earthquake restorations in the house that were ongoing in the final phase. While its shape and depth are unusual for an ancient slaking pit, Adam (2003, 72) does suggest that the hydration (slaking) of lime might have been done largely on the construction site after having purchased quicklime stones from a lime burner and Pliny's (*HN* 36.55) recommendation that lime be hydrated and left to sit for at least three years might not have been followed consistently, particularly in the period of rebuilding after the earthquake(s) of AD 62/3. Following such an interpretation, the slaking pit (at 9.4 cubic metres) would seem to be entirely too large to have been intended simply to supply the repairs of a single house. According to Vitruvius's recommendations (*De arch.* 2.5.5–7), this would have produced between about 28 and 38 cubic metres of mortar, depending on the ratio of aggregate employed, perhaps indicating that such a feature would have been involved in the provision of lime to other nearby properties, such as Maiuri (1929, 330*ff*) suggested for the Casa di Stalius Eros. On the whole, however, it seems safest to see this feature as an undocumented, modern and likely Bourbon period addition to the house.

245 *PAH* I, 2, Addenda IV, 172–3, (23rd November 1792) "*Nelle notte passata di giovedi a venerdi, in vicinanza della Porta della città, hanno tagliate (nella case detta del Chirurgo) quattro pitture, cioè: Nella stanza, dove si tagliò un quadro che rappresentava un pittore nell'atto di prendere a ritratto un idolo, una testa. Nel cortile coniguo a questo casamento, e propriamente nel tablino, una quaglia. Finalmente nell'ultimo cortile, nella stanza col fondo turchino, e propriamente dove il disegnatore Lo Manto non potè finire il disegno, una delle Baccanti, ed una testa. Il tutto è statto fatto con arte, e portato via. La notte è stata orrida, si per l'acqua che per lo vento.*"

246 *PAH* I, 2, 44 (8th January 1789) "*Nella presente settimana si è impiegata la gente sotto la lamione della masseria de' RR. PP. Celestini, e siccome il tempo ha permesso, si è impiegata l'opera a levare le nevi dai cortili e stanze dove sono toniche, per evitare maggiori danni che le gelate hanno cagionati. Le quali gelate non solo hanno danneggiate molte toniche, ma pure i marmi.*" and (15–22nd January 1789) "*Si è levata terra da sopra le abitazione contigue alle ultime scoperte, ed a pulire e sfrattare le tonache cadute.*"

247 *PAH* I, 2, 73 (16–27th December 1799) "*Si è impiegato il lavoro in pulire e sfrattare le terre sì dagli edificj, che dalle strade, per rendere lo scavo nello stato regolare di prima, senza novità.*"

5

ROOM BY ROOM DISCUSSION OF STRATIGRAPHY AND ARCHITECTURE

Michael A. Anderson and Damian Robinson

This chapter contains detailed discussion of each room of the Casa del Chirurgo, organised in numerical order except in those cases where the study of several rooms was undertaken at once. Individual stratigraphic units recovered and their local interpretations are highlighted and detailed photos and plans of many of the key deposits and wall features are provided. Where these appear in the illustrations, they are marked in bold in the text.

1. Via Consolare façade
Casa del Chirurgo; southern Casa delle Vestali (AA507)

Description

The façade of the Casa del Chirurgo is an iconic feature in Pompeian archaeology, long emblematic of

the earliest surviving form of house construction.[1] At the time of the final phase prior to the eruption, four doorways penetrated the façade: the main doorway into the Casa del Chirurgo (doorway 10); two wide doorways into commercial spaces located to the north and south of the main doorway (doorways 9 and 12); and a narrow set of four steps (doorway 11) leading up to a now lost upstairs property that extended over the commercial space of Rooms 3 and 4, Room 23, and a corridor (Room 11) within the Casa del Chirurgo.

Archaeological investigations

A limited amount of stratigraphic excavation was undertaken in this area during the summer of 2005, in conjunction with excavation within Room 2 of the Casa del Chirurgo (AA507),[2] to characterise the western pavements adjacent to the house, together with those of

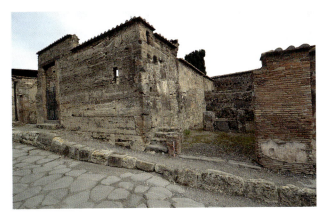

Figure 5.1.1. The Via Consolare façade of the Casa del Chirurgo from the south (image D. J. Robinson).

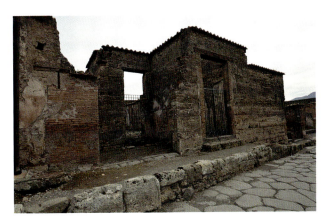

Figure 5.1.2. The Via Consolare façade of the Casa del Chirurgo from the north (image D. J. Robinson).

its neighbour to the north, the Casa delle Vestali (Room 3). The analysis of the standing architecture of the façade was undertaken together with these activities. The initial interpretation was completed during the 2009 architectural study season and confirmed in 2013.[3]

1.1 Phase 1. Natural soils

No evidence of this period was recovered in this area.

1.2 Phase 2. Volcanic deposits and early constructions

No evidence of this period was recovered in this area.

1.3 Phase 3. The Casa del Chirurgo (c. 200–130 BC)

1.3.1 The construction of the façade
The façade of the Casa del Chirurgo (Figs. 5.1.1 and 5.1.2) was built in *opus quadratum* using Sarno stone blocks. No trace of bonding material was observed, although it should be noted that W06.117, the reverse side of the façade in Room 6A, was bonded with a very pale brown (10 YR 7/3) clay. When originally constructed, the façade contained only a single doorway (10), the main entrance to the Casa del Chirurgo. At this time, the façade would also have continued northwards, across the space later occupied by doorway 9, until it would have met the northern *opus africanum* plot boundary wall. The façade also continued southwards across the spaces later occupied by doorways 11 and 12, where it met the southern *opus africanum* plot boundary wall, which may have simply been a low retaining wall. A window, which allowed light and air into Room 6A, was an original feature of the facade.[4] There are no traces of a plaster attributable to this phase.

1.4 Phase 4. Changes in the Casa del Chirurgo (c. 100–50 BC)

No evidence of this period was recovered in this area.

1.5 Phase 5. The addition of the northern and southern commercial units

1.5.1 The opening of doorways 9 and 12 – the creation of the commercial units
The northern and southern commercial units were added simultaneously to the Casa del Chirurgo during the late first century BC. The northern doorway (9) was created by the removal of the Sarno stone *opus quadratum* blocks of the façade (Fig. 5.1.3). The northern edge of the new doorway (W06.001) was built in *opus mixtum*, using *opus testaceum* with *opus quasi-reticulatum*, and was added to the remaining stub of the *opus quadratum*, which remained at the northern

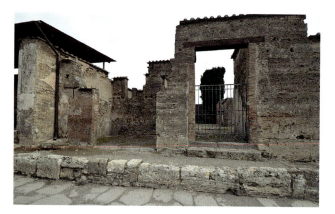

Figure 5.1.3. Doorways 9 and 10 (image D. J. Robinson).

intersection with the northern plot boundary wall. The new northern edge of the doorway was bonded with a very pale brown (10R 8/3) mortar containing angular black volcanic mineral inclusions, including ceramic and lime. The southern side of doorway 9 was created by removing and cutting the remaining *opus quadratum* blocks in order to make a vertical edge.

A grey lava threshold was installed in doorway 10, which was used as the base for two narrow (0.25 m wide) pillars of *opus testaceum* that formed a new frame for the main entrance in to the Casa del Chirurgo. The bricks/tiles in the pillars were bonded with a very pale brown (10R 8/3) mortar containing angular black volcanic mineral inclusions, including ceramic and lime. This was very similar to that used to bond the new *opus mixtum* northern edge of doorway 9 and, while there is no direct stratigraphic evidence to confirm this, the mortars suggest that not only were these were built during the same building phase but that their construction took place at the same time.[5]

Doorways 11 and 12 were also built during this phase of construction, seemingly providing both a wide and narrow entrance into the same shop (Fig. 5.1.4). An *opus testaceum* pilaster formed the southern side of doorway 11 and the northern side of doorway 12, with the bricks/tiles being bonded with a very pale brown (10 YR 8/2) mortar with angular volcanic mineral fragments and lime inclusions. It is notable that despite doorways 9, 11, and 12 being cut as part of the same phase of construction, the mortars used were slightly different. The mortars would suggest that doorway 9 and the new brick/tile door surround for doorway 10 were constructed at the same time, with that of doorways 11 and 12 probably being constructed either shortly before or after.

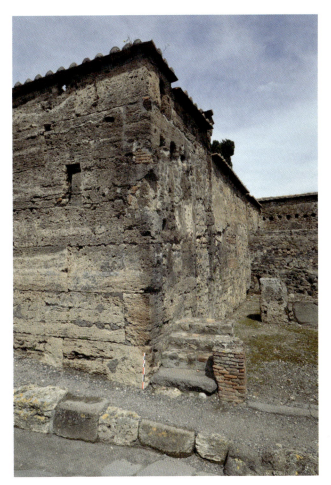

Figure 5.1.4. Repairs to the façade undertaken during the creation of doorway 12 into the new southern commercial unit (image D. J. Robinson).

1.5.2 Wall decoration

There are traces of a phase of plaster decoration that covers the bottom of the northern *opus mixtum* frame to doorway 9, as well as being present on the main *opus quadratum* section of the façade. This consists of both a backing plaster and a final plaster. The backing plaster is a light bluish grey (Gley 2 8/1) colour with coarse black volcanic sand and pieces of ceramic. The thickness of the backing plaster varies from c. 10 mm on W06.001 to 40 mm adjacent to the northern side of doorway 10, to 2–3 mm on the *opus quadratum* to the north of doorway 11. It is possible that varying thicknesses of the backing plaster were necessary to enable the creation of a flat surface. The final plaster surface was executed with a fine layer of pale red (10R 7/4) plaster containing ceramic fragments. It should be noted that on wall W06.001 (507.026), this layer was overlaid by a later plaster running on the southern wall of the Casa delle Vestali (507.025) indicating that the decoration of the façade of this property took place after that of the Casa del Chirurgo.

1.5.3 Pavement in front of the Casa del Chirurgo

The earliest *opus signinum* surface (**507.022** = **507.073**) recovered from the pavement outside the Casa del Chirurgo, measures 0.6 m by 1.60 m (Figs. 5.1.5 and 5.1.6). It has been assigned to this phase since it was poured after the red wall plaster decoration had been added to the façade on W06.001 and was cut for the placement of a grey lava threshold stone in doorway 9 during Phase 6. Although excavations in this area did not penetrate below this surface, evidence of a levelling layer (507.096) underneath the *opus signinum* as well as signs of a linear cut running east–west across its northern extent were identified. Given its relationship to activities within Room 2, this was probably undertaken at some point after the original opening of the doorway but before the changes of the following phase. The linear cut (**507.074**) may relate to the final build of the Casa delle Vestali frontage, which protrudes westwards from the line of the Casa del Chirurgo façade and probably also involved the placement of a step between the pavements at the boundary of the two properties. Its fill was a firm, silty sand containing much varied monochrome and polychrome plaster, deposited so that it produced 'stripes' on the surface (507.090[6]). A patch (507.004) of *opus signinum* was poured above this, implying that the changes were the result of otherwise unattested damage caused by the creation of the Casa delle Vestali frontage. Unfortunately, the relationship of this surface to the kerbing stones that define the edge of the street has been lost due to a trench cut for a modern pipe running north–south along the kerbing stones (cf. infra).[7]

Figure 5.1.5. The Phase 5 *opus signinum* paving in front of wall W06.001 and doorway 9 (image AAPP).

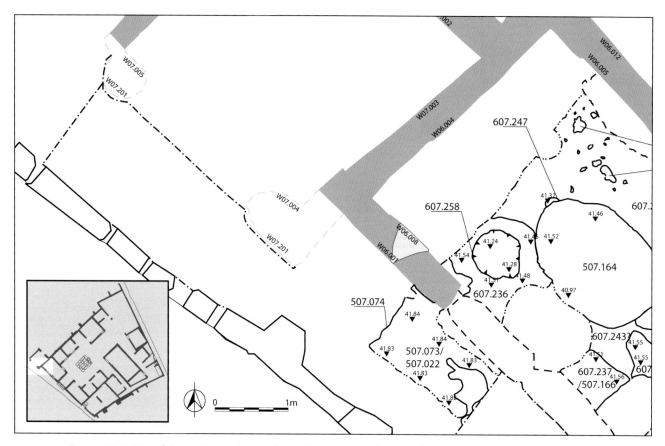

Figure 5.1.6. Plan of the stratigraphic units for the Phase 5 *opus signinum* flooring (illustration M. A. Anderson).

1.6 Phase 6. Upper storeys and final decoration (c. mid-first century AD)

1.6.1 Phase 6 plaster decoration

Alterations to the upper storeys within the Casa del Chirurgo and associated changes to the south of the façade precipitated a new phase of redecoration that can be traced across the entire frontage of the house. This may be witnessed in the northern *opus mixtum* frame of doorway 9 (W06.001), the main *opus quadratum* section of the façade (W06.002–003), and on the southern doorframe of doorway 12 (W06.007). It is likely that the majority of the previous *opus signinum*-like final plaster surface would have been removed from the walls prior to the addition of a c. 10 mm thick layer of light bluish grey (Gley 2 8/1) plaster with fine angular volcanic mineral inclusions and larger pieces of lime. In the upper portion of the walls, the backing plaster was overlain by a white (10 YR 8/1) mortar with mineral crystal fragments. Towards the bottom of the walls, the backing plaster was overlain with a thin (1–2 mm) layer of pale red (10R 7/3) plaster containing ceramic, lime, and black volcanic mineral fragments. To the south of doorway 10 at the base of the wall façade today, there are traces to suggest that a yellow (10 YR 7/6) pigment

may have been applied to the final plaster. The interface between the upper and lower zones of the wall plaster was at 1.78 m above the *opus signinum* surface of the pavement on the northern side of doorway 9. It should also be noted that the pavement of this phase was only laid after W06.001 had received its decoration.

1.6.2 The stairway at doorway 11, new thresholds at doorway 9

The shop entrances at doorways 9, 11, and 12 were reworked in the middle of the first century AD. At doorways 11 and 12, the changes were undertaken in order to modify the entrance to the upstairs apartment that had been situated over Rooms 3 and 4 in the previous phase (Fig. 5.1.7). Alongside these changes, the new southern *opus testaceum* corner of doorway 12 was bonded with a very pale brown (10 YR 8/3) mortar with angular black volcanic mineral inclusions and rounded grey tuff. The same mortar was also used to bond together the bricks/tiles that were used to patch, repair, and square up the southern edge of W06.003 (the northern edge of the new wide doorway 12). Following this, grey lava threshold stones were also inserted into both doorways, which required the

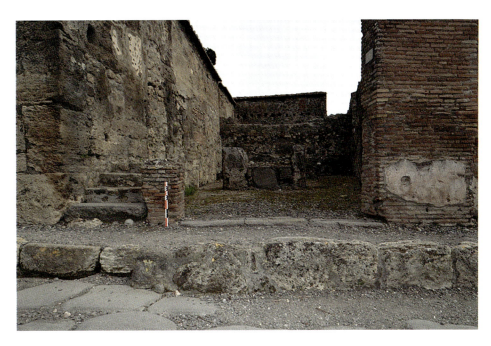

Figure 5.1.7. The mid-first century AD doorway configuration for the southern commercial unit (image D. J. Robinson).

careful shaping and cutting of both the northern and southern the brick/tile piers to accommodate them. In doorway 11, this was followed by the construction of three steps in *opus incertum*.[8] The steps have been heavily repaired in modern times but certainly must have existed. In doorway 12 a grey lava threshold was also inserted, following what appears to have been considerable works to strengthen the upper lintels of the doorway in preparation for changes to the upper storey or modifications to the southern wall of the shop. This resulted in the cutting of the *opus testaceum* pier that formed the southern side of doorway. At doorway 9, grey lava threshold stones were also added, probably in conjunction with a change in the character of the business undertaken in Room 2. The cut required for their placement (507.075), penetrated the earlier *opus signinum* pavement (507.022 = 507.073). The cut was curvilinear and irregular, but generally followed the rough course of the threshold stones themselves.

1.6.3 Opus signinum *pavement in front of the Casa del Chirurgo*

Cutting through the pavement for the threshold stones was followed by the creation of a new one. Traces of this final phase pavement are preserved in a small triangular section in the corner between the façade of the Casa del Chirurgo and the southern wall of the Casa delle Vestali (Figs. 5.1.8 and 5.1.9). This *opus signinum* surface (42.12–42.14 MASL) seems intended to slope towards the south and west, where it would have capped or met neatly with the kerbing stones (507.191) that form the western edge of the pavement. The top

layer of *opus signinum* (**507.002**) has been damaged by water flowing from a modern gutter that empties in this location. Below the *opus signinum* is a brown rubble sub-floor layer of silty sand matrix (507.099) that was not excavated due to the preservation of the *opus signinum*. While the kerbstones situated to the west of these pavements have been stripped of all stratigraphic relationships by trenches cut for modern piping, they must date from either this or the previous phase. In these kerbstones are 4 holes that have been tentatively identified for tying up animals.[9]

1.6.4 The pavement in front of the Casa delle Vestali

Though no clear trace of a final phase *opus signinum* was recovered from in front of the Casa delle Vestali, a series of levelling layers against the final phase frontage (507.175, 507.134) may be footings of an

Figure 5.1.8. The Phase 6 *opus signinum* paving in front of wall W06.001 (image AAPP).

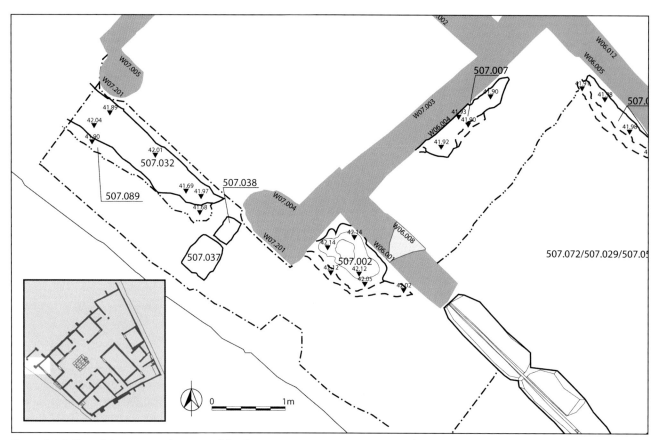

Figure 5.1.9. Plan of the stratigraphic units of the Phase 6 *opus signinum* pavement in front of the Casa del Chirurgo and the excavations in front of the Casa delle Vestali (illustration M. A. Anderson).

earlier pavement (507.093 = 507.094 = 507.095, **507.089**, 507.041[10]) (Fig. 5.1.10). After the original Sarno stone foundation (507.183, 507.184) of the area had been reworked, a thin layer of mortar (507.188) was laid down. The level of the area was then raised by means of rubble and plaster (507.187). This seems to have related to the placing of a step, consisting of two grey tuff blocks, in the pavement between the two properties (Figs. 5.1.9 and 5.1.10) that bridged the difference in elevation between the pavement in front of the Vestals and that in front of the Casa del Chirurgo. The step was placed by first making a shallow irregular cut (507.039) to seat two stones (**507.037**, 507.038) and the fills around them. The smaller of the stones (**507.038**) was then bonded to a lower lava stone with a soft light brownish grey (10 YR 6/2) mortar (507.033). The larger block (507.037) shows signs of having been removed and replaced during the cutting of the trench for the modern water pipe that runs underneath it. A dark brown (10 YR 3/3) silty sand underlay the tuff blocks in the bottom of the cut and may have acted as a footing layer for the stones.

The final surface of the pavement in front of the

Casa delle Vestali has not survived, but two surfaces potentially represent sub-floors for a final *opus signinum* surface. The first (**507.032**[11]) was a dark brown (10 YR 3/3) firm sandy silty soil that produced a large amount of marble chips, possibly suggesting that it had been associated with the reworking of a marble veneered frontage of the Casa delle Vestali. The second deposit (507.005) was a solid plaster and mortar rubble deposit with face-up, single-colour plaster forming a significant component of the upper part of the fill, and face down plaster comprising the lower part. It is possible that this was a modern attempt to produce a walking surface, or it is a sub-floor seating layer for a now missing final phase *opus signinum* pavement.

1.7 Phase 7. Post-earthquake changes
No evidence of this period was recovered in this area.

1.8 Phase 8. Eruption and early modern interventions
The upper areas of walls W06.001, W06.002–003 and W06.007 were all rebuilt to a greater or lesser extent during the early modern period after the initial

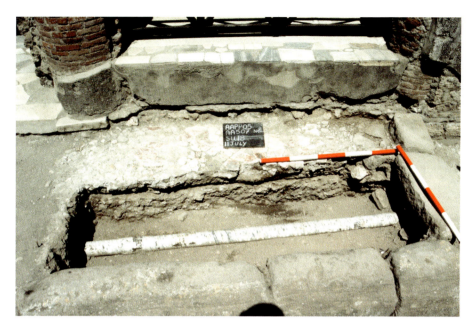

Figure 5.1.10. Excavations in front of the Casa delle Vestali (image AAPP).

excavations. From the mortars, it would appear that this was achieved in two separate sub-phases, an initial repair of the northern W06.001 and W06.002–003 around and above doorway 10, which was followed by the repair of W06.007 and the addition of a course of tiles capping the tops of the walls. The upper region of W06.001 was rebuilt using courses of brick/tile set within a light greenish grey (Gley 1 7/1) mortar containing angular fragments of volcanic rock and small crushed pieces of lapilli. On top of this, the reconstruction continued adjacent to the northern boundary wall of the property in *opus incertum* using Sarno stone and cruma set in the same mortar, indicating that this was simply a continuation of the rebuilding. Included in this area of reconstruction was a wooden lintel, which was used to help create or rebuild a window. On W06.002–W06.003, the area to the north of doorway 10 was rebuilt with predominantly with brick/tile. A piece of Sarno stone was used to raise the height of the northern *opus testaceum* doorframe equal to that of the south. This was undertaken so that a wooden lintel could be placed over doorway 10. All of the rebuild was set within a light greenish grey (Gley 1 7/1) mortar containing angular small fragments of volcanic rock and small crushed lapilli. The reconstruction continued above the level of the lintel in *opus incertum* using predominantly Sarno stone set within the same light greenish grey mortar. It should also be noted that this was the same mortar that was used in the repair of W06.001, indicating that the repairs to both of these walls were contemporaneous. The upper 0.4 m of W06.007 was rebuilt in brick/tile set in a light bluish grey (Gley 2 7/1) mortar with black volcanic stone and lime inclusions. On top of

all of the newly rebuilt walls, as well as directly on top of the surviving *opus quadratum* of W06.003, a line of roof tiles was placed. They were set with the same light bluish grey mortar that was used to rebuild the *opus testaceum* of W06.007. The final phase pavement was also consolidated with cement (**507.003**). Many of these cements were cut within Room 2 by the trenches of Maiuri and thus predate his investigations.

1.9 Phase 9. Modern interventions

1.9.1 Restoration following Maiuri's excavations

Following the excavations of Maiuri into the pavement directly in front of doorway 10,[12] some restoration was undertaken to the threshold and the area (Fig. 5.1.11). A step was provided (507.012), at first in metal and later in Sarno stone, providing access to the house through doorway 10. *Opus signinum* fragments in this area also received consolidation (**507.003**) in cement and the western half of the pavement was cut for the placement of a modern water pipe running north–south down the Via Consolare (507.017). Its fill (507.018) contained a friable very dark greyish brown sandy silt (10 YR 3/2) with a mixture of ancient and modern artefacts. Overlying the possibly ancient plaster filling to the east of this was a modern mortar smear (507.031) across the tops of the plaster fill material beneath it.

1.9.2 1970's restoration campaign

The lower three courses of *opus quadratum* blocks in W06.003 were repaired with a coarse bluish grey (Gley 2 5/1) mortar with angular black volcanic mineral inclusions, crushed volcanic rock, lapilli, and lime. The same mortar was also used to point around the

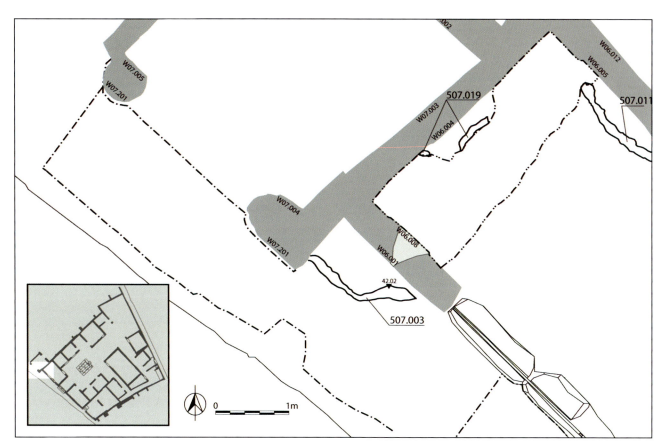

Figure 5.1.11. Plan of the stratigraphic units of the Phase 8–9 *opus signinum* pavement in front of the Casa del Chirurgo and the excavations in front of the Casa delle Vestali (illustration M. A. Anderson).

northern edge of doorway 9. The surviving edges of the ancient wall plaster were given a protective coating of light bluish grey (Gley 2 7/1) mortar with angular fragments of black volcanic rock.

1.9.3 2000's restoration campaign
A rough light bluish grey (Gley 2 7/1) mortar was used to point around the *opus quadratum* blocks in W06.002 and W06.003, as well as the intersections between

the brick/tile doorframe and the *opus quadratum*. The same mortar was also used to point around the *opus reticulatum* and early modern repair on W06.001. The final change to the façade was the addition of a new drainpipe at the northern end, adjacent to W06.001, which takes the rainwater runoff from the modern roof over the fauces and flanking rooms of the Casa delle Vestali and deposits it on a tile set in the light bluish grey mortar on the *opus signinum* pavement.

2. Room 1
Fauces (Not excavated)

Description

Room 1 was created during the initial construction of the Casa del Chirurgo (Fig. 5.2.1). Walls W06.030 and W06.031, the southern and northern walls, are keyed into the adjacent walls of the façade (W06.003 and W06.002) and the atrium (W06.028/W06.029 and W06.032), indicating that they were all built together. The room would have functioned as the main entrance to the property throughout its history conveying inhabitants and visitors from the Via Consolare into the atrium. In this volume, Room 1 is referred to as the fauces and measures 1.73 m by 2.74 m. Due to the presence of a complete *opus signinum* floor surface, no excavations other than a light cleaning were undertaken. Excavation was undertaken, however, by Maiuri in 1926 at the western end of the room,[13] where he recovered what he believed was the most compelling evidence for the earlier flooring of the house, a supposed earlier doorway arrangement, and what he thought to be earlier plastering events. It seems likely that on the basis of the elevations recovered from our

Figure 5.2.1. Room 1 (image D. J. Robinson).

excavations that the surface that Maiuri interpreted as the earliest floor of the house was actually the natural deposits themselves. Unlike Maiuri's trenches in the area of the atrium, triclinium, and hortus, his trench in the fauces was not re-excavated.

2.1 Phase 1. Natural soils

Other than the assumption that Maiuri's lower floor was probably actually the surface of the natural soils, no evidence was recovered of this phase in Room 1.

2.2 Phase 2. Volcanic deposits and early constructions

There is no indication that Maiuri recovered any evidence for any Pre-Surgeon activity in the fauces.

2.3 Phase 3. The Casa del Chirurgo (c. 200–130 BC)

2.3.1 The construction of the fauces

The walls of the fauces were keyed into the adjacent walls of the façade and the atrium as part of a coherent scheme of construction. The western and eastern ends of W06.030 and W06.031 are built in *opus quadratum* using large blocks of Sarno stone, which were used to key the walls of the fauces into both the façade and western wall of the atrium. The central area of both W06.030 and W06.031 were constructed in *opus africanum* using Sarno stone, the rubblework of which was bonded together with a very pale brown (10 R 8/3) clay with black volcanic mineral and lime inclusions. Two square beam holes at c. 3.45 m from the contemporary ground surface at the western and eastern edges of both walls that are most likely putlog holes for scaffolding associated with the construction of the fauces. Although Maiuri's trench in Room 1 was not re-excavated, it is possible to reflect upon the evidence that he maintained proved the existence of a smaller *vestibulum* in the initial layout of the house. His primary evidence for this was two Sarno stone pillars that had been chipped away to the level of the floor surface, which he believed had originally been *antae* that divided the room into two parts. He noted that these were reflected in Room 2 and 6A.[14] While re-excavation in these areas confirmed his discovery, the elevation where this supposed chipping away terminates, may simply have been traces of wider foundations, similar to that observed throughout the walls of the Casa del Chirurgo. Nevertheless, his interpretation of *antae* walls has been retained in our interpretation.

2.3.2 The decoration of the fauces

There was a small quantity of the probable first layer of decorated plaster still attached to W06.030 (Fig. 5.2.2,

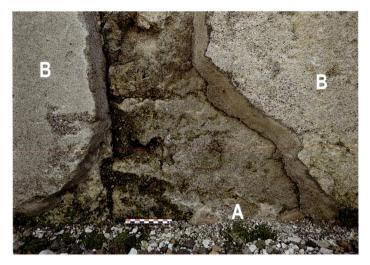

Figure 5.2.2. (*Above*) Traces of the initial plastering of wall W06.030. (A) Phase 3 plaster; (B) Phase 6 or 7 plaster (image D. J. Robinson).

Figure 5.2.3. (*Right*) Traces of the initial plastering of wall W06.030. (A) brick/tile doorframe; (B) grey lava threshold; (C) Phase 5 plaster; (D) Phase 6 or 7 plaster (image D. J. Robinson).

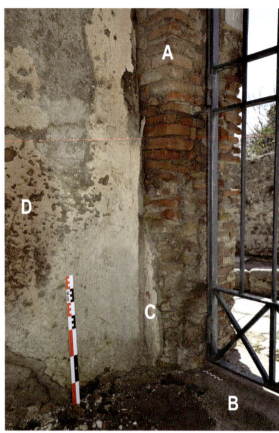

A). This took the form of a white (10 R 8/1) mortar backing with rounded black gravel inclusions, faced by a fine white plaster on which the red pigment of the fresco was applied, and has now weathered to a weak red (10 R 5/4) colour. The backing plaster is also to be found elsewhere on the wall in some of the deep natural holes in the Sarno stone.

2.4 Phase 4. Changes in the Casa del Chirurgo (c. 100–50 BC)

No evidence of this period was recovered in this area.

2.5 Phase 5. Redecoration and redevelopment (late first century BC to early first century AD)

2.5.1 The addition of a brick/tile doorframe[15]
In Phase 5, a new doorframe was added to the eastern end of the fauces. This undoubtedly replaced an earlier frame, perhaps constructed in wood, which would have matched the early doorframes in the atrium. The new frame was constructed in quoins of *opus testaceum*, set in a very pale brown (10R 8/3) mortar containing sub-angular black volcanic mineral inclusions, including ceramic and lime. The brick/tile doorframe overlies a dark grey lava threshold. It should be noted that the threshold is significantly thinner than the width of the fauces threshold prior to the addition of the brick/tile

surround and also that the pivot holes for the doors correspond to the brick/tile version of the doorway (Fig. 5.2.3, A and B). Consequently, it is suggested that the lava threshold was laid immediately prior to the construction of the frame, but as part of the same phase of building work. If the *antae* walls that Maiuri suggested had existed,[16] then it seems likely that they would have been removed by this stage. The *opus signinum* floor of the fauces also appears to have been laid at this point.

2.5.2 The decoration of the fauces
On W06.031, there are traces of a white (10 R 8/1) sandy plaster applied directly to the *opus africanum* construction of the wall. This is an extremely characteristic mortar seen elsewhere in the house, particularly in the atrium during this phase of redecoration. It is suggested that this was used to create a smooth base layer or to perhaps seal the wall prior to the application of further layers of backing plaster. Consequently, its use in the fauces would suggest that the original plaster layers were mainly stripped from the walls as part of the process of redecoration. A layer of light greenish grey (Gley 1 8/1) backing plaster was then applied to the walls and flattened at the surface. The backing plaster was then overlain by a fine white (10 R 8/1)

plaster, which provided the base onto which dark red (10 R 3/6) pigments of the fresco were applied. Traces of this phase of plastering and its fresco can be seen to overlie the southern brick doorframe directly (Fig. 5.2.3, C). Incised engaged pilasters were used to adorn the eastern side of the fauces at this time.

2.6 Phase 6. Upper storeys and final decoration (c. mid-first century AD)

2.6.1 Final plaster phase
With the exception of the small piece of painted plaster still visible adjacent to the doorway threshold on W06.030 (Fig. 5.2.3, C) and at the base of W06.031, where they were protected by the *opus signinum* of the floor, the majority of the previous decorative surface was carefully removed prior to the application of a c. 10 mm thick layer of white backing plaster with frequent small black inclusions. This was subsequently covered by a new thin layer of white (2.5 Y 8/1) plaster containing angular translucent crystals in the upper and middle registers. The lower register of the wall was covered in a similarly thin layer of plaster containing powdered and crushed ceramics, with the occasional piece of lime and black volcanic mineral fragments. The quantity of the ceramic in the plaster gives it a light red (10 R 7/6) colour. The stratigraphic relationships between the layers allow the reconstruction of the sequence of plastering. The upper and middle registers were finished first, followed by the lower register. Incised lines on the final surface of the middle and upper register of the fresco allow a reconstruction of the decorative scheme of two large panels with stylised tapestry and other decorative borders and

bands, separated by a single, smaller panel zone (Fig. 5.2.4). Records from the initial excavations combined with information from the cork model in the *Museo Archeologico Nazionle* in Naples make it clear that this involved a complicated Fourth Style design with a central mustard yellow middle zone flanked by two red panels, all above a black socle.[17]

2.7 Phase 7. Post-earthquake changes
No evidence of this period was recovered in this area.

2.8 Phase 8. Eruption and early modern interventions
The upper portions of W06.030 and W06.031 were rebuilt to a constant height in *opus incertum* using Sarno blocks with occasional pieces of grey lava and tile. This was set within a light greenish grey (Gley 1 7/1) mortar containing angular small fragments of volcanic rock and small crushed lapilli. The reconstruction continued above the level of the lintel in *opus incertum* using predominantly Sarno stone set within the same light greenish grey mortar. This was followed by the setting of a line of tiles on top of the reconstructed portion of the wall. The line of roof tiles and early modern rebuilding continued over the brick/tile doorway and, consequently, it is suggested that a lintel must have been placed across the threshold into the fauces in the early modern period. A rendering layer of a thick grey mortar, which has weathered to a brown surface and includes pieces of lapilli, was applied to the upper portions of the wall down to the level of the surviving wall plaster. It is likely that both of these actions were undertaken to protect and preserve the historic fabric of the wall. Stratigraphically it can be observed that the

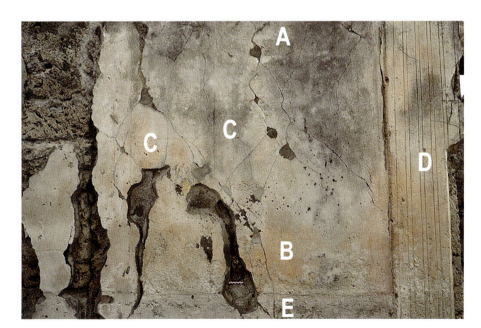

Figure 5.2.4. Incised guidelines on the final frescoed surface of wall W06.031. (A) upper tapestry delimiter; (B) lower tapestry delimiter; (C) edge of tapestry panel; (D) raised engaged plaster column; (E) lower socle (image D. J. Robinson).

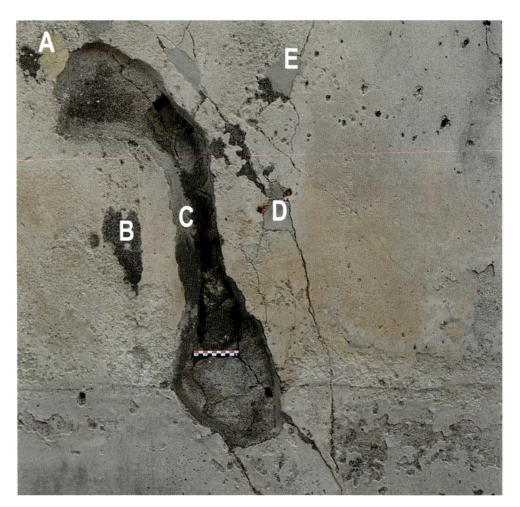

rendering layer was initially applied to the wall, with the mortar being used to bed the tiles being spread down over the render.

Further early modern attempts to conserve the final wall plaster can be seen in the use of a fine yellow (10 YR 7/6) mortar that was used to repair cracks on W06.030 and W06.031 (Fig. 5.2.5, A). A similar weak red (10 R 4/4) mortar with black volcanic inclusions was also used. A hard bluish grey (Gley 2 5/1) mortar (Fig. 5.2.5, B) with black volcanic mineral inclusions and the occasional piece of lime was used to fill in larger holes in the plaster layer and to repair damage to the flutes of the incised pilaster. A number of butterfly clips, or more accurately, indications of the iron staining following their removal or disappearance (Fig. 5.2.5, C), are also indicators of other early attempts at keeping the surviving wall plaster attached to the underlying masonry of the wall.

2.9 Phase 9. Modern interventions

2.9.1 1970's restoration campaign

A new phase of wall plaster conservation involved either the removal of the entire butterfly clips, or simply their wings (Fig. 5.2.5, B) and the repairing of holes in the plaster surface with a fine smooth light grey mortar (Fig. 5.2.5, D). The surviving wall plaster was also edged with a light bluish grey (Gley 2 7/1) mortar with angular black volcanic stone inclusions (Fig. 5.2.5, E). It is likely that the modern lintel over the doorway was replaced at this time, although due to the amount of modern pointing, it is difficult to see this.

2.9.2 2000's restoration campaign

Finally, a light bluish grey (Gley 2 7/1) mortar was used to point around large Sarno blocks of the original wall and around some of the early modern *opus incertum* reconstruction of the wall.

3. Room 2
Northern commercial space
(AA507 and AA607)

Description

Room 2 is a rectangular space (5.55 m by 3.26 m) situated at the extreme north-west corner of the Casa del Chirurgo. During the final phase prior to the eruption, it was employed in some form of commercial activity and outfitted with a wide western entrance and sliding door front, together with a notch for a smaller access door fitted into the larger sliding one at the southern end. This entrance led onto a wide pavement area, a result of the fact that the Casa delle Vestali extends further to the west than the Casa del Chirurgo, producing a small dogleg. It seems likely that the room was also connected to the atrium (Room 5) at this time. A stairway, the base of which is preserved in the south-east corner of the room, led to an upper storey that seems to have been restricted entirely to the area of Room 2

The area of the pavement directly in front of Room 2, and the southern area of pavement to the west of the Casa delle Vestali, was excavated alongside work inside the room during the first season of excavation (cf. supra). The areas in front of the properties were clearly paved with an *opus signinum* surface during the final ancient phase of the city, little of which has survived into the present day.

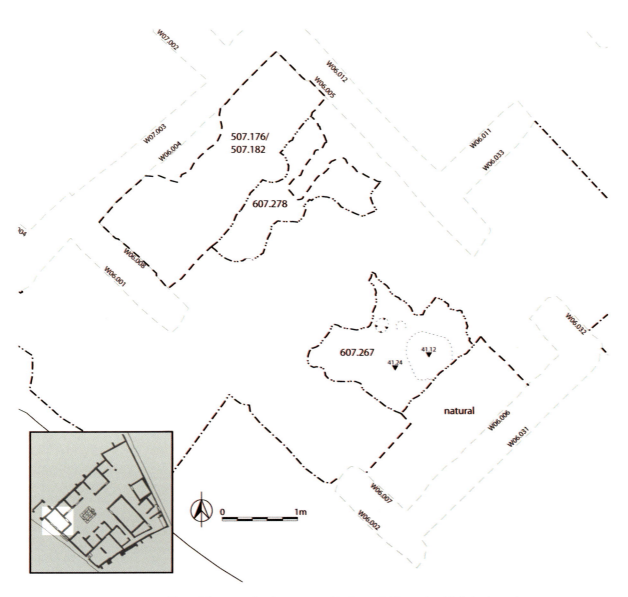

Figure 5.3.1. Plan of the natural soils uncovered in Room 2 (illustration M. A. Anderson).

Archaeological investigations

Excavations in Room 2 were undertaken over a period of two seasons of fieldwork.[18] The first campaign during the summer of 2005 (AA507) exposed the entire area of Room 2, including the area of pavement directly to the west, and extending northward so as to encompass the southern pavement in front of the Casa delle Vestali (Room 3) (cf. supra). Excavation was bounded on many sides by Maiuri's earlier sondages, which flanked either side of Room 2 on the north and south and were also located at the termination of excavations in the pavement on the southern side (directly in front of the fauces of the Casa del Chirurgo). Excavations proceeded to the level of black sandy soils in the area in front of the Casa delle Vestali, but did not reach natural soils. Excavations in the following summer of 2006 (AA607) reopened only the area of Room 2 for further exploration and continued to the natural deposits. The standing architecture was analysed individually[19] and their interpretations were initially checked and then later amalgamated into a coherent narrative for the entire room during two further seasons of architectural analysis in 2009 and 2013.

3.1 Phase 1. Natural soils

Natural soils in the area of Room 2 were observed at the base of later pit cuts and within the sections exposed by Maiuri's deep sondages (Figs. 5.3.1, 5.3.2 and 5.3.3). Due to the depth of these cuts, the natural soils (607.267) exposed were generally yellow in colour, as commonly found directly underlying more silty and chocolate-coloured soils recovered elsewhere in the insula. This was clearly equal stratigraphically equivalent to natural soils (**507.176 = 507.182**) seen in Maiuri's northern and southern sondages. That these deposits were heavily disturbed both in ancient and modern times is clear from the example of 507.176 which produced pottery spot dated to the second half of the first century BC, a date that is entirely incompatible with the deposits and must derive from contamination during later periods when the area was re-exposed. Within Room 2, the depth of this deposit ranged from 41.12–41.24 MASL. A very thin (1 cm) component of darker soil was recovered from the north-eastern side of Room 2 in plan (**607.278**),[20] which was probably a small remnant of the 'chocolate' natural topping to the yellow of the natural sequence seen elsewhere in the block.

The later truncation of the upper deposits makes reconstruction of the original topography of the area difficult. Nevertheless, the natural soils suggest that the area was probably a component of the 'upper terrace' represented by the zone from the tablinum of the Casa del Chirurgo through the atrium (cf. Chapter 4). Certainly no signs of a removal of soils prior to the building of the Casa del Chirurgo were preserved in the area. The western extent of these soils was not recovered.

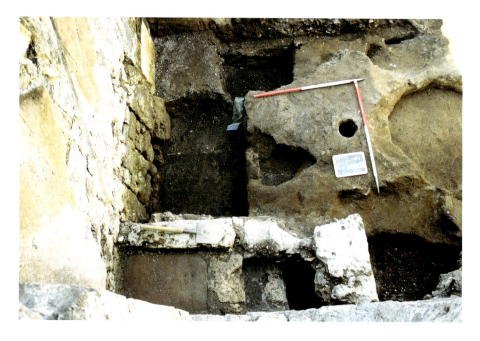

Figure 5.3.2. Natural soils uncovered on the southern end of Room 2 (image AAPP).

Figure 5.3.3. Natural soils uncovered on the eastern side of Room 2 (image AAPP).

3.2 Phase 2. Volcanic deposits and early constructions

3.2.1 Pit cuts and fills

Room 2 did not preserve evidence of the layers of volcanic origin recovered elsewhere (cf. AA200, AA508, AA612), probably as a result of the removal of these deposits when the elevation of the area was lowered during Phase 5. Nevertheless, sufficient evidence of inter-cutting pits in this area serves to connect it generally to similar activities documented within the atrium (Room 5) and Room 6C (Fig. 5.3.4). The subsequent removal of the upper stratigraphic sequence has cut away the top surfaces from which most of these cuts were made and has tended to truncate the sequence overall. It has therefore seemed best to sequence all of these cuts into later phases (generally into Phases 3 and 5 below), while acknowledging that some early pits may have been sequenced later than they should have been.

Figure 5.3.4. Evidence of pits and cuts in the bottom of Maiuri's northern trench in Room 2 (image AAPP).

3.3 Phase 3. The Casa del Chirurgo (c. 200–130 BC)

This phase saw the construction of the Casa del Chirurgo. Elsewhere in the property, and especially to the south, the construction was heralded by the destruction of the Pre-Surgeon Structure and the filling in of the lower terrace (Fig. 5.3.5). Little evidence of this extensive activity was recovered within the area of Room 2, possibly because it was free from previous construction. As noted above, the truncation caused by the later cutting away of these soils has also served to obscure evidence from this phase. Nevertheless, it is possible to suggest that the imminent construction of a new house was preceded by several preparatory cuts probably related to the building activity that characterises the rest of the phase.

3.3.1 Cuts and fills prior to the construction of the Casa del Chirurgo

Directly overlying the natural soils on the south-east side of the room was a layer of dark yellowish brown soil (**607.311**[21]), roughly 20 cm thick, that may be layers of the re-deposited natural soils intermixed with building debris, rubble, and other domestic rubbish that presumably derived from the destruction of more substantial structures to the south. Thereafter, a series of cuts were made into these soils and subsequently filled with a variety of deposits that also likely derived from demolition (Figs. 5.3.6, 5.3.7 and 5.3.8). One of these was flat-bottomed circular pit cut (607.313), filled with a loose, sandy silt and debris (**607.312**). Another cut (507.035) was recovered at depth within one of Maiuri's trenches. This was filled with a loose dark grey, ashy, silty sand (507.034). While the precise purpose for most of these cuts is unknown, the recovery of dolium fragments in one (607.315) suggested to the

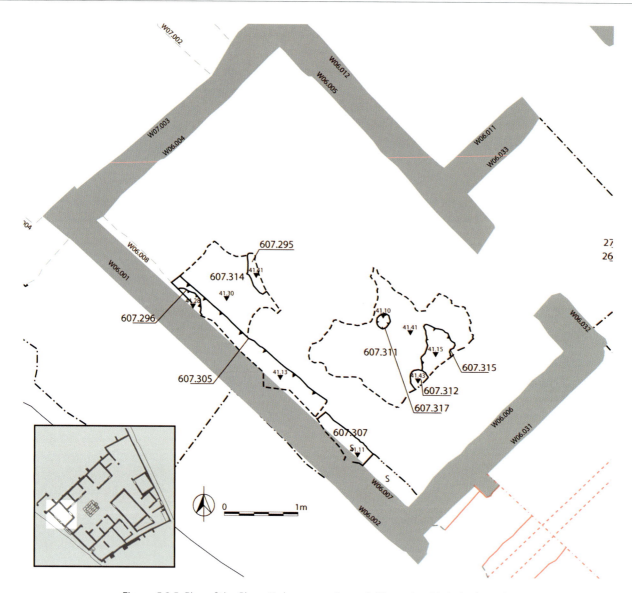

Figure 5.3.5. Plan of the Phase 3 changes to Room 2 (illustration M. A. Anderson).

excavators that it may once have held such a vessel. This was an irregularly shaped cut (**607.315**) with vertical sides and a flat bottom located on the south-eastern side of Room 2. It was filled with a dark brown (10 YR 3/3) soil (607.316) with the traces of the dolium, which was possibly in situ. Inclusions in the fill were bone, charcoal, pottery, and an abundance of ash. Below this fill layer was a very dark greyish brown (2.5 Y 3/2) ashy sandy silt that also appeared to be within the dolium or lined area of the pit (607.320). It may be best to see these activities as related either to the removal of ephemeral structures in the area – potentially represented by a single posthole (607.317) – or as part of the preparations for construction of the new structure. The posthole was situated on the southern and central side of Room 2. Its cut (**607.317**) was roughly 10 cm in diameter and about

15 cm in depth. The fill (607.318) was a firm rubble deposit with plaster in an orange coloured matrix. In no case do these pits appear to have been very deep, so it is unlikely that they were the result of the procurement of natural soils for construction activities as often appears to be the case elsewhere in the insula. Unfortunately, the later removal of the upper layers of soil of Room 2 during the creation of a shop in the area means that most of these deposits have been truncated and their top surfaces entirely confused through later trample. The most important of these features was a linear cut (607.319) made into the natural soils and filled with a brown (10 YR 4/3) soil with large amounts of rubble (**607.314**[22]) that produced a coin dating from c. 206–144 BC.[23] Although possibly contaminated as well, this deposit was clearly cut by the foundations of the

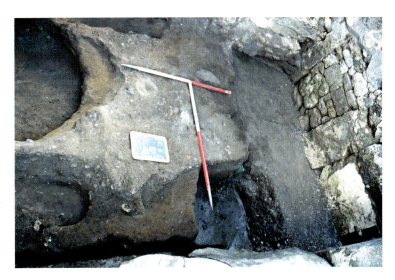

Clockwise from top right:

Figure 5.3.6. Evidence of cuts and fills in Room 2 prior to the construction of the Casa del Chirurgo (image AAPP).

Figure 5.3.7. Cut with *dolium* elements possibly hinting a possible original purpose (image AAPP).

Figure 5.3.8. Cuts into natural soils on the western side of Room 2, themselves subsequently cut by the foundation trench and Sarno blocks of the southern end of the façade of the Casa del Chirurgo (image AAPP).

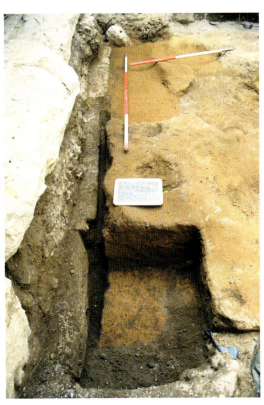

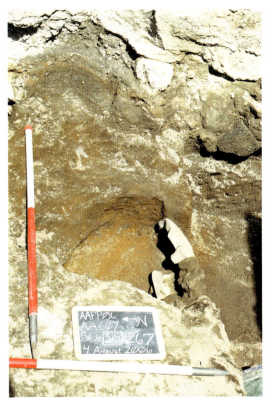

Casa del Chirurgo, and therefore suggests a *terminus post quem* for its date of construction.

On the north-western side of Room 2, after this final linear cut had been filled, a floor-like, compact deposit with many mortar and plaster inclusions (**607.295**) was laid down. It was a dark yellowish brown (10 YR 4/4) sandy silt becoming a loose brown (10 YR 5/3) sandy silt on the southern side (607.310). This should probably be seen as a temporary working surface utilised during the construction. Into this deposit a semicircular cut was made with irregularly sloping sides and an irregular base (**607.296**). It was filled with

a dark brown (10 YR 3/3) soil with few finds (607.297) and is of uncertain purpose.

3.3.2 Creation of the walls of the Casa del Chirurgo
After the completion of these preparations, the construction of the walls of the Casa del Chirurgo began. Within the area of Room 2, this activity is revealed only by the house's façade since Maiuri's trenches have served to obliterate all evidence of the construction of the northern and southern walls (W06.004 and W06.006 respectively), while preserved flooring and features have obscured evidence of the creation of the eastern wall

(W06.005). Nevertheless, it is clear that the construction of these walls took place contemporaneously since they are keyed into each other.

The western façade (W06.007/W06.008) was constructed in *opus quadratum* within a deep, straight-sided cut (**607.305** = 507.179, 607.309) with a flat bottom that goes through earlier deposits and into the natural soils below (Fig. 5.3.9).[24] The edge of the cut runs very close to the lowest foundation stones, in a manner not dissimilar from that discovered in the atrium.

After the cut had been made, it was filled with the first course of large (c. 1.3 by 0.57 by 0.4 m) Sarno stone blocks (**607.307** = 507.036, 507.135) producing the solid façade wall on the western side of the space. As in the atrium, these initial blocks of the foundations were wider than the upper blocks that followed them, serving to form a solid foundation upon which the load-bearing wall could rest. They also seem to have been placed at the same time as the foundations for wall W06.004 (507.186, 507.185).

Wall W06.004 was constructed using *opus africanum* of which there are some elements of the Sarno stone framework visible at the top. Wall W06.005 was constructed from a mixture of *opus quadratum*,

which was used to frame the doorway into the atrium (Room 5), and *opus africanum*, which was used for the remainder of the wall. The *opus quadratum* doorframe used large blocks of Sarno stone (c. 1.59 by 0.63 by 0.4 m). The *opus africanum* remainder of the wall was also made out of Sarno stone with the framework being composed of headers (c. 1.4 by 0.3 m) and stretchers (c. 0.97 by 0.27 m) and its rubble infill composed of square to rectangular blocks of Sarno stone and cruma (c. 0.1 by 0.1 m to 0.2 to 0.3 m). The doorway into Room 5 was clearly an original feature of the wall. Its northern and southern edges are chamfered, continuing down below the floor level of Room 5 into the foundations. Wall W06.006 was also constructed from a combination of large ashlar blocks of *opus quadratum* at the western end of the wall where it interlinks with the *opus quadratum* of the façade of the Casa del Chirurgo, and *opus africanum*, with rubblework composed of square and rectangular blocks that vary in size generally between 0.1 by 0.1 m to 0.2 by 0.3 m. The bonding agent employed in these walls was a very pale brown (10R 8/3) clay with black volcanic mineral and lime inclusions (< 1 mm in diameter).

After the creation of at least the first few courses of these walls, the foundation trenches were filled with soil and building debris, including a dark yellowish brown (10 YR 3/4) soil with few inclusions aside from occasional pieces of plaster and mortar (607.306 = 507.180). In the middle of the wall, the cut was filled with a dark-brown, firm, sandy silt with building debris similar to the fills of the pre-Surgeon terrace (607.308). The extremely hard-packed soils found in the atrium and tablinum capping the filling of the foundation trenches (cf. infra) were not encountered in Room 2.

The course of the foundation cut confirms that the frontage of the Casa del Chirurgo once continued along the precise alignment preserved by the rest of the façade. The creation of a shop front in a subsequent phase seems to have involved a flattening of the façade, possibly in order to create more space in front of the shop for a wider pavement. The role of Room 2 during Phase 3 was no different from the rest of the northern range of rooms arranged around the atrium. Its floor level was originally equal to that of the other atrium rooms (probably roughly 42.33–42.37 MASL on the basis of flooring found in AA184 and AA612). No trace of either this floor level or flooring itself was recovered from Room 2.

Figure 5.3.9. Cuts into natural soils on the western side of Room 2, also cut by subsequent foundation trench and Sarno blocks of the Casa del Chirurgo northern façade (image AAPP).

3.3.3 Phase 3 wall plaster
There are feint traces of a degraded backing plaster still adhering to some of the Sarno stone framing elements

and rubblework that could represent an early plastering of Room 2. This consists of a light bluish grey (Gley 2 7/1) plaster with small (< 1 mm in diameter) volcanic minerals and sand inclusions, with occasional larger (up to 3 mm) pieces of lime. On W06.004, there are possible traces of a final surface, which might simply have been created by flattening the backing plaster. Similar traces are pressed deep into the recesses in the *opus africanum* in the upper portion of wall W06.005, and on the northern chamfered edge of the doorway into Room 5, extensively on W06.006, and on walls W06.007 and W06.008. Crucially none of this backing plaster is present on the areas of the walls that were rebuilt in order to create the shop doorway.

3.4 Phase 4. Changes in the Casa del Chirurgo (c. 100–50 BC)
No evidence of this period was recovered in this area.

3.5 Phase 5. Redecoration and redevelopment (late first century BC to early first century AD)

3.5.1 Removal of soils and opening of western doorway
Significant changes within Room 2 began during the late first century BC, which altered its function entirely (Fig. 5.3.10). Access to the room was provided on the western side by the removal of the majority of the western façade. The initial stages of this work produced several cuts related to the removal of Sarno stones from the wall. The first was a linear cut along the later threshold stone (**607.292**, 607.289), later filled with a dark brown soil with rubble and other debris (607.293). This was likely identical to another linear cut with vertical sides running under the northern end of the threshold stones (**607.287**) that had been separated by later activity. The fills of this latter cut were more varied, including loose to firm sandy silt with large amounts of building material and even some possible residue of waste materials related to metal working or production (607.263, 607.275, 607.288). These cuts penetrated through a deposit similar to the natural soils, but which had experienced much disturbance during either these or previous activities (**607.294**).

In order that the new room should be on the same level as the pavement outside, the room's floor was lowered by as much as 0.75 m to 1 m before the creation of features necessary for the new function of the space began. This truncated the stratigraphic profile in the room, removing the soils associated with the creation of the Casa del Chirurgo serving to confuse the earlier sequence significantly (cf. supra). The significant difference in elevation between the atrium and Room

2, makes it seem likely that the eastern doorway was closed at this time by means either of a wooden partition or plausibly a light wall in *opus craticium*, at least until a small step had been put in place in this location in the following phase.

Creation of the doorway in wall W06.007/W06.008 involved the removal of much of the original *opus quadratum* wall. At wall W06.007, the voids left by the removal of the Sarno stone blocks were filled with layers of bricks/tiles set in a very pale brown mortar (10R 8/3) containing angular black volcanic mineral inclusions, ceramic, and pieces of lime (up to 5 mm). Wall W06.008 was largely rebuilt using *opus testaceum* with two small areas of *opus quasi-reticulatum* using Nocera tuff and grey lava roughly shaped into diamonds (c. 0.1 by 0.1 m). This was set within the same very pale brown mortar used on wall W06.007 (and also on walls W06.004 and W06.005). It is likely that the *opus mixtum* construction was undertaken in order to create the window in wall W06.008. It should be noted, however, that the 'beam holes' above the lintel are early modern creations designed to complement the actual ancient evidence for a second storey in Phase 6 (cf. infra).

The lowering of the level of the floor in the space also required changes to the surrounding walls. At the bottom of wall W06.004 in the now exposed *opus africanum* foundations, a 0.3 m thick layer of mortar render was applied to the wall, which overlies the Phase 3 backing plaster. This render was composed of a very pale brown (10 YR 8/3) mortar containing angular black volcanic fragments, pieces of lime and crushed stone (up to 10 mm in diameter). The mortar was also thickened with ceramics as well as pieces of Nocera tuff and cruma in square blocks (c. 0.1 by 0.1 m). The render may also have been used to repair the wall where elements of the original *opus africanum* rubblework had become unstable. Similarly, the newly lowered level necessitated the construction of a retaining wall between the Sarno stone *opus quadratum* blocks of the doorway into the atrium. The retaining wall was constructed out of *opus incertum* using Sarno stone and a single piece of cruma set within a very pale brown mortar, which was identical to that used on wall W06.004. The same mortar was also used to bond a 0.3 m wide pillar to the south side of the doorway, which appears to have been formed using shuttering: its northern edge was chamfered in imitation of the original chamfering on the Sarno stone. The purpose of this pillar was to help close the doorway into Room 5. There is evidence on wall W06.032, and in section in the doorway, to suggest that a backing and final plaster once covered the doorway on the inside of Room 5. The

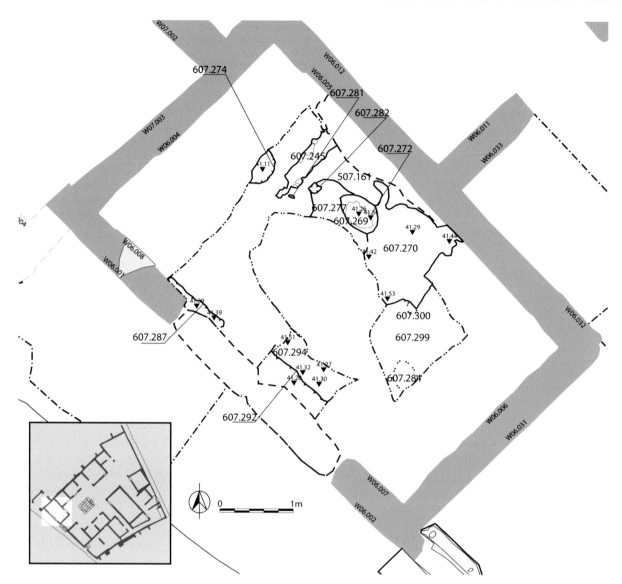

Figure 5.3.10. Plan of the traces of the earliest elements of metal working activity in Phase 5 (illustration M. A. Anderson).

evidence from Room 2 would indicate that this closure would probably have been completed using wood c. 0.7 m thick and that the area of the former doorway above the level of the newly inserted retaining wall could have been used as a small niche.

3.5.2 Phase 5 wall plaster

The lowering of the level also necessitated a new decoration scheme. The final surface of the plaster from Phase 3 on the walls was removed. This was then overlain by a bluish grey (Gley 2 8/1) backing plaster containing angular volcanic mineral fragments, which was covered by a layer of pink (10R 8/3) final plaster containing ceramic and the occasional volcanic mineral fragment (< 1 mm in diameter). Certainly the pink *opus signinum*-like plaster would have been appropriate for a

utilitarian space such as the commercial unit that Room 2 had now become. The pink plaster on wall W06.006 is in the area of the scar caused by the staircase that would be added in the next sub-phase.

3.5.3 First sub-phase of metal working/production activity

After the room had been reoriented, it began to be used for some sort of light production activity, possibly involving metals. This is clear from the significant amount of metal working/production residues, including slag and flux, which were found in all subsequent deposits. Although analysis on the slag and flux was not undertaken, given the percentage of iron finds from the deposits of this phase, it is likely that they document iron working. A high temperature of work is suggested by discolouration and reddening

of the soils. These activities began immediately upon the top surface of the newly levelled soils, without sign of any provision of a floor or working surface other than the packed down residues of the earliest production activities themselves (607.299[25]). Thereafter, the area was subjected to a series of cuts and fills of indeterminate function, but clearly related to the activities underway in this space at that time. A potential function for some of these cuts is suggested strongly by a feature located just to the north and east of the centre of the room that involved an amphora placed sideways into a shallow pit, which was likely part of a furnace. To the north of this, low traces of a wall suggest that a larger structure once surrounded this feature, and further cutting in the area for postholes may relate either to its creation or on-going use. This may imply that the series of cuts and fills recovered from this phase indicate a repeated sequence of short-lived furnace structures that were dismantled after use.

3.5.3.1 FLOORING OF THE FIRST SUB-PHASE

No formal flooring was recovered for this first phase of activity, but traces of a firmly packed layer located in the south-eastern quarter of the room (**607.299**) suggest a rough working surface into which some of the features of this phase were cut. Finds from the surface, which include slag, suggest that metalworking began immediately upon the surface produced by lowering the level of the floor in Room 2. This surface would have been continually trampled down as work in the room continued and similar processes were repeated over time (cf. infra).

3.5.3.2 AMPHORA FEATURE AND SMALL WALL (POSSIBLE FURNACE)

The best evidence of metal working/production activity in the first phase was a reused Dressel 2–4[26] amphora (**607.269**) and the low remains of a small wall (**607.245**) situated directly to its north 10 cm in height (Figs. 5.3.11 and 5.3.12). Soil to the north of the low wall was a reddish white, silty, sand (607.246[27]). It may represent an area that experienced extreme heat, though little charcoal was recovered by soil flotation. The amphora was placed on its side with a deliberately broken end pointing roughly to the south-east. Other deliberate breaks in the amphora may have been for the insertion of a set of bellows.[28] A shallow cut was made for the placement of the amphora, which afterwards was carefully packed around with fills to hold it in place. The cut (607.276) was filled initially with a firm, grey-brown soil with some bone and pottery fragments and patches of grey soil (**607.277**), which might be parts of the early layers of volcanic origin not otherwise observed within Room 2. Above this was a yellow-brown, loose, sandy, silt (607.279) followed by a compacted soil filled with considerable debris including possible production waste and worked stone (607.261[29]). Dates from this deposit provide a *terminus post quem* of the third quarter of the early first century AD for this activity. The amphora

Figure 5.3.11. Amphora, possibly used as a small-scale furnace, with discoloured reddish soil in apparent discharge pattern (image AAPP).

Figure 5.3.12. Inside the amphora and its contents (image AAPP).

was packed carefully into this cut, and secured with a dark yellowish brown (10 YR 3/6) loose sandy silt packed in around the amphora body itself, presumably to help to hold it in place or act as insulation (**607.272**). Deposits from within the amphora and immediately surrounding it were found to be particularly rich in metal-working residues and charcoal. The fills of the amphora itself consisted of several deposits (607.264, 607.265) that were found to contain fragments of metal and slag from these activities. Presumably these fills derive not from the use of this feature but from its burial. Other deposits also (607.266) appeared to have been reddened by heat. The fills around the amphora also seem to be related to metal working activities. A copper wire was recovered from 607.260 and a compact ashy deposit (607.244) may have originated from related activities. Most importantly, a large patch of reddish soil (**607.270**), rich in metalworking residues including fused fragments of iron, lead, and a sandy stone like substance that may likely be remnants of flux residue, was recovered directly in association with the southern opening of the amphora, appearing to have been expelled from the amphora itself. On the basis of these observations, it seems likely that this feature related to the working of metals, notably bronze and iron.[30]

3.5.3.3 CUTS AND POSTHOLES

Surrounding the amphora feature were a number of postholes and cuts, that may indicate activities similar to that preserved in the amphora feature. The postholes (**607.281, 607.282, 607.300, 607.284**) possibly suggest a wooden or partly wooden superstructure for the amphora furnace (Fig. 5.3.13). As the heat involved in

its operation might have rendered a wooden covering impractical, perhaps they are best explained as temporary posts involved in the construction of the feature. They certainly do not seem to coordinate in any meaningful way. After their use, they were filled with a diverse set of deposits (607.280, 607.283, 607.285, 607.301). Another cut (**607.274**) to the north of the preserved amphora feature and to the south under the later reddish soils nearby (607.298) are roughly the same shape and size as the cut made for the amphora left in situ. Both were subsequently filled (607.273, and 607.302 respectively) with deposits rich in debris, including iron and charcoal. It is possible that they represent similar furnaces that were dismantled more completely at the end of their working lives. This would suggest a repetitive nature to the work carried out in Room 2 that is consistent with its interpretation as a metalworking facility. The well-preserved amphora

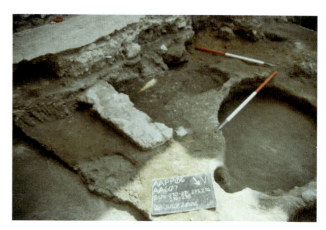

Figure 5.3.13. Postholes and the hollow into which the amphora had been placed, with remnants of possibly related small wall feature (image AAPP).

feature would then simply be the final version of an activity that was carried out repeatedly throughout the end of the first century BC.

3.5.4 Sub-phase 2 of the metal working/production activities (c. late first century BC to early first century AD)
Traces of the continuation of production activities from the late first century BC through the early first century AD are more ephemeral than those related to the beginning of this phase, but nevertheless suggest a continuation of the working or production of metals (Fig. 5.3.14).

3.5.4.1 WORKING SURFACE
The working surface of the second sub-phase of metal working/production seemed to be formed from residues of the activities that had taken place within

Room 2 compacted over the top of the earlier features. The best evidence of this floor was a compact, grey surface found extending over much of Room 2 in the central and eastern area (607.236[31] = **607.243**[32] = 607.304 = 507.161) (Figs. 5.3.15 and 5.3.16). This layer was characterised by continued iron-working deposits and orange-red tints, especially towards the southern side of the trench. It was a particularly rich deposit that included large amounts of charcoal, plaster, metal working waste, and copper alloy. On the southern side of Room 2, the area of highest iron concentration (607.043) was excavated as a separate deposit, largely because of its colour (reddish brown, 5YR 4/4), even though finds were consistent with other elements of the working surface. It is possible that this colour change was the result of heating on this half of the surface. Under the stair base extension, a similar deposit

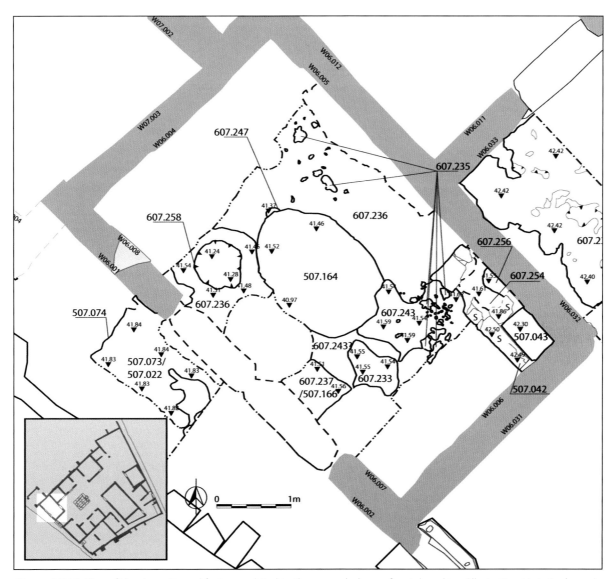

Figure 5.3.14. Plan of the deposits and features related to the second phase of metal working (illustration M. A. Anderson).

(607.304) was separated from the others by areas that were not excavated, but was likely the result of the same deposition process. The several apparent 'pits' or 'cuts' (607.259, 607.303, **607.256**, **607.254**, 507.163, 507.162) identified by the excavators within the varied deposits were simply components of the extremely varied fill. As in the first phase of these activities, this rough surface suggests a period of repeated activity with a large amount of charcoal and other residual build-up, some of which remained long enough within the area of Room 2 to be compressed into the working surface.

3.5.4.2 Continued working activities
Unlike the initial sub-phase of metal working/ production, traces of cuts and postholes in the second sub-phase were relatively few in number. One possible posthole (**607.247**) and a shallow (15–20 cm deep) irregularly shaped pit measuring 47 × 80 cm (607.247, **607.233**[33]) suggest some continuity of activity from

the former phase. The fills of these cuts also contained traces of metal working waste among building materials and domestic refuse. The general lack of features similar to the previous sub-phase may suggest a change in the type of metalworking activity undertaken within Room 2 or result from a reorganisation of space in the shop.

3.5.4.3 Stairway
The most significant change during this phase was the creation of a stairway in the south-east corner of the room leading up to an upper storey (Fig. 5.3.17). A rubblework masonry base for a stair began 0.84 m to the north of the south-eastern corner of the room and then turned to the west. A wooden staircase ran against the southern wall of the shop, leaving a clearly observable scar on W06.006. The construction of the first phase of the stairway involved a cut and fill for the foundation (507.190, 507.169) and a base made of Sarno stone and mortar (**507.042**). The first step of this stairway, a terracotta slab (**507.043**), was preserved by secondary changes to the structure. Further *opus incertum* was then used to fill-in around the stair base and the walls (507.189). More significant in terms of building must have been the creation of the upper storey to which this stairway led. Its presence is clearly marked by joist holes in the surviving walls, which also suggest that the second storey construction in this area did not extend further than the area of Room 2 itself. Presumably, this means that in this phase the *cenaculum* above was intended for the use of those who worked in the metal working shop below and not for the inhabitants of the Casa del Chirurgo who were prevented access into this space by the blocked doorway in W06.005.

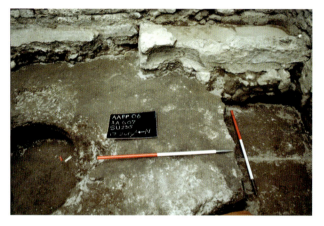

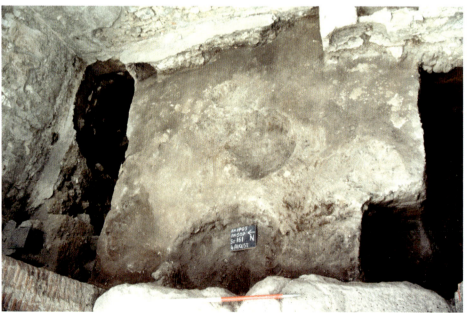

Figure 5.3.15. (*Top*) Grey packed earthen surface with mortar fragments, possibly representing a coarse working surface (image AAPP).

Figure 5.3.16. (*Bottom*) Mortar fragments capping the working surface (image AAPP).

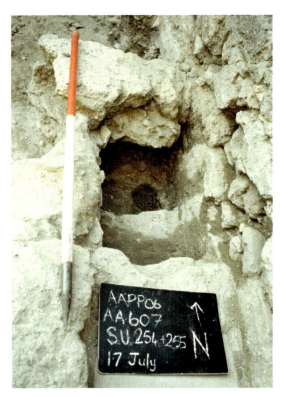

Figure 5.3.17. The base of the stairway, revealing the original lower step. The first step lies within later northward extension that itself was subsequently cut on the western side (image AAPP).

3.5.4.4 INTER-CUTTING PITS

While this sub-phase did not preserve a great deal of evidence for on-going production activities, it is likely that this is due to the damage caused by several large pits (Fig. 5.3.18) (the largest nearly 2 m in diameter), including one along the threshold itself (607.238).

A further cut was found in the north-west corner of the room (**607.258**) and another (507.167) on the west. While it is extremely difficult to be certain of the precise function of these pits, the central one (507.165) was deep enough that excavation did not reach its bottom. Pits of this type, which seem to have removed a significant amount of natural soil and replaced it with building debris, have generally been interpreted as efforts to provide clean natural soils used for mortars or plasters used in construction. Certainly, the fills of these cuts (607.257, 607.252, **507.166**, **607.237**, **507.164**[34]) largely consisted of building materials and general detritus, with almost no trace of the soils into which the cuts had originally been made. The fill of the central cut (**507.164**), included material that must have come from outside the Casa del Chirurgo, since mosaic tesserae recovered do not match any known to have been used in the house. It seems likely that these cuts relate to the construction of a new upper storey for the shop and its related stairway. The fact that several are located near the threshold, may also suggest that some changes were necessary in this area as well. The later placement of the final phase threshold stones has unfortunately served to obscure any evidence of alterations undertaken at this time.

3.5.4.5 PAVEMENT IN FRONT OF THE *CASA DEL CHIRURGO*

The earliest *opus signinum* surface (507.022 = **507.073**) recovered from the pavement outside the Casa del Chirurgo is probably roughly contemporaneous with this second sub-phase of activities within the room (cf. supra).

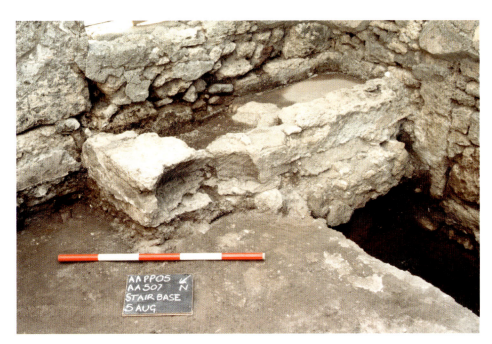

Figure 5.3.18. Evidence for cutting and filling under the later northern extension of the stairway (image AAPP).

3.6 Phase 6. Upper storeys and final decoration (c. mid-first century AD)

3.6.1 Metal working/production Phase 3. First half of first century AD

Metal working/production activities continued throughout the first half of the first century AD (Fig. 5.3.19). This sub-phase was initiated with the creation of the first substantial flooring attested within the workshop, which was itself subsequently cut by activities seemingly not dissimilar from those witnessed in the previous two sub-phases. Changes were also made during this time to the stairway, plausibly related to a re-opening of the eastern doorway into the atrium, either because the stairway was now made accessible only from the atrium or because access was now desired between the shop, the atrium, and the upper storey. At the end of this sub-phase and probably heralding the planned alterations to the function of the area in Phase 6, a new threshold was created for the shop in lava stone.

3.6.1.1 MORTAR FLOOR REMNANT

This simple, grey, mortar-like surface (**507.080**,[35] **607.235**) (cf. Fig. 5.3.14) was made of firmly packed sandy silt with pottery inclusions. It appears to have been intended as a working surface and, from the degree of degradation, seems to have been used heavily for some period of time. Two similar, though disconnected, components of this floor were also found within the build of the later stair (**607.239**) and in a pedestal of soil left within Maiuri's excavations to the north (**507.071**). This surface was cut through by pits and postholes in a manner very similar to that of the previous two periods of activity, suggesting that much the same sorts of work was being carried out across all three sub-phases.

3.6.1.2 STAIRWAY – SECOND CONSTRUCTION

This phase also saw changes to the stairway, which seem designed to transform the base of the stair so that it could also serve as a step from the atrium (Fig. 5.3.20). It therefore seems likely that the doorway between these two spaces was open once again by this time. This involved extending the area of the base to the north and, in the process, covering two of the lowest steps and the terracotta slab (507.043) that had formed the landing of the earlier version of the stairway. The extension was made in rubblework and had no foundations (**507.170**). Fills within the base extension (507.158, 607.251) served to make the framework solid.

At some point thereafter, the exterior wall of the stair was cut by a nearly semi-circular incision (507.160), that, having been isolated by Maiuri's excavations must remain unexplained. Covering the stairs were two fills (607.251, 507.158) both consisting of general building detritus and probably the result of cleaning up after construction was completed. Two different layers of plaster are present on the stair base (507.171 = 507.173, 507.172 = 507.174). Another disconnected fragment of plaster on wall W06.005 (507.030) near the stair base is also plausibly associated with these stairway plasters. It remains unclear, however, whether a screen or narrow wall, similar to that preserved and reconstructed in the stairway from the atrium in the Casa dei Ceii (I 6, 15) was present in Room 2, separating off the stair from the shop itself. Such might be suggested by the mortar construction to the north of the original step, but it is not conclusive. Unfortunately, any trace of such a wall would have run through the area of Maiuri's southern trench in the area and has therefore been lost.

3.6.1.3 PITS AND METAL WORKING/PRODUCTION FEATURES

The cuts into the mortar floor and their fills are particularly indicative of the continuation of activities related to the working of metals (Figs. 5.3.21 and 5.3.22). The cut of a central pit (**507.120**) in particular appears to mirror the shape of the previous amphora feature of the first sub-phase, and the recovery of iron, slag, charcoal, copper, and possible flux from fills (507.111[36] = 607.286) suggest no break in work focused on metals. At the very base of the cut there was a large fragment of iron, possibly an iron bloom, which might hint at small scale smelting as well as general metal working in the area. A second large lump of iron, which may have been another iron bloom (507.150) from smelting, formed the base of the fill (507.082) of a cut on the north-eastern side of the room (**507.086**). In addition, an oval shaped, straight-sided cut located roughly in the centre of Room 2 and measuring approximately 50 cm in length and 30 cm in depth (**507.084**) is reminiscent of the amphora feature found in the initial metalworking phases. This was accompanied by a sub-circular cut on the north side (**507.114**) halved by Maiuri's sondage and another small cut on the southern side of Room 2 (**507.132**). The fills of these cuts (507.079,[37] 507.113,[38] 507.117) were similar in composition to the general layers of build-up associated with the on-going workshop activity. Further cuts were encountered elsewhere in the room. A roughly circular cut with steep sides 20 cm deep (**507.085**), may complete this grouping,

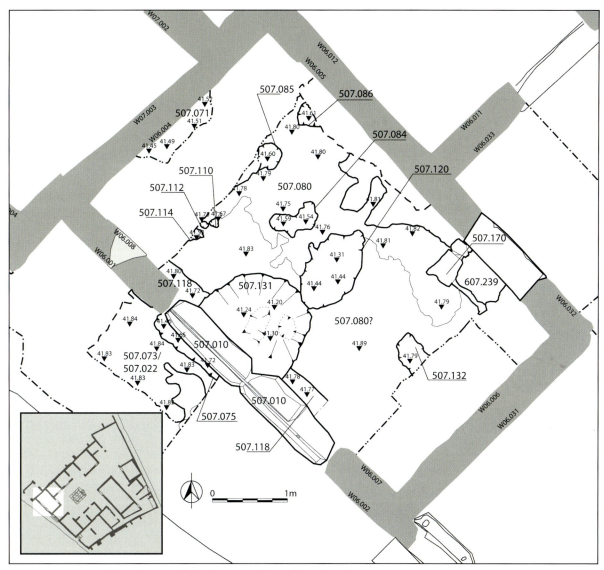

Figure 5.3.19. Plan of the features of the third sub-phase of metal working activity in Room 2 (illustration M. A. Anderson).

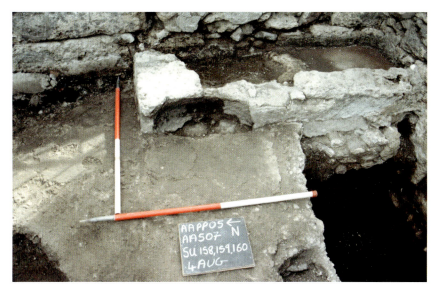

Figure 5.3.20. Extension of the stairway base to the west, encasing the final step (image AAPP).

possibly forming a line with 507.086 and 507.084. It was found filled largely with charcoal (507.081[39]). While is it impossible to be completely certain of the use of each of these cuts, it is possible that these shallower, smaller, cuts found throughout the three sub-phases of metal working/production represent the bases of small smelting towers or hearths. A dark grey-black (2.5 Y /1) loose sandy silty ashy layer (507.078[40]) overlying a good part of the mortar floor in Room 2 appears to be direct residue from the final phase of metalworking as it contained charcoal, slag, iron and fragments of copper tools. This sealed many of the cuts described

above, in particular small holes and wear (**507.112, 507.110**, 507.109) of the mortar floor, implying that it was the result of a general build-up and trample of daily working debris. On the northern part of the room this surface showed evidence of burning (507.070).

3.6.2 Final Changes to Room 2 (c. mid-first century AD)

After roughly a hundred years of metal working/production, Room 2 received its final set of changes at a point after the mid-first century AD (Fig. 5.3.23). While it is possible that these changes occurred after the earthquake of AD 62/3, they seem more likely to

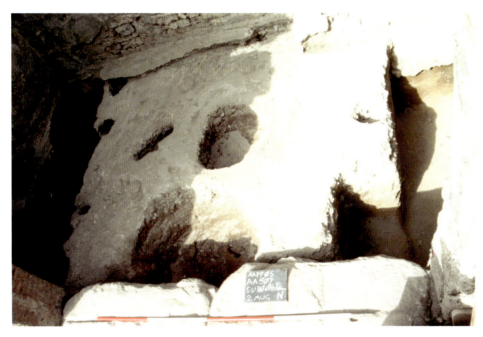

Figure 5.3.21. (*Top*) Final cuts related to the end of metal working activity in Room 2 (image AAPP).

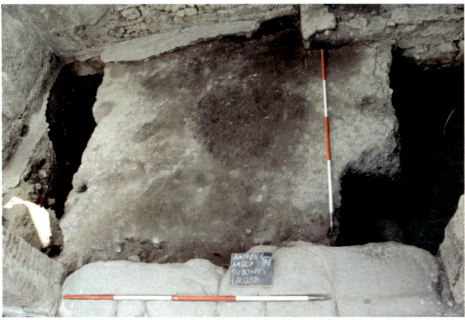

Figure 5.3.22. (*Bottom*) Fills of the cuts with ashy final layer that sealed the industrial activities or represented their final elements of by-product (image AAPP).

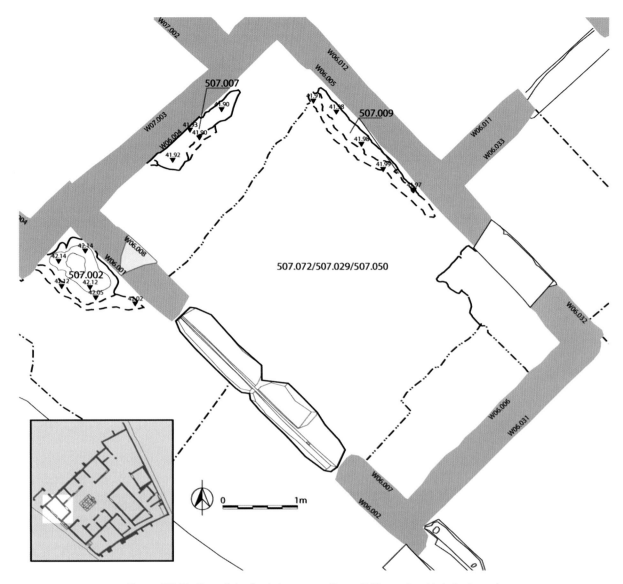

Figure 5.3.23. Plan of the final changes to Room 2 (illustration M. A. Anderson).

be a component of the final phase of improvements within the house that took place prior to the earthquake, possibly suggesting an up-market shift in the presentation of the household to the street, or a shift away from the activities of production. Heralding this change in the use of the space, a new set of lava threshold stones was placed at the western opening of the shop. Thereafter, the area received its final deposit of metal working/production residues, probably as a component of closing down these activities, and was subsequently paved over with a fine *opus signinum* surface.

3.6.2.1 THE CONSTRUCTION OF A LAVA STONE THRESHOLD FOR THE VIA CONSOLARE DOORWAY
The placement of new lava stone threshold stones in the

wide doorway to the Via Consolare involved work both on the footpath of the street and inside Room 2. This work would have first removed any traces of the earlier threshold (if one had existed) and door arrangements (pivots etc). The cut for the new lava stone threshold was visible on both sides of the doorway. On the western side it cuts through the earlier *opus signinum* (**507.075**) pavement. The cut was curvilinear and irregular, but generally followed the rough course of the threshold stones themselves. On the eastern side (507.091) of the doorway, the cut was steep and linear and clearly followed the outline of the threshold. A second linear cut (607.242) at depth within the main cut indicates that this process may have had several stages.

The area was then prepared to receive the threshold stones (**507.010**) by means of deposits of soil (607.262).

After the stones had been worked into position, the remaining gaps were filled with further deposits (**507.118**, 607.241). On the western side of the doorway, a grey mortar (507.076) was a part of the fill, overlying a brown loose sandy deposit (507.077). The top of this cut and fill appears to have been truncated by the loss of the top *opus signinum* surfaces of the footpath. At a point after the cut for the threshold, but prior to any subsequent flooring, a cut was made on western side of the room (**507.131**) directly against the threshold stones. The fills (**507.115**[41]) included a sling bullet, but were otherwise similar to those excavated elsewhere in the previous metal working phase.

3.6.2.2 LEVELLING POST-METAL WORKING/PRODUCTION ACTIVITIES

The first step in the transformation of Room 2 was decommissioning the workshop. This can be seen in a grey, compacted layer of deposits filled with working/production residues (**507.072**[42] = **507.029**, **507.050**[43]) that sealed the metal working workshop activities and formed the base for the subsequent *opus signinum* flooring. This deposit, similar in nature to the previous two described above, was a dark greyish brown (10 YR 4/2) loose silty sandy soil that ran across the entirety of the room and contained large amounts of production waste, charcoal, and slag. It was probably derived from materials present during the final stages of metal working. Dated to after the middle of the first century AD on the basis of coins and glass recovered from this deposit,[44] it provides evidence of both the continuation of the workshop through the first half of the first century AD and its final termination.

3.6.2.3 *OPUS SIGNINUM* FLOOR SURFACE

Traces of an *opus signinum* floor (Fig. 5.3.24) that covered the entire room are present in two distinct areas: one along wall W06.005 (**507.009**). The other was located atop a pedestal of unexcavated materials left by Maiuri in his northern trench (**507.007**). It is heavily degraded with only small sections of the original surface surviving. Similar overall elevations (41.92–41.98 MASL) of these badly degraded remains, which have received much modern consolidation at their edges (cf. infra), strengthen the conclusion that they comprise components of a once much more extensive *opus signinum* surface in this area. No further traces of metal working or production activities are found in Room 2, and it seems likely that this new type of floor and threshold was associated with a new manner of business.

3.6.2.4 PHASE 6B WALL DECORATION AND THE REOPENING OF THE DOORWAY TO THE *ATRIUM*

A change in function also heralded a new phase of decoration in Room 2. The reopening of the doorway into Room 5 prefaced this, although it was a somewhat narrower doorway during this period as the chamfered *opus incertum* narrowing from the previous phase was retained. The *opus signinum*-like final plaster of the previous phase of decoration was removed prior to the application of new layers of backing and final plaster. On wall W06.004, some care appears to have been taken to preserve the backing plaster for reuse, which was then covered by two layers of final plaster. A 3 mm thick layer of white (10R 8/1) plaster with mineral crystal inclusions was applied to the upper part of the wall, which was followed by a pinkish white (10R 8/2) plaster containing ceramic and rounded black volcanic inclusions at the bottom of the wall. The intersection between the two plasters occurs at 1.66 m above the current floor surface. It is notable that in the upper area of wall W06.004 at its western end, it would appear that the previous plaster was not removed and there are no traces of the final upper plaster. This is most likely due to the continuing presence of the second storey. It suggests that while the lower part of Room 2 was redecorated as part of the redevelopment of the commercial space, the upper part of the room retained the wall plaster from Phase 5; presumably there was no need to change the decoration of this upper space.

On walls W06.005, W06.006, W06.007 and W06.008 it would appear that a new backing plaster was required, which was applied in a thick (c. 30 mm) layer and was composed of a coarse light bluish grey (Gley 2 7/1) plaster containing rounded volcanic gravel, ceramic, and lime (up to 10 mm). This backing plaster was then covered with the two final layers, the pinkish while plaster on the lower portion of the wall and the white plaster with mineral crystal inclusions on the upper. On walls W06.007 and W06.008 at the interface between the upper white and lower pinkish white final plasters, there are traces of a 10 mm wide horizontal border.

It is notable that on wall W06.006 this plaster phase can be traced both above and below the level of the mezzanine floor on the eastern side of the wall, which suggests that unlike wall W06.004, where the upper parts of the wall retained the Phase 5 phase wall plaster, wall W0.006 was completely redecorated. This may have been the result of changes to the staircase. The final layer of the upper parts of this wall was simply a white plaster with mineral crystal inclusions. Division of the wall surface into a high socle of reddish utilitarian ceramic rich plaster with a white upper zone seems

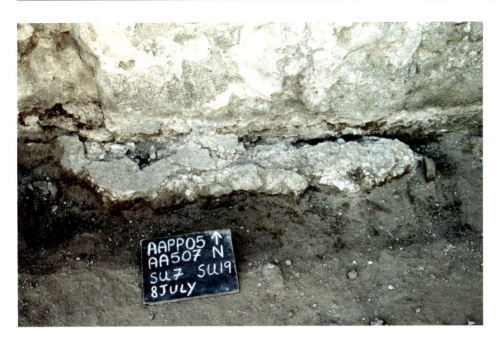

Figure 5.3.24. Elements of the surviving *opus signinum* flooring on the eastern side of Room 2 (image AAPP).

entirely in keeping with the commercial function of the space.

3.6.3 Opus signinum pavement in front of the Casa del Chirurgo
The changes inside Room 2 were accompanied by roughly simultaneous alterations to the street pavement that also appear to have been intended to help transform the function of the space (cf. supra).

3.7 Phase 7. Post-earthquake changes
No evidence of this period was recovered in this area.

3.8 Phase 8. Eruption and early modern interventions
Changes after the excavation of Room 2 appear to have included rebuilding the upper components of wall W06.006, probably in order to bring it up to an appropriate height for the construction of the doorway over the main entrance of the Casa del Chirurgo. The same was also done to the upper zone of wall W06.005 in order to permit a lintel to be set above the doorway into Room 5, and the area above it rebuilt up to a height consistent with the neighbouring wall W06.006. This work was undertaken in *opus incertum* using Sarno stone, cruma, yellow tuff, and brick/tile set within a light bluish grey (Gley 2 7/1) mortar with black volcanic stone, lime, and lapilli inclusions (all up to 20 mm). The same mortar was also used as a 10–20 mm thick render across the upper zone of the wall, whereas towards the base of the wall it was used to point around some of the *opus africanum* rubblework.

The upper parts of wall W06.007 were rebuilt using

courses of brick/tile set within a light greenish grey (Gley 1 7/1) mortar containing angular fragments of volcanic rock and small crushed pieces of lapilli. On top of this, adjacent to wall W06.006, the wall was further reconstructed in *opus incertum* using Sarno stone and cruma set within the same light greenish grey mortar. In wall W06.008, the same light greenish grey mortar was also used with courses of brick/tile to repair a hole within the northern edge of the doorway. As part of this process of rebuilding, a wooden lintel was also set over the top of the window and the wall above it largely rebuilt.

Following this patching and reconstruction, wall W06.008 was rendered with a 0.1 m thick coat of a light bluish grey (Gley 2 7/1) mortar with black volcanic stone, lime, and lapilli. This was the same mortar that was used in the reconstruction of walls W06.005 and W06.006. The mortar was also used to point around the base of the doorway into Room 5, as well as to rebuild a small area of the doorway narrowing with brick/tile. It was also used as a thick render and pointing mortar on walls W06.004, W06.005, and W06.006.

Roof tiles were then set above these newly reconstructed and rendered walls, which were bedded on a light bluish grey (Gley 2 7/1) mortar with lime inclusions that was spread down the wall over the layer of render.

An early conservation measure is seen in the repair of large cracks in the final plaster surface to the south of the doorway on wall W06.005 and also on wall W06.006. These were filled with a fine yellow (10 YR 7/6) mortar.

3.9 Phase 9. Modern interventions

This phase saw a number of modern changes to Room 2 and the external pavement areas (Fig. 5.3.25).

3.9.1 Initial floor conservation event

It would appear that the exposed edges of the *opus signinum* floor surface were given a protective covering of mortar at some point in the early years of the 20th century. This is seen around the edges of the *opus signinum* left standing within Maiuri's trench (**507.019**) and against a small fragment of *opus signinum* flooring remaining on the eastern wall (**507.011**). It is clear that this cement predated the excavations by Maiuri as the fragment against wall W06.005 is cut by Maiuri's northern trench (**507.023**).

3.9.2 Excavations by Maiuri

The most significant modern intervention in the area were the three excavation trenches placed by Maiuri during his investigations of the Casa del Chirurgo on the northern (**507.023**) and southern (**507.027**) sides of Room 2 and at the front step of the fauces of the house.[45] The two trenches were both backfilled with mainly the deposits that had been excavated from them, which is indicated by their characteristic yellow colouration (507.024, 507.028).

3.9.3 1970's Consolidation and restoration

On wall W06.004, the central area of ancient render appears to have become detached. This was repaired using a small patch of *opus incertum* with Nocera tuff and cruma set in a coarse bluish grey (Gley 2 6/1) mortar with angular volcanic mineral fragments (up to 2 mm in length) and larger pieces of volcanic stone (up to 30 mm). The same mortar was also used to point

around the ancient wall and a slightly finer version was used to cover the exposed top of the ancient rendering layer. The doorway in wall W06.005 received a metal grill to help control access into the house from the Via Consolare. This necessitated the reconstruction of a small area on top of the early modern repair of the ancient doorway narrowing and used sawn rectangular blocks of yellow tuff set within a bluish grey (Gley 2 6/1) mortar with black volcanic stones and lime inclusions (both up to 10 mm). The same mortar was also used on the northern side of the grill to point around the wall where the grill was embedded into it. At roughly the same time, the edges of the surviving areas of wall plaster throughout the room were covered with a light bluish grey (Gley 2 7/1) mortar with angular black volcanic stone inclusions (up to 2 mm). This phase also saw the placement of a lightning rod against wall W06.004 that was earthed into the soils on the northern side of Room 2 in the middle of one of Maiuri's trenches. The lightning rod instillation consisted of a cut (507.021) and brown (7.5YR 4/3) clayish silty fill (507.020) around a metal plate (507.006), and fixtures set into concrete (507.008) attached it to the roofing over the frontage of the Casa delle Vestali.

3.9.4 2000's Consolidation and restoration

A final phase of consolidation can be seen in the area of the early modern reconstruction above the lintel of the doorway in wall W06.005 into the atrium, which was pointed with a coarse light bluish grey (Gley 2 7/1) mortar. The final change to the soil deposits was an addition of an upper level of modern gravel, dust, modern build-up, and debris in the area of Room 2, and the pavement outside the Casa del Chirurgo and the Casa delle Vestali (507.001).

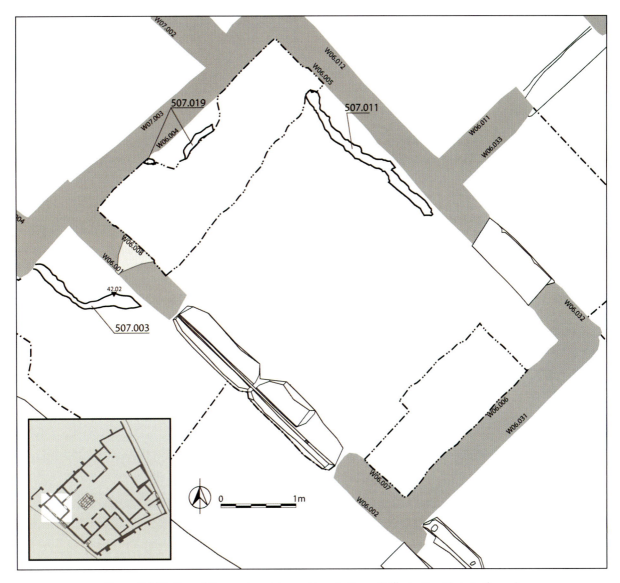

Figure 5.3.25. Plan of the modern interventions in Room 2 (illustration M. A. Anderson).

4. Rooms 3 and 4
Southern commercial space
(AA277 and AA606)

Description

Rooms 3 and 4 consist of a c. 8.44 by 5.03 m space that had been completely separated from the Casa del Chirurgo by the final period of Pompeii's development and was used for an unidentified type of commercial activity (Fig. 5.4.1). Although the commercial unit was without a doorway into the Casa del Chirurgo, it seems likely that it remained under the ownership of the household. This may be implied by the presence of a stairway that led up from doorway 11 to upper storey rooms that probably formed an independent rental property that ran not only over Rooms 3 and 4, but also over the Casa del Chirurgo itself. While ownership is impossible to determine with certainty from the evidence at hand, such a situation has been interpreted elsewhere as indicating that the owner of the ground floor, in this case the Casa del Chirurgo, was also the owner of the rental apartment over it. By extension, this would mean that the house also owned the shop, which continues under the same rental apartment.[46] Rooms 3 and 4 are separated from each other by the remnant of a central wall that appears to have been outfitted with a window in its centre in order to permit more light to reach the back room. The front room (Room 3) was separated from the street in the final phase by a sliding door, traces of the track for which are visible in a row of three large lava stones that form the final

phase threshold. The front façade of the shop aligns neatly with the Via Consolare, though its proximity to the street means that the pavement in front of the shop is quite narrow (0.88 m) at this point.

Archaeological investigations

Excavations in Rooms 3 and 4 were carried out during two campaigns of fieldwork.[47] The first was undertaken during the summer of 2004 (AA277) and covered the entire area of Rooms 3 and 4, up to the ancient threshold of the room, but concentrated on and completed the eastern half of the area (Room 4). Excavation of the western half of the area was also largely completed during this season and produced evidence of the chronology of later features, including the stairway to the upper floors. The second phase of excavation followed in 2006 (AA606) and re-opened only the western half of Room 3, up to the extent delineated by the ancient threshold stones. This was in order to settle key questions that had been raised in intervening years that had not been resolved in the previous excavations, particularly to do with the original form and southern extent of the façade of the Casa del Chirurgo. The western area was excavated down to natural deposits. During the 2004 season, the walls of both rooms were analysed, although due to time pressures, only the ancient features in them were documented.[48] The interpretations of the architecture were re-examined in 2009, including the modern features, and verified once more in 2013. Although wall W05.005–W05.006 separates Room 3 from Room 4, walls

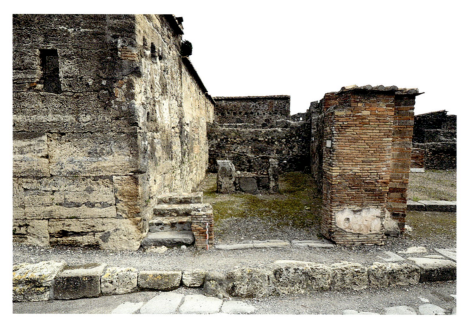

Figure 5.4.1. Rooms 3 and 4 (image D. J. Robinson).

W05.001 and W05.003 were recorded as single walls rather than splitting them into a and b, with sections corresponding to each room.

4.1 Phase 1. Natural soils

Prior to any human activity, the area that would later become Rooms 3 and 4 seems to have been simply another part of the gentle rise of naturally accumulated soils over the lava tongue upon which Pompeii is built. Activities in subsequent phases in Rooms 3 and 4 removed all traces of the original top surface of these natural soils. Instead, the natural present in AA277/ AA606 has a gritty, green appearance and represents a point in the natural sequence between the yellow and orange upper soils and the lowest black scoriae-filled

soils below.[49] Within Rooms 3 and 4, only small windows onto this natural were recovered: in section beneath the western side of wall W05.003 (606.064), in a sondage in the centre of Room 4 underlying mixed yellow deposits (**277.099**), and in the north-western corner of Room 3 underlying all deposits at the base of a large deep cut (**606.087** = poss. **606.017** = poss. **606.060**) (Fig. 5.4.2). The identification of natural soils in AA277/AA606 was complicated by the excavation and re-deposition of these soils both during the earliest phases of activity and the building of the Casa del Chirurgo, resulting in a number of deposits which appeared to be natural but were actually the result of these deposits having been excavated and then re-deposited.

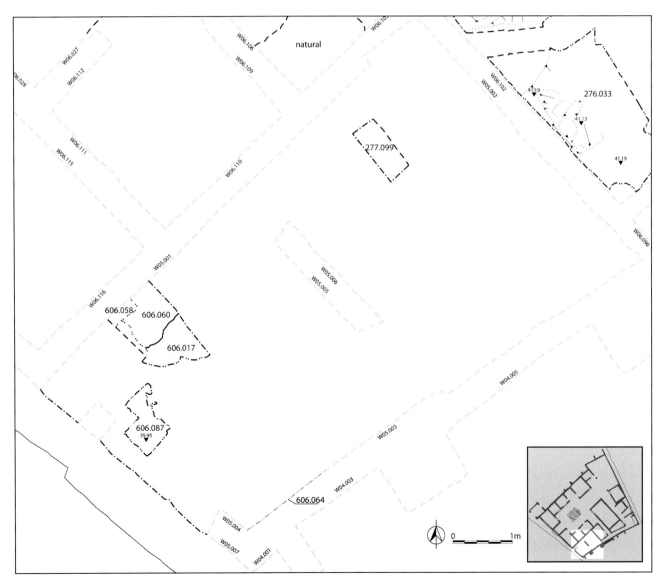

Figure 5.4.2. Plan of natural soils uncovered in Rooms 3 and 4 (illustration M. A. Anderson).

4.2 Phase 2. Volcanic deposits and early constructions

4.2.1 Terracing the natural soils

The first recorded human activity in Rooms 3 and 4 was the removal of approximately one metre[50] of the pre-existing natural soils to form a lower, roughly level, surface upon which activities could be carried out (cf. Fig. 4.11). The terrace edge runs diagonally across multiple areas under the southern side of the Casa del Chirurgo and aligns more convincingly with the Vicolo di Narciso than the Via Consolare. The northern edge of the terrace was situated just outside of the northern boundary of Rooms 3 and 4, but traces of a second, stepped, terracing cut parallel to it on the southern side may be visible within the later cut for wall W05.003 (**277.157**) (visible in plan for Phase 3 infra). In addition, the underlying yellow soil (**606.011**) appears to have had a series of diagonal steps cut into its surface in rough alignment, not only with the cistern head in Room 3, but also the linear cuts from Rooms 3 and 4 and those recovered in Room 23 to the east (Fig. 5.4.3).

4.2.2 Trample and levelling

After the ground surface had been lowered, the area was made level by means of re-depositing some of the natural soils that had just been removed. A series of yellowish-brown (10 YR 5/4)[51] loose sandy to silty-sandy soils, some containing fragments of black lava and other signs suggestive of significant churning, covered the area of Rooms 3 and 4. Traces of levelling and trample were also observed on the north-western side of Room 3 (**277.092**), in the centre of Room 4 (**277.156**[52]), and on the south-western side of Room 3 (**606.011**). Further yellow soils were found as edging for the linear cut features below in the south (**277.095**).

In addition, two further areas of re-deposited natural soils were uncovered in the south-west corner at the very deepest parts of the excavations in these areas (606.091, 606.092), which are difficult to sequence with certainty. Taken together, these deposits must indicate a phase of activity immediately after the removal of natural soils and the final preparations of the terrace for the Pre-Surgeon Structure. This interpretation is strengthened further by the deposition of a firm dark (5 Y 2.5/2 black) silty sand (606.063) in the south-western corner of Room 3 near the southern threshold, which seems to derive from an even lower component of the natural sequence of soils that contained finds of anthropogenic origin. The later (Phase 3) destruction of the Pre-Surgeon Structure itself and the re-filling of this terrace also re-exposed this interface, contaminating it further with later materials. An example of this is a coin recovered from one of the trampled layers (**277.156**), which presents one of the most important pieces of dating evidence for the Casa del Chirurgo, providing a *terminus post quem* of the late third century BC for the re-filling of the terrace that anticipated the creation of the house.

4.2.3 Use of the space

At some point after the terraced surface had been made level, it was used for a variety of different activities (Fig. 5.4.4). A cistern or well seems to have been built on the western side of the area in what later became Room 3, and a small hearth or posthole base was constructed in the north-eastern side of Room 4. In addition, a series of cuts were made that penetrated into both the lower natural soils and the trample/levelling deposits, some of which were seemingly a

Figure 5.4.3. Stepped terracing cuts into the natural visible on the southern side of the trench (image AAPP).

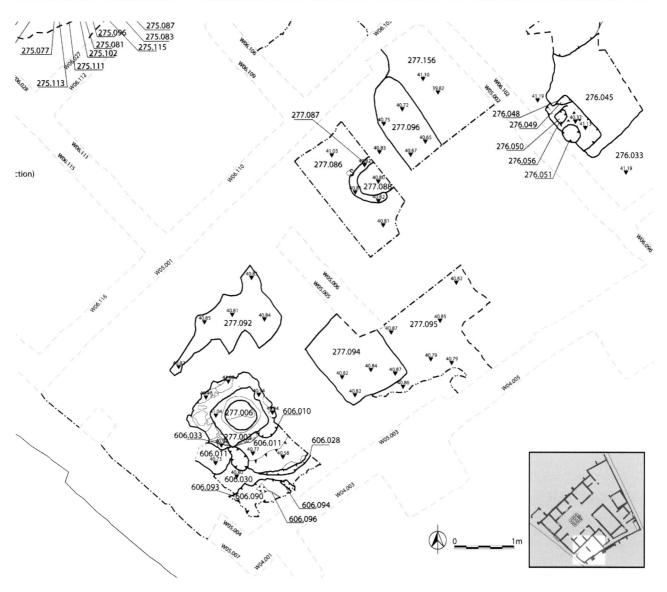

Figure 5.4.4. Plan of the deposits and features of Phase 2 in Rooms 3 and 4 (illustration M. A. Anderson).

component of the construction of these two features. Other cuts, however, while related to some sort of coordinated, or potentially repeated activity, are more difficult to explain. It is possible that they represent either activities in preparation for the subsequent creation of the 'Pre-Surgeon Structures(s),' of which more substantial traces were recovered to the east in Room 23, or activities taking place outside of that space, contemporary with its use.

4.2.3.1 CISTERN CONSTRUCTION

The nearly vertical rubblework sides of the cistern (277.003/277.006) make it extremely difficult to sequence this feature with certainty. Nevertheless, a variety of factors make it likely that it was created during this phase and that it continued to be reused

throughout the history of the Casa del Chirurgo. The feature itself was not extensively excavated because of safety concerns, and it is not possible to be certain whether the feature is a well or cistern, but given the small footprint taken up by its construction (1.15 m in diameter), a long narrow cistern seems the most likely interpretation. This would also have assisted in its continued reuse as the level of its lining could easily have been raised and lowered to suit the surrounding floor level. Indeed, repeated sequences of postholes present within its construction are suggestive of multiple phases of alteration. It is also unknown whether this feature was situated outside or inside the Pre-Surgeon Structure, but its alignment matches it, which is strongly indicative of contemporaneous use. Two cuts to the south of this feature were also made at this time, likely as a part of

the construction process. The first (**606.010**) consisted of square edges against the build of the cistern in Room 3, measuring roughly 35 by 30 cm; the second (**606.033**) was situated in the south-west corner and was roughly semi-circular in shape. Their fills (606.019, 606.031) consisted of jumbled debris (Fig. 5.4.4).

4.2.3.2 CUTS

At the same time, a group of additional cuts and fills were made to the south of the cistern (Fig. 5.4.5). These were directly within the southern terrace edge and may simply represent a part of the levelling described above or be the result of confusion on the part of the excavators. A linear cut in the south-west corner of Room 3 (**606.028**), as well as an enigmatic series of cuts and fills nearby and against wall W05.003 (**606.093**, **606.094**, **606.096**), were possibly related to, or heavily disturbed by, the placement of the Sarno blocks of the Casa del Chirurgo in Phase 3. It is more likely, however, that they are a part of cuts and fills of the Pre-Surgeon Structure and hence sequenced here to this phase. Their fills (**606.030**, 606.029, 606.090, 606.095, 606.097) were largely dark to greyish brown and filled with debris. Indeed, the fact that the southernmost of these cuts penetrated into the natural soils may lend support to the conclusion that they were actually a part of the terracing, or the construction of the nearby cistern.

4.2.3.3 RECTANGULAR CUTS

To the east of the cistern head, a cut was made into the re-deposited natural soils with a roughly square shape and subsequently filled with a brown, silty-sandy deposit (**277.094**) (Fig. 5.4.6). The alignment of this feature matches contemporary activity recovered within Room 4 (**277.096**), and further to the east within Room 23 (Phase 2), where similar squared cuts were found at a comparable depth (**276.048** and **276.039**) (cf. Fig. 5.24.2). These roughly squared features align neatly with each other and conform to the alignment of the terracing edges. Unfortunately, their incomplete preservation means that it is not possible to determine whether they were all the same size and is an impediment to understanding their intended function. Interpretation of these features is also confused by the fact that the later removal of soils has brought these early deposits into contact with later materials at the end of the first century BC (cf. Phase 5 infra).

4.2.3.4 HEARTH OR POST-FOOTING

Located nearby the easternmost of the square-shaped cuts, but separated by a further layer of re-deposited friable silty sandy natural soil (**277.086**), a hard-packed ring of soil roughly 0.53 m in diameter (**277.088**) was constructed after the square cuts (Fig. 5.4.7). The ring was then filled with a dark, silty-ashy deposit (**277.087**), suggesting that it functioned either as a temporary hearth, or was the footing of a rather substantial post that rotted or burned afterwards.[53] Whatever the function of this feature, its general alignment seems to conform with the Pre-Surgeon Structure and it is a likely component of the activities in this area related to it.

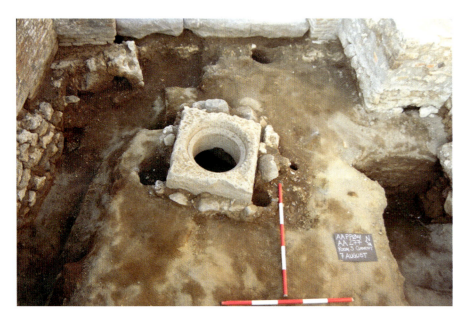

Figure 5.4.5. Cistern head with related cuts surrounding it (image AAPP).

Figure 5.4.6. Traces of a square shaped cut just visible in the natural soils (image AAPP).

Figure 5.4.7. Hard-packed ring of soil forming the base for a post or hearth (image AAPP).

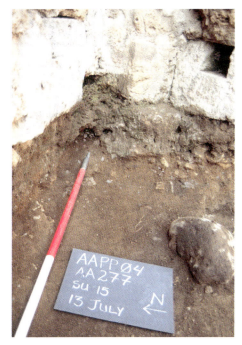

Figure 5.4.8. Deposits deriving from the destruction of the Pre-Surgeon Structure and subsequent filling of the lower terrace, preserved at the base of the later eastern wall of Room 4. Note the characteristic bluish plaster fragments (image AAPP).

4.3 Phase 3. The Casa del Chirurgo (c. 200–130 BC)

4.3.1 Destruction and level raising

After the activities of the Pre-Surgeon Structure had concluded, the area witnessed a wide series of changes that involved the destruction of the structure and the filling in of the terraced area so as to be level with the the higher terrace to the north and east. Within Room 3 and 4, this activity was heralded by a cut (**277.022**) that was made in the area that later became the north-east corner of Room 4 (it was itself later cut by the creation of wall W05.002). This may be interpreted as a part of the destruction of the previous structure, or possibly the removal of a useful component of this structure for reuse elsewhere. This cut was filled with a dark grey ashy-silty sandy layer (277.011 = 277.016) marked by significant charcoal inclusions. Similar cuts and fills were found to the east in Room 23, which also date to this sub-phase of activity.

The terraced area was then filled with a diverse mixture of different deposits. In some places in the property (Rooms 23, 6A, and 1) these fills took the form of a characteristic orange-coloured deposit with bluish mortar inclusions. Due to the subsequent removal of soils from Rooms 3 and 4, however, the majority of these filling layers were no longer present within Rooms 3 and 4. It was, however, visible in section under the eastern wall of Room 4 (W05.002) (**277.015**) (Fig. 5.4.8). Elsewhere, a mix of re-deposited yellow to yellow-brown soils similar to those recovered from previous phases, but with a higher concentration of building debris, seem to have been used to raise the level of the soil. The first of these deposits (**277.079**) may simply represent the final phase of activity in the area. Following this, a mixed and loose to friable differential fill of apparently re-deposited natural yellow to yellow-brown silty sandy soils with some building materials (especially stones and plaster) was placed over most of the eastern area of Room 4. These were excavated as a series of deposits (**277.019**, 277.036,[54] 277.014, 277.013, 277.027) but likely consisted of a single stratum. Certainly, these yellowish soils must be interpreted as activities related to the destruction of the Pre-Surgeon Structure and the raising of the floor level of the area. The subsequent removal of these soils in Phase 5 caused their truncation and churning. For example, a coin dated to the third century BC, which possibly supports the overall dating of the construction of the Sarno stone house, was found combined with elements of lamps dated from the late first century BC to first century AD.[55] These must originate from the removal of the soils in Phase 5 rather than from the initial deposition of these soils.

4.3.2 Building of the Casa del Chirurgo

After this destruction and levelling had taken place cuts, were made for placing the Sarno-stone foundations of the Casa del Chirurgo. In AA277/AA606, this involved the creation of three walls: one each on the north, west, and south. Although much of the upper portion of the stratigraphy relating to this action was lost when the soils were removed in Phase 5, traces of the very deep foundations for these walls were recovered from AA277 and AA606 where they penetrated into the natural soils (Fig. 5.4.9). Other features of the creation of the Casa del Chirurgo included the construction of a north-south aligned drain in U-shaped Nocera tuff blocks that at one point ran out of a (now closed) doorway in the northern wall before turning to continue into the area of Room 23. All other activities associated with the early Casa

del Chirurgo were lost within Rooms 3 and 4 when the widespread removal of soils from this phase took place in order to bring the level in these rooms into line with that of the Via Consolare in Phase 5. This means that the only activities that can be identified from the creation of the Casa del Chirurgo are those that happened to have survived later cutting and removal.

4.3.2.1 CONSTRUCTION OF WALL W05.003A AND WALL W05.004 (FRONT FAÇADE)

The creation of the western wall of Rooms 3 and 4 was part of the construction of the façade of the Casa del Chirurgo and continued the line of ashlar blocks of Sarno stone, two of which (**606.007, 606.006**) are still in situ at depth on the same alignment (Fig. 5.4.10). Most of this western wall, however, does not survive

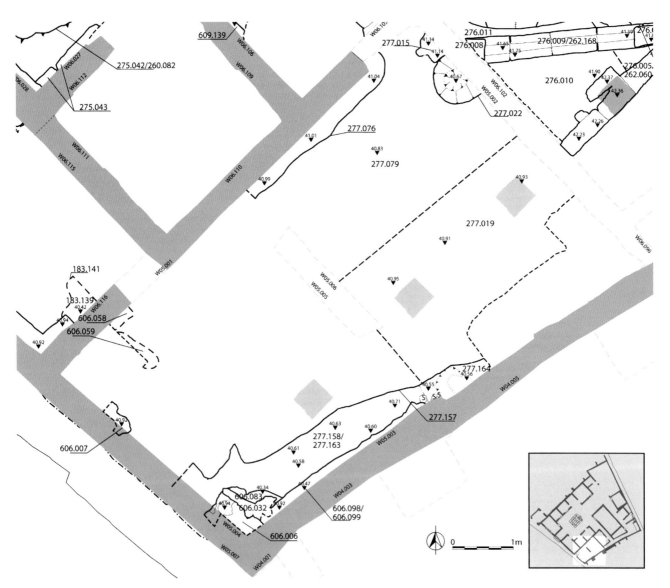

Figure 5.4.9. Plan of the deposits and features in Room 3 and 4 associated with the creation of the Casa del Chirurgo (illustration M. A. Anderson).

because it was removed when Rooms 3 and 4 were converted into a shop in Phase 5 and then at depth when new threshold stones were added in Phase 6. The construction of the western wall, and part of the southern, displays the same concern for solid foundations for load bearing walls found throughout the rest of the house. These have wide lower blocks and extremely deep foundation cuts, filled carefully with soils and capped with a hard-packed fill.

In the south-west section of Room 3, the cut (**277.157** = 606.080) for the façade was recovered (Fig. 5.4.11). It clearly signals a planned return towards the east and at its lowest levels contained a Sarno stone block (**277.048** = **606.006, 606.098**) still in situ. After the placement of the Sarno stones, the trenches were filled. In the walls of the atrium and tablinum of the Casa del Chirurgo, this comprised of two fills of differing compaction. The composition of the foundations in Room 3, however, was undifferentiated: the lower fill (606.088) was a dark brown, loose sandy silt with few inclusions and the subsequent layers (**606.083** and 606.081) were likewise very similar brown loose sandy silts that produced few finds. The upper levels of the foundation cut were filled with a

Figure 5.4.11. Sarno stone blocks present on the SW corner of Room 3, consisting of the southernmost elements of the western façade and beginnings of the southern wall (W05.003) (image AAPP).

dark sandy (**277.158**, **606.032**) and loose sandy soils (**277.163** and **277.164**). The cut (277.157), however, at the top was not as carefully aligned with the walls as the lower parts of the foundation cut (606.080). A very hard-packed dark brown (7.5YR 3/2) silty sand with some inclusions marked the top layers of this fill and underlay the initial courses of wall W05.004 (606.006).

Only scant remains of the southern boundary wall of the property were recovered (**606.099**) as the wall preserved today was repaired and thickened at a later date, obscuring the original. Given that the cut clearly begins to round out at the end of the final Sarno-stone block, it seems to have been completed in *opus africanum*, a conclusion supported by the presence of headers and stringers visible elsewhere in the preserved elements of this wall. While the return on the southern end of wall W05.004 suggests that some sort of wall continued on the southern side of the Casa del Chirurgo, it may simply have been a retaining wall that only reached to the general height of the ground floor and provided vistas to the south from the areas of Rooms 3 and 4.

4.3.2.2 CONSTRUCTION OF WALL W05.001
The northern wall of Rooms 3 and 4 is keyed into that of the western façade and was built contemporaneously. Wall W05.001 was constructed predominantly using the *opus africanum* technique. At the base of the western end of the wall, where it intersected with the façade, it was built in *opus quadratum*. The framework of the *opus africanum* section of the wall used larger blocks of Sarno stone, similar to those used for the *quadratum* section. At the base of the wall, the rubblework fill of the *africanum* used large square to rectangular blocks of Sarno stone, which tend to decrease in size the higher

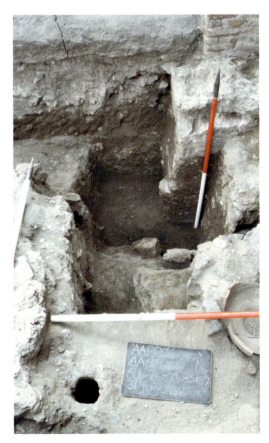

Figure 5.4.10. Sarno stone blocks at the NW corner of Room 3, consisting of elements of the original western façade (image AAPP).

up the wall. Due to the extent of early modern and modern pointing, no bonding material can be seen for this phase of construction.

As initially built, wall W05.001 had two doorways opening out of it. At the western end of the wall was a narrow (0.7 m) doorway framed with Sarno stone stretchers, with an archway over the entrance made from seven shaped Sarno stone blocks (5.4.12, A). This doorway would have provided access into Room 6A. The second doorway was located at the eastern end of wall W005.001 and would have provided access into Room 6C. This was a 1.1 m wide doorway framed with wide Sarno stone headers and stretchers (5.4.12, B). It was infilled at a later date. At the base of the fill, set upon earth, is the drain from the impluvium in the atrium of the Casa del Chirurgo (5.4.12, C). The same drain is also seen in wall W05.002, where the wall was clearly built around and over the top of the drain (5.4.12, C). As originally constructed, the drain would have run below the floor level across the north east corner of Rooms 3 and 4. The cut for wall W05.001 was narrower and shallower than the cut for the western ashlar construction, and did not continue across spaces that were intended to become doorways, implying that the plan of the house was known in detail prior to excavation and that the workers saw fit to minimise their work. At each of the doorways, the *opus africanum* is finished by a quoin in Sarno stone.

Evidence for the construction of wall W05.001 came to light in the north-west corner of Room 3 and along the northern side of Rooms 3 and 4. The cut of the

foundation trench (**277.076**) ran the almost the entire length of wall W05.001 and is considerably wider than the corresponding trench recovered within Room 6C and Room 8A (Fig. 5.4.13). This would suggest that the wall was built from the southern side against the northern side of the trench. On the west, where the trench was not recovered, the wall itself (**606.058**) is represented by a Sarno stone of the foundation under the later stairway. The foundation cut was subsequently filled with a firm, fine, dark soil containing some plaster (277.075) and probably also a deposit with rubble (**606.059**).

4.3.2.3 CONSTRUCTION OF WALL W05.003 –
THE SOUTHERN BOUNDARY WALL

The construction of the original southern plot boundary wall of the house was contemporary with the main walls of its Sarno stone core. Only a short stretch of this wall still remains in Room 4 at the eastern end of wall W05.003, although it can also be seen continuing in walls W06.093 and W06.095 in Rooms 12 and 22. The southern boundary was originally built in *opus africanum* using Sarno stone for both the framing elements and the rubblework, which was set in a very pale brown (10 YR 7/4) clay.

4.3.3 *Phase 3 decoration*

The southern wall of the core of the house and the southern plot boundary wall appear to have been decorated with different plasters (Fig. 5.4.14). On wall W05.001 above the level of the initial ground

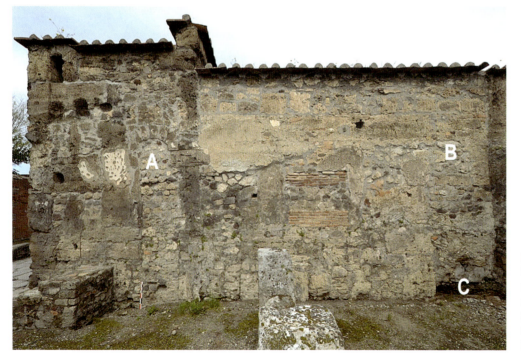

Figure 5.4.12. Wall W05.001 in Rooms 3 and 4. (A) sealed narrow arched doorway; (B) sealed wide doorway; (C) grey tuff drain and Sarno stone cap (image D. J. Robinson).

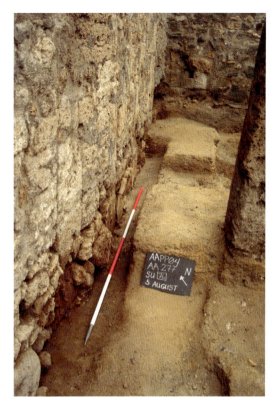

Figure 5.4.13. Lower surviving elements of the foundation trench for the northern wall of Rooms 3 and 4 (W05.001); the southernmost wall of the Sarno stone core of the Casa del Chirurgo (image AAPP).

opus signinum-like exterior plaster for wall W05.001: a similar plaster is also observable on wall W06.097, the continuation of wall W05.001 in Room 23. In the narrow arched doorway a sequence of a backing and final plaster have been preserved on the western Sarno stone frame. The backing plaster is a light bluish grey (Gley 2 8/1) with fine volcanic inclusions, which was overlain by a thin layer of pale red (10 R 6/4) plaster with ceramic inclusions.

On wall W05.003, there are traces of a single phase of plaster in place prior to the construction of wall W05.002, which butts up against it. There is evidence of a backing plaster, which is composed of a weathered bluish grey (Gley 2 5/1) plaster with rounded inclusions of volcanic gravel, ceramic, and lime. At the base of the wall, this was smeared flat to create a white (10 R 8/1) surface. This backing plaster is rather curious as it appears to have been applied to the wall down to c. 40 cm below the level of the original ground surface, if we take it to be at roughly the level of the top of the foundation pad for wall W05.002. Although excavation has revealed that many of the Sarno stone blocks used in the construction of the house were reused and had traces of an even earlier plaster on them, this is ruled out in this case as the backing plaster on wall W05.002 spreads coherently across both the Sarno stone framework and the rubblework of the *opus africanum*. Consequently, it could be suggested that the backing plaster was applied to the wall either when the foundation trench in which the wall was built was still open or partially filled, or that the floor surface varied

surface and stratigraphically underlying later backing plasters, is a thin spread of fine pale red (10 R 7/4) mortar containing ceramic, lime, and volcanic mineral fragments. It is possible that this represents an exterior

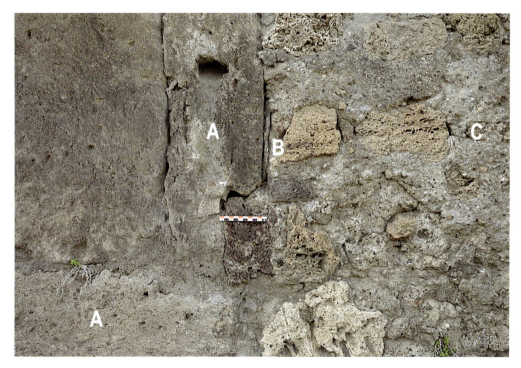

Figure 5.4.14. Details of the plaster on the western arched doorway in wall W05.001 from Rooms 3 and 4. (A) Sarno door frame; (B) original plaster; (C) fill of the door (image D. J. Robinson).

in height between the addition of the backing plaster and the later construction of wall W05.002. In the upper part of wall W05.003, above present ground level, the backing plaster is overlain by a layer of pinkish white (10 R 8/2) plaster containing ceramic, lime, and rounded black volcanic sand. A similar plaster was also found on wall W06.093, the continuation of wall W05.003 in Room 12. Like the plaster on wall W05.001, the *opus signinum*-like plaster on wall W05.003 may also have been a weather-resistant outdoor plaster. It is interesting to note that the composition of the *signinum*-like plasters on walls W05.001 and W05.003 are different, which might indicate that they were applied to the walls at different times, or that the decorators were aiming for different shades of red on the southern property wall and the southern plot boundary wall. It should also be noted that no trace of either the backing, nor final plaster, was found beyond the *opus africanum* section of wall W05.003.

4.4 Phase 4. Changes in the Casa del Chirurgo (c. 100–50 BC)

No traces of this phase were recovered from this area.

4.5 Phase 5. Redecoration and redevelopment (late first century BC to early first century AD)

4.5.1 Removal of deposits for the placement of the southern commercial unit

The most dramatic changes to take place within the area of Rooms 3 and 4 were a component of the widespread remodelling of the Casa del Chirurgo in the late first century BC. This saw efforts directed towards converting this area of the house into a separate shop facing the Via Consolare. In order for this to happen, the current ground level of the house had to be brought down to the level of the outside street and the façade punctured to make a new doorway on the west. It seems likely that at first the façade above ground level was simply removed, leaving the lower course of Sarno stones in place as a rough threshold. These would be removed and replaced in a subsequent phase. The doorways in wall W05.001 that previously led into the rooms off the atrium must have been sealed before or during this stage as well. A relatively thick mortar element (**277.044** = **606.004**) was recovered still protruding from north Wall W05.001, which appears to have been the lowest element in the *opus incertum* fill that followed it.

4.5.1.1 Construction of wall W05.002
The eastern wall, W05.002, was built as part of the creation of the southern commercial unit. This was undertaken prior to the complete removal of the soils from this area, since the foundations of this wall do not continue down to the level of the shop floor, terminating above this elevation and leaving a section of the fills visible (as mentioned above in Phase 2). The lower 0.80–0.90 m of wall W05.002 is approximately 0.1 m wider than the upper portion of the wall, which indicates that the upper wall was constructed on top of a foundation pad, the western side of which was later exposed as the ground surface inside the commercial unit was lowered (Fig. 5.4.15). The entire wall was built in *opus incertum* using roughly sub-square to sub-rectangular pieces of grey lava with lesser amounts of Sarno stone and cruma. The build also included pieces of building rubble, which included mortar chunks, plaster fragments, and *opus signinum*. This was set in a very pale brown mortar (10 YR 8/2) with angular volcanic mineral pieces and lime. The surface of the foundation pad was uneven, indicating that a foundation trench was simply dug and then filled with rubble and mortar, whereas the flat surface of the upper portion of the wall would indicate that it was made with shuttering.

It should be noted that the *imbrix* set on top of the foundation pad at the southern end of the wall is an original feature (Fig. 5.4.15, D). It is an overflow probably from the nearby cistern beneath Room 12.

4.5.1.2 Other necessary structural changes to create the shop
As the two doorways in wall W05.001 had been built without any foundations – a common feature of all doorways from the original construction of the house – this required that they be blocked from the level of the floor surface of the new commercial space upwards. Both doorways were filled with *opus incertum* using grey lava, Sarno stone, and cruma, as well as reused building materials. Unfortunately, the extensive early modern pointing of the narrow western doorway has obscured any traces of how this *incertum* was bonded. The *incertum* of the wider eastern doorway, however, was bonded with a very pale brown (10 YR 7/3) mortar with angular black volcanic mineral inclusions and brown tuff.

The drain that had originally led from the impluvium of the Casa del Chirurgo into the cistern in Room 12 was also cut through at this point, leaving traces in the wall where new *opus incertum* masonry was used to fill around it to retain the higher levels of soil within the house. Since it no longer connected to its destination, it is possible to associate this activity directly with the simultaneous remodelling of the atrium and impluvium

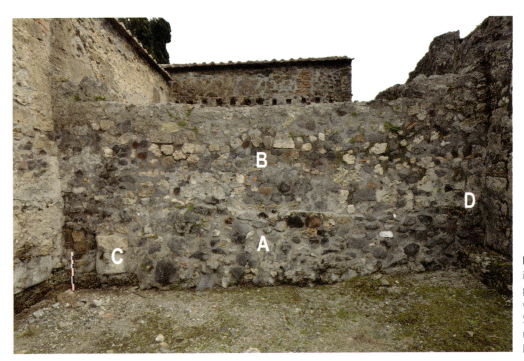

Figure 5.4.15. Wall W05.002 in Room 4. (A) foundation pad; (B) upper element of wall; (C) grey tuff drain with Sarno stone cap; (D) drain made from an *imbrix* (image D. J. Robinson).

within the house necessitated by this change. This in turn provides the general time frame for these changes (Fig. 5.4.16).

4.5.2 First phase of the shop

The initial phases of the shop are only partially preserved as a result of later changes and the continued use of certain features. Nevertheless, some features present in this phase can be implied, including two doorways opening on to the Via Consolare: a wide shop entrance and a smaller 'private' door. Inside the new commercial space there was a renewed or continuing use of the cistern in the centre of Room 3, remnants of what may have been a soak-away nearby designed to drain fluids, likely spills from the cistern, into the earth, and a more substantial drainage feature or cesspit (possibly originally a toilet) in the south-east corner of Room 4. The commercial unit clearly also comprised of two rooms from the time of its construction with different final plasters being applied – albeit with the same backing plaster – in each room.

4.5.2.1 BRICK/TILE PILLAR

Situated in the doorway at the front of Room 3 opening onto the Via Consolare is a brick/tile pillar. Though little information was recovered permitting its sequencing, it is certainly built prior to the placement of the threshold stones and the stairway of Phase 6 because it is cut by both of them, and therefore it is best sequenced within this phase. The brick/tile pillar (**277.162**) is roughly square, measuring 44.4 cm on the

front face, and is located 0.88 m from the northern wall (W005.001), meaning that it creates a narrow entrance on northern side, with a wider doorway to the south. The brick/tiles of the pillar are bonded with a very pale brown (10 YR 8/2) mortar with angular volcanic mineral fragments and lime inclusions. This is a different form of mortar than was used in the creation of the southern side of the doorway (wall W05.004) and indicates they were built at different times. It is most likely that the southern side of the doorway represents a later rebuild of the configuration established at this time.

In Phase 6, the small entrance to the north of the brick/tile pillar became a stairway with a step, but as the insertion of the step cut through the pillar, it cannot be contemporary. Conceivably, this doorway opened to an earlier stairway for which all evidence was covered by the later stair base, or perhaps it presented a small 'private' doorway into the shop beyond that did not depend upon the wider opening to the south being open.

4.5.2.2 NORTH-WESTERN AMPHORA SOAK-AWAY

Extremely ephemeral traces of a feature situated in the north-west corner of Room 3 relate to the initial phases of the shop that was tentatively identified as a soak-away. Perhaps such a feature was intended to assist in cases where the cisterns in the shop were full and overflowed. Most of these traces were destroyed when the area was filled with a number of diverse soils that have served even to obscure whether the feature was functioning in tandem with the floor surface of the first

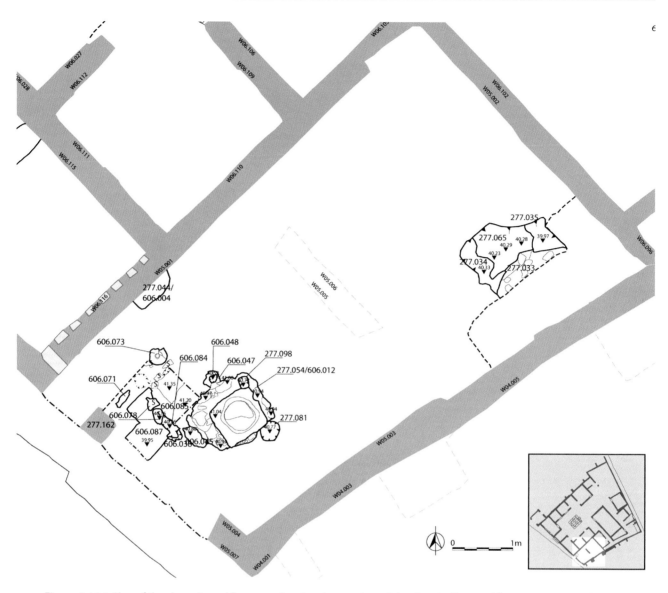

Figure 5.4.16. Plan of the deposits and features related to the creation of the shop in Phase 5 (illustration M. A. Anderson).

shop phase. This situation is made more confusing by the later cutting of the base of a stairway through this area, disturbing these traces yet further. The soak-away was composed of a number of small stones (606.072) placed carefully around an inverted broken amphora (**606.073**) acting as a funnel for liquids into a rubble filled space where it could dissipate easily into the surrounding soil (Fig. 5.4.17).

Some further potential components of the feature are presented by a small group of rocks (**606.071, 606.078**) which coordinated closely with a flat 'surface'-like deposit of dark brown (10 YR 3/4) sandy silt with rubble and stone inclusions in the north-west area an irregular cut (**606.084**), and its loose sandy silty fill (**606.085**) that seemed to follow the course of the stones. A cut (606.024) and loose rubble fill (606.023)

identified by the excavators in the north-west corner against wall W05.001 could be further components of the feature. A firm variable dark yellowish brown (10 YR 3/4) rubble was observed overlying the soak-away (606.043[56]), including some very hard rubble fills (**277.083** = 277.093) and silty sandy soils (**277.084** and 606.015[57]). Slightly to the south, a dark brown (10 YR 3/3) friable slightly pebbly deposit (606.056) also was likely also a component of this activity.

4.5.2.3 CONTINUED USE OR PLACEMENT OF THE FRONT CISTERN

The cistern that may have been constructed during the Pre-Surgeon phase seems to have continued to be used during this period. Whether or not this means that it had also continued to be used during the

first phases of the Casa del Chirurgo is impossible to determine, but seems likely. As previously mentioned, the nearly vertical nature of the cistern means that any sequencing of this feature must remain somewhat tentative, and it is possible that the original placement of the feature may have occurred during this phase. However, the particular alignment of the cistern head – which is at an angle and off centre to the room but aligns neatly with the Pre-Surgeon Structure – needs to be explained. The cistern walls were built in a loose mortar and stone-rubble (**277.054** = **606.012**). A series of four postholes, which mainly cut into the mortared rubble of the cistern (**606.048**, **277.081**, **277.098**, **606.038**), were probably supports for works being performed on the cistern either in this phase or in the following. Afterward, soils were used to cover over the cistern build in preparation for the a floor surface (**606.047**, 606.049 = 277.160, [277.159], 277.080, 277.097, 606.050, 606.040, 606.042).

4.5.2.4 POSSIBLE WATER STORAGE FEATURE OR CESSPIT IN SOUTH-EASTERN CORNER

In the south-east corner of Room 4, this phase also saw the construction of a large circular feature and surrounding rubble-work housing over a deep cut (Fig. 5.4.18). Since the receptacle did not seem to be lined, the excavators interpreted it as being for water disposal rather than storage. It is also conceivable that it was designed for the disposal of waste materials other than water, and could even have been a toilet, though on the whole a cistern is probably more likely. It was obscured greatly by subsequent rebuilding in the following phase, and therefore remains somewhat enigmatic. Construction of the feature began with a cut (**277.035**), which seemingly was filled with a firm clayish silt deposit (**277.065**[58]) and a loose silty sand with rubble (including pottery, shells, and degraded *opus signinum* in its topmost layers) (277.030 = **277.034**[59] = 277.010[60]) after the mortar construction of the feature itself (**277.033**).

4.5.2.5 EARTHEN FLOOR

After the features of the commercial unit had been created and/or reworked, the area of Room 3 was covered with a packed earth surface that may have served as a floor for the shop (Fig. 5.4.19). Traces of a similar earthen surface were recovered from the southern side of Room 4 and probably once connected across both rooms. It was created from a firm clayish silt to silty sand (277.078, **277.018**,[61] **277.026**, **277.009**). Slight indications in the southern extent of these surfaces suggested to the excavators that a drain (**277.040**) had run along the southern wall of the shop (W05.003). This

Figure 5.4.17. Inverted amphora neck comprising fragmentary elements of a soak-away to the north of the cistern (image AAPP).

would make sense with the water feature situated to the east. Unfortunately, so little of this drain survived later interventions and rebuilding, that it must remain largely hypothetical. It should be noted, however, that if the activities documented in the north-west part of Room 3 are accurate, then the beaten earth floor cannot be the very first phase of the flooring in the southern commercial unit, since it would align with the period after the destruction and removal of a soak-away in the north-west corner of Room 3. Given the fact that this stratum is simply earth that has been beaten into a rudimentary surface, it is entirely likely that it simply represents one particular phase of a simple working surface that was frequently refreshed. No traces of the activities undertaken within the shop were recovered from the earth floor.[62]

4.5.2.6 PHASE 5 PLASTER

There are traces of a backing and final plaster at the

Figure 5.4.18. Lower build of the eastern water feature or cesspit (image AAPP).

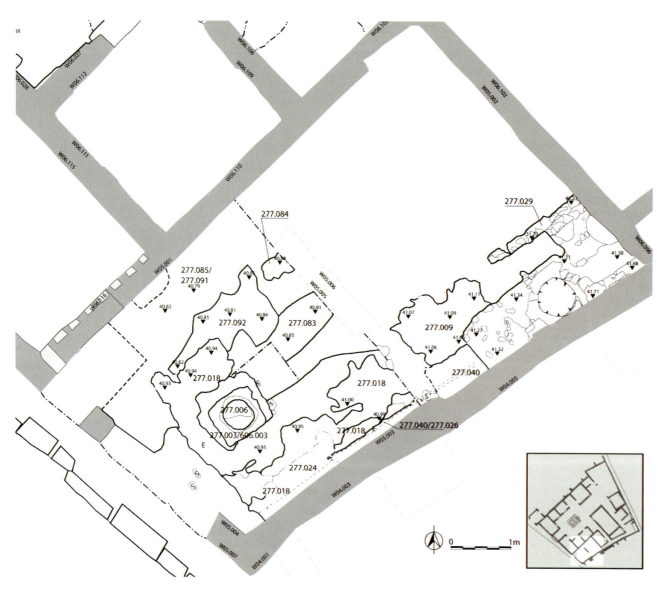

Figure 5.4.19. Plan of the traces of the possible earthen floor in Rooms 3 and 4 (illustration M. A. Anderson).

eastern end of wall W05.001, which also appears to have once been a surface on wall W05.002. The backing plaster was composed of a light bluish grey (Gley 2 7/1) plaster with rounded black volcanic sand inclusions and occasional pieces of ceramic and lime. At the eastern end of wall W05.001 in Room 4, this overlays the *opus incertum* that was used to block the former wider eastern doorway, where it is itself overlain by a thin layer of pale red (10 R 6/4) plaster containing ceramic, lime and black volcanic sand. At the western end of wall W05.001, however, in Room 3, the same backing plaster was overlain by a think layer of white (10 R 8/1) plaster with mineral crystal inclusions. This would suggest that although part of the same coherent phase of decoration that saw the application of the same backing plaster throughout the new commercial space, Rooms 3 and 4 were finished with different decorative surfaces. This is important because it suggests that there were two rooms in the southern commercial unit from its initial configuration, despite the fact that the wall between the two rooms (walls W05.005/6) appears to be a feature that dates to the changes associated with Phase 6.

4.6 Phase 6. Upper storeys and final decoration (c. mid-first century AD)

This phase saw the reconfiguration of the shop with the raising and alteration of a number of features already in place during the first phase, plus the addition of a new soak-away feature in Room 4 and the placement of a set of lava threshold stones at the western end of Room 3 (Fig. 5.4.20). Related to this, seems to have been the removal of the lower course of stones from the original façade of the Casa del Chirurgo. While the lower blocks of the original western wall may have been used as a threshold during the first phase of the shop, they presumably were now in the way of the placing of new stones in this location. A significant amount construction activity is documented related to the removal of these earlier Sarno stones and the creation of a solid footing for the new lava stone thresholds. As a component of these activities the stairway from doorway 11 was also remodelled. Several activities related to the repair or thickening of wall W05.003 also took place during this phase. While it is tempting to suggest that these changes were in response to earthquake damage, there is no direct evidence that these were not simply routine repairs in an older *opus incertum/africanum* wall. The dating of related changes in Room 23 is inconclusive and it should be observed that, like many of the changes of Phase 6 within the Casa del Chirurgo, these could have occurred at any point from the mid-first century AD until the eruption. Since

the changes in Rooms 3 and 4 are related to changes in Phase 6 inside the Casa del Chirurgo that seem to have been complete prior to the earthquake of AD 62/3, they have been sequenced to this phase as well.

4.6.1 Changes to the south-eastern 'water feature'
The south-eastern drainage feature was also significantly augmented in this period by the addition of a waterproofed tank in the corner of Room 4 and a small wall to the north (Fig. 5.4.21) (**277.029**). The precise function of this short wall is unclear, but it must have related to the use of the tank or the drainage feature.

4.6.2 Front cistern, Phase 2
The second phase of the shop saw the continued use of the western cistern from the previous phase (Fig. 5.4.22). The cistern head (**277.003** = **606.003**) would not have needed to be raised as the floor level did not change significantly between the two phases. The cistern had a cap (**277.006**), which was found broken, having fallen into the cistern-head and covered by modern debris. The fills of the cistern were removed in three layers (277.031, 277.032,[63] and 277.039) before a maximum safe depth was reached. In all cases these were sandy silty soils, but one deposit (277.032) contained traces of hammerscale and iron flakes, evidence that might support a metalworking function in the shop during this phase. Since it is also possible that these fills were entirely modern however, this observation must not be pressed too far.

4.6.3 Creation of a new threshold
The second phase of the shop witnessed the placement of a new set of lava threshold stones, outfitted with a groove for a sliding door like many Pompeian shop fronts. The replacement of whatever had served for a threshold during the first phase involved the removal of the lowest course of Sarno stones that had once made up the façade of the Casa del Chirurgo and the placement of the new lava stones themselves. Removal was undertaken by the cutting of a wide trench (606.070 = 606.074) down to the depth of the original cut for the placement of the Sarno stones. The cutting of this trench also damaged the southern side of the brick/tile pillar, which was cut back to accommodate the threshold stones. The trench was then filled with a differential fill of rubble and building materials that varied in consistency from firm to friable silty sand (7.5YR 3/2 – 7.5 YR 4/2 – 7.5/YR 5/2) in colour (606.066, 606.069, 606.068, 06.054, 277.047, **277.046**,[64] 606.053, 606.067, 606.057[65]), and even included some re-deposited black (5 Y 2.5/2) silty sandy soil that

Figure 5.4.20. Plan of the deposits and features of Phase 6 in Rooms 3 and 4 (illustration M. A. Anderson).

presumably derived from the bottom of the cut where it penetrated the natural soils on the western side. Overall, this deposit was well compacted and firm, and seems to have been heavily characterised by Sarno stones, perhaps indicating that the blocks were broken up as they were removed, or at least that they were heavily chipped as they were wrestled from the earth. There is some evidence to suggest that the mortared rubblework around the edge of the cistern feature was also picked at this point (606.045). Following the removal of the *opus quadratum* and the re-levelling of the soils, a small cut was made into these deposits for the placement of the new lava threshold stones (277.161 = 606.016). The cut was then filled with a loose, dark greyish brown (10 YR 4/2) silty sand (606.055).

4.6.4 Rebuilding walls W05.003 and W05.004; postholes in the threshold

As a component of the placement of the threshold stones – and potentially as a part of the reworking of the upper storey as discussed below, five postholes of various sizes and shapes (**277.055, 277.037, 277.090** = 606.046, **277.077, 277.070**), plus one large cut (**277.028** = 606.008), were made into the firmly packed deposits in the threshold (Fig. 5.4.23). The number of cuts and postholes seems rather too many for the placement of the threshold stones alone unless they provided pivot points for pulleys used for moving the stones. Alternatively, the posts could have held the lintels in place while the stairway was modified or the upper storey was reworked. After the activity for which the

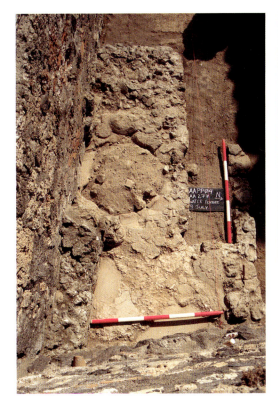

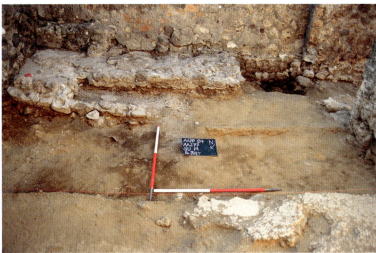

Figure 5.4.21. The eastern water feature (image AAPP).

Figure 5.4.22. The eastern water feature and the thin wall extending from it (image AAPP).

posts had been required was completed, the postholes were filled with loose rubble and other debris (277.056, 277.038,[66] 277.089 = 606.039, 277.072, 277.071, 277.023 = 606.009).

4.6.5 External stairway leading to an upper storey
Probably related to the number of postholes found in the threshold area, this phase also witnessed a new stairway and significant changes to the upper storey of the commercial unit. Several cuts relate to the building of the new stairway, which began with four steps in a rubblework mortar construction (277.166) – now mainly modern restoration. It is nevertheless clear that this activity took place after the completion of the threshold. A larger cut (**606.020**) along the southern side of the mortar stairs seems to have related to their construction, which was itself cut (**606.037**) by a small posthole in the north-west corner of the threshold that was filled with a dark brown (10 YR 3/3) soil. A second general cut (**606.044**) that was identified within the larger cut, augmented the first, possibly as a second phase in the work (Fig. 5.4.24). The final extent of this was marked by a large cut that encompassed much of the north-west corner of Rooms 3 and 4 (277.165 = 606.005),[67] which contained differential fills of sandy silt to clayish silty soils of varied compaction (firm to loose) and of varied colour from yellowish to dark

greyish brown (10 YR 3/6, 10 YR 5/3, 10 YR 4/2, 10 YR 3/3). In general, these were rubble deposits with building materials (606.027, 606.052, 606.025, 606.026; 606.014, 606.021). Below this were further differential fill deposits (277.091 = 277.085, 277.073). It is very likely that the coins, one dated from the reign of Tiberius (c. 22/3–30 AD) and the other from the reign of Claudius (c. AD 42) that were recovered from 277.085 provide an appropriate general dating of this activity to at least the Claudian period.[68]

The construction of the external stairway also resulted in a number of repairs to the western corner of wall W05.001. This work may well have involved further squaring off or removal of the former large Sarno stone blocks of the façade (Fig. 5.4.25, B). Evidence for a repair following such work can be seen in the small patch of brick/tile that is used to repair the south-western corner of the Sarno stone core of the house following the removal of a *quadratum* block (Fig. 5.4.25, A). The tile was bonded with a very pale brown (10 YR 8/3) mortar with angular black volcanic mineral inclusions. This mortar is very similar to that used to create the eastern *opus testaceum* parts of wall W05.003 and the southern doorway of wall W05.004 at this time, and logically indicates that the repairs to the corner were undertaken at the same time as the reconstruction of the entranceway.

4.6.6 Creation of a new southern side of the shop doorway (Wall W05.004) and the repair and thickening of wall W05.003

Rebuilding the upper storey of the commercial unit, perhaps in conjunction with changes in the 'Shrine' area to the south, and particularly the placement of new stresses upon the walls created by roofing alterations, may well have necessitated a programme of rebuilding and strengthening the south-western walls of the commercial unit. This consisted of two construction elements: an *opus testaceum* pier that forms the end of wall W05.003 and bends around to form wall W05.004, the southern side of the shop doorway; and the eastern extension of wall W05.003 in *opus incertum*, which most likely replaced an earlier section of the original southern boundary wall of the Casa del Chirurgo. It is important to note that the same mortar was also used to bond together both the *opus testaceum* and *opus incertum* sections of the wall indicating that both building elements belonged to the same phase of construction.

The placement of the *opus testaceum* section of the rebuilding in the south-western corner of Room 3 involved a cut (**277.050**) for this re-build of the wall (**606.018**[69] = **606.022**). The cut was filled with a silty to loamy sand and some rubble (277.041, 277.051). At the western end of the cut, a wider hole (**277.024**) was observed that was conceivably a component of the boards and posts used as formers for the support of the *opus testaceum* wall as it set (Fig. 5.4.26). After their removal, the cut was filled with a loose, rubbly silty

loamy soil (277.052 = 277.025). The brick/tile used for the wall were set within a very pale brown (10 YR 8/3) mortar with angular black volcanic mineral inclusions and pieces of rounded grey tuff.

The eastern area of repairs to wall W05.003 took place in conjunction with the western ones. The cut (**277.021**) here seems also to have been designed for the placement of supporting timberwork in the re-construction or thickening of the southern wall (277.069). This involved a pronounced widening of the base not far from the south-eastern feature. The *opus incertum* predominantly used irregularly shaped pieces of Sarno stone set in a very pale brown (10 YR 8/3) mortar with angular black volcanic mineral inclusions and pieces of rounded grey tuff. After this was completed, the construction trench was filled with a dark grey silty loamy soil containing mainly small pebbles. Notably, these repairs would have destroyed most traces of the possible east–west drain that ran along wall W05.003 in Phase 5, meaning that it could have no longer been in use during the second phase of the shop.

Following the rebuilding of wall W05.003, a *tegula* was inserted into the western end of the wall horizontally to form a shelf. The damage to the wall caused by the addition of the tiles was repaired with a small patch of irregularly set brick/tile set in a pink (7.5 YR 7/4) mortar with lime and angular black volcanic mineral fragments.

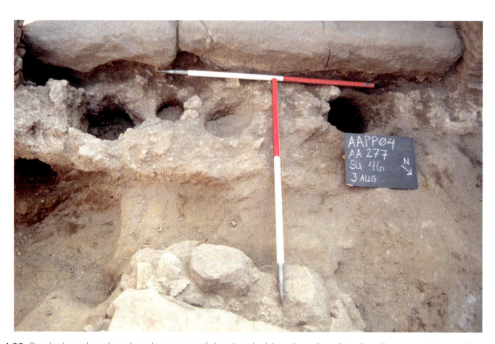

Figure 5.4.23. Postholes related to the placement of the threshold and works related to the new stairway (image AAPP).

4.6.7 Opus signinum flooring in the east and the addition of a soak-away

The only piece of substantial flooring recovered from either phase of the southern commercial unit is a relatively small area of degraded *opus signinum* (**277.005**) flooring in roughly the centre of Room 4. This runs underneath the wall that separates Rooms 3 and 4, but has few stratigraphic relationships with other deposits around it. After the *opus signinum* had been poured, a circular cut (**277.066**) was made centrally for the placement of a soak-away feature, involving fragments of two different amphorae (277.064 and 277.053) held in place with a packing of rubble on the top (277.053) and loose silty sand with few inclusions on the bottom (277.064). This produced a single, small hole that was patched around with *opus signinum* of a

smoother consistency (277.008) acting as a drain that could disperse water or other fluids into the ground (Figs. 5.4.27 and 5.4.28). The precise reason why an additional means of drainage was needed at this point is unknown, but it is nevertheless interesting that the builders had not seemingly anticipated these needs in the original floor construction. There is no sign that the drainage feature near the tanks to the south of this had gone out of use at this time. The fills of the first amphora in the soak-away were excavated in shallow layers, in order to control for modern contamination, but generally consisted of loose sandy silt (277.060, 277.061, 277.062, 277.063), while those of the second, which were also sandy silty, were excavated in two layers (277.067, 277.068).

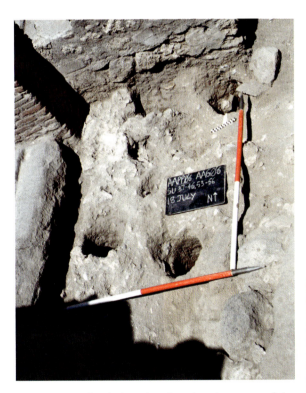

Figure 5.4.24. Postholes related to the placement of the threshold and works related to the new stairway on the north (image AAPP).

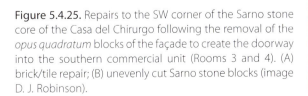

Figure 5.4.25. Repairs to the SW corner of the Sarno stone core of the Casa del Chirurgo following the removal of the *opus quadratum* blocks of the façade to create the doorway into the southern commercial unit (Rooms 3 and 4). (A) brick/tile repair; (B) unevenly cut Sarno stone blocks (image D. J. Robinson).

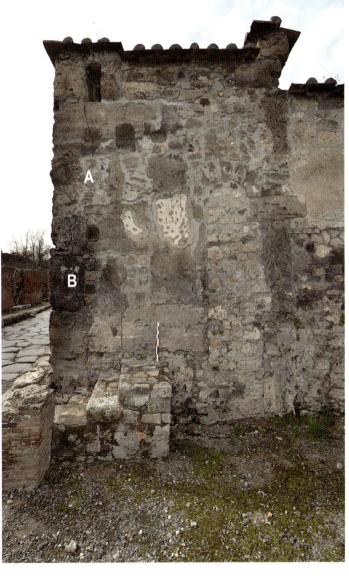

4.6.8 Building of the central dividing wall (W05.005/ W05.006)

Potentially, one of the final activities within Rooms 3 and 4 was the creation of the central dividing wall (W05.005/W05.006) that split the area into two rooms. The wall was directly overlying the *opus signinum* surface to the east of it, and must have come after this. It is likely that the wall relates to the changes to the the upper storey and the thickening of the southern wall, but it could also represent changes that took place during Phase 7 in response to instabilities caused by the earthquake(s) of AD 62/3. It should be noted, however, that the differences in the plaster decoration in Rooms 3 and 4 during Phase 5 would suggest that two rooms existed at the time of the initial construction of the southern commercial unit. Consequently, the new central dividing wall inserted at this time in Phase 6 most likely replaced an earlier, and perhaps more ephemeral, division.

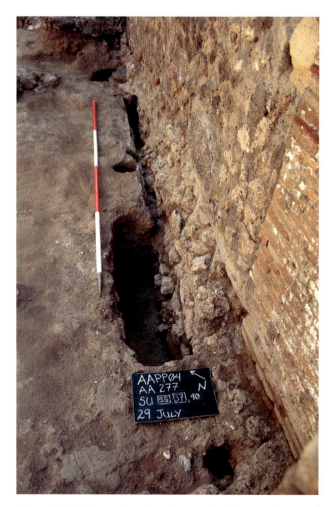

Figure 5.4.26. Cuts related to the repair of the southern wall W05.003, demonstrating clear evidence of at least two postholes supporting shuttering (image AAPP).

4.6.9 Phase 6 plaster

The extensive rebuilding of the south-western walls of Room 3 resulted in the necessity to redecorate. It is intriguing to note that many of the Sarno stones at the western end of wall W05.001 in Room 3 are blackened. Sarno stone turns black when burnt and so it is possible that the blackened stones in Room 3 are indicative of a fire having taken place here. The blackened Sarno stones are found at the level of the commercial unit, indicating that any conflagration took place in this unit rather than earlier in the life history of the space. Consequently, a fire could have provided a context for the reconstruction and redecoration of the room. On walls W05.003 and W05.004, the surface was sealed with a thin lime wash, followed by the application of a coarse light bluish grey (Gley 2 8/1) backing plaster containing volcanic gravel, ceramic, and lime. At the western end of wall W05.001, however, there is no trace of this backing plaster. Here, the previous phase of plaster had been picked, suggesting that the wall was either being prepared for plaster or simply that no trace of the subsequent backing plaster survives. No trace of any final plaster was found in Room 3. The evidence from the walls in Room 4 would suggest that although it was also redecorated during this phase, the plasters used are dissimilar from those in Room 3. Attached to the construction mortar of wall W05.002 in Room 4 is a bluish grey (Gley 2 6/1) mortar with black angular volcanic mineral fragments, ceramic, and lime, which is also seen at the eastern end of wall W05.003 at the junction with wall W05.002. A similar plaster, although of a slightly different colour, was also applied to the eastern end of wall W05.001 in Room 4. This directly overlies the backing plaster from the previous phase and would indicate that its previous final layer was removed prior to the application of the new backing plaster (unlike the case at the western end of the same wall in Room 3). This was composed of a light reddish brown (2.5 YR 7/3) plaster with angular volcanic mineral fragments, ceramic, and lime. Two distinct 10 mm thick layers of this backing plaster were applied to the wall. No trace of any final plaster was found in Room 4.

4.7 Phase 7. Post-earthquake changes

It is notable that the *opus signinum* floor found from Room 4 was not recovered in Room 3, suggesting that it may have been removed during a final period of rebuilding. Fragments of a light grey coarse mortar or plaster skim were found directly overlying the packed earth surface of the Phase 5 (**277.045**,[70] **277.017**), perhaps as a temporary measure (Figs. 5.4.29 and 5.4.30).

4.8 Phase 8. Eruption and early modern interventions

The only traces of the eruption from Rooms 3 and 4 are to be found in the lapilli rich fills of the cistern. Interventions of the post-eruption period are also infrequent in this area and comprise mainly the top fills of the cistern (277.004) and the drainage feature (277.057).

The walls of the southern commercial unit were variously patched-up, rebuilt, pointed, and repaired in the early modern period, likely immediately after excavation. At least the upper 1 m of walls W05.001 and W05.002, and probably more of the eastern end of wall W05.001, were rebuilt in *opus incertum* set within the same coarse light bluish grey (Gley 2 8/1) mortar with angular volcanic mineral inclusions, crushed black

volcanic rock, lapilli, and lime. The *incertum* of the two walls differs slightly with that of wall W05.001 using large pieces of Sarno stone with smaller pieces filling in around them and wall W05.002 using smaller pieces of rubble that were probably remnants from the original wall with additional pieces of Nocera and yellow tuff. A great deal of restoration work was also undertaken on wall W05.003 at this time. While the *opus testaceum* and *opus incertum* build at the western end of the wall and the *opus africanum* at the east were heavily pointed, the *opus incertum* section linking the two parts appears to have little in it that can ascribed to the ancient periods with any confidence. This includes a Sarno stone block with a backing plaster and accompanying dark red (10 R 3/6) fresco that is recessed by approximately 0.30 m

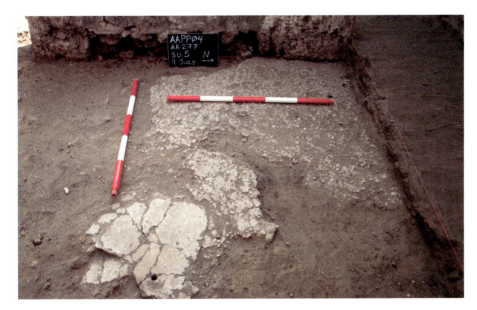

Figure 5.4.27. *Opus signinum* floor and soak-away in Room 4 (image AAPP).

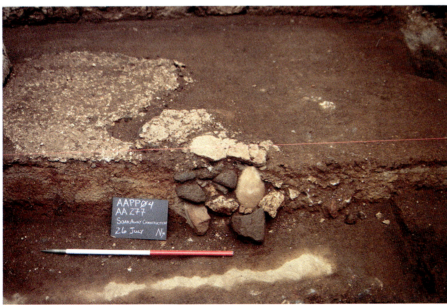

Figure 5.4.28. *Opus signinum* floor and soak-away in Room 4 in section (image AAPP).

into the wall. Unfortunately, the block is bedded on a layer of early modern mortar and the fresco cannot be regarded as being in its ancient context. The mortar used in the *opus incertum* reconstruction was the same coarse light bluish grey (Gley 2 8/1) mortar with angular volcanic mineral inclusions, crushed black volcanic rock, lapilli, and lime that was also used in walls W05.001 and W05.002.

The same coarse light bluish grey (Gley 2 8/1) mortar was also used to bond a small section of *opus incertum* using Sarno stones on top of the *opus testaceum* at the western end of wall W05.003, which also continues around onto wall W05.004, although here the rebuild was completed in brick/tile. The purpose of this was simply to level up the walls for a small line of roof tiles. Similarly, the rebuilding of the upper parts of wall W05.001 was also done for the same purpose. The tiles on walls W05.001, W05.003, and W05.004 were set using a light bluish grey (Gley 2 7/1) mortar with black stone and lime inclusions, which was smoothed vertically down the wall. The coarse lapilli-rich mortar used in the reconstruction of walls W05.001, W05.002, and W05.003 was also used to point across the fills of the blocked doorways and also as a 10–20 mm thick layer of render across the upper central area of the wall of wall W05.001, and also as a render on wall W05.002 and at the top of wall W05.003.

4.9 Phase 9. Modern interventions

Sealed beneath the uppermost layer of protective gravel placed by the Soprintendenza (277.001, 606.001) are a range of deposits of modern origin (277.007, 277.002, 277.043) that accumulated across the areas of Room 3

and 4. These consisted of dark grey to yellowish loose silty loamy layers with remnants of gravel from the above layer and loam from significant bioturbation. They clearly result from exposure of the area after the original excavation and, while not without ancient inclusions, they also contained considerable modern debris. These deposits included the topmost layers of the fills in the cistern.

4.9.1 1970's restoration campaign

Wall W05.002 must have suffered further degradation following its repairs in the early modern period to necessitate a further rebuild in *opus incertum* that was bonded with a mortar which varies in colour due to weathering from a light bluish grey to bluish grey (Gley 2 7/1 to 5/1) with inclusions of black angular volcanic minerals, crushed volcanic rock, lapilli, and lime. In the central area of the upper wall, this mortar was also used as a rendering layer and was thickened using pieces of ceramic. The same technique with the same mortar was also used at the eastern end of wall W05.003 at the base of the wall. Furthermore, the same mortar was also heavily used to point walls W05.001, W05.002, and W05.003.

4.9.2 2000's restoration campaign

Walls W05.001, W05.002, and W5.003 were pointed with a rough light bluish grey (Gley 2 7/1) mortar, which was also used to fill the *imbrices* of the early modern roof tiles. A further modern activity included the cleaning and investigation of the south-east 'water feature' by the Anglo-American Project in Pompeii during 2003, which mainly removed modern build-up (277.049).

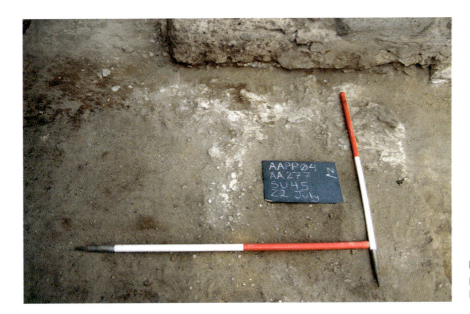

Figure 5.4.29. Remains of a mortar surface, possibly representing a temporary floor in Room 3 (image AAPP).

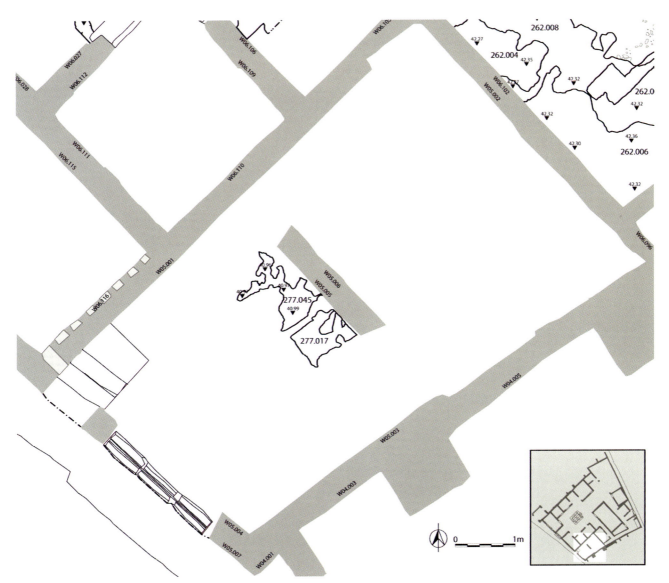

Figure 5.4.30. Plan of the deposits and features of Phase 7 in Rooms 3 and 4 (illustration M. A. Anderson).

5. Rooms 5, 8, and 8A
Atrium and Alae
(AA260, AA275, AA505, AA608
and AA201*, 202, 209*, 211*)[71]

Description

Rooms 5, 8, and 8A are the atrium (Room 5) and the southern and northern alae (8 and 8A) of the Casa del Chirurgo. These areas were examined together and comprise the largest open area available for sub-surface investigation within the house. Measuring 9.67 m by 8.17 m, the atrium of the house functioned as the central coordinating space within it, providing access to the rest of the property from the Via Consolare via the fauces and the front entrance of the house. On the southern side and directly attached to the atrium, Room 8A measures 3.16 m by 2.71 m and in the final phase additionally functioned to provide access through its southern doorway to the service wing and Corridor 12. The Nocera tuff impluvium situated in the centre of Room 5 suggests that the roofing of the space followed the pattern of Vitruvius' 'Tuscan atrium' and would therefore have had a compluvium opening in the roof allowing for the collection of water in the impluvium below. While the walls of the atrium itself no longer preserve conclusive ancient evidence to confirm this arrangement, the continued collection of water is a marked feature of the atrium in the Casa del Chirurgo, which, unlike some properties in Pompeii, including its immediate neighbour the Casa delle Vestali, never seems to have abandoned this practice in favour of piped aqueduct water or a fountain feature.[72]

Archaeological investigations

Rooms 5 and 8A were excavated over a period of five years (2002–2006). The first season was simply a re-excavation of the trenches cut by Maiuri's workmen during his work in the house in 1926. It should be noted that his report[73] only discussed two of these trenches (AA201 and AA211), which correspond to his areas 6 and 7. The other trenches, re-excavated as AA202 and AA209 are only noted on his plan and do not appear in his primary narrative.[74] The purpose of removing the back-fill from the earlier excavations was to see clearly in section the nature and depth of the potential archaeology across the rest of atrium. With the exception of AA202, no further excavation of ancient deposits was carried out in these areas other than that necessary to clean the sections for recording. AA202

involved the removal of some ancient materials that are sequenced below with the more extensive excavation of subsequent years. Reviewing the sections revealed many new aspects of the stratigraphy that had not been recorded by Maiuri and justified the commencement of area-wide excavation of the surrounding zones, which themselves produced a much more detailed record of archaeological features and deposits than could possibly have been revealed by these original window trenches alone. Because of this, archaeological areas AA201, AA202, AA209, and AA211 and the deposits identified in their sections but not excavated, are not discussed in detail in this narrative except where they provide information that was not also encountered through stratigraphic excavation.

Beginning in 2003, the south-western corner of the atrium, running from the southern end of AA211 and including AA209 on its eastern extent, was opened for excavation (AA260), but due to the complexity of the subsurface deposits, did not reach natural soils. The following year the same area was reopened for excavation (AA275) in order to complete excavation within the original trench which was also augmented to the east to include the south-eastern quarter of the atrium. While the natural soils were reached in the western half of this widened area, the eastern half required further work, which was undertaken in two further campaigns of excavation (AA505, AA608). The summer of 2005 witnessed the complete excavation of the south-eastern quarter of the atrium, including Room 8A. This large area was completed during the summer of 2006 when excavation was undertaken in tandem with efforts to complete those in Room 6C. This allowed the connections between these two areas to be documented fully (especially via photography). Analysis of the walls of the atrium and alae took place alongside these excavations.

After numerous years of excavation, stratigraphic data were recovered from the entire southern side of the atrium. The northern side of the atrium and its well-preserved final phase floor was left untouched and preserved. The excavations consequently permit the understanding of the complete history of development in this area, from the final natural deposits until the last seventeen years of the city's life.

5.1 Phase 1. Natural soils

Prior to the earliest human activities, the areas later occupied by the atrium (Room 5) and Room 8A of the Casa del Chirurgo were probably open areas, with a small gully to the west where the Via Consolare runs

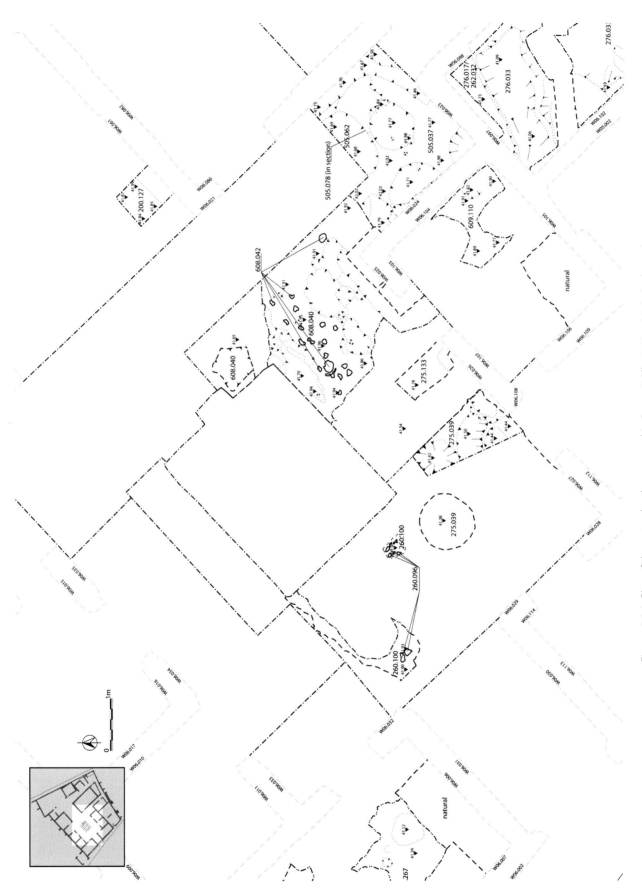

Figure 5.5.1. Plan of the natural soils recovered in Room 5 (illustration M. A. Anderson).

today. Natural soils were recovered from several areas of the atrium and southern ala (8A). Due to the extensive later cutting activities and soil removal, the elevation of the preserved natural deposits was generally higher on the eastern side of the atrium and in Room 8A than on the western side of the property, sometimes varying by as much as 0.52 m. For this reason, the soils on this side of the room tended to display the rich chocolate-coloured (7.5 YR 3/3) soil at the top of the sequence, including traces of tan-yellow spotted silty soils (**505.037, 505.062 = 275.039** (various locations, especially in the central cut), **608.040, 260.100**) that were interpreted as a decayed turf line (**505.078, 608.042, 260.096**, 275.106) (Figs. 5.5.1, and 5.5.2). These traces were recovered on the south-eastern side of the atrium (608.040, and 608.042), on the western side of the later north–south drain (275.133), and at depth nearby (505.078). Although not excavated, these deposits appear to have been lacking evidence of anthropogenic activity. In the atrium, the elevation of the natural soils (41.91–41.02 MASL) is roughly comparable with that found for similar deposits in the tablinum (41.83–41.97 MASL).

In the western half of the atrium, natural soils appeared at the bottom of a series of later pit cuts that had removed the upper components, revealing a yellowish part of the natural sequence. Here the general elevation of these lower soils (41.78 to 41.38 MASL), though truncated by later cuts, was similar to that recovered in the bottom of the terracing cut in Room 23 (41.73–41.06 MASL). In the eastern part of the atrium (AA505), the lower yellowish natural soils (505.062 and 505.037) were only witnessed at the bottom of pits cut at a later date in the western part and south-west corner of Room 8A (505.057 and 505.075).

5.2 Phase 2. Volcanic deposits and early constructions
5.2.1 Early deposits
The earliest deposits after the natural sediments comprised of a series of soils of likely volcanic origin, primarily recovered in the eastern half of Room 5 and Room 8A. Where present, the first layer consisted of a varying thickness of pea sized (2–10 mm) gravel of light, pumice-like stones of a similar light grey colour, followed by a silty grey capping. Small fragments and heavily pulverised areas of this surface were recovered from the eastern half of the atrium and Room 8A (**505.077**, 608.041), and were visible in the sections of later pits where the cuts had not destroyed or removed these deposits. Above the pea-sized gravel, and bonded

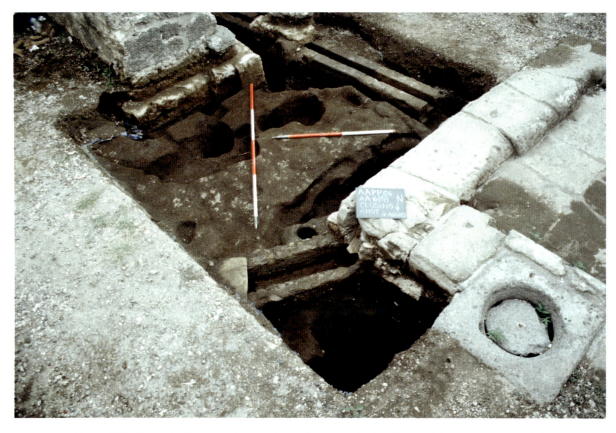

Figure 5.5.2. Natural soils and early volcanic levelling layers in the SE part of Room 5 (image AAPP).

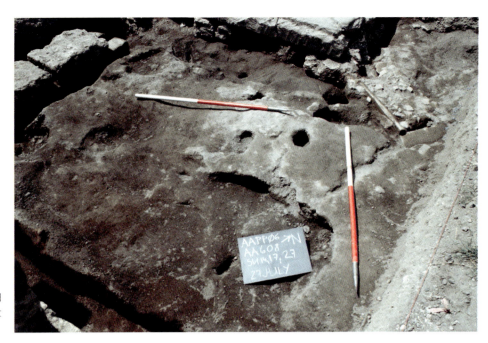

Figure 5.5.3. Heavily degraded pocked earth surface in the SE part of Room 5 (image AAPP).

with it, was a light grey silty deposit that in its best preserved components displayed a pock-marked surface with various small holes and thin fracture lines of indeterminate, but apparently natural cause. It consisted of a brownish grey (7.5 YR 4/1 to 10 YR 5/2 to 2.5 Y 3/2) hard-packed silty soil that to be a laminate of many thinner layers compressed into one (roughly 2–3 cm thick). Traces of this stratum were found in a variety of areas in the atrium and Room 8A. Due to later cuts, however, this important early deposit rarely survived in large fragments and was most frequently seen in the section of later pit cuts. This once extensive stratum was found in traces within Room 8A (**505.032**, **505.031**), while similar evidence to the east of the impluvium survived later cuts and construction (**505.067**, **505.050**, **505.021**, **505.022**, **505.023**) and in the south-east corner of the atrium (**608.014**) where it was badly degraded and very thin, generally being recovered as dusty, pulverised soil (Fig. 5.5.3, 5.5.4). Additional traces were recovered in section (608.018) of the south-eastern drain and to the north of the impluvium (**202.011**).

Overlying these earliest deposits elsewhere in Insula VI 1 was a layer of fine, dark grey or black sand of varying thickness and of clear volcanic origin. This stratum, however, was generally not recovered from the area of the atrium and appeared in only an exceptionally small area (less than 31 cm by 25 cm in the north-western corner of Room 8A where it appeared re-deposited at the bottom of a cut (**505.098**). The general absence of this deposit may suggest that it had been

Figure 5.5.4. Natural soils and pocked earth surface visible in Room 8A (image AAPP).

removed during the activities in the second half of this phase. This means that the pits and cuts documented below may, as in AA508, have been cut directly into a now missing layer of black sand.

5.2.2 Early pit cuts and fills on the eastern side

Characterising the southern half of the atrium on the eastern side was evidence of a seemingly prolonged period of pit cutting and posthole creation that left the area entirely pock-marked with inter-cutting cuts (**505.097**, **505.076**, **505.072**, **608.066** = 609.136, **608.021**, **608.063**, **505.057**, 608.048) and postholes (occasionally cut directly into or prior to cuts) (Figs. 5.5.5 and 5.5.6). These were cut either immediately after the removal of a layer of black sand or through the sand itself. While

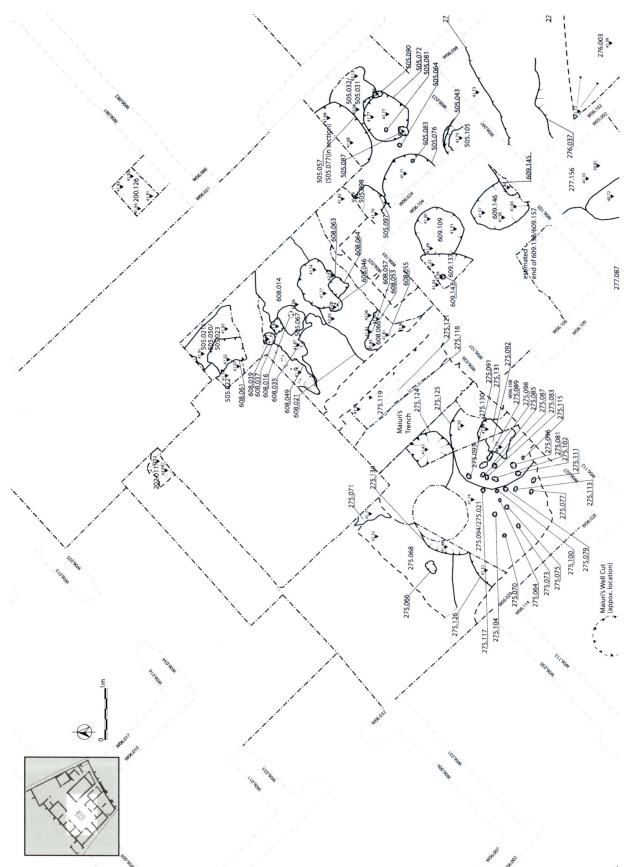

Figure 5.5.5. Plan of early cuts into the natural soils in Rooms 5 and 8A (illustration M. A. Anderson).

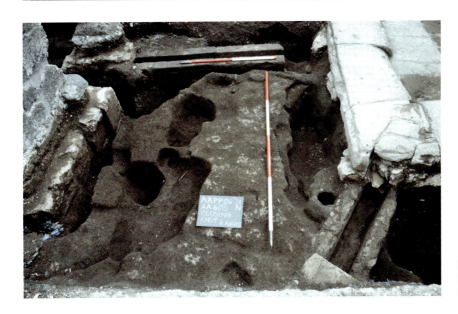

Figure 5.5.6. Cuts of early pits penetrating into the natural surface in the SE part of Room 5 (image AAPP).

it has been possible to provide a relative sequence for these cuts and to document their stratigraphic relationships, this has unfortunately not produced a clear explanation of this activity or a particularly refined time frame. Nor do most of the pits coordinate to form groupings or clearly defined features that might help to explain their cause or function. Nevertheless, the overall rounded shape of several of the larger ones might indicate the location of sunken dolia, silos, or other features that were removed later. It is likely that at least some of the cuts relate to the construction of the Pre-Surgeon Structure, but many seem to have come after this. While the most commonly invoked explanation for deeply excavated cuts with building material fills has been the search for clean, natural soils for plaster and mortar, this can only account for the deepest of these cuts and it does not explain the repetition of the smaller and shallower ones. The pits were re-filled with materials that were different from the soils that had been removed, generally consisting of detritus from building or demolition combined with general domestic refuse. The extremely diverse quality of these fills is documented by the large numbers of individual stratigraphic unit numbers assigned by the excavators (**505.098**, 505.096, 505.095, 505.075 = 505.092, 505.094, **505.105**, **505.043**, 505.071,[75] 608.032, 608.043, **608.064**, 505.048, 505.047).

Perhaps more meaningful than the cuts are the postholes. It is difficult to imagine what function the posts might have served, though it is conceivable that the specifics of alignments have been lost due to repeated changes over a prolonged period of use. At the maximum, this period could have run throughout much of the late fourth and third century BC. Even

when mild linear alignments are observable, such as a row of three postholes (**505.064**, **505.081**, **505.083**) in Room 8A, it is difficult to interpret them as a component of an organised system of support, especially given the size of the posts and the occasionally angled nature of the cuts. On the same general alignment are two larger postholes (**505.090**, **505.087**), which, taken with the previous, may imply that many of these posts relate to the eventual creation of the Casa del Chirurgo in Phase 3. Their fills (505.084, 505.082, 505.063, 505.091, 505.088) did not provide further information to help to answer this question.

Complicating matters is the fact that the southern half of the atrium also seems to have had its flooring removed multiple times. As a result, the tops of many of these cuts have been truncated and later cuts and fills have served to contaminate the upper levels of the earliest cuts. While it can be seen that many of these early cuts predate the construction of the walls of the Casa del Chirurgo (since they are themselves cut by these walls or their foundation trenches), it is nevertheless possible that at least some of these cuts and postholes date from later phases due to the removal of the flooring levels prior to construction work. Stray ceramic sherds of later date recovered during the excavations of these cuts also make their dating problematic. Particularly difficult is the area against the impluvium where later cuts were clearly cut themselves by numerous later postholes. Consequently, it is impossible to be certain about the sequence of these features. They have been grouped into their most logical arrangement for the purpose of this volume, but with an admitted degree of uncertainty. One group of postholes (**608.016**, **608.039**, **608.035**, **608.037**,

608.026, 608.051) and cuts (**608.061** = **608.049**) close to the impluvium seem particularly likely to relate to later activities, especially the replacement and/or raising of the impluvium itself, but can not be excluded completely from this general phase of cutting and inter-cutting. For this reason they have been sequenced here. These too were filled with a diverse mixture of rubble and detritus fills (608.030, 608.029, 608.024/608.027, 608.015, 608.038, 608.034, 608.036, 608.025, 608.050). In addition to filling the inter-cutting pits and postholes, levelling layers were found to cover the area of Room 8A (505.039) and the eastern side of the atrium (**275.119**). The case of the latter deposit was found to overlie natural soils directly.

5.2.3 Early pit cuts and fills on the western side

Similar to the eastern half of the atrium, the western half also produced several large cuts into the natural soils in this phase (Fig. 5.5.7). In the absence of the early widespread layers, which were not found in this area, these cuts were made directly into the natural soils and their fills generally contained small numbers of finds that produced no clear dating material. From the fact that they are themselves cut by the construction of the Casa del Chirurgo and the second impluvium, it is possible to sequence them to this phase. This is particularly true of one pit cut (**275.125**) located directly at what later became the south-west threshold of the atrium, which was cut by the walls and threshold of the Casa del Chirurgo, once having continued into the area of cubiculum 6B. Additional cuts to the south and east of this (**275.124**, **275.131**, 275.136, 275.128, **275.134**, **275.126**) suggest repeated and extensive activity. Their fills (275.127, **275.093**,[76]

275.132, **275.130**, **275.092**, 275.135, **275.094**) were similar to the rubble and building detritus deposits filling similar inter-cutting pits on the eastern side of the atrium. Related, but clearly contaminated, were several other cuts near the later western drain of the impluvium (260.126, 260.125, 260.124). Finally, two relatively confused deposits (**275.068**, **275.071**) were uncovered in a test pit near the drain that ran from the impluvium of the Casa del Chirurgo to the street. Although only removed in part, they seem to consist of pit cutting action similar to that suggested by the other cuts from this phase. As with the cuts and postholes discussed above, the precise reason for these cuts or their function in the period prior to the creation of the Casa del Chirurgo is unclear and likely to derive from a number of different causes. Conceivably, some of the cuts may once have held features that have been removed. If so, then such features could have been dolia or other vessels of similar nature, potentially constructed of ephemeral materials.

5.2.4 Numerous postholes in the south-western corner of the atrium

After whatever activity had generated the series of inter-cutting pits and fills had finished, the area was covered with several thin and varied deposits of packed or tamped rubble (275.032, **275.021** = 275.031) that sealed the earlier deposits. Thereafter, a series of 26 postholes were cut (**275.118**, **275.121**, 275.062, **275.066**, **275.070**, **275.077**, **275.064**, **275.100**, 275.103, **275.075**, **275.091**, 275.089, **275.102**, **275.096**, 275.079, **275.081**, **275.085**, **275.098**, **275.087**, **275.083**, 275.073, **275.111**, **275.113**, **275.115**, **275.117**, **275.104**) in the south-west corner of the atrium, penetrating both the sealing fills

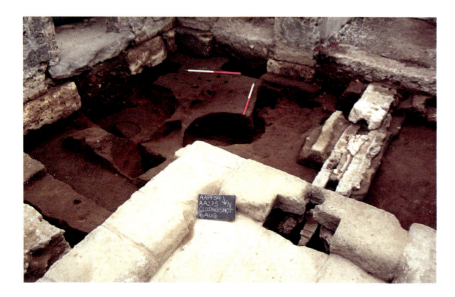

Figure 5.5.7. Cuts of early pits penetrating into the natural surface in the SW part of Room 5 (image AAPP).

Figure 5.5.8. Collection of small postholes situated in the SW part of Room 5 (image AAPP).

and the cuts and earlier postholes described above (Figs. 5.5.5 and 5.5.8). It is difficult to find any pattern in their arrangement that might suggest a functional reason for their placement. Their fills (275.120, 275.122, 275.061, 275.063, 275.069, 275.076, 275.065, 275.099, 275.074, 275.090, 275.101, 275.095, 275.078, 275.080, 275.084, 275.088, 275.097, 275.086, 275.082, 275.072, 275.110, 275.112, 275.114, 275.116) were largely sterile and the size and shape of the holes does not vary greatly amongst them. Perhaps they served to support some form of light construction, or derive from several phases of temporary framework. Interpretation is made even more difficult by the fact that no dates or finds have been recovered for these features, which might suggest a chronology among them.

5.2.5 Area north of fauces (mainly seen in section)
Although only a small fraction of this area was excavated, it is possible to suggest a continuity of pits and cuts (260.127, 260.128, 260.122, 260.121) to the north and west of the impluvium on the basis of cuts and fills visible in the northern section. No deposits were excavated from this zone, but they nevertheless seem to document that the same activities observed in the south-west corner of the atrium were also being carried out further to the north.

5.3 Phase 3. The Casa del Chirurgo (c. 200–130 BC)
5.3.1 Post-Pre-Surgeon levelling
At a point after between 200 and 130 BC, the Pre-Surgeon activities came to an end and the lower terrace was filled in. Within the areas of the atrium and Room

8A, this meant widespread filling over the top of the cuts and postholes, particularly in the west. This was clearly intended to equalize the soil with the original elevation of the tablinum so that the Casa del Chirurgo could be built upon a new, larger platform. The mixture of fills is diverse and seems to have come from a variety of sources including the Pre-Surgeon Structure itself. In general the deposit comprised of a dark brown matrix containing rubble and building debris, mixed with small amounts of domestic refuse (**505.061**, **260.109**, 608.019, 608.031, **275.022** = ?275.038,[77] 202.010, **202.019**, **202.020**, **202.021**, **202.013**, 260.118, 260.107, **260.111**). In some places (608.031) light grey inclusions were identified within the mixture, conceivably a part of the underlying pocked earth soils having been churned up by construction activity. Unlike some locations in the Casa del Chirurgo where a characteristic orange deposit with bluish mortar was recovered as a component of these activities, no similar deposits were present in the atrium or Room 8A.

5.3.2 Creation of the Casa del Chirurgo
After the Pre-Surgeon terrace had been filled, the creation of the Casa del Chirurgo began (Fig. 5.5.9). In the case of the façade and atrium walls, this involved the cutting of very deep trenches for the placement of large, ashlar Sarno blocks. The depth of these suggests that the builders may have been concerned with the stability of the refilled terrace, but this type of foundation is also in keeping with a practice for the construction of ashlar walls to which Vitruvius would later testify.[78] Lighter, non-load bearing walls

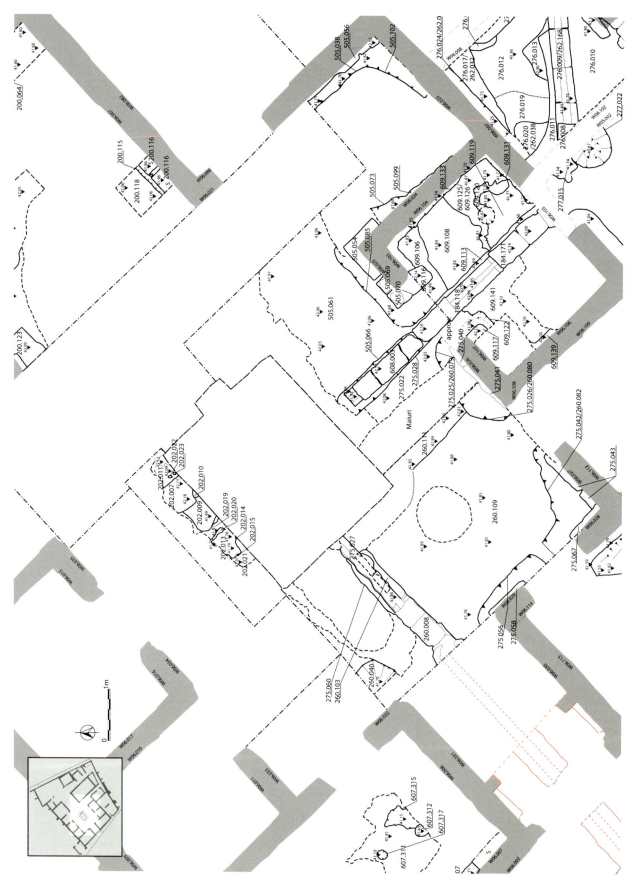

Figure 5.5.9. Plan of deposits and features in Rooms 5 and 8A related to the construction of the Casa del Chirurgo (illustration M. A. Anderson).

such as the southernmost wall of Room 8A and all the lateral walls, were constructed much more lightly in a Sarno-stone *opus africanum* method. These walls were provided with much narrower and shallower foundation trenches. Beyond the creation of the walls, this phase also witnessed the building of the first impluvium, of which hardly any trace survives. Despite this, the original north–south drain that carried water from it suggests some sort of water collection feature in the centre of the atrium at this time.

The walls of the atrium were constructed using large, regularly-sized *opus quadratum* blocks between 0.65 and 0.70 m in width. Doorways originally provided access to Rooms 6A, 6B, 6C, 6D, 6E, and Room 2, with wide openings into alae 8 and 8A. The blocks of the atrium walls appear to have been dry bonded, with the *opus africanum* rubblework elements connected using a pale yellow (2.5 YR 7/3) clay. A recess flanking the doorways into Room 6A, 6B, 6D, and 6E, approximately 15 cm wide and 2 cm deep, suggests that a wooden frame was originally fitted in this place (Fig. 5.5.10, A).[79] A similar recess is also observable on the eastern side of wall W06.026 (Fig. 5.5.10, B), although it is no longer visible at the edge of the doorway due to damage caused during later narrowing. The widths of all of the original atrium doorways into cubicula (i.e. Rooms 2 and 6B–E) are all approximately 125 cm, whereas the width of the doorway into Room 6C is 115 cm. A centrally placed square hole is present in walls W06.033, W06.034, W6.035, W06.026, and W06.027. These holes are below the level of the original door lintels and may represent putlog holes for scaffolding. The alae were also constructed at this time in Sarno stone *opus africanum* with *opus quadratum* being used for the northern parts of walls W06.024 and W06.021/22 where they join further construction in the tablinum in *opus quadratum*. Here it may be observed that the blocks were bedded upon a pale yellow (2.5 YR 7/3) clay – the same material that was also used to bond together the rubblework infill of contemporary *opus africanum* walls. Excavation confirms that W06.023 did not initially contain a doorway.

5.3.2.1 CREATION OF WALLS W06.022 AND W06.023

Wall W06.023 was built in *opus africanum* with large Sarno stone blocks. This is clearly visible in its lower foundations, which preserve the original stringers and infill construction. The foundation trench (**505.102, 505.038**) for this wall also included the northern half of wall W06.022, against which wall W06.023 butted (Fig. 5.5.11). Wall W06.022 seems to have been built using a mortar-less, ashlar technique of *opus quadratum*, in keeping with the construction of Wall W06.061/

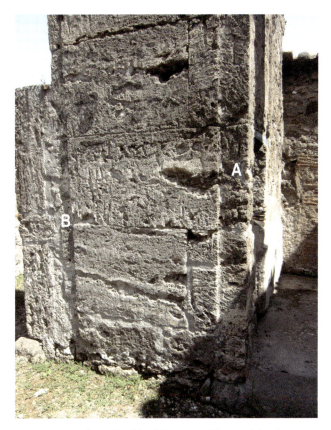

Figure 5.5.10. The walls of the SW corner of Room 5. The doorways show clear traces of a recess for a wooden jambs (A and B) (image M. A. Anderson).

W06.082 of the tablinum (Room 7) and the triclinium (Room 10). The foundation trenches cut into the natural deposits on the eastern side of the atrium in the south-eastern and southern sides of Room 8A. The trench was cut very close to the western face of these walls, suggesting that a wider foundation trench might have once been recoverable on the eastern side (in the triclinium (Room 10) or in Corridor 12, however, this is not verifiable due to the preservation of intact flooring

Figure 5.5.11. *Opus africanum* foundations of wall W06.022/ W06.023 (image AAPP).

in these areas. Certainly, placing large blocks of Sarno stone so close against the edge of the cut would have otherwise been difficult. Indeed, it was not possible to reach the bottom of the cut during excavation due to the extreme narrowness of the resulting trench. The cut bends around the 90–degree connection between these two walls, clearly indicating that they were built as a single action. Traces of a slightly wider foundation stone were visible in Room 8A, but there was no sign of a wide foundation trench around these stones as recovered elsewhere. Within the cut at the bottom of wall W06.022, there was a course of ashlar blocks (**505.056**) in Sarno stone that provided the foundations for an upper wall built in *opus africanum*. These were keyed into the foundations of wall W06.023. After the walls had been created, the trenches around them were filled with a dark brown silty soil that produced few finds (505.103, 505.036).

5.3.2.2 CREATION OF WALL W06.024
Construction of wall W06.024 must have occurred almost simultaneously with wall W06.023/W06.022, even though the foundation trenches themselves no longer connect with each other. It was also built in the lighter *opus africanum* method, with extremely narrow foundation trenches (**505.099**) extending no more than a few centimetres from the wall (Fig. 5.5.12). The rubblework placement of the foundations meant that the wall filled the trench as it was built, leaving only the width of whatever reinforcing boards or braces were left to aid in the construction process. The foundation trench was filled (505.100) after the construction of the wall had been completed.

5.3.2.3 CREATION OF WALL W06.025
Wall W06.025 was built in a much more substantial manner since it was one of the primary load bearing walls of the atrium. The foundation trench (**505.073**, **505.085**, 608.006), which was essentially the same cut as that for wall W06.024 but separated from it by later cuts, was uncovered 30 cm to the north of the wall itself in the section of a later pit. It continued (**505.085**) along the north face of wall W06.025. The trench is cut deeply and runs straight through the levelling deposits and cuts of the previous phase into the underlying natural deposits. The width (43 cm) of the foundation trench permitted the placement of a lower course of over-width Sarno blocks (**505.069**, **505.054**, **505.070**, 608.007) designed to act as the foundations for the ashlar construction of the rest of the upper part of the wall (Fig. 5.5.13). As is the case for most of these foundation stones in the Casa del Chirurgo, these large ashlar blocks seem to have been reused from some earlier building as they retained traces of plaster attached to random surfaces of the blocks and at levels too deep to be considered a part of an initial decorative scheme.[80] The fill of the trench (505.074, 505.086, 608.033) around these stones also indicated that significant effort had been made to pack this deposit into place firmly, securing the foundations and providing confidence in the stability of the structure as a whole.

5.3.2.4 CREATION OF WALL W06.026
The foundation trench for wall W06.026 was separated from those of the adjacent walls W06.027 and W06.027. The isolation of this foundation trench was due to them not being cut across spaces that were destined to become doorways. This practice was commonly adhered to throughout the atrium. Like the other atrium foundation trenches, that for wall W06.026 was wide (61 cm) providing ample space for working the oversized foundation blocks into place (Fig. 5.5.14). The fills of the trench appeared to be carried out in

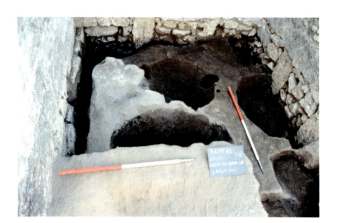

Figure 5.5.12. *Opus africanum* foundation of wall W06.024 (image AAPP).

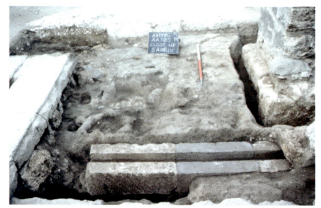

Figure 5.5.13. Broad foundation trench and Sarno block foundations of wall W06.025 in the SE part of Room 5 (image AAPP).

two phases, permitting the careful packing of deposits around the foundations.

The foundation cut for wall W06.026 was divided into three segments by the later excavations of Maiuri (**275.025** = **260.079**, **275.026** = **260.080**). The cut was deep, penetrating into the natural soils and wider at the top than the bottom where the first, wider course of Sarno stone blocks was placed. Within the foundation trench there were two levels of fill. The first (260.093[81] = 260.101) was a very dark greyish brown (10 YR 3/2) silty clay that was heavily compacted. It would seem that it was probably a fine layer intended as a footing for the foundation Sarno stone blocks (west to east **275.041**, **275.040**) intended to provide stability. The second fill (260.081,[82] 260.059 = 260.058) was a dark yellowish brown clayish silt (10 YR 3/6 to 10 YR 4/6) packed in around the first courses of the upper wall. Additionally, a yellowish, very fine hard-packed silty soil (260.058) was found in many places in the excavations associated with stones that likely was a component of the original clay that bound the stones together. As with wall W06.026, the foundation blocks were wider than the upper blocks.

5.3.2.5 CREATION OF WALL W06.027

The construction of wall W06.027 followed a similar pattern to that already discussed for walls W06.026 and W06.025. Here the foundation trench was a little narrower (0.47 m) (**275.042** = **260.082**) and it swept outward so as to include a similarly narrow (29 cm) trench for wall W06.028 and W06.029 (Fig. 5.5.14). While the records suggest that the cut here did connect across

the threshold, this only appears to be the case because of a later cut and possibly overzealous excavation. Elsewhere in the construction of the Casa del Chirurgo foundation trenches were not cut across doorways. Two levels of fill followed the creation of the walls. The first (lower) fill (260.110, 260.120[83]) was a fine, silty, very dark greyish brown (10 YR 3/2) soil, under and around the initial Sarno blocks (**275.043**). The second fill (260.119, 260.108 = 260.028) was a yellow deposit (10 YR 4/3) similar to the analogous fill for wall W06.026 (260.081, 260.059) already discussed above. It was completely devoid of finds.

5.3.2.6 CREATION OF WALL W06.028/W06.029

The foundation trench for walls W06.028 and W06.029 (**275.056**)[84] was cut together with that for wall W06.027. At the bottom of this wall, as with the other major walls of the atrium, several over-width Sarno blocks were placed as a footing (**275.058**, 275.067). The fill (275.057) was a dark brown silty sand (10 YR 3/3), which was either not placed in two separate deposits, as was the case for the walls W06.026 and W06.027, or this distinction was missed by the excavators. The fill had a large amount of charcoal, animal bone, plaster, and mortar fragments, and should be seen as equivalent to other upper fills such as those found in the tablinum.

5.3.2.7 CREATION OF ALA 8

The construction of the walls of ala 8 followed a pattern very similar to that recovered for Room 8A involving *opus africanum* and some *opus quadratum*.

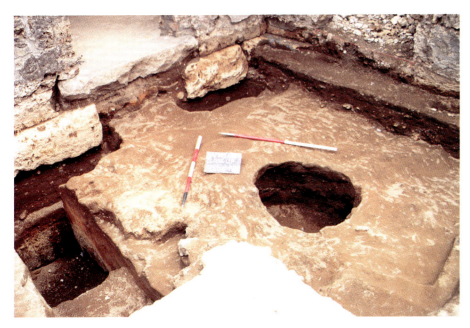

Figure 5.5.14. Broad foundation trench and Sarno block foundations of walls W06.026 and W06.027 in the SW part of Room 5 (image AAPP).

5.3.3 Original decoration

A fine white mortar with varying quantities of fine black angular inclusions was applied to the walls of the atrium that probably served as the primary decoration. No evidence of a final decorative surface was identified. Traces of a blue-grey plaster with frequent black and white inclusions, preserved in the junction between walls W06.027 and W06.028, most likely represent elements of this backing plaster. In Room 8A, this first plaster had a white mortar matrix with inclusions of black sand and the occasional larger (up to 2 mm) pieces of lime, which with weathering has turned a dark bluish grey (Gley 2 4/1) hue. It seems a strong possibility that the atrium and alae constituted a single decorative scheme.

5.3.4 Build of original impluvium

While no trace of the original impluvium or water catchment feature was recovered by excavation (the large part of which, if it survives at all would have been under the present impluvium), nevertheless, the existence of such a feature can be suggested by the presence of a north–south running drain built at the same time and designed to carry water collected in the atrium south and then east to a cistern situated under a portico on southern side of the property. This drain (275.030, 275.037), which was constructed with a base in Nocera tuff (505.030 = 260.099) that had been worked into U-shaped sections, was capped with thin Sarno blocks (**608.003**) and aligned carefully with the middle southern doorway of the atrium and with a further doorway on the southern side of Room 6C. It is likely that the drain was built after the walls had been laid out and was clearly part of the initial construction of the house. The cut for the placement of this drain (**505.066** = **275.028**, **608.010**, 260.098) was very narrow, providing no more than 8–10 cm of leeway on either side of the drain. After construction was complete, a fill of building debris and soils was packed in around it on both sides (505.065, 275.029, 260.129).

5.3.4.1 WESTERN OVERFLOW DRAIN

The catchment feature that fed the north–south drain must also have had an overflow system, probably the same that was reused by the later impluvium and found running east–west through the fauces of the house. This interpretation is bolstered by the fact that the lower construction of the western drain is very similar to that for the north–south drain, comprising identical U-shaped Nocera tuff blocks, topped originally with Sarno capstones (Fig. 5.5.15). While the precise stratigraphic excavation of this drain was complicated

by one or two later phases of later intervention, repair, or cleaning, it is clear that most of the associated deposits relate to its original construction. Its cut (**275.060** = 260.115, 260.116) goes into the building rubble below and was relatively wide, making room for the lower drain (**260.103**, **275.027**, 260.102) and its Sarno stone capping (**260.008**). Around the drain was a confused differential fill comprising of a variety of deposits (260.031, 260.116, 260.114, 275.059) of building debris, probably used to pack in around the drain once it had been constructed.

5.3.4.2 POSTHOLES ON THE SOUTH SIDE

A large number of postholes, that were not numbered by the excavators, were cut directly into underlying soils and probably relate to the construction of the Casa del Chirurgo or its impluvium, around which they seem to cluster (cf. Fig. 5.5.16). Potentially, they represent temporary posts in order to aid with the movement of large blocks, but do not have any appreciable coordination or structure. They seem to have been excavated upon the removal of overlying deposits and their fills must have been taken out with these upper filling layers. Their cuts, recorded in plan, nevertheless

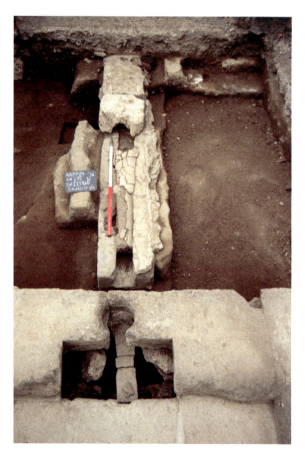

Figure 5.5.15. Remnants of the western overflow drain reused by the later impluvium (image AAPP).

permit some observations to be made about their nature, if not their precise function.

5.3.4.2 POSTHOLES ON THE NORTH SIDE

Another set of postholes (**202.014**, **202.015**, **202.023**, and **202.022**) was identified in the section of AA202 on the northern side of the overflow drain. These were probably associated with the postholes on the south side of the impluvium but little more may be observed about these features.

5.3.5 Possible 'use' floor

On the western side of the atrium, traces of a packed earthen floor (**260.014**[85] = 260.020 = 260.104) (cf. Fig. 5.5.16) suggest that the original surface of the Casa del Chirurgo was probably of beaten earth. Notably, no equivalent for this deposit was recovered on the east, possibly due to later cutting during the changes in Phase 5. Prior to the placement of this surface, a series of general fills (**260.036**, 260.040, 260.094[86]) had raised the height of the surface of the atrium and Room 8A to the required level.

5.3.6 Possible traces of a northern drain

An enigmatic component of the excavations on the northern side of the impluvium is a feature that appeared to be a continuation of the north–south drain, or possibly another drain from the early impluvium leading to the northern side of the atrium. As very little excavation was undertaken in this area, it is difficult to be certain, but the feature consisted of a Sarno stone block (**202.007**) with a tuff stone (**202.009**) underneath, which is similar to the U-shaped base and capping stones of the north–south drain to the south. Alternatively these elements could simply be components of the chocks that hold the later impluvium in place.

5.4 Phase 4. Changes in the Casa del Chirurgo (c. 100–50 BC)

While there are no obvious traces of this phase in the atrium of the house, it is probable that Phase 4 witnessed the provision of some sort of luxurious pavement similar to those still in situ in the rooms on its northern side. It would seem improbable that Room 16 and the northern cubicula should have received such treatment while the atrium remained undecorated. Remnants of this earliest flooring appear to have been preserved in the fauces from which they were never removed. Further elements of flooring decoration from this phase are present in central area of the northern

ala (Room 8) where a tessellated floor was laid with white tesserae and a series of coloured oblong tesserae, and which was framed by a black band (cf. Chapter 9 for more details).

5.5 Phase 5. Redecoration and redevelopment (late first century BC to early first century AD)

The last quarter of the first century BC to the early first century AD saw significant reworking of the atrium, and in particular, the formalisation of the space in line with features that are generally seen as characteristic of an 'atrium house' providing a grander and more axially aligned space. This change was part of a wider scheme of development that also saw two commercial units created in Room 2 and Rooms 3/4. The removal of soils in Rooms 3 and 4 resulted in the cutting of the north–south drain from the impluvium and necessitated the complete reworking of the water catchment and storage facilities in the atrium. This indicates that the development of the luxurious atrium was part of the same coherent plan that also resulted in the opening of the shops.

5.5.1 Removal of any previous flooring

Although there is no obvious sign of the removal of any previous flooring, it is highly likely that this occurred at this time and was undertaken in order to provide access to the soils underneath the atrium and to permit the excavation of two new cisterns.

5.5.2 Holes, cuts, and general fills

After the earlier flooring had been removed, a series of cuts were made into the underlying deposit (Fig. 5.5.16). The largest (**260.056**) was over a metre (1.06m) in diameter and penetrated deep into the natural deposits below. The sides of the pit were nearly vertical and the bottom was rounded. It should be noted that the pit did not continue into the natural deposits to a great depth (unlike many of the pits generally interpreted in the excavations in Insula VI 1 for the recovery of sand or clean natural soils for building). It is however, difficult to provide an alternative explanation for this feature. Its fill (260.057, 260.029) consisted of a brown (7.5YR 4/3) soil mixed with notable amounts of cruma, charcoal, and small amounts of bone and pottery, including fragments of worked bone.

A curvilinear and shallow cut (**260.033**, 275.033) was located directly to the east of the pit and centrally against wall W06.029. Its fill (260.027[87] = 260.034, 260.032) consisted primarily of loose decayed or chipped Sarno stone fragments of very small size mixed with brown

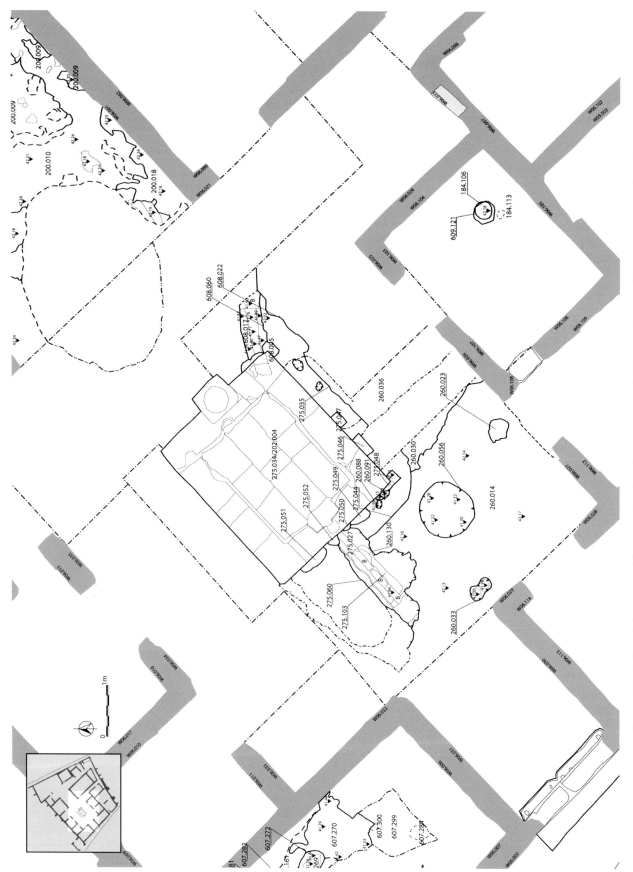

Figure 5.5.16. Plan of deposits and features related to the preparations for Phase 5 changes (Illustration M. A. Anderson).

to light olive brown soil. The remnants, while being unclear in function or cause, are likely the result of temporary building activities during the rebuilding of the atrium floor, the placement of the second impluvium, and work upon the drains (especially their Sarno stone capping) – all of which would have produced residues of this type. Other, smaller holes (**260.091**, **260.088**) not far from the impluvium and respecting its final alignment, could have been for temporary posts involved in work on the impluvium itself. The fills of these (260.092, 260.089), along with other small areas of fill (**260.030, 260.023**), must equally be the result of building activity.

5.5.3 Building of the new impluvium
The area of the current impluvium shows significant signs of reworking in this phase. While it is possible that this relates exclusively to a raising of the level or a reworking of the piping under the old atrium, it is more likely that the Nocera tuff atrium present in the house today was installed *ex novo* at this time. In either case, the drainage system of the original impluvium was completely reworked, since the north–south drain no longer connected to a cistern for storage, its course having been cut through by the creation of the shop in Rooms 3 and 4. The system of water management was therefore altered so that rather than channelling water through the north–south drain, it was collected in two new cisterns (now collapsed) that were added to the north-east and south-east, between the impluvium and the tablinum. Connecting to these cisterns were two new drains, each running off one of the eastern corners of the impluvium. It is possible that damage

visible on the south-eastern corner of the impluvium relates to the creation of this feature (but it may also relate to servicing and repairs of a later date). In the event that these two cisterns became filled with water, the system was provided with the reworked overflow from Phase 3 that ran out through the fauces of the house draining into the Via Consolare.

5.5.3.1 NEW *IMPLUVIUM* PLACEMENT OR RAISING OF ORIGINAL *IMPLUVIUM*
The cut (**275.035** = **275.044** = 260.106, 260.112) for the placement of a new impluvium, or the raising of the old one, is relatively wide where preserved on the southern side, presumably to allow for the placement of the Sarno stone chocks (**275.046, 275.047, 275.048, 275.049, 275.050, 275.051, 275.052** = 260.090, 260.037, 260.021, 260.060 = 505.068, 608.005, 608.028, 202.016, 202.017) upon which the Nocera tuff impluvium (**275.034** = 260.011 = 505.034 = 608.004 = **202.004**) was set. This process also appears have included some mortar (202.012, 260.035). The Sarno stone footings appear to be the correct size, shape, and thickness to have been used previously as the capping of now missing elements of the north–south drain or the original western overflow drain, which are both cut by the foundation trench for the impluvium (Fig. 5.5.17). In one case (260.021), a grey (10 YR 5/1) mortar from the construction of the impluvium was found overlying the stones and helping to cement them into place. After the impluvium had been built, a differential fill was packed in around to seal the foundation trench (275.036 = 275.045 = 260.105, 260.113). This was a loose sandy silty soil containing numerous fragments of tuff

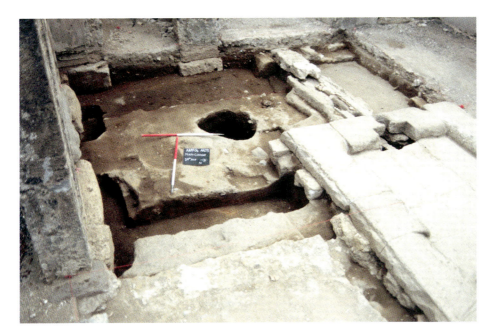

Figure 5.5.17. Sarno stone blocks used as chocks under Nocera tuff impluvium (image AAPP).

and Sarno, which were interpreted as pieces of the broken north–south drain. The cutting of the drain at this time means that its fills (260.097,[88] 505.089, 608.062) are likely to originate from roughly this period since there was no other way for materials to enter the drain subsequently.

5.5.3.2 CONSTRUCTION OF THE SOUTH-EASTERN AND NORTH-EASTERN DRAINS TO THE NEW CISTERNS

Since the north–south drain that had originally served to conduct water away from the atrium to a cistern under Room 12 had been broken by the lowering of soils in Rooms 3 and 4 for the creation of a shop, a new system of water collection had to be devised. This consisted of two drains running diagonally from the impluvium, roughly to the north-east and the south-east, feeding two large cisterns situated to the east of the impluvium. Due to the later collapse of these features, and also to subsequent repairs on both of the drains probably after damage caused by the earthquake(s) of AD 62/3, the stratigraphic relationships of these features are relatively confused.

The south-eastern drain leads from the impluvium to the southern of two now-collapsed cisterns between the atrium and the tablinum/triclinium area of the Casa del Chirurgo (Figs. 5.5.18, 5.5.19). No traces of the cut of the drain were discovered, probably because the

capping and drain entirely filled up the trench. The drain (**608.017**) was sealed with lose pieces of brick and tile (505.049) in the western part and with tuff and mortar (505.055, 275.017) towards the eastern extent (roughly 1.1 m to the east). It was then covered with fill (608.020). It is also possible that the highly fragmented and confused nature of these deposits indicate that it was re-cut later for repairs or maintenance of some sort. A long cut running roughly parallel with the drain cut may also relate to this activity (**608.022**), as might another cut on the northern side (**608.060**) and its fill (608.059). Mostly visible on the southern side, and only in section on the north, the cut was filled with a firm sandy silt with plaster inclusions (608.058, 608.044). Although it was not excavated, a similar channel fed a cistern situated further to the north and lead to the north-east.

5.5.3.3 THE WESTERN OVERFLOW DRAIN REPAIRS

A second component of the placement of a new impluvium was the reworking of the drain that led westward through the fauces of the Casa del Chirurgo and emptied into the street. Evidence of recapping with mortar (260.117) and tiles (275.055), rather than the original Sarno blocks, may either be dated to this phase (or may be part of later repair work) (Fig. 5.5.20). If these changes are to be seen as a part of this phase,

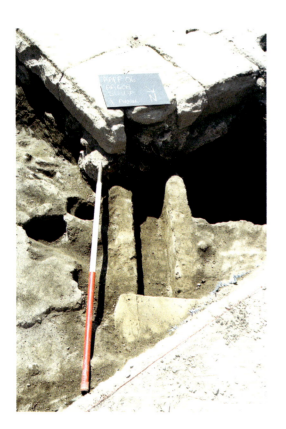

Figure 5.5.18. (*Left*) The new SE drain running from the corner of the impluvium (image AAPP).

Figure 5.5.19. (*Above*) The new SE drain as it enters the southern cistern (collapsed) (image AAPP).

then they must relate to the damage caused to the eastern end of this drain, which was reworked in order to feed into the new impluvium and then covered via a series of rounded roofing cover tiles in lieu of the original Sarno stone covers. It is interesting that the workmen decided to hack through the tops of these covers rather than remove them, especially since this meant that the covers then had to be repaired rather than simply being replaced. Clearly those carrying out the work did not have a clear understanding of how the drainage system had originally been built. Other elements of this work included the fills used to pack in around the drain afterwards (275.123, 275.107, **260.130**) and a final smear of lime (275.129). On the whole, it is likely that most of these deposits relate to maintenance or repair undertaken in Phase 7 (cf. infra).

5.5.4 Doorway into Room 2
This period of transformation also saw the closure of the doorway that had led into Room 2, using *opus incertum* containing brick/tile, Sarno stone, Nocera tuff, and re-used pieces of *opus signinum* set in a brown mortar matrix with occasional large white inclusions.

5.5.5 New doorways in alae 8 and 8A
A doorway was inserted into wall W06.023 to provide

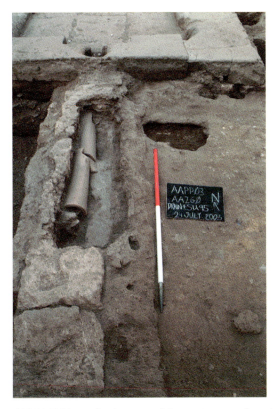

Figure 5.5.20. Evidence for the reuse of the western overflow drain, probably related to modifications made at this time (image AAPP).

access to the service wing, which resulted in the reconstruction of much of this wall and the addition of a large Sarno stone orthostat to form the western side of the doorway. To the east of the doorway, a large niche was also created at this time. Perhaps this was done to create a sense of symmetry in the wall, with two openings either side of the central Sarno stone block. The western side of the niche was built in *opus incertum* using pieces of Sarno stone, grey lava, and a piece of tile set in a coarse light bluish grey mortar with large inclusions of crushed cruma and lime (both up to 10 mm in length). This mortar was also used to fill in the lower portion of the niche. In ala 8, a doorway was also cut through wall W06.036 to create an access way into Room 6D at this time.

5.5.6 New threshold stones
As a component of the redecoration of the walls, new lava threshold stones were added to the doorways to Rooms 6B, 6C, 2, 6D, and 6E. Notably, Room 6A did not preserve any evidence for a threshold, although this may have been lost in the excavations of Maiuri. The entrance into Room 2 also did not receive a threshold, presumably because this entrance was closed at this time. The new threshold for 6C was made up of two smaller stones at either side of the doorway (Fig. 5.5.21). Perhaps this was because the doorway was also narrowed at this time by moving the western jamb further to the east. On the east, the placement of these stones involved cutting out space for their insertion. Similarly, in the case of the doorway into Room 6C, a squeeze of mortar (**505.107, 505.080**) appears to have preceded the placement of the lava stone threshold elements (**505.106** = 608.008, **505.079** = 608.009), presumably in order to help hold them in place. After this action, fills were packed in around the threshold (**505.041, 505.040**). In most other walls, the installation of the threshold stones required at least a bit of chipping away at the original walls of the house in order to be able to fit the stone under the jamb, which may help explain the decision to conduct this renovation in concert with a redecoration of the walls. The holes were subsequently repaired with a variety of materials before being re-plastered.

5.5.7 Opus signinum floor in the atrium and the mosaic threshold to ala 8
After the placement of the new impluvium, the atrium and at least five rooms (ala 8, cubiculum 6C, 6B, 6E, and 6D) were repaved with a new *opus signinum* surface (Figs. 5.5.22, 5.5.23). Prior to the placement of the these *opus signinum* surfaces, a thick levelling layer or sub-floor was

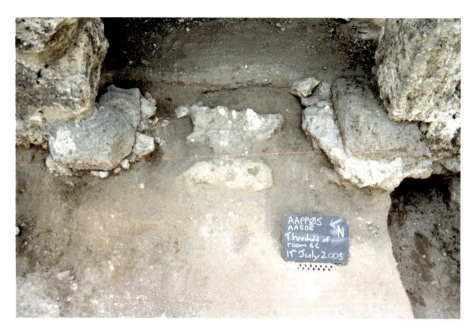

Figure 5.5.21. Damage to walls W06.026 and W06.025 due to addition of the lava stone threshold (image AAPP).

laid down in preparation (**505.010**[89] = **505.005** = 275.011, 275.010 = **260.013**, 260.012,[90] 505.011, 505.042, = **202.006** = 202.018 = **202.008**). The sub-floor was a dark greyish brown to dark olive brown (10 YR 4/2 to 2.5 Y 3/3) rubble and soil deposit containing large amounts of general building debris. It comprised a layer approximately 20 cm thick and was flattened after deposition to provide an appropriate under-floor. The *opus signinum* itself (**505.002** = **275.002** = **260.006** = **202.005**) was very degraded on the southern side of the atrium, and in particular, had cracked and fallen in toward the eastern side of the atrium where the two cisterns had collapsed. It is likely that the *opus signinum* covered all of Room 8A in Phase 5 (although traces of it were not preserved). The earlier flooring of ala 8 was retained, but given a new decorative border (cf. Chapter 9). The north-west corner of the atrium's final phase *opus signinum* flooring (**607.231**) was not excavated. However, it possible to sequence the *opus signinum* flooring on the atrium side of the doorway at Room 2 to this phase (Fig. 5.5.24). It is badly degraded, especially at the edges revealing tile and plaster inclusions. Underlying this surface appears to be a significant layer of coloured plaster, which is different from what was found in the areas that were excavated. The fact that this flooring did not extend into Room 2 supports the idea of a division between them at this time.

5.5.8 Wall decoration

During the general demolition that heralded this phase, the pre-existing wall plaster was clearly removed from the atrium and alae. The previous decorative coat was cleared down to its grey sandy mortar preparation layer. After the new flooring had been completed, the walls were subsequently coated by a light grey backing plaster with black and white inclusions. Traces of this plaster are also present on the narrowing Sarno stone orthostats, where it incorporates pieces of brick/tile to bulk out the plaster (wall W06.026/W06.027), confirming that the doorway into Room 6C was narrowed at this time. The plaster is also present in the recessed areas adjacent to the doorways. This suggests that the original wooden doorway edges were replaced on all of the atrium doorways during this phase of decoration. In Rooms 8 and 8A, plaster from this phase is represented by a light bluish grey to bluish grey (Gley 2 8/1- Gley 2 6/1) layer with inclusions of rounded black volcanic sand and occasional larger pieces of lime (c. 2 mm in diameter), and in Room 8, overlies the mosaic. It seems that here too the final surface of the plaster had been carefully and comprehensively removed prior to the new decoration. The new plaster layer was 10 – 20 mm thick and was bulked out in places through the inclusion of ceramic material such as amphora. It is also present on walls W06.019, W06.020, and W06.036. Although no clear final surface survives to permit the reconstruction of the decoration, in Room 8A, it is possible that this plaster was simply smoothed to create a final white (Gley 1 8/N) surface with occasional black speckles without a final layer of fresco.

The best window onto the decoration of this phase derives from the closure of the doorway into Room 2. Here, a white plaster, again only seen in section on the southern side of the doorway, was applied and flattened at the surface for the application of pigments to decorate the newly blocked former doorway (Fig. 5.5.25, A, D). The colour scheme would appear to have

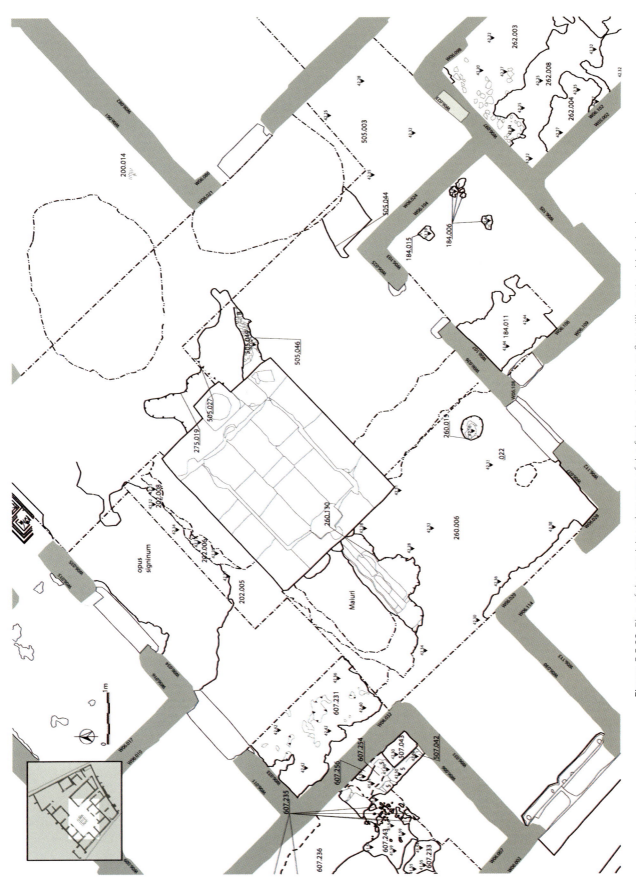

Figure 5.5.22. Plan of the surviving elements of the final *opus signinum* floor (illustration M. A. Anderson).

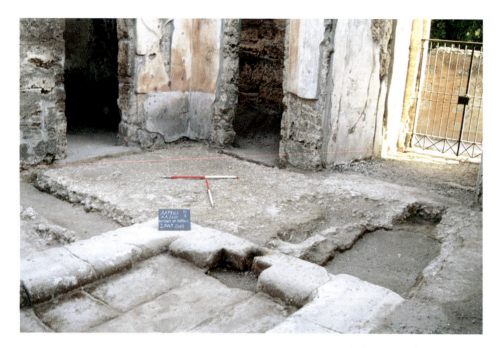

Figure 5.5.23. *Opus signinum* flooring in the SW corner of Room 5 (image AAPP).

Figure 5.5.24. *Opus signinum* flooring in the NW corner of Room 5 (image AAPP).

included elements of gold with red or brown decorative bands (Fig. 5.5.25, B). The white backing plaster with black and occasional white inclusions is also observable on the northern side of the doorway. The face of the wall painting is stepped back from the surface of the wall by approximately 22 cm. This would have created a recessed area, perhaps representing a false door (Fig. 5.5.25, C). Plaster from the final phase of decoration

(Phase 6) (Fig. 5.5.26, E) served to seal this small remnant of the earlier plaster.

5.5.9 Redecoration to the ala 8A?
Perhaps shortly after this period, the decoration of wall W06.023 and the niche in ala 8A appear to have been redecorated yet again. The original layer of plaster was simply picked to roughen up the surface prior to the application of the next layer. This was a thick (up to 20 mm) layer of light bluish grey (Gley 2 8/1) plaster with rounded inclusions of sand/pebbles, including pieces of shell, crushed ceramic, and larger pieces (up to 3 mm in length) of lime. At the bottom of the western side of the doorway, larger (up to 0.1 m) pieces of tile were included in the plaster to help provide bulk to it. This was also done as part of the same second phase of plastering as wall W06.022. Evidence from wall W06.022 would also suggest that this layer of plaster was simply flattened and left white.

5.6 Phase 6. Upper storeys and final decoration (c. mid-first century AD)
The changes of Phase 6 appear to have focused largely upon the service wings of the house and the provision of upper storeys. The height of the atrium, as Mau noticed,[91] did not leave room for an upper storey, and with the major changes in this area already undertaken in Phase 5, modifications at this time appear to have been limited largely to the addition of new Fourth Style frescoes. These extended to most of the important areas of the structure and may have been motivated by the decision to reopen access to the stairway in Room 2,

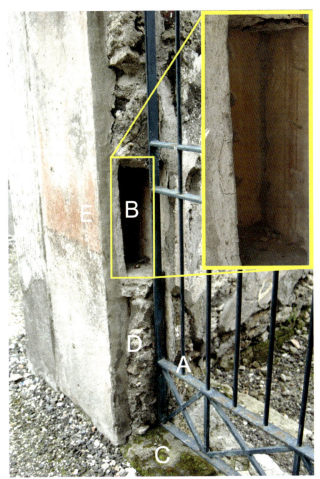

Figure 5.5.25. The blocking of the doorway in wall W06.032 seen in section. (A) doorway blocking; (B) wall plaster face; (C) grey lava threshold; (D) partial blocking of the door associated with the opening of the door in the final phase; (E) final phase wall plaster (image D. J. Robinson).

which would have damaged existing wall decoration (Fig. 5.5.26).

5.6.1 Reopening the doorway to Room 2
This phase witnessed the reopening of the doorway into Room 2. It was effectively narrowed from its previous width on its southern side by a 20 cm wide pilaster of Sarno stone *opus incertum* set in a grey mortar with frequent black and occasional white and crushed ceramic inclusions (Fig. 5.5.25, D). Prior to this construction event the remaining wall plaster was picked improve the adhesion of the new *opus incertum* pilaster.

5.6.2 Redecoration – early fourth style painting
The final phase of wall decoration in the atrium (Room 5) and the northern and southern alae (8 and 8A), is visible throughout. The absence of previous plaster surface would indicate that some care was taken to

remove it, although the decorators appear to have taken some pains to preserve the previous phase of backing plaster. Overlying the re-used backing plaster was a fine white mortar with translucent to light brown angular quartz inclusions. This was flattened to provide a surface upon which a pigment was applied that now appears red but which was originally mustard yellow. The lower painting register was applied afterwards and had a matrix comprising of quartz, crushed ceramic, and black inclusions. Traces of linear incised lines produced by the laying out of the decoration, including a central roundel and lower swag on wall W06.027, are visible. Walls W06.033, W06.034, and W06.035 reveal that the lower register of decoration was applied after the middle register, which has a different plaster composition, with fewer quartz crystals and increased amounts of crushed ceramic and black inclusions. Pilasters present at the eastern end of the fauces, mirrored those flanking the entrance to the tablinum and to the northern ala (Room 8). There is sufficient evidence in their backing plaster to suggest that these were preexisting features from Phase 5 that were reused at this time. The pilaster on wall W06.035, unlike those at the tablinum or fauces, was covered with the pinkish plaster of the lower register. In the northern ala (Room 8) itself, the previous plaster was roughed, before the application of a c. 30 mm thick layer of light greenish grey (Gley 1 7/1) backing plaster. Final plasters followed, first a white (2.5 YR 7/1) plaster with mineral crystal inclusions and the occasional black volcanic minerals in the middle, then a pinkish white (10 R 8/2) plaster containing ceramic, rounded black volcanic sand and the occasional piece of lime in the lower register, onto which the final fresco was added (cf. Chapters 4 and 8 for discussion of the decoration).

The decoration of 8A at this time appears to have been partially brought into line with the simple red and white decoration of the remaining service wing, while combining at least some elements from the atrium as a whole. There is evidence on the niche and on the face of wall W06.023 to suggest that the previous layer of plaster was simply picked to roughen up the surface prior to the application of a new backing plaster. This was applied as a thick layer of light of bluish grey (Gley 2 8/1) plaster with rounded inclusions of sand/pebbles, including pieces of shell, crushed ceramic, and larger pieces of lime, which is also observable on walls W06.021, W06.022a, and W06.024. At the bottom of the western side of the doorway in wall W06.023, larger pieces of tile were included in the plaster to help provide bulk to it. Such additional thickness was unnecessary on wall W06.022a, where there is evidence

to suggest that this layer of plaster was simply flattened in preparation for the application of a final layer.

In the niche, the final plaster was a thin layer of white (10R 8/1) plaster with mineral crystal inclusions. The same plaster was also used in the middle zone of the wall to either side of the niche. The lower zone either side of the niche, however, had a final plaster with a different composition – a similar white mortar with quartz crystals, that also included a significant quantity of crushed ceramic, giving the plaster a pink (10 R 8/3) final colour. This plaster was also used on the bottom 0.12 m of the niche. There are also faint traces of the colouration of pigments applied to the final plaster layer. The pink plaster appears to have had a dark blue/black pigment applied to it, which is now a grey (Gley 1 6/N) hue. These could be traces of largely vanished *secco* decoration. The upper zone is today a reddish yellow (7.5 R 8/6) but was originally mustard coloured according to the cork model in the *Museo Archeologico Nazionale* in Naples. A red band runs vertically up the wall in the western corner. The lowest 0.12 m of the niche, mirroring the socle of the atrium was originally black, but appears as dark red today (10 R 3/6).

5.7 *Phase 7. Post-earthquake changes*

The atrium and Room 8A preserve some evidence for an additional phase of changes in the Casa del Chirurgo, probably as a result of mild damage during the earthquake(s) that began and followed AD 62 (Fig. 5.5.30). These changes involve the removal of the flooring of ala 8A, potentially in anticipation of works in the area that were possibly never undertaken, and the placement of two large (45.6 cm and 47.4 cm diameter) posts flanking the doorway into Room 6B, which were cut directly into the *opus signinum* surface of the previous phase. Finally, a number of disturbed deposits overlying the impluvium drains suggest some sort of disturbance to the drainage system that required attention. It seems unlikely that the repairs and renovations to which these changes attest were complete by the time of the eruption, but it does imply the desire and will to continue to live within the city, despite significant delays in repair work. It is also important to suggest that the two cisterns to the east of the impluvium, could have collapsed at this time.

5.7.1 Removal of flooring in ala 8A

The interface between the *opus signinum* flooring in the atrium and its missing analogue in 8A was unfortunately obscured by the collapse of the cisterns just to the north of this area. It is therefore impossible to be completely certain that the ala was indeed ever covered with *opus signinum*. On the basis of the mosaic flooring still preserved in ala 8, however, it seems likely that the Phase 5 decorations would have included at least *opus signinum* pavement within ala 8A. This implies that the floor had been removed shortly prior to the eruption, perhaps has a result of restoration efforts and repairs made necessary by the earthquake of AD 62/3, the damage from which seems focused on the southern side of the atrium. After this removal, a series of cuts, fills, and trampled areas suggest that this zone was in use for temporary construction activities. Across the western side of ala 8A and over the top of the fills of the two cuts mentioned above, two very thin layers of soil were spread (505.058, 505.059), probably as a result of activities in the area more than from a deliberate levelling layer. The final deposit in ala 8A was a relatively thick layer of dark greyish brown to very dark greyish brown (2.5 Y 4/2 to 2.5 Y 3/2) sandy silt (505.008[92] = 505.009, 505.028), which covered the entire area to the level of the *opus signinum* of the atrium. Some component of the deposits may also have been the result of ancient or modern trample (505.003).

In the northern part of ala 8A, between the collapse of the cistern and wall W06.024, a very dark greyish brown (10 YR 3/2) silty sand deposit (505.004) was present in a shallow cut (**505.044**) which exposed the first row of Sarno stone blocks present in the western wall. The fill was relatively loose and contained pottery and *opus signinum* fragments among other debris, seemingly the residue from removing the *opus signinum* flooring in this area. The precise function or purpose of this cut is entirely opaque, but seems to relate to the construction activities underway in the area at this time. Against the southern wall of ala 8A, there was another cut (505.020) characterised by a yellow-brown (10 YR 3/6) fine silt fill (505.006). The cut was also relatively shallow and its intended function remains equally unclear.

5.7.2 South-eastern impluvium drain repairs

A confused set of deposits over the top of the south-eastern drain in a hole that had been cut into the overlying *opus signinum* surface may testify to repair work carried out in the area during the final phases of the house. It is possible too that the damage to the impluvium on the south-eastern corner also occurred as a part of this activity. After the drain had been repaired, the area was refilled with a mix of fills including elements probably broken from the drain itself. The south-eastern drain leading from the AD 79 impluvium is an area of confused and complicated

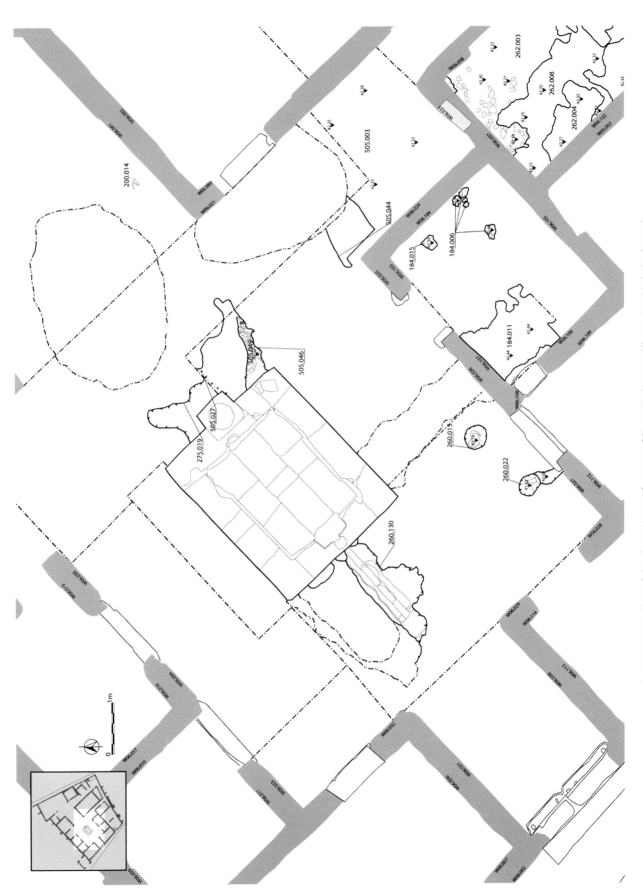

Figure 5.5.26. Plan of the deposits and features of Phase 7 changes (illustration M. A. Anderson).

archaeological sequences. Possibly as many as three different cuts down to the level of this drain were uncovered within this small area (505.025, **505.027**, and **505.046**) (Fig. 5.5.27). Each was differentiated according to its fill (505.024, 505.026, 505.045) suggesting a series of incisions made into the floor at this point in order to repair or service the south-eastern drain.

It seems likely that these events are related to post-earthquake disturbances, but equally they might be the result of normal daily life and maintenance of the house. Understanding the exact sequence has been made impossible by the collapse of the cisterns. The first was on the eastern side of this small area, roughly parallel to the south-eastern corner of the present impluvium. The fill of this cut (505.024) was a dark brown (10 YR 3/3) loose silty sand containing small amounts of apparently domestic debris. The second was located slightly to the west of the first. The cut once again reached the level of the south-eastern drain, and was filled with a very dark greyish brown (10 YR 3/2) loose silty sand (505.026). The final cut was a slightly more extensive size (**505.046**), being somewhat wider than the previous cuts. Its fill was a brown (10 YR 4/3) sandy silt (505.045) that ran over the top of the brick and tile capping of the drain (**505.049**). These cuts appear to have allowed access to the drain via the original top capping (505.055), which was destroyed in this process. Within its fill was a fragment (505.019) that seemed to very similar to the *opus signinum* sub-flooring and may have been a re-deposited fragment of it.

5.7.3 Possible repair of the western drain area
Similar repairs seem to have been necessary on the western drain, which required the cutting through of

the *opus signinum* and the drain and the replacement of some of the capping stones with tiles (Fig. 5.5.20). Here, disturbance (**260.130**) in the soils directly over the drain may indicate repair or maintenance on this feature. The fills presumably were excavated with the overlying deposits and were only visible in the section left to the north.

5.7.4 Repair of north-eastern drain
Some traces of similar repairs to the north-eastern drain were also recorded, although they were not fully excavated (Fig. 5.5.29). Nevertheless, they seem in line with those described for the other drains of the area. In the *opus signinum* near the north-eastern corner of the impluvium was an irregularly shaped cut (**275.019**), which encompassed the eastern end of the impluvium. Within the cut it was possible to discern pick marks suggesting that it had been necessary to lift the floor in order to gain access to the drain. The dark greyish brown fill (275.020) (10 YR 4/2) contained rubble and some plaster.

5.7.5 Postholes for emergency support
It seems likely that the atrium roof or walls had suffered some damage. Several postholes, in addition to similar cuts in Room 8A and 6C, might suggest that it was necessary to erect posts in order to support certain elements of the roof, or perhaps the lintels over doorways. These were cut into the *opus signinum* surface. The two clearest (**260.015**,[93] **260.022**) flank the entrance to Room 6B. The eastern of these (**260.015**), contained a number of different dark brown (7.5 YR 2–3/3) silty sand fills (260.016, 260.017, 260.018, 260.019) and seemed to preserve

Figure 5.5.27. Cut into the *opus signinum* flooring near the impluvium and the collapsed cistern (image AAPP).

the charcoal outline of the post itself at the centre (Fig. 5.5.28). This suggests that the support was still in place during the eruption and burnt as a result of a related fire. At the bottom of the posthole, pieces of mortar were placed as a footing for the post, and fragments of the *opus signinum* floor were used as chocks to secure the post within the hole that had been cut for it (260.017). The posthole to the west (**260.022**) was of similar dimensions and also made use of *opus signinum* fragments to wedge the post more securely into place (260.024). Connected to the posthole was a shallow pit of similar size (260.026). Its brown (10 YR 4/3) silty sand fill (260.025) was made up of rubble and mortar inclusions. It is unclear why this was cut, perhaps it was initially planned to be the location of the posthole and was subsequently decided to move it a little to the north. In the south-eastern quarter of the atrium, near the beginnings of the cistern collapse and directly in front of wall W06.025, another, much smaller posthole (505.013) was found cut into the sub-floor of the *opus signinum*. The difference in size suggests that it was intended for a different function, but what this may have been is unclear. Its fill (505.015) was devoid of finds and was likely of modern origin. In the atrium these postholes were cut directly into the once fine *opus signinum* and would have significantly downgraded the grandeur of the space. It seems unlikely that the repairs testified by these changes were ever completed. Fills found over the *opus signinum* (260.004, 260.007) may relate to these final phase changes, but may also have been from the modern period.

Figure 5.5.28. Eastern large posthole in the SW corner of Room 5 filled with burnt residue (image AAPP).

5.8 Phase 8. Eruption and early modern interventions

Either during the earthquake, the eruption, or after the initial excavations, the two cisterns located to the south-east and north-east of the impluvium collapsed (**275.014**, **275.012**, 505.012, 505.014), bringing with them the *opus signinum* surfaces that had once covered them (Fig. 5.5.30). Their fills (275.015,[94] 275.016,[95] 275.018, 275.108, 275.109) clearly contained elements of the eruption debris, but they were also filled with a large amount of plaster from nearby rooms. This wall plaster seems to have been placed into the holes after its removal from the walls, as is recorded in the early records of the city.[96] These cavities were at least partially excavated during the initial uncovering of the house and certain deposits contain apparently Bourbon

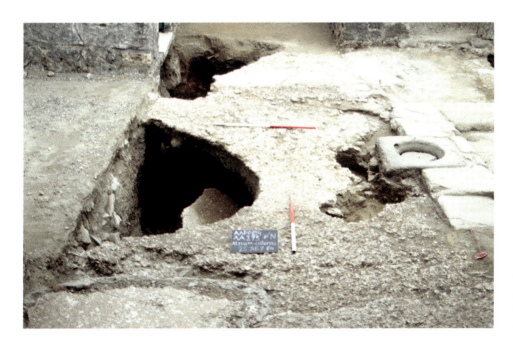

Figure 5.5.29. Overview of collapsed cisterns and damage to Room 5 and 8A in Phase 7 and 8 (image AAPP)

period artefacts. However, subsequent to being filled with plaster, the two holes appear to have remained undisturbed prior to our own investigations, preserving the high-quality plaster decoration from several areas that otherwise would likely not have survived (cf. Chapter 8).

5.8.1 Wall changes after excavation

Major changes involved the raising and levelling of walls using an *opus incertum* of Sarno stone and a small quantity of tile, including the provision of lintels over a number of doorways and the capping of these walls with roof tiles. This was mainly set within a light bluish grey (Gley 2 7/1) mortar with black volcanic stone, lime, and lapilli. During this phase of reconstruction, wooden lintels were added over the doors to Rooms 2, 6A, 6B, and 6E in order to support the continuation of the rebuilding across the doorways. The walls of the atrium were then pointed with a rendering layer of a light bluish grey (Gley 2 7/1) mortar with black volcanic stone, lime, and lapilli. Following this, a layer of roof tiles set on a light bluish grey (Gley 2 7/1) mortar with lime inclusions, that was spread down the wall over the layer of render, was added to the tops of walls W06.027, W06.028, W06.029, and W06.032. The modern nature of these constructions was especially apparent in ala 8A, where a form of *opus incertum* laid in regular courses was used, which was bonded with a reddish yellow (7.5 YR 7/6) mortar with occasional pieces of lime.

Butterfly clips survive, especially on walls W06.025, W06.027, W06.034, and W06.036 indicating that this early method of conservation was used to help pin any still surviving wall plaster to the walls. Unfortunately, this was ultimately unsuccessful on wall W06.025 where there is no longer any final phase plaster. Another unsuccessful early attempt at plaster conservation can also be seen on wall W06.027. Here bands of a smooth pale red (10 R 6/4) mortar with black volcanic mineral and lime inclusions are present that 'echo' the edges of the surviving wall plaster, although they are 10–15 cm removed from them. This suggests that this mortar was used to edge the wall plaster to stop water infiltrating its exposed edges. This obviously failed, with the result that the edges of the plaster have eroded and come away from the wall, leaving the red mortar to define the areas where plaster had once been. A more successful use of this pale red mortar was to fill in several holes in the surface of the final phase wall plaster. A similar smooth yellow (10 YR 7/6) mortar was also used to patch holes in the final decorative surface of wall W06.032 where a coarse light bluish grey (Gley

2 7/1) mortar with small black, white, and ceramic inclusions was used to coat the lower portion of the plaster pilaster, probably as a conservation measure designed to protect the delicate plaster.

5.9 Phase 9. Modern interventions

Modern changes to the soils of rooms 5 and 8A were few in number and primarily the result of natural build-up of soils after the original excavations, detritus, and root damage (260.005, 275.004, 275.009, 275.005, 275.003), plus the interventions and investigations of Maiuri, who cut four medium to large sized sondages into the atrium (202.003, 202.002, 260.010, 608.023, 260.009, 260.038, 505.007, 275.007, 275.023, 275.024). These were filled with characteristic yellowish soil (260.039, 260.002, 260.003). At least some of the layers of soils recovered on the top surface may be a result of his activities and backfilling. Modern patching on the edge of the *opus signinum* in front of the entrance to Room 9 from the atrium and facing in particular the collapse area of the northern cistern in the tablinum area (265.013) attests to conservation efforts. A final layer comprised blue-grey gravel was placed in recent modern times in order to reduce damage to the underlying deposits and to prevent dust from being a problem on site (505.001 = 275.001 = 260.001 = 202.001, 608.001). There was also fill inside the impluvium drain on the west side that contained plastic (275.054).

Modern changes to the architecture included the addition of a metal grill to the doorway leading into Room 2, the levelling up of walls on the north side of the atrium, the replacement of wooden lintels with concrete ones, and the construction of the roof over ala 8 with the addition of new roof tiles on some walls. In addition, several campaigns of rendering and consolidation are testified to by several grey mortars.

Walls W06.035 and W06.036 were levelled up to the same height as wall W06.034 with predominantly Sarno stone *opus incertum* with occasional pieces of grey lava. This involved the insertion of two concrete lintels over the entrances to rooms 6D and 8. On the northern side of the atrium, this was associated with the construction of the roof over the ala (Room 8) and the extension of the line of roof tiles over the newly levelled up walls. It should be noted that the roof tiles slightly change their form between the early modern and modern periods. The more modern roof tiles have flatter, squarer edges and appear to be slightly thicker. There is also a change in how the tiles are laid between the two periods, with the early modern roof having two imbrices laid on top of each other, one orientated north–south, with the upper one orientated east–west. The modern portion

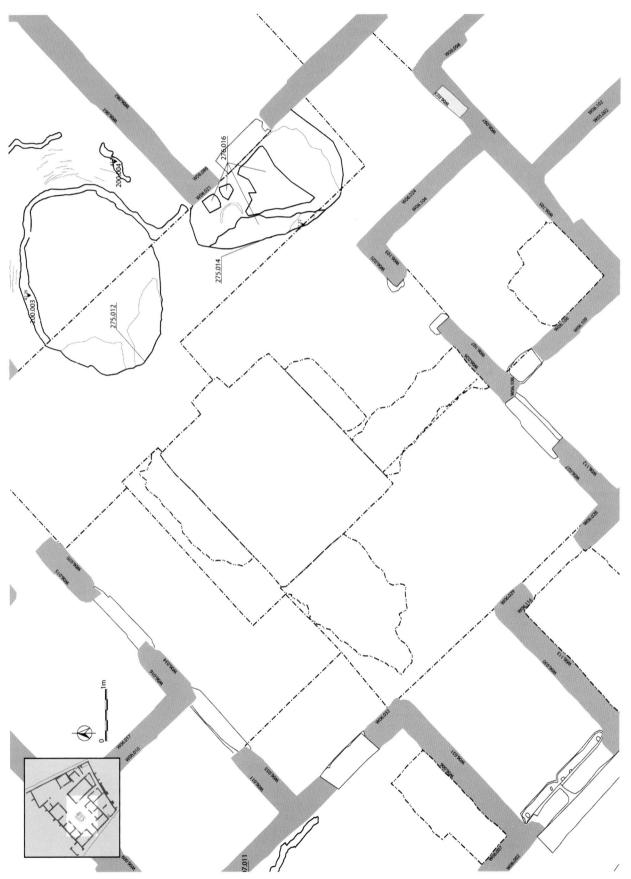

Figure 5.5.30. Plan of the changes in Rooms 5 and 8A in the final phases (illustration M. A. Anderson).

of the tiled roof only has the east–west orientated imbrices. As part of this phase of construction, however, the early modern imbrices were pointed in the same medium grey mortar associated with the construction of the new portion of the wall and new tiles. A similar reinforced concrete beam was also inserted over the doorway to Room 6B, and the area above it was also raised in height with *opus incertum* using Sarno stone set in a grey (Gley 2 2/7) mortar with large inclusions of lime.

A metal grill was attached to the doorway into the northern commercial unit to close off access between it and the atrium. A bluish grey (Gley 2 6/1) mortar with black volcanic stones and lime inclusions was used to patch up around the holes associated with the gate supports. This was presumably part of a scheme designed to control admittance to the property by the visiting public.

The surviving areas of wall plaster underwent a further period of plaster conservation where holes in the surface of the plaster were filled with a hard light bluish grey (Gley 2 8/1) mortar with black volcanic mineral and lime inclusions. The same mortar was also used to cover the exposed edges of the surviving wall plaster. On walls W06.028 and W06.029, this mortar was also used to consolidate the lower part of the wall.

The walls were finally pointed with a rough coarse light bluish grey (Gley 2 7/1) mortar that was largely used around the edges of the Sarno stone *opus quadratum* blocks. The reinforced concrete lintel above the doorway into Room 6B was replaced with a wooden one with lead sheathing where it comes into contact with the masonry. This was associated with a light bluish grey (Gley 2 7/1) mortar. Finally, a wooden brace was placed against the surviving wall plaster on wall W06.034.

6. Room 6A
South-western Cubiculum (AA183)

Description

Room 6A is situated at the south-west corner of the atrium (Room 5), occupying the space between the fauces of the Casa del Chirurgo and the southern shop in Rooms 3 and 4. Roughly rectangular in shape, the room measures approximately 5.58 m by 2.55 m. During the final phase of occupation, the room was accessible only via a single doorway near the north-east quarter of the atrium and is symmetrically arranged opposite a similarly sized and shaped room (Room 2) on the northern side of the fauces. Unlike Room 2, however, it remained entirely part of the interior of the house throughout its history. A niche and shelves were added to the room in about 100 BC, followed by a mezzanine floor in the late first century BC.

To the west, Room 6A is bounded by the reverse of the façade of the Casa del Chirurgo (W06.117) and to the north by the fauces (W06.113). A doorway at the northern end of the eastern wall (W06.114–115) leads into the atrium, while in the initial phase of the property, a small doorway in the southern wall (W06.116) would have led through into the southern portico and outdoor space. This doorway was blocked during the building changes in Phase 5, at which time a mezzanine floor was added to the room with the floor joists inserted into wall W06.116. There are no corresponding joist holes on the northern wall, indicating that the mezzanine did not encompass the entire length of Room 6A and instead was supported on a now-missing central wall. This would suggest that the room had a service function that continued into the first century AD.

Archaeological investigations

Room 6A was investigated during the 2002 field season when the area of the entire room was opened for excavation.[97] The work continued to the level of natural deposits, recovered at the base of near final phase cuts. The northern half of the room had previously been subjected to the investigations of Maiuri, who discovered what he identified as an early well in roughly the north-eastern corner. This area was re-opened partially during the 2002 investigations, but no attempt was made to clear Maiuri's backfill entirely or to recover the well that he excavated due to the same safety concerns that had caused him to abandon his excavations.[98] As a result of the extensive removal

of soils for the creation of a lime-slaking tank in the modern period, much of the sequence within Room 6A was found to be truncated. It has nevertheless been possible to reconstruct much of the development of the Casa del Chirurgo from this material, and even to situate some of the more ephemeral traces of activities within the larger framework of phases identified elsewhere within the house.

6.1 Phase 1. Natural soils

Within Room 6A, the only indication of natural soils consisted of a gritty, yellow to green silty soil with frequent inclusions of black and white volcanic scoriae (**183.132**) (Fig. 5.6.1). Although this soil frequently appears to have been excavated and then re-deposited in the southern areas of Insula VI 1, there is nothing to indicate that its appearance here was not indicative of an actual level of the natural gradient discussed in Chapter 4. Within Room 6A, this type of soil was observed in the northern section of a small sondage, cut through the base of a later lime tank in the south-west corner in order to investigate its creation. Here, it could be seen to underlie all later features and its full extent is imperfectly known, but given the ubiquitous presence of this soil in excavations south of the Casa del Chirurgo, it is probable that it originally continued in all directions. It is likely that the presence of these lower elements of the natural sequence in Room 6A indicates the general removal of the upper layers of the natural deposits, both during the construction of the Pre-Surgeon Structure in Phase 2 and later during the creation of the lime-slaking tank in Phase 8.

6.2 Phase 2. Volcanic deposits and early constructions

Activities associated with the construction, habitation, and destruction of the Pre-Surgeon Structure were not generally identified in Room 6A, largely due to the small area that was cleared to an appropriate depth, but also because of the later removal of soils involved in creating the lime-slaking tank in the modern period. Nevertheless, the deep (3.40 m) well identified by Maiuri[99] in the centre of the northern end of this room at roughly the same level as the Pre-Surgeon features recovered in Room 23 suggests that the area was involved in these early activities, and provides some meaning to a cut identified in section beneath the later lime tank (Fig. 5.6.2).

6.2.1 Pre-Surgeon terrace cut
The cut seen in the section below the later lime-slaking tank may indicate that the area of Room 6A was a

Figure 5.6.1. Plan of the deposits and features of Room 6A in Phase 1 (illustration M. A. Anderson).

component of the lower terrace of the Pre-Surgeon Structure, slightly set back from what is now the line of the Via Consolare. Here, the natural soil (183.132) was truncated on the western side by a nearly-vertical cut (**183.135**) (Fig. 5.6.3 and 5.6.4) that was visible roughly 50 cm to the east of the inner face of the later façade of the Casa del Chirurgo.[100] The cut for the creation of this wall (W06.117) was clearly observed to go through the fill of the earlier cut. Unfortunately, since the terracing cut only appears in the northern section, the other side having been destroyed later by the creation of the southern wall (W06.116) of Room 6A, it is not possible to determine the alignment or direction of the cut with any precision. Nevertheless, it seems probable that it followed a course similar to the alignment of the Via Consolare, perhaps intersecting with the hypothetical extension of the northern face of the terrace cut observed in this phase in Room 23 (263.276). Indeed,

the vertical nature of this cut, which is very similar to the terracing cuts recovered elsewhere, suggests strongly that this represents the westernmost extent of the Pre-Surgeon terracing as it reached the original course of the Via Consolare.

6.2.2 Pre-Surgeon well

The northern side of the room contained evidence for a well, roughly 0.75 m in diameter, which Maiuri identified as belonging to a phase prior to the creation of the Casa del Chirurgo on the basis of its contents. He excavated the well to a depth of 3.40 m, but then terminated the excavation due to safety concerns. He dated it's contents to the third century BC, a date which caused some consternation given the early date he wished to assign to the Casa del Chirurgo itself. Consequently, he suggested that possibly the well had continued to be used in later phases of the house. The

Figure 5.6.2. Plan of the deposits and features of Room 6A in Phase 2 (illustration M. A. Anderson).

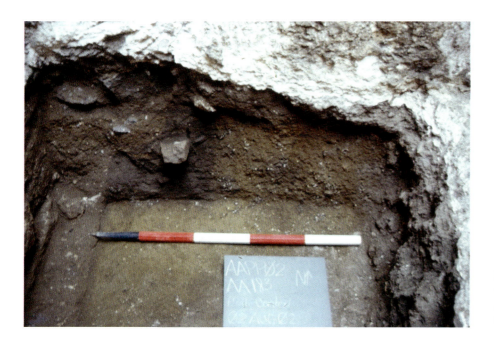

Figure 5.6.3. Northern section of the sondage under the lime tank, revealing an early terracing cut (image AAPP).

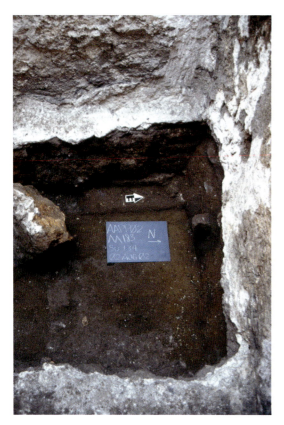

Figure 5.6.4. Western section of the sondage under the lime-tank, showing the early terracing cut and its relationship to the foundation trench for the façade of the Casa del Chirurgo (image AAPP).

fill of the third century BC or later, however, accords well with the end of the Pre-Surgeon Structure in the chronology of our excavations and no such continuation in use need be hypothesised.[101]

6.3 Phase 3. The Casa del Chirurgo (c. 200–130 BC)

This phase initially saw the destruction of the Pre-Surgeon Structure and the subsequent filling-in of the terracing cut. This was followed by the construction of the Casa del Chirurgo, during which all of the walls of Room 6A were built. Following this a floor was laid in the room and it was decorated with wall plaster.

6.3.1 Destruction of the Pre-Surgeon Structure

The Pre-Surgeon terracing cut was filled with a variety of deposits, mainly deriving from building material debris. These are likely to have been residues from the destruction of the Pre-Surgeon Structure (Fig. 5.6.5). Several of these soils in particular connect the filling activities within Room 6A with those undertaken on the whole southern side of the property (Rooms 5, 6C, 8A, 23, 10 and 11) at this time. The initial fill of the Pre-Surgeon terracing cut was a dark brown sandy clay

(183.136) containing some rubble and building debris, including the broken fragment of a *tegula* roof tile and pottery visible in section. Following this was a second distinctive soil, which was characterised by a bright orange tinge with bluish mortar inclusions (183.126). Recovered similarly within the atrium (Room 5) and areas to the east of Room 6A, this distinctive deposit may comprise of the remains of the rammed-earth walls of the Pre-Surgeon Structure itself. Found in Room 6A in the area of the threshold into the atrium (Room 5), it certainly equates this deposit with those from Room 5. Similar fill deposits were recorded elsewhere in Room 6A (183.005, 183.128), which are themselves simply remnants of much more extensive fills that were excavated and removed during the creation of the lime tank in Phase 8. Their precise stratigraphic relationship is, however, uncertain due to the interventions of Maiuri, which served to isolate several of these stratigraphic units. The filling in of the Pre-Surgeon terrace allowed for the Casa del Chirurgo to be built on a new flat level with its highest point, the tablinum, almost a whole storey taller than the properties immediately to the south in the insula.

6.3.2 Construction of the Casa del Chirurgo

After the levelling had been completed, deep foundations were cut for the walls of the Casa del Chirurgo. Excavation has revealed the foundation trenches for the southern and western walls, which were constructed at the same time. Surviving architecture demonstrates that the eastern and western walls of Room 6A were also constructed contemporaneously and that all of the walls of the room were keyed into each other.

The construction trench (183.133) for the façade of the Casa del Chirurgo (W06.117) was visible in the northern section under the later lime tank (Fig. 5.6.4). It runs roughly parallel with the large Sarno stone ashlars that form this wall. As elsewhere in the house when *opus quadratum* construction was employed, the wall rested at its base upon a wider foundation pad of Sarno stone blocks, which are roughly 10 cm wider than those placed above them. It is important to note that the foundation blocks of the façade are considerably (1.23 m) deeper than those recovered in the atrium, which nevertheless have a similar construction. It is likely that this relates to the depth and slope of the Via Consolare towards the south. The cut (183.133) is wider at height, penetrating directly through the dark sandy deposit (183.126) that filled the Pre-Surgeon terrace and narrows with a small step approximately 10 cm in width. Presumably this was because the foundations were extremely deep and the precise placement of

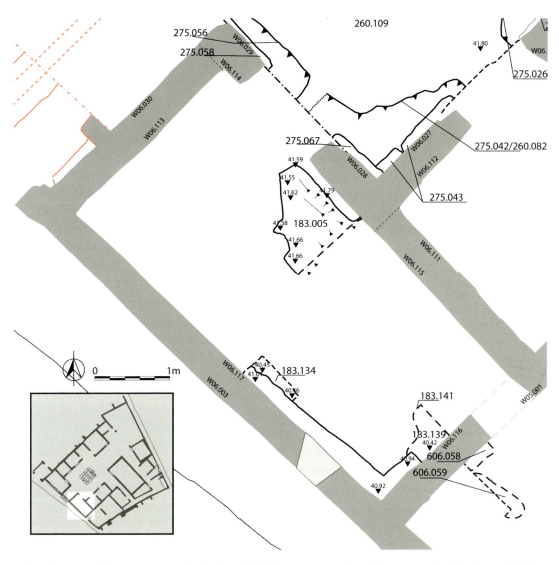

Figure 5.6.5. Plan of terrace fills in preparation for the Casa del Chirurgo recovered and documented within Room 6A (NB: some details not recorded by the excavators have been approximated in this plan from excavator notes) (illustration M. A. Anderson).

large Sarno stone blocks in the bottom of the trench would have required wider access at the top (Fig. 5.6.5). After the placement of the blocks and the creation of at the least the first few courses of the wall, the trench was filled in with a medium-brown soil (**183.134**) containing some building material. This included at least one fragment of bluish mortar similar to those from the filling deposits, which presumably had been re-excavated during the cutting of the foundation trenches for the walls and then re-buried in their fill.

At the same time, a second cut (183.141) was made on the south for the creation of wall W06.116. Although excavation produced an awkward shape for this cut, after the creation of the wall, it was filled with an orange-brown soil which was noted as being similar to the fills through which the foundation trenches themselves had recently been cut. Since wall W06.116

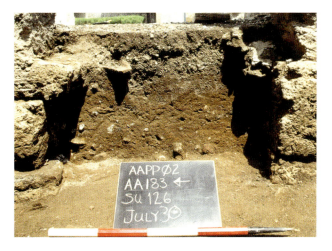

Figure 5.6.6. Orange soil with bluish mortar inclusions characteristic of the filling of the Pre-Surgeon terrace cuts, situated at the eastern doorway of Room 6A (image AAPP).

was constructed in *opus africanum*, it was not necessary for the foundation trench to be as wide or as consistent as was required for the construction of the front façade in ashlar blocks.

From the standing architecture it is clear that all of the walls of Room 6A were constructed as part of the initial build of the Casa del Chirurgo. The western wall of Room 6A (W06.117) was formed by the façade of the property and was constructed in *opus quadratum* using large blocks of Sarno stone. Faint traces of a very pale brown (10 YR 7/3) clay was recovered from in between the courses of the ashlars. Where the façade joined wall W06.113 at its northern and wall W06.116 at its southern end, it was keyed in using large Sarno stone blocks. The remainder of these walls was constructed in *opus africanum* using Sarno stone for both the framework and the rubblework infill. There are two large, irregularly shaped blocks of Nocera tuff in the central section of the *opus africanum* of W06.113, forming an exception to this rule. They may consequently represent a repair to the infill of the wall; although due to the modern pointing around them, it is impossible to separate this from the original wall construction. The *opus africanum* rubblework was bonded with the same very pale brown clay that was used to bond the *opus quadratum* elements. At the eastern end of W06.113, *opus quadratum* blocks are further used to form the corner of the room and to create the doorway in W06.114/W06.115, with *opus africanum* making up the main area of the wall.

At the western end of W06.116, there are traces of a small arched doorway, approximately 0.57 m wide and 1.8 m high (from the modern ground surface). This is an unusual location for a doorway, which also rather narrow and short. Nevertheless, the doorway appears to have been part of the primary build of W06.116 and may well have simply provided low-status access from Room 6A to the southern portico.

6.3.3 The initial decoration and occupation of Room 6A

It is likely that wall W06.117 incorporated a low shelf at its northern end during Phase 3 (Figs. 5.6.7 and 5.6.8). This is seen by the presence of two small square holes that would have provided the support for the shelf. The southern beam hole measured 80 by 80 mm and the northern one 70 by 70 mm. The distance between the two beam holes spans 1.62 m. The shelf has been assigned to this phase since the northern beam hole was filled with the plaster of Phase 4, and the shelf must have been out of use by this time. It also appears to have continued onto the western end of wall W06.113 where there are identical upper and lower square holes for wooden shelf supports (Fig. 5.6.9). Here the upper

and lower beam holes measure 50 by 50 mm. The lower beam hole was always offset to the right by between 40–120 mm.

There are faint traces of an initial layer of plaster that is visible on all of the walls of Room 6A. This was composed of a white (Gley 1 8/N) plaster with occasional black volcanic mineral inclusions. No evidence survives for the initial floor layer in Room 6A. It is suggested, however, that an elevation equal to that of the north–south drain that runs from the impluvium of the Casa del Chirurgo is a likely elevation for a now-missing, earthen floor.

6.4 Phase 4. Changes in the Casa del Chirurgo (c. 100–50 BC)

The second major phase of activity in Room 6A is seen only in the standing architecture of the room and is characterised by the addition of further shelves and a niche. The new shelves would suggest a continuation of the storage function of the room, although the original shelf in W06.117, which had been present in the initial phase, was removed at this time. It would appear that prior to any developments, the previous phase of plaster was largely removed from the walls of the room. A small (0.37 m by 0.37 m) niche with a semicircular top was cut into the one of the ashlar blocks at the western end of W06.113, in which the chisel marks are still observable (Fig. 5.6.9). The hole created during the construction of the niche in the surrounding Sarno stone was squared up with a white (10 R 8/1) plaster with occasional small black volcanic mineral inclusions. This was smoothed flat to create a surface suitable for the application of a skim of lime wash. It is also likely that the adjacent rectangular cut (0.33 by 0.13 m) into the Sarno stone was made at this time, as the base of it was also repaired using the same white mortar with small black inclusions. It is difficult to be definitive as to the function of this cut. Perhaps it was for a lamp to help light the niche? Four square (c. 0.1 by 0.1 m) beam holes were cut into W06.115 (Fig. 5.6.10). These would have supported a shelf, of approximately 3 m in length. The shelf was approximately 2 m above the present day floor level. It was built prior to the decoration of the wall, as the backing plaster from this phase was also used to repair the damage to the Sarno stone *opus africanum* header caused by the excavation of the beam socket holes for the construction of the shelf.

There is some evidence to suggest the presence of a tile shelf at the western end of wall W06.116 that spanned the junction between W06.116 and W06.117 (Fig. 5.6.11). It was approximately 1 m above the present ground level.

Following the addition of the shelves and niche to

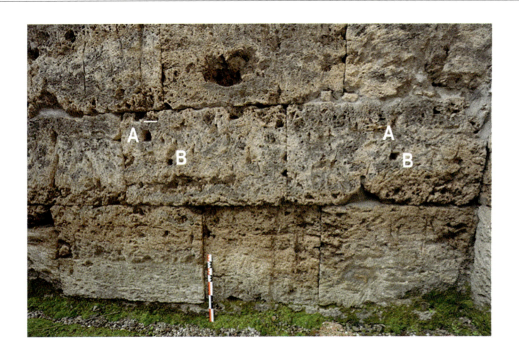

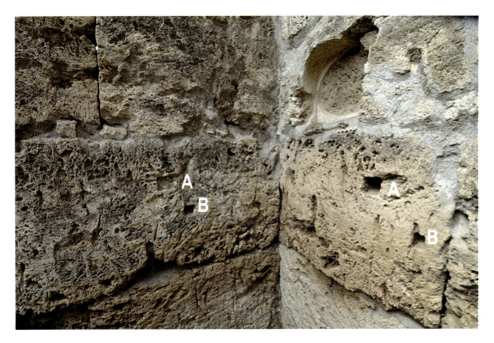

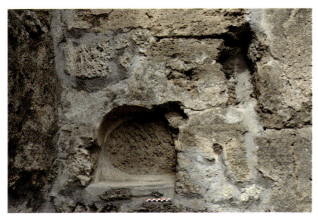

Top to botom:

Figure 5.6.7. Support holes for a shelf on wall W06.117. (A) upper support hole; (B) lower support hole (image D. J. Robinson).

Figure 5.6.8. Support holes for a shelf on wall W06.117. (A) upper support hole; (B) lower support hole (image D. J. Robinson).

Figure 5.6.9. Niche in W06.113, with a rectangular cut above and to the right of it possibly for a lamp (image D. J. Robinson).

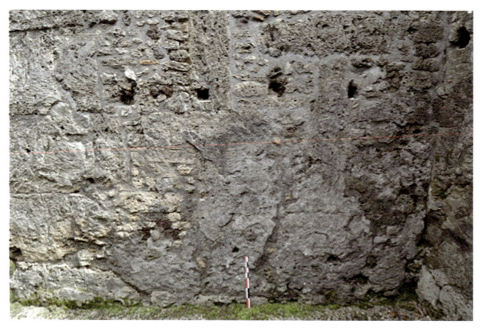

Figure 5.6.10. Beam holes for a shelf in W06.115 (image D. J. Robinson).

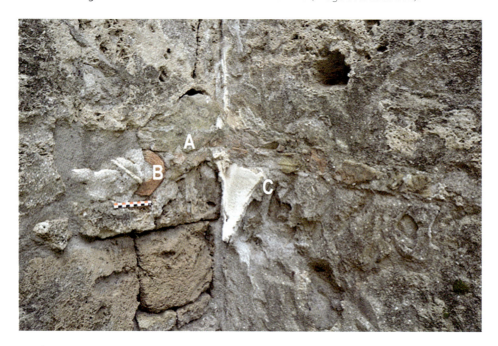

Figure 5.6.11. Tile shelf between W06.116 and W06.117. (A) remnants of brick/tile shelf; (B) repairs following the removal of the shelf; (C) Phase 4 plaster (image D. J. Robinson).

the walls of Room 6A, a new coat of wall plaster was required. A rough light bluish grey (Gley 2 8/1) plaster with intense coarse black rounded sand inclusions, including occasional pieces of lime and ceramic, was used as a backing plaster. This was simply smoothed to create a flat surface for the application of a thin layer of fine white (1 R 8/2) plaster, as seen on walls W06.113, W06.115, and W06.116.

6.5 Phase 5. Redecoration and redevelopment (late first century BC to early first century AD)

Like many of the rooms in the Casa del Chirurgo, Room 6A underwent a significant period of alteration during Phase 5 (Fig. 5.6.12). This involved the filling in of the small arched doorway in W06.116 and the creation of a mezzanine floor at the southern end of the room. The closure of the small doorway was also related to

the creation of the southern shop unit (Rooms 3 and 4), which has been dated to the late first century BC. Importantly, it would appear that these changes did not alter the utilitarian nature of this space, which continued from the previous phase.

6.5.1 The addition of the mezzanine floor

The major structural change during Phase 5 was the addition of a mezzanine floor to Room 6A. At this time, the small arched doorway at the eastern end of W06.116 was closed with *opus incertum*, composed of pieces of black lava, cruma, and Sarno stone set in a very pale brown (10 YR 7/3) mortar with angular black volcanic mineral inclusions, and the occasional piece of lime that was smoothed around the edges of the stones (Fig. 5.6.13, A). It should be noted that this same mortar was

also used to smooth and repair the sections of *opus africanum* rubblework of the four eastern beam holes of the mezzanine (Fig. 5.6.13, B). Consequently, it is suggested that the doorway was filled at the same time that the mezzanine was inserted. This also involved cutting a further three beam holes into the Sarno stone blocks at the western end of W06.116 (Fig. 5.6.13, C). The beam holes corresponded with a large rectangular cut on W06.117, measuring 0.32 by 0.1 m, which would have held a cross-beam into which the beams from W06.116 would have fitted. The area above the newly cut beam slot was repaired with brick/tile set in the same very pale brown mortar used in the creation/repair of the beam holes in W06.116.

There are no corresponding beam holes on the northern wall (W06.113) of Room 6A, which would

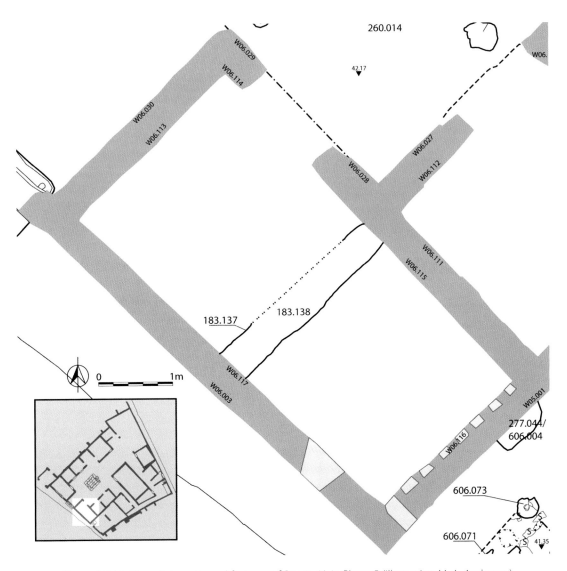

Figure 5.6.12. Plan of deposits and features of Room 6A in Phase 5 (illustration M. A. Anderson).

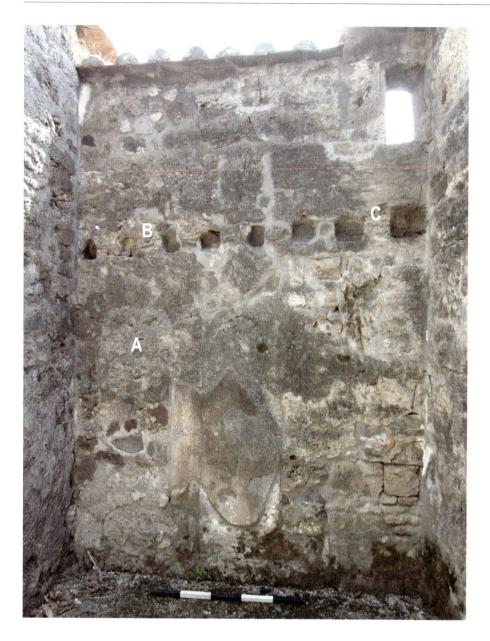

Figure 5.6.13. Wall W06.116. (A) fill of narrow arch-like doorway; (B) eastern mezzanine beam holes with brick/tile repairs; (C) western beam holes cut into Sarno stone (image M. A. Anderson).

indicate that the mezzanine level did not continue across the entire extent of the room. Instead, it must have been confined to the southern half of the room and was supported in the centre of it by a new wall of *opus incertum*. In order to create the *opus incertum* dividing wall, a trench (**183.137**) was cut for insertion of the foundations (**183.138**). The cut truncates the previous cuts and fills mentioned above, which were visible in the northern section of the later lime tank (183.133, 183.134, 183.135, 183.136 and 183.132). While later intervention in the area related to the re-use of at least part of this wall's foundations for one side of the lime tank has confused the stratigraphy, the original cut may be deduced since the wall foundations (**183.138**) generally filled the cut. Notably, very little of the original upper part of the *opus incertum* wall

survives today. The wall can be seen to have spanned the entire width of the room, running from west to east. It is likely that there would have been a doorway in this wall to allow access into the space underneath the mezzanine floor, which would have been a dark, cellar-like space lit only by the narrow lower window. Equally, there would also have been a stair case – or perhaps a ladder – with which to ascend to the space above that would have located in the northern part of Room 6A. No evidence, however, has been preserved for either the doorway in the east–west wall or means of accessing the mezzanine.

On W06.115 it is likely that the shelf from the previous phase was removed as part of the changes associated with the addition of the mezzanine. This is suggested by the heights of the beam holes for the

mezzanine floor in W06.116. Here they are located at c. 2.15 m above the ground surface. This would have allowed only c. 0.1–0.15 m of clearance for items on the shelf. The construction of the new floor resulted in a small patch of repair to W06.115, which was undertaken in *opus incertum* using pieces of tile, cruma, and Sarno stone set in the same very pale brown (10 YR 7/3) mortar with angular black volcanic mineral inclusions and the occasional piece of lime that was used to help create the beam holes for the mezzanine floor in W06.116.

6.5.2 Decoration of Room 6A

It would appear that a new phase of decoration in Room 6A was undertaken at the time of the addition of the mezzanine floor. This would have included the removal of much of the Phase 4 final white plaster from the walls of the room and the picking of the backing plaster, as seen on W06.115. At the southern end of the cross beam hole in W06.117, a light bluish grey (Gley 2 8/1) plaster with angular black volcanic mineral and lime inclusions was used to pack the remainder of the rectangular cut once the cross beam was in place. This is the backing plaster that was used throughout Room 6A during this phase of decoration. It is also significant to note that the upper and lower windows in wall W06.117 were also lined with this plaster and were then given an extremely thin final white (7.5 YR 7/1) surface. This would perhaps suggest that the upper and lower windows were installed at the time of the construction of the mezzanine to provide light to its upper and lower portions.

Beneath the mezzanine floor, at the junction between W06.116 and W06.117, the shelf from Phase 4 was removed and its hole filled with brick/tile bonded with the same coarse light bluish grey (Gley 2 8/1) backing plaster with black volcanic and lime inclusions that was used above the level mezzanine floor and in the windows (Fig. 5.6.13). It was also used as a backing plaster on the lower part of W06.117 and was faced with a very thin layer of plaster with crushed and powdered ceramic and occasional fragments of black volcanic minerals, which gave the plaster an overall light red (10 R 6/8) colour. This was a utilitarian and hardwearing *opus signinum*-like plaster, which was also seen on W06.115 and W06.116. During the excavation of the room, these plasters were assigned the numbers 183.021, 183.081, and 183.036. A single example of this plaster (183.056), had a place in the stratigraphic sequence of the sub-soils because it was found to be underlying the plaster/lime lining of the lime tank (183.027) of Phase 8.

6.6 Phase 6. Upper storeys and final decoration (c. mid-first century AD)

The only traces of activity from Phase 6 within Room 6A consist of a final layer of white (10 R 8/1) plaster with mineral crystal inclusions in the niche in W06.113. Such a plaster is highly characteristic of the final plaster seen throughout the house in this period and possibly indicates that at least the niche in the room was redecorated during the final ancient phase of activity.

6.7 Phase 7. Post-earthquake changes

No traces of this phase were recovered from this area.

6.8 Phase 8. Eruption and early modern interventions

The early modern period saw significant changes to Room 6A related to the first excavations in the Casa del Chirurgo and early attempts at restoration and conservation. The most dramatic of these changes was the creation of a large-scale lime-slaking tank in the southern half of the room. Although not mentioned in any recorded literature, it seems likely that the Bourbon investigators or later restorers excavated this feature in order to supply materials for the restoration of much of Insula VI 1 and the surrounding areas.

6.8.1 Lime-slaking tank

The foundations of the east–west wall (**183.138**) were reused as the northern retaining wall for the lime tank while on the south, east, and west, it was bounded by the walls of Room 6A (Fig. 5.6.14). At just over a metre in depth, its base coincided with the elevation of the lower, wider foundation Sarno stones of the façade of the house. Against the foundations, a fill of rubble and building material (presumably in order to level up the bottom of the tank) was placed immediately prior to finishing its surface. This consisted of roughly 20 cm of mixed rubble and loose building material which was seen two distinct layers – an upper, coarse mix (183.130) that notably contained terra sigillata (red gloss), fragments from an *opus signinum* floor, and large pieces of Sarno stone. It was clearly distinguished from a greyish deposit with some plaster and small black inclusions (183.131). Both of these deposits were excavated as **183.129**[102] due to time constraints and were interpreted as levelling layers under the tank. It is not entirely clear, however, why levelling would have been necessary, unless an original plan to cut deeper into the soils had been foiled by the wide Sarno stones. On the western side of the remains of the east–west partition wall, a patching of mortar and small stones (**183.140**) was recovered which must relate to the reuse

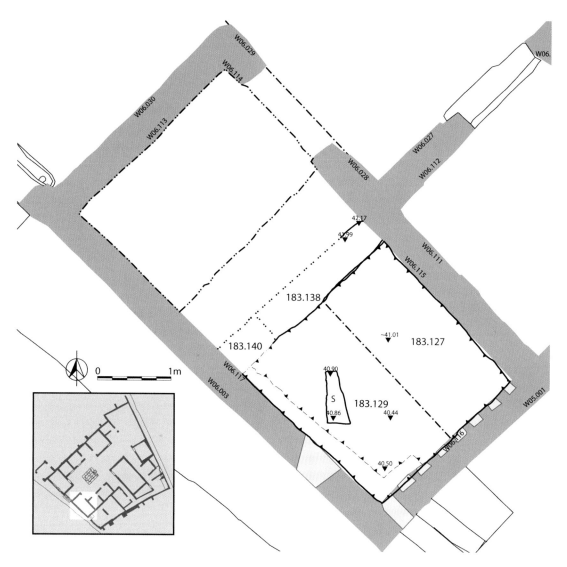

Figure 5.6.14. Plan of lime tank in Room 6A during Phase 8 (illustration M. A. Anderson).

of the wall for the lime tank. The inside of the tank appears to have been lined with a course plaster or lime (**183.127**), which still preserved marks from tools on its surface. This may simply have been residues and accretions from the use of the tank itself.

6.8.2 Use of the lime tank

The tank was used for the slaking of lime, producing a number of confused deposits including pure lime and lime mixed with other materials (Figs. 5.6.14, 5.6.15, 5.6.16, 5.6.17). After the initial coats of lime or plaster, the tank was filled with a variety of different deposits related to its use and subsequent disuse. Piled up in the corners of the tank were several deposits of pure white lime found streaked with black gritty sand (**183.117, 183.122**). Above this was a thicker clay-like layer (**183.118, 183.120**), particularly in

the south and south-west. Overlying these remnants of the lime itself was a heavier deposit of grey clay-like material (**183.116** on the west = **183.121** on the eastern side), which filled in between the corner deposits and presumably was the reason for their thin coating in grey clay-like material. Additional components of this grey clay-like deposit are **183.009** and 183.008, which were situated in the north-west corner at a higher level due to a thicker deposit of pure lime underneath. Similar grey clay-like material was recovered running over the edge of the lime tank on the eastern side (**183.006**) and may have represented a more substantial deposit truncated on the north by Maiuri's excavations in this area, which notably appear to have avoided the area of the lime-tank entirely. Related to this deposit was a nearly circular feature consisting of charcoal (183.007), which

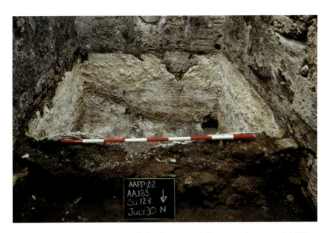

Figure 5.6.15. Overview of the lime tank feature (image AAPP).

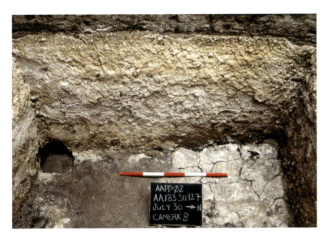

Figure 5.6.16. Detail of the fills of the lime tank on the western side (image AAPP).

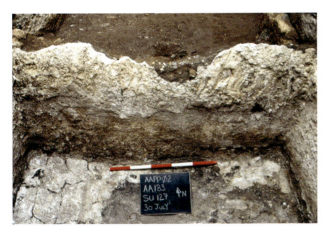

Figure 5.6.17. The lime tank and remnants of the mezzanine dividing wall reused as the northern wall of the tank (image AAPP).

may have been the residue from a component of the workings of the lime tank itself.

After the use of the lime tank, it appears to have lain exposed for some time. It is likely that the traces of water damage to the ancient fill of the lime tank (183.009) occurred during this time and appears to

derive from drips falling from the roof tiles that had been placed along the tops of the walls to conserve them. Eventually the tank must have been reburied. The fills of the tank (183.003, 183.004) contained a glazed pottery and a clay pipe, both of early modern origin. The matrix of the soil was noted as loamy and loose with inclusions of lapilli, which were probably residues from the original excavations (Fig. 5.6.18).

6.8.3 Rebuilding the walls

The upper sections of W06.113 and W06.114/W06.115 were rebuilt in the early modern period with the addition of 0.25 to 1 m high sections of *opus incertum*, consisting of a mixture of large, irregularly shaped blocks of Sarno stone with pieces of tile and smaller pieces of Sarno stone and cruma. Modern pointing obscures the mortar used to bond the *incertum*. It is possible that the wooden beam used as the lintel over the doorway in wall W06.114/W06.115 into Room 5, the atrium, may also belong to this period of restoration. The purpose of this reconstruction was to raise the walls to a consistent height in order to accommodate a row of roof tiles that would have offered some protection from the elements to the core of the wall. The roofing tiles, which were added to W06.113, W06.114/115, and W06.117 were bedded on a coarse light bluish grey (Gley 2 7/1) mortar with lime inclusions. A layer of light bluish grey (Gley 2 8/1) mortar render was applied to the wall in the area immediately beneath the roof tiles on W06.113. The same mortar was also used to point around the large Sano stone blocks in the centre of the *opus africanum* section of the wall. An additional protective render of hard light greenish grey (Gley 1 8/1) mortar, including pieces of lapilli and lime, was also added to the lower portion of the fill of the small doorway of W06.116. This rendering layer may once have covered more of the wall. From the stratigraphic relationship of the rendering mortar to the roof tile bedding mortar, it is possible to note that the wall was rendered before the roof tiles were added.

6.9 Phase 9. Modern interventions

Modern interventions in the area include the excavations of Maiuri and modern build-up and detritus since the house's initial excavation. These also include further conservation and restoration efforts (Fig. 5.6.19).

6.9.1 Excavations by Maiuri

The earliest of these activities is the excavation in the northern half of Room 6A by Maiuri. It is likely that Maiuri's trenches might have sloped downward

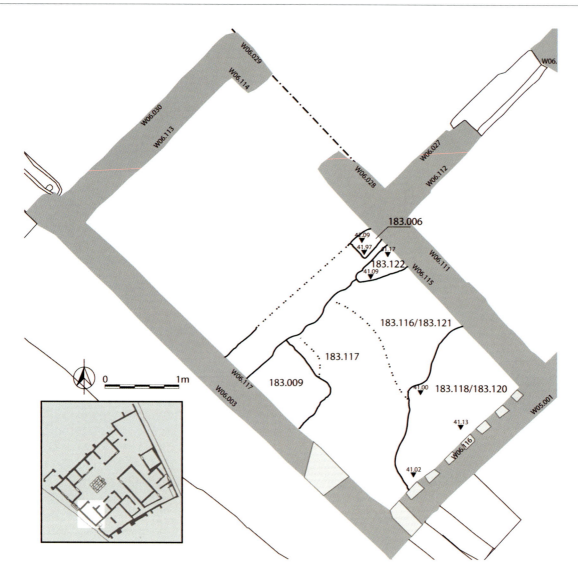

Figure 5.6.18. Plan of the fills of the lime tank (illustration M. A. Anderson).

from the doorway towards the west for the purpose of access. The excavations seem to have focused on the northern side and line up very neatly with the edge of the lime tank, which might suggest that at least the northern wall of this tank (183.138) was used as a guide for his excavations. If so, he failed to mention it at all in his report. The southern area of the room was then refilled with a thin layer of modern material overlying the Bourbon dated fill of the lime tank (183.002). This matched a similar deposit (183.119) that consisted of the backfill of Maiuri's excavations in this room. On the northern side of the lime tank wall, silty sandy deposits were recovered (183.123 = 183.124), in combination with a sterile soil located in the doorway between Room 6A and Room 5 (183.125), all of which probably represent further post-Maiuri filling.

6.9.2 1970's Plaster restoration
The surviving large central section of wall plaster on W06.116 was edged with a protective coating mortar that varied in colour between light grey (10 R 7/2) and light bluish grey (Gley 2 7/1), depending upon its degree of weathering. The same mortar was also used to fill in several holes in the surface of the plaster, where it was smoothed to create a flat surface.

6.9.3 2000's Building restorations
All of the walls in Room 6A were pointed with a rough light bluish grey (Gley 2 7/1) mortar, which was applied between the surviving large ashlar bocks and in particular around the rubblework of the *opus africanum* sections of the walls. On W06.113, this was followed by the restoration of the niche. Here the base

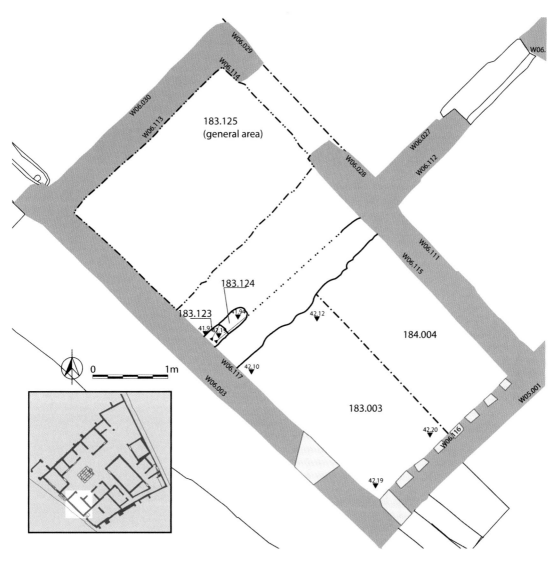

Figure 5.6.19. Plan of the final fills of the tank and modern build-up (illustration M. A. Anderson).

of the niche was repaired and the surviving edges of the white wall plaster were edged in a rough white (2.5 Y 8/1) mortar containing large amounts of fine white quartz fragments. Finally, overlying all earlier deposits, a layer of modern bluish gravel was placed in order to preserve the underlying archaeology and reduce the development of dust through exposure (183.001).

7. Room 6B
Southern-central Cubiculum
(not excavated)

Description
Room 6B is the second cubiculum from the west on the southern side of the atrium of the Casa del Chirurgo and had a single doorway into this central space. The room measures 2.75 m by 2.75 m. Room 6B was created during the initial construction of the Casa del Chirurgo with all four walls keyed into each other. Wall W06.108/112 was part of the continuous *opus quadratum* wall of the south side of the atrium, to which W06.109 and W06.111, the eastern and western walls of the room, were keyed. These were themselves keyed into W06.110, which was part of the southern boundary wall of the atrium house. Room 6B remained largely unchanged structurally until the end of the first century BC when a new threshold and *opus signinum* floor was laid in the room and a small doorway opened into the adjacent Room 6B. A small step was created in the doorway to Room 6C in the mid-first century AD, probably to ensure that whatever 'rebuilding' activities were taking place in Room 6C did not spill over into Room 6B, which most likely remained a small simply decorated service cubiculum.

7.1 Phase 1. Natural soils
No evidence of this period was recovered in this area.

7.2 Phase 2. Volcanic deposits and early constructions
No evidence of this period was recovered in this area.

7.3 Phase 3. The Casa del Chirurgo (c. 200–130 BC)
7.3.1 The construction of Room 6B
All of the walls of Room 6B were constructed as part of the initial build of the Casa del Chirurgo. Wall W06.108/112 was built from large blocks of Sarno stone using the *opus quadratum* building technique to form the doorway in the wall into the atrium. It should be noted that the *quadratum* blocks on the western side of the doorway are chamfered. It is possible that this feature, which was also present on some of the other primary doorways into the atrium, is a design feature that dates back to the initial construction of the house. Support for this comes from the presence of the initial layer of backing plaster over the chamfering. This would suggest that the backing plaster was added to the wall prior to the fitting of any wooden doorframe (Fig. 5.7.1, A).

The remaining walls of Room 6B, W06.109–111, were all constructed in *opus africanum* using Sarno stone for both the framework and predominantly Sarno stone and occasional pieces of cruma and Nocera tuff in the rubblework infill that was bonded with a very pale brown (10 YR 7/3) clay with very occasional inclusions of black volcanic minerals. At the northern end of wall W06.109, the *opus africanum* is keyed into the large Sarno stone *opus quadratum* blocks of walls W06.108/112 and W06.107.

7.3.2 The Phase 3 decoration of Room 6B
All of the walls of Room 6B show traces of the first layer of backing plaster. This was comprised of a white mortar (2.5 YR 8/1) with black volcanic mineral inclusions and occasional pieces of lime, which in places has a distinctly bluish grey (Gley 2 6/1) hue. This was flattened at the surface to enable the application of a final layer, which is observable on walls W06.108/112 and W06.110 as a thin layer of pink (2.5 YR 8/3) plaster with inclusions of crushed ceramic within a white matrix.

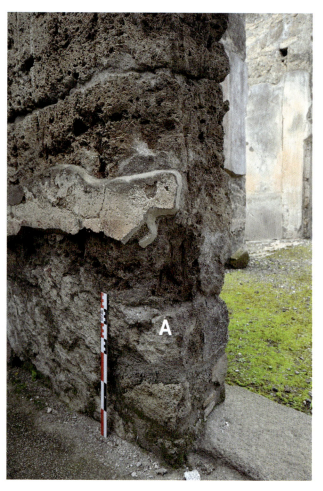

Figure 5.7.1. Phase 3 backing plaster covering the chamfer on the doorway in wall W06.108/W06.112 into the atrium (Room 5). (A) Phase 3 plaster (image D. J. Robinson).

7.4 Phase 4. Changes in the Casa del Chirurgo (c. 100–50 BC)

No evidence of this period was recovered in this area.

7.5 Phase 5. Redecoration and redevelopment (late first century BC to early first century AD)

7.5.1 The laying of the opus signinum floor and addition of the grey lava threshold

A new floor surface made from *opus signinum* was laid in Room 6B, which was also associated with the addition of the grey lava threshold into the atrium. Such thresholds are common throughout the atrium and their insertion has been dated to the late first century BC. The new floor also appears to 'lip up' at its edges roughly where the ceramic-rich plaster surface from Phase 3 would have been. The insertion of the new threshold stone resulted in damage to the bottom of the doorway on wall W06.108/112 and also wall W06.109, which was patched up with a small amount of *opus incertum* using Sarno stone rubble and pieces of brick/tile (Fig. 5.7.2, A). On wall W06.109 the damage was repaired with a very hard light grey (5 YR 7/1) mortar with occasional black volcanic mineral inclusions. Unfortunately modern pointing obscures the bonding material for the *opus incertum* of wall W06.108/112, although it is assumed to be the same as for wall W06.109.

7.5.2 The opening of the small doorway into Room 6C

At this time a small doorway was also cut in wall W06.109 to provide access to Room 6C. As part of this event the southern side of the doorway was repaired with pieces of brick/tile and squared off Sarno stone. These were set in a white (5 YR 8/1) mortar with black volcanic stone and occasional quartz inclusions and larger pieces of lime. The *opus africanum* rubblework of wall W06.110 was repaired either side of the Sarno stone header of the *africanum* framework in the centre of the wall. This was undertaken using courses of brick/tile and *opus incertum* using cruma and black lava rubble set in a pinkish white (7.5 YR 8/1) mortar with angular black volcanic mineral fragments, black and red cruma, and tuff.

7.5.3 The Phase 5 wall decoration

Following the laying of the floor in Room 6C, the previous phase fresco would have been carefully removed in order to retain the backing plaster of the previous phase for reuse, which on wall W06.108/112 was lightly roughened to prepare it to receive a new layer of backing plaster. This was a relatively thick (20–30 mm) layer of a light bluish grey (Gley 2 8/1)

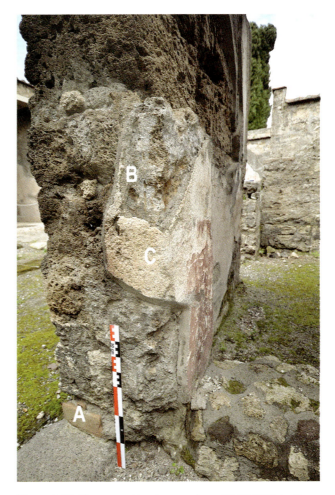

Figure 5.7.2. Plasters on the doorway in wall W06.109 into Room 6C from Room 6B. (A) Opus incertum repair to wall; (B) Phase 5 backing plaster; (C) Phase 6 or 7 final plaster (image D. J. Robinson).

plaster containing inclusions of black/brown sand and the occasional larger piece of lime. This plaster was flattened to receive the final fresco surface. On wall W06.109, the plaster overlies the *opus signinum* floor surface, which also carries on through the doorway into Room 6C (Fig. 5.7.2, B), as does the backing plaster on wall W06.108/112. On wall W06.111 there are the traces of a final layer of fresco overlying the backing plaster, which has now weathered to a weak red (10 R 5/4) colour.

7.6 Phase 6. Upper storeys and final decoration (c. mid-first century AD)

7.6.1 The final phase wall decoration

It would appear that the final surface of the previous phase of plaster was carefully removed from wall W06.108/112. This is seen by the small striations in the surface of the Phase 5 backing plaster, which indicates that a small comb-like tool was used to carefully strip

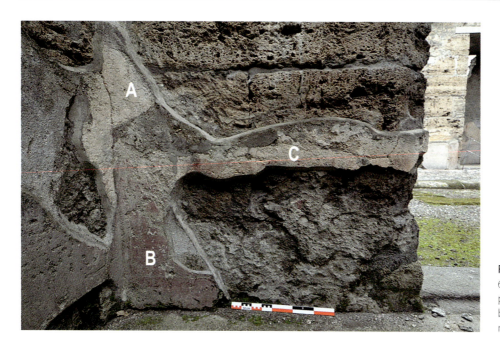

Figure 5.7.3. Wall W06.108 Phase 6 or 7 plaster. (A) white crystalline plaster; (B) pale red plaster; (C) border between white and pale red plasters (image D. J. Robinson).

the previous final layer from the wall to preserve the previous backing plaster for reuse. This was now covered with two thin layers of plaster, which are also seen on all of the other walls of Room 6B, apart from W06.110, which was extensively repaired in the early modern period. In the upper portion of the walls, a white (10 R 8/1) plaster containing translucent mineral crystals was applied (Fig. 5.7.2, B and 5.7.3, A). In the lower portion of the walls, a plaster with a similar white mortar matrix was used, although it contained fewer crystals and inclusions of crushed ceramic and black volcanic minerals, giving the plaster an overall pale red (10 R 7/3) hue (Fig. 5.7.3, B). The white crystalline plaster in the middle zone of the wall was applied before pale red plaster in the lower zone, although both form part of the same phase of decoration. The plaster in the upper part of the wall was left white, whereas in the lower 0.75 m of the wall, red pigments were added giving the plaster today an overall pale red (10 R 7/3) colour, that this varies to a dark red (10 R 3/6) where the fresco has suffered least from weathering. In the northern and southern corners of wall W06.111, adjacent to walls W06.108/112 and W06.110, there is evidence to suggest that a 40 mm wide border of red was also used to edge the white middle zone of the final surface (Fig. 5.7.3, C). On wall W06.108/112, the lowest horizontal band of the border is 0.18 m above the present floor level.

7.7 Phase 7. Post-earthquake changes
7.7.1 The insertion of the opus incertum 'step' between Rooms 6B and 6C
The final ancient event in wall W06.109 was the insertion of the 'step' in the narrow doorway between Rooms 6B and 6C (Fig. 5.7.4). This was composed of a rough opus incertum of Sarno stone and black lava. The feature has been extensively pointed in the modern period, which unfortunately precludes a description of its original construction mortar.[103] With reference to the features observable in Room 6C, however, it is suggested that the insertion of this step took place in the post-earthquake period. Perhaps the function of the step was to keep the rebuilding works in Room 6C apart from Room 6B, which appears to have remained otherwise untouched in this phase and presumably continued to operate as a small service cubiculum. Alternatively, the step may also represent the remains of the base of a wall blocking the doorway between the rooms.

7.8 Phase 8. Eruption and early modern interventions
7.8.1 Wall reconstruction
The upper 0.5 m of wall W06.110 was rebuilt with large blocks of Sarno stone with the occasional piece of red cruma and brick/tile. These were set in three rough courses and bonded with a light greenish grey (Gley 1 8/1) mortar with angular black volcanic rock and tuff, nclusions, likely lapilli. The northern and southern portions of wall W06.109 was also rebuilt and it is likely that the wooden lintel would have been inserted over

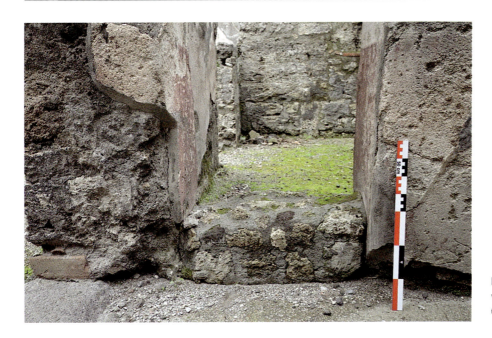

Figure 5.7.4. Step in the doorway of wall W06.109 between rooms 6B and 6C (image D. J. Robinson).

the doorway into Room 6C. The area above the lintel was packed with pieces of brick/tile. This area was heavily pointed in the modern period, obscuring any details of the mortar with which this may have been fixed. The western end of wall W06.108/112 was also raised in height by c. 0.25 m in order bring it up to the same height as other walls in the south western corner of the atrium. The same light greenish grey mortar that was used in the rebuilding of the wall W06.110 was used as a thick render on all of the walls of Room 6B. This mortar weathers to a darker greenish grey (Gley 1 6/1) colour. At the intersection of wall W06.110–111, the render was also bulked out using pieces of brick/tile. Following the reconstruction and rendering of the walls of Room 6B, a line of roof tiles was set upon the uppermost surviving *opus quadratum* block at the western end of wall W06.108/112 and also on walls W06.109 and W06.111. These were bedded on a light bluish grey (Gley 2 7/1) mortar with lime inclusions that was spread down the wall.

7.8.2 Plaster conservation

An early modern attempt at plaster conservation can also be seen on wall W06.109, which involved the use of a fine light grey (10 YR 7/2) mortar to fill a crack in the final surface of the plaster.

7.9 Phase 9. Modern interventions

7.9.1 1970's restoration campaign

The upper 0.5 m of the western portion of wall W06.108/113 was rebuilt during the modern period with pieces of Sarno stone, cruma, and black lava set in

a set in a very hard white (5 R 8/1) mortar with black volcanic mineral inclusions. This rebuild was associated with the insertion of a reinforced concrete lintel over the doorway in to the atrium. The newly rebuilt wall was topped with a line of roof tiles that appear to be set in the same mortar as was used to reconstruct the wall.

7.9.2 Continued plaster conservation/restoration

The exposed edges of the surviving wall plaster on walls W06.108/112, W06.109, and W06.111 were capped with a hard light grey (Gley 1 7/N) mortar with black stone inclusions. The same mortar was also used to fill in and repair cracks in the final fresco surface. The stratigraphic relationship between the mortars used in the repairs of wall W06.109 would suggest that the surface of the plaster was done first, followed by the edging.

7.9.3 2000's restoration campaign

The final set of interventions on walls W06.108/112, W06.110, and W06.112 saw their pointing with a rough light bluish grey (Gley 2 8/1) mortar with black volcanic stone inclusions and the occasional piece of lime. This was used to fill in between the gaps of the large Sarno stone *opus quadratum* blocks, to patch up some holes in the walls, and to fill around the western end of the concrete lintel in wall W06.108/112. This appears to have been associated with the replacement of the concrete lintel over the doorway in wall W06.108/112 with one made of wood with a lead lining. This was bonded with the same light bluish grey mortar (Gley 2 8/1) as was used to point the wall.

8. Room 6C
South-eastern Cubiculum
(AA184 and AA609)

Description

Room 6C is the third cubiculum from the west on the southern side of the atrium of the Casa del Chirurgo, and had a single doorway on the northern side. The room is relatively small, measuring only 3.46 by 2.71 m. The use of this room during the final phase is unclear, but it appears to have been relatively menial and was plausibly involved in the building activities underway at this time.

Archaeological investigations

Stratigraphic excavations in Room 6C were carried out during two separate seasons, the first in the summer of 2002 (AA184), with a second, follow-up excavation in the summer of 2006 (AA609).[104] This latter phase was undertaken in tandem with the finalisation of excavations within the atrium (Room 5) and permitted important early phase interconnections between these two areas of the house to be recorded in tandem. Both seasons of excavation concentrated on the entire area of Room 6C and produced evidence from the full spectrum of phases identified within the Casa del Chirurgo as a whole. The first season did not reach natural soils except in the section of a trench cut during the previous excavations of Maiuri that runs eastward from the south-western corner of the room for approximately 1.96 m.[105] Excavations during the second campaign uncovered the top surface of natural soils only on the eastern half of the area. An initial analysis of the standing architecture of Room 6C was undertaken as part of the two seasons of excavation in the room.[106] The walls were documented individually and their interpretations were checked and then later amalgamated into a coherent narrative for the entire room during three further seasons of architectural analysis in 2006, 2009, and 2013.

8.1 Phase 1. Natural soils

Excavations in Room 6C reached the underlying natural soils, whose stratigraphy followed the pattern established for the majority of Insula VI 1. The eastern half of the room produced the best evidence for these levels, where the natural soils were visible in two separate locations: the first in the north and east sections of Maiuri's trench, and the second in the south-east corner of the room (both **609.110**; Figs. 5.8.1 and 5.8.2). Described as a dark brown (10 YR 3/3) firm silty sand, the natural soils varied at depth to yellow and

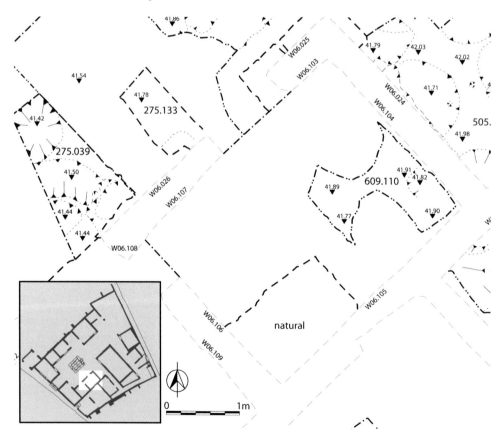

Figure 5.8.1. Plan of the natural soils recovered in Room 6C (illustration M. A. Anderson).

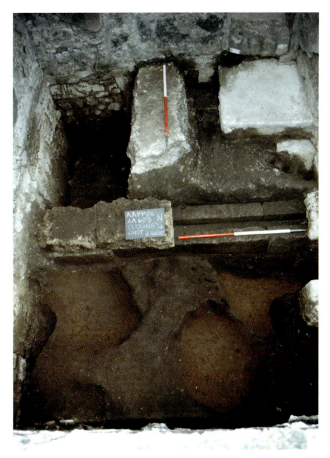

Figure 5.8.2. Natural soils visible in the bottom of pits and in Maiuri's sondage in the SW corner of the room (image AAPP).

8.2.1 Terrace cut

At depth in the section of Maiuri's trench, a cut (no SU assigned) into the natural deposits (**609.158**) was observed that aligns relatively well with the diagonal cut visible in Rooms 11 and 23. This suggests that this is part of the long straight cut that created a higher northern terrace and lower middle terrace within the natural soils. The cut itself was filled with a dark brown loose soil (**609.157**) and some pottery, possibly representing the first layer of filling of Phase 3 below, or potentially the collapse of the terrace scarp during Phase 2.

8.2.2 Inter-cutting pits and postholes

The most substantial evidence for activities in the phase before the construction of the Casa del Chirurgo within Room 6C are the occasionally inter-cutting pit cuts and postholes into the natural soils (Fig. 5.8.2). This was part of a coherent sub-phase of similar activities that were also found to the north in the atrium and in ala 8A. Indeed, several of the cuts in Room 6C were initially parts of larger cuts divided by the creation of the walls of the Casa del Chirurgo, and were thus excavated as parts of different Archaeological Areas (AA). For example, **609.137** is part of the same cut as **608.066** within the atrium and formed a roughly oval shaped pit later broken into sections by the creation of wall W06.103–W06.107 and the north–south drain in Room 6C.

The pits and postholes are found on the higher northern terrace from the Pre-Surgeon Structure and represent roughly contemporary activity outside of this structure. It is difficult to suggest a purpose for which these cuts might have served, especially since the postholes do not seem to align in any clearly meaningful way, while the pits are generally quite shallow (e.g. **609.146** is only 33 cm in depth) and tend to inter-cut each other in a bewildering fashion. Possibly, they represent the shallow footings for dolia or similar vessels that were partially buried by surrounding soils to be held in place temporarily (though clearly these do not mirror the sunken dolia such as in the villae rusticae of the AD 79 period, which are set much more deeply), or potentially they are the result of agricultural activities undertaken on a relatively small scale and repeated over time. In no case do these cuts appear to have been in search of building materials, as is frequently the case for deep cuts of later phases.

8.2.2.1 PRE-SURGEON INTER-CUTTING PITS SEEN IN EXCAVATION
On the eastern side of Room 6C, a series of four cuts

even orangey-yellow in colour and became increasingly gritty in texture at depth. In Room 6C, as in the atrium, the natural soils are situated at approximately the same level (41.77–41.91 MASL) as in the tablinum (41.84–41.99 MASL), suggesting that this area was a continuation of the crest or slight hillock upon which the centre of the later Casa del Chirurgo was centred.

8.2 Phase 2. Volcanic deposits and early constructions

Room 6C revealed evidence of activities prior to the building of the Casa del Chirurgo, documenting a potentially protracted period that produced numerous and diverse inter-cutting pits and postholes with mixed and largely non-diagnostic fills. This mirrors the situation in the atrium during this phase. In Room 6C, the material culture recovered from the pit fills did not permit a date to be assigned to these activities. In addition, a cut visible in the section of Maiuri's trench may reveal the northernmost extent of the terracing of natural soils that took place prior to the building of the Pre-Surgeon Structure in the area to the south of Room 6C.

and their fills were excavated (Fig. 5.8.3). The first (**609.137**) was cut into the natural soils and filled with a diverse mixture of fills, some of which seem to have been largely building detritus (609.136, 609.138), while others were probably simply re-deposited natural soils (609.135 = 608.066). Within the confused deposits of cut 609.137, a posthole was also uncovered. The posthole (**609.143**) was small, only 10 cm in diameter and roughly 16 cm in depth, and was filled very loose greyish soil (609.142). A second, roughly oval shaped pit, approximately 1.2 m in length and 80 cm in width, (**609.109**) also cut through 609.137 in the north-eastern corner of Room 6C. Subsequently it was filled with a laminate, very dark greyish brown firm sandy silty soil (609.108). A third oval shaped cut, roughly 45 by 30 cm, was made in the south-eastern corner of Room 6C (**609.146**).[107] Its fill was a dark olive grey (5 Y 3/2) gritty deposit of sandy silt (**609.119**). This in turn was cut by pit **609.145**, which was filled with a dark greyish brown (10 YR 3/2) loose sandy silt that produced few finds (609.144). Finally, overlaying this was a dark yellowish brown sticky clayish silt with grey inclusions (**609.120**) that may plausibly have been a re-deposited part of the upper natural layer.[108]

8.2.2.2 PRE-SURGEON INTER-CUTTING PITS AND LEVELLING LAYERS SEEN IN THE SECTION OF MAIURI'S TRENCH

It was also possible to identify a number of inter-cutting pits in the northern face of Maiuri's trench that document similar pre-Surgeon activity on the western side of the room to that excavated to its eastern side (Fig. 5.8.4). At the base of this sequence were a series of dark to black (5 Y 2.5/1) sands (**609.156, 609.152, 609.150, 609.155**). Some of the black sands in Room 6C contained small amounts of plaster, pottery, tile, and stone (**609.150, 609.152,** and **609.155**) and may be disturbed aspects of cleaner, more hard-packed soils (**609.149**). It is possible that some of the darker deposits may also have been degraded or re-deposited 'pocked earth', which is often found in conjunction with the black sands. The presence of these deposits implies that certain elements of the early volcanic layers may have collapsed into the terrace cut over time, perhaps during Phase 3. This might explain their jumbled appearance.

A pit was cut into the black sand (**609.161**), which was filled with a firmly packed dark brown (10 YR 3/3) silty sand (**609.156**) with plaster, bone, and pottery. The cut (**609.160**) may represent the upper continuation of **609.161**, and in this case, the upper sandy deposits would simply be fills along with the more rubbly

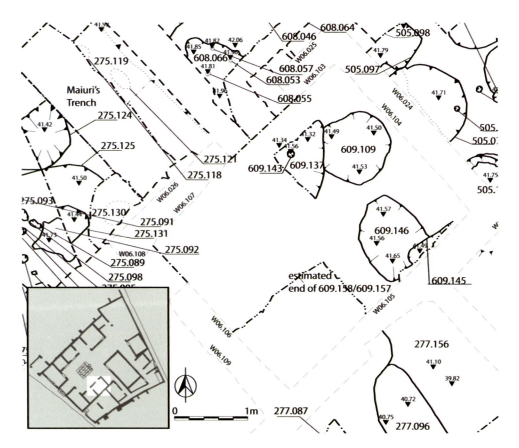

Figure 5.8.3. Plan of the inter-cutting pits and features of Phase 2 in Room 6C (illustration M. A. Anderson).

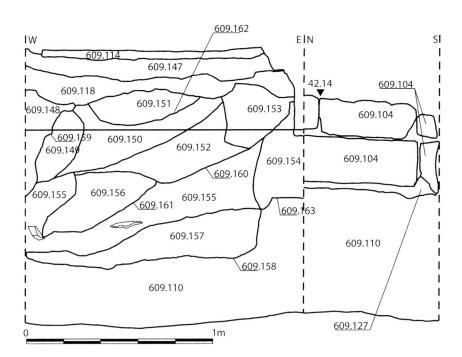

Figure 5.8.4. Northern and eastern sections of Maiuri's Trench in Room 6C, showing evidence of the terracing cut (illustration M. A. Anderson).

609.156. The strange western section of this cut can also be explained by the slippery nature of black sand, which might have collapsed into the fill as the cut was being filled in Phase 3. Two further pits were cut into lower sandy deposits: the first was a deep one running under the later north–south drain (**609.163**) that penetrated the 'natural' soils and was subsequently filled with a dark brown soil (**609.154**), while the second was more enigmatic (cut: no SU assigned, fill **609.153**).

The latest feature observable in the section of Maiuri's trench was a small lens of loose greyish brown (10 YR 5/2) silt and rubble (**609.151**), which was visible within a shallow cut (**609.162**). The SU sheet notes that it was similar to 609.115 in its consistency and if so, it is perhaps a lens within this later Phase 5 layer.[109]

8.3 Phase 3. Construction of the Casa del Chirurgo (c. 200–130 BC)

The construction of the Casa del Chirurgo represents the most important change observable Room 6C. This would have necessitated the demolition of the Pre-Surgeon Structure to the south of Room 6C and the levelling up of the lower terrace on which it was built. Some of this activity took place in the area of Room 6C. Following this, the area received several new walls (W06.104–W06.107). Either after these had been built or at least after their intended courses had been laid out, a drain was placed, running north–south centrally through the northern and southern doorways of the room. This connected the water collection feature of the atrium with a cistern or cisterns located to the

south-east. Further levelling and postholes (probably due to this construction work), characterise the completion of these construction activities.

8.3.1 Removal of the Pre-Surgeon Structure and the filling of its lower terrace

First, the lower terrace to the south of Room 6C on which the Pre-Surgeon Structure had been built was filled to the level of the upper terrace surface. This activity involved the deposition of a series of mixed soil and deposits of building materials, which are evident everywhere on the southern side of the property. In Room 6C, this took the form of a thin dusting of dark olive brown soil (**609.125** = **609.126**) (Fig. 5.8.5). Similar soils on the north-western side of Room 6C (609.129, **609.141**[110]) also sealed the underlying inter-cutting pits of the previous phase. The construction trenches for the walls were then cut from the surface of these deposits. None of the characteristic orange-coloured levelling layers that are occasionally recovered from the filling in of the Pre-Surgeon terraced areas were present in Room 6C, but Maiuri's trench effectively removed most of the actual filling of the terrace cut present within the area. For this reason, certain elements of the apparent cuts and fills observed in the bulks of this trench might simply be the edge of these diverse fills, truncated and confused by the placement of Maiuri's trench.

8.3.2 Constructing the walls of the Casa del Chirurgo

The walls of Room 6C were constructed as part of the initial build of the Casa del Chirurgo, with a doorway

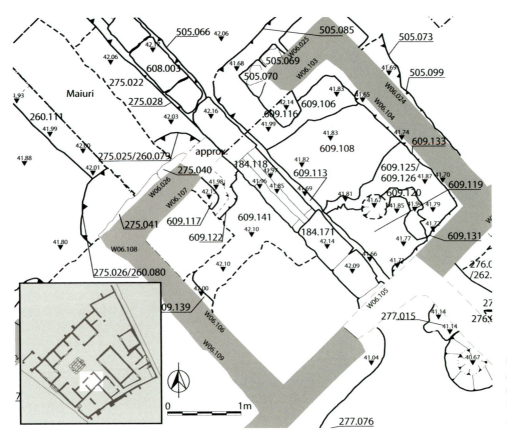

Figure 5.8.5. Plan of the foundation trenches and north–south drain of the Casa del Chirurgo in Room 6C (illustration M. A. Anderson).

providing access to the atrium through the northern wall (W06.103–W06.107), paired with a similar doorway in the southern wall (W05.105 Fig. 5.8.6) that opened to the southern portico. The walls were built using both *opus quadratum* and *opus africanum*. From the standing architecture it can be seen that the *opus quadratum* blocks of wall W06.103–107 were keyed into wall W06.106, while excavation in the eastern sector of the room demonstrates that a single foundation trench was cut for walls W06.103–105 (cf. Fig. 5.8.5). Together this clearly indicates that the walls of the room were built contemporaneously.

The northern wall of Room 6C (W06.103–W06.107) was built in *opus quadratum*. The western portion of wall W06.107 was built using a deep (at least 40 cm within the atrium) and broad (c. 1.27 m wide) foundation

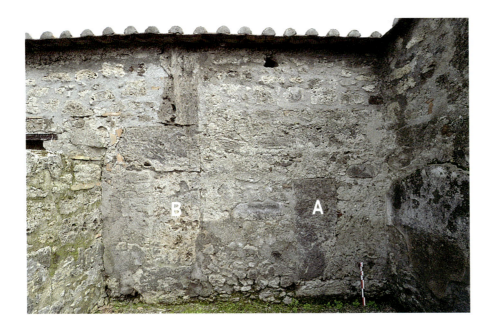

Figure 5.8.6. Sarno stone block door frame in wall W06.105. (A) western side; (B) eastern side (image D. J. Robinson).

trench designed to facilitate the placement of large blocks in Sarno stone of a greater width (c. 0.81 m) than upper part of the wall itself (c. 0.42 m) (Fig. 5.8.7). Following the placement of the larger lower stones (**609.117**), and presumably at least the first several courses of the upper walls, the trenches were filled with an olive brown (2.5 Y 4/3) firm sandy silt with plaster and mortar inclusions. The upper part of the fill was noted as orange-ish in colour (184.119, 609.123), suggesting that it may have derived from similar sources as the characteristic orangey fills of the terrace as a whole. The deposits were firmly packed, indicating the care taken in tamping down the soils in order to provide the strongest possible foundations. These deposits are similar in composition to those found in the other foundation trenches of the Casa del Chirurgo. An analogous wide construction trench and foundation pad was also used for the eastern portion of the northern wall W06.103 (Fig. 5.8.8). The cut for the foundation trench descended into the natural deposits and was approximately 0.30–0.40 m wide (from the Sarno blocks of the wall itself) and over 0.50 m in

depth (184.124 = 609.107). Here the Sarno stones of the foundation pad (**609.116**) were placed at depth and then the trench was filled with a firm grey-yellow brown (10 YR 2/2) sandy silt with some finds of pottery, brick/tile, mortar, plaster, and charcoal (**609.106**). This side did not produce evidence of the two-layer fill identified for W06.107. The walls surrounding the atrium (along with the front façade of the house) appear to have been considered to be the most important structural walls of the property, hence the utilisation of the wide foundation pad. This is logical since the majority of the loads from the roof of a Tuscan impluviate roofing arrangement would have been borne by these walls.

As part of the same phase of construction, the southern (W06.105), eastern (W06.104), and western (W06.106) walls of the room were built in a mixed *opus africanum* and *opus incertum* technique. This method did not require such wide foundations, and in fact, the trenches made for the construction of the lower footing of these walls were much narrower (generally less than 9 cm), with the foundations filling most of the cut. The cut for walls W06.104 and W06.105 (**609.131**,

Figure 5.8.7. Construction trench for walls W06.104 and W06.105 (image AAPP).

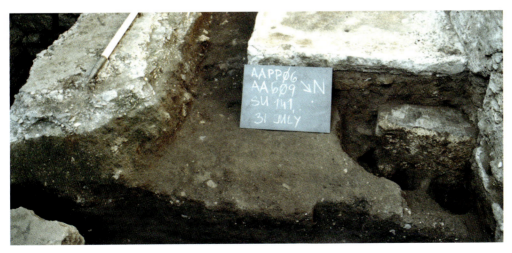

Figure 5.8.8. Foundation trench for wall W06.107 (image AAPP).

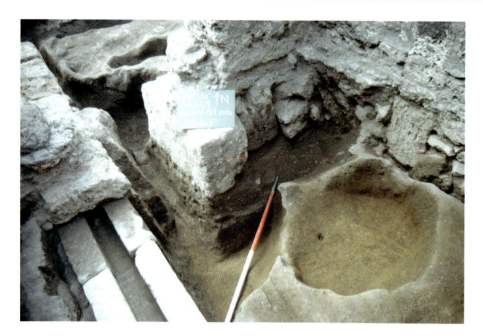

Figure 5.8.9. Foundation trench for wall W06.103 (image AAPP).

609.133) (Fig. 5.8.9) was c. 5–7 cm wide and seems to have connected around the south-eastern corner of Room 6C, although its fills (609.124, 609.132, 609.130) were excavated separately from the other walls. This foundation trench could not be excavated to its full depth because of the narrowness of the cut, implying that the blocks of the wall had been placed into the cut from the other side.

Only a small area of the foundation trench was uncovered for wall W06.106, but it was clearly visible in the section of Maiuri's trench. The foundation was excavated to a depth of over 0.30 m, but could not be continued to its full depth due to its narrowness. It was filled with a dark brown (7.5 YR 3/2) loose sandy silty soil that containing debris including Sarno stone chips that likely derived from the working of the blocks of the house in situ (**609.139**, 609.148). These *opus africanum* walls, especially the dividing interior walls, were clearly considered to be less important for the structural integrity of the whole, and they were built with less costly and time intensive techniques. Notably, in no case were foundation trenches cut where a doorway was planned to penetrate the walls, as this would have created unnecessary work. Walls were built only up to the planned doorway edges. This is particularly evident in the doorway in wall W06.105 which connected Room 6C to the southern portico during this phase, where the foundation trench clearly stops just beyond the eastern Sarno stone block of the door frame.

8.3.3 The north–south drain from an impluvium

As part of the same phase of construction that saw the creation of the walls of the Casa del Chirurgo, a drain was created bisecting Room 6C from north-west to south-east. This drain ran from the centre of the atrium through the doorway into Room 6C in wall W06.103–W06.107, across the room and exited through the southern doorway in wall W06.105 (Fig. 5.8.10). After leaving Room 6C, the drain originally continued into the space occupied by Room 4 before turning to the east, running through Room 23 and towards a cistern. Although it is no longer centrally situated with regards to the northern doorway due to later changes in that doorway's width in Phase 5 (cf. infra), the drain originally bisected it perfectly, suggesting that it was built as a part of the originally conceived plan and was not a later addition as Maiuri believed.[111] The drain was created by cutting a foundation trench (184.121 = **609.113**(east) = 609.128(west)) into which modular, U-shaped blocks of Nocera tuff, c. 38 cm wide and 75 cm long were placed, which formed the base of the drain (**184.071**) = **609.104**). These were sealed with thin (c. 17 cm) Sarno capping-stones (**184.118** = **609.104**), which covered the 12 cm deep and 10.8 cm wide groove cut into the centre of the tuff blocks that acted as the water conduit. The construction trench was filled on the west with a dark olive brown (2.5 Y 3/3) sandy silty soil (609.127), while on the east it was a very dark brown (7.5YR 2.5/2) silty sand (184.120, 609.112).

8.3.4 Final levelling

After the elements of the Casa del Chirurgo had been put in place, several layers of soil were deposited prior to an earthen floor. This produced a grey, undulating deposit (184.117 = 184.123) with charcoal inclusions that ran throughout the eastern side of Room 6C,

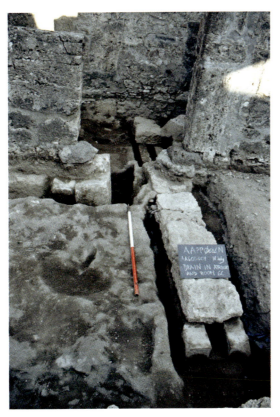

Figure 5.8.10. Drain running from the atrium into Room 6C (image AAPP).

including very firmly packed components (609.111). This was found to be quite variable in colour and to include dark brown soils (609.118) within the levelling and filling activity. The earthen surface was, however, not recovered in an undisturbed state, having received some contamination from the activities of Phase 5.

8.3.5 Phase 3 decoration

There are traces of the complete original decorative surface on wall W06.103. A light bluish grey (Gley 2 8/1) plaster with black volcanic mineral inclusions and larger pieces of lime was initially applied to the wall and then followed by a thinner layer of white plaster with crushed ceramic inclusions, giving it a pale red (10 R 6/4) colour that acted as the final surface upon which a yellow (2.5 Y 8/6) pigment was applied (Fig. 5.8.11). The same sequence of plastering is also preserved on wall W06.104 and W06.106.

8.4 Phase 4. Changes in the Casa del Chirurgo (c. 100–50 BC)

No certain elements of changes may be traced to this phase within Room 6C. It is possible that the room received a new floor in tandem with the redecoration of other rooms around the atrium at this time, but the changes of the subsequent phase have ensured that no evidence survives to confirm such a suggestion.

8.5 Phase 5. The addition of the northern and southern commercial units (late first century BC to early first century AD)

Room 6C underwent a major phase of redevelopment in the late first century BC in which the character of the space was changed significantly by the blocking of the doorway in wall W06.105, from a transitional space into an independent room. This was a component of a wider series of changes in the house, which included the creation of the southern commercial unit (Rooms 3 and 4). As a result of these changes the drain that ran under Room 6C was put out of use,[112] and water

Figure 5.8.11. Initial plaster layer on wall W06.103. (A) backing plaster layer; (B) final pink plaster layer with yellow fresco (image D. J. Robinson).

was now directed to new cisterns cut into the floor of the atrium. In Room 6C, this phase of redevelopment also saw the creation of a doorway to the west into Room 6B. The doorway in wall W06.107–W06.103 was narrowed through the addition of two blocks of Sarno stone that measured c. 1 m by 0.36 m by 0.36 m. These measurements correspond with the Sarno blocks used for the framework in the original *opus africanum* phase of the property and consequently may derive from elsewhere in the house were such walls were removed at this time. These changes were most likely accompanied by the laying of an *opus signinum* floor in the room and also in the redecoration of its walls.

8.5.1 Rebuilding Room 6C

A first step in the rebuilding of Room 6C must have been the removal of its original flooring, which was either the beaten earth of Phase 3 or perhaps a more elaborate surface that may have been added in Phase 4. This was followed by the cutting of two postholes into the underlying stratigraphy, which were likely associated with the building activities underway. A large (diameter 0.36 m) shallow posthole was located in the south-east corner of Room 6C (**609.121 = 184.106**) (Figs. 5.8.12 and 5.8.13). It was filled with a loose brownish grey soil with pieces of clay (184.104) and had a lighter grey capping of clay (184.103[113] = 184.010). A smaller posthole (**184.113**) was found in conjunction with the larger and cut into the same firm underlying deposit, a reddish clay (184.112). This was filled with a grey sandy fill (184.114), similar to that in the larger posthole next to it. From the location of the postholes, it is likely that they were related to the filling of the doorway in wall W06.105. Possibly, it was necessary to support the roof as the doorway in the wall was filled or its lintel removed. The doorway was filled with an *opus incertum*, comprising predominantly of Sarno stone, with a limited quantity of brick/tile and *cruma*. Due to the extent of the early modern and modern reconstruction and rendering, it is impossible to discern how the *incertum* was bonded.

A series of deposits were also recovered that were probably related to cleaning up and a general raising of the level of the floor after construction. These were a diverse series of deposits, which included a lens (184.116) composed mainly of charcoal and bones, a yellow earthen fill with only a few finds of plaster and pottery (184.110), a mottled yellow-brown lens with few finds (184.105), and a layer of dark (black 5 Y 2.5/2) firm silty sandy soil containing a mixture of debris (609.115).

8.5.2 Structural changes observable in the architecture

A low doorway was cut at the northern end of wall W06.106 to provide access into Room 6B. The northern edge of the door was flush with the *opus quadratum* blocks used for the walls surrounding the atrium, while the southern side of the doorway was cut into the rubblework portion of the *opus africanum* of the original wall. This necessitated the squaring up of the rubblework with a number of small brick/tiles set within a pinkish white (5 YR 8/2) mortar with black volcanic mineral and lime inclusions in order to create a straight edge for the door. Towards the upper part of the door, squared off Sarno blocks set within a similar mortar were used for the same purpose.

8.5.3 Narrowing to the northern doorway and opening into Room 6B

In order to narrow the doorway leading into the atrium, two rectangular blocks of Sarno stone were used, with the gap between them and the original edge of wall W06.107 filled with Sarno stone *opus incertum*. Unfortunately, due to the presence of modern pointing it was impossible to discern the character of the mortar used for the *incertum*. Like most other doorways of the atrium, this one also received a new threshold in lava stone. Perhaps because of the underlying drain or some other consideration, the doorway into Room 6C was fitted with a two part threshold rather than a solid stone. On the eastern side of the doorway, the lowest observable Sarno stone *quadratum* block was carved out to create a space into which a new grey lava threshold (**505.106**) could be accommodated. A similar grey lava threshold stone was also added to the western edge of

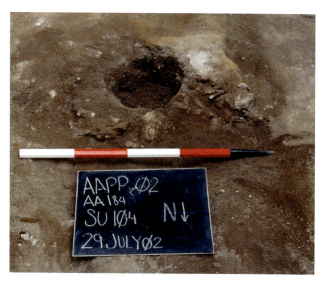

Figure 5.8.12. Large posthole footing in Room 6C (image AAPP).

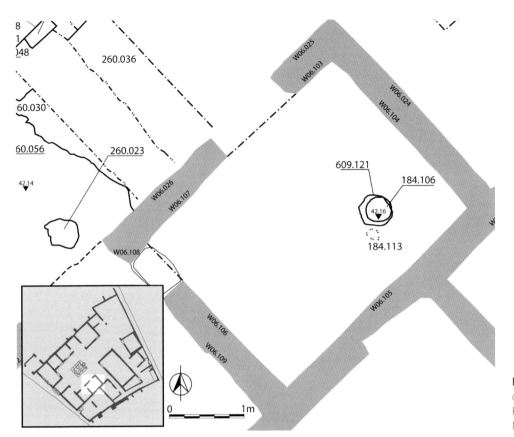

Figure 5.8.13. Plan of the deposits and features of early Phase 5 in Room 6C (illustration M. A. Anderson).

the new doorway (**505.079**). It is within this context that the opening of a doorway between rooms 6C and 6B occurred.

8.5.4 Opus signinum flooring and Phase 5 wall plaster
Like many of the rooms around the atrium, as a final step in these changes, Room 6C received a flooring of *opus signinum*, poured over a thick earthen sub-floor (**184.009**,[115] 184.115) (Figs. 5.8.14 and 5.8.15). Much of this floor is now missing, but a roughly square-shaped section survives, measuring 88 by 84 cm and approximately 8 cm thick. The surviving piece of floor has a small hole in it and potentially preserves traces of a thin lip at the edges (**184.018** = **609.105**, 184.020). It is likely that it covered a soak-away feature designed to facilitate the drainage of water. Traces of a lip at the edge of this surface hint that it once had a more complicated relationship with the surrounding floor, from which it was perhaps originally separated by a raised region. A full understanding of this feature is complicated by the fact that the deposits directly underneath were not excavated because the surface was so well preserved. Because the square surface had been cut, it is not possible to be certain that the deposits around it also ran underneath it. Indeed, the mid-first century AD date that derived from these

deposits suggests that much of the material around the surviving patch of floor originated from the period immediately prior to the pouring of a new and later *opus signinum* surface that clearly did extend across the extent of the room. This may be due to the later cutting and removal of the rest of the floor once associated with this surface in Phase 6.

The changes throughout Room 6C necessitated a new phase of decoration. The evidence from wall W06.107 would suggest that the majority of the previous phase of plaster was removed from the wall and was replaced by a relatively thick layer of smooth light bluish grey (Gley 2 7/1) sandy plaster. This is a very characteristic mortar that was used throughout the atrium of the property during this phase of redecoration, as the first layer of backing plaster against the bare walls. This was overlain by a layer of white (10 R 8/1) plaster with black volcanic mineral inclusions and larger pieces of lime and rounded gravel. The same white plaster is also present across the fill of the wide door on wall W06.105, indicating that it was blocked and the wall redecorated part of this phase of activity.

8.6 Phase 6. Upper storeys and final decoration (c. mid-first century AD)
The mid-first century AD saw renovation across of

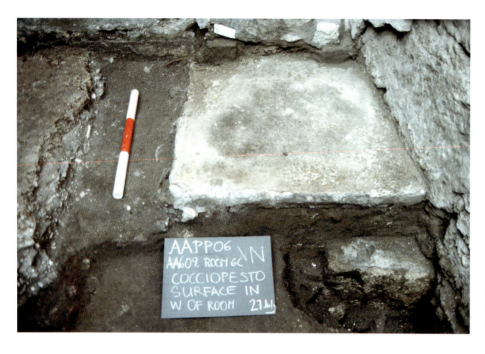

Figure 5.8.14. Remnant of Phase 5 *opus signinum* floor with hole for probable soak-away (image AAPP).

much of the house with the addition of upper storeys and new floors. The flooring of the previous phase in Room 6C was removed at this time, with the exception of a square piece of *opus signinum* over the probable soak-away. Perhaps this was intended to retain this feature. A yellow deposit with white flecks (184.019) and a general fill layer across the area (184.097[116]) are also associated with this phase of rebuilding, during which artefacts from the mid-first century AD were trampled into the upper surface of deposits from previous phases, contaminating them. Finally, a thin (about 7 cm thick) layer of wall plaster fragments was reused as a sub-floor for a new *opus signinum* surface that sealed all of these changes (**184.008**,[117] **184.017**). Traces of this

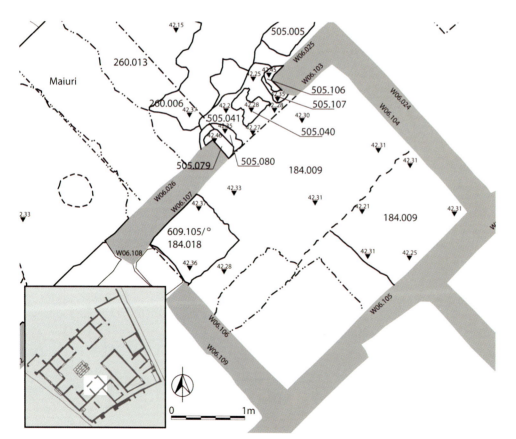

Figure 5.8.15. Plan of the deposits and features of Phase 5 in Room 6C (illustration M. A. Anderson).

floor survived in four different areas (**184.007**, **184.014**, **184.016**, 184.068) underlying the *opus signinum* surface that was poured over them (609.114, 609.147) (Figs. 5.8.16 and 5.8.17).

A final phase of decoration can be seen on walls W06.106 and W06.107 of Room 6C (Fig. 5.8.18). On wall W06.107, there is evidence to suggest that the final surface of the Phase 5 plaster appears to have been picked, or even removed, in places prior to the application of a new layer of backing plaster. This was composed of a light bluish grey (Gley 2 7/1) mortar with rounded sand inclusions and pieces of ceramic. Overlying this in the middle and upper portions of the wall was a thin layer of white (2.5 YR 8/1) mortar containing translucent mineral crystals, whereas in the lower portion of the wall the white mortar matrix contained inclusions of crushed ceramic and black volcanic minerals, giving the plaster an overall pale red (10 R 7/3) hue. The white, crystalline plaster in the middle zone was applied before pink plaster in the lower zone, although both form part of the same phase of decoration. The plaster in the middle zone carries traces of a very pale brown (10 YR 8/4) pigment colouration, whereas the lower zone was a weak red colour (10R 4/3). The boundary between the lower and middle zones are at approximately 0.94 m above the present ground surface. There is no evidence for any painted or additional decoration on the walls, suggesting that Room 6C functioned as a service room during the middle of the first century AD.

8.7 Phase 7. Post-earthquake changes

Despite some evidence for post-earthquake disruption on the southern area of the atrium of the Casa del Chirurgo, no unequivocal evidence for such was present in Room 6C. A thin skim of mortar was poured over the final phase of *opus signinum* throughout the room (184.013 = **184.011**, **184.015**, **184.006**[118]), which may relate to restoration activities, the storage of building materials, or temporary works taking place during the final phase (Figs. 5.8.19 and 5.8.20). Although this could also have been the remains of the nucleus for a mosaic floor, no other traces of mosaic, or impressions in the surface, were recovered to support such an interpretation. It is more likely therefore that this indicates that the room was being used to stage repair activities, resulting from the wide-spread post-earthquake repairs in the atrium and its surrounding rooms.

At this point, a step or threshold between rooms 6C and 6B may have been added. This was made in *opus incertum* using predominantly Sarno stone with pieces

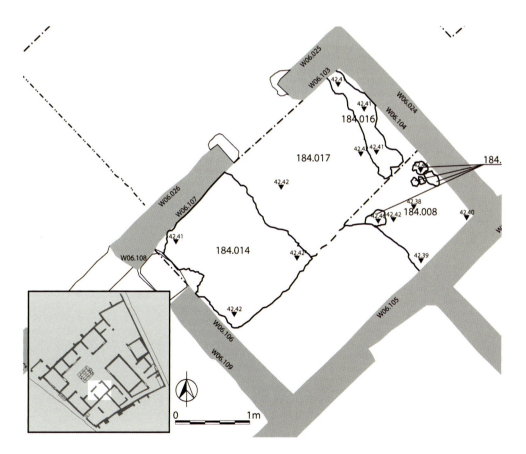

Figure 5.8.16. Plan of the deposits and features of Phase 6 in Room 6C (illustration M. A. Anderson).

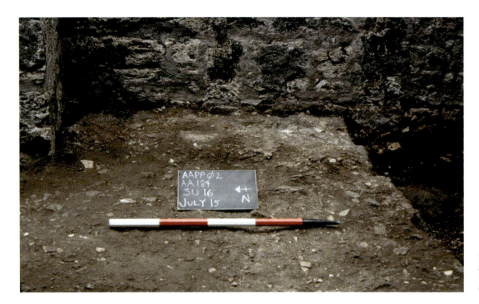

Figure 5.8.17. Traces of *opus signinum* floor from Phase 6 in Room 6C (image AAPP).

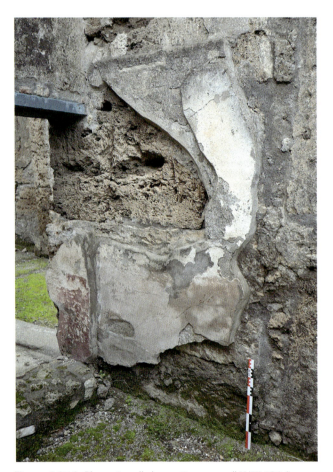

Figure 5.8.18. Phase 6 wall decoration on wall W06.106 (image D. J. Robinson).

of cruma and a small white marble off-cut. The step, or perhaps the base of the fill of this doorway, was clearly intended to separate whatever restoration work that was happening in Room 6C from Room 6B, which appears to have been unaffected by these changes.[114]

8.8 Phase 8. Eruption and early modern interventions

Following the excavation of the Casa del Chirurgo, a sequence of restoration and conservation measures were put into place that left traces in the standing fabric of Room 6C. A single tile was used to cap the eastern most part of the original section of wall W06.107, and tiles were also set on parts of wall W06.106. These were bedded on of a light bluish grey (Gley 2 7/1) mortar with lime inclusions that weathers to a dark brown colour. Tiles were also set on wall W06.105, where it is likely that much of the uppermost part of the wall was also levelled up as part of this process. This was undertaken using *opus incertum* set in rough courses in the upper 0.75 m of the wall, which was set in a light bluish grey (Gley 2 7/1) mortar with angular black volcanic mineral fragments, lapilli, and lime. The same mortar was also used extensively to render and point the remainder of the wall. It is likely that as part of this phase of reconstruction a wooden lintel was placed over the small doorway in wall W06.106 leading to Room 6B. Around the doorway there is evidence of a hard light bluish grey (Gley 2 7/1) mortar with occasional black volcanic mineral and lime inclusions. This was predominantly in the area surrounding the door lintel and was probably associated with the insertion of it. The upper portion of wall W06.104 changes its construction type from *opus africanum* to *opus incertum*. Although modern pointing obscures the original mortars, the change in construction style is a likely indicator of a phase of rebuilding. At the lowest level of the rebuilding are a series of horizontally set tiles. sometimes this technique was used by early modern restorers to indicate the start of rebuilding. Consequently it is tentatively suggested that the upper portion of wall

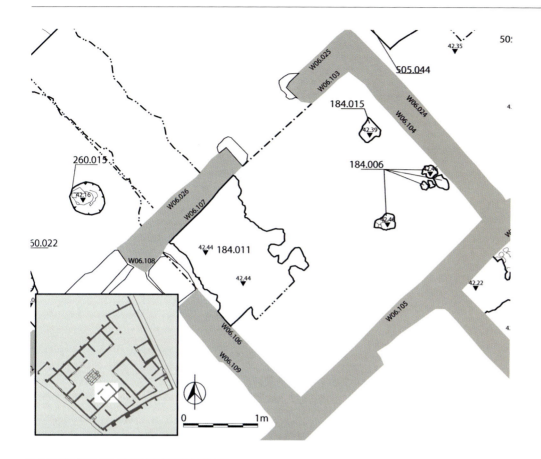

Figure 5.8.19. Plan of the deposits and features of Phase 7 in Room 6C (illustration M. A. Anderson).

Figure 5.8.20. Mortar floor from Phase 7 in Room 6C (image AAPP).

W06.104 dates to the early modern period. Walls W06.104–107 all show evidence of having been covered in a layer of protective mortar render. This was the same mortar used to rebuild wall W06.105 and was composed of a light bluish grey (Gley 2 7/1) mortar with angular black volcanic mineral inclusions, lapilli, and lime.

This has slight variations in colour, composition, and hardness depending upon their position on the walls and the degree of weathering. For example, close to the upper junction with walls W06.104–105 this rendering coat contains large fragments of tile, presumably to help bulk out this section of the render. The presence

of the remains of three butterfly clips in wall W06.105 suggests that, when initially excavated, sufficient finished wall plaster remained affixed to the wall to warrant this early conservation method. Unfortunately, this plaster has subsequently been lost.

8.9 Phase 9. Modern interventions

8.9.1 The creation of modern soils and excavations by Maiuri

The process of deposit formation has continued in Room 6C since its initial excavation, and there has been a gradual accretion of modern soils, rubbish, and bioturbation. These included a yellowish silty loamy sand layer, roughly in line with the doorway and probably the result of modern traffic (184.012) and an organic fill in the south-eastern corner of Room 6C overlying the final *opus signinum* and plaster. This was clearly the result of modern churning, but with some ancient finds mixed in as well (184.002). One major modern intervention, in the form of an exploratory trench placed by Maiuri as a component of in investigations into Casa del Chirurgo, was present on the south-western corner of the room along most of wall W06.105 (184.005). The excavation trench was filled with a distinctive yellow soil of unknown origin found in all of Maiuri's investigations in the house (184.003 = 609.103).

8.9.2 The restoration campaign of the 1970's

The upper c. 0.6 m of the western part of wall W06.107 was rebuilt in *opus incertum* using Sarno stone and black lava set in a light greenish grey (Gley 1 7/1) mortar with inclusions of lime. This was undertaken as part of a phase of restoration that saw the construction of a reinforced concrete lintel over the doorway into Room 6B from the atrium. The edges of the surviving sections of wall plaster on walls W06.106 and W06.107 were covered with a bluish grey (Gley 2 6/1) mortar with black volcanic mineral inclusions. This same mortar was also used to patch up holes in the surface of the wall plaster.

8.9.3 The restoration campaign of the 2000's

A rough light bluish-grey to bluish grey (Gley 2 7/1 to Gley 2 5/1) mortar with black inclusions was used to point around the large Sarno stone blocks of *opus quadratum* in wall W06.107 and extensively across the remainder of walls of the room. It was also used to point around the doorway lintel in wall W06.106, which was then painted green, some of which overlies the blue-grey mortar. Most recently, a protective layer of gravel (184.001, 609.101) was spread across the surface of the entire room.

9. Room 6D
Cubiculum (not excavated)

Description
Room 6D was created during the initial build of the Casa del Chirurgo. It is the eastern cubiculum of the range of three rooms on the northern side of the atrium and had a doorway into this central space. Another doorway in its eastern wall led into the northern ala (Room 8), which was cut during a major phase of redevelopment at the end of the first century BC. The room measures 2.68 by 3.37 m. Due to the extent of early modern rendering and reconstruction, it is difficult to be entirely sure about the extent to which the walls were keyed into each other, although it is likely.

9.1 Phase 1. Natural soils
No evidence of this period was recovered in this area.

9.2 Phase 2. Volcanic deposits and early constructions
No evidence of this period was recovered in this area.

9.3 Phase 3. The Casa del Chirurgo (c. 200–130 BC)
9.3.1 The construction of Room 6D
All of the walls of Room 6D were constructed as part of the initial build of the Casa del Chirurgo. W06.013 was part of the original northern boundary wall of the property and was built in *opus africanum* using Sarno stone, with the rubblework bonded together using a very pale brown (10 YR 8/3) clay. Due to the extent of early modern and modern restoration and repair, only a single header of the Sarno stone framework of the wall is visible. Walls W06.014, W06.015/W06.016, and W06.017 were also built during this phase of

construction, along with the rest of the rooms around the atrium. The western and eastern walls (W06.017 and W06.014) were built in *opus africanum* for the main body of the walls, using Sarno stone for the both the framework and the rubblework, and the same very pale brown clay with occasional angular black volcanic mineral fragments and lime as a bonding agent that was used to bond the northern boundary wall. Wall W06.015/W06.016 was built out of Sarno stone in *opus quadratum*. At the intersection of wall W06.015 and wall W06.014 – the south-east corner of Room 6D – the Sarno stone *opus quadratum* blocks interlink with those of wall W06.014. A similar situation also probably occurred at the intersection between walls W06.016 and W06.017, although it is difficult to be sure due to the extent of early modern and modern interventions on the walls.

9.3.2 The Phase 3 decoration
There is evidence on all of the walls of Room 6D for an early phase of backing and plaster that predates the addition of the *opus signinum* floor surface in the room and as such has been tentatively dated to Phase 3. This was composed of a 20–30 mm thick layer of backing plaster that was applied directly to the stone surface of the walls. It consists of a light bluish grey (Gley 2 7/1) plaster with fine rounded black volcanic sand and occasional larger pieces of lime. This was overlain by a thin skim of pinkish white (10 R 8/2) plaster with ceramic inclusions, to which pigments were added to create the final fresco surface, which has now weathered to a reddish yellow (7.5 YR 7/6) colour. The backing plaster is present on all of the walls within Room 6D with the final plaster only being recorded on walls W06.013 (Fig. 5.9.1), W06.014, and W06.017.

From the overlapping stratigraphic relationships between the backing plasters from this phase of

Figure 5.9.1. Phase 3 wall plaster overlain by the Phase 5 *opus signinum* floor on wall W06.013 (image D. J. Robinson).

decoration, it is possible to note that it was applied to walls W06.014 and W06.017 before W06.013. This would perhaps indicate that the eastern and western walls of the room were plastered before the northern wall, and also probably before the southern walls.

9.4 Phase 4. Changes in the Casa del Chirurgo (c. 100–50 BC)

No evidence of this period was recovered in this area.

9.5 Phase 5. Redecoration and redevelopment (late first century BC to early first century AD)

9.5.1 The addition of the doorway in wall 14 and the laying of the opus signinum *floor*

A small doorway into the northern ala (Room 8) was opened during a phase of development at the end of the first century BC that also saw the laying of the *opus signinum* floor throughout the room and in the new doorway threshold. The doorway was simply constructed by removing the rubblework from the *opus africanum* wall and the cutting in half of the

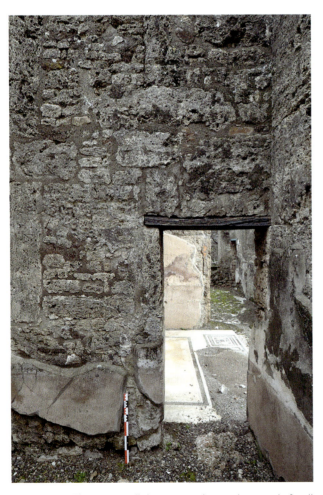

Figure 5.9.2. The new small doorway at the southern end of wall W06.014 (image D. J. Robinson).

southernmost Sarno stone framework pilaster for use as the northern edge of the new doorway (Fig. 5.9.2). The new *opus signinum* floor was associated with the grey lava threshold stone at the entrance to the room in wall W06.015/W06.016, although there are no signs of damage or repair to the Sarno stone blocks of the doorway associated with this event. The *opus signinum* floor was poured up against and overlies the final fresco surface of the Phase 3 plaster.

9.5.2 The Phase 5 decoration

The redevelopments within Room 6D would have necessitated a new phase of wall decoration. This would have begun with the removal of the Phase 3 fresco surface from much of the room and the roughening of its underlying backing plaster, which left visible pick marks on wall W06.013. A new layer of backing plaster was subsequently applied to the walls and also in the area of the newly cut small doorway in wall W06.014, indicating that this new backing plaster post-dated the opening of the doorway. The backing plaster consisted of a rough light bluish grey (Gley 2 8/1) plaster with large rounded black beach gravel and the occasional piece of ceramic and lime. No final plaster surface survives from this phase.

9.6 Phase 6. Upper storeys and final decoration (c. mid-first century AD)

Room 6D underwent a final redecoration in the middle of the first century AD. There were no observable structural changes in the room to which these changes related.

The final decorative surface of the plaster from Phase 5 was carefully removed so that the backing plaster could be reused. A new layer of backing plaster was then applied to the walls. This was composed of a white (10 R 8/1) mortar with angular black volcanic mineral fragments, larger pieces of rounded beach gravel, ceramic, and the occasional piece of lime. This was flattened at the surface to receive the final plaster layers, which are today observable in the lower and middle decorative registers of the walls. The middle register was plastered first with a 2–3 mm thick layer of white (7.5 YR 7/1) plaster with mineral crystal inclusions. This was followed by the lower register of the walls with a similarly thin layer of pinkish white (10 R 8/2) plaster with ceramic, rounded black volcanic sand, and the occasional piece of lime. The join between the two plasters is at 0.67 m above the *opus signinum* floor. Some idea of the sequence of plastering can also be gleaned from the stratigraphic relationship between the same plasters on different walls, with wall W06.017 being plastered before wall W06.013. Interestingly, the backing

Figure 5.9.3. The final decorative scheme as seen on wall W06.013 (image D. J. Robinson).

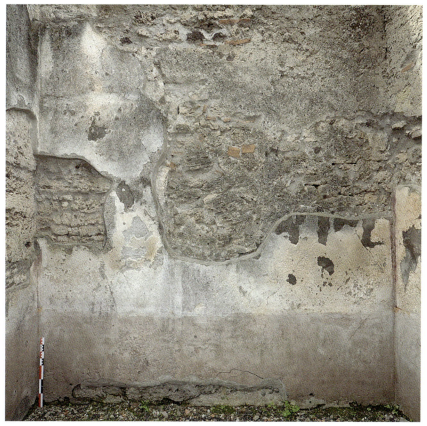

Figure 5.9.4. The two decorative panels on wall W06.017 (image D. J. Robinson).

plaster from Phase 3 had followed a similar pattern.

Wall W06.013 has evidence to suggest that the decoration was divided into a lower and a middle register and would have had three vertical panels (Fig. 5.9.3). On wall W06.015/06.016 it is also possible to add that there would also have been an upper decorative zone, with the boundary between the lower and middle zones at 0.68 m and the middle and upper zones at 2.3 m above the *opus signinum* floor.

The division between the lower and middle registers on wall W06.013 was decorated with a broad (50 mm) stripe, which was composed of a 10 mm wide upper band of dark red (10 R 3/6) and a 40 mm wide lower band of yellow (10 R 8/2). The same dark red pigment was also used in a border running vertically up the edge of the wall: a feature of the decoration also seen on wall W06.015/W06.016. The boundary between the western and central panels of the middle zone of wall

W06.013 was delineated by a yellow (10 YR 8/8) border. In the lower zone this boundary is 130 mm thick and is delineated by two white vertical lines. There are traces of a bluish grey (Gley 2 6/1) colouring in the lower zone suggesting that in the Phase 6 decoration the surface of this may have been considerably darker (it appears as black on the cork model in the *Museo Archeologico Nazionale* in Naples). On wall W06.015/W06.016 there is also a 6 mm wide white line that appears to delineate a lower border at 0.18 m above the floor level.

From the surviving evidence on wall W06.017, it is possible to suggest that it was divided into three horizontal registers but had only two vertical panels (Fig. 5.9.4). In both of the vertical panels in the middle register, there were borders defining a vertically rectangular space. The borders were composed of small rectangles (30 by 20 mm) with five internal dots. They appear to have been made from yellow (10 R 7/8) pigment.

Phase 7. Post-earthquake changes
No evidence of this period was recovered in this area.

9.8 Phase 8. Eruption and early modern interventions
9.8.1 Wall reconstruction
Wall W06.017 was repaired and rebuilt during the early modern period. In the central section of the wall the rubblework of the *opus africanum* was repaired with a rough *opus incertum* using Sarno stone, grey tuff, and brick/tile set in a coarse light bluish grey (Gley 2 7/1) mortar containing volcanic mineral fragments and larger pieces of lapilli, lime, ceramic, and black volcanic stone. The upper c. 1 m of the wall was also probably rebuilt at this time using Sarno stone, cruma, and brick/tile set in rough courses. This was likely bonded with the lapilli-rich mortar, although the modern pointing of this area of wall W06.017 makes it difficult to be conclusive. The same mortar though was used as a thick render across the rebuilt upper part of the wall. The upper portion of wall W06.013 was similarly covered with a thick layer of the rendering mortar, which has weathered to a light brown colour (7.5 YR 6/3). Similar mortar was also used along with brick/tiles to repair and point around the *opus africanum* in the area above the surviving wall plaster. A coarse light bluish grey mortar was used on wall W06.014 on the northern edge of the small doorway, particularly around the lintel, suggesting that it was inserted at this point. The wall above the lintel also appears to have been repaired, although this was covered by later modern pointing, and so it is not

possible to confirm whether the damage had been repaired in the early modern period or subsequently. The same light bluish grey mortar was also used on wall W06.015/W06.016 to point the intersection between two *opus quadratum* blocks. Following the repairs and rendering to wall W06.013 and W06.017, a layer of roof tiles was set in a light bluish grey (Gley 2 7/1) mortar with the occasional piece of lime, which was smoothed down the wall over the mortar of the rendering layer. This mortar weathers to a brown (7.5 YR 5/2) colour.

9.8.2 Plaster conservation
It is possible that holes in the surface of the wall plaster were filled with a coarse dark bluish grey (Gley 2 4/1) mortar containing black volcanic stone, translucent mineral crystals, and the occasional piece of lime. This was certainly applied to the wall plaster prior to the edging mortar that dates to the modern period.

9.9 Phase 9. Modern interventions
9.9.1 1970's restoration campaign
9.9.1.1 WALL RESTORATION
The upper 1.5 m of wall W06.014 was rebuilt, along with parts of wall W06.015/W06.016 during the modern period as part of the construction of a roof over Room 8. This was undertaken in *opus incertum* using Sarno stone and grey lava set in a greenish grey (Gley 1 6/1) mortar with black volcanic stone and lime inclusions. As part of this build, a concrete lintel was placed over the doorway in wall W06.015/W06.016 into Room 5, and the wall above rebuilt in *opus incertum* using the same greenish grey mortar, which was also used to point the walls.

9.9.1.2 PLASTER CONSERVATION
The edges of the surviving ancient wall plaster in Room 6D were covered in a layer of light bluish grey (Gley 2 7/1) mortar with angular black volcanic stone inclusions. The same mortar was also used to fill in some of the holes in the surviving plaster surface. It was also used to point around the *imbrices* of the early modern roof tiles.

9.9.2 2000's restoration campaign
Finally, the walls of Room 6D were pointed with a rough bluish grey (Gley 2 6/1) mortar. This was used to point areas where the early modern rendering coat had become detached, around the rubblework infill of the *opus africanum* walls, and between the *opus quadratum* Sarno stone blocks of wall W06.015/W06.016.

10. Room 6E
Cubiculum (not excavated)

Description
Room 6E was created during the initial build of the Casa del Chirurgo. It is the central cubiculum of the range of three rooms on the northern side of the atrium and had a doorway into this central space. The room measures 2.78 by 2.73 m. The structure of the room did not change during its history, apart from the addition of a new grey lava threshold and an *opus signinum* floor surface at the end of the first century BC. It was this complete floor surface that precluded subsurface investigations within this room and consequently the interpretations presented in this chapter are the results of the analysis of the walls and their decoration.

10.1 Phase 1. Natural soils
No evidence of this period was recovered in this area.

10.2 Phase 2. Volcanic deposits and early constructions
No evidence of this period was recovered in this area.

10.3 Phase 3. The Casa del Chirurgo (c. 200–130 BC)
10.3.1 The construction of Room 6E
All of the walls of Room 6E were constructed as part of the initial build of the Casa del Chirurgo. Walls W06.009, W06.010, and W06.012 were built in *opus africanum* using Sarno stone for the headers and stretchers of the framework and Sarno stone and cruma for the rubblework infill. Evidence from wall W06.012 would indicate that a fine brown (10 YR 4/3) clay with occasional volcanic minerals and lime inclusions was

used to bond the *opus africanum*. Wall W06.011, which contained the doorway into the atrium, was built from large blocks of Sarno stone in *opus quadratum*. This wall was keyed into wall W06.012 and W06.016 in Room 6D at its western and eastern extents, indicating that they were built at the same time. The relationship of walls W06.010 and W06.012 to W06.009 is difficult to resolve, although it is suggested that they but up against wall W06.009, possibly suggesting that the northern *opus africanum* boundary wall of the property was built first, followed by the rooms around the atrium.

10.3.2 The Phase 3 decoration
A coherent phase of decoration survives from the initial build of Room 6E. This comprises of a light bluish grey (Gley 2 8/1) plaster with black volcanic mineral inclusions and the occasional piece of lime. On wall W06.009, this backing plaster is bulked out through the addition of large fragments of amphora, whereas on walls W06.010–12, this plaster was much thinner. It was overlain by a thin final layer of white plaster to which pigments were added to create a red fresco, which has now weathered to a pale red (10 R 7/3) colour. This is observable on walls W06.009, W06.010 and W06.012 (Fig. 5.10.1).

10.4 Phase 4. Changes in the Casa del Chirurgo (c. 100–50 BC)
10.4.1 The opus signinum *floor*
The next major phase of redecoration in Room 6E can be seen to be associated with the laying of an *opus signinum* floor that may tentatively be assigned to the Second Style. The floor was poured against the Phase 3 decorative plaster, as the north-western corner of the room lips up over it (cf. Chapter 9 for further details on this floor).

Figure 5.10.1. The Phase 3 plaster on wall W06.010 (image D. J. Robinson).

10.4.2

No wall decoration can be associated with this phase with certainty.

10.5 Phase 5. Redecoration and redevelopment (late first century BC to early first century AD)

10.5.1 The Phase 5 decoration

It would appear that the majority of the previous fresco decoration was first removed from the wall prior to redecoration, with trouble taken to preserve the backing plaster. A new, very thin (1–2 mm) layer of plaster was then added to the wall and a dark, probably blue/back pigment was applied. This has subsequently weathered to a bluish grey colour (Gley 2 5/1). Only very small fragments of this second decorative fresco has survived on walls W06.009 and W06.012 (Fig. 5.10.2). The decorative layer overlies the *opus signinum* floor, which was modified at this time by the addition of a lava stone threshold at the atrium.

10.6 Phase 6. Upper storeys and final decoration (c. mid-first century AD)

The decorative layer from Phase 5 must have been largely removed from the walls of Room 6E. As large quantities of previous layers of backing plaster still remain, this would indicate that some care was taken in this process not to completely strip the walls with the idea of reusing it. On wall W06.010, in the area between the surviving ancient wall plaster and the early modern render, the Phase 5 backing plaster has a characteristic 'wave-like' upper surface. This would suggest that its fresco surface was removed with a slightly concave scooped blade c. 60 mm wide. A new layer of backing plaster was then added to the walls as a 30 mm thick layer of white (10 R 8/1) plaster with

rounded black volcanic gravel and the occasional piece of ceramic. This plaster was flattened in preparation for a 2 mm thick layer of final white (7.5 YR 7/1) plaster with mineral crystal inclusions. This was the surface upon which lines were incised to guide the decorators and the pigment itself was applied. Of what little that remains, it is possible to suggest that the room was relatively elaborately decorated in its final phase. The lower register of the walls appears to have been a dark red (10 R 3/6) colour, which continued upwards in two c. 40 mm wide bands at either edge of the walls. There are also traces of a golden border design in the middle register of wall W06.009 at the western end of the surviving wall painting (Fig. 5.10.3).

Phase 7. Post-earthquake changes

No evidence of this period was recovered in this area.

10.8 Phase 8. Eruption and early modern interventions

10.8.1 Wall reconstruction

The walls of Room 6E were both repaired and rebuilt during the early modern period. In the central section of wall W06.010, the *opus quadratum* rubblework was repaired or replaced by a patch of *opus incertum* using predominantly square and rectangular pieces of Sarno stone of the original wall set in a less regular way and with pieces of brick/tile. This was bonded with a course light bluish grey (Gley 2 7/1) mortar with inclusions of volcanic mineral fragments and larger pieces of lapilli, lime, crushed black volcanic stone, and ceramic. The top of the wall was also rebuilt with up to 1 m of *opus incertum* using Sarno stone, yellow tuff, cruma, Nocera tuff, and grey lava set within the same light bluish grey mortar used in the repairs lower down the wall. Similarly walls W06.011 and W06.012, and also most

Figure 5.10.2. The Phase 5 plaster on wall W06.010 (image D. J. Robinson).

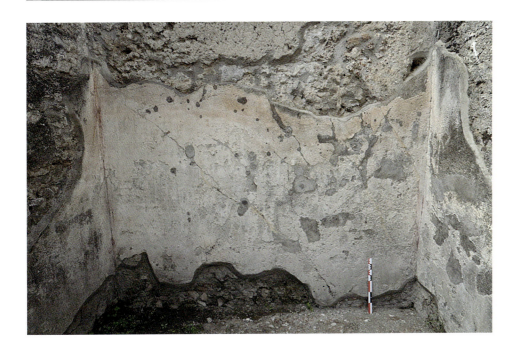

Figure 5.10.3. Phase 6 or 7 wall decoration on wall W06.009 (image D. J. Robinson).

probably wall W06.009, were also rebuilt to a consistent height using the same mortar. During this phase of reconstruction, a wooden lintel over the doorway in wall W06.011 was inserted and the wall above it rebuilt. At its eastern end, the lintel is set in a similar light bluish grey (Gley 2 7/1) mortar with black volcanic stone, lime and lapilli inclusions, as used elsewhere in the room at this time.

It is likely that the walls were brought up to a consistent height prior to the placement of the capping roof tiles. These were set upon a bed of a light bluish grey (Gley 2 7/1) mortar with lime inclusions, which weathers to a dark brown colour. At the same time, a layer of mortar was applied to all of the walls in the room as a protective render. This used a relatively soft mortar containing abundant fragments of lapilli, cruma, crushed ceramic, and limestone. From the differences in the hardness and composition of this mortar, it would appear that the render was applied on a wall by wall basis and mixed in different batches, as the render on wall W06.012 was a very hard grey colour (Gley1 5/1), while the same render on wall W06.010 was again a rather soft mortar and a light grey colour (Gley1 7/N). On walls W06.009 and W06.010, it is apparent that the render was applied to the wall prior to the setting of the tiles, as the mortar used for this purpose spreads down over the render.

10.8.2 Plaster conservation
There was also an early attempt at plaster conservation and restoration. Some of the holes in the face of the final wall painting surface on walls W06.009 and W06.012 were filled with a rough grey mortar with black volcanic stone and lime inclusions that had weathered to a light greenish grey colour (Gley1 7/1). Subsequently, some of the large diagonal cracks in the plaster were filled with a fine yellow (10 YR 8/6) mortar, which may be associated with the use of butterfly clips to hold the plaster to the wall (observable today via their iron stains).

10.9 Phase 9. Modern interventions

10.9.1 1970's restoration campaign
The exposed edges of the surviving wall plaster on walls W06.009–12 were covered in a thin coat of hard bluish grey mortar (Gley2 6/1) with black volcanic stone inclusions. This was done in order to protect the exposed edges of the plaster from further damage due to water infiltration. On walls W06.009, W06.010, and W06.012, the same mortar was then applied as a thin rendering layer to patch up large areas of the wall plaster where the final surface had come away. It is likely that the butterfly clips that were inserted into the wall plaster during the early modern period were removed during this phase of plaster restoration.

10.9.2 2000's restoration campaign
Finally, the walls of Room 6E were pointed with a rough bluish grey (Gley 2 8/1) mortar, with particular attention being paid to the area around the lintel on wall W06.011 and around the exposed *opus africanum* rubblework of wall W06.010. This was part of a coherent phase of pointing and is seen throughout Room 6E and the core of the house.

11. Room 7
Tablinum (AA200)

Description

Room 7 is the tablinum of the Casa del Chirurgo. It measures 4.60 m wide by 5.40 m long. The relatively high status of this room is clearly reflected by its décor, which in the final phase was one of the most ornate areas of the house, including fine wall paintings in the Fourth Style, and also black and white decorative mosaics. The location of the room also served to highlight its important role, axially aligned within the vista from the front door and fauces of the house, and separating the atrium from the garden space beyond. Evidence of several phases prior to the construction of the Casa del Chirurgo were recovered in this area, including a fragment of a wall potentially belonging in Phase 2; seemingly part of a building that was not related to other elements of the Pre-Surgeon Structure recovered further to the south. At the time of the initial creation of the tablinum proper in Phase 3 c. 200 BC, a wall at the eastern end of the room closed off the space from the eastern portico and hortus beyond. As part of the larger programme of redevelopment in the house during late first century BC, the eastern wall of the tablinum was removed entirely and the small doorway in wall W06.060 filled. There were no further structural changes to the room after this date.

Archaeological investigations

Excavations in Room 7 were undertaken during the summer of 2002 within the entire area of the room.[119] The analysis of the standing architecture was undertaken at the same time and was also checked during additional study seasons in 2006 and 2013.[120] As removing the modern overburden immediately exposed the underlying mosaic floor and *opus signinum* sub-floor in many places, the excavated area was subsequently restricted to zones where the latter was not well preserved and the mosaic was no longer present. The centre of the room, where the mosaic survived to the greatest extent, was therefore recorded and preserved. Excavation subsequently concentrated on the western area, which included the fill of a collapsed cistern and the eastern area, which was excavated to natural soils. In order to verify the stratigraphic sequences already recovered, and to examine more of the foundation trenches for walls W06.060 and W06.061, two test-pits

were excavated on the northern and southern sides of the room, avoiding the central areas. Data recovered from these excavations permit the reconstruction of the use of this area of the house during each phase from the period prior to the Casa del Chirurgo until its final phase of occupation. Especially important early traces of occupation, that differed in nature from those recovered elsewhere within the house, were uncovered in this area, providing additional information on the activities of Phase 2.

11.1 Phase 1. Natural soils

Excavations in Room 7 revealed the top of the natural sequence commonly found in the northern part of Insula VI 1. This was present in both the sides of the collapsed cistern and in the northern and southwestern test pits, as well as in the eastern area (Fig. 5.11.1). The natural soils (200.121, **200.137** and 200.128) generally encountered during excavations in Room 7 were a yellowish brown (10 YR 5/4) sand-silt-loam. In the section through this deposit caused by the collapse of the cistern, it could be seen to grade smoothly into a grittier version of the same deposit observed elsewhere in the excavations. Here too, the natural soil was topped by a mottled very pale to pale brown (10 YR 7/3 – 4/4) silt deposit (**200.120**, 200.136 and **200.127**), possibly a decayed turf line. The overall elevations of these deposits indicate that the original topography of the middle of Insula VI 1 rose gradually to the area of the tablinum (Room 7), such that this part of the Casa del Chirurgo is situated upon what was originally a local highpoint. This is visible within the difference between the yellowish silty soil normally interpreted as a turf layer (**200.120** and **200.127**), which is at an elevation of roughly 41.84 MASL, whereas the natural soils recovered in the northernmost sondage (**200.137**) are at 41.89–97 MASL. It seems likely that the gradient became more pronounced towards the west and south of this area.

11.2 Phase 2. Volcanic deposits and early constructions

This phase began with a series of likely volcanic deposits distinct from the natural soils of Phase 1, but which are clearly not anthropogenic. The earliest activities in the area took place directly upon them, and for that reason, they are included in this phase. The extensive survival of the mosaic in the central area of the room, and the consequent 'key-hole' nature of the excavations in Room 7, do not allow a more detailed

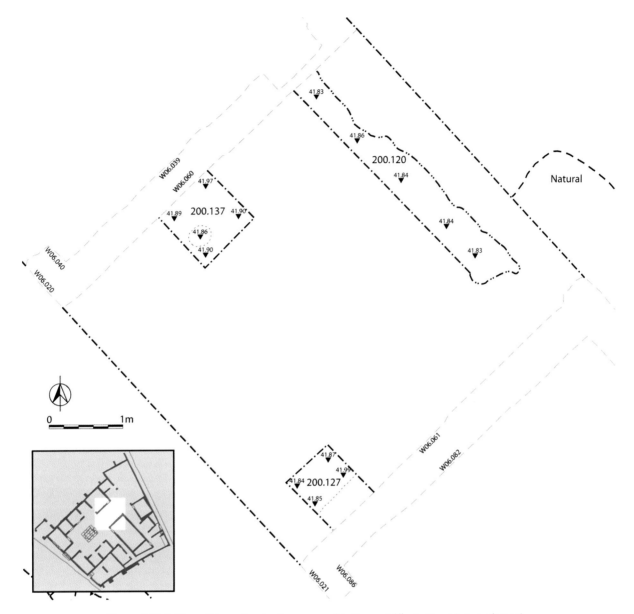

Figure 5.11.1. Plan of the natural soils recovered in Room 7 (illustration M. A. Anderson).

picture of these early activities to be produced, but it seems likely that they relate to the Pre-Surgeon-Structure recovered to the south and west of this area.

11.2.1 'Pea gravel,' 'pocked-earth' layers, and the 'black sand'
The plausibly volcanic sequence of soils recovered across the insula was well represented in Room 7 where they were recovered in three sondages on the east, north, and south sides of the area (Fig. 5.11.3) The brownish grey sandy 'pea-sized' gravel (200.119, 200.135, **200.126**) layer here was 0.08 m thick, varying in texture from pea sized lumps to sand size fragments of a light, almost pumice-like material. Generally found to be devoid of finds in the insula, here this deposit produced sherds dated to the second half of

the second century BC. These cannot derive from the initial deposition of the layer, however, but represent contamination from interventions and disturbance caused by later activities. Capping this was a hard-packed greyish brown deposit, bonded to the upper parts of the 'pea-sized' gravel and displaying its characteristic pocked appearance (**200.111, 200.129,** 200.125). Traces of two roots (200.133, and 200.134) may suggest a period of exposure or at least plant growth over this deposit. Following this, another pocked earth surface (200.107, **200.114**, 200.117) was deposited, producing an unexplained repeated pattern that does not generally occur within the insula except in Rooms 13 and 14. Directly overlying these pocked earth and pea gravels was a 0.12 m thick layer of 'black'[121] volcanic

sand (**200.061**, 200.113, **200.118**) that formed the base upon which the first traces of human activity appeared. A small quantity of painted plaster was recovered from the sand layer, along with a limited number of pottery sherds dated from the second half of the second century BC. These also clearly derive from trample and intrusion from later phases and cannot be used to date the events of this phase.

11.2.2 Early activities

The earliest human activities attested in Room 7 began with a posthole (200.130) found in the northern test-pit. A deposit of mostly sterile black sand (**200.131**, **200.130**) may have slipped into the hole after the removal of a wooden post, although the remainder of the hole was filled with a very dark greyish brown loamy sand (**200.132**). Seemingly associated with this was a shallow (0.49 by 0.35 by 0.13 m) stretch of loosely bonded Sarno stone rubble (**200.106**), possibly the remains of a wall (Fig. 5.11.2) that was recovered in the northern portion of the eastern area of the trench. Both the upper and lower 'pocked earth' surfaces were cut by and abutted the wall, and it is likely that the cut for the wall also removed the overlying black sand.[122] The wall's Sarno stone rubble was set in a yellow earthen mortar, a colour resulting from the inclusion of a considerable amount of yellowish clay-silt, which has been observed elsewhere Insula VI 1 in use as an earthen bonding material and comprised the rammed earth wall found in the atrium of the Casa delle Vestali.[123] As a result, the wall was extremely friable and poorly preserved. Furthermore, only a limited amount of the wall was recovered, since it had been truncated

on the east by a later cut, and its western extent was not recoverable due to a well-preserved final phase floor present in the centre of Room 7. Nevertheless, it appears to have had an east–west orientation and probably continued westwards, terminating before the northern sondage, where it did not appear. No evidence for the continuation of this wall eastwards was observed in the excavations in Room 16 (AA508).

11.3 Phase 3. The Casa del Chirurgo (c. 200–130 BC)

The tablinum was built as part of the initial phase of construction of the Casa del Chirurgo. This would first have involved the demolition of the Pre-Surgeon Structure represented by the earth-bonded rubble wall from the previous phase.

11.3.1 Destruction of the Pre-Surgeon Structure, a central circular cut

Phase 3 saw first the demolition of the Pre-Surgeon Structure and the initial construction of the Casa del Chirurgo. To the south of Room 7, the significant amount of debris created by this destruction was used to fill in the terracing cut that runs through these rooms (Fig. 5.11.4). Within Room 7, however, this material was largely removed from the space, perhaps because the generally higher elevation of this upper terrace meant that it did not require any terrace fill to prepare it for a new phase of construction. Indeed, the higher elevation and preservation of the original level of natural soils might have recommended the area to the builders for the excavation of a rough pit, 2.72 m across and 0.97 m deep that was cut (**200.122**) through the black sands of the previous phase in the centre of

Figure 5.11.2. Small section of Sarno stone rubble wall with earthen mortar recovered in Room 7 (image AAPP).

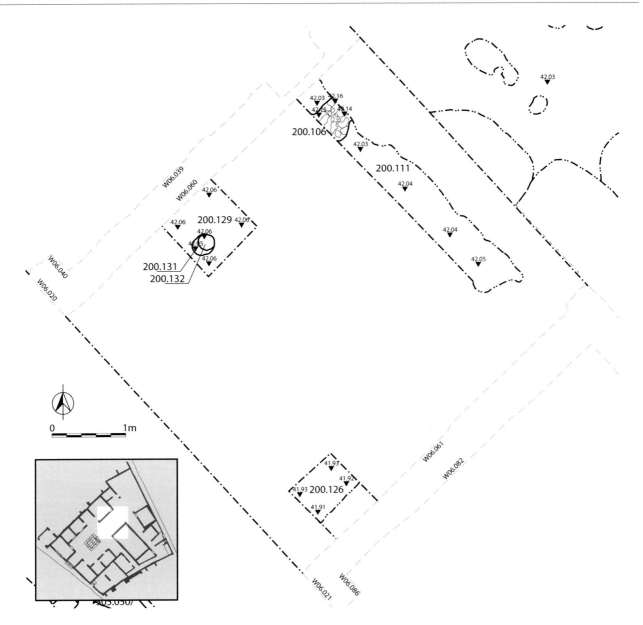

Figure 5.11.3. Plan of the deposits and features of Phase 2 recovered in sondages in Room 7 (illustration M. A. Anderson).

what was about to become Room 7. Afterwards, it was filled with a large quantity of building debris, including brick/tile, unfinished plaster, and iron nails, alongside a quantity of large Sarno stones (up to 0.18 by 0.2 m in size) (**200.112**), remains that could plausibly have come from construction activities or the destruction of the previous structure. Although the precise purpose of this pit is unknown, it is possible that it was intended to produce materials such as clean natural soils, clay, or sand for use in the planned building. Certainly, the soils excavated were consumed elsewhere, since they did not end up back in the cut.

11.3.2 Construction of the tablinum

Both of the standing walls of Room 7 (W06.060 = 200.067 and W06.061) were constructed as part of the initial build of the Casa del Chirurgo, although in slightly different styles. Excavation also revealed the presence of the robber trench that was used to remove the original eastern wall to the room (W06.059). Despite the slight difference in construction techniques, all three walls were clearly built at the same time.[124] Access to the southern portico and hortus at the rear of the Casa del Chirurgo was provided though a narrow doorway at the eastern end of wall W06.060. This led into Room 9, which, at the time of the initial foundation of the property, did not have an eastern

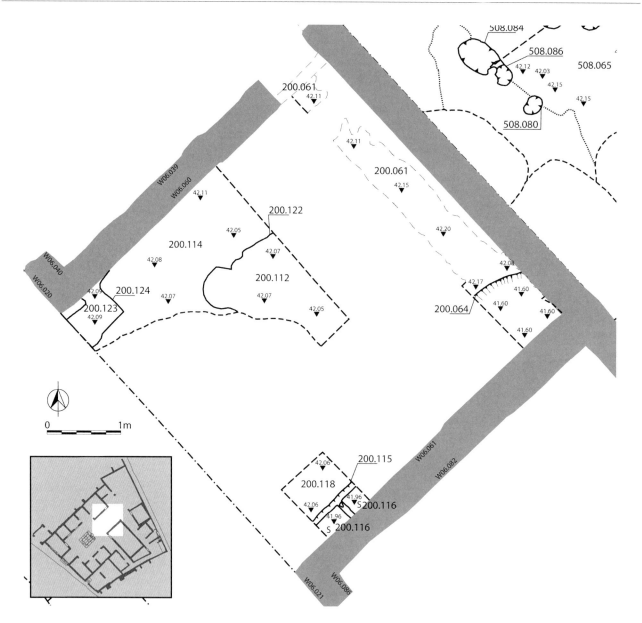

Figure 5.11.4. Plan of deposits and features associated with the construction of the Casa del Chirurgo in Room 7 (illustration M. A. Anderson).

wall and was open onto the portico. The removal of the eastern wall of the tablinum, W06.059, makes it impossible to ascertain whether it originally contained a window or a small doorway to provide visual or physical access to the adjacent portico. The foundation trenches for the walls of Room 7 were generally cut directly through the 'black sand' deposits of Phase 2 and vary somewhat in their morphology. The differences between the foundation trenches are most likely related to the differences in the method of construction.

11.3.2.1 WALL W06.061
At the eastern end of the southern wall (W06.061)

the foundation trench is marked by a 1 m wide, semi circular cut (**200.064**) that narrows to 0.7 m towards the corner of the wall (Fig. 5.11.5, A). Further to the west, the same foundation trench (**200.115**) narrows to only 0.32 m in width. The extra width of the foundation trench at the south-eastern corner was perhaps in order to provide the greater access necessary for the precise placement of the interlocking stones of the corner of the room. Blocks from the lowest course of the Sarno stones in the southern wall were 0.24 m wider than the remaining courses of the wall. This would have provided a stable base for the upper portions of the Sarno stone *opus quadratum* wall which contained two areas of rubblework infill in the upper central sector of the wall

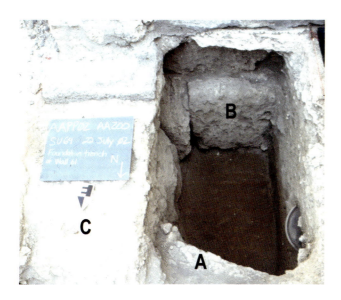

Figure 5.11.5. The stepped-out lowest foundation course of wall W06.061. (A) foundation cut for wall W06.061; (B) stepped foundation of wall W06.061; (C) eastern wall of tablinum (image AAPP).

(200.062 and **200.116**; Fig. 5.11.5, B). The rubblework was bonded with a fine brown (10 YR 4/3) clay with occasional volcanic mineral and lime inclusions. At the eastern corner of the wall, the foundation trench was filled with two different soil deposits (200.063, 200.022), while towards the western end of the foundation trench, the lower deposit was not observed and only the upper fill was encountered. This final deposit shares its coloration with a characteristic orange fill of the lower terracing to the south-west associated with the destruction of the Pre-Surgeon Structure. This implies a roughly simultaneous process of construction involving the cutting of foundation trenches for the walls of the atrium while the filling of the open terrace to the south was underway.

11.3.2.2 WALL W06.060
At the western end of wall W06.060, the foundation trench (**200.124**) was 0.48 m wide, perhaps to accommodate the setting of the north-western corner stones of the tablinum. This cut abruptly finishes only 0.7 m from the north-western corner of wall W06.060, and thereafter, the edge of the cut virtually abuts the Sarno stone foundations (200.138) of the wall. The wide part of the foundation trench was filled with a dark yellowish brown (10 YR 3/6) sand-silt-loam (**200.123**). The corners of wall W06.060 (200.067) were constructed in *opus quadratum* using Sarno stone with the central portion of the wall being constructed in *opus africanum*, which also used Sarno stone for both the framework and the rubblework infill. This was bonded with a fine

brown (10 YR 4/3) clay with occasional volcanic mineral and lime inclusions.

11.3.2.3 WALL W06.059
In the south-eastern corner of Room 7 there are the fragmentary remains of a heavily robbed 1.13 m long section of the rear wall of the tablinum (200.059; Figs. 5.11.5, C and 5.11.6), which was originally 0.48 m wide. All that remains is a section of Sarno stone and cruma *opus incertum* (200.059) that is unlikely to have been an element of the original construction. It is probable that this is the remnants of patching and repairs of the original *opus africanum* wall that were made prior its removal. The remaining fragments survive only because they were used as footings for later threshold stones. The clay-bonded construction used for the original *opus africanum* walls of the Casa del Chirurgo must have required a degree of maintenance, and throughout the house, other walls display clear signs of having been replaced or repaired with mortared *opus incertum*.[125] The significant depth of the cut made for the removal of the foundations suggests the presence of several large Sarno stones, which in turn imply a mixed construction technique intended to support a full height wall. This is also attested by evidence from the upper portions of walls W06.061 and W06.060. At the eastern end of wall W06.061, some of the Sarno stones project some 0.12–0.14 mm beyond the line of the original wall (Fig. 5.11.7, A) to create a northward projecting spur. This is also evident on wall W06.060, although here the early modern pointing obscures the ancient detail of the wall. These 'stepped' constructions therefore represent a spur that was associated with the keying in of at least

Figure 5.11.6. Traces of the *opus incertum* construction of the rear wall of the tablinum (image AAPP).

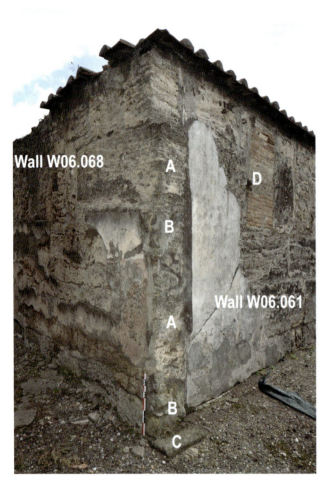

Figure 5.11.7. The corner between wall W06.061 and wall W06.068. (A) projecting Sarno block; (B) later *opus incertum* infill; (C) grey lava door pivot stone; (D) wall repair (image D. J. Robinson).

three large blocks that would have formed part of wall W06.059, closing off the eastern end of the tablinum.[126]

11.4 Phase 4. Changes in the Casa del Chirurgo (c. 100–50 BC)

As an element in the new phase of construction c. 100 BC, which saw the enclosure of the hortus and the construction of Rooms 19 and 21, the small doorway in the northern wall of the tablinum (W06.060), that provided access to Room 9, received a limestone threshold. This was in conjunction with a new floor constructed in Room 9 that can be dated to the period of the second Style (cf. Chapter 9). These changes may have provided the context for further alterations to the eastern wall (W06.059) of the tablinum, possibly including the creation of some sort of doorway into the newly redeveloped hortus. The traces of *opus incertum* discussed in Phase 3 above may represent the reconsolidation of this wall as a component of

these activities (**200.059**) (Figs. 5.11.8). Without such a doorway, the hortus area would have been entirely cut off from the rest of the house by the creation of Room 21 and the sealing of the eastern side of Room 9. Unfortunately, the later removal of wall W06.059, the eastern wall of the tablinum, has served to obliterate all certain traces of this phase from Room 7. Indeed, the provision of a mosaic floor for the tablinum in Phase 5 may well have also involved the removal of an earlier second Style floor for the space that would have matched those present in the cubicula on the north side of the atrium. The high state of preservation of this mosaic floor prevented excavation that might have recovered evidence of such an earlier floor.

11.5 Phase 5. Redecoration and redevelopment (late first century BC to early first century AD)

The late first century BC was a period of significant structural change in the Casa del Chirurgo that saw the redevelopment of the service wing of the house and the addition of two commercial units on the Via Consolare. The tablinum was also included in these changes with the removal of the rear, eastern wall (W06.059) of the room, followed by new mosaic flooring and plaster decoration.

11.5.1 Removal of wall W06.059

The majority of the rear wall of the tablinum was removed, leaving behind only a small *opus incertum* stub (**200.059**; Fig. 5.11.8), which itself appears to have been cut (**200.058**; Fig. 5.11.9). The remainder of the wall was completely removed, leaving only the robber trench (**200.058, 200.101**), which was thereafter filled with rubble and debris (200.057[127]) including a large quantity of *opus signinum* flooring and brick/tile as well as finished and unfinished plaster. Finds from this deposit enable the removal of the eastern wall of the tablinum to be given a *terminus post quem* of roughly the end of the first century BC. It is possible that the *opus signinum* floor recovered in this deposit was part of the previous floor of the tablinum that was removed down to the level of the underlying 'black' sand as part of this redevelopment.

After the initial removal of the back wall, two inter-cutting pits were then dug into the fill deposit inside of the former foundation trench. The first roughly circular pit, 1.6 m in diameter (200.103), was located approximately in the centre of the rubble fill of the former foundation trench. The second (**200.105, 200.101**) was approximately the same diameter (1.5 m), and was cut directly through the first, and extended to wall W06.060. The exact purpose of the pits is difficult

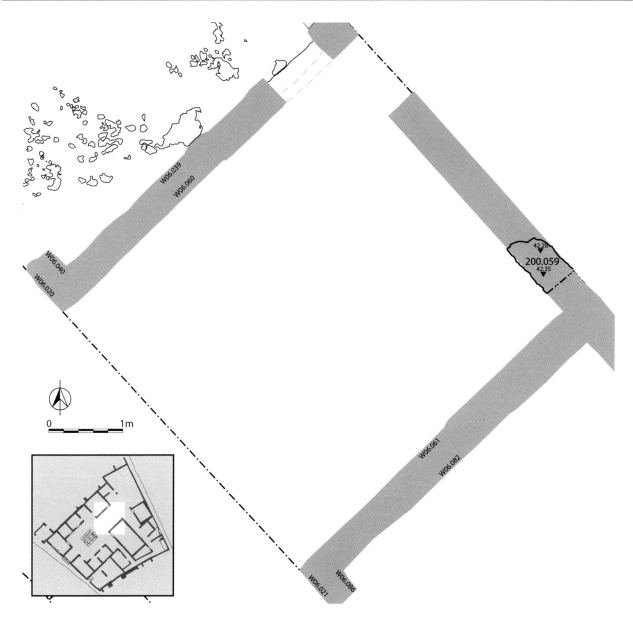

Figure 5.11.8. Plan of the deposits and features of Phase 4 related to the repair or modification of the eastern wall of Room 7 (illustration M. A. Anderson).

to ascertain, as they are cut directly into the rubble fill of the former foundation trench and do not cut deep enough to penetrate natural soils. Consequently they cannot have been for the provision of such material. Both of the pits were filled subsequently with deposits of building rubble that was very similar to the fill of the former foundation trench itself. This implies a temporary purpose, perhaps simply related to continued removal of the wall. It is also clear that the upper levels of these pits had been contaminated by later activities resulting in later pottery dates for 200.060, 200.100, 200.102, 200.104 and 200.108 than their place in the stratigraphic sequence would suggest. This is probably the result of materials from later activities,

including damage to the mosaic floor, intruding upon these earlier deposits.

11.5.2 The mosaic floor
The removal of the eastern wall of the tablinum would have necessitated the redecoration of the room, including the addition of a new floor (Figs. 5.11.10, 5.11.11, and 5.11.12). Whatever flooring the tablinum previously had seems to have been removed down to the level of 'black' sand (a deposit that would have made the breaking up and removal of an *opus signinum* floor particularly easy). Any such removal must have taken place at the same time as the removal of the eastern wall. After this had been completed, threshold stones were placed on either

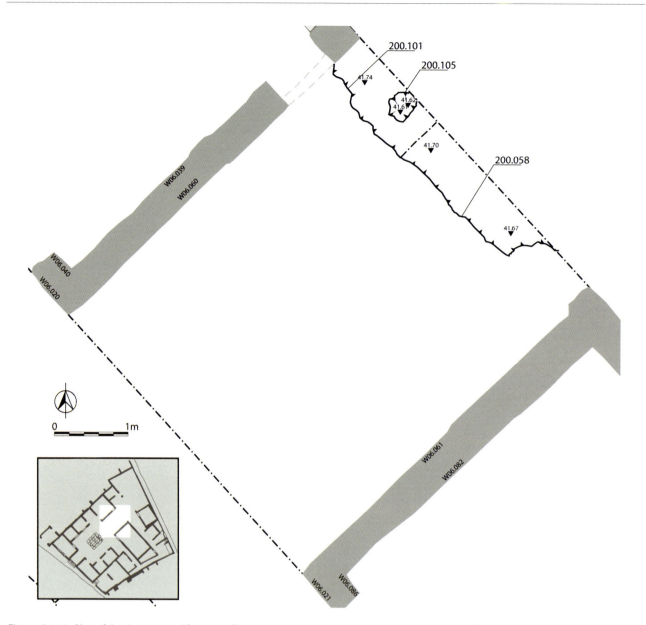

Figure 5.11.9. Plan of the deposits and features of Phase 5 related to the removal of the eastern wall of Room 7 (illustration M. A. Anderson).

end of the newly opened space in order to hold engaged pilasters that were added to decorate and formalise the vista through the atrium to the tablinum and hortus. In addition, the newly opened eastern doorway in the tablinum to the portico and garden space was fitted with a wooden partition or door frame. This rested upon two grey lava threshold stones, one adjacent to each wall. The southern lava threshold stone (**200.030/200.021**) was bedded directly onto the rubble rich fill of cut 200.105 (**200.101**)(cf. supra), although its placement against wall W06.060 required a shallow cut into the Sarno stone of the wall itself. This threshold stone also used the remains of the former eastern wall of the tablinum (200.059) as its foundation.

Following the placement of the threshold stones, a number of levels of rubble and construction debris were used to form the base of an *opus signinum* floor. The first, a mixed blackish brown sandy soil (200.026), likely residue from the destruction of the previous flooring and cutting down to the earlier black sands, was dumped across the area of the former foundation trench. This thin deposit contained pieces of building rubble of similar composition to the fills of the foundation trench and pits that it overlay, although the finds were significantly fewer in number and generally of a smaller size. It was most likely intended as a levelling layer to prepare this highly disturbed area for the construction of the mosaic floor. A roughly 0.10

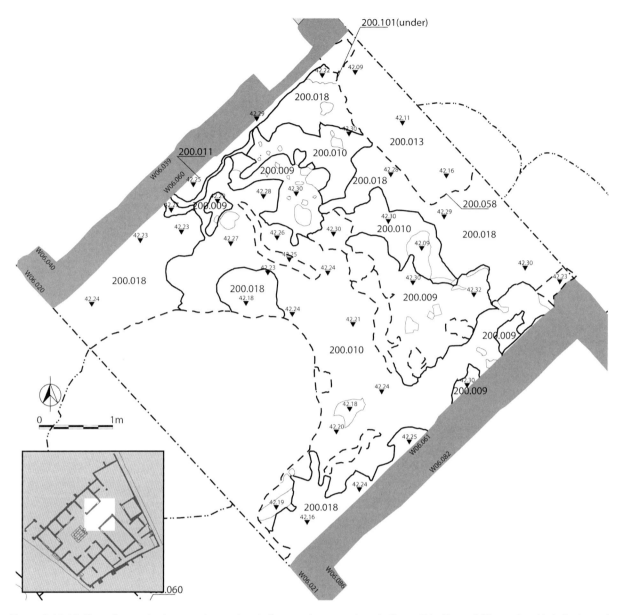

Figure 5.11.10. Plan of *opus signinum* and mosaic sub-floor and preparations in Room 7 in Phase 5 (illustration M. A. Anderson).

m thick layer of rubble set in loamy sand (**200.011**, **200.013**[128]) was then laid throughout the area of Room 7. The deposit contained large quantities of ceramic, finished and unfinished plaster, mortar, and pieces of an *opus signinum* floor decorated with white mosaic tesserae. Overlying the rubble was a patchy layer of thin reddish grey mortar (**200.018**) (Fig. 5.11.10). This was probably not an intentionally laid surface, but rather formed as an accidental by-product when the building rubble layer was tamped down. The pressure of this may have brought moisture to the surface of the rubble that would have bonded with the crumbled mortar and plaster in the rubble deposit, forming this patchy layer.

Overlying the deposit of building rubble was a 20

mm thick layer of dark red *opus signinum* (**200.010**). This would have been levelled off to create a sub-floor onto which a thin spread of pinkish white mortar (**200.009**) was deposited. This was the nucleus into which the tesserae of the mosaic (**200.008**, **200.015**, **200.016**, **200.017**) were set (Figs. 5.11.11, 5.11.12). The tesserae were roughly square measuring on average 7 mm by 7 mm. Against the wall the tesserae were set parallel, in a black border, four tesserae wide. From a fragment of mosaic recovered from the base of the collapsed cistern, it would appear that the border was composed of a series of black rectangles 18 tesserae long by 6 wide, separated by a single line of white tesserae. It is possible that this border had two parallel black lines. In the central portion of the room the

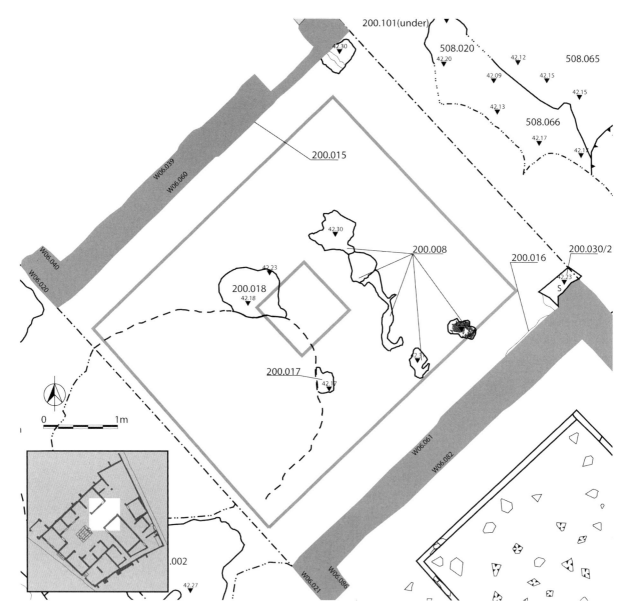

Figure 5.11.11. Plan of *opus signinum* and mosaic decoration of Room 7 in Phase 5 (illustration M. A. Anderson).

white tesserae were set on a 45–degree angle to the tablinum walls.

11.5.3 Phase 5 plaster decoration

It was at this time that projecting spurs at the eastern ends of walls W06.060 and W06.061 were created, forming two engaged pilasters that served to decorate the new wider opening. The removal of the eastern wall W06.059 left at least two Sarno stone blocks projecting beyond the line of the original wall (Fig. 5.11.7, A). Rather than shave off these projections they were retained to help create the edge of a new wide doorway into the garden area. The spaces between the projecting Sarno blocks were filled with *opus incertum*, the lowest of which overlies a new grey lava door pivot

stone, which was also inserted at this time (Fig. 5.11.7, B and C). Although it is difficult to be certain due to the extensive early modern and modern pointing, it would appear that the *opus incertum* was bonded with a yellow (10 YR 7/6) mortar containing black volcanic mineral fragments and the occasional larger piece of lime.

Sections of the *opus africanum* rubblework on both walls were replaced with regular courses of brick/ tile set in a hard very pale brown (10 YR 8/4) mortar with small volcanic mineral fragments, tuff, ceramic, and black cruma inclusions. The same materials were also used to fill the doorway at the eastern end of wall W06.060, which blocked off direct access to Room 9. Here the early modern mortar that was used to either point or perhaps even reset the brick/tile

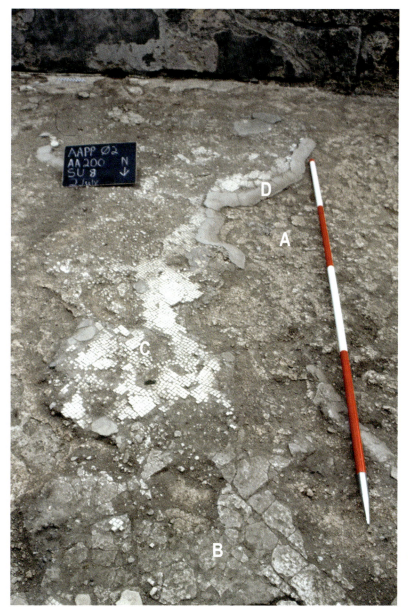

Figure 5.11.12. Remains of the mosaic and its bedding layers (A) *opus signinum* sub-floor; (B) mosaic nucleus; (C) tesserae; (D) modern patching and repair (image AAPP).

makes it impossible to know whether the same ancient very pale brown mortar was used in the brick/tile repairs. On the reverse side of the door blockage (wall W06.039), however, it is clear that the blockage was rebuilt in the early modern period. It is nevertheless likely that the door would have been blocked at this time, especially considering evidence from the plaster (cf. infra).

There are traces of a coherent phase of plastering that can be dated to the Phase 5 redecoration of the house through their use of an extremely characteristic white (10 R 8/1) sandy mortar that was used as the first layer of backing plaster directly against the Sarno stone walls (Fig. 5.11.13, A). As there is little evidence in the tablinum for a phase of plaster attributable to previous phases of the house, this would suggest that

it was systematically stripped from the walls as part of the initial rebuild of Room 7. The sandy sealing layer was then overlain by a light bluish grey (Gley 2 7/1) mortar with black volcanic mineral inclusions and larger pieces of rounded beach gravel and lime. At the western corner of wall W06.060, this layer was substantially thicker (c. 50–70 mm) and was used to create the five flutes in the upper zone of the western edge of the wall (Fig. 5.11.13, B). It would appear that the plaster was simply flattened and a fine white (10 R 8/1) final plaster added (Fig. 5.11.13, C).

It should be noted that the backing plaster also extends across the brick/tile fill of the doorway at the eastern end of wall W06.060, demonstrating that it was closed prior to the redecoration of Room 7 during this phase. Also on wall W06.061, it was used around some

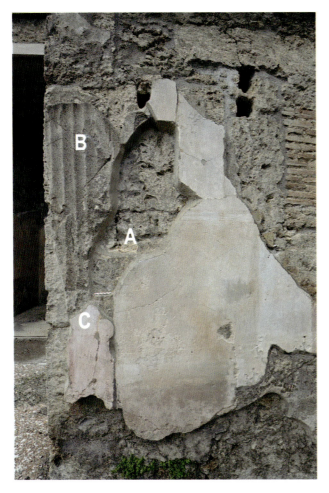

Figure 5.11.13. Detail of the Phase 5 plaster on the western end of wall W06.060. (A) sandy mortar sealing layer; (B) fluted mortar column; (C) final white plaster (image D. J. Robinson).

of the *opus incertum* that filled in the voids left by the removal of the *opus quadratum* blocks.

11.6 Phase 6. Upper storeys and final decoration (c. mid-first century AD)

Like much of the remainder of the property, the tablinum underwent a further phase of redecoration in the middle of the first century AD.

11.6.1 Phase 6 plaster decoration

In preparation for the redecoration of the room, the previous final plaster surface was carefully removed and the backing plaster repeatedly picked to roughen up the surface prior to the addition of a new final surface (Fig. 5.11.14, A and B). There is also some evidence of a rippled surface on the previous backing plaster on wall W06.060, which could also suggest the use of a scoop-shaped tool for the removal of its former final surface.

A new 10 mm thick layer of backing plaster was then added to the walls. This was composed of a white (10 R 8/1) plaster with rounded black volcanic sand and larger pieces of lime. This was flattened in preparation for a thin layer of final white (7.5 YR 7/1) plaster with mineral crystal inclusions. This was the surface upon which guidelines were incised, indicating the location of different panels of painting. Evidence from wall W06.060 would suggest that it was divided into three vertical panels. The central contains evidence for a red (10 R 4/6) fresco, with yellow (10 YR 8/8) in the lower

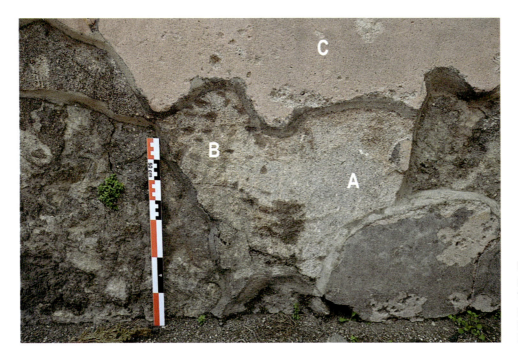

Figure 5.11.14. Pick marks to prepare the initial plaster layer to receive the final layer. (A) previous backing plaster; (B) pick marks; (C) final plaster layer (image D. J. Robinson).

Figure 5.11.15. Plan of pick marks and cuts made during the renovations of Phase 7 (illustration M. A. Anderson).

zone beneath it. There are traces of a bluish grey (Gley 2 5/1) colouration in the western panel. A 0.11 m wide border separated the middle from the lower registers of the wall, which was divided into an 80 mm wide lower border with a 30 mm wide upper. At the western and eastern extremities of the wall there are flanking engaged pilasters protruding from the surface of the wall on which there are trances of a dark red (10 R 3/6) pigment.

11.7 Phase 7. Post-earthquake changes

It would appear that the Casa del Chirurgo was damaged by seismic turbulence in the period following the redecoration of the mid-first century AD. The result of this was the need to redecorate or repair areas of the house, which can be seen most clearly in the service wing. It would also appear that while the tablinum may not have been damaged in the seismic activity *per se*, the traces of pick marks and scratching into the underlying *opus signinum* sub-floor are likely indicative of damage having taken place to the tablinum floor during a period renovation that was never completed. Repeated dragging of heavy items between the atrium and the hortus seems to have damaged especially the central part of the mosaic at this time. In addition, at the north-eastern end of the room, the *opus signinum* sub-floor was cut (**200.012**). This was a slightly wider cut than had been made for the removal of wall W06.059 and may perhaps be associated with the removal of the wooden screen that closed off the eastern end of the

Figure 5.11.16. Plan of radial cracks and other changes of Phases 8 and 9 in Room 7 (illustration M. A. Anderson).

tablinum from the hortus. This was perhaps done in order to facilitate the movement of materials to and from the service wing that was under repair at the time of the eruption.

The south-western corner of Room 7 received a series of pick-marks in the *opus signinum* (**200.014** Fig. 5.11.15, cf. Fig. 4.43). The pick-marks are between 40 and 50 mm wide, and were made with a flat-headed tool. Given their location near to the wall it is possible that they occurred as part of an attempt to remove a piece of border of the mosaic floor. It is of course conceivable that this damage occurred is the early modern period and initial excavations described below, when other pieces of decoration were removed from the property. However, given the damage to the reminder

of the flooring in the tablinum as well as elsewhere in the house – notably in southern ala – it is thought more likely that the damage to the atrium floor was also a result of the widespread building activity being undertaken in the service wing and elsewhere in the property in Phase 7.

11.8 Phase 8. Eruption and early modern interventions

It would appear that during the eruption in AD 79, the two cisterns at the eastern end of the atrium collapsed, creating a void into which fragments of mosaic floor and much of its *opus signinum* sub-flooring at the western end of the tablinum fell. The result was a roughly semi-circular cut, 2.82 m in width, in the mosaic and its bedding layers marks the edge of the

void created by the collapse of the cistern at the eastern end of the impluvium. The failure in the integrity of the mosaic floor can furthermore be seen in the numerous concentric cracks in the *opus signinum* sub-floor, radiating outwards from the collapse (200.019; Fig. 5.11.16). At the base of the collapse are the multiple large fragments of the mosaic and its underlying sub-floor and base (200.020,[129] 200.065, 200.066, 200.025, 200.110). These fragments were encased in a dark greyish brown clay, which was directly comparable to a similar grey clay found towards the bottom of an intact cistern in the adjacent atrium of the Casa

delle Vestali.[130] Consequently, it is suggested that the collapse of both the cistern and floor occurred within a relatively short time of one another, as the grey clay was sufficiently wet and plastic enough to envelop the pieces of collapsed floor. The void was subsequently filled with a reasonably well-stratified deposit of lapilli. A section through this deposit revealed that the lapilli were laid in gently sloping bands. At the base of the deposit was a 0.43 m deep dark yellow brown band of lapilli. This was overlain by four other bands of lapilli that alternated between thinner yellowish brown layers, approximately 0.1 m thick and very dark grey

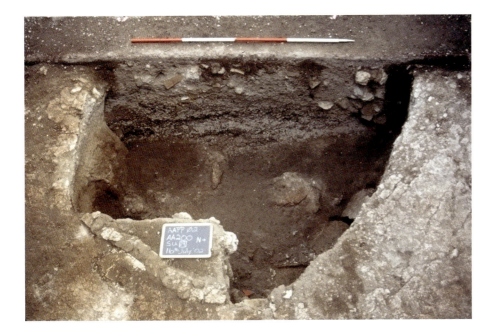

Figure 5.11.17. View of the fill of the collapsed cistern (image AAPP).

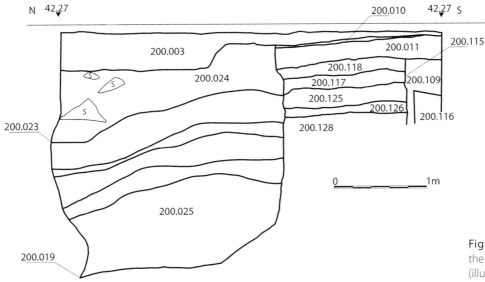

Figure 5.11.18. Section through the AD 79 lapilli in cistern collapse (illustration M. A. Anderson).

bands 0.14 m thick, representing phases in the eruption itself. (Figs. 5.11.17, 5.11.18).

11.8.1 Investigations into the collapsed cistern

During the initial clearance excavations in Room 7 in January 1771, there was some investigation into the lapilli fill of the collapsed cistern involving the removal of debris down to the pieces of collapsed floor, although this was not mentioned in what survives of the original reports.[131] The early modern investigators of the Casa del Chirurgo dug a pit (200.023, 200.024) into the lapilli filled cistern collapse (**200.019**). This modern intrusion was only recognised in section when its undifferentiated nature made it distinguishable from the coloured bands of the naturally deposited lapilli elsewhere in the cistern fill. The pit was clearly left open until such time when some of the wall painting from the property was being removed from the walls. It would appear that during this process, several large panels were broken. These decorative panels, along with a quantity of other more plain plaster, were simply thrown into the empty pit, which was then backfilled with the same lapilli that had recently been taken out of it (cf. Chapter 8).

11.8.2 Wall and floor restoration and consolidation

The edges of the exposed mosaic were consolidated, by means of a line of small blocks of Sarno stone (between 0.1 and 0.2 m) set in a greyish brown mortar (200.003), which included pieces of pottery in its makeup. The upper part of wall W06.060 was levelled up to a consistent height in a rough *opus incertum*, using large pieces of Nocera tuff set within a light bluish grey (Gley 2 7/1) mortar with black volcanic stone, lime, and lapilli. The same mortar was also used as a thick layer of render over the eastern engaged pilaster and over the upper surface of wall W06.060. Following this, a line of tiles was added to the tops of the walls that were bedded on a layer of light bluish grey (Gley 2 7/1) mortar with lime inclusions.

11.8.3 Wall plaster consolidation and conservation

On both walls, the final phase wall plaster was secured to the wall by iron butterfly clips and a number of cracks were filled with a fine-grained yellow mortar, presumably in an attempt to blend the repairs into the colour scheme of the wall. On wall W06.061, there is also evidence of a further attempt at plaster consolidation. Here, there is a thin, intermittent line of weak red mortar (10 R 5/4) c. 0.1 m out from the surviving wall plaster, which follows the line of the exposed edges of the wall plaster. This probably demarcates a wide edging band of the early modern mortar, although judging by the limited survival of this, it cannot have been very effective as a conservation measure. More effective was the filling areas where the final layer of plaster had come away from the backing with a bluish grey (Gley 2 5/1) mortar containing fine black volcanic mineral fragments and the occasional piece of lime.

11.9 Phase 9. Modern interventions

During recent years, the surviving remnants of the mosaic floor and walls of the tablinum experienced various methods of conservation. Initially, a greyish brown mortar was applied to the edges of the surviving areas of mosaic (SU **200.003, 200.004, 200.005, 200.006**) and to fill a hole in it (200.007). The aim of this conservation measure was to prevent further fragmentation of the mosaic (cf. Fig. 5.11.12). A light bluish grey (Gley 2 7/1) mortar with angular fragments of black volcanic rock was used on walls W06.060 and W06.061 for plaster conservation, and was used to both fill holes in the surface of the surviving wall plaster and also to provide a protective covering for its exposed edges. A similar mortar was also used to square up around the projecting spur at the western end of wall W06.061 and to point around the *opus incertum* patches of the spur.

More recently, a coarse grey gravel (200.001) was spread throughout the tablinum. This was bedded on top of a soil layer that contained numerous pieces of modern material, such as cigarette butts and pieces of plastic. It is suggested that this was a natural deposit of soil that developed in the area over the mosaic in the years after the last cleaning of the mosaic and its edging of greyish brown mortar. Finally, a rough, light bluish grey (Gley 2 7/1) mortar was used to point around the edges of the Sarno blocks on both walls of the tablinum.

12. Room 9
Triclinium (not excavated)

Description

Room 9 was created during the initial construction of the Casa del Chirurgo (Fig. 5.12.1). It measures 4.56 by 4.53 m. At first, there was no western wall in the room, leaving it open onto the eastern portico and the hortus beyond. A small doorway at the western end of wall W06.039 allowed access from Room 7, the tablinum, to the portico and hortus. The room underwent a significant alteration during the major phase of changes in the house at the end of the first century BC. At this time the small doorway was blocked, as was the western end of the room through the creation of wall W06.038, which was built as part of the construction of Room 21.

As part of the initial cleaning of this room, which involved the removal of the topsoil, a relatively intact floor surface was discovered. Due to the extent of preservation, no further excavations were undertaken. Consequently, all of the interpretations contained here are based upon the examination of the walls and decoration.

12.1 Phase 1. Natural soils

No evidence of this period was recovered in this area.

12.2 Phase 2. Volcanic deposits and early constructions

No evidence of this period was recovered in this area.

12.3 Phase 3. The Casa del Chirurgo (c. 200–130 BC)

12.3.1 The construction of Room 9

Walls W06.037, W06.039, and W06.040/41 were constructed as part of the initial build of the Casa del Chirurgo. Wall W06.037 forms part of the original northern boundary wall of the property and was probably built shortly before the other primary walls of Room 9. Walls W06.037 and W06.039 were built in *opus africanum* using Sarno stone for the framework of the wall and Sarno stone with the occasional piece of cruma and grey tuff for the rubblework. The small doorway at the eastern end of wall W06.039 was an initial feature of the wall as the Sarno stone blocks that form the jambs of the doorway were deliberately aligned to create it. Wall W06.040/41 differs slightly from the other primary walls of the room as it was constructed from a mixture of *opus quadratum* to form the doorway into Room 5 and *opus africanum* for the remainder of the wall. All of the walls were bonded with a very pale brown (10 YR 8/3)

Figure 5.12.1. Room 9 (image D. J. Robinson).

clay with occasional volcanic minerals. At the time of initial construction no wall was built on the eastern side of the room. This would have left Room 9 open to the eastern portico and the hortus beyond it, although there was probably a wooden shuttered doorway to close off the room from the elements.

Figure 5.12.2. Phase 3 wall plaster on walls W06.038 and W06.039. (A) Eastern end of wall W06.039 (niche produced by blocked doorway); (B) southern end of wall W06.038; (C) backing and final plaster from Phase 3 (image D. J. Robinson).

12.3.2 The Phase 3 decoration

At the southern corner of wall W06.040, at the junction with wall W06.039, there are the remnants of the earliest surviving wall plaster in Room 9. This is composed of a layer of light bluish grey (Gley 2 8/1) plaster with black volcanic mineral inclusions, which was covered with a thin layer of white (5 YR 8/1) final plaster. This plaster layer is also seen on the northern face of the Sarno stone blocks that form the eastern end of the original build of the wall. This is abutted by wall W06.038, clearly demonstrating that there was no wall in the initial phase (Fig. 5.12.2, A, B, and C).

12.4 Phase 4. Changes in the Casa del Chirurgo (c. 100–50 BC)

12.4.1 The construction of wall W06.038

Room 9 underwent a substantial change in Phase 4, which saw the construction of wall W06.038, the simultaneous construction of Room 21, and the opening of a doorway in the back wall of the tablinum (Room 7), if one had not been present before. Wall W06.038 was constructed in *opus incertum* using Sarno stone, red cruma, and the occasional piece of Nocera tuff set in a very pale brown (10 YR 8/4) mortar containing small black volcanic mineral inclusions and larger but less frequent pieces of crushed black cruma and lime. There is some evidence to suggest that care was taken to smooth the mortar flat around the rubblework in order to prepare the wall for plastering. Effectively, this sealed off Room 9 from the hortus. A further component of these changes

involved the placement of a limestone threshold stone in the doorway between Room 9 and the tablinum (Room 7). After this had been positioned, a mortar floor, dating stylistically to the second Style, was added to the room. No plaster decoration from this phase survived, having been extensively removed in the subsequent phase.

12.5 Phase 5. Redecoration and redevelopment (late first century BC to early first century AD)

12.5.1 Closure of Doorway

Phase 5 witnessed significant changes throughout the house, including the removal of the back wall of the tablinum (Room 7). In Room 9, this phase saw only the closing of the doorway that led into the tablinum, a change that seems to have inspired a new phase of plaster decoration. The first step in this process appears to have been to remove all traces of any previous wall decoration. From the extent of early modern render on wall W06.039, it is difficult to be certain when the small doorway was filled. Nevertheless, it has been assigned to the late first century BC because of the evidence from the reverse of wall W06.039 (wall W06.060 in the tablinum) where the bottom of the doorway fill is overlain by backing plaster from Phase 5. The doorway was filled with layers of brick/tile. In a similar way, the rubblework of the *opus africanum* of wall W06.039 were also repaired using courses of brick/tile set in a very pale brown (10 YR 8/4) mortar containing small volcanic mineral fragments, lapilli, ceramic, and crushed volcanic stone.

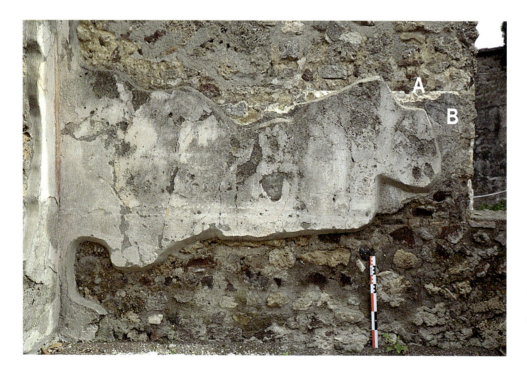

Figure 5.12.3. Surviving wall plaster on wall W06.038. (A) white sandy mortar sealing layer; (B) backing plaster (image D. J. Robinson).

12.5.2 The Phase 5 decoration

Wall W06.038 was covered with a layer of smooth white (7.5 Y 8/1) plaster that was applied directly to the face of the *opus incertum*, perhaps as a sealing layer (Fig. 5.12.3, A). This was a technique that was used in the house only during the late first century BC phase of decoration. Directly overlying the white plaster was a layer of backing plaster composed of a white mortar matrix with rounded black volcanic sand inclusions, which gives the plaster a light bluish grey (Gley 2 8/1) overall hue (Fig. 5.12.3, B). This plaster was flattened at the surface in preparation for a final layer of plaster. The same sequence of white sealing layer and backing plaster is also seen on wall W06.039 and possibly W06.040/41, with just the backing plaster surviving on wall W06.037. On the walls of the initial build (W06.037, W06.039 and W06.040/W06.041), the plaster from the late first century BC phase of decoration directly overlies the 'bare' *opus africanum* walls, which would indicate that prior to the redecoration of the room, the great majority of the previous phase of wall decoration had been systematically removed.

12.6 *Phase 6. Upper storeys and final decoration (c. mid-first century AD)*

12.6.1 Wall decoration

The lack of any final plaster surface from the preceding phase would suggest that it was largely stripped from the walls of Room 9 prior to a new phase of decoration in the middle of the first century AD. Evidence from walls W06.038 and W06.039 suggests that this was done using a tool with a slightly scooped blade approximately 55 mm wide, which produced a wave-like effect in the surface of the underlying backing plaster (Fig. 5.12.4). It would appear that some care was taken to retain this earlier backing layer, which was then simply plastered over with a light bluish grey (Gley 2 7/1) plaster with small volcanic mineral inclusions and occasional larger pieces of rounded black volcanic stone, ceramic, and lime. The backing plaster on wall W06.038 appears to butt up against that on wall W06.037, indicating that the walls of the room were probably plastered in a sequence with wall W06.037 receiving its backing plaster prior to that on wall W06.038.

The new layer of backing plaster was flattened at the surface in preparation for a layer of final white (2.5 YR 8/1) plaster containing translucent mineral crystal fragments. At the junction between walls W06.037 and W06.038, the final plaster appears to lip around from wall W06.038 onto wall W06.037, indicating that the final plaster was applied to both of these walls at the same time. The surface of the final plaster on wall W06.038 was incised with two horizontal guidelines 62 mm apart, which delineated a border dividing the decoration into a lower and middle register. The start of this border was at 0.72 m from the ancient floor surface. Another border, c. 50 mm wide, appears to run horizontally across the surviving wall plaster at 0.99 m above the ancient floor surface. The surface of the plaster in the area of what would have been the middle register on walls W06.037 and W06.039 have a pinkish white (10 R 8/2) colouration, suggesting that a pigment was applied. Whereas on wall W06.038, there are traces of a pale red (10 R 7/3) colour in the lower

Figure 5.12.4. Waves in the surface of the Phase 5 backing plaster on wall W06.039 (image D. J. Robinson).

register, perhaps hinting that it would have been a darker shade of red in antiquity (Cf. Chapter 8). There are also traces of vertical incised guidelines on wall W06.038, although little of the structure of the resultant paintings can be discerned. At the eastern edge of wall W06.037, there is a vertical weak red (10 R 4/4) stripe 40 mm wide. There also appears to be a small (20 cm in diameter) weak red roundel preserved in the final plaster surface.

12.7 Phase 7. Post-earthquake changes
No evidence of this period was recovered in this area.

12.8 Phase 8. Eruption and early modern interventions
12.8.1 Wall reconstruction
During the early modern period the upper portion of wall W06.037 was rebuilt to bring it up to a constant height with the walls surrounding it. This was undertaken in *opus incertum* using Sarno stone, brick/tile, and cruma. Due to the extent of early modern and modern rendering and pointing, it is not possible to discern accurately the mortar with which this was bonded. At the western end of the wall, however, the repair is associated with a layer of early modern rendering mortar, which could also have been used to bond the *opus incertum* rubblework. This was composed of a coarse light greenish grey (Gley 1 8/1) mortar, which weathers to a greenish grey (Gley 1 6/1) containing black volcanic mineral inclusions, and larger pieces of lapilli, lime ceramic, and black cruma.

A line of roof tiles that was set upon a bed of fine light bluish grey (Gley 2 7/1) mortar containing occasional pieces of lime were placed on top of walls W06.038 and W06.039. On wall W06.038, the tiles and mortar appear to have been laid directly upon the top of the surviving wall. A line of tiles set in the same mortar was also placed on top of the southern edge of the window in wall W06.038, which was also covered in a layer of early modern render composed of the same light greenish grey mortar that was used to render wall W06.037. It would appear that the mortar in which the tiles were bedded was smeared down over the final surface on wall W06.039, indicating that they were placed there after the wall was rendered.

The small doorway at the eastern end of the wall was repaired and/or rebuilt using brick/tile set in a light bluish grey (Gley 2 8/1) mortar containing black volcanic mineral inclusions and larger pieces of lapilli, lime, tesserae, ceramic, and black cruma. This mortar also surrounds the wooden lintel over the doorway,

indicating that it would also have been put in place as part of the reconstruction of the blocked doorway. It also used a layer of render across the upper surface of wall W06.039 and also on wall W06.040/W06.041, while lower down, this wall the mortar was simply used to point around the rubblework.

12.8.2 Plaster conservation
At the intersection between the preserved final plaster layers on walls W06.037 and W06.038, there is evidence of an early plaster restoration in the form of a thin smear of yellow (10 R 8/6) plaster that was smoothed over the joint between the two and then over the red border. On wall W06.038, this was also used to repair holes in the surface of the plaster. The same yellow plaster was also used to repair areas of damage plaster on wall W06.039.

12.9 Phase 9. Modern interventions
12.9.1 1970's restoration campaign
12.9.1.1 WALL RESTORATION
It would appear that a small patch of wall W06.038 either failed and came away from the wall or else the fabric required pointing and patching. This was undertaken with a coarse bluish grey (Gley 2 5/1) mortar containing fine black volcanic mineral fragments and flecks of lime as well as larger pieces of lime and lapilli. The early modern rebuild of the small doorway at the eastern end of wall W06.039 was also patched up using a bluish grey (Gley 2 6/1) mortar with lapilli and crushed volcanic inclusions.

12.9.1.2 PLASTER CONSERVATION
Further attempts were made to preserve the remaining ancient plaster during the modern period. A light greenish grey (Gley 1 8/1) to light bluish grey (Gley 2 7/1) mortar with angular black volcanic inclusions was applied to the exposed edges of the plaster and was also used to fill in holes in the surface of the plaster on walls W06.037, W06.038, and W06.039.

12.9.2 2000's restoration campaign
A new copper alloy downpipe from the roof over Room 8 was fixed to the top of wall W06.041 using a smooth white (Gley 2 8/N) mortar. Finally, all of the walls in Room 9 were pointed with a coarse light bluish grey (Gley 2 7/1) mortar that was used both around the rubblework and the headers and stretchers of the *opus africanum*.

13. Room 10
Triclinium (AA261, AA701)

Description

Room 10 is a large, rectangular room (8.61 by 4.47 m) situated off of the south-east corner of the atrium of the Casa del Chirurgo. Its position, shape, and size have generally led it to be interpreted as a triclinium, a function that is confirmed during its final phases due to traces of a marble fragment *emblema* offset to the south of the centre of its *opus signinum* flooring, around which the three dining benches could have been arranged. It is accessible by a single doorway in its western wall (1.41 m wide) decorated with a limestone threshold. Wall plaster decoration from the final phase helps to confirm the relatively high status of this room within the decorative programme of the house. Though well preserved on the northern half of the room, the walls of the southern end have not survived equally and questions about the ceiling arrangement or the possible presence of a second storey over this room cannot be discounted. Stairs to the east in Room 16 clearly led to upper storey rooms over Rooms 18, 17, and 15, which probably also continued over Rooms 13 and 14. Nevertheless, given the status of the room, it is likely that it was completed with a decorated high ceiling (potentially including a hanging vault similar to that preserved in Room 19).

Archaeological investigations

Excavations within Room 10 were carried out primarily during a single campaign of excavation during the summer of 2003, which focused initially upon the entire extent of the room.[132] Analysis of the architecture was also undertaken at this time and checked in 2006, 2009, and 2013.[133] Upon the discovery of well-preserved traces of the final phase *opus signinum* flooring, this trench was reduced in size to only the eastern half of the area (that part of the floor which had already been perforated by Maiuri's original investigations into this space).[134] These excavations proceeded to the depth of the natural soils throughout, producing the entire available sequence within the area. A small re-investigation in order to resolve minor questions that had been raised by adjacent excavations during the intervening years was planned in the summer of 2007 (AA701).[135] This was never undertaken and was limited to uncovering the remains of the AD 79 surface on the west and recording of the upper surface.

13.1 Phase 1. Natural soils

The excavations in Room 10 were of no small importance in revealing the full range of the natural sequence of soils observable in the Casa del Chirurgo and in Insula VI 1 as a whole. The large pit excavated during the early phases of Room 10 (see Phase 2 below) produced a deep section through the natural which documented the full stratigraphic profile of the natural soils, demonstrating

Figure 5.13.1. Natural deposits revealed by later cuts and the Pre-Surgeon terrace. (A) decomposed turf line; (B) yellowish brown natural; (C) Pre-Surgeon posthole; (D) pre-Surgeon latrine pit; (E) 'pocked earth' in section (image AAPP).

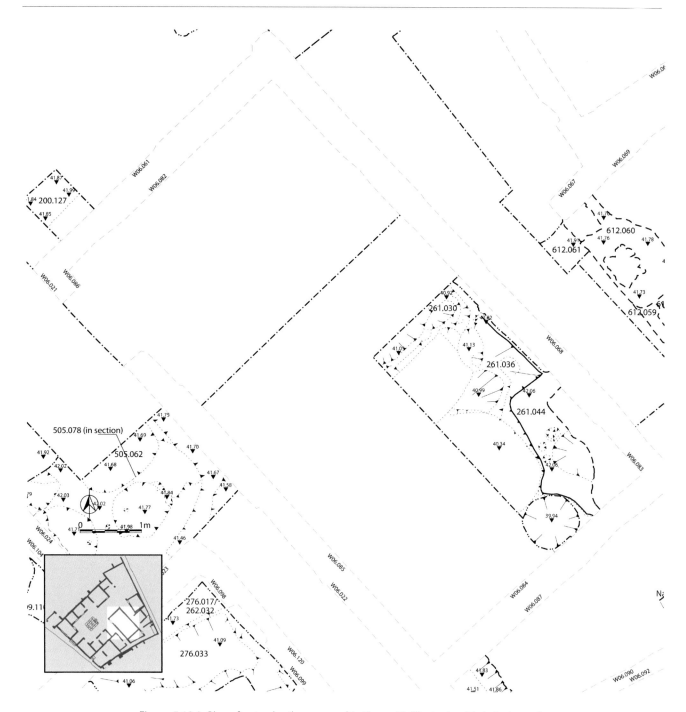

Figure 5.13.2. Plan of natural soils recovered in Room 10 (illustration M. A. Anderson).

that the numerous seemingly different colours of natural soils recovered throughout the insula were each simply different elevations within a uniform gradient of soils as described in Chapter 4.

In Room 10, a thin deposit of mottled light greyish brown (10 YR 5/2) silt (261.044) (Fig. 5.13.1, A), possibly the remains of an early turf layer (**261.044**), overlay the natural yellowish brown (10 YR 5/4) firm sandy silt (**261.030** and **261.036**) (Figs. 5.13.1, B and 5.13.2). This was only visible in the south-east of the archaeological area due to later activities that had removed the upper levels of this soil elsewhere. The full sequence of the natural soil was observable in the exposed eastern face of pit 261.051. Three distinct layers could be seen in the natural soils, which graded from a fine yellowish brown sandy silt at the top of the profile, through an intermediate sandy/gravely version with an even grittier brown to black deposit at the base, which included large (10–20 mm in diameter) black and white volcanic scoriae.

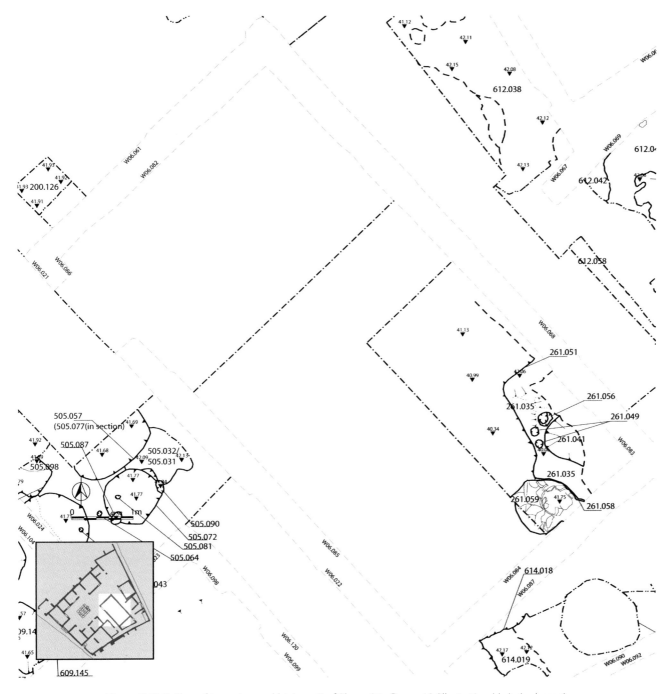

Figure 5.13.3. Plan of terracing and latrine pit of Phase 2 in Room 10 (illustration M. A. Anderson).

13.2 Phase 2. Volcanic deposits and early constructions

The first anthropogenic activities that occurred in Room 10, followed a series of likely volcanic strata that have been recovered from throughout Insula VI 1 (Fig. 5.13.3). In Room 10 the precise relationship between these the earliest naturals and the volcanic deposits have been lost due to later cuts and fills which destroyed many of their stratigraphic relationships. Nevertheless, on the basis of similar strata elsewhere

within the Casa del Chirurgo, it is possible to suggest that these layers were cut through as part of activities related to the construction of the Pre-Surgeon Structure to the west and south. These produced a long, linear cut running roughly north–south that aligned at a near right-angle to a similar cut into the natural soils recovered within Room 11 (Fig. 5.13.3) creating a lower terrace in which the Pre-Surgeon Structure was constructed. At the southern end of Room 10, a deep but narrow pit plausibly represented the toilet of the

early structure(s), that produced numerous Greco-Italic amphorae dated between the fourth and second century BC.

13.2.1 The early layers

The first deposit on top of the natural soil with its traces of turf was a layer of pea-sized gravel capped by a compact sandy or silty surface of pocked earth (**261.053**).[136] In section, the top surface to this deposit was more apparent. Together, the whole ensemble produced a 30 mm thick layer, characteristic of the early deposits elsewhere in the insula. There was, however, little trace of the dark sandy (261.035) stratum so prominent elsewhere in the block. It is possible that, similar to the atrium, little of the black sand survived the repeated activities of Phase 2 and 3. These deposits were cut through by the earliest attested human activities. Surviving traces suggest that the elevation of this surface (42.18 MASL) was roughly the same as those recovered in the tablinum (42.05–42.11 MASL).

13.2.2 Early cuts and fills; the Pre-Surgeon terrace cut

Following these deposits, a series of cuts were made into the soils designed to carve out a lower terrace across much of the southern half what later became the Casa del Chirurgo. In Room 10, this is represented by a long, roughly north–south aligned cut (**261.051**). This cut plausibly had its origins in a number of smaller pits that coalesced into the single large pit. This can be deduced from the two shallower sectors of the pit and the much larger and deeper main section of the cut. The true extent of the cut is, however, difficult to determine.

The section excavated was 3.45 m long and joined the latrine pit (261.059) at its southern end. The evidence for the true northern extent of the cut was removed by the sondages of Maiuri (cf. infra). Excavations were halted for safety reasons at a depth of 2.20 m. Numerous ancient 'pick-marks' were exposed in the eastern side of the pit wall (Fig. 5.13.4) (261.052), which indicate that it was cut with a flat-bladed implement, with a blade width of approximately 8 cm. The marks are present throughout. At the north-east section of the main cut, the edge of small posthole (261.054), 0.1 m wide by 0.35 m deep, was also observed. It was later filled with a brown (10 YR, 5/3) sandy silt.

In the south-east corner, an oval pit (**261.041**), measuring 0.44 m on its long north-east to south-west axis by 0.3 m on its short north-west to south-east axis, by 0.28 m deep, with moderately sloping sides was also cut. It was filled with a greyish brown deposit containing some pottery, tile, and plaster – characteristic of the post-Pre-Surgeon fills described below. This deposit was almost identical in its matrix and contents to the fill of the central terracing cut. It is possible that this was a separate cut, but it is probably simply the uneven bottom of this larger removal of soil. In addition, a small cut (**261.056**), roughly 0.24 m wide and located nearby to a series of depressions, possibly caused by rocks that were later removed (**261.049**), plausibly formed the footing of a temporary post, or simply represented incidental damage that occurred during the process of soil removal. These depressions were also filled with debris that is likely a component of the later filling up of the terrace (261.057, 261.050).

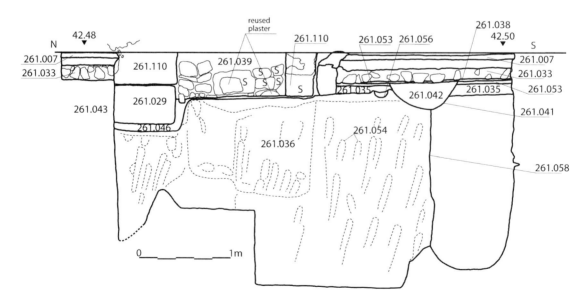

Figure 5.13.4. Section of Room 10 (illustration C. L. O'Bryen).

A deep, roughly circular pit that seems to have been functioning as a latrine or large-scale soak-away was cut at the extreme southern end of the terrace cut in the south-west corner of the excavation area, partially underneath the overlying later wall W06.084. It was a narrow, vertical-sided pit, measuring 0.90 m wide by 2.25 m deep (261.058; Fig. 5.13.2), filled with a loose green deposit (**261.059**) containing twelve almost complete Greco-Italic amphorae (Fig. 5.13.5) intermixed throughout the whole of its depth with large black lava stones, as well as pottery, plaster, other ceramic materials, and a quantity of iron nails.

The morphology of the pit is unusual and it suggests that its purpose was not the recovery of clean, natural soils or sand, as these types of pits, as identified elsewhere in the excavations of the Casa del Chirurgo, tended to be wider and shallower in form. It is perhaps significant that the pit fill imparted a characteristic yellow-green mineral stain to the material contents, which is seen most clearly on the amphorae. This form of mineralisation and staining is most commonly found elsewhere in the insula in drains and cesspits.[137] Consequently it is suggested that the pit (261.058, 261.059) was used either as a latrine or a cesspit for the Pre-Surgeon Structure. The fill of the pit can be roughly dated by the amphorae to between or at least after the fourth and second centuries BC.[138]

13.3 Phase 3. The *Casa del Chirurgo (c. 200–130 BC)*

At a point between about 200–130 BC, the construction and initial decoration of the Casa del Chirurgo was undertaken. Prior to this, the Pre-Surgeon Structure needed to be demolished. To the south, and especially to the west of Room 10, this involved the filling in of the Pre-Surgeon terrace, likely with material from the

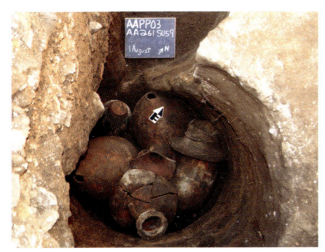

Figure 5.13.5. Greco-Italic amphora in the fill of the pre-Casa del Chirurgo latrine pit (image AAPP).

destruction of the structure itself (Fig. 5.13.6). This action also sealed the latrine (261.058, 261.059). The foundations of the walls of the Casa del Chirurgo were then excavated with deep foundations that penetrated the natural soils. No evidence to support the presence of the much hypothesized (cf. Chapter 3) lateral east–west wall of Room 10 was revealed by our excavations. Consequently, the room must have been open to the south in its original layout.

13.3.1 Post-Pre-Surgeon levelling

A diverse series of fills, often containing large amounts of building material, were used to fill in the terraced cut. Although the cut itself may have started out as multiple pits, they were filled with a single deposit of loose rubble set in a sandy silt matrix (**261.043**,[139] **261.045**,[140] 261.047[141]). The fill varied occasionally in terms of its colour, ranging from greyish brown (10 YR 5/2) through to brown (10 YR 4/3) and was of varied levels of composition. It is likely, however, that this was simply the result of different loads of material that were dumped as part of the filling process. A significant quantity of both building and domestic material was recovered during excavation, including decorated wall plaster, *opus signinum*, iron nails, pottery, tile, coins,[142] and a silver ring. These deposits often have associated artefacts that could suggest a date in the late first century BC for their deposition. It must be remembered, however, that the removal of floors in this area during later phases, served to re-expose the tops of these deposits and contaminate them with artefacts of later date. It is suggested that any contamination of the dating is a result of these later periods of construction and in particular the changes of the late first century BC (Phase 5). To the east and south of the cut itself, where some elements of the underlying black sand still existed, a 20 mm thick spread of white mortar (**261.034**) capped the fills. The exact function of this deposit is enigmatic. As only small amounts of lime were used in the mainly clay-based bonding material for the *opus quadratum* and *africanum* walls in the original layout of the Casa del Chirurgo, the mortar in question might have been related to the mixing of plaster for the original decorative phase of the walls.

13.3.2 Walls of the Casa del Chirurgo

This phase saw the creation of the Casa del Chirurgo, the foundations of which cut directly into the deposits that had been used to bury the Pre-Surgeon Structure. Within Room 10, this activity was represented by the construction of walls W06.083, W6.082, and W06.085 in the northern part of the room. No evidence for a

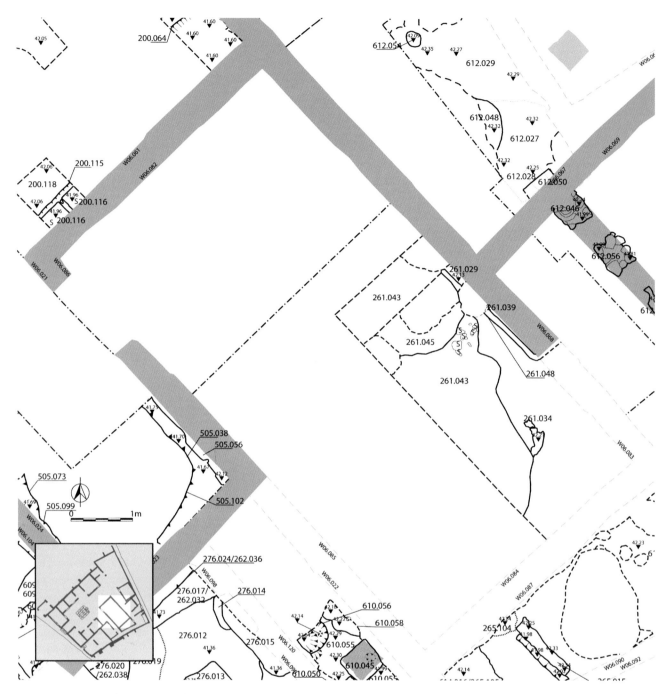

Figure 5.13.6. Plan of deposits and features related to the construction of the Casa del Chirurgo in Room 10 (illustration M. A. Anderson).

southern wall was recovered, suggesting that the room must have been open on its southern end. The doorway in between walls W06.085/W06.086, which provided access to the atrium, was an element of the primary layout. All three of the primary walls were keyed together, with wall W06.082 being keyed into wall W06.086 at its western end and wall W06.083 at its eastern end. These were all built primarily in *opus quadratum* using large blocks of Sarno stone for their lowest three or four courses. Above this level there is also evidence on walls W06.082, W06.083

(mainly observed in the northern part of W06.068, as the extant plaster on W06.083 obscures much of the early wall), and W06.085 for the use of rubblework more characteristic of *opus africanum*. This can be seen in the upper central area of walls W06.082 and W06.083 where there are areas of Sarno stone rubble bonded with a very pale brown (10 YR 7/4) clay, and on wall W06.085 where there are also areas of rubble, although here it has been extensively pointed so that none of the primary bonding material is visible.

Excavation was only possible against wall W06.083, which revealed that the foundation trench for the *opus quadratum/africanum* section of wall (Fig. 5.13.7, A) continued for another c. 1.50 m beyond the apparent end of the wall terminating at an upright Sarno stone quoin (Fig. 5.13.7, B). Indeed, the jagged appearance of the southern end of the *quadratum* wall section of the wall does not indicate its terminal point and rather suggests that it was created deliberately to enable the keying together of two sectors of the wall built with different construction techniques. The foundation cut for wall W06.083 was square-shaped with vertical sides and a flat base and was approximately 0.52 m deep (Fig. 5.13.8, A) from the uppermost surface of the 'black' sand (261.053) that remained to the east of the terrace cut (observed only in section). In the northern part of the foundation trench this was sufficiently deep to encompass the lowest large Sarno block of the *opus quadratum* section of the wall (**261.029**; Fig. 5.13.8, B). This was bedded on a black sandy deposit (261.046), probably representing the collapse of the black sand layer into the foundation trench during its excavation. To the south of the *opus quadratum* section of the wall

was a 1.40 m length *of opus africanum* (**261.039**; Figs. 5.13.7, B, 5.13.8, C). Again this portion of the wall was built using Sarno stone, with two orthostats; the first, 0.3 m wide, terminated the southern end of the wall, while a slightly wider 0.4 m orthostat was present in the middle of this portion of the wall. Between these was a Sarno stone rubble infill composed of roughly rectangular Sarno stone blocks, the largest of which measured approximately 0.15–0.2 m in length by 0.1 m in height, packed around with smaller pieces of Sarno stone. The same black sandy deposit (261.046) into which the Sarno stone *opus quadratum* blocks of the northern sector of the wall were bedded was also used to fill in the remainder of the construction trench along its entire length after the completion of the lower portion of the wall.

Our excavations clearly demonstrate that there was no initial east–west wall closing off the southern end of Room 10 in its initial form. While a great deal of evidence was removed by the sondages of Maiuri (Fig. 5.13.8, D), sufficient remained to confirm his conclusion that there is no trace of an east–west wall or its foundations. Nor is there any evidence of the removal

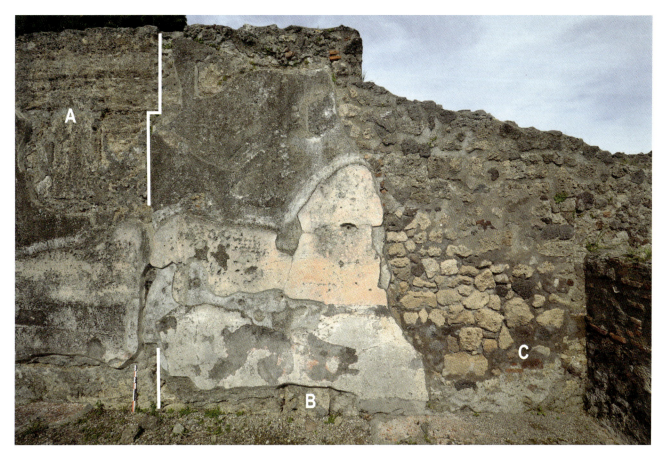

Figure 5.13.7. The southern end of wall W06.083. (A) large block *opus quadratum/africanum* sectors of wall; (B) small block *opus africanum* sector of wall; (C) *opus incertum* southern extension (image D. J. Robinson).

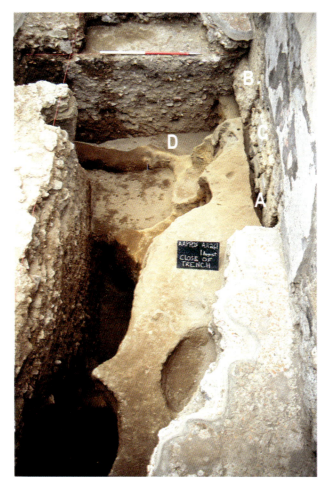

Figure 5.13.8. Details of the initial construction of wall W06.083. (A) foundation trench; (B) *opus quadratum* build; (C) *opus africanum* build; (D) area of a sondage by A. Maiuri (image AAPP).

of such a wall. The construction trench (**261.048**) of the eastern wall of Room 10 (W06.083) was found to continue further to the south, beyond the line of the of the *opus quadratum* section of the wall (**261.029**), incorporating an extension in *opus africanum* (**261.039**). This is further demonstrated by the continuation of the fill of the foundation trench (261.046). It is highly likely that this relates to the *opus africanum* elements of the original layout that lie further to the east (cf. Section 20 infra), even though the precise nature of that area of the house in the first phase is not entirely clear.

13.3.3 Possible early plaster remnants
On the northern Sarno stone sections of walls W06.082, W06.083, and W06.085/W06.086 are traces of an early backing plaster that is attached directly to the stone work and most likely relates to an early phase of decoration in Room 10, possibly to be associated with Phase 3. It is not found on any of the extended parts of

the walls dating to Phase 5 and was certainly in place prior to the laying of the *opus signinum* floor surface in the enlarged room. The backing plaster is composed of a light bluish grey (Gley 2 7/1) plaster with rounded black volcanic beach gravel and some larger pieces of gravel and lime.

13.4 Phase 4. Changes in the Casa del Chirurgo (c. 100–50 BC)
No evidence of this period was recovered in this area.

13.5 Phase 5. Redecoration and redevelopment (late first century BC to early first century AD)
The widespread changes that encompassed much of the Casa del Chirurgo during the late first century BC resulted in considerable modifications to Room 10, many of which it would retain until its final phase of use (Fig. 5.13.9). The space was enlarged southwards by the extension of the eastern and western walls and the construction of the new southern wall, and then redecorated with an *opus signinum* floor inlaid with pieces of marble throughout and an *opus sectile emblema* located in the centre of the southern end of the room. The enlargement of the room also saw a reversal of its visual focus. Previously, occupants of the room and activities taking place within it would have been drawn visually towards the wide southern doorway and its view out through the portico and into a small garden space. The construction of the southern wall and the placement of the *emblema* at the southern end of the room, would suggest that the dining couches were set against the southern wall and that diners looked northwards into the remainder of the room and in the direction of the atrium.

13.5.1 Architectural changes
In the architectural analysis of the walls, and in excavations in the adjacent Room 11, it was noted that the walls of Room 10 were extended southward in two phases that are probably part of the same general action. First, wall W06.083 was extended to the south. A foundation trench (no SU assigned) was cut down into the natural for this construction of this wall, which was undertaken in *opus incertum*, predominantly using Sarno stone for the rubblework, but also with pieces of cruma and grey lava. This was bonded with a light bluish grey (Gley 2 7/1) mortar with angular black volcanic inclusions and crushed black cruma, which was used in excessive quantities around the edges of the rubble (Fig. 5.13.7, C). This was followed by wall W06.085, with wall W06.084 being inserted between

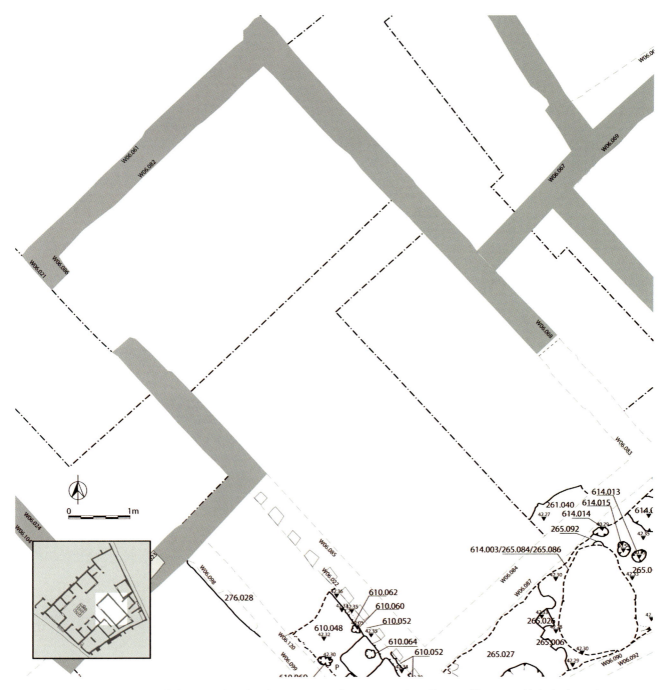

Figure 5.13.9. Plan of changes related to the extension of Room 10 early in Phase 5 (illustration M. A. Anderson).

these walls to create the southern boundary of the room. The southern extension of wall W06.085 was built in *opus incertum* using grey lava, cruma, and Sarno stones set in a very pale brown (10 YR 8/3) mortar with angular black volcanic minerals and lime inclusions. An excess of this mortar was smeared around the edges of this *incertum* rubblework, perhaps to help flatten out the surface of the wall for the application of plaster. Although stratigraphically later than the southern extension of wall W06.085, wall W06.084 was

constructed in largely the same style and technique. A foundation trench for this wall (261.139) was cut down into the early latrine pit (261.058). It is likely that the loose nature of the latrine fill, or the subsidence of its contents, necessitated the deposition of a firmly packed light yellowish brown (10 YR 6/4) earth layer (**261.040**) through which the upper part of the foundation trench was then re-cut. The foundation trench was then filled with mortar and lava blocks to the level of the ground surface (Fig. 5.13.10, A). This foundation pad was used to

provide a slightly wider level platform (261.130, 261.140; Fig. 5.13.10, B) for the construction of the upper portion of the walls (261.105, 261.141; Fig. 5.13.10, C). These were built in *opus incertum* using grey lava bonded with a very similar very pale brown (10 YR 8/3) mortar with angular black volcanic minerals and lime inclusions. This was also used for the southern extension of wall W06.085, suggesting that although these two walls were built sequentially, they were part of the same overall building phase for the elongation of Room 10.

It would appear that as part of the changes to the walls of Room 10, the eastern section of *opus africanum* rubblework in wall W06.082 was repaired with regular courses of brick/tile set in a hard very pale brown (10 YR 8/4) mortar with small volcanic mineral fragments, tuff, ceramic, and black cruma inclusions.

13.5.2 Opus signinum floor

A thick layer of angular grey lava cobbles was carefully set throughout the excavation area (**261.033**; Figs. 5.13.11 and 5.13.13), which acted as a base for the *opus signinum* floor. The cobbles were packed onto a fine reddish grey (2.5YR 6/1) rubble deposit (261.038). The cobbles were composed of both larger and smaller stones, with the larger measuring approximately 0.2 by 0.1 m and the smaller around 0.1 by 0.1 m. Such a massive foundation for a floor is highly unusual in Insula VI 1, where both *opus signinum* and mosaic surfaces are usually laid simply on thick deposits of material,

not specifically designed platforms.[143] Nevertheless, a similar cobble layer was found underlying the mosaic of the "Shrine" (VI 1, 13) and also over a cistern in Room 22. The similarity between all of these is that the cobbles capped significant depths of relatively loosely compacted rubble fill over deep holes. It is consequently suggested that the cobbles were specifically laid in order to ensure a firm bedding for the overlying floor, despite the poor compaction of the underlying deposits.

Overlying the cobbles was a 0.11 m thick layer of rough *opus signinum* that would have acted as the sub-floor (**261.003, 261.004,[144] 261.005, 261.020, 261.021, 261.024**). This was toped by a 50 mm thick layer of finer *opus signinum* that was smoothed to create the final floor surface, into which marble *opus sectile* marble in various polygonal shapes were set, including diamonds and other less regular forms (measuring approximately 0.2 by 0.2 m) (**261.022**) (Figs. 5.13.12 and 5.13.13, C). An 8 cm wide marble *opus sectile* band, set 0.7 m from the eastern and western walls (W06.083 and W06.085) and 0.6 m from the northern wall (W06.082), bordered the room.

In the centre of the southern end of Room 10, approximately 1.6 m from walls W06.083, W06.084, and W06.085, is a rectangular (1.4 m north–south axis, 1.2 m east–west) section of pink mortar (261.022). In the upper surface of this mortar are the indentations from pieces of marble *opus sectile* (261.037) that would have formed a decorative *emblema*. The pink mortar uses the same sub-floor as the rest of the final floor surface and

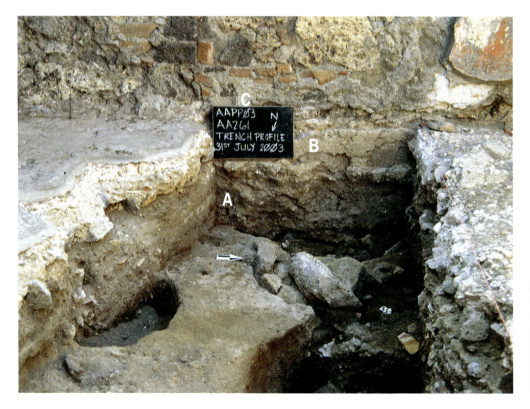

Figure 5.13.10. Details of the foundations of wall W06.084. (A) irregularly shaped cut and fill of lowest foundation; (B) shuttered horizontal foundation pad; (C) upper *opus incertum* wall (image AAPP).

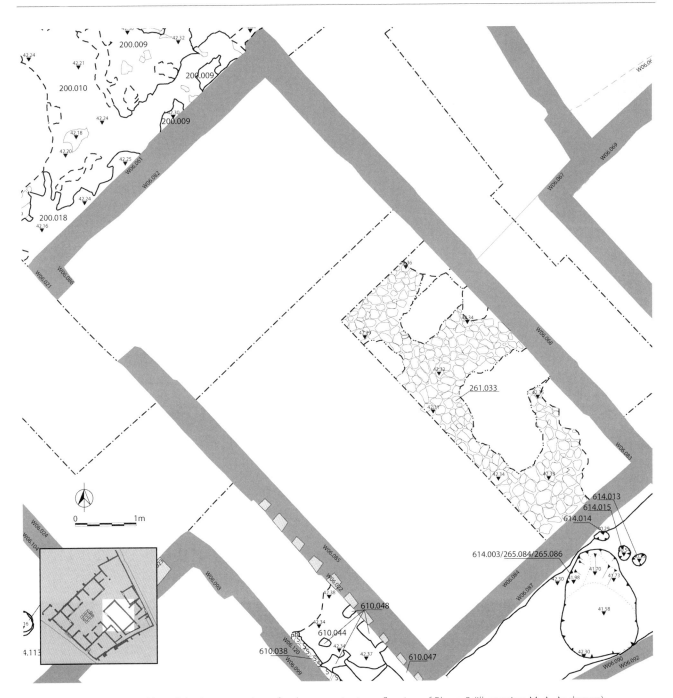

Figure 5.13.11. Plan of the lava stone base for the *opus signinum* flooring of Phase 5 (illustration M. A. Anderson).

consequently, it is suggested that this area would have been kept free of the upper *opus signinum* during its pour by means of wooden shutters. These would have been removed once the final floor surface had hardened so that the pink mortar *emblema* base poured and the *opus sectile* pieces could be assembled. The entire floor surface would then have received its final polish.

13.5.3 Phase 5 plaster

The original plaster decorative surface from the room

was removed prior to the laying of the *opus signinum* floor surface. This is clear since the *signinum* lips up to overlie the plaster backing on wall W06.082 and covers the bottom 10–20 mm of the backing plaster at the base of the wall. On wall W06.083, the *signinum* overlies the thick mortar used to construct this wall. The removal of the former final decorative surface is seen in the rippled surface of the remaining backing plaster, which suggests that a tool with a concave blade c. 60 mm wide, was used on walls W06.082, W06.083, and W06.085 (Fig.

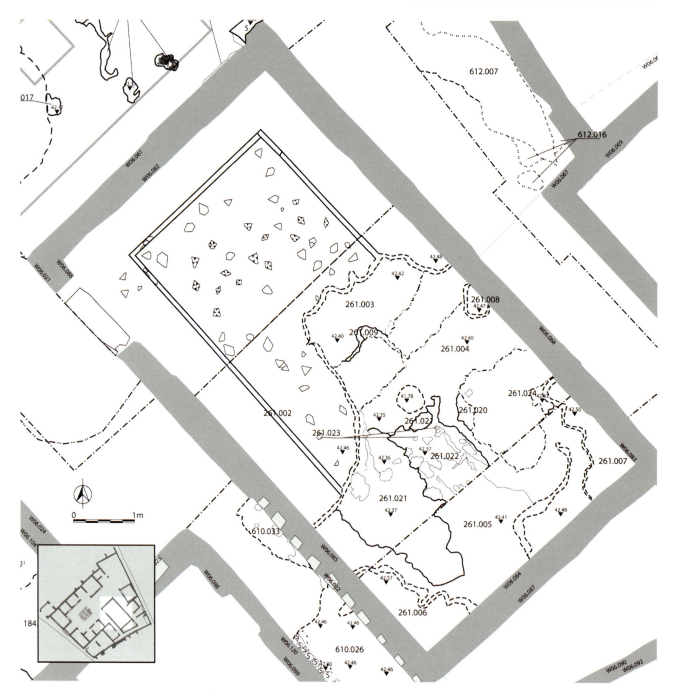

Figure 5.13.12. Plan of the *opus signinum* flooring of Phase 5 in Room 10 (illustration M. A. Anderson).

5.13.14, A). A new coat of backing plaster, 40–70 mm thick, was then applied to all of the walls. There are indications on wall W06.085 that this was achieved in two layers, using the same mix of plaster, which was composed of a white (10 R 8/1) matrix with black and rounded volcanic beach sand and the occasional piece of ceramic. Although no final surface has been preserved, there are traces of both a yellow (10 R 8/8) and a pale red (10 R 7/3) pigment on the flattened outer surface of this plaster (Fig. 5.13.14, B).

13.6 Phase 6. Upper storeys and final decoration (c. mid-first century AD)

This phase appears not to have resulted in any sub-surface changes. The decoration of the walls was updated, along with that throughout much of the rest of the Casa del Chirurgo.

13.6.1 Phase 6 plaster

It would appear that the final surface of the previous layer of plaster was removed with some care taken to

preserve a flat face, although this surface was picked (Figs. 5.13.14, C and 5.13.15) on walls W06.082, W06.084, and W06.085 in order to improve the adhesion of a new layer of backing plaster. This was a c. 10 mm thick layer light bluish grey (Gley 2 8/1) plaster with inclusions of black volcanic beach sand, mineral crystals, and fragments of ceramic. This was overlain by a thin (1–2 mm) layer of white (10 R 8/1) plaster with mineral crystal inclusions in the middle zone of the wall, followed by a white plaster with mineral crystals and black volcanic mineral inclusions in the lower zone. The boundary between the two plasters is at c. 0.91 m above the *opus signinum* floor surface, and the stratigraphy in the plasters indicates that it was applied to the middle and upper zones of the wall first and to the lower zone afterwards. Guidelines were incised in the wet plaster prior to the application of pigments, of which red (10 R 4/8) is the most easily discernible, which has often weathered to a pink (10 R 8/4) colour. Traces of the division between the lower and middle registers are still observable throughout the room, and on wall W06.085, the differential weathering of the plaster would suggest that there was a panel with probably a large rectangular painting towards the southern end of the wall, approximately level with the *opus sectile emblema* set into the floor.

On wall W06.082, it is possible to suggest that the wall was divided into three vertical panels. The lower zone of the wall retains traces of a dark red (10 R 3/6) colour, above which a 0.1 m wide border defined the top of the lower yellow (2.5 Y 7/8) zone. The upper zone retains traces of pink (10 R 8/4) plaster suggesting that it was also mainly a red/yellow colour in the final phase of its decoration.

13.7 Phase 7. Post-earthquake changes
No clear signs of activity in this phase were recovered, unless the removal of the marble elements from the central *emblema* (cf. infra) belongs to this phase.

13.8 Phase 8. Eruption and early modern interventions
13.8.1 Activities associated with the opus signinum floor surface
This phase of activity encompasses all of the excavated features that can be securely assigned to the period after the initial clearance of Room 10 of the Casa del Chirurgo from April 1771 onwards (Fig. 5.13.16).[145] There are three clear sub-phases of activity. The first was the removal of the *opus sectile emblema* (261.022; Fig. 5.13.17, A), which was most likely undertaken during the Bourbon period. This is seen by the pick marks (**261.022**) that were the result of the forcible extraction of the pieces of marble *sectile* (the pattern of which is seen in 261.037).

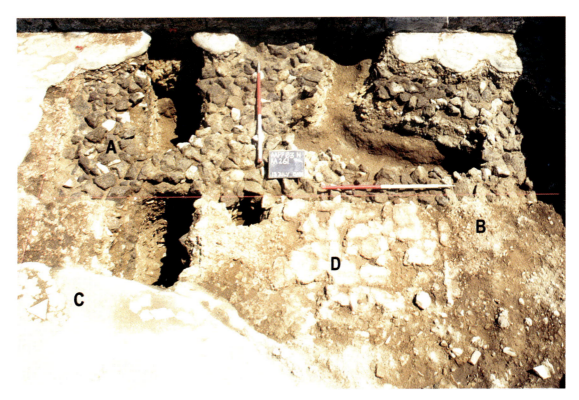

Figure 5.13.13. *Opus signinum* flooring. (A) set stone base; (B) *opus signinum* sub-floor; (C) *opus signinum* with *sectile* inlay final floor; (D) pink mortar base for *opus sectile emblema* (image AAPP).

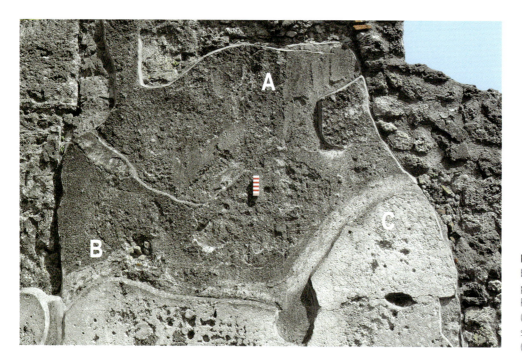

Figure 5.13.14. The rippled backing layer and second painting surface (A) rippled Phase 4 backing plaster; (B) Phase 5 backing plaster surface; (C) Phase 6 plaster (image D. J. Robinson).

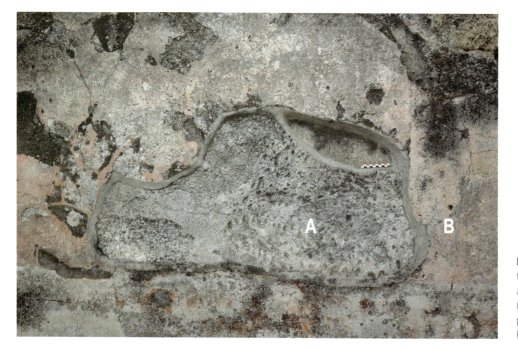

Figure 5.13.15. Pick marks in the second painting surface and the final painting surface. (A) pick marks; (B) final painting surface (image D. J. Robinson).

The robbing of the *emblema* has been placed in the early modern period as pieces of the *sectile* from the *emblema* were also recovered from the fill (261.028) of a nearby posthole (**261.027**), along with significant quantities of lapilli. This was cut into the *opus signinum* sub-floor (Fig. 5.13.17, B). The posthole, which measured 0.4 m in width by 0.56 m deep, was located in the middle of the northern edge of the pink mortar *opus sectile emblema* bedding layer (**261.022**). The posthole was filled with a brown (10 YR 5/3) deposit overwhelmingly (roughly 90% of the matrix)

composed of lapilli. The deposit also contained two diamond-shaped pieces of marble *sectile* that most likely came from the nearby *emblema*.[146] Given the close juxtaposition of the pink mortar square bedding layer and the posthole, as well as the lapilli-rich fill, it is suggested that the posthole was also cut during the early modern period when Room 10 was first cleared of lapilli, and that it was somehow associated with the removal of either a large intact section of the *emblema*, or with the salvaging of pieces of *sectile*. An alternative explanation would see the cut as ancient

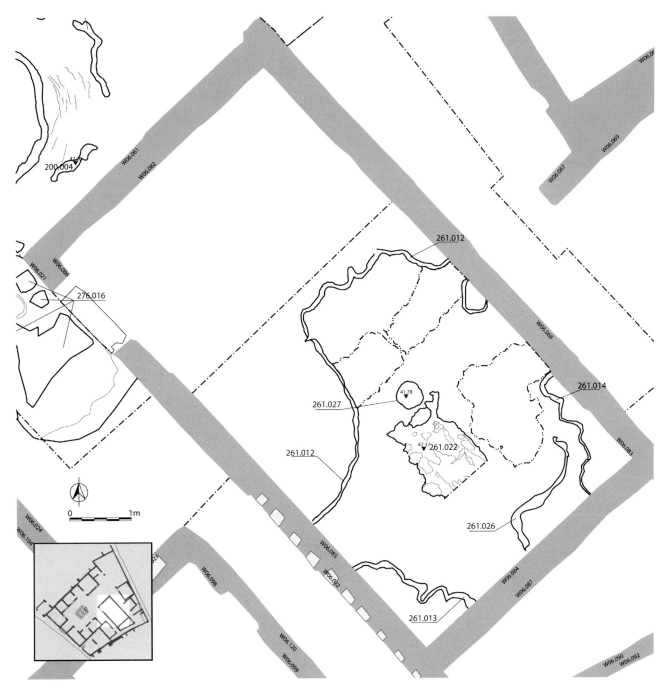

Figure 5.13.16. Plan of changes from Phases 8 and 9 (illustration M. A. Anderson).

and for the placement of a decorative element that was itself removed during the early modern period.

A firm mortar (261.010; Fig. 5.13.17, C) was applied to a small section of the exposed edge of the *opus signinum* floor (261.002) immediately to the north-west of the pink mortar *opus sectile emblema* bedding layer. This was very similar to the early modern mortars used to conserve the walls in Room 10. It is consequently suggested that it was applied to preserve the floor

surface and the hole within it that had been created by the removal of the *opus sectile emblema*. It is also likely that this mortar was applied all around the hole, although when this was enlarged in 1923 during the excavations by Maiuri, the majority of this early modern mortar was removed.

13.8.2 Wall conservation and restoration
The early modern period also saw the evening up of

Figure 5.13.17. Modern interventions in Room 10. (A) pick marks on pink mortar *opus sectile* bedding layer; (B) posthole; (C) early modern floor edging; (D), (E), and (F) Maiuri's sondages (image AAPP).

the northern walls of Room 10. At the southern end of wall W06.085, a large (c. 2 by 1 m) section of the wall was patched and rebuilt. This was undertaken in *opus incertum* using reasonably large pieces of Sarno stone, cruma, and Nocera tuff set in a light grey (Gley 2 7/1) mortar with black volcanic mineral inclusions and larger pieces of lapilli, lime, and black lava stone. Remnants in the central section of the wall also suggest that the same mortar was used as a render over the *opus incertum* section of wall W06.085, above the level of the surviving wall plaster, to point around the large *quadratum* blocks of Sarno stone at the northern end of the wall.

The top of wall W06.085 was covered in a line of roof tiles that were set on a bed of light bluish grey (Gley 2 7/1) mortar with lime inclusions. This mortar was smeared down the wall for c. 0.2 m, covering up any potential early modern levelling up of the wall to create a flat surface on which the tiles could be laid. Tiles were also added to wall W06.082 at this time using the same mortar to bed them on. On wall W06.082, it is possible to see that the upper c. 0.25 m of the *opus africanum* rubblework had been repaired and brought up to the same height as the adjoining wall W06.083, which was also levelled up at this time. This was undertaken in *opus incertum* using a light grey (10 R 7/1) mortar with small volcanic mineral inclusions and larger pieces of lapilli, lime, ceramic, and the occasional tesserae. The same mortar was also used to point around the

western side of the tile repair to wall W06.082 that had occurred in Phase 5.

Wall W06.084 has a characteristic 'smile-shaped' repair to the ancient wall, other examples of which are often interpreted as being the result of seismic activity, possibly the eruption of AD 62/3 or else those associated with the AD 79 eruption. The damage was repaired using a great deal of brick/tile laid in roughly horizontal courses and bonded with a hard light grey (7.5 YR 7/1) mortar containing an aggregate of angular black volcanic minerals and larger pieces of crushed tuff or lapilli. This is slightly built out from the surface of the wall where the final phase of wall plaster would have been, which, when coupled with the absence of the final phase wall plaster from the area of the repair, enables the suggestion that it was undertaken in the early modern period rather than after the AD 62/3 earthquake, and that the damage to the wall was most likely due to the eruption.

13.8.3 Plaster conservation

At least six butterfly clips were driven through the surviving ancient plasterwork on wall W06.085 in order to anchor it to the wall. There is also evidence to suggest that these were also used on the other walls in the room. Cracks and holes in the surface of the final plaster were then filled with a fine yellow (10 YR 7/6) mortar on all of the walls of the room. There are also traces of the use of a pale red (10 R 7/2) mortar with

fine lack minerals and lime inclusions c. 0.1 m above the top of the surviving plaster on wall W06.082, where it appears to trace the now missing former edge of the ancient plaster. This may well have been an early unsuccessful attempt to conserve the edges of the plaster. This is also seen on wall W06.085. The same mortar is also apparent in the middle zone of wall W06.082 where it was used to both patch small areas of wall plaster and as a thin rendering layer over the lower zone of the wall.

13.9 Phase 9. Modern interventions

To this phase belong the excavations by Maiuri as well as modern repairs and conservation of the *opus signinum* floor and walls. Following this last sub-phase of activity in the room a build up of an organic soil accumulated.

13.9.1 Excavations by Maiuri

Maiuri and his team, excavated a number of small sondages in Room 10.[147] The purpose of these excavations was to produce evidence of a transverse wall that would have formed the original southern boundary of the core of the house. If present, this would have been removed as part of the southern extension of this room during Phase 5 (cf. supra). The change in the construction style for walls W06.083 and W06.085 from Sarno stone *opus quadratum* in the northern sectors of these walls and what appears to be *opus incertum* in the southern sectors, had until then mistakenly been taken to suggest a now missing *opus quadratum* wall. Three small sondages were excavated: two rectangular ones on the east–west line of the potential wall and an irregularly L-shaped one to the south of these. Although the exact purpose of the L-shaped sondage is difficult to discern, at its eastern end it intersects the junction in wall W06.083 between the *opus africanum* and *opus incertum* sections (261.105), so it was likely intended to investigate this transition.

The first sondage was roughly rectangular, and vertically sided (261.016; Fig. 5.13.17, D) measuring 1.36 m long by 0.56 m wide by 0.9 m deep. Its western end abutted the *opus quadratum* section of wall W06.083 (261.029). The excavators undercut the lowest course of Sarno ashlar blocks to ensure that the base of the wall had been reached. The trench then proceeded westwards, following the line of the potential transverse wall. No trace of this wall was located with the excavations reaching the natural soil (261.030). The sondage was filled with a brown (10 YR 5/3) deposit containing quantities of rubble, plaster, tile, pottery, and pieces of *opus signinum* flooring most likely from Room 10.

The second sondage was located 0.34 m to the west of the first and was on the same alignment (Fig. 5.13.17, E). The sondage had a sub-rectangular shape, with straight vertical sides on the north, south, and western sides, with a steeply sloping eastern side. It measured 1 m long by 0.7 m wide by 0.93 m deep. No trace of the hypothesised transverse wall was observed here either. The excavation trench was backfilled with a dark greyish brown (10 YR 4/2) rubble deposit containing significant quantities of tile, ceramic, wall plaster, and *opus signinum* fragments.

The third sondage was an unusual 'L-shape' (Fig. 5.13.17, F). It intersected with wall W06.083 at the junction between the *opus africanum* (no SU assigned) and *opus incertum* (261.105) sections of the wall. The trench may then have continued to the south, as excavations at the western end of the east–west section of the trench would have encountered the upper rubble layer (261.038) of the large, deep central cut from Phase 3 (261.051). Presumably the southern extension of the trench was undertaken to investigate the deposits within it. Following the completion of the excavation in this sondage, it was back filled with a brown (10 YR 5/7) rubble filled deposit (261.019), which also contained tile, ceramic, wall plaster, and pieces of *opus signinum*. It should be noted that the fills of the three are consistent in their compaction, colour, and in the range of finds recovered from them. Consequently it is suggested that they are all essentially contemporary and that the back filling of the three sondages took place simultaneously.

13.9.2 Conservation of the opus signinum floor

As a method of conserving the friable edges of the *opus signinum* floor, especially where the early modern and modern excavations had removed the upper and lower surfaces, mortar (261.009, 261.011, **261.012, 261.013, 261.014,** 261.015, 261.025, **261.026**) was applied. This provided a hard, protective layer and consequently hindered further abrasion and the destructive infiltration of plant roots, as well as providing something of a barrier against the weather. Numerous context numbers were assigned to mortars throughout the area of investigation, on the basis of their spatial separation. For example, 261.012 was given to the mortar used to cover the edge of the upper *opus signinum* surface on the northern side of the excavation area (261.002), while the virtually identical mortar 261.013 did the same job for the upper *opus signinum* surface on the south western side of the trench (261.006). Nevertheless there are some stratigraphic relationships between the different mortars, for

example, mortar 261.010 underlies mortar 261.012 and overlies mortar 261.011. The overall similarity in of the mortars, however, would suggest that they were applied within a very short time of one another.

13.9.3 Wall plaster conservation

Wall plaster conservation also continued in the modern period. Initially, the wings of the butterfly clips that were driven into the plaster in the early modern period were removed and the cracks and holes in the surface of the plaster were filled with a light bluish grey (Gley 2 7/1) mortar with angular black volcanic stone inclusions and occasional pieces of lime. This was also used as a rendering layer over large areas of the lower zone of surviving wall plaster throughout the room, and also to fill in higher up in the walls where the final plaster surface had weathered away. This rendering was undertaken in order to protect the underlying plaster.

Also as part of this phase of restoration, the edges of the surviving plaster were covered with a protective coating of a very similar mortar. This was also used to point around the roof tiles set on top of the walls in the previous phase. Finally, the walls of Room 10 were pointed around the intersections between the *opus quadratum* blocks and *opus incertum* with a rough light bluish grey (Gley 2 7/1) mortar.

13.9.4 Modern build-up and debris

The central area of the room was covered by a greyish brown (10 YR 5/2) deposit of soil (261.001) containing both modern and re-deposited ancient artefacts. This deposit was the result of the accumulation of wind blown soil particles and other heavier modern materials and re-deposited ancient materials such as pottery, wall plaster fragments, pieces of mosaic, and leaf litter.

14. Room 11
Service room (AA265 and AA614)

Description

Room 11 is the smallest room of the 'service wing' of the Casa del Chirurgo, consisting of a small, roughly trapezoidal space, measuring approximately 2.28 m at the widest and 1.06 m at the narrowest by about 4.61 m. It is situated to the south of the triclinium (Room 10) and bordered by Corridor 12 on its west and south (Fig. 5.14.1). During the final phase of the house, the room was accessed via a relatively narrow (1.03 m) doorway with a lava threshold that led into the kitchen (Room 13) and was situated nearby a short corridor that led to the rear entrance. Without any doubt, the room was quite cramped and likely used for service functions, a character that it seems to have retained throughout its history. Although the precise use of the room at any time is elusive, it seems likely that, stripped of its final period floors, the area was employed for the temporary storing of building materials at the time of the eruption, in a manner similar to Room 23 (AA262/AA263/AA276).

Archaeological investigations

Excavations in Room 11 were undertaken during two separate campaigns during the summers of 2003 (AA265) and 2006 (AA614).[148] In both cases, the entire span of the room was opened to excavation, with the second season tending to concentrate upon the eastern half of the area. Due to time constraints, natural soils were reached only in the sections of ancient pit cuts. The walls

in the area were analysed in 2003, but only the ancient features were documented.[149] The interpretations of the architecture were checked and the walls fully written up in 2008 and checked again in 2013.

14.1 Phase 1. Natural soils

The top-most level of the natural sequence of soils, as identified elsewhere in Insula VI 1, was not recovered in open plan within Room 11. Nevertheless, the topmost of the natural deposits, a rich, brown natural soil, was clearly visible within the sections of later cuts (especially on the eastern side in 614.024 and 614.007/265.103) (Fig. 5.14.2). Although these natural soils were not assigned an SU number or fully recorded by the excavators, they nevertheless suggest that the original topography of the area may have been as much as 30 cm lower (41.48–41.51 MASL) than similar soils recovered from within the tablinum (200.127) (41.84–41.99 MASL).

14.2 Phase 2. Volcanic deposits and early constructions

14.2.1 Early volcanic layers; 'pea gravel' and 'pocked-earth' deposits

The earliest layers within Room 11 consist of two deposits found in numerous areas across the whole of Insula VI 1 and in the northern parts of the Casa del Chirurgo. These probably derive from volcanic activity of an uncertain date prior to the earliest human activities (Figs. 5.14.3 and 5.14.4). In each case where they have been recovered, these deposits have been found to overlie the natural deposits directly. Within Room 11, these layers were observed only

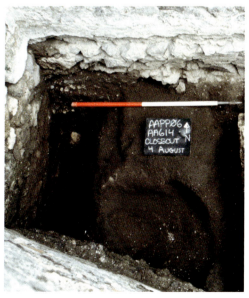

Figure 5.14.1. (*Left*) Room 11 (image D. J. Robinson).
Figure 5.14.2. (*Right*) Natural soils at eastern end of Room 11 (image AAPP).

Figure 5.14.3. Plan of natural soils in Room 11 (illustration M. A. Anderson).

within the sections of later cuts. Described as 'grey gritty' friable silty soil by the excavators, 265.086 (**265.094**) and 265.099 (**265.097** = **614.019**) could easily be seen to connect with the tops of surfaces **614.022** = **265.098**, which while not excavated, were similar to those deposits recovered elsewhere and described as pea gravel and 'pocked earth.' The lower deposit, a loose, light, roughly pea-sized (normally 2–10 mm in diameter) gravel with a fairly uniform light grey (5 Y 3/2) colouration, graded so seamlessly into the upper deposit that the two could easily be seen to result from a single event. The upper deposit – a silty grey soil, often with a pock-marked surface – caps the pea-gravel and bonds the whole together. In common with the neighbouring Rooms 12, 13, and 14, no trace of a dark grey to reddish black sandy layer was recovered in Room 11 overlying these early deposits. This is probably because this stratum had been removed during the activities related to the creation or use of the Pre-Surgeon Structure (cf. infra).

14.2.2 Pre-Surgeon terrace cut

Subsequent to the early volcanic layers, a deep, diagonal cut (265.107 = **614.018**, **614.024**) was made through the centre of the area later occupied by Room 11. This runs roughly through the middle of the eastern edge of the room toward the north-west until it disappears under wall W06.087, leaving the earlier levelling layers intact on its southern side (Figs. 5.14.4 and 5.14.5). While complicated by later cuts that went directly through it, the general trajectory of the cut is clearly discernible, especially in coordinated plans. Although not identified at the time of the excavation, the fact that the path of this cut is aligned with another cut in Room 23 suggests strongly that the two are a part of the same action. This involved cutting back the soils in this area to form a lower terrace in preparation for the creation of the Pre-Surgeon Structure. Though the walls

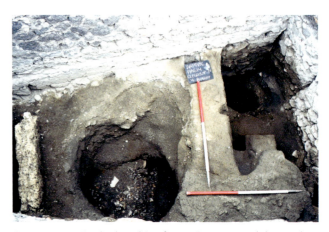

Figure 5.14.4. 'Pocked earth' surface in Room 11 and diagonal cut running through it (image AAPP).

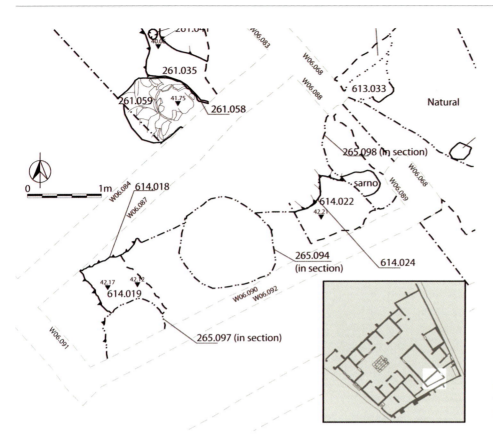

Figure 5.14.5. Plan of the diagonal terracing cut of Phase 2 in Room 11 (illustration M. A. Anderson).

of this structure seem to have run along these cuts, in general no evidence of stonework or foundations was recovered, perhaps with the exception of a large Sarno stone observed at the bottom of the much later pit (614.007/265.103). This seems to have been on a similar alignment, but any direct connection with this phase has been obscured by later pits.

14.3 Phase 3. The Casa del Chirurgo (c. 200–130 BC)

At a point between roughly 200 and 130 BC, the Pre-Surgeon Structure was destroyed and the Pre-Surgeon lower terrace filled in with debris.[150] Thereafter, the walls of the Casa del Chirurgo were constructed, cutting directly into this artificial platform. Although the walls of the original house did not extend to the area of Room 11, it is nevertheless clear that the area was included in the space defined by the new property boundary. A single Sarno block with shallow footings was recovered from this phase in the area of Room 11.

14.3.1 Post-Pre-Surgeon fills

Before the Casa del Chirurgo was built, the Pre-Surgeon Structure was demolished and the lower terrace upon which the Pre-Surgeon Structure had been constructed was filled in with a diverse mixture of fills containing large amounts of building debris and domestic rubbish. One of these fills in particular, distinctive by means

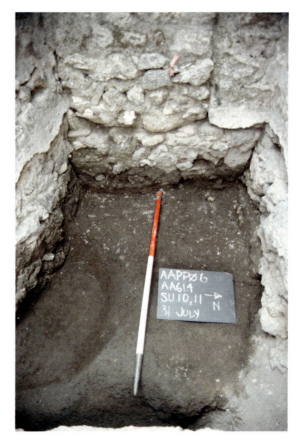

Figure 5.14.6. Characteristic orange with bluish plaster fill deriving from the filling of the terrace against the later western wall of Room 11 (west of photo board) (image AAPP).

of its orange colour and characteristic bluish mortar inclusions (Fig. 5.14.6), has been found within Rooms 3, 4, 10, 11, 12, and in sections within 6A and 6C, suggesting that it once ran between all of these areas. A yellowish silty clay that was used elsewhere in the insula to create rammed earth-walls at an early date, appears to have been the source of this colouration.[151] In combination with the pieces of bluish mortar, this suggests that this particular deposit may derive from the remains of the walls of the Pre-Surgeon Structure, demolished in the course of removing the foundation stones. In Room 11, traces of this distinctive deposit were recovered, filling a cut into the pocked earth at the western end of the room (**265.105**). They were identical to deposits found in Corridor 12 further to the west. Fragments of Sarno stones recovered at the bottom of this deposit (**614.016**) ran under the western wall and may have been components of the cistern and drain found in Corridor 12. The fills of the linear cut running through the area are clearly a part of the same terrace fill event seen elsewhere across the lower terrace. This consisted of additional layers of debris and building rubble (265.108, **265.104**, 265.093, 614.020, **614.023** = 614.012), which while not entirely excavated in Room 11, may safely be connected with the same terrace filling activity.

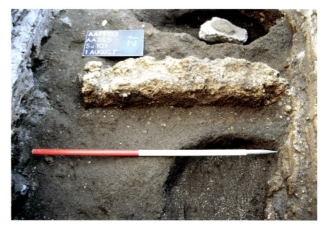

Figure 5.14.7. Sarno stone block aligned roughly north–south in Room 11 (image AAPP).

14.3.2 Construction of the Casa del Chirurgo portico

Elsewhere within the house, it is possible to observe that the construction trenches for the Casa del Chirurgo were cut directly into the newly levelled surface. Within Room 11 the construction of the house is documented by a single Sarno stone (Fig. 5.14.7) situated roughly north–south in alignment. Notably, this is at right angles to the course of a pilaster portico that originally decorated the southern side of the house. Cuts for the placement of the block (**265.100** = **614.021**, 265.088) descend directly through earlier deposits.

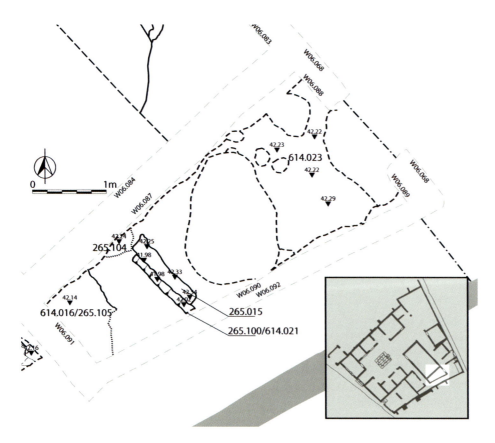

Figure 5.14.8. Remains of Casa del Chirurgo portico and its construction present in Room 11 (illustration M. A. Anderson).

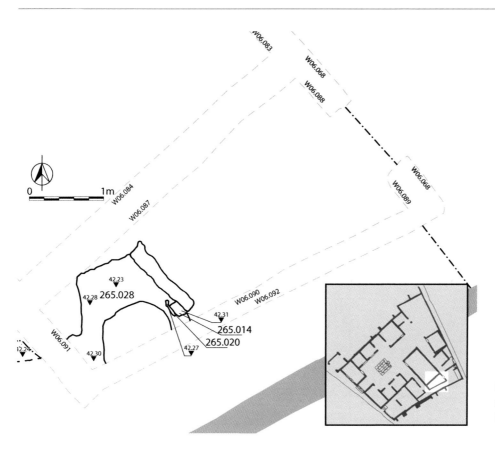

Figure 5.14.9. Remnants of *opus signinum* against Sarno stone block (illustration M. A. Anderson).

The alignment of this block suggests that the portico recovered in Room 23 terminated at this point (Fig. 5.14.8), since no further trace has been found to the east of Room 10. This would mean that the total length of the portico was identical to that on the eastern side of the property. While the thickness of the Sarno stone (21.4 cm) and its shallow foundations mean that it could not have supported a substantial wall, it is possible that represents an element of the portico base similar to that recovered in Room 23. If so, then the portico may have turned south at this point, though no other evidence was recovered to support such a conclusion. Slight traces of *opus signinum* (**265.020**, **265.014**) and its compacted grey (7.5 YR 3/2) sub-flooring (**265.028**, 265.027) were recovered overlying the fills (265.101 = 265.089) of the cuts made to place the Sarno stone (Fig. 5.14.9) on its western side.

14.4 Phase 4. Changes in the Casa del Chirurgo (c. 100–50 BC)

Within Room 11, Phase 4 witnessed the addition of an L-shaped wall (W06.076/W06.077) that narrowed the back door of the Casa del Chirurgo and ran from this location to the north-east corner of Room 11 (Fig. 5.14.10). This formed the edge of an opening that defined a larger, earlier version of Room 13 to the east. Although little remains of this wall in Room 11

(W06.088) due to extensive rebuilding/pointing in the early modern/modern periods, it was constructed in *opus incertum* using sub-square pieces of Sarno stone, grey lava, and cruma bonded with an extremely hard light bluish grey (Gley 2 7/1) mortar containing small black volcanic mineral fragments and pieces of lime. A patch of the very pale brown mortar that was used for the remaining walls of Room 11 was smeared across wall W06.088, indicating that it had been built earlier. It is possible that some of the cuts and postholes sequenced in the subsequent phase may actually belong to this phase, but later truncation of soils has made it necessary to sequence all of these cuts to the following phase.

14.5 Phase 5. Redecoration and redevelopment (late first century BC to early first century AD)

Phase 5 saw the creation of Room 11, which involved the division of this space away from the triclinium (Room 10) to the north and from the new rooms being built to the west, as a result of the creation of a westward facing shop at Rooms 3 and 4 (cf. supra). These changes necessitated the removal of the southern pilaster portico, which was entirely demolished. Room 11 was created as a component of these activities, and at this time was provided with a west-facing doorway that connected it directly to these areas.

Figure 5.14.10. Plan of wall W06.088 as it appeared in Phase 4 (illustration M. A. Anderson).

14.5.1 Thin surfaces and fills

Preceding these changes, a series of fills (265.090, 265.012, **265.006**) and plaster skims (265.013, **265.026**) covered the eastern half of the area covered by Room 11 (Figs. 5.14.11, 5.14.12). Since the early first century BC (Phase 4) had seen the creation of a room to the east of this area, it is possible that these may be remnants of sub-flooring from whatever floors covered the area at that time. Certainly, the removal of previous floor levels would help to explain the compression of the chronology within the cuts described below. It is also possible that these fills represent temporary or working surfaces deposited when the area was a garden space or yard at the end of the original southern portico of the Casa del Chirurgo. However, it is most likely that these fills simply document activities that took place immediately prior to the widespread construction in this phase (late first century BC), that became compacted through trample during building works.

14.5.2 Pits and cuts

In preparation for the building activities carried out across the property during the phase, and possibly also as the result of construction, a large number of cuts were made into the area of Room 11 (Figs. 5.14.11, 5.14.12, and 5.14.13). Supporting the sequencing of these cuts in this phase is the fact that in each case,

the removal of soils respected the position of the 'L' shaped wall spur W06.088, which had been created in the previous phase of building activity, but were cut by the creation of the walls constructed later in Phase 5 (W06.087, W06.089, and W06.090). The subsequent removal of any floor surface that may have followed the initial creation of Room 11 means that there has been considerable contamination from later activities, as is reflected in the ceramic and glass dates recovered from these fills. Given this contamination, it is possible that at least some of these cuts derive from construction activities taking place in Phase 6 or 7, but the majority appear to relate to the widespread changes that took place in Phase 5.

The deepest pits, including a large central pit (265.086, **265.084 = 614.003**, 614.025) and a long cut running through the eastern threshold (**265.103 = 614.007**) were possibly for the purpose of recovering undisturbed natural soils for use in construction.[152] Given that the sub-surface soils in this area will have consisted primarily of post-Pre-Surgeon fills, it seems likely that if this was their purpose, they were not particularly successful. Indeed, this fact may help to explain the number of pits, which may therefore indicate repeated, non-productive attempts that were quickly abandoned. At the same time, the shallowness and size of some of the pits, including one in the

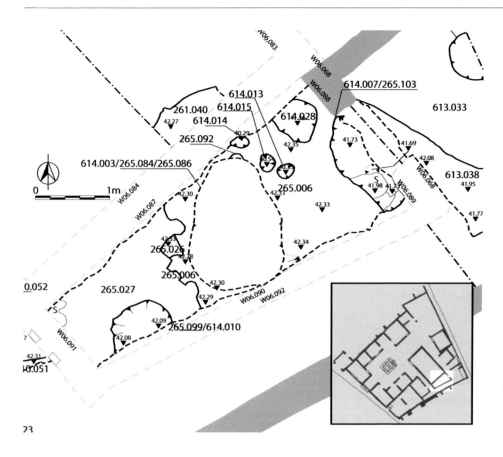

Figure 5.14.11. Plan of cuts and fills that occurred early in Phase 5 in Room 11 (illustration M. A. Anderson).

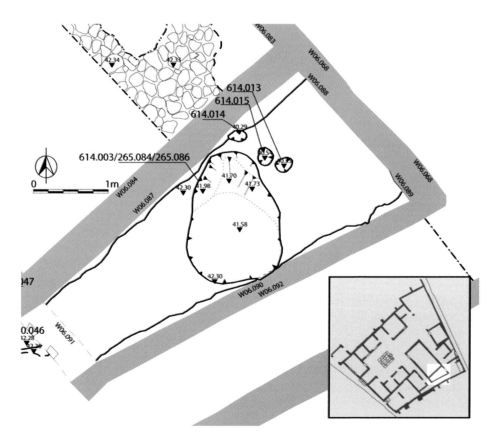

Figure 5.14.12. Plan of second stage of cuts and fills that occurred in Phase 5 in Room 11 (illustration M. A. Anderson).

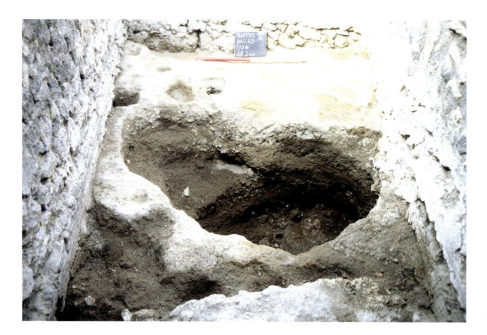

Figure 5.14.13. Cuts and fills during early Phase 5 on the eastern end of Room 11 (image AAPP).

north-east corner of Room 11 (**614.028**), and one in the south-west (**265.099** = **614.010**), may imply another use, possibly as a component of the construction process itself. The deep central cut (265.086, **265.084** = **614.003**/614.025), which penetrated through the earlier deposits and into the natural soils, was subsequently filled with a mixed and diverse series of deposits of building materials and refuse (265.022,[153] 265.025, 265.083, 265.085,[154] 265.095 = 614.006,[155] 614.004, 614.002, 614.026). Similarly, a cut at the eastern threshold, which continued into the area of Room 13, was filled with large amounts of pottery and building detritus (613.038), including what appeared to be elements of moulded antefixes (265.011, 265.102 = 614.008 = 265.096, 614.009). The postholes (**614.014**, **614.015**, **614.013**, **265.092**) evident during this phase defy explanation via either their alignment or their fills (265.016, 265.017, 265.023, 265.091). Since they appear to cluster on the eastern side of the room, they may plausibly be connected with work on the eastern and northern *opus incertum* walls (W06.087, W06.088), which would presumably have required scaffolding or shuttering of some sort during their construction. It is also possible that they were used more generally during the building process, perhaps to support timber elements as walls were altered or inserted. Unfortunately, a more detailed explanation is not possible from the preserved remains.

14.5.3 Construction of the walls
The creation of the walls of Room 11 was either simultaneous with, or shortly subsequent to, the cuts and postholes. These served to define the area of Room 11 for the first time, orientating the space towards the

newly created rooms on the west. The pouring of an *opus incertum* wall (W06.084/W06.087), that sealed off this space from what became Room 10, was undertaken in two stages. First, the eastern wall of the Room 10 (W06.083–W06.088/W06.068) was extended to the south. Then, the remaining walls of Room 11 were constructed, including the extension of the western side of Room 10 (W06.022b) as a single action (Figs. 5.14.14 and 5.14.17). As part of this, wall W06.084/W06.087 was also built, which separated the extended Room 10 from the newly built Room 11 (Fig. 4.14.15). The mortars and construction method of the two main stages of construction are so similar that the sequence of building must be purely a result of the construction process, rather than an indication of any period of delay between steps. The process of integrating the pre-existing 'L' shaped wall (W06.076/W06.077), that ran from the back door of the Casa del Chirurgo into this area, may have been the reason for the separate phases of work.

Walls W06.087, W06.090, and W06.091 were all built in *opus incertum* and set within a very pale brown (10 YR 8/2) mortar with angular inclusions of volcanic minerals, larger pieces of lime, fragments of tuff and the occasional piece of crushed ceramic. An excessive quantity of the mortar was used around the edges of the rubblework in order to create a roughly flat surface for the wall. The rubblework for walls W06.087 and W06.091 was composed of sub-rectangular blocks of grey lava with black inclusions, Sarno stone, cruma, and the occasional piece of building rubble. In wall W06.087, it can be seen that the grey lava was used mainly at the base of the wall and the Sarno stone in the upper portions. The transition between the two

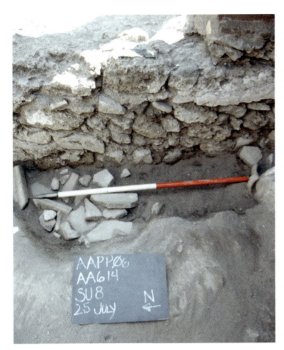

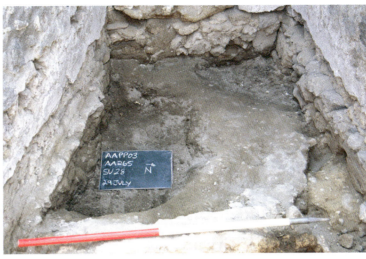

Figure 5.14.14. (*Left*) Lower part of the construction of wall W06.089/W06.068 cutting pit a pit that continues into Room 13 (image AAPP).

Figure 5.14.15. (*Right*) Evidence of the construction method for wall W06.087 that divides Room 11 from Room 10 (image AAPP).

occurs at 1.8 m above present the day ground surface. A similar technique was also noted for wall W06.022b in Room 12, which was built at the same time as wall W06.087. The rubblework for wall W06.090, was slightly different from walls W06.087 and W06.091 with a greater amount of building debris, including pieces of former *opus signinum* floor surfaces, nevertheless, it was bonded with the same very pale brown mortar and therefore is likely to have been part of the same phase of construction. A section of brick/tile (W06.089) was used at the end of wall W06.090 to help create the south-eastern corner of Room 11. This was bonded with

the same very pale brown mortar as that used elsewhere on wall W06.090, suggesting that both sections of the wall were built as part of the same phase of building.

It would appear that the small 'furniture-niche' recess in wall W06.090 was an original feature of this wall, given the lack of any observable repair work that would have been necessary had the niche been created at a later phase. As part of this phase of construction work, a small doorway was built at the western end of Room 11 in wall W06.091 to provide access to the room. The door must have been constructed using a wooden formwork, at least on its northern side where mortar

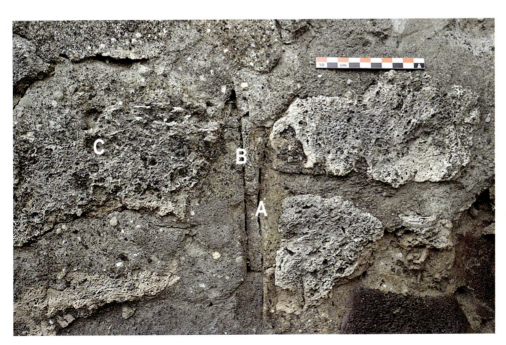

Figure 5.14.16. Evidence for the initial open doorway in wall W06.091, its wooden formwork construction and the first phase of plaster. (A) initial wall construction and mortar; (B) Phase 6 plaster; (C) blocking of doorway (image D. J. Robinson)

remains preserve the line and grain of the wood (Fig. 5.14.16, A). It should be noted that the evidence from wall W06.091 indicates that the original construction of the wall continues across the top of the doorway.

14.5.4 Phase 5 plaster decoration
The later blocking of the doorway at the western end of Room 11 preserved a small piece of plaster in section that would have formed part of the initial plaster phase of this wall (Fig. 5.14.16, B). This was applied as a single layer of light greenish grey (Gley 1 7/1) plaster with rounded volcanic mineral inclusions, larger pieces of lime, and the occasional fleck of crushed ceramic. This layer of plaster was simply flattened to create a final face. There are heavily degraded traces of this plaster stratigraphically underlying the later Phase 6 plaster surface elsewhere on wall W06.091, and it is also observable on walls W06.087 and W06.090.

14.6 Phase 6. Upper storeys and final decoration (c. mid-first century AD)
The mid-first century AD witnessed the additions of a range of upper floors over the service wing of the Casa del Chirurgo, which in turn, generated a number of alterations to the ground floor. Accessible from Room 16, just off of the hortus, this upper storey likely included rooms over much of Rooms 13, 14, 15, 17, and 18.

14.6.1 The reorientation of Room 11 to the east
The major changes in this phase for Room 11 were the moving of the entrance from its original location on the

west to the eastern side of the room and the blocking of the previous doorway. The fill of the western doorway comprised of large, sub-square blocks of Sarno stone, grey tuff, and a piece of cruma (Fig. 5.14.16, C). It is impossible to characterise the mortar with which this *opus incertum* was bonded due to the extensive modern pointing present on this portion of the wall. Opening up a new doorway at the eastern end of the room to provide access to the kitchen (Room 13) necessitated breaking through the brick/tile section (W06.089) present on the corner of Corridor 12 (Fig. 5.14.18). This is observable in the northern face of the quoin in the new doorway, which reveals its concrete core and evidence for cut brick/tiles. Additionally, it should be noted that if the quoin had been built specifically to provide a square corner for the southern corner of the eastern doorway, it would have had brick/tiles on its northern face as it does on its southern face. The lower part of the original eastern *opus incertum* wall was used as a footing for a new lava threshold stone.

14.6.2 The addition of an opus signinum floor?
Since many of the other service rooms received *opus signinum* flooring at this time, it seems likely that the final step of this phase of rebuilding also involved the creation of an *opus signinum* floor in Room 11 (Fig. 5.14.18). However, no trace of such a floor has been preserved. The later removal of this supposed floor means that aside from the walls themselves, this phase has left virtually no trace in the archaeological record. In fact, the complete absence of deposits relating to the

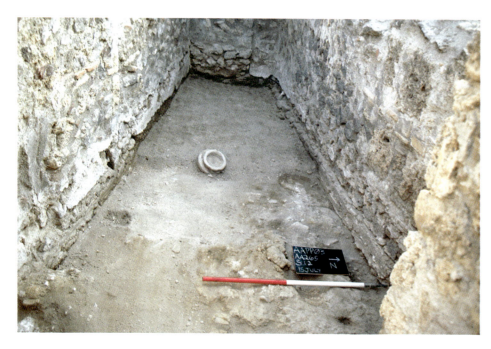

Figure 5.14.17. Lower foundations of wall W06.090 (left hand side of image) (image AAPP).

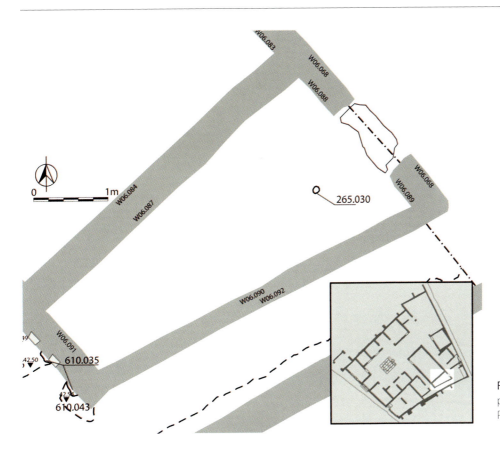

265.030

610.035

610.043

Figure 5.14.18. Plan of the single posthole in Room 11, probably from Phase 6 (illustration M. A. Anderson).

this phase within the room, the creation of the southern wall, and the sealing of the western doorway, help to support the notion that these were removed during the final phase (cf. infra). It is nevertheless plausible to sequence at least one posthole (265.029), filled with (**265.030**, 265.106), to this phase on the basis of the date of the glass in its fill. It remains possible that some of the cuts and postholes sequenced in Phase 5 above may actually belong to this phase.

14.6.3 Phase 6 plaster decoration
The blocking of the western doorway in wall W06.091 was the catalyst for a second phase of decoration in Room 11, where a new layer of plaster was applied directly over the remnants of that from the previous phase. It comprised of a single 10 mm thick layer of light bluish grey (Gley 2 7/1) plaster containing rounded volcanic mineral fragments, frequent larger pieces of crushed ceramic, and occasional larger pieces of lime. This plaster was roughly flattened to create a surface upon which a fine layer, 1–2 mm thick, of white (10 YR 8/1) plaster was added. The same backing and final plaster was also observed on wall W06.087, while only the backing plaster was observed on wall W06.090.

Some evidence for the sequencing of the decoration of the walls of Room 11 can be gleaned from the interface between the backing plasters on wall W06.091 and W06.087. The backing plaster on wall W06.091 butts up against the identical backing plaster on wall W06.087. This would indicate that the backing plaster on wall W06.091 was applied after that on wall W06.087, and may suggest that the backing plasters to the walls of Room 11 were applied one wall at a time. The same interface between wall W06.091 and W06.087, however, also suggests that the final white plaster face for Room 11 was instead applied to both walls simultaneously, since the plaster appears to lap around from one wall to the next without any evidence for a break in the process.

14.7 Phase 7. Post-earthquake changes
The period after the earthquake(s) of AD 62/3 is documented within Room 11 by a series of changes that took place, including the likely removal of room's floor and sub-floors. This was possibly undertaken in preparation for further excavations in search of natural soils or in aid of repair activities that never commenced. Afterwards, a series of deposits of fragmentary building materials and detritus, including darker lenses within the general rubble, were dumped into the room (**265.002**[156] = 265.009 = 265.010, 265.008, 265.004[157]) (Fig. 5.14.19, 5.14.20). Several of these layers contained

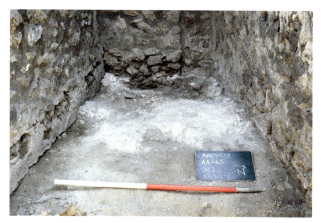

Figure 5.14.19. Building materials and lime dumped at the western end of Room 11 (image AAPP).

detritus including broken pottery and a coin dated to the end of the first century BC. These early dates suggest simply that these deposits consisted of material that derived from earlier phases. It is, therefore, likely that Room 11 was being used as a space in which debris from the redevelopment of the property was being temporarily stored. These deposits may have been intended for use within the phase of post-earthquake redevelopment. This line of argument is strengthened by the discovery of a pile of lime in the western half

of the room, which was much thinned by the time of our excavations (**265.003**[158]). Much of this deposit may either have been removed by the original excavators or simply have degraded through continued exposure, but it left behind clear traces.

14.8 Phase 8. Eruption and early modern interventions

The upper metre of the southern part of wall W06.091 was rebuilt in the early modern period. This was undertaken in a very regular form of *opus incertum* using rectangular blocks of Sarno stone laid in courses, set in a light grey (10 YR 7/2) mortar containing angular volcanic minerals, pieces of lime, and crushed brown tuff. The wall was rebuilt in order to raise it up to a level consistent with other surrounding walls, which were capped with roof files as a protective measure. These were set upon a light grey mortar with flecks of lime that is weathering to a dark reddish grey (2.5 YR 3/1) colour.

The majority of the eastern end of wall W06.087 was also reconstructed using a number of large blocks of Sarno stone and pieces of roof tile set in courses. The reconstruction filled a characteristic 'smile-shaped' hole in the wall caused by seismic turbulence probably associated with the AD 79 eruption (Fig. 5.14.21). The reconstruction was set in a hard light grey (7.5 YR

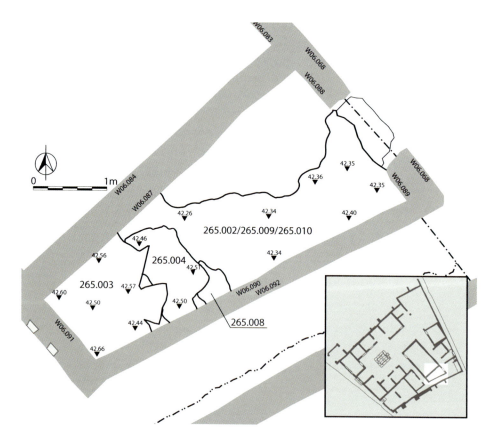

Figure 5.14.20. Plan of materials dumped in Room 11 during Phase 7 (illustration M. A. Anderson).

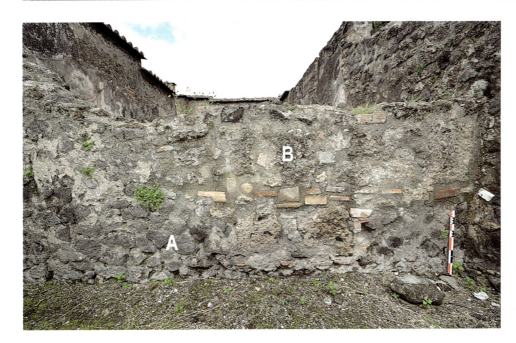

Figure 5.14.21. The 'smile-shaped' repair at the eastern end of wall W06.087. (A) original wall; (B) early modern repair (image D. J. Robinson).

7/1) mortar containing an aggregate of angular black volcanic minerals and larger pieces of crushed tuff or lapilli. Wall W06.088 was also largely rebuilt using *opus incertum* of sub-square to sub-rectangular Sarno stone, cruma, lava, and a single piece of white limestone bonded with a similar light grey mortar. A piece of brick/tile at the base of the wall may indicate the level from which reconstruction was undertaken.

At the western end of wall W06.087, there are traces of a 20 mm thick layer of a light greenish grey (Gley 2 7/1) mortar containing larger pieces of very pale brown tuff or lapilli. This was most likely used as a protective rendering over the surface of the wall. Rendering is also seen on wall W06.091, where a light grey (Gley 1 7/) mortar with small angular volcanic minerals and the occasional ceramic inclusion, as well as large pieces of tuff or lapilli, was used both to render and also to point around the rubblework at the edge of wall W06.091. It should be noted that this is essentially the same mortar that was used to reconstruct wall W06.087. On wall W06.090, there are two layers of render; a light bluish grey (Gley 2 8/1) mortar containing round black volcanic mineral fragments, frequent larger pieces of crushed ceramic, and larger pieces of crushed tuff or lapilli, and a white (10 YR 8/1) mortar of identical composition that overlies it. Both mortars lap around onto wall W06.091. All of these early modern mortars were most likely created at the same time for the reconstruction and restoration of the room, but had slightly different mixes.

14.9 Phase 9. Modern interventions

The modern period has witnessed little change to Room 11 aside from the effects of exposure and the natural build-up of detritus and overburden as found everywhere within the insula. Traces of a fire (265.007) attest to the disposal of rubbish or vegetation at some point in the post-excavated history of the site, but the greatest change was a layer of gravel (265.001, 614.001) placed by the SAP in order to keep down dust and to protect the underlying archaeology.

14.9.1 Plaster conservation

There is some evidence to suggest that the surviving wall plaster on wall W06.090 had its exposed edges covered in a bluish grey (Gley 2 6/1) mortar with angular volcanic mineral fragments. The larger areas of wall plaster on walls W06.087 and W06.090, however, do not appear to have undergone this conservation measure.

14.9.2 Wall conservation

All of the walls in Room 11 were extensively pointed with a coarse mortar containing an aggregate of volcanic minerals, tuff, and ceramic during the phase of restoration in the 2000's. Depending upon its position on the wall and possibly its corresponding degree of weathering, this mortar varies in colouration from a light bluish grey (Gley 2 7/1) to a dark bluish grey (Gley 2 5/1).

15. Room 12
Corridor (AA610)

Description

Room 12 is a long, 'L'-shaped corridor that runs 6.64 m from the southern side of Room 8A southward towards the southern property boundary of the Casa del Chirurgo (Fig. 5.15.1), at which point it turns to the east and continues 6.41 m to the final phase kitchen in Room 13 and the other eastern service rooms. At no point is the room particularly wide, measuring approximately 1.10 m at its greatest width. It provides access to Rooms 22 and 23, and, at an earlier point in its history, also connected to Room 11. In the final phase of the house, an *opus signinum* surface stretched across the entirety of this corridor, connecting with similar flooring throughout the service wing. At the bend, it is flanked by a light well (Room 22), which provided light to the corridor. A drain also ran from west to east along the southern half of the corridor, providing a conduit for water collected in the light well.

Archaeological investigations

Excavations in Room 12 were carried out in a single field season in 2006 (AA610)[159] and opened the entire

width and breath of the corridor for excavation. However, owing to the largely well-preserved and intact *opus signinum* surface in most of this area, excavation concentrated on the one area where this flooring was not preserved: the southern half of the western leg of Room 12. The walls of this area were also analysed at this time.[160] The interpretations of the architecture were checked and written up in 2008 and 2013.

15.1 Phase 1. Natural soils
No deposits from this phase were recovered in this area.

15.2 Phase 2. Volcanic deposits and early constructions

15.2.1 An early cistern
The only feature possibly originating from the period prior to the creation of the Casa del Chirurgo is the lower part of a cistern (**610.071**) that continued in use during subsequent periods (Fig. 5.15.2). Photographs taken into the shaft of this cistern clearly indicate a lower feed pipe connecting to the north–south drain that runs from the atrium of the Casa del Chirurgo. It is therefore possible that this cistern was built at the same time (Phase 3), however, the depth and position of the cistern make it likely that it was also one of the original water storage locations attached to the Pre-

Figure 5.15.1. Room 12. (left) North–south part of corridor looking north; (right) east–west part of corridor looking west (image AAPP).

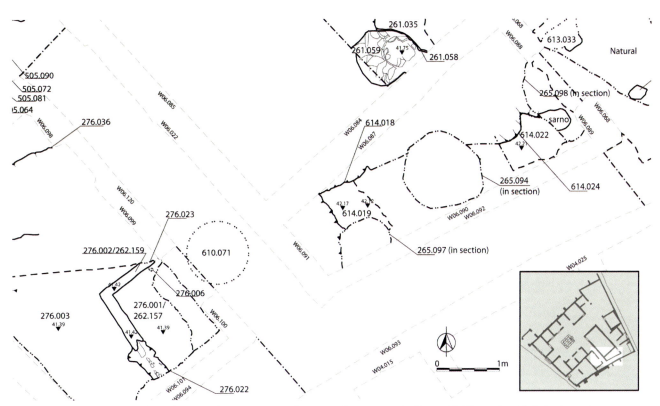

Figure 5.15.2. Plan indicating the approximate location of cistern under Room 12 (illustration M. A. Anderson).

Surgeon Structure's 'impluvium' recovered at depth in Room 23, a use for which its position would have been highly appropriate. It could also be argued that this cistern coordinates neatly with not only the cistern within Room 22, but also that found in Room 3. As no other water collection feature was found directly in association with the impluvium of the Pre-Surgeon Structure, it is possible that both of these played roles in the provision of water to the early structure. The method of building the cistern is difficult to determine

Figure 5.15.3. Image of the cistern interior (image M. A. Anderson).

since it was not fully excavated (Fig. 5.15.3). The upper construction, which seems to relate to the creation of the Casa del Chirurgo, was lined in waterproof plaster and the end of the Nocera tuff drain that empties into it is clearly visible. Below this, the walls of the shaft continue downwards past a small widening that may represent the original build of the cistern – the part possibly constructed during this phase.

15.3 Phase 3. The Casa del Chirurgo (c. 200–130 BC)

This phase saw the construction of the Casa del Chirurgo, numerous traces of which were found in Corridor 12, including primary walls and elements of the portico that surrounded the original core together with its drainage system.

15.3.1 Wall W06.023/W06.097

While it was not possible to excavate the northern part of Room 12 due to the preservation of AD 79 flooring, this area would presumably have contained evidence of the construction of wall W06.023/W06.097. Evidence from the northern side (in Room 8A) suggests that there was no doorway in the wall in this phase since the foundations and foundation trenches carried on uninterrupted here at depth. Elsewhere in the construction of the house, the builders consistently seem to have left spaces open for intended doorways.

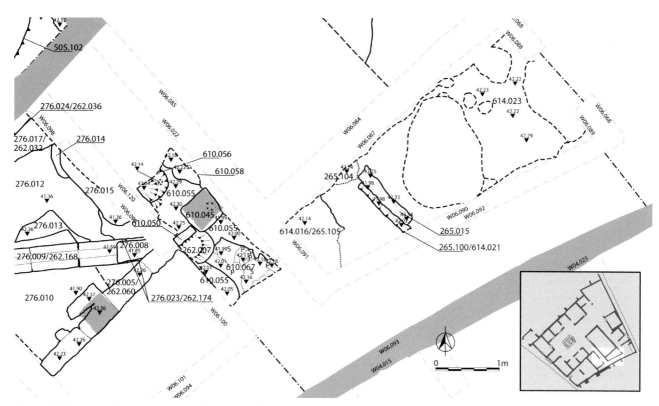

Figure 5.15.4. Plan of the deposits and features in Room 11 associated with the construction of the Casa del Chirurgo. (Illustration M. A. Anderson).

The wall itself was made in *opus africanum* with Sarno stone used for both the framework and the irregularly shaped rubblework. In between the blocks of the framework, there is evidence that they were bonded with a brown (7.5 YR 5/4) clay with small inclusions of lime, which would also have been used to bond the rubblework.

15.3.2 Portico, low wall, and cistern

The most significant component of the construction of the Casa del Chirurgo to take place within the area of Room 12 was the creation of a Sarno stone portico that ran parallel to the southern side of the Casa del Chirurgo's central rooms and continued to the west (plausibly all the way to the façade of the property on the Via Consolare). This rested upon a series of roughly square (0.56 by 0.50 m) Sarno stone bases and long rectangular blocks (Fig. 5.15.4). The remains recovered from the corridor connect neatly with more extensive remains recovered in Room 23. A single, roughly square block (**610.045**) with a posthole cut into the top (possibly residue from the original use of the block or result of a later activity) was recovered in Room 12. In addition, fragments of a long block were recovered, running west (**610.050**) toward Room 23. This was later reused as a component of the base for the later wall W06.099.

On the southern side of the portico, there was an inlet for a downspout that once connected to a Sarno stone capped drain, running roughly south-east, that itself connected to the upper portion of the cistern (Figs. 5.15.5 and 5.15.6). The block for the base of the low wall was used in the construction of the downspout, forming a Sarno capped drain (**610.067**) designed for the collection of water from the roof. This in turn was connected to the north–south drain that ran from the atrium across Room 23 towards this location, meaning that two different water sources drained into a single repository. This served to connect the whole securely as part of a single building phase. It is notable that the U-shaped Nocera tuff base of the drain terminated directly into this shaft without further elaboration, allowing water from the atrium to cascade down the side of the waterproof plaster into the storage below. The cistern itself (610.071), approximately 6.15 m deep and 1–2 m wide, was extended upwards so as to match the level of surrounding surface at this time. Beam holes run down the internal face of the cistern either in order to provide access or as a residue from the construction process.

15.3.3 The southern boundary wall (W06.093)

The southern section of Room 12 (wall W06.093, Fig. 5.15.7, B) runs along the boundary wall of the Casa del

Figure 5.15.5. Downspout termination, drain into cistern, and pilaster base (image AAPP).

Figure 5.15.6. Downspout termination, drain into cistern, and pilaster base (detail) (image AAPP).

Chirurgo (cf. Fig. 5.16.3). Wall W06.093 was originally built in *opus africanum* using Sarno stone for both the framework and the rubblework infill, which also utilised occasional pieces of cruma and grey lava. The headers measure c. 1.1 by 0.35 m. No complete, or indeed substantial stretcher has survived. The rubblework infill for the *opus africanum* was sub-rectangular to sub-square in shape and set within a fine clay-like mortar, very pale brown (10 YR 7/4) in colour, with flecks of lime and fine angular black volcanic mineral inclusions. There is evidence that the large Sarno stone blocks for the framework were re-used as there is a final plaster surface facing inwards into the rubblework on one of the headers at the northern end of the wall. The backing plaster for this surface was a light bluish grey (Gley 2 8/1) with rounded gravel inclusions. This was subsequently covered with a 5 mm thick layer of white plaster (Gley 1 8/N) containing fine angular black inclusions.

15.3.4 Post-Pre-Surgeon fills

After the required components of the Casa del Chirurgo had been built, the level of the surrounding soil was raised to cover them. This was presumably sealed by some sort of flooring surface that has not survived, such as a simple beaten earth floor. Elsewhere in the construction of the Sarno stone house, the filling up of the lower terrace and burial of the Pre-Surgeon structure seems to have been completed prior to construction, but in the area of Room 12, the reverse seems to have been true, at least in the case of the north–south drain. Without knowing the state of the underlying natural deposits, it is difficult to be certain of the reason for this reversal in building methodology. It is possible that it resulted from the need to first raise the cistern feature (those elements in Room 12) prior to connecting with the north–south drain. The fills used to raise the level of the area were highly variable in nature, but among them was the characteristic orange (10 YR 3/4) sandy silt deposit (**610.055**) with bluish mortar/plaster inclusions that likely derives from the walls of the Pre-Surgeon Structure itself (Figs. 5.15.8 and 5.15.9). Besides filling layers, this phase also produced several cuts and fills, including one near the pilaster base (**610.058**) that was filled with a dark olive brown (2.5 Y 3/3) silty sand (610.059) and another (**610.056**) on the western side of corridor filled with a dark yellowish brown (10 YR 3/4) loose sandy silt (610.057).

15.3.5 Phase 3 plaster

Wall W06.093 was covered in a layer of *opus*

Figure 5.15.7. Re-used Sarno stone framework block in wall W06.093. (A) reused Sarno block of the framework; (B) backing plaster; (C) final plaster surface; (D) *opus africanum* rubblework; (E) early modern render (image D. J. Robinson).

signinum that would have given this exterior wall an appropriately waterproof covering. Traces of this survive pressed deep into fissures in the Sarno stone at the eastern end of the wall. It is a hard pinkish white (10 R 8/2) mortar containing angular pieces of black volcanic minerals and smaller pieces of lime and crushed cruma. A similar, but not identical,

weatherproof *opus signinum* was also found in a 25 mm thick layer on wall W06.097 in Room 23. This had a pink (10 R 8/3) matrix containing numerous small black volcanic mineral inclusions and larger pieces of crushed ceramic, with the mortar being simply flattened to create a final outer surface.

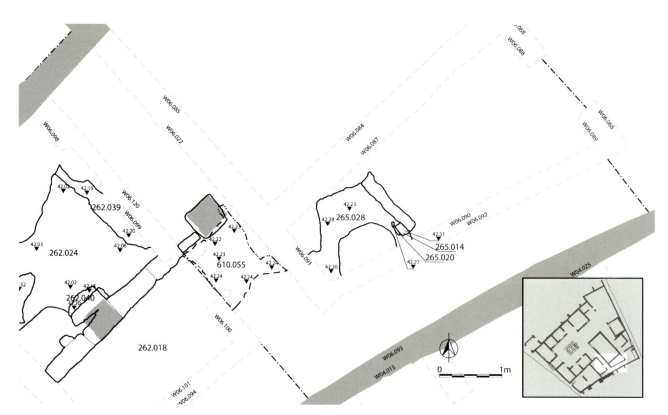

Figure 5.15.8. Plan of deposits and features related to the construction of the Casa del Chirurgo (illustration M. A. Anderson).

Figure 5.15.9. Fills overlying drain and cistern (image AAPP).

15.4 Phase 4. Changes in the Casa del Chirurgo (c. 100–50 BC)

No deposits from this phase were recovered in this area.

15.5 Phase 5. Redecoration and redevelopment (late first century BC to early first century AD)

The late first century BC saw significant changes to the Casa del Chirurgo, including the conversion of two areas of the house into commercial units that faced the Via Consolare, as well as general renovations in the atrium.

This same phase also witnessed further restructuring of the service rooms, the creation of new ones (Rooms 22 and 23) on the west, including the extension of the triclinium (Room 10), and the definition of Room 11. This effectively created the L-shape of Room 12 which ran between them. The northern doorway in wall W06.097/W06.023 must also have been cut through at this time to permit the flow of traffic to the new service wing and presumably replaced access on the southern side that had once been possible through the southern rooms of the atrium. A final change in this phase was the addition of an upper storey over the new shop spaces that continued over Rooms 22 and 23 and the western arm of Corridor 12.

15.5.1 Postholes and closing of the cistern

In order to begin these renovations, the southern portico of the house and its downpipe from the roof was dismantled. Work began on the construction of a wall that would serve to retain the areas of Rooms 22 and 23, permitting the lowering of the area of Rooms 3 and 4, cutting the north–south drain that had formerly run from the atrium into the cistern. Without a source of water to fill it, the cistern was sealed with a hard mortar and stone capping (**610.051**) which at once made it both inaccessible and stable so that further surfaces

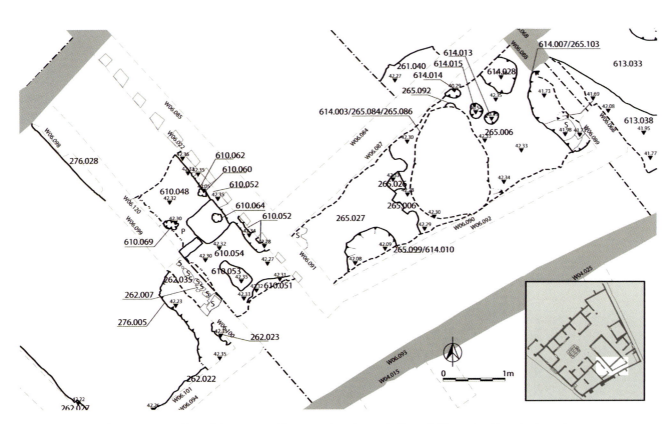

Figure 5.15.10. Plan of deposits and features related to early Phase 5 (illustration M. A. Anderson).

or fills could be placed over the top (Fig. 5.15.10). The drain itself was filled with a loose dark brown (7.5 YR 3/2) sandy silt (610.068) that probably derived from these activities. Simultaneously, a number of postholes (**610.060**, **610.069**, **610.064**) were cut for posts, either to help with the successful sealing of the cistern or to assist other construction. One of these (**610.064**) was almost square, but for rounded-off corners, and was cut directly into the stone base. While it is possible that it derives previous use of the stone, it is most likely an aborted attempt at a posthole moved to another location, perhaps due to encountering the Sarno stone base (610.045) (Fig. 5.15.11).

15.5.2 Filling over the cistern
Prior to the construction of the walls flanking Room 12, a levelling layer (**610.054** = **610.048**[161]) was applied over the now closed cistern. The levelling layers consisted of a firm dark grey (10 YR 3/2) loose sandy silt deposit with building materials and other general debris.

15.5.3 Creation of the eastern corridor wall (W06.022b, W06.090/W06.092 and fills)
After this, two sets of walls were created in *opus incertum*. The first (W06.022b) was an extension of the western side of Rooms 10 and 11, and was built at the same time and defined the southern extent of Room 11 and the eastern wing of Corridor 12. The cut of the construction trench (**610.062**) and shuttering of the lower foundation (**610.052**) of wall W06.022b suggests that it terminated at the doorway at the western end of Room 11. The rest of the cut was filled with a loose olive brown (2.5 Y 3/2) silty sand (610.063). The top layer of the fill (610.047) was equally gritty with some rubble.

Figure 5.15.11. Postholes related to the sealing of the cistern in Phase 5 in Room 11 (illustration M. A. Anderson).

Walls W06.022b and W06.090/W06.092 were constructed in *opus incertum* using grey lava with black mineral inclusions and Sarno stone with the occasional piece of cruma for the rubblework. The rubblework of wall W06.090/W06.092 also included occasional pieces of brick/tile and elements of an *opus signinum* floor. The mortar in which the *opus incertum* rubble was set is a very pale brown (10 YR 8/2) colour with angular inclusions of volcanic minerals, larger pieces of lime, fragments of tuff, and the occasional piece of crushed ceramic. Excess mortar was used to smooth around the edges of the rubblework, with the aim of creating a flat surface, possibly for the application of a plaster coating. More of wall W06.022b survives, and here it is noticeable that grey lava was used exclusively in the lower portions of the wall, with Sarno stone and cruma for the upper portions. The transition between the lava and Sarno occurs at c. 1.8–2 m above modern ground level. It is likely that this banding in the use of stone was deliberate with the lighter Sarno being used in upper portions of the wall and the denser, heavier lava being used to provide stability at the base of the wall. Such a decision may be related to the line of beam holes that traverse the wall and would have supported a second storey in this area. The twelve beam holes run the full length of wall W06.022 from Room 8A to the southern end of the wall. They are contemporary with the construction of the wall as there are no signs of repair that would have accompanied the insertion of beam sockets at a later date. The beams measured c. 0.14 m wide by 0.1 m deep. At the southern end of wall W06.022b, there is evidence to suggest the presence of a small doorway into Room 11. This was approximately 0.75 m wide and 1.6 m tall. The southern side of this doorway was quoined with a large Sarno stone block, which was also used to define the western end of the contemporary wall W06.092. It should be noted that the very pale brown mortar used for the *opus incertum* of walls W06.022b and W06.092 was also used to mortar together the brick/tile quoin at the eastern end of wall W06.092.

15.5.4 Creation of the western walls of the corridor (W06.120/W06.121)
After the eastern walls of the corridor had been finished, a further series of levelling layers was applied to the area before a second wall (W06.120/W06.121) was built to the west. The levelling layers were comprised of a series of diverse fills made up largely of building refuse and some apparently domestic detritus (**610.049**, **610.053**, 610.046). It was capped on both sides of the pilaster base with a hard-packed orangey layer that

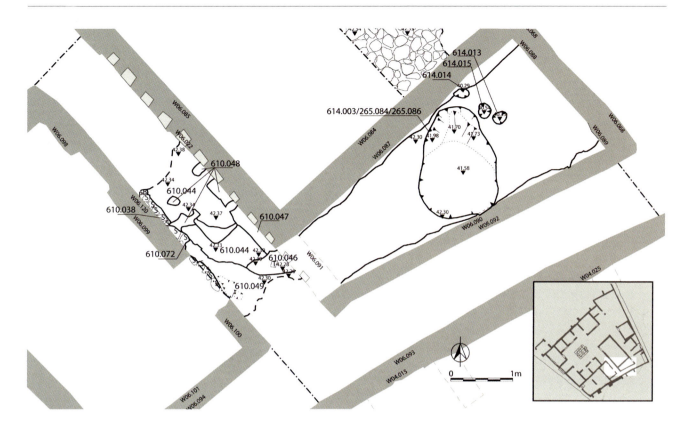

Figure 5.15.12. Plan of deposits and features related to continued work in Room 11 during Phase 5 (illustration M. A. Anderson).

was likely a temporary floor surface (**610.044**) (Figs. 5.15.12 and 5.15.13).

Wall W06.120/W06.121 was built in two stages. The first entailed a foundation pad in a cut (**610.072**) that was slightly wider than the final wall and topped with a series of loosely aligned stones that were found to extend beyond the upper part of the wall. Wall W06.121 was built in *opus incertum* using sub-square blocks of black lava set within a very pale brown (10 YR 7/3) mortar with black volcanic inclusions (**610.038**). The northern end of the wall butted up against the original southern wall of the Casa del Chirurgo, through which a doorway was cut into ala 8A. It is notable that pieces of brick/tile were used at the base of wall W06.121 adjacent to this doorway, to repair and 'square-up' the Sarno stone orthostat through which the doorway had been cut. The extensive modern pointing of this area of the wall makes it impossible to characterise the nature of the mortar in which the brick/tile was set, although it is likely that the repair was necessitated by the creation of this doorway to provide access through to the southern ala and the atrium beyond it. It is difficult to know the extent to which the original portion of wall W06.120 survives, due to its extensive rebuilding and early modern/modern pointing. Certainly, the large Sarno stone orthostat that was used to form the

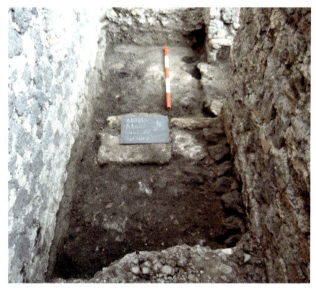

Figure 5.15.13. Foundations of walls W06.022 and W06.098/W06.099/W06.100 demonstrating the manner of their construction. (image AAPP).

southern corner of the wall and the doorway into Room 22, as well as the lower courses of the Sarno stone *opus incertum*, are part of the original construction of the wall, though the pointing obscures any sign of the ancient mortar. From observations in Rooms 22 and 23, however, it is possible to say that the *opus incertum*

would have been bonded with the same very pale brown mortar used to bond wall W06.121 together.

The reason for the staged nature of this construction – the eastern rooms being built prior to those on the west – may easily be explained due to the tight quarters presented by these areas. It would surely have been difficult to work on both walls at once, and so a sequential method was undertaken. The origin of the fill layers might well be the soils removed from the south western side of the property or general trample caused by work underway. This is especially true of an orangey fill (**610.044**), which is reminiscent of earlier filling layers used to fill in the terrace after Phase 2 and may simply represent these same soils, mixed up through removal and subsequent redeposition. It is easy to imagine that during the extensive removal of soil from Rooms 3 and 4, the area of Room 12 and Rooms 22/23 would have been a convenient staging point for work taking place to the west, especially considering that the major focus of this work would have initially been the creation of the western wall of Room 23 to provide support for the soils that were not to be removed to the east of Room 4.

15.5.5 Phase 5 plaster

In the north–south portion of Room 12, there is evidence to suggest a coherent initial plastering of its walls and also links to the plastering of the walls of Room 22 and the southern ala. There are traces of a layer of plaster on the large Sarno stone orthostat of wall W06.120 that may be related to the initial phase of decoration. This can be seen to loop around onto wall W06.094 in Room 22, where it formed part of the initial plaster layer in this room. This was applied as a single layer of grey (10 YR 6/1) plaster containing a coarse, rounded aggregate of volcanic minerals and the occasional larger piece of lime. A similar plaster is also found on wall W06.022b, at least in the area of the wall beneath the beams, which survived in only limited areas pressed into gaps in between rubblework. Preserved beneath the later final plaster layer of wall W06.121, at its northern corner where it becomes wall W06.023 of Room 8A, are also traces of this initial phase of plastering. As the traces of plaster are only preserved on the Sarno stone edge of the doorway into Room 8A, the plaster therefore relates to a phase when the doorway was open and Corridor 12 was in operation. The plaster was deliberately flattened to create a face onto which a pigment could be applied. This plaster can be seen lip around onto wall W06.023 of Room 8A, where there are traces of a red pigment.

It would appear that the wall decoration in the west–east portion of Corridor 12 was different from that in the north–south portion. On wall W06.092, there are faint traces of both a backing layer and a final surface. The backing plaster was a light bluish grey colour (Gley 2 7/1) with angular black volcanic minerals and crushed ceramic, which was overlain by a 4 mm thick layer of pinkish white (10 R 8/2) *opus signinum* plaster. There appears to be no matching Phase 5 plaster on the opposite wall W06.093, which may well have retained the *opus signinum* plaster applied to it in Phase 3. The differences in the decorative schemes in the different 'arms' of the corridor are notable and the lack of coherent plaster further enhances the idea that this was a service area of the house that simply did not require a carefully planned decorative scheme.

15.5.6 Packed earth surface

After all of the construction work in the area had been completed, a final levelling layer or potentially an intended use floor was placed across the entirety of Room 12 (Figs. 5.15.14 and 5.15.15). Consisting of a rough yellowish brown (10 YR 3/4) packed earth (610.025,[162] **610.026**[163] = **610.033**), this deposit ran across most of northern part of the corridor. The hard-packed upper part of this deposit (610.025) was very dark brown (10 YR 3/2) in colour and should probably be interpreted as the trample layer running down the centre of the corridor. This packed surface (610.026) produced a coin dated between AD 14–37, suggesting that the use of this floor continued for some time and a coin was lost into its surface.[164]

15.6 Phase 6. Upper storeys and final decoration (c. mid-first century AD)

During the middle years of the first century AD, further changes were made to Corridor 12 which seem to have been a result of modifications that took place to the upper storeys to the west of this area at this time. There is evidence for a range of repairs and reconstruction to the walls of Corridor 12, some of which appear to use mortars similar to those employed contemporaneously elsewhere in the service wing, indicating a coherent phase of work. This took place prior to the application of a unified final phase of utilitarian *opus signinum* plaster throughout the room.

15.6.1 Repairs to wall W06.093

There are two distinct phases of repair on wall W06.093, which are at opposite ends of the wall and lack any direct stratigraphic relationship. Consequently, they are roughly assigned to the same phase while accepting the possibility that the repairs were undertaken at slightly

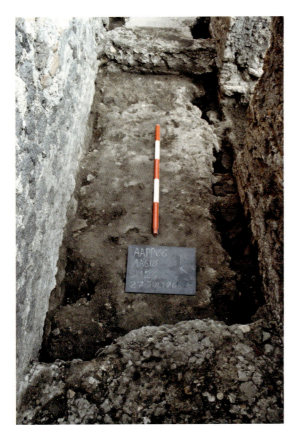

Figure 5.15.14. Packed earthen floor surface possibly representing an initial use surface in Room 11 (image AAPP).

different times. At the western end there is an area where the rubblework of the original *opus africanum* wall was repaired. This was undertaken with a rough *opus incertum* containing Sarno stone and cruma. This was set within a hard bluish grey (Gley 2 6/1) mortar containing a very coarse aggregate composed of angular volcanic rock, including red cruma. Pieces of brick/tile were set into the mortar to help bulk out the repair and to create a flat surface for the application of a plaster layer.

At the eastern end of wall W06.093, much of the original *opus africanum* work was removed. This was most likely associated with the insertion of a cistern in Room 13, the presence of which was suggested by excavations in this area (cf. infra). Wall W06.081, the continuation of wall W06.093 in Room 13, was completely rebuilt during this phase and these changes would have affected the wall to the west as well. This reconstruction did not stop at the brickwork in wall W06.081, but continued beyond it into the area designated as part of wall W06.093. It was undertaken in *opus incertum*, using cruma, Sarno stone, and the occasional piece of brick/tile and grey lava set in a white (5 YR 8/1) mortar with a coarse aggregate of angular volcanic minerals, pieces of crushed ceramic, and the occasional piece of lime.

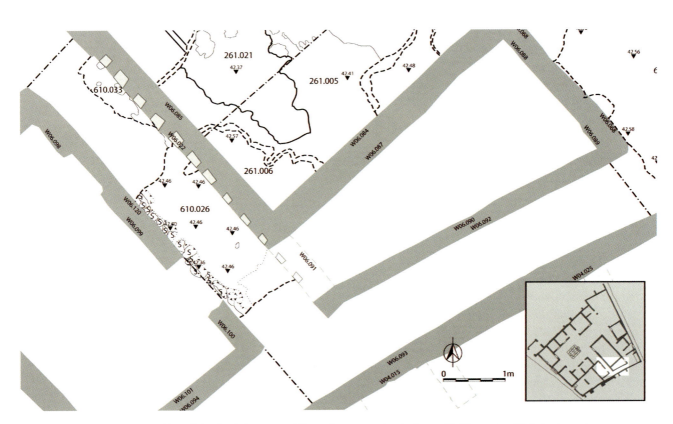

Figure 5.15.15. Plan of the final elements of Phase 5 construction in Room 11 (illustration M. A. Anderson).

15.6.2 The closure of the doorway into Room 11

A phase of repairs and redecoration is also apparent in the north–south section of the corridor, when the doorway at the southern end of wall W06.022b was blocked with *opus incertum* containing grey lava, Sarno stone, cruma, and the remains of a former *opus signinum* floor surface. Part of this construction involved the deposition of an orange, hard-packed, soil/mortar (**610.035**). As a result of this activity, both ends of this wall required new corners and significant reworking. The rubblework was bonded with a hard white (5 YR 8/1) mortar containing rounded black volcanic minerals and pieces of ceramic and the occasional larger piece of crushed volcanic lava. It should be noted that this light-coloured mortar with a very coarse aggregate is similar in its composition to that used to repair wall W06.093, as well as walls W06.097 and W06.098/W06.099 in Room 23. Consequently, the closure of the doorway in Corridor 12 into Room 11, and general repairs to earlier walls, could all have been part of a single phase of reconstruction in this part of the service wing. As part of this phase of reconstruction, the area above the former door was also repaired. This was undertaken in *opus incertum* using grey lava, Sarno stone, and cruma rubble bonded with a white (Gley 1 8/N) mortar with angular pieces of crushed black volcanic tuff and lime of various sizes. This mortar was set directly on top of the of the wooden floor beams, leaving the impression of their upper surface in the mortar. The use of a different mortar here is perhaps unsurprising if it is considered that the area above the level of the beam holes would have belonged to an entirely separate second storey room, where repairs may have been undertaken at a slightly different time.

15.6.3 The rebuilding of wall W06.120

Wall W06.120 was also largely rebuilt at this time. A cut (**610.027**) that runs along the western side of the corridor seems to represent a re-exposure of the wall foundations for the rebuilding or strengthening of the wall (Figs. 5.15.16, 5.15.17 and 5.15.18). A posthole (**610.039**) (fill, 610.040) at the southern end of the work suggests that this involved shuttering. The wall was then reconstructed using a rough form of *opus incertum* with courses of generally sub-square Sarno stone and occasionally cruma interspersed with lines of tile. This was bonded with a hard light bluish grey (Gley 2 8/1) mortar containing small rounded inclusions of many different colours. Many of the stones used in this rebuild were re-used and retain traces of a backing plaster with a final white surface. Occasionally these plaster surfaces face outwards from the wall, giving the misleading impression that the white plaster once covered this second phase of wall W06.120. This can be seen not to have been the case, however, as other pieces of the backing plaster and the surface of the fresco face into the core of the wall, or appear to enter into the wall at an unnatural angle. The large Sarno stone block is a good example of this, which retains the plaster on its northern face and points into the core of wall W06.120. After this work had been completed, the cut was filled with a dark yellowish brown (10 YR 3/4) loose sandy silt (610.028[165]) containing a variety of building and domestic debris. As a component of this work, a series of skims of limey mortar or plaster build-up (610.031, 610.032, 610.036) seems to have occurred in the corridor, probably deriving from excess building materials disposed of in the space during the process of construction.

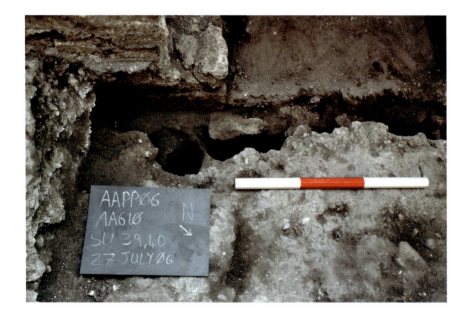

Figure 5.15.16. Cuts made for supporting beams and shuttering in the reconstruction of wall W06.098/ W06.099/W06.100 at the southern end (image AAPP).

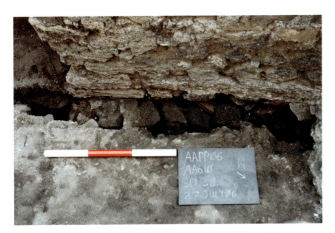

Figure 5.15.17. Cuts made for supporting beams and shuttering in the reconstruction of wall W06.098/W06.099/W06.100 ad the northern end (image AAPP).

15.6.4 General filling and levelling

After these construction events had taken place, the floor level of Corridor 12 was raised by roughly 14 cm of fills, which included a variety of building materials and construction debris. The lower fill consisted of a loose brown sandy silt (610.030[166] = **610.043**,[167] 610.042), running along the eastern side of the corridor and visible within several keyhole cuts in the upper *opus signinum*. It was quite shallow (2–3 cm in depth) at

points and consisted of building detritus and general rubble. The final layer of the fills was an even deposit of wall plaster (610.041[168] = 610.034 = **610.021**[169]) in multiple colours mixed with smaller amounts of other construction material and debris, in a loose olive brown (2.4 Y 4/4 – to 5 YR 2.5/1) sandy silt. It is not known what the source of this plaster might have been, but it should be noted that there was a coherent new phase of decoration throughout the property at this time that required the removal of the previous one. As such, the plaster dumps may well have been a convenient way of getting rid of the debris associated with redecoration. Wherever its source, the plaster was used consistently as a sub-floor under the *opus signinum* in the entire service wing of the Casa del Chirurgo. It is possible that it was viewed by the builders as a clean, odour free means to raise the level in the room, or potentially as a compact sub-floor suitable for *opus signinum*.

15.6.5 Opus signinum *floor surface*

An *opus signinum* floor (**610.013** = **610.020** = 610.023 = **610.003**) was recovered across all of Corridor 12, representing the final period of flooring, which was poured directly over the plaster sub-floor (Figs. 5.15.19, 5.15.20 and 5.15.21). Thus it connects this action with a similar final phase *opus signinum* over the rest of

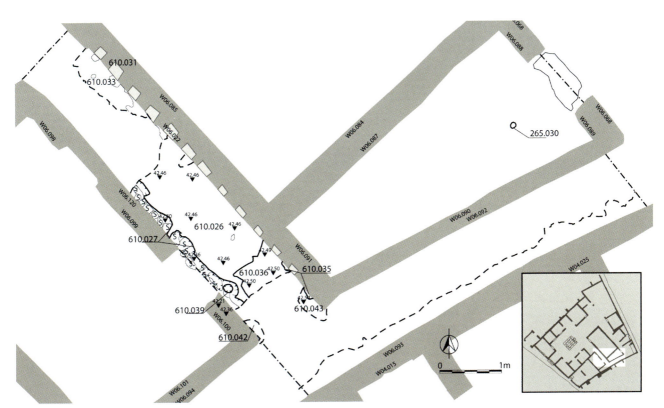

Figure 5.15.18. Plan of deposits and features related to the rebuilding of wall W06.098/W06.099/W06.100 in Phase 6 (illustration M. A. Anderson).

the service area that was constructed in an identical fashion, and seemingly, as a single, coordinated effort of renovation (cf. other related changes in Rooms 16, 18, 17, 13 and 6C). The final phase *opus signinum* was much better preserved (**610.007**) in the south and east of the corridor and was separated by a break between these two areas.

15.6.6 Long drain from the light well

Either at the same time or shortly thereafter, a long covered drain was installed running from Room 22 along the southern leg of Corridor 12 that terminated in a now-collapsed cistern in Room 13 and overflow drain into a pit under the pavement of the Vicolo di Narciso. It consisted of a stone and mortar base (610.024) and tile capping (**610.019**), which descended from west to east and was contemporary with the final phase of the *opus signinum* preserved in this area. This was likely a new component of the light well in Room 22, where the former cistern head was blocked and the new drain allowed for water collected on the roofs over this area to be saved and stored in the vicinity of the final phase kitchen. On the extreme western side of the area, the tile drain stood proud of the surface of the *opus signinum* at the height of what must have been a low containing wall. As it gradually declined in elevation towards the

cistern in Room 13, it disappeared under the surface of the *opus signinum*. The upper sections have been lost, but were likely of tile, like the remaining elements of the drain.

While the fact that the drain appears to have been cut into the *opus signinum*, rather than having been poured against it, permits the suggestion that the drain may have been an afterthought, it is difficult to imagine that the cistern in the kitchen and the changes to the light well would have originally been planned without thought to where run-off might otherwise escape or be collected. Consequently, it is likely that this peculiarity is simply a result of the building process and complications caused by modern damage to the feature.

15.6.7 Phase 6 plaster

It is probably the rebuilding in both the north–south and east–west parts of Room 12 that provided the catalyst for a new phase of redecoration. Unlike previously in Phase 5, redecoration in this phase was coherent throughout the room using a backing plaster with an *opus signinum* surface. The backing was composed of a white to grey (10 YR 5/1) plaster with volcanic minerals with the occasional piece of lime and crushed ceramic material. This was overlain by a thin layer of *opus signinum* plaster containing a dense

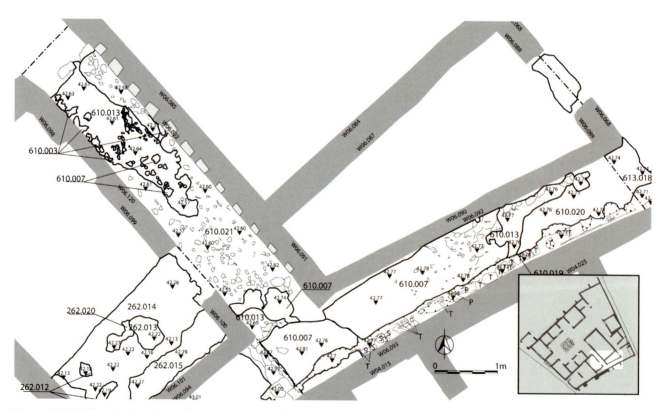

Figure 5.15.19. Plan of deposits and features related to the new *opus signinum* surface and drainage systems in Room 11. 'T' indicates tile, 'S' indicates Sarno stone (illustration M. A. Anderson).

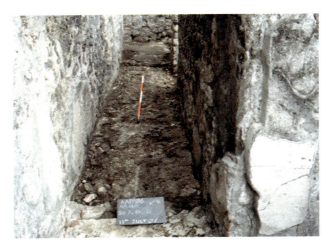

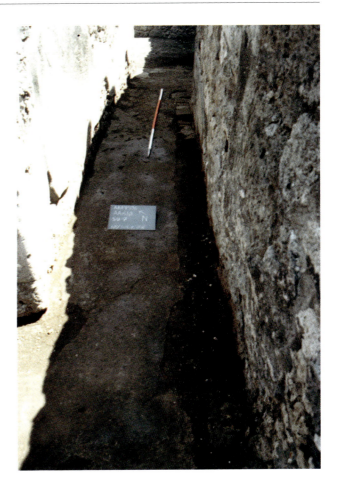

Figure 5.15.20. (*Left*) Plaster fragments in sub-floor of *opus signinum* in western half of Room 11 (image AAPP).

Figure 5.15.21. (*Right*) Final phase *opus signinum* in the eastern half of Room 11 (image AAPP).

amount of crushed ceramic fragments set in a pale red (10 R 7/2) mortar with inclusions of crushed ceramic, lime, and smaller black volcanic minerals. It should be noted that the same backing plaster was also used in the Phase 6 redecoration of Room 22, which must have been undertaken simultaneously and is a further indicator of the coherence of the changes affecting both of these spaces. It is useful to note that there are different plasters dating from this phase present in the upper and lower portions of wall W06.022b. This is the result of the plasters being part of the decorative schemes of separate rooms, the plasters being separated by the line of beam holes denoting upper and lower storeys. The backing plaster from the second storey comprises of a white (Gley 1 8/) matrix with black volcanic mineral inclusions, which was overlain by a thin layer of final red (10 R 5/8) *opus signinum* plaster with pieces of lime visible at the surface. The upper backing plaster contains a smaller quantity of inclusions and a relative absence of crushed ceramic fragments characterise the lower backing plaster, while the *opus signinum* final plaster contains a greater quantity of crushed ceramic fragments, giving it a darker colouration.

15.7 Phase 7. Post-earthquake changes

No evidence of this period was recovered in this area.

15.8 Phase 8. Eruption and early modern interventions

There is evidence for the repair and reconstruction of all of the walls in Room 12 during the early modern period. It would appear that the upper portions of wall W06.093, possibly as much as the top 1 m, was rebuilt

during the early modern period. Similarly, the upper portion of the southern end of wall W06.022b and the western end of wall W06.092 were also rebuilt at this time. This was undertaken in *opus incertum* utilising sub-square Sarno stone blocks laid in regular courses set within a light grey (10 YR 7/2) mortar containing angular black volcanic minerals, larger pieces of lime, and crushed brown tuff. Here the reconstruction was done to facilitate the laying of a course of roof tiles on top of wall W06.022b as a conservation measure. The tiles were set in a light grey mortar with flecks of lime that is weathering in places to a reddish grey/brown colour. The exposed southern end of wall W06.092 at its junction with wall W06.022b was also pointed with a light bluish grey (Gley 2 7/1) mortar with black volcanic minerals and larger pieces of tuff or lapilli. The same mortar was also used to fill a hole in the ancient plaster at the western end of the wall and also to point the brick/tile pilaster at the eastern terminus of wall W06.092.

A large area of the eastern end of wall W06.093, as well as areas of W06.022b, were covered in a rendering mortar, or least heavily pointed with it. This was done using a friable light bluish grey (Gley 2 7/1) mortar

containing crushed volcanic tuff or lapilli, as well as smaller pieces of cruma, ceramic, and fine black particles of volcanic minerals. At the western end of wall W06.093, there is evidence for another phase of wall consolidation. This utilised a very hard light bluish grey (Gley 2 8/1) mortar with large inclusions of volcanic tuff or lapilli, angular volcanic minerals, and the occasional piece of abraded ceramic. Areas of this mortar were deliberately flattened to create the appearance of a final plaster surface. A similar mortar was used to point the upper portion of wall W06.120, and there is also some evidence to suggest that a white mortar wash or paint was applied to this surface, which was also seen in Room 23.

Finally, there is the strong possibly that the Sarno block threshold (610.002, 610.037) on the northern exit of Corridor 12 was added at this time. While the rough stone and mortar construction of the threshold (610.002, 610.037) possibly represents the real threshold under a Sarno block restoration, it was not possible to determine the precise relationships since the adjoining *opus signinum* could not be excavated. Certainly the modern or early modern pointing suggests that this structure could be a modern fabrication.

15.9 Phase 9. Modern interventions
Modern interventions in Corridor 12 were few in number and limited in scope.

15.9.1 Changes to the stratigraphy in the modern period
The east–west drain (610.019, 610.024) in the southern side of Corridor 12 was damaged (610.017), most likely in the period after the original excavation of the house. The parts of the drain that once stood proud of the *opus signinum* are no longer extant and the drain itself was filled (610.018) with modern deposits. A build-up

of detritus and soils were present on the north–south (610.015, 610.16, 610.006) and the east–west (610.009, 610.005) orientated sides of the corridor and must have developed during the period after the original excavation. Some deposits were even the result of previous years of excavation by the AAPP (610.022, 610.011, 610.010). The final modern layer was the protective gravel (610.001) placed by the SAP.

15.9.2 1970's restoration campaign
The surviving areas of wall plaster on walls W06.092, W06.093, W06.022b, and W06.120 were edged with a light greenish grey (Gley 2 8/1) mortar containing angular volcanic minerals. This was undertaken as a protective measure. The same mortar was also used to patch holes in the surface of the final plaster. On wall W06.022b, a light bluish grey (Gley 1 8/1) mortar containing fine inclusions of black volcanic minerals and crushed red cruma was used to edge the largest area of surviving wall plaster in the upper portion of the wall. Here, however, the method of application was different with not just the edges but also the surviving plaster covered with the mortar in a band c. 10 cm wide. The mortar is of a different colour and composition from that used for the same purpose in the lower portion of the wall.

15.9.3 2000's restoration campaign
Walls W06.092, W06.093, W06.022b, and W06.120 were finally extensively pointed with a coarse light bluish grey (Gley 2 6/1) mortar, containing an aggregate of angular volcanic minerals. At this time, loose stones on the top of walls W06.092 and W06.120 were reset using the same mortar, which was also used on wall W06.121 to reset the stones of the edges of the doorway into Room 22.

16. Room 13
Kitchen (AA613)

Description

Room 13 is located in the south-eastern corner of the building plot of the Casa del Chirurgo, measuring roughly 3.66 by 2.93 m. It is connected to Room 11 and Corridor 12, by which it is ultimately connected to the atrium and the southern ala 8A. To the north, Room 13 communicates directly to Rooms 17 and 18 and hence to the hortus. The kitchen is outfitted with a built masonry bench with a top of inverted roof tiles, to the north of which is a masonry fitting for what appears to have been a small toilet or drain. Both of these features have experienced such heavy modern restoration that the original ancient material is hardly visible.

It is likely that, in the earliest phases of occupation, this space was part of the southern hortus of the property and that it was bordered to the south by the *opus africanum* plot boundary wall. A further boundary wall was added to the property in the east, with a wide back door framed with large blocks of Sarno stone c. 100 BC. Room 13, as we see it today, was constructed at the end of the first century BC during the development of the service wing, at the same time that the wide Sarno framed doorway was narrowed and wall W06.077 constructed. Thereafter, it remained largely unchanged, save for the addition of a now-collapsed cistern, the built cooking platform, and a drain/toilet. Although it cannot be proven that the area was covered with upper storeys during the final phases of the city, the presence of an upstairs toilet in nearby Room 15 makes this likely.

Archaeological investigations

Excavations in Room 13 were undertaken in 2006 in a single archaeological area designated as AA613.[170] At the same time, the standing architecture from the room was recorded with additional study seasons in 2010 and 2013.[171] The excavated area included the kitchen floor up to the built platform and within the toilet/drain (termed 'the north-eastern feature' below). The eastern half of the area was left in place, due to concerns over undermining the cooking platform and associated features. Despite the fact that only a restricted area could be subjected to full excavation, Room 13 nevertheless produced important information about the early phases of the service wing, including

evidence for the natural deposits and topography and some traces of Pre-Surgeon Phase activity.

16.1 Phase 1. Natural soils
No deposits from this phase were recovered in this area.

16.2 Phase 2. Volcanic deposits and early constructions

The majority of evidence for the Pre-Surgeon Structure comes from Room 23 in the south-western area of the property, where it can be seen that a phase of terracing occurred. Some evidence of related strata was also seen in the excavations in Rooms 13 and 14.

16.2.1 'Pocked-earth' surfaces

The earliest deposits from Room 13 comprise a light grey, silty surface, generally displayed with a characteristic pocked surface (**613.023 = 613.033**)[172] (Figs. 5.16.1 and 5.16.2). In Room 13, this deposit was recovered in two small areas but it is likely that it would have extended across the whole area if not for extensive later cuts. Below these, there was a pea-sized (normally 2–10 mm in diameter) gravel (**613.037**), heavily bonded with the upper surface but distinct in character, which was found intermittently near to north-west corner of the excavated area. A fine, dark volcanic sand was often recovered overlying the earlier deposits in the excavations of Insula VI 1. Within Rooms 13 and 14, it was encountered on the north side of the AA only (**613.021 = 613.036**).

16.2.2 Terracing activities

The pocked earth layers appear to have been cut by the terracing of soils that marks the beginning of the construction of the Pre-Surgeon Structure. This is suggested by the fact that these deposits were generally only found in the northern side of Room 13, with scant traces of 'pea gravel' deposits in the middle of the room (**613.037**). Such removal of soil aligns neatly with similar, more clearly defined cuts recovered within Room 11 in the same phase. It is also possible to detect the outline of a narrow cut, which runs from Room 13 directly through Room 11 and continues into Rooms 23 and possibly 6C, in connection with the early toilet or cesspit recovered from Room 10. On the whole it is clear that while Room 13 did not experience extensive terracing like that found to the west, it does display evidence of narrow cuts that are in alignment with the earliest features recovered in Room 23.[173]

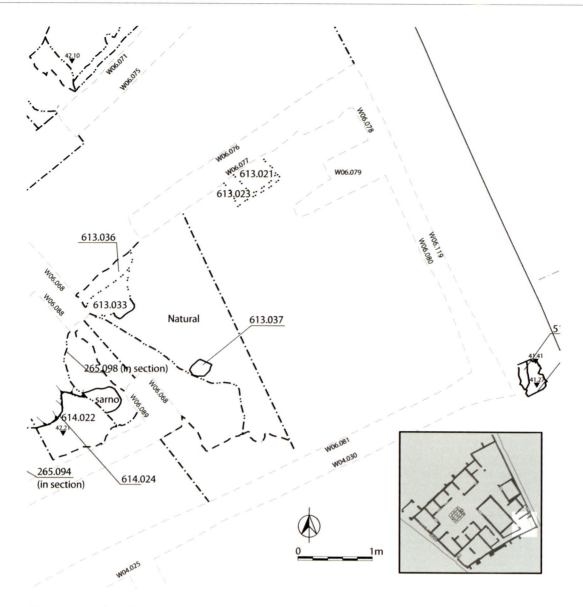

Figure 5.16.1. Plan of natural soils and early volcanic levels of Phase 2 in Room 13 (illustration M. A. Anderson).

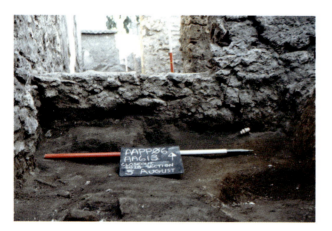

Figure 5.16.2. View of the trench section in the NW corner of Room 13, showing the early deposits and natural (image AAPP).

16.3 Phase 3. The Casa del Chirurgo (c. 200–130 BC)

Significant evidence for the creation of the Casa del Chirurgo did not survive in Room 13. The initial design of the Casa del Chirurgo appears to have left the area of Room 13 open, presumably as garden, work yard, or other type of open-air space. To the south, the *opus africanum* wall, that defined the southern boundary of the property, continued in Room 13 as wall W06.081. Significant later rebuilding of this, however, has served to obscure any traces of the original wall in both the standing architecture and the subsurface remains.

16.4 Phase 4. Changes in the Casa del Chirurgo (c. 100–50 BC)

The end of the second century BC (c. 100 BC) saw the first movement towards filling this space, with the creation or replacement of an eastern boundary wall and the first clear designation of the area as a component of the interior space of the house.

16.4.1. Reworking of the southern property boundary wall and the creation of the eastern boundary wall and back door

The construction or reconstruction of wall W06.080/ W06.078 on the eastern side of Room 13 is one of the earliest observable construction events in the area. This wall included a wide (1.98 m) doorway (number 23), defined by a series of orthostats which continued to

the point where it intersected with wall W06.081. The building of this wall likely related to the development of the area of the hortus, which saw the construction of Rooms 19 and 21 by roughly 100 BC.[174] The eastern end of the southern boundary wall was also reworked at this time in order to integrate the new wall into the opus africanum of wall W06.081.

Wall W06.080/W06.078 was constructed from *opus incertum*, predominantly using irregularly-shaped Sarno stone and cruma rubble. The only traces of ancient mortar discernable were between the three large Sarno stone quoins that define the northern end of the original wall, and which help to bond them together. This pinkish grey (5 YR 6/2) mortar had fine angular volcanic inclusions with ceramic and larger pieces of crushed cruma. This mortar was also most

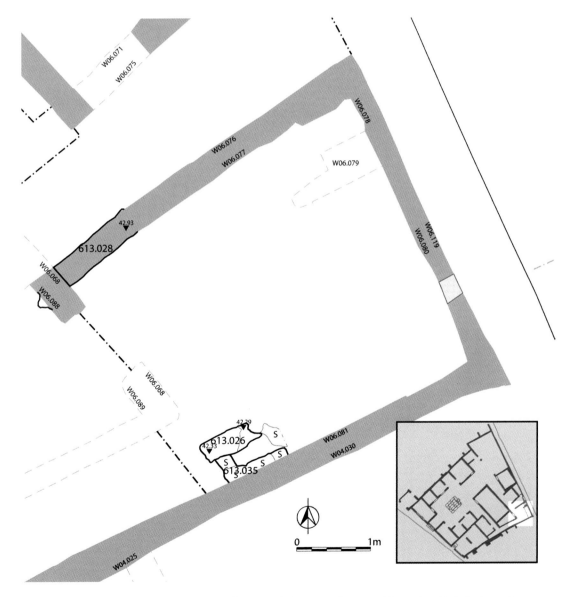

Figure 5.16.3. Plan of deposits and features of Phase 4 in Room 13 (illustration M. A. Anderson).

likely used to bond together the *opus incertum* portion of the wall, which was composed of black lava stone and used Sarno stone blocks as quoins; a building method that seems related to that employed for a range of property additions to area of the hortus to the north. Although it is difficult to be certain due to the scale of later pointing to the wall, it would appear that the window was a primary feature, there are certainly no obvious repairs that could be associated with a later addition.

16.4.2 Phase 4b. Narrowing the back door and the creation of Room 13

Although the window in wall W06.080/W06.078 may suggest some sort of earlier room in this area, it was not until some point after the creation of the eastern property boundary wall and its broad back door that changes were made to define formally the interior space of Rooms 13. Because these changes were complete by the time of widespread renovations in Phase 5, it is clear that they must belong to roughly the period

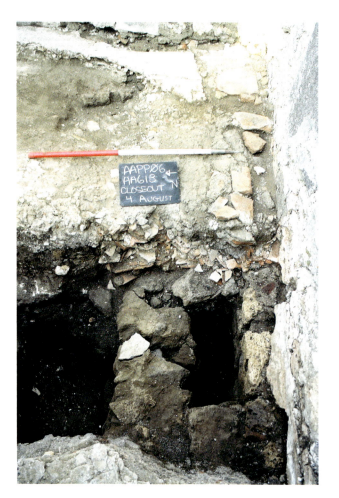

Figure 5.16.4. Remnants of an early rubblework construction on the southern side of Room 13 (image AAPP).

between c. 100 BC and the end of the first century BC. This second sub-phase witnessed the construction of an L-shaped wall running to the north of Room 13, which narrowed the back door on the eastern side of the room and created the northern and western walls of the space. Effectively, this formed both a rear 'fauces' for the Casa del Chirurgo and also served to define the area of Room 13.

The narrowing was undertaken using Sarno stone, cruma, and grey lava. Unfortunately, no bonding mortar can be seen on wall W06.080/W06.078 due to the extensive early modern and modern pointing. As part of the same building phase, wall W06.077 was also constructed in *opus incertum* using irregularly shaped pieces of primarily Sarno stone and cruma (Figs. 5.16.3 and 5.16.4). This wall (**613.028**) continued to the west before turning to form a small return at what would become the north-east corner of Room 11. Unusually, the *incertum* is bonded together with two different mortars mixed throughout the build that most likely results from two batches of mortar being used simultaneously. There is no evidence to suggest a primary and secondary construction or that one mortar was used to build and the other to patch or repair. Both mortars appear to have been mixed together so that certain areas of the wall are characterised more by one than the other. The majority of the mortar is a light bluish grey (Gley 2 7/1) with angular black volcanic inclusions and crushed black cruma. The other mortar is a pink (5 YR 7/3) colour with black angular volcanic inclusions and crushed red cruma. The difference in colour is most likely due to the use of black and red cruma in the different batches of mortar. Excess mortar was used to smear around the edges of the *incertum* with the aim of creating a reasonably flat surface ready to receive wall plaster.

16.4.3 Southern east-west wall

A further component of these alterations was seen in the excavations in the form of a small segment of rubblework (**613.035**), largely in Sarno stone, situated against the course of the final southern boundary wall (Figs. 5.16.3 and 5.16.4). Possibly contemporary with this action was a fragment of a wall running east–west (**613.026**) found roughly 65 cm to the north of the final phase southern boundary wall in Room 13. The wall was built of volcanic stones and packed earth, and was found to have collapsed towards its eastern extent, presumably the result of the undermining and subsidence of a cistern in this area at a later date. Cut directly into dark natural soils, and without a surviving builder's trench, it has proved to be very

difficult to sequence. Since it underlies the earliest *opus signinum* in Room 13, but appears to play no role in the original layout of the Casa del Chirurgo, it must have been constructed at some point during Phase 4, and is probably best sequenced as a component of Phase 4b. From the remains preserved, it is not possible to know whether this wall was structural or was for some now largely-destroyed feature. It is possible that it represents a corner that responds to the 'L' shaped wall on the northern side of this space that was also added in this phase, but the alignment is not perfect, and it actually serves to create a small niche at this point more than the return of a wall.

16.5 Phase 5. Redecoration and redevelopment (late first century BC to early first century AD)

The late first century BC saw widespread changes throughout the Casa del Chirurgo, which included the redevelopment of the western side of the service wing and involved the extension of Room 10 and the creation of Rooms 11, Corridor 12, and Rooms 22 and 23. These changes also resulted in the creation of the room in which the kitchen was located.

16.5.1 Preparations for construction

In preparation for these changes, a series of cuts penetrated the early levelling layers and likely carried

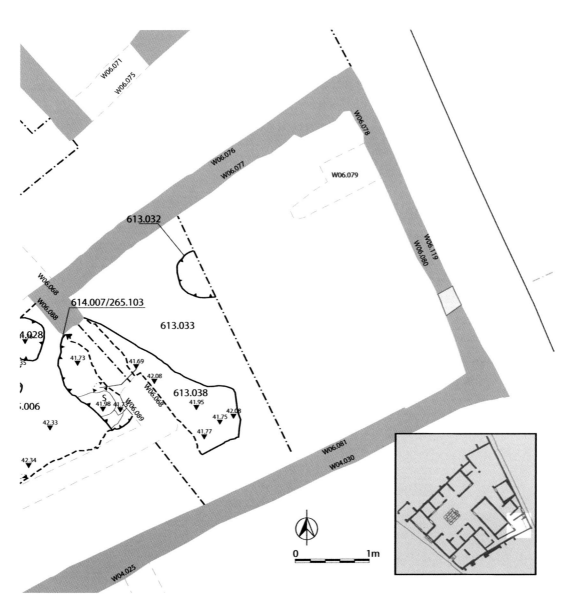

Figure 5.16.5. Plan of deposits and features related to the beginning of changes in Phase 5 in Room 13 (illustration M. A. Anderson).

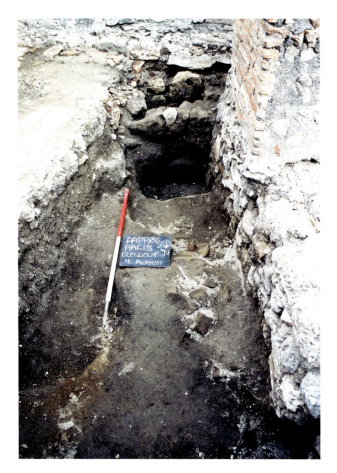

Figure 5.16.6. Cuts related to the beginning of changes, including a large pit that continued into the area later occupied by Room 11 (image AAPP).

on into the natural soils below (Figs. 5.16.5 and 5.16.6). Most of these cuts (**613.032**) (fill 613.209) could not be excavated completely. One such cut (613.034) connected neatly with another cut within Room 11 (614.007/265.103), providing evidence that the wall and threshold that now separates them was not in place when the cut was made or its fill deposited. Other cuts, however, generally avoid the area of the walls constructed in this phase. While the precise purpose for these cuts remains opaque, it is possible to link them generally with construction activities – possibly the retrieval of natural soils or sands for mortar, plaster, or similar materials. Certainly, the soils that were removed do not seem to have been returned to these pits, which were instead filled with building rubble, debris, and detritus, including significant amounts of pottery (613.029, **613.038**, 265.102, 614.009, 614.008).

16.5.2 Structural changes associated with the creation of the kitchen
The kitchen was then created through the redefinition

of space in the south-eastern corner of the building plot of the Casa del Chirurgo. This involved the creation of a door in the northern wall (W06.077) to provide an access route from the new kitchen through to the hortus. During this phase of changes, the western side of Room 13 was also defined through the southward extension of Room 10 and the creation of Room 11.

16.5.3 Rebuilding the southern wall (W06.081)
Wall W06.081 was rebuilt as part of the changes associated with the construction of Corridor 12 and Room 11. This resulted in the removal of the former *opus africanum* wall and its replacement with one in *opus incertum* using predominantly cruma and Sarno stone with occasional pieces of brick/tile, *opus signinum* floor surface, and grey lava. The lower portion of the wall was constructed almost exclusively from larger blocks of Sarno stone, with cruma being used more commonly in the central and upper portions of the wall. The *opus incertum* was set with a white (5 YR 8/1) mortar with a coarse aggregate of angular volcanic minerals, occasional larger pieces of lime, and crushed ceramic and tuff. The same mortar was also used to bond the brick/tile work at the western end of the area designated as wall W06.081 and beyond into the area of wall W06.093, where it was used in a further patch of *opus incertum* that intersects with the original *opus africanum* wall. This was clearly a repair patch that bonded the old and new sections of the wall W06.081/W06.093 together. It should be noted that the brick/tile work in wall W06.081 was not built first in its entirety and then the *opus incertum* filled in around it. Instead, the mortar appears to flow between the *incertum* and brickwork suggesting that both parts of the wall were built at the same time.

16.5.4 The construction of the western wall of the kitchen
Importantly, the brick/tile work in wall W06.081/W06.093 was constructed to provide a strong point in the wall to support the lintel over the doorway into Corridor 12. The other end of the lintel would have been bedded into the brick/tile work on the opposite, northern side of the doorway into Corridor 12. This brick/tile was recorded as wall W06.089 in Room 11. A similar, but not identical, mortar was used to bond both areas, which were built as part of the same phase of construction. The doorway from the kitchen into Room 11 was not open in Phase 5 ,and excavation in this threshold, as part of AA613, revealed the continuation of this wall northwards where it joined the north-western arm of the L-shaped wall from Phase 4b (cf. 16.4.2 supra).

16.5.5 The cutting of the doorway in the northern wall W06.077

This phase must have also witnessed the opening of the northern doorway of the kitchen by punching a hole into the L-shaped wall from the previous phase in order to provide access to the rooms from the north and the hortus beyond. The cutting of the doorway would certainly have damaged wall W06.077. However, due to the extensive modern pointing of the wall, any repairs undertaken at this time can no longer be seen clearly.

16.5.6 The addition of the cooking platform

The cooking platform is a feature that has proven difficult to sequence securely as no edge could be excavated. Fortunately, traces of the initial *opus signinum* floor (**613.010**) of the kitchen abut the north-

east corner of the platform, indicating that it was in place at least by the time the floor was poured at the end of this phase. This implies that the creation of the formal kitchen for the Casa del Chirurgo may have been one of the intended outcomes of the structural changes of this period.

16.5.7 The first opus signinum *floor*

After the walls had been modified, the surface in Room 13 was raised via a series of levelling layers before the pouring of an *opus signinum* floor. These levelling layers, which were quite diverse in colour and texture, sat directly upon the lowest naturals and earliest soils and contained considerable amounts of pottery, building material, and domestic detritus (613.027, 613.030, 613.025, 613.024[175]). The upmost levelling

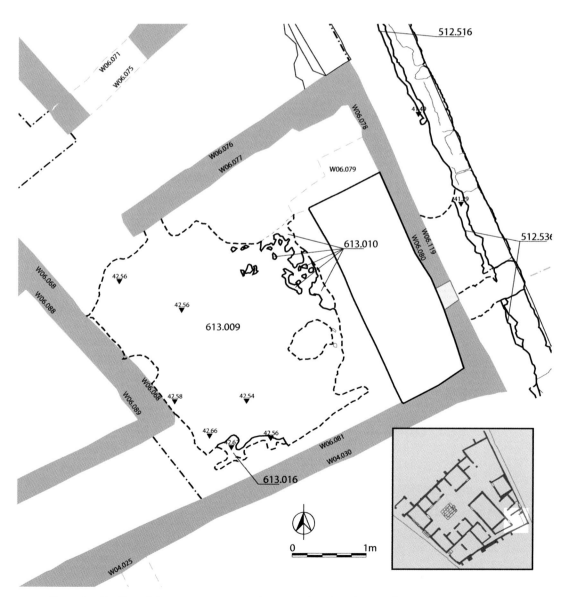

Figure 5.16.7. Plan of the *opus signinum* surface completed in Phase 5 (illustration M. A. Anderson.)

Figure 5.16.8. Traces of Phase 5 *opus signinum* and sub-floor (image AAPP).

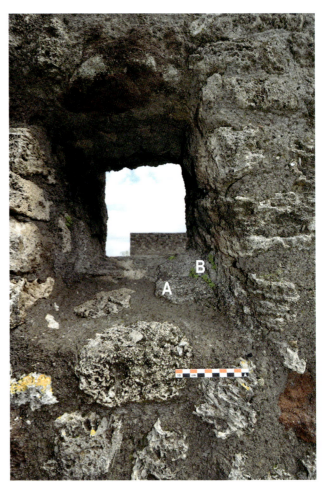

Figure 5.16.9. Original window in wall W06.080/W06.076. (A) Phase 4b plaster; (B) Phase 6 or 7 plaster (image D. J. Robinson).

layer comprised of wall plaster in a variety of different colours (**613.009**) that was probably intended as a sub-floor for the *opus signinum* (Fig. 5.16.7 and 5.16.8). This consistent deposit was recovered in sufficient areas to suggest that it once ran across most of the room. Clean plaster, used as final layer prior to *opus signinum*, is a technique that has been observed throughout Insula VI 1, and was presumably intended as a soft or compact, clean buffer to cushion the pouring of the top surface. Traces of the *opus signinum* of this early floor were recovered only against the north-east corner of the masonry cooking platform (**613.010**) and in a highly degraded and uneven form in the south-west corner of Room 13 (**613.016**).

The extremely degraded nature of the earlier *opus signinum* surface may indicate long-term use prior to its later replacement, or be a result of later cutting of the feature for the placement of a now collapsed cistern in the following phase. It is equivalent to the second level of *opus signinum* recovered to the north in Room 16 and it is likely that these floor surfaces would have linked up at this time. This would have provided a coherent floor surface from the kitchen through to the hortus via the doorways in walls W06.076/W06.077, W06.071/W06.075, and W06.067/W06.069.

16.5.8 Phase 5 plaster

There are suggestions of a plastering layer associated with this phase, which survives in limited areas pressed into the space between the rubble of the *opus incertum* on wall W06.081 and attached to the face of the Sarno stones in the lower section of the central part of the wall. This plaster is characterised by a white (Gley 1 8/N) matrix with fine dense inclusions of black volcanic minerals. The same plaster is also seen in the window of wall W06.080/W06.076 (Fig. 5.16.9, A).

16.6 Phase 6. Upper storeys and final decoration (c. mid-first century AD)

The mid-first century AD saw the final set of major changes in the area Room 13, most of which appear to have been caused by the addition of a range of upper storeys across the service wing of the property. In the kitchen itself, the earlier *opus signinum* surface from Phase 5 was largely removed, except where it was near to the cooking platform (Fig. 5.16.10). To the north of this, a cut was made for the placement of a toilet/refuse disposal chute, which connected to a cesspit that was located to the east under the pavement of the Vicolo di Narciso. At the same time, a large part of the centre of the room, including at least some of the southern side of the masonry platform, was cut out for the insertion of a cistern that has since collapsed (likely during the eruption). The dimensions of this feature area are imperfectly known as it was not possible to excavate it. Better understood is the long east–west drain that ran down the southern side of Corridor 12 to feed this

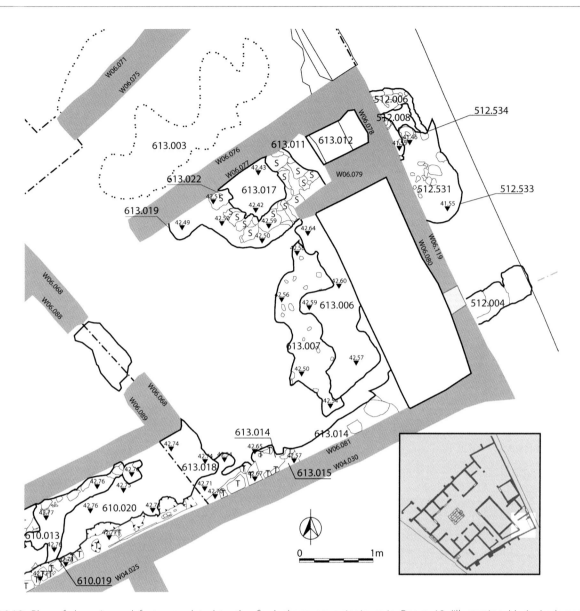

Figure 5.16.10. Plan of deposits and features related to the final phase *opus signinum* in Room 13 (illustration M. A. Anderson).

cistern. This tile-built drain was designed to carry water from a light well in Room 22 to the cistern, which was itself connected to an overflow drain that is visible on the Vicolo di Narciso. At this time, a new doorway into Room 11 was cut through the western wall of the kitchen, which was finished with a grey lava threshold stone. Finally, a new *opus signinum* surface was placed throughout the service wing, again following a final levelling/bedding layer of coloured wall plaster.

16.6.1 The cistern and the east–west drain from Room 22
The *opus signinum* surface from Phase 5 would have been largely removed from the kitchen in order to build a new underground cistern in roughly the south-east part of Room 13. This new cistern was fed by a long

east–west aligned drain (**613.014**) that was lined with tile and covered with a tile capping that rose above the level of its related *opus signinum* at its western end (Figs. 5.16.11 and 5.16.12). This feature was designed to channel water collected in the light well in Room 22 along the southern side of the east–west portion of Corridor 12 and into the cistern. The drain was set into packed earth (**613.015**), which was presumably used to help produce an even gradient within the cut. The angle at which the drain ran resulted in it running below the level of the final *opus signinum* floor (**613.018**) as it entered the cistern. Precisely how this water was accessed is unknown however, as the cistern has collapsed and this area was not excavated due to concerns over causing damage to the cooking platform.

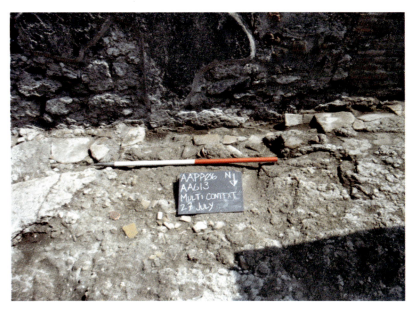

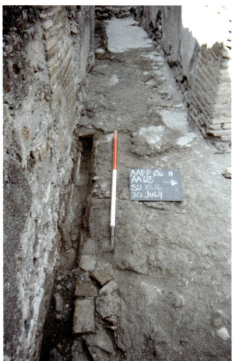

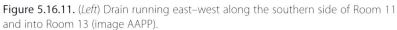

Figure 5.16.11. (*Left*) Drain running east–west along the southern side of Room 11 and into Room 13 (image AAPP).

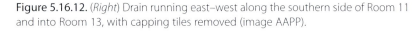

Figure 5.16.12. (*Right*) Drain running east–west along the southern side of Room 11 and into Room 13, with capping tiles removed (image AAPP).

An early image by Piranesi of this kitchen suggests that the platform may have had an open arch beneath it, perhaps to provide access to the cistern.

16.6.2 North-eastern toilet/waste disposal chute

The area between the north of the masonry cooking platform and wall W06.077 was redeveloped during this phase with what appear to have been the fittings of a toilet, now surviving as a largely modern reconstruction. This is curious, as in this phase, a toilet was also added to Room 15, together with a further toilet in the upper storey room above it. Unfortunately, we are unable to tell whether the kitchen feature was initially constructed and then replaced by the larger facilities in Room 15, or whether they operated in tandem. Given the relatively small size of the feature in the kitchen, it is possible that it functioned more for kitchen waste disposal than as a toilet (Fig. 5.16.13).

The small area under the toilet and immediately to the west produced evidence of a large cut and tile lined chute. The tile surface (**613.012**) sloped towards the east to drain into a cesspit situated outside of the house on the Vicolo di Narciso. The eastern end of the chute was obscured by modern material and was not excavated (613.013). Under the tile surface there was a thin plaster filled deposit (**613.011**), which is likely to be the same as the plaster levelling layer found under the *opus signinum* surface (613.006, 613.003) from Phase 6 (cf. infra). To the west, a roughly square alignment

of lava stones (**613.022**) (c. 22 × 22 cm) was arranged around an open space. Presumably this was intended as the access point for the chute or is a remnant of its construction. Between the stones, there was a black (10 YR 3/3) sandy deposit (**613.017**), evidence that the cut (**613.019**) for chute had penetrated into the 'black sand' and 'pocked earth' deposits below. Excavations in the pavement of the Vicolo di Narciso produced evidence of the continuation of the drain and the cesspit into which it led, directly to the east of this feature.

16.6.3 Construction of the lararium

A shelf-like feature, made from a flat terracotta roof tile (*tegula*) was inserted into the central area of wall W06.081 (Fig. 5.16.14, A). The insertion of the *tegula* into the wall would have involved the cutting of a hole in the wall in order to place the tile. The hole was filled with a form of *opus incertum* utilising small broken pieces of tile set within a white (7.5 YR 8/1) mortar containing fine angular black volcanic minerals and crushed ceramic, as well as larger pieces of crushed black volcanic rock. An illustration by Piranesi reveals that on wall W06.081, probably directly above and below this tile shelf, there was an elaborately painted *lararium* scene.[176] His etching of the scene shows an officiant, accompanied by one small attendant, and flanked by Lares, Penates or further attendants, pouring a libation at an altar. Below this, two coiled snakes flank and approach a pine cone on an altar, positioned on the wall directly below

Figure 5.16.13. Traces of the toilet or drain chute situated to the north of the cooking platform in Room 13 (image AAPP).

the tile shelf. It is consequently probable that the shelf formed part of this *lararium*, although nothing of the painting remains on the surviving wall plaster today (Fig. 5.16.14, B).

16.6.4 The opening up of Room 11 to the kitchen
The orientation of Room 11 was changed during the middle of the first century AD so that it was accessed from the kitchen. The doorway at the western end of the room was blocked up and a new doorway was cut at the southern end of wall W06.068. This necessitated breaking through the brick/tile quoin, which is observable in its northern face where its concrete core is visible and there is evidence for cut bricks. The lower part of the original eastern *opus incertum* wall was used as a footing for a lava stone threshold. Unfortunately, there was no evidence in the subsurface archaeology for this change.

16.6.5 Phase 6 opus signinum *floor*
After these features had been built the area was covered, along with the rest of the service wing, with a uniform layer of *opus signinum* (Fig. 5.16.15). In Room 13, the *opus signinum* survived as a broken and damaged surface

(**613.006** = **613.003**). The degradation of the surface is consistent with damage caused by the collapse of the cistern and exposure since the primary excavation of the property. The *opus signinum* was once again poured directly over a sub-floor containing many fragments of painted plaster (**613.007**), a fact that connects this floor with the final *opus signinum* of other nearby areas. In Room 13, these plasters were in most cases placed directly on top of the previous *opus signinum* surface without significant intervening levelling deposits.

16.6.6 The final redecoration of Room 13
The alterations to the kitchen with the creation of the doorway to Room 11 and the insertion of the shelf for the *lararium*, would have required a new phase of plastering throughout Room 13. Consequently, wall W06.081 was plastered using a white (7.5 YR 8/1) matrix of what appears to be coarse grit containing black volcanic minerals, grey and brown tuff, and ceramic. This plaster was also used extensively around the terracotta shelf and to create a flat back for it. It was most likely a backing plaster, although nothing of the final decorative layer survives on wall W06.081 (Fig. 5.16.14, B). The backing plaster can also be seen on walls W06.077 and also on W06.080/76, where it overlies the earlier plaster from Phase 5 (Fig. 5.16.14, B).

16.7 *Phase 7. Post-earthquake changes*
No deposits from this phase were recovered in this area.

16.8 *Phase 8. Eruption and early modern interventions*
Room 13 underwent a period of restoration in the early modern period. On wall W06.081 a thick layer of render was applied to large areas of the central sector of wall W06.081. This was composed of a light bluish grey (Gley 2 8/1) mortar that is weathering in places to white (10 YR 8/1) containing fine angular black volcanic minerals and larger pieces of lime and volcanic rock, including grey lava, cruma, and tuff or lapilli. A coarser version of this render was also applied to the eastern area of the wall and around a patch of surviving wall plaster. A slightly finer version of the same mortar was used as a render in the central area of the wall. At the western end of wall W06.081, the area above the surviving height of the brick/tile pilaster was rebuilt (Fig. 5.16.16, A). This was bedded on a thick layer of the coarse render (Fig. 5.16.16, B). At the same time, much of the upper metre of the wall also appears to have been rebuilt in *opus incertum* using essentially the same building materials as the original wall – Sarno and cruma (Fig. 5.16.16, C). Unfortunately, widespread modern pointing

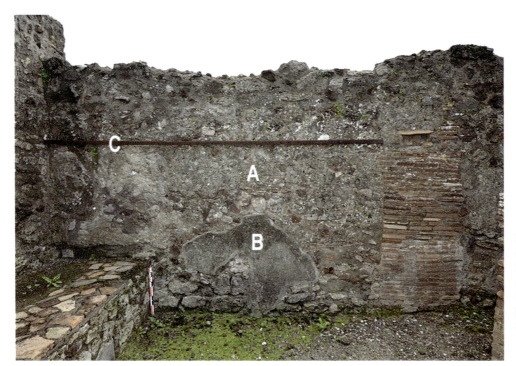

Figure 5.16.14. Wall W06.081 and the remnants of a *tegula* inserted into wall W06.081 to create a 'shelf' for the *lararium*. (A) *lararium* shelf; (B) Phase 6 plaster; (C) modern iron bar (image D. J. Robinson).

Figure 5.16.15. Final phase *opus signinum* and sub-floor consisting of fragments of painted plaster (image AAPP).

of the upper portion of the wall makes it impossible to ascertain the exact composition of the mortar. It is likely, however, that a variation of the rendering mortar was used as the bonding agent of the rebuild.

It is probable that the upper portions of walls W06.077 and W06.080/W06.076 were also rebuilt, although the extent of early modern and modern pointing makes it difficult to be certain about the true extent of this. The same light bluish grey (Gley 2 8/1) mortar that was used on wall W06.081 to bond together the *opus incertum* reconstruction is observable on the upper portion of wall W06.080/W06.076.

16.9 Phase 9. Modern interventions

Wall W06.077 was pointed at this time with a light greenish grey (Gley 1 7/7) mortar containing a coarse grit of cruma, lime, black volcanic minerals, and tuff or lapilli. This mortar was used at both the western and eastern ends of a large iron supporting bar, which must have been attached to the wall shortly before the tuff-rich mortar was applied to the wall. At the western end of the wall, above the iron bar, this mortar was flattened at the surface and used as a render. A similar iron band was also placed across the length of wall W06.081. This was fixed at its eastern end into wall W06.080/W06.076, with its western end embedded into the early modern reconstruction of the brick/tile pilaster. The purpose of these iron bands was clearly to stabilise the walls.

All of the deposits are the result of natural build up after the initial excavations and the results of bioturbation (613.004, 613.008, 613.013). Within the drain, this build-up was excavated separately (613.020). A final deposit of blue-grey gravel (613.001) follows the pattern for all areas and is the policy of the SAP for the protection of the underlying archaeology and the reducing of dust on site.

16.9.1 Plaster conservation

The exposed edges of the surviving expanse of wall plaster in the lower central portion of wall W06.081 were covered with a protective layer of mortar to prevent further damage from water penetration. This

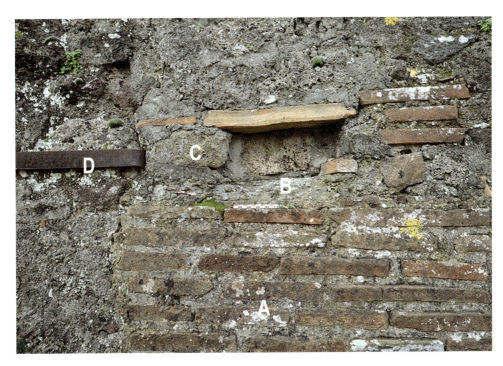

Figure 5.16.16. Detail of the upper portion of the brick/tile column in wall W06.081 showing the early modern rebuilding on top of the ancient fabric. (A) ancient brick/tile column; (B) coarse early modern mortar bedding layer; (C) early modern rebuild; (D) modern pointing (image D. J. Robinson)

was undertaken with a light greenish grey (Gley 1 8/1) mortar containing angular black volcanic minerals.

16.9.2 Structural conservation

The most substantial piece of structural conservation in the modern period is the rebuilding of the masonry cooking platform. This would probably have been necessary after the collapse of the cistern area. Piranesi's image of the kitchen,[177] suggests that the collapse and damage to the platform might have occurred in more recent times. Of course, his illustration may equally be a fanciful reconstruction. This collapse would have required substantial repairs and certainly some of the build-up seems specifically related to the modern repair and rebuild of this feature (613.002). This is also true for a layer of mortar running along the platform (613.005) that is probably a modern deposit associated with the re-pointing of the feature (Fig. 5.16.17). Finally, all of the walls in Room 13 were extensively pointed during a major phase of architectural conservation

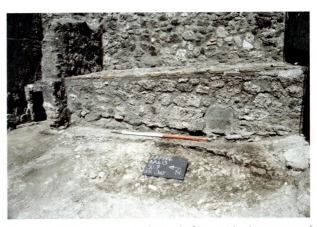

Figure 5.16.17. Masonry cooking platform with clear traces of modern mortar at the bottom and re-facing on top (image AAPP).

and restoration in the early 2000's. This used a coarse mortar that varies in colour between light bluish grey (Gley 2 7/1) and bluish grey (Gley 2 5/1), containing an aggregate of volcanic minerals, tuff, and ceramic.

17. Room 14
Posticum (not excavated)

Description

Room 14 is located at the rear doorway of the Casa del Chirurgo, where it acted as an exit for the service wing (Fig. 5.17.1). The space measures roughly 3.77 by 1.64 m. A small service space appears to have been constructed as a component of the the main Sarno stone core of the property in c. 200–130 BC. This space, which later became Rooms 15, 17, and 18, was accessed via a doorway in wall W06.075 of Room 14. The eastern end of these rooms was changed significantly with the construction of the eastern property boundary wall (W06.118–W06.119) c. 100 BC. This was pierced by a wide doorway framed with large blocks of Sarno stone, which led into this area. Room 14 finally took shape at the end of the first century AD with the narrowing of the back door to the Casa del Chirurgo and the construction of the southern wall of the corridor (W06.076). The re-

organisation of the rooms to the north of wall W06.075, which created rooms 15 and 17/18 necessitated the blocking of the Sarno stone framed doorway that formerly led into Room 15/17 and the creation of a new doorway into Room 15. The relatively well-preserved *opus signinum* floor surface that was laid during the redevelopment of Room 14 in the mid-first century AD precluded any subsurface investigation of this room. Consequently, the interpretation of the development of Room 14 is derived from the study of its walls and decoration alone.

17.1 Phase 1. Natural soils

No evidence of this period was recovered in this area.

17.2 Phase 2. Volcanic deposits and early constructions

No evidence of this period was recovered in this area.

17.3 Phase 3. The Casa del Chirurgo (c. 200–130 BC)

The area that later became Room 14 was constructed during the initial phase of development of the Casa del Chirurgo. This was likely a small service area.

17.3.1 The construction of wall W06.075

The northern wall of Room 14, W06.075, was built in *opus africanum* with Sarno stone being used for both the framework and rubblework. This wall combined with a now missing western wall served to define the areas of later Rooms 15 and 17 as a small room. Due to the extent of the alterations and rebuilding to this wall, it was not possible to see how the wall was bonded. From excavations at the base of the reverse of W06.075 in Room 17 (Fig. 5.17.2), it is clear that the room was entered via a doorway in this wall, which is no longer visible in the standing architecture. No decorative wall plaster can be confidently assigned to this phase.

17.4 Phase 4. Changes in the Casa del Chirurgo (c. 100–50 BC)

Around 100 BC, the area of the hortus to the north underwent a significant programme of development that saw both the creation of a formal garden space and also Rooms 19 and 21 around it. This phase of development was preceded by the construction of the eastern boundary wall of the property (W06.118–119), with its wide doorway framed in large blocks of Sarno stone that provided access from the Vicolo di Narciso into the house and particularly the area that became Room 14.

Figure 5.17.1. Room 14 (image D. J. Robinson).

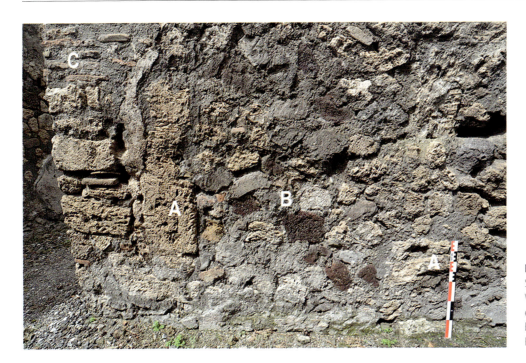

Figure **5.17.2.** The blocked Sarno framed doorway in wall W06.075. (A) Sarno framing elements; (B) doorway fill; (C) brick/tile repairs (image D. J. Robinson).

17.4.1 Reconstruction of wall W06.075

It would appear that the construction of the eastern property boundary wall resulted in the need to reconstruct wall W06.075. This work included both the filling in of the original doorway into the service space and the creation of a new doorway into Room 15/17. This was made by reusing the Sarno stone framework of the *opus africanum* to form the framework for the door (Fig. 5.17.2, A). The framing-blocks on the western side of the doorway were bonded with a pale red (10 R 7/2) mortar containing inclusions of angular black volcanic minerals and crushed cruma as well as larger pieces of lime and cruma. The remainder of the wall was heavily reconstructed in *opus incertum* using Sarno stone, grey lava, and cruma, that was probably also bonded with the pale red mortar, although the extent of the modern pointing makes it difficult to tell. The *opus incertum* was also used to fill the doorway of Phase 3, and most probably extended the wall eastwards as far as the new property boundary wall.

17.4.2 Changes to the posticum

At a point shortly after this, and prior to Phase 5, the southern wall of Room 14 was created by narrowing the wide Sarno stone framed doorway to the Vicolo di Narciso through the construction of wall W06.076. These changes effectively created the rear entrance corridor for the Casa del Chirurgo. The new room was part of a service space, that was added to the property at this time, which can be seen in the simple and utilitarian *opus signinum*-like plasters used to decorate its walls.

17.4.3 The construction of wall W06.076

The wide rear entrance to the Casa del Chirurgo was narrowed and at the same time wall W06.076 was built in *opus incertum* to create the southern side of the corridor. The *opus incertum* primarily used Sarno stone with lesser quantities of cruma, grey lava, tuff, and the occasional piece of white limestone set within a mortar that varied in colour due to the proportion of cruma used in the mix from light bluish grey (Gley 2 7/1) to pink (5 YR 7/3). Both of these mixes contained an identical suite of inclusions: black angular volcanic minerals and lime, as well as red or black cruma. This mortar was smoothed around the rubble of the *opus incertum* in order to create a flat wall surface (Fig. 5.17.3).

Figure **5.17.3.** The light bluish grey and pink mortars used in the initial build of Wall W06.076 (image D. J. Robinson).

17.4.4 The Phase 5 decoration

The first phase of plaster observable in Room 14 is preserved at the eastern end of wall W06.076 by the laying of a later *opus signinum* floor surface against it. The plaster was composed of a layer, up to 20 mm thick, of light grey (Gley 1 7/N) mortar containing small fragments of black volcanic minerals, lime, and ceramic. On wall W06.075, there are also faint traces of this backing plaster on the lower portion of the western Sarno frame of the doorway. On wall W06.076, a thin layer of pinkish white (10 R 8/2) *opus signinum*-like plaster containing crushed ceramic and the occasional black volcanic mineral was applied over the backing plaster to create a final utilitarian wall covering.

17.5 Phase 5. Redecoration and redevelopment (late first century BC to early first century AD)

This phase saw the breaking through of the wall between Rooms 13 and 14 in order to provide direct access between the kitchen, the hortus, and the posticum for the first time. This was undertaken alongside the extension of Room 10 and other significant changes throughout the property.

17.6 Phase 6. Upper storeys and final decoration (c. mid-first century AD)

The mid-first century AD saw considerable changes occurring to the rooms directly to the north of Room 14, which were associated with the splitting of the large Room 15/17 into two rooms and the combination of Rooms 18 and 17 into a single space. This resulted in a major reconfiguration of wall W06.075, which was

altered to provide entrances into these new rooms from Room 14. These developments were all part of a change to this area of the service wing that saw the construction of a latrine in Room 15 and also the addition of an upper storey over the area that was accessed from the staircase at the southern end of Room 16.

17.6.1 Reconfiguration of wall W06.075

The Sarno stone framed doorway into Room 15/17 was blocked with *opus incertum*, containing a mixture of Sarno stone, cruma, brown tuff, grey lava, and tiles (Fig. 5.17.2, B). It is difficult to gauge how they were mortared together due to the extent of early modern and modern pointing. At the same time, a new doorway was cut at the eastern end of wall W06.075 to provide access to Room 15 and 18, and the doorway at the western end of the wall was repaired with courses of brick/tile (Fig. 5.17.2, C) bonded with a white (7.5 YR 8/1) mortar containing an aggregate of angular volcanic mineral fragments and crushed dark cruma. The new doorway into Room 15 was also edged with Sarno stone blocks and smaller pieces of Sarno rubble, which was also set within the same white (7.5 YR 8/1) mortar as the western repair.

17.6.2 The Phase 6 wall decoration

As part of this phase of rebuilding in Room 14, a new *opus signinum* floor surface was laid, which was poured directly against the wall plaster from Phase 5 (Fig. 5.17.4). This preserved both the backing and final plaster of the previous phase and indicates that

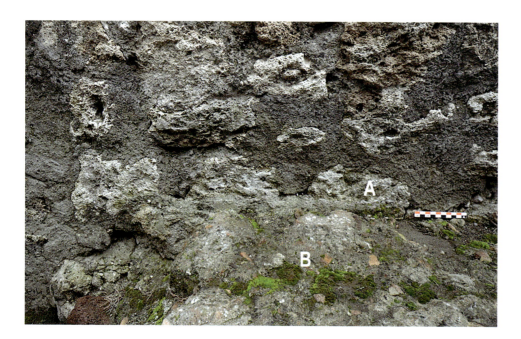

Figure **5.17.4.** The eastern end of wall W06.076 and the preserved area of the phase 5 plaster. (A) phase 5 plaster; (B) *opus signinum* floor (image D. J. Robinson).

the floor was poured prior to the redecoration of the walls. Following the laying of the floor, the previous final decorative surface was removed from its backing plaster on the upper portions of the wall. There are some indications in the lamination of the backing plaster at the western end of wall W06.076 to suggest that this was largely reused. There is evidence for two new layers of plaster being applied to both walls W06.075 and W06.076. Initially a new layer of light bluish grey (Gley 2 7/1) backing plaster with inclusions of coarse grit containing rounded volcanic stones, lime and ceramic was applied, over which was a thin layer of pink (10 R 7/3) *opus signinum*-like plaster containing crushed ceramic and the occasional angular volcanic mineral fragment, which was used as a final plaster surface for the walls.

17.7 Phase 7. Post-earthquake changes

No evidence of this period was recovered in this area.

17.8 Phase 8. Eruption and early modern interventions

17.8.1 Wall reconstruction

At the top of wall W06.076, there is a horizontally laid tile, above which there is a single layer of large Sarno stone blocks. It is possible that this represents the levelling up of the wall, which was most likely undertaken in order to prepare the house for public display in the early modern period. However, due to the modern pointing, it is impossible to tell whether the Sarno blocks were bonded with an early modern mortar. A light greenish grey (Gley 1 7/7) mortar containing a coarse grit of cruma, lime, black volcanic minerals, and tuff or lapilli, was used as a render over much of the central and upper areas of wall W06.076 and also on wall W06.075.

17.9 Phase 9. Modern interventions

17.9.1 1970's restoration campaign

An iron grill was used to close up the space formerly taken by the narrow rear door to the Casa del Chirurgo. At its southern end, the grill was fixed into wall W06.076 using a very hard light bluish grey (Gley 2 8/1) mortar containing a coarse aggregate of black volcanic stone, cruma, and tuff. The edges of the surviving areas of wall plaster on wall W06.076 were covered with a protective layer of light greenish grey (Gley 1 8/1) mortar containing angular volcanic minerals.

17.9.2 2000's restoration campaign

The walls of the rear fauces were extensively pointed with a coarse mortar that varies in colour, between a light bluish grey (Gley 2 7/1) and a bluish grey (Gley 2 5/1), dependent upon its position in the wall and degree of weathering. It contains an aggregate of volcanic minerals, ceramic, tuff, and lime.

18. Room 15
Latrine (AA264)

Description

Room 15 is located adjacent to the rear doorway of the Casa del Chirurgo (Fig. 5.18.1). It is a roughly trapezoidal space that measures between 1.49 and 0.78 m wide by 2.91 m long. The room was constructed to function as the latrine for the property during the middle of the first century AD.

Limited excavations were carried out during a single season in 2003 under the designation AA264 during which time its walls were also initially analysed.[178] The final phase use of this space as a toilet was confirmed by these excavations, but due to the underlying void of the cesspit that was recovered and the generally high level of preservation of the flooring found in the southern part of the room, only preliminary excavations were

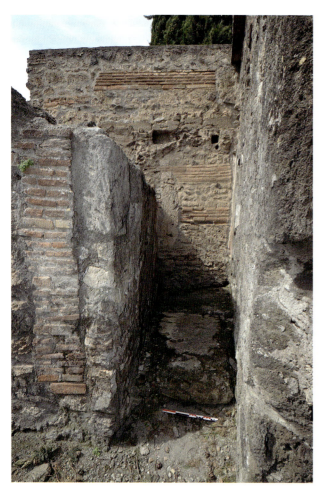

Figure 5.18.1. Room 15 (image D. J. Robinson).

possible. The earlier use of these spaces therefore remains opaque.

18.1 Phase 1. Natural soils
No evidence of this period was recovered in this area.

18.2 Phase 2. Volcanic deposits and Early constructions
No evidence of this period was recovered in this area.

18.3 Phase 3. The Casa del Chirurgo (c. 200–130 BC)
While the original core of the Casa del Chirurgo is clear, it would appear that there was also another part of the property located in the area of the service wing. The remains of this room are most clearly seen in wall W06.069/W06.072 and were revealed though excavation in the foundations of wall W06.071 in Room 17. In Room 15, wall W06.072 was built in *opus africanum* using Sarno stone blocks for the framework of the wall and also for the sub-rectangular stones of its rubblework. It is difficult to discern how this was bonded as later rebuilding and pointing has rendered any surviving original bonding material invisible. Nevertheless, wall W06.072 is a continuation of wall W06.069, which was bonded with a yellow (2.5 Y 7/6) clay-like mortar containing occasional rounded black volcanic mineral fragments and smaller flecks of lime.

18.4 Phase 4. Changes in the Casa del Chirurgo (c. 100–50 BC)
18.4.1 The addition of the eastern property boundary wall
The first phase of redevelopment in the Casa del Chirurgo involved the construction or reconstruction of an eastern plot boundary wall and wide Sarno framed rear entrance for the property. The eastern wall of Room 15, wall W06.074, is part of this plot boundary wall and terminates in large Sarno stone blocks that form the northern frame of the rear entrance to the Casa del Chirurgo. The wall was built in *opus incertum* using predominantly Sarno stone and grey lava with the occasional piece of cruma and grey tuff, bonded together with a friable white (Gley 1 8/N) mortar containing angular black volcanic mineral fragments. The wall contains two levels of windows. There are no signs of repair to the wall surrounding the lower two windows, suggesting that these were built as part of the original wall, with the upper window being a later addition, possibly in Phase 5.

18.4.2 The Phase 4 wall plaster
There are traces of an initial layer of plaster preserved

behind the butt joint at the intersection between walls W06.072 and W06.073. Consequently, it is clear that in its first phase wall W06.072 formed part of the northern wall (W06.069/W06.072) of a larger room comprising the area that later became Rooms 15 and 17. The preserved plaster is a backing plaster, which consists of a 10 mm thick layer of white (Gley 1 8/N) plaster with small rounded black volcanic mineral inclusions with occasional larger pieces of lime and tuff. Remnants of the same plaster are also found across wall W06.074. Together the evidence from the plaster indicates that it postdates the construction of the eastern property boundary wall (W06.074) in c. 100 BC and predates the construction of wall W06.073 in the mid-first century AD.

18.5 Phase 5. Redecoration and redevelopment (late first century BC to early first century AD)

The only change in this period is the possible addition of a high window to wall W06.074.

18.6 Phase 6. Upper storeys and final decoration (c. mid-first century AD)

The middle years of the first century AD saw considerable changes to the north-eastern area of the service wing, which was caused by the addition of an upper storey over this part of the property. This was accessed by a staircase at the southern end of Room 16, set against wall W06.066. Room 15 was created as part of these changes and underwent two distinct sub-phases

of activity associated with the creation of a latrine and the slightly later insertion of its chute in *opus signinum*.

18.6.1 The strengthening of the northern wall of Room 15 (W06.072)

The construction of the second storey above the north eastern end of the service wing appears to have necessitated the strengthening of the early northern *opus africanum* wall (W06.072) to bear the additional loads. Most of the *opus africanum* rubblework on the eastern side of the wall was removed and was rebuilt with a combination of courses of brick/tile separated by areas of *opus incertum* using Sarno stone, grey lava, brown tuff, and some pieces of building rubble (Fig. 5.18.2, A). Both the tiles and the *incertum* were set within a pink (7.5 YR 7/4) mortar containing angular black volcanic mineral inclusions as well as larger pieces of tuff, black cruma, and lime with occasional pieces of ceramic (Fig. 5.18.2, B). A similar mortar was used in the reconstruction of the walls of Room 19 during this phase. Two beam holes, measuring 15 by 15 cm (Fig. 5.18.2, C), for the north–south orientated beams, are observable below the bulge in the mortar that represents the location of the ceiling of the room (Fig. 5.18.2, D). Beneath both the floor and the beams is a semi-circular bulge in the mortar that must be the remnants of the hanging vaulted roof that would have covered at least the northern end of Room 15 (Fig. 5.18.2, E). Associated with this is a circular beam hole, c. 10 cm in diameter, in the vault bulge.

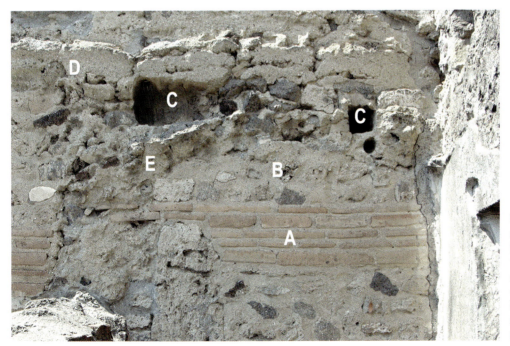

Figure 5.18.2. The rebuilding of wall W06.072 and evidence for the vault over Room 15. (A) tile course; (B) *opus incertum* course; (C) north-south beam holes; (D) mortar bulge indicating second floor; (E) semi-circular vaulted roof (image D. J. Robinson).

18.6.2 The subdivision of Room 15/17 by the addition of wall W06.073

The former single large Room 15/17 was subdivided into two smaller Rooms 15 and 17, through the addition of wall W06.073, at the same time as the completion of the rebuilding of wall W06.072. It was built from *opus incertum* using grey lava with black inclusions at the base of the wall and cruma towards the top. The transition between the two types of stone is difficult to discern, due to the excessive use of mortar in the original construction of the wall to point around the *incertum*, with the aim of creating a relatively flat surface for the reception of backing plaster (Fig. 5.18.4, A). This mortar is a white (7.5 YR 8/1) colour containing an aggregate of angular volcanic minerals, dark cruma, and the occasional piece of lime. The southern end of the wall was framed with squared Sarno stone blocks, which helped to create a doorway into the newly created Room 15. The creation of this doorway would have necessitated the removal of the eastern end of wall W06.075 and would have needed the Sarno stone blocks to repair and 'square-up' the opening into Room 15.

The four beam holes in wall W06.074 (Fig. 5.18.3, A and B) were seemingly cut into the wall during this phase. The southernmost beam hole was built into a window in W06.074, that must have been added at an earlier time. Although it is difficult to see in wall W06.074, on its reverse side, wall W06.118, it is clear that the upper window was a later addition to the wall. This involved repairing the wall using a mixture of *opus*

incertum and brick/tile. Unfortunately, due to the extent of early modern and modern repairs and rendering, it was impossible to document the mortar used and difficult to sequence its construction. Nevertheless, the addition of the upper storey and reuse of a window as a beam hole would seem to provide the context for for changes related to the installation of an upstairs toilet.

18.6.3 Phase 6A decoration

The new room required decoration. A layer of backing plaster, approximately 20 mm thick was applied to all of the walls. This was composed of a light bluish grey (Gley 2 8/1) mortar containing fine angular volcanic mineral fragments. This backing plaster was overlain by a thin layer of final plaster with two distinct compositions: a lower white (10 R 8/1) plaster containing small angular fragments of black volcanic mineral and crushed dark red (10 R 3/6) fragments of cruma (Fig. 5.18.4, B); and an upper white (10 R 8/1) plaster with occasional volcanic mineral fragments and pieces of white limestone (Fig. 5.18.4, C). There is a sharp dividing line between the two final plasters on wall W06.074, at 1.18 m above present ground level, with evidence to suggest that the lower plaster was applied shortly after the upper. The lower plaster also retains traces of a red (10 R 5/8) fresco. It would appear that the upper portion of the wall was left white.

18.6.4 The addition of the opus signinum *chute*

A sloping concrete chute was inserted into Room

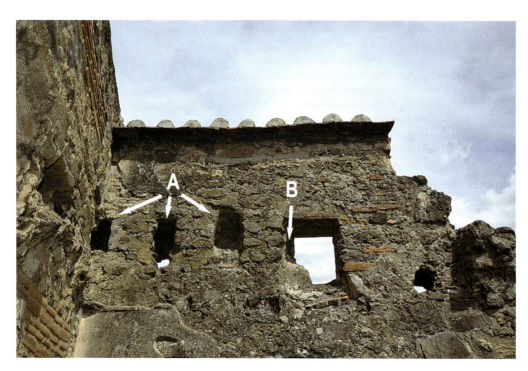

Figure 5.18.3. The upper portion of wall W06.074. (A) beam holes; (B) beam hole inserted into former window (image D. J. Robinson).

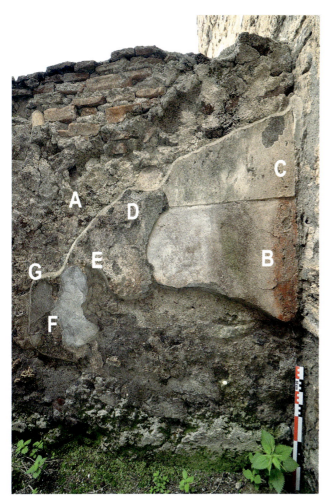

Figure 5.18.4. (*Left*) Plaster from Phases 6a and 6b on wall W06.074. (A) flattened mortar of original construction; (B) plaster phase 6a lower red final surface; (C) plaster phase 6a upper white final surface; (D) phase 6b backing plaster; (E) phase 6b *opus signinum*-like final surface; (F) modern plaster repair; (G) modern edging of plaster (image D. J. Robinson).

the Phase 6A backing plaster. This would suggest that the majority of the final plaster surface was stripped from the lower portion of the wall prior to the insertion of the concrete chute. The top surface of this *opus signinum* chute was covered with a layer of white mortar (**264.006, 264.008**).

18.6.5 Phase 6B decoration
As the previous final layer of wall plaster was practically new, it appears to have been largely retained throughout the room. There is only a very small area of the Phase 6B plaster on wall W06.073, low down at the southern end of the wall where the previous Phase 6A final layer was removed for the insertion of the chute. The Phase 6B plaster was composed of a 10 mm thick light bluish grey (Gley 2 7/1) backing plaster with rounded volcanic sand-like inclusions and lime (Fig. 5.18.4, D), overlain with a 2 mm thick layer of pink (2.5 YR 8/3) *opus signinum*-like plaster containing crushed ceramic and angular black volcanic mineral inclusions (Fig. 5.18.4, E). There is no evidence for this plaster phase on wall W06.072, which appears to have been left with the previous decorative surface in place.

18.7 Phase 7. Post-earthquake changes
Phase 7 saw the filling in of the toilet chute and cesspit (**264.009, 264.002**), which included a brown (2.5 Y 3/3) silty deposit in north-west of Room 15 that seems to represent the last layer of build-up over the cesspit area underneath. Although excavation of this layer was not completed, it seems likely that these deposits occurred prior to the eruption of Vesuvius, meaning that this toilet was effectively out of use in this period (Fig. 5.18.7). This interpretation is strengthened by the fills recovered from the cesspit on the Vicolo di Narciso, which also appear to document work in progress. It should also be noted that the redecoration of the adjacent Room 17 appears not to have been completed, suggesting that building activity was underway in the northern part of the service wing during the run-up to the eruption in AD 79. A plausible explanation for this may be the seismic activities that began in AD 62/3 and seemingly continued sporadically until the eruption itself.[179]

18.8 Phase 8. Eruption and early modern interventions
This phase encompasses the period in which the house was initially excavated and then reconstructed to stabilise the remains and allow them to be displayed effectively to a visiting public. Room 15 is relatively unusual in the Casa del Chirurgo in that it provides

15, relatively soon after the initial construction and decoration of the room (Figs. 5.18.5 and 5.18.6). This was likely to have been undertaken as part of the same phase of flooring that saw the majority of the service wing entirely paved. The chute is attached to the central southern portion of wall W06.074 with a light greenish grey (Gley 1 7/1) mortar (**264.007**) containing angular volcanic and limestone inclusions. The crack through middle of the chute may be a result of subsidence of the cesspit area. At the northern end of the room, beyond the chute, there is evidence to suggest that the same mortar was used to fix a wooden frame in place – perhaps the toilet seat plank – or else a wooden structure over the cesspit. In the north-eastern corner of Room 15, at the intersection between walls W06.074 and W06.072, it would appear that this mortar overlies

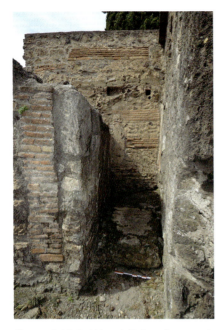

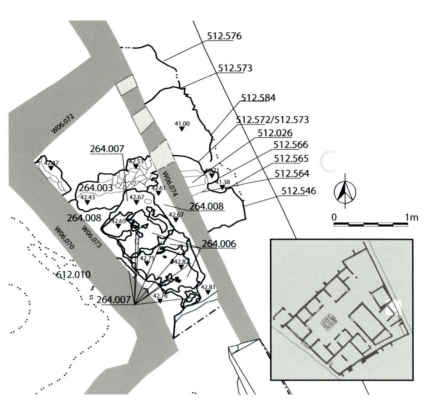

Figure 5.18.5. (*Above*) Toilet chute and plaster lining (image AAPP).

Figure 5.18.6. Plan of deposits and features of the toilet and chute in Room 15 (illustration M. A. Anderson).

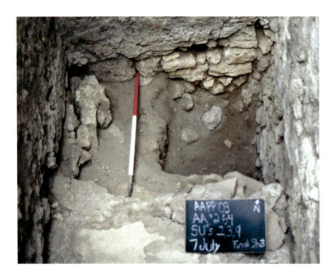

Figure 5.18.7. Fills of the toilet chute (image AAPP).

evidence for both of these distinct sub-phases of activity.

18.8.1 Early investigations
It is possible that several of the fills from the cesspit (264.005, 264.004 = **264.002**) represent the early investigations of the original excavators. These deposits were particularly churned and contain some lapilli (Fig. 5.18.8) (cf. infra).

18.8.2 Wall reconstruction
Roughly the upper 0.5 m of wall W06.073 was rebuilt, or levelled-up, during the early modern period with Sarno stone and grey tuff blocks for the laying of a protective course of roofing tiles. These were set upon a light grey (Gley 2 7/1) mortar with flecks of lime that is weathering in places to dark reddish grey (2.5 YR 3/1). The upper portion of the wall was rendered with a coarse light bluish grey (Gley 2 7/1) mortar containing small pieces of crushed volcanic tuff or lapilli, and fragments of white lime. This was also used as mortar on wall W06.074 to repair a hole in the wall with courses of brick/tile. A less coarse version of this same mortar was used to point the remainder of the wall W06.073, while another 20 mm thick version of the mortar, this time bulked out with tile, was used as a render around the surviving plaster at the north of the wall.

18.9 Phase 9. Modern interventions
Following its initial excavation there was a natural build-up of soils and overburden (264.001) in Room 15, which were buried by a layer of protective gravel.

18.9.1 1970's restoration campaign
18.9.1.1 WALL RESTORATION
The upper 0.5 to 1 m of wall W06.072 was most probably rebuilt with large blocks of Sarno stone and grey lava

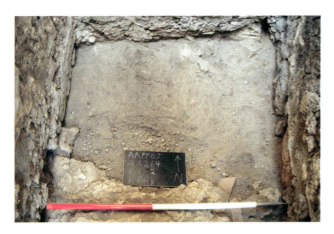

Figure 5.18.8. Lapilli fills of the toilet chute appearing in the disturbed modern layers (image AAPP).

in association with the construction of the modern roof over Room 19. It is impossible to characterise the mortar used in this rebuilding due to the extent of more recent pointing.

18.9.1.2 PLASTER CONSERVATION
The surviving plaster on all of the walls in Room 15

were edged with a layer of light greenish grey (Gley 1 8/1) mortar containing angular volcanic minerals, which weathers to a greenish grey (Gley 1 8/3) colour. This same mortar was also used to fill in holes in the plaster and to cover large extents of its surface that had probably degraded (Fig. 5.18.4, F). It is possible that the repair to the plaster in the lower windows of wall W06.073 also belongs to this phase of restoration. This was undertaken with a light bluish grey (Gley 2 8/1) plaster with rounded volcanic mineral and ceramic inclusions.

18.9.2 2000's restoration campaign
All of the walls were pointed during a recent campaign of restoration with a rough bluish grey mortar (Gley 2 6/1) containing an aggregate of angular volcanic minerals up to 8 mm in length, including pieces of crushed dark cruma, greenish grey (Gley 2 5/1) tuff, and grey lava.

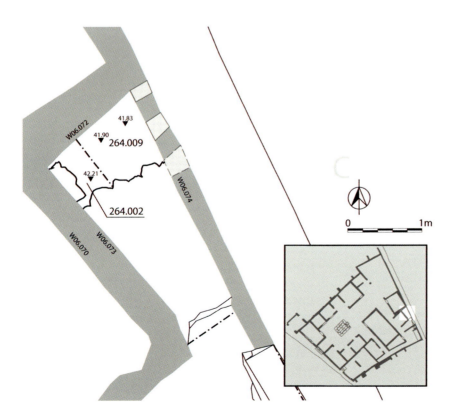

Figure 5.18.9. Plan of deposits in the chute (illustration M. A. Anderson).

19. Rooms 16 and 20
Portico and hortus (AA508)

Description

Rooms 16 and 20 represent a large total area of the Casa del Chirurgo, consisting of a portico (Room 16) 12.06 m in length and 3.38 m in width at the back of the tablinum (Room 7), and a large trapezoidal outdoor garden area (Room 20) 10.65 m in length and 6.97 m in width at its widest end and 3.87 m at its narrowest. The portico and hortus functioned in a largely similar fashion throughout the history of the property despite changes to its configuration and accessibility. The construction of Rooms 19 and 21 around 100 BC resulted in the reduction of the overall size of the portico and hortus while providing it with new features. A doorway was opened at the southern end of Room 16 in the late first century BC to allow access from this space to the service wing. Finally, in the middle of the first century AD a stairway was added to provide access to the new upper storey that was constructed over the service wing of the property.

Archaeological investigations

Excavations in Rooms 16 and 20 were undertaken in a single season during the summer of 2005, designated as AA508, which included multiple areas of excavation in the garden and portico.[180] The condition of the underlying archaeology of the two areas varied markedly, resulting in the application of differing excavation methodologies. In Room 16, formally beneath the western portico, open-area stratigraphic excavation techniques were used once the modern gravels and trample had been removed. The area excavated ran from the southern doorway of Room 21 to roughly the midpoint of the doorway into Room 19. The second, southern half of this portico space was included in the excavations of Rooms 18 and 17 to the south and is included in the discussion of these areas (cf. infra). Large-scale excavation ceased at the volcanic layers that predate the Casa del Chirurgo, with the underlying natural deposits only being observed seen in the section of the trench dug by Maiuri (Fig. 5.19.1). In the north-west and south-eastern sectors of Room 16, the largely-intact nature of the final *opus signinum* floor surface precluded further excavation. The modern curatorial policy of replanting trees, bushes, and hedges in former garden spaces prevented excavation of any large open areas. Consequently the hortus was investigated through a series of small sondages (Fig.

5.19.1, S1 to S6) squeezed into available spaces. It was found that the stratigraphy in these areas had suffered considerable disturbance and damage. As a result these areas were investigated using arbitrary spits in lieu of stratigraphic excavation.

19.1 Phase 1. Natural soils

Investigations in Rooms 16 and 20 did not reach the underlying natural deposits in open excavation and terminated at the top of the series of natural deposits that occurred at the beginning of Phase 2. Natural soils were, however, clearly revealed in the section of the small rectangular sondage cut by Maiuri, which was re-excavated (fill of that cut: **508.047**). Here a yellowish brown (10 YR 5/4) to chocolate-brown sand-silt-loam,[181] normally the top of the natural sequence of soils, was witnessed in section directly underlying the deposits of Phase 2 (Fig. 5.19.2).

19.2 Phase 2. Volcanic deposits and early constructions

This phase witnessed the creation of the Pre-Surgeon Structure on a lower terrace, cut into the natural soils and agricultural activity over the remainder of the plot. In the area that became the portico and hortus, there is some evidence of these activities (cf. infra) consisting of a short length of beaten earth that might represent the first evidence of a wall or fence along the line of the eastern plot boundary.

19.2.1 Early deposits

The first change in this area involved the deposition of the two layers of soil seemingly of volcanic origin (Fig. 5.19.4).

The first part of this sequence was observable in both the section of the sondage excavated by Maiuri (Fig. 5.19.2, B) and at the bottom of a posthole cut (**508.082**). The first layer was a deposit of brown (7.5YR 4/3) sand/gravel (no SU number assigned), which varied in texture from pea-sized lumps to sand.[182] In the section of Maiuri's trench, it could be seen that this 0.15 m thick deposit was directly overlying the natural soil. In Room 16, under the western portico of the Casa del Chirurgo, the 'pea gravel' was overlain by a 0.3 to 0.4 m thick layer of brown (10 YR 4/3) sandy silt with a distinctive pocked upper surface (Fig. 5.19.2, C and Fig. 5.19.2, A). The same deposit was also observed in all of the sondages in the garden area (**508.033**, **508.079**, **508.064**, **508.094**, **508.058**, 508.032, **508.305**).

The 'pocked earth' was not deposited at a constant height and can be seen to slope away to the east from

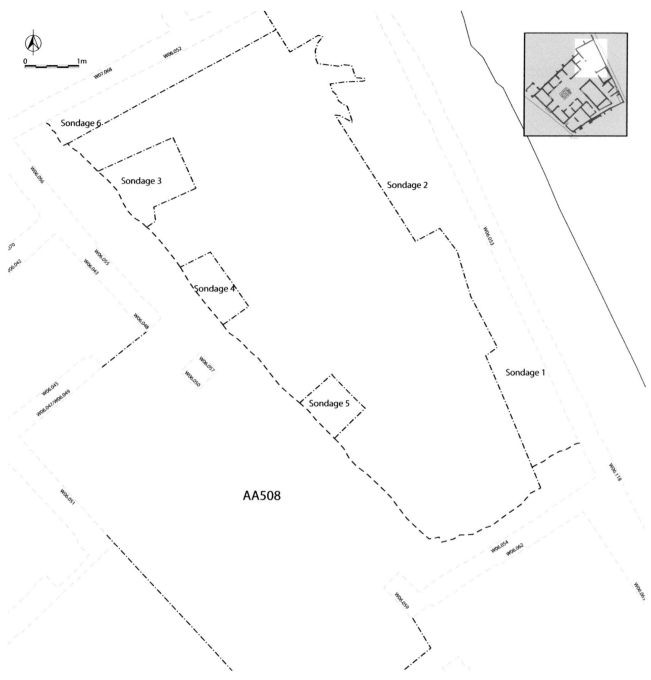

Figure 5.19.1. Plan of excavation area with sondages (1–6) indicated (illustration M. A. Anderson).

a high point in Room 16 towards the eastern garden wall (W06.053). In the area of Room 16, the elevations of this deposit (ranging between 41.94 and 42.03 MASL) are close to the elevations of the upper of two such levels recovered immediately to the west under the floor of the tablinum (c. 42.06 MASL). From this point, it appears to have sloped downwards towards the north to 41.79–41.27 MASL in sondage 6, next to the northern party wall with the Casa delle Vestali (W06.052). Directly overlying these deposits in the

area of Rooms 20 and 16, as well as in Room 7, Room 10, and even to the north in areas in the Casa delle Vestali, was a layer of reddish black to dark grey sand into which all later activities, including early walls and pits, and the Sarno stone walls of the Casa del Chirurgo itself, were cut. This comprised a 0.2 to 0.25 m thick layer of very dark greyish brown (10 YR 3/2) sand deposited throughout the area that became Room 16 (508.023,[183] 508.072, **508.065**; Fig. 5.19.2, D) (visible in plan for Phase 3) and also across the area that became

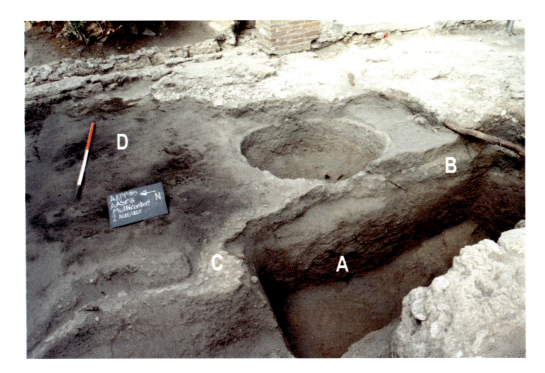

Figure 5.19.2. Natural soil and early deposits (A) natural seen in section of Maiuri's trench; (B) 'pea gravel'; (C) 'pocked earth'; (D) 'black sand' (image AAPP).

the garden (508.049, 508.062,[184] 508.018). The sand also appeared to thin out eastwards, as there was a decrease in the thickness of this deposit when seen in section in garden sondage 1 to 0.15 m. Notably, these layers of 'black sand' have produced a number of finds that cannot actually derive from the deposits themselves. Later construction of floors seems to have generally been preceded by destruction and removal of the flooring which otherwise was built directly over the top of the black sand. The repeated exposure of this early deposit means that finds, especially those from its upper parts, can date from any subsequent period without serving to date the sand itself. The loose and soft nature of the sand naturally makes it particularly easy to contaminate with later materials from above.

19.2.2 Early beaten-earth wall or footing

Traces of several early activities often could not be identified until after the 'black sand' had been removed, since they generally muddled the surface of the sand and obscured any cuts in its loose and fragile surface. In the narrow sondage (sondage 1) adjacent to the eastern wall of the hortus (wall W06.053), a very compact layer of packed silty sand (**508.071**) was found in a cut through the 'pocked earth' surface (508.032). The matrix and compaction of the deposit was unlike that of the 'pocked earth' surfaces and is not simply a lower version of such a surface. Although it is difficult to be absolutely certain in the 0.80 m wide sondage that was accessible in this area, the hard-packed earth is similar to a deposit underlying wall W06.053 at its northern

junction with the Casa delle Vestali, as seen during excavations in the pavement of the Vicolo di Narciso.[185] There, this deposit was interpreted as a length of beaten earth wall and it is possible that the hard-packed earth in sondage 1 was a continuation of this same wall a little further to the south. The stratigraphic relationship of this deposit with the 'pocked earth' surface in sondage 1 (508.032) is far from clear due to the highly disturbed nature of the garden stratigraphy, but it is possible that the hard-packed earth (**508.071**) may have functioned as either as the base of an early rear wall for the property or may be surviving traces of the rear wall itself. It is impossible to be certain whether such a boundary wall would belong to Phase 2 or to Phase 3, but it suggests that the property boundaries may have been formalised already in this period.

19.2.3 Postholes cut into the levelling

Six postholes (**508.080**,[186] **508.082**, **508.084**, **508.086**, **508.088**, **508.090**) (visible in plan for Phase 3) were cut into the early levels during the Pre-Surgeon phase of activity. In excavation, these postholes only became clear after the removal of the black sand layer (508.023, 508.072, 508.065 and 508.066), and for this reason, they were originally sequenced as being prior to it. On the basis of dates from their fills, and given the general confusion of the soils in the area of Room 16 caused by later removals of flooring and heavy reworking, it is possible that at least some of these cuts were made during later phases of activity (such as Phase 5). They have here been sequenced here in their earliest possible

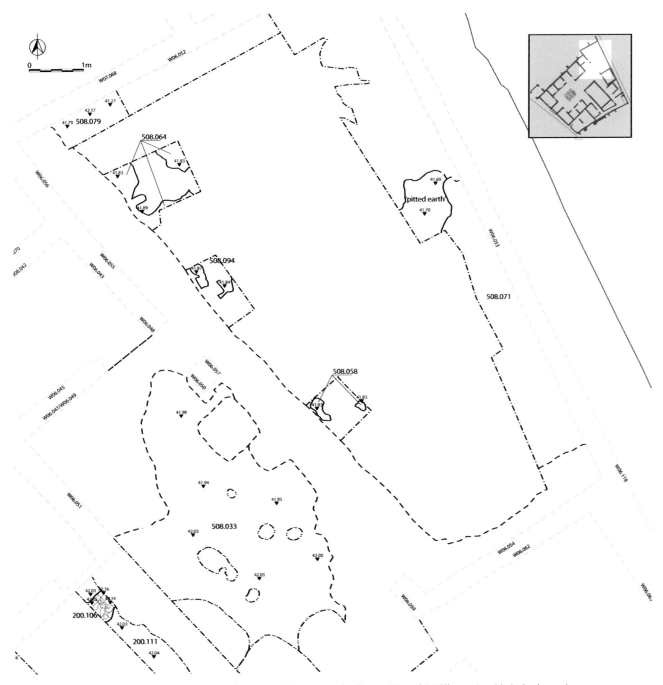

Figure 5.19.3. Deposits and features of Phase 2 in the Room 16 and 20 (illustration M. A. Anderson).

phase, suggesting that any later pottery dates are the result of contamination.

The first (**508.080**) was located at the southern end of the western line of postholes (Fig. 5.19.4, P1). It had a roughly rectangular cut, (0.2 by 0.3 m) with a vertical western side. The cut also had a stepped eastern side on top of which was a large horizontally laid piece of tile. The second (**508.082**) was located in the middle of the eastern line of postholes (Fig. 5.19.4, P2). It had a roughly circular cut measuring 0.28 by 0.3 m wide, with steep to vertical sides and an irregular base. This

cut was 0.29 m deep from the top of the pocked earth surface. The third posthole (**508.084**) was located at the northern end of this row (Fig. 5.19.4, P3). It had a rectangular cut 0.48 m long by 0.35 m wide, with steep sides and an irregular base, 0.57 m deep from the top of the 'pocked earth' surface. The fourth posthole (**508.086**) was located in the middle of the western line of postholes (Fig. 5.19.4, P4). The roughly circular cut for this posthole, measured 0.24 by 0.22 m wide, with steep sides and a concave base. The southern side of the cut was lined with plaster, which presumably helped to

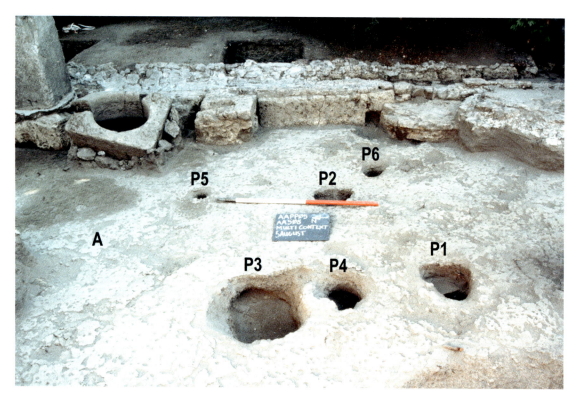

Figure 5.19.4. (A) 'Pocked earth' surface and features (P1–P6) cut into it underlying Room 16 (image AAPP).

secure the post in place. The posthole was subsequently filled with a loose black sand (508.087) containing a single piece of pottery. The fifth posthole (**508.088**) was located at the northern end of the eastern line of postholes (Fig. 5.19.4, P5). Its roughly circular cut, measured 0.18 by 0.14 m wide, with steep vertical sides and a concave base and was 0.21 m deep from the top of the 'pocked earth' surface. Posthole 6 (**508.090**) was located at the southern end of the eastern line of postholes (Fig. 5.19.4, P6). It had an oval cut measuring 0.2 by 0.3 m wide, with vertical sides and a concave base. The cut was 0.49 m deep from the top of the 'pocked earth' surface. Traces of a potentially related cut were recovered against wall W06.053 (508.097).

Although roughly arranged in two lines, it is unlikely that the postholes were part of a single structure and their exact purpose remains elusive. Their presence in this phase, however, fits well with the activities of the atrium in Phase 2, which also consisted of a large number of postholes and inter-cutting pits. While it is very difficult to be certain of precisely what activity these features document, it is clear that it was widespread, repeated, and ran across the entire area of the upper north terrace. The fills of the post-holes (508.081,[187] 508.083, 508.085, 508.087, 508.089, 508.091) were relatively sandy in nature, implying immediate filling of the hole caused by the collapse of

the surrounding black sand into which the posts had been driven.

19.3 Phase 3. The Casa del Chirurgo (c. 200–130 BC)

Phase 3 saw the development of the Casa del Chirurgo following the destruction of the Pre-Surgeon Structure and the widespread filling-in of the lower Pre-Surgeon terrace to the south. As the area of Rooms 16 and 20 had not witnessed the removal of soils, no filling-in was necessary in this area and construction of the portico began directly on the black sand (Fig. 5.19.5).

The Casa del Chirurgo was built with an eastern portico facing the hortus. It would appear that this structure reached from the later boundary with the Casa delle Vestali (the later junction between walls W06.042 and W06.056) and stretched to the opus africanum wall that divided the hortus area of the property from that of the early service wing (walls W06.067/064). The portico was built along the rear, eastern wall of the house and had an associated drain and cistern, as well as an east–west overflow drain out into the Vicolo di Narciso. The base of the pilasters, guttering, and the cistern were included in the same foundation trench and are therefore contemporary. The significance of the excavations in Rooms 16 and 20 is that they demonstrate the presence of the portico in the original layout of the Casa del Chirurgo. They

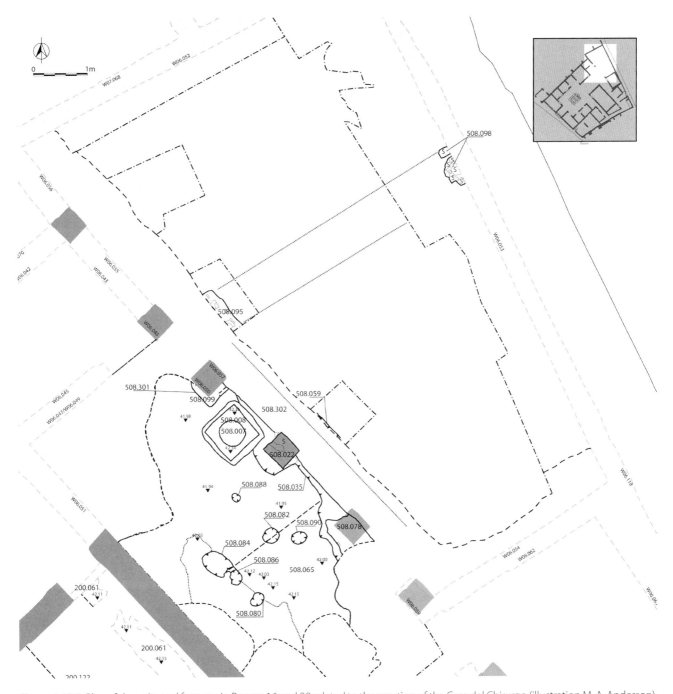

Figure 5.19.5. Plan of deposits and features in Rooms 16 and 20 related to the creation of the Casa del Chirurgo (illustration M. A. Anderson).

also provide a clear demonstration of the structure of the portico, which ran along the eastern and also the southern side of the house, where the evidence for it is much more fragmented. Consequently, the long section recovered in AA508, which included three pilaster bases and intermediate lengths of gutter base, provided a template that could be used for the identification and verification of other remains of the portico elsewhere in the property. Most notably, these fragmentary remains could be seen in Room 23 and Corridor 12, which

enabled the reconstruction of a southern portico to accompany the one on the eastern side of the house.

19.3.1 Portico, drain, and cistern
The foundation trench for the square Sarno bases of the portico (Fig. 5.19.6, A), the rectangular Sarno stones of the north–south Sarno gutter (Fig. 5.19.6, B; **508.301**, **508.035**, 508.304, **508.059**), as well as the cistern (Fig. 5.19.6, C; 508.300, **508.008**) were cut down through the 'black sand' and into the underlying 'pocked earth'.

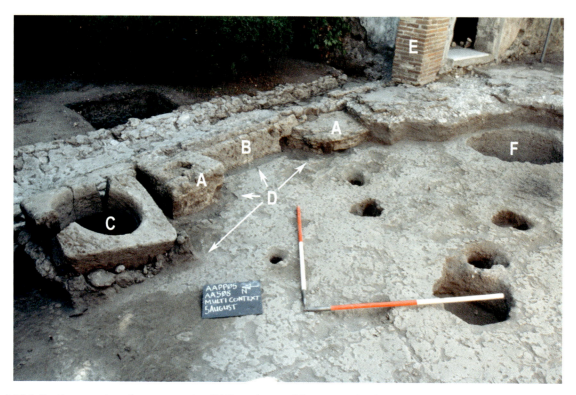

Figure 5.19.6. Northern portion of eastern portico. (A) Sarno bases of the portico; (B) the Sarno stone gutter; (C) cistern with Nocera tuff *puteal*; (D) foundation trench cut into natural soils; (E) *opus testaceum* quoin; (F) pit cut later in Phase 5 (image AAPP).

On the western side of the drain and portico, the cut is continuous and encompasses all of these structural elements, (Fig. 5.19.6, D). The Sarno stones show signs of reuse, in common with those in the foundations of the atrium during the initial phase of the property (cf. supra). The Sarno blocks of the gutter (**508.302**) were placed into the foundation trench almost flush with the eastern side of the cut, as the foundation trench visible in garden sondage 5 (**508.059**) was only 30 mm wide. The Sarno stones of the western side of the gutter were then added, and finally the square Sarno stone pilaster bases of the portico (**508.099**, **508.022**, **508.078**), leaving between 0.1 m and 0.2 m of the foundation trench unused. A greyish brown (10 YR 4/2) loose sandy silt (508.060) was then used to fill the narrow eastern foundation trench, while a similar dark brown grey deposit, although of greater compaction (508.029, 508.077, 508.092, 508.096), was used to fill the western side of the foundation trench and the narrow gap between the Sarno stones of the gutter and the pilaster bases. The three pilaster bases are roughly regularly spaced. The distance between the base beneath the upstanding pilaster (W06.057) and the middle base (**508.022**) is 1.38 m, with a further 1.40 m between the middle base (**508.022**) and that to the south (**508.078**). There is some indication of another Sarno pilaster base beneath the *opus testaceum* quoin

at the northern end of wall W06.059 (Fig. 5.19.6, E). The distance between **508.078** and this potential base is only 1.12 m, which would suggest that the spacing of the pilasters of the portico were not entirely even.

As part of this phase of construction, a cistern, that would have stored rainwater runoff from the roof of the portico, was also built. Although it is possible that the Nocera tuff cistern head (**508.008**) may be a later addition, perhaps at the same time as the raising or replacement of the impluvium in the atrium in Nocera tuff (Phase 5), the construction trench cut for the shaft is a continuation of the same cut for the gutter and portico, which makes it certain that the cistern itself was part of the original construction. A hole in the eastern side of the shaft would appear to have been the outlet of a drain that led from the gutter and into the cistern (see Fig. 5.19.8). The gutter system also had an overflow drain that led from the area of the cistern laterally through the garden space and out into the Vicolo di Narciso. Although largely removed during a later phase, traces of the drain can be discerned adjacent to the Sarno gutter in sondage 4 (**508.095**) and underlying wall W06.053 in sondage 1 (**508.098**), demonstrating that the drain ran in an west–east direction out towards the nearby street. In sondage 4, the overflow drain can be seen to have originated in a gap between the Sarno stones of the base of the

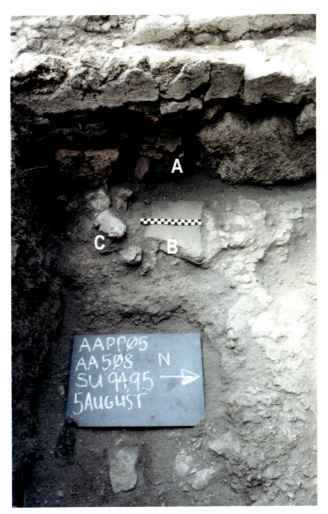

Figure 5.19.8. The *opus signinum* upper surface of the gutter and its drain to the cistern (image AAPP).

Figure 5.19.7. Western end of the east–west overflow drain (A) drain outlet; (B) tile base; (C) Sarno stone *opus incertum* drain wall (image AAPP).

gutter (Fig. 5.19.7, A). The base of the drain was lined with tile (Fig. 5.19.7, B), with the southern drain wall being constructed from an *opus incertum* using small pieces of Sarno stone (Fig. 5.19.7, C). In sondage 1, at the eastern end of the drain, a similar mortar bonded *opus incertum* was also used to form the northern and southern portions of its course.

19.4 Phase 4. Changes in the Casa del Chirurgo (c. 100–50 BC)

The first additions to the original structure of the Casa del Chirurgo occurred during Phase 4 and appear to have been focused upon enclosing the garden (Fig. 5.19.9). It is unclear whether this represents the first such enclosure, or whether the eastern wall at least was a replacement for the possible beaten earth wall/ foundation from Phase 2 (cf. supra). There are no traces of *opus africanum* or *opus quadratum* construction that

would indicate the presence of boundary walls from Phase 3. These activities in Phase 4 took place at the same time as the construction of a rear extension to the adjacent Casa delle Vestali, and imply some sort of cooperation between the owners of these two properties, or at least a combined effort in construction. In fact, it is this relationship that has permitted the suggestion of dating for these activities, which otherwise have left virtually no stratigraphic remains in the Casa del Chirurgo.

19.4.1 First alterations - construction of Room 21

The eastern portico was somewhat truncated to the north through the construction of Room 21. In Room 16, this development can be traced initially with the closure of the formerly open eastern end of Room 9 through the construction of wall W06.051. This new wall butts up against the Sarno stone *opus quadratum* blocks at the eastern end of the northern wall of the tablinum (wall W06.060). Wall W06.051 was built in *opus incertum* using Sarno stone and cruma rubble with reused building material, including fragments of *opus signinum* floor and brick/tile. This was bonded with a very pale brown mortar (10 YR 8/2) containing black volcanic mineral inclusions, crushed black cruma, and lime. As part of the same phase of construction, wall W06.047/49 was built shortly afterwards and butts up against wall W06.051 in the west. This would initially have terminated at the Sarno stone pilaster of the former portico in the east. Wall W06.047/W06.049, like wall W06.051, was constructed in *opus incertum*, predominantly using Sarno stone with cruma, grey lava, and Nocera tuff rubble. This was set within the same very pale brown mortar that was also used in wall W06.051, demonstrating that although the walls were built sequentially, they were part of the same

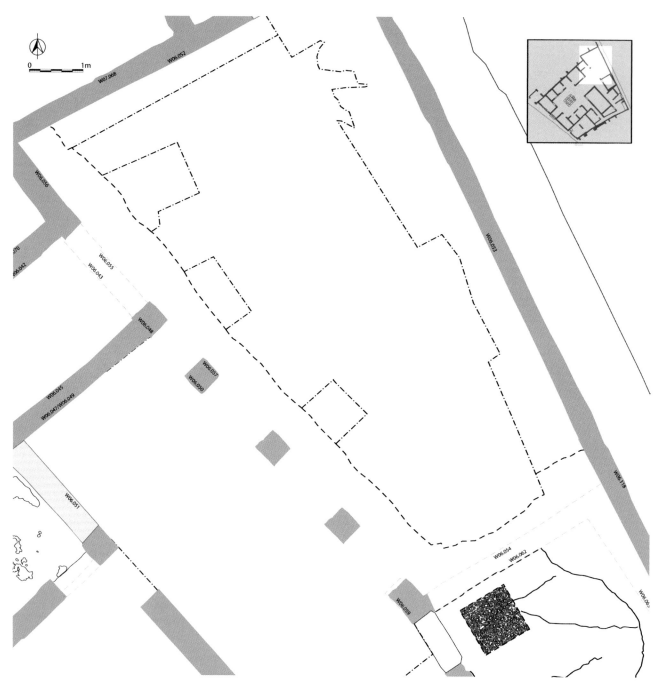

Figure 5.19.9. Plan of changes to the architecture in Phase 4 near Rooms 16 and 20 (illustration M. A. Anderson).

construction phase. On the northern side of the window ledge of wall W06.051, there is a small patch of very hard light bluish grey (Gley 2 7/1) mortar with fine black volcanic mineral inclusions. This is linear in form and appears to be associated with the window from Room 9 into Room 16. It is possible that this mortar may have been used to help fix a wooden frame into the wall.

19.4.2 Construction of the northern property boundary wall (W06.052 and W06.056)

The construction of Room 21 was part of the redevelop-

ment of the northern boundary of the Casa del Chirurgo and was, in part or whole, tied up with the development of the rear part of the Casa delle Vestali. The new rear range of rooms of the Casa delle Vestali necessitated the construction of walls W06.056 and W06.052; new party walls that separated the Casa del Chirurgo from its neighbour. Wall W06.056 was built as part of the construction of Room 21 and was a continuation of wall W06.042, being built in the same type of *opus incertum* using Sarno stone bonded with a very pale brown (10 YR 8/2) mortar containing small angular fragments

of black volcanic minerals and the occasional piece of lime. An excessive amount of mortar was used in the *incertum* and smeared around the rubble with the aim of creating a relatively flat surface. At this stage the eastern side of Room 21 was left open to the hortus.

The northern property boundary was further defined through the construction of wall W06.052. This was built in *opus incertum* using Sarno stone and Nocera tuff with occasional pieces of cruma set in a pinkish white (10 R 8/2) mortar containing angular black volcanic mineral fragments, lime, and larger pieces of red cruma (up to 30 mm in length). The window in wall W06.052 appears to be contemporary with the primary build of the wall, although it is difficult to be certain due to the amount of early modern render surrounding it. It is interesting to note that the window is wider on the side of the Casa delle Vestali where it opens into an internal room. This probably indicates that a legal arrangement had been reached between the owners of these properties over access to light. From the structure of the foundations of wall W06.052, it would appear that a narrow foundation trench for this wall was dug and then simply filled with the Sarno stone rubblework up to the top. Consequently, the absence of a cut for the foundation trench of this wall is unsurprising, as the base of the wall effectively filled its foundation trench.

19.4.3 Construction of eastern property boundary wall (W06.053)

At a slightly later date, although still within the same archaeological phase of building activity, the rear eastern wall of the property (W06.053) was constructed. Evidence for a hiatus in building between the construction of walls W06.052 and W06.053 is not found within the hortus but at the junction between the Casa del Chirurgo and the Casa delle Vestali on the Vicolo di Narciso. Here, wall W06.118 (W06.053) butts up against the southern property boundary wall of the Casa delle Vestali (wall W06.052). Between the two walls is a layer of backing and final plaster that would have decorated wall W06.052, suggesting that the length of time between the construction of these two walls was sufficient to warrant a decorative plaster layer on the northern wall of the hortus. Unfortunately no trace of this layer of plaster has been found in Room 20.

A sloping foundation trench (508.038) (visible only in section), 0.7 m at the top and 0.1 m at the base, was cut down through the 'black' sand and 'pocked earth' surfaces (Fig. 5.19.10). Wall W06.053 was constructed in the foundation trench in *opus incertum* using a mixture of Sarno stone, Nocera tuff, grey lava, and red and black cruma. The rubblework appears to have been laid in

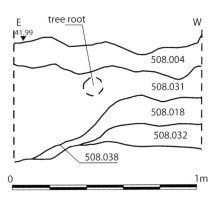

Figure 5.19.10 Foundation trench of wall W06.053 visible in southern section of sondage 1 (illustration M. A. Anderson).

regular, albeit rather rough, courses with larger stones used at the base of the wall. The mortar used in the build varies in composition and colour from light grey (5 YR 7/1) with red cruma, angular volcanic mineral and lime inclusions to a white (Gley 1 8/N) mortar. As there is no abrupt change between the two mortars and no discernable change in the building materials, which could have implied different construction phases, it is suggested that the light grey mortar used in the lower portion of the wall was essentially the same as that used in the upper, except that it included cruma within its matrix. The interface between the two mortars is between 0.4 and 0.7 m above current ground level. Excess mortar was smeared around the rubble of the *opus incertum* in order to create a flatter surface. Further evidence for the wall being built in courses comes from two lines of putlog holes, which would have provided support for the scaffolding used in its construction. The lower line of three holes is at c. 2.05 m above present ground surface and measures roughly 0.10 by 0.12 m. The upper line of putlog holes are c. 3.20 m above the present ground surface and measure roughly 0.20 by 0.15 m. The same wall runs along the entire Vicolo di Narciso length of the Casa del Chirurgo and originally incorporated a wide rear entranceway to the property framed with large Sarno stone orthostats. The foundation trench was then filled with a light grey silty sand (**508.031**). It is significant that the fill of the foundation trench directly overlies the deposit of 'black sand' (**508.018**) seen at the southern end of sondage 1 adjacent to wall W06.054 (Fig. 5.19.10). This would suggest either that the foundation trench for wall W06.053 extended beyond the bounds of the 1 m wide sondage, or that any previous garden soil had been removed down to the level of the 'black' sand as part of this phase of construction.

19.4.4 Construction of Room 19

Following the completion of the eastern boundary wall (W06.053), a similar infilling between portico pillars to that which had been used to create Room 21 took place on the southern side of the portico, producing Room 19. The stratigraphic evidence for the construction of this room within Phase 4 and the western wall of Room 19 (W06.066) is dealt with in the discussion of Rooms 16, 17, and 18 (cf. infra). In the area of the hortus, however, evidence would suggest that the northern wall of Room 19 was not constructed until the middle first century AD, in association with the construction of the upper storey over the service wing. With the construction of the room and its decorative flooring firmly set in Phase 4, two scenarios present themselves: either Room 19 was, like Room 21, open to the hortus to the north and the present of wall W06.054 simply filled this space in at a later date; or the fabric of a previous version of wall W06.054 was entirely replaced in Phase 6. Although in later phases the room is often identified as an oecus, simply the presence of the room may be attested in this phase. Its fine and unusual original pavement, however, might imply its use for elite activity.

19.5 *Phase 5. Redecoration and redevelopment (late first century BC to early first century AD)*

The creation of the formal garden in the Casa del Chirurgo needs to be set in context with the other architectural changes occurring in the property at the end of late first century BC, which were designed to emphasise the vista from the fauces through the atrium and tablinum to the garden beyond (Fig. 5.19.11). This involved the removal of the rear, eastern wall of the tablinum (Room 7) (Fig. 5.19.13), permitting an axial view of the hortus through the fauces, atrium, and tablinum from the street frontage. It is likely that this phase also saw the raising of the level of the garden through the dumping of a large quantity of topsoil and its first formal planting arrangement. Although the dating from these soils has become somewhat jumbled, this is probably because the garden soils were by their very nature subject to reworking and alteration that has served to churn up the datable materials. Following the addition of these soils, roughly thirteen evenly spaced planting pots, *ollae perforatae*, were placed along the walls of the garden. Seven pots ran along the eastern wall and six along the north wall. It is possible that there were other such pots located in the unexcavated central area of the hortus. It is clear that these plantings were intended to create a formal garden. The removal of the rear wall of the tablinum would have enabled

this space to be seen in an axial line of sight from the street.

19.5.1 Pits and widespread disturbance of the black sand

Building activities commenced with a relatively large, steep-sided oval pit with a concave base (**508.069**), which was dug in the middle of the southern end of Room 16 (Fig. 5.19.6, F). The pit measured 1.14 m long by 1 m wide and was approximately 0.59 m deep from the surface of the 'black sand' (508.072). It is possible that the pit was dug down into the 'black sand' and through the underlying natural layers in order to provide clean natural soils, important raw materials that would have been required for the building activities during this phase of development. The pit was filled with a loose brown (10 YR 4/3) silty sand (508.052[188]) that contained quantities of building debris, pottery, tile, plaster, and animal bone. This deposit was spot dated to the last quarter of the first century BC.[189] Directly to the north of this cut and partially cut by it, was a deposit of plaster and smashed up fragments of an earlier floor that filled a depression of irregular shape (**508.020** = **508.066**). It is possible that this was the final means of disposal for some of the earlier flooring of the area, which must have been removed prior to the excavation of these pits.

19.5.2 Garden soils

A significant quantity of topsoil was probably imported into the Casa del Chirurgo in order to create a formally planted garden for this property. The surviving soils in this area have been incredibly churned by modern activity and current gardening in the area. In sondages 1 and 2, this soil was a dark greyish brown (10 YR 4/2) to brown (10 YR 4/3) loose sandy silt (508.036,[190] **508.051**,[191] 508.057,[192] 508.067,[193] 508.070,[194] 508.074,[195] 508.036), which included the planting pots (W06.053; Fig. 5.19.12). This deposit (**508.051**) was spot dated to the last quarter of the first century BC.[196] In sondage 6, along the northern wall of the garden (wall W06.052) more planting pots were placed in another brown (10 YR 4/3) loose sandy silt (**508.028**,[197] 508.044[198]) (Fig. 5.19.11). The planting pots were evenly spaced suggesting that both lines of *ollae perforatae* were planted at the same time as part of a coherent scheme. The soil matrix also included significant quantities of marble, plaster, ceramic, and animal bone, perhaps suggesting that these soils were not chosen for their agricultural quality.

Although it is difficult to be precise due to the highly disturbed nature of the garden soils, a number of deposits seem to be later additions (**508.055**[199]). These deposits differ in both colour and compaction;

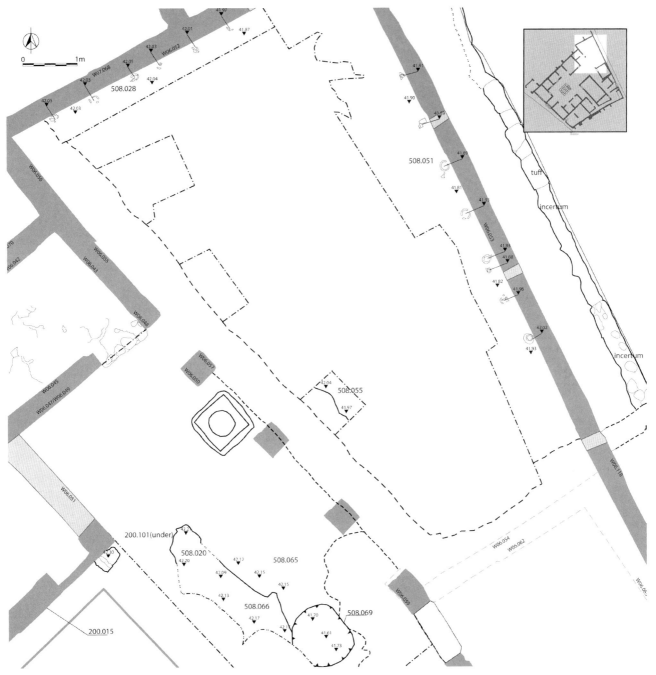

Figure 5.19.11. Plan of the deposits and features of Phase 5 in Rooms 16 and 20, including the *ollae perforate* (illustration M. A. Anderson).

for example, **508.055** is a pale brown (10 YR 6/3) firmly packed silty sand, while 508.073[200] and 508.075 are loosely packed dark brown silty sands. It is suggested that these deposits most likely originated during this phase of activity, and that they continued to be developed in the second version of the garden. A loosely packed dark brown silty sand (508.063[201]) is likely a mixture of both earlier and later soils, while similar soils (508.063, 508.056,[202] 508.054[203]) were recovered on the western side of the garden.

19.5.3 Construction of wall W06.055

Although walls W06.042 and W06.056 had been built as part of the separation of the Casa del Chirurgo from the Casa delle Vestali in Phase 4, it is clear that wall W06.055 was built during this phase, filling in the formerly wide open doorway to the hortus. This was completed in *opus incertum* using Sarno stone, grey lava, cruma, and yellow tuff, bonded with a soft pale yellow (2.5 YR 8/4) mortar with occasional black mineral and lime fragments.

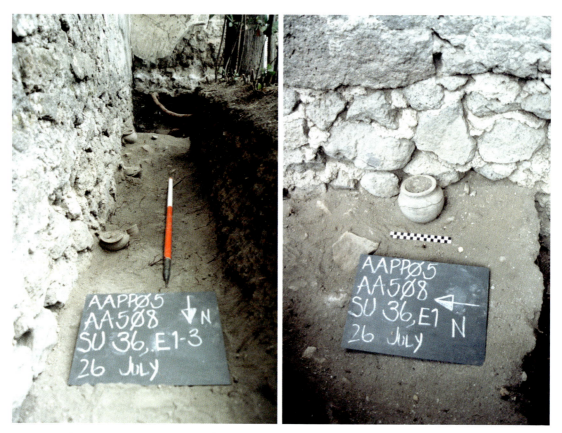

Figure 5.19.12. In situ *ollae perforatae* along the eastern wall of the garden (image AAPP).

Figure 5.19.13. Evidence of the removal of the rear wall of the tablinum and later pit that intersects with the cut (image AAPP).

19.5.4 Phase 5 plaster in Rooms 16 and 20

There is evidence to suggest a coherent phase of plaster decoration on the walls of both Rooms 16 and 20 following the closure of the formerly open eastern wall to the hortus from Room 21 and the formal planting scheme. This is seen as both a backing and final plaster in Room 20 (walls W06.050, W06.052, W06.053, and W06.055/W06.056), with just the backing plaster being observed in Room 16 (walls W06.047/W06.049 and W06.051). Importantly, the presence of this backing plaster on wall W06.055, which was built in this phase, and its absence on wall W06.054, which was built in the mid-first century AD, helps to sequence these plaster layers. The backing plaster consisted of a thick (up to 40 mm) layer of light bluish grey (Gley 2 8/1) plaster with round volcanic beach sand and ceramic inclusions (c. 1 mm in size) with the occasional larger piece of lime (up to 10 mm). On the remaining freestanding pilaster of the portico (W06.050), there are distinct layers within the plaster (Fig. 5.19.14). These do not run in concentric bands around the pilaster, and are all formed from a plaster of the same composition, suggesting that the layers all belong to the same decorative event. On wall W06.052, there are traces of a final decorative

Figure 5.19.14. Layers within the Phase 5 plaster on the freestanding column (wall W06.050) (image D. J. Robinson).

Figure 5.19.15. Backing and final layers of the Phase 5 plaster on wall W06.052 (image D. J. Robinson).

surface for this backing plaster, which was flattened to create a surface on to which a thin (2 mm) layer of white (10 R 8/1) plaster was added. Thereafter, a pigment was applied to create a weak red (10R 5/4) colouration (Fig. 5.19.15). This plaster also lips around on to wall W06.055/W06.056.

19.6 Phase 6. Upper storeys and final decoration (c. mid-first century AD)

During Phase 6, the area beneath the remaining portico (Room 16) was redecorated, probably in conjunction with the creation of upper storeys to the south. This will have necessitated considerable alterations to the overlying roof system (Fig. 5.19.16). Construction was most likely initiated by the almost complete removal of the former floor surface throughout the northern and middle sections of Room 16 and also in the narrow threshold between the tablinum and the portico, down to the level of the 'black sand.' A small part of this floor was left in place in the south-east corner, possibly because of the stairway constructions that took place there at this time. Following the removal of the floor, a small pit was dug in the middle of the western side of Room 16, whose purpose was most likely once again to provide clean natural soils for the building and redecoration activities of this phase. The pit was subsequently filled with a deposit spot dated to the middle of the first century AD. As the previous floor surface had been entirely removed down to the level of the 'black sand', any resultant undulations in the surface were levelled up with a deposit of rubble. This created a suitable surface upon which a new *opus signinum* floor was laid. As a component of this, the drainage system of the portico was altered with the east–west overflow drain through the garden space being largely removed and replaced by an *opus signinum* gutter along the base of the northern wall (W06.054) to Room 19. This emptied out onto the Vicolo di Narciso through a drain in the eastern wall of the garden (W06.053). Similar changes were undertaken on the northern end of the garden and the gutter was extended to the north, abutting the eastern wall of Room 21.

The extensive changes wrought by the addition of upper storeys to the south required heavy reconstruction in the oecus (Room 19), which included the construction or rebuilding of wall W06.054. At the western end of this reconstruction and protruding northwards roughly along the line of the portico, was an *opus testaceum* quoin, the purpose of which was to support the southern end of the portico and the upper storey that was built at this time.

19.6.1 Pit cut

A steep-sided oval pit (**508.048**), 1.5 m by approximately 1 m with a concave base, was cut in the middle of the western side of Room 16 (Fig. 5.19.16). Although the pit was most likely for the recovery of natural soils, the western sector of the pit penetrated through the fill of the robbed out eastern wall of the tablinum (Fig.

5.19.13). The pit was re-filled with a deposit of rubble containing a high quantity of mortar and finished plaster (508.045).[204] The small pottery assemblage recovered from this deposit allowed it to be spot dated to the middle of the first century AD.[205]

19.6.2 Opus signinum floor
A 0.2 m thick layer of broken plaster fragments (**508.040**, **508.042**) was deposited across Room 16. This deposit contained many pieces of finished and decorated plaster. Overlying the plaster sub-floor, a 0.1 m thick layer of *opus signinum* was poured and flattened to create the final floor surface (**508.006**, **508.010**). The base level of its sub-floor was at 42.29–42.37 MASL.

19.6.3 Construction of wall W06.054
This phase witnessed considerable alteration to the garden oecus and the construction or rebuilding of its northern wall (W06.054), which faces into the

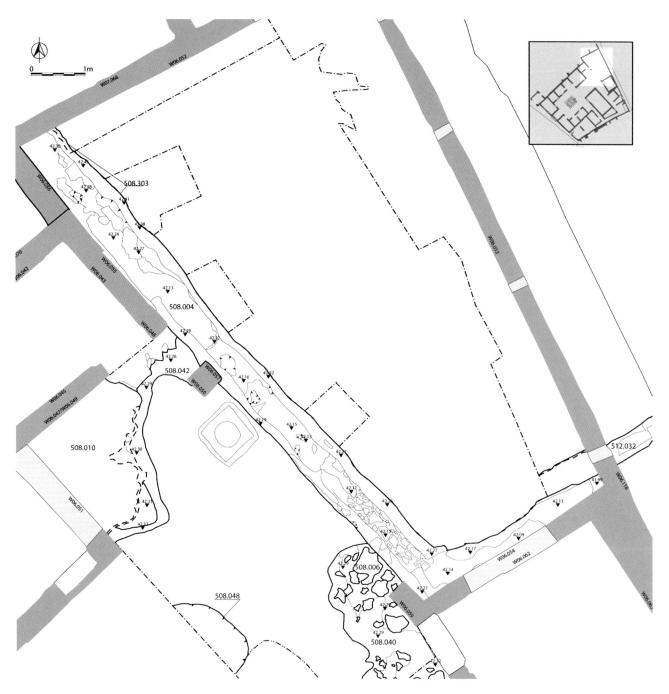

Figure 5.19.16. Plan of deposits and features of Phase 6 in Rooms 16 and 20 (illustration M. A. Anderson).

garden space and contains a window. Much of this work appears to have been made necessary by the construction of the upper storey to the south and west of Room 19. The wall was built in *opus incertum* using a mixture of Sarno stone, grey lava, and cruma with reused building materials, including pieces of a *opus signinum* floor, mortar chunks, and plaster. This was bonded with a very pale brown (10 YR 8/4) mortar with angular black volcanic mineral fragments and pieces of crushed cruma. At the top of the wall, the *opus incertum* is also accompanied by short horizontal sections of *opus testaceum*, which is also bonded with the very pale brown mortar. Similarly, the *opus testaceum* quoin at the western end of wall W06.054 was bonded with the same very pale brown mortar. In order to create a flat base for the window, brick/tile and reused wall plaster were employed, which were set within the same very pale brown mortar (Fig. 5.19.17). Due to the extent of early modern and modern pointing, it is difficult to know whether the marble windowsill was also part of the primary construction, although the lack of evidence to suggest that the wall was re-cut or repaired to any extent in ancient times may suggest that the sill was contemporary with rest of the wall.

19.6.4 New upper surface for the drain gutter
The construction of a new upper storey, along with the shortening of the portico and the re-construction of roof system, necessitated an alteration to the original guttering system the portico. The overflow drain (508.095 and 508.098) that had run from the area of the cistern to the Vicolo di Narciso was demolished at this time. Excess water was now removed via a new

opus signinum topped gutter set on a tile base running along the base of wall W06.054 (**508.004**). The same *opus signinum* was also used to pave the rest of the remaining guttering of the portico. A small terracotta pipe was set into the *opus signinum* to allow rainwater collected in the guttering to drain into the adjacent cistern.

19.6.5 Northern shuttered portion of drain
The portico drain was also extended to the north along the base of wall W06.056. This was undertaken in *opus incertum* of Sarno stone and tile set in a light grey mortar (**508.303**). The face of the *opus incertum* has a characteristic flattened surface that would suggest that wooden shuttering was used to form the extension of the gutter of the portico. This is indicated further by the protrusion of mortar at the base of the wall, where mortar escaped beneath the shuttering during the tamping of the *opus incertum*. Similar indications of shuttered construction are seen in sondage 3.

19.6.6 Phase 6 plaster in Rooms 16 and 20
All of the walls in the hortus and in Room 16 underwent a final phase of decoration, which was necessitated by the extensive rebuilding of Room 19 and the area under the portico. In Room 20, the previously flat final surfaces were removed with some care taken to retain the former backing for reuse. On wall W06.053, this process left a series of parallel 'wave-like' lines across the surface of the previous phase of backing (Fig. 5.19.18). The tool used to strip off the final face of the wall plaster appears to have had a curved profile so that the centre of the blade dug 1–2 mm deeper into the plaster. Although the previous backing was retained,

Figure 5.19.17. The *opus incertum* build of wall W06.055 and its window (image D. J. Robinson).

the uneven wave-like surface required flattening and a new layer of backing plaster was added. This was a 10 mm thick layer of light bluish grey plaster with black volcanic sand inclusions and the occasional fleck of red cruma. Overlying this is a thin layer of white (2.5 YR 8/1) plaster containing angular mineral crystals. It would appear that a different, less intrusive tool was used on wall W06.055/56, which left scratches in the previous phase of wall plaster but did not gouge marks sufficient to require a new backing plaster. Here the white crystal rich final plaster simply reused the previous phase of backing plaster. The same appears to have happened on the upper portion of the pilaster (W06.050), although here the previous final layer of plaster was retained at its base. The intersection between the two is at 1.72 m above the contemporary ground surface. On wall W06.054, a deeply incised line in the plaster divides the wall into two registers, although the final plaster remains the same above and below this line. The line is at 2.44 m above the contemporary ground surface.

Beneath the redeveloped portico, and after the laying of its new *opus signinum* floor surface, the walls of Room 16 were also redecorated. The final facing from the Phase 5 plaster was fully removed from walls W06.047/W06.049 and W06.051. Although it is possible that a new layer of backing plaster was applied to the walls, this is not observable due to modern conservation. Alternatively, the backing plaster from Phase 5 may simply have been reused as the surface upon which two new distinct plasters were applied to wall W06.047/W06.049 in the surviving middle and lower zones of the wall. Only the lower plaster is observable on wall W06.051. In the middle zone, a thin, 2 mm thick layer of

Figure 5.19.18. The wave-like cuts into the Phase 5 backing plaster on wall W06.053 in preparation for a phase of decoration in Phase 7 (image D. J. Robinson).

white (2.5 Y 8/1) plaster containing angular crystals was applied to the wall and flattened. Shortly afterwards, the lower zone of the wall was covered in a similarly thin layer of plaster containing powdered and crushed ceramic fragments, with the occasional piece of lime and black volcanic mineral fragments. The quantity of the ceramic in the plaster gives it a light red (10 R 7/6) colour. The interface between the two plaster zones is at 1.46 m above the present day ground surface. The lower plaster overlies the *opus signinum* floor surface in Room 16 and was therefore applied to the wall after the laying of the new floor.

19.7 Phase 7. Post-earthquake changes
No evidence of this period was recovered in this area.

19.8 Phase 8. Eruption and early modern interventions
Following the excavation of the Casa del Chirurgo a number of developments occurred in the portico and garden area of the property related to the repair and consolidation of the monument and its archaeological investigation. These have taken place both in the early modern period and have continued to date.

19.8.1 Early investigations of the cistern
It is probable that many of the levels of build-up within the cistern (508.024, 508.027, 508.093) derive from this earlier period of exposure. It would appear that the cistern was investigated as part of the early clearances and was subsequently filled with three distinct deposits, all of which contained modern material. The uppermost soil fill of the cistern head was a very dark greyish brown (10 YR 3/2) sand containing a large quantity of orange plaster (508.024), followed by a layer of fine dark sand (508.027), and finally a loose brown sandy silt (508.093).

19.8.2 Reconstructing the portico
The northern-most pilaster of the portico was re-erected and bedded on two layers of concrete and fill (508.011, 508.012) shortly after the property was initially excavated. The upper 0.7 m of wall W06.047/W06.049 was reconstructed in *opus incertum* with large blocks of Sarno stone bedded in a coarse bluish grey (Gley 2 6/1) mortar containing rounded volcanic sand and crushed lapilli with black volcanic rock and lime inclusions. The same mortar also appears to have been used to point parts of the remainder of the wall. On wall W06.051, much of the area beneath the level of the window was also rebuilt in *opus incertum* using Sarno stone, cruma, and grey lava rubble. This was set within

the same mortar as used on wall W06.047/W06.049, although in the reconstruction of wall W06.051, a little more lime seems to have been included in the mix. A piece of the final Phase 6 plaster was also included in the *incertum*, indicating that those rebuilding the walls used materials close at hand in their work. The tiles were then set on a bed of light bluish grey (Gley 2 8/1) mortar with lime inclusions. Possibly associated with this phase of reconstruction was a coarse light bluish grey (Gley 2 7/1) mortar containing angular volcanic minerals, black cruma, and pieces of lime. This appears to have been used to patch up and square off the western corner of the doorway into Room 21 at the eastern end of wall W06.047/W06.049.

The purpose of the rebuilding was to level up the walls and bring them roughly up to the height of wall W06.060, in order to place a line of roof tiles on top of them all as a protective measure. The true extent of the rebuilding is difficult to discern, however, due to the amount of render that was applied to the walls. This consisted of a bluish grey (Gley 2 6/1) mortar with inclusions of angular volcanic minerals, lapilli, cruma, and lime. In the lower part of wall W06.051, close to the window, the render appears to have been bulked out by the inclusion of pieces of brick/tile.

19.8.3 Reconstructing the hortus
The walls of the hortus were also repaired and reconstructed as part of the same phase of restoration that took place in the portico. As a measure to protect the ancient fabric of the walls, a line of roof tiles was set on top of walls W06.052 and W06.053. As part of this process the upper parts of the walls were levelled up in *opus incertum* using similar building materials to those employed in the original walls: Sarno stone, cruma, grey lava, and Nocera tuff with pieces of yellow tuff and reused pieces of ancient mortar. Wall W06.055/W06.056 was also largely rebuilt during this phase of activity, with only the lowest c. 30 cm of the southern section of the wall being ancient. This phase of reconstruction used a similar set of mortars that vary slightly in their composition and colour from a greenish grey (Gley 1 6/1) to white (Gley 1 8/N) with inclusions of black volcanic sand, ceramic, lime, and lapilli. This mortar was also used as a rendering coat, in places 20–30 mm thick, on walls W06.052, W06.054, and W06.055/W06.056. The tiles were set upon a light bluish grey (Gley 2 7/1) mortar with lime inclusions. The mortar was spread down over the render indicating that the tiles were applied afterwards.

On wall W06.053, there is also an arc of early modern

mortar c. 50 mm wide that could have been used to consolidate around the edges of a surviving patch of ancient wall plaster. There is, however, no surviving wall plaster on the wall in this area today, indicating that this was not an effective method of conservation. This was undertaken with a very pale brown (10 YR 7/4) mortar with black volcanic mineral and cruma inclusions.

19.9 Phase 9. Modern interventions
Modern interventions in Rooms 16 and 20 include the modern soils of the garden, the repair of the edges of the larger patches of the surviving *opus signinum* floor that was undertaken at some point in recent years, and the investigations of Maiuri (Fig. 5.19.19). It should be noted that although separated here into sub-phases, it is highly likely that the wall, plaster, and floor restoration and conservation measures all took place at roughly the same time.

19.9.1 Maiuri's trench
This consisted of a vertically sided rectangular trench (508.047) 2.0 m long by 1.04 m wide cut as part of Maiuri's campaign of excavations in 1926.[206] This was located at the southern end of Room 16, adjacent to the south-east corner of the tablinum. It is clear that the purpose of this trench was to seek evidence for an earlier rear wall of the tablinum. The excavation trench was backfilled with a dark yellowish brown (10 YR 4/6) sandy silt (508.037, 508.046, 508.053[207]) mixed with black sand and containing a high concentration of tesserae, most likely from the mosaic in the tablinum, as well as inclusions of plaster and pottery. The re-excavation of the sondage ceased after approximately 0.5 m of the backfill had been removed and did not reach the bottom of the trench.

19.9.2 Wall restoration and conservation
A new phase of conservation measures in the hortus began with the addition of a reinforced concrete lintel over the top of the window in wall W06.054. This may have replaced an early modern lintel that was put in place at the time of the initial restoration attempts following the excavation of the Casa del Chirurgo. The insertion of the lintel appears to have necessitated the repair/reconstruction of a small patch of the wall directly overlying it. This was completed in *opus incertum* using Sarno stone bonded with greenish grey (Gley 1 5/1) mortar with lime inclusions. A light bluish grey (Gley 2 8/1) mortar with angular black volcanic mineral and lime inclusions was used to point around

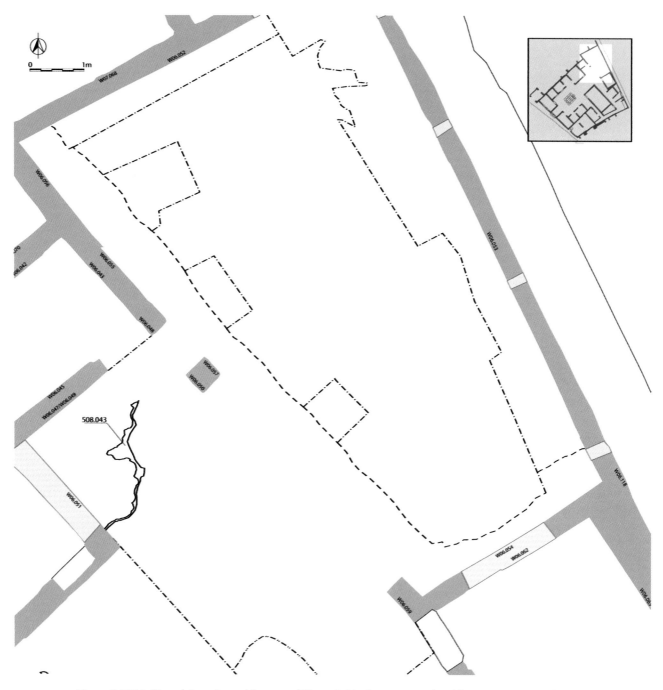

Figure 5.19.19. Plan of deposits and features of Phase 8–9 in Rooms 16 and 20 (illustration M. A. Anderson).

the base of the marble windowsill and the brick/tile underneath it on wall W06.054, as well as to fill in a hole in the final Phase 6 plaster on wall W06.053. The new lintel was put in place as part of a phase of restoration that saw the construction of the roof over Room 19. This required the raising of the level of wall W06.054 by the addition of approximately 0.5 m to the top of the wall in *opus incertum*. This was composed of Sarno stone and cruma set in the same greenish grey mortar with lime inclusions that was used to repair the area over the

concrete lintel. In Room 16, the lower portion of wall W06.051 beneath the level of the window, was heavily pointed with a hard light bluish grey (Gley 2 6/1) mortar containing angular volcanic stone inclusions and the occasional piece of lime. The same mortar was also used to fill the ends of the roof tiles *imbrices*.

19.9.3 Wall plaster conservation
It is notable that a hard light bluish grey mortar similar to that used to point wall W06.051, was also used to

seal the edges of the surviving areas of wall plaster on walls W06.051 and W06.047/W06.049. The same mortar was also used to fill in the holes in the surface of the plaster on wall W06.047/W06.049. It would appear from the stratigraphic relationship of the mortars that the pointing of wall W06.051 was undertaken prior to that of the wall plaster. In the area of the hortus, another similar hard light bluish grey (Gley 2 7/1) mortar with frequent angular black inclusions was also used to consolidate around the edges of the surviving areas of wall plaster on walls W06.050, W06.053, W06.054, and W06.055/W06.056. This same mortar was also used to fill in holes in the final plaster surfaces. This work was done after the re-roofing of Room 19, as the edging mortar overlies the new concrete lintel over the window in wall W06.054.

19.9.4 Flooring conservation
In a similar way to covering the exposed edges of wall plaster, mortar was also used as a method of conserving the friable edges of the *opus signinum* floor in the north-western corner of Room 16. This provided a hard, protective layer that hindered further mechanical abrasion and the destructive infiltration of plant roots, as well as providing something of a barrier against the weather. Two coats of mortar were used, an underlying edging (508.013, 508.041) and an overlying layer (**508.043**). The overall similarity of the mortars would overwhelmingly suggest that they were applied as part of a single campaign of conservation within a very short time of one another.

19.9.5 Garden soils
Alongside the changes that are anthropogenic in origin must also be placed the continued development of the natural soils of the garden. Although it is difficult to be certain, due to the heavily disturbed nature of the deposits in the garden area, a number of soils have been assigned to the early modern to modern phase. Although they did not always contain modern materials, the degree of disturbance is such that they must be modern. The deposits ranged in colour from a pale brown (10 YR 6/3) loose sandy silt (508.005[208]) in sondages 1 and 6 (508.015[209]), and probably represent a natural build up of soil in the garden space. A differentially compacted greyish brown (10 YR 5/2) to brown sandy silt (10 YR 4/3) (508.025, 508.009, 508.034,[210] and 508.039) containing significant quantities of modern artefacts, was recorded overlying the archaeological deposits in the area beneath the portico. In the garden, similar loose brown (10 YR 4/3) to very dark greyish brown (10 YR 3/2) sandy silts (508.002, 508.016, 508.019, 508.021, 508.026,[211] 508.076, 508.061, 508.068, 508.050,[212] 508.003) were recorded as the uppermost layers.

Overlying the modern topsoil in Room 16 (508.001) and filling the uppermost part of the cistern (508.007) was a modern layer of dark grey volcanic gravel. The SAP laid this throughout the Casa del Chirurgo in areas without significant quantities of surviving ancient flooring in the late 1990's.

19.9.6 Final wall restoration
Postdating the layer of volcanic gravel, the final phase of wall restoration saw the pointing of walls in both Room 16 (W06.051 and W06.047/W06.049) and Room 20 (W06.050, W06.052 and W06.055/W06.055) with a coarse light bluish grey (Gley 2 7/1) mortar.

20. Rooms 16, 17, and 18
Corridors and service room (AA612)

Description

This excavation included the southern end of Room 16 (hortus portico), Room 17 (service room), and Room 18 (corridor). Room 17 is almost square, measuring 2.77 by 2.74 m and presents doorway onto the corridor that is itself 1.42 m wide. A stairway ran from the southern end of Room 16 in the final phases of the house. Traces of flooring throughout suggest that the entire service wing was paved with *opus signinum* at this time. Room 18 served as a corridor connecting the hortus to the service wing, and provided access to Room 17.

Archaeological investigations[213]

Excavation in Rooms 16, 17, and 18 was undertaken in a single campaign during the summer of 2006 under the designation AA612.[214] This area consisted of the eastern half of Room 16 (against wall W06.066), the entirety of Room 17, and a small connection between the two areas around the western end of wall W06.067/W06.069. The western half of these areas was not excavated as the AD 79 surfaces were well preserved and it was necessary to provide access to these areas (and those to the south) to facilitate excavation. For this reason, excavation focused upon Room 17 and the eastern halves of the portico and corridor (Rooms 16 and 18). The study of much of the standing architecture of Rooms 16, 17, and 18 took place at the same time as the excavations in 2006, with additional work being undertaken in 2007.[215] The interpretations of the walls and their development were finalised in 2010 and 2013.

In AA612, while the level of the natural soils was not reached other than in the sections of later pit cuts, the early levelling deposits known generally to overlie them were uncovered widely and in multiple areas. As a result, excavations within Rooms 16, 17, and 18 have permitted the complete reconstruction of the sequence of development from natural soils until the final phases of the Casa del Chirurgo. The work in this area has been particularly revealing regarding the presence and layout of a group of rooms dating from the orignal foundation of the Casa del Chirurgo that lie outside of the traditionally reconstructed house plan.

20.1 Phase 1. Natural soils

The natural soils uncovered within Rooms 17 and 18 consisted of the sterile, silky, very dark brown soil (7.5YR 2.5/2) (**612.059, 612.060, 612.061, 612.062**)

thought to be the result of plant growth and decay at the top of the natural sequence. These soils were observed in the sections of later pit cuts (Figs. 5.20.1 and 5.20.2). The general elevation of this upper natural soil in Rooms 17 and 18 (between 41.70–42.09 MASL) is not far off that recovered from the tablinum (41.97–41.83 MASL) and suggests that the natural topography between these areas was roughly equivalent. This would mean that the crest of the early hillock upon which the later Casa del Chirurgo was built also extended southward into the areas of Room 17 and 18.

20.2 Phase 2. Volcanic deposits and early constructions

While Rooms 17 and 18 did not preserve traces of the Pre-Surgeon Structure or early terracing, they revealed evidence of the early sequence of seemingly naturally deposited layers known from surrounding rooms and from the northern and eastern side of the Casa del Chirurgo in general.

20.2.1 'Pocked-earth' layers

As in the area of the tablinum (Room 7), this sequence was slightly more complicated than that found in other areas, consisting of two distinct layers of compact, silty grey soil (10 YR 6/1) overlying deposits of 'pea-sized' (normally 2–10 mm in diameter) gravel of a similar colour (Figs. 5.20.3 and 5.20.4). Both of these deposits were very sporadic in coverage. The lower of these was a light grey (10 YR 6/1) highly compacted and friable soil with a characteristic 'pocked' surface (**612.041**). Above this was a layer of 'pea-sized' light brownish grey (10 YR 6/1) gravel (**612.042**), which was visible mainly in the cut for wall W06.070. The second 'pocked earth' surface was similar to the first, although it formed an unusual second layer (**612.040, 612.058, 612.038**) (Fig. 5.20.5). The upper layer was present not only on the southern side of Room 17 but was also recovered also over most of the excavated area of Room 16 (Fig. 5.20.6). Comparisons between the tablinum and this area reveal a similar elevation (42.04–42.06 MASL in the tablinum vs. 42.05 to 42.15 MASL in Rooms 17 and 18).

20.2.2 'Black sand'

Overlying the uppermost of the earlier levelling layers was a layer of fine black (10 YR 3/2) to brown volcanic sand (**612.029**, 612.039), situated within Room 16 and under the more mixed black sand deposits 612.027[216] and 612.028 (visible in plan for Phase 3) (Fig. 5.20.7). Clearly heavily disturbed during multiple later phases that often involved the re-exposure of the top surface

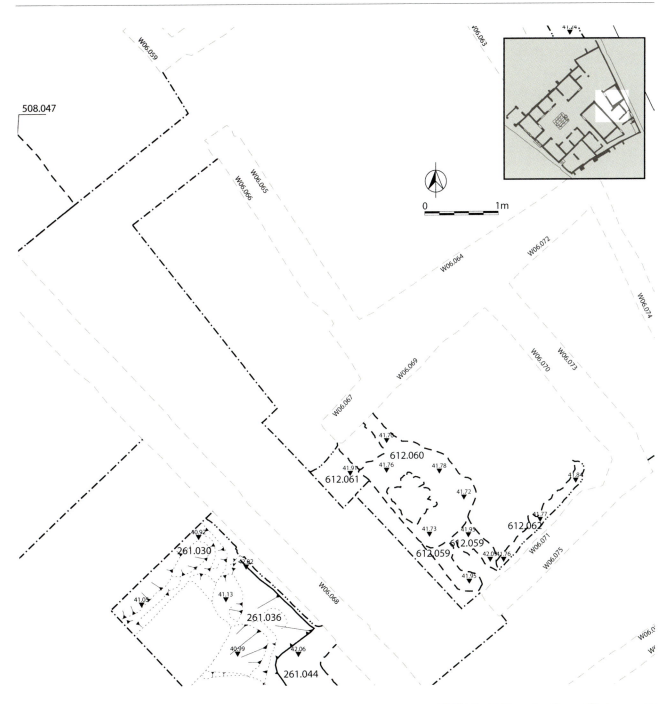

Figure 5.20.1. Plan of natural soils recovered in Rooms 16, 17, and 18 (illustration M. A. Anderson).

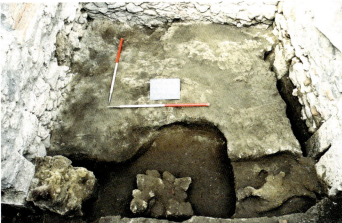

Figure 5.20.2. Natural soils visible in the bottom of later cuts and element of 'pocked earth' surfaces in Room 17 (image AAPP).

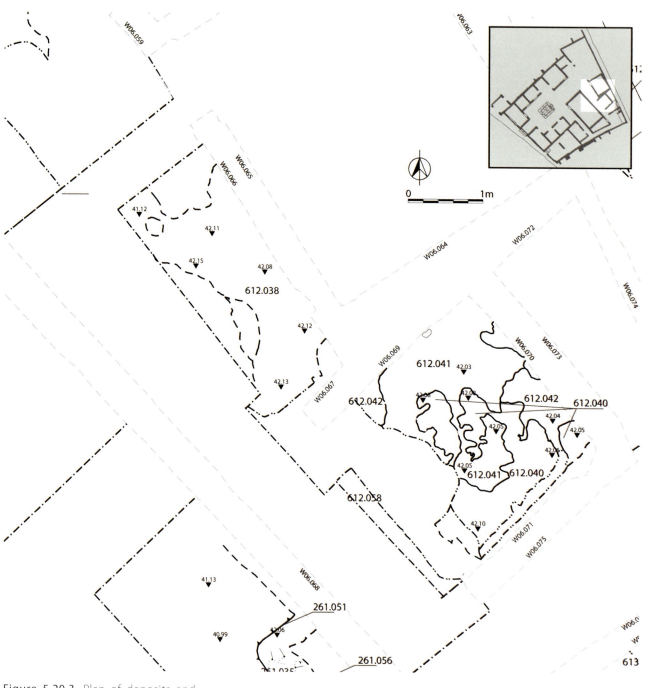

Figure 5.20.3. Plan of deposits and features of Phase 2 in Rooms 16, 17, and 18 (illustration M. A. Anderson).

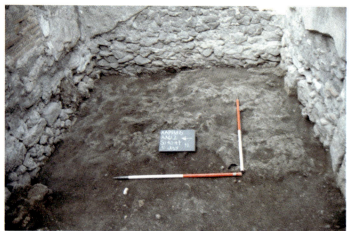

Figure 5.20.4. The lower layer of 'pocked earth' visible in Room 17 (image AAPP).

Figure 5.20.5. The upper layer of 'pocked earth' against wall W06.071 in Room 17 (image AAPP).

Figure 5.20.6. The 'pocked earth' layer in Room 16 (image AAPP).

of this soil as a preliminary step in construction, the sand produced a number of finds of considerably later date, none of which can be sequenced to the original deposition of this deposit and must be considered intrusive. Although it is likely that similar black sand layers once existed over the areas of Room 17 and 18,

later activities generally appear to have removed them from these areas.

20.3 Phase 3. The Casa del Chirurgo (c. 200–130 BC)

To the south and west of AA612, the creation of the Casa del Chirurgo was generally heralded by the destruction of the Pre-Surgeon Structure and a layer of deposits designed to fill the terrace of the previous phase. As no terracing had taken place into the area of southern part of Room 16, 17, and 18, this was not necessary and construction could begin directly upon the underlying natural layers (Fig. 5.20.7). In the area of Rooms 17, 18, and 15, a significant new discovery was made that expanded the 'footprint' of the initial Casa del Chirurgo with the addition of a range of rooms beyond those of the Sarno stone core of the property. These rooms were clearly separated off from the hortus and northern portico and may have been part of an early service area for the house. While the attribution of function is purely speculation, the fact that they were situated outside the core area of the property and in the space that later became the service area of the house makes this a likely assumption.

20.3.1 Cuts in the 'black sand'

The first actions undertaken in Phase 3 within AA612 were the excavation of two cuts into the black sand in the southern area of Room 16.[217] The first cut (612.049) had an approximate diameter of 0.91 m, while that to the north (612.054) was much smaller, at 0.27 m in diameter. They were subsequently filled with building materials intermixed with black sand that appears to have come from the pits themselves (612.037, **612.048, 612.054**). The precise purpose of the cuts is unknown, but it is likely that they were intended to recover natural soils for use in construction.

20.3.2 Construction of the walls of the Casa del Chirurgo

With the completion of the cuts and the recovery of the needed natural soils, construction could begin. The loose surface of the black sand itself experienced considerable disturbance and trampling at this time, perhaps suggesting that it was the surface upon which most of the work of building the Casa del Chirurgo was carried out (**612.027, 612.028**, 612.035[218]).

20.3.2.1 CONSTRUCTION OF WALL W06.068

On the western side of Room 16, wall W06.068 was built as part of the Sarno stone core of the Casa del Chirurgo. The space that later became Room 16 was beneath the southernmost part of the northern portico, which had

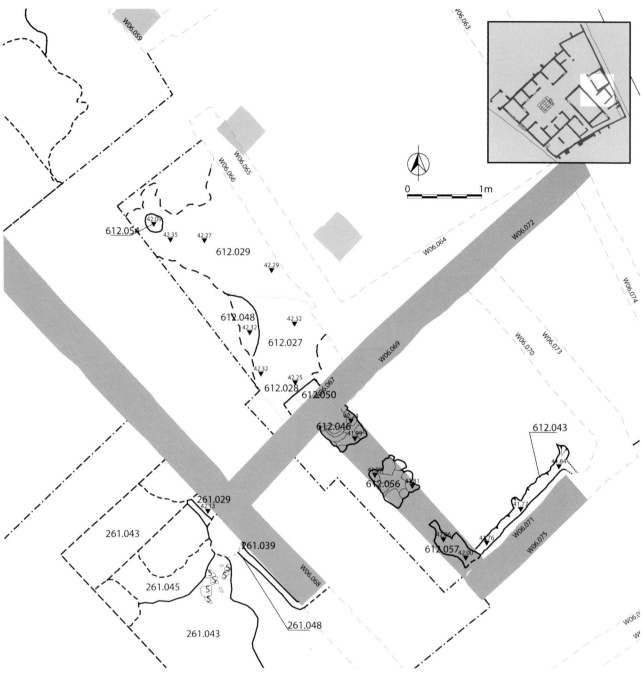

Figure 5.20.7. Plan of changes in Rooms 16, 17, and 18 related to the creation of the Casa del Chirurgo (illustration M. A. Anderson).

its southern terminus at wall W06.067. The lower three courses of the northern portion of wall W06.068 were built from large blocks of Sarno ashlar laid as *opus quadratum*. At its northern edge there are four courses, which are keyed into wall W06.061, the southern wall of the tablinum. The upper portion of the wall was built in *opus africanum* using 'quadratum-sized' blocks of Sarno stone for the framework. The Sarno rubble was bonded with a fine brown (10 YR 4/3) clay, similar to that used in all of the *opus africanum* walls from Phase

3. Excavations undertaken in Room 10 revealed that the foundation trench for the *opus quadratum/africanum* section of wall W06.083 continued for another c. 1.70 m beyond the apparent end of the *quadratum* wall. From the material in the foundation trench, it would appear that the wall continued on in smaller Sarno stone *opus africanum*. This would account for the rather jagged appearance of the southern end of the *quadratum* wall, which does not indicate the terminal point of a wall, but rather, was deliberately left rough to enable the keying

together of the more and less massively constructed sections. No plaster has been discovered that dates to this phase on wall W06.068.

20.3.2.2 CONSTRUCTION OF THE NORTH WALL OF THE 'SERVICE ROOMS' (WALL W06.067/W06.069/W06.072)
As part of the same phase wall W06.067/W06.069/ W06.072 was built in *opus africanum*. This wall effectively separated off the area of the hortus and the northern portico from the area that became the service area for the property. The foundation trench for wall W06.067/ W06.069 (612.051) was cut into the black sand and is best preserved on the northern side (although even here it was cut and partially obscured by the later robber's trench) (612.045). It is clear that the original wall continued across the whole space dividing the area of Rooms 17 and 18 from that of Room 16. The fill of the trench (**612.050**) was a black (2.5 YR 3/1) sand mixed with building rubble/pebbles similar to the fill of the southern wall. The wall itself was constructed in *opus africanum* using Sarno stone blocks for the framework and also for the rubblework, which was bonded with a yellow (2.5 Y 7/6) clay-like mortar containing occasional rounded black volcanic mineral fragments and smaller flecks of lime. The full original extent of this wall eastwards is not known, although it continued at least to the line of what became wall W06.073 – the later eastern boundary of the property. There are no surviving early plasters visible for this wall.

20.3.2.3 CONSTRUCTION OF THE SOUTH WALL OF THE 'SERVICE ROOMS' (WALL W06.071)
On the southern side of Room 17, wall W06.071 was built in *opus africanum*, the framework/stringers and fill of which are still visible in the standing architecture, although the wall was clearly reworked at a later date and repaired in mortared *opus incertum*. The cut for this wall (**612.043**) was roughly 25.6 cm wide and relatively uneven, suggesting that the stones were wrestled into place with some difficulty from the northern side (Fig. 5.20.8). The foundation trench was cut through earlier deposits and was filled (612.044) with a loose, dark brown (7.5YR 3/5) sandy silt intermixed with fragments of the lower deposits re-deposited in the fill with the addition some domestic debris. It is clear that a doorway was originally present in the wall at the eastern end since the foundation trench ends roughly 38 cm short of the final phase eastern wall (which was not present at this time). It is unclear whether this wall

Figure 5.20.8. (*Top*) Cut for wall W06.071, ending at the beginning of the original doorway that was later sealed (image AAPP).

Figure 5.20.9. (*Bottom*) Fragments of *opus africanum* foundations and part of the cut for wall W06.067/W06.069 (image AAPP).

originally continued further to the east beyond the doorway. There are no surviving early plasters visible for this wall.

20.3.2.4 CONSTRUCTION OF THE WALL SEPARATING ROOMS 17 AND 18 – DIVIDING UP THE 'SERVICE ROOMS'

The construction of walls W06.067/W06.069 and W06.071 would suggest that there were a number of rooms created as part of the initial construction of the house in the space that later became Rooms 15, 17, and 18. The only indication of dividing walls for these early rooms has been revealed through excavation, where the fragmentary remains of an *opus africanum* wall were found that separated off the area of Room 17 from that of Room 18. This wall (**612.046, 612.056, 612.057**) survives as fragments of foundations (Fig. 5.20.9).

20.4 Phase 4. Changes in the Casa del Chirurgo (c. 100–50 BC)

Phase 4 witnessed the first additions to the Casa del Chirurgo, in a phase of activity that focused on the northern side of the atrium and in the hortus, including the addition of Rooms 19 and 21. As part of these changes an eastern boundary wall (W06.118 and W06.119) was added to the property with a wide back door framed with large blocks of Sarno stone. The addition of this wall probably served to bring about the first set of structural changes to the original rooms in the area of Rooms 17 and 18 (Fig. 5.20.10).

20.4.1 The construction of Room 19 (wall W06.066)

Room 19 was constructed at the southern end of the hortus, using the early *opus africanum* wall W06.069/ W06.072 for its southern boundary. Although it is difficult to be completely certain, due to the extensive rendering and pointing of wall W06.059/W06.066 during the modern and early modern periods, the *opus testaceum* component of the northern end of the wall appears to be a later addition when extensive reworking of the room was undertaken in Phase 6. The main body of wall W06.066 was constructed in *opus incertum*, using predominantly Sarno stone and lesser quantities of cruma, tile, grey lava, and reused building materials, such as plaster. These were set in a hard white (7.5 YR 8/1) mortar containing angular black volcanic mineral fragments, cruma, and lime. It seems likely that the original room corner and doorway was situated in roughly the same location. Although the modern pointing precludes a definitive answer, it is suggested that the white marble threshold in the doorway into Room 19 would have been laid at the time of the room's construction.

20.4.2 The Phase 4 decorative plaster from Room 16

The structural changes in Rooms 16 and the addition of Room 19 would have required the decoration of these spaces. In the northern sector of wall W06.068, there is a small area of sandy light bluish grey (Gley 2 7/1) plaster with very occasional flecks of lime. This is a highly distinctive form of backing plaster that is often seen on walls either built during this phase, such as walls W06.047/W06.049 at the northern end of Room 16 and on wall W06.038 in Room 9, or those stripped of any earlier plaster and redecorated, such as the walls of the atrium (Room 5). It is invariably used as the first layer of plaster, perhaps with the intention of sealing the wall and creating a surface on which other backing plasters could be placed. At the base of the northern corner of wall W06.068 are traces of a white (5 YR 8/1) plaster with rounded inclusions of black volcanic sand. There is, unfortunately, no stratigraphic relationship of the plaster with the sandy light bluish grey plaster (although it directly underlies the backing plaster of the Phase 6 final decoration).

On walls W06.067 and W06.066, there are also several early layers of backing plaster that do not form neat stratigraphic relationships and for which a coherent interpretation is difficult. At the base of wall W06.067, at the junction with wall W06.066, there is evidence of a layer of plaster that runs around the joint between the two walls. It consists of a hard bluish grey (Gley 2 6/1) mortar with fine black volcanic mineral inclusions. There are, however, at least two other areas of plaster that are fixed directly to the *opus incertum* of wall W06.066, a highly weathered greenish grey (Gley 2 4/1) plaster composed mainly of black volcanic mineral fragments and a patch of light greenish grey (Gley 1 7/1) plaster containing rounded inclusions of beach sand and larger pieces of lime. It is possible that these are versions of the same backing plaster, which have weathered differently. Significantly, these early plasters appear to be overlain by a final layer of backing plaster composed of a white (7.5 YR 8/1) plaster with inclusions of translucent to light brown mineral crystals. This was overlain by a final layer of an almost identical plaster, which was flattened to create a surface that was incised with lines to guide the application of pigments for the creation of a final decorative surface. The guidelines created a series of isodomic courses of blocks, 90 by 39 cm, with an 8 cm wide border surrounding them. Overall, the effect is reminiscent of *opus quadratum*, and is suggestive of First Style wall decoration, although it should be noted that the blocks are flat and not in relief – as they would have been in true First Style. Given the date of construction of c. 100 BC, it is possible that this

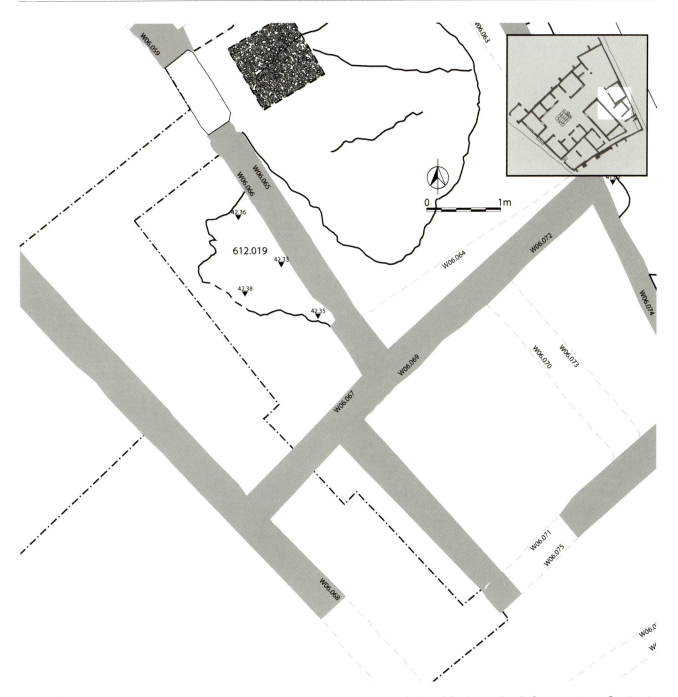

Figure 5.20.10. Plan of the architectural changes in Phase 4 in Rooms 16, 17, and 18 and the lowest level of *opus signinum* flooring in Room 16 (illustration M. A. Anderson).

was a low quality early Second Style plaster, imitating the older fashion. There are some traces of pigment, with the borders being a weak red (10 R 5/3) and the insides of the blocks yellow (10 YR 7/4) (Fig. 5.20.11, A).

20.4.3 First *opus signinum* floor (Room 16 only)
The southern end of Room 16 produced a series of three levels of *opus signinum* flooring (Fig. 5.20.12). The earliest of these appears to butt up against wall

W06.065/W06.066, the western wall of Room 19, and overlies its earliest surviving wall plaster. Both of these clearly date from the moment of the creation of the western wall of Room 19, an action that, on the basis of the dating of both the decoration of the wall plaster and the flooring inside Room 19, must have occurred at about 100 BC.[219] The *opus signinum* floor and sub-floor is found in Room 16 only and in varying degrees of preservation. In some cases only the degraded lower

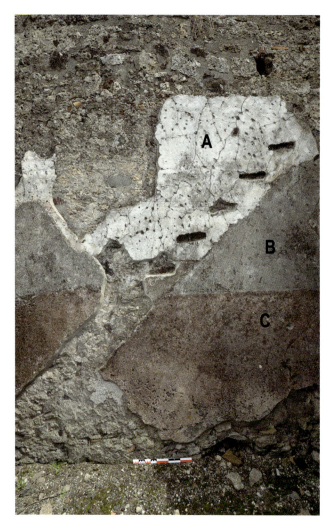

Figure 5.20.11. The surviving plaster decoration of wall W06.066. (A) Phase 4 plaster; (B) Phase 6 white plaster; (C) Phase 6 red plaster (image D. J. Robinson).

Figure 5.20.12. The earliest *opus signinum* floor in Room 16 (image AAPP).

parts of the floor (612.018) are visible with the upper surface (**612.019**[220]) having been worn away or removed. It is especially significant that the southern extent of this floor terminates at wall W06.067/W06.069, since this reinforces the fact that this wall did not contain a doorway at this time.

20.4.4 Rebuilding the rooms of the initial service wing
The construction of the eastern property boundary wall (W06.118 and W06.119) and rear entranceway during Phase 4 appears to have created the need to restructure the eastern end of the rooms of the original service wing.

20.4.4.1 REBUILDING WALLS W06.071 AND W06.068
This phase of rebuilding resulted in the large-scale reconstruction of wall W06.071 and its extension eastwards filling the doorway that provided access into

this room during Phase 3. The Sarno stone framework of the *opus africanum* version of the wall was reused and adapted to form the framework for a new doorway into the room, which is slightly offset to the west of centre of the wall as it stands today. This provided access into a wide room that was later subdivided to create Rooms 17 and 15. The remainder of the wall was rebuilt and extended using *opus incertum* with Sarno stone and cruma rubble bonded with a pale red (10 R 7/2) mortar containing angular black volcanic inclusions and crushed cruma as well as larger pieces of lime and cruma.

20.4.4.2 THE PHASE 4 DECORATIVE PLASTER IN ROOM 17/15
The original *opus africanum* wall that separated Rooms 17 from 18 was still standing at this time, which consequently resulted in two rooms occupying this space. The only evidence for wall plaster from this phase is associated with the large room that was later subdivided into Rooms 17 and 15 and comes from the junction between walls W06.070 and W06.069, where the later addition of wall W06.070 preserved the earlier plaster behind it. The preserved plaster consists of both backing and final plaster layers. The backing plaster consists of a 10 mm thick layer of white (Gley 1 8/N) plaster with angular black volcanic mineral inclusions and occasional larger pieces of lime. This was overlain with a thinner layer of pink (10 R 8/3) plaster containing crushed ceramic fragments and the occasional angular black volcanic mineral. This plaster was also seen on wall W06.073 in Room 15.

20.5 Phase 5. Redecoration and redevelopment (late first century BC to early first century AD)
The changes that the Casa del Chirurgo experienced during the late first century BC were profound and

included the considerable reworking of the service wing of the house. There was, however, little structural development of the rooms that comprised AA612 (Fig. 5.20.13) with the notable exception of the opening of a doorway at the western end of wall W06.067/W06.069. This allowed access from the area of the newly enlarged service wing to the rooms of the hortus.

20.5.1 The doorway in W06.067/W06.069 – Room 18 becomes a corridor

In the south-eastern service wing, the developments in Phase 5 were confined to the placement of a new *opus signinum* surface (**612.007**[221]) over a plaster and mortar sub floor (**612.016**) (Fig. 5.20.14). This surface is particularly important because it provides an indication of when the present opening between Rooms 16 and 18 was created. A similar lower *opus signinum* surface was recovered in the kitchen (Room 13), implying that the eastern range of rooms as a whole received this new pavement surface as a single action. No corresponding surface was found in Room 17 because the room had not yet been connected to the corridor on its west. However,

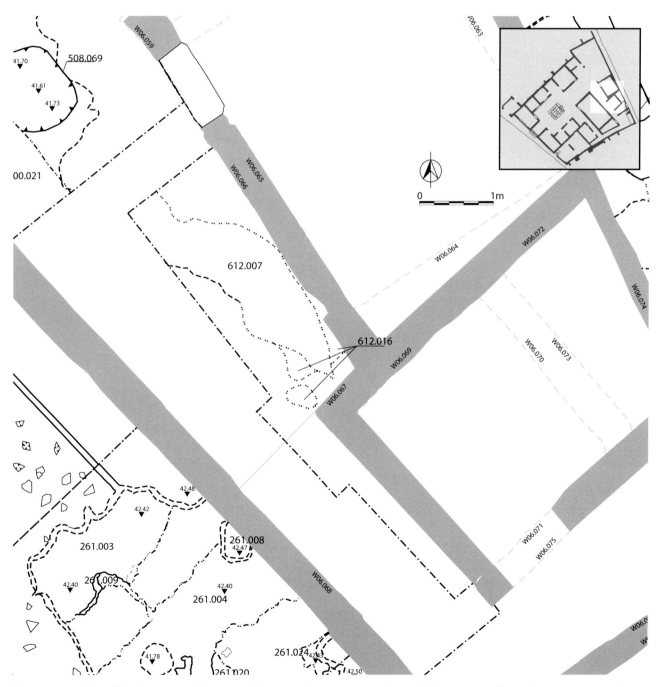

Figure 5.20.13. Plan of the deposits and features of Phase 5 in Rooms 16, 17, and 18, including a second layer of *opus signinum* in Room 16 and the opening of a doorway into Room 17 (illustration M. A. Anderson).

Figure 5.20.14. Second layer of *opus signinum* flooring in Room 16 (image AAPP).

the continuation of the *opus signinum* surface and subfloor from Room 16 through to the kitchen reveals that the opening through wall W06.067/W06.069 that exists today must have been open at this time. This provided a direct route from the kitchen to the dining rooms of the hortus. The doorway cut in W06.067 and W06.069 made use of a gap between the headers and stringers of the Sarno stone framework from Phase 3, leaving no traces of repair or patching. A rectangular slot was cut in the Sarno stones in wall W06.068, which probably represents to hole for the lintel of this new doorway. No plaster decoration has been recognised belonging to this phase in Room 18.

20.5.2 Developments in Room 16

Elements of the major structural changes taking place in the core part of the house can be seen at the northern end of wall W06.068, where there are two small patches of *opus incertum*. These were used to straighten up the edge of the wall, most likely following the removal of the rear wall of the tablinum. This was done using small pieces of Sarno stone and grey tuff set within a yellow (10 YR 7/6) mortar with volcanic mineral inclusions and larger pieces of lime.

No plaster decoration has been recognised belonging to this phase in Room 16.

20.6 Phase 6. Upper storeys and final decoration (c. mid-first century AD)

Phase 6 saw the creation of an upper storey over an area of the south-eastern part of the service wing, although the lack of preservation of the upper parts of the walls in this area makes it difficult to reconstruct its full extent. Within AA612, this caused a number of changes that served to interconnect these spaces into a coordinated structural form (Fig. 5.20.15). At the same time, the opportunity appears to have been taken to unite the service suite with a uniform flooring and a programme of wall decoration suitable to its utilitarian purpose.

20.6.1 Developments in Room 16

The changes in the southern part of Room 16 at this time are all related to the addition of the staircase and its dedication to a new service function, as evidenced by its utilitarian decoration.

20.6.1.1 THE ADDITION OF A STAIRCASE

The first step in these changes was the construction of the stairway that would lead up to the eastern wing of the upper storey. This involved the placement of a mortar footing to support a wooden stair (Fig. 5.20.16), which is awkwardly positioned on the eastern side of the stairs. The individual planks of the stair were then cut into the eastern wall, directly penetrating the pre-existing wall plaster. The stairs would have been supported on the western side by a wooden framework. The base was set in a deposit of loose rubble with dark greyish brown (10 YR 4/2) matrix (**612.034**), and an "L" shaped spread of mortar (612.033) that may have supported a wooden beam or post intended to bear most of the weight of the stairway. At this time, the northern end of wall (W06.059/W06.066) was reworked, with the addition of a quoin in *opus testaceum* designed to support elements of the new upper storey. Two large square holes, towards the top of the *opus incertum* of wall W06.059/W06.066, could have been beam holes related to these changes. The *opus testaceum* sections of the wall are composed of rows of brick/tile in two distinct thicknesses, c. 30 and 40 mm respectively. The brick/tiles were mainly 180 mm long, with some examples up to 250 mm, with smaller examples of more irregular lengths, representing perhaps brick/tiles that had been cut down to fit in to particular spaces. They were set within a hard pinkish white (7.5 YR 8/2) mortar with black volcanic inclusions.

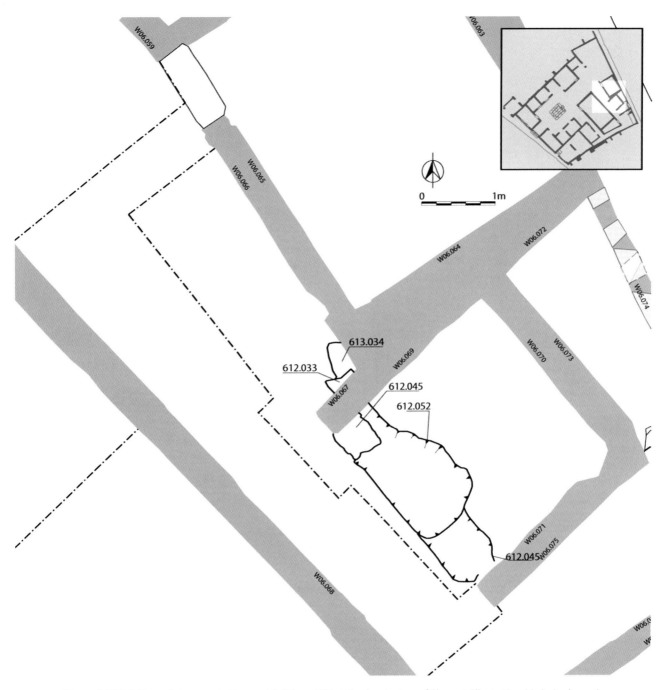

Figure 5.20.15. Plan of changes in Rooms 16, 17, and 18 at the beginning of Phase 6 (illustration M. A. Anderson).

20.6.1.2 PHASE 6 WALL PLASTER DECORATION

In the south of Room 16, the addition of an upper storey over the service area of the property, with a staircase built up against wall W06.066, created the necessity to re-plaster the walls in the room for a final time. The scar from the staircase is clearly visible in the surviving plaster on wall W06.066. The staircase was added to the wall when the Phase 4 plaster was still in place and the Phase 6 plaster added afterwards (Fig.

5.20.11). On wall W06.066, and also probably on wall W06.067, the final decorative surface of the Phase 4 plaster was picked prior to the application of the new backing plaster, whereas on wall W06.068, this final phase of backing plaster was mainly applied directly to the *opera africanum* and *quadratum* of the original wall. This indicates that here much of the previous phase of plaster had already been removed. Regardless of how the wall was prepared, the walls of Room 16 were then

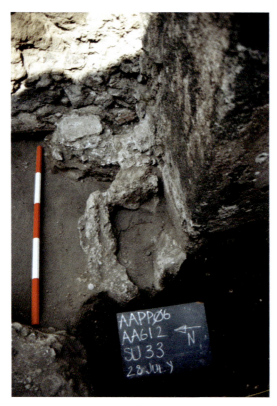

Figure 5.20.16 Mortar Footing for stairway posts (image AAPP).

covered with a 20 mm thick layer of coarse bluish grey (Gley 2 5/1) plaster with rounded black sand inclusions and larger pieces of lime (Fig. 5.20.17, A). On top of this, two further layers of final plaster were applied: first in the middle portion of the wall a white (2.5 Y 8/1)

plaster containing angular fragments of mineral crystal was added (Fig. 5.20.11, B), which was then followed in the lower portion of the wall by a red (10 R 5/6) plaster containing pieces of crushed ceramic and occasional small angular black volcanic minerals (Fig. 5.20.11, C). The dividing line between the lower red zone and the upper white was c. 1.4 m above the present floor surface. On wall W06.068, the plaster of the red lower zone overlies that of the middle, indicating that it was applied to the wall after this zone. In the northern sector of wall W06.068, opposite the doorway into Room 19, this plaster is incised with a circular geometric floral motif (Fig. 5.20.17, B). It is perhaps useful to note that the final *opus signinum* floor surface in the south of Room 16 was laid after the walls were decorated with the Phase 6 plaster.

20.6.2 Developments in Rooms 17 and 18
The redevelopment of the service wing in the mid-first century AD saw large-scale changes to the structure of the rooms, which took on their final form as two separate rooms: 17/18 and 15. It is also likely that the construction of an upper storey over this part of the service wing most likely necessitated alterations to the old *opus africanum* walls, which were heavily modified at this time.

20.6.2.1 REMOVAL OF ORIGINAL EASTERN WALL OF ROOM 18 – CREATION OF ROOM 17/18
A broad trench (varying from 0.65 m to 1.05 m in width) testifies to the significant job of removing the wall on the western side of Room 17 in this phase (Fig. 5.20.15).

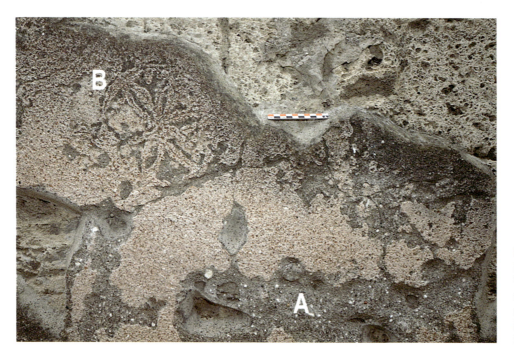

Figure 5.20.17. The Phase 6 backing and final plaster wall W06.068. (A) backing plaster; (B) final plaster with incised rosette design produced by a compass (image D. J. Robinson).

From the remains left behind, it would seem that the primary goal was to salvage any large Sarno blocks, presumably for reuse or perhaps resale elsewhere (they were seemingly not reused in other construction of this period in this house). This left behind a roughly circular cut (**612.052**) around what was probably an orthostat of the limestone framework and a linear cut (**612.045**) that removed the rest of the wall. The fills of these cuts (612.053,[222] 612.047[223]) contained re-deposited materials, including fragments of the lower strata that had been disturbed by this activity. Removing this wall served to damage the western end of wall W06.071. This was patched-up with courses of brick/tile set within a white (7.5 YR 8/1) mortar.

20.6.2.2 CREATION OF ROOMS 17/18 AND 15

The construction of the upper storey was also the catalyst for a major series of repairs to wall W06.069. It is possible that this was because this old *opus africanum* wall was now required to help support the weight of the new upper storey and needed strengthening.[224] This was undertaken by replacing much of the original clay-bonded rubblework with a combination of courses of brick/tile (Fig. 5.20.18, A), separated by areas of *opus incertum* using Sarno stone, cruma, and grey lava rubblework. This would have resulted in a much stronger wall. Both the brick/tile courses and the *opus incertum* were bonded together using a pink (7.5 YR 7/4) mortar containing angular black volcanic mineral inclusions, tuff, and lime. Two rectangular holes in the lower parts of the wall at 1.65 m and 1.5 m from the modern ground surface may have been related to the use of scaffolding during the construction of the upper parts of the wall. There is also a large, square hole that would have held a beam orientated north–south (Fig. 5.20.18, B).

The removal of the *opus africanum* western wall of Room 17 created a single large space that ran west–east from wall W06.068 to wall W06.73 – the eastern boundary of the house. This was then subdivided through the addition of wall W06.070, to create Room 17/18 and Room 15, which was developed as a latrine for the property. This new dividing wall was constructed from *opus incertum* using grey lava with black inclusions at the base of the wall and predominantly cruma in the upper portion. The transition between the two comes at c. 1.10 m above present ground level. The rubblework is set within a white (7.5 YR 8/1) mortar containing an aggregate of angular volcanic mineral fragments, red and black cruma, and occasional pieces of lime. An excessive quantity of mortar was applied to the wall in order to fill in areas around the rubble, and to present

a flat surface for the application of the backing plaster.

Precisely how the removal of the western wall assisted in the creation of upper storeys in the area is unclear. The original wall does not appear to have been in the way of the stairway construction and its removal would have taken away support from the upper storey on this side. Perhaps the primary reason was a desire to divide off part of the space for the creation of a toilet in Room 15, which was itself mirrored by a similar installation in the upper floor. This might have required an underlying load-bearing wall that predicated the removal of the original western wall of Room 17. Wall W06.071 also underwent significant changes at this time, since the removal of the western wall of Room 17 meant that access was now possible from the western side. It would appear that this end of the wall was damaged in the removal of the western

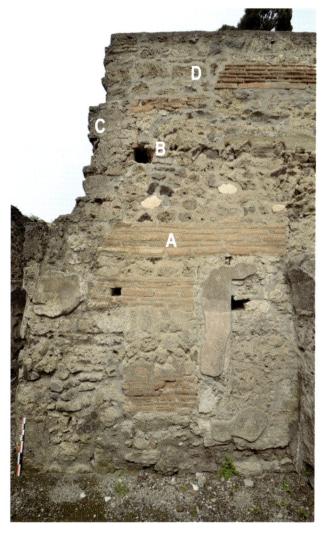

Figure 5.20.18. Wall W06.069. (A) brick/tile rebuild; (B) beam hole; (C) early modern render; (D) modern pointing (image D. J. Robinson).

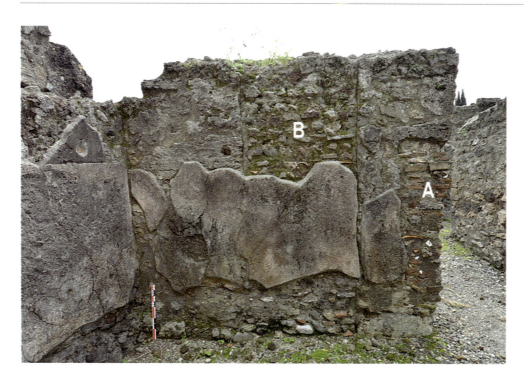

Figure 5.20.19. Wall W06.071. (A) Brick/tile repairs; (B) blocked doorway (image D. J. Robinson).

wall and was patched-up with courses of brick/tile set within the same white (7.5 YR 8/1) mortar used in the construction of wall W06.070. The Sarno block framed doorway was also filled as part of these changes. This was undertaken in *opus incertum* using a mixture of cruma, Sarno stone, grey lava, brick/tile, and ceramic. Unfortunately, due to the extent of modern pointing it is impossible to characterise the mortar that bonded this *incertum* together (Fig. 5.20.19, B), but it is likely to have been similar to that used to create wall W06.070 and repair the western end of wall W06.071.

20.6.2.3 THE PHASE 6 PLASTER DECORATION IN ROOM 17/18

The newly reconfigured Room 17/18 required a coherent scheme of decoration. As part of this phase, earlier traces of wall plaster appear to have been removed from wall W06.069, except where it was protected by the new wall W06.070 and W06.071. Following this a new layer of backing plaster was applied to all of the walls. This consists of a c. 20 mm thick layer of white (10 R 8/1) mortar with inclusions of rounded volcanic gravel. This was flattened at the surface in preparation for the application of a 2 mm thick layer of white (10 R 8/1) mortar. There is no trace of any colour on any of the surviving remnants of this surface. This phase of plaster covered the blocking *opus incertum* of the Sarno block framed doorway in the middle of wall W06.071, and the same backing plaster was found on wall W06.068. This would suggest that despite the route between the doorways in walls W06.069 and W06.071,

the entire area was considered as a single decorative space, however utilitarian that decoration may have been. No traces of this plaster on wall W06.068 were observed to the north of wall W06.069, the boundary between the hortus and the service wing, indicating that these had different decorative histories.

20.6.3 *Fills and* opus signinum

After the walls had been arranged according to the new plan, the entire area of Room 17/18 (including the rest of the service wing) was brought up to the same level by a series of dumps of building material and other detritus including a diverse set of fills consisting largely of building materials and other rubbish (612.021, 612.022,[225] 612.023,[226] 612.024, 612.025, 612.026) (Fig. 5.20.20, 5.20.21). The final layer consisted mainly of fragments of painted wall plaster, stucco, and mortar with smaller amounts other detritus (**612.010** = 613.007, 612.006). This sub-floor was then topped with the final layer of *opus signinum* (**612.017**,[227] **612.005**, 612.004 = 612.031). Two coins from beneath the *opus signinum* indicate that it could not have been poured prior to 9 BC, but the glass recovered from the same deposits provides a more useful *terminus post quem* of the middle of the first century AD.

20.7 *Phase 7. Post-earthquake changes*

It would appear that the area of the service wing was undergoing repairs and redecoration at the time of the eruption. Notably, in Room 11 there was a pile of lime suggesting that reconstruction was underway nearby

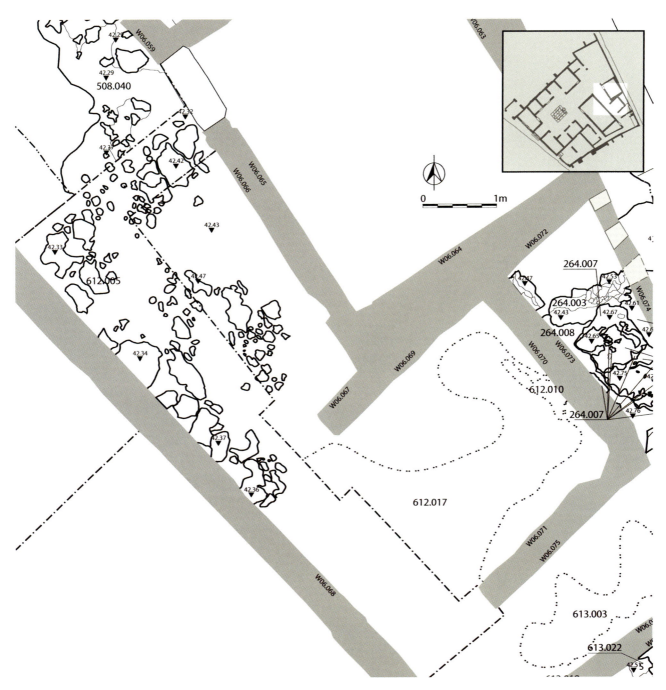

Figure 5.20.20. Plan of traces of the final phase of *opus signinum* flooring recovered in Rooms 16, 17, and 18. NB. Elements of this drawing have been sketched in from excavator notes due to the loss of drawings in field (illustration M. A. Anderson).

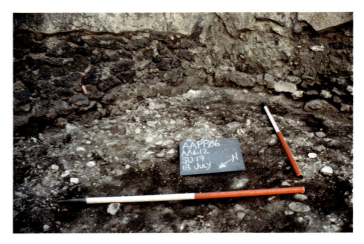

Figure 5.20.21. Sub-floor of plaster fragments visible in Room 17 (image AAPP).

Figure 5.20.22. Phase 6 final plaster directly overlain by Phase 7 plaster on wall W06.070. (A) Phase 6 backing and final plaster; (B) Phase 6 final plaster; (C) Phase 7 backing plaster; (D) Phase 7 final plaster (image D. J. Robinson).

and in Room 17/18, it would appear that the process of decoration was unfinished, but underway.

20.7.1 The Phase 7 plaster decoration in Room 17/18

Room 17/18 underwent a second phase of redecoration in the years around the middle of the first century AD, which is here assigned to the years after the earthquake of AD 62/3. On wall W06.071, the plaster of Phase 7 was applied directly over the top of the previous phase (Fig. 5.20.22, A and B). Throughout the room, the new layer of backing plaster is a light bluish grey (Gley 2 6/1) in colour with fine black volcanic

mineral inclusions and larger pieces of lime, which was applied as a single 10–20 mm thick layer (Fig. 5.20.22, C). In the lower register, this was overlain by a thin c. 3–4 mm layer of pale red (10 R 7/3) *opus signinum*-like plaster containing crushed ceramic fragments and occasional pieces of rounded black volcanic grit (Fig. 5.20.22, D).

It is notable that the lower register of the pale red plaster stops uniformly at 1.5 m above present ground level. Above this line there is a noticeable 2–3 mm 'step' between the lower final plaster and the upper backing plaster. It is consequently suggested that the upper

Figure 5.20.23. Phase 2 plaster on wall W06.070 showing the unfinished upper register (image D. J. Robinson).

area was unfinished and awaiting its final plaster coat at the time of the eruption (Fig. 5.20.23).

20.8 Phase 8. Eruption and early modern interventions

20.8.1 Early Modern wall restoration

20.8.1.1 WALL RESTORATION IN ROOM 16

A significant proportion of walls W06.059/W06.066 and W06.067 were given a protective covering of render. This comprised a coarse grey (Gley 1 6/1) mortar containing black volcanic sand with larger pieces of ceramic, lapilli, and lime. This was used both on the face of the walls and also in the doorway of wall W06.059/W06.066, where a version of it without the inclusions was used to point around the marble threshold. Here the two mortars blend seamlessly, suggesting that they were just one mortar with different quantities of inclusions used at the same time for different purposes, with the smooth version for 'fine work' around the doorway and the coarse as a render. The coarse version was also used to repair patches in the ancient fabric on wall W06.059/W06.066, where it was used as the mortar in a patch of *opus incertum* in the central portion of the wall, and on wall W06.067 where it was used to repair holes in the rubblework of the *opus africanum*. As part of the same campaign of restoration, a line of roof tiles was placed upon the top of the northern end of wall W06.068. These were set on a bed of light bluish grey (Gley 2 8/1) mortar with occasional lime inclusions, similar to the smooth version of the mortar used on wall W06.059/W06.066. The intention to undertake this work also resulted in the pointing or perhaps resetting of a small area of *opus africanum* rubblework underneath the tile course using the same mortar.

20.8.1.2 WALL RESTORATION IN ROOM 17/18

Walls W06.069 and W06.071 were extensively pointed with a light bluish grey (Gley 2 8/1) mortar containing a rounded coarse grit of black volcanic minerals, cruma, lime, and pieces of crushed tuff or lapilli. The same mortar was also used as a rendering layer (Fig. 5.20.18, C), evidence of which survives on the western side of the upper portion of wall W06.069. It is also possible that this mortar was used to rebuild the wall in this area, although the extent of the modern pointing makes it difficult to be certain of this.

20.8.2 Early Modern plaster conservation (Room 17/18)

There was an early attempt to patch and repair the degrading plaster surface of wall W06.070. This can be seen upper northern sector of the wall with the possible remains of a heavily corroded butterfly clip that would have been driven into the wall plaster to anchor it back to the wall.

20.9 Phase 9. Modern interventions

20.9.1 Modern soils and overburden in AA 612

Modern disturbances and interventions in the area were few, and restricted to the period after the original excavation of the Casa del Chirurgo. These were primarily overburden (612.008, 612.003, 612.002, 612.009, 612.011, 612.012, 612.014) and natural build-up from exposure, but also include several deposits that

might be the results of small fires (612.013, 612.015), possibly for the disposal of vegetation or other rubbish. All of these deposits contained large amounts of materials. Another modern intervention is a modern explanatory signpost and its rubble footing (612.036), designed to present the famous image of a woman painter taken from Room 19 (cf. Chapter 8). The final and most recent change in the area was the placement of gravel (612.001) for the protection of the underlying archaeology and to keep dust to a minimum.

20.9.2 1970's wall restoration campaign
20.9.2.1 WALL RESTORATION IN ROOM 16
As part of a major restoration campaign in Room 16, a new concrete lintel was placed above the doorway into Room 19 in wall W06.066. Any repairs that may have been made to the wall as a result of this are difficult to discern due to the modern pointing in this area. It may be significant to note that the wall directly over the lintel was pointed with a very pale brown (10 YR 7/4) mortar containing volcanic mineral inclusions and ceramic, which has weathered to a greyish brown (10 YR 5/2). This pointing extends over much of the northern end of wall W06.059/W06.066. It is most likely associated with the repair of the wall after the addition of the lintel. It should be noted, however, that this mortar is morphologically similar to those used in the early modern period and it is a possibility that it related to a phase of repair and re-pointing of wall W06.059/66 following the insertion of an earlier, perhaps wooden, lintel over the doorway. The upper section of wall W06.059/66 appears to have been extended upwards by up to 1 m, probably in order to add a roof over Room 19. This was done in *opus incertum* using predominantly Sarno stone with cruma, grey lava, and tile bonded with a greenish grey (Gley 1 5/1) mortar with lime inclusions. This mortar also appears to have been used to point wall W06.067.

20.9.2.2 WALL RESTORATION IN ROOM 17/18
The upper 0.5 to 1 m of wall W06.069 was most probably rebuilt with large blocks of Sarno stone and grey lava in association with the construction of the modern roof over Room 19. It was impossible to characterise the mortar used in this rebuilding due to the extent of more recent pointing.

20.9.2.3 PLASTER CONSERVATION IN ROOM 16
The restoration of the walls of the southern end of Room 16 took place prior to the application of a layer of light bluish grey (Gley 2 7/1) mortar with angular black volcanic inclusions to the edges of the surviving wall plaster. This mortar was also used to patch holes in the surface of the surviving plaster. This was a coherent phase of plaster conservation seen on all of the walls of Room 16.

20.9.2.4 PLASTER CONSERVATION IN ROOM 17/18
The surviving areas of wall plaster in Room 17/18 were edged with a light greenish grey (Gley 1 8/1) mortar containing angular volcanic minerals. This would have been undertaken as a conservation measure to help preserve the remaining plaster. A finer version of this mortar also appears to have been used to repair holes in the final plaster surface on walls W06.070 and W06.071.

20.9.3 2000's restoration campaign
20.9.3.1 WALL RESTORATION IN ROOM 16
Finally, the walls of the southern end of Room 16 were pointed with a coarse light bluish grey (Gley 2 7/1) mortar. On wall W06.068 this was applied around the edges of the large blocks of Sarno stone, while on wall W06.059/W06.066 it was also used to patch up around the doorway into Room 19.

20.9.3.2 WALL RESTORATION IN ROOM 17/18
The walls in Room 17/18 were pointed with a coarse mortar (Fig. 5.20.18, D) that varies in colour dependent upon its position in the wall and degree of weathering between a light bluish grey (Gley 2 7/1) and a bluish grey (Gley 2 5/1) and contains an aggregate of volcanic minerals, ceramic, tuff, and lime.

21. Room 19
Oecus (not excavated)

Description

Room 19 (Fig. 5.21.1) was constructed as a garden oecus at the southern end of the hortus. It measures 4.11 by 3.35 m. The room was built as part of a phase of redevelopment in the garden area of the Casa del Chirurgo that took place around 100 BC. This phase saw the enclosure of the area through the construction of property boundary walls to the north (W06.052) and east (W06.053) as well as the creation of Room 21.

The building of Room 19 utilised the east–west *opus africanum* wall (W06.069/72), from the initial build of the Casa del Chirurgo as its southern wall, and the property boundary wall (the continuation of W06.053 in Room 19 is denoted as W06.063) as its eastern wall. The room, however, was built square on to the hortus, resulting in wedge-shaped walls for the room when viewed in plan. This indicates that the pre-existing walls were thickened during the construction of Room 19. The room experienced no major change to its structure following this, aside from the rebuilding/construction of wall W06.062 during Phase 6. The complete *lithostroton* floor surface present in Room 19 resulted in no subsurface excavation being undertaken. Consequently, the interpretations of the development of the room presented here are based solely upon an examination of the walls and the plaster decoration.

21.1 Phase 1. Natural soils

No evidence of this period was recovered in this area.

21.2 Phase 2. Volcanic deposits and early constructions

No evidence of this period was recovered in this area.

21.3 Phase 3. The Casa del Chirurgo (c. 200–130 BC)

No evidence of this period was recovered in this area.

21.4 Phase 4. Changes in the Casa del Chirurgo (c. 100–50 BC)

Room 19 was constructed as part of a major phase of development in the Casa del Chirurgo in the area of the hortus that resulted in the creation of an enclosed, possibly formal, garden with two rooms – 19 and 21 – opening out on to it.

21.4.1 The construction of Room 19

Although there is little of the original wall visible due to the extensive preservation of wall plaster over the majority of wall W06.063, there are two small areas where square panels were cut out of the final Phase 6 plaster, taking with it much of the underlying backing plaster and exposing the underlying wall. Consequently, it is possible to suggest that wall W06.063 was originally constructed in *opus incertum* using Sarno stone and cruma set within a light bluish grey (Gley 2 7/1) mortar containing black volcanic mineral fragments and larger pieces of lime. It would appear that wall W06.063 was built up against the pre-existing southern boundary wall of the property (wall W06.0118, the Vicolo di Narciso façade). Perhaps this was due to the wish of the builders to create a room with walls perpendicular to each other, rather than at an angle, as they would have been had the southern boundary wall been simply reused.

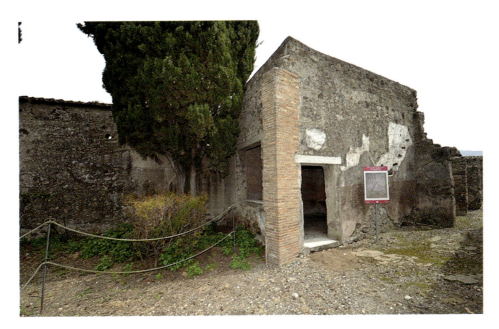

Figure 5.21.1. Room 19 (image D. J. Robinson).

It is also possible to note in the doorway into Room 19, that wall W06.065 was made from a mixture of Sarno stone, grey tuff, and cruma set in a hard white (7.5 YR 8/1) mortar containing black angular volcanic mineral fragments, and larger pieces of cruma and lime. Despite these slight differences in mortar between walls W06.063 and W06.065, it is assumed that they are contemporary and would have formed part of the initial build of Room 19. Although the evidence is obscured by both surviving plaster and the fact that much of the structure of Room 19 appears to have been rebuilt in Phase 6, it seems that the room originally did not have a northern wall, and instead opened directly onto the garden to the north. This would be analogous to the situation for Room 21 and would emphasise that the two were seen as a pair. After the completion of the walls, a highly unusual pavement, dated by Pernice to the 'Hellenistic' period,[228] comprising a mixture of white and black stones in a 'crazy paving' pattern was constructed in Room 19. A doorway on the western side was provided with a marble threshold that would seem to connect this activity with other marble thresholds added to the property at the same time (Room 7 and Room 10).

21.4.2 The Phase 4 wall plaster decoration
In the doorway at the western end of wall W06.062, there is evidence of an early phase of plaster consisting of both a backing and a final surface. It would appear that this earlier plaster was retained in the doorway, while the remainder of the room was redecorated during the mid-first century AD, although due to modern pointing, there is no direct stratigraphic relationship between the plasters. This interpretation therefore rests on the view that, as the doorway plaster does not have the high mineral crystal content characteristic of mid-first century AD Phase 6 plasters, it must belong to a previous phase. The plaster has been assigned here to Phase 4, although it is equally possible that it could also date to a period of redecoration in the room during Phase 5. Phase 4 is favoured as the most likely date of application because the backing plaster is similar to the main Phase 4 backing plaster from wall W06.066, and also because on this wall there are traces of redecoration that can be assigned to Phase 4, and then from Phase 6.

The same type of backing plaster seen in the doorway is also seen in section in the in the centre of wall W06.063, where a square panel of painting was removed from the wall. Here, it would appear that the plaster was composed of two layers, the first perhaps to seal the wall, the second to create a flat surface suitable

for decoration. The backing plaster is composed of a light bluish grey (Gley 2 8/1) plaster with small black volcanic mineral fragments and was up to 30 mm thick. This was overlain by a 2 mm thick layer of white (2.5 Y 8/1) plaster with no inclusions. In places, it has a pale yellow (2.5 Y 8/4) hue suggesting that a pigment may have been applied to this plaster.

21.5 Phase 5. Redecoration and redevelopment (late first century BC to early first century AD)
No evidence of this period was recovered in this area.

21.6 Phase 6. Upper storeys and final decoration (c. mid-first century AD)
21.6.1 The construction/reconstruction of wall W06.062
Wall W06.062 is almost entirely covered in wall painting and has been heavily restored during modern conservation campaigns in the area of the window. Nevertheless, from work in Room 20, it is possible to suggest that this wall and its window was constructed as part of the phase of development that saw the creation of the upper storey above the service area of the Casa del Chirurgo. While more detail on this is available in Room 20 (cf. supra), in Room 19 it is possible to discern that wall W06.062 was constructed from *opus incertum*, using predominantly Sarno stone and cruma set in a very pale brown (10 YR 8/4) mortar with angular black volcanic mineral fragments, along with larger pieces of crushed volcanic rock and lime.

21.6.2 The Phase 6 wall decoration
The middle of the first century AD witnessed considerable restoration of the upper structure of Room 19, most likely due to the addition of the upper storey rooms in the nearby surrounding areas of Rooms 16, 17, and 18, the stair to which was inserted into the western wall of Room 19. This phase of redevelopment also saw the addition of the northern wall to the room, which was provided with a large picture window that continued to provide an ample view onto the garden.

The walls within Room 19 were then entirely redecorated, forming the largest extent of surviving wall plaster in the Casa del Chirurgo, and the elements that were most commented upon at the time of its excavation. Although much of what remains in the room is the final decorative surface, nevertheless on walls W06.062, W06.063, and W06.065, there are small areas of a backing plaster underlying the final phase of wall decoration. For example, on wall W06.062, this can be observed where a piece of the final fresco surface has recently become detached from the wall. In the main bodies of the walls of Room 19, there are

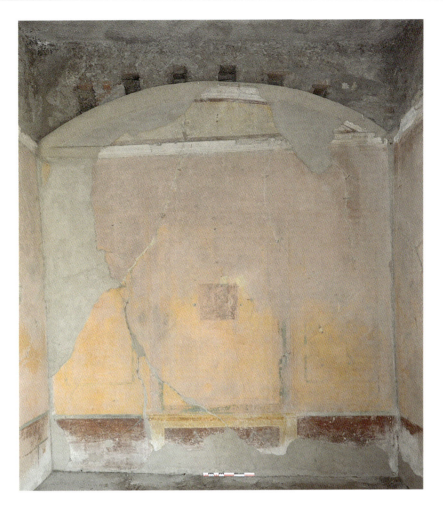

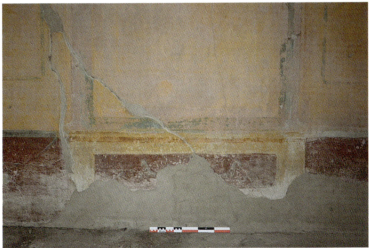

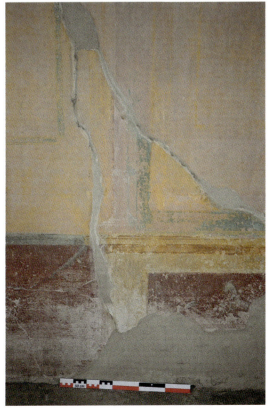

Figure 5.21.2. (*Top*) Stucco and Phase 6 plaster on wall W06.064. Also note the likely-reconstructed beam holes for the barrel vault (image D. J. Robinson).

Figure 5.21.3. (*left*) Dividing borders in the middle and lower zones of wall W06.064 with traces of a vertical column (image D. J. Robinson).

Figure 5.21.4. (*Right*) Lower and middle zones of wall W06.064 with columns, borders and animal decorations (image D. J. Robinson).

Figure 5.21.5. Embroidery border decoration on wall W06.064 displaying a pattern of five dots in a box (Barbet 1981 Type 50) (image D. J. Robinson).

Figure 5.21.6. Green foliage border in the lower panel of wall W06.063 (image D. J. Robinson).

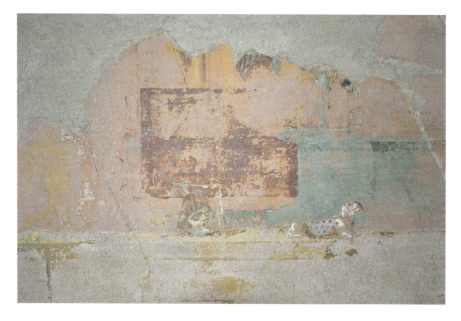

Figure 5.21.7. Decorative elements of a theatre mask and leopard on wall W06.063 (image D. J. Robinson).

no traces of final plaster from the previous decoration, which is likely to have been removed prior to the application of the new layer of backing plaster. In the doorway in wall W06.065, however, the earlier final plaster surface survives and is not covered by the next layer of backing plaster. It is possible that it was not removed because the wooden surround for the doorway covered it.

The largest extent of the Phase 6 backing plaster is visible on wall W06.063, where a c. 25 mm thick layer of light bluish grey (Gley 2 7/1) plaster with rounded black volcanic beach sand inclusions was applied to the wall. The same backing plaster is also seen on walls W06.062 and W06.065. Overlying the backing plaster are two different types of final plaster; a pinkish white (10 R 8/2) plaster containing small black angular volcanic mineral fragments, ceramic, and translucent mineral crystals in the lower zone of the walls, while in the middle and upper zones a white (10 R 8/1) plaster with mineral crystals was applied. The upper and middle zone plasters were applied to the wall before that of the lower zone. The dividing line between the plasters is at 0.64 m above the floor surface. Following, or as part of, the application of the backing plaster, stucco was applied in a horizontal band above the top of the upper zone of the painting, probably directly at the point from that which the hanging barrel vault would have sprung. This is at 3.15 m above the floor level. The stucco was formed of a bluish grey (Gley 2 6/1) plaster with black volcanic mineral inclusions and larger pieces of lime covered with a white (2.5 Y 8/1) plaster (Fig. 5.21.2). There is little evidence to suggest that pigments were applied to the stucco or that it was painted, apart from a thin band of dark red (10 R 5/6) around the top of the arch of the stucco on wall W06.064. Evidence of the hanging barrel vault is apparently clear in the northern and southern walls, which show signs of the joists that would have supported it. However, the presence of some discrepancies in how they would have aligned, suggest that at least some of these joist holes may be modern fabrications.

Pigments were applied to the final plasters to create a decorated fresco. On wall W06.062, the semi-circular portion beneath the barrel vault had a yellow pigment applied, giving it a reddish yellow (7.5 YR 6/6) colour at its darkest. Inside the semi-circle of stucco, there is a dark red (10 R 3/6) band. Beneath the stucco, a pale green (Gley 1 6/2) band runs around the edge of the central zone, also going vertically down the sides of the wall and horizontally across the dividing line between the middle and lower zones of the wall.

The band is c. 40 mm wide. It was applied after the background colours of the wall were applied to the middle and lower zones (Fig. 5.21.3). The main body colour of the middle zone today is a reddish yellow (7.5 YR 6/6) at its darkest and is weathering back to the white (10 R 8/1) of the final plaster surface. The main body colour of the lower zone is today a dark red (10 R 3/6) at its darkest and is also weathering back to the white of the final plaster. On wall W06.062, the window was bordered with a 45 mm wide band of dark red (10 R 3/6)

In general, the wall painting in Room 19 is divided into three main zones, horizontally and vertically, where the central zone is the widest and divided from the others by two painted decorative pilasters (Figs. 5.21.2 through 5.21.4). There are square paintings in the middle panels, and two small (11 cm in diameter) roundels on either side of them, apart from on wall W06.062, where the window serves as a proxy for the central panel. On wall W06.064, it can be seen that the roundels were surrounded by a 20 mm wide decorative border in pale green (Gley 1 6/2) with white (Gley 1 8/N) rectangular boxes (c. 14 mm by 10 mm) containing five white dots (Fig. 5.21.5). In the lower panel, beneath the roundels, there appears to be a garland of green foliage and box decoration, which is also seen on wall W06.063 (Fig. 5.21.6). In the central part of the lower panel, there is a wide border delineating a dark red panel in which there are two symmetrically arranged creatures painted in green (Fig. 5.21.4).

Of the three main colours used on wall W06.063 on the decorative border between the lower and middle zones, the stratigraphic relationships between the colours indicate that the dark red lower background was painted first, followed by the reddish yellow middle zone, then pale green, with the detailed decorative features such as the theatre mask and leopard being painted last (Fig. 5.21.7).

21.7 Phase 7. Post-earthquake changes

No evidence of this period was recovered in this area.

21.8 Phase 8. Eruption and early modern interventions

21.8.1 Wall conservation

The edges of the window in wall W06.062 were conserved using a white (Gley 1 8/) mortar containing black volcanic minerals, ceramic, cruma, lime, and lapilli, which weathers to a greenish grey (Gley 1 6/1) colour. The same mortar was also used to render the edge of the doorway in wall W06.065.

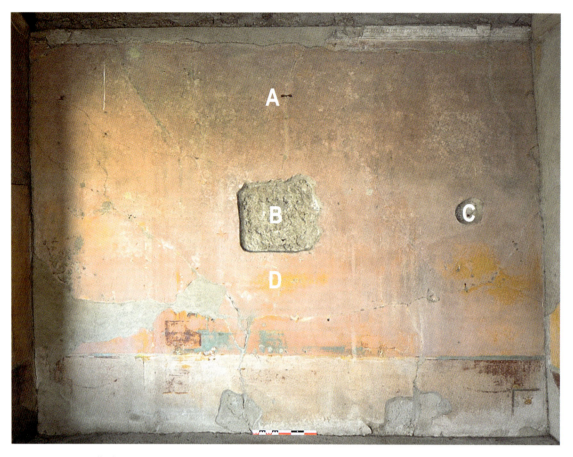

Figure 5.21.8. Surviving wall plaster on wall W06.063. (A) butterfly clip; (B) removed square panel painting; (C) removed circular panel painting; (D) area of graffiti (image D. J. Robinson).

21.8.2 Plaster conservation

Butterfly clips were hammered through the surface of the plaster as an attempt to keep the surviving wall painting attached to the underlying fabric of the wall; on walls W06.063 (Fig. 5.21.8, A), W06.064 and W06.065, 20, 17 and 27 clips were used respectively. The insertion of these clips, or their decay, was probably a major causative factor in the large cracks in the plasterwork, which almost invariably link up the clips. It was also during this early period that the central square and circular panel paintings were removed from wall W06.063 (Fig. 5.21.8, B and C).

An early conservation attempt to repair the wall plaster is the use of white (10 YR 8/1) mortar with black volcanic mineral inclusions, which was used to fill a crack in the plaster beneath the central square panel of wall W06.063. This mortar appears to have been coloured to match the surrounding plaster and is today a very pale brown (10 R 8/4) colour. The conservation measure cuts across a graffito dated 1799 and is therefore later than this date (Fig. 5.21.8, D).

21.9 Phase 9. Modern interventions

21.9.1 1970's restoration campaign

21.9.1.1 WALL RESTORATION

The upper part of the room above the line of the surviving stucco decoration was rebuilt in *opus incertum* using mainly Sarno stone, with cruma, grey lava, and brick/tile that was set within a greenish grey (Gley 1 5/1) mortar with lime inclusions. This was undertaken in order to build the roof over Room 19. It would appear that at least some of the 'beam' holes in walls W06.062 and W06.064 were created, or substantially rebuilt at this time, although due to the extent of modern pointing it is difficult to be certain whether they are ancient or simply modern creations. It is also likely that the reinforced lintels over the doorway in wall W06.065, and the window in wall W06.062, were put in place at this time. Due to the extent of modern pointing, it is difficult to know whether this replaced early modern, probably wooden, lintels, or what damage to the walls the insertion or removal of these lintels may have caused.

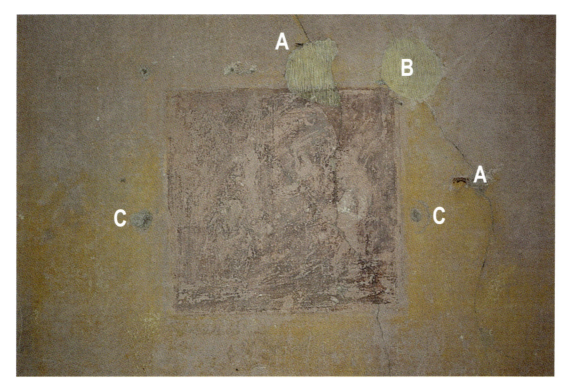

Figure 5.21.9. Central panel painting on wall W06.064. (A) removed butterfly clips; (B) striped restoration; (C) screw holes to hold pain of glass (image D. J. Robinson).

21.9.1.2 PLASTER CONSERVATION

It is likely that the majority of the butterfly clips had their 'wings' removed, although this process occasionally left part of the metallic shaft of the clip still protruding from the surface of the plaster (Fig. 5.21.9, A). The cracks and holes around the clips were filled with a smooth base mortar that had different pigments mixed into it so that it matched the colour of the surrounding wall. This restoration, however, was lightly striped to enable its easy identification as a modern repair (Fig. 5.21.9, B). During a slightly later restoration, a fine light bluish grey (Gley 2 8/1) mortar was used to repair a number of cracks within the mortar and to cover the edges of parts of the surviving plasterwork on walls W06.063 and W06.065. Two small holes either side of the square central panel of wall W06.064 would suggest that a pane of glass once covered the painting to protect it from damage (Fig. 5.21.9, C). It is probable that the glass was part of a modern restoration campaign, but it is likely that it was removed following the addition of the roof over Room 19, when the glass would no longer have served any protective function for the painting.

21.9.2 2000's restoration campaign

Room 19 underwent a second major restoration campaign that saw the upper modern reconstruction of wall W06.065 pointed with a rough light bluish grey (Gley 2 7/1) mortar. This was also used to resurface the ceiling. The lintel above the doorway in wall W06.065 was given a coat of the same mortar, which was also used on the lintel over the window in wall W06.062 and to point around the doorway and on the main part of wall itself. Holes in the surviving wall plaster, especially around floor level, were filled with a thick render of light greenish grey (Gley 1 8/1) mortar with white sand fragments and angular black volcanic minerals. This was also used to repair cracks and holes in the surface of the plaster and around the doorway. At the top of walls W06.064 and W06.065, the area of stucco was repaired with a very pale brown (10 YR 7/3) version of the same sandy mortar. The window lintel was then given a second coat of the very pale brown sandy mortar.

22. Room 21
Diaeta or Storeroom (not excavated)

Description

Room 21 is located at the northern end of the hortus of the Casa del Chirurgo. It measures 2.01 by 2.70 m and was constructed around 100 BC as part of a sequence of building that closed the formerly wide eastern doorway of Room 9 and created Room 21. This was part of the first main structural development in the house following its construction. The new room was open to the hortus (Room 20) to the east through a wide doorway that ran the full width of the room, with a smaller doorway at the eastern end of wall W06.044/45 providing access from Room 16. This arrangement was changed when Room 21 took its final shape with the construction of wall W06.043, filling in of the wide eastern doorway, in the late first century BC. The room was given a third, and final, layer of wall plaster in the mid-first century AD, when it most likely had a service function, given its plain red and white utilitarian decoration (Fig. 5.22.1). Upon initial cleaning, it was immediately clear that there was an intact *opus signinum* floor surface in Room 21, and that excavation would not be pursued. Consequently, all of the interpretations contained within this section are based upon the examination of the walls and the decoration.

Figure 5.22.1. Room 21 from the *hortus* (image D. J. Robinson).

22.1 Phase 1. Natural soils
No evidence of this period was recovered in this area.

22.2 Phase 2. Volcanic deposits and early constructions
No evidence of this period was recovered in this area.

22.3 Phase 3. The Casa del Chirurgo (c. 200–130 BC)
No evidence of this period was recovered in this area.

22.4 Phase 4. Changes in the Casa del Chirurgo (c. 100–50 BC)
Room 21 was built as part of the first coherent phase of structural additions to the Casa del Chirurgo, which aimed at developing the space around the newly enclosed hortus. Room 19 was also built at this time.

22.4.1 The construction of Room 21
Room 21 was built in the space previously occupied by the northern end of the eastern Sarno stone portico. Its construction appears to have made use of two Sarno stone pilasters from the original construction of the Casa del Chirurgo as the endpoints for walls W06.042 and W06.044/W06.045. Whether these pilasters remained in situ for the construction of Room 21, however, is difficult to determine with certainty. While the spacing between them does suggest that they originally pertained to the portico, the only still extant pilaster from Phase 3 (W06.050) is a monolithic block of Sarno stone, whereas the northern most pilaster is made out of two blocks. Consequently, it is possible that this part of the eastern portico was removed during the phase of construction in the area of the hortus of the Casa del Chirurgo, and its elements were simply reused in the walls of Room 21.

The northern wall of the room (wall W06.042/ W06.056) ran from the pre-existing Sarno stone *opus africanum* wall of Room 9 (wall W06.037) to the northern pilaster, before bending eastward again along the property line producing the house's characteristic 'kick.' Whether this replaced an earlier division between the properties is unclear, but it seems likely that the creation of the present boundary wall served as the motivation for the creation of Room 21, since the two were created as part of the same activity and share the same construction characteristics. These are built from Sarno stone *opus incertum* bonded with a soft very pale brown mortar (10 YR 8/2) with black angular mineral fragments and a small amount of crushed tuff and lime incorporated into the mortar matrix. The excess mortar between the stones was smoothed around the edges to

Figure 5.22.2. Wall W06.044/ W06.045 details of construction and decoration. (A) excess mortar used in construction; (B) Phase 5 backing plaster; (C) Phase 6 final white mineral crystal rich plaster (image D. J. Robinson).

create a flatter surface for the *incertum*, presumably to create an even surface for the application of wall plaster (Fig. 5.22.2, A).

As part of the same phase of construction, wall W06.046/W06.038/W06.051 was constructed across the eastern side of Room 9, sealing it from room 21 and cutting off its access to the hortus. Room 21 itself was left open on its eastern side, which is confirmed by flooring that butts up against wall W06.044/W06.045 but runs under the later closure (W06.055). It is less clear whether the present entrance to the Room at the eastern end of wall W06.044/W06.045 was an original feature. As there is no obvious ancient squaring up of the wall, which would indicate a repair following the cutting of a doorway, it seems likely that the door was a feature of the initial layout of this room.

22.4.2 The Phase 4 decoration

There are occasional traces of a light bluish grey (Gley 2 7/1) plaster on walls W06.042, W06.044/45, and W06.046. This was composed of a white mortar base with black mineral fragment inclusions. On wall W06.046, the surface of this backing plaster layer was smoothed in preparation for the application of a white (10 YR 8/1) pigment. The presence of three small pick marks on this surface (preparatory measures for the application of a subsequent plaster phase) indicates that, although comparatively roughly finished, this was likely to have been the initial decorative layer for this wall and the entire room.

22.5 Phase 5. Redecoration and redevelopment (late first century BC to early first century AD)

22.5.1 Construction of wall W06.043

It would appear that the wide eastern doorway to Room 21 was abandoned in the late first century BC, and the space filled with a new wall (W06.043) that was built in *opus incertum* using Sarno stone, grey lava, cruma, and yellow tuff, bonded with a soft pale yellow (2.5 YR 8/4) mortar with occasional black mineral and lime fragments. The pouring of the concrete floor in Room 21 preceded the construction of this wall. It is noted that this floor can also be observed in the threshold of the doorway in wall W06.044/W06.045, indicating that it was open at the time that the floor was poured. Consequently, if this doorway was not part of the original plan of the room, it was certainly in place by this point.

22.5.2 The Phase 5 decoration

There are faint traces observable in the lower portion of wall W06.043, of an initial layer of wall plaster. These highly weathered remnants only survive on the surface of some of the *incertum* blocks and are not a coherent layer. The plaster has a white mortar base with intense black volcanic mineral fragments and occasional ceramic and larger pieces of lime, giving it a light bluish overall appearance (Gley 2 8/1). This layer of plaster is of the same composition as that identified as the second layer of wall plaster on walls W06.042, W06.044/W06.045 (Figs. 5.22.2, B and 5.22.3, A), and W06.046, indicating that wall W06.043 was built prior

to the second plastering event in Room 21. Indeed, it is likely that the construction of wall W06.043 would have necessitated the redecoration of the room. On wall W06.046, the initial rough white plaster from Phase 4 was picked towards the top of the wall so as to help the next layer of plaster to bond with the previous layer. This second plaster layer could be up to 6 cm thick and was carefully smoothed to create a final surface. It should be noted that the *opus signinum* floor of Room 21 was laid after the construction of wall W06.043, as there were traces of the Phase 5 plaster for wall W06.043 attached to the upper surface of the floor. This would suggest a sequence of construction that involved the build of wall W06.043, followed by the laying of the floor, and then the plastering of the wall.

22.6 *Phase 6. Upper storeys and final decoration (c. mid-first century AD)*

22.6.1 *The Phase 6 wall decoration*
In preparation for the final decorative event in Room 21, it would appear that the final surface of the previous plaster layer was removed. This is seen in a series of striations in the surface of the previous plaster on wall W06.046. These are regularly spaced, approximately 10 mm apart, suggesting that the tool used in this work was something that had a set of teeth designed to scrape off the face of the plaster and leave the underlying backing plaster relatively unscathed.

A fine pinkish white (7.5 YR 8/2) plaster, with mineral crystals of up to 2–3 mm in size and ranging in colour from translucent to light brown, was then applied to the wall. This was flattened to create the final

surface. In the middle register, this was a pinkish white colour (7.5 YR 8/2) (Figs. 5.22.2, C and 5.22.3, B). The lower register, which was applied after the middle one, had a slightly different mortar composition, containing smaller quantities of mineral crystals and an increased amount of small black inclusions mixed with ground up ceramic material, which gave the plaster an overall pale red appearance (10R 7/3) (Fig. 5.22.3, C). A dark red (10 Y 4/6) pigment for the fresco was then applied to the wet plaster. The weathering of the red pigment has revealed numerous horizontal striations that could indicate that the pigment was roughly applied with a brush. No trace of the final decorative surface was observed on wall W06.043.

22.7 *Phase 7. Post-earthquake changes*
No evidence of this period was recovered in this area.

22.8 *Phase 8. Eruption and early modern interventions*
22.8.1 *Wall reconstruction*
There is evidence that, at some point during the first excavation, several of the surviving walls of Room 21 were partially rebuilt or levelled up. This can be seen in the upper portions of wall W06.043, where the large blocks of Sarno stone, particularly those that were set upon a flat tile, suggest a secondary phase of construction from the primary build of the wall. Similarly, on wall W06.042, much of the middle and upper parts, especially on the western side, were rebuilt in *opus incertum* rubblework, predominantly utilising Sarno stone, with some grey lava and cruma and notably a large piece of white limestone. The upper

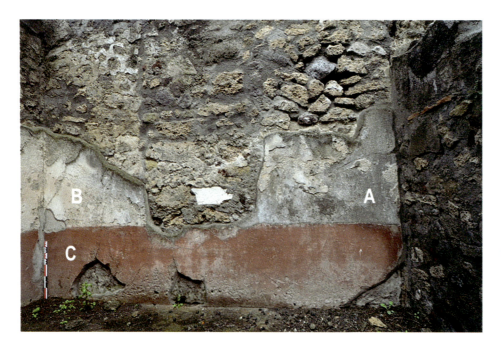

Figure 5.22.3. The final decorative phase of wall W06.042. (A) Phase 5 backing plaster; (B) pinkish white middle register; (B) dark red lower register (image D. J. Robinson).

portion of wall W06.044/W06.045 was similarly restored to a consistent height using a range of different stones, including cruma, Nocera tuff, grey lava, and fragments of tile. All of these repairs were bonded with a similar light bluish grey mortar (Gley 2 8/1) with small black volcanic minerals, black cruma, and tuff. The same mortar was also used to point around the doorway into Room 16 in wall W06.044/W06.045. At the top of wall W06.044/W06.045, and extending onto wall W06.046, this mortar was also used as a render, and a layer of roof tiles were set upon a thick bed of it, following the rendering of the walls. It should be noted that although the mortars of the rendering layer are virtually identical on walls W06.042, W06.044/W06.045, and W06.046, the stratigraphic relationships between the mortars on the individual walls suggests that the job of rendering and capping the walls of Room 21 began with wall W06.046.

22.9 Phase 9. Modern interventions

22.9.1 1970's restoration campaign

A hard light bluish grey mortar (Gley 2 8/1) with frequent black inclusions was applied to the edges of the exposed wall plaster as a conservation measure on walls W06.042, W06.044/W06.045, and W06.046. The same mortar was also used to fill in the occasional crack and hole in these final plaster surfaces.

22.9.2 2000's restoration campaign

The exposure of wall W06.046 to the elements caused in the *opus incertum* in the middle and upper portions of the wall to become unstable and come away from the wall leaving an elliptical hole. This was repaired in *opus incertum* (probably using much of the original rubble) set within a light greenish grey mortar (Gley 1 7/1). The mortar was relatively soft and contained crushed black pumice of up to 10 mm in length with the occasional piece of lime. A final modern attempt at consolidation involved the re-pointing of all of the walls of Room 21 with a roughly applied coat of bluish grey mortar (Gley 2 5/1).

23. Room 22
Light well (AA263)

Description

Room 22 is located between Room 23 and the southern plot boundary wall of the Casa del Chirurgo. It was part of the service wing of the house and was built during the same phase of construction as Room 23 at the end of the first century AD. The room measures roughly 2.92 by 1.14 m (Fig. 5.23.1). Following its initial construction, there were no significant changes to the structure of the room, although its function changed. At the time of its construction, Room 22 provided access to the cistern located in this area of the property that possibly dates from the time of the Pre-Surgeon Structure (Phase 2). The room may have acted as a form of water collection basin. A phase of repair in the mid-first century AD saw the raising of the surface in the room and the closure of the cistern shaft with an *opus incertum* floor surface. While no longer feeding the cistern underlying Corridor 12, the space was still used to collect water from the light well and probably the surrounding roofs. The water was channelled eastwards down the southern arm of Corridor 12 into a cistern in the kitchen (Room 13). The room lies at the western end of the southern part of Corridor 12 and in many ways it is an extension of this space, mirroring it in width.

Archaeological investigations

Excavations in Room 22 were conducted during the summer of 2003 (AA263) and covered the entire extent of the room.[229] Due to the discovery of a deep, partially filled cistern, it could not be excavated to any great depth for concerns over safety and the preservation of the standing remains. The standing architecture was recorded as part of the documentation of the room during its initial excavation, and then checked on subsequent architectural seasons in 2009 and 2013.[230]

23.1 Phase 1. Natural soils
No evidence of this period was recovered in this area.

23.2. Phase 2. Volcanic deposits and early constructions

The area that later became Room 22 was formerly a part of the Pre-Surgeon Structure. This can be seen most clearly in the adjacent Room 23, where there is evidence for an early 'impluvium' feature. This appears to have been constructed with at least one cistern.

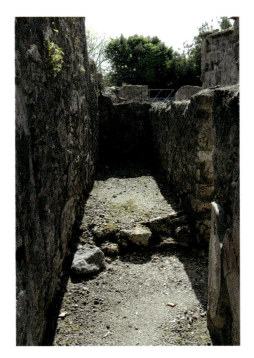

Figure 5.23.1. Room 22 (image D. J. Robinson).

That discovered in Room 22 may represent a second such cistern.

23.2.1 The cistern shaft of the early impluvium feature in Room 23

While no deposits from Room 22 were recovered from this phase, it is possible that the cistern (**263.039**) in this space was originally constructed as a component of the Pre-Surgeon Structure (Fig. 5.23.2). Visual similarities in construction techniques between this cistern and that recovered in Corridor 12 may suggest a contemporaneous construction date, although far too little information was recovered to be certain.

Figure 5.23.2. Interior of the cistern in Room 22 (image AAPP).

23.3 Phase 3. The Casa del Chirurgo (c. 200–130 BC)

Phase 3 saw the destruction of the Pre-Surgeon Structure and the creation of the core of the Casa del Chirurgo, which involved substantial redevelopment in the area of Room 22.

23.3.1 The construction of the southern plot boundary wall

The southern wall of Room 22, wall W06.095, was built as part of the original construction of the Casa del Chirurgo, as the southern boundary wall of the plot (Fig. 5.23.3). It was built in *opus africanum* using Sarno stone for both the framework and also for the sub-square to sub-rectangular rubblework. Although heavily weathered out, it would appear that the rubble was bonded together with a very pale brown (10 YR 7/4) clay with flecks of lime and sub-rounded gravel of various colours. The construction of the southern plot boundary wall does not appear to have affected the cistern of the previous phase, which, if present, seems to have simply had its access point raised in tandem with that recovered in Corridor 12.

23.3.2 Phase 3 plaster

There is no evidence on wall W06.095 to suggest that the *opus africanum* wall was plastered. Wall W06.095 continues to the east where, in Corridor 12, it is defined as wall W06.093. On wall W06.093 however, there are traces of an initial layer of *opus signinum* plaster. Consequently, it is suggested that this would have continued across the entire length of walls W06.095/ W06.093.

23.4 Phase 4. Changes in the Casa del Chirurgo (c. 100–50 BC) in the Casa del Chirurgo

No evidence of this period was recovered in this area.

23.5 Phase 5. Redecoration and redevelopment (late first century BC to early first century AD)

This phase of development in the house saw the construction of the southern commercial unit, the extension of Room 10, and the development of the service wing, all of which impacted upon the space that now became Room 22 (Fig. 5.23.4).

23.5.1 Construction of walls W06.096 and W06.094

The creation of a new commercial space to the west of this area (Rooms 3 and 4), combined with necessary construction to support a new upper storey over these areas, produced considerable change in the areas of Room 23 and 22, serving to define these rooms for the first time. In Room 22, wall joints suggest that wall W06.096 was initially constructed by cutting off the space that became the southern commercial unit from the service wing. This was followed by wall W06.094, which separated the space into Rooms 22 and 23. Both walls were both built using the *opus incertum* technique with sub-square pieces of grey lava with black particles, Sarno stone, and cruma. They were also bonded together with a clay-like pale brown (10 YR 6/3) mortar containing very fine flecks of lime. At the base of the eastern corner of wall W06.094 there is a large Sarno stone block. Another, smaller Sarno stone block was placed on top to create a square corner, which may

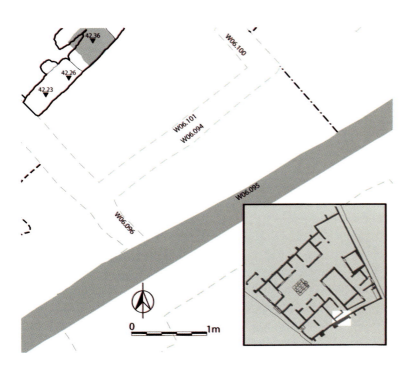

Figure 5.23.3. Plan of the area of Room 22 during Phase 3. Due to the uncertainty of the presence of the cistern in this phase, it has been omitted in the plan (illustration M. A. Anderson).

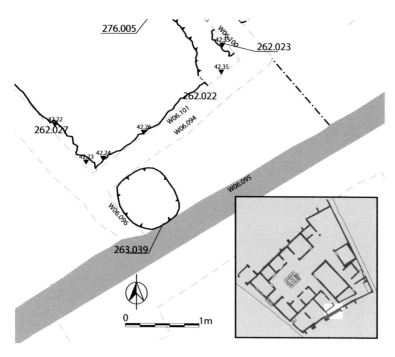

Figure 5.23.4. Plan of the changes to the walls around Room 22 in Phase 5 (illustration M. A. Anderson).

have continued up the wall in its original build. The large Sarno block was also used to form the base of the northward projection of wall W06.120. This would indicate that walls W06.094 and W06.120 were built at the same time in the co-creation of Rooms 22 and 23. Room 22 was intended as a light well to illuminate to the otherwise dark, narrow and enclosed spaced of Corridor 12. Initially, the water collecting in the convergence of roofing around this light well appears to have been channelled into a cistern below the room. If the cistern (**263.039**) had been originally created in Phase 2, then it was simply reused at this time. Otherwise, the cistern represents an addition of this phase (Fig. 5.23.2). A tile visible in wall W05.002, may suggest that the cistern overflow ran into Room 4 to the west, where a water collection or disposal feature was also put into place at this time.

23.5.2 The Phase 5 decoration
On the face of a large Sarno stone block and the lowest portions of the western end of wall W06.094, is a layer of plaster with a flattened final face. This was applied as a single, 5 mm thick, layer of grey (10 YR 6/1) plaster containing coarse inclusions of rounded volcanic minerals and the occasional piece of lime. The same plaster survives at the foot of wall W06.096 where it adheres to the *opus africanum* structure of the wall. This indicates that prior to the application of this plaster, the previous Phase 3 *opus signinum* plaster would have been removed. It is important to note that this layer of plaster can be observed as a coherent layer down to the level of the cistern shaft. Consequently, it is suggested

that the floor surface of Room 22 in Phase 5 was up to 0.5 m lower, and may indicate that at least the western end, and probably all, of the room may have acted as a water collection basin to feed the cistern below.

23.6 Phase 6. Upper storeys and final decoration (c. mid-first century AD)
In tandem with the addition of new pavements to much of the service wing of the Casa del Chirurgo, the cistern below the light well in Room 22 was closed in this phase, and water from the roof was directed via a conduit to a new cistern in the kitchen (Room 13). The blocking of the cistern head and the raising of the floor level marks the end of use for the cistern underneath Room 22 and Corridor 12.

23.6.1 Closure of the cistern, raising of floor level and new opus signinum floor
The access hole to the cistern was covered at this point with a heavy deposit of medium to large dark grey blue lava stones set into a heavy mortar (263.005,[231] 262.025) that butted the three walls of the area (W06.096, W06.095, and W06.094/W06.101) (Figs. 5.23.5 and 5.23.7). Some of this sub-floor was found to have collapsed into the void of the cistern (263.025), but consisted of exactly the same construction. As there was no evidence of a large capstone sealing the cistern, it can only be presumed that these mortared stones were laid down on top of a deposit of material that has subsequently decomposed or collapsed. The black lava cobble flooring (**263.004**) was similar in construction to that employed in the triclinium (Room 10) in Phase 5.

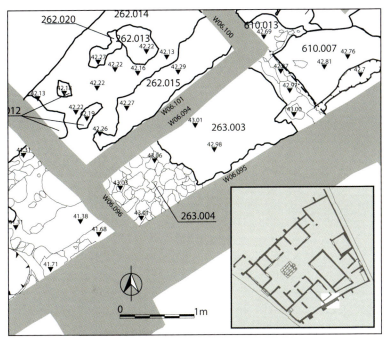

Figure 5.23.5. (above left) Plan of the changes in Room 22 during Phase 6 (illustration M. A. Anderson).

Figure 5.23.6. (left) Lava cobblestone sub-floor sealing cistern of previous phases (image AAPP).

Figure 5.23.7. (right) The *opus signinum* floor of the light well (image AAPP).

Just as in the triclinium (261.033, 261.038[232]), the heavy lava sub-flooring was surfaced with a fine pinkish *opus signinum* surface, which remained largely preserved at the time of excavation (**263.003**) (Fig. 5.23.6)

The black lava cobble flooring and *opus signinum* surface sealed the cistern, and it is certain that it went out of use at this time. Filling deposits (263.026, 263.027,[233] 263.028,[234] and 263.030[235]) must, therefore, date prior to this event. These fills comprised a sandy silt ranging from brown (10 YR 4/3) to very dark brown (10 YR 2/2) in colour which contained some pottery and bone, but which was for the most part relatively devoid of artefacts. Environmental evidence from the deposits tentatively suggested that the cistern was filled with the backfill from a midden deposit. It is likely that the void uncovered during excavation was simply the result of the decay of some component of these deposits. To the east of Room 22, a long tiled drain was built into the *opus signinum* that was used to cover the entire service area during this period. This drain was designed to carry water from the light well of Room 22 towards a cistern under the floors of the kitchen to the east.

23.6.2 Repair of walls

Perhaps as a result of damage caused by these changes, at the eastern end of wall W06.095, a small area of the infill of the *opus africanum* was repaired. This was undertaken with a rough *opus incertum* containing Sarno stone, grey lava, brick/tile, and a piece of a former *opus signinum* floor surface. The rubble was set within a very hard bluish grey (Gley 2 6/1) mortar containing a coarse aggregate with inclusions up to 20 mm long. These are composed of crushed volcanic rocks, including grey lava and cruma, as well as smaller black volcanic minerals. A similar mortar was used in Room 23 on both walls W06.098/W06.099 and W06.095, where it was also used to patch up a hole in the original *opus africanum* rubblework.

23.6.3 The Phase 6 decoration

The raising of the floor level in Room 22, coupled with the repairs to wall W06.095, necessitated its redecoration. This would have initially included the removal of the previous layer of plaster from the upper portions of the walls, which would have taken place after the laying of the new floor surfaces in the room. Evidence for this are the remnants of the previous Phase 5 plaster, which were preserved by the laying of the new floor surface up against them. A new layer of plaster was then applied over the *opus incertum* repair on wall W06.095 and also on the other walls in the room. This was composed of a grey (10 YR 5/1) plaster with a dense quantity of rounded volcanic minerals, occasional pieces of lime, and crushed ceramic material. At the eastern end of wall W06.095 the plaster layer was approximately 50 mm thick where it was used to fill out the uneven wall in order to create a reasonably flat final surface. On wall W06.093, the continuing eastwards portion of wall W06.095, in Corridor 12, the same ceramic-rich plaster layer was also continued. Here it was finished with a fine surface coat of pale red *opus signinum*. This same final surface may also have been applied to wall W06.095, as well as walls W06.094 and W06.096, although there is no direct evidence of this in Room 22.

23.7 Phase 7. Post-earthquake changes

No evidence of this period was recovered in this area.

23.8 Phase 8. Eruption and early modern interventions

23.8.1 Wall conservation

It would appear that there was a coherent phase of reconstruction of walls W06.094 and W06.096, and pointing of all of the walls in Room 22 that used the same mortar. This was a coarse light bluish grey (Gley 2 7/1) mortar containing small pieces of crushed volcanic tuff or lapilli, and pieces of lime.

The upper 0.7 to 0.9 m of wall W06.094 was recon-

structed in the early modern period. This was undertaken in *opus signinum* using roughly shaped sub-rectangular blocks of Sarno stone, grey lava, and occasional pieces of cruma. These were set within the coarse light bluish grey (Gley 2 7/1) mortar. The true extent of the scale of this is difficult to assess since it reused much of the original masonry. This is observable in the widespread examples of rubble faced with the Phase 6 backing plaster in the rebuilt upper portion of the wall. Consequently, while some rebuilding of the upper part of the wall is probable, the lower area of the 'rebuild' may simply have been extensively pointed with the tuff-rich mortar. A similar situation is also apparent with the upper 0.5 m of the eastern end of wall W06.095, which also appears to have been rebuilt at this time. Here, the rebuilding is more obvious, signified by an offset between an upper area of *opus incertum*, made from predominantly Sarno stone with the occasional piece of cruma and grey lava, from the lower portion of the wall. This was bonded with the same coarse light bluish grey (Gley 2 7/1) mortar used in the rebuilding of wall W06.094. Here, it is also used to point the remainder of the wall, thus obscuring the relationship between the early modern rebuild and ancient portion of wall W06.095.

23.9 Phase 9. Modern interventions

23.9.1 Modern overburden

A layer of modern overburden (263.001, 263.002) was excavated in Room 22. This was a clearly recent deposit with both ancient and modern artefacts recovered from the fill.

23.9.2 2000's restoration campaign

Walls W06.094 and W06.096 were pointed for a second time during a recent restoration campaign, which used a coarse bluish grey (Gley 2 5/1) mortar containing black volcanic mineral inclusions.

24. Room 23
Service rooms – function unknown
(AA262 and AA276)

Description

Room 23 is located in the space between the southern wall of the original Sarno stone core of the Casa del Chirurgo and Room 22. It is a roughly rectangular room measuring 4.68 by 2.59 m, situated to the south of the atrium and accessible via Corridor 12 which leads from the southern ala (Room 8A). This area would have been external to the original core of the house, but part of the southern portico. This space was extensively redeveloped at the end of the first century BC through the construction of Rooms 23 and 22, which were part of the service wing of the property. Room 23 did not undergo any significant structural alteration thereafter, apart from the reconstruction of wall W06.098/W06.099 in the mid-first century AD, which resulted in a second phase of decoration in the room. The interpretation of a

service function is based on the fact that it is connected with the kitchen and other parts of what might be termed a service wing for the house. Beyond this, the precise function of the room remains unknown, as is the case for many Pompeian 'service' rooms,[236] but it likely involved storage, cooking, and cleaning.

Archaeological investigations

Excavations in Room 23 were carried out during the summer of 2003 (AA262) and covered the entire width and breadth of the room. Excavations removed soils down to the level of the Pre-Surgeon Structure and halted.[237] During the summer of 2004, the area was reopened (AA276) along the same extents in order to reach natural soils.[238] The standing architecture within the room was recorded as part of its documentation during the initial excavations, and then checked on subsequent architectural seasons in 2009 and 2013.[239] Excavations within Room 23 produced some of the most important evidence for the Pre-Surgeon Structure as well

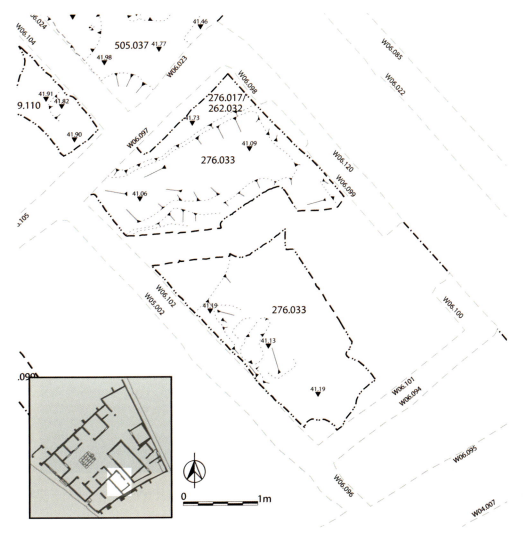

Figure 5.24.1. Plan of natural soils recovered in Room 23 (illustration M. A. Anderson).

as providing much of the backbone of the chronological understanding of the service wing of the house.

24.1 Phase 1. Natural soils

In Room 23, the natural sediments (Fig. 5.24.1) consisted of a yellow-orange soil (**276.017 = 262.032**). This was because the upper layers of the sequence had been removed as a component of the terracing activities during Phase 2. Elevations of these deposits varied in depth (41.19–41.09–41.73) and did not represent an actual surface of any kind, rather being the result of a sequence of cuts and terracing. It is therefore not possible to reconstruct the original topography of the area with any certainty, but the general depth of the yellow-orange soil in Room 23 is roughly consistent with similar soils found elsewhere in the house. Below this was a soil that had a grittier consistency with black and white inclusions, colloquially described by excavators as the 'gritty black' soil (**276.033**). It was

uncovered on the northern side of Room 23 after the removal of 276.017 = 262.032.

24.2 Phase 2. Volcanic deposits and early constructions

This phase provides significant evidence for the Pre-Surgeon Structure that occupied the site prior to the construction of the Casa del Chirurgo (Fig. 5.24.2). A terrace was cut into the natural ground surface to provide a platform on which the structure was built. Although the evidence for the extent of this structure is limited in the area that later became Room 23, significant remains were preserved, including an impluvium-like feature and associated beaten earth floor, as well as the possible course of the early northern wall of this room. These formed the second distinct sub-phase of activity in this space, as there is also evidence for earlier, and much more ephemeral, structures possibly built using Sarno stone blocks.

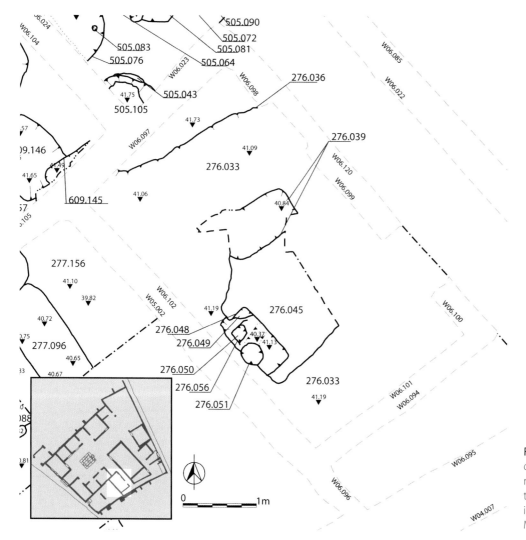

Figure 5.24.2. Plan of deposits and features related to the creation of the Pre-Surgeon Structure in Room 23 (illustration M. A. Anderson).

24.2.1 Terracing and early cuts

The earliest anthropogenic activities in the area involved the large-scale cutting back of the original sloping surface of the natural deposits to the level represented by 276.017 (= 262.032), a cutting (**276.036**) into the deeper volcanic soil (**276.033**) underlying it, and the creation of a revetment or bank to the north that preserved the upper levels of the natural soils (Figs. 5.24.2 and 5.24.3). The purpose of this cut was to produce a level surface for the construction of the earliest structures. Notably this cut is parallel to a similar one seen in Room 11, and fits into a larger alignment that includes another perpendicular cut within Room 10. Consequently, it is clear that the cut extended to the east from Room 23. Traces of the cut may also be present in Room 6C (in section only), suggesting that the original terrace ran across this space from the Vicolo di Narciso towards the Via Consolare.

24.2.2 Early cuts prior to the Pre-Surgeon Structure

After the creation of the lower terrace space, a series of early features were placed that are indicated by traces of the cuts created by their later removal (Fig. 5.24.2). This attests to the presence of two, roughly rectangular features that were aligned at approximately 90 degrees to each other. Both of these removed features flanked a larger cutting into the natural soils (276.046) that was perhaps designed to delineate a sort of central space between them. This space was filled with a brown silty sand (**276.045**) with inclusions of building materials, which may have been intended as the early working surface of the area. The exact function or purpose of the removed features is opaque. Judging from the size of the robber trenches it seems entirely possible that

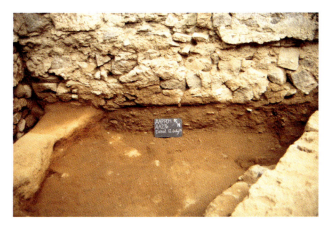

Figure 5.24.3. Natural soils and early cuts in Room 23, the terracing cut is visible on the northern side of the room (left hand side of the image) (image AAPP).

these features were stone blocks – possibly footings for a feature otherwise constructed in more ephemeral materials. Their positioning was identified by the cuts for their removal (**276.039** and **276.048**). At the base of these cuts there were traces of packing, tamping, and cutting that resulted in a variety of beaten earthen layers prior to the laying down of another deposit that was packed around the features, presumably to hold them in place (**276.045**). Possible traces of an even earlier rectangular feature (**276.056**) were recovered under the removed rectangular features, but are far too fragmentary to be certain. Several compactions into the natural soils also produced imprints in the soil surface (**276.049**, **276.050**) and a hole interpreted as the setting for a large stone or as the result of a stone being pressed down into the earth (**276.051**) was observed by the excavators. It is possible that they represent some sort of deliberate tamping in order to secure the features in place. It is curious that no similar traces were recovered from the northern rectangular feature, and this may simply have had to do with the nature of the underlying natural deposit in this area. Notably, these rectangular features align roughly with other rectangular shapes in the soil recovered at a similar depth in Rooms 3 and 4 to the west (40.84, 41.13 MASL, (277.096) 40.72, 40.65 MASL, (277.094) 40.84, 40.87 MASL). This suggests that whatever structure they document extended further to the west. They also align neatly with the terrace line itself, implying that they were a component of a single, unified construction.

24.2.3 Creation of the Pre-Surgeon Structure

The second phase of the Pre-Surgeon Structure saw the removal of the two rectangular features in preparation for a new construction. The removal of the northern feature (276.039) produced a robber trench that was subsequently filled with black sand (276.034) that likely derived from nearby areas to the north where this soil forms a component of a volcanic sequence prior to the Pre-Surgeon Structure. The removal of the western rectangular feature can be sequenced to the same moment as the removal of the northern feature on the basis of their stratigraphic connections and the similarity of their fills. The cut for the removal of the western feature (276.048) also left behind a rectangular shape, roughly the same size as the northern one, aligned at roughly 90 degrees. The void left was also filled with a black sand (276.047 = 276.052) of similar consistency to that used to fill the northern void. At the same time, a large stone that had been situated under the feature was also removed and the space it left behind was filled with a slightly different deposit

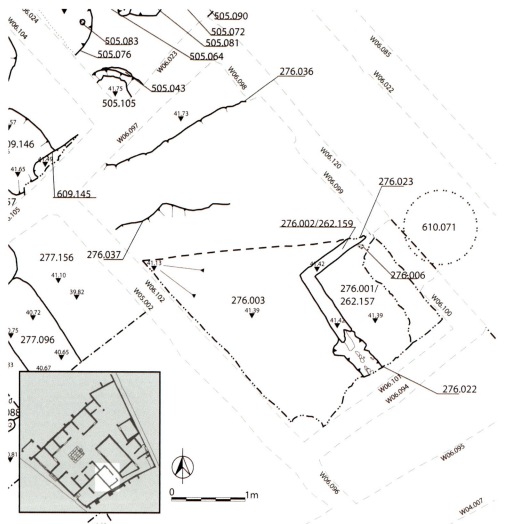

Figure 5.24.4. Plan of deposits and features related to the Pre-Surgeon Structure in Room 23 (illustration M. A. Anderson).

(276.052). After filling these voids, the entire area was covered with several levelling layers (276.040, 276.041, 276.042[240]) that contained construction debris consisting of plaster, pottery, and brick/tiles. Deposit 276.041 had more of a sandy consistency than the other two. Nevertheless, these three deposits, along with a red stain, possibly from burning (276.043), and another small lens of black sand (276.044), can be seen as components of a single action of floor raising and levelling prior the phase of construction that was about to follow. From 276.042, a rim of type Morel 1551b 1[241] dated to 300 BC gives a rough *terminus post quem* for this second phase of construction of the beginning of the third century BC.[242] These deposits were laid down in preparation for an earthy *opus signinum* surface (276.001 = 262.157) with a raised edging of mortar and Sarno construction (276.002 = 262.159) that, while only partially preserved, was strikingly similar in appearance to an impluvium (**276.001 = 262.157** (base) and **276.002 = 262.159**) (Figs. 5.24.4 and 5.24.5). Although badly damaged on the southern and eastern

sides, it is possible to suggest with a high degree of certainty that this represents an early water catchment structure. On the eastern and southern sides of the feature, but outside of Room 23 itself, at least one (Corridor 12) and possibly two (Room 22) cisterns were discovered that coordinated with it. The construction of later walls destroyed any connection that might have existed between the impluvium and cisterns, but it is likely that one or both of them were the destination for the collected water.

At this time, any walls necessary for the support of roofing to drain into the impluvium must have also been built. This includes a northern wall (276.059) that would have stood against the terracing cut into the natural soils mentioned above. It is possible that it would have consisted of a lower course of stones with a beaten or rammed earth wall above them. Such a construction method would be consistent with other early Italic houses[243] and would explain the reason for the later wholesale removal and robbing of the foundations of this wall, which, had it been constructed

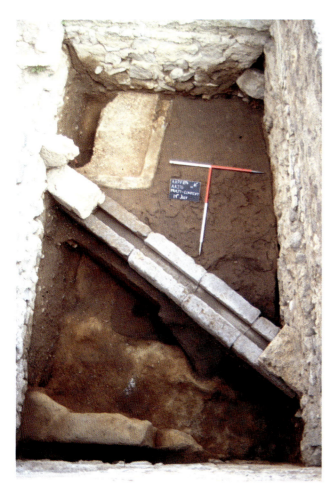

Figure 5.24.5. Elements of the Pre-Surgeon Structure, underlying a later drain in Nocera tuff (image AAPP).

entirely of rammed earth, might have been easier simply to leave in place. Remains of construction of this type were identified in the tablinum of the Casa delle Vestali, suggesting that it was not alien to the early phases of the insula.[244] The traces of a robber trench for the foundations of this wall were clearly present in Room 23, and the projected alignment of the north wall matches neatly with the orientation of the impluvium feature of the Pre-Surgeon Structure. This the only wall to have left a trace, probably due to the fact that evidence for the western, eastern, and southern walls of the space was obliterated by the later construction of the Casa del Chirurgo. A hard-packed or trampled earthen surface was associated with the impluvium and formed the floor that was in use with it (**276.003**). In 2003, this floor was given a variety of stratigraphic unit numbers (none of which were excavated) because later features had tended to divide it into sections. In 2004, the surface received the single designation of 276.003 and was excavated all together. The top surface to the lower levelling layers contained very few finds,

probably because it was intended to be a material that could be tamped into a solid, smooth, usable surface. Such a beaten earth floor will have made the high raised edging of the impluvium particularly important for keeping water away from the surface.

24.3 Phase 3. The Casa del Chirurgo (c. 200–130 BC)

24.3.1 Abandonment of the Pre-Surgeon Structure?
The Pre-Surgeon Structure (276.003) seems to have undergone a period of abandonment, with the hard-packed earthen surface showing signs of root action suggestive of vegetal growth. A shallow cut (**276.037**) was made directly into the floor surface of the Pre-Surgeon Structure, which might either have been a repair or the first stage of demolition (Fig. 5.24.6). It was filled with a black (10 YR 2/1) sandy soil (276.035) containing black gloss pottery that was dated to between 140–130 BC, providing the lower end of the dating for this phase.[245]

24.3.2 Destruction of the Pre-Surgeon Structure
Following the period of abandonment, the north wall of the building was removed, presumably alongside any other walls and roofing structures associated with the early impluvium. Initially, a large pit was dug on the western side of the area (**276.037**) and subsequently filled with a black, sandy deposit (276.035) that must have come from the perhaps recently exposed black sands on the nearby northern terrace. The impluvium structure was also damaged at this time, receiving some picking (**276.006, 276.023**). This must have been related to the sealing of its connection to the eastern cistern in preparation for its reuse for a new drain that would run from the centre of the atrium of the Casa del Chirurgo (north–south drain).

24.3.3 Filling in the terrace
After the destruction of the Pre-Surgeon Structure, the lowered terrace upon which it had been built was raised with a diverse series of fills made up largely of building materials. These fills were designed to bring the level of the soil even with that to the north, so that the creation of the Casa del Chirurgo could take place at a single, higher elevation. Due to their diverse nature, many of these deposits were identified during excavation as cuts and fills, but it is more likely that most of them represent different buckets-full of soil and are indicative largely of the diversity of sources from whence this material derived. They can generally be divided into two halves, cut by the north–south drain. Much of this material likely originated from the Pre-Surgeon Structure itself, suggesting a building

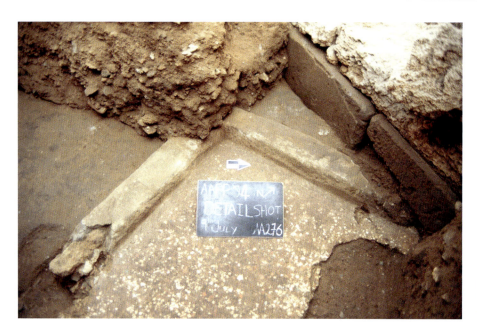

Figure 5.24.6. Pre-Surgeon impluvium-like feature and cuts made into it at end of its use (image AAPP).

constructed with rammed earth walls of orangey-yellow soil. The common presence of dark bluish grey mortar fragments and plaster backing may indicate something about the wall decoration of the Pre-Surgeon Structure (262.171 = 262.172, 262.170 = 276.015, 262.025 = 276.014, 276.016). The southern component of these levelling layers comprised a mixture of diverse soils (**276.010**[246] = 262.154 = 262.158, 262.173, 262.165, 262.015, 262.173), and varied from very dark greyish brown (10 YR 3/2) to nearly black (10 YR 2/1), consisting of heavily compacted sandy silt containing large amounts of rubble in the form of Sarno stone and tuff, with other building debris. Fills on the northern side of Room 23 (262.154, 276.007, 276.011, **276.012**, 276.013 = 262.155, 276.038, **276.019**), were as diverse as those on the south, and also contained elements identifiable as orangey soil from the rammed earth walls of the original Pre-Surgeon Structure. A nearly circular pit (262.041) was cut into the levelling layers and was filled with a very dark greyish brown (10 YR 3/2) sandy silt (**262.038** = **276.020**, 262.162) that was later cut by the northern wall of the Casa del Chirurgo (W06.097). The pit, therefore, clearly predates the construction of the wall, but also is after the general levelling of the area. It must represent a rather temporary activity, perhaps one related to the building of the house itself. On the western side, a component of this fill was a large block of tuff. This was found set into the mortar foundations of the later walls W06.101 and W06.102. The workers appear to have left this large obstacle in place rather than attempting to remove or cut through it.

24.3.4 Construction of the Casa del Chirurgo
After the terraced area had been filled to the same level as the soils on the north, the walls of the first phase of the Casa del Chirurgo were constructed (Fig. 5.24.7).

24.3.4.1 THE NORTHERN WALL (W06.097)
The only wall of this phase present in Room 23 is the northern wall (W06.097) (276.057). Built in *opus africanum,* this formed the southern wall of the house running east–west across the property and ultimately connecting with the *opus quadratum* façade. Several doorways, one of which is just to the west of Room 23, were clearly marked in advance of construction since no foundation was cut for the wall where a doorway was intended. The construction of the wall began with a deep, roughly vertical cut (**276.024** = **262.036**) for the placement of the first course of Sarno foundation blocks. The cut penetrated into the natural deposits and was filled with a dark greyish black soil (262.031 on east, 262.037 on west, 276.018) that appeared to have been a mix of the materials removed from the cut itself. The wall (W06.097) was made in *opus africanum* with Sarno stone used for both the framework and the irregularly shaped rubblework. In between the blocks of the framework, there is evidence that they were bonded with a brown (7.5 YR 5/4) clay with small inclusions of lime, which would also have been used to bond the rubblework together.

24.3.4.2 THE NORTH–SOUTH DRAIN
This phase also saw the creation of a drain that ran south from the centre of the atrium, before turning to

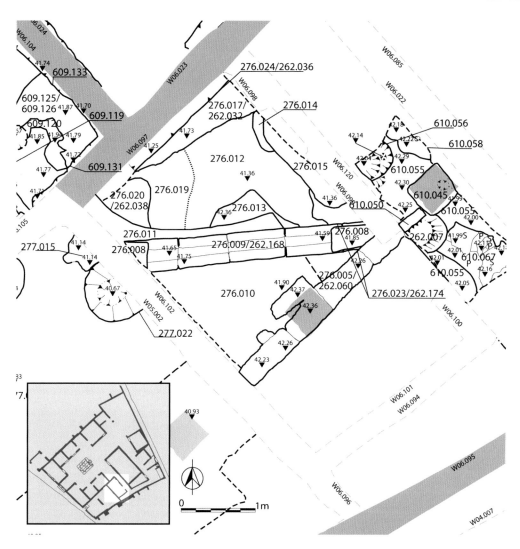

Figure 5.24.7. Plan of deposits and features in Room 23 related to the destruction and filling of the Pre-Surgeon Structure and initial elements of the Casa del Chirurgo (illustration M. A. Anderson).

the east and running diagonally across the space later occupied by Room 23, towards a cistern located within what would later become Corridor 12. This north–south drain was made out of a series of U-shaped Nocera tuff blocks with thin (roughly 10 cm in thickness) Sarno stone capping stones (Fig. 5.24.8). Excavations in 2003, on the western and northern ends of the north–south drain, found that it was set into a cut in the underlying levelling deposits before being filled over. On the other hand, the excavations of 2004 seemed to reveal that it may have been built directly on the fill in tandem with the process of levelling itself, only to be buried once construction was completed. Given the depth that the drain reached, particularly at the eastern end where the base of its construction rested nearly directly upon the earlier Pre-Surgeon Structure surfaces, it seems probable that some combination of the two processes was at work in the laying out of this feature. Perhaps this mixture of methods was necessary to coordinate the new north–south drain with the pre-existing cistern from the Pre-Surgeon Structure impluvium. It

is clear that the drain was built in conjunction with the initial walls of the house, since it is perfectly aligned with them and runs directly through planned doorway openings. Together, this indicates that the process of infilling the terrace, planning the Casa del Chirurgo, and constructing the drain were part of a single coordinated action.

The course of the drain itself was cut (**276.023** = **262.174**) into the levelling layers running diagonally across the room and eventually damaging the underlying impluvium-like feature (**276.023**). A pick mark (**276.006**) found in the northern side of the *opus signinum* base of the feature probably relates to this activity. The drain itself was built from a U-shaped tuff base (**276.009** = **262.168**), made up of a series of modular blocks aligned to form a channel. This was capped with a number of thin Sarno stone blocks, roughly square in shape (**276.008** = 262.147). The fills in the cut of the drain indicated that at least two separate methods of construction were used, probably in order to help to situate the heavy blocks into the appropriate

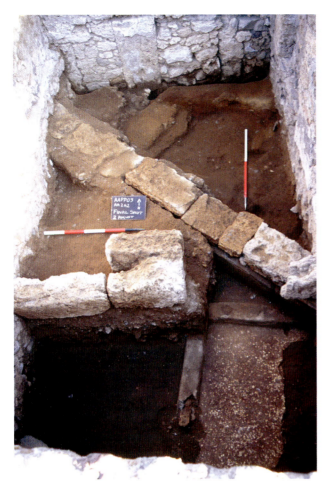

Figure 5.24.8. Elements of the Casa del Chirurgo. North–south drain, portico, and northern wall of Room 23 (image AAPP).

alignment. First, a fine very dark grey soil packing (262.166 = 262.167) was used, then supplemented by a heavier (**262.152** = **262.153**) fill to hold the drain and capping in place and to keep it as waterproof as possible.

24.3.4.3 THE SOUTHERN SARNO-STONE PORTICO

After the completion of the north–south drain, five rectangular (c. 32.5 cm wide) Sarno stone blocks (**276.060** = **262.005**), alternating with roughly square pilaster bases, were positioned parallel to the southern wall (W06.097) of the Casa del Chirurgo at a distance of roughly 3 m (2.98 cm) (Figs. 5.24.9 and 5.25.10). They were placed in conjunction with the final layers of fill over the drain, and these deposits were packed in against the blocks themselves. Together, the thin rectangular blocks and square bases formed the foundations for a portico that ran along the southern and eastern sides of the house. The inter-pilaster spacing was roughly 1.84 m.

24.3.4.4 EARTHEN FLOORING

Scarcely any trace of the original flooring of the Casa del Chirurgo has been recovered from within the house, but it appears to have been a simple beaten earth. Possible remnants of this earth surface, were recovered from the area covered by the portico. The packed earth was recovered as traces of a dark brown (7.5 YR 3/2 – 7.5 YR 3/3– 7.5YR 4/4) compact soil, recovered butting against the blocks (**262.040**) near the eastern wall (W06.098/W06.099) (**262.039**), the western wall (W06.102/W05.002) (**262.004**), and in the northern half of the area (**262.024**). This was probably equivalent to an earthen fill found to the south of the portico (**262.018**) that was much less compact.

24.3.4.5 PHASE 3 WALL DECORATION (W06.097)

It would appear that when wall W06.097 functioned as the exterior wall of the Casa del Chirurgo, it was covered with a 25 mm thick layer of weatherproof *opus signinum*. This had a pink (10 R 8/3) matrix containing numerous small black volcanic mineral inclusions and larger pieces of crushed ceramic. The mortar was flattened in order to create a final outer surface.

24.4 Phase 4. Changes in the Casa del Chirurgo (c. 100–50 BC)

No evidence of this period was recovered in this area.

24.5 Phase 5. Redecoration and redevelopment (late first century BC to early first century AD)

Phase 5 witnessed widespread changes across the Casa del Chirurgo, including the provision of two new shop facilities, the addition of a wide range of luxurious fixtures, and considerable reworking of the service wing of the house (Fig. 5.24.11). It was at this time that the area of Room 23 became a room for the first time. At the same time, a second storey, reached via a stairway in the shop to the west (Rooms 3 and 4) was extended over this space, running all the way to the eastern side of Corridor 12. Such construction necessitated the creation of underlying rooms.

24.5.1 Creation of walls W06.098/W06.099/W06.101 and W06.102

Room 23 was created through the construction of walls W06.098/W06.099/W06.101 and W06.102, whereby the area changed its character from an exterior space to an interior one (Fig. 5.24.12). This phase will also have seen the removal of the southern portico down to the level of its foundations. A direct result of this new phase of construction was that the former weatherproof exterior

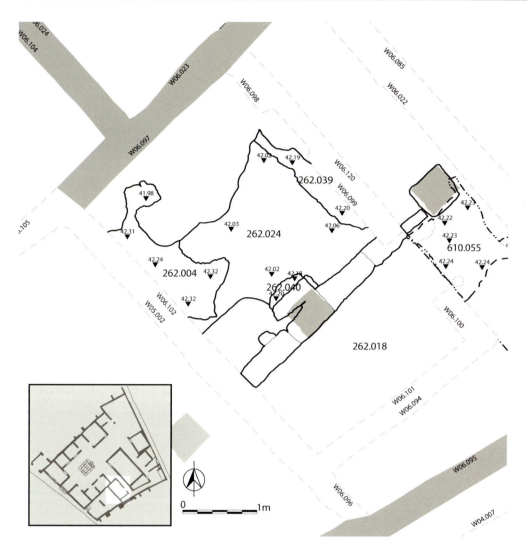

Figure 5.24.9. Plan of deposits and features in Room 23 related to the construction of the Casa del Chirurgo portico, north–south drain, and walls (illustration M. A. Anderson).

Figure 5.24.10. Sarno stone portico blocks in Room 23 (image AAPP).

coating of *opus signinum* on wall W06.097 was removed. This must have happened prior to the construction of walls W06.098/W06.099 and W06.102, as there is no evidence for this pink plaster at the intersection between the old and new walls. In all cases, the walls of Room 23 are built using the same general technique; a foundation cut into which was set an *opus incertum* fill that was smoothed level and allowed to dry before a slightly narrower shuttered *opus incertum* upper component of the wall was built on top. Wall W06.102 was built first, followed by walls W06.101, W06.100, and W06.098/W06.099. Access into Room 23 was by way of the doorway between walls W06.98/W06.099 and W06.100.

Extremely ephemeral traces of the foundation cut for wall W06.102 were recovered, which was almost entirely filled up by its foundations. Its fill (**262.027**) was a light-olive brown soil (2.5 Y 5/4) that contained some pottery and tesserae as well as fragments of mortar. Although this wall must have been planned as a retaining wall,

with the adjacent Room 4 being at a lower level, its foundations do not, in fact, extend below the new floor level to the west. Instead, elements of the soils in Room 23 are visible beneath the lowest extent of wall W06.102. The U-shaped drain from the impluvium was simply incorporated into the foundation of the wall.

The eastern wall (W06.098/W06.099/W06.100) (262.007) also did not have an easily identifiable foundation trench, as its foundations have served to fill it. A lower foundation pad (**276.028** = **262.023**), that was slightly wider than the upper part of the wall, was poured such that the mortar was found to lip over the edges of its foundation trench (**276.005**, 276.021 = **262.035**). After this, the upper part of the wall was built on top of the foundation pad (276.058). It was shuttered on its western side. A fill of a loose yellowy sandy soil containing construction debris occurred after the removal of the shuttering and supports (276.004 = 262.019). The cut (276.022 = 276.053 = 262.021) for the southern wall of Room 23 (W06.101) caused further

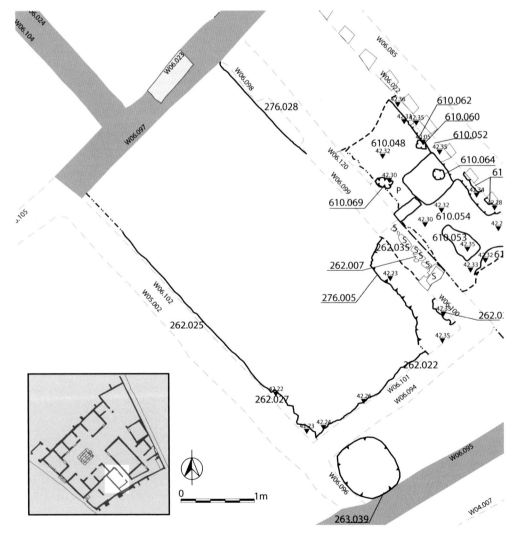

Figure 5.24.11. Plan of deposits and features related to the destruction of the portico and the creation of Room 23 in Phase 5 (illustration M. A. Anderson).

Figure 5.24.12. Course of the north–south drain as it connects through Room 4 and is cut by wall W06.102 (image AAPP).

damage to the now long-buried impluvium-like feature from Phase 2. The foundation pad (262.021 = 276.026 276.054) was created by filling the trench with *opus incertum* rubblework, followed by a second phase of *opus incertum* to finish the build of the wall. After the wall had been completed, the remaining foundation trench was filled with a confused olive-brown (2.5 Y 4/3) soil containing some mortar fragments (**262.022**). Both the foundation pad of wall W06.102 and the upper of wall W06.101, and the lowest section of walls W06.098/ W06.099 and W06.100 were built from a mixture of sub-rectangular and irregularly shaped rubble of Sarno stone, grey lava, and cruma. There are also occasional pieces of building rubble, including brick/tile and elements from a former *opus signinum* floor surface. Although difficult to see due to the extensive early modern and modern restoration and conservation work on the walls, the upper portions, except for wall W06.098/W06.099, all appear to have been bonded with the same mortar that was used to bond the foundation pad seen during excavation. This was a light brown olive (2.5 Y 5/3) mortar with black volcanic mineral inclusions. There is also evidence to suggest that the upper parts of walls W06.102 and W06.101 were built concurrently, perhaps also in conjunction with wall W06.100.

24.5.2 Phase 5 wall plaster decoration

Following the repair of wall W06.097, it was plastered with a thin (c. 3–4 mm) layer of hard light grey plaster (7.5 YR 7/1), with small volcanic mineral inclusions and fragments of lime. This same plaster surface is also seen on walls W06.100, W06.101, and W06.102, where the plaster lips around at the intersections between walls W06.100–W06.101 and W06.101–W06.102, appearing on both walls. The plaster appears to have been simply flattened to create a final surface.

24.6 Phase 6. Mid-first century AD changes to the Casa del Chirurgo

During the middle of the first century AD, the service wing of the Casa del Chirurgo underwent a major period of redevelopment (Fig. 5.24.13). In particular, this can be seen in upper storey over the north-eastern portion of the service wing and in the addition of a coherent phase of *opus signinum* flooring throughout the majority of this area. In Room 23, the catalyst for this may have been the need to repair wall W06.098/ W06.099 after changes made to the upper storeys over Rooms 3, 4, 22, and 23 rendered it unstable.

24.6.1 Repair/rebuilding of wall W06.098/W06.099 and W06.097

Although the lowest c. 0.2 m of wall W06.098/W06.099 was constructed in the same way as the other primary walls in the room, its upper section is different. This would suggest that the upper portion is a replacement. It should be noted that on the reverse side (wall W06.121 in Room 12), larger areas of the first phase of the wall survive, indicating that the wall was not completely demolished and rebuilt anew, but instead heavily reconstructed. Further evidence of reconstruction is seen in the plasterwork applied to the new elements of the wall, which reveals a single layer of plaster that is the same as the second layer of plaster seen elsewhere in the room. The reason for this renovation is unclear,

but could relate to changes made to the stairway in Rooms 3 and 4 and the rooms to which they led at this time that appear to have been quite extensive.

The upper part of wall W06.98/W06.099 is constructed in a rough form of *opus incertum*, with courses of generally sub-square Sarno stone and occasionally cruma interspersed with layers of brick/tile. The wall is bonded with a hard light bluish grey (Gley 2 8/1) mortar containing small, rounded grains of different colours that may have derived from beach sand. As the wall was rebuilt the opportunity appears to have been taken to insert a niche on the western face, which was bonded with same mortar as formed the rest of the rebuild. While it is true that the Sarno stone blocks that define the niche recall the framework of a doorway, the 'blocking' material of the 'doorway', and crucially the mortar that bonded it together, was of the same type as that which formed the rest of wall W06.098/W06.099. Consequently, the niche cannot have been a doorway that was subsequently blocked. The Sarno stones used to define the edges of the niche show signs of plaster

from a previous use. Following this, the lower portion of wall W06.097 underwent a further period of repair to patch it between the central and eastern Sarno stone orthostats. This utilised a light blue-grey (Gley 2 7/1) mortar containing large fragments of crushed dark cruma, smaller volcanic minerals, and pieces lime. This mortar, although it has a larger aggregate, is very similar to that used to rebuild wall W06.98/W06.099. Consequently, it is suggested that the reconstruction of wall W06.98/W06.099 and the repair of wall W06.097 took place at the same time.

24.6.2 Opus signinum flooring
Room 23, along with rest of the service wing, received an *opus signinum* floor during the redevelopments in the middle of the first century AD. Evidence of this surface occurred on either side of the line of Sarno stringers and bases of the earlier portico, which apparently still protruded somewhat from the floor in this phase. To the south of these, the remains of the *opus signinum* were recovered in fairly good condition (**262.015** =

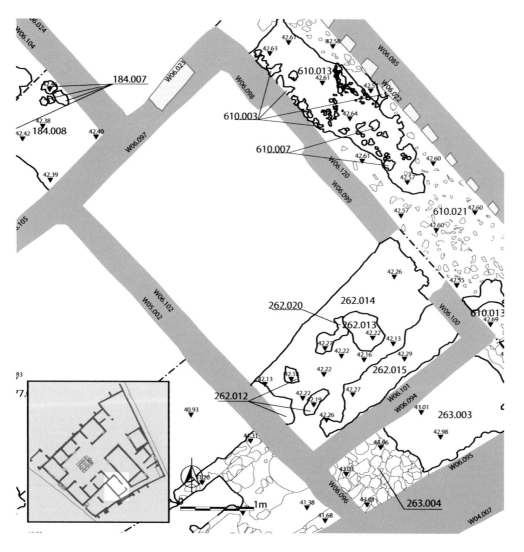

Figure 5.24.13. Plan of deposits and features of Phase 6 in Room 23 (illustration M. A. Anderson).

262.028;[247] **262.020** = 262.029), while to the north the floor remnants consisted of a thin, low quality mortar flooring or patching, possibly the result of activities of the following phase (Fig. 5.24.14). It is unclear whether the protrusion of the underlying Sarno stone blocks was the result of some sort of division or feature, or was simply the result of careless work by those who created the *opus signinum* floor in this room. Widespread removal of the flooring to the north of this feature in the following phase has removed most traces of the sub-floor. However to the south, where the surface was merely damaged, some elements do survive. Here it appears as elements of light olive brown (2.5 Y 5/4) mortar fragmented into several distinct parts (**262.012, 262.014**) in close association with a very dark brown (7.5 YR 2.5/2) sandy silt with building debris, that more generally covered the southern area of room (**262.013**).

24.6.3 Phase 6 Wall plaster decoration
The reconstruction of wall W06.098/W06.099 and the repair of wall W06.097 necessitated the re-plastering of Room 23. On wall W06.098/W06.099, there is only evidence for a single layer of plaster, which was composed of a white (7.5 YR 8/N) matrix with small black angular volcanic mineral inclusions and frequent larger pieces of lime. This plaster is also seen on the other walls of the room. At the junction between walls W06.100 and W06.101, this plaster directly overlies the plaster from Phase 5 (Fig. 5.24.15). Elsewhere on the same wall, however, the Phase 6 plaster directly overlies the fabric of the wall itself, indicating that much of the initial Phase 5 plaster may have been removed first. In the central sector of wall W06.102, the Phase 6 white plaster also adheres directly to the *opus incertum* of the wall. Here it can be seen that the white plaster layer is a laminate of up to three layers of identical plaster. The first layer seals the wall (Figs. 5.24.16 and 5.24.17, A), the second, which is approximately 10 mm thick was then applied and smoothed (Figs. 5.24.16 and 5.24.17, B), followed in places by a third layer that was also smoothed at its surface (Figs. 5.24.16 and 5.24.17, C). Interestingly the second and third layers appear to merge. Consequently the third layer may represent additional plaster applied to the wall to smooth our any irregularities in the plaster surface.

24.7 *Phase 7. Post-earthquake changes*
The Casa del Chirurgo appears to have been damaged by the earthquake(s) of AD 62/3 and subsequent years. In Room 23, this set in motion a series of changes that were not yet complete at the time of the eruption. These were heralded by the removal of the northern

Figure 5.24.14. Fragmentary *opus signinum* pavement surviving on the southern end of Room 23 (image AAPP).

half of the *opus signinum* flooring of the previous phase. Notably, the flooring in Room 8A was also removed at this time, possibly suggesting the beginning of works intended for the wall between these two spaces. Following this, a cut (262.042) was excavated in the northern part of Room 23, roughly sub-circular in shape and extending to the north and eastern walls, but apparently bounded by them. A second, small, sub-circular pit was cut (262.034) on the eastern side of Room 23, north of the remains of the portico. The fill (262.033) was a dark brown (10 YR 3/3) sandy silt that produced very few finds. Both of these cuts were sealed by a layer of dumped mortar, stucco, and other, building detritus across the majority of the room. These deposits contained a variety of materials and extended over the area in general (**262.008**,[248] **262.009**,[249] 262.017 = 262.030). Above these, a number of heavy rubble deposits (262.010, 262.011) were recovered that may testify to the storage of rubble and debris intended for the restoration of the house (Figs. 5.24.18, and 5.24.19).[250] Finally, a deposit of mortar and stucco in a

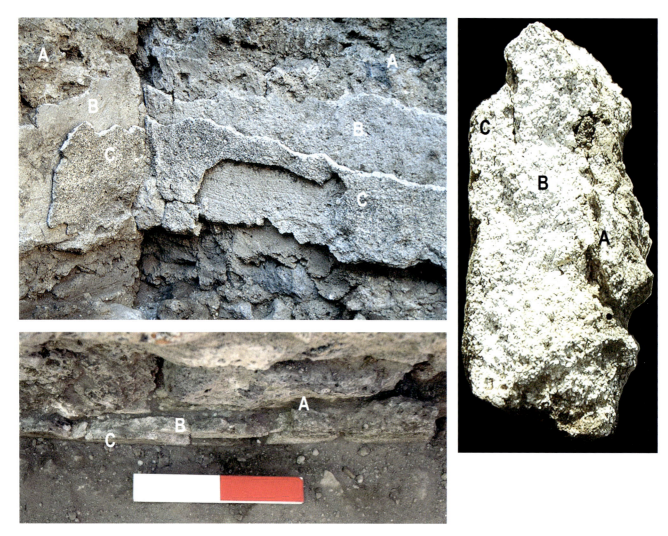

Clockwise from top left:

Figure 5.24.15. Walls W06.101 and W06.102 plaster surfaces (image taken during excavation). (A) original wall; (B) Phase 5 plaster; (C) Phase 6 or 7 plaster (image D. J. Robinson).

Figure 5.24.16. Section through the Phase 6 plaster on wall W06.102: (A) first layer; (B) second layer; (C) third layer (image D. J. Robinson).

Figure 5.24.17. Plaster of Phase 6 on wall W06.102 seen from above. (A) first layer; (B) second layer; (C) third layer (image D. J. Robinson).

very light or white (10 YR 8/1) matrix of plaster or lime (**262.002**,[251] **262.003**, 262.006,[252] 262.016) was extended over the north-east part of Room 23.

24.8 Phase 8. Eruption and early modern interventions

Walls W06.097, W06.098/099, and W06.100 show evidence of rebuilding during the early modern period. Much of the upper 1 m of wall W06.097 was rebuilt in order to raise the height of the wall and to even it up in comparison to those around it. This was done to facilitate the laying of the tile roof capping that offered some measure of protection for the ancient fabric. Wall W06.097 was rebuilt in a form of *opus incertum* using rubble of various sizes from large Sarno stone blocks that were pieces of the original *opus africanum*

framework, smaller chunks of Sarno stone rubblework, and pieces of cruma and tile. It is likely that this was bonded with the same mortar that was used to render the wall. This is composed of a white (5 YR 8/1) mortar that is weathering at its surface to a reddish yellow (5 YR 6/6) with inclusions of crushed lapilli as well as fragments of ceramic and tesserae. The newly rebuilt wall W06.097 was capped with a set of roof tiles set upon a light bluish grey (Gley 2 7/1) mortar with flecks of lime that is weathering in places to a reddish grey (10 R 5/1).

The upper part of wall W06.098/W06.099, above the level of the course of roof tiles, was also rebuilt in the early modern period in a rough *opus incertum* using Sarno stone and cruma bonded with a hard light bluish

Figure 5.24.18. Building debris in Room 23 (image AAPP).

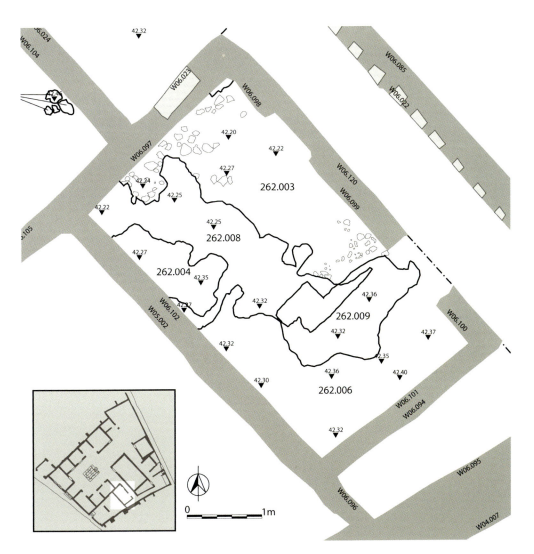

Figure 5.24.19. Plan of the building debris deposits of Phase 7 in Room 23 (illustration M. A. Anderson).

grey (Gley 2 7/1) mortar with angular black volcanic mineral inclusions and occasional pieces of crushed lapilli. A similar, although more friable, mortar was also used to bond together the *opus incertum* rebuild of wall W06.100, which used Sarno stone and grey lava. The same mortar laps around onto wall W06.101, where it is used to point the wall and may also have been used to rebuild or reset the *incertum* of the upper portion of this wall.

The use of the same mortar to both reconstruct and point walls can be seen elsewhere in Room 23. Wall W06.097 was covered in a thick layer of render, which was also used to a lesser degree on the other walls of the room with slightly different mixes, both as a rendering layer and to point the walls. On wall W06.097, a slightly less coarse version of the mortar used to reconstruct the wall was applied to its surface and flattened to create the appearance of a rough final plaster. Tool marks of this process are visible in the plaster surface. The interior of the render is a light bluish grey (Gley 2 8/1) colour while its outer surface is a weathered pink (7.5 YR 7/3). In the lower parts of the western sections of wall W06.097, another similar lapilli-rich mortar was applied to the wall as a patch or render. This extremely hard mortar is variable in colour, ranging from a light

greenish grey (Gley 1 7/1) to greenish grey (Gley 1 6/1). It was also flattened at the surface, and in the north-western corner lips around onto wall W06.102. There are also traces to suggest that a light greenish grey (Gley 1 8/1) pigment was applied to this surface, which was also used on wall W06.098/W06.099.

24.9 *Phase 9. Modern interventions*

This phase includes the few clearly modern deposits recovered from Room 23, including a layer of overburden (262.002) of very dark grey (5 YR 3/1) sandy silt which seemed to be the result of successive dumps of material in modern times. While much material recovered from these deposits was ancient, modern materials were also recovered from the fill. Overlying this was a final protective layer of gravel (262.001) designed to preserve the sub-surface archaeology and to prevent dust. Every wall in Room 23 was extensively pointed in the modern period using a rough bluish grey (Gley 2 5/1) mortar with angular black volcanic mineral inclusions. Differential weathering of this mortar around the room gives a range of colours from a bluish grey (Gley 2 6/1) in areas where the mortar has been sheltered, to a light bluish grey (Gley 2 7/1) where the mortar has been more exposed to the elements.

25. Vicolo di Narciso
Back Street (AA512)

Description

The boundary wall of the Casa del Chirurgo on the Vicolo di Narciso continues the full length of the eastern plot boundary of the property (Fig. 5.25.1). It is penetrated by a single entranceway that led into the rear, service area of the house. The Vicolo di Narciso pavement, which butts directly onto the back of the Casa del Chirurgo in this area, presents an uneven and undulating surface that stands above the elevation of the Vicolo di Narciso itself, and is separated by a row of kerbing stones and *opus incertum* rubblework. Given its relative size, the Vicolo di Narciso would appear to have been the less travelled side of Insula VI 1, but it nevertheless provides access via back doorways to both the Casa del Chirurgo and the Casa delle Vestali.

Archaeological investigations

Excavations in the western pavement of the Vicolo di Narciso were carried out during a single season in 2005 (AA512) under the direction of two different area supervisors.[253] This included the whole area from the end of the pavement at Insula VI 1 doorway

Figure 5.25.1. The rear façade of the Casa del Chirurgo (image M. A. Anderson).

22 northward to the northern boundary wall of the Casa del Chirurgo, where they butted directly against excavations carried out by the Project in 1999.[254] In order to facilitate the organisation of such a long (roughly 32.78 m), thin area, it was divided into five separate blocks, each of which was assigned letters, beginning with 'A' at the southernmost through to 'E' at the northernmost. These divisions will continue to be used here to organise discussion when useful, and will focus upon those areas from the northern part of area B to area E, which comprise the back street adjacent to the Casa del Chirurgo. After the initial excavations had begun, the area was truncated and focused shifted to roughly the southern two-thirds of the initially planned area. As a result, several northern components of the pavement are only very imperfectly known and no plans appear to have been drawn for these areas. The architecture in this area was analysed during the 2007 architecture campaign and the interpretations checked and written up in 2009. Although composed of two walls, W06.118 and W06.119 to the north and south of the rear doorway, the entire wall was analysed as one unit.

25.1 Phase 1. Natural soils

Truncation of the sequence at a later date, presumably for the purpose of creating the lower level pavement in Phase 5, meant that the natural sequence was generally uncovered quickly and without many intervening deposits (Fig. 5.25.2). The removal of much of the intervening stratigraphic information means that most cuts went directly into natural soils, providing a truncated and sometimes confused stratigraphic situation. The natural soils that appeared in the pavement of the Vicolo di Narciso were yellow to brown in colour, identifying them as components of the interface between top surface of the natural sequence and the underlying yellow naturals. The elevations taken on these deposits (admittedly themselves truncated by the cuts at the bottom of which they generally were observed), suggest that, in general, the southern areas had experienced a greater degree of soil removal than found in the north. This pattern fits with that uncovered inside of the Casa del Chirurgo and relates to the widespread terracing of soils that is well-documented on the southern side of the property. Such an observation is also supported by a comparison of the elevations, which toward the southern end of the area at 40.80–41.10 MASL, are as much as a metre below the elevations recovered for similar deposits in the tablinum (41.84). Closer to the actual property of the

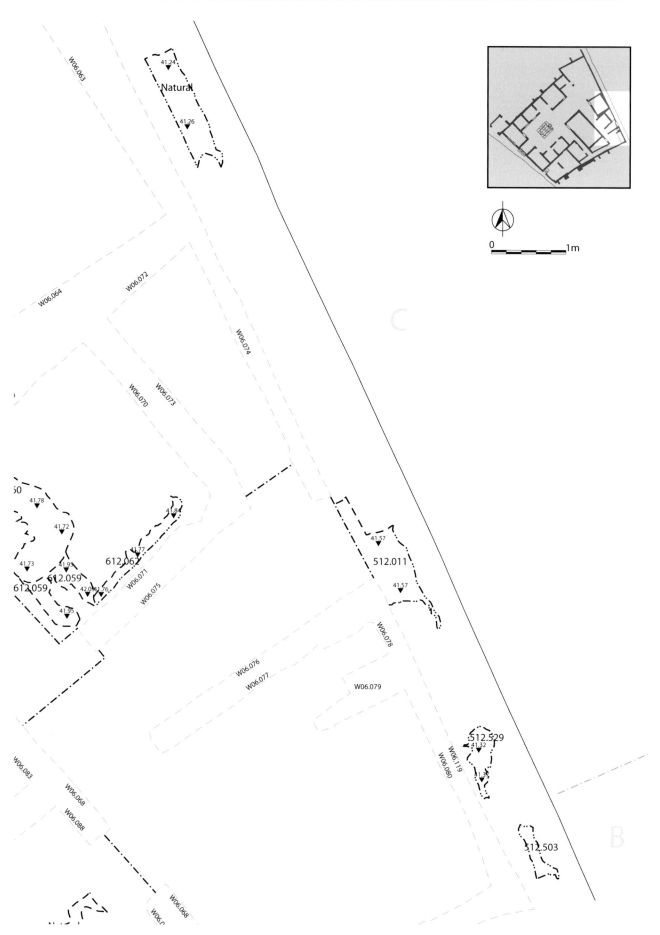

Figure 5.25.2. Natural soils recovered from along the Vicolo di Narciso (illustration M. A. Anderson).

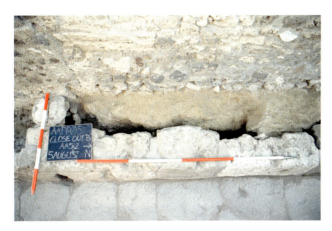

Figure 5.25.3. Natural soils visible in the southern end of Area B (image AAPP).

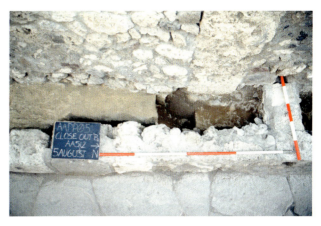

Figure 5.25.4. Natural soils visible in the northern end of Area B (image AAPP).

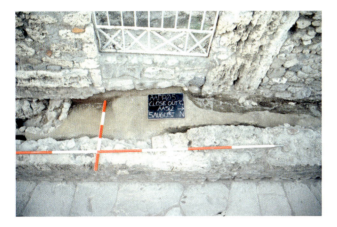

Figure 5.25.5. Natural soils visible in the southern end of Area C (image AAPP).

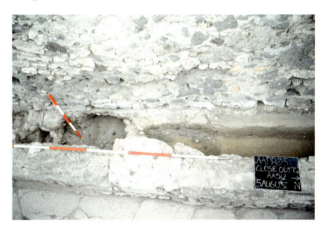

Figure 5.25.6. Natural soils visible in the northern end of Area C (image AAPP).

Casa del Chirurgo, this difference in elevation reduces to roughly 0.30–0.50 m (41.57–41.32 MASL), which is not out of order for an estimate of the depth of one step of the terracing action itself. At the north end of area B, a dark yellowish brown (10 YR 4/4) loose silty sand without inclusions (**512.503**) (Figs. 5.25.3 through 5.25.4) was recovered, which was cut into by later deposits. Also truncated by later activities, a friable, yellowish silty sand with some stones that might have been re-deposited or disturbed natural (**512.529**) (Figs. 5.25.5 through 5.25.6) formed the base of the southern end of Area C. Just outside the back door of the Casa di Chirurgo, a dark yellowish brown (10 YR 3/6) firm, silty sand was identified as a natural soil (**512.529**). Other deposits elsewhere (particularly to the north) in the excavation are noted as overlying 'natural', but SU numbers were not assigned for these and further records were not taken. They were presumably similar to the natural soils described above.

25.2 Phase 2. Volcanic deposits and early constructions

A number of cuts and fills, including some identified by the excavators as 'hard-packed' surfaces, directly overlay or were cut into the 'natural' deposits (Fig. 5.25.7). In some cases, these cuts were refilled with what was thought to be re-deposited natural soil, which would bring these activities into line with the early cuts and fills found elsewhere in the excavations of the Casa del Chirurgo (e.g. Room 23 and the atrium). Due to the high elevation of the natural soils, however, it is not possible to be entirely certain that these do not date from significantly later, especially in the case of the 'hard-packed' surfaces. Reliable dating information from these deposits was not recovered. Such surfaces may be the lower elements of earlier pavements and would find parallels with those found outside Room 2 (AA507/607). In some cases, it is possible to determine the relative sequence of a deposit with respect to the walls around it, and these are noted below.

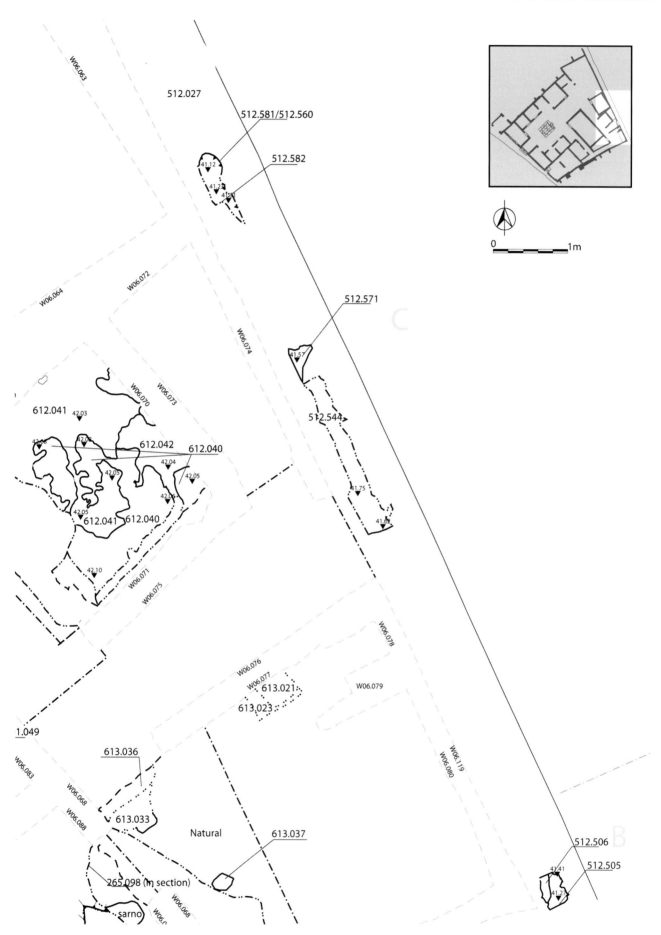

Figure 5.25.7. Plan of cuts and hard deposits related to Phase 2 from along the Vicolo di Narciso (illustration M. A. Anderson).

25.2.1 Cuts and fills

One cut was basically in line with the square shaped cuts within Rooms 3, 4, and 23, suggesting a continuity of action across all of this area. This was a roughly rectangular cut with straight, vertical sides and a flat bottom (**512.505**) that was found in the northern end of Area B. It was itself cut by the drain running through the area and was therefore relatively confused. The cut was subsequently filled with a dark yellowish brown (10 YR 4/4) loose silty sand (**512.506**) that contained only a few finds. This fill was probably a component of the natural soils, jumbled with debris and re-deposited (Fig. 5.25.8). Another cut sequenced to this phase is probably the bottom of a later cut misinterpreted by the excavators (**512.581, 512.582**) (Fig. 5.25.9). This was recovered at depth beneath the confusion of the 'soak-away feature' in Area C. It is possible that they constitute a part of that same later cut. The stratigraphic unit records seem to suggest this, although they are not sufficiently complete to be definitive. These cuts penetrated the natural soils and were seemingly filled with what was identified as 're-

deposited' natural by the excavators, which connected them with similar activities from this phase recovered elsewhere. For this reason, they have been sequenced here although they defy any satisfactory explanation.

25.2.2 Hard-packed surfaces

The northern areas under the Vicolo di Narciso pavement also produced a number of 'hard-packed' surfaces (**512.544, 512.571, 512.027**) directly over the natural soils (Fig. 5.25.10). The precise origin of these deposits is unclear, but they were certainly widespread and are present throughout the length of the footpath along the Vicolo di Narciso (**512.029, 512.035**). These surfaces were found at a higher level and are likely to be the footings for an earlier pavement or pathway. Since neither deposit was excavated, their interpretation must remain speculative. They are likely to originate from the same activity and seem to have been cut by the construction trenches for the Casa del Chirurgo's eastern boundary walls, so must predate that event in any case. At the same time, they find a parallel within the hortus (Room 20) of the Casa del Chirurgo,

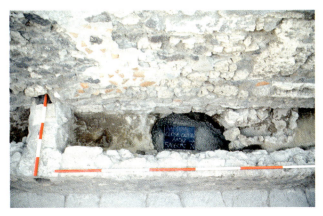

Figure 5.25.8. Square shaped cut made into early deposits on the southern end of Area C (image AAPP).

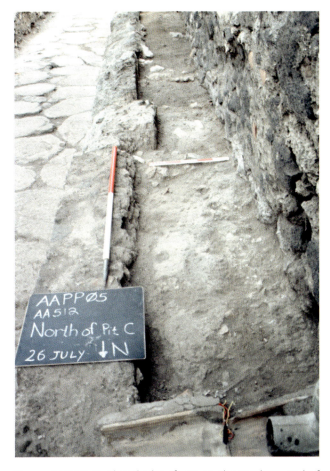

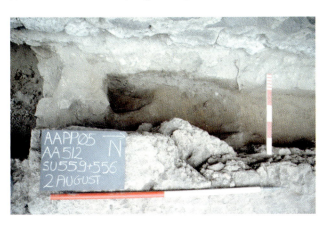

Figure 5.25.9. Cuts into the natural soils in the northern end of Area C (image AAPP).

Figure 5.25.10. Hard-packed surfaces on the northern end of Area C (image AAPP).

where similar hard-packed soils were interpreted as the base of the wall or even as the remains of an early property division. Unfortunately, due to the extremely small segment of these deposits that was recovered, truncated on both sides and only present within a narrow pavement space 1.12 m in width, it is difficult to be certain of any interpretation.

25.3 Phase 3. The Casa del Chirurgo (c. 200–130 BC)

Despite the fact that the excavations along the Vicolo di Narciso ran most of the length of the eastern property boundary of the Casa del Chirurgo, the Sarno stone walls of the first phase of this house either do not appear to have reached into the area of the pavement, or if they did, then any evidence of this must have been removed during the lowering of its level in Phase 5.

25.4 Phase 4. Changes in the Casa del Chirurgo (c. 100–50 BC)

25.4.1 Phase 4a – Casa delle Vestali

Although no deposits are present in the area that date clearly from the building of the Casa del Chirurgo, one seems to relate to the creation of the Casa delle Vestali. Situated at the northern end of the trench is a low property boundary wall (512.020) that appears related to the first construction of a series of additions to this house. As it was not excavated, its overall sequencing depends largely on what is known about the walls themselves. The extension of the Casa delle Vestali to the Vicolo di Narciso preceded later Phase 4 changes in the Casa del Chirurgo. Full discussion of this wall will be found in the publication of the Casa delle Vestali.[255]

25.4.2 Phase 4b – Changes in the Casa del Chirurgo c. 100

25.4.2.1 THE CONSTRUCTION OF THE REAR PLOT BOUNDARY WALL OF THE CASA DEL CHIRURGO

Phase 4 in the Casa del Chirurgo saw the construction of the back walls of the house – an event that is barely visible within the deposits the pavements of the western side of the Vicolo di Narciso (Fig. 5.25.11). The wall structure itself reveals that there were at least two phases to this construction, including a narrowing of the back-door following its initial construction. Unfortunately, much of the detail of these actions, including the presumed original level from which they were cut, has been lost through a combination of the widespread removal of material for the lowering of the pavement in Phase 5, which truncated the tops of all of these deposits, and the later cutting of the soils for the placement of drainage features such as cesspits and soak-away features and their associated drains during Phase 6.

25.4.2.2 BUILDING WALL W06.119

Wall W06.119 was the component of the back wall of the Casa del Chirurgo that extended from its southernmost boundary to the back doorway. This wall was built in two phases of rublework opus incertum with the upper wall constructed atop of a low mortar foundation filling a foundation cut (**512.519**). The foundations, which are slightly wider than the upper part of the wall, consisted of an opus incertum (**512.528**) construction with an irregular edge (Fig. 5.25.12). On the northern side of a drain that obscured the connection between these two elements, this was assigned the SU number **512.520**, as a dark yellowish brown, firm silty sandy mortar including brick/tile and stones in its fabric.

25.4.2.3 BUILDING WALL W06.118

The construction of wall W06.118 was similarly carried out by first filling a trench with a low foundation and then completing the upper component of an opus incertum wall on top. Like W06.119, wall W06.118 was made by filling a steeply sided, curvilinear cut 512.009 = 512.580, **512.563**), whose northern end was obscured by the collapse of a later feature (cf. infra). This led to the assignment of another cut number (512.580) for what is probably the same event. The lower wall consisted of a mortar foundation (**512.555** = **512.574** = **512.558**) (Fig. 5.25.13). After this had been built, the builder's trench was filled a very dark greyish brown (10 YR 3/2) to yellow-grey firm silty sand (**512.540**[256]) with unfinished and monochrome plaster inclusions, probably to be associated with another element of jumbled fill (512.518). This resulted in relatively wide lower foundations, protruding roughly 0.36 m east of upper wall. A gap between deposits **512.555** and **512.558** must have resulted from later interventions involving the creation of a toilet cesspit. The wall itself continued all the way north until it butted with the southern wall of the Casa delle Vestali, which has a line of wall plaster running down its southern face, indicating that this wall was plastered prior to the construction of wall W06.118. The wall served to seal off the hortus from access on the eastern side.

25.4.2.4 FABRIC AND DECORATION

Examining the fabric of these walls reveals that the lowest rubble their opus incertum construction was composed of a row of large, angular blocks of grey lava that were set upon a bed of pinkish grey (7.5 YR 7/2) mortar with large inclusions of volcanic rock, cruma, and lime. This mortar varies in colour both vertically and horizontally along the wall, most probably due to differing mixes being used in the construction and

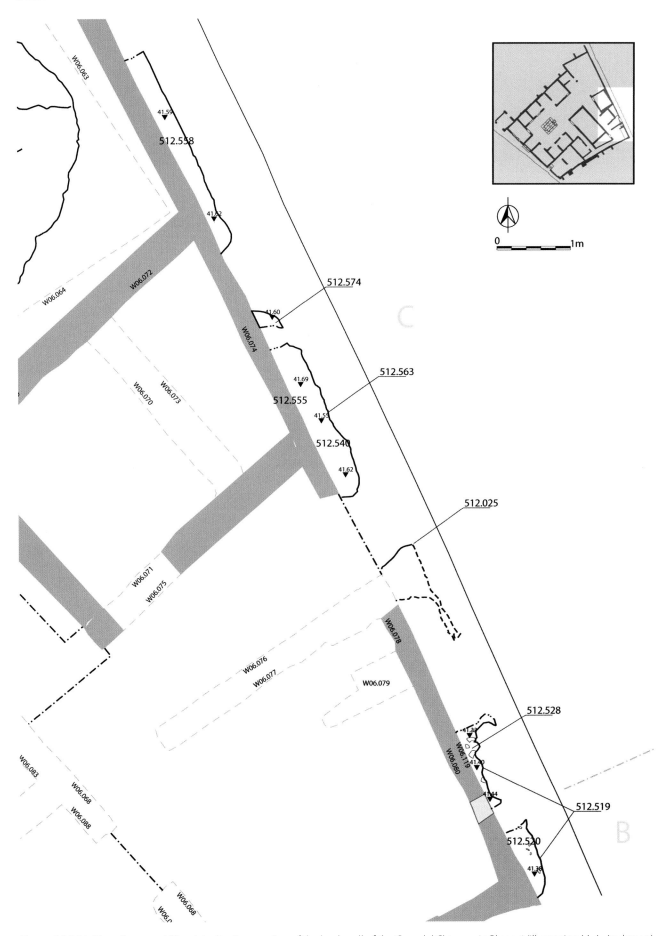

Figure 5.25.11. Plan of cuts and fills related to the creation of the back wall of the Casa del Chirurgo in Phase 4 (illustration M. A. Anderson).

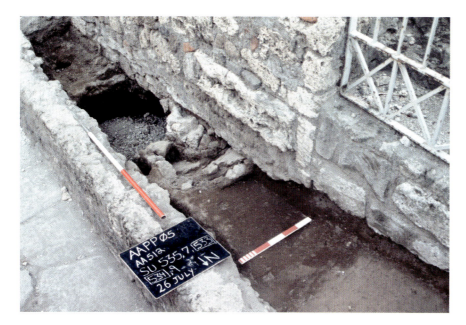

Figure 5.25.12. The foundations of wall W06.119 (image AAPP).

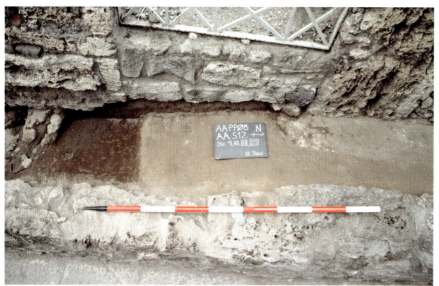

Figure 5.25.13. The foundation cut for wall W06.118 with its fill (right side of image) (image AAPP).

also perhaps the subsequent differential weathering of the mortars on the wall. Consequently, further up wall W06.118, away from the foundations, the mortar becomes a more pinkish white (10 R 8/2) colour. This variation is clearly the result of the amount and colour of the cruma used in the mortar, with ground red cruma producing a characteristic pink hue. The same mortar was found in association with the large Sarno stone quoins that form the wide read entranceway to the house, though here it appears as a very pale brown (10 YR 7/4) version of the same mortar with similar inclusions. This clearly demonstrates that the doorway was a part of the primary construction of walls W06.118/W06.119. Furthermore, it is not just the mortar that displays considerable variation. The stones employed in the *opus incertum* also varies in this wall,

with high proportions of Sarno stone and Nocera tuff in the middle of the wall, and increasing quantities of cruma towards the top of the wall. Though creating a confused wall for modern analysis, there seems to be no particular purpose behind the degree of variation encountered here. There is a line of four putlog holes in the upper part of the wall, c. 4 m above the current height of the footpath in the area of the hortus, and a further two on the same line in the region of the service wing. Here, are also three windows, of which the lower two appear to be primary with the original construction of the wall. There are traces of the weathered remains of a backing plaster visible on both walls W06.118 and W06.119, but not on the doorway narrowing *opus incertum*. It is therefore likely that it represents remnants of the first exterior decoration on

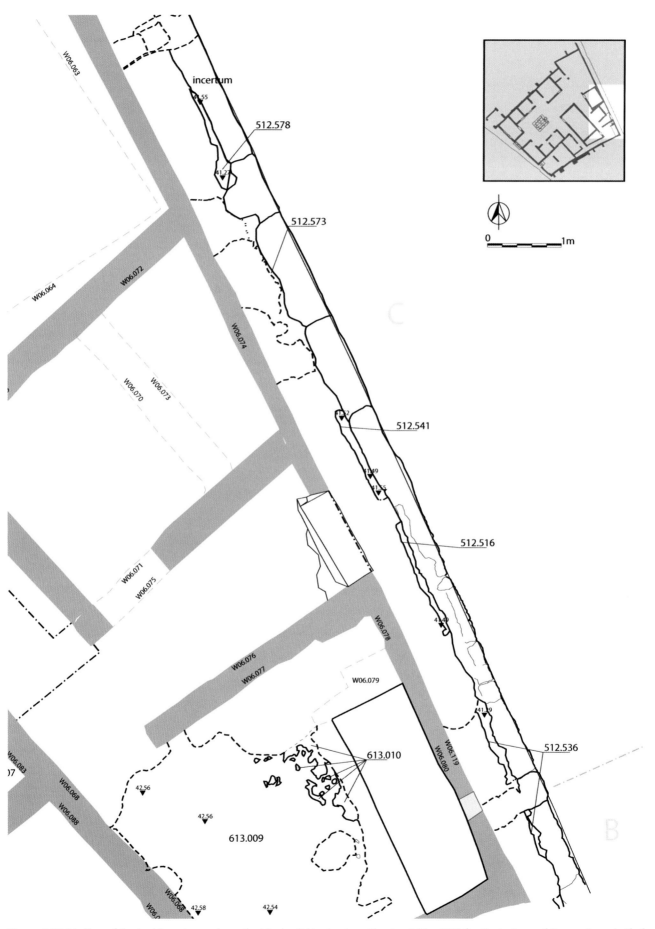

Figure 5.25.14. Plan of the kerbing stones along the Vicolo di Narciso (see Chapter 4 (Fig. 4.35) for illustrations of the northern half of the kerbing stones) (illustration M. A. Anderson).

this wall. It is composed of a white mortar matrix with angular volcanic mineral fragments and the occasional larger piece of lime.

25.4.2.5 BUILDING OF WALL W06.076/W06.077

The wide Sarno stone quoined rear doorway to the Casa del Chirurgo was narrowed through the addition of an 86 cm wide section of *opus incertum* up against the southernmost edge of the doorway, thus reducing its width from 2.10 m to 1.23 m. The new *opus incertum* was also placed underneath the lowest Sarno stone quoin stretcher. The extent of the early modern and modern pointing of wall W09.119 makes it impossible to document the mortar with which this was bonded. As part of this phase of construction, a new step was also built between the narrowing *incertum* and the northern Sarno stone door quoin. This was made from larger blocks of grey tuff, Sarno stone, and grey lava. Given the scale of the rebuilding of wall W09.119, it was likely that this area would have needed re-plastering. This was undertaken with a 10 mm thick layer of bluish grey (Gley 2 6/1) plaster with rounded volcanic inclusions with pieces of ceramic and occasional larger pieces of lime. Traces of this plaster are found on the original area of wall W06.119, as well as the narrowing section of *opus incertum* in the doorway. Similar plaster was not found further to the north on wall W06.118, perhaps indicating that this end of the wall was simply left with its previous surface. Unfortunately, no traces of the builder's trench or other datable material were recovered from AA512 that would provide greater resolution on the addition of this wall to the back of the Casa del Chirurgo. The wall served to narrow the back door and also to define the north side of Room 13. It is certain that it had occurred prior to the beginning of Phase 5, but there is little more to say about this event from the perspective of AA512.

25.5 Phase 5. Redecoration and redevelopment (late first century BC to early first century AD)

25.5.1 Kerbing stone construction (Fig. 5.25.14)

The first action in the creation of the kerbing on the Vicolo di Narciso was to remove any soils higher than the desired final elevation of the pavement. This served to remove much information about earlier phases and exposed the lower foundations of wall W06.118, which along the back wall of the hortus 'floats' directly over all deposits to the east of it, without any depth remaining to its foundations. After this was completed, a long cut running parallel to the Vicolo di Narciso was made in order to facilitate the placement of a row of roughly squared off, but irregularly sized, series of stones of

various types that was intended to serve as the kerbing of the pavement. This left a narrow trench visible in a number of places down the length of the street.

In the southern part of Area C, a small fragment of a linear cut (**512.536**), 5 cm wide and about 10 cm deep, was recovered along the line of the kerbing stones, which appears to be the result of their placement. After the kerbing stones had been positioned (Fig. 5.25.16), the cut was filled with a dark yellowish brown (10 YR 3/6) loose silty sand without inclusions (512.537). The kerbing stones themselves appear to have been reused as some bear decorated plaster on their interior faces (Fig. 5.25.16). In the middle of Area C, evidence for the placing of the kerbing stones continues in the form of a linear cut with vertical sides and an irregular base (**512.516**, **512.578**/512.579). The cut was filled with a dark yellowish brown (10 YR 4/6) loose silty sand (512.517) with some stones, pottery, and plaster. To the north (Areas D and E), the kerbing cut continued (512.541) running linearly against the kerbing stones. Traces of mortar that may have initially held the stones

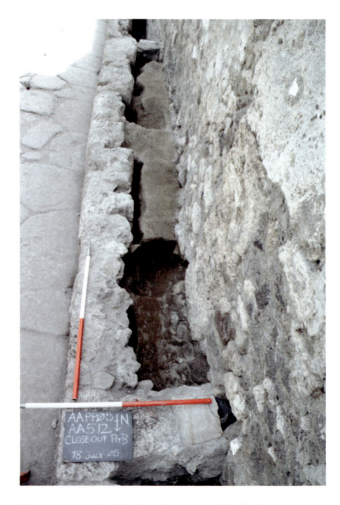

Figure 5.25.15. Cut for the placement of the kerbing stones in Area C (image AAPP).

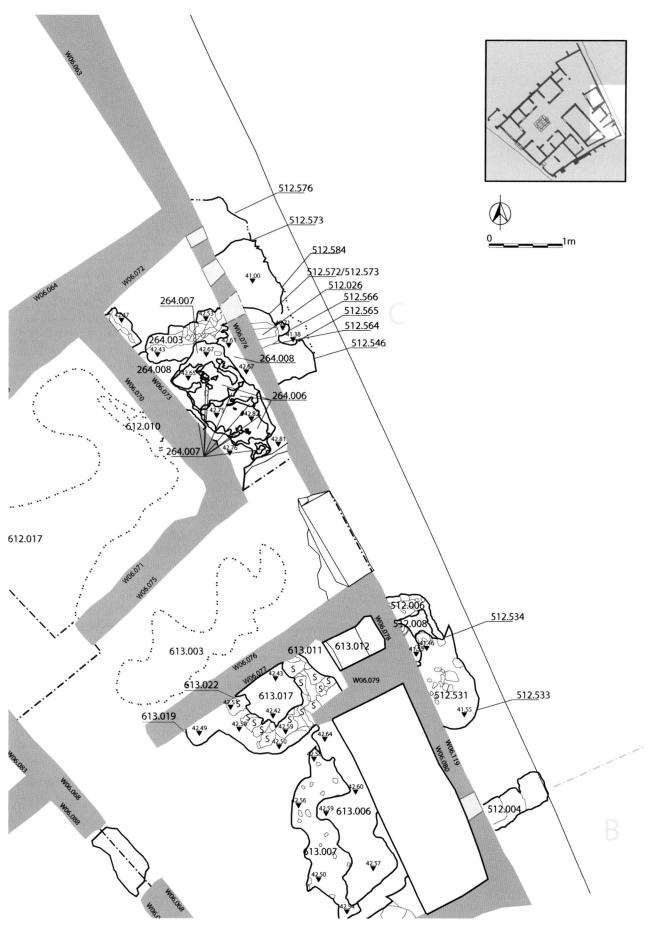

Figure 5.25.17. Plan of cesspits and drains added to the Vicolo di Narciso pavement in Phase 6 (illustration M. A. Anderson).

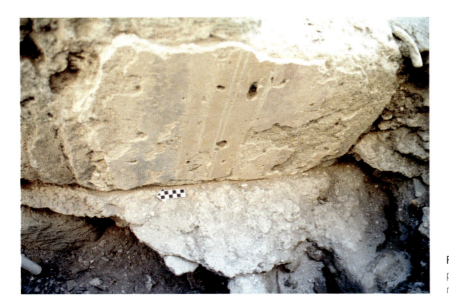

Figure 5.25.16. Kerbing stone with decorated plaster on inside face clearly documenting reuse (image AAPP).

in place (512.568) was also visible. This cut was filled with building detritus and rubble (512.542, 512.028, 512.036) (Fig. 5.25.15).

25.6 Phase 6. Upper storeys and final decoration (c. mid-first century AD)

Phase 6 witnessed alterations to the area of the pavement in response to developments within the house. Changes at this time to water collection and disposal methods within the Casa del Chirurgo led to the addition new drainage systems and the creation of a number of drains that ran through the pavement and kerb to empty onto the Vicolo di Narciso. This phase also saw cesspits and drainage features cut deep into the underlying deposits (Fig. 5.25.17). Despite the fact that these were generally filled with lapilli and lack all traces of an upper pavement surface, sufficient chronology exists in connection with activities undertaken within the Casa del Chirurgo to associate the creation of these features with Phase 6. It is likely that all of these features were undergoing renovation or repairs in the years after the earthquake(s) and immediately prior to the eruption (cf. infra), which would explain their lack of capping and lapilli in their fills.

In no place does the placement of these drainage features seem to have been hampered significantly by the kerb arrangement, implying that some of these kerbs may have been replaced or re-positioned in order to make room for the drains and cesspits.

25.6.1 Drain south Area C
This drain seems to have connected with the cistern that was the final destination of the west–east running drain from Room 22 within the Casa del Chirurgo. If so,

it would have acted as an overflow in case the cistern in the kitchen area became too full. This drain was identified as modern by the excavators, but clearly had ancient components (**512.004**). In fact, it appears to coordinate so neatly with the kerbing stone, that the stone must have been reworked or replaced with the creation of this drain. It consisted of a channel from the wall with roof tiles mortared over the top as a cover. It was associated with a fill for its construction (512.512), a dark-grey (10 YR 1/1) friable rubble that was packed in around it.

25.6.2 Cesspit at the backdoor of the house
A large cut situated immediately to the south of the back door of the Casa del Chirurgo provided the cesspit and drain for a toilet or waste disposal chute situated at the northern end of the kitchen in Room 13 (Fig. 5.25.18). A masonry drain exits the house and then bends sharply to the south before entering a depression that has been identified as a cesspit. The cut was split by the excavators into several components (**512.533**, **512.534**, and 512.535), but may easily be seen to be elements of the same activity. The drain that fed into the cesspit (512.007) is built in mortar and rubble creating a curve towards the south with a smooth channel (**512.006**). It was filled with a loose silty sand containing a mix of debris (**512.008**). A reddish mineral deposit (512.005) on the component of the drain that exited the wall of the Casa del Chirurgo, was probably a result of continued modern drainage through the system. The fills of this pit, which may very well have been heavily disturbed in modern times, do not allow a proper assessment to be made whether the feature was in operation at the time of the eruption. Nevertheless,

Figure 5.25.18. (*Left*) Drain and cesspit at the back of the Casa del Chirurgo, to the south of the back door (image AAPP).

Figure 5.25.19. (*Right*) Nearly intact pot apparently blocking the flow of the drain (image AAPP).

the distinct lack of upper pavement over this feature implies that it may have been open at the time of the eruption. This would also help to explain the significant levels of lapilli recovered from within it. A largely intact ceramic vessel found blocking the drain (512.539) (Fig. 5.25.19), however, may suggest that it was blocked at this time. The fact that the pot was tentatively identified by the excavators as preserving residues of faeces on the outside may support the identification of this feature as a cesspit for a toilet above. The fill was a friable silty sand with some inclusions (pottery, iron, bone), similar to the others recovered from this area.

25.6.3 Toilet downpipe and cesspit at the back of Chirurgo toilet

Situated in proximity to the main toilet of the Casa del Chirurgo (Room 15) was another cesspit, which was the destination of the toilet chute (Figs. 5.25.20 and 5.25.21). Combined with this feature was a pipe embedded into the wall that flowed directly into the cesspit from an upstairs toilet, situated above that on the ground floor. It is likely that the small upper window in wall W06.118 was constructed during this phase, in conjunction with this upstairs toilet. The new window was created using pieces of brick/tile, although it is impossible to ascertain what mortar this was bonded with due to the extent of the early modern and modern pointing and rendering.

The cut for the cesspit was split into multiple numbers by the excavators (**512.546**, **512.584**,

512.583, **512.566**, **512.564**, **512.565**, 512.575, **512.576**, **512.572/512.573**), but these seem to have been largely components of the same action. The build of the drain (**512.026**) was secured into the wall with modern mortar, but also consisted of an ancient northern wall or buttress (512.569) that ran along edged to the north side of the cesspit area. Both appear to have been constructed in a rubble/mortar mix, similar to that of the more southern drain. Around the drain was a layer of mortar (512.567) measuring roughly 8 cm at the bottom and 6 cm on the other sides. A large number of different deposits filled the cesspit (512.585, 512.562, 512.570, 512.559, 512.547 = 512.548 = 512.550 = 512.549, 512.551,[257] 512.556, 512.552, 512.553,[258] 512.543, 512.545, 512.554, 512.010[259]), but these should likely be seen as a single diverse fill. These fills strongly suggest that the toilet(s) and their cesspit were not functioning at the time of the eruption. A grey-white plaster fill in a matrix of grey (10 YR 6/1) loose silty sand was found over the top of the fills of the cesspit (512.010) at the northern end of Area C, and hence over all of the fills of the cesspit. This could have been the sub-floor under a now missing or eroded *opus signinum* surface. This would be similar to that found in AA507/607 in front of the Casa delle Vestali.

25.6.4 Northern drain in Area D/E

The northernmost drain within the excavated area, although unfortunately neither planned nor fully investigated by the excavators, was likely the final

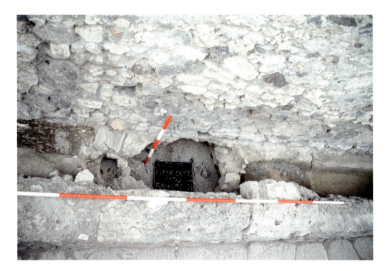

Figure 5.25.20. (*Left*) Drain, cesspit, and downpipe for toilet at back of the Casa del Chirurgo (image AAPP).

Figure 5.25.21. (*Right*) Detail of the construction of the drain, cesspit, and downpipe for toilet at back of the Casa del Chirurgo (image AAPP).

destination of the drain that ran around the hortus in Room 20 before exiting through wall W06.118. Acting as the overflow for a cistern located within the Casa del Chirurgo, excess water from this feature would have been allowed to escape directly onto the surface of the Vicolo di Narciso. The top of the drain in the northern area (**512.032**) (cf. Fig. 5.19.16) was, however, obscured by modern reconstruction in mortar and stones with terracotta capping. The cut (512.030 = 510.034) associated with its creation was only roughly linear, but did line up with the drain on either side. It is likely also to have been disturbed by later activity. Its fill consisted of a loose greyish brown silty sand that was not excavated (512.031 = 512.033).

25.7 *Phase 7. Post-earthquake changes*

Given the nature of the fills described in Phase 8–9 below, it seems likely that the cesspits and drains were undergoing considerable maintenance at the time of the eruption. Similar large-scale emptying of drainage and cess features have been uncovered elsewhere within Pompeii.[260] Evidence of interventions into the pavements has also been discovered the southern side of Insula VII 6.[261] It is therefore likely that some of the fills from the cesspits and drainage features on the Vicolo di Narciso may derive from interventions in the years before the eruption, but they have proven indistinguishable from later fills due to the considerable disturbance that the area appears to have received during the modern period.

25.8 *Phase 8. Eruption and early modern interventions*

Some fills from this period (**512.008**, **512.005**), especially in the cesspits (512.538,[262] **512.531**, 512.532, 512.539, 512.514 = 512.513,[263] 512.530) are likely to be the result of the eruption of Vesuvius in AD 79, especially given the frequency of lapilli in their matrices. This seems to support the conclusion that these features were open with work underway at the time of the eruption. Excavations within the Casa del Chirurgo also suggest that the toilet in Room 15 had been filled with debris in the period after the earthquake(s) of AD 62/3 and was out of commission for possibly a protracted period of time (cf. supra). It is possible that some of the rubble fills of the cesspits similarly represent a sustained period of disuse. Since these areas were probably also investigated by the original excavators, there is also the great likelihood that at least the upper fills of the cesspits may be early modern in origin. The early modern period also saw some interventions in the area including the reworking of some drainage features such as a round piece of mortar with inset stones capping the top of one of the drains (512.002).

The upper 0.5–0.75 m of wall W06.118 was levelled up using a section of *opus incertum* using cruma and Sarno stone set within a light brown mortar containing large pieces of ceramic and black volcanic stone with smaller lime inclusions. This was then covered with a layer of light bluish grey mortar containing black volcanic sand and larger pieces of lime, ceramic, and

tuff or lapilli that was used as a layer of render. Slightly different compositions of this render were also used extensively to point and render much of walls W06.118 and W06.119. The top of wall W06.118 was capped with a line of roof tiles set in a light brown mortar that appears to have been smoothed over the top of the rendering layer. At the southern end of wall W06.118, a hard light bluish grey (Gley 2 7/1) mortar was used to point around the stones of the lower portion of the wall. This mortar contained inclusions of rounded black volcanic beach sand and occasional larger pieces of lime. On wall W06.119, this mortar was also used as a render and thickened with pieces of broken ceramics.

25.9 Phase 9. Modern interventions

25.9.1 1970's restoration campaign

Towards the central southern end of wall W06.118, the protective tile capping for the wall was removed in order to build up the top of the wall by another c. 25 cm. This was undertaken in order to provide a roof over Room 19 and was built in opus incertum using Sarno stone and grey lava set in a greenish grey (Gley 1 5/1) mortar with lime inclusions.

An iron gate that had been fixed across the rear entranceway to the Casa del Chirurgo was fixed into place using a light bluish grey (Gley 2 7/1) mortar with large fragments of volcanic rock and smaller pieces of lime and lapilli. This mortar was also used to point around the Sarno stone of the northern doorway quoin. A large iron bar was also fixed to wall W06.119, a conservation measure designed to stabilise the upper portion of the wall. It was screwed to the wall by means

of two large nuts and bolts, one at either end of the bar. Notably, beneath the southern end of the rear, the wall is also pointed with the same light bluish grey mortar that was used to fix the gate. This mortar was also possibly used to pack behind the southern end of the iron bar, suggesting perhaps that the fixing of the bar and the doorway were carried out at the same time on wall W06.119.

25.9.2 2000's restoration campaign

Walls W06.118 and W06.119 were extensively pointed with a rough light bluish grey (Gley 2 7/1) mortar with angular black volcanic inclusions, which was also used to repair patches in the surface of wall W06.118 and for resetting the stonework of the original wall. A new copper alloy drainpipe was added in 2006, which was fastened to the wall with a smooth light bluish grey (Gley 2 8/1) mortar. This phase saw the build up of modern debris over the ancient material and some bioturbation (512.500), especially caused by falling debris from trees planted in the Casa del Chirurgo and Casa delle Vestali. This was found overlying the entirety of the trench, including those strata removed, but not recorded, by the first trench supervisor in the area. Included in the modern fills is the backfilling that resulted from our own excavation in previous seasons (AA90) (512.018, 512.019). Also modern was the creation of a new drainage system (512.013) to prevent water from the modern roofing damaging the subsurface deposits. This was a water run-off point for the guttering of the roof over Room 19, consisting of a modern terracotta tile on top of mortar.

Notes

1 Mau-Kelsey 1902, 274; Fiorelli 1873, 81; De Albentiis 1990, 81–82. Cf. discussion in Wallace-Hadrill 1997, 224–225; Carocci *et al.* 1990, 200.
2 These excavations were supervised by Phil Murgatroyd.
3 The architectural analyses were undertaken by Damian Robinson.
4 Similar windows are observable in other houses with Sarno stone *opus quadratum* façades such as the Casa degli Scienziati (VI 14, 43). See De Waele and Peterse 2005, 197–220.
5 *Contra* Maiuri (1942, 98), who suggested that this was a post-earthquake addition to the house.
6 A spot date on ceramic materials from this deposit produced during the excavation provided a *terminus post quem* of the last quarter of the first century BC on the basis of a rim sherd of terra sigillata of type Atlante II 1985, form IX. While Dore noted that this spot date was of poor quality, it is supported by presence of red slip (Accession No. 507.20115) from the end of the first century BC and vessel glass (no Finds No.) from c. 25 BC to the first century AD.
7 For this reason it is unclear whether these kerbing stones were related to the Phase 5 pavement or not. Because they are most similar in elevation with the subsequent pavement, they have been sequenced here as a component of Phase 6.
8 Cf. infra the excavations in Room 3 (AA277 and AA606) for more information on the insertion of the grey lava threshold into doorway 12.
9 Weiss 2010.
10 The presence of residual material in this deposit is shown by vessel glass (no Finds No.) dated to c. 25 BC to the first century AD, and the spot date produced during excavation which provided a *terminus post quem* of the first century BC. Dore noted that this spot date was of poor reliability.
11 A coin (Inventory Number 1074) from this deposit dated to c. 9 BC (Fig. 7.4 No. 37; Hobbs 2013, 168).
12 Maiuri 1973 (1930), 5–6.
13 Maiuri, 1973 (1930), 3–5.
14 *ibid.*
15 *Contra* Maiuri 1942, 98, who thought that this brick narrowing must have been caused by changes after the earthquake(s) of AD 62/3. Evidence of an earlier layer of plaster underlying the final phase plaster on this frame places them within Phase 5.
16 *ibid.*
17 The *PPP* II, 112 mentions a black socle, a discoloured yellow middle zone with architectural vistas flanking, and tapestry borders. This may be reflected in the cork model in the Museo Archeologico Nazionle in Naples. The atrium was certainly decorated generally with a mustard yellow ground and architectural frameworks over a black socle (*PAH* 1, 245).
18 The excavations were supervised by Phil Murgatroyd and Els Coppens.
19 The architectural analysis was supervised by Alvin Ho and Mike Rocchio.
20 Elevations on this deposit were not recorded during excavation.
21 Red slip pottery (Accession Nos. 607.32037/32014) from this deposit dating from AD 41–68 must be contamination from the reworking of the shop in Phase 6.
22 A coin (Inventory No. 882) from this deposit provides a date of c. 206–144 BC (Fig. 7.3 No. 9; Hobbs 2013, 161). Red slip (Accession No. 607.32063) dated to AD 1–40 (Berenice B 423) must result from the lowering of the floor and changes during Phase 5 and 6.

23 Inventory Number 882 (Hobbs 2013, 161). Red slip pottery dating from the end of the first century BC (607.32063) must derive from later changes to the area in Phase 5.
24 This is probably to be equated with (507.179) which was identified as the cut for walls W06.007 and W06.006. It is clear that this deposit was located in Maiuri's southern trench, and so it is possible that this cut was visible only in section.
25 Vessel glass (Finds No. 256) provides a *terminus post quem* from the late first century BC to AD 50, while red slip (Accession Nos. 607.3007, 607.30069) dates to before 10–1 BC (Sabratha 85.48). Given the probable dating of later phases of activity in this area, it is likely that a date of the late first century BC to early first century AD applies to this deposit. A coin (Inventory Number 1110) from this deposit is dated to AD 8–10 (Fig. 7.3 No. 21; Hobbs 2013, 170).
26 The reused Dressel 2–4 amphora (Accession No. 31035) of the furnace is dated to the late first century BC (Griffiths and Forster forthcoming)
27 Vessel glass (Finds No. 131) provides a *terminus post quem* of roughly the end of the first century BC (Cool 2016, 101:15).
28 The furnaces in use would then have correspond roughly to Cleere's types A 1 and B 1.ii (Cleere 1976, 127–141), although the amphora would in this case be unusual as in these types the whole furnace is constructed from raw clay. The question of slag tapping is also important. Cleere's Group A does not have provision for slag and the hearth is below the level of the soil which appears to be similar to the situation in Room 2.
29 A coin (Inventory Number 337) from this deposit provides a date of mid-second century to early first century BC (Fig. 7.3 No. 17; Hobbs 2013, 140). It is likely residual especially given red slip (Accession No. 607.30573) provides a date of AD 1–40 (similar to Berenice B 423.2).
30 A similar amphora was recovered in shop N20 of the shops outside of the Porta Ercolano (Zanella *et al.* 2017 §32). It was interpreted there as an annealing furnace, a function which is also possible for this amphora.
31 A coin (Inventory Number 1419) (Fig. 7.3 No. 25; Hobbs 2013, 179) and vessel glass (Finds No. 36) (Cool 2016, 64:13) both assign a *terminus post quem* for this deposit of roughly the end of the first century BC. Red slip (Accession No. 607.24142) dated to (AD 1–40 or AD 41–68, Berenice B 409; Campania 1, 2.13) implies the extent of later disturbance to the in the transition to Phase 6.
32 Red slip (Accession No. 607.25515) provides a *terminus post quem* of AD 1–40 (Berenice B 427.5).
33 Vessel glass (Finds No. 8) assigns a *terminus post quem* for this deposit of roughly the end of the first century BC (Cool 2016, 102:20). A coin (Inventory Number 1361) was illegible (Fig. 7.3 No. 24; Hobbs 2013, 178).
34 Red slip (507.21094) provides a *terminus post quem* of AD 1–40 (Berenice B 423).
35 A coin (Inventory Number 686) from this deposit dated to c. 125–89 BC? (Fig. 7.3 No. 31; Hobbs 2013, 161). Red slip from the deposit (Accession No. 507.20223 Berenice B 426 27 BC to AD 14; Accession No. 507.20229 Berenice B 409; Campania 1, 2.13 AD 1–40; AD 41–68; Accession No. 507.20219 Sicily 1213 AD 1–40; Accession No. 507.20221 Berenice B 409; Campania 1, 2.13 AD 1–40; AD 41–68; Accession No. 507.20226 Conspectus 33.1.1 AD 15–37) places this deposit solidly in the mid-first century AD. Blown vessel glass from this deposit (Cool 2016, 128:210) supports this date.
36 Red slip from this deposit (Accession No. 507.20138),

produces a date of AD 1–40 or AD 41–68 depending on comparanda (Berenice B 409; Campania 1, 2.13).

37 Red slip from this deposit (Accession No. 507.21054) produced a *terminus post quem* of AD 1–40 (Sicily 1248).

38 Vessel glass (Finds No. 607) provides a *terminus post quem* of c. 25 BC to the first century AD.

39 A sherd of a red slip bowl (Accession No. 507.20095) dates to AD 41–68 (Campania 1, 3.15), while another (Accession Nos. 507.20070,21095, dates to AD 1–40 or AD 41–68 depending on comparanda (Berenice B 409; Campania 1, 2.13).

40 A coin (Inventory Number 1168) from this deposit is dated to after AD 42 (Fig. 7.4 No. 41; Hobbs 2013, 172), while vessel glass dated c. 25 BC to the first century AD further suggests the presence of residual materials.

41 Vessel glass (no Finds No.) from c. 25 BC to the first century AD and red slip (Accession No. 507.20178), dated to 20 BC+ (Atlante 31) suggest that much of this material was residual.

42 A coin (Inventory Number 1163) dated c. AD 41–50 (Fig. 7.4 No. 42; Hobbs 2013, 173) was recovered in this deposit, along with vessel glass from later than AD 50, while red slip (507.20197) dated from later than the AD 1–20 (Carthage 268) and the overall spot date provided from ceramic material suggested a *terminus post quem* of the end of the first century BC on the basis of the presence of Italian terra sigillata of form Conspectus form 33, Dragendorff 24/5 and 2 wall sherds of closed forms. This may suggest that some of the pottery in this deposit was from reused contexts.

43 Possibly residual vessel glass (Finds No. 628) provides a *terminus post quem* of c. 25 BC to the first century AD.

44 Inventory Number 1163, dated c. AD 41–50 (Hobbs 2013, 173).

45 Maiuri 1930 (1973), 8–9 (Saggi 4–5).

46 E.g. Pirson 1997, 165–181; Varone, 2008, 355; Ulpian Dig. 43.17.3.7 but cf. also Saliou 1994.

47 The excavations were supervised by Claire Weiss and Els Coppens.

48 The recording of the standing architecture was supervised by Alvin Ho and Michael Rocchio.

49 NB: This deposit is frequently noted on SU sheets as sterile and devoid of finds, but was also rarely excavated by the AAPP. A small amount of soil that was 'natural' in appearance to the excavators is likely the first appearance of 606.087 and should be equated with it. A similar situation holds for SU 606.060, which is 'natural' in the base of the cut into SU 606.087. It was also not excavated.

50 As measured from the 'turf' layer recovered in the tablinum (AA200) against the elevation of lower natural soils in AA277/AA606.

51 Colour information taken from similar deposit 606.011.

52 A coin from this deposit (Inventory Number 774) dates c. 214–12 BC (Fig. 7.3 No. 7; Hobbs 2013, 157). It is likely that this coin comes from the construction of the limestone property in Phase 3.

53 Notably, this deposit contained a fragment of pottery tentatively identified as bucchero that unfortunately disappeared from the excavations overnight and is therefore unavailable for further study or complete dating.

54 A coin (Inventory No. 5) from this deposit provides a *terminus post quem* of c. 250–225 BC? (Fig. 7.3 No. 2; Hobbs 2013, 223).

55 From 277.036, Neapolis coin c. 250–225 BC? Coin Inventory No. 5 (Hobbs 2013, 223).

56 A coin (Inventory No. 1265) was found to be illegible (Fig. 7.3 No. 23; Hobbs 2013, 176).

57 Vessel glass (no Finds No.) from this deposit provides a *terminus post quem* of c. 25 BC to the first century AD.

58 A coin (Inventory No. 707) from this deposit provides a *terminus post quem* of c. 125–89 (Fig. 7.3 No. 20; Hobbs 2013, 152). Red slip from this deposit (Accession No. 277.12513) may be of form Atlante 10, which would provide a date of 10 BC+.

59 A fragment of a cast bowl (Finds No. 287) from this deposit dates to the late first century BC (Cool 2016, 102:25). Red slip (Accession No. 277.12285) produced a date of 10 BC+ (Atlante 10 v 13).

60 Vessel glass (Finds No. 62) from this deposit provides a *terminus post quem* of c. 25 BC to the first century AD.

61 Vessel glass (Finds No. 325) from this deposit also provides a *terminus post quem* of c. 25 BC to the first century AD.

62 A further complication is that stratigraphically the beaten earth floor could also be contemporary with (or slightly post-date) the *opus signinum* surface recovered in Room 4 that is dated to Phase 6. Consequently, it is possible that the earthen floor may also be from Phase 6 and that the floor associated with Phase 5 has simply not been preserved. Disjunction of the deposits and confusion in the record mean that neither interpretation can be excluded. If the earthen surface is contemporary with the *opus signinum*, then it may be simply a component of workings prior to the laying of a final surface in Room 3 that was never completed, or it may be that there were different types of flooring present in Rooms 3 and 4. While the complexities of the deposits in these areas have made it impossible to distinguish definitively between these alternatives, perhaps the simplest – and most likely – explanation is that the southern commercial unit had a beaten earth floor in Phase 5, which was later upgraded to an *opus signinum* surface in Phase 6.

63 Possibly residual vessel glass (Finds No. 75) from this deposit dates from c. 25 BC to the first century AD.

64 Possibly residual vessel glass (no Finds No.) from this deposit dates from c. 25 BC to the first century AD.

65 Vessel glass (Finds No. 60) from this deposit provides a *terminus post quem* of c. 25 BC to the first century AD. This may indicate residual material in the fill.

66 A coin (Inventory No. 1062) from this deposit provides a *terminus post quem* of 10–5 BC (Fig. 7.4 No. 34; Hobbs 2013, 167), while vessel glass (Finds No. 169) provides a *terminus post quem* of c. 25 BC to the first century AD suggesting in both cases that this material is residual.

67 This cut has been reinterpreted and enlarged on the basis of post-excavation analysis, as its originally identified extent was much smaller.

68 Inventory Nos. 1132 and 1166, RIC I Tib. 81; RIC Claud. 89 (Fig. 7.4 No. 38, 39; Hobbs 2013, 264; 267).

69 Vessel glass (Finds No. 29) from this deposit provides a *terminus post quem* of c. 25 BC to the first century AD. This may indicate residual material in the fill.

70 Vessel glass (Finds No. 123) provides a *terminus post quem* for this deposit of c. 25 BC to the first century AD.

71 Based on excavations supervised by K. Garajova

72 On the Casa delle Vestali Cf. Jones and Robinson 2004. Numerous properties in the city show signs of the addition of fountains in the final phase, presumably as a direct result of the advent of an aqueduct-driven piped water system (e.g. the Casa della Fontana piccola (VI 8, 23.24), Casa di Obellio Firmo (XI 14, 2.4.b) and others.

73 Maiuri 1930, 9–10.

74 Maiuri 1930, Fig. 1.

75 A spot date from ceramics produced during excavation

provides a *terminus post quem* of the middle of the third century BC on the basis of type Morel 4152 in Campana B, but Dore noted that this *terminus post quem* was of poor reliability. Even so, it does fit within the chronology established here.

76 A coin (Inventory No. 1268) was found to be illegible (Hobbs 2013, 176). A spot date provided during excavation suggested a not incompatible *terminus post quem* of the mid-third century BC for this deposit on the basis of black gloss of form Morel 1551a.

77 A coin (Inventory No. 567) from this deposit suggests a *terminus post quem* of the second to early first century BC? (Fig. 7.3 No. 5; Hobbs 2013, 149). It may represent contamination from later construction in the area. A spot date on the pottery for this deposit during excavation provided a third century BC *terminus post quem* on the basis of black gloss of type Morel 2424, but this was considered by Dore to be of poor reliability.

78 Cf. Adam 1994 (2005), 10; Vitruvius I, 5.

79 The original doorways into Rooms 2, 6A–E, 9 and 10 surrounding the original core of the Sarno stone atrium are flanked by similar recesses.

80 *Contra* Maiuri 1930 (1973), 4 and *passim*, who considered these plasters as evidence of the original plasters of the Casa del Chirurgo and support for his ideas of an originally much lower floor surface.

81 Contained a fragment of black gloss (Inventory No. 10906) comparable to Morel 2737f 1.

82 A knob of black gloss identified as similar to Morel 4713a 1 provides a *terminus post quem* of the end of the fouth century BC. It must represent residual material in the fill, conceivably from the Pre-Surgeon Structure.

83 A coin (Inventory No. 1270) was found to be illegible (Fig. 7.3 No. 11; Hobbs 2013, 176).

84 Although assigned as one SU, it is clear from the photographic record that this trench was in two parts, with separate trenches having been excavated for each wall element.

85 A coin (Inventory No. 772) from this deposit provides a *terminus post quem* 215–212 BC (Fig. 7.3 No. 6; Hobbs 2013, 157).

86 Black gloss (Inventory No. 9776) comparable to Morel 2791b 1 possibly provides a *terminus post quem* for this deposit of the end of the third century BC, which emphasizes the reuse of materials in the creation of this floor.

87 Vessel glass (Finds No. 38) provides a *terminus post quem* between c. 25 BC and the first century AD.

88 Vessel glass (Finds No. 114) provides a *terminus post quem* for this deposit of c. 25 BC to the first century AD.

89 Vessel glass from this deposit (no Finds No.) dated to later than AD 50 must be contamination from later phases.

90 Vessel glass provides a *terminus post quem* between the end of first century BC and 50 AD (Cool 2016, 120:147). Red slip (Accession No. 260.9951) suggests a date of between 150 to 50 BC and a coin (Inventory No. 918) was possibly from c. 206–144 BC (Fig. 7.4 No. 33; Hobbs 2013, 162).

91 Mau 1908, 292.

92 A coin from this deposit (Finds No. 100) Inventory No. 61 (Fig. 7.4 No. 43; Hobbs (2013, 131) dated to c. 250–120 BC. Blown glass was also recovered from this deposit (Cool 2016, 139:279).

93 Red gloss from this deposit (Accession No.'s 260.11120,11116, 260.11119 and 260.11118) provide a *terminus post quem* of about AD 41–68 (Campania 1, 3.15), supporting the sequencing of this deposit. The full range including forms Campania 1, 3.22 and Sicily 1213, suggest the presence of some residual material in the fill.

94 A clearly residual piece of vessel glass provides a *terminus post quem* of c. 25 BC to the 1st century AD for this deposit.

95 A coin (Inventory No. 875) from this deposit dates to c. 206–144 BC (Fig. 7.4 No. 49; Hobbs 2013, 161).

96 *PAH* 1, 2, 172–173 (Addendum II) 23rd November 1792; Parslow 1995, 207–206.

97 These excavations were supervised by Steven Ellis and Cindy Drakeman

98 Maiuri 1973 (1930), 7.

99 Maiuri 1973 (1930), 6–8.

100 This rough value was approximated from photographs and sections executed during the excavation of Room 6A.

101 Maiuri 1973 (1930), 6–8.

102 The only dated material to have been analysed from this fill are several elements of terra sigillata providing a *terminus post quem* of the end of the first century BC (Accession Nos. 183.9115/9116 and 183.9113/9114).

103 As the step post-dates the plastering of the room it is a very late addition and it is even possible that the step belongs exclusively to the early modern or even the modern periods (although not sub-Phase 9b).

104 The excavations were supervised by Steven Ellis, Cindy Drakeman, and Katerina Garajova.

105 Maiuri 1973 (1930), 10 (Saggio 8).

106 The wall analysis was supervised by Alvin Ho and Michael Roccio. Astrid Schoonhoven assisted in the checking of the interpretations of the walls in 2006.

107 Cut 609.146 was itself cut by the cut for the north–south drain and for this reason it is possible that this is the same cut as visible in section (609.160, or 609.158), although the fills seem to differ. This interpretation must remain tentative.

108 This interpretation is inferred from incomplete data recorded by the excavators.

109 It is possible that some of these may have been post-Pre-Surgeon levelling layers, but given that most were visible only in section the current interpretation appears to be the best option.

110 Pottery dates from 609.141 must result from later activities which, in removing the original floor of Room 6C, re-exposed these top surfaces and contaminated them with more recent materials.

111 Maiuri 1973 (1930), 4.

112 The deposits excavated from the channel of the drain (184.058, 184.122) could possibly have accumulated over the active use of the drain during Phases 3 and 4. The character of the deposits, however, would suggest that they are a more recent accumulation and that they are more likely to have developed more recently following the primary modern excavation of the property and are consequently attributed to Phase 9.

113 Body glass (Finds No. 73) from this deposit provides a *terminus post quem* of c. 25 BC to the first century AD.

114 As noted for Room 6B, it is difficult to sequence this feature and it is possible that the step belongs to the early modern or even the modern period.

115 Dated material from this deposit must be entirely residual, consisting of black gloss (poss. Morel 2538?) and two coins (Inventory No. 154, 647) that provide a *terminus post quem* of 125–90 BC and 125–89 BC? (Fig. 7.3 No. 16, 19; Hobbs 2013, 135, 151).

116 While the black gloss from this deposit included a rim of Morel 2286, a *terminus post quem* of AD 50 is provided by a fragment of a setting of blown glass (Finds No. 84).

117 A coin (Inventory No. 645) from this deposit provides a

terminus post quem c. 125–89 BC? (Fig. 7.3 No. 30; Hobbs 2013, 151).

118 A coin (Inventory No. 663) from this deposit provides a *terminus post quem* of c. 125–89 BC (Fig. 7.4 No. 44; Hobbs 2013, 152).

119 The excavations were supervised by Megan Dennis.

120 The architectural analysis was supervised by Amy Flint.

121 While Munsell codes taken for this deposit vary throughout Insula VI 1, the overall impression of this sand is a dark, almost purple-black colour.

122 Even though the excavators believed that this abutted the early Sarno wall on its northern and southern sides, the wall itself is so shallow that it is impossible to be certain of this, especially in the absence of any photographic documentation of the pitted earth running over the early wall. Given that the dates recovered from the fabric of the early wall base place it squarely with other structures of Phase 2, and given that the 'pea-gravel' and 'pitted earth' layers do not generally produce finds, it has been re-sequenced to this part of the phase.

123 Jones and Robinson 2004, 109; *idem* 2005, 257.

124 Peterse 2005, 199.

125 Similar observations have been made in Insula VII 6, cf. Anderson *et al.* 2012, 5.

126 Cf. the corners of the walls between the tablinum and the atrium. The western side of the tablinum was clearly open in the initial layout of the property and this is seen in the way that the Sarno quadratum blocks of wall W06.061 are seamlessly keyed into wall W06.021 and present a squared corner to the room. This is not observable at the junction between wall W06.061 and wall W06.068 and would indicate that this corner was not part of the original layout of the house.

127 Vessel glass (Finds No. 45) provides a *terminus post quem* for this deposit of c. 25 BC to the first century AD, while red slip ware (Accession No. 200.9759) provides a *terminus post quem* of prior to AD 1–40 or 10–1 BC depending on comparanda (Berenice B 400; Sabratha 85.45; Sicily 1184).

128 Red slip pottery (Accession No. 200.9719) from this deposit produced a date of AD 14–54.

129 Red slip pottery from this material (Accession Nos. 200.9702, 200.9706) produced dates of the end of the first century BC and AD 41–68 respectively. The second of these might indicate material that fell into this cistern during the eruption.

130 Unpublished excavation report for AA36 in the Casa delle Vestali

131 *PAH* 1, 248.

132 These excavations were supervised by Darren Bailey.

133 The architectural analysis was supervised by Amy Flint.

134 Maiuri 1973 (1930), 10 (Saggio 9).

135 The cleaning was supervised by Ian Sumpter.

136 These confusing deposits were sequenced incorrectly at the time of excavation. Nevertheless, the photographic documentation allowed the subsequent reconstruction of the correct sequence for this volume.

137 Cf. the drains in AA045, AA053, AA065 and the latrines in AA050 and AA069 from the Casa delle Vestali for comparative evidence of mineral staining.

138 Peacock and Williams 1986, 85.

139 The three coins (Coin Inventory Nos. 835, 901, 1445) in this assemblage were recovered from 261.043 and date from the third to the first centuries BC (Fig. 7.3 No. 8, 10, 12; Hobbs 2014, 223). Red slip (Accession Nos. 261.8142, 261.8141,

261.8026) provides a range of dates from 180–170 BC (Morel 1224a stamp: similar to BG decoration) to 25–20 BC+ (Atlante 20 v 12) to AD 41–68 (Campania 1, 3.15). This must indicate the degree of disturbance caused by later removal of the flooring in this area. Later sherds must all derive from the activities of Phases 5 and 6.

140 Fragments of black gloss identified as Morel 5814c 1 (9941) provides a *terminus post quem* of the early third century BC. The deposit also produced a fragment of Morel 2255f 1 (9942). A lamp fragment (9924) identified as Bisi Ingrasi Tipo XI, A dates after about AD 1. This must originate from disturbances to the area during Phase 5.

141 A red gloss handle (Accession No. 261.9986) from this deposit, dated to the end of the first century BC or later, must come from disturbances during Phase 5.

142 The three coins (Coin Inventory Nos. 835, 901, 1445) in this assemblage were recovered from 261.043 and date from the third to the first centuries BC (Hobbs 2014, 223). Similarly, vessel glass dated was recovered in this deposit that dates from c. 25 BC to the first century AD. The finds in general indicate a high degree of contamination from interventions of the first century BC (Phase 5), but permit a general chronological framework as outlined here.

143 Cf. the construction of the Casa del Chirurgo atrium *opus signinum* floor, and Chapter 9.

144 Two fragments of red slipped pottery (Accession Nos. 261-.8098, 261-.8099) and provide respectively a *terminus post quem* the mid-first century BC+ (Campania 2, 9.8) and 27 BC to AD 14 (Atlante II 1985, form 28). A fragment of black gloss identified as Morel 1312a 1 (Accession No. 10995) is likely residual, while a further fragment of red slip (Accession Nos. 261.11911,11825) must be intrusive from later activity as it dates from AD 41–68 (Campania 1, 3.15).

145 Eschebach 1993, 152; *PAH* 1, pp. 253.

146 The diagnostic diamond shapes were preserved in the pink mortar square *emblema* bedding layer (261.037).

147 Maiuri 1973 (1930), 10 (Saggio 9).

148 These excavations were supervised by Philip Murgatroyd and Karen Dehram.

149 The recording of the architecture was supervised by Alvin Ho and Michael Rocchio.

150 This date does not derive from materials recovered within Room 11, but rather from deposits excavated in the atrium of the house.

151 Most clearly documented in the Casa delle Vestali. See the future publication of this material for details.

152 The interpretation of deep pits penetrating through to the natural soils as mines for clean soils in preparation for construction has now become commonplace. Examples include House VI, 13, 8 (Verzár Bass *et al.* 2008, 193; Gobbo and Loccardi, 2005 191–192); the central peristyle of the Casa di Arianna (VII 4, 31–33.50.51) (Albiach Ballester *et al.* 2008 252); a pit in the atrium of House VI 2, 16 (Coarelli 2005, 97); Casa delle Nozze d'Ercole (VII 9, 47.48.51.65) (D'Alessio 2008, 281). A similar but much better preserved pit recovered in shop N19 of the shops outside of the Porta Ercolano was interpreted as attempting to reach the underlying lava plateau for exploitation (Zanella *et al.* 2017 §27).

153 Vessel glass (Finds No. 56) from this deposit provides a *terminus post quem* of c. 25 BC to the first century AD. Red slip (Accession No. 265.12087) dated to prior to 15 BC (Campania 1, 3.22).

154 Black gloss from this deposit in the form Morel 2863a 1 provides an Augustan-Tiberian *terminus post quem* for

this deposit. Additional dated materials such as two coins (Inventory Nos. 36. 214) dated to the third to second century BC and the mid-second to early first century BC? respectively (Fig. 7.3 No. 14, 15; Hobbs 2013, 129; 138). Red slip produced a range of forms (Accession Nos. 265.10368, 10627 Morel 2641a second or third quarter of the third century BC; Accession No. 265.1029 Morel 5424a approximately 200 BC; Accession No. 265.10628 Atlante 7 v 3 prior to 30–15 BC; Accession No. 65.10625 Atlante 31 v 5 20 BC+; Accession No. 265.10365 Berenice B 399 prior to AD 1–40; Accession No. 265.10278 Morel 5432a second quarter of the third century BC). Lamp fragments dated to 150–70 BC+ (Bailey Q713) (Accession Nos. 10310, 10312, 10616, 10311, 10355, 10309). Overall these appear to be compatible with a Phase 5 sequence.

155 Red slip from this deposit (Accession No. 614.25536 Morel 1432, 1441 first century BC; Accession No. 614.24505 Morel 7121a 300 BC; Accession No. 614.25535 Morel 2824a second half of the first century BC; Accession No. 614.245 Sicily 1249 AD 1–40; Accession No. 614.24508 Atlante 28 27 BC – AD 14) provides a range of dates on the later end of Phase 5.

156 This deposit contained black gloss in forms Morel 2637a 1 (11378) and 2286b 1 (11373), red slip (Accession No. 265.12087) from 20 BC+ (Atlante 31 v 5), along with vessel glass (Finds No. 74) dated from c. 25 BC to the first century AD.

157 Likely residual material from this deposit included a coin (Inventory No. 1083) dated to 7 BC (Fig. 7.4 No. 47; Hobbs 2013, 168) and vessel glass (Finds No. 31) dated from c. 25 BC to the first century AD. A fragment of lamp (Accession No. 10786) provides a *terminus post quem* of the first century AD (Bisi Ingrasi Tipo IX).

158 This deposit produced a glass cantharus (Cool 2016, 145: 326).

159 These excavations were supervised by Daniel Jackson.

160 The recording of the architecture was supervised by Alvin Ho and Michael Rocchio.

161 Red slip from this deposit (Accession No. 610.30032) provides a *terminus post quem* of prior to AD 1–40 (Berenice B 399).

162 Vessel glass (Finds No. 175) from this deposit provides a *terminus post quem* of c. 25 BC to the first century AD. It must be residual.

163 A coin (Inventory No. 17) from this deposit provides a *terminus post quem* of AD 14–37 (Fig. 7.3 No. 22; Hobbs 2013, 128), possibly indicating the precise period of use for this floor.

164 RPC I 604/1 (Hobbs 2013, 128).

165 Vessel glass (Finds No. 99) from this deposit provides a *terminus post quem* of c. 25 BC to the first century AD. It must be residual.

166 Vessel glass (Finds No. 81) from this deposit provides a *terminus post quem* of c. 25 BC to the first century AD. It must be residual.

167 Vessel glass (Finds No. 164) from this deposit provides a *terminus post quem* of later than AD 50.

168 Vessel glass (Finds No. 145) from this deposit provides a *terminus post quem* of c. 25 BC to the first century AD. It must be residual.

169 A coin (Inventory No. 79) of uncertain but possibly early date (Fig. 7.3 No. 3; Hobbs 2013, 132) and vessel glass from c. 25 BC to the first century AD must indicate the presence of residual material.

170 The excavations were supervised by Keffie Feldman.

171 The architectural analysis was supervised by Alvin Ho and Michael Rocchio.

172 Since these deposits have been roughly phased from evidence recovered elsewhere in the excavations in Insula VI 1 to prior to the mid-second century BC, a spot date for 613.023 of the end of the first century BC+ must be discarded as contamination from intrusive later activities.

173 Unfortunately, the elevations of these deposits were omitted by the excavators and so it is not possible to compare them with similar deposits elsewhere. Nevertheless, the general impression of their sequence with regard to other elevations suggest that they may be sequenced along with the same activities of early levelling discussed more extensively in the excavations in areas to the north of Room 13.

174 Jones and Robinson 2007, 393; *idem* 2004, 113.

175 Red slip pottery (Accession Nos. 613.30646, 30647, 30648, 30206 Atlante 6 v 10 30 BC+; Accession No. 613.30076 Sicily 1249 AD 1–40; Accession No. 613.30209 Morel 1544a first half-mid third century BC; Accession No. 613.30205 Berenice B 399.3 dated prior to AD 1–40) was recovered in tandem with vessel glass (Finds No. 90) dated c. 25 BC to the first century AD). A coin (Inventory No. 531) from this deposit provides a date from the second to early first century BC? (Fig. 7.3 No. 18; Hobbs 2013, 176). A lamp fragments dated after 20 BC (Bailey Type A). On the whole a date within Phase 5 is possible.

176 Piranesi 1804–7, Vol. 1 Plates XX, XXI.

177 Piranesi 1804–7, Vol. 1 Plate XIX and Plate XXI.

178 Excavations supervised by Karen Derham, architectural analysis by Alvin Ho and Michael Rocchio.

179 Nappo 1996; Berg 2008, 200; Anderson *et al.* 2012, 14.

180 The excavation was supervised by Keffie Feldman.

181 *N.B.* The colour and texture of this deposit have been taken from the descriptions given for the natural in AA 200 (200.121, 200.135 and 200.126).

182 *N.B.* The descriptions of the colour and grain size of this deposit given here are taken from AA 200 (200.119).

183 Vessel glass (Finds No. 609) dated after AD 50 must derive from Phase 6 changes in this area, in which previous flooring was removed and the black sand re-exposed.

184 Vessel glass (no Finds No.) from this deposit provides a *terminus post quem* of c. 25 BC to the first century AD.

185 See the future excavation monograph for the Casa delle Vestali and the report for AA 90 for more details.

186 Red slip pottery (Accession Nos. 508.23418, 508.23420/23421, 508.23417) dated from after the end of the first century BC found in this deposit must derive from disturbances during construction in Phase 5.

187 Red slip from this deposit (Accession No. 508.23417 Berenice B 409; Campania 1, 2.13 AD 1–40; AD 41–68; Accession No. 508.23419 Conspectus 12.1.2 10 BC – AD 14; Accession No. 508.23420, 23421 Atlante 29 v 12–14 AD 20–45; Accession No. 508.23418 Berenice B 399 prior to AD 1–40) speaks strongly to the degree of disturbance this area received in Phases 5 and 6 and may imply that at least this posthole should be sequenced during those activities.

188 Red slip (Accession Nos. 508.20416, 508.20409, and 508.20412) dated to the third quarter of the second century BC (Morel 2648c), the second to first century BC (Morel 1253b), and 20 BC+ (Atlante 31) respectively, combined with vessel glass c. 25 BC to the first century AD (Cool 2016, 156:407) supports a Phase 5 date for this deposit. Additional red slip (Accession Nos. 508.20411, 20419) dated to AD 41–68 (Campania 1, 3.15) attests to the degree of soil churning the garden experienced.

189 The spot date was assigned on the basis of terra sigillata

(Atlante II 1985, form VIII) dated to after c. 15 BC. Cf. the forthcoming publication of the pottery for more information.

190 Vessel glass (no Finds No.) from this deposit provides a *terminus post quem* of c. 25 BC to the first century AD. Spot dating on ceramic materials undertaken during the excavation provided a similar *terminus post quem* of the end of the first century BC on the basis of the presence of Italian terra sigillata (Conspectus form 33 (Dr. 24/25)). Dore noted that the reliability of this date was good.

191 A vessel glass cantharus (no Finds No.) dating from the first century AD (Cool 2016, 145: 327) and red slip (Accession No. 508.23384) from AD 1–37 (Conspectus 35.1.1) suggests that this soil may be heavily mixed with later materials.

192 Red slip (Accession Nos. 508.21352 and 508.21349) dated to 20 BC+ (Atlante 31) and AD 1–50 (Conspectus 26.2.1), combined with vessel glass dated to after AD 50 (Cool 2016, 119:133) are suggestive of churning of the soils during Phase 6.

193 Vessel glass (no Finds No.) from this deposit provides a *terminus post quem* of after AD 50. This may document the degree of jumbling that the garden soils experienced.

194 Vessel glass (no Finds No.) from this deposit provides a *terminus post quem* of c. 25 BC to the first century AD.

195 Vessel glass (no Finds No.) from this deposit provides a *terminus post quem* of c. 25 BC to the first century AD. Red slip (Accession No. 508.21332 Atlante 31 20 BC+; Accession No. 508.21333 Atlante 35 v 6 AD 20+) provided compatible dating.

196 The spot date was based on a piece of red slip pottery of Conspectus form 33 dated to the Augustan period. Vessel glass (no Finds No.) dated to the first century AD, and red slip (508.23384) (Atlante II 23 v 4) dated to after AD 5–10 suggest a slightly later date.

197 Vessel glass (no Finds No.) from this deposit provides a *terminus post quem* of c. 25 BC to the first century AD. Red slip (Accession Nos. 508.21210, 21211) provide a *terminus post quem* of 30 BC+ (Atlante 6 v 9).

198 Vessel glass (no Finds No.) from this deposit also provides a *terminus post quem* of c. 25 BC to the first century AD.

199 Spot dating of the ceramic materials from this deposit produced during the excavation provided a *terminus post quem* of the first century BC. Dore noted that this date was of poor reliability.

200 Vessel glass (no Finds No.) from this deposit provides a *terminus post quem* of c. 25 BC to the first century AD. Red slip (Accession No. 508.20616) dates to AD 20–25 (Atlante 19 v 9).

201 Vessel glass (no Finds No.) from this deposit provides a *terminus post quem* of c. 25 BC to the first century AD. Red slip (Accession No. 508.21316) dated to 10 BC+ (Atlante 10).

202 Vessel glass (Finds No. 608) from this deposit also provides a *terminus post quem* of c. 25 BC to the first century AD (Cool 2016, 102:29).

203 Vessel glass (no Finds No.) from this deposit also provides a *terminus post quem* of c. 25 BC to the first century AD. Red slip (Accession No. 508.20609) provides a *terminus post quem* of 20 BC+ (Conspectus 22.2.1).

204 A spot date based on ceramic finds from this deposit produced during excavation provided a *terminus post quem* of the mid-first century AD on the basis of one very small rim sherd identified as a Dragendorff 29 form. While Dore noted that this date was of poor reliability, it is bolstered by vessel glass (no Finds No.) dated between the late first century BC and AD 30.

205 The spot date was assigned on the basis of a small rim sherd of terra sigillata identified as a Dragendorff 29 form. Cf. the forthcoming publication of the pottery from the House of the Surgeon for more information.

206 Maiuri 1973 (1930), 11 (Saggio 10).

207 A coin from this deposit was illegible (Inventory No. 1314. Hobbs Fig. 7.4 No. 50; 2013, 177).

208 Red slip from these soils (Accession Nos. 508.21125 and 508.21127) suggests the presence of material from the final phases of the house (Conspectus 26.1.3 AD 1–50 and Campania 1, 3.15 AD 41–68 respectively).

209 Spot dating of the ceramic materials from this deposit during excavation produced a *terminus post quem* of the end of the first century BC on the basis of a terra sigillata dish of c. 15 BC – c. AD 30. Dore noted that the quality of this *terminus post quem* was poor. A coin (Inventory No. 1005) from this deposit provides a date of c. 206–144 BC (Fig. 7.5 No. 55; Hobbs 2013, 165).

210 Blown vessel glass was found in this deposit (Cool 2016, 127:188).

211 A coin (Inventory No. 854) from this deposit provides a date of c. 206–144 BC (Fig. 7.4 No. 54; Hobbs 2013, 161).

212 Residual red slip (Accession Nos. 508.20571, 508.20572) dated to 20 BC+ (Atlante 31).

213 It should be noted that excavations in AA612 experienced the unfortunate loss of a number of drawings, particularly plans. Consequently, it has been necessary to work without scaled archaeological drawings of deposits excavated during the earlier weeks of the excavation. In these cases, the deposits were added to the plans from sketches on SU sheets. In each case this is clearly noted through specific planning conventions as detailed in Chapter 2.

214 The excavations were supervised by Keffie Feldman.

215 The architectural analysis was supervised by Alvin Ho and Michael Rocchio.

216 A coin (Inventory No. 114) from c. 170–100 BC (Fig. 7.3 No. 4; Hobbs 2013, 134) and red slip (Accession Nos. 612.25557 and 612.25558) dating from the second century or first century BC (Morel 1251a) and 15–10 BC (similar to Atlante 12 v 1) must all represent intrusive material resulting from later changes in the area, possibly in Phase 4.

217 The excavators of these deposits thought that these pits had preceded the black sand, but this was due to the difficulties of identifying cuts in a deposit that tends to not hold edges of any kind and it is clear that they should instead be sequenced here.

218 Vessel body glass (Finds No. 264) dated from AD 50 or later associated with this deposit must derive from later interventions or be some sort of error.

219 While glass dates from the floor itself suggest a much later date, this must be attributed either to the contamination of the deposits, which had experienced considerable damage from roots, or possibly represents excavator error. It seems extremely unlikely that this floor, which underlies two following *opus signinum* surfaces, could date from any point much later than 100 BC, as it clearly represents a component of the first phase of changes to the Casa del Chirurgo and the creation of two rooms in the garden within the earlier porticoes. For this reason, this floor has been interpreted at belong to this phase despite of this dating anomaly. The accepted early date of the floor within Room 19 also supports this conclusion.

220 A bes coin (Inventory No. 560) dated from the second to the early first century BC (Fig. 7.3 No.13; Hobbs 2013, 149)

is compatible with this phasing. Vessel glass (Finds No. 243) dated to later than AD 50 must represent contamination during excavation or an error of some kind.

221 Red slip pottery (Accession No. 612.25084) provides a *terminus post quem* of the end of the first century BC (Morel 2831a).

222 Red slip pottery (Accession Nos. 612.30438, 612.30437) that dates from 15–10 BC (similar to Atlante 12 v 1) and the second to first century BC (Morel 1251a) is likely residual. A coin (Inventory No. 530) from this deposit provides a date of the second to early first century BC (Fig. 7.3 No. 29; Hobbs 2013, 148).

223 Vessel glass (Finds No. 403) provides a *terminus post quem* from the late first century BC to AD 50. Red slip (Accession No. 612.30361) provides a *terminus post quem* of 20 BC+ (Atlante 31). The latter end of this range is compatible with Phase 6.

224 This is clear from the use of the same mortar for the brick/tile repairs as for the vaulted roof of Room 19 and the creation of an upstairs toilet in Room 15.

225 A coin (Inventory No. 426) from this deposit provides a date of c. 214–150 BC (Fig. 7.3 No. 28; Hobbs 2013, 144).

226 Two coins (Inventory Nos. 176, 423) date from the mid-second to early first c. BC? (Hobbs (2013, 136; 144), while a third (Inventory No. 724) dates possible from 125–89 BC? (Hobbs 2013, 153). Vessel glass (Finds No. 174, 302, 320, and 408), provides a *terminus post quem* that is after AD 50 (Cool 2016, 107:43; 119:117). A vast array of red slip was recovered from this deposit (Accession No. 612.25686 Conspectus 37.5.1 AD 14+; Accession No. 612.25684 Berenice B 423.2; Campania 1, 1.1 AD 1–40; 27 BC – AD 14; Accession Nos. 612.21771, 612.24831, 612.21975 Berenice B 399 prior to AD 1–40; Accession No. 612.30088 Berenice B 423.2; Campania 1, 1.1 AD 1–40; 27 BC – AD 14; Accession No. 612.21773 Berenice B 399 prior to AD 1–40; Accession No. 612.21981 Morel 2974a 140–130 BC; Accession No. 612.21774 Morel 2621h beginning third century BC; Accession No. 612.2483 Morel 1623d second half first century BC; Accession No. 612.21976 Berenice B 409.3 AD 1–40; Accession No. 612.24834 Carthage 308 AD 1–20; Accession Nos. 612.30089, 30360 Berenice B 423.2; Campania 1, 1.1 AD 1–40; 27 BC – AD 14; Accession No. 612.3009 Morel 5424a approximately 200 BC; Accession Nos. 612.21974 and 612.24828 Morel 5432a second quarter of the third century BC; Accession No. 612.25685 Morel 5424a approximately 200 BC; Accession No. 612.21779 Atlante 7 v 6 prior to 30 BC – 15 BC; Accession No. 612.21767 Conspectus 7.2.1 to AD 14; Accession No. 612.25998 Berenice B 409; Campania 1, 2.13 AD 1–40; AD 41–68; Accession No. 612.21769 Atlante 3 v 5 prior to 40 BC +; Accession No. 612.21973,30087 Atlante 6 v 9 30 BC+; Accession No. 612.21768 Atlante 3 v 4 prior to 40 BC+ Accession No. 612.21776, 25691 Conspectus 25.1.2 27 BC – AD 37; Accession Nos. 612.25683, 21772, 21778, 21973, 25687, 25682 Morel 1253b second or first century BC; Accession No. 612.2198 Morel 7121a 300 BC), suggesting not only significant presence of residual materials, but also supporting such a date.

227 Two coins (Inventory No. 1066; 1069) provide a *terminus post quem* for this deposit of 9 BC (Hobbs (2013, 167). Vessel glass (Finds No. 170, Finds No. 174) dated between c. 25 BC and the first century AD (Cool 2016, 120:138) and red slip (Accession Nos. 612.25258 and 612.25257) dated to prior to 40 BC+ (Atlante 3 v 5 ?) and AD 1–40 (Sicily 1248) respectively support a later date.

228 Pernice 1938, 84.

229 The excavation was supervised by Karen Derham.

230 The architectural documentation was supervised by Alvin Ho and Michael Rocchio.

231 Glass unguent bottle fragments from this deposit (Finds No. 18) (Cool 2016, 65: 37) provide a *terminus post quem* for this deposit of the early first century AD or later.

232 A fragment of lamp (Accession No. 9918) provides a *terminus post quem* of 150–75 (Similar to Bailey Type O or R).

233 The red slip assemblage (Accession No. 263.8107 Berenice B 427; Campania 1, 2.14 AD 1–40; AD 41–68; Accession No. 263.811 Berenice B 415; Campania 1, 2.13 AD 1–40; AD 41–68; Accession No. 263.8108 Atlante 9 v 2 12/10 BC+; Accession No. 263.8106 Conspectus 24.4.1 10 BC+; Accession No. 263.8105 Atlante 31 v 5 20 BC+; Accession Nos. 263.8028, 10459, 10460, 12810 Atlante 31 v 5 20 BC+; Accession No. 263.8109 Atlante 35 v 10 AD 20+) supports a date for this deposit in the mid-first century AD or even later. A lamp fragment (Accession No. 13106) provides a *terminus post quem* of 20 BC+ (Bailey Type B, group i).

234 Glass unguent bottle fragments (Finds No. 84, 39, and 22) (Cool 2016, 65:38; 50) date between c. 25 BC and AD 30 (Cool 2016, 102:18; 133:235). The red slip from this deposits has a range of forms (Accession No. 263.12808 Atlante 10? 10 BC+; Accession No. 263.13638 Berenice B 427.5, stamp: Pompeii PN 500 (ITS) AD 1–40; stamp 12 BC+; Accession No. 263.10455 Berenice B 415; Campania 1, 2.13 AD 1–40; AD 41–68; Accession No. 263.10464 Conspectus 22.5.1 20 BC+; Accession No. 263.12813 Conspectus 33.4.1 AD 15–37; Accession No. 263.12814 Atlante 31 v 5 20 BC+; Accession No. 263.10465 Atlante 10 v 31 10 BC+ (possibly mid-first century AD); Accession No. 263.10454 Atlante 25 v 8 20 BC+; Accession Nos. 263.12809, 10461 Conspectus 22.5.1 20 BC+; Accession No. 263.12811 Conspectus 23.1.1 AD 25+; Accession No. 263.12812 Atlante 35 v 10 AD 20+; Accession Nos. 263.12816, 17, 21 Atlante 10 v 8 10 BC+; Accession No. 263.12886 Berenice B 409; Campania 1, 2.13 AD 1–40; AD 41–68; Accession No. 263.8102 Atlante 31 v 5 20 BC+; Accession No. 263.8101 Atlante 37 v 12 prior to AD 15+). One lamp fragment (Accession No. 12877) provides a *terminus post quem* of 20 BC+ (Bailey Type A, group iii), while another (Accession No. 10478) lowers the *terminus post quem* to 1 AD (Bisi Ingrasi Tipo VIII). These are consistent with a date for this deposit in the mid to late first century AD.

235 Vessel glass from this deposit (Finds No. 40) probably dates to AD 25 or later. Red slip pottery (Accession No. 263.13580, 13142 Atlante 37 v 12 20 BC+; Accession No. 263.13578 Conspectus 9.1.2, Atlante 34,1–3 10 BC – AD 1; Accession No. 263.10266 Atlante 31 v 4 20 BC+; Accession No. 263.13147 Atlante 31 20 BC+) provides evidence for earlier residual materials.

236 On the problems of Pompeian room use, see Allison 2004, 11–14.

237 The excavation was supervised by Karen Derham.

238 The excavation was supervised by Darren Bailey.

239 The architectural documentation was supervised by Alvin Ho and Michael Rocchio.

240 This deposit contained black gloss (12421) of type Morel 1551b 1 dated to 300 BC.

241 Accession No. 12421.

242 For more information on the pottery recovered from this deposit, *cf.* the publication of pottery from the House of the Surgeon, Griffiths and Foster, forthcoming. The present date comes from spot dating undertaken in the field season.

243 Cf. De Albentiis 1990, 81–82.

244 Bon *et al.* 1997, 44–47; Jones and Robinson 2004, 109. Pesando uses the term *opus formaceum* for internal elements of the Casa del Centauro (VI 9, 3–5) (third century BC) that were created in the same way. (Pesando 2005, 87; Coarelli and Pesando 2011, 52).

245 Accession No. 12426, identified as type Morel 2283d 1.

246 Black gloss (12394) identified as Morel 1314e 1 provides a *terminus post quem* for this deposit of 300 BC. This may represent residual material from the Pre-Surgeon Structure.

247 Vessel glass from this deposit provides a *terminus post quem* for this deposit of AD 1–40. Red slip produces forms that likely indicate the presence of residual material (Accession Nos. 262.13053 and 262.13051 Atlante 31 v 5 20 BC+).

248 Material from this deposit suggests a jumble of residual material: a coin (Inventory No. 635) provides a *terminus post quem* of c. 125–89 BC (Hobbs (2013, 151), black gloss (Morel forms 2784b 1 2255f2 (10439) 2652a 1 (10443), and Morel forms 2737e 1 (10438) dated to c. 285 BC ± 20 years, and vessel glass from c. 25 BC to the first century AD.

249 A similar range of finds from this deposit include a coin (Inventory No. 900) providing a date of c. 206–144 BC (Hobbs 2013, 162), red slip ware dated to the end of the first century BC (Accession Nos. 262.10133, 262.10125) and vessel glass from later than AD 50 (Finds No. 49). Red slip provides evidence for a similar range of residual material. (Accession No. 262.10133 Berenice B 423, AD 1–40; Accession No. 262.10125 Morel 2714a, 270 BC; Accession No. 262.10132 Sabratha 85.48, prior to 10–1 BC; Accession No. 262.10126 Atlante 28 v 1, 27 BC – AD 1; Accession Nos. 262.10134, 10130 and Atlante 8 v 1, 20 BC+).

250 While no modern materials were recovered from these deposits, naturally their stratigraphic position, near to the modern overburden does mean it is impossible to exclude entirely the possibility that these derive from modern or early modern dumping or collapse.

251 Red slip pottery (Accession Nos. 262.13953, 262.13952) from this deposit provides a date of AD 20+ (Atlante 13 v 4), and 10–15 BC+ (Atlante 12 v 1). This material is likely residual.

252 While a coin from this deposit (Inventory No. 1229) proved to be illegible (Hobbs 2013, 175), vessel glass (Finds No. 39) provides a *terminus post quem* of AD 50 (Cool 2016, 108:53).

253 Excavations were supervised by Darren Bailey and Els Coppens. The transition between the two occurred early in the excavation, but resulted in the loss of some data from the earliest moments of its execution, meaning that the initial deposits removed (particularly in the southern parts of the area) are not sequenced in this report. Happily most of this material was modern overburden, and the overall archaeological sequence in the area remains largely understood and recorded. A secondary effect of this split was that the Stratigraphic Unit numbers assigned show a marked break, with those assigned by Coppens being exclusively greater than 512.500. The area covered by AA512 was the western pavement of the Vicolo di Narciso from just beyond the party wall between the Casa del Chirurgo and the Casa delle Vestali on the north and doorway 22 of Insula VI 1. In practice, the area that received the most attention in excavation was the area from roughly the midpoint of the wall behind the hortus of the Casa del Chirurgo and Doorway 22 – the areas north of this received only cursory investigation beyond removal of the overlying modern build-up and bioturbation.

254 Excavated by Barry Hobson (AA090). To be published in the Casa delle Vestali.

255 *Forthcoming.* This wall dates to this phase at the earliest.

256 A spot date based on the ceramic evidence produced during the excavation provides a *terminus post quem* for this deposit of the second century BC. Dore notes that this is on the basis of Campana C rims and that the date is of poor reliability. Certainly it would seem to indicate the presence of residual materials in this phase.

257 Vessel glass (no Finds No.) from this deposit provides a *terminus post quem* later than AD 50.

258 Vessel glass (no Finds No.) from this deposit provides a *terminus post quem* of c. 25 BC to the first century AD. This likely indicates residual material in the fill.

259 Vessel glass (no Finds No.) from this deposit provides a *terminus post quem* of c. 25 BC to the first century AD. This likely indicates residual material in the fill.

260 Nappo 1996; Berg 2008, 200; Anderson *et al.*, 2012.

261 Anderson *et al.*, 2012.

262 Vessel glass (no Finds No.) from this deposit provides a *terminus post quem* of c. 25 BC to the first century AD. This likely indicates residual material in the fill.

263 Vessel glass (no Finds No.) from this deposit provides a *terminus post quem* of c. 25 BC to the first century AD. This likely indicates residual material in the fill.

6

GLASS VESSELS AND SMALL FINDS[1]

H. E. M. Cool

Introduction

The glass vessels and small finds from the Casa del Chirurgo are part of an insula-wide study that has already been published as a separate volume.[2] The full discussion of the finds together with the catalogue entries will be found in the wider study. Here the focus will be on what the material can tell us about this particular plot of Insula VI 1 and the people who lived in it.

Despite the house taking its name from the discovery of medical instruments in April 1771,[3] we know very little about the objects that were found during the first excavation. The practice then was for the objects found to be taken to the Royal Museum at Portici where information about the find-spot was often lost. Now it is only by chance, aided by the indefatigable work of Pagano and Prisciandro[4] in the archives, that items can sometimes be re-identified. A good case in point being the famous *momento mori* mosaic of the skeleton holding wine jugs. In the mid-1970s this was still being attributed to 'one of the sites in the Vesuvius region.'[5] It is only in the past two decades that it has been identified as the mosaic found in the Insula Occidentalis (19–26) in May 1783 and then removed in December 1787 to protect it from frost damage.[6] Objects of the type dealt with in this chapter rarely attracted sufficient attention to be described in the type of detail to allow them to be identified later. The medical instruments from the house themselves are a good example. The original records describe 15 items but Bliquez could only identify the two most unusual ones amongst the collection in the Museo Archeologico Nazionale di Napoli (henceforward MANN).[7] The volumes of the *Le antichitá di Ercolano esposte* were being prepared for

publication during the time the Casa del Chirurgo was being uncovered. The wall paintings from the house were sometimes depicted in those volumes, but small finds were rarely thought worthy of inclusion. Of all the items described as being found in the house, only a single silver mount depicting cupids playing pipes was published. The attitude towards small finds is well illustrated by the fact that in the volume this mount was not the focus of any special attention but merely acted as a space-filling picture beneath text.[8]

One important early observation of the finds from the house is the description of a group of 38 weights from the 'courtyard' recorded on January 19th 1771.[9] These are carefully described with size and weight noted and the reading of the letters EME and HABEBISI on the sides. From the descriptions it is clear that this was a loom emplacement for a warp-weighted loom with lead loomweights in the atrium. The type of loomweight is well known from eruption level deposits at Pompeii and the inscription is normally rendered EME HABEBIS – *Buy! You shall have*. In discussing a similar weight from the Casa di Lucio Elvio Severo, Gallo noted, though without further detail, that the stores at Pompeii contain numerous other weights with the same inscription.[10] Others that can be noted include a group of 18 that were found in the Casa della Venere in Conchiglia (II 3, 1–3) in 1953,[11] and another from the house at VIII.2.29–30.[12] The type does not appear to be known outside of Pompeii and the examples from the Casa del Chirurgo have a good claim to being the first ones ever found. Despite the careful description of them in the original records, and the possibility that one was drawn for the *Le antichitá di Ercolano esposte*,[13] it has not been possible to identify them in the collections of MANN.

By default, therefore, it is the finds from the recent excavations that have to inform our understanding of the house. All of the small finds and the glass have been catalogued and studied with one major and one minor exception. It has not been possible to study the iron which was very heavily corroded and generally existed as misshapen pieces with a thick corrosion crust. From the insula as a whole, well over 100kg of iron was recovered. Modern practice would be to X-radiograph the assemblage to discover what was inside the pieces. As the material was studied on-site, I had no access to X-radiography facilities or to conservators who might have been able to help identify what was present.

With regret, I therefore decided to omit the iron from my study. This means that some categories of finds such as tools and writing equipment (styli) are going to be under-represented in all that follows. The non-ferrous metal was also studied without the aid of any investigative conservation, but on the whole this did not present major problems as far as the identifications were concerned. Slingshots were also excluded from my detailed study.[14]

In addition, the pottery unguent bottles have been recorded for those properties where the pottery had been sorted by 2011. This was to enable comparisons to be made between the unguent bottles made in

Table 6.1. Diagnostic vessel glass from Insula VI 1 excluding plain blown body fragments (weight in g.)

Area	Core	Cast poly	Cast mono	Mould Blown	Blown Poly	Blown Mono	Total
Triclinium	4.3	7.3	91.8	-	112.1	450.3	665.8
Inn	0.4	5.9	289.3	0.5	0.1	118.7	414.9
Vestali	0.4	6.4	96.9	3.7	2.4	248.5	358.3
Vestals Bar	-	11.3	27.0	3.7	-	171.3	213.3
Chirurgo	-	3.2	151.2	-	-	70.3	224.7
Shrine	-	20.2	61.5	44.0	4.2	164.5	294.4
Workshop	-	79.4	93.3	2.4	-	169.4	344.5
Acisculus	-	-	69.2	-	-	104.2	173.4
Pheobus	-	1.4	32.3	-	-	17.3	51.0
Well	-	-	15.1	-	1.0	72.4	88.5
Sidewalks	0.5	13.8	57.3	-	-	64.4	136.0
Total	5.6	148.9	984.9	54.3	119.8	1651.3	2964.8

Table 6.2. Small finds from Insula VI 1 by functional categories (by count)

Area	Pers.	Toilet	House	Craft	Recr.	Relig.	Other	Misc.	Total
Triclinium	9	6	29	18	36	-	2	31	131
Inn	45	15	155	78	116	5	10	142	566
Vestali	34	8	120	47	120	2	5	84	420
Vestals Bar	18	5	34	9	26	-	2	44	138
Chirurgo	20	6	55	69	72	12	3	51	288
Shrine	16	7	84	62	94	14	-	33	310
Workshop	18	3	73	47	97	3	1	65	307
Acisculus	9	4	69	36	24	8	2	49	201
Pheobus	4	3	16	12	16	3	-	27	81
Well/Fountain	8	3	23	4	15	27	-	26	106
Sidewalks	3	6	30	15	30	-	4	24	112
Total	184	66	688	397	646	74	29	576	2660

Abbreviations

Pers. Personal ornaments and equipment.
Toilet Toilet equipment including perfume containers in alabaster and ivory;
House Household equipment including copper alloy vessels;

Craft Craft equipment;
Recr. Equipment for recreation including glass counters;
Relig. Items associated with religious practices;

Other Equipment associated with writing, transport and commercial activities;
Misc. Miscellaneous items not assigned to function.

Table 6.3. Diagnostic vessel glass from phased contexts in the Casa del Chirurgo excluding plain blown body fragments (weight in g.)

Site phase	Cast Poly	Cast Mono	Blown Mono	Total
1	-	19.2	-	19.2
3	-	6.6	-	6.6
5	-	20.5	16.9	37.4
6	-	99.0	14.0	113.0
7	2.6	0.5	18.6	21.7
8–9	0.6	5.4	20.8	26.8
Total	3.2	151.2	70.3	224.7

Table 6.4. Small finds from phased contexts in the Casa del Chirurgo (by count). Adjacent sidewalk areas not included and unstratified material is included in the Phase 8-9 category. Key to columns as in Table 6.2.

Phase	Pers.	Toilet	House	Craft	Recr.	Relig.	Other	Misc.	Total
2	-	-	2	4	2	-	-	-	8
3	6	-	6	7	11	3	-	13	46
4	-	-	-	-	1	-	-	-	1
5	5	3	7	20	12	4	2	11	64
6	7	1	32	20	22	-	1	16	99
7	2	1	3	7	9	-	-	3	25
8–9	-	1	5	11	15	5	-	8	45
Total	20	6	55	69	72	12	3	51	288

Table 6.5. Small finds from Phase 5 according to context type (by count). Key to columns as in Table 6.2.

Phase	Pers.	Toilet	House	Craft	Recr.	Relig.	Other	Misc.	Total
Pits	3	1	-	4	-	2	-	3	13
Op.Sig. Floor	1	2	4	5	3	1	1	1	18
Build	-	-	-	3	3	-	1	-	7
Other	1	-	3	8	6	1	-	7	26
Total	5	3	7	20	12	4	2	11	64

glass and other materials. These do not feature in the summary tables but will be mentioned as appropriate in the phase discussions. A similar approach has been taken to the slingshots.

Table 6.1 summarises the diagnostic vessel glass from the complete insula. The vessels have been divided into the different categories according to how they were made (core-formed, cast, mould blown, and free blown), and according to whether they are polychrome (which here includes bichrome) or monochrome. As can be seen, the diagnostic glass from the Casa del Chirurgo forms a relatively small proportion (7.5%) of the glass from the insula as a whole. In Table 6.2 the small finds from the complete insula are summarised according to standard functional categories.[15] Again the Chirurgo finds

form a relatively small proportion of the overall assemblage at just over 10%. The relatively small size of the assemblages reflects the fact that, in the area of the Casa del Chirurgo, there was not the major dumping and levelling episodes that have resulted in the large groups of material from, for example the Inn, the Casa del Triclinio, the Shrine, and the Workshop areas. Although the house lacks such major dumping episodes, as will become clear, many of the finds from the more prolific Phases 5 and 6 did come from levelling, and in some cases, they include items that are unlikely to have been in use in the house. This suggests that at least some of the material has been brought in from elsewhere and so is not directly related to the occupation on the site. Overall within the insula, however, it has been possible to show that

much of the material found in particular plots could plausibly have been derived from activity within the plot in earlier phases.[16]

Of the material considered in this chapter, it is the vessel glass which can provide the most rapid overview of whether the phasing is internally consistent. As a rule of thumb, the methods of making glass vessels by the techniques known as 'casting' are earlier than vessels made by blowing. The term 'cast glass' should be seen as a useful short-hand name for the generally open vessels which were manufactured by heating and manipulating hot sheets of glass, often with the help of formers over which the glass could be slumped. The vessels were then finished by grinding and polishing when cold. This was the manufacturing method from the fourth century BC into the first century AD with a considerable increase in the volume of vessels being produced in the latter part of that period.[17] The earliest evidence for blowing comes from a deposit of tube blowing waste found in a mid-first century BC context

in Jerusalem.[18] Generally blown fragments start to appear in contexts belonging to the later Augustan era and the quantity of blown vessels recovered increases considerably during the first half of the first century AD, becoming dominant by the middle third of it. By that stage, the long-established cast industries are in marked decline.

In Table 6.3, the vessel glass from the Casa del Chirurgo is summarised by site phase. As can be seen, diagnostic blown glass, i.e. those fragments where it is possible to suggest the form, does not appear until Phase 5 which includes the changes attributed to the late first century BC to early first century AD. This is broadly what is to be expected from our wider understanding of the development of the industry. It may be noted though, that there are a small number of undiagnostic body fragments of blown glass from earlier contexts. These include both blue/green and colourless glass fragments from the Phase 2 contexts 508.023 and 612.035, a blue/green fragment from the

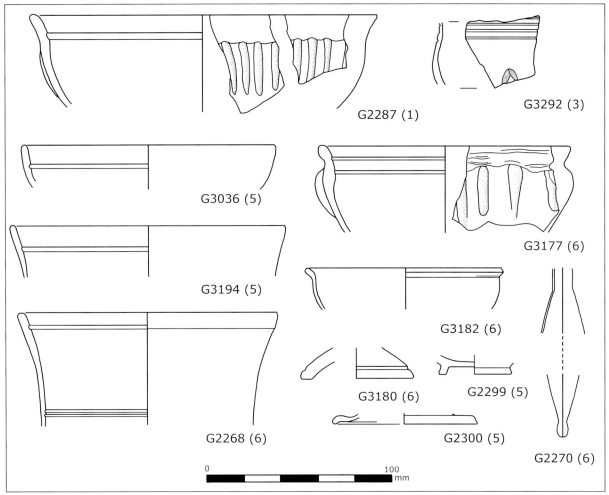

Figure 6.1. Selected glass vessels. Scale (1:2). Numbers in brackets after the identification codes indicate the phase of the context the piece was found in (image H. E. M. Cool).

Phase 3 context 261.043, and a colourless fragment from the Phase 4 context 612.019. Nothing we know about the Hellenistic and early Roman glass industries would allow blown glass to appear so early. Furthermore, colourless blown glass is a Flavian fashion,[19] i.e. in the context of Pompeii, it is a post-earthquake phenomenon. These blown body fragments must be indicating contamination or intrusion in the Phase 2–4 contexts noted.

The slingshots found in the insula can be plausibly associated with the Sullan siege of 89 BC, and so should not appear in the Casa del Chirurgo assemblage before Phase 5, and this is the pattern noted. Within the insula, the bulk of the slingshots occur in the Inn, the Casa del Triclinio, and the parts of the Casa delle Vestali that border the city walls, i.e. the obvious places where the ammunition would have landed.[20] Their occurrence in the Casa del Chirurgo suggests that some of the material in the make-up and construction deposits was being brought in from elsewhere.

As can be seen from both Tables 6.3 and 6.4, the assemblages from pre-Augustan phases are relatively small. Neither category of finds can contribute anything to our understanding of Phase 4 as the only items found were a copper alloy nail and a glass counter. In what follows, the material will be reviewed by site period, and within those according to the type of contexts the items were recovered in. This approach is designed to reveal what items might plausibly have been associated with the contemporary phase and which items clearly derived from earlier activity, possibly elsewhere. Only the pieces that can be assigned to a function will be considered as the aim of the survey is to explore the nature of the occupation through time. Items will be identified by using the unique identifying number which is being used in the site-wide survey. These take the form of a number with a letter prefix (SF – small find; G – glass; LW – loomweight) and will be printed in bold here.[21]

Phases 1 and 2

A single item came from a Phase 1 context (**G2287** from 507.176 – Fig. 6.1). It consists of two fragments of a light yellow/brown ribbed bowl belonging to Nenna's Delos Group 1.[22] These developed during the second quarter of the first century BC. The context was disturbed and within one of Maiuri's sondages, and the bowl fragments must be intrusive into these natural soils.

In the earliest black sand and pitted earth deposits of Phase 2, the commonest find type is the counter.[23] There are two deliberately-made ones of glass (**G2161** emerald green; **G3074** dark yellow/brown) and one water-worn one of oxidised fired clay (**SF1547**). This last category of counter appears to be a found object as it is the result of a fragment of pottery being rolled around in the sea to smooth the edges and naturally forms a small object that could be used as a counter. Finds like the counters could be viewed as casual losses, but the copper alloy nail (**SF1539**) is the sort of item that would have been used in the manufacture of substantial chests or door furniture and is indicative of more domestic activity in the area. A second copper alloy nail (**SF1538**) was also found in a context of this phase.[24]

There are two finds from the early cuts that pre-dated the terracing. **SF1065**[25] is a glass intaglio depicting a New Comedy theatrical mask of an old man cut onto a shallowly convex, colourless blank. The shape, material, and theme all place this piece happily within what is normally referred to as the Italic Hellenising group of intaglios that were in use during the third and second centuries BC.[26] As such it provides useful dating evidence for the activity as, though intaglios can have long lives, this fill can obviously not have been accumulating prior to the third century BC. The other find from these fills (**SF514** – Fig. 6.2) is one of the more remarkable finds from the insula as a whole. It is a large ivory cylinder (150 mm long) that had been preliminarily cut to shape and was in the process of being turned to form decorative mouldings on the outer face. It can be suggested that it may have been intended to eventually form part of the leg of a bed. The ivory fittings for these are more commonly recovered from funerary contexts[27] where segments of decoratively turned ivory cylinders, sometimes with figured panels, are used to build up the legs around an iron scaffolding. As preserved, this piece is longer than the ones normally found in graves but, given the unfinished state of **SF514**, the possibility that it may eventually have been cut into shorter segments cannot be ruled out. There is no obvious reason why the piece was abandoned unfinished.

There are some problems about the integrity of the context which is stated to be 261.050. The bag in which it was packaged retained the information that it was found inside an amphora. There are no amphorae from that context but there are complete amphorae in the latrine fill, 261.059. The two contexts were dug within a day of each other with a storm intervening and it seems possible that the items might have been mislabelled or the 9 mistaken for a 0. An unusual item like this discarded inside a complete vessel is normally a good candidate for structured deposition,

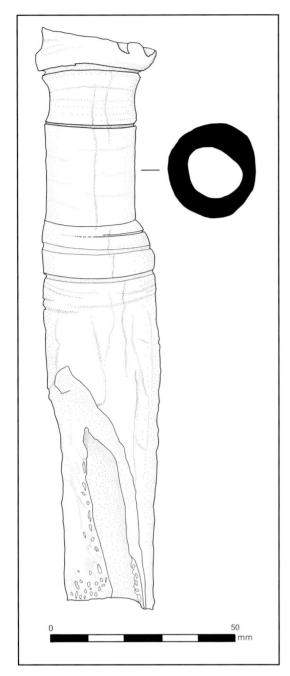

Figure 6.2. Unfinished ivory cylinder SF514 from Phase 2. (Scale 1:1) (image H. E. M. Cool).

though caution should probably be exercised in this case. Evidence of other contemporary manufacturing activities is provided by the presence of three small slightly pyramidal loom weights with rectangular cross-sections (**LW6, 116, 120**) from a yellow sand deposit.[28] Finds directly associated with the pre-Chirurgo structures were scarce. A counter deliberately made from a fragment of Black Gloss B pottery (**SF1560**) also came from the latrine infill.[29] A Black Gloss bowl rim fragment was also recovered from a posthole.[30] It

retained traced of yellow/brown powdery pigment and might have been associated with decorating the walls of the structures.

Phase 3

The bulk of the finds from contexts of this phase were found in the pre-Casa del Chirurgo levelling layers and thus relate to the Phase 2 occupation before the house was built.[31] As such, they should provide a useful snapshot of the material culture at Pompeii during the third to early second centuries BC. Some of the items also suggest that the occupation associated with the pre-Chirurgo structures was modestly affluent. Overall the functional classes represented suggest we are dealing with domestic rather than commercial or production activities. As we shall see though, some of the pieces cannot be as early as the proposed date of these deposits and would be more happily dated later.

Amongst the personal equipment, there is a silver finger ring (**SF584**). Although now much corroded, it is clear that this was a purely ornamental ring rather than a ring with its owner's seal, as it had never had an intaglio setting. Given the proposed date of the contexts, this would not be unusual as it was not until the first century BC that the use of seals in the form of intaglios spread widely through society. Another purely decorative item is a cylindrical peacock-coloured glass bead from a necklace (**G2288**). A fragmentary copper alloy button and loop fastener (**SF576**) lacks the element that would have acted as the 'button', so the precise form is unclear. The function of these is generally considered to be uncertain, and suggestions range from fasteners for some part of dress to being associated with a horse harness.[32] Although Wild could not find any evidence of them being associated with dress, Bishop has drawn attention to the very clear depictions of the fastenings on the *paenula* (cloak) worn by a soldier of the later first century AD at Camomile Street, London.[33] These could certainly be button and loop fasteners with both circular buttons and bar fastening elements. The excavations in the Casa del Chirurgo also produced an example of the latter form from a Phase 6 context (**SF556**) and that one retained minerally-preserved organics which could plausibly be interpreted as cloth. Of particular interest is an example of one clearly being used as part of the fastener for a necklace at the time of the eruption in a house in Pompeii (I 10, 7).[34] The necklace itself consists entirely of amulets, thus placing it outside of the normal run of female jewellery, so whether button and loop fasteners were habitually used in this way is open to

question. On balance, it seems reasonable to include the type amongst the personal equipment. Button and loop fasteners are a first century AD form so it is likely that SF576 is intrusive here.

There is only one small find *sensu strictu* that can be assigned to the toilet article category and that is a possible olivary probe made in ivory (**SF550**). The levelling layers also produced fragments from two pottery unguent bottles. One (**SF1812**) has the collared rim typical of fusiform unguent bottles and so could happily form part of a third to second century BC assemblage. The other, however, is the lower part of a globular unguent bottle with flat base (**SF1816**).[35] The form is generally considered to have evolved in response to the rise of unguent bottles made in glass and thus to have been in use from the end of the first century BC and into the first century AD.[36] The layer is noted as having been re-exposed during Phase 5 when the **SF1816** may have been introduced.

All of the craft items relate to textile production. The loomweights from the insula as a whole have already been the subject of two published papers. These have shown that the size and weights are clearly bimodal with it being possible to define small and large forms with a small number of very large and very small examples as well. The last-mentioned clearly being votive items.[37] The levelling layers produced three small ones (**LM113–5**), one large one (**LM111**), and two of the small number of very large ones (**LM96, 112**). When the earlier papers were written, evidence from the Casa del Chirurgo, which was then the only plot with detailed phasing, revealed a bimodality that might have been in part the result of chronological changes with smaller

ones being preferred in the third to second centuries. Now that the phasing of the insula as a whole is better understood, it can be seen that the chronological difference is not clear cut.[38]

A slightly better impression of the household fittings can be more easily gained from the material in the levelling deposits than was possible for Phase 2. Copper alloy nails of the type noted in Phase 2, and studs from chests and boxes and the like, continue to be found (**SF1337, 1474, 1521**). The bone inlay fragment (**SF243**) would also have decorated such an article. Glass (**G3292**) and possibly metal (**SF736**) vessels start to appear. The latter is represented by part of a large handle. The closest parallel for this so far traced is from an item interpreted as a small altar rather than a vessel.[39]

G3292 (Fig. 6.1) merits special note as it came from one of the earliest and rarest glass vessel types recovered from the entire insula. It is an upper body fragment in blue/green glass from a cast bowl. The facets below the grooves indicate that it belongs to the style described as 'à décor végétal', and the weak S-curve of the side suggests it would have belonged to Nenna's group 'bols hémispherique profonds à bord évasé.'[40] This is a late Hellenistic form. Nenna cites ones from dated contexts starting in the second century BC and extending to the Augustan period. It was certainly in existence prior to the final decade of the second century BC as an example was recovered from Maresha, Israel, destroyed in either 112/111 or 108/107 BC.[41] The bowls are generally assigned to the later second century BC and into the first century BC. If the context it came from[42] is associated with the deposits that pre-date the building of Chirurgo, then

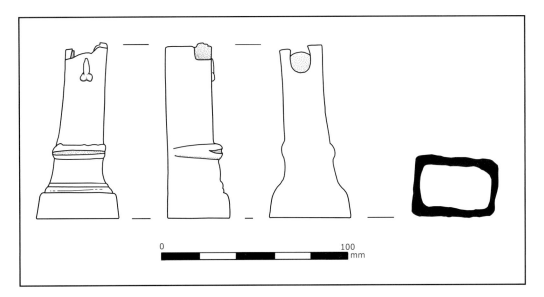

Figure 6.3. Fired clay pillar SF1045 from Phase 3 (Scale 1:2) (image H. E. M. Cool).

that would imply the house was not built until nearer the transition from the second to first centuries BC, rather than the earlier second century BC.

Gaming counters continued to be well represented in the levelling deposits. There are three deliberately ground ones made from Black Gloss pottery sherds (**SF1559, 1564–5**), and five in glass. Of these four are in yellow/brown shades (**G1776, 3066–8**) and one is in colourless (**G1778**) glass.

An explicitly religious item (**SF1045**) in the form of a small terracotta pillar or herm retaining part of a phallus was also recovered from the same context that produced the late Hellenistic glass bowl. It is damaged but still clearly recognisable as a religious artefact. The context it was found in is described as 'loose rubble', and there does not appear to be any indication that it was deliberately deposited with any votive intent (Fig. 6.3).

Another context that yielded a small amount of material is the fill around the western overflow drain in the *atrium*.[43] The range of finds is similar to that from the levelling deposits, consisting of colourless and black glass gaming counters (**G2134–5**) and a composite stud (**SF593**).

Phase 5

With Phase 5 the volume of small finds recovered increases, but the majority are not directly related to the occupation in the house during that period as the bulk were found in contexts associated with the re-construction of it. As can be seen from Table 6.5, approximately 60% of the identifiable small finds come from the pits dug to extract building material prior to the construction and renovations,[44] from the sub-floors beneath the *opus signinum* floors and sometimes incorporated into the floors themselves,[45] and in contexts associated with the construction of new walls.[46] This is clearly material that derives from earlier occupation and will be considered first before the material that might plausibly be associated with the Phase 5 occupation is discussed.

The construction deposit assemblage

As can be seen from Table 6.4, the range of functions represented has increased. Seal-boxes are generally attributed to the writing category as they were designed to protect the impressions of seals that had been attached to documents or other packages that had to be kept secure. **SF826** is the lid of a copper alloy 'U'-shaped seal box decorated like a scallop shell

(Fig. 6.4). This belongs to the earliest type known, the Augusta Raurica Gruppe 1, where they are called tongue-shaped (Zungenförmige).[47] The small bone fragment **SF551** is clearly a hinge from a second seal box. Though the shape of the box is not preserved, the piece can confidently be assigned to the same form as no other type of seal box is made in bone. The authors of the Augusta Raurica *corpus* have collated the various context dates and distributions of the type. In general, it was in use during the first century BC and the early first century AD, with the bone examples having a stronger presence in the earlier first century BC than the copper alloy ones which are more frequent in the later first century BC and into the Augustan period. Bone examples are present at other Campanian sites, but they found no records of copper alloy ones.[48] In total, the Insula VI 1 excavations found ten seal boxes in both bone and copper alloy, mainly of this type.

The small personal ornament assemblage consists of a copper alloy finger ring (**SF567** – Fig. 6.4) that has lost its intaglio and a yellow glass setting that might have come from a ring (**G2264**). The latter retains traces of a moulded surface which might have been an intaglio device. There is also a cylindrical bone bead (**SF197**) and a natural pearl pierced for suspension that could have come from an ear-ring (**SF 1074**).

The personal ornaments consisted of the same range of functional types as had been encountered in the Phase 2 and 3 deposits. With the toilet articles by contrast, there is an expansion of types. Long-handled toilet implements are represented by a bone ligula with a small dished scoop (**SF179**). There is also a base from an ivory cylindrical pyxis (**SF202** – Fig. 6.4) and part of a bichrome glass stirring rod with a black ground and an opaque white spiral trail (**G3186**).[49] These are generally considered to be a first century AD form. Whilst they may have developed during the Augustan period, dated contexts are frequently of Tiberian/Claudian date or later. This piece came from the levelling for the *opus signinum* floor in rooms 13/4,[50] which also contained fragments from another globular-bodied pottery unguent bottle (**SF1819**). As already noted in connection with that found in a Phase 3 context, these are normally found in contexts of the first half of the first century AD, i.e. contemporary with the stirring rods. This might perhaps suggest that the context is contaminated or the floor is later than is being proposed. The other pottery unguent bottle fragments from the construction deposits (**SF1800** and **1827**) appear to belong to the fusiform series and thus pose no problems as far as dating the activity to the proposed late first century date for the start of Phase 5.

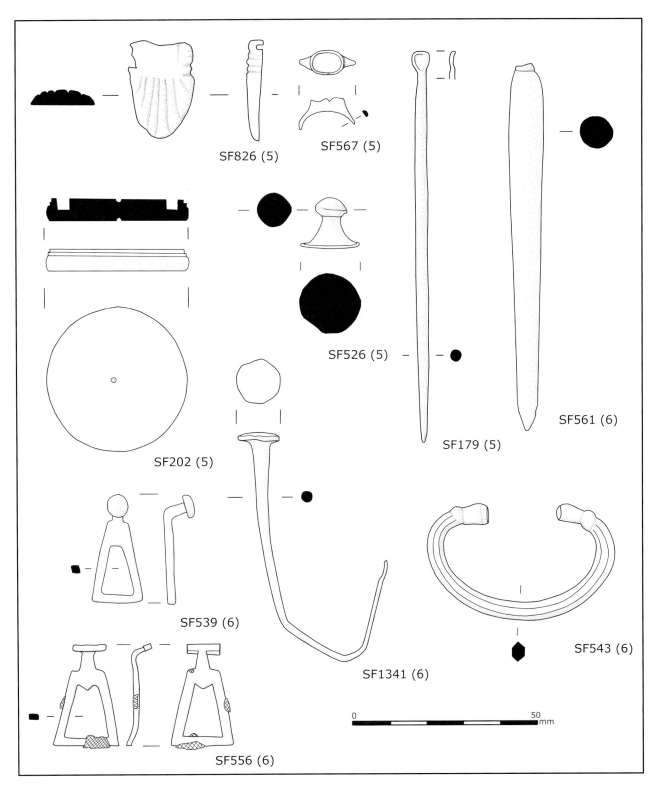

SF826 (5)

SF567 (5)

SF526 (5)

SF179 (5)

SF561 (6)

SF202 (5)

SF539 (6)

SF1341 (6)

SF543 (6)

SF556 (6)

0 50
 mm

Figure 6.4. A selection of the small finds from the Phase 5 and 6 construction deposits. Scale 1:1. Numbers in brackets after the identification codes indicate the phase of the context the piece was found in (image H. E. M. Cool).

Virtually all of the craft material again consists of loomweights, though there was one off-cut from bone working (**SF551**) in a fill[51] associated with wall construction. Household material was very scarce. A small copper alloy terminal knob (**SF526** – Fig. 6.4) might have been associated with a piece of furniture or a vessel, but there were no metal vessel fragments that could be securely identified. There were two

fragments from blown glass vessels. One was a light green blown base with an applied true base ring (**G2291**) from a pit fill in the garden.[52] This is the sort of base used on tubular rimmed bowls,[53] which are one of the commoner finds in the eruption levels at Pompeii once unguent bottles have been excluded,[54] and which were represented in the Casa del Chirurgo assemblage by two examples from Phase 7. Whilst the majority of such bowls are undoubtedly a first century AD form, fragments have occasionally been found in late first century BC contexts such as drain deposit in the Regia of the Forum at Rome.[55] It is thus possible that it is contemporary with the proposed building date for Phase 5. The other vessel was also represented by a base fragment (**G2266**) from a sub-floor of the *opus signinum* floor in Room 2.[56] Insufficient is preserved to identify the form closely but the incorporation of a blown vessel fragment into the sub-floor has to indicate that the floor was being laid down in the very late first century BC at the earliest. Fasteners were also scarce. There was one copper alloy rivet and one stud (**SF 1416, 1500**). Often fasteners can be seen as one aspect of household items, so their rarity here underlines the relative absence of other household material.

Counters, by contrast, continued to be ubiquitous. There was a single example ground from a fragment of Black Gloss pottery (**SF1557**) and six made of glass. These include colours that had not previously been encountered. Three were made in blue/green glass (**SF1760, 3063, 3230**), one in peacock glass (**SF3231**), and there was one polychrome example (**SF2456**) which had a dark translucent yellow/brown ground with an opaque white and amber marvered spot on the edge. The sixth one was colourless (**SF1773**), a colour that had previously been encountered in Phase 3.

The only item that could be associated with religious practices was a terracotta mask represented by fragments consisting of the right eye and right ear (**SF1058**). As with the herm in the Phase 3 deposit, the context these fragments were found in[57] did not suggest they had been deposited with any ritual intent.

The occupation deposits

These produced far fewer items. In Room 2, there was material in the packing of the possible amphora furnace feature[58] and from the working surface.[59] The former could be regarded in a similar light to the material considered in the previous section, i.e. incorporating material from earlier activities. It includes a rim fragment from a cast, light yellow/brown glass hemispherical bowl with internal cut line

(**G3036** – Fig. 6.1). The form is a Hellenistic one and in the eastern Mediterranean, where it is common, is known from the late second century BC. It was less common in the west where it has a *floruit* in the second half of the century and into the Augustan period.[60] Rim fragments from a similar bowl (**G3194** – Fig. 6.1) were also found in another feature associated with the second phase of activity within this room during Phase 5. Although sharing the same colour and broad shape, they are almost certainly from different vessels. The other items are not chronologically sensitive and consist of a yellow/brown glass counter (**G3065**), a flat-headed copper alloy stud (**SF1625**), and a piece of copper alloy plate (**SF531**) that probably originally formed part of inlay. The floor surface produced three more glass counters in amber (**G3037**), deep blue (**G3062**), and blue/green (**G3064**) glass, as well as a fragment of a composite stud (**SF528**). There was also the rim and neck of a short-necked glass unguent bottle in pale green glass (**G3039**). This could have come from either the short-necked bulbous form or from a tubular unguent bottle.[61] Both were in use from the Augusto-Tiberian period, and at Pompeii, the tubular form continues in common use until the time of the eruption. None of the items can throw any light on the nature of the production activity taking place in the room. The glass, for example, shows no evidence of heat distortion and so was not being used as part of the activities.

The fills[62] of the cesspit or water feature in Room 4 produced yet another blue/green glass counter (**G1872**) and a loomweight fragment (**LW129**). The earth floor in Room 3 contained a small perforated bone disc that might have functioned as the terminal plate of a hinge, though those normally have a slightly conical or domed profile, rather than the stepped profile seen here.[63] The small central diameter makes the identification as a spindle whorl less likely. An earth floor in Room 12[64] contained a lead slingshot indicating that the contents of the floor must have been derived from earlier rubbish, possibly derived from elsewhere, rather than reflecting items dropped and incorporated during the use of the room.

Finally the garden soils[65] in the hortus incorporated fragments of four vessels. One was the neck fragment of a pottery unguentarium (**SF1810**) that could not be assigned to a type and so is undateable. A rim fragment of a cast light green glass bowl (**G2293**) is of the same type as **G3036**, and can thus be dated to the second half of the first century BC. **G2299** (Fig. 6.1) is the base of a small cast cup made in opaque duck egg blue glass. It belongs to the range of vessels that are typical of Imperial glass production of the end of the

first century BC and the first part of the first century AD.[66] The garden soils are assigned to Phase 5 as they are considered to have been brought onto the site for planting at the time of the construction of the hortus in that phase. The three items considered so far could be consistent with such an interpretation. That the soils must have continued to absorb items during the later history of the house is made clear by the presence of **G2300** (Fig. 6.1). This is a base fragment of a blown dark yellow/brown stemmed cantherus.[67] Whilst it is possible that the vessel developed in the Tiberian period, most of the well-dated occurrences and the different decorative styles used on them point to a primarily Claudian to Neronian *floruit*.

Phase 6

Within this phase the bulk of the finds again came from the levelling deposits. The bulk came from those below the *opus signinum* floors laid down as part of the changes associated with this phase, or had been incorporated within the *opus signinum* itself.[68] Smaller amounts of material were also associated with the replacements of the thresholds in Rooms 2, 3, and 4[69] and in the robber trench fills associated with replacement walls in Rooms 17 and 18[70] and a posthole fill possibly associated with the building of the upper storey.[71] All of this material will be considered as a single group first before going on to consider the finds associated with the flooring and use of Room 2, and finally the groups from the various toilet features and cisterns that are a feature of the phase.

The construction fills, layers and floors

Amongst the personal ornaments there were two small beads from necklaces, or possibly from earring pendants. One was a natural emerald crystal (**SF1078**) and the other of decayed yellow glass (**G3176**). **SF1068** is a cornelian intaglio with the device of a stag running to the right in impression. This would have been old when lost as it is very closely paralleled by a stone now in the Museo Archeologico di Bari, which Tamma assigned to Furtwängler's Roman Campanian class of Italic Hellenising intaglios.[72] Given the style and the shape of the stone, both may be dated to the late second to early first century BC. Two button and loop fasteners were also found; one with a circular button (**SF539** – Fig. 6.4) and one with a transverse bar (**SF556** – Fig. 6.4). The type in general has already been discussed in connection with that found in a Phase 3 context. The

mid-first century AD date of the deposition of these two would be more in keeping with the normal date range of the type than the possible third to second century date suggested by the Phase 3 example. The pin from a copper alloy buckle (**SF564**) may also be noted here.

The only toilet equipment in these contexts are fragments from unguent bottles. Pottery ones are the most frequent (**SF1806, 1818, 1820**) and, where attributable to type, belong to the globular family (see discussion in Phase 3). There is also a single example of a glass tubular form (**SF 2273**).[73] Taken together, these unguent bottles indicate the material that formed the levelling layers was accumulating during the first half of the first century AD.

The craft items included a slightly wider range of activities than had been seen before. Loomweights were very common with four small (**LW67, 98, 101, 119**) and four large (**LW97 99, 125, 133**) ones, as well as five of uncertain size, represented by broken fragments (**LW134–7, 144**) and one unusually large example (**LW100**). It is possible that two bone rods were also associated with weaving. When cloth is produced on a warp-weighted loom, the weft threads have to be regularly adjusted and small bone tools pointed at both ends (pin beaters) can be used. The large assemblage of material from the levelling deposit in Rooms 17 and 18[74] produced two pointed bone implements that could have been used in this way (**SF561–2** – Fig. 6.4), as well as the bulk of the loomweights. Neither were the classic cigar-shaped tools usually considered to be pin beaters,[75] but **SF561** did have a glossy tip. Bone tools used regularly in textile working often acquire gloss like this,[76] so these items have been cautiously assigned to the textile working category. A bone needle (**SF560**) may also be assigned here though a good case has been made for bone needles being regularly used as hairdressing tools for the elaborate hair styles some Roman women favoured.[77] It may be noted though that, in the finds assemblage from Casa del Chirurgo, no obvious hairpins, which would also have been part of the kit expected for such hair styles, were found. Indeed, hairpins were surprisingly scarce in the VI 1 assemblage as a whole. For this reason, the needle can plausibly be considered a textile tool here.

Bone working was represented by four sawn rings from a long bone (**SF553**), possibly intended to eventually become bone hinge elements. Other activities that had not been attested to before by the small finds were copper alloy working represented by a fragment of casting waste (**SF557**) and fishing. The two copper alloy fish hooks (**SF521** and **563**) probably provide useful indications that at least some of this

levelling material was being brought onto the site from elsewhere. Clearly fishing was not an activity that would have been carried out within the house itself, nor does it seem a likely place to store fishing gear.

Both glass and copper alloy vessels are represented. The forms identifiable amongst the former are all cast. One is a light yellow/brown shallow ribbed bowl (**G3177**). The poor finish on the rim, the irregular ribs, and the colour make this a good candidate to belong to the late Hellenistic tradition of these bowls like **G2287** already discussed, rather than the more accomplished products of the early Imperial industries.[78] As such, a first century BC date is appropriate. The other two belong to the early Imperial industries and are thus likely to be contemporary with their contexts. **G3182** (Fig. 6.1) is a small emerald green bowl[79] and may be dated to the end of the first century BC and into the mid-first century AD. **G3180** (Fig. 6.1) is a blue/green pedestal base fragment from a chalice. It would have come from one of the rarer of the Gorga Form 30 categories.[80] The ribbed copper alloy handle element **SF543** (Fig. 6.4) would have come from either the side or lid of a large basin.[81] Part of the pointed bowl of a bone spoon (**SF559**) belongs to the type called a *ligula*, which is normally considered to be a first century AD form.[82]

In the recreation category, glass counters were again frequent finds. The commonest colour was deep blue with three examples (**G1875, 3071–2**), followed by yellow/brown represented by two counters (**G3060, 3070**). Blue/green (**G3218**), emerald green (**G2157**), yellow/green (**G3061**), colourless (**G3073**), and bichrome black and white (**G3185**) counters were also present. For the first time there was also a small fragment from a plain bone counter (**SF558**).

Fasteners are both much more numerous than they had been in the previous phases and also cover a wider range of forms. Previously encountered types include substantial copper alloy nails that would have been used in furniture or structural fittings (**SF1341–2, 1534, 1540, 1614–5**) and a composite stud (**SF625**). More delicate short studs appropriate for upholstery include ones with domed heads with flanges (**SF609, 613–5, 619**). There is also a group of short domed-headed studs sometimes preserving washers at the ends (**SF592, 599, 602–4, 606**). A copper alloy sheet (**SF520**) seems likely to have been the corner bracket from a box, and an ivory hinge (**SF246**) is of a size appropriate for being used on a box rather than a more substantial cupboard.

Two lead slingshots are clearly residual and, like the fish hooks, suggest that some of the levelling and construction material was being brought in from elsewhere.

Room 2

The finds from this room can be divided into three categories. There is the material in the second subphase floor,[83] that from deposits deriving from the use of the room,[84] and the levelling material laid down prior to the new floor which marked the start of a new use for the room.[85]

In the floor, there was a fragment of a blue/green cylindrical blown glass beaker with a curved and cracked-off rim and abraded decoration (**G2289**), indicating that the floor must date to the early first century AD at the earliest. There is also the lower part and point of what may have been a bone stylus (**SF492**). It would have come from an implement of the type that Béal thought most likely to be a spindle for use in spinning, whilst Schenk confidently describes it as a stylus.[86] The latter seems more likely given the lengths and diameters normally seen. The latter especially are normally greater than the usual perforation diameters of spindle whorls. Other finds were a yellow/green glass counter (**G3153**) and a fragment of a pottery unguent bottle (**SF1823**), neither of which can help refine the date of the floor. The contexts associated with the sidewalk immediately outside of Room 2[87] were equally devoid of closely dateable finds as they consisted solely of counters, one ground from a fragment of fineware pottery (**SF1568**) and the rest in glass. Of these, one was a brightly banded polychrome example (**G2457**) and there was also one of opaque green (**G3224**) and one of blue/green (**G3225**) glass.

As was the case with the finds from the previous phase of production activity in this room, nothing in the finds assemblage from the second category of contexts gave any clue to the type of work being carried out. Rather the finds had a normal domestic profile consisting of a copper alloy nail (**SF1531**), two studs (**SF995–6**), and a millefiori glass palette (**G2290**) that would have been more at home on a lady's dressing table for mixing cosmetics than in a production milieu. A lead slingshot might possibly have been gathered for re-melting, but that is the only item that would have been useful in a production environment.

A similar non-industrial character can be seen in the finds from the levelling layer. Though it is suggested that the levelling was derived from the production activity, the finds are more similar in character to the general rubbish seen in the levelling layers discussed in the previous section. There are the inevitable glass counters (**G2160, 3339** – dark yellow/brown) joined here by a counter consisting of a fragment of water-warn pottery (**SF1550**). Female personal ornaments

are represented by a necklace fastener (**SF620**) and a penannular earring (**SF612**), both in copper alloy. Household items include a composite stud (**SF607**) and a piece of metal inlay (**SF616**).

The cisterns and toilet features

The other contexts with finds which are associated with occupation during this period are the fills of the cistern in Room 3/4,[88] the toilet chute in Room 13,[89] the cesspit fill in the Vicolo di Narciso,[90] and the fill of the cistern in Room 22.[91] Of these, the first two are relatively uninformative. There are suspicions that the Room 3/4 cistern was disturbed by earlier excavators and so the fill may be the result of their activities. The finds were similar to the range of items recovered from the levelling layers and consisted of a deep blue glass counter (**G1862**), a copper alloy stud (**SF1503**), and another lead slingshot. The only find in the fill of the toilet chute was a yellow/green glass counter (**SF3075**). The material in the fills of the other cistern and the cesspit were more informative.

The cesspit again had a mix of finds very reminiscent of the sort of rubbish in the levelling layers. There was an amber glass intaglio with an indistinct moulded device (**SF1067**), two broken loomweights (**LW73, 158**), fragments from two fusiform pottery unguentaria (**SF1825, 1831**), a dark yellow/brown glass counter (**G3222**), and a fragment of another counter made from a re-used pottery sherd (**SF1571**). The range of material is in accord with the use of cesspits to dispose of a range of rubbish, not just waste matter. The fusiform unguentaria and the moulded intaglio would suggest that the fill was accumulating somewhat earlier than the mid first century AD date proposed. A first century BC date would be the latest when the combination might be expected, though of course intaglios can have long lives.

The fill of the cistern in Room 22 was a sealed deposit. It was thought to have been back-filled with midden material and the site narrative describes it as being relatively destitute of artefacts. Whilst that is the case for most of the categories of finds considered in this chapter, which are only represented here by a single copper alloy nail (**SF1536**) and the inevitable glass counter (**G1789** – yellow/brown), the group of glass vessels is of some interest.

Six different vessels are represented. The single cast vessel is a deep pale green bowl with internal grooves and a slightly concave profile (**G2268** – Fig. 6.1). It belongs to the early Imperial tradition of linear-cut bowls and would have been made during the late first century BC to early first century AD period.[92] The

fragments form a much larger proportion of the vessel than is normally the case with the cast glass from Insula VI 1. Of the blown vessels there are three unguent bottles. Two are the tubular form that has previously been encountered in the Casa del Chirurgo deposits and which has a *floruit* that stretches from the early first century AD to the mid Flavian period. One is blue/green (**G2270** – Fig. 6.1) and the other light yellow/brown (amber – **G2271**). The third unguent bottle (**G2269** – Fig. 6.1) is a blue/green amphora-shaped one with a pointed base.[93] These are normally dated to the Tiberio-Claudian period. Unlike the tubular form, it was very rare amongst the glass primarily of the eruption period at Pompeii which Scatozza Horicht studied, and she cites only two examples.[94] That it may well have gone out of use by c. AD 45 is strongly suggested by the evidence from Britain. Glass vessels were virtually unknown in Britain prior to the Claudian invasion in AD 43. After that date, glass vessels arrived in large quantities and are common on the numerous Claudian and Neronian military sites. At that time, there was not the regionality in blown glass vessels that was to become increasingly apparent from the Flavian period, and so the evidence from Britain can be taken as a good indication of what was going on within the glass industries of the Roman world generally. Unguent bottles especially were very popular and there are innumerable examples of the tubular form, but the only amphora-shaped one comes from an elite grave at Stanway that dates to just before or at the invasion date.[95] Had the form still been in use much after the Claudian invasion, it would be expected to feature more prominently in the glass from British sites. It can also be noted that coloured tubular unguent bottles like **G2271** are very rare in the British corpus, again suggesting that they might not have been much in use after the 40s.

The unguent bottles from the cistern in Room 22, like the cast bowl, are represented by fragments forming substantial parts, so it is unlikely they are residual. It should also be noted that they are not types of vessels likely to have been long-curated. They are a form of cheap packaging and once the contents have been used were likely to have been disposed of. Their breakage during use is especially likely in the case of the amphora-shaped examples as the walls of those were thin and the contents relatively solid and would have needed manipulation to remove. One from a grave at Wederath-Belginium near Trier, for example, contained rouge.[96] If, as seems likely, these vessels were disposed of directly into the cistern then this might have implications for the date of its sealing. A date in the AD 30s or very early 40s would be distinctly possible

given the combination of the cast bowl and the unguent bottles. Linear cast bowls like these are another form that is absent from the British *corpus*. The other two vessels represented by body fragments, would not argue against such a date. The deep blue **G3341** is from the plain variant of the small ribbed cup normally known as a 'Zarte Rippenschalen'.[97] This is primarily a Tiberian to Claudian form going out of use during the Neronian period. **G2272** is from a yellow/brown conical beaker. There is insufficient of it to identify the form closely but a Tiberian to Claudian date would not be out of place.

Phase 7

The finds assemblage from contexts of this phase is relatively small, but in general continues the patterns seen in the previous phase. Very little was found in the relevant contexts in the atrium[98] apart from a black glass gaming counter (**GC1772**) and the rim of a shallow blue/green blown glass bowl (**G2285**). The dumps and fills in Rooms 11[99] and Rooms 23[100] associated with the building works were more prolific.

In Room 11, personal and toilet equipment were represented by a spherical glass bead whose colour could not be identified (**G2274**) and part of a deep blue glass stirring rod (**G2280**) of the type that had first been encountered in Phase 5. Amongst the craft equipment, the working of ivory is attested by rings in the process of being made into artefacts, possibly hinge sections (**SF203**), and there was also a fragment of a loomweight (**LW152**). The household category was represented by three blown blue/green vessels. Two (**G2275, 2278**) were rims from tubular rimmed bowls of the type discussed in connection with the base ring from Phase 5.[101] As noted there, this is one of the commoner vessel types in the eruption level glass assemblages and so their presence in a post-earthquake deposit is to be expected. The other vessel may have been a modiolus.[102] This is a form that was in use during the second half of the first century AD and again is present in eruption level contexts , for example in the House of the Menander.[103] As is to be expected, the deposits also included gaming counters in colourless (**G1800**), deep blue (**G1801**), yellow/brown (**G1802**), and dark green glass (**G1803**).

It has been suggested in the stratigraphic narrative that these deposits might have resulted from the disturbance of earlier deposits within the house. A lead slingshot that was present might support that but the glass vessels certainly suggest that contemporary rubbish was being incorporated into them.

In Room 23, the finds had a slightly different profile. Most noteworthy was the pin from a silver sprung brooch. The brooch type cannot be identified with any certainty when only a pin is preserved, but the fact that it is made of silver marks it out as exceptional. Most brooches are of copper alloy and so this piece hints at a level of wealth amongst the inhabitants of the house that is not otherwise attested by the small finds. Another area where the finds differ is in the vessel glass assemblage. There is the rim fragment of a bichrome (yellow/brown with opaque white marbling) shallow ribbed bowl (**G2282**). This is an early Imperial type going out of use during the Neronian period.[104] It could have been contemporary with the deposit, but the body fragment from a yellow/green cast linear-cut bowl (**G2281**) is almost certainly residual as those vessels went out of use earlier than the ribbed bowls. Also of interest is the miniature loomweight (**LW66**). This was clearly a votive item originally being made in the same white fabric as the range of small votive vessels studied by Grasso,[105] rather than the normal coarse fabric of the other loomweights. Here though, its context in a mortar deposit does not indicate any deliberate act of religious intent.

Items in the deposits in Room 23 that are more typical of the normal range of finds found in the Casa del Chirurgo include six counters in light green (**G1779, 1783**), deep blue (**G1780, 1782**), colourless (**G1784**), and peacock (**G1781**) glass, together with a copper alloy nail (**SF1737**) and stud (**SF594**). The working of skeletal material is again indicated, this type by the sawn rings from long bones (**SF200–1**).

Phases 8 and 9

The finds from these phases will not be considered in detail given the nature of the contexts they came from and the fact that many of the types represented have already been considered in the discussion of the well-stratified finds. Of particular note though, is the rim fragment of a reticella-rimmed cast glass bowl (**G2308**) that would have been in use during the later first century BC to earlier first century AD period.[106] They are not particularly common, but in Insula VI 1, nine fragments from them were found.

Conclusions

As will be clear from this brief overview of the small finds and glass vessels, it is difficult to use them directly to inform us about life in the house because the bulk

have come from make-up and levelling deposits. If the opportunity was taken to dispose of rubbish from within the house, then the finds reflect the activity that was taking place in the previous phase. It also has to be noted that there are some indications that at least part of this levelling material was derived from elsewhere, and so there is no simple equation between the activities the items would have been used for and the activities carried out in the house. Wherever the material was coming from, this is primarily a first century BC and later assemblage. Material that can be securely dated to the third or second centuries BC is rare. What the stratified sequence shows is the increasing range of items within the functional categories as time progressed, reflecting the growth of consumer demand that becomes apparent from the late first century BC. Two categories of finds – counters and loomweights – call for special comment because they are so common.

Loomweights occur throughout the sequence up to Phase 6. What may be noted though, is that the bulk of them have been found in the levelling deposits. Other items associated with textile production such as spindle whorls are conspicuous by their rarity. These solid lumps of fired clay would be as useful as other forms of rubble in make-up deposits, so there is the possibility that they were being specially selected for that reason. It is also noticeable that there is a steady diminution of effectively complete ones. In Phases 2 and 3 all of the loomweights were complete, in Phase 5 two-thirds were broken. Possibly this is just by chance, but it does raise the question of whether there were fewer complete ones available by then. If so, could this be reflecting a declining popularity in the use of the warp-weighted loom? It is known that by the mid-first century the two beam vertical loom was rapidly replacing the warp-weighted loom.[107] The precise date of introduction is not known as it leaves no archaeological trace in the form of artefacts like loomweights, but it is likely to have been before the first century AD.[108] A declining number of loomweights would seem to be at some odds with the observations of warp-weighted loom emplacements and weaving equipment in the houses at Pompeii and Ercolano, including of course the Casa del Chirurgo. Allison has drawn attention to the concentration in what she terms front halls and has suggested that cloth production was a highly visible activity.[109] What has not been considered is that by the time of the eruption, this was quite old-fashioned technology in the Mediterranean world. If it was a purely functional activity needing the good light that an atrium might provide, then it is more likely that a two beam loom would have been the loom of choice by

then. Instead, it might be useful to consider the nature of the atrium. It was a public space and used to display the status of the family. Weaving and overseeing the production of cloth for the household was a traditional and appropriate attribute of Roman matrons. One may think of Livia, wife of Augustus, whose public face was that of the austere mistress of the house producing her husband's clothing, whilst his daughter and grand-daughter were taught to spin and weave.[110] The warp-weighted loom emplacements in the atria of houses might have been as much, or more about the proper display of old-fashioned values that the household lived by, as it was about cloth production. If correct, then the loom emplacement found in 1771 is probably telling us things about how the family who lived in the Casa del Chirurgo at the time of the eruption saw themselves.

The large number of glass counters recovered throughout the sequence is intriguing. They are normally considered to be gaming counters, but it is generally admitted of the ones found on the Vesuvian sites that we are ignorant of how they were used and what games might have been involved.[111] The wide range of sizes and colours are certainly unlike the securely identified sets of gaming counters that have occasionally been found in contemporary graves. In the Doctor's grave at Stanway, dated to AD 40–45, for example, two sets of 13 counters of similar sizes, one in opaque blue glass and one in white, were neatly laid out on a gaming board.[112] In total in the VI 1 excavations, 569 glass counters were recovered. Whilst it is possible that Pompeians were addicted to games that needed pieces such as this, it is perhaps worth considering that the counters may have had a different function. Analysis of the whole assemblage has shown that the majority of the glass 'gaming' counters were probably not used in board games at all, but are much more likely to have derived from interior decoration.[113] All of the ones from the Casa del Chirurgo are likely to have fallen into this category as, following the analysis, the assemblage from the house does not include any that can plausibly be associated with gaming.

Notes

1 The illustrations used in this chapter were drawn in the field by Kelly Atkins, Katie Huntley and Emma Hollaway and prepared for publication by the author. I am most grateful to Kelly, Katie and Emma for their work and to the Society of Antiquaries of London who provided grants which supported the illustration work in the 2007, 2008 and 2009 seasons.

2 Cool 2016a. The catalogue entries for all of the finds discussed here will be found in the digital part of this – Cool 2016b.

3 PAH, 254 (20th April); see also Bliquez 1994, 80.

4 Pagano and Prisciandro 2006.
5 *Pompeii A.D. 79*, catalogue no. 18.
6 PAH, part 2, 40 13th December; Pagano 1997, 93 22nd December; Pagano and Prisciandro 2006, 84; *Life and Death*, 243, fig. 293.
7 Bliquez 1994, 80.
8 PAH, 254 (20th April). A.D.E V, 423 with illustration on 284.
9 PAH, 248.
10 Gallo 1994, 123 no. 108, tav. 22 C–D.
11 *Homo Faber*, 142 no. 122.
12 Allison 2004b.
13 See Pagano and Prisciandro 2006, unpublished figures 134 no. E.
14 Cool 2016a, 17.
15 Based on Crummy 1983 and see Cool 2016a, 18. The catalogue entries in Cool 2016b also include the functional categories used here and show how the material is distributed.
16 Cool 2016a, 278–9.
17 See Grose 1989, 185–97 and 241–62 for overview.
18 Israeli 1991.
19 Harden and Price 1971, 321.
20 A listing of all the slingshots in the insula is available in Cool 2016b, Appendix 2.
21 The prefixes identify the appropriate database tables in Cool 2016b.
22 Nenna 1999, 103.
23 SUs 508.018, 508.033, 612.027.
24 SUs 505.023, 505.047.
25 SU 261.057.
26 Richter 1956, 56–7.
27 E.g. *Tra luce e tenebre.*
28 SU 277.156.
29 SU 261.059.
30 SU 508.080.
31 SUs 184.117, 261.043, 261.047, 277.011, 277.014, 277.019, 277.036, 277.079, 505.061, 507.168, 607.295, 607.311, 607.314, 608.019.
32 Wild 1970a, 145.
33 Bishop 1983, 34.
34 Elia 1934, 301 fig. 20.
35 SU 607.311.
36 See for example Camilli 1999, 33, Tav. 35–9.
37 Baxter and Cool 2008; Baxter *et al.* 2011.
38 Cool 2016a, 209–10.
39 Tassinari 1993, 176 fig. 350 no. 1309, Tav. CXC no. 2.
40 Nenna 1999, 94–7, especially 96 nos. C244–50.
41 Jackson-Tal 2005, 51, fig. 1 no. 12; Jackson-Tal 2004, 21. I am grateful to Dr Jackson-Tal for discussing these with me in advance of her publication in the site report.
42 SU 261.043.
43 SU 275.123.
44 SUs 260.029, 265.022, 508.052, 607.237, 614.002, 614.006, 614.008.
45 SUs 184.009, 184.097, 260.006, 260.012, 261.021, 613.024, 613.030.
46 SUs 200.057, 610.046, 610.054.
47 Furger *et al.* 2009, 49–52.
48 Furger *et al.* 2009, Abb. 25–6.
49 Isings 1957, 94 Form 79.
50 SU 613.024.
51 SU 610.046.
52 SU 508.052.
53 Isings 1957, 59–60 Forms 44–5.
54 Scatozza Höricht 2012, 36 Tav B.
55 Grose 1977, 19–20, fig. 1.10.
56 SU 260.012.
57 SU 265.022.
58 SUs 607.261, 607.246.
59 SUs 607.236, 607.243.
60 Groze 1989, 247; Nenna 1999, 79–82.
61 Isings 1957, 22–4, Forms 6 and 8.
62 SU 277.034, 277.065.
63 Schenk 2008, 97.
64 SU 610.026.
65 SUs 508.051, 508.056, 508.063.
66 Grose 1989, 256.
67 Isings 1957, 53 Form 78; see also van Lith 1991.
68 SUs 184.008, 184.017, 262.014, 262.020, 263.005, 277.008, 277.064, 610.021, 610.030, 610.042, 612.017, 612.023.
69 SUs 507.118, 606. 057, 606.066.
70 SUs 612.047, 612.053.
71 SU 277.089.
72 Tamma 1991, 33 no. 15.
73 Isings 1957, 24 Form 8.
74 SU 612.023.
75 Wild 1970b, 66.
76 Walton Rogers 2007, 33.
77 Stephens 2008.
78 Grose 1989, 245.
79 Isings 1957, 37 Form 20, see Grose 1989, 254 for discussion.
80 Petrianni 2003, 76–7.
81 Tassinari 1993, 93 type S1000 series and 98 type T.
82 Béal 1983, 252 nos. 794–5.
83 SUs 507.071, 507.080.
84 SUs 507.078, 507.115.
85 SUs 507.050, 507.072.
86 Béal 1983, 151 figs XXVIII–XXIX; Schenk 2008, 55–6, fig. 116, 482–4.
87 SUs 507.032, 507.041.
88 SU 277.032.
89 SU 613.017.
90 SUs 512.549, 512.551, 512.553, 512.559.
91 SU 263.028.
92 Grose 1989, 247, fig. 121 bottom left.
93 Isings 1957, 25 Form 9.
94 Scatozza Höricht 2012, 51.
95 Cool 2007, 344–5 for the dating of these and coloured tubular unguent bottles.
96 Goethert 1989, 276, e.
97 Isings 1957, 35 Form 17.
98 SUs 260.016, 505.008.
99 SUs 265.002, 265.004.
100 SUs 262.003, 262.006, 262.008, 262.009.
101 See p. 444.
102 Isings 1957, 52 Form 37.
103 *Menander* 165 no. E5.
104 Isings 1957, 18 Form 3a; Grose 1989, 249.
105 Grasso 2004.
106 Grose 1989, 249–54.
107 Wild 1970b, 67.
108 Gleba 2008, 124.
109 Allison 2004a, 146–8.
110 Suetonius. *Lives of the Caesars* II.63, II.73.
111 Varrone 2003.
112 Crummy *et al.* 2007, 207–212.
113 Cool 2016a, 2016c.

REPORT ON THE COINAGE RECOVERED FROM THE AAPP EXCAVATIONS IN THE CASA DEL CHIRURGO

Richard Hobbs

Coinage at Pompeii: introduction

In total the AAPP project recovered 1,512 coins over the course of the excavations, to date one of the largest assemblages recovered from Pompeiian strata beneath the AD 79 destruction level. A full study of the assemblage has now been published.[1] A brief discussion of the types of coinage found at Pompeii and their role in the town's economy is provided below, in order to place the coins from the Casa del Chirurgo in a contextual framework.

There is little evidence for coin use at Pompeii much earlier than about the third century BC. Occasional finds of fourth century BC coinage have been made, but these are few and far between.[2] From the third century BC, it seems that some 'foreign' imports were appearing, for example from nearby Neapolis (modern Naples), but caution has to be exercised when deciding how widely these circulated, or indeed if this indicates anything resembling a monetised economy during that century; it may be the case that these entered the town, and the archaeological record, some decades after they were struck. The fact that the occasional early foreign import has been found in the AD 79 assemblages[3] indicates that early coins were capable of circulating for decades, even centuries after they were struck, even if by the time of the eruption they were extremely rare.

By the second century BC, and up until the time of Sulla's siege in 89 BC, the volume of coins arriving in Pompeii increased. These originated in three principal places: Rome, which for her Republican period make up roughly 18% of the total AAPP assemblage;[4] Massalia

(modern Marseilles), accounting for around 19%; and Ebusus (modern Ibiza), the largest single group at just over 25%.[5] For these three groups, and particularly the latter two, the picture is rather more complicated. Although coins issued by Massalia and Ebusus arrived in Pompeii, and are found there in relatively large numbers, it appears that their principal impact was to serve as a catalyst for a series of episodes of localised striking of imitative coins. Some of these imitations are easily distinguished, such as the later Ebusus types, which sport a rudimentary figure of the god Bes, and Massalia coins with garbled legends; others are more difficult to disentangle typologically from their prototypes.[6] It is also unclear where precisely these imitations were struck. Although they are certainly regular finds at Pompeii, they have also been discovered at other sites in central Italy (for instance, Minturnae), so on present evidence it is necessary to reserve judgement as to the where the production centre (or centres) was located.[7] There is in fact an urgent need to establish where imported Ebusus and Massalia coins and – more pertinently – their imitations have been discovered, not least because the most interesting question about these coins is under whose authority they were struck. Another reason why Pompeii cannot be unreservedly identified as the production site is because no local coins have yet been found which bear a Pompeii mint-mark. For all these reasons, I refer to these imitative coins as 'Campanian Massalia' and 'Campanian Ebusus' coins.[8] A small number of 'anomalous local' types, unique to Pompeii, have also been found, based it would seem in the main on Roman models.[9]

From the late second century BC, until the time of the Sullan siege, these three groups of copper-alloy coins – namely Rome, Massalia/Campanian Massalia, and Ebusus/Campanian Ebusus – constitute the bulk of the monetary stock of Pompeii. What happened after the Sullan siege is less clear. The archaeology of Insula VI 1 has shown that the imitative coins were certainly in circulation before the siege, for they are found in archaeological layers which pre-date the distinctive destruction levels. Whether they continued to be struck in the post-89 BC period is difficult to judge. My sense is that there was little new striking but most of these copper-alloy coins continued to be used in the town, but inevitably – if no new coins were being produced – their presence in the circulation pool gradually dwindled. By using a technique I term 'contextual association,'[10] it appears that in this immediate post-Sullan phase, which may be related to the imposition of the colony on Pompeii in the period from roughly 80 to 40 BC, there may have been a bias towards Republican bronze coins, and particularly deliberately fractioned coins

(halved Janus head *asses* were particularly popular). By the time we reach the end of the first century BC, new coinage originating in Rome begins to appear, although it still only accounts for less than 10% of the AAPP assemblage.[11] By the early decades of imperial Rome, most coins are those struck by the Julio-Claudian emperors. Although the numbers are small, it would appear to be the case that some Massalia/Campanian Massalia and Ebusus/Campanian Ebusus coins were still circulating, but had almost certainly entirely disappeared from circulation by the time of the eruption.

How precisely this 'small change' was used in Pompeii is a matter of some debate. Obviously, these small pieces of copper-alloy must have had an economic use, but when there is no perceivable denominational structure, and no clear issuing authority, we are forced to theorise as to the practicalities.[12] Presumably it was possible to change these copper-alloy coins into intrinsically valuable metals (i.e. gold and silver) or tangible produce, and the system had to be 'bought

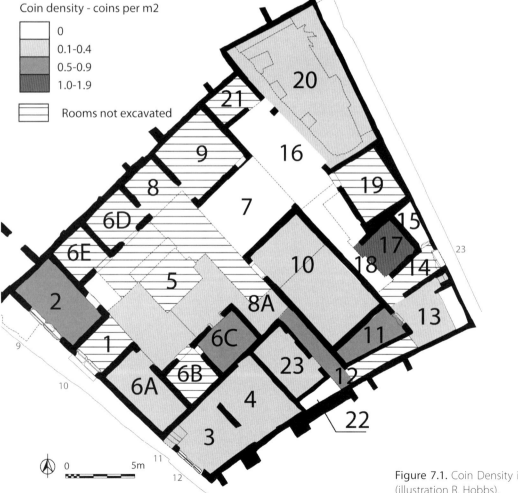

Figure 7.1. Coin Density in the Casa del Chirurgo (illustration R. Hobbs).

into' by the town's inhabitants, but the subtleties of the system remain obscure.[13]

The coins from the Casa del Chirurgo

With this contextual framework in mind, attention can now be turned to the coins from the Casa del Chirurgo itself. A total of 59 coins were recovered during the AAPP excavations of the Casa del Chirurgo;[14] eight of these coins are illegible (Figs 7.3–7.5).[15] This represents only c. 4% of the total number of coins excavated. The density of coins found in the property is shown in Fig. 7.1. The numbers are very low, normally less than a coin per m², and is extremely low when one considers that this calculation is based on surface area only, not on the volume of soil removed. Nevertheless this is entirely in keeping with the overall coin distribution pattern, whereby the two major domestic properties in Insula VI 1 – this property and the Casa delle Vestali – produced very few coins in comparison to the 'commercial'

zones.[16] By definition, one would expect that domestic spaces were not areas where coins were regularly being passed between hands, unlike the roadside bars, shops and so on, so the chances of coins being dropped were greatly reduced. There is also no particular distribution pattern to the coin types found in the property (Fig. 7.2), although there are a few clusters of coins of similar type, for instance a small group of Ebusus coins in Rooms 6C and 16. Whether this is of any significance is difficult to judge as the numbers are so low, but the exercise is worth conducting because sometimes it can suggest single episodes of group coin loss, e.g. a dropped purse.

Chronological distribution: broad observations

Four coins recorded from the Casa del Chirurgo can be dated to before 200 BC, equating to roughly twice the mean for the entire insula, although this is unlikely to be of any great significance (Table 7.1 nos. 2, 6–7, 50). The earliest coins from the house are two bronze units

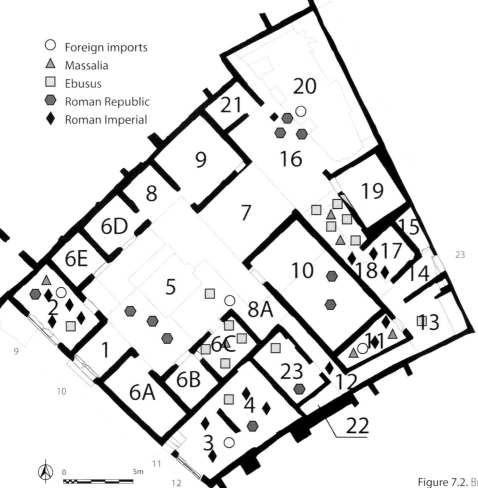

Figure 7.2. Broad coin types found in the Casa del Chirurgo (illustration R. Hobbs).

Table 7.1. Coins recovered from excavations in the Casa del Chirurgo.

No.	Room no.	AA/SU/SF	Hobbs no.	Description	date	phase
1	5	275.093, 113	1268	illegible	n/a	2
2	3&4	277.036, 137	5	Neapolis, HN 595	250–225 BC?	3
3	12	610.021, 72	79	uncertain AE, with ship prow?	?	3
4	17&18	612.027, 232	114	Massalia import type 2A	c. 170–100 BC	3
5	5	275.038, 78	567	Campanian Ebusus	second to early first century BC?	3
6	5	260.014, 78	772	Roman Republican *uncia*, Rome	c. 214–212 BC	3
7	3&4	277.156, 1003	774	Roman Republican *uncia*, Sicily	c. 214–212 BC	3
8	10	261.043, 13	835	Roman Republican *as*, issuer illegible	206–144 BC	3
9	shop 2	607.314, 300	882	Roman Republican *as*, issuer illegible	206–144 BC	3
10	10	261.043, 29	901	Roman Republican *triens*, issuer illegible	206–144 BC	3
11	5	260.120, 140	1270	illegible	n/a	3
12	10	261.043, 30	1445	illegible	n/a	3
13	17&18	612.019, 125	560	Campanian Ebusus Type 1 or 2	second to early first century BC?	4
14	11	265.085, 88	36	uncertain AE with crab, foreign import	third to second century BC?	5
15	11	265.085, 87	241	Massalia import, type 1 (bust l.)	c. 200–175 BC	5
16	6C	184.009, 22	154	Campanian Massalia, 'ΑΜΟΣ', Type 2C	c. 125–90 BC	5
17	shop 2	607.261, 170	337	Massalia import or Campanian Massalia	mid-second to early first century BC?	5
18	13	613.024, 88	531	Campanian Ebusus, type uncertain	second to early first century BC?	5
19	6C	184.009, 21	647	Campanian Ebusus type 3C	c. 125–89 BC?	5
20	3&4	277.065, 244	707	Rudimentary Bes	c. 125–89 BC?	5
21	shop 2	607.299, 255	1110	Tiberius under Augustus, RIC I Aug. 469	AD 8–10	5
22	12	610.026, 208	17	Tiberius AE, RPC 1, 604	AD 14–37	5
23	3&4	606.043, 183	1265	illegible	n/a	5
24	shop 2	607.233, 6	1361	illegible	n/a	5
25	shop 2	607.236, 39	1419	illegible	n/a	5
26	17&18	612.023, 311	176	Massalia import or Campanian Massalia	mid-second to early first century BC?	6
27	17&18	612.023, 304	423	Campanian Ebusus	c. late second century BC?	6
28	17&18	612.022, 212	426	Ebusus import type 2C	c. 214–150 BC	6
29	17&18	612.053, 376	530	Campanian Ebusus, type 1 or 2	second to early first century BC?	6
30	6C	184.008, 15	645	Campanian Ebusus type 3C	c. 125–89 BC?	6
31	shop 2	507.080, 138	686	Campanian Ebusus type 3C	c. 125–89 BC?	6
32	17&18	612.023, 291	724	Campanian Ebusus Type 3	c. 125–89 BC?	6
33	5	260.012, 4	918	Roman Republican *quadrans*, issuer illegible	206–144 BC	6
34	3&4	277.038, 168	1062	Octavian, Alexandria, RPC 1, 5021	c. 10–5 BC?	6
35	17&18	612.017, 164	1066	Octavian/Augustus, RIC I Aug. 420	c. 9 BC	6
36	17&18	612.017, 165	1069	Octavian/Augustus, RIC I Aug. 421	c. 9 BC	6
37	shop 2	507.032, 20	1074	Octavian/Augustus, RIC I Aug. 422	c. 9 BC	6

No.	Room no.	AA/SU/SF	Hobbs no.	Description	date	phase
38	3&4	277.085, 272	1132	Tiberius, RIC I Tib. 81	AD 22–?30	6
39	3&4	277.085, 271	1166	Claudius, RIC I Claud. 89	AD 42	6
40	3&4	606.013, 87	1162	Claudius, RIC I Claud. 88	AD 42	6
41	shop 2	507.078, 139	1168	Claudius, RIC I Claud. 90	AD 42	6
42	shop 2	507.072, 81	1169	Claudius, RIC I Claud. 92	c. AD 41–50	6
43	5&8A	505.008, 100	61	Cyrenaica, Ptolemy I, SNG Copenhagen 437–53	c. 250–120 BC	7
44	6C	184.006, 16	633	Campanian Ebusus type 3B	c. 125–89 BC?	7
45	23	262.008, 59	635	Campanian Ebusus type 3B	c. 125–89 BC?	7
46	23	262.009, 43	900	Roman Republican *triens*, issuer illegible	206–144 BC	7
47	11	265.004, 36	1083	Octavian/Augustus, RIC I Aug. 428	7 BC	7
48	23	262.006, 21	1229	illegible	n/a	7
49	5	275.016, 50	875	Roman Republican *as*, issuer illegible	206–144 BC	8
50	16&20	508.053, 137	1314	Neapolis, HN 593	c. 300–275 BC	9
51	shop 2	507.028, 19	13	Paestum AE *semis*, HN 1250	late first century BC	9
52	5	275.004, 34	80	uncertain AE, possibly Sabratha?	early first century AD?	9
53	6C	184.003, 25	472	Ebusus import or Campanian Ebusus	second to early first century BC?	9
54	16&20	508.026, 107	854	Roman Republican *as*, issuer illegible	206–144 BC	9
55	16&20	508.015, 75	1005	deliberately halved Roman Republican AE	c. 206–144 BC	9
56	17&18	612.009, 47	1152	Gaius, RIC I Gaius 50	AD 40–41	9
57	11	265.001, 1	1167	Claudius, RIC I Claud. 90	AD 42	9
58	11	000.000[1], 38	295	Massalia import or Campanian Massalia	mid-second to early first century BC?	unstr.
59	11, 13 or 17&18	612, 613 or 614, no no.	1242	illegible	n/a	n/a

[1] In Hobbs 2013, 139, the context is given erroneously as 614.029, an invalid context number.

Abbreviations

HN – Historia Numorum (Rutter 2001)
RIC – Roman Imperial Coinage
RPC – Roman Provincial Coinage
SNG – Sylloge Numorum Graecorum

of Neapolis, one struck in the early third century BC,[17] and the other in the period c. 250–225 BC, although the dating of Campanian bronze coins generally is somewhat subjective.[18] More reliably dated are two Roman Republican *unciae*, probably struck in 214–212 BC. About 60% of coins can be dated to the second half of the second century BC and first half of the first century BC, and in fact most of these coins probably pre-date the Social War, at least in terms of when they were struck. The final group of about 35% date from Octavian/ Augustus up until the time of Claudius; no coins later

than about AD 42 were found in the Casa del Chirurgo, with the exception of one Claudian coin which may have been struck slightly later (Table 7.1 no. 42).

The coinage in relation to site phasing

A summary of how some of the coins relate to the phasing of the Casa del Chirurgo has already been provided in Hobbs 2013, Appendix 1, Table 18 (correct at the time of publication). It is important to emphasise that the assignment of different contexts to different

phases, and the development of the phasing sequence, was conducted independently of the numismatic evidence, so in the discussion below circular arguments have been avoided.

Phase 2 (pre-Surgeon activity, probably c. fifth century BC – end of third century BC)
There is only one coin from this phase (Table 7.1 no. 1), unfortunately illegible.

Phase 3 (Casa del Chirurgo, c. 200 BC – 130 BC)
There are 11 coins from this phase: one Neapolis coin (Table 7.1, no. 2) and two early Roman Republican AE (Table 7.1 nos. 6–7), thus suggesting a *terminus post quem* of the late third century BC for the construction of the house. However, it should be borne in mind that these coins may have been lost or discarded many decades after they were struck – as is the case with a large number of coins from this insula and Pompeii as a whole – so although there remains a possibility that these coins provide evidence that the house was constructed as early as the late third century BC, they should not be considered as providing 'proof' that this was the case. Indeed, other material evidence in the form of ceramics, glass, and other small finds implies that a date in the mid to later second century BC is a more appropriate date for the house's construction (see Chapter 4).

Phase 4 (changes to Chirurgo, c. 100 BC)
There is only one coin from this phase (Table 7.1 no. 13). It is a Campanian Ebusus type, therefore locally struck, but is too worn to characterise further. However, it is likely to have been struck before the Sullan siege,[19] which fits neatly with the phase date.

Phase 5 (changes, late first century BC to early first century AD)
Twelve coins date from this phase, of which nine are legible. These include the first Roman imperial coins (Table 7.1 nos. 21–22), although, interestingly, no coins of the Roman Republican period. The rest of the coins are Massalia/Campanian Massalia and Ebusus/Campanian Ebusus types, suggesting that these continued to circulate many decades after they were struck; indeed, one of the Massalia coins is one of the earliest imported types (Table 7.1, no. 15).[20] There is also one uncertain coin with a crab on the reverse, which may have originated in Sicily or Bruttium, but is too worn to be certain (Table 7.1 no. 14); if the attribution to either mint is correct, this would make it the earliest coin deriving from this phase.

Phase 6 (further changes, mid-first century AD)
Seventeen coins can be assigned to Phase 6, the highest number of any phase. Nine – approximately half – are Roman imperial or Roman provincial coins of Augustus or Claudius, including the latest datable coin discovered in the Casa del Chirurgo, which may have been struck as late as AD 50 (Table 7.1 no. 42). There is one Roman Republican coin, which is interesting as it means that if Phases 5 and 6 are taken together, this is the only coin of this period to feature. The rest of the coins comprise one Massalia or Campanian Massalia coin (Table 7.1, no. 26), too worn to characterise further; and six Ebusus or Campanian Ebusus coins. The presence of a single Massalia coin in a context attributed to this phase accords with the conclusion I reached when examining the whole assemblage, namely that most Massalia coins and their imitations had 'dropped out of circulation by the middle of the first AD (sic).'[21] As for the Ebusus/Campanian Ebusus coins, three of these are the 'rudimentary' types (Table 7.1 nos. 30–35),[22] struck in Pompeii or the surrounding region, and certainly the latest in the Ebusus sequence, although there is little strong evidence that they continued to be struck after the period of the Social War.[23] Like Massalia, this broadly accords with my conclusion that only a small number of Ebusus coins continued to circulate into the Roman imperial period[24] - although the presence of six Ebusus coins in this phase is perhaps higher than might be expected.

Phase 7 (post-earthquake changes, post AD 62)
Six coins come from contexts assigned to Phase 7; one is illegible (Table 7.1 no. 48). Somewhat surprisingly, despite the fact that this is the latest non-disturbed phase in the Casa del Chirurgo, all these coins were struck in the BC period, with the latest coin a 7 BC issue of Octavian (Table 7.1 no. 47). There is no easy way to explain this. It is possible that this shows that these coins continued to be in use right up until the time of the eruption, which may be true in some cases. What seems more likely is that all the contexts from which these coins derive were heavily disturbed, and/or these are secondary depositions of these coins when new building activities were initiated as a response to the earthquake. The presence of two Campanian Ebusus types, both typologically late in the sequence, is interesting if the contexts from which they derive (184.006 and 262.008) have been correctly assigned to this very late phase. For, as suggested above, it is very unusual to find Ebusus types in post-AD 50 contexts.

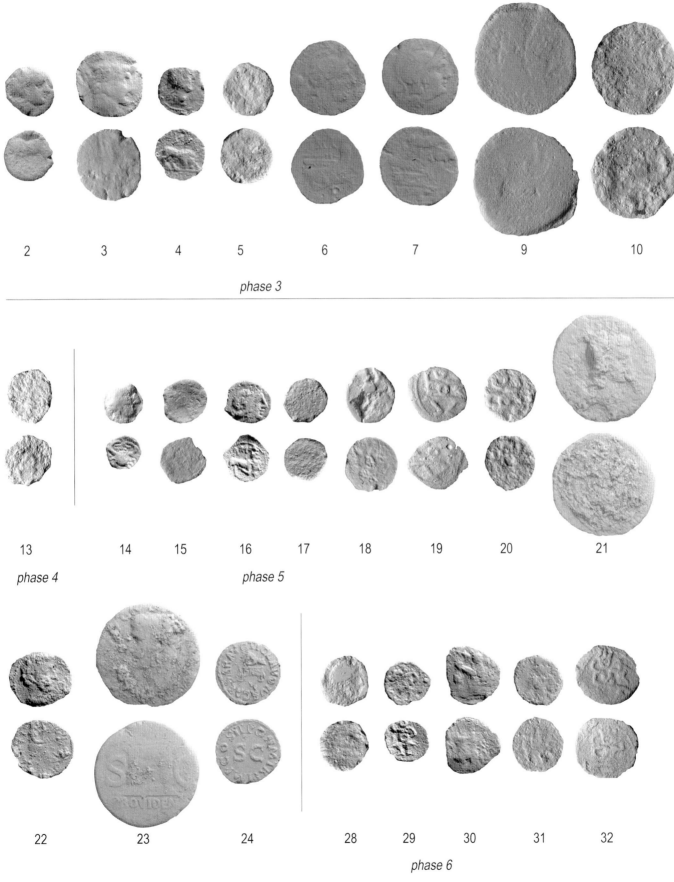

Figure 7.3. Coins from the Casa del Chirurgo by phase. The numbers refer to Table 7.1 Scale 1:1 (image R. Hobbs).

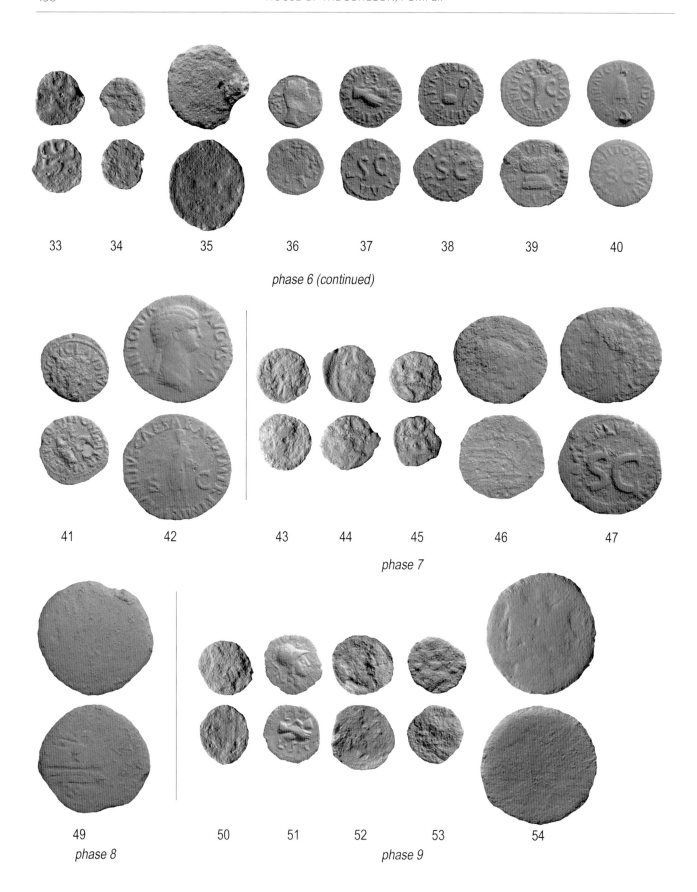

phase 6 (continued)

33 34 35 36 37 38 39 40

41 42 43 44 45 46 47

phase 7

49 50 51 52 53 54

phase 8 phase 9

Fig.ure 7.4. Coins from the Casa del Chirurgo (continued) Scale 1:1 (image R. Hobbs).

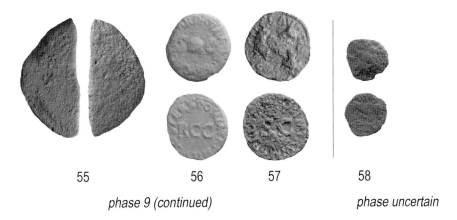

55 56 57 58

phase 9 (continued) *phase uncertain*

Figure 7.5. Coins from the Casa del Chirurgo (continued) Scale 1:1 (image R. Hobbs).

Phase 8 (eruption and early modern, AD 79 – 19th century AD)
Only one coin comes from this phase, a heavily worn
Roman Republican *as* (Table 7.1 no. 49).

Phase 9 (Modern interventions, 20th century AD)
Eight coins come from contexts assigned to this phase.
Little needs to be said, as all the contexts in this phase
are heavily disturbed as they relate to interventions
in the last century, especially those of Maiuri in 1926.
Unfortunately, given the unstratified nature of this
group, it includes some rather interesting pieces,
which, if they had been found in sealed contexts
would have been instructive to the dating of the coins
themselves and the stratigraphy of the house. One coin
(Table 7.1 no. 50) is perhaps the earliest found in the
Casa del Chirurgo, if it has correctly been attributed
to Neapolis, a type with tripod on the reverse dated
to the early part of the third century BC. The coin is
very worn, so the identification is not certain, but
as the insula produced other coins of this type[25] it is
entirely plausible that it represents another example.[26]
Another intriguing coin has not been fully identified
(Table 7.1 no. 52) but appears to have a bust on both
obverse and reverse, one with possibly a distinctive
triangular beard. This may suggest it can be attributed
to Sabratha, which would make it the only coin from
North Africa identified in the whole assemblage, but
the coin is simply too worn and corroded for the
attribution to be certain.[27] In this phase too there
is a very fresh example of a coin of Paestum (Table
7.1, no. 51), one of only a relatively small number
of Paestum coins recovered from Pompeii to date.[28]
Finally to this phase is attributed the only deliberately
halved Roman Republican coin found in the Casa
del Chirurgo (Table 7.1 no. 55). This means that cut
coins are underrepresented when compared with the

entire assemblage from the insula, for almost 10% of
the overall total were halved or further fractioned
coins.[29] That they are more prevalent in commercial
areas – roadside bars and so on – than in a domestic
property, is hardly unexpected.

Summary and conclusions

59 coins from the Casa del Chirurgo is not a high
number, and represents (as stated above) only c. 4%
of the entire assemblage recovered from the insula.
Taking this further, it also means that over the c. 250
years of likely intensive occupation of the plot, this
would equate to a loss rate of only 0.2 coins per year
(or, to put it another way, on average only one coin
was lost or deposited every five years). Nevertheless,
this in itself may be instructive: unlike other parts
of the insula block, where there is clear evidence for
fairly intensive commercial use, the Casa di Chirurgo
seems to have been primarily a residential property.
Even the conversion of some of the front rooms of the
property to metal working and production activities
does not appear to have increased the rate as which
coins were deposited in these areas since none of these
areas represents the highest concentration in the
house. Rather, the slightly elevated presence of Roman
Imperial coins in these rooms seems to emphasise that
it was primarily after they were no longer part of the
residential areas of the house that such coin loss was
more likely to occur. As observed in the publication
of the AAPP assemblage, over 50% of the coins were
recovered from the so-called 'commercial triangle',
the area of the plot immediately south and adjacent
to the Casa di Chirurgo (Hobbs 2013, 103–4, Table 16).
To my mind, this is an indication that the relationship

between the house and its neighbouring plot would benefit from further scrutiny, since the numismatic evidence clearly suggests that the use of these two areas was very different, one of the reasons why there is still much to be understood about the pre-AD79 development of Pompeii.

Notes

1 Hobbs 2013.
2 For examples from excavations conducted in different parts of Regio VI–IX by Perugia University, see Ranucci 2008a, 2008b.
3 For example a coin struck at Amestratus (Sicily) which was found in the bar of L. Vetudius Placidus (I 8, 8), see Castiello and Oliviero 1997.
4 Hobbs 2013, table 2.
5 *ibid.*
6 This will be aided by the research of Pardini (2013) who has established that there are distinct differences in the alloys used between the prototypes and the copies.
7 For a discussion see Hobbs 2013, 45, and Stannard and Frey-Kupper 2008.
8 Stannard (Stannard 2005; Stannard and Frey-Kupper 2008) favours the terms 'pseudo-Ebusus' and 'pseudo-Massalia.'
9 For a discussion of these 'anomalous local' types see Hobbs 2013, 41–43.
10 Hobbs 2013, 89–92.
11 With the caveat that as this was still circulating at the time of the eruption, it is almost certainly under-represented in the stratigraphy below the AD 79 level; large quantities of coins would have been recovered during the early decades of re-exposure of the site, records of which are generally poor (Hobbs 2013, 5–6).
12 My study of the metrology and flan size of the Massalia/ Campanian Massalia and Ebusus/Campanian Ebusus coins

concluded that no obvious denominational structure could be identified: Hobbs 2013, 50–53.
13 For a fuller discussion of these issues, see Hobbs 2013, 15–20.
14 There is only one other coin known to have been recovered from the Casa del Chirurgo during the early period of excavation of Pompeii: a silver coin, probably a Neapolitan *didrachm*, of late fourth to third century BC date, found on 16th February 1771 (Cantilena 2008, 121–22).
15 The images on the plates are photographs of the casts of the coins, not the coins themselves. The casts are kept at the British Museum, the original coins in storage in the central depository at Pompeii.
16 Hobbs 2013, 101. It should also be born in mind that a number of rooms in the house could not be excavated because of the presence of intact floors.
17 In my catalogue of this material (Hobbs 2013, no. 1314) this coin is listed as illegible; however I now believe that it is possible to distinguish enough of the design to characterise it as a Neapolitan type, not least because two other coins of the same type have also been found in the insula (Hobbs 2013, cats. 7&8).
18 Rutter 2001, 8.
19 Hobbs 2013, 95–96.
20 In the catalogue (Hobbs 2013) this is listed as a Massalia type 2 (unclassifiable), but a re-examination of the cast of the coin clearly shows a left facing bust.
21 *ibid.*, 96.
22 *ibid.*, 47.
23 *ibid.*, 87.
24 Hobbs 2013, 96.
25 *ibid.*, cats. 7–8.
26 This coin has been published as illegible, but a second inspection of the cast of the coin suggests that it can be identified as described here.
27 Another possibility is a 'Numa head' as (*RIC I*, p. 71–2), which can vary greatly in module size and metrology, but even with this proviso the coin is perhaps too small and light.
28 Hobbs 2013, 26.
29 *ibid.*, 22.

8

PLASTER FRAGMENTS FROM THE CISTERNS OF THE CASA DEL CHIRURGO: A WINDOW ONTO THE HOUSE'S LOST DECORATION[1]

Helen White

The decorative plaster that remains on the walls of the Casa del Chirurgo is rather unremarkable. While some timeworn and relatively faded examples can yet be found in situ in Room 19 (oecus),[2] elsewhere, nothing but weathered, patched, and featureless plaster backing serves as a reminder of how much has been lost in nearly 250 years since the house's original excavation. Today, virtually nothing remains of the astonishing freshness and detail remarked upon by early visitors (cf. Chapter 1), and most of the house's walls are entirely bare. Indeed, it is difficult to imagine that the decorated walls of this house were once hailed as one its most remarkable features. This regrettable condition is due largely to exposure to the elements, since, with the exception of Room 19 (oecus) and Room 8 (north ala), the house has been left without covering since the time of its discovery. It is also the result of the cutting out of details from the walls for removal to the collections at Portici, a practice that characterised the earliest excavations in Pompeii. The only way to gain some appreciation of the former glory of the house's walls today is to visit the cork model in the Museo Archeologico Nazionale di Napoli (Figs. 8.16, 8.26. 8.27, 8.30, 8.33) which provides a largely faithful and surprisingly colourful record of the decoration of the plaster apparently still in situ at the time of the model's construction in the 1860s.[3] In addition, the famous panel featuring a female painter engaged in painting an image of a herm (now in the same museum)[4] is the only wall decoration on display known to have originated from the Casa del Chirurgo.[5] Other elements that were

removed have subsequently been disassociated from their original contexts or have been lost, while the now decayed and unexceptional decorations of the house continue to fade and crumble with time.

A valuable corrective for this situation came to light in 2002 and 2004, when the AAPP excavations uncovered numerous fragments of painted wall plaster within the two collapsed cisterns on the eastern side of the atrium (Room 5) directly in front of the tablinum

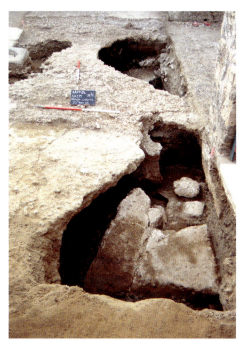

Figure 8.1. Collapsed cisterns on the eastern side of the atrium (Room 5) (image AAPP).

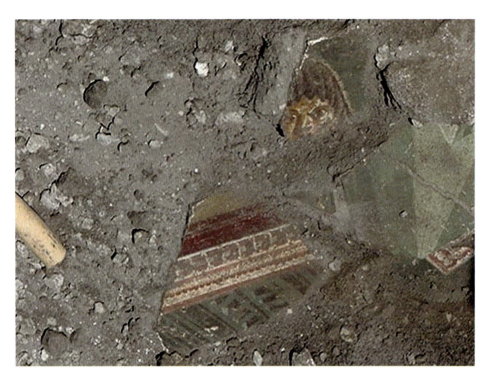

Figure 8.2. Plaster fragments in situ in the fill of the cistern (image H. White).

(Room 7) (cf. Figs. 5.5.29, 5.5.30, 5.11.15, 8.1 and 8.2). Many of these were in pristine condition, displaying the fine workmanship, colour, and detail that had originally characterised the house's decoration. Their stratigraphic location, on top of lapilli that had been disturbed in the early modern period, suggested that they originated from the time of the first excavation of the house, and meant that they might conceivably provide tangible evidence not only of the house's original decoration, but also of the damage caused by the practice of removing 'interesting' features of wall decorations that was common at this time. Had these fragments come from the Casa del Chirurgo and if they had, to which walls had they belonged? The search for answers to these questions served not only to highlight particular moments in the house's original excavation, but also to prompt a broader investigation into the overall quality and layout of its largely vanished final phase of wall decoration.

Cataloguing and analysing the plaster fragments

The plaster fragments recovered vary considerably in size, ranging from tiny pieces, only one or two centimetres across, to those more than 30 cm in size. Each was cleaned, photographed, and catalogued. While several were found to have friable and fragile surfaces that preserved few legible features, the greater part were in excellent condition and preserved vivid colour and significant detail. Taken together, the fragments present a highly varied assemblage, comprising elements of several different decorative schemes. A variety of brushwork techniques is apparent throughout, varying in treatment from detailed rendering to impressionistic strokes and suggesting the presence of a number of different hands that produced a range of decorative results from precise designs to cursory landscapes. Primary analysis of the fragments entailed associating them into discrete, numbered groups of elements that clearly derived from the same decorative components. This formed the basis of the cataloguing system.[6] While some groups could ultimately be connected as elements of the same overall decorative framework, others remained as isolated features, or were otherwise unidentifiable. The original position of many of these elements remained obscure, but several did provide key information regarding the origin of the fragments that permitted some attempts at reconstruction. Taken as a whole, these groups therefore fell into several main, functional categories (Fig. 8.3):

1. fragments that originated from a single, highly-decorated wall;
2. fragments of high-quality execution, such as faces,[7] which cannot be linked with certainty to those belonging to category 1;
3. fragments that in themselves are not particularly remarkable, but provided hints as to the probable provenance of the overall assemblage;[8]

Figure 8.3. Plaster fragments in finds trays (image R. F. J. Jones).

4. fragments that appeared to belong to a coherent design, but which could not easily be associated with any other elements;[9]
5. fragments of common decorative motifs that cannot be assigned a particular origin. These can be subdivided into those that are more complex (columns, fences etc.) and those that are simply border patterns;[10]
6. fragments that offer the suggestion that they form part of a larger image but are too fragmentary to be legible;[11]
7. fragments whose decoration is generally indecipherable.[12]

Origin of the plaster fragments

Had these fragments actually come from the Casa del Chirurgo? The large number of different groupings identified, many of which were obviously from different decorative schemes, ruled out the idea this was all simply material that had fallen from the walls directly above the voids that appeared when the cisterns had collapsed in AD 79. Furthermore, the fragments had not been recovered from within the primary lapilli and volcanic debris that had filled the cistern voids during the eruption, but were found in a secondary deposit after the cisterns had been investigated during the primary excavation of the property in the eighteenth century. Indeed, the process of deposition was clearly one of disposal. One possible source of fragmented wall plaster might have been elements of parietal decoration that had already become detached during the eruption and had been recovered during excavation or components that had fallen from the walls either during or shortly after the initial excavation of the

house. Newly uncovered plaster extant on the walls would have been particularly vulnerable and was rendered even more unstable by subsequent exposure to rain and frost. Another possible source might have been elements that fell off during or after the removal of central or 'interesting' elements from the walls for transport to the Royal collections, or those removed components considered to be 'second rate' and thereafter subject to destruction.[13] Whilst to the modern eye all of the pieces in the cistern dump are valuable, the practice of selection was borne of a mindset different from today's ideals of preservation and systematic archaeological recording. Furthermore, any elements of walls that broke during the process of their removal would likely have also been rendered 'worthless' by their incomplete and fragmentary state.

The walls of the oecus (Room 19) bear witness to just the sort of removals that occurred in this house. There is a lacuna on the east wall (W06.063) of this room where the well-known fresco of a woman painting[14] was removed in one piece, and another lacuna for a *tondo* to the right of this.[15] Beneath these, at the base of this wall, just above the dado, is a very fine, small image of a theatre mask with incisions forming a neat square frame around it (Fig. 8.4). This is likely evidence of an abandoned attempt to remove this image, or possibly even an attempted theft. The image of a leopard next to it remains intact, possibly because it was already the more faded of the two, a condition that persists today (Fig. 8.5).[16] While it must be admitted that the practice of removing elements of wall painting from Pompeian houses did serve to save several elements of the Casa del Chirurgo's decoration from the fate suffered by the timeworn panel on the south wall (W06.064) of the oecus (Room 19), which is now completely indecipherable, and those in the atrium, which survive only as incised patterning, the location of only one of the panels taken from the Casa del Chirurgo is known with certainty today. Published sources and the cork model imply the presence of other *quadrati* and *tondi* among the wall paintings of the Casa del Chirurgo (notably in the atrium and on the south wall (W06.084) of the triclinium), but these are now either lost or part of anonymous collections, and matching them with any certainty to this particular site would be impossible.

The fact that elements have been taken from the Casa del Chirurgo, however, does not prove that the fragments recovered in the cisterns derived from the house itself. They might also include fragments fallen from nearby houses during excavation or tidied-up generally from the exposed areas of the city after periods of adverse weather or abandonment, such as

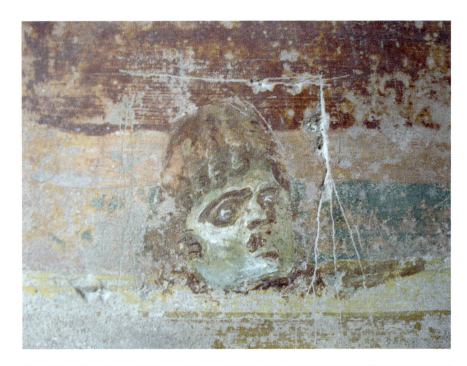

Figure 8.4. Incomplete incisions around one of the masks still visible on the walls of Room 19 (image H. White).

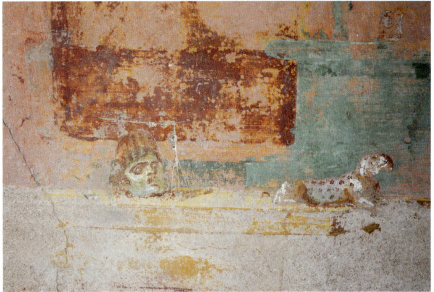

Figure 8.5. Surviving elements of the original decoration of Room 19; a leopard and mask (image H. White).

seems to have occurred immediately after the period of French occupation of Naples in 1799.[17] However, while it is impossible to be entirely certain that all of the fragments derive from the Casa del Chirurgo, it is clear that at least some of them do. Group 32, for instance, contains an example of a Fourth Style embroidery border pattern in the form of squares with five dots[18] that is identical to the surviving, albeit faded, design on the north wall (W06.013) in room 6D (Fig. 8.6).[19] While such a pattern is not unique in the decoration of the city, the scale, spacing, and execution of the border pattern are so similar to the elements yet adhering to the wall that it seems highly likely that the two belong

to the same hand and comprise elements of decoration from the same wall.

This conclusion is strengthened by the connection between two further groups of plaster (Groups 16 and 25) (Fig. 8.7) and the documentation of the original decoration of the Casa del Chirurgo. These bear torch-like candelabra remarkably similar to those seen rising-up between the central panels of the walls in Piranesi's engraving of the atrium (Fig. 8.8). While other sources,[20] combined with autopsy of incised patterns on the surviving atrium plaster, make it clear that this particular detail was not actually present in the atrium of the house, it is conceivable that Piranesi

Figure 8.6. (*Left*) Embroidery pattern matched against remaining elements on the wall of Room 6D (Barbet 1981 Type 50) (image H. White).

Figure 8.7. (*Above right*) Group 16. A flame-like pattern of volutes similar to patterns visible in Piranesi's engravings (image © 2004 Jennifer F. Stephens and Arthur E. Stephens).

Figure 8.8. (*Below*) Piranesi's engraving of the atrium of the Casa del Chirurgo (image Piranesi 1804. Courtesy of Heidelberg University Library: Digital Library).

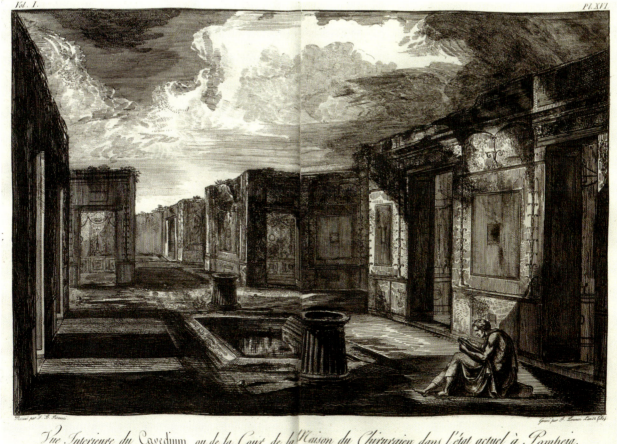

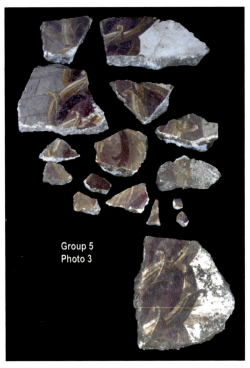

Group 5
Photo 3

took inspiration for this design from elsewhere in the house and decided, with typical artistic license, to use the motif in his drawing to enliven the atrium walls to his taste.

Finally, there is another group of fragments depicting the shaft of an ornate gold and purple foliate column in front of a receding grey *opus quadratum* wall on a white ground (Group 5) (Fig. 8.9) that is markedly similar to the two columns flanking the central zone of the east wall of the oecus (Room 19) as recorded in *Le Pitture Antiche d'Ercolano* (Fig. 8.10).[21] Although this feature is no longer visible today on the faded plasterwork, and it is clear that these fragments do not originate from Room 19 itself, the similarity suggests that this column was part of an element of decoration that could easily have fitted in with the overall scheme of the house. These connections established the possibility that the cistern fragments might be used to reconstruct some of the now missing details of the parietal decoration in the Casa del Chirurgo.

Figure 8.9. Group 5. Elements of the foliate column (image AAPP) (image © 2008 Jennifer F. Stephens and Arthur E. Stephens).

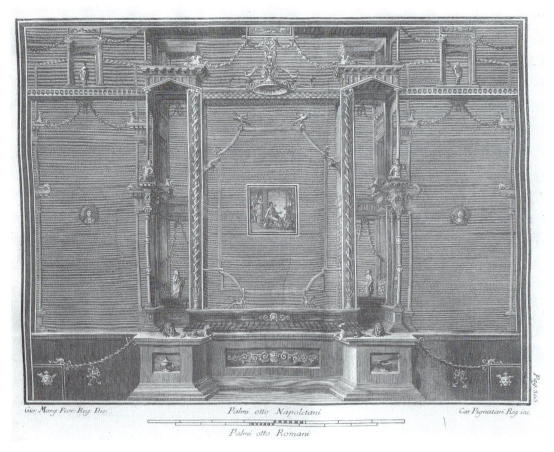

Figure 8.10. Room 19, wall W06.063 as recorded in *Pitture d'Ercolano* Vol. VII (V). Plate 83. 1779. (image courtesy of Heidelberg University Library: Digital Library).

The Primary Group – elements of a single wall

Within the fragments, several significant groups were identified that may plausibly have come from a single decorative composition. The first major group comprises elements that originate from the upper zone of a wall. The primary surviving feature consists of an oblong panel containing a finely-detailed still life, depicting a brace of ducks on the right hanging from a bow and a slain, gutted boar against a greenish-grey background and faint ground line (Fig. 8.11). This is positioned within a thin, white border producing a box set against a deep red ground. Below this, a stylised two-part entablature of hook-shaped modillions and a twisted, rope-like pattern in pinkish-white divide the panel from illusionistic architectural details in monochrome green depicting a coffered ceiling and elements of receding architectural space. In front of this space, the remains of two theatrical masks are visible surmounting further protruding illusionistic architectural elements which are rendered in a palette of ochres and deep reds producing a frame decorated with a bead-and-reel frieze, below which further receding architecture may be observed. To the left, a couchant golden griffin sits atop a separate roofline from beneath which project a further row of modillions. Vertical features may be observed to the left and right, presumably deriving respectively from a flanking area of red ground, and the leafy, yellow tendrils of a candelabra or capital that project in front of the other features.

The second major grouping almost certainly comes from the same wall. It fills in some of the details from the first, but, since it presents the same elements symmetrically reflected, must derive from the other side of an axial composition. The two certainly represent the two flanking zones of a tripartite Fourth Style decorative scheme. A similar set of two theatrical masks surmounts a frame decorated with a bead and reel frieze in pink and white. It can be seen here that this element floats in front of continuing receding architecture in a green monochrome palette. Just as in the first grouping, each unique mask is depicted with shoulder-length curls, although these do not survive intact (Fig. 8.12).[22] Shading behind the masks gives the illusion that the frame upon which they rest stands proud from the background. Illogically, and characteristically within the frame itself, further fanciful receding architecture continues but on a larger

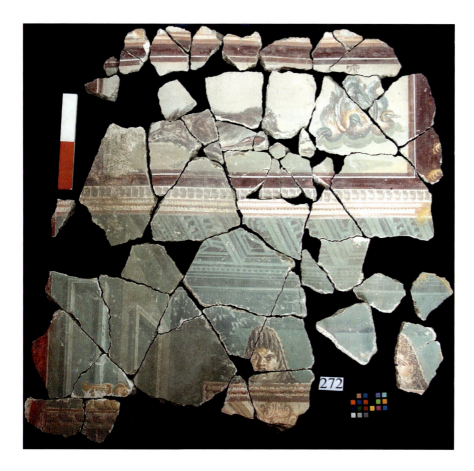

Figure 8.11. Panel with ducks and boar (image © 2004 Jennifer F. Stephens and Arthur E. Stephens).

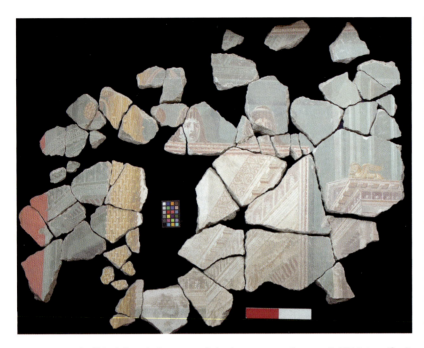

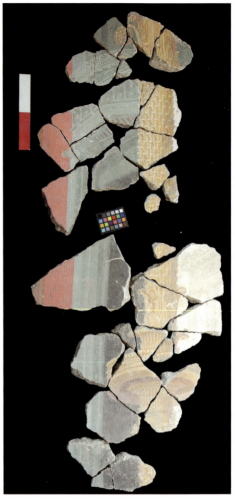

Figure 8.12. (*Left*) Left-hand elements of the large group (image © 2004 Jennifer F. Stephens and Arthur E. Stephens)

Figure 8.13. (*Right*) Continuation of the scalloped column shaft (image R. F. J. Jones).

scale and with a perspective that is entirely dissociated from the surrounding architectural framework. Here one can see the angle of an entablature above what was probably a colonnade with square modillions. It is surmounted with a vaguely illogical double volute frieze that seems to draw more inspiration from embroidery patterns than real architecture. This has been skilfully rendered, deploying atmospheric perspective so that it appears to be situated outside or behind the main architectural elements. To the right of the frame, a couchant, golden griffin, similar to that in the first group, sits along the edge of what may now be perceived to be the pediment and soffit of a Corinthian tempietto or aedicula, the entablature of which rests on two fluted columns, executed in the same palette of pink/white/blue with hints of yellow. The coffered ceiling of the tempietto appears between these two columns, and the cella wall of the tempietto is just visible at the edge of the fragments, which is rendered in an *opus quadratum* construction of large pink blocks. Behind this, the receding illusionistic architecture in a monochrome green palette continues. Above, elements of a coffered ceiling similar to that observed in the first group continue and descend to the left of the central frame where the elements of a small aedicula and doorway are visible. This is separated from the central frame by an ornate golden column or heavy candelabra with a scalloped shaft. Its elaborate Corinithian-esque

capital is decorated with flowers or fruits. As is evident from additional fragments, further down the shaft is interrupted by a circular collar decorated with bands of beading, bead-and-reel, and a cornice, separating two elements resembling modified fluted Pergamene capitals. Below, the scalloped shaft continues, flanked by dark blue ground on the left and a continuing fantasy architecture in pink and white on the right (Fig. 8.13). Foliate elements surviving along the edge of the still life panel in the first group suggest that these columns continued upwards. To the left, the whole decorative scheme appears to terminate against a solid ground of bright red and finally a border of a deeper red/brown.

Related elements

Several further groups may plausibly comprise elements from the same wall. Components of a landscape panel, surrounded by a similar white border against a deep-red ground, are likely part of a second scene in a similar position in the composition to the still

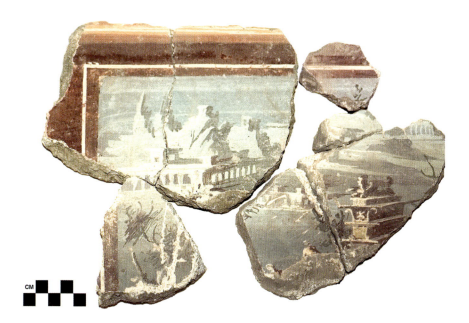

Figure 8.14. Panel with a Nilotic scene (image © 2004 Jennifer F. Stephens and Arthur E. Stephens).

life panel of the first group. The landscape is rendered in an impressionistic style in a predominantly purple/blue palette, depicting a maritime villa and a rustic altar topped by a sphinx, before a cursory mountainous landscape populated with tall trees and other structures (Fig. 8.14). This second panel and associated element of foliate column decoration suggest that the upper zone of this wall was not a part of a continuous frieze but a series of stand-alone panels, almost in the form of a pinakotheca. Evidence of additional frames within the fragments include one that abutts elements of foliage (Group 44) and a red frame with a dark blue ground (Group 18). These could belong to additional panels that would likely have been set atop the complex architectural scheme, the ornamental pilasters of which rose between them with additional architectural framing elements in a manner that is likely similar to the surviving decoration of Room 19 (oecus). Indeed, there are traces of a dark red vertical line above the landscape panel, and areas of pink, blue, and yellow above both the landscape and the still life suggest that the scheme continued above these in the form of further panels.

There are further groups within the collection which could feasibly find a place within this larger scheme, but have no definitive physical connection to it.[23] These include a number of fragmented garlands, patterns, swags, and ornamental hanging discs,[24] which bear similarities in style to the schemes of the walls of the oecus/atrium as shown in the *Pitture d'Ercolano*.[25] Another group consists of a very fine, fluted column, rendered in a yellow-cream palette running between the beginnings of a capital, and traces of a base or

decorative collar. It is flanked on the right by a ground of bright red and a flat blue ground on the left. While no feature of this group definitively connects it with the previous groups, its overall palette suggests that it may have come from the same wall.[26] The most notable however, is Group 79, which includes a very fine garlanded head (with a slight hint of shoulder) (Fig. 8.15) of a quality akin to that of the panel of the female painter from Room 19 (oecus). The figure appears to have stood before two Ionic pillars, the colours and capitals of which are of a palette markedly similar to the pink/white colonnaded aediculae of the large group. It is possible that instead of further panels directly above the duck/boar and landscape scenes, our

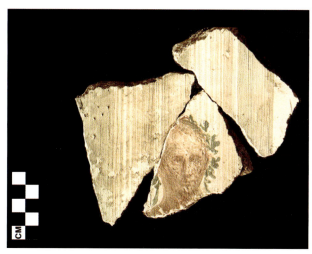

Figure 8.15. Elements of a figure before an architectural background (image © 2004 Jennifer F. Stephens and Arthur E. Stephens)

scheme was populated by one or more finely-painted figures in a manner similar to the east wall of Room 19 (oecus) where, as the *Pitture d'Ercolano* shows, there was apparently just such a figure standing in front of a column at the left hand side (cf. supra Fig. 8.10).[27]

Single wall overall

The overall composition to which these fragments belonged appears to have been the mid-upper zones of a typical Fourth Style wall, consisting of a now-missing central zone flanked on either side by symmetrical zones containing similar primary features. A series of framed panels featured towards the top of the zone, while the space behind and around the mask-topped frames was filled with complex architectural elements divided by two flanking decorative columns. These likely continued the full height of the wall serving to divide the whole composition into a central zone and two flanking zones in a common tripartite Fourth Style arrangement,[28] which is predominantly symmetrical. This may be observed in the fact that several design elements, including the griffin-topped entablatures and the architectural elements within their mask-topped frames, recede in opposing directions and clearly form two sides of a unified design. This symmetry is emphasised by the masks, the gaze of which is directed along the same lines of recession. Since only fragments from the upper part of the wall survive among those recovered,[29] it is difficult to be certain of the lower

elements of the composition, but it was likely finished off with a middle zone and dado or socle in common with most Fourth Style arrangements. There is very little evidence of any central panels among the entire collection of plaster fragments and none can be assigned to this wall with certainty. This is a frustrating, but unsurprising, result since these central scenes were often the primary target for cutting and removal.[30]

Original location

Despite a great many lacunae in this reconstruction, it was possible to conclude from the surviving elements of the perceived layout that it would have required a wall at least three metres in width. In order to determine the likely original location of this principal group within the Casa del Chirurgo, a process of elimination was undertaken. Candidates for its original location could, in some cases, be ruled out on the basis of size or by the degree of preserved plaster remaining on their walls, particularly in the upper zones whence this group must have originated. This search could be refined further by information provided by the cork model in the Museo Archeologico Nazionale di Napoli (Fig. 8.16). Its schematic but relatively accurate record of much of the house's parietal decoration, while not as detailed as the actual surviving fragments, could nevertheless be used to associate fragments on the basis of overall ground colour and to suggest the scale of preservation of wall plaster in the house at an earlier time.

Figure 8.16. The Casa del Chirurgo in the cork model in the Museo Archeologico Nazionale di Napoli (image © 2008 Jennifer F. Stephens and Arthur E. Stephens Su concessione del Ministero per i Beni e le Attività Culturali – Soprintendenza Speciale per i Beni Archeologici di Napoli e Pompei).

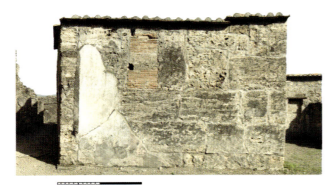

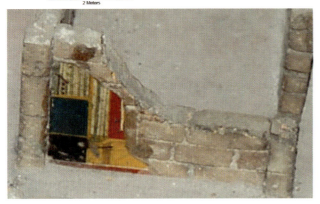

Figure 8.17. South wall (W06.061) of the tablinum (Room 7) and in the cork model in the Museo Archeologico Nazionale di Napoli. Surviving plaster matches the outline on the model (image © 2008 Jennifer F. Stephens and Arthur E. Stephens Su concessione del Ministero per i Beni e le Attività Culturali – Soprintendenza Speciale per i Beni Archeologici di Napoli e Pompei).

The cork model indicates an extent of decorated plaster on the walls of the tablinum that roughly corresponds to the outline of the degraded plaster that currently remains in the Casa del Chirurgo, suggesting that those elements that are missing today were already missing in the middle of the nineteenth century when construction of the cork model began (Fig. 8.17).[31] With these factors having been taken into consideration, the most likely candidates were the walls of the tablinum (Room 7). According to the cork model, the decorative scheme indicated on the walls of this room consisted of two symmetrically-arranged tripartite schemes, with the northern and the southern walls both decorated in the same general overall layout. Aspects of these decorations match certain faint traces on the surviving plaster, and the upper zones equally have enough non-plastered areas to accommodate the overall layout of the principal large scheme. However, insufficient fragments were recovered to restore the upper sections of two walls, suggesting that the remains of only one of these ended up in the cistern.[32] Key matches between the cistern fragments and the record of the cork model

are red and green zones situated either side of a central yellow panel.[33] These match the green monochrome architectural schemes and red fields observable in the plaster groups. The model also indicates flanking architectural zones on either side of the central panel, articulated by a yellow or golden line that might be equated with the candelabra-style columns observed in the plaster fragments. Beyond these broad observations and consistencies of colour, however, the cork model shows no specific motifs that are unequivocal matches for any of the plaster fragments, nor does it illustrate the upper zone of either tablinum wall where the decorative scheme contained in the fragments would most likely have been situated.

It was Ribau's addendum to the *PAH* that provided the crucial piece of evidence for linking these plaster groups to the walls of the tablinum. A link between the plaster fragments and an account of some removals which took place on the night of 23rd November 1792, is made possible by the mention of a painting of *una quaglia*, "a quail" that was noted as being cut from a wall in the tablinum.[34] Such an element would be thematically in keeping with the still life of the boar and ducks in the first group. While it might be temping to suggest that that the small lacuna on the left side of the still life could have been caused by the removal of the quail, this is unlikely given the amount of space in this lacuna and arguably less likely in practice to attempt to separate small elements of an in situ and complete framed panel. Furthermore, the account in the *PAH* suggests that it was a full panel that was being removed as opposed to a single, small element from a panel. It is more likely, therefore, that the quail would have been a separate panel similar to, and situated alongside, the still life and the landscape. There would certainly have been space in the overall layout for additional painted panels, and a row of such elements would be in keeping with the overall design of the decoration.[35] Closer inspection of the fracture lines around the top left hand corner fragments of the frame of the landscape panel reveal them to bear distinct chiselled straight edges, possibly suggesting a failed or abandoned attempt at removal, conceivably something that occurred at this same moment. Unlike the quail, however, the attempt to remove the landscape panel was unsuccessful – it fractured during the process and thus eventually ended up in the nearby cisterns.[36]

Taken together, this evidence proffers reasonable grounds for surmising that the walls of the tablinum itself were the original location for these connected groups of plaster fragments. These walls are certainly large enough to accommodate the principal decorative

Figure 8.18. Fluted fragments compared against in situ plaster fluting in the tablinum (Room 7) (image H. White).

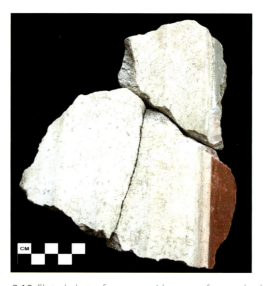

Figure 8.19. Fluted plaster fragment with traces of ground colours (image © 2008 Jennifer F. Stephens and Arthur E. Stephens).

scheme and sufficient plaster is missing at the tops of both walls (particularly on the southern side) to account for the elements that ended up in the cisterns. Finally, the close proximity between the tablinum and the cisterns also lends support to the idea that many, although certainly not all, of the fragments derived from the walls of this room.

Identification of the tablinum as the source of the main group of fragments permits additional fragments

to be associated with it. At the western edge of the north wall of the tablinum, there is evidence of stucco work rendering an engaged fluted pilaster.[37] Within the plaster fragments recovered from the cistern, there were elements of fluted columns that fit exactly with the corresponding fluting on the walls of the tablinum (Fig. 8.18). One fluted fragment in particular bears traces of red and green ground where the flutes would have met with the flat wall surface (Fig. 8.19). Running between these two colours are traces of a bead-and-reel pattern in a pink hue similar to that found within the large group. While the red ground found in this fragment directly against the flutes does not match any scheme depicted on the cork model, (which indicates only blue and black grounds adjoining the end of the walls where the fluted pilasters would have been), it is possible that this detail may come from higher up on the wall beyond the components recorded in the model. It should also be noted that the engaged pilasters themselves are entirely absent from the model, serving as a cautionary reminder that the decoration it indicates should not be taken as an infallible record.

Missing elements

It is probable that further fragments from the cisterns may also derive from the decoration of the tablinum, but too few connections have survived to permit a certain association to be established. The cork model indicates that the tablinum walls bore two sizeable blue panels over black dados on either side of the central zone. Three matches for this colour are found among the plaster fragments. The first is what appears to have been a sizeable panel (Fig. 8.20).[38] The centre of this panel is missing, but framing this lacuna is some highly decorative yellow patterning on a dark blue background with gold faces in each corner and in the centre. This feature is bordered by a flat blue ground that matches the colouring on the cork model. It is possible it could have come from the right hand side of either wall (where there is no plaster extant), but, as the cork model provides only the major colour zones and without fine details, it is difficult to be certain. A second colour match consists of a series of blue fragments that include a sort of crest bearing a golden winged grotesque (Fig. 8.21).[39] These have dark blue bordering, which is not apparent on the cork model, and may simply represent a detail that was not included.

Elements of a further blue panel are represented by the group comprising a column with a blue field to its left and a red to its right[40] (Fig. 8.22). It is difficult to

Figure 8.20. (*Top left*) Detailed decorative border elements in blue and gold on a dark blue ground flanked by blue and red panels (image H. White).

Figure 8.21. (*Bottom left*) Blue-ground fragments (Group 3), including grotesques in gold and white (image H. White).

Figure 8.22. (*Top right*) Fragments of an illusionistic fluted column (image © 2004 Jennifer F. Stephens and Arthur E. Stephens).

see how this group could have fitted into the central column scheme as represented on the cork model because it does not match the progression of colours as they move from the blue panels towards the centre. Neither can it be located definitively at the far edge of the tablinum wall because the cork model does not indicate the presence of a red ground and a column at the edges abutting the blue panels. The red in this group is also of a brighter hue than that attached to the fluted column fragment elsewhere in this group. It is possible therefore, that this fragment derives from a different wall, or, if it did come from the upper zone of the wall, it may be a component of the decoration for which no other evidence survives. Certainly the cork model may simply have omitted this particular detail.

Evidence for the central panel?

There also remains a question as to elements that might derive from the missing central decoration of this wall. The cork model shows a large central zone consisting of a broad yellow frame bordered by a thin white band[41] and encased in a larger red border, all situated above a yellow *socle*. Faint incised lines indicating some of this patterning are still visible in certain areas on the north wall of the tablinum (W06.060), and faded traces of yellow pigment survive over the pale red coloration that accord with the cork model, but the central panels on both tablinum walls are entirely missing. Given that the fragments from the cistern that may derive from this wall likely represent elements that are shown missing on the cork model, it is conceivable that elements

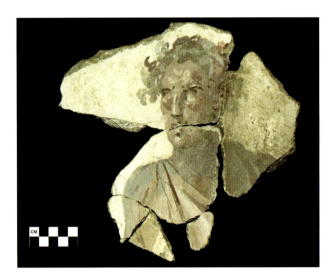

Figure 8.23. Fragments of a male figure (image © 2004 Jennifer F. Stephens and Arthur E. Stephens).

of the central decoration may also be present in the cistern assemblage.

While it is impossible to be certain of their relationship to this particular wall, one group[42] in particular may have derived from just such a central panel painting. The overall style of this group is impressionistic, and the palette of colours employed is predominantly purple, blue, and pink. The first element presents the head and shoulders of a sizeable[43] male figure crowned with a garland of leaves and wearing a *himation* (Fig. 8.23). These fragments bear distinct, straight chisel marks around the top edges which might suggest another failed attempt at a removal, either as a larger whole or as a stand-alone figure. Where these fragments fit together there is a gap, possibly representing a blundered attempt to ease the figure out with a tool, cracking the piece in the process, resulting in it being discarded. A second element that plausibly derives from a central panel shows an intimate coupling of a satyr and nymph in front of a blue/white column

(Fig. 8.24) (only the middles of their bodies appear to have survived among the fragments). Similar in style to the male figure, this detail is, however, in a smaller scale suggesting that they may come from a separate scene. Finally, there is a small head in profile that may have belonged to a pygmy (Fig. 8.25). Plate 68 of the *Pd'E* V,[44] records a scene of two bare-bottomed pygmies fighting over, or carrying, a bowl and who are observed by three others, one of which includes a face strikingly similar to this small head. The scale suggests that the width of the head is approximately the same as this fragment and it is also shown as being partly damaged. This plate could therefore record additional elements of a scene to which this head may belong. In the second scene from Plate 68, a decorative cloth awning provides shade for what appears to be a group of dining pygmies. An element of a similar patterned cloth is also among the plaster finds.[45] The provenance given for both of the illustrated fragments is "Pompeii" and the drawing was executed by Giovanni Morghen, the same artist who recorded the east wall of the oecus (Room 19) with its famous central panel of a female painter and a herm.

So little of the figure survives, however, that its attribution as a pygmy is actually far from certain. It is conceivable that instead it may depict a demure girl or perhaps an effeminate boy. Such an image could easily come from the set of women and 'geniuses' noted by the *PAH* to have been present in Room 6D,[46] or from the group of *ephebes* and Bacchus mentioned by Overbeck in 1875, a scene that he does not locate with precision.[47] All of these scenes could have been set against a white ground similar to that observed in the surviving fragments from the cistern. While stylistic differences between the painting of the fragments from the large group may make it unlikely that these fragments all derived from the same scheme, these few surviving elements may at least suggest the presence of a scene or scenes of Bacchic celebration, forming

Figure 8.24. (*Left*) Group 72. A fragment of an intimate coupling against an architectural ground (image H. White).

Figure 8.25. (*Right*) Fragments of a possible pygmy figure (image © 2004 Jennifer F. Stephens and Arthur E. Stephens).

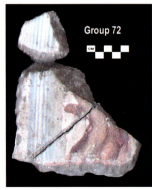

the central image of one or more of the walls of the Casa del Chirurgo, images that were no longer visible to receive the pejorative assessment of Overbeck, but which had already been partially preserved in the fragments deposited into the cistern.

That just such a scene was present in the house is further supported by the Ribau's addendum to the *PAH* noting the removal of paintings from the house in 1792.[48] He mentions that among the four paintings removed, two, consisting of a group of *baccanti* and a head, were taken before the artist Lo Manto was able to finish illustrating them. He situates these in a room "near the tablinum," in a room with a deep blue ground (*fondo turchino*). Since none of the surviving evidence from the house suggests the presence for a blue room or even a major blue feature, it is difficult to determine precisely where this activity took place. The only rooms in the Casa del Chirurgo with blue elements in their decorative schemes appear to have been the tablinum (Room 7) and the ala (Room 8).[49] The blue elements on either side of the walls of the tablinum certainly could lead to its identification as the room with a blue ground, but since Ribau mentions the tablinum specifically in his narrative, this room must be somewhere else. According to both the cork model and surviving traces on the walls there certainly were central panels with white backgrounds on the three walls of Room 8 (W06.018, W06.019 and W06.036), the northern of which (W06.018) depicted Narcissus,[50] and it is possible that fragments of a Bacchic scene or one with pygmies could have belonged to one of these. It is difficult to imagine it being described as the "room with the deep blue ground," however, especially since the primary panels of this room were in yellow, red, and green.[51] While it is conceivable that the reference was to the deeper colouring of the upper zones of Room 9, on the cork model these appear to be black rather than deep blue, and nothing survives today that would contradict this. On the whole then, while it seems probable that these elements derive from central decorative panels of the Casa del Chirurgo, their precise original location must remain a mystery.

Decoration throughout the house

So far, discussion has focused on efforts to locate those elements of the largest groupings of fragments within the house, presenting the tablinum as the major source of these elements. The cork model, taken in conjunction with surviving evidence and early documentation, also permits something to be said about the decoration in the rest of the house, even if such reconstruction must be limited to the overall colouration and patterns of large panels on the walls. Insufficient evidence generally survives that would permit a reconstruction of the details of decoration, but certain groups of plaster fragments from the cisterns can be at least tentatively associated with some of these elements of decoration.

According to the cork model, the two walls of the fauces (Room 1) were decorated with a Fourth Style scheme with a black dado[52] surmounted by a middle zone divided into three major panels (Fig. 8.26). To the east and west, red panels with black central zones flanked a central panel of yellow. As preserved on the model, these red and black panels curve inwards at the top and bottom as if blown by winds in a manner similar to the "*vorhänge*" of the alae of the Casa dei Vettii,[53] revealing additional black ground behind them. The upper zone is characterised by white that might have been filled with airy fantasy architecture, although none of the precise details are preserved on the model.

The atrium appears largely to have featured walls with ochre-yellow middle zones situated over black dados, perhaps separated by a band of white decoration (Fig. 8.27).[54] It would seem that most of this decoration was always preserved best on the northern side and

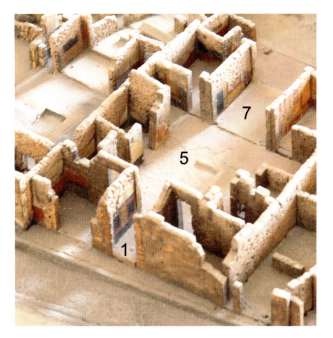

Figure 8.26. The decoration of the northern walls of the fauces (Room 1), atrium (Room 5) and tablinum (Room 7) of the Casa del Chirurgo as represented in the cork model in the Museo Archeologico Nazionale di Napoli (image © 2008 Jennifer F. Stephens and Arthur E. Stephens Su concessione del Ministero per i Beni e le Attività Culturali – Soprintendenza Speciale per i Beni Archeologici di Napoli e Pompei).

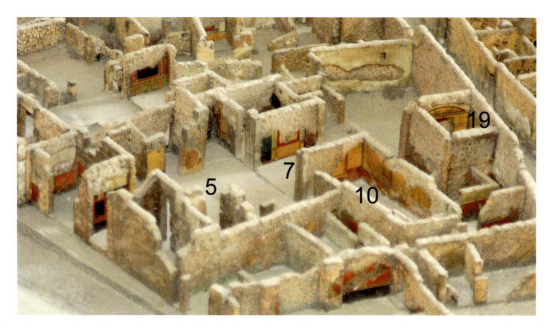

Figure 8.27. The decoration of the northern wall of the triclinium (Room 10) as represented in the cork model in the Museo Archeologico Nazionale di Napoli (image © 2008 Jennifer F. Stephens and Arthur E. Stephens Su concessione del Ministero per i Beni e le Attività Culturali – Soprintendenza Speciale per i Beni Archeologici di Napoli e Pompei).

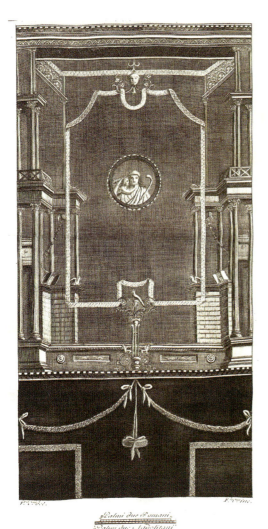

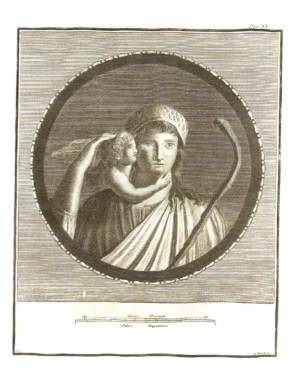

Figure 8.28. (*Left*) Atrium wall as recorded in *Pitture d'Ercolano* Vol. VII (V). Plate 81. 1779. (image courtesy of Heidelberg University Library: Digital Library).

Figure 8.29. (*Above right*) Detail of tondo in atrium as recorded in *Pitture d'Ercolano* Vol. VII (V). Plate 4. 1779. (image courtesy of Heidelberg University Library: Digital Library).

the south-west corner of the atrium, while much of the rest was not well-preserved at all. This situation is also reflected in the current surviving plaster, which though faded, remains only on these walls. In fact, the cork model seems to indicate areas of discoloration of this yellow ground on the walls towards the eastern end of the atrium that might indicate damage caused by the heat of pyroclastic surges during the eruption or perhaps even a fire. Certainly, the southern side of the property was much less well-preserved as a whole. If the attribution to the atrium of the find of a tondo of a woman with a green cap and cupid that is recorded in the *Pitture d'Ercolano* is correct,[55] then it would seem that the middle zones of the walls were also decorated with receding fantasy architectural arrangements in darker yellow that flanked the central panel, itself bordered by an elaborate tapestry border (Fig. 8.28). This find is mentioned specifically by the *PAH*, and the tondo was also recorded with a close-up engraving (Fig. 8.29).[56] Further details from these images indicate that the dado was also decorated with green garlands tied up with red ribbons,[57] flanked by smaller zones of red separated by tapestry borders.[58] Traces of tondi and

some of these details may be observed in incisions in the surviving plaster of the walls of the atrium.

Rooms adjoining the atrium were also generally finely appointed during the final phase. Room 6E today preserves very little of its surviving decoration, but the cork model indicates that the east wall (W06.010) was decorated with a low deep red or purple dado and a broad middle zone consisting of two major panels of white ground outlined with borders of red and yellow (Fig. 8.30). The *PPM* notes that the dado was decorated with plants and was divided into panels.[59] Though the treatment is cursory, the cork model suggests that these panels may have been separated by a narrow zone consisting of further red and yellow borders, candelabra, or fantasy architecture. The eastern wall (W06.014) of Room 6D appears in the cork model to have been decorated with a tall black dado and a bipartite middle zone of panels in white ground divided by yellow borders and decorated with internal tapestry patterns in yellow (Fig. 8.30). The fragment of this decoration recovered from the cisterns revealed that this design was actually a yellow ground behind a deep red border pattern (Figs. 8.6 and 8.31). The *PPM* notes that the

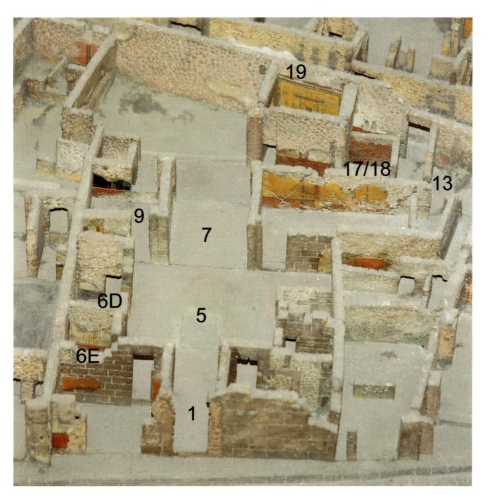

Figure 8.30. The decoration of the eastern walls of Rooms 6D, 6E, 9, 10, 19 and the service wing of the Casa del Chirurgo as represented in the cork model in the Museo Archeologico Nazionale di Napoli (image © 2008 Jennifer F. Stephens and Arthur E. Stephens Su concessione del Ministero per i Beni e le Attività Culturali – Soprintendenza Speciale per i Beni Archeologici di Napoli e Pompei).

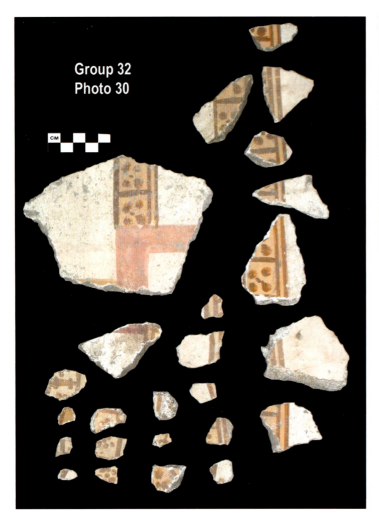

Figure 8.31. (*Left*) Tapestry border elements consisting of a dark red pattern of boxes with five dots (Barbet Type 50) on a yellow ground (image H. White).

Figure 8.32. (*Above right*) Group 74, a fragment of an arm on a white ground (image H. White).

socle was further decorated with lateral plants and a possible central medallion.[60] As was noted above, the *PAH* indicates that this room was further adorned with images of women or 'geniuses,'[61] which are probably to be thought of as figures 'floating' in the centres of the white-ground panels. An arm from a figure that might be one of these was recovered from the cisterns (Fig. 8.32).[62]

On the southern side of the atrium, Rooms 6B and 6C preserve few traces of their final phase decoration and even the cork model shows little by way of preserved plaster. As noted in Chapter 4, this is probably due to the collapse of the second stories on this side of the building during the eruption which would have served to bring down much of the wall plaster in these areas. The *PPP* notes traces of a simple red dado and white upper zone in both of these rooms, elements that survive primarily on the parts of the walls built in *opus quadratum* of Sarno stone blocks.[63] The cork model also indicates traces of a red dado in Room 6B, but on the western wall of 6C (W06.106) a dark, perhaps even

black dado appears with a single horizontal yellow band running through a middle zone in a white ground (Fig. 8.33). Neither the cork model nor the current walls of Room 6A preserve any traces of its decoration aside from the presence of a niche on the north wall which was plastered in white and does not preserve any further details. It seems likely that the function of this room had been downgraded or was in flux during the final phase.

The northern and southern alae of the house (Rooms 8 and 8A respectively), seem to have borne entirely diverse decoration in the final phase. According to the cork model, that of the southern ala (Room 8A), followed the pattern of the atrium, as elements of a black dado and yellow middle zone are clearly visible in the niche in the southern wall of this room (W06.023) (Fig. 8.34). Perhaps this decorative scheme was the result of the conversion of this space into a passageway giving access to the southern service wing corridor (Room 12). The northern ala (Room 8) on the other hand, was elaborately decorated with a black socle, and a middle

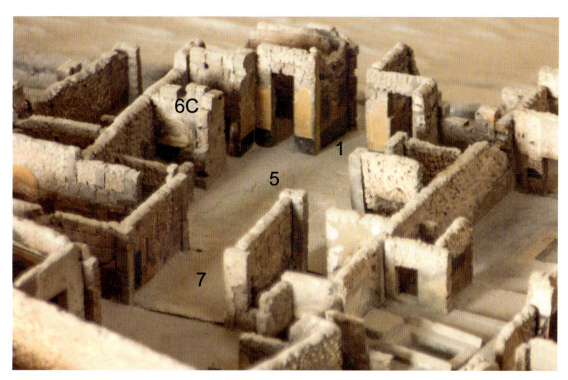

Figure 8.33. The decoration of the western wall of the Room 6C of the Casa del Chirurgo as represented in the cork model in the Museo Archeologico Nazionale di Napoli (image © 2008 Jennifer F. Stephens and Arthur E. Stephens Su concessione del Ministero per i Beni e le Attività Culturali - Soprintendenza Speciale per i Beni Archeologici di Napoli e Pompei).

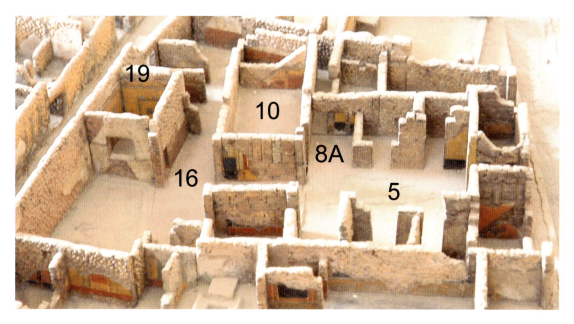

Figure 8.34. The decoration of the southern walls of the ala (Room 8A) and the oecus (Room 19) of the Casa del Chirurgo atrium as represented in the cork model in the Museo Archeologico Nazionale di Napoli (image © 2008 Jennifer F. Stephens and Arthur E. Stephens Su concessione del Ministero per i Beni e le Attività Culturali - Soprintendenza Speciale per i Beni Archeologici di Napoli e Pompei).

zone that was dominated by a large central panel in a yellow ground with a broad red border. Flanking this central panel were two smaller panels that the *PPM* and *PPP* note were green, but which might have been a dark green or even blue on the cork model (Fig. 8.27).

Above these panels, further small white panels might be interpreted as *durchblicke*. As was noted above, the central panels contained quadratti with mythological scenes that on the north wall (W06.018), contained a now lost image of Narcissus.[64] On this wall there are

traces of the outline of what appears to be a shield-shaped object suspended before a column at the edge of the left-hand side. Also surviving is a small amount of painted foliage and a suggestion of a yellow floral decoration along the dado.

The decoration of the tablinum (Room 7) has already been examined above in detail. That of Room 9, situated to the north of it, preserves sufficient traces to confirm the presence of a red dado and a black or possibly very dark blue middle zone (Fig. 8.30). The *PPM* notes that elements of a panther protome are visible in the dado on the western wall (W06.041) and that the walls were decorated with tapestry borders of inscribed palmettes.[65] If this room is indeed the one described by Ribau as that with the "fondo turchino," then it was from this room that two paintings were removed before Lo Manto could finish recording them in 1792. Unfortunately, no further details survive today to help with the assessment of this possibility.[66] To the south in the triclinium (Room 10), the cork model illustrates a red dado with walls of primarily yellow ground decoration in the middle zone, divided into three large panels separated by rectangular zones, equally in a yellow ground and flanked by borders or architectural elements in green (cf. Fig. 8.30). The *PPM* suggests that this upper zone has been discoloured and was actually also red, an observation which may be supported by apparent variation in the coloration visible in the cork model.[67] Garlands and tapestry borders still faintly visible in situ on some of the walls served to subdivide the dado into panels, the central of which were decorated with dolphins and aediculae possibly populated with central figures.[68] If, rather than the red middle zones suggested by the *PPM*, the yellow decoration visible in the cork model is accurate, then the elements of yellow panels penetrating the dado may represent podia for the support of red-coloured columns, at least on the northern wall (W06.082).

By far the most discussed element of the final decoration of the Casa del Chirurgo is that of the oecus (Room 19), which contained the famous panel of a woman painting a herm, and due to having been being covered eventually with a roof, presents the best-preserved elements of the house's decoration today. In addition to the evidence from the cork model, etchings of the rooms, decoration published in the *Pd'E* and in *Ornati*, permit a much more complete appreciation of its ultimate decoration (cf. Fig. 8.10, 8.30, 8.34). On the east wall (W06.063), a deep red or violet dado was punctuated by two yellow plinths supporting *durckblicke* and fantasy architectural constructions in the middle zone. The plinths themselves bear decorative motifs

and were flanked by garlands and sub-compartments with *gorgoneia*. Sitting above these plinths were two leopards and theatrical masks of miniature size, which are partially preserved today. The main zone in yellow was divided into three parts by the dark yellow aedicula, presenting three main zones of yellow ground. In the centre of those to the north and south was a tondo containing a head; that to the south was removed as mentioned in the addenda to the *PAH* discussed above.[69] The aedicula, decorated with acroterial dolphins and populated with figures, provides windows onto two symmetrical views of receding architectural spaces, separated from the central zone by twisted columns. In the centre, a square panel that has now been removed contained the image of the woman painting (cf. Fig. 1.10). A similar layout is found on the other walls of the room, that on the south substituting a single central plinth in the dado for the support of the central aedicula and overall presenting a much simpler layout. This dado bears the decoration of two marine monsters, while the main zone yet preserves traces of its central quadretto which appears to depict a poet and two female figures. The upper zone is filled with fantasy architecture populated by figures that have mainly disappeared, but presumably included the Bacchus mentioned by the original excavators.[70] At the top of the wall, the aedicula continued into the upper zone, contributing to a light fantasy architectural ensemble, which extends to the east and west above both side panels. A yellow ground lunette above this wall, surrounded on all sides by a stucco cyma, connected it to a false barrel vaulted ceiling above. Similar layouts must have been present on both the north and west walls of the room, but are very poorly preserved today and were not illustrated in earlier times.[71]

Much of the rest of the Casa del Chirurgo bore relatively simple, even utilitarian decoration. The walls of Room 21 were decorated with a red dado and white upper zone in a relatively fine plaster that is clearly visible in the remains adhering to the walls. Throughout the courtyard and the service wing (Rooms 11, 12, 13, 14, 16, 17, 18), the cork model depicts a similar red dado and white upper zone that, given the surviving evidence in the house, should be taken as the high dado in *opus signinum* and white upper zone of a highly functional nature (Fig. 8.30). Such decoration would be appropriate for rooms whose main function was service rather than entertaining or living. Though no evidence of this form of decoration seems to have been recovered in Rooms 22 and 23, it may be supposed that it was also present in these locations. In the kitchen, Piranesi recorded elements of a painted lararium, flanked by

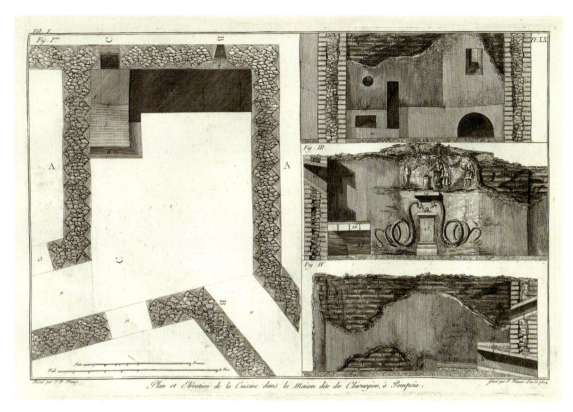

Figure 8.35. Piranesi's engraving of the kitchen of the Casa del Chirurgo (image Piranesi 1804. Plate XX. Courtesy of Heidelberg University Library: Digital Library).

two snakes that has now disappeared entirely (Fig. 8.35). In the hortus itself (Room 20), a thick layer of white plaster surviving on the walls is reflected in the cork model by traces of white plaster without dado or further elaboration. A high *opus signinum* dado and white upper zone similar to that in the service areas of

Group 51
Photo 50

Figure 8.36. Yellow ground fragments (Group 51) with decorative elements that include a face (image H. White).

the house was also seen appropriate for the decoration of the shop in Room 2. While the shop in Rooms 3 and 4 preserves no evidence of its decoration, it presumably would have borne a similar functional scheme.

Given the overall prevalence of yellow in the decoration of the rooms of the Casa del Chirurgo, as corroborated by numerous sources, it is perhaps surprising that the plaster from the cisterns produced so few examples of this colour. The sole noteworthy elements on a yellow ground[72] consist of five small fragments:

1. a fragment bearing the corner of a purple/blue frame for a panel image (Group 6);
2. a fragment (possibly from the same wall since it shares a similar impressionistic style and colouring) that portrays a bird's foot in a brown/purple hue (Group 14);
3. a group containing some yellow decoration and a face (Group 51) (Fig. 8.36);
4. a fragment with a tiny white frame and possibly a white garment (Group 54); and
5. a fragment containing a yellow border around the beginnings of a white panel (Group 56).

Since it is certain that the cutting of panels from some of these yellow walls occurred, and would presumably

have created some elements to be discarded, the general absence of yellow background amongst the cistern finds may attest to a selection process that operated on this deposit. It may also mean that the majority of the fragments within the cistern come from a moment before such cutting took place, such as during the primary excavation itself.

Summary

The painted walls of the Casa del Chirurgo caused much excitement at the time of its discovery. It is therefore a great shame that its decorative scheme has for the most part crumbled and faded today. Uncovering tantalising clues as to the former glory of this house's walls in the fragments recovered from the cisterns has been a great privilege, but also a frustrating experience, for many of the questions raised by these pieces remain unanswerable. While the house's full decoration at the time of the eruption will never be completely reconstructed, the combination of data available: the original excavation records; the cork model in the Museo Archeologico Nazionale in Naples; and particularly, the trove of plaster disposed of in a cistern and recovered by our excavations in 2004, provide a valuable window onto much of the lost grandeur of this property as it stood shortly after its owner had commissioned work in the early Fourth Style. Moreover, while some records are clearly only partially accurate, the overall reliability and accuracy of the PAH, the Pd'E, Ornati, and the cork model have been confirmed by this research.

The plaster fragments recovered in our excavation have provided greater resolution on the original decoration of, in particular, the tablinum, the atrium, and Room 6D, where the matching embroidery pattern served to encourage the investigation of likely locations for the hoard of fragments and the reconstruction of the decoration of the house as a whole. A number of recurring features across several of the rooms have been identified, most notably: complex and elaborate architectural designs; repeated decorative elements such as theatre masks; and a predominance of yellow amongst the decorated rooms of the house. The principal group reconstructed from these fragments accords with this overall scheme and was clearly part of a single, coordinated decorative plan undertaken for the whole house.

The plaster fragments also attest to the high quality of this programme of decoration, which includes the panel with the female painter from Room 19, greatly

admired since its removal in the eighteenth century. They also provide a rare window onto early excavation practices in process. Accounts from the eighteenth and nineteenth centuries (along with chiselled lacunae in the oecus) highlight that removal was the fate of much of the decorative plaster in this house, perhaps leading to the ultimate condemnation of the overall value of the walls by Mazois in 1824 and Overbeck in 1875.[73] As visible chiselling marks on some of the excavated fragments attest, many of these pieces ironically have come to survive better as the result of failed attempts at removal than the plaster that remained on the walls. In this sense they may represent a selection of the very best of what the Casa del Chirurgo had to offer, surviving as those desirable elements that did not endure the process of removal and ended up as broken and discarded fragments.

This collection of vivid and high-quality fragments shows that the walls of the Casa del Chirurgo were justifiably viewed as striking and not just because they were a novelty from a particularly early discovery at Pompeii. At the very least, the fragments and the reconstructions they have provoked demonstrate that the decoration of this house can be counted alongside many other finely decorated houses of Pompeii's final years.

Notes

1 The author would like to acknowledge Rick Jones, Carrie Sulosky-Weaver, and Michael Anderson for their collaboration with this study.
2 One of only two rooms in the house ever to have received protective roofing post-excavation.
3 Cf. Tascone 1879; also David 1997.
4 *Ornati*, I 36; Helbig 1459 NAP Inv. No. 9018; Schefold 1957, 92.
5 *PAH* I, 2, Addenda II, 172–173 (23rd November 1792); *PAH* I, 2, Addenda IV, 156.
6 In total roughly 90 groups (of varying sizes, some spread across more than one finds tray) are in finds storage at Pompeii. Further groupings were configured during the piecing together of those elements that derive from a single wall. This included sorting by background colour and by common elements e.g. faces, columns, foliage, etc. This numbering was solely for cataloguing purposes on site and should be understood to offer no qualitative or hierarchical indication. A full catalogue of the groups will be included in the forthcoming digital archive for the property.
7 E.g. group 79 includes a very finely painted head of a man crowned with a green garland.
8 Discussed later in this chapter, this includes features such as the embroidery pattern of a square and five dots and the fragment with a torch-like candelabra reflected in Piranesi's engravings.
9 E.g. group 5, the foliate column/wall fragments, discussed below. Groups 41–45 bear various foliage images.

10 E.g. groups 17, 85 and 87: architectural features such as roofs/fences/columns; and groups 4, 28 and 49: border patterns.

11 E.g. group 20 which consists of two fragments both with a dark blue background with what appears to be either a wing or a garment rendered in purple and yellow; and group 27 has part of a flowing garment and a small lion's head.

12 Sadly, little attention can profitably be given to this last group, beyond that of basic cataloguing.

13 Parslow 1995, 207–206.

14 *Ornati*, I 36; Helbig 1459 NAP Inv. No. 9018; Schefold 1957, 92.

15 This is likely one of the *tondi* mentioned in the *PAH* I, 2, Addenda II, 172–173 (23rd November 1792), since the same account mentions the female painter panel from Room 19.

16 Beyond these two images any other detail is barely visible. The cork model gives some suggestion of intricate and finely detailed walls, their interlacing columns, figures, arabesques, *quadrati* and *tondi*. This is confirmed by drawings of these walls published in *Ornati*, I 36 and *Pd'E* 1779 (Vol. V) Tav. 1, 5; 82, 365.

17 *PAH* I, 2, 73.

18 Barbet Type 50 (Barbet 1981, 961).

19 No laboratory analysis has been carried out to confirm the link between the fragments and the in situ plaster, which has been established simply by visual matching.

20 Piranesi (1804, Pl. XVI) replaces the *tondi* depicted by Hamilton (1777, Pl. VIII, IX, and X) in the atrium with square panels (Cf. also Eristov 1994). Outline traces of *tondi* and some very faint embroidery patterning are extant on the atrium walls. Furthermore, the torch-like candelabra pattern is red on a white background and the walls of the atrium were most likely to have been yellow, according to the cork model.

21 *Pd'E* 1779 (Vol. V) Tav. 1, 5; 82, 365.

22 Another mask fragment exists (group 75) but it is not from this ensemble. It is larger and the form is very coarse, almost clumsy in execution. The masks in from the main group bear greater resemblance to the surviving mask in Room 19 (oecus).

23 For example, groups 85–89 include similar architectural elements. Group 89 also includes two columns similar to those in group 79 but there is no evidence supporting a definitive match. Group 89 also bears evidence of the same coursed masonry as group 5.

24 For example, groups 26, 45 and 80; the foliate column (group 5).

25 *Pd'E* 1779 (Vol. V) Tav. 1, 5; 4, 23; 81, 361; 82, 365.

26 Group 57, cf. infra.

27 Group 79 also has some pale green and white framing or ground. It is possible that these elements derive from the interior of the architectural scheme, although no physical link serves to connect them. Regrettably no further figures were found beyond these groups.

28 The lower parts of the walls must have been similar to that documented in Room 19.

29 Roofs collapsing during the eruption of Vesuvius would have taken the tops of the plastered walls with them. The resulting tops of the decorative plaster remaining on the walls would likely have been unstable and easily loosened or lost when the site was discovered and a lot of these fragments may have been lost or discarded during excavation. The cork model shows that there was very little plaster remaining on the top third of the walls in the Casa del Chirurgo in the 1860s. Only the upper zones of the walls of Room 19 (oecus) seem to have escaped relatively unscathed.

30 Several groups (for example 22, 28) consist of frames with no centres. An elaborately patterned group (64) bears stylised yellow-gold theatre masks in the corners of the frames. There are also several blocks of colour, some with simple frames, which may have surrounded central panels which have since been removed/lost. Group 4 is unusual in that it is a mostly complete thin red frame with a central plain white panel.

31 Cf. Tascone 1879; also David 1997.

32 We do not have sufficient fragments for both walls and this raises the question as to where the equivalents from the other wall may have ended up, whether still buried, lost in early excavations, or disappeared into various untraceable private collections. We do have, however, a group (90) which has the same panelled ceiling scheme but wrought in a pink hue.

33 No fragments of plain yellow within the plaster fragments were recovered that could have filled the lacunae evident in the main zones of the tablinum walls.

34 '*Nelle notte passata di giovedi a venerdi, in vicinanza della Porta della città, hanno tagliate (nella case detta del Chirurgo) quattro pitture, cioè: Nella stanza, dove si tagliò un quadro che rappresentava un pittore nell'atto di prendere a ritratto un idolo, una testa. Nel cortile contiguo a questo casamento, e propriamente nel tablino, una quaglia. Finalmente nell'ultimo cortile, nella stanza col fondo turchino, e propriamente dove il disegnatore Lo Manto non potè finire il disegno, una delle Baccanti, ed una testa. Il tutto è statto fatto con arte, e portato via. La notte è stata orrida, si per l'acqua che per lo vento.*' PAH I, 2, Addenda II, 172–173 (23rd November 1792).

35 There are many examples of panels containing still lives of single birds in the collections of the Museo Archeologico Nazionale di Napoli. This subject was clearly an attractive target for removal from walls.

36 The night-time and stormy conditions accompanying the removal of these panels may have contributed to accidental breakage. A number of fragments bear similar chisel-like marks, suggesting that several are the result of similar activities. In many cases, it appears that the central image was successfully removed, while the framing material which broke away at the same time was discarded.

37 Similar engaged pilasters flanked the eastern side of the fauces (Room 1).

38 Group 64.

39 Group 3.

40 Group 57.

41 Group 54 does consist of a fragment of yellow ground with a white border, but this is followed by further white elements right inside the border, clearly disqualifying it as a component of this wall.

42 Group 72.

43 This figure is markedly larger than the only surviving head from the fragments (group 79).

44 *Pd'E* 1779 (Vol. V) Tav. 68, 305.

45 Group 8.

46 *PAH* I, 1, 255 (16 May 1771) "*Si è evacuata una stanza dell'abitazione dentro della città, cioè del Chirurgo, della quale resta il zoccolo dipinto in campo nero con alcuni riquadri ed arabeschi, e con sette figure alcune di donne ed altre di Genj molto logore. Tra gli oggetti ivi trovati vi erano due pezzi de vetro dipinti, con dell'oro.*" It is possible that group 74 came from here (note 15 above).

47 Overbeck 1875, 245. "*Gemäldeschmuck hat dieses Haus nicht aufzuweisen; ein jetzt fast ganz zerstörtes Brustbild des Paris*

mit Eros in rundem Rahmen links in Atrium und ein Bild des epheubekranzten Bakchos daselbst sind ganz unbedeutend, interessant ist ein nicht sicher gedeutetes Bild in dem Triclinium 19; dasselbe (Hlb. No. 1459.) stellt einen Mann mit einem geöffneten Diptychon (einem Dichter?) und zwei mit ihm im Gespräche begriffene Mädchen dar; diesem Bilde entsprach die jetzt im Museum in Neapel befindliche Darstellung einer Malerin in ihrem Atelier (Hlb. No. 1443)."

48 Cf. Note 34 above. The passage leaves it unclear as to whether Lo Manto was drawing a bacchante on that night as part of the programme of recording paintings. It seems he was unable to finish his drawing because of the weather. Lo Manto's drawings may survive in the archives of the Museo Archeologica Nazionale di Napoli but it has not yet been possible to ascertain this.

49 *PAH* I, 2, Addenda II, 172–173 (23rd November 1792). The cork model attests to this. There is some pigment on the walls of Room 8 but it is no longer evident on the walls of the tablinum.

50 There are also traces of Fourth Style painted foliage in the lower third of wall W06.019, cf. *PPP* II, 112.

51 *PPM* IV (1993), 63.

52 *Pace PPM* IV (1993), 55 where a red dado was identified.

53 Cf. Ling 1991, 75.

54 *Pace PPM* IV (1993), 58 where these are reconstructed as red. Faint races of yellow pigment survives over the largely pink/faded red of the extant plaster in the atrium, as in the tablinum.

55 *Pd'E* 1779 (Vol. V) Tav. 81, 361.

56 *Pd'E* 1779 (Vol. V) Tav. 4, 25.

57 Cf. Group 43 which includes green garlands tied with red ribbon.

58 E.g. Groups 9 and 48.

59 *PPM* IV (1993), 83.

60 *PPM* IV (1993), 83.

61 Cf. note 64.

62 Group 74 the arm ends in a hand which holds a wand. There is another example of a border of squares with 5 dots, Group 31, which is green. The yellow-backed fragment has been selected as a match because the cork model bears touches of yellow on the north wall of room 6D (W13) at the point where this may be matched to the extant patterning on the wall of the house. Within this group are some red frames that the embroidery pattern crosses, suggesting a limited decorative scheme on this wall. It would seem that the embroidery pattern framed large central white panels, which likely contained floating figural images. Group 74's arm against a white background represent a possible candidate for such a figure.

63 *PPM* IV (1993), 81.

64 *PPP* II, 112; *PPM* IV (1993), 63.

65 *PPM* IV (1993), 65.

66 Fragments from groups 10, 12, 13, and 84 do contain a dark blue ground and might derive from this removal.

67 *PPM* IV (1993), 69.

68 *PPM* IV (1993), 69.

69 Cf. Note 34.

70 *PPM* IV (1993), 77 and *PAH* I, 1, 259.

71 Amongst the fragments from the cistern hoard are similar stucco cyma elements to those extant in the oecus – group 73. It is impossible to ascertain where these were originally sited but they represent a further suggestion as to schematic decoration across certain of the rooms.

72 Other fragments include yellow elements: yellow framing, yellow architecture/roofing (groups 40 and 68, which included fragments of red ground with touches of yellow ground at the edges – it is possible that these may belong to a single large group), and yellow embroidery patterns, though most of these groups include a small number of fragments.

73 Mazois 1824 (Vol 2), 51; Overbeck 1875, 245.

9

PAVEMENTS OF MORTAR, MOSAIC, AND MARBLE INLAY[1]

Will Wootton

Introduction

In his brief review of the Casa del Chirurgo, Erich Pernice saw little of interest in the house's pavements except for the tessellated mosaic in Room 8.[2] This, however, does not do justice to the intricacy of the floors and their value for understanding the changing decorative priorities of the owners. This chapter will characterise the pavement types deployed and investigate their production history.[3] In particular, the decorative forms will be explored in order to expose the original, intended look of the pavements and their place in the phasing of the property. The manufacture of the floors will also be assessed, with special regard to the materials employed and the surviving evidence for specific working practices. Finally these data will be used to consider the significance and function of the decoration in individual rooms, across the house, and over time.

Pavement typology and decoration

On a basic level, the various types of pavement found in the Casa del Chirurgo can be characterised by the nature and decoration of their surfaces: mortar with an aggregate of terracotta or so-called *opus signinum*,[4] mortar with an aggregate of stone,[5] tessellated mosaic,[6] irregular pieces of stone,[7] and *opus sectile*.[8] Of course assigning the floors to such broad types does not account for their individual complexity, especially the subtle differences in the combination of materials and techniques. In this section, the typology will be

described in order to expose the range of decorative options used in the house over the course of around 150 years.

The most common floor, found in some thirteen rooms, is made completely, or in part, of *opus signinum* (Fig. 9.1).[9] These pavements are characterised by a lime mortar binder with a high quantity of terracotta forming part of the aggregate, combined to produced a flat surface which is predominantly pink to red in colour. Six of these floors – Rooms 12, 14, 16, 21, 22, 23 – are formed only of this flooring type and belong to the first century AD. They are made up of crushed terracotta, black volcanic stone, and basalt in similar or slightly different ratios (Figs. 9.2 and 9.3). These pavements are highly functional as they are hard-wearing and waterproof. Their mottled red and black surfaces are not unattractive. Polishing and further colour, added in the form of a fine red stucco, may have enhanced their decorative quality. These *opus signinum* floors paved the eastern part of the house; the southern rooms belonged to service areas (12, 14, 22, 23). To the north, a similar pavement was used in Room 21 (Figs. 9.4 and 9.5), identified as a cubiculum, and in Room 16 (Figs. 9.6, 9.7 and 9.8), which formed the interface between the tablinum (Room 7), the garden and the so-called oecus (19) to the south.

The atrium (Room 5) and most of the rooms around it (6B, 6C, 6D, 6E) were paved with some form of *opus signinum* (cf. Fig. 5.5.23). Room 6C seems to have been a simple floor of this type (cf. Fig. 5.8.20).[10] Room 6E had an *opus signinum* floor with white limestone and occasional grey-black stone scattered through the

Figure 9.1. Room 15. *Opus signinum* surface (image W. Wootton).

Figure 9.2. Room 12. *Opus signinum* surface (image W. Wootton).

Figure 9.3. Room 14. *Opus signinum* surface (image W. Wootton).

Figure 9.4. Room 21. *Opus signinum* surface (image W. Wootton).

Figure 9.5. Overview of flooring in Room 21 (image AAPP).

Figure 9.6. Room 16. *Opus signinum* surface (image W. Wootton).

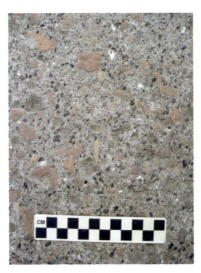

Figure 9.7. Room 16. *Opus signinum* surface (image W. Wootton).

Figure 9.8. Overview of flooring in Room 16 (image AAPP).

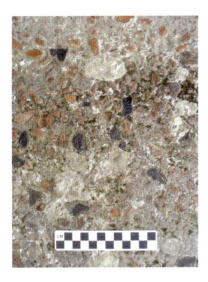

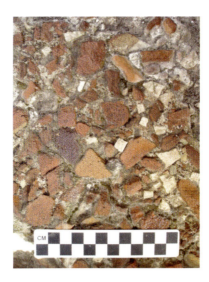

Figure 9.9. (*Left*) Room 6E. *Opus signinum* surface (image W. Wootton).

Figure 9.10. (*Right*) Room 6D. *Opus signinum* surface (image W. Wootton).

surface (Fig. 9.9).[11] Room 6B had a greater quantity of stone in its surface, which dominates the appearance, and evenly-spread large pieces of terracotta. Likewise Room 6D has larger pieces of ceramic forming its surface, but there are, in addition, white limestone tesserae distributed irregularly amongst the upper elements (Fig. 9.10). The atrium pavement (Room 5) also includes tesserae as part of its *opus signinum* surface alongside chips of white limestone and grey-black stone as well as occasional irregular pieces of pink, green, and yellow stone, the same as those in Rooms 1, 8, and 10.[12]

Turning first to Room 1 (fauces), coloured stones make up both the surface and aggregate of the pavement (Figs. 9.11, 9.12 and 9.13). This flooring is quite different from those in *opus signinum*, however, and is better described as a mortar floor.[13] There is very little crushed terracotta and black volcanic stone, instead the lime mortar has been mixed with

an aggregate made up of pieces of white limestone and other coloured stones which results in an attractive and colourful decorative effect. The atrium and fauces are separated by a simple, spaced serrated fillet in alternating black and white tesserae.[14] This line is inscribed in the *opus signinum* of the atrium floor and marks the interface between the two. Room 9, which is connected to the atrium via a doorway, has a mortar floor similar to Room 1. Like the fauces, the whiteness of the lime mortar is a significant component in the overall visual impact of the floor. Room 9, however, does not include coloured stones in its aggregate, instead having a surface made up of pieces of white limestone and grey slate (Figs. 9.14 and 9.15).[15] This gives the floor a more muted colouristic quality.

Physically connected to the atrium are two further rooms which display the only examples of tessellation in the house. The tablinum (Room 7) is the simpler of

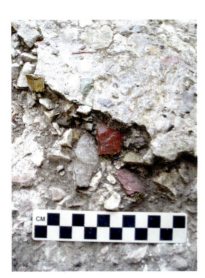

Figure 9.11. Room 1. *Opus signinum* bedding (image W. Wootton).

Figure 9.12. Room 1. *Opus signinum* surface (image W. Wootton).

Figure 9.13. Room 1. *Opus signinum* surface (image W. Wootton).

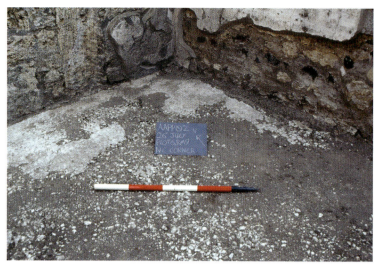

Figure 9.14. (*Left*) Room 9. *Opus signinum* surface (image W. Wootton). **Figure 9.15.** (*Right*) Overview of flooring in Room 9, south-east corner (image AAPP).

the two, although this may be due to its poor state of preservation (cf. Fig. 5.11.11).[16] Areas of tessellated mosaic survive only at the edges of the room (Fig. 9.16), revealing a pavement made up of an adjusting border – the area between the wall and the first decorative frame – of obliquely-laid white tesserae (Fig. 9.17), then three rows of white forming the frame to a black monochrome band, four tesserae wide, then three further rows of white followed by another black band also four tesserae wide.[17] There are then a further three rows of white as an outline and finally the inner field made up of white tesserae laid obliquely (Fig. 9.17, cf. Fig. 4.31).[18] A number of similar floors can be found in Regio VI, whether in the neighbouring Casa delle Vestali or further away such as the Casa di Inaco e Io.[19]

The other tessellated pavement comes from Room 8 (Figs. 9.18, 9.19, 9.20, 9.21, 9.22, and 9.23), which is also connected to the atrium and communicates with Room 6D. Across the wide entrance is a threshold surrounded on either side by white tesserae running horizontally to the walls. The threshold design is framed by a black

band, four tesserae wide, and followed by a white band which is three tesserae wide. Inside of this, there is another rectangular black frame, four tesserae wide, and then a serrated fillet of poised squares of four tesserae each which runs around the five panels.[20] Each square is further defined by a black frame, two tesserae wide, and then an interior field of white tesserae laid to follow the frame and surround the geometric motif at the centre (Fig. 9.18, 9.19 and 9.21). Moving from left to right – if looking from the entrance – the first panel has a square frame, made up of two rows of black tesserae, around two black ivy leaves, their tips pointing diagonally into the central area of the room, each connected to a thicker branch by a curling stem. The outer frame of the subsequent panel is formed of a band of zig-zag pattern around a square inscribed with a cross. The cross is damaged but enough survives to indicate that the arms were made up of a simple serrated fillet with squares of four tesserae at each end.

The panel in the centre is much damaged. Only the black frame survives but the laying of the surviving white

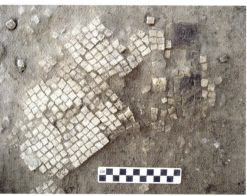

Figure 9.16. (*Left*) Room 7. Bedding of tesssellated surface as preserved in the side wall under later plaster (image W. Wootton).

Figure 9.17. (*Right*) Room 7. Tessellated surface (image W. Wootton).

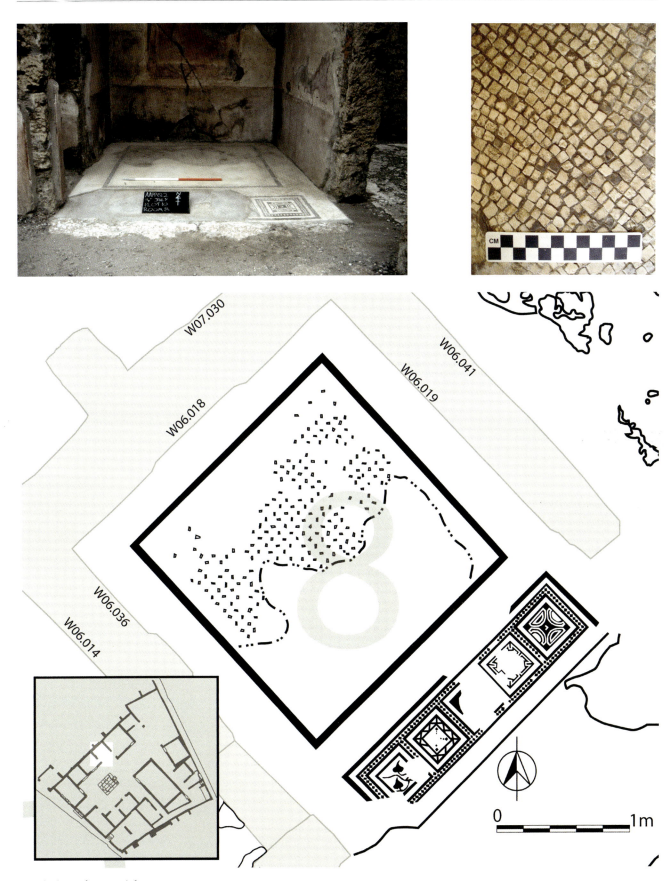

Anticlockwise from top left:
Figure 9.18. Overview of flooring in Room 8 (image AAPP); **Figure 9.19.** Room 8. Rectified plan after Pernice (image M. A. Anderson);
Figure 9.20. Room 8. Tesssellated surface (detail) (image W. Wootton).

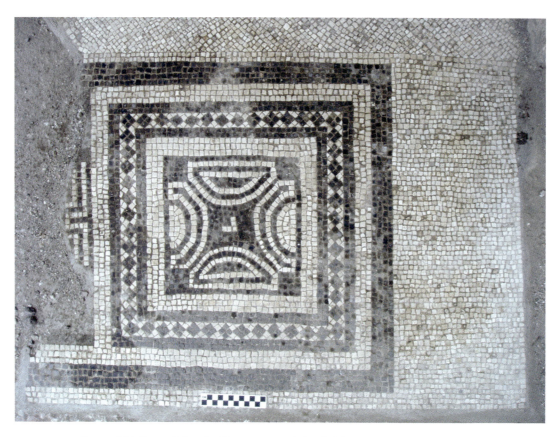

Figure 9.21. Room 8. Detail of best preserved threshold square (image W. Wootton).

background tesserae suggests a circular composition. The central area of the next panel is also mostly lost. A single row of black tesserae delineates a square frame which has short black fillets, at each corner and in the middle of each side, running diagonally towards the centre.[21] A single black fillet runs around the inside of these short lines creating a stepped band of decoration. This pattern enclosed further decoration, either a circle or quadrilateral. Although unusual, the design looks like the representations of wall circuits with towers positioned at regular intervals facing in towards the middle.[22] Such designs are often combined with labyrinths, but the remaining space is too small for even the simplest type.

The final panel also seems architectural in form. A single row of black tesserae forms the frame containing an inscribed black concave square with four spindles ending in squares at each corner. The four remaining semi-circular spaces are decorated with curving black fillets on either side and then segments of circles above and below. In the centre is a reversed L-shape. There are no comparanda for this design. The semi-circles give

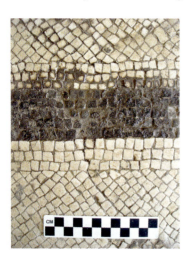

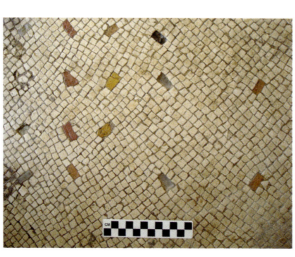

Figure 9.22. (Left) Room 8. Black band decoration (image W. Wootton).

Figure 9.23. (Right) Room 8. Coloured semis in the tessellated floor (image W. Wootton).

the sense of three-dimensional form, the differences between them suggesting a dome with a tunnel. It is not apparent, however, whether there was an intention to reference a particular structural form. Furthermore the central backward L is enigmatic.[23] This might have helped the ancient viewer to make sense of the design or could be some sort of personal mark of the maker.

The threshold design is highly unusual. The Casa degli Epigrammi contains the only comparable example.[24] It has the same serrated fillet of poised squares and similar designs, including a cross and an ivy leaf at the centre of the square panels, and a crenelated border motif.[25] The threshold in Room 8 appears to be a one-off, perhaps part of a special design for the patron or completed by a craftsperson working flexibly with the repertoire.

There is a clear white line, two tesserae wide, that runs above the long threshold panel and separates it from the obliquely-laid white tesserae of the rest of the mosaic. These tesserae run up to the edges of the wall and meet a black band, five tesserae wide, with three rows of white tesserae on either side (Fig. 9.22). This demarcates an inner field, also made up of white tesserae laid obliquely. The laying of the tesserae and the double black band is similar to the technique and framing in Room 7 and can be compared to examples from Regio VI.[26] In this case, however, the field is decorated with a semis of coloured oblong tesserae set obliquely in opposed rows forming a zigzag pattern.[27] The semis consists of the same four colours as the materials found in the atrium and fauces: grey-black stone, green, pink, and yellow limestones (Fig. 9.23).

The frames of the threshold and the main decorative field do not align. This fact, the difference in decoration and laying, as well as the lack of colour in the threshold, indicates their separate date of production; the

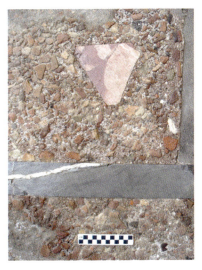

Figure 9.24. (*Left*) Room 10. *Opus signinum* surface (image W. Wootton).

Figure 9.25. (*Right*) Room 10. Inset band and coloured stone (image W. Wootton).

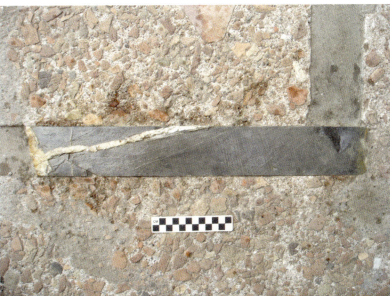

Figure 9.26. Room 10. Inset band and coloured stone (image W. Wootton).

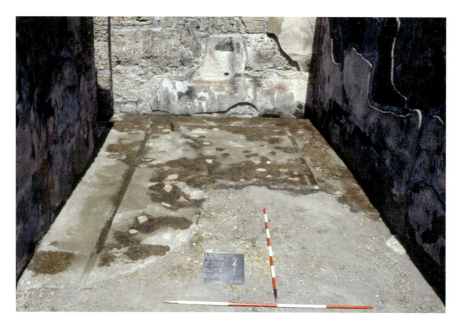

Figure 9.27. Overview of flooring in Room 10 (image AAPP).

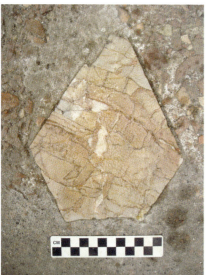 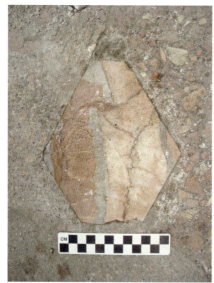

Figures 9.28–29. Room 10. Detail of coloured inset stones (image W. Wootton).

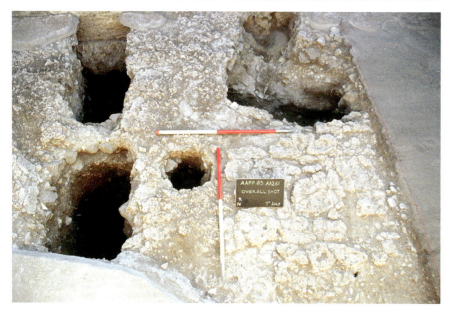

Figure 9.30. Traces of the central panel mortar in Room 10 during excavation (image AAPP).

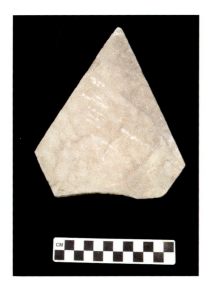
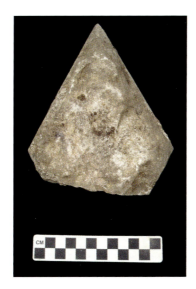
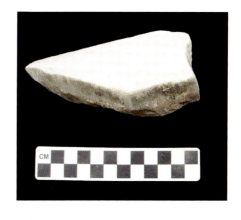

Left to right:

Figures 9.31–9.33. Room 10. Details of coloured inset stones (image W. Wootton).

threshold is later.[28] The seam that runs between the two patterns of laying, oblique and orthogonal, supports this distinction. Although the white tesserae in Rooms 7 and 8 are similar in size, those in Room 8 are slightly smaller.[29] The tesserae are the same size and material as those found scattered through the *opus signinum* floors in and around the atrium (Rooms 5, 6D, 10).

The pavement in Room 10 has occasional white tesserae and large coloured stones in the surface of the *opus signinum* (Figs. 9.24 and 9.25).[30] The complete decoration is as follows. Away from the wall, a dark grey frame of slate followed the edge of the room (Fig. 9.26). Inside of this border, large pieces of coloured stone, cut to specific shapes, were distributed at intervals across the surface (Figs. 9.27, 9.28 and 9.29).[31] Towards the south-east end of the room, a central panel in *opus sectile* was positioned (Fig. 9.30). The mortar survives retaining the deep triangular impressions of the undersides of the pieces. Polychrome stones with matching pyramidal bottoms were found in a circular deposit nearby (Figs. 9.31, 9.32 and 9.33). The final flooring type is found in Room 19, next to the garden. The pavement is made up of medium-sized irregular pieces of blue-black slate with bright white limestone, probably *palombino* (Fig. 9.34).[32] They are distributed randomly but are tightly packed so as to keep the interstices small.[33] It bears some similarities to Room 6E in terms of materials but the close laying and total surface coverage is indicative of a different technique and much greater investment.

Production phases

The pavements of the house have been associated with the Second (so-called Architectural) Style with some later interventions.[34] The phases of decoration, however, are more complicated than has been previously acknowledged. Although all the surviving pavements belong to the first century BC and first century AD, they can be associated with three major phases of building activity. The first belongs in the early first century BC, perhaps around 80 BC, and is part of the Second Style; it was short and well defined. A second in the later first century BC lasted longer, probably taking place between the 40s and 10s, perhaps even a bit later. It, therefore, conforms to the late Second Style and the early Third (so-called Augustan) Style. There is further activity after the mid-first century AD within the Fourth (so-called Intricate) Style of decoration.

The key pavements that survive from the earliest phase are those in Rooms 1, 8, 9 and 19, and perhaps Rooms 6B and 6E. In terms of surface decoration, Room 19 is the only example of its type within the house. Room 6E has some decorative similarities which might indicate a close date of manufacture. Room 19 can be compared to other early floors of irregular stones, such as those from the highest status houses in Pompeii and the surrounding area.[35] This pavement must have carried significant value within the Casa del Chirurgo. The careful laying and high-quality black and white materials produced a solid, hard wearing floor which was attractive and impressive in its decorative simplicity (Fig. 9.34). These aspects retained their desirability in the long term as the pavement was kept during a series of changes to the room's wall decoration, relating to the Third and Fourth Styles, and alterations to the flooring in the rest of the property.

The mosaic in Room 8 also belongs to this phase but has a much wider colour palette. Its date is confirmed by the setting of the tesserae, in particular the obliquely-

Figure 9.34. Room 19. Detail of floor surface (image W. Wootton).

laid adjusting border, and the interior decoration with oblong coloured stones set in a serrated pattern. Comparanda are usually dated to the Second Style and have the same combination of oblique laying with two black bands forming the frame.[36] Although later pavements have the same framing device, the tesserae of the adjusting border run parallel to the walls.[37] The coloured stones, all of which are limestones, clay marls, or slate, fit well with the earlier date before the use of marbles increases in the latter part of the century.[38]

The carefully-cut coloured stones are the same as those that appear in Room 1, at the entrance to the property, and in Room 9. In both cases, however, the stone used is irregular in shape and forms part of an aggregate which makes up the upper surface of the mortar floors. In all three pavements, the stones are employed to create different visual effects: one ordered, the other two more random and colourful. Rooms 6B and 6E, located off the atrium, probably belong to this phase as well. Room 6E contains large pieces of white limestone and black stone, perhaps slate, similar to those in Room 19, laid to form a *crustae* floor. Room 6B's floor also has more in common with the earlier floors in terms of its materials and overall decorative effect (Fig. 9.35). Neither of these floors have any tesserae inserted randomly in to their surface. This is significant in terms of the phasing, because all the *opus signinum* pavements of the next phase do.

The subsequent decorative phase belongs later in the first century BC and the renovations may have taken place over a longer period of time, perhaps a few decades even. These works involved the creation

of a new mosaic floor (Room 7), the remodelling of an old one (Room 8), and the laying of a series of new *opus signinum* pavements (Rooms 5, 6D, 10). The new mosaic in the tablinum (Room 7) recalls closely the composition, materials, and laying found in Room 8. The slightly larger tesserae and lower density in Room 7 support a later date but such criteria are not entirely reliable. Interestingly, one might expect, if Augustan, that the pavement would be laid in a different manner with the tesserae parallel to the walls. When considered with the other pavements of this phase, however, it seems that an older decorative style was purposefully evoked in Room 7 with the makers intentionally mimicking the earlier laying methods used in Room 8.

This makes sense of the decoration in the three other rooms of this phase (Rooms 5, 6D, 10). All of them have floors of *opus signinum* which contain fragments of the same coloured stones found in the earlier phases and, in addition, occasional tesserae set irregularly in their surfaces. In the atrium (Room 5), these stones would have been visible and colourful, recalling older, more traditional types of flooring (Fig. 9.36). This update would have fitted aesthetically with the fauces (Room 1), the intersection between the two indicating that Room 5 is a later addition; where they meet, the *opus signinum* of the atrium overlaps the mortar flooring of Room 1 (Fig. 9.37). At the same time tesserae were set in a line to mark the interface and designate the transition from fauces to atrium. Visual indicators demarcating space are common in Pompeian pavements of the later first century BC.

The materials used in Room 6D are very similar to those in Room 5. The floor in 6D may have been laid to create a new antechamber for Room 8, whose mosaic was also renovated during this phase. In Room 8, a new threshold area was inserted with a decorated black and white mosaic (cf. Figs. 9.18, 9.19 and 9.21). This addition may have taken place some time after the decoration of Room 7. For whatever reasons, it was decided not to follow the established pattern of laying but, instead, to set the tesserae, which surround the panel, parallel to the walls. This might indicate a date in the late first century BC, perhaps even the early first century AD.[39] The earlier date seems more likely because the tesserae of all the mosaics have a similar size and density.

The *opus signinum* flooring in Room 10 has the same materials as the other rooms of this phase (Rooms 5 and 6D). The inclusion of coloured stones and individual tesserae are indicative of coeval construction. The overall decorative effect of the pavement, however, is quite different. It consists of a slate frame which encloses a field with pieces of *portasanta* set in to the

Figure 9.35. Room 6B. *Opus signinum* surface (image W. Wootton).

Figure 9.36. Room 5. *Opus signinum* surface (image W. Wootton).

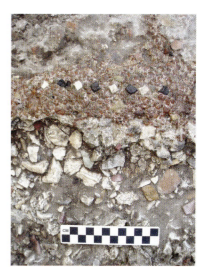

Figure 9.37. Line of tesserae dividing Room 5 from Room 1 and the bedding of the *opus signinum* surface (image W. Wootton).

opus signinum and, further in, an *opus sectile* panel made up of marble and other stone pieces. The appearance of Chian *portasanta*, and perhaps other marbles, might indicate a later date for the floor or, at least, those elements of the decoration (Fig. 9.38). The fashion for foreign marbles in Rome seems to be picked up later elsewhere, first appearing in Pompeii during the first century BC and then becoming more popular, presumably as availability increased, during the first century AD.[40] As a result it has been proposed that Room 10 experienced two different phases of decoration.[41]

The technical evidence from the bedding confirms that Room 10 was constructed and decorated in a single phase. The room, therefore, may be an example of the early adoption of this new fashion and a claim to status by the owner. The recycling of materials may have enabled greater expenditure in Room 10, an important place for reception and entertainment. At the same time, the overall decorative effect served the purpose of reiterating traditional values. Further attempts to adjust expenditure can be seen in the *opus sectile* pieces themselves which also seem to have been recycled; those embedded in the areas of *opus signinum* are damaged. They have been set into the floor in this state as proven by the mortar abutting the lost tips of the triangles or lozenges. The decoration of this room may have offered a balance between the traditional flooring styles in the more public rooms and the new taste for exotic, and expensive, materials in a more intimate setting.[42] This may have been achieved more cheaply by recycling materials, some of which were damaged. The technical information suggests that the floor should probably

still be placed in the later first century BC with the remodelling of the other rooms in this phase.

The remaining *opus signinum* pavements from the north and north-eastern areas of the property belong to a final phase of redecoration in the mid-first century AD.[43] Further renovations, taking place after the earthquake, are indicated by damage to the mosaic in Room 7, resulting from objects being dragged across the floor, and a deposit of lime found in Room 11. It seems likely that these materials were intended for works within the house rather than building activity beyond it.

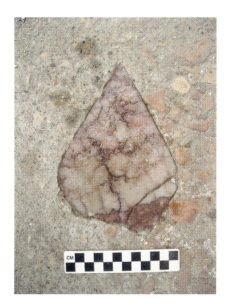

Figure 9.38. Room 10. Detail of coloured inset stone (image W. Wootton).

Materials, techniques, and working practices

Recycling formed a key component of the working practices of the craftspeople, especially during the second decorative phase. On one level, this activity had an ideological function as it preserved original, or at least authentic-looking stones from earlier paving types in later floors. It also had economic value in reducing expenditure on materials and, more significantly, the time required to process them.[44] Reuse of materials is evident in the surface of the pavements and also in the bedding. In addition to the appropriation of old building materials as aggregate for the mortar, the nucleus of the mosaic in Room 7 retained pick marks close to the walls. These record attempts to reclaim the tesserae following the earthquake in AD 62/3.[45] This salvage work probably began once it was realised that the floor had been damaged beyond repair, whether in the natural disaster or during subsequent building works, which caused significant harm to the integrity of the surface.

Of course, it is the major interventions that impress themselves most heavily on the archaeological record. At the Casa del Chirurgo, pavements from the early first century BC continue in use until the eruption in AD 79. This is not just the case for the high-quality floors in the more visible areas of the property, but longer-term repair and maintenance is also evident in the series of mortar laminations in the rooms of the service area.[46] When renovation was destructive, however, a variety of different materials would have been made available that lent themselves well to recycling. Interestingly, during such phases of redecoration, floors were rarely laid on top of each other, instead the pavements themselves seem to have been removed.[47] The decision, on the whole, seems to have been to save materials for the surface such as tesserae, thereby avoiding the time and labour needed to process, or others with special decorative or symbolic value such as the coloured stones.[48] These were then reused in the pavements of the later first century BC, whether for the new tessellated floor in Room 7 or the threshold in Room 8. It seems unlikely that the tesserae scattered through the *opus signinum* floors of Rooms 5, 6D, and 10 were prepared specially for this purpose; they probably came from earlier mosaics. The same can be said for the *opus sectile* pieces of Room 10. Their damaged state suggests earlier use, whether in this house or another.

It is difficult to identify with precision the immediate provenance of the recycled coloured stones. They were probably retained from floors similar to Room 1, which

paved areas subsequently identified for redecoration. If correct, then it suggests that there were other pavements similar in decoration and date to the fauces. For that decorative phase, perhaps the coloured stones were acquired in a single batch and then shared

Figure 9.39. Room 5. Fragment of *opus signinum* showing the bedding (image W. Wootton).

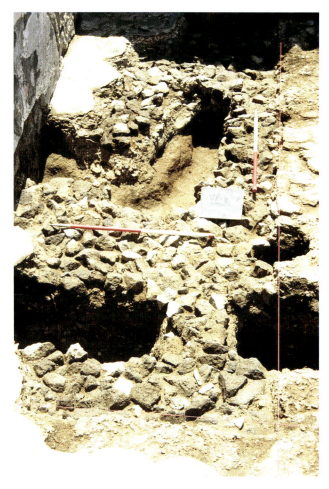

Figure 9.40. Grey-black lava stone cobbles underlying the flooring in Room 10 (image AAPP).

between the various paving needs. It seems sensible to suggest that the requirement for small, more regular, cut tesserae may have necessitated the laying of Room 8, prior to those with large irregular chips of stone. When analysing the few known examples where the craftspeople can be tracked as they laid the floors in a single phase of decoration, they seem to have worked the closed off rooms first, such as that of Room 8, before paving their way out of the house and finishing at the entrance.[49] It may also be the case that stones, such as the white *palombino* and the dark grey-black stone, *palombino* or slate, were also shared between Room 19, presumably constructed first, then Rooms 9 and 6E.

The geological provenance of the surface materials is also worth addressing.[50] Visual identification, as opposed to scientific, of the coloured stones indicates that they mostly have an Italian source. They are usually characterised as marls (*litomarga*) and the following suggestions can be made for their type and location: yellow is probably a Neapolitan *Pietra Paesina*,[51] the green might be *Persichino di Romegiano* from Veneto or *Argilla Antica*,[52] the pinkish red could be *Rosso di Terni* from Umbria or *Rosso di Syracusa*.[53] The white used in Room 19 is a true *palombino*, called a marble although it is in fact a limestone, probably from northern Italy.[54] The black stone from the same room is either a black *palombino* or a slate. The frame in Room 10 is certainly a slate or *lavagna*.[55] The dark grey-black stones, therefore, may not all be from the same source. The black tesserae in the mosaics are a coarser stone, most likely a basalt, while the white tesserae are a limestone similar to the *palombino* but with a more pronounced yellowish tint. The *portasanta* from Room 10 is not from the Italian mainland but comes rather from the island of Chios in Greece.[56] This is the only surviving imported stone, belonging to the redecoration in the later first century BC. As many of the cut stones were removed from Room 10, it is possible that there were other exotic materials.

Moving beneath the surface, there are discernible approaches to the laying of the bedding. Especially prevalent in the final decorative phase is the use of painted wall plaster fragments as an aggregate (Rooms 12, 13, 14, 16, 17, 18). This practice is particularly common in the service area. Such an action could be viewed as practical, improving the longevity or stability of the floor. To enhance the functional properties of the mortar, however, the fragments would need to be crushed. This is not the case here. Their location and the lack of processing suggest a plentiful and available source of filler, which could quickly and easily raise the floor levels across this wing of the house. They are the waste products of building and were sensibly disposed of or 'recycled.'

These are not the only floors where construction materials were used in the foundations. The later first century BC renovations also produced a lot of debris which subsequently appears in the pavements. In Room 5, for example, there is a thick levelling layer, some 20 cm deep, containing the refuse of building activity (Fig. 9.39). This was carefully compacted in preparation for the *opus signinum* pavement. Similarly in Room 7, there were layers of rubble and rubbish which formed a base that was compressed and flattened in advance of the mosaic pavement (Fig. 9.16). In this case, and in contrast to Room 5, there is greater attention paid to the pavement's foundations. Firstly, a 10 cm layer of rubble and sand was laid down, including ceramic, wall plaster, and *opus signinum* fragments, some still with white tesserae. This was tamped down and a thick red layer of mortar with crushed terracotta laid over the top. The tesserae were then set into a thin pink lime setting bed on top.

Even more time, energy, and resources were spent on the foundations of Room 10. This might coincide with the increased investment in the surface materials and the prestigious nature of the room, but is likely also due to the poor underlying deposits which required shoring up to ensure that the laying of the pavement was successful.[57] Laid down on top of a rubble deposit was a thick layer of closely-packed angular grey-black lava cobbles on top of which was a layer of mortar with a coarse aggregate around 11 cm thick (Fig. 9.40, cf. Fig. 5.13.13).[58] The final *opus signinum* floor, around 5 cm thick, was laid on top into which the slate and *portasanta* were set. At the southern end was found a rectangle of pinkish mortar, 120 × 140 cm, which was the setting bed for an *opus sectile* panel evident from the surviving impressions of the individual pieces.[59] Like those for the rest of the pavement, the imprints were the shape of an inverted pyramid. There were no small fragments of marble or terracotta as often found when the surface of the *opus sectile* has been removed.[60] These fragments were used to bind together the backs of the pieces which make up the *opus sectile* panel before a 'tile' is created, usually off site.

The shape of the stone pieces, with a flat upper surface and an inverted pyramid for a base, are one explanation as to why such a process was not used here: this was, presumably, to improve adhesion. It also seems that the panel was not prefabricated.[61] In profile, the edges of the mortar rectangle were vertical, indicating that the panel had been made using a shuttering technique with wooden boards.[62] What differentiates the process here from off-site manufacture is the appearance, at the bottom of the

vertical edges, of mortar deposits which had seeped out under the boards. This indicates that the *opus sectile* was made on site as were all the pavements in the house. Furthermore, the *opus signinum* surround ran over this leakage demonstrating that the *opus sectile* panel was laid beforehand.[63] Presumably, it was the first area to be made after the general layout of the decoration was planned.

There is no surviving evidence for the installation in the house of an *emblema* that had been produced off site. Making floors is largely an art of installation requiring the craftspeople to produce pavements quickly and in situ. In order to facilitate this work, they made as much use as possible of local, and hence accessible, materials. In the Casa del Chirurgo, they sank pits in the garden in order to dig out sand and/or pozzolana. In the final life of the house, renovations were required, as indicated by a large pile of lime stored in Room 11.

Although the evidence from the property is rich, there is nothing to tell us about the initial planning or laying out of these pavements, in particular for the more complicated tessellated floors. Even those, however, were fairly simple in Pompeian terms and probably required simple methods of measurement with the addition of minimal guidelines.[64] We also know little about the finishing processes applied to the different flooring types. It is likely that the mortar pavements were polished to give their surfaces a more pleasing effect. The same may have been done for the mosaics, but the regular size of the tesserae, the thin setting beds and the levelled layers below would have kept this to a minimum. There might have been other additions, such as organic materials including pigments, that do not survive.[65] The surface of the pavement in Room 19 was further elaborated. In the interstices, a white *stuccatura* was used to mask the gaps between the irregular chips and enhance, for aesthetic reasons, the colour contrast between the black and white pieces.

Conclusions: function, location, and status

The impression that arises from the study of the pavements of the Casa del Chirurgo is multifaceted. The different phases of decoration were predicated on the particular intentions of the owner and were resolved to serve specific purposes within a designated budget. What survives of the early first century BC decoration is indicative of owners who wanted to meet current fashions in high-status flooring. Room 19 in particular was meant to be an impressive statement, picking up

on trends in black and white *opus sectile* floors while also fitting in with the polychrome pavements of irregular chips of stone and glass. Its more austere colour palette evoked distinction, a message it carried to those privileged enough to be invited for private receptions in this more secluded part of the house next to the garden.

Also from this phase is a tessellated floor (Room 8) which makes use of coloured stones, all carefully-cut and set into a regular pattern in the centre of the floor. This *ala* was probably for more frequent use as the position off the atrium suggests. The other pavements from this phase, all mortar floors, created different effects depending on the use of more austere or more elaborate palettes of materials. Particularly striking is the entrance (Room 1). Although employing the same range of coloured stones as Room 8, here they are packed tightly together giving a highly-variegated effect enhanced through polishing. This floor would have been the first room encountered and it therefore set the tone for the visit. Like Room 19, the pavement is similar to those found in other high status houses, its vibrant and impressive selection of materials signifying the wealth of the property's owners.

In the subsequent renovation during the later first century BC, these pavements were retained. They had not lost their power of allusion, in fact they seem to have acquired greater prestige as indicated by the desire to create floors in keeping with their original effect. The new pavements refer back to these earlier types in terms of their superficial decoration and material composition. The old fauces (Room 1) now led in to a newly decorated atrium. Here the same coloured stones were now scattered through the *opus signinum* floor. This traditional-looking pavement provided an appropriate backdrop for the display of prestigious objects such as a loom, whether or not weaving actually took place there.[66] The old-fashioned look was also retained in the tablinum (7) and the large reception room (10) off the atrium. Room 10 was further elaborated with large pieces of specially-cut stone. These were dispersed through the floor and then set together to form an *opus sectile* panel. Like the other materials these were likely recycled, perhaps from earlier prestigious floors in the house. The *portasanta*, however, may have been a new acquisition to show off their ability to acquire exotic marble at a time when such materials were only just coming on to the market. The new threshold in Room 8 is also unusual. Without parallels, the motifs exist outside of the repertoire, as known to us, even if the type of black and white tessellated mosaic was immediately recognisable.

The property largely remained in this state through to the earthquake of AD 62/3. There are some alterations to the *opus signinum* floors in the rooms to the rear. These would have had little impact on the way the house was seen by a visitor. The flooring decoration, therefore, remained traditional through its long life; a feature that was intentionally maintained during the renovation in the later first century BC. Once complete, older floors coexisted with new ones created specially to evoke a similar decorative effect. The decision was intended to be meaningful and have value to the owners, even if there were also economic imperatives. The reasons for this choice seem to have been related to old-fashioned values and a desire to reiterate traditional ideas of status based on prestigious indicators of wealth. These signs would have been recognised by visitors, even if those versed in such decoration may have spotted some of the more unusual features of the pavements, whether the integration of different styles, the recycling, or the oddities of some of the geometric motifs.

Notes

1 I would like to thank Michael Anderson for his patience and help with this chapter. I was invited to examine the pavements from Regio VI as part of the AAPP in 2004, when I was a DPhil student at Oxford University. By this time a significant amount of the archaeological activity had already taken place. It was, therefore, often difficult, even impossible in some cases, to gain access to the floors in their excavated state. This impacted the primary analysis because it was not possible to assess the characteristics of some pavements. In the end, these floors did not form part of my doctoral thesis. The research, started at Oxford, was developed as a scholar at the British School at Rome. It was completed at King's College London. I offer my gratitude to these institutions for supporting my work.

2 Pernice 1938, 84. Blake (1930, 59, 63, 107, 120) only mentions Room 8 in her discussions.

3 For a different approach to the floors, concerning their condition and management as part of the conservation and presentation of the whole insula, see Fortenberry and Goalen 2007, 17–18, 37.

4 Rooms 5, 6B, 6C, 6D, 6E, 10, 12, 14, 15, 16, 21, 22, 23.

5 Rooms 1, 9.

6 Rooms 7, 8.

7 Room 19.

8 Room 10.

9 For definitions and discussion of this flooring type and the associated terminology, see Dunbabin 1978; Farneti 1993, 131–2, 149–50; Grandi Carletti 2001; Grandi and Guidobaldi 2006; Tang 2006, 101–2; Vassal 2006, 23–7, 28–31, 32–5; Grandi 2011. For the purposes of this volume, the term *opus signinum* was assigned by the excavators. The use of the term "cementizio" in Italian and "mortar" offer greater flexibility in describing the variety of floors made up of mortar with different types of aggregate.

10 I was not able to view this pavement in person.

11 These inset stones are sometimes called *crustae*. See, for example, Balmelle *et al.* 1985, 157–6, the glossary in Dunbabin 1999, 342, and the publications cited above in n. 9.

12 According to Pernice (1938, 84) and the *PPM* (IV 1993, 65) coloured limestones were also found in Room 9.

13 In Italian, all these floors would be termed *cementizi* with the different colours and surface elements distinguishing between them. See above n. 9 for the useful publications in Italian, French and English on such terminological issues.

14 Balmelle *et al.* 1985, 26–7 (1f). This decoration has not previously been observed, although it is visible in the *PPM* (IV 1993, fig. 2 on 54).

15 As observed above in n. 12, other scholars have mentioned limestones in violet, yellow, and green. The areas available to me, however, did not contain these materials. If they are present, and there is no reason to disbelieve the earlier reports, then it would further tie the room to the *fauces* in terms of the flooring type and production date.

16 Different extents of preservation can be seen in *PPM* (IV 1993, 59–61).

17 Balmelle *et al.* 1985, 26–7 (1y).

18 Both black bands are clearly documented in *PPM* (IV 1993, 59, 60, figs. 13, 15).

19 Casa delle Vestali (VI 1, 5), Room 23 (*PPM* IV 1993, 17–19, figs. 26–8, 30); Casa di Inaco e Io (V 7, 19), Room 14 (*PPM* IV 1993, 447–8, fig. 30).

20 Balmelle *et al.* 1985, 26–7 (1e). Only one of the threshold panels, that to the north-east, survived when the pavement was examined in the 2004 season. This is the same as that pictured in the *PPM* (IV 1993, 62, figs. 18–19). Pernice, however, documented the pavement when all, except the central square, survived to a good degree (Pernice 1938, pl. 37.3). The plate in Pernice's publication demonstrates that the north-eastern panel, as it is currently displayed, has been incorrectly reconstructed.

21 For something similar, see Balmelle *et al.* 1985, 70–1 (30i).

22 Usually the walls and towers face outwards from the centre: Balmelle *et al.* 1985, 150–1 and Balmelle *et al.* 2002, 127–31.

23 L shapes appear in the centre of three surviving square panels found in Room p of the Casa di Ganimede (VIII 13, 4.17–18), see *PPM* (VII) 1997, 635.

24 This example is cited by Blake (1930, 107, 120, pl. 28).

25 The serrated fillet can also be found in the apse of the Caldarium (48) in the House of Menander (I 10, 4), usually thought to be Second Style and dated in the later first century BC (*PPM* II 1990, 387–8; Ling and Ling 2005, 248–9).

26 Cf. above n. 19.

27 Balmelle *et al.* 1985, 164 (107d). Blake (1930, 59) cites as a comparison the Casa delle Nozze d'Argento (V 2, 1).

28 Blake 1930, 107; Pernice 1938, 84; *PPM* (IV) 1993, 62.

29 The tesserae range in the size from 0.6 × 0.6 to 1.1 × 1.1 but the density in the obliquely-laid areas of mosaics are around 110 dm^2 in Room 8 and 95 dm^2 in Room 7.

30 It was not possible to gain access to the complete pavement but chips of green limestone, the same as those from elsewhere, where identified in the areas observed.

31 Although these stones are largely confined within the slate frame, the occasional piece was found outside of it.

32 The size of the black pieces is between 1.4 × 2.0 and 5.8 × 6.9 cm, while the white are between 1.9 × 3.5 and 4.0 × 5.8 cm.

33 Such floors have been called *crustae* pavements, for example Dunbabin 1999, 53–5, or *scutulatum*, for example Balmelle *et al.* 1985, 158 (102a). Farneti 1992, 148 (*opus scutulatum*), 153 (chip pavement), 184 (*crusta*).

34 Pernice 1938, 84; *PPM* (IV) 1993, 52–3.

35 Pernice 1938, 122–5, 129–31. The decoration in black and white is unusual, although it is known in early *opus sectile* (Guidobaldi 1994a). Similar floors are either white or use a selection of coloured materials as known in Rome (Boldrighini 2000) and a number of properties in Pompeii, for example Room 29 of the Casa del Fauno (VI 12, 2; see *PPM* (V) 1994, 102) or Room 29 of the Casa di Cipius Pamphilus (VII 6, 38; see *PPM* (VII) 1997, 217). They can also be found around the Bay of Naples, for example in the Villa dei Misteri (Cicirelli and Guidobaldi 2000, Rooms F¹, F², P³, F³, 63) and Herculaneum (Guidobaldi *et al.* 2014, 342–3, Cat. No. 315). For an overview of the early use of coloured stones, especially marble, in Italy focusing on Ostia and Rome, see Pensabene 2007, 14–18.

36 Ling and Ling 2005, 10. See above n. 19.

37 De Vos 1991, 49–50. For example Room 24 in VI 2,16 (*PPM* IV – 1993, 219), which is attributed to the Third Style.

38 De Vos 1991, 41; Fant 1999; Ling and Ling 2005, 18; Fant 2007; Pensabene 2007, 14–18.

39 Cf. above n. 37.

40 Cf. above n. 38.

41 Pernice 1938, 84. The *PPM* (IV) 1993, 65–70, places the whole floor in the later first century AD. Bastet and De Vos (1979, 114) attribute the *opus sectile* panel to the Fourth Style on the basis that this seems to be the time when they are most popular.

42 At this time it seems that other houses were updating some of their materials, such as the House of the Faun (Fant 2009, 6; see also Dunbabin 1999, 39, 254–5).

43 In the levelling layer of Room 13/14 was found a glass stirring rod dated to the first century AD (see Chapter 6). The renovation of Rooms 12, 13, 14, 16, 17 and 18 was a coordinated effort as evidenced by the wall plaster in the bedding, and the coins show that this can not have taken place before 9 BC.

44 Wootton 2015.

45 Most commonly evidenced for marble *opus sectile* (see Barker 2012), but tesserae were stripped too, for example in Room 15 of the Casa delle Vestali (VI 1, 7) and, much later, in Britain (Johnston 1983; Crummy 1984, 166).

46 For example Room 15.

47 Room 13 is the only example of a pavement being laid over another: *opus signinum* on top of *opus signinum* with a layer of plaster fragments in between.

48 Building debris was used to fill a cistern, or well, in the late first century BC under Rooms 7 and 12. The materials included fragments of *opus signinum* and tesserae amongst others suggesting they were not always removed and saved.

49 Cf., for example, the evidence from Benghazi and Nabeul (Wootton 2014).

50 Cf., for example, the valuable research on materials at the Villa of Oplontis: Fant and Barker 2016.

51 Pensabene 2013, 448. Corsi's *Giallo di Napoli*: http://www.oum.ox.ac.uk/corsi/stones/view/519/classi/corsi_519 (accessed 01.04.2015).

52 *Persichino di Romegiano*: http://www.oum.ox.ac.uk/corsi/stones/view/500/classi/corsi_500 (accessed 01.04.2015) or *Argilla Antica*: http://www.oum.ox.ac.uk/corsi/stones/view/512/classi/corsi_512 (accessed 01.04.2015).

53 Bruno 2002, 287. There are numerous stones with these characteristics, for example *Rosso di Terni*: http://www.oum.ox.ac.uk/corsi/stones/view/517/classi/corsi_517 (accessed 01.04.2015) or *Rosso di Syracuse* and others.

54 Bruno 2002, 289.

55 Bruno 2002, 277–8.

56 Lazzarini 1995; Pensabene 2013, 305–6.

57 Only two other floors in Regio VI 1 have such strong foundations, this room (22) and the shrine (VI 1 13), and both are associated with deep holes containing loosely-compacted materials.

58 The cobbles ranged in size from c. 10 × 10 to 10 × 20 cm.

59 Guidobaldi *et al.* 1994; Guidobaldi and Olevano 1998; Esposito and Olevano 2011.

60 Guidobaldi 1994b, 49–55; Dunbabin 1999, 254–61.

61 As normally seems to have been the case, see Guidobaldi 1994b, 50, Fig. 3. See also the important experimental work on the production of glass *opus sectile* and wall incrustation: Guarino and Valente 2011; Giorgi *et al.* 2011.

62 This does not seem to be the result of prefabrication in a wooden box (Guidobaldi 1994b, 50, Fig. 3) but rather in situ manufacture with wooden boards (Wootton 2014).

63 Wootton 2014.

64 Cf., for example, the examples cited by Robotti (1983) at Pompeii and Stabiae (1973). For more complex underpainting, see the finds from the Casa di Marco Fabio Rufo (Grimaldi 2011, 146, figs. 14, 15.)

65 Recent work at Oplontis by Clarke and Cline has demonstrated that painting was not reserved for more complex, or figurative, areas but was also used for simple colour bands. Paper given at 11th AIEMA Colloquium (Bursa, Turkey) in 2009 and published online at https://www.academia.edu/428626/_New_Light_on_Mosaic_Metrics_Research_at_Villa_A_Torre_Annunziata_Italy._ (Accessed 01.04.2015)

66 Cf. Hilary Cool's identification of loom weights from the atrium (Chapter 6).

10

THE FAUNAL REMAINS

Jane Richardson

Introduction

Animal and bird bone fragments were analysed from all contexts associated with the Casa del Chirurgo and were assigned to the phases outlined in Chapters 4 and 5. A total of 8853 bone fragments were recovered, although only those from Phases 3, 5, and 6 had sufficiently large assemblages to warrant further study (Table 10.1). Of these, 24% were assigned to Phase 3, the period of the construction of the Casa del Chirurgo c. 200–140 BC, 27% to Phase 5, the changes to the property between the end of the first century BC and the early first century AD, and 38% to Phase 6, the final phase of major redevelopment after the mid-first century AD.[1] Consequently, the majority of the faunal remains come from the three main periods of construction in the house, which are the times when it might be expected that discarded bones could become incorporated into the deposits that came to form the archaeological record.

Methodology

Bones were identified to taxa wherever possible, and the separation of sheep and goat bones was routinely attempted,[2] but lower-order categories were also used (e.g. sheep/goat, cattle-sized). It was also difficult to separate the bones of the closely related domestic fowl (*Gallus gallus*) and pheasant (*Phasianus colchicus*) and they tended to be separated (subjectively) on size. This suggested that domestic fowl was exclusive and, reassuringly, this was confirmed by the absence of any air-sac foramen (a pheasant characteristic) on proximal femurs. Through necessity, the Casa del Chirurgo bone had to be recorded in the field without access to reference material, although suitable manuals were used.[3] It is likely that the identification of the bones of the common domestic animals was not significantly compromised, however, identification of the rarer bird and small mammal bones was more problematic and often broad categories had to be used (e.g. small corvid).

All fragments were recorded in a database. In order to assess a minimum number of anatomical units, diagnostic element zones, which by definition are easily identifiable and non-reproducible, were also noted (Table 10.2). This eliminated the possibility of recording an anatomical zone more than once.

For age-at-death data, epiphyseal fusion[4] and the eruption and wear of deciduous and permanent check teeth were considered. Dental eruption and wear for cattle, sheep, and pig were recorded using the letter codes of Grant.[5] Age stages were calculated using Payne[6] for sheep and a similar wear progression was assumed for pig. The sexing of the cattle and sheep populations was attempted,[7] although very few were documented, while the sexually dimorphic tusks of pigs were noted.

Bone condition, erosion, and fragment size were recorded in order to assess bone preservation, while gnawing, burning, and butchery marks were noted to determine bone treatment. Butchery was routinely differentiated into chop and cut (knife) marks and the position and direction of these marks were recorded.

Finally, pathological bones were considered and biometrical data recorded.[8] Given the very high levels

of fragmentation, however, too few measureable bones were recovered to warrant assessment and no pathological bones were noted from the Casa del Chirurgo deposits.

Taphonomic bias

In order to assess the usefulness of a bone assemblage for reconstructing dietary patterns, relevant taphonomic processes need to be considered. Factors influencing bone survival and retrieval include the ways in which the carcass was butchered, methods of cooking, speed of burial, and the choice of excavation strategy.

The levels of fragmentation and erosion noted suggest that many bones were left exposed prior to their final burial. Such exposure to the effects of weathering and trampling will have biased against the most fragile bones (often those of the younger animals). In addition, the bones that were eventually deposited in the negative features or buried in surface layers represent only a minority of the bones associated with a thriving house in a city. Instead, most of the bones, along with other household rubbish, would have been gathered up and disposed of beyond the city.[9] In contrast, bone recovery during excavation was as comprehensive as possible with all excavated deposits sieved through a 5 mm mesh, and a 20-litre soil sample from every secure context was processed using a flotation tank and a 1 mm mesh. This explains the very high proportion of small fragments of undiagnostic bone within the assemblage, but it will also have maximised the recovery of the smallest bones of the smaller species.

To determine how deposits were formed, bone preservation and gnawing were assessed and articulated bones noted. Primary deposits are most clearly indicated by articulated parts, although the type of bones present, in addition to a good state of preservation, may identify the rapid disposal of bones from a particular activity (e.g. primary butchery waste). Only one possible partial skeleton was noted, a neonatal calf from SU 184.116. The dearth of any other primary deposits suggests that the assemblage from this property was trampled, well mixed, and probably often re-deposited. This hypothesis is supported by the highly fragmented nature of the collection and the eroded surfaces of many of the bones.

Comparing the treatment of bones by phase, which may also influence bone survival, indicates that those from Phase 6 were less frequently gnawed, burnt or butchered than those from Phases 3 and 5 (Table 10.3).

From no phase, however, were any of these factors considered to be particularly significant in terms of taphonomic bias. The proportion of loose teeth suggests that the bones from Phase 6 were also less fragmented, and unsurprisingly the proportion of diagnostic zones was also higher.

Dietary preferences

An assumption has been made that the animals consumed within the city were bred elsewhere and that those represented in the deposits excavated are likely to say more about the diet of the city's inhabitants than they do about animal husbandry practices in the surrounding countryside or even further afield. To illuminate dietary preferences, taxa, age and sex data, and the body parts present have been considered.

Animals present

The proportions of taxa reveal an overwhelming dominance of domestic animals (Tables 10.1 and 10.2). Only one roe deer metatarsal may represent food waste (the other is a sawn antler fragment), while fox, rat, mouse, vole, and amphibian bones are likely to represent wild animals that probably occupied the city itself and its immediate surroundings. The few horse and dog bones probably represent animals that had worked and/or lived within the city, as neither was routinely consumed.[10] Clearly domestic livestock, in conjunction with fish, served to satisfy the inhabitants' need for meat.

Comparing the relative proportions of the main domestic animals indicates a dominance of pork in the diet, the availability of lamb and mutton, and a preference for chicken when compared to veal or beef (Table 10.4). This pattern has already been noted from excavations within other properties of Insula VI 1, where it has been suggested that the more sizable bones of the larger animals were more likely to be gathered up for disposal beyond the city walls,[11] and from pre-Roman deposits beneath the Casa di Amarantus.[12] The proportions of the main domesticates over time indicates that chicken increased sharply and pork consumption rose steadily, largely at the expense of lamb and mutton. A similar decline in the proportion of sheep and a concomitant rise in pigs have been reported by MacKinnon for other urban sites in central Italy from the Republican to the Imperial period.[13] This reflects a shift towards a more market-orientated husbandry that

was reacting to an increase in the dietary popularity of pigs.[14]

Age data for pigs, sheep, and cattle

Fusion data for pig indicate that, regardless of phase, around three quarters of animals were killed for their meat before 30 months old (Table 10.5), a slaughter pattern seen elsewhere in the city.[15] This is hardly surprising in the absence of any major secondary products, and hence slaughter at an optimum age for meat is indicated. Over time it seems that the average age at which pigs were slaughtered rose with 90% of animals surviving its first year in Phase 6 compared to only 56% of pigs from Phase 3. This trend is supported by the dental data where older animals are apparent from Phases 5 and 6 (Table 10.6). Perhaps as the city

grew, pigs were raised closer to this thriving market, allowing older breeding animals to make it into the city's food chain more regularly. Alternatively the trend towards older animals may reflect the relative status of the Casa del Chirurgo in particular phases: it was the largest, most socially important property in the insula during Phase 3, in contrast to Phases 5 and 6 when it had become overshadowed by its neighbour, the Casa delle Vestali.

Nevertheless, the presence of some neonatal pig bones suggests that suckling pig was available as a delicacy[16] regardless of phase. Suckling pigs were considered pure on the tenth day after birth according to Varro[17] but could be offered for sacrifice after only four days.[18] Certainly, piglet bones were associated with a probable foundation deposit for the Casa delle Vestali,[19] and similar sacrificial deposits have been

Table 10.1. Fragment count by phase.

	1	2	3	4	5	6	7	8	9	Total
Horse			2			2				4
Cattle			3		49	5			2	59
Cattle-sized		2	18		6	2	1		1	30
Pig	1	30	270	3	243	233	12	3	108	903
Pig-sized	1	27	110		68	68	7	1	23	305
Sheep		2	21		1	2			1	27
Goat			1			1				2
Sheep/goat		36	119	1	103	109	8		20	396
Sheep-sized	3	18	68	2	47	23	1	3	16	181
Dog		1	2		1	1				5
Cat					1					1
Roe deer			2							2
Fox					2					2
Canid spp.									1	1
Small carnivore (<cat)					1	1				2
Rat					1	1	1		2	5
Vole spp.					2					2
Small mammal (mouse sized)			42		22	2	1		2	69
Domestic fowl		4	4	1	29	25	2		9	74
Duck spp.					1	2			1	4
Columba spp.					4	1			1	6
Small corvid			1		1	4				6
Bird		1	12		28	9	1		15	66
Frog/toad		1				8	1			10
Undiagnostic	6	360	1472	18	1485	2897	107	6	340	6691
Total	11	482	2147	25	2095	3396	142	13	542	8853

Table 10.2. Number of diagnostic zones by phase.

	2	3	4	5	6	7	8	9	Total
Cattle		1		3	3			1	8
Cattle-sized				3					3
Pig	13	96	3	131	146	7	2	54	452
Pig-sized	5	19		15	19	1		6	65
Sheep	2	21		1	2			1	27
Goat					1				1
Sheep/goat	18	42		39	46	3		9	157
Sheep-sized	3	11	1	8	10			2	35
Dog		1		1	1				3
Cat				1					1
Roe deer		1							1
Fox				1					1
Small carnivore (<cat)				1	1				2
Rat				1	1	1		2	5
Vole spp.				1					1
Small mammal (mouse sized)		10		14		1		1	26
Domestic fowl	4	4	1	28	25	2		9	73
Duck spp.				1	2			1	4
Columba spp.				4	1			1	6
Small corvid		1		1	4				6
Bird	1	2		12	8			3	26
Frog/toad	1					1			2
Undiagnostic		16							16
Total	47	225	5	266	270	16	2	90	921

Table 10.3. Bone preservation and treatment by phase.

Phase	3	5	6
% zones	14.1	9.1	18.5
% loose teeth	5.9	7.6	4.2
% butchered	2.1	1.6	1.0
% gnawed	0.6	0.3	0.4
% burnt	0.3	0.4	0.2

Table 10.4. Proportion of the main domestic animals by phase (based on number of zones).

	3	5	6
Cattle	1	1	1
Pig	59	65	66
Sheep (and sheep/goat)	38	20	22
Domestic fowl	2	14	11

identified beneath the Casa di Amarantus and in other gardens in the city.[20] A bias towards the slaughter of males, presumably those animals surplus to breeding requirements, is likely as a greater proportion of male tusks were present compared to female.

Unfortunately, fusion data from sheep were relatively scarce and too much weight should not be given to the interpretations made. What is clear, however, is that from all phases, many lambs and yearlings (the

6–16 month category) were slaughtered to provide premium tender meat (Table 10.7). The presence of some (osteologically) mature animals indicates that, like the pigs, a few older breeding animals also made their way into the city's diet. The dental data confirm this pattern of slaughter, although they indicate that lambs tended to be killed in their first year, and that the adult animals (ex-breeding stock and milk and wool producers) were mature before being slaughtered (Table

Table 10.5. Fusion data for pig by period (zones only, F = fused, NF = not fused).

Phase	3			5			6		
	F	NF	%F	F	NF	%F	F	NF	%F
12 months	9	7	56	21	7	75	27	3	90
24–30 months	6	20	23	7	22	24	10	29	26
36–42 months		4	0		6	0	1	7	13

12 months calculated from distal scapula, distal humerus, proximal radius, second phalanx

24-30 months calculated from distal metacarpal, distal tibia, calcaneus, distal metatarsal, first phalanx

36-42 months calculated from proximal humerus, proximal ulna, distal radius, proximal femur, distal femur, proximal tibia

Table 10.6. Number of pig jaws at various wear stages by phase.

Master Period	3	5	6
A: d4 unworn	1	2	2
B: d4 in wear, M1 unworn	1	2	1
C: M1 in wear, M2 unworn	1		
D: M2 in wear, M3 unworn	1	1	
E: M3 in early wear		1	
F: M3 beyond wear stage c			1
Total	4	6	4

Table 10.8. Number of sheep jaws at various wear stages by phase (after Payne 1973).

Master Period	3	5	6
A: 0–2 mths		2	1
B: 2–6 mths	6	4	9
C: 6–12 mths	4		
D: 1–2 yrs			
E: 2–3 yrs			
F: 3–4 yrs			
G: 4–6 yrs			
H: 6–8 yrs	1		1
I: 8–10 yrs			
Total	11	6	11

Table 10.7. Fusion data for sheep by period (zones only, F = fused, NF = not fused).

Phase	3			5			6		
	F	NF	%F	F	NF	%F	F	NF	%F
6–16 months	6	8	43	2	5	29	4	4	50
18–28 months	1	4	20		2	0		7	0
30–42 months	1	2	33	1	4	20	1	1	50

6–16 months calculated from distal scapula, distal humerus, proximal radius, first phalanx, second phalanx

18–28 months calculated from distal metacarpal, distal tibia, distal metatarsal

30–42 months calculated from proximal humerus, proximal ulna, distal radius, proximal femur, distal femur, proximal tibia, calcaneus

10.8). A few neonatal bones from Phases 3 and 5 suggest the youngest animals were also occasionally eaten.

The fusion data for cattle are negligible with only five ageable bones noted from Phases 3, 5, and 6. Subadult bones from Phases 5 and 6 suggest that some animals were slaughtered when their meat was at its best. A possible neonatal calf skeleton (rib, vertebra, skull fragments, and a toe bone) from 184.116 is highly unusual and, associated with notable quantities of ash, may represent a ritual deposit akin to the piglet bones found beneath the tablinum of the Casa delle Vestali.[21] It should be noted, however, that this deposit has been interpreted as a general filling layer suggesting that the neonatal calf bones may have been redeposited.

Carcass processing

Unfortunately, relatively few butchery marks were noted during the recording process (Table 10.9), partly due to the highly fragmented nature of the assemblage, but also due to the unwashed state of some of the bones. Nevertheless, cuts on pig-sized and sheep-sized rib bones highlight meat removal, while the halving of vertebrae along the sagital line suggests that carcasses were beheaded and hung before being cleaved in two,

a procedure that may have been restricted to larger sites.[22] Bone working evidence was scant, although a sawn roe deer antler fragment and a sawn goat horncore were recovered.

It might be expected that the butchers of the city would have removed typically low-value body parts such as heads and feet before halving the carcass and reducing it further into manageable joints for sale. The cheaper joints with little associated meat (e.g. trotters) may have been available to a broader clientele than the meat-rich, high-value joints of the shoulder and rump.[23] Certainly preliminary comparisons of faunal data from the Casa delle Vestali and the bars of VI 1 seem to show a pattern of distribution that may have been related to the relative wealth of those inhabiting or visiting the various properties of the insula.[24] Interestingly then, for a high-status property such as the Casa del Chirurgo in Phase 3, and still a comparably wealthy house in subsequent phases, the proportion of foot bones identified was unexpectedly high (Table 10.10), in contrast to data from other urban sites in Roman Italy.[25] Despite being a bland food,[26] pigs' trotters do show up in the cuisine of both the rich and the poor,[27] but the similar pattern seen for sheep and even cattle is harder to explain given their inedibility.[28]

Table 10.9. The number of cut and chopped bones by phase.

Phase	3		5		6	
	Cut	Chop	Cut	Chop	Cut	Chop
Cattle			1	1		1
Cattle-sized		1	1	2		1
Pig	1	7	2	6		4
Pig-sized	3	8	3	4	5	12
Sheep/goat		2		2		2
Sheep-sized	7	3	7	1	6	2
Goat		1				
Roe deer		1				
Domestic fowl				1		
Undiagnostic	2	9	2			
Total	13	32	16	17	11	22

Table 10.10. Body part representation for cattle, sheep, and pig by phase (zones only).

	3		5		6		MacKinnon (see n. 25)	
	N.	%	N.	%	N.	%	N.	%
Pig								
Head (occipital, mandible)	6	20	6	15	5	11	–	50
Meat joints (humerus, femur)	4	14	8	20	8	18	–	20
Lower leg (radius, tibia)	4	14	11	27	10	23	–	14
Feet (metacarpal, metatarsal ÷2, first phalanx ÷2)	15	52	15.5	38	21	48	–	16
Sheep								
Head (occipital, mandible)	6	34	4	35	4	22	–	40
Meat joints (humerus, femur)	1	6	3	26	3	16	–	20
Lower leg (radius, tibia)	3	17	2	17	5	27	–	16
Feet (metacarpal, metatarsal, first phalanx ÷2)	7.5	43	2.5	22	6.5	35	–	24
Cattle								
Head (occipital, mandible)								
Meat joints (humerus, femur)								
Lower leg (radius, tibia)								
Feet (metacarpal, metatarsal, first phalanx ÷2)	1		0.5		0.5			

Conclusions

The faunal data from the Casa del Chirurgo are limited in terms of sample size when sub-divided by phase and also in terms of taphonomic bias. The material is highly fragmented and probably well-mixed and it may say little about the rooms or even the property in which it was found. In contrast, however, retrieval was exemplary and the efforts of the field team should be applauded.

The analysis of the faunal remains has concentrated on the larger assemblages from Phases 3, 5, and 6, although it should be noted that the high proportion of sheep from Phase 2, albeit from a very small sample (Table 10.1), reflects a tendency for fewer pigs and more sheep from other pre-Roman sites in Campania.[29] The larger assemblages from the later phases continue the trends seen elsewhere in the region with a rise in the importance of pigs in the diet, as lamb/mutton consumption declines. Much of the meat consumed came from young animals in their prime, although older livestock that had been used for breeding also contributed to feeding the city, particularly pigs from Phases 5 and 6. Over time the popularity and/or the availability of chickens, and perhaps their eggs, also rose.

Unexpectedly, the proportion of foot bones was high, in particular for pigs but also for sheep and cattle. There was an assumption that the inhabitants of a higher-status property such as the Casa del Chirurgo would have accessed meat from animals in their prime and would have selected the choicest cuts. It is not the case that these low-utility parts are concentrated in the service rooms or the shops of Phases 5 and 6, but instead appear to be evenly distributed throughout the assemblage regardless of area or phase. Foot bones have been linked to the processing of skins and hides as they were often carried with the hide to the tanner.[30] There is no evidence, however, that the Casa del Chirurgo was ever engaged in this malodorous production process, particularly over such a long period of time that saw many changes to the property as it embraced Augustan *luxuria* and further developed the property in the middle of the first century AD. Furthermore, while the northern and southern shops were functioning at this time, the northern was engaged in metalworking and then in a much cleaner form of economic activity, and the archaeology of the southern shop gives no indication that it could have been a tannery. Consequently, given the evidence for middened and/or redeposited material from elsewhere in the city, it is possible that tanning waste has been incorporated into the levelling deposits of the Casa del Chirurgo.

Interpretatively this has been a quite difficult assemblage, as the material excavated is likely to have been introduced during major building phases when middened material (as indicated by the level of fragmentation, gnawing, and erosion) was incorporated into levelling layers or used to backfill the many pits that appear in the record.[31] Consequently the assemblage may have very little to do with house and may say little about the daily consumption of the inhabitants in any one phase. Despite these taphonomic issues, what is striking is that the patterns seen by MacKinnon for other urban sites in central Italy are repeated here. Perhaps what was thrown away beyond the city walls came back as hardcore during episodes of construction, indicating that the assemblage should be seen as a reflection of the city rather than a single house.

Notes

1 Similarly, the archaeobotanical material is also most prevalent in Phases 5 and 6, see Murphy this vol. Ch 11.
2 Boessneck 1969; Payne 1969; Payne 1985.
3 Schmid 1972; Cohen and Serjeantson 1996.
4 After Silver 1969.
5 Grant 1982.
6 Payne 1973.
7 With reference to the sexually dimorphic distinctions of the pelvis after Prummel and Frisch 1986, 575.
8 Following the standards given by von den Driesch 1976 and Boessneck 1969.
9 See Maiuri 1930, 230–273; 1942, 174–175; 1943, 279–281 for details about refuse heaps resting against the city walls between the Herculaneum and Vesuvian Gates.
10 See Simoons 1994, 187 for an avoidance of horseflesh and 1994, 237–8 for only rare evidence for dog consumption.
11 Richardson *et al.* 1997, 91.
12 Fulford *et al.* 1999, 86.
13 MacKinnon 2004, 101 and 194.
14 MacKinnon 2004, 217 and 243.
15 Fulford *et al.* 1999, 86.
16 Cf. King 1999, 169.
17 Varro *Rust* 2.4.16.
18 Pliny *NH* 8.77.206.
19 Richardson *et al.* 1997, 91–2.
20 Fulford *et al.* 1999, 92; Hesse 2016.
21 Jones, *forthcoming;* and cf. Hesse 2016 for further comparanda.
22 MacKinnon 2004, 171.
23 MacKinnon 2004, 26 and 224.
24 Data represented in a conference paper 'Feeding the City' by the author at the University of Bradford 2004.
25 MacKinnon's 2004, 32 data in Table 10.10 comes from 'urban1' sites defined as large urban: for his data see table 56 for sheep/goat and table 59 for pig.
26 Celsus 2.22.2
27 MacKinnon 2004, 218.
28 MacKinnon 2004, 180.
29 King 1999, 169.
30 Serjeantson 1989, 136.
31 Cf. Ellis 2017 for example, suggests that in Insulae VIII 7, and I 1 coins enter into the archaeological record through secondary processes.

11

ARCHAEOBOTANICAL REMAINS[1]

Charlene Murphy

Introduction

All of the archaeobotanical material examined was collected from the Casa del Chirurgo in Insula VI I between 2002–2006 by the AAPP under the supervision of the author.[2] It was analysed using the University College London, Institute of Archaeology Mediterranean and Near Eastern reference collection. The archaeobotanical remains were identified using a low-powered binocular microscope, 4.8× to 56× magnification. There was a general paucity of archaeobotanical remains from the Casa del Chirurgo (Table 11.2). The majority of the recovered assemblage was in poor preservational condition, most likely attributable to the porous nature of the archaeological matrix, the number of levelling and construction events taking place over the life span of the house, and the recovery process itself.

Results

The lack of archaeobotanical evidence from Phases 7, 8, and 9 speaks to the fact that the majority of remains have been lost from the post-AD 62–79 destruction horizons when it was first exposed in the eighteenth century. Unsurprisingly, no archaeobotanical material was recovered from Phase 1, the natural deposits. Phase 6, however, dating roughly to the middle of the first century AD, stands out as being particularly rich in archaeobotanical material (Fig. 11.1). This may be due to the scale of construction taking place during this phase, particularly in the areas of the atrium, tablinium, and the triclinium, in which botanical remains were incorporated into the levelling fills.

The majority of the carbonised assemblage was dominated by fruits (Fig. 11.2). This could in part be due to preservational bias. It is known that small household shrines were established in individual

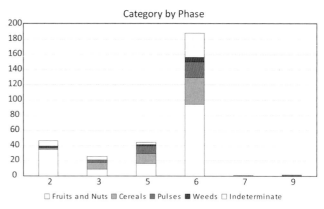

Figure 11.1. Total count of archaeobotanical remains by food category by phase.

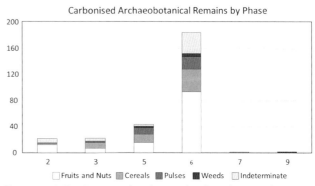

Figure 11.2. Total count of carbonised archaeobotanical remains by phase and category type. No carbonised archaeobotanical remains were recovered from phase 1, 4, or 8.

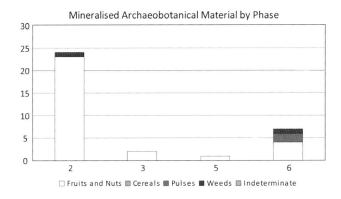

Figure 11.3. Total count of mineralised remains by phase and category type.

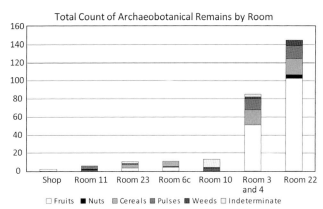

Figure 11.4. Total count of archaeobotanical material per room from the Casa del Chirurgo (VI 1, 9.10.23) (the Atrium, Room 2, Room 16 and 20, Garden and Room 5 had less than 2 counts and were removed from this graph for clarity).

Table 11.1. Data for Figure 12.4.

Room	Fruit	Nuts	Cereals	Pulses	Weeds	Indeterminate	Total
Shop	2.12	0	0	0	0	0	2.12
Room 11	0	1	1	4	0	0	6
Room 23	3.3	0	4	1	0	2	10.3
Room 6c	4	1	6	0	0	0	11
Room 10	0	0	1	1	2	9	13
Room 3 and 4	51	0	17	12	2	3	85
Room 22	102.735	4	18	14	6	0	144.735

properties at Pompeii and that offerings of fruits, nuts, and cereals were made to the household guardian deities, the Lares, before every meal.[3.] In this manner, fruits and nuts, which are not normally exposed to fire in their preparation, may have been carbonised and preserved. Fruit seeds are often more numerous than cereals and seem to have been disposed of in a careless manner. Fruit stones and nut shells are also more easily recovered by excavators than smaller types of seeds due to their recognisable shape and larger size. In contrast, other taxa such as pulses, cereals, and millets have to be cooked before consumption and are often soaked or boiled and thus are less readily preserved via carbonisation. The low numbers of recovered wheat and millet provide little evidence of food processing and no evidence of crop-processing or bread making from any of the phases from the Casa del Chirurgo (Table 11.3).

Olive is frequently recovered from Mediterranean sites and fragmentary remains of charred olive endocarps[4] dominated the fruit and nut category. Figure 11.5 demonstrates that there is a relatively high ubiquity of carbonised olive endocarp fragments recovered from the Casa del Chirurgo. The fragmentation of the olive endocarp may be due to depositional as well as post-depositional processes, and may also be caused by recovery methods such as flotation and sorting.[5]

The majority of mineralised remains were composed of fruit, particularly small seeds, which pass through the human digestive system and are preferentially preserved (Fig. 11.3). No mineralised remains were recovered from Phases 1, 4, 7, 8, or 9. This bias can likely be explained by the nature of the excavations themselves, which tended not to sample the natural soils of Phase 1, could not sample Phase 4, which produced no soil stratigraphy, and studiously avoided sampling modern deposits such as Phase 8 and 9 entirely. The absence of mineralised remains from Phase 7 may relate to the incomplete state of changes during this phase, which involved the deposition of building materials and some shoring, but had not yet involved the deposition of levelling layers or the filling of pits and cuts witnessed in earlier phases.

Throughout the properties of Insula VI 1, many of the rooms generally had low scatterings of archaeobotanical remains. In the Casa del Chirurgo, however, some interesting distributions become apparent when

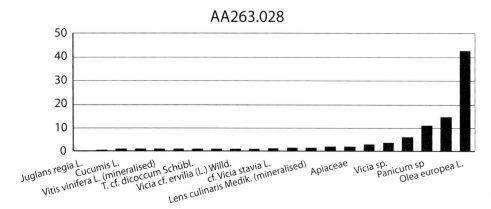

Figure 11.5. Archaeobotanical remains from Room 22 from the Casa del Chirurgo (VI 1, 9.10.23).

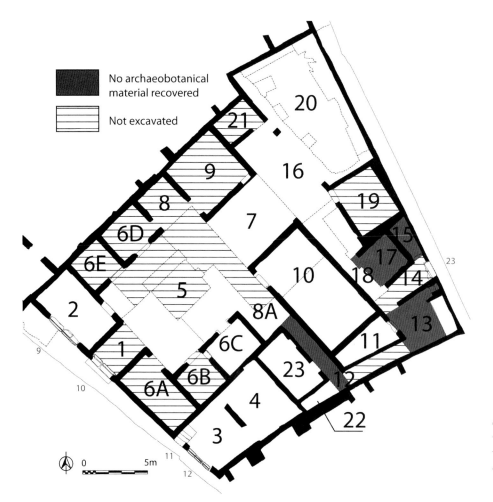

Figure 11.6. Plan of the Casa del Chirurgo (VI 1, 9.10.23) showing the presence of *opus signinum* floors and rooms where no archaeobotanical material was recovered.

viewed room-by-room. Firstly, Rooms 6B, 6E, 6D, 8, 9, 14, 19, and 21 initially need to be discounted because they were not excavated due to the presence of semi-intact mosaic and *opus signinum* floors. On the southern side of the property, there is a marked absence of archaeobotanical remains from Rooms 6C, 8A, 12, 13, 15, 17, and 18 (Fig. 11.4), which is surprising, as many of these rooms had a service function, particularly the kitchen (Room 13), where food preparation was most

likely to have occurred. Indeed, in terms of the spatial recovery of archaeobotanical remains, it is the rooms of the core atrium area in Phases 5 and 6 that the majority of the evidence was recovered. While food may have been consumed here, it is unlikely that it would have been prepared here. Furthermore as noted above, this part of the house had substantial floor surfaces that would have largely prevented remains becoming incorporated into the archaeological record during the

Table 11.2. Archaeobotanical results from the Casa del Chirurgo (VI 1, 9.10.23).

	Flotation (Residue and Flot Data combined)	In situ/handpicked
Total number of samples examined	113	
	Count	Count
Number of taxa recovered	20	12
Cereals		
Triticum aestivum/durum L.	1	
Triticum cf. *aestivum/durum* L.	1	1
Triticum dicoccum Schübl.	1	
Triticum cf. *dicoccum* Schübl.	1	3
Triticum monococcum L.	1	
Triticum sp.	17	6
Panicum miliaceum L.	1	
Panicum cf. *miliaceum* L.	3	
Setaria italica (L.) Beauv.	1	
cf. *Setaria italica* (L.) Beauv.	2	
Panicum sp.	15	4
Pulses		
Lens culinaris Medik.	6	
Lens culinaris Medik. (cotyledon)	1	
cf. *Lens culinaris* Medik. (cotyledon)	1	1
Lens culinaris Medik. mineralised		1
Lens culinaris Medik. mineralised (cotyledon)		1
Vicia cf. *ervilia* L. (Willd)		1
Vicia sativa L.	1	1
Vicia sativa L. (cotyledon)	1	
Vicia cf. *sativa* L. (cotyledon)		1
cf. *Vicia sativa* L.		1
cf. *Vicia sativa* L. (partial seed <1/3)		1
Vicia sp.	4	3
Vicia sp. (cotyledon)	3	2
Vicia sp. (partial seed <1/3)	5	2
Fruits/nuts		
Cucumis cf. *melo* (apical tip)	1	
Cucumis cf. *melo* (seed)	1	
Ficus carica L. achenes (mineralised)	25	
Ficus carica L. achenes (carbonised)	1	
Ficus carica L. Mesocarp (fragment)	1	1
Juglans regia L. (shell fragment)	4	2
Olea europea L. (whole endocarp)	22	5
Olea europea L. (endocarp fragment)	362	28
Pinus pinea L. (shell fragment)		1
Vitis vinifera L. (fruit fragments)	9	1
Vitis vinifera L. (petiole)	3	

	Flotation (Residue and Flot Data combined)	In situ/handpicked
Vitis vinifera L. seed	20	15
Vitis vinifera L. seed (fragment)	28	51
Vitis vinifera L. seed (mineralised)	4	1
Vitis vinifera L. seed fragment (mineralised)	8	7
Unidentified fruit flesh (fragments)	6	
Fruit exocarp	8	
Weeds		
Apiaceae	2	
Lamiaceae	2	
Ornithopus perpusillus L./*sativus* Brot.	2	
Panicoid	1	1
Polygonum sp. (mineralised)	1	
Rumex sp.	1	
Solanum nigrum L.	1	
Solanum nigrum L. (mineralised)	1	
Plant parts		
Thorns	6	
Indeterminate carbonised plant remains	45	1
Total	631	139

Table 11.3. Presence and absence of recovered archaeobotanical material by phase.

							Phase				
Taxa	Fruit		1	2	3	4	5	6	7	8	9
Cucumis L.	Melon	c	-	-	-	-	-	x	-	-	-
Cucumis L.	Melon	m	-	-	-	-	-	-	-	-	-
Ficus carica L.	Fig	m	-	x	x	-	-	-	-	-	-
Ficus carica L.	Fig	c	-	-	-	-	x	-	-	-	-
Ficus carica L.	Mesocarp	c	-	x	x	-	-	-	-	-	-
Olea europea L.	Olive	c	-	x	x	-	x	x	-	-	-
Vitis vinifera L.	Grape	c	-	x	x	-	x	x	-	-	-
Vitis vinifera L.	Grape	m	-	x	-	-	x	x	-	-	-
	Vascular tissue indeterminate	c	-	-	-	-	-	x	-	-	-
	Fruit exocarp	c	-	x	-	-	x	-	-	-	-
	Nuts		-	-	-	-	-	-	-	-	-
Juglans regia L.	Walnut	c	-	-	-	-	x	x	-	-	-
Pinus pinea L.	Pinenut	c	-	-	-	-	x	-	-	-	-
Nut shell	Nuts (generic)	c	-	-	-	-	-	-	-	-	-
	Cereals		-	-	-	-	-	-	-	-	-
T. aestivum/T.durum L.	free-threshing wheat	c	-	-	x	-	-	-	-	-	-
T. cf. *aestivum/T.durum* L.	free-threshing wheat	c	-	-	-	-	x	x	-	-	-
cf. *T. aestivum/durum* L.	free-threshing wheat	c	-	-	-	-	-	-	-	-	-

Taxa	Fruit		Phase 1	2	3	4	5	6	7	8	9
T. dicoccum Schübl.	Emmer wheat	c	-	-	x	-	-	-	-	-	-
T. cf. dicoccum Schübl.	Emmer wheat	c	-	-	x	-	x	x	-	-	-
T. cf. monoccocum	Einkorn	c	-	-	-	-	-	-	x	-	-
Triticum sp	Wheat	c	-	x	x	-	x	x	-	-	-
Panicum miliaceum L.	Common millet	c	-	-	x	-	x	-	-	-	-
Panicum miliaceum L.	Common millet	m	-	-	-	-	-	-	-	-	-
Panicum cf. *miliaceum* L.	Panicum	c	-	-	-	-	x	x	-	-	-
Panicum sp	Panicum	c	-	-	-	-	-	x	-	-	-
Setaria italica Beauv.	Italian millet	c	-	-	-	-	x	-	-	-	-
cf. *Setaria italica* Beauv.	Italian millet	c	-	-	x	-	-	x	-	-	-
	Pulses		-	-	-	-	-	-	-	-	-
Cicer arietinum L.	Chickpea	c	-	-	-	-	-	-	-	-	-
Lens culinaris Medik.	lentil	c	-	-	x	-	x	x	-	-	-
Lens culinaris Medik.	lentil	m	-	-	-	-	-	x	-	-	-
Vicia cf. *ervilia* (L.) Willd.	Bitter vetch	c	-	-	-	-	-	x	-	-	-
Vicia cf. *faba* L.	Broadbean	c	-	-	-	-	-	-	-	-	-
Vicia sativa L.	common vetch	c	-	-	-	-	x	-	-	-	-
Vicia cf. *sativa* L.	common vetch	c	-	-	-	-	-	x	-	-	-
cf. *Vicia sativa* L.	common vetch	c	-	-	-	-	-	x	-	-	-
Vicia sp.	vetch	c	-	x	x	-	x	x	-	-	-
	Grasses		-	-	-	-	-	-	-	-	-
Panicoid	Grass-like	c	-	-	-	-	-	x	-	-	-
	Weeds		-	-	-	-	-	-	-	-	-
Apiaceae		c	-	-	-	-	-	-	-	-	-
Agrostemma githago	Corncockle	m	-	-	-	-	-	-	-	-	-
Lamiaceae		c	-	-	-	-	-	x	-	x	-
Lithospermum/Buglossoides		m	-	-	-	-	-	-	-	-	-
Ornithopus perpusillus/sativus	Bird's Foot	c	-	-	-	-	x	x	-	-	-
Polygonum sp.		c	-	x	-	-	-	-	-	-	-
Polygonum sp.		m	-	-	-	-	-	-	-	-	-
Solanum nigrum L.		c	-	-	-	-	x	-	-	-	-
Solanum nigrum L.		m	-	-	-	-	-	x	x	-	-
Rumex	Dock	c	-	-	-	-	-	x	-	-	-
Umbelliferae	Daisy family	c	-	-	-	-	-	x	-	-	-
Cupressus sempervirens L.	Cypress	c	-	-	-	-	-	-	-	-	-
	Thorn	c	-	x	-	-	x	-	-	-	-
	Indeterminate	c	-	x	x	-	x	x	-	x	-

carbonised c

mineralised m

'use-life' of the spaces. Instead we must conclude that archaeobotanical remains appear to have become part of the archaeological record mainly in leveling deposits during periods of construction and alteration in the area of the atrium. This is also seen in the few remains that were also recovered from the commercial areas opening on to the Via Consolare (N=3.12 from Room 2; N=57.41 from Rooms 3 and 4), which is hardly surprising as neither space has extensive levelling layers, and the build-up of deposits in the northern shop is the result of ashy deposits associated with metalworking. Surprisingly, the garden area of the Casa del Chirurgo produced few recovered archaeobotanical remains despite the suggestion by ancient literary sources that many meals were taken *alfresco* in the garden during the warm months, with daily offerings also made to the household gods.[6] However, the very poor preservation conditions in the garden area certainly impacted upon the archaeobotanical results.

Discussion

The majority of contexts examined from the Casa del Chirurgo produced one to two taxa of preserved botanical remains.[7] When viewed as a whole, the recovered archaeobotanical assemblage provides evidence of day-to-day 'background noise' of a standard Mediterranean assemblage, which included olives, wheat, legumes, grapes, and figs. The preserved food remains recovered likely represent incidental food waste from consumption or the final stages of food preparation that were incorporated into levelling deposits during periods of construction as opposed to specific deposits or contexts of interest, such as a foundation ritual deposit, drains, ritual offerings, or fodder.[8] Despite its status initially as an elite and then as a relatively wealthy property, no spices or exotic food items were recovered, unlike in its larger and more lavish neighbour, the Casa delle Vestali, in which a more exotic range of archaeobotanical material was recovered.[9]

It cannot be entirely discounted that some of the charred archaeobotanical background scatter may be composed of burnt offerings re-worked into the archaeological matrix.[10] The recent archaeobotanical analysis from the necropolis at the Porta Nocera, revealed that the majority of burnt funerary offerings were composed of standard Mediterranean fare.[11] Hence, it would be difficult to discern those food items created as burnt offerings – perhaps in the *hortus* of the property – and those that were disposed of due

to culinary accidents if they were deposited in the same archaeological matrix.[12] Furthermore, given the amount of material that comes from levelling layers and activities undertaken during phases of construction, any material that does, in fact, derive from actions undertaken within this property, surely has been lost within the general background noise of material being introduced into the soil matricies from diverse, and unidentifiable locales. On the whole, therefore, it seems appropriate to interpret most of the ecofactual data recovered as deriving from materials brought in from outside of the Casa del Chirurgo and therefore not specifically related to activities within the house itself. This is emphasised by the decided lack of archaeobotanical material from the service rooms of the property and during the final phases – precisely those areas that would have tended to produce archaeobotanical residues.

Conclusions

The relative paucity of macrobotanical remains recovered from the Casa del Chirurgo may be attributed to several factors, the most important of which was the presence of intact mosaic and *opus signinum* floors throughout the property, which were likely kept clean with the systematic collection and removal of this rubbish to areas outside the city walls.[13] Consequently, it is unlikely that botanical materials were incorporated into the archaeological record on a 'day-to-day' basis, perhaps with the exception of sacrificial remains from the hortus, which due to the turbation of the soils in this area are unlikely to have remained as discrete entities.[14] The main opportunity for the incorporation of archaeobotanical remains was likely to have been during phases of building and redevelopment, and in particular, during the type of work in which deposits were added, such as the filling in of pits and the laying down of levelling layers. Nevertheless, it is surely significant that the limited remains recovered do seem to suggest a standard Mediterranean diet, albeit one that was deficient in exotic taxa.

The archaeobotanical evidence would further suggest that there were limited opportunities for the preservation of foodstuffs, as the crucial preparation stages during which this might happen simply did not occur inside the Casa del Chirurgo. No substantial evidence of cereal crop-processing remains has been recovered from within the city of Pompeii during the latter phases of its history. This is in direct contrast to the early years of Pompeii, during which food

processing seems to have taken place inside the houses.[15] Consequently, during the latter years of Pompeii's life, the final consumable forms of food such as loaves of bread were likely purchased directly from nearby bakeries rather than made within the house, where the is also no evidence to indicate the presence of a bread oven.[16] Indeed, it is likely that bakeries received cereal grains already dehusked from their rural suppliers in the surrounding hinterland.[17] Hence, it now appears instead of what had previously been a routine domestic task, the final stages of cleaning/ de-husking cereals for daily use within or near the household, can be read as an index of the development of complexity and of urbanisation. This provides clear evidence of the visible separation of the division of tasks between the countryside and city, and the supply mechanisms that ensured that it was fed.[18]

Notes

1 General thanks and acknowledgement to all the hard work contributed by staff and students over the course of the AAPP working on the ecofact material, particularly the archaeobotanical remains. Thanks to Dr. Dorian Q. Fuller and Dr. Michéle Wollstonecroft for their helpful comments on early drafts of this chapter. Finally, thanks to Prof. Pietro Giovanni Guzzo, Dott. Antonio D'Ambrosio, the helpful *custodi* and laboratory staff of the Soprintendenza Archeologica di Pompei, particularly the late Prof.ssa Annamaria Ciarallo for the kind use of the laboratory facilities over the course of the AAPP field seasons in Pompeii. Also, thanks are due to the European Research Council (ERC AdG. 323842 "ComPAg" 2013–2018).

2 For collection methodology cf. Chapter 2.

3 For Insula VI 1 see Ciaraldi and Richardson 2000; Jones 2008; For Pompeii in general see Foss 1997; Matterne and Derreumaux 2008; Mau 1902.

4 Corrected for fragmentation rate equals N= 55.5 whole olive endocarps.

5 Margaritis and Jones 2008.

6 For examples and ancient citations cf. Foss 1997.

7 Murphy 2011, 437.

8 Murphy *et al.* 2013, 416.

9 Ciaraldi and Richardson 2000; Ciaraldi 2001, 2005.

10 Robinson 2002.

11 Matterne and Derreumaux 2008, 105.

12 Murphy 2011, 442.

13 See Richardson this volume; Ciaraldi and Richardson 2000, 81; Richardson *et al.* 1997, 94.

14 Unlike in the House of Amarantus Fulford *et al.* 1999, 46, or those identified by Robinson 2002 and Hesse 2016.

15 Ciaraldi 2001, 2005.

16 It must be noted, however, that the cooking platform in the kitchen (Room 13) was heavily restored during the modern period, which may have removed evidence for such a feature. In contrast the cooking platform from the neighbouring Casa delle Vestali does preserve evidence of an arched feature that may well be a small oven in which bread could have been baked.

17 Murphy *et al.* 2013, 416.

18 Murphy *et al.* 2013, 416–417.

12

FUEL AND TIMBER IN THE CASA DEL CHIRURGO

Robyn Veal[1]

Overview

Carbonised wood remains collected during the AAPP excavations in the Casa del Chirurgo contribute to an understanding of the wood and fuel economy both of the house and the wider city through taxonomic identification and examination of wood cropping indicators. Through close reading of individual context details in association with charcoal analysis, assessment can often be made as to whether the remains represent fuel in the forms of burnt wood or charcoal, or burnt timber either from construction or furniture. Small (<1 cm in length) wood charcoal recovered by sieving will often represent the remains of fuel that has been consumed domestically for cooking and heating, although there are other types of activities, such as domestic craft production, which can result in the deposition of fuel refuse in a Roman building. Larger charcoals often represent building timbers, or alternatively, unburnt charcoal fuel in an industrial/ production context. The destruction of a structure means that wood fuel remains may become mixed with timbers from construction and furniture, muddying interpretation (i.e. as to whether the remains originated as timber or fuel). In this study charcoals collected from seven of the nine phases of the Casa del Chirurgo were analysed. No charcoal was examined from Phase 1 (Natural), or Phase 4 (c. 100 BC – 50 BC).[2] The high state of preservation of the material permitted identification to genus and even species level in some cases, with at least 17 wood types represented. The size of the branch of origin could also often be estimated.

The most important wood in the assemblage was found to be *Fagus sylvatica* (beech) constituting around 50% of wood use from the earliest to the latest phase.

It likely originated from raw wood and charcoal fuel. A secondary group of woods, used as fuels and probably occasionally as timber, was characterised by the oaks (both deciduous and evergreen, i.e. *Quercus* spp.), hornbeams (*Carpinus* spp.), and maples (*Acer* spp.). A further trend was the occurrence of fruit and nut woods, likely used as kindling, which increased in number and variety over time. In Phase 7, the normal fuel consumption pattern is supplanted by a different range of woods dominated by *Abies alba* (alpine fir), of a dimension that its use as timber is strongly suggested. This result supports the identification of damage suffered by the house during the earthquake of AD 62/3.[3] Overall, the results demonstrate the cropping of timber from the highest altitudes of the Apennine Mountains (beech and alpine fir), from the mid and lower slopes (and plain) of an oak-based mixed deciduous woodland, and from the lower slopes to nearby (and even in the household garden) for the fruit and nut orchard cuttings.

Depositional environment and sampling

Kitchen and cooking activities are usually the primary means by which charcoal is introduced into the Roman archaeological record. Also to be considered are: heating, of rooms and/or water for bathing suite(s); building activities (e.g. making of lime); ritual or craft production activities (which are often associated with domestic structures); reuse of burnt charcoal for sanitation or garden fertilisation (which might be site externally sourced); and major fire events. Most of the

excavated charcoal analysed in this study arises from mixed secondary fills, mostly the result of activities local to the house, although re-deposition of material from other areas nearby during construction and terracing activities,[4] or the destruction level pyroclastic surges cannot be discounted. During excavation, charcoal was collected by hand, through meticulous dry sieving over 5 mm mesh of all soils, and by flotation. Charcoal is ubiquitous in urban Pompeii, occurring in about two-thirds of all contexts, in varying quantities, from only a few fragments to several hundred, per context.

Due to the large quantity of charcoal available, only dry-sieved and hand collected fragments were considered for analysis and even this dataset required sub-sampling at the microscope. It is a particular difficulty with charcoal that its fragile nature means that fragmentation continues post-excavation. Sub-sampling of the available material is necessary in order to provide a timely and cost-efficient analysis. A preliminary test conducted on flotation charcoal from the Casa delle Vestali demonstrated a preservation

bias towards sturdier wood types, suggesting that it is better to analyse dry-sieved charcoal as this collection methodology tends to retain less robust woods.[5] This test also provided a sound basis for sub-sampling by demonstrating that around 250 fragments/century produced a reliable and repeatable result. This is proven by the use of a saturation curve that plots a count for each individual fragment on the x-axis, against a count of new taxa on the y-axis. Typically this curve flattens out as fewer new taxa are found; the graph is often drawn using a log scale.[6]

The present study is based upon the detailed results of 809 fragments of charcoal from 55 contexts from the Casa del Chrirurgo. Figure 12.1 shows the spatial areas reported here for charcoal and figure 12.2 shows the related saturation curve. This demonstrates the adequacy of the sampling strategy since no more new taxa are found for approximately the last 20% of fragments analysed. This does not necessarily mean that all taxa have been discovered, as very small and unidentifiable fragments may include taxa not identified, however, these are unlikely to have been significant.

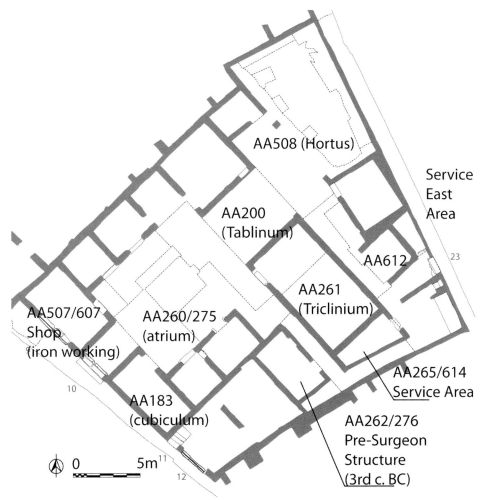

Figure 12.1. Areas sub-sampled from collected charcoals within the Casa del Chirurgo (illustration R. Veal).

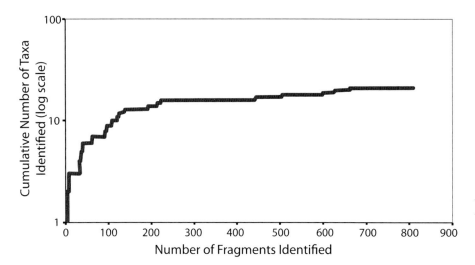

Figure 12.2. Identification saturation curve for 809 fragments (55 contexts) from the Casa del Chirurgo. No new taxa were found for approximately the last 20% of the assemblage (illustration R. Veal).

Charcoal analysis

Charcoal is analysed by identifying charred wood cellular structures under reflective light microscopy.[7] Identification is made by comparison with wood atlases[8] and modern reference charcoal.[9] The structures closely resemble those of wood in its natural state and so identification is sometimes possible to species level. Where this is not possible, identification to the most refined level possible (genus, sub-family, or family level) is made. Interpretation is further assisted by the use of regional flora guides. The nomenclature used in this study follows IPNI, the International Plant Name Index.[10] Charcoal results are computed either by fragment count (per wood type), if numbers of fragments to be identified are sufficient, or by weight. In this study fragment count was employed.

The analysis of tree rings in charcoal scholarship is a developing field.[11] During identification, observations were made of the cropping indicators, i.e. annual growth ring counts, rates of growth, and their curvature. Results allow broad comparative information to be collated, i.e. whether 'small,' 'medium,' or 'large' wood has been used. For the best results, heartwood (pith) and bark should be observed, but these were rarely seen in the charcoal from the Casa del Chirurgo. Estimates are also possible for fragments where a significant portion of the diameter is preserved (i.e. 'incomplete' fragments) and in these cases, the diameter recorded is the *minimum* size of the branch or stem from which the charcoal originated. Tree ring curves were estimated on a scale from 1 (flat) to 5 (highly curved),[12] indicating the use of a range of wood sizes from stem/large branch wood, medium-sized branches, and small branches/ twigs. This is a subjective process. Measurements in millimetres across observed tree rings of partial branches were taken where possible in order to calculate average annual growth rates (aAGRs) for those rings observable. Very small average AGRs indicate very slow to slow grown wood (<1–2 mm) and sometimes, but not always, older wood; larger average AGRs (>3–5 mm or more) show moderate to faster growing wood, which may be associated with coppicing.[13]

Woods were classified into the following groups:

<10 mm diameter = twig
10–30 mm diameter = small branch
31–50 mm diameter = medium branch
> 50 mm = large branch or small stem (trunk)

It should be noted that these are the measurements observed directly from the charcoal and the actual green measurements of the wood prior to charring would be some 10–15% longer and up to 25% larger in diameter.[14]

Overview of results

Woods identified

Figure 12.3 tabulates the results of the wood identifications by phase. Indeterminate types are so classified if they crumbled to a size too small for analysis upon preparation, or if they had poorly observable features. On average, nearly 18% of the fragments observed were indeterminate, mostly due to them being too heavily burnt. It is likely that they were all one of the woods already identified. This is a reasonable rate of indeterminate fragments (15% is common in the author's experience in Pompeii) and reflects the good

level of preservation and general ease of identification due to the size of most fragments. It is interesting to note that the indeterminate rates for the earlier phases (Phases 2 and 3) are higher at over 20% than those for later phases (Phases 6–9), which drop to between 9–12%. This is a general trend in other studies in Pompeii and possibly represents higher fragmentation rates occurring as a result of cutting and levelling activities in the third to second centuries BC.

Beech (*Fagus sylvatica*), is the major taxon through time (50%), constituting most likely, raw wood, or charcoal fuel. Beech is less likely to have been used in construction, being less resistant to insect attack or breakdown in air than oak, alpine fir, and other woods used in building, although some of the furniture at Herculaneum was made of beech.[15] The most important secondary fuel woods are the oaks, both evergreen and deciduous, (*Quercus* spp.) and the hornbeams (*Carpinus betulus, C. orientalis*, and one fragment of *Ostrya carpinifolia*). Very small numbers of ash (*Fraxinus* spp.), alder (*Alnus* sp.), and elm (*Ulmus* sp.) were also observed. Some of these woods may be timbers, rather than fuel woods. A significant quantity of maple (*Acer* spp.), and grapevine (*Vitis vinifera*) were also identified. Besides the primary and secondary woods, a range of nut and fruit woods were found, and these increase in diversity through time.

Results by phase

Figure 12.3 graphs the results by phase by grouping the woods into primary and secondary fuel sources, fruits/nuts, and conifers. These patterns conform in general with the overall patterns for Pompeii.[16]

Phase 2 (c. fifth to end of the third century BC)

This phase covers roughly 250 years and includes both the levelling activity for the construction of the Pre-Surgeon Structure and the use period of the early building itself. Since the levelling activities do not appear to include destruction/burning of any other structure, it is reasonable to infer that the wood fragments observed constitute mostly fuel remains, or potentially timber offcuts used as fuel. Beech is 50% of the assemblage, with maple (probably the native Italian maple *Acer opalus*), around 25%. Very low numbers (1–4 fragments) of oaks and hornbeam were observed. The diameters of the beech and maple are rather large (flat, or mildly curved tree rings) in comparison with wood fuel diameters in later periods. This reflects a trend becoming observable in studies underway in Pompeii and on the slopes of Vesuvius.[17] In the so-called "Samnite period" (late fifth to mid-third century BC) of Pompeii's life, fuel wood does not seem to reflect the use of exclusively small to medium-sized woods, a pattern of use that would

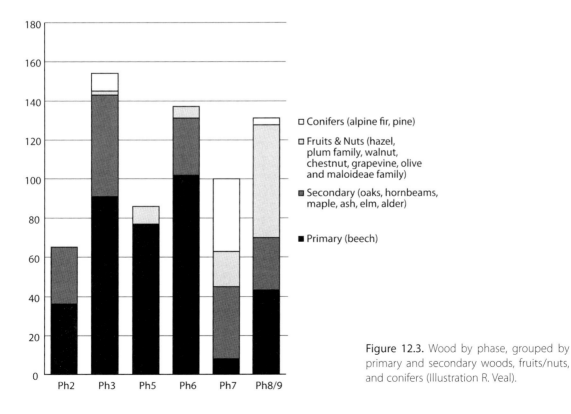

Figure 12.3. Wood by phase, grouped by primary and secondary woods, fruits/nuts, and conifers (Illustration R. Veal).

Table 12.1. Summary wood charcoal identification results by phase (no data for phases 1 or 4).

Name	Count	Taxon % of Total	Ph2	Ph3	Ph5	Ph6	Ph7	Ph8	Ph9
Fagus sylvatica	357	53.7%	36	91	77	102	8	0	43
Quercus (decid)	12	1.8%	1	10	0	1	0	0	0
Quercus (evergr)	38	5.7%	3	23	8	0	4	0	0
Quercus (indist)	1	0.2%	0	0	0	0	1	0	0
Castanea sativa	2	0.3%	0	0	0	0	2	0	0
Fagaceae	1	0.2%	1	0	0	0	0	0	0
Ostrya carpinifolia	1	0.2%	0	0	0	0	0	0	1
Carpinus sp.	65	9.8%	4	8	14	27	11	0	1
Corylus avellana	9	1.4%	0	0	7	0	2	0	0
Corylaceae	1	0.2%	0	0	0	1	0	0	0
Alnus sp.	6	0.9%	0	0	0	1	0	0	5
Acer sp.	50	7.5%	20	8	6	8	7	0	1
Maloideae	6	0.9%	0	2	1	2	1	0	0
Juglans regia	1	0.2%	0	0	0	0	1	0	0
Vitis vinifera	54	8.1%	0	0	1	0	12	40	1
Olea europea	3	0.5%	0	0	0	3	0	0	0
Fraxinus sp.	6	0.9%	0	1	1	0	4	0	0
Ulmus sp.	3	0.5%	0	2	0	0	0	0	1
Abies alba	40	6.0%	0	0	0	0	37	0	3
Pinus sp.	5	0.8%	0	5	0	0	0	0	0
Coniferale	4	0.6%	0	4	0	0	0	0	0
Indeterminate	144		18	54	24	20	17	4	7
TOTAL	809	100%	83	208	139	165	107	44	63
Average % Indeterminate	17.8%								
% Indeterminate / Phase			21.7%	26.0%	17.3%	12%	16%	9%	11%
Diversity / Phase			5	10	8	8	12	1	8

tend to indicate highly managed woodland. Instead, a picture of a city not yet putting strong pressure on its natural wood resources suggests that there was little need for woodland management.[18]

Phase 3 (c. 200–130 BC)
This phase incorporates the destruction of the Pre-Surgeon Structure, significant levelling activities and the construction of the core of the Casa del Chirurgo, as well as the early years of the use of the house. Beech constitutes slightly less than 50%, with modest quantities of evergreen and deciduous oaks, hornbeam, and maple, and small numbers of ash and elm. The Conifer is likely alpine fir (*Abies alba*). Where measurable, the originating wood sizes range from many small and medium branches, to a few of much larger dimensions. The alpine fir is of large dimensions,

suggesting its use as timber. Additionally, conifers in general are poorer fuels than most deciduous hardwoods, as their resinous nature makes them spit, smoke, and burn quickly. Fir is observed and interpreted as roof timber in Insula VII 6[19] and fir has also been reported elsewhere in Pompeii.[20] Some evergreen oak, from very large branch(es) or trunk(s), also likely originated as construction timber. Structurally, it is not possible to differentiate *Q. ilex* from the other native Italian evergreens, *Q. suber* (cork), and *Q. coccifera*, however, the growth habits of the latter two types (being considerably shorter), would preclude their use in the production of large and long oak timbers. Evergreen oak, being durable and straight, is the wood most likely under observation, agreeing with Vitruvius who declares *Q. ilex* (holm oak) to be of "great use in building".[21] The second century flowering of building

activities in Pompeii appears to go hand in hand with signs of quite managed woodland for fuel use.

Phase 4 (c. 100–50 BC)
As previously noted, data were not found for Phase 4 as there were only three soil deposits in this phase from which no charcoal was collected. This is not a large limitation to the overall analysis.

Phase 5 (late first century BC to early first century AD)
Woods in this phase follow the pattern observed in Phase 3. Beech is still about 50%, with reasonable numbers of evergreen oak, hornbeam, and hazel (*Corylus avellana*), which is observed for the first time. Hazel is the quintessential 'coppice' or small wood fuel, in Europe, with its natural growth normally kept small or medium-sized. It was also routinely used in 'wattle and daub' construction for internal walls and ceilings. In the Casa del Chirurgo, however, we do not see large quantities of it. Some of the charcoal fragments are very damaged and 'rumbled,' likely reflecting reworking/deposition as a result of the building work going on in this period, or maybe the direct result of the redeposition of materials from outside of the Casa del Chirurgo as a component of construction. Much of the beech is quite large in size and it is in this phase that an iron workshop operates in the northern shop (Room 2). The beech charcoal recovered from the associated deposits was very orange-stained, suggesting the presence of ferrous or ferric ions, and the fuel, if iron smithing was occurring, would have had to have been charcoal for the appropriate temperatures to be reached.[22] No other contexts contained orange-stained charcoal in Insula VI 1, except those associated with metal working.[23]

Phase 6 (c. mid-first century AD)
Signs of the ironworking continue into this period with large, orange-stained beech being present. Beech again constitutes the major wood type found, comprising slightly less than 50% of the assemblage. Modest quantities of hornbeam and maple are found. The wood identified as being from the Maloideae family is one of the apple/pear/dogwood (*Malus* sp./*Pyrus* sp./*Crateagus* sp.) group. These are probably cuttings from fruit trees and/or small building elements used for fuel. The olive (*Olea europaea*) charcoal probably also came from cuttings, or perhaps more remotely, from small timber elements consumed as fuel.

Phase 7 (post AD 62/3 earthquake)
The pattern for this phase is remarkably different to the previous ones as the normal fuel consumption pattern of primary beech, and secondary oaks, hornbeams, and some maple is obscured. In this phase, beech represents less than 10% of the assemblage, which is dominated by a large quantity of alpine fir (c. 30%) of large diameter, and evergreen oak (also of large diameter), and some hornbeam (useful as timber or fuel). Ash and chestnut (*Castanea sativa*) are present in small quantities, with chestnut appearing for the first time in this period in the house: it is not found elsewhere in Pompeii in great quantity. Grapevine (*Vitis vinifera*) appears in quantity here and in Phase 8. The wood charcoal from this phase suggests that the earthquake caused significant damage to the Casa del Chirurgo. A localised fire may have broken out as a result of the tremors that might have burned the roof. In rebuilding, damaged timber woods may have been burnt in situ or been recycled for fuel. Additional evidence of a fire is evident in Rooms 3 and 4 where the Sarno stone headers are blackened, and the generally poor level of preservation on the southern side of the property itself may be the result of just this sort of damage to the upper stories in this area. Grapevine from contexts 262.003 and 262.017 may represent a damaged plant burnt completely (small and medium-sized branches were observed), or small and large cuttings from a surviving one. Further grapevine, in significant quantity, is also found in the next phase.

Phases 8 (AD 79 – 19th century AD) and Phase 9 (modern)
While for the most part the deposits of these two periods are the results of modern activities, they may also contain some surviving remains of the final moments of the life of the Casa del Chirurgo and the eruption of AD 79, jumbled with debris from the early excavations and modern period. While the presence of modern material in these deposits means that some of the charcoal remains are also possibly modern, ecological and preservational evidence strongly suggests that much of the charcoal may actually be of ancient origin (i.e. AD 79 or even earlier). Certainly during the excavation, the remains of small fires with modern contaminating material were occasionally noted in the uppermost levels, the result of one means of disposing of gardening clippings and other rubbish that occurred in the recent past. Such activity would likely introduce modern carbonised wood into the mix of these soils. However, the trees and shrubs currently growing in the garden currently consist of a mature cypress (*Cupressus sempervirens*) and some box (*Buxus* sp.), as well as other small shrubs of the Rosaceae family, while growing nearby Insula VI 1 are fig (*Ficus carica*) and oleander (*Nerium oleander*), which are endemic

to Campania. It is significant that none of these were recovered in the charcoal from the Casa del Chirurgo. Furthermore, beech, fir, and hornbeam require high altitudes in central and southern Italy, and certainly in the modern period, there are no specimens anywhere nearby. Regarding the very small elements of other woods not already presented in this discussion that are present – alder and elm – we may note that very little elm has been recovered from ancient Pompeii and although alder is present in these assemblages, it is not currently grown nearby.

It may therefore still be possible through this evidence to gain a general view of the last period of the house's occupation or the general nature of deposits blown into the structure during the pyroclastic flows of the eruption from the study of this material. As this situation excludes considerations of phasing by bioarchaeological means they are graphed together. Phase 8 consists exclusively of grapevine,[24] although in this instance (context 275.015) only very small diameter cuttings of 2–3 years were observed, compared with the larger grapevine material in Phase 7. This context (275.015) was a fill of a sub-floor cistern.

The beech observed in Phase 9 constitutes two-thirds of the charcoals for this context and the originating branches range in size from twigs to small and medium-sized branches, as well as one larger (80 mm) one. Some of the beech (for example from 508.15 located in the hortus) has insect holes suggesting the presence of dead wood. One interpretation is the possibility of raw beech wood or charcoal fuel stored in or near the garden area. We must further allow for the possibility of the movement of, especially outside materials, from their original locations, as a result of the force of the pyroclastic flows. Small quantities of a range of other woods are observed: hornbeam, alder, elm, and alpine fir. These could be timber from furniture, indoor or outdoor, other construction elements, or potentially garden tree remains – some of which may have been relocated from areas outside the Casa del Chirurgo.

Ecology and economic interpretation

High altitude forest: Abies alba (silver/alpine fir), *Fagus sylvatica* (beech).

Alpine fir, which was likely used exclusively as timber, and beech, which was mostly consumed as fuel,[25] together constitute the highest ecological niche in modern Italian forest ecology (above about 1000 m in central Italy)[26] and thus likely originated from

the highest reaches of the Apennine Mountains. They would have required considerable resources to grow, crop, and transport. These assumptions are based in part on new confidence that the Roman climate was not overly dissimilar to that of today.[27]

Mid and low slopes (managed) forest medium-large trees: Quercus spp. (oaks), *Carpinus betulus/orientalis*, *Ostrya carpinifolia* (hornbeams), *Acer* spp. (cf. *campestre* type, *pseudoplatanus* type, or *A. obtusatum*) (maples), *Fraxinus* sp. *(ash), Ulmus* cf. *glabra* (elm), *Alder* cf. *cordata* (Italian alder).

Of the woods identified, *Carpinus betulus* prefers the mid- to higher mountain reaches and is found close to beech. It is the hardest of the woods named, with its related cousins *C. orientalis* and *O. carpinifolia*, offering timbers of similar durability but of slightly lesser height and girth. All are suitable both as fuel and as timber, but for the most part they appear to be mostly used as fuel in the Casa del Chirurgo due to their small to medium-sized branches.[28] At least two maples are observed. Both *A. pseudoplatanus* (type) and *A. obtusatum*, grow at relatively high altitudes,[29] while *Fraxinus* sp. (ash), tends to prefer slightly lower altitudes. Maple is a good hard wood used for building, furniture, and also for wood fuel; it also makes good charcoal.[30] *Ulmus* sp. (elm) is likely *U. glabra*, a timber that prefers a wet environment close to a river or stream, as does *Alnus* cf. *cordata* (alder).

It is often possible to differentiate between deciduous and evergreen oaks, but not usually between the various oak species in each category. There are a variety of deciduous oaks in Italy and many of them hybridise to some extent, making identification to species level problematic. Oak had many functions in the ancient world, as it still does today. Its low presence in the assemblage from the Casa del Chirurgo is therefore interesting and can perhaps be accounted for by its use mostly as timber, at least in the case of the evergreen material. Besides being one of the highest calorific value woods and making excellent charcoal, it was also used for furniture and building.[31] Its leaves, especially of the deciduous types, are highly palatable to all herd animals, and its acorns were used to fatten pigs in particular.[32] Acorn flour was also used in cooking.[33]

The woods that grew on the low-mid slopes of the approaches to the Apennine area were potentially 15–25 km away on the Lattari Mountains, or more distantly, the central Apennine Mountains. They could potentially have grown on Mount Vesuvius and would have also grown to some extent in the Sarno Plain, both inside and outside the city walls. On Vesuvius, and in

the plain, they would have been in competition with (especially) grapevines, olives, stone fruits, and cereals.

Smaller and cultivated trees and vines for fruits and nuts: Corylus avellana (hazel), Maloideae family (apple/pear/ dogwood group), Vitis Vinifera (grapevine), Olea europaea (olive), Juglans regia (walnut), Castanea sativa (chestnut).

Hazel had many uses: nuts for food for animals and humans, flour, stakes for agricultural supports, and wood for raw fuel and charcoal.[34] It could also be used in 'wattle and daub' construction of walls.[35] Similarly, the members of the Maloideae family could be grown for food (the fruit) and fuel as their heat values are in general as good as that of oak. The small quantities of olive, walnut, and chestnut suggest that their inclusion was accidental, or as potentially represents garden trees (most are from Phase 7).[36]

Conclusions

Wood supply areas included the highest reaches of the Apennine Mountains (above 1000 m, as evidenced by the presence of the high mountain types of alpine fir and beech), although most timber and fuel woods were sourced from the mid-slopes (c. 300–600 m). These wood types were also very probably present on the plain and would likely have grown on small and large farms and as woodland allotments, border trees in the city and plain, and in gardens inside and outside the city walls. Transport was probably by mule train down the mountain and possibly down the Sarno river (as it was on the Tiber), probably on a seasonal basis. A managed timber and wood fuel supply to Pompeii seems likely to have existed from at least the third century BC.

Notes

1 The laboratory work for this study was completed at the University of Sydney, Department of Archaeology, and the Pompeii environmental research laboratory ('Laboratorio per le ricerche applicate'). The report was drafted at the University of Sydney and finalised at the McDonald Institute for Archaeological Research, University of Cambridge. Thanks go to the staff of the Pompeii Soprintendenza laboratory for their interest and assistance: Directors (past and present, respectively) Dr Annamaria Ciarallo and Dr Ernesto de Carolis; and senior staff Antonio Stampone, and Luigi Buffone.

2 The lack of charcoal in Phase 4, a specific moment in time (as opposed to a date range) is unsurprising as few soil-based contexts relate to this phase.

3 We cannot completely discount the possibility of charred timbers from the eruption phase potentially being mixed in with the post earthquake phase by excavators.

4 See Richardson this volume, Chapter 10 and Murphy this volume, Chapter 11, for a discussion of the likelihood of former midden deposits being used as leveling layers in the Casa del Chirurgo.

5 Veal 2014. This suggests that charcoals originating from highly friable soils suggest flotation is not the most efficient method for charcoal recovery (although it will be essential for clay based or saturated soils).

6 Drennan 1996, 59.

7 Leney and Casteel 1975.

8 The IAWA handbooks for hardwood and softwood identification to Wheeler *et al.* 1989 and Richter *et al.* 2004 were used as the basis of nomenclature for recognising the possible macro and microscopic wood structures. Schweingrüber 1990 is the standard for European charcoal identification, as well as an online atlas; Schoch *et al.* 2004.

9 The reference collection includes woods collected from in and around Pompeii and the Apennine Mountains.

10 Flora d'Italia Pignatti 2003; http://www.ipni.org/ (last accessed 27th March 2017).

11 Ludemann 2003; 2006; Marguerie and Hunot 2007; Heiss and Oeggl 2008.

12 Marguerie and Hunot 2007.

13 Goodburn 2005 describes oak wood from a Roman well, which was 130 mm wide by 100 mm thick with an average AGR rate of about 3.5 mm/annum. He describes this as 'fast grown'. Gale 2005 examining charcoal describes average AGRs of 'about 3 mm/annum,' as 'slow to moderate growth,' while '6 mm' is considered 'fast.' Robinson 1979, cited in Smith 2002, describes wet wood oaks he examined as being 'coppiced' with 7 years of growth over a 75 mm diameter. This equates to an average AGR of about 5 mm. The presence of 'fast grown' wood, whatever the dimension chosen, cannot always be ascribed to 'coppicing,' and in this assemblage, very little fast grown wood was observed. This is an area that requires more research.

14 A charring trial of raw woods of various sizes and types, which measured changes in dimensions and weights, is given in Veal 2009. The diameter of the raw wood may shrink as little as 12% and up to 40% depending on the wood type and original branch dimensions; 25% is the average in the study, but for small oak branches, (c. 14 cm long and 2 cm in diameter), the shrinkage rate varied from 11–19%.

15 Mols 2002.

16 Veal 2012.

17 These studies include the Casa delle Vestali Veal 2014, the Casa di Amarantus (Challinor *pers. comm.*), the Porta Stabia, and beyond Pompeii at the Apolline Project (Vairo *et al.* 2015).

18 It should be noted, however, that this interpretation is based upon only 83 fragments and more work needs to be done on the early wood fuel economy of Pompeii before this can be definitively proven.

19 This will shortly be reported by the Via Consolare Project in Insula VII 6.

20 Moser *et al.* 2013. Work in progress also indicates fir in Herculaneum in significant quantities.

21 Vitruvius *de Arch.* 2.9.9.

22 Raw wood fires cannot reach the temperature for smelting iron (c. 1200° C). Smithing is carried out at lower temperatures but requires a constant heat also not easily achievable with raw wood. See Sim 2003.

23 Ferric/ferrous staining may potentially also occur in damp, iron rich soils (not observed at Pompeii). Archaeometric

studies are currently underway to test this hypothesis. Veal *et al.* 2011; Veal *et al.* 2016.

24 It may in fact be part of Phase 7, or vice versa; Cf. Chapter 4 for the difficulties in this regard, and the in Chapter 6 of Hilary Cool also suggests much more mixing of levels may have been occurring, than at first suspected.

25 Beech was the commonest fuel in Pompeii from the third century BC to the first century AD, and studies in other areas of the city confirm this trend, see Veal 2012, as does work currently underway by Challinor (*pers. comm.*) in the Casa di Amarantus. Beech is also a common component of fuel in bakeries in AD 79 (Coubray *pers. comm.*).

26 Veal 2012, 30–1.

27 See for example Büntgen *et al.* 2011; McCormick *et al.* 2012.

28 'Hardness' or durability usually corresponds with calorific potential (i.e. heat value). The specific gravity of a wood is a proxy for estimating hardness and calorific value, see Veal 2012, 33–5. Thus, the best building woods are also good fuel woods. The reverse is not true, however; good fuel woods such as beech, do not necessarily make good timber, if for example they are not resistant to insect attack or do not survive well in the atmosphere.

29 Pignatti 2003, 67–71.

30 Gale and Cutler 2000, 27.

31 Gale and Cutler 2000, 204–5.

32 Grove and Rackham 2001, 195.

33 Veal 2012, 32.

34 Grove and Rackham 2001, 88–9.

35 Graham 2004, 23.

36 Good correspondence between the wood charcoal and carpological taxa in a phase can suggest cuttings used from a tree maintained in a house's garden, but in the case of the Casa del Chirurgo the correspondence is low and does not relate to the latest dated levels and so this association is not well supported in this case.

13

THE ANCIENT CAMPANIAN ENVIRONMENT AND RESULTS FROM THE CASA DEL CHIRURGO

Robyn Veal and Charlene Murphy

Reconstructing the environment

Published records from Campania allow a reconstruction of the regional landscape using palynological, macrobotanical, and limited charcoal data. These, together with the historical record, permit us to frame a view of the local landscape. The environmental remains that could be identified from the Casa del Chirurgo may then be interpreted in light of the broader data and a more detailed understanding of Pompeii and its local environment may be obtained.

Climate and local pollen studies

Research has now arrived at a broad consensus that the amount of variability in the climate during the Roman period was reduced when compared with time periods before and after, particularly from the first century BC to the second century AD – the so-called 'Roman warming period'.[1] During this period the climate was not very dissimilar to that of today. Ecologically, the Mediterranean climate consists of hot dry summers and mild winters, but microclimate variation is considerable.[2] From pollen studies in areas not far from Pompeii,[3] some data can be gleaned to assess the ancient arboreal and agricultural conditions. Cold climate trees that typically exist at lower altitudes in northern Europe were restricted to the mountainous areas delineating the Campanian plain, i.e. Mount Vesuvius, the central Apennine range, and the Lattari Mountains. Examples of such taxa include: *Abies alba* (alpine or silver fir), above 1000 m, and *Fagus sylvatica*

(beech), from about 800 to 1000 m.[4] These three taxa are now reasonably rare in the mountain areas surrounding the plain due to anthropogenic pressures.[5] European *Larix* sp. (larch) does not occur naturally in Southern Italy and *Picea* sp. (spruce), while being present in much earlier time periods (c. 14,000 BC), had disappeared by the classical period. The mid-montane altitudes, 400 to 800 m, are thought to have been dominated by mixed deciduous forests of *Quercus* spp. (oaks), *Castanea sativa* (chestnut), *Alnus* spp. (alders), *Fraxinus* spp. (ash), *Ulmus* spp. (elms), *Acer* spp. (maples), and members of the closely related Corylaceae family: *Carpinus* spp. (hornbeams), *Ostrya carpinifolia* (hop hornbeam) and *Corylus avellana* (hazel). Evergreen oak was also present. Lower down, in the optimal agricultural climes from the plain to about 400 m, cereals (free-threshing wheat and glume wheat), millets (Italian and common millet), pulses (lentil and pea) and fruit and nut trees (fig and walnut) would likely have prevailed. Riverine species such as types of *Alnus* spp. (alders), and members of the Saliceae family – *Salix* spp. (willows) and *Populus* spp. (poplars) – would have commonly spread along the river flats, wherever agriculture did not occupy the fertile soil of *Campania Felix*. On the lower montane areas, the plain and woodland margins, more degraded forms of forest may also have also occurred, i.e. *macchia*.[6] Taxa from this environment include *Erica arborea* (tree heather), *Arbutus unedo* (strawberry tree), and *Pistacia* spp. Close by on the coast, various types of *Pinus* spp. (pines) and *Cupressus sempervirens* (cypress) grew. Some *macchia* species such as *Pistacia* spp. and *Arbutus* spp. may also have been grown for commercial

and medicinal use,[7] and were cultivated to some extent in city gardens and orchards.

Pollen preservation in Pompeii itself has generally been poor.[8] Even with improved recovery methods, based on the comparative modern soil samples taken from similar areas, the majority of ancient pollen appears to have been lost and "that necessarily makes any quantitative interpretation appear doubtful."[9] The examination of sediments from several excavated *ollae perforatae* from the garden area of the Casa del Chirurgo showed no pollen.[10] From the garden of the Casa delle Nozze di Ercole ed Ebe (VII 9, 47.48.51.65), Pompeii *Vitis* (grapevine) and a few pollen grains of *Citrus* (lemon) were identified.[11] A ground cover of herbs, similar to those found in the Vesuvian area today, was also evident.[12] The majority of the Campanian flora were and are, wind-pollinated species, therefore it is difficult to reconstruct the past vegetation from pollen for such small defined areas as gardens, and often not possible to specify which plants were grown in individual garden plots.[13] Other archaeological sources, however, do assist. These are summarised in a number of different publications,[14] and include Jashemski's[15] detailed archaeological examinations of root holes, and pollen, seed, fruits, and nuts from the gardens of Pompeii, which have contributed greatly to an understanding of the plants in the city grown for food, medicine, perfume, and shade.

Topography and soil fertility

The ancient coastline was considerably further inland than today,[16] probably less than 1 km from the city of Pompeii.[17] The Campanian plain is low-lying with some parts below sea level and thus areas around the Sarno would likely have been prone to flooding. Pompeii is set on the only landform of any height (at 30 m altitude), on a small ancient lava plateau.[18] The plain is bounded by the Lattari Mountains, about 15 km south, the Apennines, 20–25 km west, and Mount Vesuvius, 10 km north. Currently Vesuvius is about 1,200 m high, but it was naturally much higher prior to the AD 79 eruption. By simple visual projection of the remaining cone, its peak was at least 1,600–1,800 m, which accords with some of the studies of changes in Vesuvius' profile.[19] All of the mountains rise rapidly from the flat plain, with the first 300–400 m of gentle hills providing optimal space for agriculture. The middle and upper slopes have steeper inclines and are consequently more difficult to farm and for much of the more distant mountain areas it is likely that they

were covered by managed forest and food trees. Strabo describes the Campanian border as being at the edge of the cultivated areas in the hills (i.e. at about 300–400 m) and the local soils as being capable of supporting two to three crops per year.[20] The fertility of the slopes of Vesuvius is also depicted in the fresco of Bacchus from the Casa del Centenario (IX 8, 6.3.a) that shows a steep mountain covered with vines.

The exceptional fertility of the land is largely due to its spongy, volcanic earth. The palaeosols of Pompeii are rich in phosphorus and potash deposited over centuries of repeated volcanic eruptions and includes pumice, ash, volcanic glass, cindery grains, and some clastic material. The soils possess a high content of extractable nutrients including nitrogen, phosphorus, and potassium and have an alkaline pH throughout their profiles, likely due to Ca^{++} and Mg^{++} ions leaching into overlying materials and recharging the surface horizons of the palaeosols.[21] The soil composition also allows for the retention of the abundant seasonal rainfall and thus suffers no ill effects from the annual long summer droughts. All these factors contribute to the agricultural potential of these soils.[22] The favourable climate can be largely attributed to the moist, south-westerly winds which cross the plains and the mild, short winters. These factors make the region well-suited to viticulture and the growing of fruit and cereals. It was, however, access to the sea and the burgeoning maritime trade through Pompeii's port, as well as its location with respect to two main Roman roads, the Via Appia and the Via Latina, which helped make this region so prosperous and attractive to commercial exploitation in the later Republican and the Imperial periods.[23]

Ancient Campania

The environment surrounding Pompeii was lush and highly cultivated, probably with a strong dominance of the most valuable crops, such as grapes for wine. Other support crops for viticulture (chestnut and other wood types for stakes) would have been likely, with areas set aside for fruit, nut, and vegetable cultivation. This possibly included the raising of birds such as chickens, but also quail for villa consumption or sale.[24] Cereals, millets, and pulses would have been raised on the plain, as the more poorly drained soils at this low altitude would have been less optimal for vines. However, it is probable that farmers would have attempted vine growing in most places, even for smaller returns. Land suitable for vines includes some of the river plain and all of the low (and potentially to mid) mountain altitudes.

These areas would have been less likely to have been used extensively for meat production in this period, especially as the upper mountain areas on Vesuvius, the Lattari Mountains, and the Apennines, would have provided a suitable environment for raising pigs, sheep, and cattle, while also supporting deer and other wild animals for hunting. No precise data survive on where the domesticated animals were raised, despite ample evidence for meat consumption in Pompeii and in the Casa del Chirurgo. Significantly, little is known of Pompeii's relationship with its surrounding hinterland, including the *villa rusticae* and trade on the River Sarno, though it is likely to have been brisk if it was the port of Nola and Nuceria.[25] Some of the data reported from the Casa del Chirurgo give more weight to a regional agricultural economy, perhaps more specialised than has been previously reported.

The environmental evidence recovered

Within the Casa del Chirurgo, a range of environmental data were recovered, and most have been reported here: macrobotanicals/seeds (Murphy); charcoal (Veal); animal and bird bones (Richardson). All of these have been reported in varying degrees of detail. For seeds, charcoal, and animal bones, comprehensive recovery of remains was possible, although the seeds were very fragmented, while the charcoal was less so – a result in part due to differing recovery methods. Shells – both terrestrial and marine, and potentially, fluvial types – and fish bones were also recovered. At the time of writing these studies were not yet complete and will be reported separately.[26] Researchers reporting here have completed some parts of these studies as part of doctoral theses (Murphy and Veal) and most work has been completed on an unfunded basis. The collaboration during excavation and subsequently of the environmental team, together with the encouragement and direction of the post-excavation managers (Cool, Anderson, and Robinson) has assisted in bringing this study to fruition.

Ecofactual trends in the Chirurgo Assemblage

Possible trends in the Casa del Chirurgo itself

The food, fuel, and timber consumed within the Casa del Chirurgo provide a picture of a well-supplied house consuming the expected range of items in the Roman diet. Little support for a luxury diet is provided in the carpological remains, although the animal and bird bones provide some evidence of prime cuts and young animals being consumed. Within the bone assemblage, however, Richardson noted their more ordinary nature in the final years of the house's existence, in contrast with its earlier, possibly more elite beginnings. This is mirrored in the overall character of small finds recovered from the destruction of the Pre-Surgeon Structure in contrast to a more 'average' assemblage from later periods.[27] Indeed, the disordered state of the house in its final stages may be interpreted as evidence for some sort of decline. The lack of any seeds at all in this period speaks to both the possibility of fewer spaces being occupied during the renovation and to the very disturbed nature of the uppermost archaeological soils. The charcoal however, may provide a useful index for the state of the post-earthquake house. In this period, the 'normal' fuel signature is lost in the wood charcoal results, which are subsumed by large quantities of alpine fir that may derive from roof timbers, burnt either in fire caused by the earthquake(s) or in the disposal or reuse of broken elements of architecture and possibly furniture during the rebuilding process.

Phasing and trends over time

Phasing of necessity follows major events of building construction changes. Their varying temporal spans, in the case of the Casa del Chirurgo, range from an instant in time to c. 200 years in length, which can make attempts to find trends over time more difficult. Nevertheless, the organic finds do provide some trends that generally agree with those observable elsewhere in Pompeii and Roman Italy: the overall increase in the popularity of pork, perhaps also with a growth in utilisation of chicken meat and eggs, and the increase in diversity of fruits and nuts as seen primarily through the wood charcoal rather than the seeds. The increasing popularity of pork may suggest an increase in the range, size, and sophistication of farming concerns that raised these animals – from small sites that were perhaps quite local, to larger piggeries raising many animals on a highly organised basis. The expanding diversity of fruits and nuts seen in the Casa del Chirurgo, and across the city, commences in the first century BC and is roughly coeval with the foundation of the Roman colony.[28]

These trends provoke questions of how and where these foods may have been grown. Grapes were anecdotally important and De Simone[29] suggests that wine production was also an important factor in the Campanian agricultural economy. The evidence

from this study highlights a comparative advantage for growing grapes in the economic and ecological conditions of the region. Vines occupied the majority of land (roughly 65–85%) in a number of documented farms. Cereals must have been raised to some extent, although not, it would appear, on a surplus basis.[30] But questions remain concerning where pigs, cattle, and sheep were raised and where soft fruits were grown. Were these activities carried out much further away – or in closer locations less suited to raising the prized grapevine? Definitive answers to these questions will remain elusive without a greater emphasis on sites situated outside of Pompeii and on the lower reaches of the Apennines.

In tandem with new extra mural excavation, we must also attempt more quantitative analyses of the foods consumed. This has been attempted for fuel in the case of Pompeii and the results suggest that the carrying capacity of the region for the high altitude beech most often consumed was not sufficient for the wood to have been supplied solely from within Campania.[31] The matter is yet to be examined fully, but it appears that elements of market economy behaviour, i.e. of comparative advantage and specialised farming (at least of grapes) were at work in Campania. The provision of wood from climes distant from Pompeii, pointing to a more sophisticated agricultural and market arrangement than has previously been considered, suggests that even mundane crops may have been supplied from outside the region.

Notes

1 See especially, Büntgen *et al.* 2011; McCormick *et al.* 2012.
2 Grove and Rackham 2001, 24–5, 57.
3 Lake Avernus, Grüger *et al.* 2002, 240–73; the Bay of Naples, Allevato *et al.*, 2010; the Bay of Salerno, Ermolli and di Pasquale 2002, 211–9; Di Donato *et al.* 2008.
4 Pignatti 2003, 112.
5 Grove and Rackham 2001, 159; Ciarallo 2002, 174.
6 Foss *et al.* 2002, 66.

7 Both are mentioned by Pliny *HN.* 13.10; 15.28.
8 Dimbleby and Grüger 2002, 181–216.
9 Dimbleby and Grüger 2002, 199.
10 Veal 2009.
11 Lippi 2000, 108.
12 Lippi 1993.
13 Dimbleby and Grüger 2002, 189.
14 Borgongino 1993; Ciarallo 2002; Ciarallo and De Carolis 1998; Allevato *et al.* 2010; Robinson 2002.
15 For example Jashemski, 1979; 1993; Jashemski and Meyer 2002.
16 Mastroroberto 1990, 10.
17 Pescatore *et al.* 2001.
18 Stefani 1990, 11.
19 For example, Nazzaro 1997 estimates Vesuvius' height at about 2,000 m, 20,000 years ago, with subsequent loss of height from eruptions from this time to the ancient period, notably the eruption c. 865 BC. Cioni *et al.* (1999) suggest a height of 1,900 m.
20 Strabo, *Geog.* 5.4.3: "...in the course of one year, some of the plains are seeded twice with spelt, the third time with millet, and others still the fourth time with vegetables."
21 Foss 1988; Foss *et al.* 2002.
22 Foss 1988.
23 Frayn 1979.
24 The *villatica pastio* mentioned by Varro *Ling.* 3.
25 Cooley and Cooley 2004; Strabo 5.4.8.
26 For example, the eggshells, for which a promising preliminary study has been completed in the adjacent Casa delle Vestali, will be reported by Veal and Murphy (*forthcoming*).
27 See Cool this volume Chapter 6.
28 Veal 2012. This trend seems observable in Rome as well, and may more generally reflect the prosperity of the state and the increasing rate of trade with more distant climes from where exotics were imported, in particular the large variety of *Prunus* sp. and various spices. Ultimately many of these would have been cultivated locally by the first century AD, and were 'exotic' but no longer a true sign of import behaviour. For the Casa del Chirurgo, the lack of any exotic fruit or spice is noteworthy and this should be compared to the neighbouring Casa delle Vestali, in which there is ample evidence for the presence of exotic species such as lemon and pepper; see Ciaraldi 2001, 2005.
29 De Simone 2016.
30 Jongman 1988. With the grape growing intensity suggested by De Simone's study, Jongman's framing of cereal production as not necessarily being conducted at a high level of production seems well-supported, at least in southern Campania.
31 Veal 2012.

14

CONCLUSIONS

Michael A. Anderson

The Casa del Chirurgo has long held an iconic status in Pompeian scholarship, not for the surgical instruments that gave the house its name and are still its most prominent characteristic in tourist guidebooks, but for the perceived importance of its hypothetical early plan and the presumed antiquity of its material and manner of construction. Repeatedly, though often uncritically, it has been cited as an early example of the 'Roman' or 'Italic' atrium house, thereby playing a pivotal role in the evolutionary narrative of this form that still dominates the study of Roman domestic architecture. At the same time, the date and method of its construction have been important factors in the explanation of the chronology of Pompeian urbanism and have been pivotal points in the material and construction method based chronologies upon which such explanations rest.

The comprehensive excavations undertaken by the Anglo-American Project in Pompeii in the Casa del Chirurgo between 2002–2006 have now altered considerably our understanding of both of these aspects of this famous dwelling – establishing that the actual primary house layout differed in important ways from what had long been imagined and also uncovering a much later date for its *opus quadratum* construction in Sarno stone. Furthermore, the discovery of an earlier structure underneath the Sarno stone house finally puts to rest the idea that the Casa del Chirurgo represents one of Pompeii's earliest houses. While these new data tend to undermine the traditional role of the house in Pompeian archaeology, beyond this, our excavations and architectural research have also documented the particular steps by which the original Casa del Chirurgo developed into the final form preserved by the eruption

of Vesuvius in AD 79. This story reveals much about Pompeii's urban development and employs a range of evidence from artefacts and ecofacts to understand this process. Many of these phases also reveal aspects of ancient construction methodology that shed light on the decisions made in the planning and execution of domestic construction projects. They raise questions about the original source of rubble and debris used to fill holes and raise floor levels.

The iconic Casa del Chirurgo, therefore, has a new role to play in Pompeian studies. Like other excavated houses in Pompeii, it can now begin to illuminate the broader history of urban development in the town, not just from the perspective of its earliest masonry constructions, but throughout its long history of growth and change. At the same time, it has not lost entirely its significance in the narrative of the development of the 'Roman atrium house.' This final chapter will attempt to illustrate the new role to be played by this famous property by examining some of the major new conclusions that result from the AAPP's investigations, before considering the effect this new information may have on the house's traditional significance.

What was there *before* the Casa del Chirurgo?

While the absence of evidence for activity in the sixth and fifth centuries does not exclude the possibility of some human presence in the area of the city block at this time, it is clear that, unlike much of Regio VI and Pompeii as a whole, the area of the Casa del Chirurgo was either devoid of structures during the archaic

period, or the evidence for these periods was removed during the widespread terracing that comprises the earliest identifiable activity within the block. If the area was indeed empty during these centuries, the reason may have had something to do with its proximity to the city walls, the Via Consolare itself, or perhaps the influence of other, nearby features such as the sacred grove suggested by Bonghi Jovino to have been within Insula VI 5.[1] It may yet be possible to say more about this phase with the future analysis and publication of the excavations of the Casa delle Vestali to the north.

Regardless of this early lacuna, it is now also certain that the Sarno limestone house known as the Casa del Chirurgo was not the first structure to be built in this location. The remains of the structure underlying the later dwelling prove what Maiuri had only suspected,[2] that the famed 'earliest Pompeian house' had been preceded an earlier phase of inhabitation. While insufficient data were recovered to be entirely certain that this structure was a house, the presence of an impluvium-like feature in opus signinum, coordinated with one or two nearby cisterns for the storage of water, makes this quite likely.[3]

Regardless of the actual function of the building, these represent the earliest surviving remains of settlement in the area that was later occupied by the Casa del Chirurgo and its dependencies. The orientation of the Pre-Surgeon Structure's layout, which aligns most strongly with the Vicolo di Narciso, implies strong influence from the overall orientation of the grid layout of Regio VI and the central Via Mercurio. Indeed, it would be tempting to suggest that the Pre-Surgeon Structure was built in response to this urban planning and might provide an indication of when this planning was undertaken. Some scholars believe this to have occurred during the Samnite reorganisation of the city in the late fourth or third century BC.[4] The scant datable evidence provided from excavation in the Pre-Surgeon Structure permits a date no earlier than the first half of the third century BC to be suggested for its construction, with a date in the later third century BC probably being more likely. In turn, this implies that the planning of Regio VI in the area of Insula VI 1 did not find its expression in the construction of buildings, but instead resulted in the wide-spread terracing that preceded them. While firm evidence of the structure's front doorway was not recovered, the overall layout and alignment strongly suggests this to have been situated on the Vicolo di Narciso. The earliest properties of Insula VI 16 display a similar orientation, facing away from the older Via Vesuvio, a fact that has been interpreted as the result of a desire to avoid

seasonal floods or the noise and commotion of the earlier through-routes.[5] Perhaps a similar motivation dictated the orientation of the Pre-Surgeon Structure.

From analysis of the materials recovered from layers associated with the destruction of the Pre-Surgeon Structure, it is possible to suggest that its owners were probably comfortably affluent. Small finds produced sufficient evidence to suggest modest luxury in this phase. This conclusion is strengthened by the presence of a higher percentage of young cuts of meat in these deposits, which include not only the fills thought to derive from the destruction of the Pre-Surgeon Structure, but also elements of the construction of its successor. The creation of the Sarno stone property alone surely attests to the continued prosperity on the part of the owners of the property, regardless of whether they were from the same or a new family. Naturally, drawing conclusions of this type from material deriving from construction deposits requires faith that the material originated from the Pre-Surgeon Structure itself and not from elsewhere. Given the nature of the change in the property at this time, it seems highly likely that most, if not all, of the material did in fact come from the Phase 2 structure. The much higher percentage of wood charcoal from timbers and structure in these deposits might also support the idea that most of these levelling layers derived from Phase 2 to early Phase 3 activities within the area. If so, then the presence of some evidence for textile production in the craft items discovered in these deposits, might also support the idea of a 'traditional' atrium as imagined by Augustan period authors such as Livy (1.9.9).[6]

Casa del Chirurgo, a new date and a new primary plan

Area-wide excavation has now produced ceramic and coin data that argue in favour of Mau's conservative terminus post quem for the construction of the Casa del Chirurgo,[7] indicating it could not have been built prior to the last quarter of the third century BC (c. 216 BC), and in fact, was most likely a product of the years around 200 BC or even the following half century or so.[8] While this might have been relatively unexpected ten years ago (and indeed was the cause of considerable excitement in the project at the time of its initial discovery in 2002), in the wake of now widespread sub-surface excavation across the city and the general acceptance that even the oldest Pompeian houses preserved can not date much earlier than the late third century BC,[9] this observation is now a little

anticlimactic. Even allowing for the possibility of a few rare earlier exceptions,[10] the chronology of building materials and techniques long-employed to provide a rough chronology for Pompeian structures has witnessed a considerable lowering of dates as a result of most recent archaeological work. It has furthermore been demonstrated that these relative chronologies can only be used as general guidelines and not hard and fast rules, even to the point where some of the earliest construction methods may still have been employed as late as the first century BC.[11]

It is therefore now not quite as surprising to find that the iconic Casa del Chirurgo, far from representing an abnormally early example of a Pompeian domestic structure, instead fits in neatly with the now well-documented explosion of domestic construction in stone shortly before the beginning of the second century BC.[12] While it is easy to fit the creation of the Casa del Chirurgo into this pattern, it should be noted that it does serve to lower the established masonry style chronology considerably. Peterse's dates for *opus africanum B* (c. 420–275 BC),[13] the style to which the walls of the Casa del Chirurgo belong, is either too early or it was employed over a much longer period of time. Greater problems arise from the attempt to interconnect the Casa del Chirurgo with other houses with Sarno stone *opus quadratum* façades, *opus africanum* interior walls, and remarkably similar layouts, such as the Casa dei Scienziati (VI 14, 43) and the Casa del Naviglio (VI 10, 8.9.11.14). These have recently been dated by excavation to the fourth century BC and first half of the third century BC respectively,[14] results that differ dramatically from those recovered in the Casa del Chirurgo. While it is possible that the Casa del Chirurgo represents the end of the era of Sarno stone atrium construction,[15] it seems improbable that the single concept and layout of Sarno stone atrium house, which clearly interconnects these properties,[16] could have been in place for roughly a hundred years without any sort of modification. Since in all cases the data produced from these excavations appear to have been simply a *terminus post quem*, it is possible that all of them were built somewhat later than has been thought.[17] This has a great impact on attempts to identify the precise cause of the appearance of stone domestic construction in the middle to late Samnite period.

Pesando has explained this phenomenon as a result of the end of the Samnite wars and the effect of Roman expansion, and maintains this interpretation with the Casa del Chirurgo as the last great example of a phenomenon of the late fourth to third century BC.[18] The date provided by our work in the Casa del

Chirurgo, however, perhaps aligns better with Mau's original explanation of the house as one of many built in the wake of the Second Punic War, either as a result of population influx caused by Hannibal's predations in Italy,[19] or perhaps more likely, the significant post-war growth in prosperity that the Roman state and her allies must have experienced during late third and early second century BC as the ultimate victor in this war. At the end of the day, it must be conceded that a single cause is unlikely to have been the actual driving force and a Pompeian housing boom should be explained as the result of a combination of numerous factors, including, but not exclusive to the expansion of Roman domination of Italy, the destructions of wars of conquest and defence, and ultimately the successful conclusion of conflict and a resulting overseas commercial empire.

The primary layout

Comprehensive excavation has also provided new data that hopefully settle some of the more contentious aspects about the primary layout of the house. Contrary to what Maiuri and Fiorelli believed, and others have debated,[20] the atrium of the Casa del Chirurgo was clearly impluviate from the start. The drain found running north-west to south-east across the atrium was necessarily a component of the primary plan and can be demonstrated to have been created at the same time as the Sarno stone walls themselves. It must have originated as some sort of water catchment facility in the atrium and drained this water away for storage in a deep, narrow cistern to the south. The current impluvium, though conceivably reworked or reused in the Augustan modifications to the house, has no way of flowing into this drain and cannot belong to this first phase. Unfortunately, no traces of an earlier water catchment feature were recovered and while hints of what may have been the continuation of a drain running to the north-west to south-east from the present impluvium might permit the hypothetical reconstruction of the central space without a central water collection feature, this seems unlikely. The presence of an overflow drain of identical construction running from the centre of the atrium to the street all but requires the presence of a central water collection feature, implying that the system was created as a single entity, with a nexus of the drains roughly in the centre of the atrium present from the initial construction of the house. The apparent continuation of the north-west to south-east drain on the northern side of the impluvium might therefore simply be a second drain leading away from the centre of the structure, ending

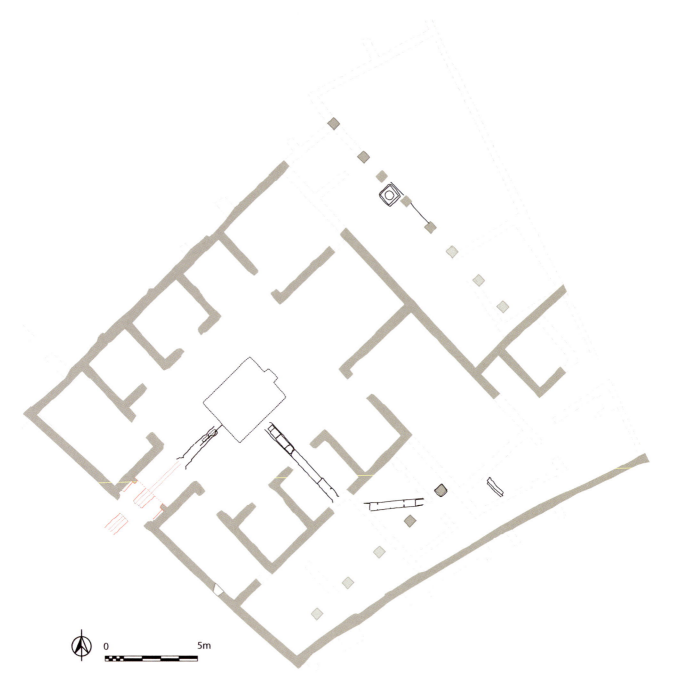

Figure 14.1. Plan of the first phase of the Casa del Chirurgo as revealed by the AAPP excavations (illustration M. A. Anderson).

in a cistern on the northern side of the property in one of the areas that could not be excavated due to well-preserved flooring. Although the likelihood of an impluvium in the original house does not *ipso facto* prove the presence of a Tuscan roofing arrangement,[21] the care with which the atrium walls were built also supports the conclusion that they were intended as load-bearing features of a Tuscan roofing system. A testudinate atrium of the type suggested by Nappo for the *case a schiera* in Regio I and II, would not have

required the load-bearing walls on the north and south sides of the atrium that are present in the Casa del Chirurgo. The original beaten earth floor that appears to have completed the atrium in its first phase might also have been ill suited for the channelling of the water that was to be retained in the cisterns.

The primary plan of the Casa del Chirurgo as revealed now by our excavations also reveals a number of important differences between its actual layout and the hypothetical one that has featured so frequently in

scholarly discussion. Though symmetrical and clearly carefully planned in its proportions, the overall form of the house seems to have had more in common with a rustic villa or farmhouse than the canonical urban 'atrium house.' Perhaps this was because the area around the Casa del Chirurgo was sufficiently free from structures that such a form, later generally associated with sub-urban and rustic contexts, was not out of place at this time. To be sure, an atrium and its surrounding rooms were present in the original plan and this suggests that the central hall was always an important component of the house layout. Rather than emphasising the fauces–atrium–tablinum axis so often identified in the structure of the 'early atrium house' however,[22] the primary visual focus of the property seems rather to have been directed out and away to the south from the atrium through its southern and eastern rooms. Indeed, the primary vistas of the house were directed from the inside outwards, much as has been suggested for countryside villas.[23] The importance of the outward-facing view is particularly apparent in Rooms 9 and 10, which in the initial design were open towards the east and south respectively. The fact that each is perfectly square and shares an identical position in the structure, produced by the simple rotation of the pattern from the eastern to the southern side of the house layout, also suggests that the lengthening of the width of the tablinum noticed by Peterse in comparison to the Casa degli Scienziati (VI 14, 43) and the Casa del Naviglio (VI 10, 8.9.11.14),[24] was not caused by a desire to make the room grander, but was due instead to the prominence of these two rooms and their outward-facing vistas.

The tablinum (Room 7), later the clear focus of an axial vista from the fauces through the house entrance to the hortus beyond, was originally sealed on its eastern side by a wall and lacked the flanking engaged pilasters that would later highlight and frame this view. While it is impossible to exclude the possibility of a window in its eastern wall,[25] the arrangement as a whole would have done little to highlight or emphasise the fauces–atrium–tablinum axis in the original layout of the house. On the southern side of the atrium, cubicula 6A and 6C functioned primarily for access to the southern portico. Most activity surely would have taken place in these exterior porticoes, which were not generally open to the view from the street. Service activities, such as cooking and storage, may initially have taken place along the southern portico, perhaps in conjunction with the southern rooms such as Room 6C, or the southeastern end of the garden space, where a kitchen would ultimately be built.

Further complications in the actual original form of the Casa del Chirurgo are caused by the area in which the southern and eastern portico met (Fig 14.1), which creates an awkward arrangement of walls that seems either to have created a small room or at least shielded the southern portico from the view of the street. The continuation of the structure in opus africanum to the very edge of the property division also implies the presence some sort of boundary, even if it left no trace. None of these features are elements of the 'canonical' atrium house and whilst they do not take away from the presence of certain spatial arrangements present in the primary structure, they do tend to undermine the idea that the atrium, the tablinum, or any particular set of features was primary in consideration at the outset. In fact, the earliest form of the Casa del Chirurgo has just as many features in common with the case a schiera of Regiones I and II,[26] which also share a relatively similar date at the end of the third century BC.[27] Undoubtedly, as identified by De Albentiis, the differences that do exist between the Casa del Chirurgo and the case a schiera suggest that the original owner likely had acess to a greater amount of wealth.[28] Nevertheless, the two forms are clearly parts of a single, contiguous spectrum rather than representing entirely distinct ideals. The major difference between them is one of size, with the Casa del Chirurgo at roughly 2.5 times wider than the 8–10 m wide frontages common in the case a schiera.[29] In terms of layout, the central hall of the house is certainly larger and grander than those in its smaller cousins and it was surrounded on all sides by rooms, but otherwise the overall concept was rather similar. Indeed, the hortus area to the east was virtually identical to those found in these more diminutive variants, and in fact, the overall depth of the plot at ~30 m, is roughly equivalent with those found in Regiones I and II. It seems to be primarily the larger plot size and unusual shape of the insula in which the Casa del Chirurgo was built that generated these differences, facilitating the creation of a more elaborate atrium with garden space to the southern side of the property.

Changes to the Casa del Chirurgo

It has long been observed that the Casa del Chirurgo witnessed relatively few periods of renovation.[30] Some of these, however, appear to have been more extensive than has generally been acknowledged. The excavations presented in this volume have now provided a chronological framework for these modifications, allowing them to be situated within their appropriate socio-economic and historical contexts and suggesting possible motivations behind them.

First century BC changes

The earliest identifiable changes likely took place at some point in the first century BC, possibly just after the founding of the Roman *Colonia Cornelia Veneria Pompeiana* at Pompeii in 80 BC and the addition of Roman veterans to the urban population.[31] The thorny question of where the colonist veterans were first settled at this time has yet to be resolved and while it now seems likely to have been in the northern territory outside of the city,[32] it nevertheless remains possible that the Casa del Chirurgo changed hands at this time. If so, its new owner might be expected to have initiated alterations to make the property more suited to Roman tastes. Indeed, this might be anticipated at this time even without a hypothetical change in ownership, since the gradual adoption of Roman tastes, fashions, and trends at Pompeii was a process that had clearly been underway since at least the middle of the second century BC.[33] The changes that occurred during this period in the Casa del Chirurgo were the addition or formalisation of a property boundary wall on the eastern and possibly southern sides, a mild development of the service area including the creation of a back-door, the addition of two small rooms viewing out onto the hortus, and the paving of several of these rooms with fashionable new floors.[34] These modifications did nothing to alter the preexisting spatial arrangement of the house, but seem to have been motivated rather by the desire for more private space and a garden area that was separated from the city itself. Perhaps they were a response to an urban environment that had become increasingly densely occupied throughout the past century that was now exacerbated further by a new influx of people. Certainly, the vista from the front door and the back wall of the tablinum remained unaltered. Some emphasis was placed upon the newly enclosed hortus, but only from the perspective of the house's inhabitants and seemingly as a replacement for a now-missing exterior vista.

Elsewhere in the city, changes to houses had been underway, possibly as early as the second century BC,[35] and were characterised by the addition of 'Hellenistic luxuries,' most clearly represented by the addition of Greek inspired forms such as a peristyle and those reception rooms given Greek or Greek-sounding names, by Vitruvius (tetrastyle, Corinthian, Egyptian, and Cyzicene oeci).[36] Clearly grandeur of this type found little expression in the Casa del Chirurgo in its first phase. While its building plot was insufficiently large for a peristyle, the garden areas that did exist nevertheless became the 'outside' vista for the house.

Here the two garden rooms might be considered a form of the same Hellenising phenomenon, especially as their floors incorporated fancy inset stones in the latest fashion. Perhaps the creation of grand peristyles in the houses of Pompeii was actually motivated by the same reasons that governed these changes in the Casa del Chirurgo, a reaction to the increasingly dense urban environment in which they were situated. Though the form taken by these additions, clearly a quotation of the *luxuria* of the palaces of the Hellenistic rulers or the *gymnasia* of Hellenistic cities, expressed current elite architectural tastes, the original motivation may therefore have been much more mundane.

Augustan reorientation

The second phase of renovations within the Casa del Chirurgo was considerably more extensive than the first, but did not take place until the late first century BC to early first century AD. At this time, the house witnessed widespread alterations and substantial redecoration, as a result of the conversion of two spaces into independent shops, the resulting complete reworking of systems for water-collection and storage, and the addition of new luxurious pavements and formal reception rooms. The southern cubicula became proper rooms, as opposed to transitional corridor spaces, with the sealing of their southern doorways and in at least in some cases seem to have received fine *opus signinum* floors. The same type of flooring was used in a reorganisation of the atrium. At this time, the fauces–atrium–tablinum vista was emphasised by the addition of attention focusing devices such as pilasters on the tablinum, north ala, and fauces walls, the removal of the back wall of the tablinum, and the addition of a fine decorative mosaic on the floor of this now clearly important room. In order to highlight this vista further, the hortus was decorated with newly planted foliage, which, as is attested by planting pots (*ollae perforatae*), were apparently procured in an advanced state of maturity from some external source. By this time the division of the fauces into vestibulum and entryway, as identified by Maiuri,[37] had also been eliminated so that this vista could have its greatest impact upon a visitor to the house or even a passer-by. All of these changes suggest that it was only now, at a moment long after its initial foundation, that the fauces-atrium-tablinum-hortus axis became important.

This period of alteration also saw a new focus on providing a range of rooms appropriate for reception and entertainment that had not been particularly prominent either in the original version of the structure or during its first phase of renovations. The

room to the south of the tablinum (Room 10) was converted into an elongated room appropriate for use as a triclinium. Its pavement, having been carefully constructed over a solid foundation of cobbles, was outfitted by a central *emblema* in *opus sectile*, revealing that the dining benches were intended to be arranged facing northward. Plausibly this was intended as a winter triclinium, given that the room was no longer accessible from the south.

The addition of *luxuria* and reception rooms in the Casa del Chirurgo was spurred, at least structurally, by the conversion of two spaces into commercial properties, both of which were at first intended to be 'independent' from the main house, and at least one of which involved small scale production activity in the form of metal working. While on the one hand, these would seem to be entirely at odds with the sumptuous interiors and service facilities of the main house, on the other it may be that it was these very ventures that were intended to finance either the rebuilding itself, or the lifestyle of the occupants that the new decoration of the main house was intended to accommodate.[38] It is strange that neither the artefact assemblage nor the archaeobotanical remains from this phase produced strong corroboration of the presence of craft production activity in the area, but instead continued trends for the general disposal of waste observed in other periods. This suggests that many of the deposits excavated from the later phases of the house may not have derived from the activities within it but may have been imported from elsewhere (cf. infra).[39] Even the scant evidence of the gradual accumulation of deposits related to on-going metal working activity during this phase seems to point to the general removal of specific rubbish from the Casa del Chirurgo to some sort of city dump, perhaps combined with the occasional return of elements of general city-wide waste in times of filling or levelling during construction. Nevertheless, even with regular cleaning, evidence related to the use of these spaces did gradually accumulate, as may be suggested by the presence of a larger percentage of beech charcoal at this period, plausibly the result of fuels intended to produce high temperatures necessary for production activities in the workshops.

The early addition of these shops can also help to dispel once and for all Maiuri's belief that the intrusion of commercialism into domestic space was to be associated with the invasion of the lower classes in the wake of an evacuation by elites after the earthquake(s) of AD 62/3.[40] Rather, it suggests that for elites in Pompeii, the Augustan lifestyle was intertwined with profit from business, and that if there was any need

to disassociate the two, it was perfunctory at best. Certainly it is clear that the city of the late Augustan period witnessed an economic surge that presented new opportunities. The owners of the Casa del Chirurgo clearly sought to capitalise upon this with commercial and craft production ventures.

Later changes to the Casa del Chirurgo
The final period of changes within the Casa del Chirurgo took place at a point within the first century AD, probably prior to the earthquake(s) of AD 62/3. These were largely focused on the addition of new upper stories and the transition away from possibly dangerous and messy metal working activities that had characterised the northern shop, to some type of cleaner 'service' or 'commercial' activity, documented by the amphorae or *hydriai* found here during the initial excavation.[41] Though it proved impossible to be entirely certain of the division between these changes and modifications associated with post-earthquake damage, the focus on new upper-floor rooms implies an increasing urban density at this time that has long been identified within the Pompeian evidence. Modifications or improvements to the upper story apartment over Rooms 3 and 4, combined with new additions within the house, strongly suggest that the pressures of urban density, that had probably been one of the major driving forces for most of the changes in the house, were now more even more acute. Given that these changes appear to have occurred prior to the earthquake(s), it would seem that these units are more likely to have been the result of a spike in urban population in the first century AD, rather than temporary workers drawn by post-earthquake activities as has also been suggested.[42] Unfortunately the lack of precise resolution from the archaeological record means that this latter explanation cannot be excluded. These modifications required the redecoration of the walls of much of the house, in the style of wall painting currently in fashion. While the present house preserves little of this grandeur, White (Chapter 8) reveals that remains discarded into the cisterns during the original excavations of the house suggest that it was vibrant and largely well executed.

While the earthquake(s) of AD 62/3 are all too often invoked as an explanation for change in Pompeian archaeology, it is nevertheless clear that the Casa del Chirurgo was also one of the many victims of this natural disaster, even if the damage sustained seems moderate. Furthermore, the evidence from this house permits further light to be shed on this period and the state of the property at the time of the eruption. The

southern side of house, possibly because of the recently added second stories in this area, appears to have been in a state of some collapse or instability. Some repair work was underway, focused first in the service areas that were directly under those second stories where the need appears to have been most pressing. While reconstruction was incomplete in the Casa del Chirurgo, the neighbouring Casa delle Vestali had made much greater progress.[43] Indeed, while there is nothing to suggest a decline in the prosperity of the owner of the Casa del Chirurgo at the time of the erruption in AD 79, certainly this property had long been overshadowed by that of its neighbour to the north. This discrepancy may well also be reflected in their relative ability to deal quickly with damage to their respective houses.

Significantly, it is precisely these phases that produced the most distinctive changes in the artefactual and bioarchaeological record. The range of artefacts recovered speak to a wider range of craft activity than could result in part from changed circumstances for the Casa del Chirurgo. Indeed, the presence of older pig bones in the later deposits might suggest a shift in circumstances away from eating younger animals, though given the uncertain origin of much of this material, it may be impossible to separate this pattern from a broader change in society as a whole. The most striking change in the ecofactual evidence is witnessed in the charcoal remains, which point to extensive burning of timber and structural wooden elements. Possibly a fire took place during the earthquake or perhaps the replaced wooden elements were reused as fuel in fires thereafter. Given the degree of intermixing of the upper deposits, it is also possible that such evidence represents results of the subsequent eruption itself.

Builders and building in the Casa del Chirurgo

Each of the structural changes discussed above, from the original construction of the Pre-Surgeon Structure to the addition of the final second stories to the Casa del Chirurgo, required the services and talents of Pompeian builders. The resolution of the data recovered from our excavations within the Casa del Chirurgo provide a window into the planning and execution of domestic construction and renovations carried out by such workers. While it is impossible to know precisely who these workers may have been, their clear practical knowledge, which included at least a working understanding of the static stresses and loads involved

in architecture, argues against them being complete amateurs without formal training. Rather, clear evidence of sequential planning and the coordination of multiple working groups in the construction process imply a group of experienced professionals, working under centralised coordination. This sort of behaviour could easily be associated with a single shop within a builders' guilds, such as those discussed by DeLaine in the construction of imperial projects in Rome and Ostia.[44] These features are most evident in the original construction of the Casa del Chirurgo and less obvious in later elements of construction, which could sometimes be undertaken in a relatively haphazard manner. Perhaps this means that later work or more minor jobs generally involved crews of lesser quality or experience. What follows is brief discussion of the observations that can be drawn from these data in regards to the practice and methodology of ancient Pompeian builders.

Soil removal

One of the repeated construction activities attested by the evidence of the Casa del Chirurgo involved the removal of large quantities of soil, either to produce a stepped terrace or to change the level of individual rooms within the structure. During the levelling and terracing that occurred prior to the creation of the Pre-Surgeon Structure, it is clear that the terracing work itself caused little or no trouble for the workers. There are no signs of support for the embanked edges, implying a distinct lack of concern over possible collapse of the edge, either during its excavation or after its completion. It must be imagined that this activity required a considerable amount of work and a relatively large force of labourers to accomplish in a reasonable time frame, but the apparent lack of pre-existing structures in the area means that little seems to have interfered with the process of excavation itself.

A second phase of terracing excavation was undertaken in Phase 5 between the late first century BC and early first century AD, this time within the considerably more confined built spaces of the Casa del Chirurgo, a situation that required careful logistical planning. Since a major goal of these changes was to convert the southwestern part of the property into a shop on the Via Consolare, it was necessary to remove the southern section of the original frontage of the house and to lower the soil in this area to match the elevation of the street to the west once again. The most important walls in this procedure, were therefore the western wall of Room 23 and the blockages of the

openings in Rooms 6A, 6B, and 6C. These would serve to retain the soils to the north and east of Rooms 3 and 4, enabling the removal of soil. It is clear that the doorways were filled first, seemingly in a single concrete construction from foundation to the top jamb. Similarly, the lower part of the new western wall of Room 23 was created prior to any further terracing work. This involved the cutting of a deep trench that ultimately struck a large stone in the fills on the southern side (Fig 14.2). The builders decided simply to leave this stone in place and to dig around it rather than to remove it. As a result, the *opus incertum* build of the foundations for this wall bonded with this stone during construction and it remained in situ. Similarly, the drain that had previously run from the atrium through this space was left intact and the retaining wall was built around it.

That the builders did not measure the depth of the new foundation trenches precisely is clear from the fact that neither the doorway fillings nor the foundations of the wall to the west of Room 23 actually reach to the level of the Via Consolare, but stop short of the intended depth, leaving exposed the lowest part of the soils that they were intended to hold back. In order to facilitate access to the area where soil was to be removed, the upper section of the retaining wall was constructed as a final step in the process. This appears to have been planned from the start since work crews would have needed to be able to enter the room to excavate the soils before the western façade of the Casa del Chirurgo could be removed, as it was itself holding back soils from collapsing into the Via Consolare. After these retaining walls had been constructed, the removal of soils to the west could begin. Soil must have been carried through the house's atrium or through the back door onto the Vicolo di Narciso. Once this action was complete, the remaining western façade could be removed and the western wall of Room 23 could be created. It remains an open question where this removed soil would have been taken, since it was not deposited in the area of Insula VI 1.

Planning and ad hoc construction

Sophistication in logistical planning is also evident in the conception and construction of the original Sarno stone layout of the Casa del Chirurgo. Following the ideals laid out in the prescriptions of Vitruvius for ashlar walls of cities and towers, each wall of the house which was built in the *opus quadratum* technique, received with relatively deep foundations and a single wider course of Sarno stones (Fig. 14.3), clearly

intended to provide a solid footing for the rest of the wall.[45] The trench, which was deeper (c. 40 cm) than necessary for the first row of Sarno stone blocks, was also initially refilled with a deposit of building debris that was subsequently packed down to form a very hard layer of bedding under the Sarno blocks, permitting their level placement. This material was so compact that during excavation it could only be removed by means of pick-axes and similar heavy tools. After this first course of stones had been positioned, the foundation trench was filled to the floor level with a looser material.

The specific walls of the house that were selected to be constructed in *opus quadratum*, presumably an expensive technique given its use of large hewn blocks of Sarno stone, also present an interesting pattern. The front façade was chosen, presumably because of the social prestige to be gained from displaying such a grand frontage in a style that previously may have been associated strongly with public buildings and temples.[46] This also helped to seal the newly redeposited materials that had been used to fill in the lower terrace of the Pre-Surgeon Structure with a wall of considerable strength. Similar considerations may have also governed the use of *opus quadratum* for the southern wall of the tablinum (Room 7). While it is also possible that insufficient stone blocks, or funds for their procurement, were available in order to complete the northern wall of the tablinum in *opus quadratum*, it seems more likely that the southern wall was deliberately constructed in a more substantial technique because it stood closest to the edge of the earlier terrace that had just been refilled. Perhaps it was felt that a wall with footings in such material required special attention while the northern wall could be completed in the lighter *opus africanum* technique. The decision to employ *opus quadratum* in the walls of the atrium (Room 5) was likely governed by both of these considerations. On the one hand, the construction method would provide the space with grandeur and status, while on the other it would be strong enough to bear the structural loads of the Tuscan roof arrangement that fed water into the first phase impluvium.

In the actual process of construction, it is clear that the foundation trenches for these walls were cut more or less simultaneously, as part of a thoroughly pre-conceived plan that included the precise location of doorways, where the cutting of foundations was discontinued. That the trenches of the tablinum walls were exposed at the same time as those in the atrium is suggested by the fact that the fills of the tablinum trenches appear to have derived from the cutting of the

Figure 14.2. Photo of walls W06.101, and W06.102 at the south-west corner of Room 23, showing large stone embedded in the foundations of both walls, and the earthen surface of the Pre-Surgeon Structure (image AAPP).

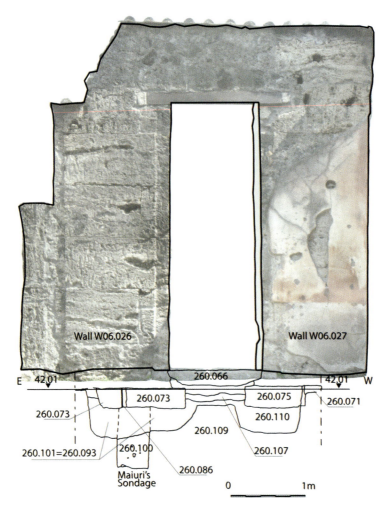

Figure 14.3. Southern section of the atrium (Room 5), showing the foundation trenches for the Casa del Chirurgo (illustration C. L. O'Bryen and M. A. Anderson).

atrium trenches themselves. Perhaps the earth from all of the foundation trenches was simply piled in a single heap in the centre of the structure or another nearby location and was returned once work on all of these walls had been completed, producing a jumbled mix of soils and building debris in the fill of each trench.

Construction of the walls then proceeded in a pre-established order. The foundations of the interior walls of the atrium on the western side (walls W06.029/W06.028) seem to have been constructed prior to those on the southern side (W06.027). This may relate to the apparently ongoing process of refilling the terrace and the desire to provide the necessary retaining walls for these activities on the west, particularly against the course of the Via Consolare. Shortly thereafter, the crossing interior walls, including the northern and southern circuit walls, were built in the lighter and probably more cost-efficient *opus africanum* technique. In most cases, the foundations of these walls were relatively insignificant compared to those of the *opus quadratum* walls, involving a shallow wide trench on one side, ending in a scarp, against which the first courses of the wall were placed. Insufficient data were recovered on these walls to suggest more about the precise order in which the work itself was undertaken throughout the property as a whole, but an organised process is clearly visible in the division of necessary skills for these tasks. The southern side of the structure, which stood within the area of the earlier terrace that had just been filled in, though not built in the sturdy *opus quadratum* technique, was nevertheless provided with deeper foundations than other interior walls, matching the depth of the foundation trenches of walls in *opus quadratum*. In fact, these walls had such deep foundations that, during the removal of soils and the creation of the shop in Rooms 3 and 4 on their southern side in Phase 5, it was unnecessary to extend them further, since they already reached well below the new, lower level of the shop.

Overall, the impression given by the evidence from the construction of the Casa del Chirurgo is one of a carefully planned and precisely executed construction, plausibly coordinating several different teams of workmen (possibly specialists in *opus quadratum* and *opus incertum* respectively) and executed in a staged process that would have facilitated movement during the work and maximised the stability of the resulting structure. A much more *ad hoc* manner of construction characterises most later additions and modifications. This is particularly clear from the insertion of second stories, which frequently appear to have been built less carefully and with little concern for the resulting

change in loads and stresses in the overall structure. Certainly, the sheer number of postholes necessary for the shoring up for repairs or alterations to the upper story over Rooms 3 and 4 in Phase 6 suggest not only that the initial construction was probably somewhat sub-standard in quality, but that the process of repairing it experienced considerable difficulty. Similar shortcuts appear to have been taken in the creation of upper stories over the eastern service rooms, where the stairway was constructed in open steps without either the normal risers at the back of the step or the eastern string support.[47] Instead, the wooden steps seem to have been cut directly in to the previous layer of wall plaster (Fig. 14.4). The western string itself seems only to have been supported by a single squared post set in mortar located at the highest point of the stairs. Presumably this permitted the stairs to take up only half of the width of this space, which also included the passage that provided access to the ground floor service rooms. All in all, when compared to other preserved traces of stairways in Pompeii and Herculaneum, this rickety and poorly made variant, implies low-cost or shoddy craftsmanship, quite unlike that in earlier construction of the house.

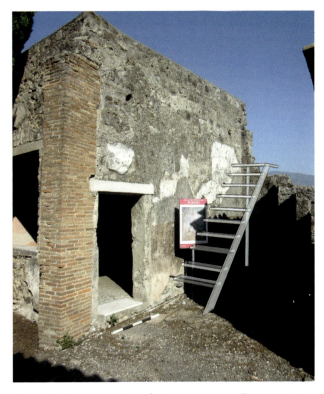

Figure 14.4. Reconstruction of stairway against wall W06.066 using Trimble SketchUp (illustration M. A. Anderson).

Post-earthquake construction

The post-earthquake reconstruction of the Casa del Chirurgo was interrupted by the eruption of Vesuvius in AD 79, presenting an excellent opportunity to examine the work process underway. This seems to have involved the combination of temporary measures intended to support weak spots in the structure of the building combined with preparations for planned extensive renovation. Two large (36–43 cm in diameter) postholes indicate the presence of posts supporting the southern side of the atrium roof, while similar, smaller posts throughout Room 8A and damage to the final *opus signinum* surfaces in Room 6C, suggest that some of the southern side of the property may have been in a precarious state at this time, even if the walls themselves generally seem to have held firm. This probably helps to explain why this side of the atrium appears never to have been as well preserved as the northern side, as is clear in the cork model in the Museo Archeologico Nazionale di Napoli. This might also explain the much lower elevation of preserved walls throughout the southern half of the property. Preparations for rebuilding are plausibly indicated by traces of piles of lime and rubble found in the upper deposits of Rooms 11 and 23, while the apparent removal of floors might indicate that these areas were intended to receive the first restoration efforts. On the whole, it seems that the recently added and seemingly poorly constructed upper stories that stretched across all of these areas, might have contributed to the structural problems of the house. Signs that work had begun can be found in the walls of Room 17, the re-plastering of which had clearly started, even if it was not complete. Overall, it appears that the workers focused on the most damaged areas first, making use of them for the storage and preparation of raw materials, attempting to present the least disturbance to whatever daily life may have continued in the house.[48]

Interpretation of construction fill layers

Construction and renovation in the Casa del Chirurgo consistently involved the movement of materials, either in the form of terracing and the removal of walls, structures, and floor levels, or in the deposition of material intended to raise the floor surface, normally employing elements of former building material such as rubble, mortar fragments, plaster, and other rubbish. In practice, these processes appear to have been highly variable in their execution. The filling of the Pre-Surgeon terrace for instance, was accomplished in tandem with the complete demolition of the Pre-

Surgeon Structure, which likely contributed much of the material used to raise the level of the lower terrace. Other projects, such as the removal of the wall between Room 17 and 18, show little sign of reuse of the primary demolition material, since most of the elements of the wall were apparently salvaged for reuse, resale, or abandonment elsewhere. As a result, the hole left behind was filled with building debris that likely consisted mainly of foreign material brought in from somewhere else, perhaps from other contemporary construction projects or from dumps of material located outside of the city. Indeed, even the filling of the Pre-Surgeon terrace might have required some additional fill if demolition debris proved to be insufficient. The absence of any elements that might be identified as foundations or stone blocks certainly suggest that certain elements of the Pre-Surgeon Structure were removed for reuse in another place. It is clear, therefore, that many of the archaeological strata recovered in excavation may contain a jumble of material, including elements that do not pertain to the house in which they were recovered. This observation has a distinct impact upon the way that artefacts and bioarchaeological remains from the house can be interpreted.[49]

Analysis of the assemblage from the excavations in the Casa del Chirurgo provides a preliminary window onto this question, which may be illuminated further by results of the Porta Stabia Project and the Via Consolare Project, both of which have examined this question more systematically.[50] Throughout the Casa del Chirurgo, both the macrocarpological and animal bones were found to be generally in poor condition. Richardson (Chapter 10) suggests that this was a direct result of their initial and likely repeated re-deposition in fill layers related to construction activity. Concluding that this material cannot reveal aspects of use in the particular house in which it was recovered, she employs these data to examine the changing diet of the city in general. In this, the faunal assemblage from the Casa del Chirurgo corresponds with trends witnessed in the Roman world as a whole, including a growth in utilisation for pig, chicken, and eggs. Murphy (Chapter 11) also notes that the relatively few archaeobotanical remains recovered in the Casa del Chirurgo appear to derive from the city in general rather than from this particular house, while noting their specific concentration in areas where midden-like conditions might have resulted from particular patterns of use, cleanliness, and deposition.

On the other hand, charcoal fragments were found to be numerous and in quite good condition, including

in strata likely related to the post-earthquake period. Given that charcoal is fragile, Veal (Chapter 13) suggests that its survival through multiple re-deposition events is unlikely, and considers the assemblage to be the result of use patterns within the house. Similarly, in the analysis of the artefacts recovered, Cool (Chapter 6) notes the presence of some small finds of a nature that may suggest foreign origin (e.g. fishhooks), but concludes that some of the small finds may be considered to be from a local source. Hobbs' (Chapter 7) analysis of the distribution of coins from throughout the insula, reveals the highest concentrations of lost coins in areas of economic transaction and the lowest in areas of domestic life. This also accords with the idea that in some cases material recovered through excavation can derive from actual use.

It is difficult to reconcile these differences of opinion. For the ecofacts, one factor might be the influence of differing recovery strategies, since floatation tends to produce results that are more fragmented than dry-sieving. Examination of remains from both processes will therefore naturally present a slightly different picture than one alone. This does nothing however, to explain either the unlikely preservation of charcoal in highly jumbled deposits or the seemingly logical distribution of certain artefact types within the house. Thus, while levelling deposits may generally have consisted of material originating from outside the property, it is clear that in some cases, and particularly with certain types of materials or objects, they were mixed with debris that originated from localised activities. Simply concluding that all or most material recovered in the Casa del Chirurgo must derive from outside sources does nothing to explain why differences between wealthier and more humble periods or spaces within the house tend to align across numerous categories of artefact, ecofact, and architecture, without obvious correspondence to the general economic development of the city as a whole. This is especially apparent when such trends, such as in Phases 6 and 7 hint at a decline or financial stagnation in the Casa del Chirurgo that cannot be found to be reflected by city-wide trends. At the end of the day, it is clear that the situation is simply more complicated than can be covered by a single explanation. These finds must represent local domestic trends jumbled within the static of larger city wide phenomena caused by the importation of jumbled material from a variety of sources and time periods. Indeed, it should also be considered that the workers undertaking construction could themselves have constituted yet another source of material for deposition in the form of foods they consumed during the work process that were simply added to levelling layers.

The Casa del Chirurgo and the Roman atrium house

The two most famous features of the Casa del Chirurgo, its supposed great antiquity and early plan, have been called into question by our excavations. The new later date of its construction and non-canonical plan might, therefore, seem to lessen the importance of this house in the study of the 'Roman house' and its development, since the Casa del Chirurgo now simply joins the ranks of numerous others houses built at roughly the same time as part of a general Pompeii-wide phenomenon. Does this mean that the Casa del Chirurgo has nothing left to give to the study of the development of the Roman house?

On the one hand, the impluviate Pre-Surgeon Structure might be able to take over the role the Casa del Chirurgo has long played as an example of an early impluviate house, revealing much about the architecture of early houses in Pompeii and connecting to a narrative of the development of the atrium-house. Despite its mid-third century BC date, the structure nevertheless has much in common with earlier houses in southern Etruria and generally supports the long-accepted narrative of development of this form, while perhaps adjusting its chronology and imagined distribution. Indeed, this would suggest that the 'Samnite period' (late fifth and mid-third century BC) of the city, a phase during which the planning and expansion of the city has been hypothesised,[51] was likely characterised by houses built in ephemeral materials that were similar in form to the so-called early Italic tradition.

But far from becoming an unimportant side-note, the development and creation of the Sarno stone Casa del Chirurgo itself still has much to contribute to our understanding of the development of the 'Roman house.' It is now clear from excavation that the primary layout of the Casa del Chirurgo took the form of a small suburban property that lacked many of the essential characteristics of the ideal 'Roman atrium house.' In fact, the structure seems simply to have been a rather larger and grander form of a *casa a schiera*, sharing many features with these modest row-houses. While it is clear that there was an atrium with an impluvium, emphasis on the vista from the street to the hortus along the fauces-atrium-tablinum axis was largely absent. No evidence survives suggesting that these so-called canonical rooms received

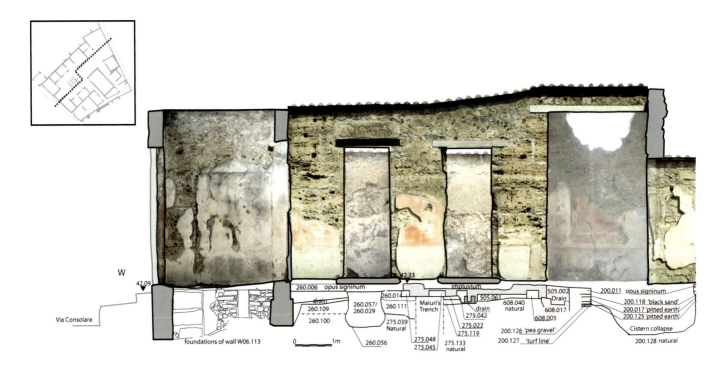

Figure 14.5. Northern section of the Casa del Chirurgo combining all recorded sections and preserved elements of wall decoration. Where necessary sections connected by extrapoloation of elevations from plan information. Atrium and tablinum are photomosaics © 2004 Jennifer F. Stephens and Arthur E. Stephens. Remaining wall elements are orthographic 3D textures created by M. A. Anderson.

special treatment or emphasis at this time. Indeed, the primary focus of the house appears to have been its two exterior porticos and the spaces that led onto them. Subsequent changes in the following phase did little to alter this situation, simply adding extra rooms within these outdoor spaces. Instead, it was in roughly the late Augustan period to early Principate (Phase 5) that the house gained many of the key characteristics of a 'Roman atrium house,' including an emphasised vista from the front door, elaborate decoration in the tablinum, and engaged pilasters that helped to frame the vista through the house and create the 'look' of an archaic Roman dwelling. Beyond these structural changes, there was the addition of a new *opus signinum* floor in the atrium, made necessary by the scope of the developments undertaken in the house at this time. As Wootton notes (Chapter 9), the use or reuse of characteristically early coloured stones embedded in its fabric might suggest that the intent was to match carefully curated elements of earlier floors, such as those in the fauces, and in the northern ala (Room 8).

The Casa del Chirurgo, therefore, really became a 'classic' representative of an archaic dwelling not at the moment of its initial conception but rather as a result of deliberate modifications in the early Principate. The highly convincing archaic layout that has led to its primary role in scholarship was not due

to the lack of modifications, but was the direct result of changes designed precisely to produce this appearance. Older elements of the structure, such as some of the pavements, were deliberately retained or imitated in aid of this. In fact, these archaising changes were made in tandem with precisely those modifications that have traditionally been seen as deformations to the primary layout of the house. Most of the service rooms, luxurious reception facilities, shops, and formal garden were all fitted into the structure at this time. The final layout of the Casa del Chirurgo therefore represents the result of a comprehensive plan to produce a specific effect, not the result of accidental preservation and haphazard additions.

The timing of these changes to the Casa del Chirurgo, in roughly the late Augustan period, might help to explain this archaising phenomenon. The particular emphasis on the atrium house, a form that, at Rome at least, was already clearly somewhat 'antique' by this time, seems to have been connected to the revival of 'Roman Republican values' that formed the core of Augustan propaganda and ideology, and which were sometimes new inventions. This was a time when Augustus himself had done much to revitalise and renew aspects of *romanitas*, both in Rome and throughout Italy, as witnessed by the rediscovery (or fabrication) of many 'Republican' Roman institutions,

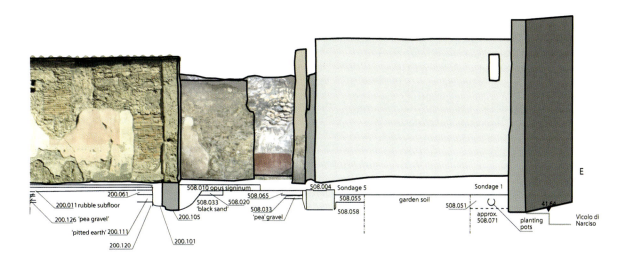

such as the Arval Brethren, the Vestal Virgins, the *Fetiales*, or the Lares Augusti,[52] ideals enshrined in the roughly contemporary histories of Livy, the epics and pastoral visions of Virgil, and the poetry of Horace and Ovid. The priorities expressed through the late Augustan modifications to the Casa del Chirurgo that emphasized exclusive elite reception areas, enshrined supposed 'older' social rituals such as the *salutatio* in the tablinum, and promoted its status as an archaic 'Roman atrium house', appear to be entirely in line with this trend. The elites of Pompeii moreover, generally appear to have been sensitive to changes underway in the capital and to have reflected their allegiance to the Augustan "cultural revolution"[53] throughout their city infrastructure.[54] It should perhaps be of no surprise that much of the city might have followed suit in their domestic architecture.

Similar modifications are mirrored in many of the houses of Pompeii, from the grand to humble, which saw the addition of atrium-like characteristics, even in areas that had never been intended for impluvia or were ill-suited for this type of architecture.[55] Perhaps this reflects a fashion motivated by a desire to associate with what it meant to be 'Roman' during the reign of Augustus. Such would certainly help to explain the wide social dispersal of the atrium form in a variety of Pompeian houses, including those of quite diminutive

size, which, as Vitruvius memorably pointed out, would have had little need for such facilities.[56] The Augustan period at Cosa also saw the replacement of a number of row houses with a classic atrium house, dubbed the House of the Skeleton.[57] Social competition in the early Principate, already identified as the important factor behind the distribution of Third and Fourth Style wall painting,[58] may plausbily help to explain why Pompeii had become a city largely of atrium houses by the time of the eruption.[59] For many houses in Pompeii, the emphasis on, or the addition of, these features may have been a phenomenon most strongly expressed not during their first construction, but as a statement of a new Italy-wide Roman identity in a period of profound and deliberate social change.

The Casa del Chirurgo and its famed archaic plan is not a fossilised early structure and testament to an early ideal, but rather the result of an idealised model projected backwards from the Augustan age. It is, at least partially, an illusion of an early atrium-house, created through the opportunistic modification and introduction of particular characteristics into a structure that was particularly well-suited to receive them, a fabrication that has understandably served to deceive modern scholarship just as effectively as the first century AD audiences it was originally intended to impress.

Conclusions

The thorough and careful excavation of the Casa del Chirurgo by the University of Bradford's AAPP has not only re-dated the construction of the house and permitted it to contribute to a full understanding of the urban development of the city, it has also served to question when the ideal of the 'early atrium house' might have been created and has provided some explanation for the widespread distribution of this form throughout the houses of Campania in the first century AD. Ironically, while it was the famed early phases of the house that originally motivated Mairui's excavation in the Casa del Chirurgo, it was the later changes which turned out to be the most instructive. Far from undermining the historic role of this famous structure, our excavations have transformed and augmented the understanding of the house's development and history so that the prominent role of the Casa del Chirurgo in Pompeian studies and Roman archaeology may continue for many more years to come.

Notes

1 Bonghi Jovino 1984, 363; Pucci et al. 2008, 230.
2 Maiuri 1973, 11.
3 Certainly the presence alone of water catchment is not enough call the structure a house, nor would its absence be sufficient to rule out such an attribution. Cf. Wallace-Hadrill 1997 on the overly strong connections between house, atrium, and impluvium attributions in Pompeian archaeology.
4 D'Ambrosio and De Caro 1989, 197; Coarelli and Pesando 2006, 24; Coarelli 2008, 175; Pesando 2008, 159; Geertman 1998; 2007, 87; Schoonhoven 2006, 33; Guzzo 2011, 16; Holappa and Viitanen 2011, but cf. Berg 2008, 374.
5 Seiler et al. 2005, 217; For recent ideas concerning the primacy of the Via del Mercurio alignment see Guzzo 2011 15; D'Ambrosio and De Caro 1989, 197.
6 Livy (1.9.9) 'ubi Lucretiam haudquaquam ut regias nurus, quas in convivio luxuque cum aequalibus viderant tempus terentes, sed nocte sera deditum lanae inter lucubrantes ancillas in medio aedium sedentem inveniunt.' 'when they found Lucretia, she was no means like the daughters-in-law of the king, whom they had seen passing away time in a feast and luxury with their acquaintances, but rather, was seated in the middle of the house, given to wool working among maids late at night.' Text Müller 1898.
7 Mau-Kelsey 1899, 39–40 and 274–276.
8 Ironically, while serving to lower the entire chronology (significantly from the suggestions of Fiorelli, but only marginally from Maiuri), this solves the temporal difference between the 'earliest' attestations of opus caementicium (in opus africanum form) identified by Lugli 1968, 402, who felt that it forms the basis of all building in Rome from end of the third century BC.
9 The examples are too numerous to list comprehensively here, but specific examples of publications of archaeological research suggesting that the oldest standing remains belong to the third century BC include: Nappo 1997, 91; Dickmann and Pirson, 2005, 157; Pesando 2008, 159, Amoroso 2008, 41; Coarelli 2008, 175; Coarelli and Pesando 2006, 24; and Staub Gierow 2008, 95. Cf. also Wallace-Hadrill 2007, 281 and Ling 2005, 36.
10 Excavations in the Casa degli Scienziati (VI 13, 43) (De Haan et al. 2005, 245) support a fourth century date for Peterse's opus africanum B, which he assigns to c. 420–275 BC: Peterse 1999, 56–57, 164; 2008, 377. This type is also present in the Casa del Chirurgo. Certainly it may be accepted therefore that the use of this construction method ranged throughout the so-called 'Samnite period' and beyond into the period after the Second Punic War and the growth of Roman cultural influence.
11 Fulford and Wallace-Hadrill 1996, 94; 2005 103 controversially date opus africanum structural work in Insula I, 9 to the mid first century BC.
12 Coarelli and Pesando 2011, 48–54.
13 Peterse 1999, 56–57, 164; 2008, 377.
14 De Haan et al. 2005; Coarelli and Pesando 2006, 244.
15 Recently suggested by Pesando (2008, 159).
16 See Peterse and De Waele's (2005, 197–221) metric analysis – though not identical, it is clear that a single concept connected them all.
17 The keyhole excavation and hand-recovery techniques employed in many recent excavations will encourage dates that are somewhat too early. Cf. critiques by D'Alessio (2008, 281), suggesting that more than half of the pottery recovered in excavation is residual, and Carafa's (2011, 95) concern that the earliest structures have generally been recovered within Regio VI alone, by projects that were expressly looking for them.
18 Pesando 2008, 159.
19 Notably suggested already by Mau Kelsey 1899, 39–40 and 274–276; Nappo 1997, 120. Cf. also Castrén 1975, 39ff on the influx of new gentes to the city at this time and Lepore 1984, 17 on the long held idea that Regiones I and II were the result of veterans settled at this time. Certainly the re-dating of the Casa del Chirurgo and other houses from excavation means that many of the standing remains in the city originate from this period, not simply the eastern half.
20 Fiorelli 1873, 78–86; Nissen 1877, 38. Cf. especially Wallace-Hadrill 1997, 224. De Albentiis 1990, 101 repeats this idea suggesting that the early Chirurgo must have used the well in the front room discovered by Maiuri.
21 As has been convincingly argued by Wallace-Hadrill 1997, 224.
22 Drerup 1959; Bek 1980, 164–203; Jung 1984; Hales 2003, 107–122.
23 Purcell 1995, 170.
24 Peterse and De Waele 2005, 211.
25 De Albentiis 1990, 83 reconstructs one here in this phase, and this seems very likely.
26 Hoffmann 1984, 97–118.
27 Nappo 1997, 120.
28 De Albentiis 1990, 91.
29 Nappo 1997, 99.
30 Mau-Kelsey 1899, 274; Fiorelli 1873, 81; De Albentiis 1990, 82; Cf. discussion in Wallace-Hadrill 1997, 224–225; Carocci et al. 1990, 200.
31 Ling 2005, 51; Descœudres 2007, 16; Cicero Pro Sulla, 60–2.
32 Zevi 1996, 125–138; Descœudres 2007, 16.
33 Cf. Curti 2008, 47–60.

34 Cf. Wootton, Chapter 9.

35 Dickmann 1997, 122.

36 Vitr. 6.3.9–10.

37 Maiuri 1973, 3–4.

38 Robinson 2017 has recently suggested that this sort of balancing between economic and luxurious was a key aspect of Roman economic thought.

39 This is an issue that has recently seen considerable archaeological interest at Pompeii, notably by Ellis 2017.

40 Maiuri 1942, *passim.*

41 *PAH* I, 1, 248–249.

42 Dobbins 2007, 175.

43 Jones and Robinson 2007, 401.

44 DeLaine 1997; 2000.

45 Vitruvius mentions a similar type of construction for city walls (Vitr. 1.5.1) *'turrium murorumque fundamenta sic sunt facienda uti fodiantur, si queat inveniri, ad solidum et in solido, quantum ex amplitudine operis pro ratione videatur, crassitudine ampliore quam parietum qui supra terram sunt futuri, et ea impleantur quam solidissima structura.'* 'foundations of towers and city-walls thus should be made so they are dug down to and in solid ground, if such can be found, and so much as may seem reasonable from the scope of the work, wider than the part of the walls that are to stand above the natural level of the ground, and these are to be filled with as solid structure as possible.' Text, Teubner Rose 1899.

46 Similar arguments surround the extensive use of First Style decoration. Cf. Wallace-Hadrill 1994, 26; Ling 1991, 12–13.

47 A modified version of Adam's Type II (2003, 203).

48 This is a pattern that has also been observed elsewhere in the city, cf. Anderson 2011.

49 In particular having been raised by Ellis at RAC 2014.

50 Ellis, pers. comm. RAC 2014; The Via Consolare Project under my direction, has recorded the elements of all fill layers in considerable detail in order to help differentiate between different types or sources. Results of both Projects on this issue are forthcoming.

51 Coarelli 2008, 175.

52 Beard *et al.* 1998, 192–195; Scheid 1990.

53 Syme 1939.

54 On the changes to the Forum, cf. Dobbins 1994, 629–94; Dobbins and Ball 2005, 60–72.

55 Cf. Tamm 1973.

56 *"qui communi sunt fortuna, non necessaria magnifica vestibula nec tabulina neque atria, quod aliis officia praestant ambiundo neque ab aliis ambiuntur."* Vitr. *De arch.* 6.5.1 'Those of common fortune, do not need magnificent vestibules or tablina or *atria*, because they fulfill their duties by going around to others and not being visited by others.' Text: Rose 1899.

57 Bruno and Scott 1993, 29.

58 Wallace-Hadrill 1994, 160–174.

59 Dwyer 1991, 25.

APPENDIX I
LISTING OF STRATIGRAPHIC UNITS AND HARRIS MATRICES

The following two appendices contain a listing of the Stratigraphic Units (SUs) utilised in the text with their feature description, phase number, original SU description, and their specific location in Chapter 5. SU's marked as 'dead' are those which were voided at trench side due to clerical error or other administrative oversight and contain no data. The Harris Matrices for each area are contained in Appendix II. The stratigraphic relationships they illustrate are the result of intensive revision and often modification of the data recorded on the SU sheets themselves, which often contained errors, contradictions, or inversions, leading to overly complicated relationships or the necessity to sequence coarsely without indicating full stratigraphic position. Despite this, the overall sequence presented here is correct, and the full sequence of relationships is presented here in aid of any future work that might be undertaken and to help in the process of connecting the later full publication of materials from the excavations in Insula VI 1. In these Harris Matrices, deposits appear in normal text, cuts are underlined, and constructions (walls or other built features) are marked in bold.

SU No.	Type	Description/Feature	Phase	Ch. 5 Section	Original SU Sheet Description (NB. Can contain errors and some inconsistencies)
183.001	Deposit	Protective gravel and overburden	9	6.9.3	Modern loose fill over extent of AA
183.002	Deposit	Modern fills and deposits	9	6.9.1	Fill of soil and lapilli in S tank feature
183.003	Deposit	Modern lime tank fills - Bourbon fill	8	6.8.2	Fill of lapilli in tank feature
183.004	Deposit	Modern time tank fills - Bourbon fill	8	6.8.2	Lower level of fill within tank below 183.003
183.005	Deposit	Levelling post pre-Surgeon house orange w/grey mortar fill	3	6.2.2	Level of orange soil, part of tank wall fill?
183.006	Deposit	Grey, clay-like material	7	6.8.2	Grey clay within tank
183.007	Deposit	Charcoal	7	6.8.2	Charcoal section at E end of outer tank wall
183.008	Deposit	Lime and other fills of tank	7	6.8.2	Grey clay along N wall of tank (inside)
183.009	Deposit	Lime and other fills of tank	7	6.8.2	Brown/black clay in NW corner of tank
183.021	Wall	Wall plaster	3	6.3.3	Red plaster
183.036	Wall	Wall plaster	3	6.3.3	Red plaster
183.056	Wall	Wall plaster	3	6.3.3	Red plaster
183.081	Wall	Wall plaster	3	6.3.3	Red plaster
183.116	Deposit	Lime and other fills of tank	9	6.8.2	Grey clay in W half of tank
183.117	Deposit	Lime and other fills of tank	9	6.8.2	Lime deposit in NW corner of tank
183.118	Deposit	Lime and other fills of tank	9	6.8.2	Brown/black deposit in W side of tank
183.119	Deposit	Modern fills and deposits	9	6.9.1	Yellow earthen deposit on E half of tank
183.120	Deposit	Lime and other fills of tank	9	6.8.2	Grey clay mixed with degraded lime in SE corner of tank
183.121	Deposit	Lime and other fills of tank	9	6.8.2	Hard grey clay across centre of tank
183.122	Deposit	Lime and other fills of tank	9	6.8.2	White plaster covered in ash in NE corner of tank
183.123	Deposit	Fills on W side	9	6.9.1	Loose brown soil against tanks N wall, on outside
183.124	Deposit	Fills on W side	9	6.9.1	Sand next to 183.123
183.125	Deposit	General atrium fills	9	6.9.1	Fill under threshold
183.126	Deposit	Levelling post pre-Surgeon house orange w/grey mortar fill	3	6.2.2	Orange fill under 183.125 in threshold

183.127	Deposit	Plaster/lime coating on interior of tank	9	6.8.1	Tank
183.128	Deposit	Levelling post pre-Surgeon house orange w/grey mortar fill	3	6.3.2	Possible construction trench for E wall
183.129	Cut	Tank cut and construction	9	6.8.1	Mixed fill under tank
183.130	Cut	Tank cut and construction	9	6.8.1	Rubble fill below 183.127 and underlying foundation Sarno on W wall
183.131	Cut	Tank cut and construction	7	6.8.1	Grey levelling with lapilli underlying lime at base of tank
183.132	Deposit	Gritty green natural	1	6.1	Green grit under N half of tank
183.133	Cut	Wall W06.117 foundation trench	3	6.3.2	Cut for construction trench of W wall
183.134	Deposit	Wall W06.117 foundation trench	3	6.3.2	Fill of construction trench
183.135	Cut	Pre-Surgeon terracing cut	2	6.2.1	Cut into green grit
183.136	Deposit	Pre-Surgeon terracing cut	2	6.2.2	Brown fill with rubble
183.137	Cut	Cut for wall foundation (tank or partition wall)	5	6.5.1	Cut for N wall of tank, construction trench
183.138	Cut	Opus incertum wall	5	6.5.1	Fill of N wall of tank construction trench
183.139	Deposit	Wall W06.116 foundation trench	3	6.3.2	Possible construction trench for S wall
183.140	Deposit	Additional topping on wall	7	6.8.1	Fill sitting on top of 183.138, extension of wall
183.141	Cut	Wall W06.116 foundation trench	3	6.3.2	Cut for 183.139, possible construction trench
184.001	Deposit	Protective gravel and overburden	9	8.9	Modern deposit over extent of trench
184.002	Deposit	Modern fills	9	8.9	Dark organic fill overlying plaster floor remnants
184.003	Deposit	Maiuri's trench	9	8.9	Fill of Maiuri's trench
184.005	Cut	Maiuri's trench	9	8.9	Cut for Maiuri's trench
184.006	Deposit	Mortar over opus signinum	7	8.7	Mortar patching over opus signinum surface
184.007	Deposit	Degraded opus signinum	6	8.6	Opus signinum surface in SE corner of room
184.008	Deposit	Opus signinum 2 Subfloor	6	8.6	Subfloor surface below 184.008
184.009	Deposit	Subfloor for early opus signinum or levelling layers	5	8.5.4	Levelling fill from SE corner
184.010	Deposit	Big posthole	5	8.5.1	Clay levelling fill from SE corner
184.011	Deposit	Mortar over opus signinum	7	8.7	Mortar surface in NE corner
184.012	Deposit	Modern fills	9	8.9	Modern deposit over central area of room
184.013	Deposit	Mortar over opus signinum	7	8.7	Opus signinum surface underlying mortar smear
184.014	Deposit	Degraded opus signinum	6	8.6	Opus signinum surface in NW corner
184.015	Deposit	Mortar over opus signinum	7	8.7	Mortar surface in E corner
184.016	Deposit	Degraded opus signinum	6	8.6	Opus signinum surface in NE corner
184.017	Deposit	Opus signinum 2 subfloor	6	8.6	Subfloor surface below opus signinum floor in N half of room
184.018	Deposit	So-called kitchen feature	5	8.5.4	Opus signinum surface cap below 184.017
184.019	Deposit	Fills around cut of original floor (or kitchen feature)	6	8.6	Opus signinum surface lapping around 184.018
184.020	Deposit	Fills around cut of original floor (or kitchen feature)	6	8.5.4	Yellow subfloor below 184.019 and 184.017
184.058	Deposit	Fill of N-S drain	5	FN112	Fill of drain running N-S through centre of trench
184.068	Deposit	Degraded opus signinum	6	8.6	Opus signinum flooring = 184.014
184.069	dead				Cut for the drain in the tuff blocks running through centre of room (Dead number)
184.071	Constr.	Tuff drain bottom	3	8.3.3	Grey tuff stones (with drain carved into them) running through centre of room (N-S)

184.096	cut				Cut of construction trench for E/W wall filled with 184.083
184.097	Deposit	Subfloor for early opus signinum or levelling layers	5	8.5.4	Earthen fill across N half of room
184.103	Deposit	Big posthole	5	8.5.1	Round clay lens in centre S, cap for posthole
184.104	Deposit	Big posthole	5	8.5.1	Sandy material with clay inclusions, fill of posthole 184.106
184.105	Deposit	General fills	5	8.5.1	Yellow loamy deposit in NE corner of trench
184.106	Cut	Big posthole	5	8.5.1	Cut for small pit in E side of room
184.110	Deposit	General fills	5	8.5.1	Yellow fill of pit against wall W06.101, lense
184.111	cut				Cut for deep pit, containing 184.010
184.112	Deposit	Posthole 1	5	8.5.1	Red, clay-like deposit around W side of small pit
184.113	Cut	Posthole 1	5	8.5.1	Cut for small posthole in SE corner of room
184.114	Deposit	Posthole 1	5	8.5.1	Grey sandy fill of 184.113
184.115	Deposit	Subfloor for early opus signinum or levelling layers	5	8.5.4	Brown earth in SE corner equals 184.009
184.116	Deposit	General fills	5	8.5.1	Charcoal layer in SE corner of room
184.117	Deposit	Levelling post pre-Surgeon house: grey deposits	3	8.3.4	Grey with charcoal in E half of room
184.118	Constr.	Drain capping	3	8.3.3	Sarno stone capping of drain
184.119	Deposit	Fills	3	8.3.2	Construction trench for wall W06.107
184.120	Deposit	Fill	3	8.3.3	Construction trench for drain
184.121	Cut	Cut	3	8.3.3	Cut of drain and fill SU 184.120
184.122	Deposit	Fill of N-S drain	5	FN112	Lower fill of drain overlying 184.058 (equals 184.058)
184.123	Deposit	Levelling post pre-Surgeon house: grey deposits	3	8.3.4	Grey with charcoal on E side of 184.118
184.124	Cut	Foundation cut	3	8.3.2	Cut for deposit 184.105, possible construction trench in NE corner of room
184.125	Cut	Foundation cut	3	8.3.2	Cut for construction of wall W06.107
200.001	Deposit	Modern gravel	9	11.9	Grey gravel modern fill, covering the whole area of AA200
200.002	Deposit	Cistern collapse lapilli deposit	8	11.8.1	Brown earth fill in W of area
200.003	Deposit	Sarno stone consolidation around collapse	9	11.9	Half circle of small Sarno blocks, grey mortar and occasional pottery sherds stretching from the NW edge to near the centre, circle is 10-20 cm wide
200.004	Deposit	Mosaic edging	9	11.9	Modern grey mortar patching in SW corner of the area
200.005	Deposit	Mosaic edging	9	11.9	Modern uniform dark grey mortar patching in S centre
200.006	Deposit	Mosaic edging	9	11.9	Modern mortar, constructed as a border or support for mosaic edge, N-centre
200.007	Deposit	Mosaic edging	9	11.9	Modern mortar patch, dark grey in S-centre of area
200.008	Deposit	Mosaic	5	11.5.2	Mosaic tesserae in centre of area
200.009	Deposit	Nucleus	5	11.5.2	Mosaic nucleus composed of white mortar
200.010	Deposit	Opus signinum subfloor	5	11.5.2	Opus signinum in various patches across the area, with red mortar
200.011	Deposit	Mosaic building rubble base	5	11.5.2	Building rubble in W of area
200.012	Cut	E wall of tablinum cut	7	11.7	Cut of trench in NE of area
200.013	Deposit	Mosaic building rubble base	5	11.5.2	Building rubble fill in E of area

200.014	Cut	Pick marks in opus signinum	7	11.7	Pick marks in SW corner of area
200.015	Deposit	Mosaic	5	11.5.2	Mosaic tesserae to N of area beneath wall W06.060
200.016	Deposit	Mosaic	5	11.5.2	Mosaic tesserae under wall W06.061
200.017	Deposit	Mosaic	5	11.5.2	Mosaic tesserae on W of the area near 200.002 and 200.003
200.018	Deposit	Mortar sealing layer	5	11.5.2	Mortar layer formed over building rubble 200.011 and 200.013
200.019	Cut	Cistern collapse and associated radial fractures in the opus signinum	8	11.8.1	Collapse of cistern and radial fracturing of opus signinum 200.010 in W of area
200.020	Deposit	Cistern collapse lapilli deposit	8	11.8.1	Lower lapilli fill of cistern collapse in N of area
200.021	Constr.	Threshold stones	5	11.5.2	Threshold stone SE corner of Room 7
200.022	Deposit	Upper foundation trench fill	3	11.3.2.1	Orange brown deposit in SE corner of the area
200.023	Cut	Early modern pit in lapilli	8	11.8.1	Bourbon cut seen in section of 200.002 and 200.028
200.024	Deposit	Early modern pit in lapilli	8	11.8.1	Fill of Bourbon cut (200.023)
200.025	Deposit	Cistern collapse lapilli deposit	8	11.8.1	Natural lapilli deposit with clear stratigraphy in yellow, brown, grey bands
200.026	Deposit	Black sand intermixed with some of the debris from upper layers	2	11.5.2	Mixed brown and black sandy soil to E of area
200.030	Constr.	Threshold stones	5	11.5.2	Threshold stone SE corner of Room 7 and Sarno stone addition to SE column
200.057	Deposit	E wall of tablinum cut	5	11.5.1	Fill in E end of AA200 by 200.059
200.058	Cut	E wall of tablinum cut	5	11.5.1	Cut of wall 200.058 to E of the area
200.059	Constr.	Traces of removed Wall	3	11.3.2.3	Opus incertum wall fragment in SE corner
200.060	Deposit	E pit 2	5	11.5.1	Pit fill to NE of trench with Sarno stones and yellow plaster inclusions
200.061	Deposit	Black sand	2	11.2.1	Black volcanic sand in E of area
200.062	Constr.	Wall construction	3	11.3.2.1	Sarno foundation stones in SE corner
200.063	Deposit	Lower foundation trench fill	3	11.3.2.1	Bbrown earth fill of foundation trench in SE corner of area next to wall W06.061
200.064	Cut	Foundation trench	3	11.3.2.1	Cut of the foundation trench for wall W06.061 in SE corner of the area
200.065	Deposit	Fragments of mosaic at the base of the collapse	8	11.8.1	Fragments of floor at the base of cistern collapse 200.019
200.066	Deposit	Enveloping grey clay	8	11.8.1	Clay like deposit over 200.065 (floor fragments)
200.067	Deposit	Wall construction	3	11.3.2	Ancient construction of wall W06.060
200.068	Constr.	Marble footing for door opening	4	11.4	Marble threshold for door opening
200.100	Deposit	E pit 2	5	11.5.1	Pit fill to NE of area containing yellow plaster inclusions
200.101	Cut	E pit 2	5	11.5.1	Pit cut in NE corner of the area
200.102	Deposit	E pit 1	5	11.5.1	Rubble fill cut 200.103 in E of area
200.103	Cut	E pit 1	5	11.5.1	Pit cut for rubble fill 200.102 in E of the area
200.104	Deposit	E pit 2	5	11.5.1	Fill of pit within 200.101 in E of the area
200.105	Cut	E pit 2	5	11.5.1	Cut of pit within 200.101 pit cut in E of area
200.106	Deposit	Yellow earthen mortared wall	2	11.2.2	Yellow mortar construction in E of the area
200.107	Deposit	Upper pitted earth surface	2	11.2.1	Pitted earth surface to E of area
200.108	Deposit	E pit 2	5	11.5.1	Large Sarno stone block and yellow mortar construction in E of the area
200.109	Deposit	Upper foundation trench fill	3	11.3.2.1	Orange flecked deposit to SW of area

200.110	Deposit	Cistern collapse lapilli deposit	8	11.8.1	Cistern collapsed deposit in SW corner
200.111	Deposit	Lower pitted earth surface	2	11.2.1	Second yellow grey pitted earth layer in E of area
200.112	Deposit	Pit cut into black sand	3	11.3.1	Hard packed yellow deposit in N corner
200.113	Deposit	Black sand	2	11.2.1	Black sand in N corner
200.114	Deposit	Upper pitted earth surface	2	11.2.1	Hard pitted earth in N corner
200.115	Cut	Foundation trench	3	11.3.2.1	Cut of foundation trench in SW corner - wall W06.061
200.116	Constr.	Wall construction	3	11.3.2.1	Sarno foundation stones in SW corner - wall W06.061
200.117	Deposit	Upper pitted earth surface	2	11.2.1	Pitted earth in SW corner
200.118	Deposit	Black sand	2	11.2.1	Black sand in SW corner
200.119	Deposit	Pea gravel	2	11.2.1	Loose gravel layer in the E of area
200.120	Deposit	Turf layer	1	11.1	Yellow decayed turf line in E of area
200.121	Deposit	Natural	1	11.1	Brown levelling deposit in E of area
200.122	Cut	Pit cut into black sand	3	11.3.1	Pit cut in centre of N area
200.123	Deposit	Foundation trench fill	3	11.3.2.2	Foundation trench fill in NW corner
200.124	Cut	Foundation trench cut	3	11.3.2.2	Foundation trench cut in NW corner
200.125	Deposit	Lower pitted earth surface	2	11.2.1	Second layer pf pitted earth in SW corner
200.126	Deposit	Pea gravel	2	11.2.1	Pea gravel in SW corner
200.127	Deposit	Turf layer	1	11.1	Yellow decayed turf found in SW corner
200.128	Deposit	Natural	1	11.1	Brown natural layer in SW corner
200.129	Deposit	Lower pitted earth surface	2	11.2.1	Second pitted earth in N test pit
200.130	Cut	Posthole	2	11.2.2	Posthole cut in N of area
200.131	Deposit	Posthole	2	11.2.2	Black sand packing for posthole 200.130
200.132	Deposit	Posthole	2	11.2.2	Fill of posthole in N of area
200.133	Deposit	Traces of decayed tree root	2	11.2.1	Decayed root in 200.129
200.134	Deposit	Traces of decayed tree root	2	11.2.1	Decayed root in 200.129
200.135	Deposit	Pea gravel	2	11.2.1	Pea gravel in N of area
200.136	Deposit	Turf layer	1	11.1	Yellow decayed turf layer in N test pit
200.137	Deposit	Natural	1	11.1	Natural levelling layer in N
200.138	Constr.	Wall construction	3	11.3.2.2	Sarno foundation stones revealed in NW corner by excavation - wall W06.060
202.001	Deposit	Modern protective gravel and overburden	9	5.9	Modern gravel
202.002	Deposit	Maiuri's Trenches (AA202)	9	5.9	Fill of Maiuri's trench
202.003	Cut	Maiuri's Trenches (AA202)	9	5.9	Cut of Maiuri's trench
202.004	Constr.	Tuff impluvium in centre of atrium	5	5.5.3.1	Impluvium made of tufa blocks
202.005	Deposit	Opus signinum	5	5.5.7	Opus signinum surface
202.006	Deposit	Subfloor	5	5.5.7	Mortar core of the opus signinum surface
202.007	Constr.	Sarno block	3	5.3.6	Sarno block in NW of the area
202.008	Deposit	Subfloor	5	5.5.7	Hard mortar in N of the area
202.009	Constr.	Tuff stone	3	5.3.6	Large tufa block under sarno block (202.008)
202.010	Deposit	Fills N of impluvium	3	5.3.1	Grey soft tufa stone with rectangular cut, underlies the impluvium
202.011	Deposit	Pocked earth traces north of impluvium	2	5.2.1	Packed earth on the top of the sarno block and in the N of the area
202.012	Deposit	Mortar under impluvium on N side	5	5.5.3.1	Mortar lip under impluvium
202.013	Deposit	Fills N of impluvium	3	5.3.1	Soil under the S part of the Maiuri's trench
202.014	Cut	Posthole	3	5.3.4.2	Posthole under the impluvium

202.015	Cut	Posthole	3	5.3.4.2	Posthole in 202.021
202.016	Deposit	N Sarno chocks	5	5.5.3.1	Small sarno stone in the very N edge of the area
202.017	Deposit	N Sarno chocks	5	5.5.3.1	Mortar lip underneath the large tufa stone
202.018	Deposit	Subfloor	5	5.5.7	Grey mortar in the N of the area
202.019	Deposit	Fills N of impluvium	3	5.3.1	Loose soil under 202.017
202.020	Deposit	Fills N of impluvium	3	5.3.1	Layer of soil with inclusions, lies between 202.013 and 202.019
202.021	Deposit	Fills N of impluvium	3	5.3.1	Soil in the sections NW, SW, SE
202.022	Cut	Posthole	3	5.3.4.2	Posthole cut into 202.011
202.023	Cut	Posthole	3	5.3.4.2	Posthole cut into 202.011
260.001	Deposit	Modern protective gravel and overburden	9	5.9	Modern gravel all over the extent of the area
260.002	Deposit	Maiuri's trench fill	9	5.9	Backfill of AA 201 from 2002
260.003	Deposit	Maiuri's trench fill	9	5.9	Backfill of AA211
260.004	Deposit	General fills	7	5.7.5	Lies at the S end of impluvium, rubble adjoining the NE end of AA201 but separate from last year's trench
260.005	Deposit	Fills over opus signinum	9	5.9	Blinding layer covering opus signinum floor layer, soft yellow deposit
260.006	Deposit	Opus signinum	5	5.5.7	Opus signinum flooring in the S of area, covering the whole extent of the area
260.007	Deposit	Hard-packed earth over the opus signinum	7	5.7.5	Hard packed earth covering opus signinum floor
260.008	Constr.	Original Sarno capstones	3	5.3.4.1	Sarno drain capping for drain into area
260.009	Cut	Maiuri's cuts	9	5.9	Cut for trench AA201
260.010	Cut	Maiuri's cuts	9	5.9	Cut for 260.003 for AA211, 2002
260.011	Constr.	Tuff impluvium in centre of atrium	5	5.5.3.1	Impluvium in the centre of atrium
260.012	Deposit	Subfloor	5	5.5.7	Base of opus signinum floor between AA211 and 201
260.013	Deposit	Subfloor	5	5.5.7	Base of opus signinum floor underneath 260.004 NE in the area
260.014	Deposit	Earth use floor? W	3	5.3.5	Hard packed earth surface below opus signinum floor under SU12
260.015	Deposit	Posthole 1	7	5.7.5	Posthole in SE of area with big piece of charcoal
260.016	Deposit	Posthole 1	7	5.7.5	Posthole area of dark brown inner fill
260.017	Deposit	Posthole 1	7	5.7.5	Posthole in SE of area, lighter brown exterior fill
260.018	Cut	Posthole 1	7	5.7.5	Posthole in SE area - cut for the light brown fill
260.019	Cut	Posthole 1	7	5.7.5	Possible posthole in SE of area - the cut for the dark brown fil
260.020	Deposit	Earth use floor? W	3	5.3.5	Hard packed surface below 260.013 in NE of area
260.021	Constr.	(Reused?) Sarno under impluvium	5	5.5.3.1	The first Sarno block under impluvium in the section of AA201
260.022	Cut	Posthole 2	7	5.7.5	Cut for the posthole in SE of the area of wall W06.027, with large stones in it
260.023	Deposit	General fills	5	5.5.2	Pink mortar between post holes and threshold, closer to wall W06.026 and bits of it on the top of 260.014
260.024	Deposit	Posthole 3	7	5.7.5	Fill of the posthole in SE of the area at wall W06.024

260.025	Deposit	Cut 2a	7	5.7.5	Small hole in floor foundation level for opus signinum floor - the fill
260.026	Cut	Cut 2a	7	5.7.5	Small hole in foundation level for opus signinum floor
260.027	Deposit	Cut 1	5	5.5.2	Packed earth mixed with mortar at wall W06.029
260.028	Deposit	Second (excavated - i.e. lower) fill	3	5.3.2.5	Soft fill area in corner of trench with Sarno stone flakes
260.029	Deposit	Cut in centre cut	5	5.5.2	Grey circular packed earth in the centre of area
260.030	Deposit	General fills	5	5.5.2	Grey smear on top of 260.014 at the edge of AA201
260.031	Deposit	Fills	3	5.3.4.1	Grey hard packed layer running over the drain
260.032	Deposit	Cut 1	5	5.5.2	VOID
260.033	Cut	Cut 1	5	5.5.2	Cut for hole by wall W06.029
260.034	Deposit	Cut 1	5	5.5.2	Fill for 260.033
260.035	Deposit	Mortar overlying impluvium construction (and wall W06.026)	5	5.5.3.1	Grey packed mortar on 260.036, running over Sarno block 260.021
260.036	Deposit	Fills over N-S drain	3	5.3.5	Yellow-brown surface layer N of AA201
260.037	Constr.	(Reused?) Sarno under impluvium	5	5.5.3.1	Second Sarno block in last seasons AA 209
260.038	Cut	Maiuri's cuts	9	5.9	Cut of Maiuri's trench
260.039	Deposit	Maiuri's trench fill	9	5.9	Fill of Maiuri's trench
260.040	Deposit	Fills over N-S drain	3	5.3.5	Fill material W and S of AA211
260.056	Cut	Cut in centre cut	5	5.5.2	Circular feature cut into middle of area
260.057	Deposit	Cut in centre cut	5	5.5.2	Fill of 260.056 - red volcanic stones mixed with charcoal
260.058	Deposit	First (excavated, i.e. upper) fill	3	5.3.2.4	Yellow packed surface on top of Sarno block of the left of wall W06.026, the bottom lined by flakes of white stone
260.059	Deposit	First (excavated, i.e. upper) fill	3	5.3.2.4	Yellow brown fill of the foundation cut 260.079 of wall W06.026 to left of AA201
260.060	Constr.	(Reused?) Sarno under impluvium	5	5.5.3.1	Third foundation stone of the impluvium
260.079	Cut	Foundation trench	3	5.3.2.4	Foundation cut of wall W06.026, left of AA201
260.080	Cut	Foundation trench	3	5.3.2.4	Cut for foundation trench of wall W06.026, right of AA201
260.081	Deposit	First (excavated, i.e. upper) fill	3	5.3.2.4	First fill of foundation trench for wall W06.076 to the right of AA201
260.082	Cut	Foundation trench	3	5.3.2.5	Foundation trench (No SU sheet)
260.088	Cut	Two small (post?) holes	5	5.5.2	Small hole at impluvium between 260.060 and 260.090
260.089	Deposit	Two small (post?) holes	5	5.5.2	Fill of 260.088
260.090	Constr.	(Reused?) Sarno under impluvium	5	5.5.3.1	Fourth Sarno stone under impluvium
260.091	Cut	Two small (post?) holes	5	5.5.2	Cut for second small hole cut into Sarno stone 260.090
260.092	Deposit	Two small (post?) holes	5	5.5.2	Fill of 260.091
260.093	Deposit	Second (excavated, i.e. lower) fill	3	5.3.2.4	Second fill of foundation cut 260.079 of wall W06.026
260.094	Deposit	All part of cut of new Impluvium	5	5.5.3.1	Charcoal layer under 260.014, right up to AA201
260.095	Constr.	Drain	3	5.3.4.1	Grey pebbly layer between impluvium and drain
260.096	Deposit	Turf layer	1	5.1	Plant residue layer (turf)

260.097	Deposit	Fill inside N-S drain	3 to 4	5.5.3.1	Fill of drain highly contaminated broken and fallen bits in it
260.098	Cut	Fill around drain	3	5.3.4	Cut for drain
260.099	Constr.	Drain (tuff and Sarno construction)	3	5.3.4	Drain left of AA201
260.100	Deposit	Natural	1	5.1	Natural yellow soil in centre of AA
260.101	Deposit	Second (excavated, i.e. lower) fill	3	5.3.2.4	Second fill of foundation trench for N wall W06.026
260.102	Constr.	Drain	3	5.3.4.1	Drain W to area
260.103	Constr.	Lower drain (grey tuff)	3	5.3.4.1	Drain, grey tuff stone in the bottom
260.104	Deposit	Earth use floor? W	3	5.3.5	Hard packed earth at the left of the impluvium
260.105	Deposit	Fills	5	5.5.3.1	Fill of foundation trench of impluvium
260.106	Cut	Cut	5	5.5.3.1	Cut of foundation trench of impluvium
260.107	Deposit	Top fills into which Surgeon cut	3	5.3.1	Soft dark brown deposit of threshold between walls W06.026 and W06.027
260.108	Deposit	First (excavated - i.e. upper) fill	3	5.3.2.5	First fill of foundation trench of wall W06.027
260.109	Deposit	E fill layer	3	5.3.1	Dark brown soil layer under 260.014
260.110	Deposit	Second (excavated - i.e. lower) fill	3	5.3.2.5	Second fill layer of foundation trench for wall W06.027
260.111	Deposit	Top fills into which Surgeon cut	3	5.3.1	Grey grit with charcoal to right of AA201
260.112	Cut	Cut	5	5.5.3.1	Cut for foundation trench of impluvium to right of AA201
260.113	Deposit	Fills	5	5.5.3.1	Fill of AA112
260.114	Deposit	Fills	3	5.3.4.1	Grey earth on top of the cut of the drain
260.115	Cut	Cut	3	5.3.4.1	Cut for drain
260.116	Deposit	Fill inside W drain (not excavated)	N/A	N/A	Fill of 260.115
260.117	Deposit	Mortar in drain construction	5	5.5.3.2	Mortar covering sides of drain
260.118	Deposit	Top fills into which Surgeon cut	3	5.3.1	Dark brown soil layer under 260.036
260.119	Deposit	First (excavated - i.e. upper) fill	3	5.3.2.5	Yellow soil part of the first fill of foundation trench for walls W06.026 and W06.027
260.120	Deposit	Second (excavated - i.e. lower) fill	3	5.3.2.5	Second fill of foundation trench for wall No. 26 and 27
260.121	Cut	Inter-cutting pits and fills	2	5.2.5	Pit cut into right section of AA211 with grey sandy silt fill
260.122	Deposit	Inter-cutting pits and fills	2	5.2.5	Fill of 260.121
260.123	dead				Cut of small pit hole NO SU SHEET
260.124	Deposit	Cut and fills plausibly related to this activity	5	5.5.2	Small hole with light brown fill in section right to AA211
260.125	Cut	Cut and fills plausibly related to this activity	5	5.5.2	Cut of pit in corner of section in AA211
260.126	Deposit	Cut and fills plausibly related to this activity	5	5.5.2	Fill of 260.125
260.127	Deposit	Inter-cutting pits and fills	2	5.2.5	Fill of small hole in 260.126
260.128	Cut	Inter-cutting pits and fills	2	5.2.5	Cut of 260.127
260.129	Deposit	Fill around drain	3	5.3.4	Fill of foundation for drain 260.99
260.130	Cut	Disturbance repair?	7	5.7.3	Disturbance of the drain
261.001	Deposit	modern soil and rubble covering the trench	9	13.9.2	Modern rubble fill over entire excavation area between opus signinum finished surfaces
261.002	Deposit	Opus signinum finished surface	5	13.5.2	Ancient reconstructed floor
261.003	Deposit	Opus signinum subfloor	5	13.5.2	Second opus signinum layer - N to the room
261.004	Deposit	Opus signinum subfloor	5	13.5.2	Ancient opus signinum floor surface, covering the central area of AA261

261.005	Deposit	Opus signinum subfloor	5	13.5.2	Opus signinum base up against wall W06.085 in AA261
261.006	Deposit	Opus signinum finished surface	5	13.5.2	Original upper opus signinum finished surface, cut into on its NE edge.
261.007	Deposit	Opus signinum finished surface	5	13.5.2	Original upper opus signinum finished surface, located in the SE corner
261.008	Deposit	Opus signinum finished surface	5	13.5.2	Small half circle of original upper opus signinum finished surface along the E wall
261.009	Deposit	Mortar edging to the remnants of the opus signinum floor	9	13.9.2	Small grey blob of concrete masonry of unknown origin. Located in centre of room
261.010	Deposit	Possible repair of the opus signinum after the removal of the emblema	8	13.8.1	Bourbon render against 261.002
261.011	Deposit	Mortar edging to the remnants of the opus signinum floor	9	13.9.2	Modern cement with boot print located against 261.002 and 261.005
261.012	Deposit	Mortar edging to the remnants of the opus signinum floor	9	13.9.2	Modern conservation render of 261.002
261.013	Deposit	Mortar edging to the remnants of the opus signinum floor	9	13.9.2	Modern conservation render located up against 261.006
261.014	Deposit	Mortar edging to the remnants of the opus signinum floor	9	13.9.2	Modern conservation render of 261.007
261.015	Deposit	Mortar edging to the remnants of the opus signinum floor	9	13.9.2	Modern conservation render up against 261.008
261.016	Cut	Sondage 1	9	13.9.1	Cut of trench 261.017 (probably Maiuri)
261.017	Deposit	Sondage 1	9	13.9.1	Remaining fill presumably from one of Maiuri's trenches. It runs E to W in the centre of the room
261.018	Cut	Sondage 3	9	13.9.1	Cut of trench (261.019). Possibly Maiuri
261.019	Deposit	Sondage 3	9	13.9.1	Fill of trench, possibly Maiuri's
261.020	Deposit	Opus signinum subfloor	5	13.5.2	Opus signinum base mortar under 261.004
261.021	Deposit	Opus signinum subfloor	5	13.5.2	Opus signinum base under 261.022
261.022	Deposit	Opus sectile emblema	5	13.5.2	Opus signinum pink mortar feature (with pick marks)
261.023	Cut	Pick marks in the emblema (Bourbon removal?)	8	13.8.1	Pick marks cut into 261.022 opus signinum floor
261.024	Deposit	Opus signinum Subfloor	5	13.5.2	Opus signinum base below 261.007
261.025	Deposit	Mortar edging to the remnants of the opus signinum floor	9	13.9.2	Masonry/pointing preservation layer
261.026	Deposit	Mortar edging to the remnants of the opus signinum floor	9	13.9.2	Masonry/pointing preservation layer
261.027	Cut	Posthole	8	13.8.1	Cut of hole in 261.004
261.028	Deposit	Posthole	8	13.8.1	Fill of hole cut in 261.004
261.029	Constr.	Sarno stone opus quadratum	3	13.3.2	Sarno foundation stone of wall W06.083 in trench 261.016
261.030	Deposit	Natural	1	13.1	Packed earth surface under 261.029 in trench 261.016
261.031	Cut	Sondage 2	9	13.9.1	Cut of trench in 261.003 and 261.004
261.032	Deposit	Sondage 2	9	13.9.1	Fill of trench in opus signinum 261.003 and 261.004
261.033	Deposit	Grey lava cobble layer	5	13.5.2	Lava hardcore base layer under opus signinum base and above deep rubble fill
261.034	Deposit	Spread of white mortar	3	13.3.1	White mortar spread above black sand deposit
261.035	Deposit	Black sand deposit	3	13.2.1	Black sand deposit to the SE corner AA261 above 261.036

261.036	Deposit	Natural	1	13.1	Natural packed surface, re-deposited fill (terrace material?)	
261.037	Cut	Opus sectile emblema	5	13.5.2	Indentations of diamond floor decorations	
261.038	Deposit	Grey lava cobble layer	5	13.5.2	Rubble layer (deep) below 261.033 and 261.038	
261.039	Constr.	Sarno stone opus africanum	3	13.3.2	Sarno foundation stone with render coat to one edge.	
261.040	Deposit	Firmly packed earth	5	13.5.1	Light brown earth layer abutting 261.140 and above 261.035	
261.041	Cut	Cut at base of terrace	2	13.2.2	Cut of pit in 261.035	
261.042	Deposit	Cut at base of terrace	2	13.2.2	Fill of 261.041	
261.043	Deposit	Fills of pre-Surgeon terrace cut	3	13.3.1	Deep rubble fill below 261.038	
261.044	Deposit	Turf layer	1	13.1	Light grey-band - evidence of turf	
261.045	Deposit	Fills of pre-Surgeon terrace cut	3	13.3.1	Grey hard packed layer	
261.046	Deposit	Foundation trench fill	3	13.3.2	Foundation fill of dark deposit abutting wall W06.083	
261.047	Deposit	Fills of pre-Surgeon terrace cut	3	13.3.1	Sandy grey soil butting 261.043 along 261.017 and 261.016	
261.048	Cut	Foundation trench cut	3	13.3.2	Cut of wall foundation trench	
261.049	Cut	Rock formed depressions	2	13.2.2	Circular holes near SE corner of Room 10	
261.050	Deposit	Rock formed depressions	2	13.2.2	Fill of hole in 261.034 (white mortar)	
261.051	Cut	Pre-Surgeon terracing cut	2	13.2.2	Cut into 261.036 for deep hole filled with 261.043	
261.052	Cut	Ancient pick marks	2	13.2.2	Pick marks in 261.030 and 261.036	
261.053	Deposit	Pocked earth surface	2	13.2.1	Packed earth surface above 261.035	
261.054	Cut	Posthole	2	13.2.2	Cut of post hole in 261.036	
261.055	Deposit	Posthole	2	13.2.2	Fill of posthole	
261.056	Cut	Cut at base of terrace	2	13.2.2	Cut into 261.035 N of 261.049 and 261.050	
261.057	Deposit	Cut at base of terrace	2	13.2.2	Fill of 261.056	
261.058	Cut	Latrine pit: cut	2	13.2.2	Cut of earlier pit against wall W06.084	
261.059	Deposit	Latrine pit: cut	2	13.2.2	Fill of earlier pit against wall W06.084	
261.061	dead	261.061-261.099 all dead			Dead number	
261.100	cut				Cut of foundation trench into 261.035 and 261.036	
261.139	Cut	Wall W06.084 foundation trench	5	13.5.1	Cut of foundation trench	
261.140	Constr.	Foundation trench fill and shuttered foundation	5	13.5.1	Shuttered foundation	
262.001	Deposit	Gravel	9	24.9	Modern gravel	
262.002	Deposit	Modern overburden fills	9	24.9	Modern dumped deposit	
262.003	Deposit	White plaster fill	7	24.7	Mortar subfloor	
262.004	Deposit	Compact fill overlying others	3	24.3.4.4	Compact earth possible floor	
262.005	Deposit	Sarno blocks	3	24.3.4.3	Sarno blocks	
262.006	Deposit	White plaster fill	7	24.7	Gravel at E end of trench	
262.007	Constr.	Wall W06.098/W06.099/W06.100 (E Wall)	5	24.5.1	Stones, possibly representing a threshold in open doorway	
262.008	Deposit	N central cut	7	24.7	Brown earth deposit N end of trench	
262.009	Deposit	N central cut	7	24.7	Brown earth deposit not physically associated with 262.008	
262.010	Deposit	Heavy rubble	7	24.7	Compact but friable area of stone and marble	
262.011	Deposit	Heavy rubble	7	24.7	As 262.010, but not physically associated	
262.012	Deposit	Mortar chunks	6	24.6.2	Mortar patching	
262.013	Deposit	Earth subfloor and mortar fragments	6	24.6.2	Concerted mortar in depression	

262.014	Deposit	Earth subfloor and mortar fragments	6	24.6.2	Brown earth deposit
262.015	Deposit	Opus signinum flooring	6	24.6.2	opus signinum floor
262.016	Deposit	White plaster fill	7	24.7	Mortar floor remains, NE corner
262.017	Deposit	Fills	7	24.7	Upper fill of pit, N end
262.018	Deposit	S of portico fill	3	24.3.4.4	Compacted earth beneath opus signinum
262.019	Deposit	Wall W06.098/W06.099/W06.100 (E wall)	5	24.5.1	Fill of foundation trench to N of wall W06.100
262.020	Deposit	Dusty underfloor of opus signinum	6	24.6.2	Patch of degraded opus signinum, N of 262.015
262.021	Constr.	Wall W06.101 (S wall) foundation	6	24.6.1	Fill of foundation trench for walls W06.101 and W06.102
262.022	Deposit	Compacted earth sealing trench	6	24.6.1	Compacted earth underlying 262.021
262.023	Constr.	Wall W06.098/W06.099/W06.100 (E wall)	5	24.5.1	Compacted earth abutting wall W06.100
262.024	Deposit	Compact fill overlying others	3	24.3.4.4	Compact earth overlain by fragmented earth deposit
262.025	Deposit	So called Cut 2	3	24.3.3	Yellow silty deposit underlying 262.017
262.026	Deposit	Wall W06.097 (N wall)	3	24.3.4.1	Brown silty deposit along N wall
262.027	Deposit	Wall W06.102 (W wall)	5	24.5.1	Fill of possible foundation trench for wall W06.102
262.028	Deposit	Dusty underfloor of opus signinum	6	24.6.2	Degraded opus signinum in S of room
262.029	Deposit	Opus signinum flooring	6	24.6.2	Degraded opus signinum S of Sarno blocks
262.030	Deposit	Fills	7	24.7	Yellow/grey deposit abutting 262.026
262.031	Deposit	Wall W06.097 (N wall)	3	24.3.4.1	Grey deposit cut into 262.032
262.032	Deposit	Natural	1	24.1	Yellow/orange deposit along N wall
262.033	Deposit	Small pit on E	7	24.7	Dark brown deposit along E wall
262.034	Cut	Small pit on E	7	24.7	Cut of pit in N part of AA
262.035	Cut	Wall W06.098/W06.099/W06.100 (E wall)	5	24.5.1	Cut for foundation trench for wall W06.100
262.036	Cut	Wall W06.097 (N wall)	3	24.3.4.1	Cut for foundation trench in NW corner
262.037	Deposit	Wall W06.097 (N wall)	3	24.3.4.1	Fill of foundation trench
262.038	Deposit	So called Cut 3 part of building/ levelling process	3	24.3.3	Fill of pit in NW of trench
262.039	Deposit	Compact fill overlying others	3	24.3.4.4	Compacted earth, possible subfloor, E side of trench
262.040	Deposit	Compact Fill overlying others	3	24.3.4.4	Compacted earth, possible subfloor, against Sarno blocks
262.041	Cut	So called Cut 3 part of building/ levelling process	3	24.3.3	Cut of pit, fill being 262.038
262.042	Cut	N central cut	7	24.7	Cut of pit, fill being 262.017
262.147	Constr.	Sarno topping	3	24.3.4.2	Sarno drain cap stones
262.152	Deposit	Fills around drain	3	24.3.4.2	Foundation fill for drain on S side
262.153	Deposit	Fills around drain	3	24.3.4.2	Foundation fill for drain on N side
262.154	Deposit	N fills post pre-Surgeon	3	24.3.3	Compacted earth deposit that the drain was cut into, S side
262.155	Deposit	N fills post pre-Surgeon	3	24.3.3	Compacted earth deposit that the drain was cut into, N side
262.156	Deposit	Drain fills	N/A	N/A	Fill of drain
262.157	Constr.	Impluvium	2	24.2.3	Opus signinum floor, SE corner of AA
262.158	Deposit	S fills post pre-Surgeon	3	24.3.3	Dark grey compact earth floor, SW corner of AA
262.159	Constr.	Impluvium	2	24.2.3	Mortar division between 262.157 and 262.158

262.162	Deposit	So called Cut 3 part of building/ levelling process	3	24.3.3	Rocky deposit in NW corner
262.163	Deposit	Drain fills	N/A	N/A	Top 8 cm of drain fill
262.164	Deposit	Drain fills	N/A	N/A	Bottom of drain fill, stratigraphically the same as 262.163
262.165	Deposit	S fills post pre-Surgeon	3	24.3.3	Compact earth N of drain
262.166	Deposit	Fills around drain	3	24.3.4.2	Silty foundation deposit S of drain
262.167	Deposit	Fills around drain	3	24.3.4.2	Silty foundation deposit N of drain
262.168	Constr.	Tuff drain base	3	24.3.4.2	Tuff drain
262.169	Deposit	Wall W06.098/W06.099/W06.100 (E wall)	5	24.5.1	Deposit E of 262.157
262.170	Deposit	So called Cut 2	3	24.3.3	Yellow deposit running S near E wall
262.171	Deposit	So called Cut 2	3	24.3.3	Orange deposit along the bottom of the pit
262.172	Deposit	So called Cut 2	3	24.3.3	Loose compaction possibly of 262.165
262.173	Deposit	S fills post pre-Surgeon	3	24.3.3	Compact earth surface between drain and 262.159
262.174	Cut	N-S Drain	3	24.3.4.2	Cut of drain
263.001	Deposit	Gravel	9	23.9.1	Modern gravel
263.002	Deposit	Modern overburden fills	9	23.9.1	Build up deposit
263.003	Deposit	Opus signinum flooring	6	23.6.1	Floor surface
263.004	Deposit	Black lava flooring	6	23.6.1	Lava rock fill
263.005	Deposit	Mortar subfloor and stone capping	6	23.6.1	Heavily mortared stone layer
263.025	Deposit	Mortar subfloor and stone capping	6	23.6.1	Collapsed flooring into cistern
263.026	Deposit	Fills of cistern in Room 22	6	23.6.1	First layer of soil with medium mortar pieces
263.027	Deposit	Fills of cistern in Room 22	6	23.6.1	Second layer of soil with very little mortar inclusions
263.028	Deposit	Fills of cistern in Room 22	6	23.6.1	Third layer of soil, heavy pottery inclusions
263.030	Deposit	Fills of cistern in Room 22	6	23.6.1	Fourth layer of soil, fairly sterile
263.039	Constr.	Drain into S cistern (Room 22)	2	23.2.1	Cistern
264.001	Deposit	Modern overburden	9	18.9	Grey modern deposit covering whole of N end of AA
264.002	Deposit	Fills in the toilet	7	18.8.1	Firm grey rubble deposit at N end
264.003	Deposit	Lapilli fill	8	18.8	Lapilli deposit N of mortar surface
264.004	Deposit	Fills in the toilet	7	18.8.1	Loose grey deposit with large rubble chunks at N end of AA
264.005	Deposit	Fills in the toilet	7	18.8.1	Loose brown deposit in S end of AA
264.006	Deposit	Thin white layer on top of mortar surface	6	18.6.4	Thin white mortar surface
264.007	Deposit	Toilet chute	6	18.6.4	Grey mortar layer with black inclusions
264.008	Deposit	Fills in the toilet	6	18.6.4	Thick white mortar layer
264.009	Deposit	Fills in the toilet	7	18.8.1	Brown silty deposit in NW corner of AA264
265.001	Deposit	Gravel and overburden	9	14.9	Gravel layer and modern deposits
265.002	Deposit	Rubble levelling deposits and detritus	7	14.7	Brown layer at E end of AA
265.003	Deposit	Possible Lime Residues	7	14.7	White limey mortar surface
265.004	Deposit	Rubble levelling deposits and detritus	7	14.7	Yellow deposit in W end of AA
265.005	Deposit	Modern Deposits	9	14.9	Burnt layer over mortar surface
265.006	Deposit	Fills and Partially Removed and Compacted Subfloor	5	14.5.1	Compact surface underlying N wall
265.007	Deposit	Modern Deposits	9	14.9	Brown fill of cut in 265.003
265.008	Deposit	Rubble levelling deposits and detritus	7	14.7	Brown layer with pot in it against S wall
265.009	Deposit	Rubble levelling deposits and detritus	7	14.7	Compacted yellow deposit in centre of E half of AA

265.010	Deposit	Rubble levelling deposits and detritus	7	14.7	Brown layer at W end of AA under 265.003
265.011	Deposit	Cut in E threshold	5	14.5.2	Yellow layer underlying 265.006 in NE corner
265.012	Deposit	Fills and partially removed and compacted subfloor	5	14.5.1	Grey layer underlying SU6 in NE corner
265.013	Deposit	Plaster or mortar surface skims	5	14.5.1	White/ pink mortar skim over 265.006
265.014	Deposit	Opus signinum flooring fragment	3	14.3.2	Opus signinum remains in W side of AA
265.015	Constr.	Sarno block	3	14.3.2	Sarno wall running N-S
265.016	Cut	Posthole 1	5	14.5.2	Cut in 265.006 against N wall
265.017	Cut	Posthole 2	5	14.5.2	Cut S of 265.016
265.018	Deposit	Posthole 1	5	14.5.2	Fill of 265.016
265.019	Deposit	Posthole 2	5	14.5.2	Fill of 265.017
265.020	Deposit	Opus signinum flooring fragment	3	14.3.2	Grey mortar underlying 265.014
265.021	Deposit	Cut in SW corner	5	14.5.2	Loose grey/ brown deposit in W side against S wall
265.022	Deposit	Central cut	5	14.5.2	Loose grey/ brown deposit with mortar crust in E surrounded by 265.006
265.023	Cut	Posthole 3	5	14.5.2	Cut S of 265.017 containing white mortar
265.024	Deposit	Posthole 3	5	14.5.2	White mortar fill of 265.023
265.025	Deposit	Central cut	5	14.5.2	White rubbly mortar at N end of 265.022
265.026	Deposit	Plaster or mortar surface skims	5	14.5.1	Thick grey mortar layer on 265.006
265.027	Deposit	Opus signinum subflooring or fill	3	14.3.2	Grey layer in NW corner with vast numbers of inclusions
265.028	Deposit	Opus signinum subflooring or fill	3	14.3.2	Compact grey surface at W side of 265.015
265.029	Cut	Posthole 4	6	14.6.2	Cut in 265.006 S of 265.023
265.030	Deposit	Posthole 4	6	14.6.2	Fill of 265.029
265.049	dead				SU assigned by mistake
265.083	Deposit	Central cut	5	14.5.2	Brown fill in N pit
265.084	Cut	Central cut	5	14.5.2	Cut of N pit
265.085	Deposit	Central cut	5	14.5.2	Grey fill of S pit
265.086	Cut	Central cut	5	14.5.2	Cut of S pit
265.088	Cut	Sarno block	3	14.3.2	Cut of construction trench
265.089	Deposit	Fill layers in room	3	14.3.2	Fill of construction trench
265.090	Deposit	Fills and partially removed and compacted subfloor	5	14.5.1	Grey surface underlying 265.006
265.091	Cut	Posthole 5	5	14.5.2	Small cut at N end of 265.084
265.092	Deposit	Posthole 5	5	14.5.2	Fill of 265.091
265.093	Deposit	Post pre-Surgeon fills (general)	3	14.3.1	Gritty deposit with large numbers of inclusions
265.094	Deposit	Fragmentary pocked earth/pea gravel deposits	2	14.2.1	Grey gritty deposit seen in section of 265.086
265.095	Deposit	Central cut	5	14.5.2	Rubble deposit at the bottom of 265.086
265.096	Deposit	Post pre-Surgeon fills (general)	3	14.3.1	Brown deposit abutting E wall
265.097	Deposit	Fragmentary pocked earth/pea gravel deposits	2	14.2.1	Grey gritty deposit W of Sarno
265.098	Deposit	Fragmentary pocked earth/pea gravel deposits	2	14.2.1	Grey gritty deposit near doorway
265.099	Cut	Cut in SW corner	5	14.5.2	Pit in W side of 265.015
265.100	Cut	Sarno block	3	14.3.2	Cut of construction trench W of 265.015
265.101	Deposit	Fill layers in room	3	14.3.2	Fill of 265.100
265.102	Deposit	Cut in E threshold	5	14.5.2	Rubble fill W of E edge of trench
265.103	Cut	Cut in E threshold	5	14.5.2	Cut of pit W of entrance to trench

265.104	Deposit	Post pre-Surgeon fills (general)	3	14.3.1	Yellow mortar deposit against N wall
265.105	Deposit	Post pre-Surgeon fills (orange)	3	14.3.1	Brown deposit with large chunks of grey mortar, against W wall
265.106	Deposit	Posthole 4	6	14.6.2	Loose brown deposit seen in 265.029
265.107	Cut	Diagonal cut, N side of room	2	14.2.2	Cut intersecting 265.100
265.108	Deposit	Post pre-Surgeon fills (general)	3	14.3.1	Compact brown deposit seen under 265.104
275.001	Deposit	Modern protective gravel and overburden	9	5.9	Modern gravel on all area
275.002	Deposit	Opus signinum	5	5.5.7	Opus signinum flooring in SW part of the AA
275.003	Deposit	Modern deposits, root damage etc.	9	5.9	Yellow-Brown soil deposit in Room 8A
275.004	Deposit	Modern deposits, root damage etc.	9	5.9	Brown Soil with high concentration of lapilli in the N corner of AA, in front of wall W06.021
275.005	Deposit	Modern deposits, root damage etc.	9	5.9	Dark brown deposit in SW corner of the AA with possible plant remains, along wall W06.024
275.006	Deposit	Backfill previous seasons	N/A	N/A	Backfill of AA209 in 2002, E of the impluvium
275.007	Cut	Maiuri's cuts	9	5.9	Cut for AA209 in 2002 E of the impluvium
275.008	Deposit	Backfill previous seasons	N/A	N/A	Backfill of AA260 from 2003 in the S and SW of AA
275.009	Deposit	Modern deposits, root damage etc.	9	5.9	Brown soil next to 275.003 infront of wall W06.022, NE area of AA, high concentration of lapilli, equal to 275.004, part of the same deposit
275.010	Deposit	Subfloor	5	5.5.7	Brown rubbly deposit, possibly a subfloor for opus signinum. Located E of the impluvium
275.011	Deposit	Subfloor	5	5.5.7	Packed earthen surface underneath 275.010 (subfloor of opus signinum)
275.012	Cut	Collapse of cistern E	8	5.8	Cistern collapsed in the edge between Rooms 5, 7, 8a, 10 in NE part of the AA, in front of wall W06.021
275.013	Deposit	Modern patching on opus signinum	9	5.9	Modern consolidation of opus signinum floor in the threshold area of Room 9
275.014	Cut	Collapse of cistern E	8	5.8	Cistern No. 2 collapsed in the middle of the tablinum and back of atrium
275.015	Deposit	Fill of Cistern (N)	8	5.8	Fill of cistern No. 2 (275.014) to N of impluvium
275.016	Deposit	Collapsed opus signinum in cistern	8	5.8	Collapsed part of opus signinum floor on the bottom of cistern No.1 (275.012)
275.017	Constr.	Tile drain (SE from impluvium)	5	5.5.3.3	Drain connecting the impluvium with cistern No.1
275.018	Deposit	Collapsed Opus signinum in cistern	8	5.8	Collapsed part of opus signinum floor on the bottom of cistern No. 2 (275.014)
275.019	Cut	Repair: cut	7	5.7.4	Irregular cut into the floor NE of the impluvium (possible Maiuri or Bourbon trench)
275.020	Deposit	Repair: cut	7	5.7.4	Fill of 275.019 (irregular cut into the opus signinum floor NE of impluvium, possible Maiuri or Bourbon trench)
275.021	Deposit	Fill above these cuts	2	5.2.4	Hard packed surface in SW of the AA. Dark brown rubble deposit, all over the SW part of the AA
275.022	Deposit	Fill W of N-S Drain	3	5.3.1	Rubble fill (levelling deposit). Left of AA 201/02
275.023	Cut	Maiuri's cuts	9	5.9	First Maiuri trench
275.024	Cut	Maiuri's cuts	9	5.9	Second Maiuri trench

275.025	Cut	Foundation trench	3	5.3.2.4	Foundation cut for wall W06.026-left
275.026	Cut	Foundation trench	3	5.3.2.4	Foundation cut for wall W06.026-right
275.027	Constr.	Drain	3	5.3.4.1	Drain W of AA, heading towards entrance of house
275.028	Cut	Cut for drain	3	5.3.4	Foundation cut for drain (275.030) E of AA
275.029	Deposit	Fill around drain	3	5.3.4	Strip of yellowish brown deposit next to Sarno stone caps to E drain (275.030), centre of trench SE of impluvium
275.030	Constr.	Drain (various pieces)	3	5.3.4	Drain E of AA, left of 275.023
275.031	Deposit	Fill above these cuts	2	5.2.4	Layer of gritty grey soil cut into 275.021
275.032	Deposit	Fill above these cuts	2	5.2.4	Layer of yellow soil in 275.021
275.033	Cut	Cut 1	5	5.5.2	Circular feature in the middle of SW part of the AA
275.034	Constr.	Tuff impluvium in centre of atrium	5	5.5.3.1	Impluvium
275.035	Cut	Cut	5	5.5.3.1	Foundation cut for the impluvium (left of AA 201/02)
275.036	Deposit	Fills	5	5.5.3.1	Fill of 275.035
275.037	Constr.	Drain (various pieces)	3	5.3.4	Smear on top of drain (275.030)
275.038	Deposit	Fill W of N-S drain	3	5.3.1	Hard levelling deposit over 275.021, now only in section W of AA
275.039	Deposit	Natural	1	5.1	Yellow natural soil with volcanic stones in the bottom of the whole W part of AA
275.040	Constr.	Sarno base	3	5.3.2.4	Foundation stone of wall W06.026 in left of AA 201/02
275.041	Constr.	Sarno base	3	5.3.2.4	Foundation stone of wall W06.026 in right of AA 201/02
275.042	Cut	Foundation trench	3	5.3.2.5	Foundation cut for wall W06.027
275.043	Constr.	Sarno base	3	5.3.2.5	Foundation stone of wall W06.027
275.044	Cut	Cut	5	5.5.3.1	Cut for foundation trench of impluvium at the W drain (275.027)
275.045	Deposit	Fills	5	5.5.3.1	Fill of foundation trench of impluvium (at the W drain)
275.046	Constr.	(Reused?) Sarno under impluvium	5	5.5.3.1	First Sarno stone in the section of AA 201/02, under impluvium
275.047	Constr.	(Reused?) Sarno under impluvium	5	5.5.3.1	Second Sarno stone under impluvium, in section of AA 209/02
275.048	Constr.	(Reused?) Sarno under impluvium	5	5.5.3.1	Third Sarno stone under S corner of impluvium
275.049	Constr.	(Reused?) Sarno under impluvium	5	5.5.3.1	Fourth Sarno stone under impluvium next to 275.079
275.050	Constr.	(Reused?) Sarno under impluvium	5	5.5.3.1	Fifth Sarno stone under impluvium left of drain 275.027
275.051	Constr.	(Reused?) Sarno under impluvium	5	5.5.3.1	Sixth Sarno stone under impluvium in section of AA 201/02
275.052	Constr.	(Reused?) Sarno under impluvium	5	5.5.3.1	Seventh Sarno stone under impluvium, right of drain (W06.027)
275.053	dead				Dead number
275.054	Deposit	Fill from inside impluvium	5	5.5.3.2	S end of impluvium, deposit cut into the stone
275.055	Deposit	Tiles within impluvium cut	5	5.5.3.2	Brick and tile remains of an early drain S of impluvium, in 275.054
275.056	Cut	Foundation trench	3	5.3.2.6	Foundation cut for walls W06.028 and W06.029, on the SW side of atrium
275.057	Deposit	Fill	3	5.3.2.6	Foundation fill of 275.056, for walls W06.028 and W06.029, in SW side of atrium

275.058	Constr.	Sarno base	3	5.3.2.6	Foundation stone of wall W06.029
275.059	Deposit	Fills	3	5.3.4.1	Foundation fill of W drain (275.027)
275.060	Cut	Cut	3	5.3.4.1	Foundation cut of W drain (275.027)
275.061	Deposit	Numerous postholes	2	5.2.4	Grey soil deposit next to W drain (275.027)
275.062	Deposit	Numerous postholes	2	5.2.4	Yellow-brown deposit next to W drain
275.063	Deposit	Numerous postholes	2	5.2.4	Small oval deposit S of W drain (275.027)
275.064	Cut	Numerous postholes	2	5.2.4	Circular posthole No. 1, in S corner of atrium
275.065	Deposit	Numerous postholes	2	5.2.4	Fill of posthole No. 1 (275.064)
275.066	Cut	Numerous postholes	2	5.2.4	Cut of 275.063, SE of W drain (275.027)
275.067	Constr.	Sarno base	3	5.3.2.6	Foundation stone of wall W06.028
275.068	Deposit	Sectioned cuts group 2 N	2	5.2.3	Brown soil deposit at the impluvium (abutting 275.038) silt, excavated partially in 2003
275.069	Deposit	Numerous postholes	2	5.2.4	Fill of posthole No. 2
275.070	Cut	Numerous postholes	2	5.2.4	Cut of 275.069 (Posthole No. 2)
275.071	Deposit	Sectioned cuts group 2 N	2	5.2.3	Grey deposit into 275.068 at W edge of impluvium
275.072	Deposit	Numerous postholes	2	5.2.4	Fill of posthole No. 3
275.073	Cut	Numerous postholes	2	5.2.4	Cut of posthole No. 3
275.074	Deposit	Numerous postholes	2	5.2.4	Fill of posthole No. 4
275.075	Cut	Numerous postholes	2	5.2.4	Cut of posthole No. 4
275.076	Deposit	Numerous postholes	2	5.2.4	Fill of posthole No. 5
275.077	Cut	Numerous postholes	2	5.2.4	Cut of posthole No. 5
275.078	Deposit	Numerous postholes	2	5.2.4	Fill of posthole No. 6
275.079	Cut	Numerous postholes	2	5.2.4	Cut of posthole No. 6
275.080	Deposit	Numerous postholes	2	5.2.4	Fill of posthole No. 7
275.081	Cut	Numerous postholes	2	5.2.4	Cut for posthole No. 7
275.082	Deposit	Numerous postholes	2	5.2.4	Fill of posthole No. 8
275.083	Cut	Numerous postholes	2	5.2.4	Cut of posthole No. 8
275.084	Deposit	Numerous postholes	2	5.2.4	Fill of posthole No. 9
275.085	Cut	Numerous postholes	2	5.2.4	Cut of posthole No. 9
275.086	Deposit	Numerous postholes	2	5.2.4	Fill of posthole No. 10
275.087	Cut	Numerous postholes	2	5.2.4	Cut of posthole No.10
275.088	Deposit	Numerous postholes	2	5.2.4	Fill of possible posthole No. 11
275.089	Cut	Numerous postholes	2	5.2.4	Cut of possible posthole No. 11
275.090	Deposit	Numerous postholes	2	5.2.4	Fill of possible posthole No. 12
275.091	Cut	Numerous postholes	2	5.2.4	Cut of possible posthole No. 12
275.092	Deposit	Sectioned cuts group 1 S and E	2	5.2.3	Yellow deposit with red cruma at threshold between walls W06.026 and W06.027
275.093	Deposit	Sectioned cuts group 1 S and E	2	5.2.3	Grey-brown deposit with broken Sarno flakes in centre of SW corner of atrium
275.094	Deposit	Sectioned cuts group 2 N	2	5.2.3	Dark brown silt deposit between 275.093 And 275.033 (circular feature)
275.095	Deposit	Numerous postholes	2	5.2.4	Fill of posthole No. 13
275.096	Cut	Numerous postholes	2	5.2.4	Cut of posthole No. 13
275.097	Deposit	Numerous postholes	2	5.2.4	Fill of posthole No. 14
275.098	Cut	Numerous postholes	2	5.2.4	Cut of posthole No. 14
275.099	Deposit	Numerous postholes	2	5.2.4	Fill of posthole No. 15
275.100	Cut	Numerous postholes	2	5.2.4	Cut of posthole No. 15
275.101	Deposit	Numerous postholes	2	5.2.4	Fill of posthole No. 16

275.102	Cut	Numerous postholes	2	5.2.4	Cut of posthole No. 16
275.103	Deposit	Numerous postholes	2	5.2.4	Fill of posthole No. 17 (275.104)
275.104	Cut	Numerous postholes	2	5.2.4	Cut of posthole No. 17
275.105	Deposit	New cistern cap	5	5.5.3.1	Head of collapsed cistern No. 1 (275.012)
275.106	Deposit	Turf layer	1	5.1	Turf under 275.022, near E drain (275.030)
275.107	Deposit	Fills	3	5.3.4.1	Grey-brown sandy silt deposit on top of 275.068 in section at the W drain (275.027)
275.108	Deposit	Collapsed drain in SE cistern	8	5.8	Collapsed part of drain in bottom of cistern No. 1
275.109	Deposit	Fill of cistern SE	8	5.8	Dark brown silt on bottom of cistern No. 1 (under collapsed opus signinum floor)
275.110	Deposit	Numerous postholes	2	5.2.4	Fill of posthole No. 18
275.111	Cut	Numerous postholes	2	5.2.4	Cut for posthole No. 18
275.112	Deposit	Numerous postholes	2	5.2.4	Fill of posthole No. 19
275.113	Cut	Numerous postholes	2	5.2.4	Cut of posthole No. 19
275.114	Deposit	Numerous postholes	2	5.2.4	Fill of posthole No. 20
275.115	Cut	Numerous postholes	2	5.2.4	Cut of posthole No. 20
275.116	Deposit	Numerous postholes	2	5.2.4	Fill of posthole No. 21
275.117	Cut	Numerous postholes	2	5.2.4	Cut of posthole No. 21
275.118	Cut	Numerous postholes	2	5.2.4	Posthole No. 1 cut into 275.119, closest to impluvium of 2 postholes
275.119	Deposit	General fills	2	5.2.2	Brown deposit underneath the turf, to E of Maiuri's trench, next to E drain (275.030)
275.120	Deposit	Numerous postholes	2	5.2.4	Posthole fill of 275.118 (No. 1 by impluvium)
275.121	Cut	Numerous postholes	2	5.2.4	Second posthole cut into 275.119, further from impluvium of 2 postholes in 275.119
275.122	Deposit	Numerous postholes	2	5.2.4	Fill of 275.121, second posthole in 275.119
275.123	Deposit	Fills	3	5.3.4.1	Soft dark brown soil at W edge of the impluvium near the drain (275.027)
275.124	Cut	Sectioned cuts group 1 S and E	2	5.2.3	Cut for dark grey pit at left of AA 201/02
275.125	Cut	Sectioned cuts group 1 S and E	2	5.2.3	Cut for 275.093 (with Sarno chips)
275.126	Cut	Sectioned cuts group 2 N	2	5.2.3	Cut for 275.094 (brown soil)
275.127	Deposit	Sectioned cuts group 1 S and E	2	5.2.3	Dark grey fill of pit left of AA 201/02 (275.124)
275.128	Cut	Sectioned cuts group 1 S and E	2	5.2.3	Cut for 275.092 (yellow soil)
275.129	Deposit	Fills	3	5.3.4.1	Lime smear on top of section right of W drain (275.027)
275.130	Deposit	Sectioned cuts group 1 S and E	2	5.2.3	Dark grey deposit at threshold of walls W06.026 and W06.027, overlying 275.131
275.131	Cut	Sectioned cuts group 1 S and E	2	5.2.3	Pit cut into 275.093 with yellow deposit (Fill = 275.092)
275.132	Deposit	Sectioned cuts group 1 S and E	2	5.2.3	Fill of 275.131
275.133	Deposit	Natural	1	5.1	Brown soil deposit seen in W side of AA (left of AA 201/02)
275.134	Cut	Sectioned cuts group 2 N	2	5.2.3	Cut of pit with hard dark brown-grey deposit (275.135)
275.135	Deposit	Sectioned cuts group 2 N	2	5.2.3	Pit with mixed hard dark brown-grey deposit (Cut 275.134)
275.136	Cut	Sectioned cuts group 1 S and E	2	5.2.3	Cut for 275.130
275.137	Deposit	Sectioned cuts group 1 S and E	2	5.2.3	Hard packed surface in bottom of 275.093, part of bottom of 275.125
276.001	Constr.	Impluvium	2	24.2.3	Opus signinum impluvium floor, W corner

276.002	Constr.	Impluvium	2	24.2.3	Mortar and Sarno sides of impluvium
276.003	Deposit	Packed earth surface around impluvium	2	24.2.3	Dark grey compacted earth floor, S corner
276.004	Deposit	Wall W06.098/W06.099/W06.100 (E wall)	5	24.5.1	Deposit next to 276.001
276.005	Cut	Wall W06.098/W06.099/W06.100 (E wall)	5	24.5.1	Cut into opus signinum floor, filled with 276.004
276.006	Cut	Pick mark in impluvium	3	24.3.4.2	Pick mark in 276.001
276.007	Deposit	Large tuff stone in fill	3	24.3.3	Large tuff stone set in corner of walls W06.101 and W06.102
276.008	Constr.	Sarno topping	3	24.3.4.2	Sarno drain cap stones
276.009	Constr.	Tuff drain base	3	24.3.4.2	Large tuff stones (drain base structure)
276.010	Deposit	S fills post pre-Surgeon	3	24.3.3	Levelling rubbly fill possibly same as 276.020
276.011	Deposit	N fills post pre-Surgeon	3	24.3.3	Foundation fill for drain (N side) (same as 276.020)
276.012	Deposit	N fills post pre-Surgeon	3	24.3.3	Orangey deposit, with construction (possibly same as 276.020) - confusion from 2003
276.013	Deposit	N fills post pre-Surgeon	3	24.3.3	Compacted earth N of drain, same as 276.010/276.020
276.014	Deposit	So called cut 2	3	24.3.3	Yellow deposit running S, linear to wall W06.098/99, same as 276.038, confusion from 2003
276.015	Deposit	So called cut 2	3	24.3.3	Looser compaction, rubbly fill, plaster inclusions, later fill into cut for foundation of wall W06.098/99
276.016	Deposit	So called cut 2	3	24.3.3	Yellow deposit, possibly natural, lateral to N wall, same as 276.010/276.020
276.017	Deposit	Natural	1	24.1	Yellow-orange deposit
276.018	Deposit	Wall W06.097 (N wall)	3	24.3.4.1	Foundation trench for wall W06.097 (fill)
276.019	Deposit	N fills post pre-Surgeon	3	24.3.3	Yellow sandy deposit, same as 276.038
276.020	Deposit	So called cut 3 part of building/ levelling process	3	24.3.3	Levelling rubble fill, possibly same as 276.010
276.021	Cut	Wall W06.098/W06.099/W06.100 (E wall)	5	24.5.1	Cut of 276.015 running lateral to walls W06.098/99
276.022	Cut	Wall W06.101 (S wall)	6	24.6.1	Cut and removal of 276.002 to the S
276.023	Cut	Cut into impluvium	3	24.3.4.2	Cut in 276.002 to the N
276.024	Cut	Wall W06.097 (N wall)	3	24.3.4.1	Cut of wall W06.097 foundation trench
276.025	Constr.	Wall W06.102 foundations	5	24.5.1	Wall W06.102 foundation
276.026	Constr.	Wall W06.101 (S wall) foundation	6	24.6.1	Wall W06.101 foundation
276.027	Cut	Wall W06.102 (W wall)	5	24.5.1	Cut in 276.003 for wall W06.0102 (276.025 foundation)
276.028	Constr.	Wall W06.099 foundations	5	24.5.1	Wall W06.098/99 foundation
276.029	Deposit	Drain fills	N/A	N/A	Contaminated drain fill (upper residue from 2003 interference)
276.030	Deposit	Drain fills	N/A	N/A	Drain fill (upper sample)
276.031	Deposit	Drain fills	N/A	N/A	Drain fill (middle deposit)
276.032	Deposit	Drain fills	N/A	N/A	Drain fill bottom (From drain 276.009)
276.033	Deposit	Natural	1	24.1	Natural volcanic soil (with black and white specs)
276.034	Deposit	Removal of N rectangular feature	2	24.2.3	Lower packed surface below 276.009, black sandy pit fill
276.035	Deposit	Cut after end of pre-Surgeon structure(s)	3	24.3.1	Black sandy deposit immediately N of 276.009 deposited or cut into early fill 276.038

276.036	Cut	Diagonal cut	2	24.2.1	Cut lateral and vertical into natural ground as part of early construction events
276.037	Cut	Cut after end of pre-Surgeon structure(s)	3	24.3.1	Cut of 276.035
276.038	Deposit	N fills post pre-Surgeon	3	24.3.3	Earliest levelling fill after cuts into natural 276.033 in preparation for impluvium and associated structures
276.039	Cut	Removal of N rectangular feature	2	24.2.3	Cut of 276.034
276.040	Deposit	Levelling layers under the impluvium	2	24.2.3	Levelling fill beneath 276.003 (abutting impluvium 276.001 and 276.002)
276.041	Deposit	Series of levelling layers	2	24.2.3	Intermittent packed surface below upper levelling deposit 276.040
276.042	Deposit	Series of levelling layers	2	24.2.3	Lower early levelling fill below 276.041
276.043	Deposit	Lenses of charcoal or burning	2	24.2.3	Possible evidence of burning in 276.040 below 276.003, orangey red stain
276.044	Deposit	Lenses of charcoal or burning	2	24.2.3	Small black sand compacted deposit in 276.040
276.045	Deposit	Fill around both features	2	24.2.2	Brown sandy levelling deposit under 276.042
276.046	Cut	Cut 2	2	24.2.2	Cut for 276.045 into 276.033 (natural)
276.047	Deposit	Black sandy deposit fills	2	24.2.3	Black sandy deposit formed into 276.033 and 276.045
276.048	Cut	Removal of W rectangular feature cut for removal of feature	2	24.2.3	Cut of 276.047 into 276.033 and 276.045
276.049	Deposit	Compaction, imprints of features	2	24.2.2	Black packed surface running under 276.045 above 276.033 (natural)
276.050	Cut	Compaction, imprints of features	2	24.2.2	Possible indentations into pit base (caused by stones)
276.051	Cut	Posthole or stone packed into feature W	2	24.2.2	Cut of possible posthole into 276.048 (or stone indentation)
276.052	Deposit	Posthole or stone packed into feature W	2	24.2.3	Fill of possible posthole in 276.051, or stone indentation
276.053	Cut	Wall W06.101 (S wall)	6	24.6.1	Cut for wall W06.101 foundation fill
276.054	Constr.	Wall W06.101 (S wall) foundation	6	24.6.1	Wall W06.101 construction
276.055	Constr.	Wall W06.102 foundations	5	24.5.1	Wall W06.102 construction
276.056	cut				Rectangular early pre-impluvium structure (missing) only imprints show its former presence
276.057	Constr.	Wall W06.102 foundations	5	24.5.1	Dead number
276.058	dead				Dead number
276.059	Constr.	Conjectural wall	2	24.2.3	Conjectural wall
276.060	Deposit	Sarno blocks	3	24.3.4.3	Tuff colonnade (pilasters)
277.001	Deposit	Gravel layer	9	4.9	Covers entire AA - loamy/silts and with modern inclusions
277.002	Deposit	Removal of old backfill	9	4.9	Deposit of yellowish sandy soil covering extent of excavated area in Room 3.
277.003	Constr.	Cistern head	6	4.6.2	Stone cistern head centred in Room 3
277.004	Deposit	Cistern modern fill	9	4.8	Upper fill of well head 277.003 in Room 3
277.005	Deposit	Opus signinum	6	4.6.7	Opus signinum (first construction) in Room 4 abutting wall W05.005/6 to the E. Degraded
277.006	Constr.	Cap of cistern	6	4.6.2	Well cap found within the well head (277.003) and covered by 277.004 (fill).
277.007	Deposit	Removal of old backfill	9	4.9	Dark grey silty soil near S wall (Room 3) running from wall W05.003 to section line

277.008	Deposit	Soakaway cut	6	4.6.7	Smooth patch of opus signinum floor in the centre of Room 4. 277.008 abuts 277.005 (the patch for soak away construction)
277.009	Deposit	E earthen floor	5	4.5.2.5	Patch of earth packed surface near the SE water feature and wall W05.003. Equal to 277.018
277.010	Deposit	Fills	5	4.5.2.4	A deposit in NE corner of a possible tank that was found in SE corner of Room 4, bounded by a low course of stone and mortar. Equal to 277.034
277.011	Deposit	Cut prior to extensive fills	3	4.3.1	Ashy, charcoal - included deposit overlying yellow deposit, running under wall W05.002
277.012	dead				Dead number
277.013	Deposit	Further levelling in back	3	4.3.1	Brown-yellow soil with plaster inclusions underlying opus signinum construction - levelling fill for entire space?
277.014	Deposit	Further levelling in back	3	4.3.1	Clean of sondage to establish the location of the cut for 277.013 (the soak away)
277.015	Deposit	Post pre-Surgeon fills orange-blue plaster fill	3	4.3.1	Sticky orange deposit in NE corner of Room 4 underlying both wall W05.007 and wall W05.002, overlying the light grey deposit which is 277.016
277.016	Deposit	Cut prior to extensive fills	3	4.3.1	Light grey deposit under Wall 2 (equals SU 11)
277.017	Deposit	Mortar floor	6	4.7	Degraded mortar surface left in patches along centre of room three (NB, soil volume on SU sheet refers to '1 tray of plaster' rather than to 1 bucket)
277.018	Deposit	W central earthen floor	5	4.5.2.5	Packed earth surface appearing in patches along wall W05.003 in Room 3
277.019	Deposit	Further levelling in back	3	4.3.1	A brown/yellow deposit which seems to underlie everything, equals 277.013, having plaster inclusions
277.020	Deposit	E area cut	6	4.6.6	Dark grey loamy silt deposit near the S wall of AA, Room 4 - the fill for the cut 277.021
277.021	Cut	E area cut	6	4.6.6	An irregularly shaped cut for 277.020 along the middle portion of wall W05.003
277.022	Cut	Cut prior to extensive fills	3	4.3.1	Cut for fill 277.016, steeply sloping sides. Located against wall W05.002 at the N end
277.023	Deposit	Upper cut	6	4.6.4	Deposit of large potsherds and brown soil at the threshold of AA 277
277.024	Cut	Posthole/cut	6	4.6.6	Cut into hard packed earth (277.018) along wall W05.003 (to the N in Room 3
277.025	Deposit	Posthole/cut	6	4.6.6	Fill of 277.024, along wall W05.003
277.026	Deposit	S earthen floor	5	4.5.2.5	Lip of surface, probably part of 277.018 in the S of the doorway. Between Rooms 3 and 4 (equals 277.040)
277.027	Deposit	Further levelling in back	3	4.3.1	Yellow bulk to W of water feature
277.028	Cut	Upper cut	6	4.6.4	Cut for fill 277.023 for inside of threshold in Room 3
277.029	Constr.	Wallette (upper build)	6	4.6.1	Arm of water feature
277.030	Deposit	Fills	5	4.5.2.4	Rubble created by the destruction of the arm of the water feature
277.031	Deposit	Fills in cistern (possibly modern)	6	4.6.2	Fill of cistern in front room underlying 277.006
277.032	Deposit	Fills in cistern (possibly modern)	6	4.6.2	Fill of cistern head 277.003 in Room 3 - underlies top skim of fill 277.031

277.033	Constr.	Mortar build of water feature	5	4.5.2.4	Mortar construction of water feature, bowing out beneath superstructure of cistern head
277.034	Deposit	Fills	5	4.5.2.4	Fill for construction of 277.033 - dark brown deposit with a high concentration of large inclusions
277.035	Cut	Cut for water feature	5	4.5.2.4	Cut for 277.034
277.036	Deposit	Further levelling in back	3	4.3.1	Brown layer with plaster inclusions in Room 4
277.037	Cut	SW corner posthole 2	6	4.6.4	Posthole cut in the SW corner of Room 3
277.038	Deposit	SW corner posthole 2	6	4.6.4	Dark sandy fill for the cut (277.037) in 277.018 in the SW corner of Room 3
277.039	Deposit	Fills in cistern (possibly modern)	6	4.6.2	Fill of cistern in Room 3
277.040	Deposit	S earthen floor	5	4.5.2.5	Plaster drain running parallel to S wall in Room 3
277.041	Deposit	Fills in W cut	6	4.6.6	Fill of plaster drain running along S wall of Room 3
277.042	Deposit	Fills around cistern build	5	4.5.2.3	Sondage at NE corner of well head
277.043	Deposit	Modern overburden fills	9	4.9	Gravely layer composed of the first three modern deposits N of the section in Room 3 (equals 277.002, 277.007, and 277.009)
277.044	Constr.	Step of mortar, at level of N doorway	5	4.5.1	Small area of final phase floor on wall W05.001
277.045	Deposit	Mortar floor	6	4.7	Mortar/plaster surface equals 277.017
277.046	Deposit	Removal of Surgeon wall stones	6	4.6.3	Directly behind the threshold, grey, loose with rubble inclusions, possible area of Sarno block robbing
277.047	Deposit	Removal of Surgeon wall stones	6	4.6.3	Loose deposit with many inclusions bound by the threshold and by 277.046
277.048	Constr.	Sarno build	3	4.3.2.1	Sarno stone and E side of brick pier, wall W05.004
277.049	Deposit	Removal of previous year's investigations	9	4.9	Backfill of cistern head in Room 4, part of water feature
277.050	Cut	Cut in W area	6	4.6.6	Possible construction cut for upper construction of wall W05.003B
277.051	Deposit	Fills in W cut	6	4.6.6	Fill of cut 277.050
277.052	Deposit	Posthole/cut	6	4.6.6	Fill of cut at W end of S wall in Room 3
277.053	Deposit	Soakaway cut	6	4.6.7	Soak away underlying opus signinum floor in Room 4, delineated by large stone/rubble inclusions
277.054	Constr.	Build of cistern	5	4.5.2.3	Stone and mortar construction of cistern head in Room 3
277.055	Cut	SW posthole 1	6	4.6.4	Small quasi-circular cut (posthole?) into the packed earth (277.018) to the north of drain 277.040
277.056	Deposit	SW posthole 1	6	4.6.4	Fill of cut 277.055
277.057	Deposit	Modern fill of SE water feature	9	4.8	Fill of circular water feature beneath 277.049, Room 4
277.058	dead				Dead number
277.059	dead				Dead number
277.060	Deposit	Soakaway fills	6	4.6.7	High contamination third of the fill of the soak away (277.053)
277.061	Deposit	Soakaway fills	6	4.6.7	Medium contamination layer of deposit in soak away amphora
277.062	Deposit	Soakaway fills	6	4.6.7	Low contamination layer of deposit in soak away amphora

277.063	Deposit	Soakaway fills	6	4.6.7	Material lost from removal of amphora soak away
277.064	Deposit	Soakaway cut	6	4.6.7	Contamination of soak away fill
277.065	Deposit	Clay fill	5	4.5.2.4	Clayish deposit in cut 277.035 underlying 277.034, lens ('domed deposit') of firm soil
277.066	Cut	Soakaway cut	6	4.6.7	Cut for the construction of the soak away
277.067	Deposit	Soakaway fills	6	4.6.7	Fill of amphora (second/lower one) in soak away (277.053), the stratigraphically higher portion of the fill
277.068	Deposit	Soakaway fills	6	4.6.7	Fill of second amphora of soak away, the stratigraphically lower portion of the fill
277.069	Constr.	Wall thickening	6	4.6.6	Course of stones and mortar abutting wall W05.003A, cutting drain 277.040
277.070	Cut	W posthole 5	6	4.6.4	Small circular cut (into 277.018?) to the E of the threshold stones, S of cut 277.028
277.071	Deposit	W posthole 5	6	4.6.4	Fill in 277.070 - see 277.070 SU sheet
277.072	Deposit	W posthole 4	6	4.6.4	Deposit with large inclusions of pottery in a circular pattern E of the threshold and N of Sarno stone fill of 277.077
277.073	Deposit	Removal of NW feature/removal of stairs, pit with diverse fills	5	4.6.5	Mortar/plaster deposit centred in N half of Room 3
277.074	Deposit	Further levelling in back	3	4.3.1	Lens of yellow, abutting E wall in Room 4
277.075	Deposit	Fills	3	4.3.2.2	Construction trench for N wall, deposit is firm, fine and dark soil (fill of 277.076).
277.076	Cut	Cut	3	4.3.2.2	Cut for 277.075 construction trench
277.077	Cut	W posthole 4	6	4.6.4	Cut for fill 277.072
277.078	Deposit	SW earthen floor	5	4.5.2.5	Packed earth in corner of walls W05.003 and W05.004, abutting wall W05.003 and forms E extent of posthole 277.037
277.079	Deposit	Further levelling in back	3	4.3.1	Yellow deposit in Room 4 that does not contain plaster inclusions
277.080	Deposit	Posthole 2	5	4.5.2.3	Circular deposit of ashy soil butting the hard packed earth surface 277.018 lying to the S of the cistern head
277.081	Cut	Posthole 2	5	4.5.2.3	Circular cut for 277.080 that butts the S side of the cistern head
277.082	Deposit	Clean	N/A	N/A	Clean of loose in N half of Room 3
277.083	Deposit	Removal of NW feature/removal of stairs, pit with diverse fills	5	4.5.2.2	Mortar and rubble filled earth butting wall W05.005, 277.084 and underlying 277.018 in the front room
277.084	Deposit	Removal of NW feature/removal of stairs, pit with diverse fills	5	4.5.2.2	277.084 butts 277.083 and 277.085 as well as wall W05.005 in the front room. It also underlies 277.018
277.085	Deposit	Removal of NW feature/removal of stairs, pit with diverse fills	5	4.5.2.2	Dark soft deposit of soil butting wall W05.001 and extending to the stairs at the threshold. It overlies 277.018 and also butts 277.084
277.086	Deposit	Levelling	2	4.2.3.4	Moderately hard packed dark yellow deposit with degrading black volcanic inclusions with white spots
277.087	Deposit	Hearth or posthole footing	2	4.2.3.4	Semicircular deposit that is ashy colour - a hard-packed silt
277.088	Deposit	Hearth or posthole footing	2	4.2.3.4	Dark silty ash deposit surrounded by 277.087
277.089	Deposit	W posthole 3	6	4.6.4	Fill of cut 277.090 along the threshold
277.090	Cut	W posthole 3	6	4.6.4	Northernmost cut (of 4) along threshold in Room 3

277.091	Deposit	Removal of NW feature/removal of stairs, pit with diverse fills	5	4.5.2.2	Dark grey deposit abutting wall W05.001 in Room 3
277.092	Deposit	Yellow soils	2	4.2.2	Yellow deposit abutting 277.091
277.093	Deposit	Removal of NW feature/removal of stairs, pit with diverse fills	5	4.5.2.2	Very hard packed deposit running E/W down middle of wall W05.005
277.094	Deposit	Square shaped cut	2	4.2.3.3	Brown/orange deposit bound by 277.095
277.095	Deposit	Yellow soils	2	4.2.2	Yellow edging (square) around 277.094
277.096	Deposit	Square shaped cut Room 4	2	4.2.3.3	Brown deposit with mortar inclusions in Room 4, bound on E side and W side by yellow in a line approximately one meter across with a concave base in section
277.097	Deposit	Posthole 3	5	4.5.2.3	Circular deposit of ashy brown silty sand at NE side of cistern head
277.098	Cut	Posthole 3	5	4.5.2.3	Cut for 277.097
277.099	Deposit	Gritty green natural deposits	1	4.1	Gritty green natural
277.156	Deposit	Yellow soils	2	4.2.2	E yellow deposit bound by 277.096 and wall W05.002 in sondage in Room 4
277.157	Cut	Wall 3A SW corner	3	4.3.2.1	Cut for construction trench for wall W05.003
277.158	Deposit	Possibly upper levels represented by	3	4.3.2.1	Fill of 277.158 abutting S wall in Rooms 3 and 4
277.159	Cut	Posthole 1	5	4.5.2.3	Cut of third posthole, N side of cistern
277.160	Deposit	Posthole 1	5	4.5.2.3	Fill of 277.159
277.161	Constr.	Threshold stones	6	4.6.3	Threshold stones
277.162	Constr.	Brick pillar	5	4.5.2.1	N brick pier along threshold
277.163	Deposit	Possibly upper levels represented by	3	4.3.2.1	Fill of cut 277.157 located along S wall in Room 3 (wall W05.003b), having orange/yellow loamy sand
277.164	Deposit	Possibly upper levels represented by	3	4.3.2.1	Fill of cut 277.157 located in Room 4 along wall W05.003a
277.165	Cut	Removal of NW feature/removal of stairs, pit with diverse fills	5	4.5.2.2	Cut in 277.092 for fill 277.091
277.166	Constr.	Stairway mortar build	6	4.6.5	Stairs in NW corner of AA
505.001	Deposit	Modern protective gravel and overburden	9	5.9	Modern protective layer of gravel and backfill all over the extent of the area
505.002	Deposit	Opus signinum	5	5.5.7	Opus signinum floor, to the N of the area
505.003	Deposit	Fills and trample?	7	5.7.1	Brown soil deposit covering the whole extent of Room 8a
505.004	Deposit	Cut near end of wall 25	7	5.7.1	Lapilli deposit in the corner of Room 8a against corner of walls W06.024 and W06.025
505.005	Deposit	Subfloor	5	5.5.7	Patch with large amount of mortar and plaster inclusions in the subfloor in the central area
505.006	Deposit	Cut in 8A: cut in corner	7	5.7.1	Yellow brown deposit at the threshold area in Room 8a against wall W06.023
505.007	Cut	Maiuri's cuts	9	5.9	Cut of Maiuri's trench on SE side of the impluvium
505.008	Deposit	Area wide filling	7	5.7.1	Brown loose soil with lapilli inclusions in W side of Room 8a
505.009	Deposit	Area wide filling	7	5.7.1	Brown loose soil with lapilli inclusions in E side of Room 8a
505.010	Deposit	Subfloor	5	5.5.7	Subfloor underneath opus signinum in the centre of the area in Room 5
505.011	Deposit	Subfloor	5	5.5.7	Packed earth surface underlying 505.010 in SW of area

505.012	Cut	Collapse of cistern E	8	5.8	Cut of a collapsed cistern along E perimeter of the excavation area
505.013	Cut	Posthole 3	7	5.7.5	Cut of posthole through subfloor (505.010)
505.014	Cut	Collapse of cistern E	8	5.8	Cut of collapsed cistern in NE corner of the trench
505.015	Deposit	Posthole 4	7	5.7.5	Fill of a small posthole (505.015) cut into the subfloor (505.010)
505.016	dead				Dead number
505.017	dead				Dead number
505.018	dead				Dead number
505.019	Deposit	Fills over repairs	7	5.7.2	Part of compacted mortar surface, possibly part of 505.010
505.020	Cut	Cut in 8A: cut in corner	7	5.7.1	Cut of a pit against wall W06.023 in Room 8a filled by 505.006
505.021	Deposit	Pocked earth	2	5.2.1	Packed earth surface underlying 505.019
505.022	Deposit	Pocked earth	2	5.2.1	Packed earth at the corner of the impluvium cistern head
505.023	Deposit	Pocked earth	2	5.2.1	Packed earth surface, strip cut by 505.025 and 505.027 in N part of the area
505.024	Deposit	Repair (?) cut 1	7	5.7.2	Brown silty sand deposit in NE area abutting packed earth 505.023
505.025	Cut	Repair (?) cut 1	7	5.7.2	Cut in 505.023 for 505.024
505.026	Deposit	Repair (?) cut 2	7	5.7.2	Dark grey deposit in NE of area abutting cut 505.027
505.027	Cut	Repair (?) cut 2	7	5.7.2	Cut in 505.023 for 505.026
505.028	Deposit	Area wide filling	7	5.7.1	Very dark grey ash deposit in Room 8a at wall W06.024 possibly as a result of something being burnt
505.029	dead				Dead number
505.030	Constr.	Drain (tuff and Sarno construction)	3	5.3.4	Drain with Sarno stone capping in W part of the area running towards Room 6c
505.031	Deposit	Pocked earth	2	5.2.1	Grey packed earth surface in NE of Room 8a
505.032	Deposit	Pocked earth	2	5.2.1	Brown-grey packed earth surface under 505.008 in Room 8a
505.033	dead				Dead number
505.034	Constr.	Tuff impluvium in centre of atrium	5	5.5.3.1	Impluvium in the atrium of the Surgeon
505.035	Deposit	Multi-context clean	N/A	N/A	Cleaning layer in threshold between Rooms 5 and 6c
505.036	Deposit	Fill of trench	3	5.3.2.1	Brown yellow soil deposit in E of Room 8a
505.037	Deposit	Natural	1	5.1	Very dark brown deposit in SWt of Room 8a
505.038	Cut	Foundation trench	3	5.3.2.1	Foundation cut for walls W06.022 and W06.023
505.039	Deposit	General fills	2	5.2.2	Loose yellow soil deposit in Room 8a overlying 505.032
505.040	Deposit	Fills above this	5	5.5.6	Packed earth in the threshold of Room 6c
505.041	Deposit	Fills above this	5	5.5.6	Loose brown soil in the threshold area of Room 6c
505.042	Deposit	Subfloor	5	5.5.7	Yellow brown soil against wall W06.025
505.043	Deposit	Fills cut 3 (SW corner)	2	5.2.2	Very dark grey brown soil overlying 505.037 in the SW corner of Room 8a
505.044	Cut	Cut near end of wall 25	7	5.7.1	Cut for lapilli pit 505.004
505.045	Deposit	Repair (?) cut 3	7	5.7.2	Fill of 505.046
505.046	Cut	Repair (?) cut 3	7	5.7.2	Cut for possible repair of drain at the NE corner of the impluvium

505.047	Deposit	Cut 9	2	5.2.2	Brown silt deposit in the NW part of room 8a
505.048	Deposit	Cut 9	2	5.2.2	Grey loose soil in NWt part of Room 8a
505.049	Deposit	Brick capping of drain	7	5.7.2	Brick capping of drain in NE corner of the impluvium heading towards cistern 505.012
505.050	Deposit	Pocked earth	2	5.2.1	Packed earth surface underneath black sand 505.026 to the NE of the impluvium
505.051	dead				Dead number
505.052	dead				Dead number
505.053	dead				Dead number
505.054	Constr.	Sarno base	3	5.3.2.3	Sarno stone underlying wall W06.025 in its NE corner
505.055	Constr.	Tile drain (SE from impluvium)	5	5.5.3.3	Tuff and mortar capping for drain 505.049
505.056	Constr.	Sarno base	3	5.3.2.1	Sarno blocks underlying wall W06.022 in its SE corner
505.057	Cut	Cut 9	2	5.2.2	Cut for 505.047
505.058	Deposit	Fills	7	5.7.1	Thin light brown soil layer covering 505.059 in Room 8a
505.059	Deposit	Fills	7	5.7.1	Dark grey soil overlying 505.037 in Room 8a
505.060	dead				Dark grey deposit with charcoal under 505.011
505.061	Deposit	E fill layer	3	5.3.1	Very hard dark grey brown layer underlying 505.011 in the NW part of the atrium
505.062	Deposit	Natural	1	5.1	Chocolate brown natural layer seen in section of 505.057 in Room 8a
505.063	Deposit	Alignment 1	2	5.2.2	Fill of posthole cut into 505.037 of Room 8a
505.064	Cut	Alignment 1	2	5.2.2	Cut of 505.063
505.065	Deposit	Fill around drain	3	5.3.4	Fill of foundation cut for drain 505.030
505.066	Cut	Cut for drain	3	5.3.4	Foundation cut for drain 505.030
505.067	Deposit	Pocked earth	2	5.2.1	Light grey compacted silt deposit at the NE edge of the impluvium
505.068	Constr.	(Reused?) Sarno under impluvium	5	5.5.3.1	Sarno blocks underlying the impluvium 505.034
505.069	Constr.	Sarno base	3	5.3.2.3	Sarno stone underlying the central part of wall W06.025
505.070	Constr.	Sarno base	3	5.3.2.3	Sarno stone with bonded plaster underlying S edge of wall W06.025
505.071	Deposit	Cut 4: (large) cut	2	5.2.2	Grey deposit in the middle of Room 8a cut into natural 505.063 and 505.032
505.072	Cut	Cut 4: (large) cut	2	5.2.2	Cut for 505.071
505.073	Cut	Foundation trench	3	5.3.2.3	Foundation cut for wall W06.025
505.074	Deposit	Fill of trench	3	5.3.2.3	Fill of 505.073
505.075	Deposit	Cut 2 (W)	2	5.2.2	Brown soil deposit with mortar inclusions near to wall W06.024
505.076	Cut	Cut 2 (W)	2	5.2.2	Cut of 505.075 abutting wall W06.024
505.077	Deposit	Pea gravel	2	5.2.1	Pea gravel found in several areas of the trench
505.078	Deposit	Turf layer	1	5.1	Turf, vegetation remnant, observed in multiple places in area
505.079	Constr.	Stones	5	5.5.6	Threshold stone of wall W06.026 to Room 6c
505.080	Deposit	Mortar under stones	5	5.5.6	Grey mortar underlying 505.079 in threshold area of Room 6c
505.081	Cut	Alignment 1	2	5.2.2	Cut of posthole into 505.071 in Room 8a

505.082	Deposit	Alignment 1	2	5.2.2	Fill of post hole 505.081 cut into 505.071
505.083	Cut	Alignment 1	2	5.2.2	Posthole cut into 505.075 at wall W06.024 in Room 8a
505.084	Deposit	Alignment 1	2	5.2.2	Fill of posthole 505.083 located near wall W06.024 in Room 8a
505.085	Cut	Foundation trench	3	5.3.2.3	Construction cut for wall W06.025
505.086	Deposit	Fill of trench	3	5.3.2.3	Fill of 505.085
505.087	Cut	Alignment 2	2	5.2.2	Cut of large posthole through edge of 505.071
505.088	Deposit	Alignment 2	2	5.2.2	Fill of posthole 505.087 cut through 505.071
505.089	Deposit	Fill inside N-S drain	3 to 4	5.5.3.1	Fill of the drain 505.030
505.090	Cut	Alignment 2	2	5.2.2	Cut of large posthole in 505.071 near to wall W06.022
505.091	Deposit	Alignment 2	2	5.2.2	Fill of posthole 505.090 in 505.071 near to wall W06.022
505.092	Deposit	Cut 2 (W)	2	5.2.2	Light grey deposit overlying 505.075
505.093	dead				Dead number
505.094	Deposit	Cut 2 (W)	2	5.2.2	Yellow brown deposit overlying 505.092
505.095	Deposit	Cut 1	2	5.2.2	Yellow brown deposit with clay inclusions in NW part of Room 8a
505.096	Deposit	Cut 1	2	5.2.2	Yellow brown deposit with Sarno inclusions in NW part of Room 8a
505.097	Cut	Cut 1	2	5.2.2	Cut for 505.096
505.098	Deposit	Cut 1	2	5.2.2	Black sand deposit underlying 505.004 and 505.096
505.099	Cut	Foundation trench	3	5.3.2.2	Construction cut for wall W06.024
505.100	Deposit	Fill of trench	3	5.3.2.2	Fill of 505.099
505.101	dead				Dead number
505.102	Cut	Foundation trench	3	5.3.2.1	Foundation cut for wall W06.023
505.103	Deposit	Fill of trench	3	5.3.2.1	Fill of 505.102
505.104	dead				Dead number
505.105	Deposit	Fills Cut 3 (SW corner)	2	5.2.2	Yellow packed earth in the corner of walls W06.023 and W06.024 in Room 8a
505.106	Constr.	Stones	5	5.5.6	Threshold stone of wall W06.035 to Room 6c
505.107	Deposit	Mortar under stones	5	5.5.6	Grey mortar underlying 505.106 in the threshold area of Room 6c
507.001	Deposit	Gravel and overburden	9	3.9.4	Modern contaminated upper deposit, including gravel
507.002	Deposit	Opus signinum surface	6	1.6.3	Probably ancient opus signinum footpath surface in the NE corner of the footpath
507.003	Deposit	Modern cement	9	1.8.1	Modern reconstruction around 507.002 (ancient opus signinum footpath surface)
507.004	Deposit	Lower opus signinum pavement patching	5	1.5.3	Lower opus signinum floor running under 507.003
507.005	Deposit	Plaster under-surface or modern build-up	6 to 9	1.6.4	Plaster and mortar deposit located on the E half of the upper N footpath
507.006	Deposit	Metal plate	9	3.9.3	Modern metal lightning plate in the NW corner of Room 2
507.007	Deposit	Final phase opus signinum N in Maiuri trench pedestal	6	3.6.2.3	Probably ancient in situ flooring along the N wall of Room 2
507.008	Deposit	Lightning rod	9	3.9.3	Concrete around the modern metal lightning plate in the NW corner of Room 2

507.009	Deposit	Final phase opus signinum remnant along wall 5	6	3.6.2.3	Possibly in situ ancient flooring along the E wall of Room 2
507.010	Constr.	Threshold stones	6	3.6.2.1	Ancient in situ threshold stones into Room 2
507.011	Deposit	Cement consolidation on N and E sides	9	3.9.1	Cement reconstruction around 507.009 (the ancient in situ flooring along the E wall of Room 2)
507.012	Deposit	Sarno step	9	1.9.1	Surgeon Step, modern reconstruction
507.013	Cut	Hitching holes in kerbing stones	6	1.6.3	Hitching post (probable), 6.7 m along baseline
507.014	Cut	Hitching holes in kerbing stones	6	1.6.3	Hitching post (probable), 8.2 m along baseline
507.015	Cut	Hitching holes in kerbing stones	6	1.6.3	Hitching post (probable) 9.7 m along baseline, partially eroded
507.016	Cut	Hitching holes in kerbing stones	6	1.6.3	Hitching post (probable) 10.3 m along baseline complete
507.017	Deposit	Modern pipe cut pipe trench	9	1.9.1	Modern water pipe trench on the W side of the upper N footpath
507.018	Cut	Modern pipe cut pipe trench	9	1.9.1	Cut of 507.017 (the modern water pipe trench on the W side of the upper N footpath)
507.019	Deposit	Cement consolidation on N and E sides	9	3.9.1	Cement reconstruction around 507.007 (the in situ opus signinum flooring along the N wall of Room 2)
507.020	Deposit	Lightning rod	9	1.9.1	Fill for the lightning conductor plate in the NW corner of Room 2 (507.008)
507.021	Cut	Lightning rod	9	3.9.3	Cut for lightning conductor trench
507.022	Deposit	Lower opus signinum surface	5	1.5.3	Opus signinum underneath wall W06.001 plaster (duplicate SU equals SU 73)
507.023	Cut	Maiuri trench N cut	9	3.9.2	Cut for Maiuri's trench (N wall)
507.024	Deposit	Maiuri trench N cut	9	3.9.2	Fill for Maiuri's trench (N wall)
507.025	Deposit	Earlier wall plaster (Vestals exterior)	5	1.5.3	Wall plaster along footpath corner, N wall
507.026	Deposit	Earlier wall Plaster (Surgeon exterior)	5	1.5.3	Wall plaster along footpath corner, E wall
507.027	Cut	Maiuri trench S cut	9	3.9.2	Cut of 507.028 (Maiuri's S trench)
507.028	Deposit	Maiuri trench S cut	9	3.9.2	Fill of S Maiuri trench
507.029	Deposit	Grey compacted levelling layer	6	3.6.2.2	Mid-pale grey deposit cut by Maiuri's trench. Duplicate SU equals507.072
507.030	Wall	Plaster on E wall	6	3.6.1.2	Single piece of wall plaster on wall W06.006, Room 2, near stair base
507.031	Deposit	Modern mortar	9	1.9.1	Hard modern mortar over 507.005 in the upper N footpath
507.032	Deposit	Subflooring of now missing final opus signinum surface	6	1.6.4	Rubble and soil layer on the E half of the upper N footpath underlying 507.005 (the mortar and plaster deposit)
507.033	Deposit	Fill under stones	6	1.6.4	Grey mortared deposit containing sharp lava stone fragments
507.034	Deposit	Pit in the Bottom of Maiuri's N trench	3	3.3.1	Dark grey deposits in pit in 507.023 (cut for Maiuri's N trench in Room 2)
507.035	Cut	Pit in the Bottom of Maiuri's N trench	3	3.3.1	Oblong or oval cut under 507.034
507.036	Deposit	Low wide Surgeon stones	3	3.3.2	Foundation of wall W06.007 (equals 507.135)
507.037	Deposit	Stones of step from front of Surgeon to Vestals	6	1.6.4	Large lava stone, same as threshold stones 507.038
507.038	Deposit	Stones of step from front of Surgeon to Vestals	6	1.6.4	Smaller and more E of two lava stones forming the step from the Surgeon footpath into the Vestals footpath

507.039	Cut	Cut for step placement	6	1.6.4	Cut for the deposition of 507.040 (a brown fill in the lower portion of the cut) and 507.033 (a deposit of sharp lava and brown mortar in the upper portion of the cut) in the upper N footpath
507.040	Deposit	Brown fill	6	1.6.4	Brown fill in cut 507.039, located on the E half of the upper N footpath
507.041	Deposit	Rubble	6	1.6.4	Grey compacted layer containing plaster and pottery inclusions
507.042	Deposit	SE stairway	5	3.5.4.3	Sarno mortar stair base in SE corner of Room 2
507.043	Deposit	Terracotta slab in SE stairway	5	3.5.4.3	Step terracotta plate
507.044	dead				Foundation for 507.042 (equals 507.169)
507.050	Deposit	Grey compacted levelling layer	6	3.6.2.2	Grey rubbly layer on N end of Room 2
507.070	Deposit	Burning on N	6	3.6.1.3	Burnt layer underlying 507.050
507.071	Deposit	Mortar-like floor	6	3.6.1.1	Flat mortar ancient floor layer under 507.070
507.072	Deposit	Grey compacted levelling layer	6	3.6.2.2	Light brown compacted layer in Room 2 below 507.001
507.073	Deposit	Lower opus signinum surface	5	1.5.3	Opus signinum flooring below 507.001 on footpath outside threshold stone equal to 507.022
507.074	Cut	Lower opus signinum pavement patching	5	1.5.3	Cut running E-W along N edge of 507.073
507.075	Cut	Cut for new threshold	6	3.6.2.1	Cut running N-S along E edge of 507.073 for threshold
507.076	Deposit	Mortar fill	6	3.6.2.1	Mortar fill of 507.075
507.077	Deposit	Brown soil fill	6	3.6.2.1	Brown soil layer below 507.076
507.078	Deposit	Ash metalworking residue layer	6	3.6.1.3	Ash deposit overlying mortar floor in Room 2
507.079	Deposit	Oval pit 4	6	3.6.1.3	Deposits within pit of floor 507.089
507.080	Deposit	Mortar-like floor	6	3.6.1.1	Concrete floor in Room 2
507.081	Deposit	Cut 5	6	3.6.1.3	Deposit within pit of concrete floor 507.080
507.082	Deposit	Cut 6	6	3.6.1.3	Deposit within pit of concrete floor 507.086
507.083	dead				Dead number
507.084	Cut	Oval pit 4	6	3.6.1.3	Cut for 507.079
507.085	Cut	Cut 5	6	3.6.1.3	Cut for 507.081
507.086	Cut	Cut 6	6	3.6.1.3	Cut for 507.082
507.087	dead				Dead number
507.088	dead				Dead number
507.089	Deposit	Compacted deposit	6	1.6.4	Compacted deposit located in the upper N footpath below 507.041
507.090	Deposit	Lower opus signinum pavement patching	5	1.5.3	Brown deposit in 507.074
507.091	Cut	Cut for new threshold	6	3.6.2.1	Cut of threshold construction on E side
507.092	dead				Dead number
507.093	Deposit	Hard packed surface	6	1.6.4	Hard packed surface on the E half of the upper N footpath below 507.089
507.094	Deposit	Hard packed surface	6	1.6.4	Small circular cut in the hard-packed Sward sloping deposit of 507.093 in the upper N footpath
507.095	Deposit	Hard packed surface	6	1.6.4	Fill within the possible posthole cut of 507.094 in the hard-packed deposit of 507.093 in the upper N footpath
507.096	Deposit	Lower Opus signinum surface levelling layer	5	1.5.3	Levelling layer under opus signinum floor 507.073

507.097	dead				Cut in the NE corner of 507.093, the hard-packed deposit in the upper N footpath
507.098	dead				Fill of cut 507.097 in the NE corner of the hard packed deposit of 507.093 in the upper N footpath
507.099	Deposit	Subfloor	6	1.6.4.1	Brown rubbly layer under 507.002
507.108	dead				skipped SU
507.109	Cut	Cuts filled with burning layer	6	3.6.1.3	Cut on E wall through 507.080
507.110	Cut	Cuts filled with burning layer	6	3.6.1.3	Cut circular approx 12 cm
507.111	Deposit	Dark brown central pit	6	3.6.1.3	Dark brown deposit in middle of Room 7
507.112	Cut	Cuts filled with burning layer	6	3.6.1.3	Cut to left of 507.110, smaller in diameter
507.113	Deposit	Small cut 7	6	3.6.1.3	Ashy deposit to left of 507.112
507.114	Cut	Small cut 7	6	3.6.1.3	Cut of 507.113
507.115	Deposit	Central W cut	6	3.6.1.3	Light brown deposit in 507.080 on W wall
507.116	dead				Light brown deposit in centre of Room 2 through 507.080 (equals 507.111)
507.117	Deposit	Small cut on S 8	6	3.6.1.3	Light brown/grey deposit in pit cut through 507.080 on N edge of Maiuri trench
507.118	Deposit	Fill of construction trench	6	3.6.2.1	Fill of construction trench for E side of threshold stones
507.119	dead				Cut of 507.118. Equals 507.092
507.120	Cut	Dark brown central pit	6	3.6.1.3	Cut of 507.111
507.131	Cut	Central W cut	6	3.6.1.3	Cut of 507.115
507.132	Cut	Small cut on S 8	6	3.6.1.3	Cut of 507.117
507.133	dead				Duplicate SU of 507.111
507.134	Deposit	Pulverised sarno	6	1.6.4	Pulverized Sarno blend layer
507.135	Deposit	Low wide Surgeon stones	3	3.3.2	Foundation Sarno stones
507.150	Deposit	Iron blob	6	3.6.1.3	Large iron blob in 507.086
507.158	Deposit	Fill north of stairway addition	6	3.6.1.2	Fill of cut in N end of 507.042
507.159	Cut	Cut in stairway	6	3.6.1.2	Sub-circular cut in 507.170
507.160	Deposit	Cut in stairway	6	3.6.1.2	Mortar patch over 507.080 against 507.042
507.161	Deposit	Grey packed surface	5	3.5.4.1	Compacted mortar skimmed surface under 507.080
507.162	Deposit	Cut 3	5	3.5.4.1	Smallish pit in NW of 507.161
507.163	Cut	Cut 3	5	3.5.4.1	Cut of 507.162
507.164	Deposit	Large central	5	3.5.4.4	Fill of large central pit in 507.161
507.165	Cut	Large central	5	3.5.4.4	Cut of 507.164
507.166	Deposit	W side cut	5	3.5.4.4	Fill of cut against W side on Room 2 in 507.161
507.167	Cut	W side cut	5	3.5.4.4	Cut of 507.166
507.168	Deposit	Pit in the Bottom of Maiuri's N trench	3	3.3.1	Brown deposit beneath 507.034
507.169	Deposit	Stair foundation	5	3.5.4.3	Foundation for 507.042
507.170	Deposit	Base of N part of stair 2 (covering two steps)	6	3.6.1.2	Foundation N section of staircase
507.171	Wall	Plaster on stairs	6	3.6.1.2	Lower plaster layer on 507.042
507.172	Wall	Plaster on stairs	6	3.6.1.2	Upper pink plaster layer on 507.042
507.173	Wall	Plaster on stairs	6	3.6.1.2	Lower plaster layer on 507.170
507.174	Wall	Plaster on stairs	6	3.6.1.2	Upper pink plaster layer on 507.170
507.175	Deposit	Dark grey compact layer	6	1.6.4	Dark grey compact layer beneath 507.134
507.176	Deposit	Yellow/orange natural seen in low pits	1	3.1	Grey deposit underlying 507.071

507.177	dead					Dead number
507.178	dead					Dead number
507.179	Cut	Foundation cut	3	3.3.2	Construction trench for walls W06.006 and W06.007	
507.180	Deposit	Fill	3	3.3.2	Fill of 507.179	
507.181	Cut	Cut in stairway	6	3.6.1.2	Cut of foundation of stair base 507.169	
507.182	Deposit	Yellow/orange natural seen in low pits	1	3.1	Deposit Room 2 underlying 507.176 N wall W06.004	
507.183	Deposit	Sarno foundation of Vestals	6	1.6.4	Foundation layer under Vestals S frontage	
507.184	Deposit	Sarno step under frontage	6	1.6.4	Mortared step layer in Vestals S frontage	
507.185	Deposit	Low wide Surgeon stones	3	3.3.2	Flat mortared foundation for wall W06.004	
507.186	Deposit	Low wide Surgeon stones	3	3.3.2	Rough lowest foundation for wall W06.004	
507.187	Deposit	Plaster filled construction layer	6	1.6.4	Plaster filled mortar layer overlying 507.184 on Vestals S frontage	
507.188	Deposit	Mortar squeeze against frontage	6	1.6.4	Mortar squeeze layer in Vestals frontage	
507.189	Deposit	Fill of cut for foundation	5	3.5.4.3	Fill of construction trench for 507.169	
507.190	Cut	Cut for stair foundation	5	3.5.4.4	Cut for 507.189	
507.191	Deposit	Kerbing stones of pavement	6	1.6.3	Via Consolare kerbstones	
508.001	Deposit	Gravel	9	19.9.5	Modern covering of gravel over extent of AA	
508.002	Deposit	Modern garden soil build-up	9	19.9.5	Modern layer of dirt around perimeter of garden area at E and N extent of AA	
508.003	Deposit	Modern garden soil build-up	9	19.9.5	Probable modern layer along S wall of garden	
508.004	Constr.	New upper for the drain gutter	6	19.6.4	Drain feature around the W and S edges of the garden	
508.005	Deposit	Modern garden soil	9	19.9.5	Deposit of light brown soil along E wall of garden. Several deposits taken in sondage 1 called 508.005	
508.006	Deposit	Opus signinum upper	6	19.6.2	Opus signinum floor scattered along the corridor between the SW and SE walls of 508.001	
508.007	Deposit	Gravel	9	19.9.4	Fill of cistern head at the N end of Room 16	
508.008	Constr.	Cistern or well SUs	3	19.3.1	Cistern head at E extent of Room 16	
508.009	Deposit	Modern soil build-up	9	19.9.5	A differentially compact deposit running from the E side of the opus signinum 508.010 and threshold between walls W06.047 and W06.049 to section line at 4 m along the baseline, from the NE to SE edge of Room 16	
508.010	Deposit	Opus signinum upper	6	19.6.2	Opus signinum floor in NW corner of Room 16	
508.011	Constr.	Re-erection of column	8	19.8.2	Concrete (modern) underneath ancient column on E side of N half of Room 16	
508.012	Constr.	Re-erection of column	8	19.8.2	Opus signinum floor under modern concrete layer underlying column on E edge of Room 16, N of 508.007	
508.013	Deposit	Consolidation of opus signinum floor	9	19.9.4	Modern pointing/reconsolidation around edge of opus signinum floor 508.010 in NW corner of Room 16	
508.014	Deposit	Modern garden soil	9		Mixed assortment of material, probably left over from 508.001, in centre of Room 16	
508.015	Deposit	Modern garden soil	9	19.9.5	Deposit of light brown soil along N wall of garden	
508.016	Deposit	Modern garden soil build-up	9	19.9.5	Deposit of light brown layer of sandy silt in Room 20, W of wall W06.053. Taken in small sondage between tree roots and bushes - central W garden sondage	

508.017	dead				Yellow silty sand in SE corner of Room 20 extending N from drain. Dead
508.018	Deposit	Black sand	2	19.2.1	Deposit of black sandy silt in SE corner of Room 20, 'natural' level for site
508.019	Deposit	Modern garden soil build-up	9	19.9.5	Firm uneven layer of yellow deposit in the NE area of Room 20, W of wall W06.053
508.020	Deposit	Rubble filling hole in black sand	5	19.5.1	Rubbly deposit in Room 16, S of 508.010, E of W extent of trench
508.021	Deposit	Modern garden soil build-up	9	19.9.5	Deposit of a dark grey loamy sand situated in the NE area of Room 20, underlying 508.019 - a yellow gritty soil deposit. Central W garden sondage
508.022	Constr.	Sarno stone	3	19.3.1	Sarno block, possibly a column base in E of Room 16 and W of the drain and just S of the cistern head
508.023	Deposit	Black sand	2	19.2.1	Black sand deposit in Room 16, underlying 508.009. Covers almost full extent of section
508.024	Deposit	Stratified fill of well - cistern	8	19.8.1	Lower (second) layer of cistern fill, underlying 508.007
508.025	Deposit	Modern soil build-up	9	19.9.5	Probable modern sandy silt, light brown solid mixed with rubble, opus signinum and between modern consolidation of the N threshold (Room 16) and possible modern (Bourbon) consolidation of the opus signinum flooring just S
508.026	Deposit	Modern garden soil build-up	9	19.9.5	Garden topsoil in NW garden sondage. First deposit in NW garden sondage
508.027	Deposit	Stratified fill of well - cistern	8	19.8.1	Fine dark sand deposit, lightly packed, underlying 508.024, in the cistern. Contained within the waterproof plaster
508.028	Deposit	Soils associated with the ollae perforatae planting of the garden	5	19.5.2	Deposit of yellow-brown sandy silt underlying 508.015 along N wall of garden
508.029	Deposit	Fill of foundation trench	3	19.3.1	Hard packed earth on W and S faces of Sarno stone, 508.022
508.030	dead				Dead number
508.031	Deposit	fill of foundation trench	4	19.4.3	Light grey deposit underlying 508.004 and 598.030 at SE extent of drain. Includes large pieces of plaster
508.032	Deposit	Pitted earth	2	19.2.1	Hard packed dark brown clayish deposit underlying 508.018 as seen in section of SE garden sondage. Probably cut (with 508.018 for construction of wall W06.053)
508.033	Deposit	Pitted earth	2	19.2.1	Packed earth surface extending nearly fully under 508.023, from the opus signinum and the threshold in to N to the S bulk. Continuation of 508.033 to the S section line at 4 m along the baseline in Room 16
508.034	Deposit	Modern soil build-up	9	19.9.5	Dark brown deposit running from the opus signinum 508.006 in the S of Room 16 to the section line (at 4 m along the baseline). Probably modern
508.035	Cut	Foundation cuts for Sarno stones	3	19.3.1	Cut in 508.033 possibly for the Sarno construction phase of the drain 508.004 and the Sarno stone 508.022
508.036	Deposit	Soils associated with the ollae perforatae planting of the garden	5	19.5.2	Loose, light brown deposit along E wall of the garden Room 20, formerly 508.006
508.037	Deposit	Maiuri trench	9	19.9.1	Orange yellow deposit in the far SW corner of Room 16

508.038	Cut	Foundation trench	4	19.4.3	Possible construction for E wall of garden (wall W06.053) through 508.018 and 508.032
508.039	Deposit	Modern soil build-up	9	19.9.5	508.039 is a deposit of the material removed when the S extent of the drain was cleaned on the W face. It is a light brown sandy silt with pottery and plaster inclusions
508.040	Deposit	Plaster base layer	6	19.6.2	Plaster subfloor underlying 508.006 opus signinum in SE extent of Room 16
508.041	Deposit	Consolidation of opus signinum floor	9	19.9.4	Modern consolidation overlying plaster subfloor (508.040) at its N extent
508.042	Deposit	Plaster base layer	6	19.6.2	Plaster subfloor underlying opus signinum (508.010) in NW extent of Room 16
508.043	Deposit	Consolidation of opus signinum floor	9	19.9.4	Modern consolidation of opus signinum (508.010) overlying plaster subfloor (508.042) and underlying second stage of modern consolidation (508.013)
508.044	Deposit	Soils associated with the ollae perforatae planting of the garden	5	19.5.2	Relatively loose brown deposit of sandy silt underlying 508.028 along the N wall W06.052 of garden
508.045	Deposit	Pit	6	19.6.1	Rubble deposit situated in the NW area of the S half of the AA along the W section. Cuts the cut and fill of 508.037 and 508.047
508.046	Deposit	Maiuri trench	9	19.9.1	Yellow silty sand deposit sectioned from the roots in the SW corner to 508.040 in Room 16. Taken in section to explore whether any stratigraphy survived despite extensive root damage
508.047	Cut	Maiuri trench	9	19.9.1	It is the cut of fill 508.037. It is in the SW corner of Room 16, running along the W and S trench lines. The cut is disrupted by root damage at the S extent
508.048	Cut	Pit	6	19.6.1	It is a cut and filled with 508.045. It is on the W side of room 16 and runs along the W and N trenches
508.049	Deposit	Black sand	2	19.2.1	Black sandy deposit underlying 508.044 along the N wall of Room 20
508.050	Deposit	Modern garden soil build-up	9	19.9.5	Topsoil deposit of light brown silty sand middle of drain extending E into garden
508.051	Deposit	Soils associated with the ollae perforatae planting of the garden	5	19.5.2	The deposit of pottery and surrounding soil along the E wall 508.053. The soil is greyish brown and contains many inclusions. The pots are both intact and in sherds
508.052	Deposit	Pit	5	19.5.1	Circularish brown deposit in S of Room 16, probably the fill of a cut
508.053	Deposit	Maiuri trench	9	19.9.1	Second level of the fill of cut 508.047 in the S half of the AA, against the W section line and wall W06.068 in Room 16
508.054	Deposit	Other garden soils, W side	5	19.5.2	Garden sondage in NW or garden, underlying 508.026 - second deposit in NW garden sondage 3
508.055	Deposit	More disturbed garden soils	5	19.5.2	Light brown packed earth in SW garden sondage 5
508.056	Deposit	Other garden soils, W side	5	19.5.2	A deposit of packed greyish brown soil in the NW sondage 3 of Room 20
508.057	Deposit	Soils associated with the ollae perforatae planting of the garden	5	19.5.2	Brown sandy silt deposit underlying 508.051 along wall W06.053 of Room 20, just N of SE garden sondage 1

508.058	Deposit	Pitted earth	2	19.2.1	Brown pocked earth in central-W garden sondage 5
508.059	Cut	N-S gutter cut	3	19.3.1	Cut into 508.058 for 508.060 in mid-W garden sondage 5
508.060	Deposit	Fill of drain	3	19.3.1	Fill for cut 508.059 in central W garden sondage 5, sandy silt light brown loose soil with few inclusions
508.061	Deposit	Modern garden soil build-up	9	19.9.5	Modern topsoil of garden sondage 4 in Room 20
508.062	Deposit	Black sand	2	19.2.1	Black sandy deposit in garden sondage 3 underlying 508.056
508.063	Deposit	Other garden soils, W side	5	19.5.2	Sandy differential deposit varying in colour underlying 508.061 in garden sondage 4
508.064	Deposit	Pitted earth	2	19.2.1	Greyish brown pocked earth in patches in garden sondage 3; underlying 508.062 (deposit of black sand)
508.065	Deposit	Black sand	2	19.2.1	Brown sand deposit found in the S section of Room 16. Runs from the N section line to the beginning of the opus signinum on the W edge. Underlies 508.040. Overlies 508.072
508.066	Deposit	Rubble filling hole in black sand	5	19.5.1	Rubbly deposit in W side of Room 16. Probably cut into black sand 508.072. Probably cut by cuts 508.048 and 508.047. Rubble inclusions in black sand matrix
508.067	Deposit	Soils associated with the ollae perforatae planting of the garden	5	19.5.2	Cleaning soils along E wall W06.053
508.068	Deposit	Modern garden soil build-up	9	19.9.5	Extension of garden sondage 4, NW portion as far N as possible to bushes, modern topsoil and loose light brown sandy silt
508.069	Cut	Pit	5	19.5.1	Circular cut (pozzolana pit) into black sand 508.072 in S section of Room 16. Filled by 508.052
508.070	Deposit	Soils associated with the ollae perforatae planting of the garden	5	19.5.2	Brown sandy deposit W of wall W06.053 and 508.057 in Room 20. Extension along wall to trace path of potential drain feature 508.098
508.071	Deposit	Hard packed earth	2	19.2.2	Layer of packed earth extending along the E wall of Room 20, running N from the S extent of the drain, 508.004. 508.097 dug to explore section of this deposit
508.072	Deposit	Black sand	2	19.2.1	Black sand in S section of Room 16. Equal to 508.023. Underlies 508.034 and overlies 508.033
508.073	Deposit	More disturbed garden soils	5	19.5.2	Dark brown sand, underlying 508.071 with few inclusions. Lower stratigraphy layer than 508.070 in extensions of section for continuation of 508.098
508.074	Deposit	Soils associated with the ollae perforatae planting of the garden	5	19.5.2	Brown sandy deposit W of wall W06.053, in Room 20
508.075	Deposit	More disturbed garden soils	5	19.5.2	Dark brown sand underlying 508.074
508.076	Deposit	Modern garden soil build-up	9	19.9.5	508.076 is an extension of sondage 3 in Room 20. It extends S from the SW corner of the sondage. It has a high level of contamination-topsoil
508.077	Deposit	Fill of foundation trench	3	19.3.1	Clayish layer abutting the S Sarno block, 508.078, along its N and W faces
508.078	Constr.	Sarno stone	3	19.3.1	Sarno block, possibly a column base in SE extent of Room 16 just N of opus signinum 508.006

508.079	Deposit	Pitted earth	2	19.2.1	Dark brown pocked earth underlying 508.049 in NW garden sondage 6
508.080	Cut	Posthole 1	2	19.2.3	Circular cut near S end of 508.033 just to the E of 508.048 - S cut on the W side
508.081	Deposit	Posthole 1	2	19.2.3	Fill of 508.080 - S cut on the W side
508.082	Cut	Posthole 2	2	19.2.3	Circular cut in 508.033 in the centre of Room 16, directly NE of 508.080 -middle cut on the E side
508.083	Deposit	Posthole 2	2	19.2.3	Fill of 508.082 - the middle cut on the E side
508.084	Cut	Posthole 3	2	19.2.3	Cut in 508.033 in centre of Room 16, near the W side. Directly to the N of 508.080 - N cut on the W side
508.085	Deposit	Posthole 3	2	19.2.3	Fill for 508.084
508.086	Cut	Posthole 4	2	19.2.3	Middle cut on the W side
508.087	Deposit	Posthole 4	2	19.2.3	Fill for cut 508.086
508.088	Cut	Posthole 5	2	19.2.3	N cut on the E side
508.089	Deposit	Posthole 5	2	19.2.3	Fill of 508.088
508.090	Cut	Posthole 6	2	19.2.3	S cut on the E side
508.091	Deposit	Posthole 6	2	19.2.3	Fill of 508.090
508.092	Deposit	Fill of foundation trench	3	19.3.1	Colonnade, drain and well fill of foundation trench
508.093	Deposit	Stratified fill of well - cistern	8	19.8.1	Stratified fill of well/cistern head
508.094	Deposit	Pitted earth	2	19.2.1	Pitted earth
508.095	Constr.	E-W overflow drain	3	19.3.1	Drain like feature perpendicular to 508.004
508.096	Deposit	Fill of foundation trench	3	19.3.1	Colonnade, drain and well fill of foundation trench
508.097	Deposit	Section cut into the pitted earth in the SE against wall W06.053	2	19.2.3	Section cut into SE packed earth underlying 508.057 along wall W06.053
508.098	Constr.	E-W overflow drain	3	19.3.1	E-W overflow drain
508.099	Constr.	Sarno stone	3	19.3.1	Colonnade, drain and well Sarno stone
508.300	Constr.	Cistern or well SUs	3	19.3.1	Well
508.301	Cut	Foundation cuts for Sarno stones	3	19.3.1	Colonnade, drain and well foundation cuts for Sarno stones
508.302	Constr.	Sarno drain build	3	19.3.1	Sarno drain build
508.303	Constr.	Light grey mortar shuttered drain	6	19.6.5	Shuttered construction of drain
508.304	Cut	N-S gutter cut	3	19.3.1	Cut of Sarno construction of drain in Room 16
508.305	Deposit	Pitted earth	2	19.2.1	Pocked earth underlying drain-like feature 508.098 along wall W06.053
512.001	Constr.	Kerb area A	5		Large stone of Sarno at the SW side of the trench and of pit A
512.002	Deposit	Modern mortar on S drain	8 to 9	25.8	Round piece of mortar with 2 large stones in it, between pit A and B
512.003	dead				Dead number
512.004	Constr.	Drain S area C	6	25.6.1	A modern drain between pit B and C coming off the back of the Surgeon, going into the street
512.005	Deposit	Eruption fills	8 to 9	25.8	A reddish residue coming out of the drain into the footpath. Coming out of the SE side of the back of the Surgeon
512.006	Constr.	Build of drain	6	25.6.2	Fill of drain at SE side of the door to the Surgeon
512.007	Constr.	Build of drain	6	25.6.2	Build of the drain, bends in a S direction

512.008	Deposit	Eruption fills	8 to 9	25.8	Most S fill of the drain on the back of the Surgeon on the SE side
512.009	Cut	Wall W06.118 construction	4	25.4.2.3	Cut for 512.010. It has a stretched S-shaped form
512.010	Deposit	Grey-white plaster fill over top	6	25.6.3	White grey soil with loads of plaster in it. Runs along the footpath after 512.009 and untill 512.027
512.011	Deposit	Yellow natural in area C	1	25.1	Yellowish brown soil of pit C in the footpath with a cut for the S side of the door of the Surgeon
512.012	dead				Dead number
512.013	Deposit	Modern construction of drain from roof	8 to 9	25.8	A modern drain to clear the rain from the roof of the Surgeon
512.014	dead				Dead number
512.015	dead				Dead number
512.016	dead				Dead number
512.017	dead				Dead number
512.018	Cut	AAPP backfill	8 to 9	25.8	Cut for excavation of AA90 in 1999
512.019	Deposit	AAPP backfill	8 to 9	25.8	Fill of excavation of trench AA90 in 1999
512.020	Constr.	Vestals wall	4	25.4.1	Low Vestals/Surgeon boundary wall
512.021	dead				No SU Sheet
512.022	dead				No SU Sheet
512.023	dead				No SU Sheet
512.024	dead				No SU Sheet
512.025	cut				Cut in 512.011, probably for the build of the wall to narrow the door at the back of the Surgeon
512.026	Constr.	Build of drain	6	25.6.3	Drain coming out of the wall into the footpath in pit C, N of the door to the Surgeon
512.027	Deposit	Hard packed surfaces over natural	2	25.2.2	Compact hard surface alongside the end of pit C, probably underlies 512.010
512.028	Deposit	Kerbing area D	5	25.5.1	Fill of plaster and mortar in pit D at N side of the drain running along the footpath stones
512.029	Deposit	N hard surfaces	2	25.2.2	Hard compact dirt surface that runs along the wall of pit D, between the drains, that define the edges of pit D
512.030	Cut	N drain in area D/E	5	25.5.1	Cut for construction trench for the drain (512.032)
512.031	Deposit	N drain in area D/E	5	25.5.1	Fill of the construction trench along the drain. It has a greyish-brown colour and is situated at the S side of the drain
512.032	Constr.	N drain in area D/E	5	25.5.1	Modern reconstruction drain that divides pit D and E
512.033	Deposit	N drain in area D/E	5	25.5.1	Fill of the construction trench on the N side of the drain
512.034	Cut	N drain in area D/E	5		Cut at N side of the drain 512.032 for the builders' trench
512.035	Deposit	N hard surfaces	2	25.2.2	Hardened surface with big rock in the middle at the S side of pit E. Along the whole footpath area
512.036	Deposit	Kerbing area E	5	25.5.1	Dark grey rocks beginning in about the middle of pit E along the curb stones
512.500	Deposit	Modern overburden	8 to 9	25.8	Runs over the footpath, contains pieces of plaster, tesserae, a loom weight, glass and part of an oil lamp

512.501	Deposit	Possible early cut	2	25.2.1	A grey brownish layer in pit A. Fill of a builders trench, containing pilaster and pottery
512.502	Deposit	Brown-yellow natural in area A	1	25.1	Natural brown yellow layer where builders trench was cut into in pit A
512.503	Deposit	Natural in area B	1	25.1	Natural brown yellow layer filling pit B. Cut into by builders trench, circular and rectangular cuts
512.504	cut				Circular cut near the middle of pit B. Purpose is unknown
512.505	Cut	Plausibly early rectangular cut	2	25.2.1	A cut for the rectangular pit on the N of pit B
512.506	Deposit	Plausibly early rectangular cut	2	25.2.1	Fill of the rectangular cut in the N area of pit B
512.507	dead				Cut for modern mortar block in the S of pit B (Dead number)
512.508	Cut	Kerb area B	5		Builders' cut. Fill is unknown, in S of pit B, going N along the footpath stones
512.509	cut				Cut into the brown yellow soil, at the SE side of pit B
512.510	Cut	Kerb area B	5		Cut for builders' trench along the footpath in pit B. It is cut into the brown yellow soil
512.511	Deposit	Kerb area B	5		Fill of the builders' trench alongside the footpath in pit B
512.512	Deposit	Drain S area C fill	6 to 9	25.6.1	Modern deposit probably for the construction of modern drain in the N of pit B. It overlies the hard packed surface
512.513	Deposit	Confused upper fills (over lapilli and kerb stone construction)	8 to 9	25.8	Greyish soil situated at the S side of pit C
512.514	Deposit	Confused upper fills (over lapilli and kerb stone construction)	8 to 9	25.8	Dark grey brown soil between the dark grey soil and the drain in pit C
512.515	Cut	Possible early cut	2	25.2.1	Cut of the builders' trench to the natural brownish-yellow soil in pit A
512.516	Cut	Kerb area A middle	5	25.5.1	Cut of the builders' trench in pit C for curb stones. It stops suddenly around the middle of the door. W side of the trench
512.517	Deposit	Kerb area A middle	5	25.5.1	Fill of the builders' cut in pit C, starting at the end of the drain, ending in the middle of the door. The colour is middle dark greyish brown
512.518	Deposit	Wall W06.118 construction	4	25.4.2.3	N side of pit C. Rubble underneath the hard packed layer on the E side along the wall
512.519	Cut	Wall W06.119 building	4	25.4.2.2	End of a cut for the builders' trench in the north of pit B, probably to build the wall
512.520	Deposit	Wall W06.119 building	4	25.4.2.2	Fill of builders' trench for wall of the Surgeon at the NW side of the footpath in pit B
512.521	Deposit	Kerb area B plaster on one stone	5		Plaster against the inside of a kerbstone at the S end of pit B
512.522	Deposit	Kerb area B	5		Fill of cut at S end of pit B
512.523	Deposit	Kerb area B	5		Fill of cut for construction between pit A and B at S end of pit B
512.524	cut				Cut for construction between pit A and B at S end of pit B
512.525	deposit				Fill of drain under the modern reconstruction at the S end of pit B (between pit A and B)
512.526	deposit				Build of the drain at the S end of pit B. Mortar and stone construction underlying modern reconstruction

512.527	cut					A linear cut between the footpath stones and the wall of the house. It goes from W to E and is situated at the S end of pit C. It separates 512.513 and 512.514
512.528	Deposit	Wall W06.119 building	4	25.4.2.2	A hard packed feature running along the wall at the S end of pit C	
512.529	Deposit	Possible yellow natural	1	25.1	9 m N from the back door of the Shrine area along the W side of Vicolo di Narciso. Yellowish soil, compacted, no visible large rock inclusions	
512.530	Deposit	Confused upper fills (over lapilli and kerb stone construction)	8 to 9	25.8	A rubble layer at the very S end of pit C, rubbing along the drain and the curb stones for about a metre	
512.531	Deposit	Fills of associated lapilli pit	8 to 9	25.8	Layer between 512.514 and the lapilli layers, toward the S end of S drain in pit C (512.007)	
512.532	Deposit	Fills of associated lapilli pit	8 to 9	25.8	Deposit with rubble infill at S end of drain (512.007) in pit C	
512.533	Cut	Cesspit	6	25.6.2	Cut into the brown yellowish soil filled with dark grey brown deposit mixed with lapilli. It goes from the wall to the kerbstones on the S side of the drain (512.007)	
512.534	Cut	Cesspit	6	25.6.2	A small cut made between the build of the drain (512.007) and the curb stones. It is cut into the brown yellowish soil (512.011)	
512.535	Deposit	Cesspit	6	25.6.2	End of the drain approximately 15 cm wide, at about 1.5 m from the backdoor of Surgeon in pit C	
512.536	Cut	Kerb area C	5	25.5.1	Cut made for builders' trench for footpath at S end of pit C	
512.537	Deposit	Kerb area C	5	25.5.1	Fill of builders' trench for footpath stones in the S of pit C	
512.538	Deposit	Fills of associated lapilli pit	8 to 9	25.8	Lapilli deposit located at the end of the drain, in S end of pit C	
512.539	Deposit	Fills of associated lapilli pit	8 to 9	25.8	Fill of the pot situated in the drain from the E side of the Surgeon, in the S of pit C	
512.540	Deposit	Wall W06.118 construction	4	25.4.2.3	Fill or deposit in pit C along the back wall of the Surgeon. The soil is brown-yellow and grey with plaster inclusions	
512.541	Cut	Area C: N	5	25.5.1	Cut into the brown soil along the footpath stones starting at the middle of the backdoor of the Surgeon and continuing for approximately 1.15m in N direction in pit	
512.542	Deposit	Area C: N fill	5	25.5.1	Fill of the cut (512.541) along the footpath of pit C. Starting at the backdoor of the Surgeon N and continuing for approximately 1.15 m. The soil is brown yellowish	
512.543	Deposit	Top fills	6	25.6.3	A rubble fill along the back wall of the Surgeon in pit C. Approximately 26 cm long and 20 cm wide	
512.544	Deposit	Hard packed surfaces over natural	2	25.2.2	Hard packed earth floor outside the backdoor of Surgeon. This door is located on the E side of the house. The floor runs further up N of pit C until it is cut into	
512.545	Deposit	Top fills	6	25.6.3	Fill along the back wall of the Surgeon running N approximately 80 cm. The soil is medium brown. Situated in pit C	
512.546	Cut	Cesspit	6	25.6.3	Cut between the hard packed earth and a different layer of dark earth. Pit C, W side	

512.547	Deposit	Top fills		6	25.6.3	This is a fill located along the back wall of the Surgeon by a drain in pit C (between the footpath and the wall)
512.548	Deposit	Top fills		6	25.6.3	This stratigraphic unit is hypothesized as the build of a feature. This unit is located on the W side of the trench, pit C, behind the E wall of the Surgeon
512.549	Deposit	Top fills		6	25.6.3	This is a fill along the back wall of the Surgeon to the N side of the drain in pit C.The soil is brownish grey and is firm
512.550	Deposit	Top fills		6	25.6.3	This is a feature of rocks running between the back wall of the Surgeon and the footpath
512.551	Deposit	Top fills		6	25.6.3	Fill is between two rock features located on the W side of the trench in pit C, behind the E side of the Surgeon
512.552	Deposit	Top fills		6	25.6.3	This is a feature of rocks in pit C along the back wall of the Surgeon. It runs from the wall to the footpath W-E
512.553	Deposit	Top fills		6	25.6.3	Rubble fill to the N of a feature of rocks along the back wall of the Surgeon. The soil is light brownish-grey
512.554	Deposit	Top fills		6	25.6.3	Rubble that is overlying the hard packed surface. This is located on the W side of the trench behind the E side of Surgeon in pit C
512.555	Constr.	Wall W06.118 construction		4	25.4.2.3	A mortar fill running along the wall in pit C. It starts at the N end of the Sarno block going N for about 1.5 m and stops about 7 cm before the drain. Equal to 512.540
512.556	Deposit	Top fills		6	25.6.3	A grey-brownish fill running along the footpath between the big rock (N of stone/mortar feature) and the hard packed earth feature. Equal to 512.559
512.557	Deposit	Cuts into natural and possibly redeposited natural		2	25.2.1	Brown fill on the N side of the mortar/stone feature and S of the hard packed earth surface
512.558	Constr.	Wall W06.118 construction		4	25.4.2.3	End of mortar foundation running along the wall in the N of pit C
512.559	Deposit	Fills		6	25.6.3	Brown greyish hard packed layer at the N of pit C, S of the hard packed earth surface. Equal to 512.556
512.560	Cut	Wall W06.118 construction		4	25.4.2.3	Cut in the hard packed earth surface for the brown greyish soil deposit, also cut into natural
512.561	dead					Dead number
512.562	Deposit	Fills		6	25.6.3	Fill of soak away under 512.026, a drain north of Surgeon. Equal to 512.551
512.563	Cut	Wall W06.118 construction		4	25.4.2.3	Cut of 512.555 to make the foundation of the wall. It is situated in pit C to the N of Surgeon's backdoor
512.564	Cut	Cesspit		6	25.6.3	Cut into 512.544. Situated in pit C to the N of Surgeon's backdoor. This cut also cuts through 512.563
512.565	Cut	Cesspit		6	25.6.3	Cut in pit C through 512.571 to the N of Surgeon's backdoor
512.566	Cut	Cesspit		6	25.6.3	Cut for the soak away in pit C to the N of Surgeon's backdoor
512.567	Deposit	Mortar around drain		6	25.6.3	Mortar around the drain (512.026) which keeps it in place. It is situated in pit C to the N of Surgeon's backdoor

512.568	Deposit	Mortar under stones	5	25.5.1	Mortar deposit put in when placing the footpath stones in their place. It is found in pit C to the N of the backdoor
512.569	Constr.	Build N side of pit	6	25.6.3	Stone construction of the side of the pit/cesspit (512.551). Equal to 512.573
512.570	Deposit	Fills	6	25.6.3	Layer on top of natural soil. It was cut into for the soak away
512.571	Deposit	Hard packed surfaces over natural	2	25.2.2	Deposit which was cut into to make the drain
512.572	Cut	Cesspit	6	25.6.3	Cut for cesspit at north side of backdoor of Surgeon in pit C into the foundation of the back wall of Surgeon
512.573	Cut	Cesspit	6	25.6.3	Build of the cesspit at the N side of the pit. It is made out of 10 blocks of stone. Equal to 512.569
512.574	Constr.	Wall W06.118 construction	4	25.4.2.3	Foundation of the wall of the Surgeon, cut into for the cesspit, situated at about 2 m from the backdoor of Surgeon in pit C
512.575	Cut	Cesspit	6	25.6.3	Cut into the re-deposited natural for the build of the cesspit in pit C. It is located at about 3 m N of the backdoor of the Surgeon
512.576	Cut	Cesspit	6	25.6.3	Cut into natural on the N side of the re-deposited natural at about 30 cm of the N edge of the cesspit and 2 m of the drain between pit C and D
512.577	dead				Dead number
512.578	Cut	Area A cut	5	25.5.1	Cut into re-deposited natural for builders' trench of footpath stones
512.579	Cut	Area A cut	5	25.5.1	Cut into re-deposited natural for builders' trench of footpath stones
512.580	Cut	Wall W06.118 construction	4	25.4.2.3	Cut for the foundation of the back wall of the Surgeon on the N of pit C
512.581	Cut	Cuts into natural and possibly redeposited natural	2	25.2.1	Cut in 512.557 to go deeper into natural, has a irregular shape and runs E-W. About 40 cm long from footpath to foundation of the wall of Surgeon
512.582	Cut	Cuts into natural and possibly redeposited natural	2	25.2.1	Cut into natural for build of cesspit (N side) in the N of pit C
512.583	Cut	Cesspit	6	25.6.3	Cut into a silty, friable layer for build of soak away at the S side of the N drain in pit C
512.584	Cut	Cesspit	6	25.6.3	A probable cut made into the mortar layer underneath the large Sarno block on the street side of the N drain in pit C
512.585	Deposit	Fills	6	25.6.3	Two stones that seem to block the soak away at its N end in the N drain of pit C
606.001	Deposit	Gravel layer	9	4.9	Gravel layer overlying backfill covering extent of trench
606.002	Deposit	Removal of old backfill	N/A	N/A	Backfill underlying gravel put down in 2004 and covering the extent of the trench
606.003	Constr.	Cistern head	6	4.6.2	Stone cistern head located at the E extent of trench partially embedded in the E trench
606.004	Constr.	Step of mortar, at level of N doorway	5	4.5.1	Mortar structure deposit thought to probably be a step up into blocked up doorway at the NE extent of trench, modern?
606.005	Cut	Removal of NW feature/removal of stairs, pit with diverse fills	5	4.5.2.2	Pit located at the NW region of the trench abutting the trench wall
606.006	Constr.	Wall 4	3	4.3.2.1	Sarno stone located at the SE corner of the trench

606.007	Constr.	Wall 4	3	4.3.2.1	Irregular shaped Sarno stone located S of the stairs abutting the brick pillar
606.008	Cut	Upper cut	6	4.6.4	Semicircular cut into SU out it deepest gradient
606.009	Deposit	Upper cut	6	4.6.4	Fill of 606.008 in the W end of the trench
606.010	Cut	SW corner square shaped cut	2	4.2.3.1	Roughly square cut in possibly re-deposited natural located to SE corner of cistern head
606.011	Deposit	Yellow soils	2	4.2.2	Re-deposited natural that is S of 606.019
606.012	Constr.	Build of cistern	5	4.5.2.3	A series of rocks grouped to form a structural boundary around the cistern
606.013	Deposit	Fills	6	4.6.5	Dark soil at the NE corner of the trench. Probably backfill
606.014	Deposit	Fills	6	4.6.5	Small collection of irregular stones abutting 606.007 and surrounding boundary of fill 606.021
606.015	Deposit	Fill plus other mixed context	5	4.5.2.2	Semi-compact layer of dark stone that is irregular in surface
606.016	Constr.	Threshold stones	6	4.6.3	Threshold stones located at the W extent of the trench
606.017	Deposit	Gritty green natural deposits	1	4.1	Re-deposited natural directly to N of cistern head
606.018	Constr.	Lower foundations	6	4.6.6	Foundation of wall W05.003 running E-W, W extent ending at brick quoining where SU begins
606.019	Deposit	SW corner square shaped cut	2	4.2.3.1	Fill of 606.010, silty sand with stone inclusions
606.020	Cut	Building cuts	6	4.6.5	Cut abutting the stone boundary formed by 606.014
606.021	Deposit	Fills	6	4.6.5	Fill from the cut 606.020 in the NW of the trench to the S of the stairs
606.022	Constr.	Lower foundations	6	4.6.6	Remnant rubble feature projecting northward from quoining at the W end of wall W05.003
606.023	Deposit	Cut and fill in NW corner (possibly from earlier phase)	5	4.5.2.2	Loose collection of rubble abutting wall W05.001, fill of 606.024
606.024	Cut	Cut and fill in NW corner (possibly from earlier phase)	5	4.5.2.2	Semicircular cut of soil that abuts wall W05.001
606.025	Deposit	Fills	6	4.6.5	Circular fill of dark soil located at E end of cut 606.010 and directly abutting stair foundation
606.026	Deposit	Fills	6	4.6.5	Compact soil, yellowish in nature, between 606.087 and 606.025
606.027	Deposit	Fills	6	4.6.5	Fill of the W side of cut 606.020 underlying 606.021 and abutting 606.006 and 606.026
606.028	Cut	Linear cut	2	4.2.3.2	Linear cut into 606.030 located at the SE corner of the bench
606.029	Deposit	Linear cut	2	4.2.3.2	Fill of 606.028 a linear cut at the S of the re-deposited natural
606.030	Deposit	Fill possibly from a cut	2	4.2.3.2	Soil deposit extending over much of the SE corner of the trench underlying 606.015 into which 606.034 and 606.028 have been cut
606.031	Deposit	SW corner semi-circular cut	2	4.2.3.1	Fill of cut 606.033 a semi circular pit cut into 606.011 at its N extent
606.032	Deposit	Upper final fill	3	4.3.2.1	Layer of very hard packed soil underlying the Sarno SU and the wall remnant 606.022 at SW corner of the cistern
606.033	Cut	SW corner semi-circular cut	2	4.2.3.1	Semicircular cut in 606.011 at its N extent

606.034	dead				Irregularly shaped cut at S extent of trench (Dead number)
606.035	dead				Dead number
606.036	dead				Dead number
606.037	Cut	Posthole	6	4.6.5	Posthole abutting 606.007 which is Sarno stones in the NW extent of the trench
606.038	Cut	Posthole 4	5	4.5.2.3	Posthole underlies 606.015 on NW side of trench between the threshold stones and cistern head
606.039	Deposit	W posthole 3	6	4.6.4	Fill of cut 606.046 W of AA 606 possible posthole
606.040	Deposit	Posthole 4	5	4.5.2.3	Fill of cut 606.038 possible posthole directly to the SE of cut 606.046
606.041	Deposit	Posthole	6	4.6.5	Fill of cut 606.037 possible posthole directly to the E of 606.017 the Sarno stone
606.042	Deposit	Fills around cistern build	5	4.5.2.3	Light brown soil deposit extending over a large part of the NE extent of trench
606.043	Deposit	Fills around (over?) soak away	5	4.5.2.2	Firm plaster and gravel dump spread unevenly over a large part of the NW extent of the trench
606.044	Cut	Building cuts	6	4.6.5	Cut, possible posthole in N extent of trench, appears to be cut into the bottom of cut 606.020
606.045	Constr.	Mortar fragment (later picked)	5	4.5.2.3	Beaten surface to the NW side of cistern, very hard and smooth, appears to contain pick marks
606.046	Cut	W posthole 3	6	4.6.4	Cut of possible posthole fill is 606.039 cut in 606.054 directly to the E of the Nmost threshold stone
606.047	Deposit	Posthole 1	5	4.5.2.3	Plaster/mortar layer around post hole to N of the cistern head
606.048	Cut	Posthole 1	5	4.5.2.3	Cut for a small posthole directly to the N of the cistern head
606.049	Deposit	Posthole 1	5	4.5.2.3	Fill of 606.048 a posthole to the N of the cistern head
606.050	Deposit	Posthole 4	5	4.5.2.3	Fill of 606.038, a cut between the threshold stones and the cistern head, towards the centre of the trench, underlies 606.040 the upper fill
606.051	dead				Cut in bottom of pit 606.044, thin and on the N edge of the pit
606.052	Deposit	Fills	6	4.6.5	Fill of 606.044 underlying 606.025 at the N extent of the trench
606.053	Deposit	Removal of Surgeon wall stones	6	4.6.3	Deposit containing Sarno plaster and packed soil protruding from the E side of 606.007 and extending towards the S
606.054	Deposit	Removal of Surgeon wall stones	6	4.6.3	Sarno and mortar deposit directly to the E of 606.016 and roughly aligned between 606.006 and 606.007
606.055	Deposit	Placement of new threshold stones	6	4.6.3	Linear deposit to the W of 606.054, filling the space between threshold stones and the Sarno
606.056	Deposit	Fills around (over?) soak away	5	4.5.2.2	Friable deposit to the N of 606.011 abutting 606.054
606.057	Deposit	Removal of Surgeon wall stones	6	4.6.3	Section cut out of 606.054 at its S extent in order to see the Sarno fill in section, facing N

606.058	Constr.	W06.001	3	4.3.2.2	Possible foundation stone partially uncovered to N of AA606 to the side of the stairs under wall
606.059	Deposit	Fills	3	4.3.2.2	Dark natural deposit possible construction trench, under 606.013
606.060	Deposit	Gritty green natural deposits	1	4.1	Natural layer under 606.013 to side of 606.059
606.061	Cut	Cut of posthole (possibly rexcavation of previous year)	N/A	N/A	Cut of 606.062, possible posthole, to SW of trench
606.062	Deposit	Cut of posthole (possibly rexcavation of previous year)	N/A	N/A	Fill of cut 606.061, possible posthole, in SW extent of trench
606.063	Deposit	Black sand (probably gritty black below all)	2	4.2.2	Re-deposited natural abutting 606.062 and located in SW of trench, parallel to threshold stones
606.064	Deposit	Gritty green natural deposits	1	4.1	Deposit seen in section (drawing 6) facing S in the NE corner of the trench
606.065	Deposit	Removal of Surgeon wall stones	6	4.6.3	Soft loose natural deposit underlying 606.066 to the E of the threshold equivalent to 606.066
606.066	Deposit	Removal of Surgeon wall stones	6	4.6.3	Hard packed earth deposit underlying 606.054 to E of cistern equivalent to 606.030
606.067	Deposit	Removal of Surgeon wall stones	6	4.6.3	Raised section of 606.015 that is distinguished by the N-S linear cuts that run parallel to 606.016
606.068	Deposit	Removal of Surgeon wall stones	6	4.6.3	Cut that contained the deposit of 606.069, in the NE corner of AA 606
606.069	Deposit	Removal of Surgeon wall stones	6	4.6.3	Hard-packed deposit that is part of an earlier excavation of 606.054
606.070	Cut	Removal of Surgeon wall stones	6	4.6.3	Sarno and mortar cut directly to the E of 606.016 and roughly aligned between 606.006 and 606.007
606.071	Deposit	Stones (in a line?)	5	4.5.2.2	Structure, rocks to N of AA606 abutting 606.044 and 606.007
606.072	Deposit	NW feature possibly amphora soak away	5	4.5.2.2	Lava stones around amphora, situated at E side of stairs
606.073	Deposit	NW feature possibly amphora soak away	5	4.5.2.2	Amphora mostly broken, one end with handle only removed
606.074	Cut	Removal of Surgeon wall stones	6	4.6.3	Cut between 606.065 and 606.063
606.075	Deposit	Flattish surface	5	4.5.2.2	Flat based deposit located below the removed 606.043
606.076	cut				Cut of the yellowish brown deposit (606.017) located in the NE corner of AA
606.077	dead				Yellowish brown soil deposit (Dead number)
606.078	Deposit	Stones (in a line?)	5	4.5.2.2	Rock faced structure located in the N section of 606.075
606.079	dead				Dead number
606.080	Cut	Wall 3A SW corner	3	4.3.2.1	Cut running curved out from base of wall W05.003 to wall W06.007 (Sarno block)
606.081	Deposit	Upper fill in builder's trench	3	4.3.2.1	fill of cut 606.080, running from base of wall W05.003 curving out to wall W05.007 (Sarno block)
606.082	dead				Dead number
606.083	Deposit	Middle fill in builders trench	3	4.3.2.1	Fill of cut 606.080, underlying fill 606.081
606.084	Cut	Cut possibly aligned with stones	5	4.5.2.2	Re-deposited natural over 606.075 in the NW middle of AA606

606.085	Deposit	Cut possibly aligned with stones	5	4.5.2.2	Re-deposited natural over 606.075 in the NW middle of AA 606
606.086	dead				Hard packed soil deposit (Dead Number)
606.087	Deposit	Gritty green natural deposits	1	4.1	Natural layer of soil S of the N stairways
606.088	Deposit	Lower fill in builders trench	3	4.3.2.1	Fill of cut 606.080 underlying fill 606.083
606.089	dead				Packed earth underlying 606.086 (Dead number)
606.090	Deposit	SW corner square cut and cut within cut	2	4.2.3.2	Packed brown soil layer inside cut 606.093, now incorporating 606.086 and 606.089
606.091	Deposit	Yellow soils	2	4.2.2	Loose layer resembling 606.011
606.092	Deposit	Yellow soils	2	4.2.2	Loose layer under 606.091, resembling 606.011 but darker and many more inclusions
606.093	Cut	SW corner square cut and cut within cut	2	4.2.3.2	Cut underlying 606.032 it is situated at the S side of the trench
606.094	Cut	SW corner square cut and cut within cut	2	4.2.3.2	Small square cut projecting lengthways out from wall W06.003
606.095	Deposit	SW corner square cut and cut within cut	2	4.2.3.2	Fill for cut 606.094 situated at the S side of the AA
606.096	Cut	SW corner square cut and cut within cut	2	4.2.3.2	Larger cut projecting from wall W05.003, to W of cut 606.094
606.097	Deposit	SW corner square cut and cut within cut	2	4.2.3.2	Fill of cut 606.096 situated at the S side of the trench
606.098	Constr.	Sarno build	3	4.3.2.1	Sarno block E-W aligned underlying 606.022 at S side of trench
606.099	Constr.	Sarno build	3	4.3.2.1	Wall built against the Sarno block E-W underlying 606.018
607.231	Deposit	NW corner of opus signinum in atrium	5	5.5.7	Opus signinum floor in Surgeon atrium
607.232	dead				Sticky organic deposit - no SU sheet
607.233	Deposit	SW corner cut	5	3.5.4.2	Loose grey plaster fill of 607.234
607.234	Cut	SW corner cut	5	3.5.4.2	Cut at S end of Room 2 cut by S Maiuri trench
607.235	Deposit	Mortar fragments at base of floor	6	3.6.1.1	Mortar fragments on top 607.236 in Room 2
607.236	Deposit	Grey packed surface	5	3.5.4.1	Compact grey floor surface in centre of room
607.237	Deposit	SW corner threshold cut 2	5	3.5.4.4	Rubble like deposit along E side of threshold to street
607.238	Cut	SW corner threshold cut 2	5	3.5.4.4	Cut of 607.237 at W end of Room 2
607.239	Deposit	Mortar-like floor	6	3.6.1.1	Deposit below stair in SE corner of Room 2 equals 607.80 AA 507
607.240	dead				Dark brown rubbly deposit underlying 607.236 and seen extensively in section
607.241	Deposit	Possible previous construction on threshold	6	3.6.1.2	Koose grey fill with rubble inclusions of 607.242
607.242	Cut	Possible previous construction on threshold	6	3.6.1.2	Cut of 607.241 along E side of threshold to street running N-S
607.243	Deposit	Grey packed surface	5	3.5.4.1	Area of high iron corrosion equal to 607.236
607.244	Deposit	Compact charcoal layer	5	3.5.3.2	Compact grey surface with charcoal flecks underneath 607.236 in NE corner
607.245	Deposit	Low wallette	5	3.5.3.2	Mortar stone feature, possibly wall
607.246	Deposit	Reddish deposit near amphora feature	5	3.5.3.2	Compacted burnt deposit abutting 607.245
607.247	Deposit	Posthole	5	3.5.4.2	Dark yellowy brown fill in cut 607.248
607.248	Cut	Posthole	5	3.5.4.2	Cut of 607.247 on N side of the deep central pit

607.249	dead				Dead number
607.250	dead				Dead number
607.251	Deposit	Lower fill of stair phase 2 (covers lower stairs)	6	3.6.1.2	Deposit inside the step located in the SW corner of the room
607.252	Deposit	NW corner pit 1	5	3.5.4.4	Grey-brown deposit in NW area of Room 2
607.253	dead				Dead number
607.254	Deposit	Cut 2	5	3.5.4.1	Compacted surface at base of stair base under 607.251
607.255	Deposit	Fill of stair with much lime	5		Limey deposit at edges under 607.251
607.256	Deposit	Cut 1	5	3.5.4.1	Loose dark grey deposit under 607.251
607.257	Deposit	NW corner pit 1	5	3.5.4.4	Very loose brown deposit filling cut 607.258
607.258	Cut	NW corner pit 1	5	3.5.4.4	Cut in NW of Room 2 containing 607.257 construction pit
607.259	Cut	Cut 1	5	3.5.4.1	Cut of 607.256 in the steps area
607.260	Deposit	General fills near amphora	5	3.5.3.2	Rubbly yellow-brown deposit in NW of Room 2
607.261	Deposit	Rubble layer under amphora	5	3.5.3.2	Area to N of 607.243 encompassing metalworking deposits
607.262	Deposit	Possible previous construction on threshold	6	3.6.1.2	Rubbly deposit immediately below N end of threshold
607.263	Deposit	Second cut related to stone removal	5	3.5.1	Grey rubbly deposit at N end of threshold
607.264	Deposit	Amphora fills	5	3.5.3.2	Grey deposit found within amphora on E side along wall W06.005
607.265	Deposit	Amphora fills	5	3.5.3.2	Charcoal filled deposit found within amphora on E side along wall W06.005
607.266	Deposit	Amphora fills	5	3.5.3.2	Dark reddish brown iron rich deposit in amphora under 607.265, softish
607.267	Deposit	Yellow/orange natural seen in low pits	1	3.1	Natural soil
607.268	dead				Dead number - same as SU 261
607.269	Deposit	Amphora	5	3.5.3.2	Amphora partially buried lengthwise (N-S) located immediately E of central big hole
607.270	Deposit	Likely metalworking residue	5	3.5.3.2	Dark reddish brown iron rich deposit under 607.261 very firm, approx 70 cm N-S 40 cm E-W
607.271	Cut	Cut (in amphora?)	5	3.5.3.2	Cut for 607.269 (amphora)
607.272	Deposit	Fill around amphora	5	3.5.3.2	Fill of cut 607.271 between cut and amphora 607.269
607.273	Deposit	Earlier amphora cut	5	3.5.3.3	Small greyish pit in N part of Room 2 cut by Maiuri trench 607.274
607.274	Cut	Earlier amphora cut	5	3.5.3.3	Cut of fill 607.273
607.275	Deposit	Second cut related to stone removal	5	3.5.1	Compact grey-brown deposit NE of threshold
607.276	Cut	Cut and fills under amphora feature	5	3.5.3.2	Cut between chocolate deposit 607.278 and iron coloured deposit
607.277	Deposit	Cut and fills under amphora feature	5	3.5.3.2	Fill of cut 607.276, grey brown deposit N of amphora
607.278	Deposit	Dark chocolate natural	1	3.1	Dark chocolate brown deposit
607.279	Deposit	Cut and fills under amphora feature	5	3.5.3.2	Yellow-brown deposit with small grey lens and noticeable inclusions below 607.277
607.280	Deposit	Posthole 1	5	3.5.3.3	Small posthole with very loose soil near wall
607.281	Cut	Posthole 1	5	3.5.3.3	Cut of 607.280 posthole
607.282	Cut	Posthole 2	5	3.5.3.3	Cut of 607.283 posthole

607.283	Deposit	Posthole 2	5	3.5.3.3	Medium posthole with fill containing 3 limestone chips
607.284	Cut	Posthole 4	5	3.5.3.3	Cut of posthole 607.285
607.285	Deposit	Posthole 4	5	3.5.3.3	Small posthole
607.286	Deposit	Dark brown central pit	6	3.6.1.3	Dark grey deposit near S iron area and large pit
607.287	Cut	Second cut related to stone removal	5	3.5.1	Long narrow cut under the threshold stones running along the E wall
607.288	Deposit	Second cut related to stone removal	5	3.5.1	Deposit of cut 607.287
607.289	Cut	Cut related to stone removal	5	3.5.1	Cut along threshold stone (most S one)
607.290	dead				Dead number
607.291	dead				Dead number
607.292	Cut	Cut related to stone removal	5	3.5.1	N-S running cut situated at the E side of the gap between the threshold stones
607.293	Deposit	Cut related to stone removal	5	3.5.1	Fill of 607.292
607.294	Deposit	Possibly re-deposited natural	5	3.5.1	Yellow-brown deposit with rubble E of threshold in S area
607.295	Deposit	Subsequent layers N-W	3	3.3.1	Floor between large pits E of former 607.288
607.296	Cut	Semicircular cut (NW side)	3	3.3.1	Cut in floor 607.295
607.297	Deposit	Semicircular cut (NW side)	3	3.3.1	Fill of 607.296
607.298	Cut	Earlier amphora cut	5	3.5.3.3	Iron between natural and 607.270 near stairs possibly same as 607.261
607.299	Deposit	Compacted grey deposit	5	3.5.3.1	S grey floor bordered by Maiuri trench
607.300	Cut	Posthole 3	5	3.5.3.3	Cut for posthole bordering former edge of 607.270
607.301	Deposit	Posthole 3	5	3.5.3.3	Fill of cut 607.300
607.302	Deposit	Earlier amphora cut	5	3.5.3.3	Chocolaty-orange fill of 607.298
607.303	Cut	Cut 2	5	3.5.4.1	Cut in stairs between 607.254 and 607.256
607.304	Deposit	Grey packed surface	5	3.5.4.1	Iron grey deposit below 607.254 possibly same as 607.243
607.305	Cut	Foundation cut	3	3.3.2	Foundation cut into natural along threshold stones
607.306	Deposit	Fill	3	3.3.2	Fill of foundation cut
607.307	Deposit	Low wide Surgeon stones	3	3.3.2	Sarno blocks of earlier wall in foundation cut
607.308	Deposit	Fill	3	3.3.2	Fill above foundation wall stones underlying the threshold stones
607.309	Cut	Foundation cut	3	3.3.2	Cut of 607.308
607.310	Deposit	Subsequent layers N-W	3	3.3.1	Grey loose rubbly SU just north of pit
607.311	Deposit	Deposit overlying natural	3	3.3.1	Brown-yellow layer with inclusions
607.312	Deposit	Semicircular cut	3	3.3.1	Small loose pit or area at edge of Maiuri's trench
607.313	Cut	Semicircular cut	3	3.3.1	Cut of 607.312
607.314	Deposit	Cut in natural	3	3.3.1	Brown rubbly layer E of N threshold and physically below 607.295
607.315	Cut	SE semicircular cut	3	3.3.1	Cut in natural underneath 607.311
607.316	Deposit	SE semicircular cut	3	3.3.1	Fill of cut 607.315
607.317	Cut	Posthole cut	3	3.3.1	Posthole cut in 607.311
607.318	Deposit	Posthole cut	3	3.3.1	Fill of posthole cut
607.319	Cut	Cut in natural	3	3.3.1	Cut into natural filled by 607.314
607.320	Deposit	SE semicircular cut	3	3.3.1	Ash deposit below 607.316
608.001	Deposit	Modern protective gravel and overburden	9	5.9	Protective layer of gravel covering the whole extent of the area

608.002	Deposit	Backfill previous seasons	N/A	N/A	Backfill from excavation in 2005
608.003	Constr.	Drain (top Sarno stones)	3	5.3.4	Sarno and tuff drain in the W part of the area = 609.104
608.004	Constr.	Tuff impluvium in centre of atrium	5	5.5.3.1	Tuff impluvium in the centre of the atrium
608.005	Constr.	(Reused?) Sarno under impluvium	5	5.5.3.1	Sarno foundation stones supporting impluvium
608.006	Cut	Foundation trench	3	5.3.2.3	Cut of foundation trench for wall W06.025
608.007	Constr.	Sarno base	3	5.3.2.3	Foundation stones of wall W06.028/103 reused Sarno blocks with plaster
608.008	Constr.	Threshold stone of doorway between wall W06.025 andW06.026	5	5.5.6	Threshold stone of doorway between wall W06.025-26 underneath wall W06.025
608.009	Constr.	Threshold stone of doorway between wall W06.025 andW06.027	5	5.5.6	Threshold stone of doorway between walls W06.025-26 under wall W06.026
608.010	Cut	Cut for drain	3	5.3.4	Foundation cut of Sarno drain (608.003)
608.011	dead				Dead number
608.012	dead				Dead number
608.013	dead				Dead number
608.014	Deposit	Pocked earth	2	5.2.1	Grey pocked earth surface in the centre of the area
608.015	Deposit	Possibly to do with impluvium	2	5.2.2	Fill of posthole cut into the grey pocked earth surface in the centre of the area
608.016	Cut	Possibly to do with impluvium	2	5.2.2	Cut of 608.015
608.017	Constr.	Tile drain (SE from impluvium)	5	5.5.3.3	Tile drain in the E corner of the impluvium, broken
608.018	Deposit	Pocked earth	2	5.2.1	Grey pocked earth surface to the left of the drain No.2 (608.017)
608.019	Deposit	Earlier levelling and fills E	3	5.3.1	Brown hard-packed deposit cutting 608.014 on its S side
608.020	Deposit	Cut above postholes (for SE drain?)	5	5.5.3.3	Brown hard packed deposit cutting 608.014 on its N side
608.021	Cut	Cut 6 (imaginary)	2	5.2.2	Cut for 608.019
608.022	Cut	Cut above postholes (for SE drain?)	5	5.5.3.3	Cut for 608.020
608.023	Cut	Maiuri's cuts	9	5.9	Maiuri's trench
608.024	Deposit	Possibly to do with impluvium	2	5.2.2	Hard-packed earth in the corner of impluvium, between impluvium and cistern head
608.025	Deposit	Possibly to do with impluvium	2	5.2.2	Fill of Posthole in NE part of Maiuri's trench
608.026	Cut	Possibly to do with impluvium	2	5.2.2	Cut of posthole in NE part of Maiuri's trench
608.027	Deposit	Possibly to do with impluvium	2	5.2.2	Sandy silt underlying the impluvium, located on the S side of the impluvium
608.028	Constr.	(Reused?) Sarno under impluvium	5	5.5.3.1	Sarno stone in the W part of the impluvium, to the right of the cistern head, one of the supports for the impluvium
608.029	Deposit	Possibly to do with impluvium	2	5.2.2	Dark deposit in the corner of the impluvium with Sarno fragments, located under 608.024
608.030	Deposit	Possibly to do with Impluvium	2	5.2.2	Dark grey deposit in the N part of the NE corner of the impluvium
608.031	Deposit	Earlier levelling and fills E	3	5.3.1	Brown deposit in the centre-S part of the area with large amount of charcoal, bones, pottery
608.032	Deposit	Cut 5 (= 609.136)	2	5.2.2	Light brown deposit with large amount of Sarno in the SW part of area
608.033	Deposit	Fill of trench	3	5.3.2.3	Fill of foundation trench of wall 06.025 between walls W06.025 and W06.026

608.034	Deposit	Possibly to do with impluvium	2	5.2.2	Fill of posthole S from impluvium cut into 608.014
608.035	Cut	Possibly to do with impluvium	2	5.2.2	Cut for posthole 608.034
608.036	Deposit	Possibly to do with impluvium	2	5.2.2	Fill of posthole No. 2 S from the corner of impluvium cut into 608.024
608.037	Cut	Possibly to do with impluvium	2	5.2.2	Cut of 608.036
608.038	Deposit	Possibly to do with impluvium	2	5.2.2	Fill of posthole No. 3 of the corner of the impluvium
608.039	Cut	Possibly to do with impluvium	2	5.2.2	Cut of 608.038
608.040	Deposit	Natural	1	5.1	Natural brown deposit seem in the whole extent of the area
608.041	Deposit	Pea gravel	2	5.2.1	Pea gravel, underlying immediately pocked earth (608.014)
608.042	Deposit	Turf layer	1	5.1	Turf layer of decomposed plant matter underlying pea gravel
608.043	Deposit	Central cut 7	2	5.2.2	Grey brown fill for cuts 608.063 and 608.064 located in NE corner of AA
608.044	Deposit	Cut (N side, visible S section)	5	5.5.3.3	Fill of foundation trench of tile drain (608.017) to the N of drain
608.045	Deposit	Posthole 1 in central cut	2	5.2.2	Fill of posthole cutting through 608.043 and 608.040
608.046	Cut	Posthole 1 in central cut	2	5.2.2	Cut of posthole (Fill 608.045)
608.047	Deposit	Cut 10	2	5.2.2	Dark brown fill with grey inclusions for cut (608.048) located in SE corner of trench
608.048	Cut	Cut 10	2	5.2.2	Cut of 608.047, located in SE corner of trench
608.049	Cut	Possibly to do with impluvium	2	5.2.2	Cut of 608.027 foundation trench of impluvium S of impluvium
608.050	Deposit	Possibly to do with impluvium	2	5.2.2	E hole fill of 608.051 located at the bottom of 608.048 in the SE corner of the trench
608.051	Cut	Possibly to do with impluvium	2	5.2.2	Cut of 608.050 post hole located at the bottom of 608.048 in the SE corner of the trench
608.052	Deposit	Posthole 4	2	5.2.2	Small posthole located in 608.032 in SE corner of atrium
608.053	Cut	Posthole 4	2	5.2.2	Cut of posthole in 608.032
608.054	Deposit	Posthole 3	2	5.2.2	Fill of posthole located in 608.032 in SE corner of the trench
608.055	Cut	Posthole 3	2	5.2.2	Cut of 608.054 located in 608.032
608.056	Deposit	Posthole 2	2	5.2.2	Fill of small posthole in 608.032 located in SE corner of the trench
608.057	Cut	Posthole 2	2	5.2.2	Cut of posthole located in 608.032
608.058	Cut	Cut (N side, visible S section)	5	5.5.3.3	Cut of 608.04 foundation trench of tile drain (608.017)
608.059	Deposit	Cut (N side)	5	5.5.3.3	Fill of foundation trench to the S of the tile drain (608.017)
608.060	Cut	Cut (N side)	5	5.5.3.3	Cut of 608.059 S foundation trench of tile drain (608.017)
608.061	Cut	Possibly to do with impluvium	2	5.2.2	Cut of 608.030 on N end of impluvium that is not completely found
608.062	Deposit	Fill inside N-S drain	3 to 4	5.5.3.1	Fill of 608.017 fill of drain in NE corner
608.063	Cut	Central cut 7	2	5.2.2	Cut for 608.043 in NE corner of AA
608.064	Cut	Central cut 7	2	5.2.2	Cut of posthole filled with 608.043 at bottom of 608.063

608.065	dead					Dead number
608.066	Cut	Cut 5 (= 609.136)	2		5.2.2	Cut of 608.032 located in SE corner of the trench
609.101	Deposit	Protective gravel and overburden	9		8.9	Protective cover of modern gravel covering entire AA
609.102	Deposit	Backfill from the first season	9		8.9	Dark brown backfill from 2002 excavation covered entire extent of AA
609.103	Cut	Maiuri's trench	9		8.9	Trench from Maiuri's 1920's excavation located in SW corner of the room
609.104	Constr.	Drain top and bottom	3		8.3.3	Tuff and Sarno drain running N-S equals 608.003
609.105	Deposit	So called kitchen feature	5		8.5.4	Opus signinum surface in NW corner of area
609.106	Deposit	Fill	3		8.3.2	Fill of foundation trench on wall W06.103 in NE corner of room
609.107	Cut	Foundation cut	3		8.3.2	Cut of foundation trench for wall W06.0103
609.108	Deposit	NE cut 2	2		8.2.2.1	Fill of pit cut into dark brown deposit (609.110) NE of AA
609.109	Cut	NE cut 2	2		8.2.2.1	Cut of pit that is cut into dark brown deposit of 609.110
609.110	Deposit	Natural soils	1		8.1	Dark brown deposit in E part of room, part of the levelling deposit
609.111	Deposit	Levelling post pre-Surgeon house: grey deposits	3		8.3.4	Circular feature in the SE part of the area made of hard packed compaction
609.112	Deposit	Fill	3		8.3.3	Foundation trench of drain
609.113	Cut	Cut	3		8.3.3	Foundation trench of drain
609.114	Deposit	Degraded opus signinum	6		8.6	Opus signinum floor N of Maiuri's trench
609.115	Deposit	General fills	5		8.5.1	Hard packed earth in the section between 609.105 and 609.114
609.116	Constr.	Foundation Sarno stones	3		8.3.2	Foundation stones of wall W06.103, Sarno block
609.117	Constr.	Foundation stones	3		8.3.2	Foundation stone of wall W06.107, Sarno block
609.118	Deposit	Levelling post pre-Surgeon house: grey deposits	3		8.3.4	Dark brown deposit at wall W06.105
609.119	Deposit	SE cut 1	2		8.2.2.1	Dark grey gritty deposit in the NE part of the area cut by posthole (609.121)
609.120	Deposit	SE cut 2	2		8.2.2.1	Yellow-brown deposit in NE part of area
609.121	Cut	Big posthole	5		8.5.1	Posthole in SE part of area
609.122	Cut	Foundation cut	3		8.3.2	Foundation cut for wall W06.107
609.123	Deposit	Fills	3		8.3.2	Fill of foundation cut for wall W06.107 (with Sarno block 609.117)
609.124	Deposit	Fill for wall W06.105	3		8.3.2	Loose dark brown deposit in corner of walls W06.104 and W06.105 equals fill of foundation trench of walls W06.104 and W06.105
609.125	Deposit	Post-pre Surgeon levelling E	3		8.3.1	Dark grey deposit in E part of area
609.126	Deposit	Post-pre Surgeon levelling E	3		8.3.1	Dark brown deposit in the NE corner of Room 6C cut by 609.124
609.127	Deposit	Fill	3		8.3.3	Fill of foundation trench of drain (609.104) W of the drain
609.128	Cut	Cut	3		8.3.3	Cut for 609.127
609.129	Deposit	Post-pre Surgeon levelling NW	3		8.3.1	Packed greyish brown deposit underlying 609.141

609.130	Constr.	Fill	3	8.3.2	Loose soil at walls W06.103 and W06.104, left unexcavated in 2002, underneath remnants of floor
609.131	Cut	Cut	3	8.3.2	Cut of foundation trench of wall W06.104 and W06.105 in the SE part of the area
609.132	Deposit	Fill for wall W06.104	3	8.3.2	Light-brown yellow fill of foundation trench of wall W06.104 in E of area
609.133	Cut	Cut	3	8.3.2	Foundation trench of wall W06.104 E part of the wall
609.134	dead				Dead number
609.135	Deposit	NE cut 1	2	8.2.2.1	Dark olive brown deposit in the NE part of the area
609.136	Deposit	NE cut 1	2	8.2.2.1	Fill of pit in N of area which extends under wall W06.103 and 609.104
609.137	Cut	NE cut 1	2	8.2.2.1	Cut of pit 609.136 in N of area which extends into AA608 (equal to SU 608.066)
609.138	Deposit	NE cut 1	2	8.2.2.1	Dull grey brown deposit on E side of drain
609.139	Deposit	Fills	3	8.3.2	Foundation trench of W06.106, as seen between 609.114 and 609.105
609.140	Cut	Cut	3	8.3.2	Cut of foundation trench of wall W06.106
609.141	Deposit	Post-pre Surgeon levelling NW	3	8.3.1	Hard-packed earth underlying 609.115 in section between 609.114 and 609.104
609.142	Deposit	Posthole within pit	2	8.2.2.1	Posthole in 609.136 with fill of loose grey soil
609.143	Cut	Posthole within pit	2	8.2.2.1	Cut of 609.142
609.144	Deposit	SE cut 2	2	8.2.2.1	Fill of pit cut into 609.119 at wall W06.105, intersected by foundation trench of wall W06.105
609.145	Cut	SE cut 2	2	8.2.2.1	Cut of pit 609.144
609.146	Cut	SE cut 1	2	8.2.2.1	Cut of pit 609.119
609.147	Deposit	Degraded opus signinum	6	8.6	Subfloor of opus signinum surface 609.114
609.148	Deposit	Fills	3	8.3.2	Fill of foundation trench for wall W06.106 equal to 609.139, fill of 609.159
609.149	Deposit	Redeposited grey/black sand deposits and rubble fill of large cut into black sand	2	8.2.2.2	Hard packed brown deposit next to 609.148
609.150	Deposit	Redeposited grey/black sand deposits and rubble fill of large cut into black sand	2	8.2.2.2	Loose brown deposit next to 609.149 and below 609.151, similar in colour and inclusions to 609.152
609.151	Deposit	Lens or shallow pit	2	8.2.2.2	Light grey rubble deposit under 609.115 similar in colour and inclusions to 609.141
609.152	Deposit	Redeposited grey/black sand deposits and rubble fill of large cut into black sand	2	8.2.2.2	Loose grey deposit with small rocks and plaster similar in colour and inclusions to 609.150 located above 609.155
609.153	Deposit	Cut in section	2	8.2.2.2	Brown deposit with a large amount of plaster stone and mortar W of foundation trench for Sarno drain (609.104)
609.154	Deposit	Cut into black sands	2	8.2.2.2	Brown deposit with large stones underlying 609.153
609.155	Deposit	Redeposited grey/black sand deposits and rubble fill of large cut into black sand	2	8.2.2.2	Black sand deposit with pottery and tile pieces directly overlays 609.157
609.156	Deposit	Redeposited grey/black sand deposits and rubble fill of large cut into black sand	2	8.2.2.2	Firmly packed brown deposit underlying 609.152 and overlying 609.155

609.157	Deposit	Levelling layer of redeposited, churned-up natural	2	8.2.1	Brown deposit with natural soil-coloured inclusions directly overlying the natural (609.110) fill of 609.158	
609.158	Cut	Levelling layer of redeposited, churned-up natural	2	8.2.1	Cut fill with 609.157 cut into natural seen in N section of Maiuri's trench (609.103)	
609.159	Cut	Cut	3	8.3.2	Cut of foundation trench for wall W06.106, filled with 609.148 and seen in the N section of Maiuri's trench (609.103)	
609.160	Cut	Redeposited grey/black sand deposits and rubble fill of large cut into black sand	2	8.2.2.2	Cut filled with 609.150, and 609.152 seen in N section of Maiuri's trench	
609.161	Cut	Redeposited grey/black sand deposits and rubble fill of large cut into black sand	2	8.2.2.2	Cut filled with 609.156 seen in N section of Maiuri's trench (609.103)	
609.162	Cut	Lens or shallow pit	2	8.2.2.2	Cut filled with 609.151, seen in N section of Maiuri's trench	
609.163	Cut	Cut into black sands	2	8.2.2.2	Cut filled with 609.154, seen in N section of Maiuri's trench	
610.001	Deposit	Modern protective gravel and overburden	9	15.9	Modern gravel over whole area	
610.002	Constr.	Possibly modern threshold, Sarno block	8	15.8	Threshold stone at atrium end of N-S corridor	
610.003	Deposit	Strange part of opus signinum, possibly later repair	6	15.6.5	Final phase opus signinum	
610.004	dead				Dead number	
610.005	Deposit	Modern fills	9	15.9	Blonde/brown soil along E-W corridor	
610.006	Deposit	Modern fills	9	15.9	Blonde/brown soil N-S corridor	
610.007	Deposit	S final phase opus signinum	6	15.6.5	Floor surface against back wall and step in join of corridors	
610.008	dead				Dark black brown deposit across N-S corridor	
610.009	Deposit	Modern fills	9	15.9	Dark brown loose deposit under 610.005 in E-W corridor	
610.010	Cut	Wooden plank	9	15.9	Cut for modern threshold wood plank 610.011	
610.011	Deposit	Wooden plank	9	15.9	Wood threshold plank modern	
610.012	dead				Dead number	
610.013	Deposit	Final phase opus signinum floor	6	15.6.5	Subfloor	
610.014	dead				Dead number	
610.015	Deposit	Modern fills	9	15.9	Thin layer of brown sandy silt overlying 610.013	
610.016	Deposit	Modern fills	9	15.9	Think grey spread in N/S under 610.006 lens	
610.017	Cut	Damage to drain	9	15.9	Cut through 610.007 against S wall repair	
610.018	Deposit	Damage to drain	9	15.9	Fill of cut 610.017	
610.019	Constr.	Brick and tile top to drain	6	15.6.6	Brick and tile construction in cut 610.017 roof	
610.020	Deposit	Strange part of signinum, possibly later repair	6	15.6.5	Grey and white subfloor at E end of E/W corridor	
610.021	Deposit	Large general fill layer of painted plaster and other debris	6	15.6.4	Layer of painted plaster under subfloor 610.013	
610.022	Deposit	AAPP backfill	9	15.9	Modern backfill of threshold to Room 23	
610.023	Deposit	Strange part of signinum, possibly later repair	6	15.6.5	Plaster overlying 610.019, small patch underlying 610.020, repair with smaller inclusions	
610.024	Constr.	Stone and mortar base of drain	6	15.6.6	Stone and mortar drain construction base	
610.025	Deposit	Packed earth floor	5	15.5.6	Compact material overlying 610.026 possible occupation layer	

610.026	Deposit	Packed earth floor	5	15.5.6	Rough packed earth floor underlying 610.021 and 610.025
610.027	Cut	Wall W06.099 changes or foundation	6	15.6.3	Possible foundation cut through 610.026, W side
610.028	Deposit	Wall W06.099 changes or foundation	6	15.6.3	Fill of 610.027, similar to lower level of 610.021
610.029	dead				Dead number
610.030	Deposit	Fill layer	6	15.6.4	Loose dark deposit with pottery
610.031	Deposit	Plaster skims	6	15.6.3	Think plaster skim over 610.033 in N area near threshold
610.032	Deposit	Plaster skims	6	15.6.3	Think plaster skim over 610.028 at N end
610.033	Deposit	Packed earth floor	5	15.5.6	Rough packed earth floor under 610.031
610.034	Deposit	Large general fill layer of painted plaster and other debris	6	15.6.4	Equal to 610.021, around corner of corridor
610.035	Constr.	Blocking of E doorway into Room 11	6	15.6.2	Orangey soil mortar related to blocked door in S end of N-S corridor
610.036	Deposit	Plaster skims	6	15.6.3	Plaster skim overlying 610.025 at S end of N-S corridor
610.037	Constr.	Possibly modern threshold, Sarno block	8	15.8	Stone construction next to threshold of the door at N end of N-S corridor
610.038	Deposit	Building of wall W06.099	5	15.5.4	Stone foundations along W of N/S
610.039	Cut	Posthole shuttering support	6	15.6.3	Posthole possile wall shuttering near threshold to Room 23
610.040	Deposit	Posthole shuttering support	6	15.6.3	Fill of posthole 610.039
610.041	Deposit	Large general fill layer of painted plaster and other debris	6	15.6.4	Plaster deposit same as 610.021 against W wall just S of Room 23
610.042	Deposit	Loose brown fill Layer	6	15.6.4	Loose brown deposit underneath 610.041
610.043	Deposit	Fill layer	6	15.6.4	Loose brown deposit under 610.034
610.044	Deposit	Further fills and lenses	5	15.5.4	Hard-packed orange floor beneath 610.026
610.045	Constr.	Column base	3	15.3.2	Pilaster base Sarno
610.046	Deposit	Further fills and lenses	5	15.5.4	Gritty black deposit
610.047	Deposit	Extension of wall W06.023	5	15.5.3	Loose grey brown deposit along E wall
610.048	Deposit	Levelling fill	5	15.5.2	Dark grey deposit near NW corner of SU 45
610.049	Deposit	Further fills and lenses	5	15.5.4	Thin yellow hard deposit over S of trench
610.050	Constr.	Puteal base	3	15.3.2	Sarno stone possible small wall between pilaster bases
610.051	Deposit	Closing of cistern	5	15.5.1	Mortar pour at S end heading under section - cistern cap
610.052	Constr.	Extension of wall W06.024	5	15.5.3	Small patches of wall mortar bottom of shuttering foundation
610.053	Deposit	Further fills and lenses	5	15.5.4	Patch of degraded Sarno stone at S end of N/S corridor
610.054	Deposit	Levelling fill	5	15.5.2	Firm dark grey deposit with lots of inclusions at S end similar to 610.048
610.055	Deposit	Orange post pre-Surgeon fill	3	14.3.4	Packed orangey-brown surface very firm blue-plaster inclusions
610.056	Cut	Pit 2	3	14.3.4	Pit cut through 610.055, on W side of corridor
610.057	Deposit	Pit 2	3	14.3.4	FIll of 610.056
610.058	Cut	Pit 1	3	14.3.4	Pit cut through 610.055 on E side of corridor
610.059	Deposit	Pit 1	3	14.3.4	Fill of 610.058
610.060	Cut	Posthole 1	5	15.5.1	Posthole at N of 610.045 possibly associated with wall foundation
610.061	Deposit	Posthole 1	5	15.5.1	Fill of 610.060

610.062	Cut	Extension of wall W06.025	5	15.5.3	Foundation cut S of trench, possibly associated with wall foundation
610.063	Deposit	Extension of wall W06.022	5	15.5.3	Fill of 610.062
610.064	Cut	Posthole 3	5	15.5.1	Posthole possibly cut through column base
610.065	Deposit	Posthole 3	5	15.5.1	Fill of 610.064
610.066	dead				Dead number
610.067	Constr.	Downspout	3	15.3.2	Construction for drain against S side of 610.080 underlying 610.055
610.068	Deposit	Fill of drain downpipe	5	15.5.1	Fill of cut 610.067
610.069	Cut	Posthole 2	5	15.5.1	Rounded rectilinear posthole near NW corner of 610.045
610.070	Deposit	Posthole 2	5	15.5.1	Fill of 610.069
610.071	Constr.	Build of cistern/well	2 to 3	15.2	Construction of cistern
610.072	Cut	Building of wall W06.099	5	15.5.4	Cut for foundation of wall SU 610.099 and 610.038
612.001	Deposit	Protective gravel	9	20.9.1	Custodi gravel covering the extent of AA 612
612.002	Deposit	Overburden	9	20.9.1	Silty sand with gravel and small rocks covering the extent of Room 17
612.003	Deposit	Overburden	9	20.9.1	Deposit butts against E wall W06.066 and S wall W06.067 - loose silty sand with few small rocks and visible roots
612.004	Deposit	Preserved final phase opus signinum flooring in S end of Room 16	6	20.6.3	Opus signinum floor at W extent of 612.001 in Room 16 final phase floor in this area
612.005	Deposit	Final phase opus signinum in Room 16	6	20.6.3	Opus signinum floor running along wall W06.068 in AA612
612.006	Deposit	Subfloor consisting of multicoloured plaster	6	20.6.3	Subflooring under partially extant opus signinum 612.004 in Room 16 with lost of coloured plaster inclusions
612.007	Deposit	Opus signinum flooring preserved in E side of Room 17	5	20.5.1	Opus signinum or plaster/mortar flooring under 612.006 in E extent of Room 16
612.008	Deposit	Overburden	9	20.9.1	Soil mixed with very degraded opus signinum along E wall
612.009	Deposit	Overburden	9	20.9.1	Loose very dark greyish brown soil layer in majority of Room 17 area underlies 612.002
612.010	Deposit	Rubble fills in Room 17	6	20.6.3	Surviving but degraded opus signinum floor running along E wall of Room 17
612.011	Deposit	Overburden	9	20.9.1	Loose rubbly deposit in SE corner of Room 17 abutting walls W06.070 and W06.071
612.012	Deposit	Modern deposits	9	20.9.1	Charcoal filled black deposit in E half of room 17 oval shaped with modern inclusions
612.013	Deposit	Modern deposits	9	20.9.1	Charcoal filled deposit circular in shape in W half of Room 17, contains modern inclusions
612.014	Cut	Modern deposits	9	20.9.1	Irregular shaped cut in E half of Room 17, running N-S, cut through 612.009, filled with 612.012 (high in modern contamination)
612.015	Cut	Modern deposits	9	20.9.1	Roughly oval cut in W half of Room 17, running E/W cut through 612.009 filled with 612.013
612.016	Deposit	plaster and mortar Subfloor for the opus signinum in Room 17	5	20.5.1	Plaster underfloor associated with opus signinum floor 612.007 of sondage 1
612.017	Deposit	Rubble fills in Room 17	6	20.6.3	Plaster rubble levelling layer in majority of Room 17 action as a subfloor for opus signinum floor

612.018	Deposit	Opus signinum 1	4	20.4.3	Very friable degraded in places relatively thick, in others, opus signinum floor underlying plaster subfloor 612.016 in sondage 1 of Room 16
612.019	Deposit	Opus signinum 1	4	20.4.3	Plaster mortar subfloor with no decorated plaster inclusions
612.020	dead				Dead number
612.021	Deposit	Rubble fills in Room 17	6	20.6.3	Loose sandy silt soil deposit in central area of Room 17
612.022	Deposit	Rubble fills in Room 17	6	20.6.3	Orange-brown deposit in N-middle of Room 17 near wall W06.069
612.023	Deposit	Rubble fills in Room 17	6	20.6.3	Mortar and pottery subfloor in Room 17
612.024	Deposit	Rubble fills in Room 17	6	20.6.3	Circular deposit in Room 17
612.025	Deposit	Rubble fills in Room 17	6	20.6.3	Small circular deposit of mortar sealing against wall W06.091
612.026	Deposit	Rubble fills in Room 17	6	20.6.3	Small round mortar and pottery deposit in SW corner of Room 17, equated with 612.023-25 and removed with 612.023
612.027	Deposit	Disturbed black sand	2	20.2.2	Black sand matrix with rubble inclusions and lenses of yellow to brown soil types in the S part of Room 16
612.028	Deposit	Disturbed black sand	2	20.2.2	Black sand matrix with small pebble inclusions bounded by mortar/opus signinum build in the SW corner of Room 16
612.029	Deposit	Black sand	2	20.2.2	Black sand matrix with very few inclusions of small cruma pieces underlying 612.019
612.030	Deposit	Multicontext clean	N/A	N/A	Multi-context extension of trench between Rooms 16 and 17
612.031	Deposit	Preserved final phase opus signinum flooring in S end of Room 16	6	20.6.3	Remnant of 612.004 and 612.006 which were clinging to wall W06.067 but were undermined during the course of excavation
612.032	Deposit	Multicontext clean	N/A	N/A	Multi-context extension of Room 17 and Room 16 W side
612.033	Deposit	L-shaped mortar build	6	20.6.1.1	Mortar build with opus signinum inclusions in SW corner of sondage 1
612.034	Deposit	Rubbly footing of the stair	6	20.6.1.1	Rubble underlying the wall foundation of wall W06.068, SE corner of Sondage 1 Room 16
612.035	Deposit	Disturbed black sand	2	20.2.2	Brown sand with rubble inclusions in NW corner of sondage 1, Room 16
612.036	Deposit	Rubble surrounding sign pole	9	20.9.1	Rubble surrounding the sign pole in the NE corner of sondage 1 Room 16
612.037	Deposit	Middle cut	3	20.3.1	Brown pebbly sand on the W side of sondage 1, Room 16, circular in shape with part under the section
612.038	Deposit	Pitted earth (upper)	2	20.2.1	Pitted earth deposit in sondage 1 covers almost full extent of sondage 1 Room 16
612.039	Deposit	Black sand	2	20.2.2	Marbled brown and black sand running from S wall of sondage 1 into NW corner of Room 17
612.040	Deposit	Pitted earth (upper)	2	20.2.1	Pocked earth surface in the S half of Room 17, light grey and highly friable
612.041	Deposit	Pitted earth (lower)	2	20.2.1	Pocked earth surface in the N half of Room 17, light bluish grey in colour and highly friable
612.042	Deposit	Pea gravel	2	20.2.1	Pea gravel in SE edge of Room 17

612.043	Cut	Construction of wall W06.071	3	20.3.2.3	Foundation trench for wall W06.071, cut through 612.040
612.044	Deposit	Construction of wall W06.071	3	20.3.2.3	Fill for foundation trench for wall W06.071
612.045	Cut	Linear cut	6	20.6.2.1	Possible robbing trench in same alignment as wall 612.046
612.046	Deposit	Portico	3	20.3.2.4	Possible wall remnant from a wall N-S that extends from S side of W end of wall W06.067/69
612.047	Deposit	Linear cut	6	20.6.2.1	Fill for possible robbing trench in alignment with wall SU 612.046
612.048	Deposit	Middle cut	3	20.3.1	Firm brown sand with few pebbly inclusions on the W side of sondage 1 equals 612.037
612.049	Cut	Middle cut	3	20.3.1	Cut through 612.029 and 612.038 filled with 612.048 along the W side of sondage 1
612.050	Deposit	Construction of wall W06.067/ W06.069	3	20.3.2.2	Fill of cut 612.051, foundation trench for wall W06.067/69
612.051	Cut	Construction of wall W06.067/ W06.069	3	20.3.2.2	Cut for foundation trench along wall W06.067 in Room 16
612.052	Cut	Robber trench for colonnade or wall	6	20.6.2.1	Cut for circular pit in central-W side of Room 17, cuts through SUs 45/47
612.053	Deposit	Robber trench for colonnade or wall	6	20.6.2.1	Fill of cut 612.052 in W half of Room 17
612.054	Deposit	N cut	3	20.3.1	Brown pebbly sand cut through 612.029 and 612.038 fill of cut 612.055 in NW corner of sondage 1
612.055	Cut	N cut	3	20.3.1	Circular cut in NW corner of sondage 1 cut through 612.029, 612.038 and filled with 612.054
612.056	Deposit	Portico	3	20.3.2.4	Possible wall remnant in centre-W edge of Room 17
612.057	Deposit	Portico	3	20.3.2.4	Orange-brown soil deposit running N-S along W side of Room 17, in SW corner
612.058	Deposit	Pitted earth (upper)	2	20.2.1	Pitted earth running along the far W side of Room 17 up against W section baulk
612.059	Deposit	Natural soil	1	20.1	Natural soil below cut 612.045 in the SW corner of Room 17
612.060	Deposit	Natural soil	1	20.1	Natural soil below cut 612.045 at NW corner of Room 17 and cut 612.052 in the central-W area of Room 17
612.061	Deposit	Natural soil	1	20.1	Natural soil in the NW corner of Room 17
612.062	Deposit	Natural soil	1	20.1	Natural soil along the S edge of Room 17
613.001	Deposit	Modern protective gravel	9	16.9	Custodi gravel covering the extent of AA 613
613.002	Deposit	Silty sand with stone gravel and charcoal inclusions	9	16.9	Silty sand in Room 13 with stone gravel and charcoal inclusions as well as Rooms 14 with a opus signinum floor and Room 18 as it is within the boundaries of AA 613
613.003	Deposit	Final opus signinum floor	6	16.6.5	Opus signinum fragmented and surviving along wall W06.068 in Rooms 18 and 14
613.004	Deposit	Light brown broken opus signinum and debris	9	16.9	loose light brown deposit with large opus signinum inclusions underlying feature in NE corner of room 13
613.005	Deposit	Light grey mortar deposit at edge of cooking surface	9	16.9	Light grey friable plaster mortar about 20 cm in width running along E side of Room 13 to the W of cooking surface
613.006	Deposit	Final opus signinum floor	6	16.6.5	Degraded opus signinum running in a N-S orientation W of cooking surface underlying 613.005 and overlying 613.007

613.007	Deposit	Plaster subfloor	6	16.6.5	Loose light grey plaster with inclusions running along E side of Room 13 to the W of the cooking surface
613.008	Deposit	mottled yellowish brown deposit	9	16.9	Loose yellowish brown deposit with large stone inclusions extending from W edge of 613.011 to E edge of 613.004
613.009	Deposit	Subfloor	5	16.5.7	Plaster Subfloor underlying opus signinum 613.010 extending over the W extent of Room 13
613.010	Deposit	Earlier opus signinum surface	5	16.5.6	Degraded opus signinum underlying subfloor 613.007 near NE corner of Room 13
613.011	Deposit	Plaster fill	6	16.6.2	Plaster deposit underlying sloping tiles (613.012) and abutting 613.008 at NE extent of Room 13
613.012	Constr.	Tile surface	6	16.6.2	Sloping tiles running E down towards dark sand (613.013) underlying feature in NE corner of Room 13 overlying 613.011)
613.013	Deposit	Dark, sandy brown under the built toilet	9	16.9	Dark sand deposit directly to the E of 613.012 in the far NE corner of Room 13 underlying feature
613.014	Constr.	Elements of E-W drain including the tile capping and mortar used to seal drain	6	16.6.1	Upper build of drain running along S wall W06.081 plaster/mortar matrix with tiles
613.015	Deposit	Lower part of drain/mortar and packed earth	6	16.6.1	Lower build of the drain running along S wall W06.081 composed of brown packed earth and mortar
613.016	Deposit	Earlier opus signinum surface	5	16.5.7	Opus signinum floor in SE corner of Room 13 underlying 613.015 and overlying 613.09
613.017	Deposit	Fill	6	16.6.2	Black sand deposit surrounded by large stones (lava) roughly square in shape in the NE corner of Room 13
613.018	Deposit	Remnant of opus signinum surface in SW	6	16.6.1	Opus signinum floor in SW corner of Room 13
613.019	Cut	Cut for toilet placement	6	16.6.2	Circular cut made into 613.009 and 613.010 at the NE extent of Room 13 filled with volcanic stones in circular patter and 613.008 and 613.017
613.020	Deposit	Fill of drain	9	16.9	Underlying layer of sand beneath drain tiles of 613.014 along wall W06.081
613.021	Deposit	Black sand	2	16.2.1	Black sand deposit in the NE corner of the area bounded by 613.022 underlying 613.017
613.022	Deposit	Stones	6	16.6.2	Volcanic stone feature at NE of Room 13 roughly square bound on one side by Wall W06.077
613.023	Deposit	Pocked earth surface	2	16.2.1	Pitted earth surface underlying 613.017 and 613.021 at the N extent of the area bound by 613.022 at NE of Room 13
613.024	Deposit	Fill layer	5	16.5.7	Rubbly silty sand layer underlying 613.009 covering the extent of the section created at the W of Room 13
613.025	Deposit	Fill layer	5	16.5.7	Pottery deposit at the SE extent of the W section of Room 13
613.026	Constr.	S E-W wall	4	16.4.3	E-W oriented wall in Room 13 along wall W06.081 composed of volcanic stones and packed earth
613.027	Deposit	Fill layer	5	16.5.7	Orangey yellow deposit along the W half of the section in Room 13 runs from the N face of 613.026 through the centre of the section

613.028	Constr.	N E-W wall W06.076/W06.077	4	16.4.2	Wall at N extent of Room 13 underlying wall W06.077 runs in E-W orientation
613.029	Deposit	Semicircular cut	5	16.5.1	Fill of pit cut into orange deposit NE corner of W section in Room 13 high concentration of pottery inclusions
613.030	Deposit	Fill layer	5	16.5.7	Sandy silt deposit to the S of 613.026 at the SW extent of Room 13 abutting wall W06.081
613.031	dead				Dead number
613.032	Cut	Semicircular cut	5	16.5.1	Oval shaped cut at the NE extent of the W section of Room 13
613.033	Deposit	Pocked earth surface	2	16.2.1	Pocked earth concentrated at the NW extent of Room 13
613.034	Cut	Cut through W threshold area	5	16.5.1	Elongated oval shaped cut at the W extent of Room 13 probably extends under the wall into AA614
613.035	Constr.	Surgeon S boundary	4	16.4.3	Possible remnant wall feature found directly to the S of 613.026 in the SW extent of Room 13
613.036	Deposit	Black sand	2	16.2.1	Black sand concentrated at the NW extent of Room 13
613.037	Deposit	Pea gravel	2	16.2.2	Pea gravel dispersed intermittently throughout the W section of Room 13 surrounded by the remains of SU 27 (partially excavated)
613.038	Deposit	Cut through W threshold area	5	16.5.1	Fill of cut 613.034 an oval shaped cut at the W extent of Room 13
614.001	Deposit	Gravel and overburden	9	14.9	Custodi gravel covering extent of AA 614
614.002	Deposit	Central cut	5	14.5.2	Dark brown deposit butting 614.003 on the S side of AA 614 fill of cut 614.003 possibly backfill possibly not fully excavated fill of cut from 2003 season
614.003	Cut	Central cut	5	14.5.2	Cut in S-centre of AA614
614.004	Deposit	Central cut	5	14.5.2	Deposited with lots of cultural material contained in 614.003 may be backfill from 2003 assigned SU number for control
614.005	Deposit	Multicontext clean	N/A	N/A	Multi-context surface clean in preparation for excavation
614.006	Deposit	Central cut	5	14.5.2	Fill of cut 614.003, located in the central-S area of AA 614, fill of silty sand
614.007	Cut	Cut in E threshold	5	14.5.2	Cut running along E wall of AA 614
614.008	Deposit	Cut in E threshold	5	14.5.2	Silty sand fill of 614.007 on E end of AA614 with ceramic inclusions
614.009	Deposit	Cut in E threshold	5	14.5.2	Yellowish deposit located within 614.007 and underlying 614.008 in the threshold pit E side of room)
614.010	Cut	Cut in SW corner	5	14.5.2	Shallow cut in SW of AA614 Room 11 filled with 614.011
614.011	Deposit	Cut in SW corner	5	14.5.2	Fill of cut 614.010 along wall W06.091 in Room 11
614.012	Deposit	Post pre-Surgeon fills (general)	3	14.3.1	Dark brown deposit with orange inclusions in random areas along with packed earth running N-S in between walls W06.090 and W06.087
614.013	Cut	Posthole 3	5	14.5.2	Posthole located along wall W06.087 towards the E edge of Room 11
614.014	Cut	Posthole 1	5	14.5.2	Posthole located along wall W06.087 towards the E part of AA614

614.015	Cut	Posthole 2	5	14.5.2	Small and shallow posthole located between 614.013 and 614.014 in a N-S line
614.016	Deposit	Post pre-Surgeon fills (orange)	3	14.3.1	Orangey deposit with blue and yellow plaster inclusions running in N-S orientation between walls W06.087 and W06.091
614.017	dead				Dead number
614.018	Cut	Diagonal cut, N side of room	2	14.2.2	Cut along N wall (W06.087) cut into 614.019 filled by 614.020
614.019	Deposit	Fragmentary pocked earth/pea gravel deposits	2	14.2.1	Pea gravel in W part of Room 11 to E of 614.016 and W of 614.017
614.020	Deposit	Post pre-Surgeon fills (general)	3	14.3.1	Fill of cut 614.018
614.021	Cut	Sarno block	3	14.3.2	Cut for the Sarno wall running N-S at the W extent of Room 11 construction out directly to the E of the Sarno
614.022	Deposit	Fragmentary pocked earth/pea gravel deposits	2	14.2.1	Pitted earth located at the W extent of Room 11
614.023	Deposit	Post pre-Surgeon fills (general)	3	14.3.1	Brownish deposit with orange and mortar-like inclusions, fill of 614.024
614.024	Cut	Diagonal cut, N side of room	2	14.2.2	Cut into pitted earth in the central area between the two main pits, it possibly underlies wall W06.087
614.025	Cut	Central cut	5	14.5.2	Cut running underneath wall W06.090 filled with mortar and various pieces of pottery, brick and tile building materials to support wall W06.090 in the SE corner of the room
614.026	Deposit	Central cut	5	14.5.2	Yellowish deposit filled with brick and tile/pottery building materials and then filled with plaster in order to provide structural support to wall W06.090 (SE corner of room)
614.027	Cut	Cut in NE corner	5	14.5.2	Circular cut into 614.023 in the NE corner of the Room in AA 614
614.028	Deposit	Cut in NE corner	5	14.5.2	Fill of 614.027 brownish dirt with no real inclusions along with a small amount of pea gravel located along wall W06.087

APPENDIX II

HARRIS MATRICES

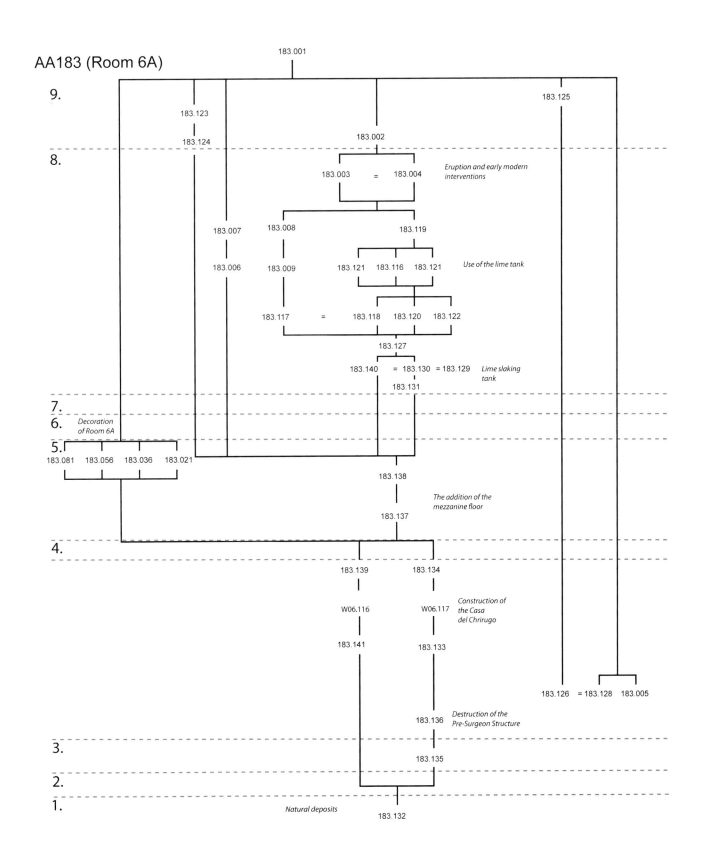

AA183 (Room 6A)

183.001

9.

183.125

183.123

183.124

8.

183.002

183.003 = 183.004 *Eruption and early modern interventions*

183.007 183.008 183.119

183.006 183.009 183.121 183.116 183.121 *Use of the lime tank*

183.117 = 183.118 183.120 183.122

183.127

183.140 = 183.130 = 183.129 *Lime slaking tank*

183.131

7.

6. *Decoration of Room 6A*

5.

183.081 183.056 183.036 183.021

183.138

The addition of the mezzanine floor

183.137

4.

183.139 183.134

W06.116 W06.117 *Construction of the Casa del Chrirugo*

183.141 183.133

183.126 = 183.128 183.005

Destruction of the Pre-Surgeon Structure

183.136

3.

183.135

2.

1.

Natural deposits

183.132

AA184/AA609 (Room 6C)

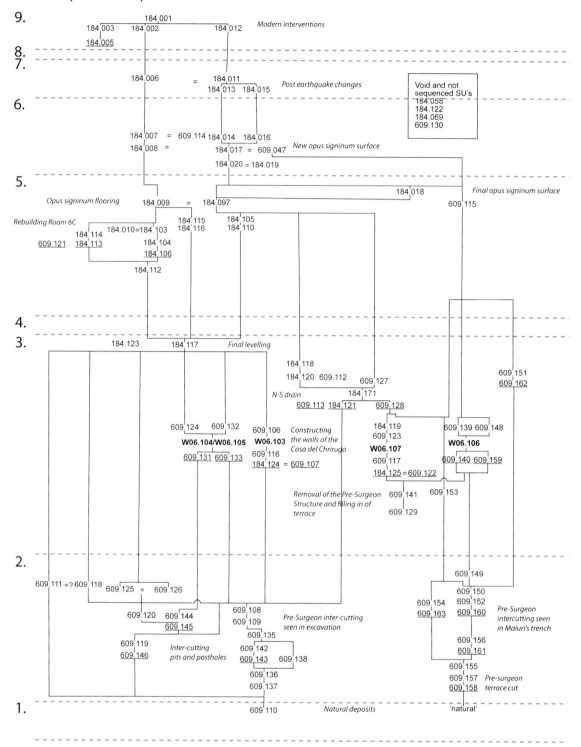

AA260, AA275, AA505, AA608 (Atrium and Room 8A)

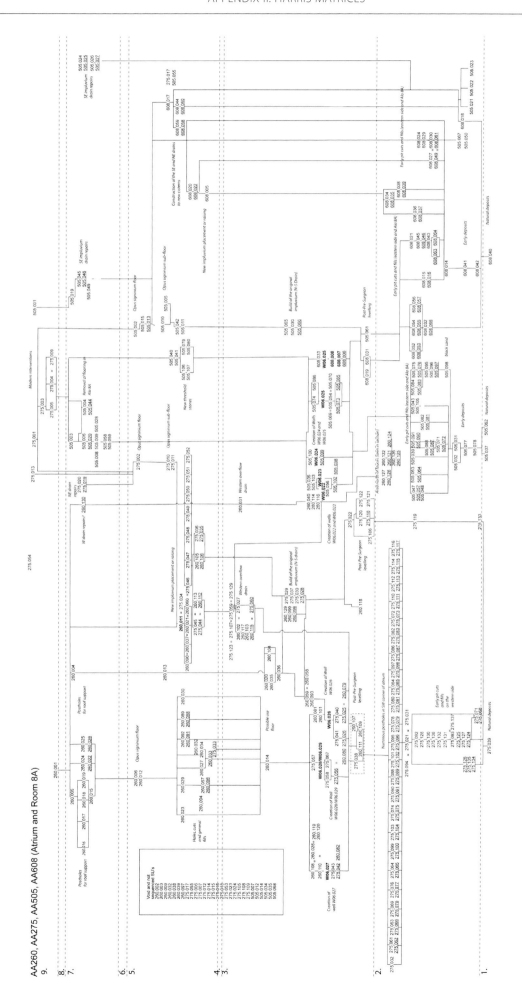

AA261 (Room 10)

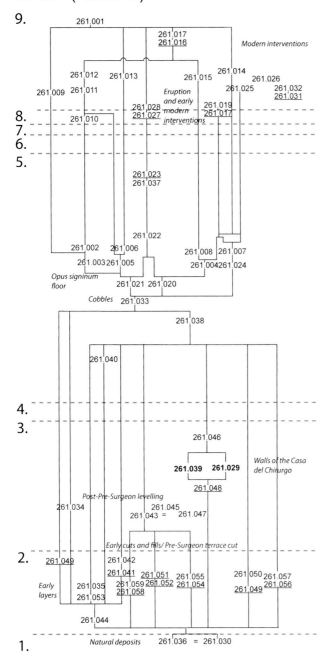

AA 264 (Room 15)

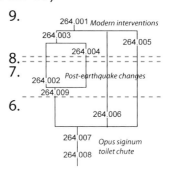

AA262, 263, 276 (Rooms 22 and 23)

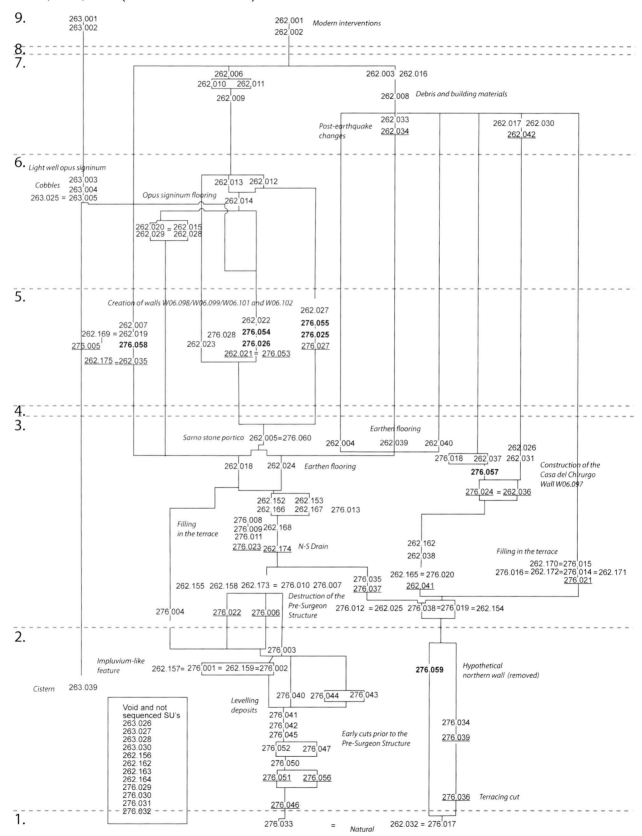

AA265 / AA614 (Room 11)

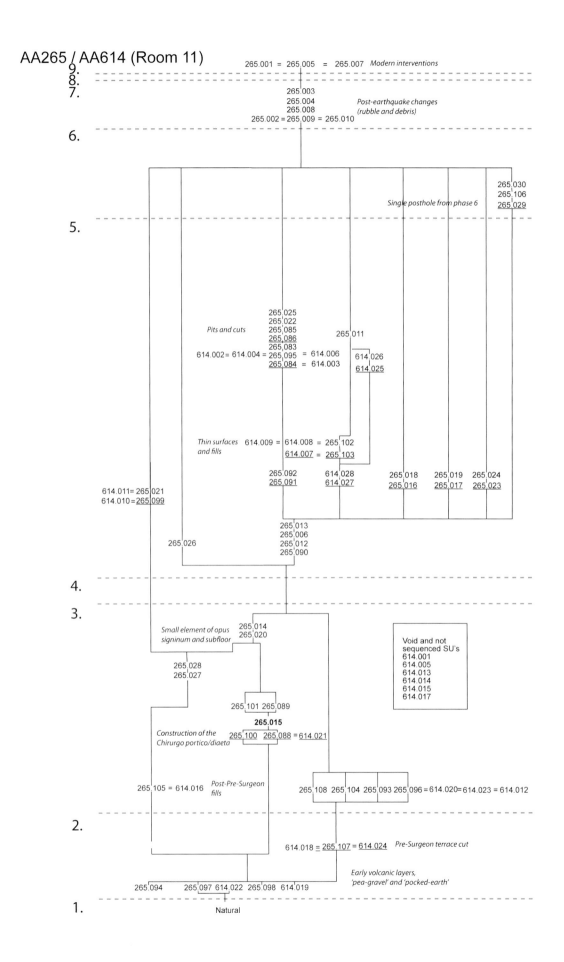

AA277 / AA606 (Room 3 and 4)

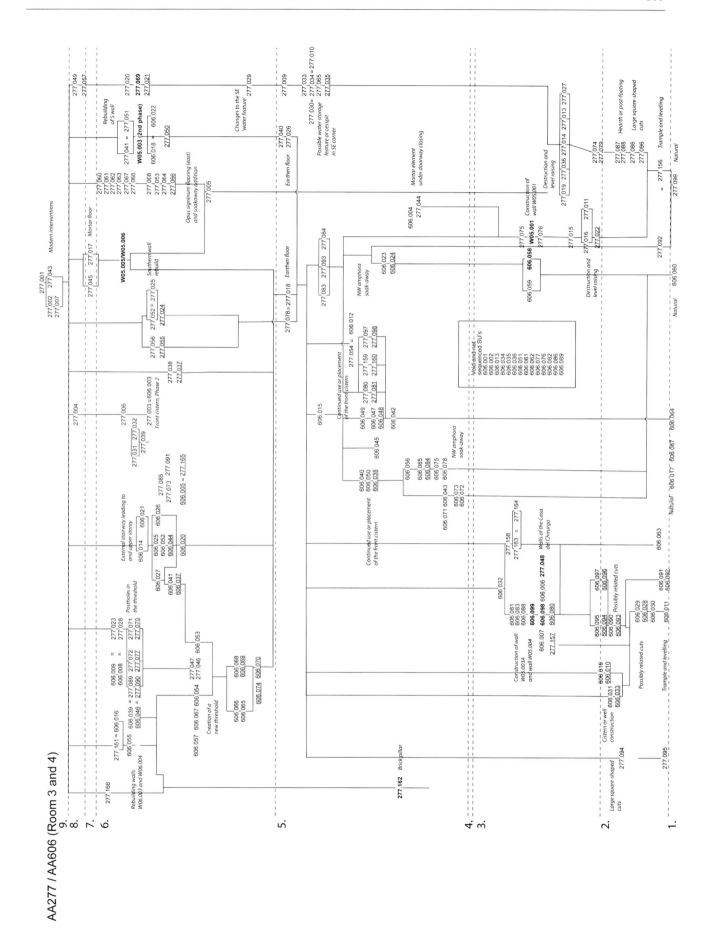

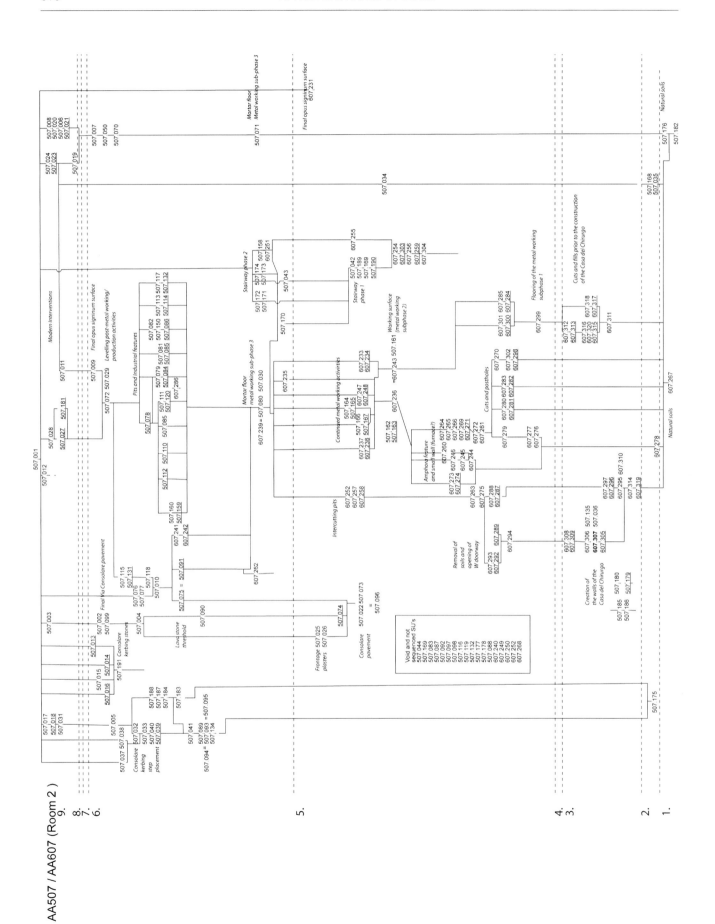

AA507 / AA607 (Room 2)

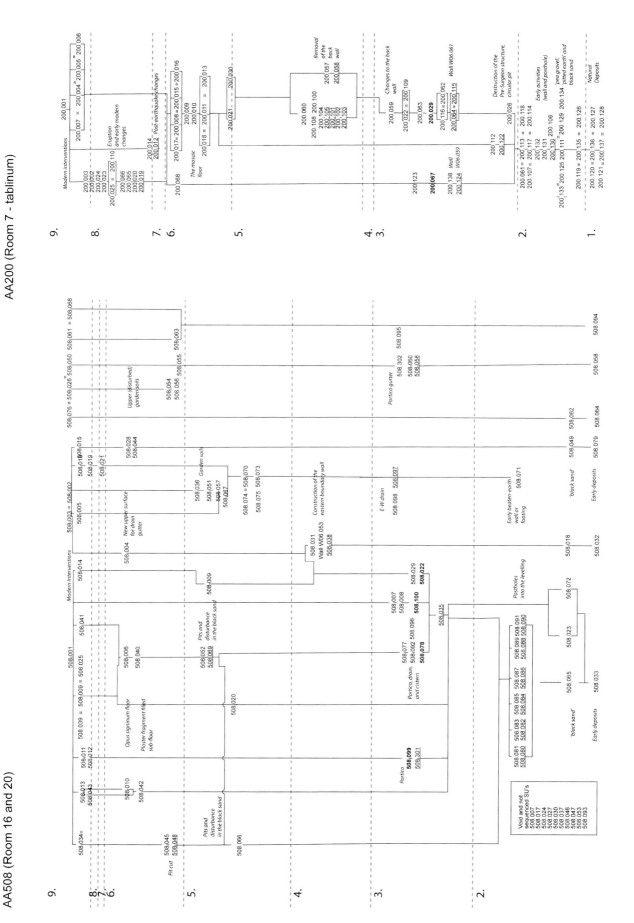

AA200 (Room 7 - tablinum)

AA508 (Room 16 and 20)

512 (Vicolo di Narciso Pavement)

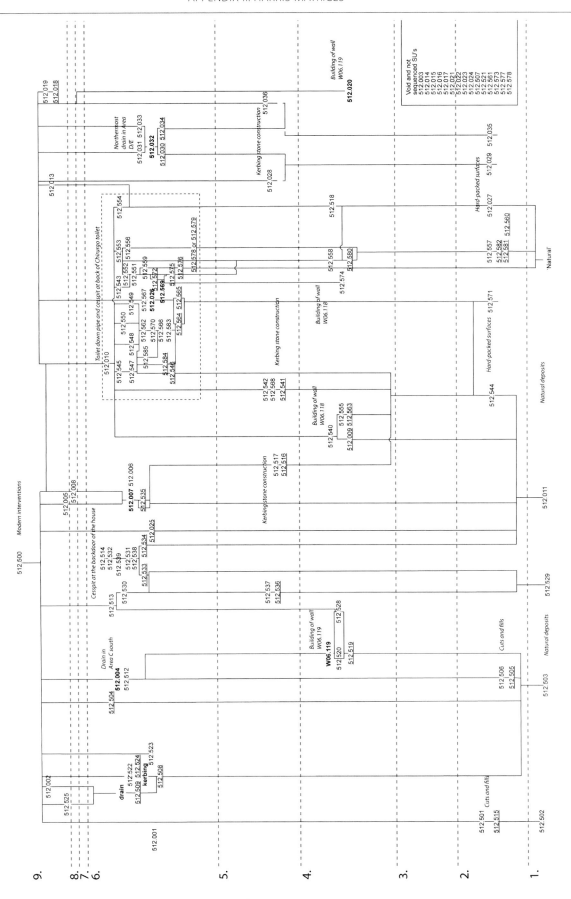

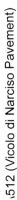

AA610 (Room 12)

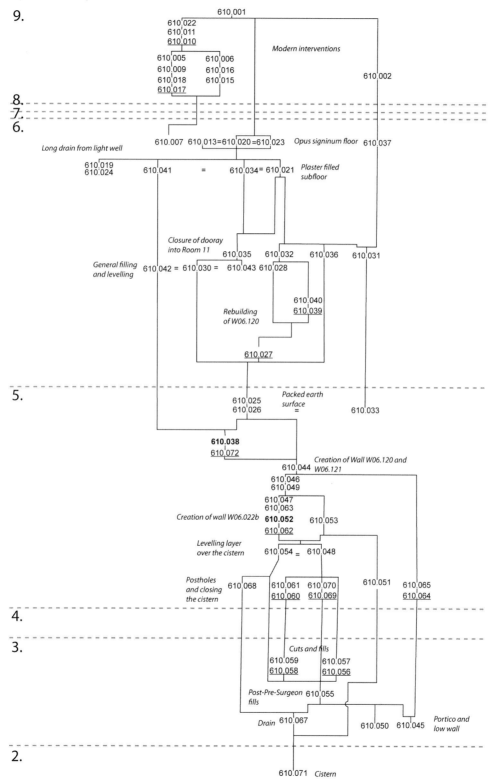

AA612 (Room 17 and 18)

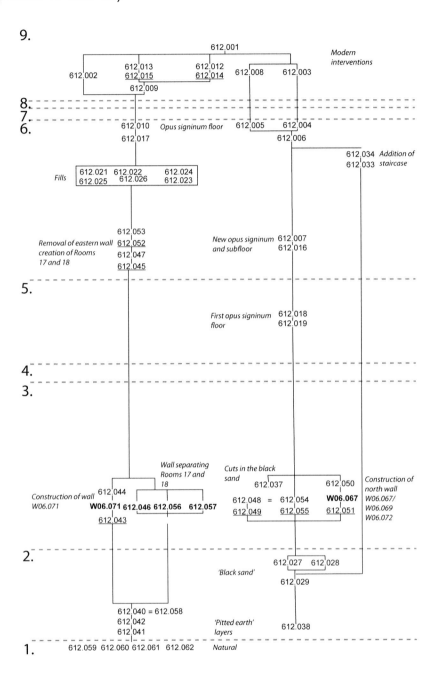

AA613 (Room 13)

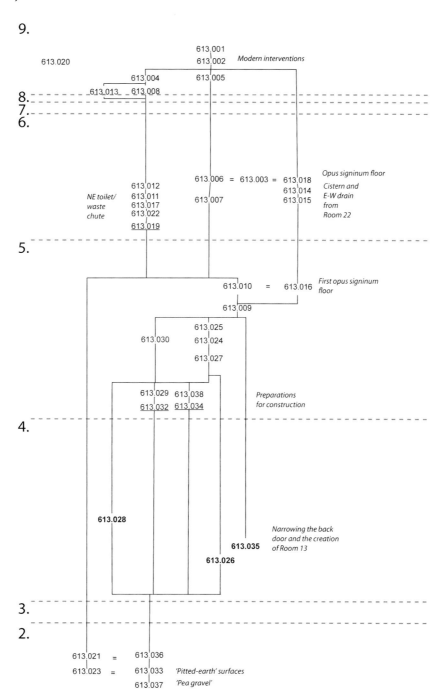

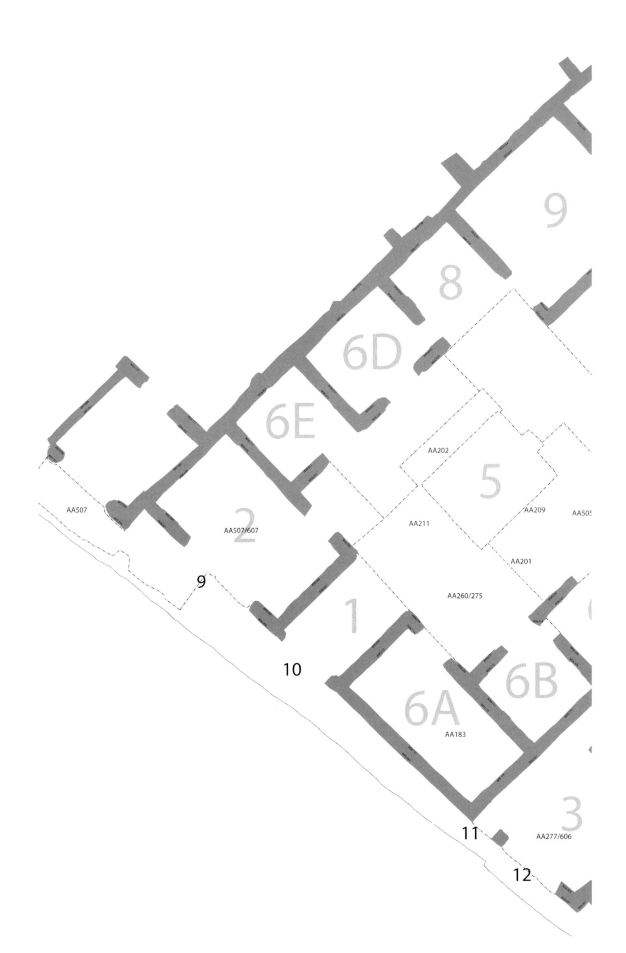

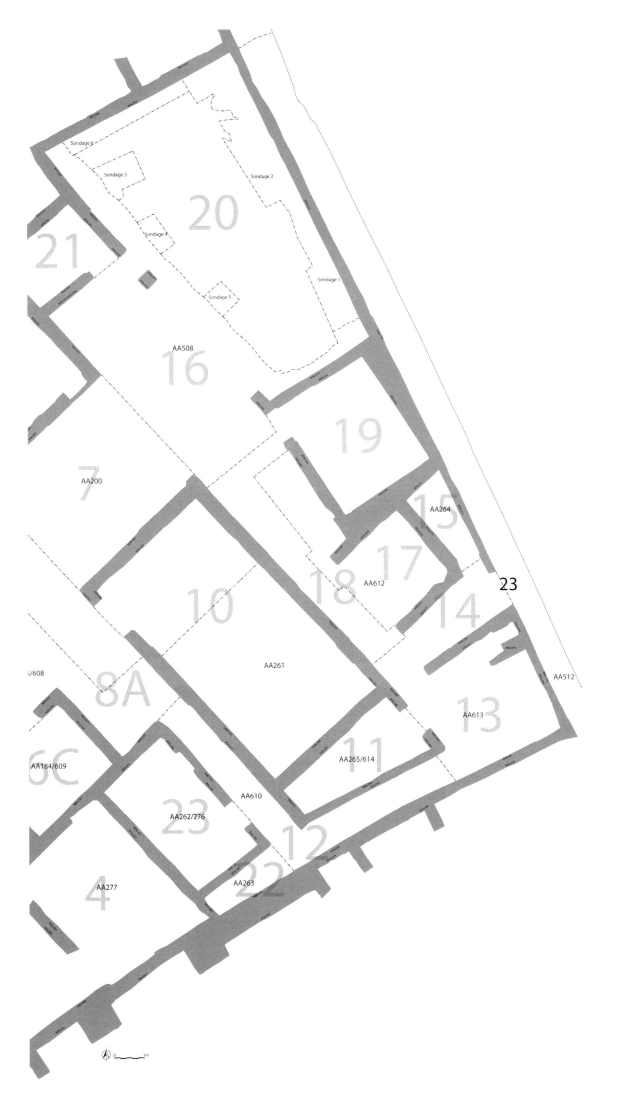

Sondage 6

Sondage 3

Sondage 2

20

21

Sondage 4

Sondage 1

AA508

16

Sondage 5

19

7

AA200

AA264

15

17

10

18 AA612

14

23

8A

AA261

AA512

S/608

AA613

13

6C

AA184/609

11

AA265/614

AA262/276

23

AA610

12

4

AA277

AA263

22

0 1m

BIBLIOGRAPHY

Works Cited

Abbreviations

ADE *Le antichitá di Ercolano esposte* (1757–92).

Atlante I *Enciclopedia dell'arte antica classica e orientale. 1981. Atlante delle forme ceramiche I. Ceramica fine romana nel bacino Mediterraneo (medio e tardo impero).* Rome: Istituto della Enciclopedia Italiana.

Atlante II *Enciclopedia dell'arte antica classica e orientale. 1985. Atlante delle forme ceramiche I. Ceramica fine romana nel bacino Mediterraneo (medio e tardo impero).* Rome: Istituto della Enciclopedia Italiana.

Conspectus Ettlinger, E. Hedinger, B., Hoffmann, B., Kentrick, P. M., Pucci, G., Roth-Rubi, K., Schneider, G., von Schnurbein S., Wells, C. M. and Zabehlicky-Scheffenegger S. 1990. *Conspectus formarum Terrae Sigillatae Italico Modo Confectae.* Materialien zur römisch-germanischen Keramik 10. Bonn: R. Habelt.

CIL *Corpus Inscriptionum Latinarum.* Berlin: G. Reimerum.

CTP Van del Poel, H. 1981. *Corpus Topographicum Pompeianum. Pars V: Cartography.* Rome: University of Texas at Austin.

PAH Fiorelli, I. 1860. *Pompeinarvm Antiquitatum Historia.* Naples.

Pd'E Baiardi, O. A., Carcani. P. and the Accademia ercolanese di archeologia. 1779. *Le Pitture Antiche d'Ercolano e Contorni Incise conqualche Spiegazione* (Vol. 7 o sia 5 delle pitture). Naples: Regia Stamperia.

Morel Morel, J.-P. 1981. *Céramique campanienne: Les formes.* Bibliothèque des Écoles Françaises d'Athènes et de Rome. 244. 2 vols. Paris.

Ornati 1796–1829. Gli Ornati delle pareti ed i pavimenti delle stanze dell' antica Pompei incisi in rame. Naples: Dalla stamperia regale.

PPP Bragantini, I., De Vos, M., Parise Badoni, F. and Sampaolo, V. (eds) 1981–1986. *Pitture e pavimenti di Pompei.* Rome: Ministero per i beni culturali e ambientali, Istituto centrale per il catalogo e la documentazione.

PPM Pugliese Carratelli, G. and Baldassarre, I. (eds) 1990–2003. *Pompei: Pitture e mosaici.* 11 Vols. Rome: Istituto della Enciclopedia italiana.

Abbreviations Exhibition Catalogues

Homo Faber. Ciarallo, A. and De Carolis, E. (eds) 1999. *Homer Faber. Natura, scienza e tecnica nell'antica Pompei* (Napoli, Museo Archeologica Nazionale 27 marzo–18 luglio 1999). Milan: Electa.

Life and Death. Roberts, P. 2013. *Life and Death in Pompeii and Herculaneum* (London, British Museum 28 March–29 September, 2013). London: British Museum Press.

Menander. Stefani, G. (ed). *La Casa del Menandro di Pompei* (Antiquarium di Boscoreale 8 marzo–8 guigno 2003). Milan: Mondadori Electa S. p. A.

Pompeii A. D. 79. Ward-Perkins, J. and Claridge, A. 1979. *Pompeii A. D. 79* (Royal Academy of Arts Piccadilly, London 20 November 1976–27 February 1977) Bristol: Imperial Tobacco Limited.

Tra luce e tenebre. Ragni, M. S. 2008. *Tra luce e tenebre. Letti funerari in osso da Lazio e Abruzzo* (Tivoli, Villa Adriana Antiquarium del Canopo 24 aprile–2 novembre 2008). Milan: Mondadori Electa.

Modern Sources

Adam, J.-P. 2003. *Roman Building: Materials and Techniques*. London: Routledge.

Adam, J.-P. 2007. Building materials, construction techniques and chronologies. In J. J. Dobbins and P. W. Foss (eds) *The World of Pompeii*, 98–116. London: Routledge.

Adams, K. R. and Gasser R. E. 1980. Plant microfossils from archaeological sites: research considerations, and sampling techniques and approaches. *Kiva* 45.4: 293–300.

Albiach, R., Ballester, C., Escrivà, I., Fernández, A., Huguet, E., Olcina, M., Padín, J., Pascual, G., Pedroni, L. and Ribera, A. 2005. Estudios estratigráficos y geofísicos entre la casa de Ariadna y el Vicolo Storto (VIII, 4). In P. G. Guzzo and M. P. Guidobaldi (eds) *Nuove ricerche archeologiche nell'area vesuviana (scavi 2003-2006). Atti del Convegno Internazionale, Roma 1-3 febbraio 2007*, 249–64. Rome: L'Erma di Bretschneider.

Allevato, E., Russo Ermolli, E., Boetto, G. and Di Pasquale, G. 2010. Pollen-wood analysis at the Neapolis harbour site (1st–3rd century AD, southern Italy) and its archaeobotanical implications. *Journal of Archaeological Science* 37: 2365–75.

Allison, P. M. 1991. Artefact assemblages: not 'the Pompeii Premise'. In E. Herring, R. Whitehouse, and J. Wilkins *Papers of the fourth Conference of Italian Archaeology: New Developments in Italian Archaeology Part 1*, 49–56. London: Accordia Research Centre.

Allison, P. M. 1993. How do we identify the use of space in Roman housing? In E. M. Moorman (ed) *Functional and Spatial Analysis of Wall Painting: Proceedings of the Fifth International Congress on Ancient Wall Painting*, 1–8. Leiden: BABESCH.

Allison, P. M. 1994a. Room use in Pompeian houses. In J.-P. Descœudres (ed) *Pompeii Revisited: The Life and Death of a Roman Town*, 82–9. Sydney: Meditarch.

Allison, P. M. 1994b. *The Distribution of Pompeiian House Contents and Its Significance*. Unpublished thesis, University of Sydney: University Microfilms, Ann Arbor.

Allison, P. M. 1995. On-going seismic activity and its effects on the living conditions in Pompeii in the last decades. In T. Fröhlich and L. Jacobelli (eds) *Archäologie und Seismologie: La regione vesuviana dal 62 al 79 d. C. Problemi archeologici e sismologici*, 183–9. Munich: Bierung & Brinkmann.

Allison, P. M. 2001. Using the material and written sources: turn of the millennium approaches to Roman domestic space. *American Journal of Archaeology* 105.2: 181–208.

Allison, P. M. 2004a. *Pompeian Households: An Analysis of the Material Culture*. Los Angeles: Cotsen Institute of Archaeology, UCLA.

Allison, P. M. 2004b. *Pompeian Households. An On-line Companion* http://www.stoa.org/pompeianhouseholds (checked 23: 01: 2014).

Allison, P. M. 2006. *The Insula of the Menander at Pompeii: Volume III: The Finds, a Contextual Study*. Oxford: Clarendon Press.

Allison, P. M. 2007. Domestic spaces and activities. In J. J. Dobbins and P. W. Foss (eds) *The World of Pompeii*, 269–78. London: Routledge.

Allison, P. M. and Sear, F. B. 2002. *Casa della Caccia Antica (VII, 4, 48)*. Häuser in Pompeji, Band 11. Munich: Hirmer.

Amoroso, A. 2008. Analisi stratigrafica e prime proposte di ricostruzione dell'*insula* VII 10 di Pompei. In P. G. Guzzo and M. P. Guidobaldi (eds) *Nuove ricerche archeologiche nell'area vesuviana (scavi 2003-2006). Atti del Convegno Internazionale, Roma 1-3 febbraio 2007*, 36–59. Rome: L'Erma di Bretschneider.

Anderson, M. 2005. Houses, GIS and the micro-topology of Pompeian domestic space. In J. Bruhn, B. Croxford and D. Grigoropoulos (eds) *TRAC 2004: proceedings of the Fourteenth Annual Theoretical Roman Archaeology Conference*, 144–56. Oxford: Oxbow Books.

Anderson, M. 2010a. Mapping the domestic landscape: GIS, visibility and the Pompeian house. In F. Niccolucci and S. Hermon (eds), *Beyond the Artefact – Digital Interpretation of the Past – Proceedings of CAA2004 – Prato 13-17 April 2004*, 183–9. Budapest: Archaeolingua.

Anderson, M. 2010b. Precision recording of Pompeian standing remains via stitched rectified photography. In B. Frischer, J. W. Crawford and D. Koller (eds) *Making History Interactive. Computer Applications and Quantitative Methods in Archaeology (CAA). Proceedings of the 37th International Conference, Williamsburg, Virginia, United States of America, March 22-26, 2009*, 1–10. Oxford: Archaeopress.

Anderson, M. 2011. Disruption or continuity? The spatio-visual evidence of post earthquake Pompeii. In M. Flohr, K. Cole and E. Poehler (eds) *Pompeii: Art, Industry and Infrastructure*, 74–87. Oxford: Oxbow Books.

Anderson, M., Weiss, C. J., Edwards, B. R., Gorman, M., Hobbs, R., Jackson, D., Keitel, V., Lutes-Koths, D., O'Bryen, C., Pearson, S., Pitt, E. and Tucker, A. 2012. Via Consolare Project – 2007–2011 Field Seasons in Insula VII 6. *FOLD&R*. (www.fastionline.org/docs/FOLDER-it-2012-247.pdf).

Andrews, J. 2006. *The Use and Development of Upper Floors in Houses at Herculaneum*. Unpublished thesis, University of Reading.

Anniboletti, L., Befani, V. and Boila, P. 2009. Progetto "Rileggere Pompei": per una nuova forma urbis della città. Le indagini geofisiche nell'area non scavata e l'urbanizzazione del settore orientale. *FOLD&R*. (www.fastionline.org/docs/FOLDER-it-2009-148.pdf).

Archer, W. 1990. The paintings in the Alae of the Casa dei Vettii and a definition of the Fourth Pompeian Style. *American Journal of Archaeology* 94.1: 95–123.

Arthur, P. 1986. Problems of the urbanisation of Pompeii: excavations 1980–1981. *Antiquaries Journal* 66: 29–44.

Baiardi, O. A., Carcani. P. and the Accademia ercolanese di archeologia. 1779. *Le Pitture Antiche d'Ercolano e Contorni Incise conqualche Spiegazione* (Vol. 7 o sia 5 delle pitture). Naples: Regia Stamperia.

Bailey, D. M. 1980. *A Catalogue of the Lamps in the British Museum*. London: British Museum Publications.

Balmelle, C., Blanchard-Lemée, M., Christophe, J., Darmon, J.-P., Guimier-Sorbets, A.-M., Lavagne, H., Prudhomme, R. and Stern, H. 1985. *Le Décor géométrique de la mosaïque romaine: répertoire graphique et descriptif des compositions linéaires et isotropes*. Paris: Picard.

Balmelle, C., Blanchard-Lemée, M., Darmon, J.-P., Gozlan, S. and Raynaud, M.-P. 2002. *Le Décor géométrique de la mosaïque romaine II: répertoire graphique et descriptif des décors centrés*. Paris: Picard.

Barbet, A. 1981. Les bordures ajourées dans le IV^e style de Pompéi. *Mélanges de l'École française de Rome. Antiquité* 93.2: 917–98.

Barker, S. J. 2012. Roman marble salvaging. In A. G. Garcia-Moreno, P. L. Mercadal and I. Rodà de Llanza (eds) *Interdisciplinary studies on ancient stone: proceedings of the IX Association for the Study of Marbles and Other Stones in Antiquity (ASMOSIA), Conference (Tarragona 2009)*, 22–30. Tarragona: Institut Català d'Arqueologia Clàssica.

Barton, I. M. 1996. *Roman Domestic Buldings*. Exeter. University of Exeter Press.

Bastet, F. L. and De Vos, M. 1979. *Proposta per una classificazione del terzo stile pompeiano*. 's-Gravenhage: Ministerie van Cultuur, Recreatie en Maatschappelijk Werk.

Baxter, M. J. and Cool, H. E. M. 2008. Notes on the statistical analysis of some loom weights from Pompeii. *Archeologia e Calcolatori* 18: 49–66.

Baxter, M. J., Cool, H. E. M. and Anderson, M. 2010. Statistical analysis of some loom weights from Pompeii: a postscript. *Archeologia e Calcolatori* 21: 185–200.

Béal, J.-C. 1983. *Catalogue des Objets de Tabletterie du Musee de la Civilisation Gallo-Romaine de Lyon*, Centre d'études Romaines et Gallo-Romaine de l'université Jean Moulin Lyon III Nouvelle série 1. Lyon: Université Jean Moulin Lyon III.

Beard, M., North, J. and Price, S. R. F. 1998. *Religions of Rome: A Sourcebook*. Cambridge: Cambridge University Press.

Beckford, P. 1786. *Letters and Observations: Written in a Short Tour Through France and Italy*, Salisbury: E. Easton.

Bek, L. 1980. *Towards Paradise on Earth: Modern Space Conception in Architecture A Creation of Renaissance Humanism*. Odense: Odense University Press.

Bek, L. 1983. Questiones convivales: the idea of the triclinium and the staging of convivial ceremony from Rome to Byzantium. *Analecta Romana Instituti Danici* 12: 81–107.

Berg, R. P. 2005. Saggi archeologici nell'insula dei Casti Amanti. In P. G. Guzzo and M. P. Guidobaldi (eds) *Nuove ricerche archeologiche a Pompei ed Ercolano*, 200–15. Naples: Electa.

Berg, R. P. 2008. Saggi stratigrafici nei vicoli a est e a ouest dell'Insula dei Casti Amanti (IX, 12) Materiali e fasi. In P. G. Guzzo and M. P. Guidobaldi (eds) *Nuove ricerche archeologiche nell'area vesuviana (scavi 2003-2006). Atti del Convegno Internazionale, Roma 1-3 febbraio 2007*, 263–377. Rome: L'Erma di Bretschneider.

Berry, J. 1993. *The Roman House at Work*. Unpublished thesis, University of Reading.

Berry, J. 1997. Household artefacts: towards a re-interpretation of Roman domestic space. In R. Laurence and A. Wallace-Hadrill (eds) *Domestic Space in the Ancient World*. Journal of Roman Archaeology Supplement 22, 183–95. Portsmouth, RI: Journal of Roman Archaeology.

Berry, J. (ed) 1998. *Unpeeling Pompeii*. Roma: Electa.

Bishop, M. C. 1983. The Camomile Street soldier reconsidered. *Transactions of the London and Middlesex Archaeological Society* 34: 31–48.

Bisi Ingrassia, A. M. 1977. Le lucerne fittili dei nuovi scavi di Ercolano. In M. Annecchino (ed.) *L'instrumentum domesticum di Ercolano e Pompei nella prima età imperiale*. 73–104. Rome: L'Erma di Bretschneider.

Blake, M. 1930. The pavements of the Roman buildings of the Republic and Early Empire. *Memoirs of the American Academy in Rome* 8: 7–159.

Blessington, M. 1839. *The Idler in Italy. Vol. 2*. London: H. Colburn.

Bliquez, L. J. 1994. *Roman Surgical Instruments and other Minor Object in the National Archaeological Museum of Naples*. Mainz: Philipp von Zabern.

Boessneck, J. 1969. Osteological difference between sheep (*Ovis aiies* Linne) and goats (*Capra hircus* Linne). In D. Brothwell and E. Higgs (eds) *Science in Archaeology*, 331–58. London: Thames and Hudson

Boëthius, A. 1934. Remarks on the development of domestic architecture in Rome. *American Journal of Archaeology* 38.1: 158–70.

Boëthius, A. and Ward-Perkins, J. B. 1970. *Etruscan and Roman Architecture*. Harmondsworth: Penguin.

Boldrighini, F. 2000. Aventino: I Pavimenti della Domus di Largo Arrigo VII. In F. Guidobaldi and A. Paribeni (eds) *Atti del VI Colloquio dell'Associazione italiana per lo studio e la conservazione del mosaico (Venezia, 20-23 gennaio 1999)*, 203–10. Ravenna: Edizioni del Girasole.

Bon, S. E. and Jones R. F. J. (eds) 1997. *Sequence and Space in Pompeii*. Oxbow Monograph 77. Oxford: Oxbow Books.

Bon, S. E., Jones, R. F. J. and Robinson, D. J. 1995. Anglo-American research in Pompeii, 1994. *Old World Archaeology Newsletter* 8.2: 18–24.

Bon, S. E., Jones, R. F. J., Kurchin, B. and Robinson D. J. 1997. The context of the House of the Surgeon: investigations in Insula VI, 1 at Pompeii. In S. E. Bon and R. F. J. Jones (eds) *Sequence and Space in Pompeii*, 32–49. Oxford: Oxbow Books.

Bon, S. E., Jones, R. F. J., Kurchin, B. and Robinson, D. J. 1996a. Documenting the monument: digital imaging and building analysis at Pompeii. *Innovation et technologie au service du patrimoine de l'humanité Actes du colloque organise par ADMITECH en collaboration avec l'UNESCO*, 369–79. Paris: ADMITECH.

Bon, S. E., Jones, R. F. J., Kurchin, B. and Robinson, D. J. 1996b. Digital imaging of standing buildings in Insula VI,1 at Pompeii. *Archeologia e Calcolatori* 7: 939–50.

Bon, S. E., Jones, R. F. J., Kurchin, B. and Robinson, D. J. 1998. Research in Insula VI,1 by the Anglo-American Pompeii Project, 1994-6. *Rivista di Studi Pompeiana* 7: 153–7.

Bonghi Jovino, M. (ed) 1984. *Ricerche a Pompei: l'insula 5 della Regio VI dalle origini al 79 d. C.* Rome: L'Erma di Bretschneider.

Bonucci, C. 1828. *Pompéi décrite par Charles Bonucci, ou, Précis historique des excavations depuis l'année 1748 jusqu'a nos jours*. Naples: Imprimerie française.

Borgongino, M. 1993. La Flora Vesuviana del 79 d. C. In M. Borgongino, A. Ciarallo, C. Mazza and S. Striano (eds) *Parchi e Giardini Storici, Parchi Letterari – Atti del III Convegno (primo internazionale), Paesaggi e Giardini del Mediterraneo*, 115–40. Salerno: GRG ipolitografica srl.

Boyce, G. K. 1937. *Corpus of the Lararia of Pompeii*. Memoirs of the American Academy in Rome 14. Rome: American Academy in Rome.

Bruno, M. 2002. Il mondo delle cave in Italia: considerazioni su alcuni marmi e pietre usati nell'antichità. In M. De Nuccio and L. Ungaro (eds) *I marmi colorati della Roma imperiale. Catalogue of an exhibition held at Mercati di Traiano, Rome, Sep. 28, 2002-Jan. 19, 2003*, 277–90. Venezia: Marsili.

Bruno, V. J. and Scott, R. T. 1993. *Cosa IV. The Houses*. Memoirs of the American Academy in Rome 38. Philadelphia: Pennsylvania State University Press.

Bulwer-Lytton, E. 1834. *The Last Days of Pompeii*. London: Scott.

Büntgen, U., Tegel, W., Nicolussi, K., McCormick, M., Frank, D., Trouet, V., Kaplan, J. O., Herzig, F., Heussner, K.-U., Wanner, H., Luterbacher, J. and Esper, J. 2011. 2500 years of European climate variability and human susceptibility. *Science* 331 (4 February): 578–82.

Burns, M. 2003-4. Pompeii under siege: a missile assemblage from the Social War. *Journal of Roman Military Equipment Studies* 14/15: 1–10.

Camilli, A. 1999. *Ampullae. Balsmari ceramici di età ellenistica e romana*. Rome: Fratelli Palombi Editori Roma.

Cantilena, R. 2008. *Pompei. Rinvenimenti monetali nella Regio VI*. Rome: Istituto Italiano di Numismatica.

Carafa, P. 2005. Pubblicando la Casa di Giuseppe II (VIII 2, 38–39) e il Foro Triangolare. In P. G. Guzzo and M. P. Guidobaldi (eds) *Nuove ricerche archeologiche a Pompei ed Ercolano*, 19–35. Naples: Electa.

Carafa, P. 1997. What was Pompeii before 200 BC? Excavations in the House of Joseph II, in the Triangular Forum and in the House of the Wedding of Hercules. In S. E. Bon and R. Jones

Sequence and Space in Pompeii, 13–31. Oxbow Monograph 77. Oxford: Oxbow Books.

Carafa, P. 2011. Minervae et Marti et Herculi aedes doricae fient (Vitr. 1. 2. 5). The monumental history of the sanctuary in the Triangular Forum. In S. J. R. Ellis (ed) *The Making of Pompeii: Studies in the History and Urban Development of an Ancient Town.* Journal of Roman Archaeology Supplementary Series 85, 89–111. Portsmouth, RI: Journal of Roman Archaeology.

Carafa, P. 2007. Recent work on early Pompeii. In J. J. Dobbins and P. W. Foss (eds) *The World of Pompeii,* 63–72. London: Routledge.

Carocci, F., De Albentiis, E., Gargiulo, M. and Pesando, F. 1990. *Le Insulae 3 e 4 della Regio VI di Pompei: Un'Analisi Storico - Urbanistica.* Rome: G. Bretschneider.

Carrington, R. C. 1933a. Notes on the building materials of Pompeii. *Journal of Roman Studies* 23: 125–38

Carrington, R. C. 1933b. The Ancient Italian town-house. *Antiquity* 7(26): 133–52.

Cassanelli, R., Ciapparelli, P. L., Colle, E., David, M., De Caro, S. and Hartmann, T. M. 2002. *Houses and Monuments of Pompeii: the works of Fausto and Felice Niccolini.* Los Angeles: J. Paul Getty Museum.

Castellan, A. L. 1819. *Lettres Sur L'Italie, faisant suite aux Lettres sur Morée, l'Hellespont et Constantinople.* Paris: A. Nepveu.

Castiello, D. and Oliviero, S. 1997. Il ripostiglio del termopolio I. 8. 8 di Pompei. Annali dell'Istituto Italiano di Numismatica 44: 93–205.

Castrén, P. 1975. *Ordo populusque pompeianus. Polity and Society in Roman Pompeii.* Rome: Bardi.

Castrén, P., Berg, R., Tammistro, A. and Vitanen, E.-M. 2008. In the heart of Pompeii – archaeological studies in the Casa di Marco Lucrezio (IX,3,5. 24). In P. G. Guzzo and M. P. Guidobaldi (eds) *Nuove ricerche archeologiche nell'area vesuviana (scavi 2003-2006). Atti del Convegno Internazionale, Roma 1-3 febbraio 2007,* 331–40. Rome: L'Erma di Bretschneider.

Chateaubriand, F.-R. 1921. *Voyage in Italie. Nouvelle édition précédee d'une étude sur Les Six Voyages de Chateaubriand en Italie.* Faure, G. (ed) Grenoble: J. Rey.

Chiaramonte, C. 2007. The walls and gates. In J. J. Dobbins and P. W. Foss (eds) *The World of Pompeii,* 140–9. London: Routledge.

Ciaraldi, M. R. A. 2001. *Food and Fodder, Religion and Medicine at Pompeii.* Unpublished thesis, University of Bradford.

Ciaraldi, M. R. A. 2005. How many lives depended on plants? Specialisation and agricultural production at Pompeii. In A. MacMahon and J. Price (eds) *Roman Working Lives and Urban Living,* 191–201. Oxford: Oxbow Books.

Ciaraldi, M. R. A. 2007. *People and Plants in Ancient Pompeii: a New Approach to Urbanism from the Microscope Room, the Use of Plant Resources at Pompeii and in the Pompeian Area from the 6th century BC to AD 79.* Accordia specialist studies on Italy 12. London: Accordia Research Insititute, University of London.

Ciaraldi, M. R. A. and Richardson, J. 2000. Food, ritual and rubbish in the making of Pompeii. In G. Fincham, G. Harrison, R. R. Holland and L. Revel (eds) *TRAC 99, Proceedings of the Ninth annual Theoretical Roman Archaeology Conference Durham, April 1999,* 74–82. Oxford: Oxbow Books.

Ciarallo, A. 2000. *Gardens of Pompeii.* Rome: L'Erma di Bretschneider.

Ciarallo, A. 2002. Colture e Habitat del Territorio Vesuviano nel 79 d. C. *Rivista di Studi Pompeiani* XII–XIII: 167–76.

Ciarallo, A. and De Carolis, E. (eds) 1998. *Around The Walls of Pompeii. The Ancient City in its Natural Environment.* Milan: Electa.

Ciarallo, A. and Lippi, M. 1993. The garden of 'Casa dei Casti Amanti' (Pompeii, Italy). *Garden History* 21: 110–16.

Cicirelli, C. and Albore Livadie, C. 2008. Stato delle ricerche a Longa Poggiomarino: quadro insediamentale e problematiche. In P. G. Guzzo and M. P. Guidobaldi (eds) *Nuove ricerche archeologiche nell'area vesuviana (scavi 2003-2006). Atti del Convegno Internazionale, Roma 1-3 febbraio 2007,* 473–488. Rome: L'Erma di Bretschneider.

Cicirelli, C. and Guidobaldi, M. P. 2000. *Pavimenti e mosaici nella Villa dei Misteri di Pompei.* Napoli: Electa.

Cioni, R., Santacroce. R. and Sbrana, A. 1999. Pyroclastic deposits as a guide for reconstructing the multi-stage evolution of the Somma-Vesuvius Caldera. *Bulletin of Volcanology* 60: 207–22.

Clarke, J. R. 1991. *The Houses of Roman Italy, 100 B.C.-A.D. 250: Ritual, Space, and Decoration.* Oxford: University of California Press.

Cleere, H. 1976. Ironmaking. In D. E. Strong and D. Brown (eds) *Roman Crafts.* London: Duckworth.

Coarelli, F. 1989. La casa dell'aristocrazia romano secondo Vitruvio. In H. A. Alphons, P. Geertman and J. J. de Jong (eds) *Munus non ingratum: proceedings of the International Symposium on Vitruvius' De Architectura and the Hellenistic and Republican Architecture, Leiden 20-23 January 1987,* 178–87. Leiden: Bulletin antieke beschaving.

Coarelli, F. 2008. Il settore nord-occidentale di Pompei e lo sviluppo urbanistico della città dall'età arcaica al III secolo a. C. In P. G. Guzzo and M. P. Guidobaldi (eds) *Nuove ricerche archeologiche nell'area vesuviana (scavi 2003-2006). Atti del Convegno Internazionale, Roma 1-3 febbraio 2007,* 173–6. Rome: L'Erma di Bretschneider.

Coarelli, F. and Pesando, F. (eds) 2006. *Rileggere Pompei. 1. L'Insula 10 della Regio VI.* Rome: L'Erma di Bretscheider.

Coarelli, F. and Pesando, F. 2011. The urban development of NW Pompeii: the Archaic period to the 3rd c. B. C. In S. J. R. Ellis (ed) *The Making of Pompeii: Studies in the History and Urban Development of an Ancient Town.* Journal of Roman Archaeology Supplementary Series 85, 37–58. Portsmouth, RI: Journal of Roman Archaeology.

Cockburn, J. P. and Cooke, W. B. 1818. *Delineations of the Celebrated City of Pompeii. Engraved by W. B. Cooke, from accurate drawings made by Major Cockburn, of the Royal Artillery in the year 1817.* London: Murry & Cooke.

Cohen, A. and Serjeantson D. 1996. *A Manual for the Identification of Bird Bones from Archaeological Sites* (2nd edition). London: Birkbeck College.

Conticello, B. 1990. *Rediscovering Pompeii.* Roma: L'Erma di Bretschneider.

Cooke, W. B. 1827. *Pompeii, Illustrated with Picturesque Views, with Engravings by W. B. Cooke, from the Original Drawings of Lieut. Col. Cockburn, and with Plans and Details of the Public and Domestic Edifices, Including the Recent Excavations; and a Descriptive Letterpress to Each Plate, by T. L. Donaldson.* London: W. B. Cooke.

Cool, H. E. M. 2007. The glass vessels. In P. Crummy, S. Benfield, N. Crummy, V. Rigby, and D. Shimmin (eds) *Stanway: an Elite Burial Site at Camulodunum. Britannia* Monograph 24, 340–46. London: Society for the Promotion of Roman Studies.

Cool, H. E. M. 2016a. *The Small Finds and Vessel Glass from Insula VI. 1, Pompeii: Excavations 1995-2006.* Archaeopress Roman Archaeology 17. Oxford: Archaeopress.

Cool, H. E. M. 2016b. *The Small finds and Vessel Glass from Insula VI. 1 Pompeii: Excavations 1995-2006* (Archaeology Data Service, York) (doi: 10. 5284/1039937). Available at http: // archaeologydataservice. ac. uk/archives/view/pompeii_ soa_2016/

Cool, H. E. M. 2016c. Recreation or decoration: what were the glass counters from Pompeii used for? *Papers of the British School at Rome* 84: 157–77.

Cooley, A. E. 2003. *Pompeii.* London: Duckworth.

Cooley, A. E. and M. G. L. Cooley. 2004. *Pompeii. A Sourcebook.* London: Routledge.

Cornell, T. J. 1995. *The Beginnings of Rome: Italy and Rome from the Bronze Age to the Punic Wars (c.* 1000–264 BC). London: Routledge.

Coubray, S. 2012. Combustibles, modes opératoires des bûchers et rituels. L'analyse anthracologique. In W. van Andringa, H. Duday, S. Lepetz, D. Joly and T. Lind (eds) *Mourir à Pompéi. Fouille d'un quartier funéraire de la nécropole romaine de Porta Nocera (2003-2007)*, 1433–1448. Rome: Collection de l'École française de Rome.

Crummy, N. 1983. *The Roman Small Finds from Excavations in Colchester 1971-9*, Colchester Archaeological Report 2. Colchester: Colchester Archaeological Trust.

Crummy, P. 1984. *Excavations at Lion Walk, Balkerne Lane and Middleborough, Colchester, Essex.* Colchester Archaeological Report 3. Colchester: Colchester Archaeological Trust.

Crummy, P., Benfield, S., Crummy, N., Rigby, V. and Shimmin, D. 2007. *Stanway: an Elite Burial Site at Camulodunum. Britannia* Monograph 24. London: Society for the Promotion of Roman Studies.

Cunliffe, B. 1971. *Excavations at Fishbourne. Volume II: The Finds*, Report of the Research Committee of the Society of Antiquaries London 27. Leeds: Society of Antiquaries.

Curti, E. 2008. Il Tempio di Venere Fisica e il porto di Pompei. In P. G. Guzzo and M. P. Guidobaldi (eds) *Nuove ricerche archeologiche nell'area vesuviana (scavi 2003-2006). Atti del Convegno Internazionale, Roma 1-3 febbraio 2007*, 47–60. Rome: L'Erma di Bretschneider.

D'Alessio, M. T. 2008. La Casa delle Nozze di Ercole (VII, 9, 47): storia di un isolato presso il Foro all luce dei nuovi dati ceramici. In P. G. Guzzo and M. P. Guidobaldi (eds) *Nuove ricerche archeologiche nell'area vesuviana (scavi 2003-2006). Atti del Convegno Internazionale, Roma 1-3 febbraio 2007,*275–82. Rome: L'Erma di Bretschneider.

D'Ambrosio, A. and De Caro, S. 1989. Un contributo all'architettura e all'urbanistica di Pompei in età ellenistica. I saggi nella casa VII. 4. 62. *Annali dell'istituto universitaria orientale di Napoli* 11: 173–215.

D'Ancora, G. 1803. *Prospetto Storico-Fisico degli scavi di Ercolano e di Pompei. E dell'antico e presente stato del Vesuvio.* Naples: Stamperia reale.

Dapling, A. and Thompson, J. 2005. Shells from the House of the Vestals, *Provisioning the city - hinterland and marine resource exploitation: evidence from ecofacts at Pompeii.* Unpublished paper read at the UK Archaeological Science Conference 2005, 13–16 April, University of Bradford.

David, M. 1997. Fiorelli and documentation methods in archaeology in houses and monuments of Pompeii. In R. Cassanelli, P. L. Ciapparelli, E. Colle and M. David (eds) *Houses and Monuments of Pompeii: The Work of Fausto and Felice Niccolini,* 52–7. Los Angeles: Getty.

De Albentiis, E. 1990. *La Casa dei Romani.* Milano: Longanesi.

De Caro, S. 1992. Lo sviluppo urbanistico di Pompei *Atti e Memorie della Società Magna Grecia* III Serie 1: 67–90.

De Caro, S. 1985. Nuove indagini sulle fortificazioni di Pompeii *Annali dell'istituto universitaria orientale di Napoli* 7: 75–114.

De Caro, S. 2007. The first sanctuaries. In J. J. Dobbins and P. W. Foss (eds) *The World of Pompeii*, 73–81. London: Routledge.

De Haan, N., Peterse, K., Piras, S. and Schipper, F. with Iorio, V. 2005. The Casa degli Scienziati (VI 14, 43): Elite Architecture in Fourth Century B. C. Pompeii. In P. G. Guzzo and M. P. Guidobaldi (eds) *Nuove ricerche archeologiche a Pompei ed Ercolano*, 240–56. Naples: Electa.

De Hann, N. and Wallat, K. 2008. Le Terme Centrali a Pompei: ricerche e scavi 2003–2006. In P. G. Guzzo and M. P. Guidobaldi (eds) *Nuove ricerche archeologiche nell'area vesuviana (scavi 2003-2006). Atti del Convegno Internazionale, Roma 1-3 febbraio 2007*, 15–24. Rome: L'Erma di Bretschneider.

De Simone, A., Lubrano, M., Cannella, R., Caprio, L., Carannante, S., Grazioso, M. R., De Luca, M. and Franciosi., V. 2008. Pompei, VII 14. In P. G. Guzzo and M. P. Guidobaldi (eds) *Nuove ricerche archeologiche nell'area vesuviana (scavi 2003-2006). Atti del Convegno Internazionale, Roma 1-3 febbraio 2007*, 283–92. Rome: L'Erma di Bretschneider.

De Simone, G. F. 2017. The Agricultural Economy of Pompeii: Surplus and Dependence. In M. Flohr and A. I. Wilson (eds) *The Economy of Pompeii*, 23–51. Oxford. Oxford University Press.

De Vos, M. 1977. Primo stile figurato e maturo quarto stile negli scarichi provenienti dalle macerie del terremoto del 62. d. C. a Pompei. *MededRome* 39: 29–47.

De Vos, M. 1991. Paving techniques at Pompeii. *ArchNews* 16: 36–60.

De Vos, M. and De Vos, A. 1994. *Guida Archeologica di Pompei.* Milano: A. Mondadori.

De Waele, J. A. K. E. and Peterse, K. 2005. The standardized design of the Casa degli Scientizati (VI, 14, 43) in Pompeii. In J. A. K. E. De Waele, S. T. A. M. Mols and E. M. Moorman (eds) *Omni pede stare: saggi architettonici e circumvesuviani in memoriam Jos de Waele*, 196–219. Naples: Electa.

DeLaine, J. 1997. *The Baths of Caracalla: A study in the design, construction, and economics of large-scale building projects in imperial Rome.* Journal of Roman Archaeology Supplementary Series 25. Portsmouth, RI: Journal of Roman Archaeology.

DeLaine, J. 2000. Building the Eternal City: the construction industry in imperial Rome. In J. C. Coulston and H. Dodge (eds) *Ancient Rome: The Archaeology of the Eternal City.* Oxford University School Monograph 54, 119–141. Oxford: Oxford University School of Archaeology.

Della Corte, M. 1954. *Case ed abitanti di Pompei.* Naples: Faustino Fiorentino.

Deneauve, J. 1969. *Lampes de Carthage.* Centre de Recherches sur L'Afrique Méditerranéenne. Paris: Centre National de la Recherche Scientifique.

Dennis, M. 2001. Field Report for AA160. Unpublished field notebook. Bradford: University of Bradford.

Descœudres, J.-P. 2007. History and historical sources. In J. J. Dobbins and P. W. Foss (eds) *The World of Pompeii*, 9–27. London: Routledge.

Descœudres, J.-P., Allison, P. M. and Harrison, D. 1994. *Pompeii Revisited: The Life and Death of a Roman Town.* Sydney: Meditarch.

DeSena, E. and Ikäheimo, J. 2003. The supply of amphora-borne commodities and domestic pottery in Pompeii 150 BC–AD 79: preliminary evidence from the House of the Vestals. *European Journal of Archaeology* 6: 301–21.

Dessales, H. 2013. *Le partage de l'eau. Fontaines et distribution hydraulique dans l'architecture domestique de l'Occident romain.* Bibliothèque de l'Ecole française de Rome, 351. Rome: Ecole française de Rome.

Di Donato, V., Esposito, P., Russo-Ermolli, E., Scarano, A. and Cheddadi, R. 2008. Coupled atmospheric and marine palaeoclimatic reconstruction for the last 35ka in the Sele Plain – Gulf of Salerno area (southern Italy). *Quaternary International* 190.1: 146–57.

Dickmann, J.-A. 1997. The peristyle and the transformation of domestic space in Hellenistic Pompeii. In R. Laurence and A. Wallace-Hadrill (eds) *Domestic Space in the Roman World: Pompeii and Beyond.* Journal of Roman Archaeology Supplementary

Series 22. Portsmouth, RI: Journal of Roman Archaeology, 121–136.

Dickmann, J. A. and Pirson, F. 2005. Il progetto Casa dei Postumii. In P. G. Guzzo and M. P. Guidobaldi (eds) *Nuove ricerche archeologiche a Pompei ed Ercolano*, 156–69. Naples: Electa.

Dimbleby, G. W. and Eberhard Grüger. 2002. Pollen analysis of soil samples from the A.D. 79 Level. Pompeii, Oplontis, and Boscoreale. In W. F. Jashemski and F. G. Meyer (eds) *The Natural History of Pompeii*, 181–216. Cambridge: Cambridge University Press.

Dobbins, J. J. 1994. Problems of chronology, decoration, and urban design on the Forum at Pompeii. *American Journal of Archaeology* 98.4: 629–94.

Dobbins, J. J. and Ball, L. F. 2005. The Pompeii Forum Project. In P. G. Guzzo and M. P. Guidobaldi (eds) *Nuove ricerche archeologiche a Pompei ed Ercolano*, 60–72. Naples: Electa.

Dobbins, J. J. 2007. The Forum and its dependencies. In J. J. Dobbins and P. W. Foss (eds) *The World of Pompeii*, 150–183. London: Routledge.

Dobbins, J. J. and Foss, P. W. (eds). 2007. *The World of Pompeii*. London: Routledge.

Drennan, R. D. 1996. *Statistics for Archaeologists. A Commonsense Approach*. New York: Plenum Press.

Drerup, H. 1959. Bildraum und Realraum in der römischen Architecktur. *Mitteilungen des Deutschen Archäologischen Instituts: Roemische Abteilung* 66: 147–74.

Dunbabin, K. M. D. 1978. The pavement fragments and their typology. In J. H. Humphrey (ed) *Excavations at Carthage: Conducted by the University of Michigan IV*, 169–80. Tunis: Cérès Productions.

Dunbabin, K. M. D. 1999. *Mosaics of the Greek and Roman World*. Cambridge: Cambridge University Press.

Duval, A. 1821. *Mémoires historiques politiques et litteraires sur le royaume de Naples, par M. Le Comte Grégoire Orloff*. Vol 5. Paris: Chasseriau et Hécart.

Dwyer, E. 1991. The Pompeian atrium house in theory and practice. In E. Gazda (ed) *Roman Art in the Private Sphere: New Perspectives on the Architecture and Decor of the Domus, Villa, and Insula*, 25–48. Ann Arbour: University of Michigan Press.

Dyson, S. L. 1997. Some random thoughts on a collection of papers on Roman archaeology. In S. E. Bon and R. F. J. Jones (eds) *Sequence and Space in Pompeii*, 150–7. Oxbow Monograph 77. Oxford: Oxbow Books.

École nationale supérieure des beaux-arts. 1981. *Pompei e gli architetti francesi dell'Ottocento: Parigi, gennaio-marzo 1981, Napoli-Pompei, aprile-luglio 1981*. Rome: École française de Rome.

Ehrhardt W. 1995. Seismische Schäden un Reparaturen in der Casa di Paquius Proculus (I, 7, 1). In T. Fröhlich and L. Jacobelli (eds) *Archäologie und Seismologie: La regione vesuviana dal 62 al 79 d. C. Problemi archeologici e sismologici*, 57–152. Munich: Bierung & Brinkmann.

Ehrhardt, W. 1988. *Casa dell'Orso. Häuser in Pompeji*, Band 2. Munich: Hirmer.

Ehrhardt, W. 1998. *Casa di Paquius Proculus. Häuser in Pompeji*, Band 9. Munich: Hirmer.

Ehrhardt, W. 2005. *Casa delle Nozze d'Argento. Häuser in Pompeji*, Band 12. Munich: Hirmer.

Elia, O. 1934. 'Relazione sullo scavo dell'Insula X della Regio I (1)', *Notizie degli Scavi di Antichita* 10, 264–344.

Ellis, S. J. R. and Devore, G. 2008. Uncovering Plebeian Pompeii: Broader implications from excavating a forgotten working-class neighbourhood. In P. G. Guzzo and M. P. Guidobaldi (eds) *Nuove ricerche archeologiche nell'area vesuviana (scavi 2003-2006)*.

Atti del Convegno Internazionale, Roma 1-3 febbraio 2007, 309–20. Rome: L'Erma di Bretschneider.

Ellis, S. J. R. 2005. *The Pompeian bar and city: defining food and drink outlets and identifying their place in an urban environment*. Unpublished thesis, University of Sydney.

Ellis, S. J. R. (ed) 2011. *The Making of Pompeii*. Journal of Roman Archaeology Supplementary Series 85: Portsmouth, RI: Journal of Roman Archaeology.

Ellis, S. J. R. 2017. Re-evaluating Pompeii's coin finds: monetary transactions and urban waste in the retail economy of an ancient city. In M. Flohr and A. Wilson (eds) *The Economy of Pompeii*, 293–338. Oxford: Oxford University Press.

Ellis, S. P. 2000. *Roman Housing*. London: Duckworth.

Engelbach L. 1815. *Naples and the Campagna Felice: in a Series of Letters Addressed to a friend in England in 1802*. London: R. Ackermann.

Eristov, H. 1994. *Les éléments architecturaux dans la peinture campanienne du quatième style*. Collection de l'École française de Rome 187. Rome: École Française de Rome.

Ermolli, E. R. and di Pasquale, G. 2002. Vegetation dynamics of south-western Italy in the last 28kyr inferred from pollen analysis of a Tyrrhenian sea core. *Vegetation History and Archaeobotany* 11: 211–9.

Eschebach, H. 1970. *Die städtebauliche Entwicklung des antiken Pompeji: die Baugeschichte der Stabianer Thermen*. Heidelberg: F. H. Kerle.

Eschebach, H. 1984. Die Artzthäuser in Pompeji. *Antike Welt* 15: 6–10.

Eschebach, L., Müller-Trollius, J. and Eschebach, H. 1993. *Gebäudeverzeichnis und Stadtplan der anticken Stadt Pompeji*. Köln: Böhlau.

Esposito, D. 2008. Un contributo allo studio di Pompei arcaica. I saggi nella Regio V, Ins. 5 (Casa dei Gladiatori). In P. G. Guzzo and M. P. Guidobaldi (eds) *Nuove ricerche archeologiche nell'area vesuviana (scavi 2003-2006). Atti del Convegno Internazionale, Roma 1-3 febbraio 2007*, 71–80. Rome: L'Erma di Bretschneider.

Esposito, D., Kastenmeier, P. and Imperatore, C. 2011. Excavations in the Caserma dei Gladiatori: a contribution to our understanding of Archaic Pompeii. In S. J. R. Ellis (ed) *The Making of Pompeii: Studies in the History and Urban Development of an Ancient Town*. Journal of Roman Archaeology Supplementary Series 85, 89–111. Portsmouth, RI: Journal of Roman Archaeology.

Esposito, M. R. and Olevano, F. 2011. Sectilia Pavimenta dal litorale napoletano: spunti di reflessione tra vecchi dati e nuove acquiszioni. In O. Brandt and P. Pergola. *Marmoribus vestita: miscellanea in onore di Federico Guidobaldi*, 511–32. Città del Vaticano: Pontificio Istituto di archeologia cristiana.

Evans, E. 1978. A group of atrium houses without side rooms in Pompeii. In T. W. Potter, D. Whitehouse and H. McK. Blake (eds) *Papers in Italian Archaeology I*, British Archaeological Report S41, 175–91. Oxford: British Archaeological Reports.

Faber, A. and Hoffmann, A. 2009. *Die Casa del Fauno in Pompeji (VI, 12) 1*. Deutsches Archäogisches Institut Archäologische Forschungen 25. Reichert: Weisbaden.

Fant, J. C. 1999. Augustus and the City of Marble. In M. Schvoerer, N. Herz, K. A. Holbrow and S. Sturman (eds) *Archéomatériaux: marbres et autres roches. ASMOSIA IV, Bordeaux-Talence, 9-13 octobre 1995: actes de la IVème Conférence internationale de l'Association pour l'étude des marbres et autres roches utilisés dans le passé*, 277–280. Talence: CRPAA.

Fant, J. C. 2007. Real and painted (imitation) marble at Pompeii. In J. J. Dobbins and P. W. Foss (eds) *The World of Pompeii*, 336–46. London: Routledge.

Fant, J. C. 2009. Bars with marble surfaces at Pompeii: evidence for sub-elite marble use. *Fasti Online*. Available at http://www.fastionline.org/docs/FOLDER-it-2009-159.pdf (Accessed 01. 04. 2015).

Fant, J. C. and Barker, S. J. 2016. The cost of luxury: procurement and labour for the marble décor of Villa A. In E. K. Gazda and J. R. Clarke (eds) *Leisure & Luxury in the Age of Nero: The Villas of Oplontis near Pompeii*, 126–32. Ann Arbor, MI: Kelsey Museum.

Farneti, M. 1993. *Glossario tecnico-storico del mosaico. Technical-historical Glossary of Mosaic Art, con una breve storia del mosaico*. Ravenna: Longo Editore.

Fino, L. 2006. *Herculaneum and Pompeii in the 18th and 19th Centuries: Water-Colours, Drawings, Prints and Travel Mementoes*. Naples: Grimaldi.

Fiorelli, G. 1858. *Sulle regioni Pompeiane e della loro antica distribuzione: programma pubblicato in ricoorrenza dell'onomastico di sua altezza reale il Conte di Siracusa*. Naples: Limongi.

Fiorelli, G. 1873. Gli scavi di Pompei dal 1861 al 1872. Relazione al Ministro della instruzione pubblica di Giuseppe Fiorelli. Naples: Tipografia Italiana nel Liceo V. Emanuele.

Fiorelli, G. 1875. *Descrizione di Pompeii*. Naples: Tipografia Italiano.

Fiorelli, G. 1877. *Guida di Pompei*. Rome: Tipografia Elzevirana.

Fiorelli, G. 1897. *Gli Scavi di Pompei dal 1861 al 1872*. Naples: Tipografia italiana nel liceo V. Emanuele.

Flohr, M. 2003. Fullones and Roman society. *Journal of Roman Archaeology* 16: 447–50.

Flohr, M. 2007. *Nec quicquam ingenuum habere potest officina?* Spatial contexts of urban production at Pompeii, AD 79. *BABesch* 82.1: 129–48.

Flohr, M. 2011. Reconsidering the atrium house: domestic fullonicae at Pompeii. In E. Poehler, M. Flohr and K. Cole (eds) *Pompeii: Art, Industry and Infrastructure*, 88–102. Oxford: Oxbow Books.

Flohr, M. 2013. *The World of the Fullo: Work, Economy, and Society in Roman Italy*. Oxford Studies on the Roman Economy. Oxford. Oxford University Press.

Fortenberry, D. and Goalen, M. 2007. *Report on the Conservation and Presentation of Regio VI Insula I, Pompeii*. London: Academy Projects (Archaeology–Architecture) LLP.

Foss, J. E. 1988. Paleosols of Pompeii and Oplontis. In R. I. Curtis. (ed.) *Studia Pompeiana & Classica in Honor of Wilhelmina F. Jashemski I*. New York: Artistide D. Caratzas, 127–144.

Foss, J. E., Timpson, M. E., Ammons, J. T. and Lee, S. Y. 2002. Paleosols of the Pompeii area. In W. F. Jashemski and F. G. Meyer (eds) *The Natural History of Pompeii*, 65–79. Cambridge: Cambridge University Press.

Foss, P. W. 1997. Watchful Lares: Roman household organization and the rituals of cooking and eating. In R. Laurence and A. Wallace-Hadrill (eds) A. *Domestic Space in the Ancient World*. Journal of Roman Archaeology Supplementary Series 22, 197–218. Portsmouth, RI: Journal of Roman Archaeology.

Foss. P. W. 2007. Rediscovery and resurrection. In J. J. Dobbins and P. W. Foss (eds) *The World of Pompeii*, 28–42. London: Routledge.

Frankel, R. and Cheetham, P. 1995. Geophysical Survey. In S. E. Bon, R. F. J. Jones and D. J. Robinson (eds) Anglo-American Research in Pompeii, *Old World Archaeology Newsletter* 18.2: 19–21.

Frayn, J. M. 1979. Subsistence Farming in Roman Italy. London: Centaur Press.

Fröhlich, T. 1997. *Casa della Fontana Piccola*. Häuser in Pompeji, Band 8. Munich: Hirmer.

Fulford, M. and Wallace-Hadrill, A. 1996. The House of Amarantus at Pompeii (I, 9, 11–12): an interim report on survey and excavations in 1995–96. *Rivista di Studi Pompeiani* 7: 77–113.

Fulford, M., Wallace-Hadrill, A., Clark, G., Clarke, A., Eckardt, H.,

Locker A., Powell, A., Rendeli, M., Richards, D., Robinson, J., Robinson, M. and Timby, J. 1999. Towards a history of pre-Roman Pompeii: excavations beneath the House of Amarantus (I. 9. 11–12). *Papers of the British School at Rome* 67: 37–144.

Furger, A. R., Wartmann, M. and Riha, E. 2009. *Die römischen Siegelkapseln aus Augusta Raurica*. Forschungen in Augst 44. Basel: Werner Druck.

Gale, R. 2005. The charcoal. In F. Seeley and J. Drummond-Murray (eds) *Roman Pottery Production in the Walbrook Valley. Excavations at 20-28 Moorgate, City of London, 1998-2000*, 197–9. MoLAS Monograph 25. London: Museum of London Archaeology Service.

Gale, R. and Cutler. D. 2000. *Plants in Archaeology. Identification Manual of Vegetative Plant Materials used in Europe and the Southern Mediterranean to c. 1500*. Kew: Westbury Publishing and Royal Botanic Gardens.

Gallo, A. 1994. *La Casa di Lucio Elvio Severo a Pompei*. Naples: Arte tipografica.

Gallo, A. 2008. Nuove ricerche stratigraphiche nella Casa di M. Epidio Sabino (IX, 1, 29) a Pompei. In P. G. Guzzo and M. P. Guidobaldi (eds) *Nuove ricerche archeologiche nell'area vesuviana (scavi 2003-2006). Atti del Convegno Internazionale, Roma 1-3 febbraio 2007*, 321–30. Rome: L'Erma di Bretschneider.

Gamble, C. 2007. *Origins and Revolutions: Human identity in Earliest Prehistory*. Cambridge University Press. Cambridge.

García y García, L. 2006. *Danni di guerra a Pompei. Una dolorosa vicenda quasi dimenticata*. Rome: L'Erma di Bretschneider.

Gassner, V. 1986. *Die Kaufläden in Pompeii*. Vienna: Association Scientific Societies of Austria (VWGÖ).

Geertman, H. 1998. The layout of the city and its history: the Dutch project. In J. Berry (ed) *Unpeeling Pompeii*, 17–25. Roma: Electa.

Geertman, H. 2007. The urban development of the pre-Roman city. In J. J. Dobbins and P. W. Foss (eds) *The World of Pompeii*, 82–97. London: Routledge.

Gell, W. 1817. *Pompeiana: The Topography, Edifices, and Ornaments of Pompeii*. London: Rodwell and Martin.

Giglio, M. 2008. Indagini archeologiche nell'insula 7 della Regio IX. In P. G. Guzzo and M. P. Guidobaldi (eds) *Nuove ricerche archeologiche nell'area vesuviana (scavi 2003-2006). Atti del Convegno Internazionale, Roma 1-3 febbraio 2007*, 341–348. Rome: L'Erma di Bretschneider.

Giorgi C., Festa, L. and Lugari, A. 2011. La tecnica esecutiva dei rivestimenti parietali marmorei (incrustationes): studio esperimentazione. In C. Angelelli (ed) *Atti del XVI Colloquio dell'Associazione italiana per lo studio e la conservazione del mosaic (Palermo, 17-19 marzo 2010 - Piazza Armerina, 20 marzo 2010)*, 101–8. Tivoli: Edizioni Scripta Manent di Tipografia Mancini.

Gleba, M. 2008. *Textile Production in Pre-Roman Italy*. Ancient Textiles Series 4. Oxford: Oxbow Books.

Gobbo, B. and Loccardi, P. 2005. Domus VI, 13, 6 (Casa di Marcus Terentius Eudoxsus). *Rivista di Studi Pompeiani* 16: 191–2.

Goethe, J. W. von. 1913. *Italienische Reise*. Leipzig: Insel.

Goethert, K. 1989. Zur Körper- und Schönheitspflege in frührömischer Zeit. In A. Haffner (ed) *Gräbe - Spiegel des Lebens: Zum Totenbrauchtum der Kelten und Römer am Beispiel des Treverer Gräberfeldes Wederath Belginum*. Schriftenreihe des Rheinischen Landesmuseums Trier 2, 275–88. Mainz am Rhein: Zabern.

Goldicut, J. 1825. *Specimens of Ancient Decorations from Pompeii*. London: Rodwell & Martin.

Goodburn, D. 2005. Woodworking used in Well 2. In F. Seeley and J. Drummond-Murray (eds) *Roman Pottery Production in*

the *Walbrook Valley. Excavations at 20-28 Moorgate, City of London, 1998-2000*, 20-8. MoLAS Monograph 25. London: Museum of London Archaeology Service.

Graham, J. W. 1966. Origins and interrelations of the Greek house and the Roman house. *The Phoenix* 20: 3-31.

Graham, T. 2004. Wattle and Daub: Craft, Conservation and Wiltshire Case Study. Unpublished Masters dissertation, University of Bath.

Grahame, M. 1997. Public and private in the Roman house: investigating the social order of the Casa del Fauno. In R. Laurence and A. Wallace-Hadrill (eds) *Domestic Space in the Ancient World*. Journal of Roman Archaeology Supplementary Series 22, 137-64. Portsmouth, RI: Journal of Roman Archaeology.

Grahame, M. 2000. *Reading Space: Social Interaction and Identity in the Houses of Roman Pompeii: a Syntactical Approach to the Analysis and Interpretation of Built Space*. Oxford: Archaeopress.

Grandi Carletti, M. 2001. Opus signinum e cocciopesto: alcune osservazioni terminologiche. In A. Paribeni (ed) *Atti del VII Colloquio dell'Associazione Italiana per lo Studio e la Conservazione del Mosaico (Pompei, 22-25 Marzo 2000)*, 183-97. Ravenna: Edizioni del Girasole.

Grandi, M. 2011. Considerazioni sulla terminologia applicata allo studio dei sistemi pavimentali romani. In O. Brandt and P. Pergola (eds) *Marmoribus vestita: miscellanea in onore di Federico Guidobaldi*, 677-91. Città del Vaticano: Pontificio Istituto di archeologia cristiana.

Grandi, M. and Guidobaldi, F. 2006. Proposta di classificazione dei cementizi e mosaici omogenei ed eterogenei. In C. Angelelli (ed) *Atti dell'XI Colloquio dell'Associazione Italiana per lo Studio e la Conservazione del Mosaico (Ancona, 16-19 Febbraio 2005)*, 31-8. Tivoli: Edizioni Scripta Manent di Tipografia mancini.

Grant, A. 1982. The use of tooth wear as a guide to the age of domestic ungulates. In B. Wilson, C. Grigson and S. Payne (eds) *Ageing and Sexing Animal Bones from Archaeological Sites*, 91-108. British Archaeological Report 109. Oxford: British Archaeological Reports.

Grasso, L. 2004. *Ceramica miniaturistica da Pompei*, Quaderni di Ostraka 9. Naples: Loffredo.

Grimaldi, M. 2011. Charting the urban development of the Insula Occidentalis and Casa di Marcus Fabius Rufus. In S. J. R. Ellis (ed) *The Making of Pompeii: Studies in the History and Urban Development of an Ancient Town*. Journal of Roman Archaeology Supplementary Series 85, 137-57. Portsmouth, R. I.: Journal of Roman Archaeology.

Gros, P. 2001. *L'Architecture Romaine du Début du IIIe Siècle av. J.-C. à la Fin du Haut-Empire 2: Maisons, Palais, Villas et Tombeaux*. Paris: Picard.

Grose, D. F. 1977. Early blown glass: the western evidence. *Journal of Glass Studies* 19: 9-29.

Grose, D. F. 1989. *Toledo Museum of Art. Early Ancient Glass*. New York and Toledo: Hudson Hills Press.

Grove, A. T. and Rackham, O. 2001. *The Nature of Mediterranean Europe. An Ecological History*. New Haven: Yale University Press.

Grüger, E., Thulin, B., Müller, J., Schneider, J., Alefs, J. and Welter-Schultes, F. W. 2002. Environmental changes in and around Lake Avernus in Greek and Roman times: a study of the plant and animal remains preserved in the lake's sediments. In W. F. Jashemski and F. G. Meyer (eds) *The Natural History of Pompeii*, 240-263. Cambridge: Cambridge University Press.

Guarino, R. and Valente, F. 2011. L'opus sectile vitreo: studio dei sistemi di lavorazione diretto e indiretto. In C. Angelelli (ed) *Atti del XVI Colloquio dell'Associazione italiana per lo studio*

e la conservazione del mosaic *(Palermo, 17-19 marzo 2010 - Piazza Armerina, 20 marzo 2010)*, 91-9. Tivoli: Edizioni Scripta Manent di Tipografia Mancini.

Guidi, G., Remondino, F., Russo, M., Menna, F., Rizzi, A. and Ercoli, S. 2010. Digitizing Pompeii's Forum. In B. Frischer, J. W. Crawford and D. Koller (eds) *Making History Interactive. Computer Applications and Quantitative Methods in Archaeology (CAA). Proceedings of the 37th International Conference, Williamsburg, Virginia, United States of America, March 22-26, 2009*, 106-16. Oxford: Archaeopress.

Guidobaldi, F. 1994a. Sectilia pavimenta: la produzione più antica in materiali non marmorei o misti. In R. F. Campanati (ed) *Atti del 1o colloquio (Ravenna, 29 aprile-3 maggio 1993)*. Associazione italiana per lo studio e la conservazione del mosaico, 451-71. Ravenna: Edizioni del Girasole.

Guidobaldi, F. 1994b. *Sectilia pavimenta di Villa Adriana*. Mosaici antichi in Italia, Studi Monografici 2. Roma, Istituto Poligrafico e Zecca dello Stato: Libreria dello Stato.

Guidobaldi, F. and Olevano, F. 1998. *Sectilia pavimenta dell'area vesuviana*. In P. Pensabene (ed) *Marmi antichi II: cave e tecnica di lavorazione, provenienze e distribuzione*, 223-58. Studi miscellanei 31. Roma: L'Erma di Bretschneider.

Guidobaldi, F., Olevano, F. and Trucchi, D. 1994. Classificazione preliminare dei sectilia pavimenta di Pompei. In C. M. Batalla (ed) *VI Coloquio internacional sobre mosaico antiguo: Palencia-Mérida, Octubre 1990*, 49-61. Palencia: Asociación Española del Mosaico.

Guidobaldi, F., Grandi, M., Pisapia, M. S., Balzanetti, R. and Bigliati, A. 2014. *Mosaici antichi in Italia. Regione 1a, Ercolano*. Roma: Fabrizio Serra editore.

Guzzo, P. G. 2011. The origins and development of Pompeii: the state of our understanding and some working hypotheses. In S. J. R. Ellis (ed) *The Making of Pompeii: Studies in the History and Urban Development of an Ancient Town*. Journal of Roman Archaeology Supplementary Series 85, 11-18. Portsmouth, RI: Journal of Roman Archaeology.

Hales, S. 2003. *The Roman House and Social Identity*. Cambridge: Cambridge University Press.

Hamilton, W. 1777. *Account of the Discoveries at Pompeii: Communicated to the Society of Antiquaries of London*. London: W. Bowyer and J. Nichols.

Harden, D. B. and Price, J. 1971. The glass. In B. Cunliffe (ed) *Excavations at Fishbourne. Volume II: The Finds*, 317-68. Report of the Research Committee of the Society of Antiquaries of London 27. Leeds: Society of Antiquaries.

Harris, E. C. 1989. *Principles of Archaeological Stratigraphy*. London. Academic Press.

Haverfield, F. 1913. *Ancient Town Planning*. Oxford: Clarendon Press.

Heiss, A. G. and Oeggl, K. 2008. Analysis of the fuel wood used in Late Bronze Age and Early Iron Age Copper Mining sites of the Schwaz and Brixlegg area (Tyrol, Austria). *Vegetation History and Achaeobotany* 17: 211-21.

Helbig, W. 1868. *Wandgemälde der vom Vesuv verschütteten Städte Campaniens*. Leipzig: Breitkopf und Härtel.

Hesse, R. 2016. *Roman Religious Ritual: A Zooarcheological Perspective*. Unpublished thesis, University of Oxford.

Hobbs, R. 2013. *Currency and Exchange in Ancient Pompeii. Coins from the AAPP Excavations at Regio VI, Insula 1*. London: Institute of Classical Studies.

Hobson, B. 2009a. *Latrinae et Foricae: Toilets in the Roman World*. London: Duckworth.

Hobson, B. 2009b. *Pompeii, Latrines and Down Pipes, A General Discussion and Photographic Record of Toilet facilities in Pompeii*.

British Archaeological Report S2041. Oxford: John and Erica Hedges.

Hoffmann, A. 1979. L'architettura privata. In F. Zevi (ed) *Pompei 79*, 97–118. Naples: G. Macchiaroli.

Hoffmann, A. and Faber, A. 2009. *Die Casa del Fauno in Pompeji (VI 12)*. Archäologische Forschungen. Wiesbaden: Reichert.

Holappa, M. and Viitanen, E.-M. 2011. Topographic conditions in the urban plan of Pompeii: the urban landscape in 3D. In S. J. R. Ellis (ed) *The Making of Pompeii: Studies in the History and Urban Development of an Ancient Town*. Journal of Roman Archaeology Supplementary Series 85, 169–89. Portsmouth, RI: Journal of Roman Archaeology.

Holloway, R. R. 1994. *The Archaeology of Early Rome and Latium*. London: Routledge.

Hopkins, H. J. 2007. *An investigation of the parameters that would influence the scale of the dyeing industry in Pompeii. An application of experimental archaeology and computer simulation techniques to investigate the scale of manufacture of the dyeing industry and the factors that influence output*. Unpublished thesis, University of Bradford.

Hopkins, H. J. 2008. Using experimental archaeology to answer the unanswerable: A case study using Roman dyeing. In P. Cunningham, J. Heeb, and R. Paardekooper (eds) *Experiencing Archaeology by Experiment. Proceedings from the Second Conference of Experimental Archaeology*, 103–18. Oxford: Oxbow Books.

Isings, C. 1957. *Roman Glass from Dated Finds*. Groningen: J. B. Wolters.

Israeli, Y. 1991. The invention of blowing. In M. Newby and K. Painter (eds) *Roman Glass: Two Centuries of Art and Invention*, 46–55. Society of Antiquaries of London Occasional Paper 13. London: Society of Antiquaries of London.

Jackson-Tal, R. 2005. A preliminary survey of the late Hellenistic glass from Maresha (Marisa), Israel. *Annales du 16ᵉ Congrès de l'Association International pour l'Histoire du Verre (London 2003)*, 49–53. Nottingham: L'Association International pour l'Histoire du Verre.

Jackson-Tal, T. 2004. The late Hellenistic glass industry in Syro-Palestine: a reappraisal. *Journal of Glass Studies* 46: 11–32.

Jacobelli, L. 1995. I terrimoti fra il 62 e il 79 d. C. nell'area Vesuviana: le ragioni di un convegno. In T. Fröhlich and L. Jacobelli (eds) *Archäologie und Seismologie: La regione vesuviana dal 62 al 79 d. C. Problemi archeologici e sismologici*, 17–22. Munich: Bierung & Brinkmann.

Janaway, R. 1995. Textile workshops. In S. E. Bon, R. F. J. Jones and D. J. Robinson (eds) Anglo-American Research in Pompeii, 1994. *Old World Archaeology Newsletter* XVIII (2): 22–3.

Jansen, G. C. M. 1991. Water systems and sanitation in the houses of Herculaneum. *MededRom* 50: 145–66.

Jansen, G. C. M. 1997. Private toilets at Pompeii: appearance and operation. In S. E. Bon and R. Jones (eds) *Sequence and Space in Pompeii*, 121–34. Oxbow Monograph 77. Oxford: Oxbow Books

Jashemski, W. F. and Meyer, F. 2002. *The Natural History of Pompeii*. Cambridge: Cambridge University Press.

Jashemski, W. F. 1979. *The Gardens of Pompeii, Herculaneum and the Villas Destroyed by Vesuvius*. New Rochelle, NY: Caratzas Brothers.

Johnston, D. E. 1983. The prefabrication and removal of mosaics in Roman Britain. In R. F. Campanati (ed) *III Colloquio Internazionale sul mosaico antico: Ravenna, 6–10 settembre 1980*, 525–30. Ravenna: Edizioni del Girasole.

Jolivet, V. 2011. *Tristes portiques: sur le plan canonique de la maison étrusque et romaine des origines au principat d'Auguste (VIe-Ier siècles av. J.-C.)*. Rome: École française de Rome.

Jones, R F. J. 2008. The urbanisation of Insula VI, 1 at Pompeii.

In P. G. Guzzo and M. P. Guidobaldi (eds) *Nuove ricerche archeologiche nell'area vesuviana (scavi 2003-2006). Atti del Convegno Internazionale, Roma 1-3 febbraio 2007*. 139–146. Rome: L'Erma di Bretschneider.

Jones, R F. J. and Robinson, D. J. 1998. *The House of the Vestals at Pompeii (VI, 1 6-8) Preliminary Report 1995-7*. Bradford Archaeological Science Research 3. Bradford: University of Bradford.

Jones, R. F. J. and Robinson, D. J. 2004. The making of an elite Roman house: the House of the Vestals at Pompeii. *Journal of Roman Archaeology* 18: 107–30.

Jones, R F. J. and Robinson, D. J. 2005. Water, wealth, and social status at Pompeii: The House of the Vestals in the first century. *American Journal of Archaeology* 109.4: 695–710.

Jones, R F. J. and Robinson, D. J. 2006. The development of inequality in Pompeii: the evidence from the northern end of Insula VI I. In C. C. Mattusch, A. A. Donohue, and A. Brauer (eds) *Common Ground: Archaeology, Art, Science and the Humanities, Proc. of the XVI International Congress of Classical Archaeology*, 498–502. Oxford: Oxbow Books.

Jones, R F. J. and Robinson, D. J. 2007. Intensification, heterogeneity and power in the development of Insula VI I. In J. J. Dobbins and P. W. Foss (eds) *The World of Pompeii*, 389–406. London: Routledge.

Jones, R. F. J. and Schoonhoven, A. 2003. The story of a street: The vicolo di Narciso and the urban development of Pompeii. In P. Wilson (ed), *The Archaeology of Roman Towns*, 128–36. Oxford: Oxbow Books

Jones, R., Robinson, D. J. and Stephens, J. (eds) 2006. *Anglo-American Project in Pompeii 2006 Resource Book*. Unpublished work.

Jongman, W. 1988. *The Economy and Society of Pompeii*. Dutch Monographs on Ancient History and Archaeology. Amsterdam: J. C. Gieben.

Joyce, H. 1979. Form, function and technique in the pavements of Delos and Pompeii. *American Journal of Archaeology* 83.3: 253–63.

Judd, M. 1995. Human remains. In S. E. Bon, R. F. J. Jones and D. J. Robinson (eds) Anglo-American Research in Pompeii, 1994. *Old World Archaeology Newsletter* XVIII (2): 22.

Jung, F. 1984. Gebaute Bilder. *Antike Kunst* 27: 71–121.

King, A. 1999. Diet in the Roman world: a regional inter-site comparison of the mammal bones. *Journal of Roman Archaeology* 12: 168–202.

Laidlaw, A. 1985. *The First Style in Pompeii: Painting and Architecture*. Rome: G. Bretschneider.

Laidlaw, A. 2007. Mining the early published sources: problems and pitfalls. In J. J. Dobbins and P. W. Foss (eds) *The World of Pompeii*, 620–36. London: Routledge.

Laidlaw, A. and Stella, M. S. 2014. *The House of Sallust in Pompeii (VI 2, 4)*. Journal of Roman Archaeology Supplementary Series 98. Portsmouth, RI: Journal of Roman Archaeology.

Laurence, R. 1994. *Roman Pompeii: Space and Society*. London: Routledge.

Lazer E. 2007. Victims of the cataclysm. In J. J. Dobbins and P. W. Foss (eds) *The World of Pompeii*, 607–19. London: Routledge.

Lazer E. 2009. *Resurrecting Pompeii*. London: Routledge.

Lazzarini, L. 1995. Il marmo Chio detto di Portasanta. In A. Lio (ed) *La Fontana di Piazza Colonna. Restauri in Piazza*, 75–8. Roma: Bonsignori.

Le Riche, J. M. 1827. *Vues des Monuments antiques de Naples, gravées à l'aqua-tinta, accompagnées des Notices et de Dissertations*. Paris: T. Bruère.

Leach, E. W. 1997. Oecus on Ibycus: investigating the vocabulary

of the Roman house. In S. E. Bon and R. F. J. Jones (eds) *Sequence and Space in Pompeii*, 50–72. Oxford: Oxbow Books.

Leander Touati, A.-M. 2010. Water, well-being and social complexity in *Insula* V, 1. *Opuscula* 3: 105–61.

Leney, L. and Casteel, R. W. 1975. Simplified procedure for examining charcoal specimens for identification. *Journal of Archaeological Science* 2: 153–9.

Lepore, E. 1984. Il quadro storico. In F. Zevi (ed) *Pompei 79*, 13–23. Naples. G. Macchiaroli.

Ling, R. 1991. *Roman Painting*. Cambridge. Cambridge University Press.

Ling, R. 1995. Earthquake damage in Pompeii I, 10: one earthquake or two? In T. Fröhlich and L. Jacobelli (eds) *Archäologie und Seismologie: La regione vesuviana dal 62 al 79 d. C. Problemi archeologici e sismologici*, 201–9. Munich: Bierung & Brinkmann.

Ling, R. 1997. *The Insula of the Menander at Pompeii. Vol. 1, The Structures*. Oxford: Clarendon Press.

Ling, R. 2005. *Pompeii: History, Life and Afterlife*. Stroud: Tempus.

Ling, R. and Ling, L. 2005. *The Insula of the Menander at Pompeii. Vol. 2, The Decorations*. Oxford: Clarendon Press.

Lippi, M. M. 1993. Contributo alla Conoscenza del Paesaggio Vegetale dell'area di Pompei nel 79 d. C. In M. Borgongino, A. Ciarallo, C. Mazza and S. Striano (eds) *Parchi e Giardini Storici, Parchi Letterari - Atti del III Convegno (primo internazionale), Paesaggi e Giardini del Mediterraneo*, 141–148. Salerno: GRG ipolitografica srl.

Lomas, K. 2003. Public building, urban renewal and euergetism in early Imperial Italy. In K. Lomas and T. Cornell (eds) *'Bread and circuses': euergetism and municipal patronage in Roman Italy*, 28–45. London: Routledge.

Ludemann, T. 2003. Large-scale reconstruction of ancient forest vegetation by anthracology – a contribution from the Black Forest. *Journal of Phytocoenologia* 33.4: 645–66.

Ludemann, T. 2006. Anthracological analysis of recent charcoal-burning in the Black Forest, SW Germany. In A. Dufraisse (ed) *Charcoal Analysis: New Analytical Tools and Methods for Archaeology*, 61–70. Oxford: Archaeopress.

Lugli, G. 1968. *La Technica Edilizia Romana*. Rome. Bardi.

Macaulay-Lewis, E. 2006. The role of ollae perforatae in understanding horticulture, planting techniques, garden design, and plant trade in the Roman World. In J. P. Morel, J. T. Juan and J. C. Matamala (eds) *The Archaeology of Crop Fields and Gardens: Proceedings from 1st Conference on Crop Fields and Gardens Archaeology, University of Barcelona, Barcelona, Spain, June 1-3rd 2006*, 207–20. Bari: EdiPuglia.

MacKinnon, M. 2004. *Production and Consumption of Animals in Roman Italy: Integrating the Zooarchaeological and Textual Evidence*. Journal of Roman Archaeology Supplementary Series 54. Portsmouth, R. I. Journal of Roman Archaeology.

Maiuri, A. 1929. Pompei: Relazione sui lavori di scavo dall'aprile 1926 al dicembre 1927. *Notizie degli Scavi di Antichità*: 354–438.

Maiuri, A. 1930. Studie ricerche sulla fortificazione di Pompei. *Monumenti Antichi* 33: 8–276.

Maiuri, A. 1933. *La casa del Menandro e il suo tesoro di argenteria*. Rome: Libreria dello Stato.

Maiuri, A. 1942. *L'Ultima Fase Edilizia di Pomei*. Spoleto: Institute di Studi Romani.

Maiuri, A. 1943. Pompei. Isolamento della cintamurale fra Porta Vesuvio e Porta Ercolano. *Notizie delgi Scavi di Antichita* 4: 275–314.

Maiuri, A. 1973. *Alla Ricerca di Pompei Preromana (saggi stratigrafici)*. Napoli: Societa editrice napoletana.

Maiuri, A. 1978. *Pompeii*. Rome: Istituto poligraifco dello Stato.

Maiuri, A. and Ragozzino, A. M. (eds) 2000. *La Casa Pompeiana: Struttura, Ambienti, Storia nella Magistrale Descrizione d'un Grande Archeologo*. Napoli: Generoso Procaccini.

Margaritis, E. and Jones, M. 2008. Crop processing of *Olea europaea* L.: an experimental approach for the interpretation of archaeobotanical olive remains. *Vegetation History and Archaeobotany* 17.4: 381–92.

Marguerie, D. and Hunot, J.-Y. 2007. Charcoal analysis and dendrology: data from archaeological sites in north-western France. *Journal of Archaeological Science* 34: 1417–33.

Mastroroberto, M. 1990. Il Mare e la Costa. In G. Stefani (ed) *Uomo e Ambiente nel Territorio Vesuviano*, 10–19. Pompei: Marius Edizioni.

Matterne, V. and Derreumaux, M. 2008. A Franco-Italian investigation of funerary rituals in the Roman world, les rites et la mort a Pompei, the plant part: a preliminary report. *Vegetation History and Archaeobotany* 17.1: 105–12.

Mau, A. 1879. *Pompejanische Beiträge*. Berlin: G. Reimer.

Mau, A. 1882. *Geschichte der decorativen Wandmalerei in Pompeji*. Berlin: G. Reimer.

Mau, A. 1899. *Pompeii: Its Life and Art*. Translated F. W. Kelsey. New York: MacMillian.

Mau, A. 1902. *Pompeii: Its Life and Art*. Translated by F. W. Kelsey. New York & London: MacMillan.

Mau, A. 1908. *Pompeji in Leben und Kunst* (2nd edition). Leipzig: Wilhelm Englemann.

Mazois, F. 1824–1838. *Les ruines de Pompéi*. Paris: Firmim Didot.

McCormick, M., Büntgen, U., Cane, M. A., Cook, E. R., Harper, K., Huybers, P., Litt, T., Manning, S. W., Mayewski, P. A., More, A. F. M., Nicolussi, K. and Tegel, W. 2012. Climate Change during and after the Roman Empire: reconstructing the past from scientific and historical evidence. *Journal of Interdisciplinary History* 43.2: 169–220.

McKay, A. G. 1975. *Houses, Villas and Palaces in the Roman World*. London. Republished Baltimore ML: Johns Hopkins University Press.

McKenzie-Clark, K. 2006. *A Reconsideration of Red Slip Tableware at Pompeii*. Unpublished thesis, Macquarie University, Sydney.

McKenzie-Clark, J. 2009. Ceramic production in Campania: the supply and distribution of red slip tableware to Pompeii and beyond. *Papers of the British School at Rome* 77: 309–10.

McKenzie-Clark, J. 2012a. *Vesuvian Sigillata at Pompeii*. Archaeological Monograph of the British School at Rome 20. London: British School at Rome.

McKenzie-Clark, J. 2012b. The supply of Campanian-made *Sigillata* to Pompeii. *Archaeometry* 54.5: 796–820.

Meyer, F. G. 1980. Carbonized food plants of Pompeii, Herculaneum, and the Villa at Torre Annunziata. *Economic Botany* 34: 401–37.

Michel, D. 1990. *Casa dei Cei*. Häuser in Pompeji, Band 3. München: Hirmer.

Miller, A. R. 1777. *Letters from Italy, Describing the Manners, Customs, Antiquities, Paintings, &c. of that Country, in the Years 1770 and 1771, to a Friend Residing in France*. London: Edward and Charles Dilly.

Mols, S. T. A. M. 2002. Identification of the woods used in the furniture at Herculaneum. In W. F. Jashemski and F. G. Meyer (eds) *The Natural History of Pompeii*, 225–234. Cambridge: Cambridge University Press.

Mols, S. T. A. M. and Moormann, E. M. (eds) 2005. *Omni pede stare. Saggi architettonici e circumvesuviani in memoriam Jos de Waele*. Studi della Soprintendenza archeologica di Pompei 9. Naples: Electa Napoli and Ministero per i Beni e le Attività Culturali.

Monteix, N. 2007. Cauponae, popinae et thermopolia, de la norme littéraire à la réalité pompéienne. In *Contributi di Archeologia*

Vesuviana III, 117–28. Soprintendenza archeologica di Pompei 20. Rome: L'Erma di Bretschneider.

Monteix, N. 2009. Pompéi, recherches sur les boulangeries de l'Italie romaine. *FOLD&R* 168 (www.fastionline.org/docs/FOLDER-it-2009-168.pdf).

Monteix, N. 2010. *Les Lieux de Métier: Boutiques et Ateliers d'Herculaneum*. Rome: École Française de Rome.

Moore, J. 1781. *A View of Society and Manners in Italy: with Anecdotes Relating to Some Eminent Characters*. Dublin: Price, W. Watson, W. and H. Whitestone et al Publishers.

Morichi, R., Paone, R., Rispoli, P. and Sampaolo, F. 2008. Nuova cartografia di Pompei. In P. G. Guzzo and M. P. Guidobaldi (eds) *Nuove ricerche archeologiche nell'area vesuviana (scavi 2003-2006). Atti del Convegno Internazionale, Roma 1-3 febbraio 2007*, 554–5. Rome: L'Erma di Bretschneider.

Moser, D., Allevato, E., Clarke, J. R., Di Pasquale, G. and Nelle, O. 2013. Archaeobotany at Oplontis: woody remains from the Roman Villa of Poppaea (Naples, Italy). *Vegetation History and Archaeobotany* 22: 397–408.

Motta, L. 2002. Planting the seed of Rome. *Vegetation History and Archaeobotany* 11.1: 71–7.

Murphy, C. 2011. *Pompeii, A Changing City: The Archaeobotanical Assemblage of Regione VI, insula i*. Unpublished thesis. University College London.

Murphy, C. 2015. *Romans, Rubbish, and Refuse. The Archaeobotanical Assemblage of Regione VI, insula I, Pompeii*. Archaeopress Roman Archaeology 8: Oxford: Archaeopress.

Murphy, C., Thompson, G. and Fuller, D. Q. 2013. Roman food refuse: urban archaeobotany in Pompeii, Regio VI, Insula 1. *Vegetation History and Archaeobotany* 22: 409–19.

Nappo, S. C. 1996. L'impianto idrico a Pompei nel 79 d. C. Nuovi dati. In N. de Haan and G. M. C. Jansen. *Cura aquarum in Campania (Proceedings of the Ninth International Congress on the History of Water Management and Hydraulic Engineering in the Mediterranean Region, Pompeii 1-8 October 1994)*, 37–45. Leiden: BABESCH.

Nappo, S. C. 1997. Urban transformation at Pompeii in the late 3rd and 2nd c. B. C. In R. Laurence and A. Wallace-Hadrill (eds) *Domestic Space in the Ancient World*, 97–120. Journal of Roman Archaeology Supplementry Series 22. Portsmouth, R. I. Journal of Roman Archaeology.

Nappo, S. C. 1998. *Pompeii, Guide to the Lost City*. London: Weidenfeld & Nicolson.

Nappo, S. C. 2007. Houses of Regions I and II. In J. J. Dobbins and P. W. Foss (eds) *The World of Pompeii*, 347–72. London: Routledge.

Nazzaro, A. 1997. *Il Vesuvio*. Milano: Liguori Editore, S. r. l.

Nenna, M.-D. 1999. *Les Verres*. Exploration Archéologique de Délos Fascicule 37. Paris: École française d'Athènes.

Newby, M. and Painter, K. (eds). *Roman Glass: Two Centuries of Art and Invention*. Society of Antiquaries of London Occasional Paper 13. London: Society of Antiquaries of London.

Niccolini, F. and Niccolini, F. 1854–1896. *Le case ed i monumenti di Pompei disegnati e descritti*. Napoli: sine nomine.

Nilsson, M. 2008. Evidence of Palma Campania settlement at Pompeii. In P. G. Guzzo and M. P. Guidobaldi (eds) *Nuove ricerche archeologiche nell'area vesuviana (scavi 2003-2006). Atti del Convegno Internazionale, Roma 1-3 febbraio 2007*, 81–6. Rome: L'Erma di Bretschneider.

Nissen, H. 1877. *Pompeianische Studien zur Städtkunde des Altertums*. Leipzig: Brietkopf und Härtel.

Oriolo, F. and Verzar-Bass, M. 2010. *Rileggere Pompei 2. L'insula 13 della Regio VI*. Studi della Soprintendenza Archeologica di Pompei, 30. Rome: L'Erma di Bretschneider.

Overbeck, J. 1856. *Pompeji in seinen Gebäuden, Alterhümern und Kunstwerken für Kunst- und Alterhumsfreunde*. Leipzig: W. Engelmann.

Overbeck, J. and Mau, A. 1884. *Pompeji in seinen Gebäuden, Alterthümern und Kunstwerken*. Leipzig: W. Engelmann.

Pace, R. 1997. Il complesso dei Riti Magici a Pompei. *Rivista di Studi Pompeiani* 8: 73–97.

Pagano, M. 1997. *I Diari di Scavo di Pompei, Ercolano e Stabia di Francesco e Pietro La Vega (1764-1810)*. Ministero per I Beni Culturali e Ambientali Soprintendenza Archeologica di Pompei Monografie 13. Rome: L'Erma di Bretschneider.

Pagano, M. and Prisciandaro, R. 2006. *Studio sulle provenienze degli oggetti rinvenuti negli scavi borbonici del Regno di Napoli*. Castellammare di Stabia: N. Longobardi.

Painter, K. S. 2001. *The Insula of the Menander at Pompeii. Volume IV: The Silver Treasure*. Oxford: Clarendon Press.

Pappalardo, U. 2001. *La Descrizione di Pompei per Guiseppe Fiorelli (1875)*. Naples: Massa Editore.

Pardini, G. 2013. *Rinvenimenti monetali a Pompei. Contesti e circolazione*. Unpublished thesis, Università degli studi di Salerno.

Paribeni, R. 1902. *Notizie degli Scavi* 1902: 7, 567.

Parslow, C. C. 1995. *Rediscovering Antiquity. Karl Weber and the Excavation of Herculaneum, Pompeii, and Stabiae*. Cambridge: Cambridge University Press.

Patroni, G. 1902. *Rendiconti Reale Accademia dei Lincei*, 467–507.

Payne, S. 1969. A metrical distinction between sheep and goat metacarpals. In P. J. Ucko and D. W. Dimbleby (eds) *The Domestication and Exploitation of Plants and Animals*, 295–305. London: Duckworth.

Payne, S. 1973. Kill-off patterns in sheep and goats: the mandibles from Asvan Kale. *Anatolian Studies* 23: 281–303.

Payne, S. 1985. Morphological distinctions between the mandibular teeth of young sheep (Ovis) and goats (Capra). *Journal of Archaeological Sciences* 12: 139–47.

Peacock, D. P. S. and Williams, D. F. 1986. *Amphorae and the Roman Economy: an Introductory Guide*. London: Longman.

Peacock, D. P. S. 1989. The mills of Pompeii. *Antiquity* 62: 205–14.

Pearsall, D. M. 2000. *Paleoethnobotany: a Handbook of Procedures* (2nd edition). London: Academic Press.

Pedroni, L. 2008. Pompei, Regio VII, Insula 2, pars occidentalis. Le indagini dell'Institut für Archäologien dell'Universität Innsbruck finanziated dal FWF austriaco. In P. G. Guzzo and M. P. Guidobaldi (eds) *Nuove ricerche archeologiche nell'area vesuviana (scavi 2003-2006). Atti del Convegno Internazionale, Roma 1-3 febbraio 2007*, 237–38. Rome: L'Erma di Bretschneider.

Pensabene, P. 2007. *Ostiensium marmorum decus et decor: studi architettonici, decorativi e archeometrici*. Rome: L'Erma di Bretschneider.

Pensabene, P. 2013. *I marmi nella Roma antica*. Roma: Carocci editore.

Pernice, E. 1926. *Pompeji*. Leipzig: Quelle & Meyer.

Pernice, E. 1938. *Pavimente und figürliche Mosaiken. Die hellenistische Kunst in Pompeji 6*. Berlin: Walter de Gruyter.

Pesando, F. 1997. *Domus: edilizia privata e società pompeiana fra III e I secolo a. C.* Rome: L'Erma di Bretscheider.

Pesando, F. 2005. Il Progetto *Regio VI*: le campagne di scavo 2001-2002 nelle *insulae* 9 e 10. In P. G. Guzzo and M. P. Guidobaldi (eds) *Nuove ricerche archeologiche a Pompei ed Ercolano*, 73–96. Naples: Electa.

Pesando, F. 2008. Casa di età medio-sannitica nella *Regio VI*: tipologia edilizia e apparati decorative. In P. G. Guzzo and M. P. Guidobaldi (eds) *Nuove ricerche archeologiche nell'area vesuviana (scavi 2003-2006). Atti del Convegno Internazionale, Roma 1-3 febbraio 2007*, 159–71. Rome: L'Erma di Bretschneider.

Pesando, F. and Guidobaldi, M. P. 2006. *Pompei, Oplontis, Ercolano, Stabia*, Guide Archeologiche Laterza. Rome: Laterza.

Pescatore, T., Senatore, M. R., Capretto, G. and Lerro, G. 2001. Holocene coastal environments near Pompeii before the A. D. 79 eruption of Mount Vesuvius, Italy. *Quaternary Research* 55: 77–85.

Peterse, K. 1999. *Steinfachwerk in Pompeji: Bautechnik und Architecktur*. Amsterdam: J. C. Gieben.

Peterse, K. 2007. Select residences in Regiones V and IX: early anonymous domestic architecture. In J. J. Dobbins and P. W. Foss (eds) *The World of Pompeii*, 377–88. London: Routledge.

Peterse, K. and De Waele, J. 2005. The standardized design of the Casa degli Scienziati. In S. T. A. M. Mols and E. M. Moormann (eds) *Omni pede stare. Saggi architettonici e circumvesuviani in memoriam Jos de Waele.* Studi della Soprintendenza archeologica di Pompei 9, 197–220. Naples: Electa Napoli and Ministero per i Beni e le Attività Culturali.

Petrianni, A. 2003. *Il Vasellame a Matrice della Prima Età Imperiale, Collezione Gorga Vetri I.* Firenze: All'Insegna del Giglio, Firenze.

Pignatti, S. 2003. *Flora d'Italia.* (reprint of 1982 edition). Bologna: Edagricole.

Pinon, P. and Amprimoz, F.-X. 1988. *Les envois de Rome (1778-1968), architecture et archéologie.* Collection de l'Ecole Française de Rome, 110. Rome. Ecole Française de Rome.

Piranesi, F. and J. Guattani. 1804–1807. *Antiquités de la Grande-Grèce, aujourd' hui royaume de Naples.* Paris: Chez les Piranesi, frères 1804–07.

Pirson, F. 1997. Rented accomodation at Pompeii: the evidence of the *Insula Arriana Polliana* VI 6. In R. Laurence and A. Wallace-Hadrill (eds) *Domestic Space in the Ancient World.* Journal of Roman Archaeology Supplementary Series 22. 165–181. Portsmouth, RI: Journal of Roman Archaeology.

Prummel, W. and Frisch, H.-J. 1986. A guide for the distinction of species, sex and body size in bones of sheep and goat. *Journal of Archaeological Science* 13: 567–77.

Pucci, G., Chirico, E., Salerno, V. and Marri, F. 2008. Le ricerche dell'Università di Siena a Pompei. In P. G. Guzzo and M. P. Guidobaldi (eds) *Nuove ricerche archeologiche nell'area vesuviana (scavi 2003-2006). Atti del Convegno Internazionale, Roma 1-3 febbraio 2007*, 223–36. Rome: L'Erma di Bretschneider.

Purcell, N. 1995. The Roman villa and the landscape of production. In T. Cornell and K. Lomas (eds) *Urban Society in Roman Italy*, 151–79. London: UCL Press.

Ranucci, S. 2008a. Circolazione monetaria a Pompei. La documentazione numismatica dagli scavi dell'università di Perugia. *AIIN* 54: 151–74.

Ranucci, S. 2008b. Moneta straniera a Pompei in età Repubblicana: nuove acquisizioni. In J. Uroz, J. M. Noguera and F. Coaelli. (eds) *Iberia e Italia. Modelos Romanos de Integración territorial*, 249–58. Murcia: Tabularium.

Reinach, S. 1922. *Répertoire de peintures grecques et romaines.* Paris: Leroux.

Renfrew, J. M., Monk, M. and Murphy, M. 1976. *First Aid for Seeds.* Hertford: Rescue Publication.

Richardson, J. E. 1995. Faunal remains. In S. E. Bon, R. F. J. Jones and D. J. Robinson (eds) *Anglo-American Research in Pompeii, 1994. Old World Archaeology Newsletter* XVIII.2: 21–2.

Richardson, J., Thompson, G. and Genovese, A. 1997. New directions in economic and environmental research in Pompeii. In S. E. Bon and R. Jones (eds) *Sequence and Space in Pompeii*, 88–101. Oxbow Monograph 77. Oxford: Oxbow Books.

Richter, G. M. A. 1956. *Metropolitan Museum of Art, New York. Catalogue of the engraved gems, Greek, Etruscan and Roman.* New York: Metropolitian Museum of Art.

Richter, H. G., Grosser, D., Heinz, I. and Gasson, P. E. (eds) 2004. *Iawa List of Microscopic Features for Softwood Identification.* Leiden: International Association of Wood Anatomists at the National Herbarium Nederlands.

Robinson, D. J. 2005. Re-thinking the social organisation of trade and industry in first century AD Pompeii. In A. MacMahon and J. Price (eds) *Roman Working Lives and Urban Living*, 88–107. Oxford: Oxbow Books.

Robinson, D. J. 2017. Wealthy entrapreneurs and the urban economy: Insula VI. i in its wider economic contexts. In M. Flohr and A. Wilson (eds) *The Economy of Pompeii*, 243–62. Oxford: Oxford University Press.

Robinson, M. A. 1979. Plant remains preserved by waterlogging. In G. Lambick and M. Robinson (eds) *Iron Age and Roman Riverside Settlements at Farmoor, Oxfordshire. Report 2.* Council for British Archaeology Research Report 32. Oxford & London: Oxfordshire Archaeological Unit and Council for British Archaeology.

Robinson, M. A. 1999. The macroscopic plant remains. In M. Fulford and A. Wallace-Hadrill. *Towards a History of pre-Roman Pompeii: Excavations Beneath the Casa di Amarantus (I. 9. 11-12).* 95–102, 139–44. Papers of the British School at Rome 67. London: British School at Rome.

Robinson, M. A. 2002. Domestic burnt offerings and sacrifices at Roman and pre-Roman Pompeii, Italy. *Vegetation History and Archaeobotany* 11: 93–9.

Robinson, M. 2008. La stratigrafia nello studio dell'archeologia preistorica e protostorica a Pompei. In P. G. Guzzo and M. P. Guidobaldi (eds) *Nuove ricerche archeologiche nell'area vesuviana (scavi 2003-2006). Atti del Convegno Internazionale, Roma 1-3 febbraio 2007.* 125–38. Rome: L'Erma di Bretschneider.

Robinson, M., Fulford, M. and Tootell, K. 2006. The macroscopic plant remains. In M. Fulford, A. Clarke and H. Eckardt. *Life and Labour in Late Roman Silchester, Excavations in Insula IX since 1997.* Britannia Monograph 22, 206–16. London: Society for the Promotion of Roman Studies.

Robotti, C. 1973. Una sinopia musiva pavimentale a Stabia. *Bollettino d'arte*, 58, 42–4.

Robotti, C. 1983. Una sinopia musiva negli scavi nuovi di Pompei. In R. Ginouvès *Mosaïque: recueil d'hommages à Henri Stern*, 311–14. Paris: Editions Recherches sur les civilisations.

Rochette R. 1867. *Choix de peintures de Pompéi: lithographiées en couleur part M. Roux et publiées avec l'explication archéologique de chaque peinture par M. Raoul-Rochette.* Paris: Adophe Labitte.

Russo, F. and Russo, F. 2005. *89 a. C. Assedio a Pompei.* Pompeii: Flavius.

Rutter, N. K. (ed) 2001. *Historia Numorum. Italy.* London: British Museum Press.

Saint Non, J. C. R. de. 1781–1786. *Voyage pittoresque; ou, Description des royaumes de Naples et de Sicile.* Paris: Imprint de Clousier.

Sakai, S. 2000–2001. La storia sotto il suolo del 79 d. C. Considerazioni sui dati provenienti dalle attività archeologiche svolte sulle fortificazioni di Pompei. *Opuscula Pompeiana* X: 87–100.

Sakai, S. and Iorio, V. 2008. L'indagine del J. I. P. S. nel vicolo di M. Lucrezio Frontone: un'ipotesi sul periodo dell'urbanizzazione della città in relazione agli assi stradali. In P. G. Guzzo and M. P. Guidobaldi (eds) *Nuove ricerche archeologiche nell'area vesuviana (scavi 2003-2006). Atti del Convegno Internazionale, Roma 1-3 febbraio 2007*, 399–408. Rome: L'Erma di Bretschneider.

Saller, R. P. 1982. *Personal Patronage in the Early Empire.* Cambridge: Cambridge University Press.

Scatozza Höricht, L. A. 2012. *L'instrumentum Vitreum di Pompei.* Rome: Aracne editrice.

Schefold, K. 1957. *Die Wände Pompejis: topographisches Verzeichnis der Bildmotive.* Berlin: DeGruyter.

Scheid, J. 1990. *Romulus et ses frères. Le collège des frères Arvales, modèle du culte public romain dans la Rome des empereurs.* Rome: Ecole française de Rome.

Schenk, A. 2008. *Regard sur la tabletterie antique: les objets en os, bois de cerf et ivoire du Musée Romain d'Avenches.* Documents du Musée Romain d'Avenches 15. Avenches: Asssociation Pro Aventico.

Schmid, E. S. 1972. *Atlas of Animal Bones.* Amsterdam: Elsevier.

Schoch, W., Heller, I., Schweingrüber, F. H. and Kienast, F. 2004. *Wood Anatomy of Central European Species.* http://www.woodanatomy.ch/.

Schoonhoven, A. V. 2006. *Metrology and Meaning in Pompeii: the Urban Arrangement of Regio VI.* Rome: L'Erma di Bretschneider.

Schweingrüber, F. H. 1990. *Anatomie europaischer Holzer.* Bern: Paul Haupt.

Sear, F. 1982. *Roman Architecture.* Ithaca, NY: Cornell University Press.

Seiler, F. 1992. *Casa degli Amorini dorati.* Häuser in Pompeji, Band 5. Hirmer: München

Seiler, F., Beste, H., Piraino, C. and Esposito, D. 2005. Le *Regio VI Insula 16* e la zona della Porta Vesuvio. In P. G. Guzzo and M. P. Guidobaldi (eds) *Nuove ricerche archeologiche a Pompei ed Ercolano,* 216–34. Naples: Electa.

Serjeantson, D. 1989. Animal remains and the tanning trade. In D. Serjeantson and T. Waldron (eds) *Diet and Crafts in Towns. The Evidence of Animal Remains from the Roman to the Post-Medieval Periods,* 129–146. British Archaeological Report 199. Oxford: British Archaeological Reports.

Silver, I. A. 1969. The ageing of domestic animals. In D. Brothwell and E. Higgs (eds) *Science in Archaeology,* 283–302. London: Thames and Hudson.

Sim, D. 2003. Roman smithing. In F. Hammer (ed) *Industry in north-west Roman Southwark. Excavations 1984-8,* 131–140. MoLAS Monograph 17. London: Museum of London and English Heritage.

Simoons, F. J. 1994. *Eat Not this Flesh. Food Avoidances from Prehistory to the Present.* Wisconsin: University of Wisconsin Press.

Smith, W. 2002. *A review of archaeological wood analyses in southern England.* In Centre for Archaeology Report 75. Portsmouth: English Heritage.

Stannard, C. 2005. The monetary stock at Pompeii at the turn of the second and first centuries BC: pseudo-Ebusus and pseudo-Massalia. In P. G. Guzzo and M. P. Guidobaldi (eds) *Nuove ricerche archeologiche a Pompei ed Ercolano,* 120–43. Naples: Electa.

Stannard, C. and Frey-Kupper, S. 2008. 'Pseudo-mints' and small change in Italy and Sicily in the late Republic. *American Numismatic Review* (2nd series) 20: 351–404.

Staub Gierow, M. 2008. Some results from the last years' field work in Casa degli Epigrammi Greci (V 1, 18. 11–12). In P. G. Guzzo and M. P. Guidobaldi (eds) *Nuove ricerche archeologiche nell'area vesuviana (scavi 2003-2006). Atti del Convegno Internazionale, Roma 1-3 febbraio 2007,* 93–102. Rome: L'Erma di Bretschneider.

Staub Gierow, M. 1994. *Casa del Granduca. Casa dei Capitelli figurarti.* Häuser in Pompeji, Band 7. Munich: Hirmer.

Staub Gierow, M. 2000. *Casa della Parete nera. Casa delle Forme di creta.* Häuser in Pompeji, Band 10. Munich: Hirmer.

Stefani, G. (ed) 1990. *Uomo e Ambiente nel Territorio Vesuviano.* Pompei: Marius Edizioni.

Stella, M. S. and Laidlaw, A. 2008. Nuovi indagini nella Casa di Sallustio (VI 2, 4). In P. G. Guzzo and M. P. Guidobaldi (eds) *Nuove ricerche archeologiche nell'area vesuviana (scavi 2003-2006). Atti del Convegno Internazionale, Roma 1-3 febbraio 2007,* 147–157. Rome: L'Erma di Bretschneider.

Stella, M. S. and Laidlaw, A. 2014. *The House of Sallust in Pompeii (VI 2, 4).* Journal of Roman Archaeology Supplementary Series 98. Portsmouth, R. I.: Journal of Roman Archaeology.

Stemmer, K. 1993. *Casa dell'Ara massima.* Häuser in Pompeji, Band 6. Munich: Hirmer.

Stephens J. 2008. Ancient Roman hairdressing: on (hair)pins and needles. *Journal of Roman Archaeology* 21: 111–32.

Strocka, V. M. 1984. *Casa del Principe di Napoli.* Häuser in Pompeji, Band 1. Tübingen: Wasmuth.

Strocka, V. M. 1991. *Casa del Labirinto.* Häuser in Pompeji, Band 4. Hirmer: München

Stutz, R. 2005. Bemerkungen zu einigen Mittelbildern des Vierten Stils der Casa del Chirurgo, Pompeji VI 1, 10. In V. M. Stocka, T. Ganschow and M. Steinhart (eds) *Otium: Festschrift für Volker Michael Strocka,* 375–79. Remshalden: B. A. Greiner.

Sutherland, D. 1790. *A Tour up the Straits, from Gibraltar to Constantinople: With the Leading Events in the Present War Between Austrians, Russians, and the Turks, to the Commencement of Year 1789.* London: David Sutherland/J. Johnson.

Syme, R. 1939. *The Roman Revolution.* Oxford. Clarendon Press.

Talbert, J. A. and Bagnal R. S. 2000. *Barrington Atlas of the Greek and Roman World.* Princeton, NJ: Princeton University Press.

Tamm B. 1973. Some notes on Roman houses. *Opuscula Romana* 9: 53–60.

Tamma, G. 1991. *Le Gemme del Museo Archeologico di Bari.* Bari: Edipuglia.

Tang, B. 2006. Towards a typology and terminology of ancient pavements. *AnalRom* 32: 93–104.

Tascone, G. 1879. Sui lavori geodetici e topografici di Pompei. In M. Ruggiero (ed) *Pompei e la regione sotterrata dal Vesuvio nell'anno LXXIX.* Part 2, 1–6. Naples: Franceso Giannini.

Tassinari, S. 1993. *Il vasellame bronzeo di Pompei.* Ministero per i beni culturali ed ambientali soprintendenza archeologica di Pompei Cataloghi 5. Rome: L'Erma di Bretschneider.

Ternite, W. 1839–1858. *Wandgemälde aus Pompeji und Herculanum nach den Zeichnungen und Nchbildungen in Farben: von W. Ternite; mit einem erläuternden text von C. O. Müller.* Berlin: G. Reimer.

Thébert, Y. 1993. Private and public spaces: The components of the domus. In E. D'Ambra (ed) *Roman Art in Context: An Anthology,* 213–37. New Jersey: Prentice Hall.

Thomas, C. 2008. *Sade. Voyage à Naples.* Paris: Éditions Payot & Rivages.

Tornézy, M. A. 1894–1895. Bergeret et Fragonard. Journal inédit d'un voyage en Italie 1773-1774. *Bulletin et Mémoires de la Société des Antiquarers de l'Ouest* XVII.

Turpin de Crissé, L. T. 1828. *Souvenirs du golfe de Naples recueillis en 1808, 1818 et 1824, dédiés à Son Altesse royale Madame, duchesse de Berry.* Paris: Chaillon-Potrelle.

Vairo, M. R., Veal, R. and de Simone, G. F. 2015. L'evidenza per l'economia del legno e legna in Campania: i carboni dal nord Vesuvio del tardo antico. *Rivista di Studi Pompeiani* 24: 71–78.

Van der Veen, M. 2003. When is food a luxury? *World Archaeology* 34: 405–27.

Van Lith, S. M. E. 1991. First century cantheroi with a stemmed foot: their distribution and social context. In M. Newby and K. Painter (eds) *Roman Glass: Two Centuries of Art and Invention,* 99–110. Society of Antiquaries of London Occasional Paper 13. London: Society of Antiquarites of London.

Varone, A. 1995. Più terremoti a Pompei? I nuovi dati degli scavi di Via dell'Abbondanza. In T. Fröhlich and L. Jacobelli (eds) *Archäologie und Seismologie,* 29–35. Munich: Bierung & Brinkmann.

Varone, A. 2008. Per la storia recente, antica e antichissima del sito di Pompei. In P. G. Guzzo and M. P. Guidobaldi (eds) *Nuove*

ricerche archeologiche nell'area vesuviana (scavi 2003-2006). Atti del Convegno Internazionale, Roma 1-3 febbraio 2007, 349–62. Rome: L'Erma di Bretschneider.

Varrone, A. 2003. Il gioco. In G. Stefani (ed) *La Casa del Menandro di Pompei* (Antiquarium di Boscoreale 8 marzo–8 guigno 2003), 192–3. Milan: Mondadori Electa S. p. A.

Vassal, V. 2006. *Les pavements d'opus signinum: technique, décor, fonction architecturale.* Oxford: Archaeopress.

Veal, R. 2009. *The Wood Fuel Supply to Pompeii Third century BC to AD79: An Environmental, Historical and Economic Study Based on Charcoal Analysis.* Unpublished thesis, University of Sydney.

Veal, R. 2012. From context to economy: charcoal as an archaeological interpretative tool, a case study from Pompeii 3rd c. BC to AD 79. In I. Schrufer-Kolb (ed) *More than Just Numbers: The Role of Science in Roman Archaeology.* Journal of Roman Archaeology Supplementary Series 91. Portsmouth, R. I. Journal of Roman Archaeology.

Veal, R. 2014. Pompeii and Its hinterland connection: the fuel consumption of the House of the Vestals, c. third century BC to AD 79. *European Journal of Archaeology* 17.1: 27–44.

Veal, R. and Thompson, G. 2006. Fuel: Preliminary findings Regio VI Insula I, 1994–2006. Unpublished paper presented at the AAPP Pompeii Specialist Conference, Pompeii (NA), Italy, June 2006.

Veal, R. and Thompson, G. 2008. Fuel supplies for Pompeii: Pre-Roman and Roman charcoals of the Casa delle Vestali. In G. Fiorentino and D. Magri (eds) *Charcoals from the Past: Cultural and Palaeoenvironmental Implications. Proceedings of the third International meeting of Anthracology, Cavallino-Leece (Italy), June 28-July first century, 2004.* British Archaeological Report S1807. Oxford: Archaeopress.

Veal, R., O'Donnell, L. and McParland, L. 2016. Reflectance – Current state of research and future directions for archaeological charcoal; Results from a pilot study on Irish Bronze Age cremation charcoals. *Journal of Archaeological Science* 75. 72–81.

Veal, R., O'Donnell, L. and McParland, L. 2011. Measuring burn temperatures from charcoal using the reflectance method, first results from an Irish Bronze Age cremation site. In E. Badal, Y. Carriòn, E. Grau, and M. Macias (eds) *The Charcoal as Cultural and Biological Heritage: 5th International Meeting of Charcoal Analysis, Valencia, Spain September 5th-9th 2011.* València: Universidad de València, Dep. de Prehistòria i Arqueologia.

Verzár Bass, M., Oriolo, F. and Zanini, F. 2008. L'Insula VI, 13 di Pompei alla luce delle recenti indagini. In P. G. Guzzo and M. P. Guidobaldi (eds) *Nuove ricerche archeologiche nell'area vesuviana (scavi 2003-2006). Atti del Convegno Internazionale, Roma 1-3 febbraio 2007,* 189–96. Rome: L'Erma di Bretschneider.

von den Driesch, A. 1976. *A Guide to the Measurement of Animal Bones from Archaeological Sites.* Cambridge, MA: Harvard University.

von Gerkan, A. 1940. *Der Stadtplan von Pompeji.* Berlin: Archäologisches Institut des Deutschen Reiches.

Wallace-Hadrill, A. 1994. *Houses and Society in Pompeii and Herculaneum.* Princeton, NJ: Princeton University Press.

Wallace-Hadrill, A. 1997. Rethinking the Roman atrium house. In R. Laurence and A. Wallace-Hadrill (eds) *Domestic Space in the Ancient World.* Journal of Roman Archaeology Supplementary Series 22, 219–40. Portsmouth, R. I. Journal of Roman Archaeology.

Wallace-Hadrill, A. 2005. Excavation and standing structures in Pompeii Insula I. 9. In P. G. Guzzo and M. P. Guidobaldi (eds) *Nuove ricerche archeologiche a Pompei ed Ercolano,* 101–8. Naples: Electa.

Wallace-Hadrill, A. 2007. The development of the Campanian house. In J. J. Dobbins and P. W. Foss (eds) *The World of Pompeii,* 279–91. London: Routledge.

Walton Rogers, P. 2007. *Cloth and Clothing in Early Anglo-Saxon England.* Council for British Archaeology Research Report 145. York: Council for British Archaeology.

Watson, A. 1998. *The Digest of Justinian.* Philadelphia PA: University of Pennsylvania Press.

Weiss, C. 2010. Determining function of Pompeian sidewalk features through GIS analysis. In B. Frischer, J. W. Crawford, and D. Koller (eds) *Making History Interactive. Computer Applications and Quantitative Methods in Archaeology (CAA). Proceedings of the 37th International Conference, Williamsburg, Virginia, United States of America, March 22-26, 2009,* 363–72. Oxford: Archaeopress.

Wheeler, E. A., Baas, P. and Gasson, P. E. 1989. *IAWA List of Microscopic Features for Hardwood Identification.* Leiden: International Association of Wood Anatomists at the Rijksherbarium.

Wild, J. P. 1970a. Button-and-loop fasteners in the Roman provinces. *Britannia* 1: 137–55.

Wild, J. P. 1970b. *Textile Manufacture in the Northern Roman Provinces.* Cambridge: Cambridge University Press.

Wilkins, H. 1819. *Suite de Vues Pittoresques des Ruines de Pompéi et un précis historique de la ville avec un plan des fouilles qui ont été faites jusqu'en février 1819 et une description des objects les plus intéressants, par Henry Wilkins.* Rome: sine nomine.

Wootton, W. T. 2014. Ancient mosaic techniques and modern conservation: an archaeologist's perspective. In D. Michaelides (ed) *The 10th Conference of the International Committee for the Conservation of Mosaics (ICCM). Conservation: An Act of Discovery (Palermo),* 99–110. Palermo: Regione Siciliana – Assessorato dei Beni Culturali e dell'Identità Siciliana – Dipartimento dei Beni Culturali e dell'Identità Siciliana.

Wootton, W. T. 2015. Figuring out the facts: calculating mosaic labour times in 4th-c. AD Britain. *Journal of Roman Archaeology* 28: 261–82.

Zaccaria Riggiu, A. P. and Maratini, C. 2008. Saggi e ricerche nell'insula 7 della Regio Vi, informatizzazione dei dati, GIS. In P. G. Guzzo and M. P. Guidobaldi (eds) *Nuove ricerche archeologiche nell'area vesuviana (scavi 2003-2006). Atti del Convegno Internazionale, Roma 1-3 febbraio 2007,* 177–88. Rome: L'Erma di Bretschneider.

Zahn, W. 1828–1859. *Die schönsten Ornamente und merkwürdigsten Gamälde aus Pompeji, Herculanum und Stabiae.* Berlin: Georg Reimer.

Zanella, S., Cavassa, L., Laubry, N., Monteix, N., Chapelin, G., Coutelas, A., Delvigne Ryrko, A., Errera M., Gerardin, L., Lemaire, B., Macario, R., Ortis, F., Pellegrino, V. and Sachau-Carcel, G. 2017. Pompéi, Porta Ercolano: organisation, gestion et transformations d'une zone suburbaine Campagne 2016 http://cefr.revues.org/1676§32.

Zanker, P. 1998. *Pompeii: Public and Private Life.* Translated by D. L. Schneider. Cambridge, MA: Harvard University Press.

Zevi, F. 1981. La storia degli scavi e della documentazione. In Istituto centrale per il catalogo e la documentazione and Il Ministero per i beni culturali e ambientali. *Pompeii 1748-1980, I tempi della documentazionem,* 11–21. Rome: Multigrafica Editrice.

Zevi, F. 1996. Pompei dalla città sannitica alla colonia sillana: per un'interpretazione dei dati archeologici. In *Les élites municipales de l'Italie péninsulaire des gracques á Néron (Actes de la table ronde internationale de Clermond-Ferrand, 1991),* 125–38. Rome: École française de Rome.

INDEX